GARDNER'S

ART

AGES

THE WESTERN PERSPECTIVE

THIRTEENTH EDITION

Volume II

FRED S. KLEINER

Gardner's Art through the Ages: The Western Perspective, Thirteenth Edition, Vol. II Fred S. Kleiner

Publisher: Clark Baxter

Senior Development Editor: Sharon Adams Poore

Assistant Editor: Kimberly Apfelbaum

Editorial Assistant: Nell Pepper

Senior Media Editor: Wendy Constantine

Senior Marketing Manager: Diane Wenckebach

Marketing Communications Manager: Heather Baxley

Senior Project Manager, Editorial Production: Lianne Ames

Senior Art Director: Cate Rikard Barr

Senior Print Buyer: Judy Inouye

Production Service/Layout: Joan Keyes,

Dovetail Publishing Services

Text Designer: tani hasegawa

Photo Researchers: Sarah Evertson, Stephen Forsling

Cover Designer: tani hasegawa

Cover Image: ÉDOUARD MANET, Claude Monet and His Wife

in His Floating Studio. © The Gallery Collection. Corbis.

Compositor: Thompson Type

© 2010, 2006 Wadsworth, Cengage Learning

ALL RIGHTS RESERVED. No part of this work covered by the copyright herein may be reproduced, transmitted, stored, or used in any form or by any means graphic, electronic, or mechanical, including but not limited to photocopying, recording, scanning, digitizing, taping, Web distribution, information networks, or information storage and retrieval systems, except as permitted under Section 107 or 108 of the 1976 United States Copyright Act, without the prior written permission of the publisher.

For product information and technology assistance, contact us at Cengage Learning Academic Resource Center, 1-800-423-0563

For permission to use material from this text or product, submit all requests online at www.cengage.com/permissions.

Further permissions questions can be emailed to permissionrequest@cengage.com

Library of Congress Control Number: 2008936368

Student Edition ISBN-13: 978-0-495-57364-7 ISBN-10: 0-495-57364-7

Wadsworth

25 Thomson Place Boston, MA 02210-1202 USA

Cengage Learning products are represented in Canada by Nelson Education, Ltd.

For your course and learning solutions, visit academic.cengage.com

Purchase any of our products at your local college store or at our preferred online store **www.ichapters.com**

About the Cover Art

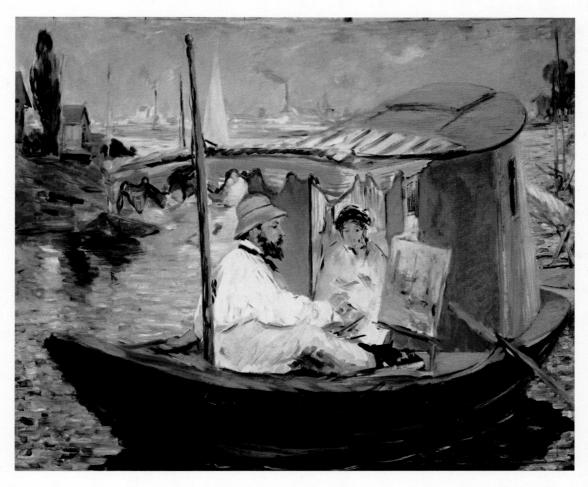

ÉDOUARD MANET, Claude Monet in His Studio Boat, 1874. Oil on canvas, 2' $8'' \times 3'$ $3\frac{1}{4}''$. Neue Pinkothek, Munich.

In a famous 1860 essay entitled "The Painter of Modern Life, the French poet and critic Charles Beaude-laire (1821–1867) argued that "modernity is the transitory, the fugitive, the contingent." That definition well describes the work of the Impressionists, especially Claude Monet (1840–1926), represented here in a painting by Édouard Manet (1832–1883), seated in his floating studio on the Seine River at Argenteuil in 1874. Monet's paintings of Parisians at leisure and of the industrialization of 19th-century France stand in forceful opposition to that era's government-sponsored academic art featuring traditional religious, historical, and mythological subjects and highly polished technique. In contrast, Monet painted the people and places around him, and he did so outdoors (*en plein air*) directly on white canvases without any preliminary sketches and using short, clearly visible brush strokes. The canvas that he is painting characteristically has as its subject sailboats on the Seine and, in the distance, the factories and smokestacks of Argenteuil, but Monet was equally interestsed in the reflection of light on water at different times of day.

Monet, unlike many of his contemporaries, lived long enough to enjoy international acclaim, but for most of the history or art, artists toiled in anonymity in the services of their patrons, whether Egyptian pharaohs, Roman emperors, or medievel monks. *Art through the Ages* surveys the art of all periods from prehistory to the present and examines how artworks of all kinds, anonymous and signed, have always reflected the historical contexts in which they were created.

CONTENTS

PREFACE vii BEFORE 1300 xiii

INTRODUCTION WHAT IS ART HISTORY? xxv

Art History in the 21st Century xxvi

Different Ways of Seeing xxxvi

CHAPTER 14

ITALY, 1200 TO 1400 375

The 13th Century 375

The 14th Century 380

- ART AND SOCIETY: Italian Artists' Names 376
- RELIGION AND MYTHOLOGY: The Great Schism, Mendicant Orders, and Confraternities 379
- MATERIALS AND TECHNIQUES: Fresco Painting 382
- WRITTEN SOURCES: Artists' Guilds, Commissions, and Contracts 384
- ART AND SOCIETY: Artistic Training in Renaissance Italy 388

THE BIG PICTURE 395

CHAPTER 15

NORTHERN EUROPE, 1400 TO 1500 397

Burgundy and Flanders 397

France 410

Holy Roman Empire 412

- MATERIALS AND TECHNIQUES: Tempera and Oil Painting 401
- MATERIALS AND TECHNIQUES: Framed Paintings 404
- ART AND SOCIETY: The Artist's Profession in Flanders 406

MATERIALS AND TECHNIQUES: Woodcuts, Engravings, and Etchings 415

THE BIG PICTURE 417

CHAPTER 16

ITALY, 1400 TO 1500 419

Florence 420

The Princely Courts 446

- MATERIALS AND TECHNIQUES: Renaissance Perspectival Systems 425
- ARTISTS ON ART: Cennino Cennini on Imitation and Emulation in Renaissance Art 431
- ART AND SOCIETY: Renaissance Family Chapel Endowments 442
- ART AND SOCIETY: Italian Princely Courts and Artistic Patronage 447

THE BIG PICTURE 455

CHAPTER 17

ITALY, 1500 TO 1600 457

High and Late Renaissance 457

Mannerism 490

- MATERIALS AND TECHNIQUES: Renaissance Drawings 459
- ARTISTS ON ART: Leonardo and Michelangelo on Painting versus Sculpture 466
- MATERIALS AND TECHNIQUES: Restoring Renaissance Paintings 473
- WRITTEN SOURCES: Religious Art in Counter-Reformation Italy 474
- ARTISTS ON ART: Palma il Giovane on Titian 487
- ART AND SOCIETY: Women in the Renaissance Art World 489

THE BIG PICTURE 501

CHAPTER 18

NORTHERN EUROPE AND SPAIN, 1500 TO 1600 503

Holy Roman Empire 504

France 512

The Netherlands 515

Spain 521

RELIGION AND MYTHOLOGY: Catholic and Protestant Views of Salvation 509

■ ART AND SOCIETY: Protestantism and Iconoclasm 510

THE BIG PICTURE 525

CHAPTER 19

ITALY AND SPAIN, 1600 TO 1700 527

Italy 527

Spain 543

- WRITTEN SOURCES: Giovanni Pietro Bellori on Annibale Carracci and Caravaggio 538
- ARTISTS ON ART: The Letters of Artemisia Gentileschi 540
- ART AND SOCIETY: Velázquez and Philip IV 546

THE BIG PICTURE 549

CHAPTER 20

NORTHERN EUROPE, 1600 TO 1700 551

Flanders 552

Dutch Republic 557

France 569

England 579

- ARTISTS ON ART: Rubens on Consequences of War 555
- ART AND SOCIETY: Middle-Class Patronage and the Art Market in the Dutch Republic 558
- ARTISTS ON ART: Poussin's Notes for a Treatise on Painting 570

THE BIG PICTURE 581

CHAPTER 21

EUROPE AND AMERICA, 1700 TO 1800 583

Rococo 583

The Enlightenment 589

Neoclassicism 598

- WRITTEN SOURCES: Femmes Savantes and Salon Culture 585
- WRITTEN SOURCES: Diderot on Chardin 592
- ART AND SOCIETY: The Grand Tour and Veduta Painting 597
- ART AND SOCIETY: The Excavations of Herculaneum and Pompeii 598
- ARTISTS ON ART: David on Greek Style and Public Art 600

THE BIG PICTURE 607

CHAPTER 22

EUROPE AND AMERICA, 1800 TO 1870 609

Art under Napoleon 609

Romanticism 616

Realism 630

Architecture 642

Photography 647

- ART AND SOCIETY: The Romantic Spirit in Art, Music, and Literature 622
- ARTISTS ON ART: Delacroix in Morocco 624
- ARTISTS ON ART: Courbet on Realism 631
- MATERIALS AND TECHNIQUES: Lithography 633
- MATERIALS AND TECHNIQUES: Daguerreotype, Calotype, and Wet-Plate Photography 646

THE BIG PICTURE 651

CHAPTER 23 EUROPE AND AMERICA, 1870 TO 1900 653

Impressionism 654

Post-Impressionism 663

Symbolism 670

Sculpture 675

Architecture and Decorative Arts 678

- ART AND SOCIETY: Academic Salons and Independent Art Exhibitions 655
- ARTISTS ON ART: Renoir on the Art of Painting 659
- ART AND SOCIETY: Japonisme 661
- MATERIALS AND TECHNIQUES: 19th-Century Color Theory 664
- ARTISTS ON ART: The Letters of Vincent van Gogh 666
- ARTISTS ON ART: Rodin on Movement in Art and Photography 677

THE BIG PICTURE 683

CHAPTER 24

EUROPE AND AMERICA, 1900 TO 1945 685

Europe, 1900 to 1920 686

America, 1900 to 1930 708

Europe, 1920 to 1945 716

America, 1930 to 1945 729

Architecture 736

- ARTISTS ON ART: Matisse on Color 688
- ART AND SOCIETY: Science and Art in the Early 20th Century 691
- ART AND SOCIETY: Gertrude and Leo Stein and the Avant-Garde 694
- ART AND SOCIETY: Primitivism and Colonialism 696
- ARTISTS ON ART: Picasso on Cubism 700
- ARTISTS ON ART: Futurist Manifestos 703
- ART AND SOCIETY: Art "Matronage" in America 709
- ART AND SOCIETY: The Armory Show 710
- ART AND SOCIETY: Degenerate Art 721
- ARTISTS ON ART: Brancusi, Hepworth, and Moore on Abstract Sculpture 727
- ART AND SOCIETY: The Museum of Modern Art and the Avant-Garde 730
- ARTISTS ON ART: Rivera on Art for the People 735

THE BIG PICTURE 743

CHAPTER 25 EUROPE AND AMERICA AFTER 1945 745

Painting and Sculpture, 1945 to 1970 746

Painting and Sculpture since 1970 763

Architecture and Site-Specific Art 778

Performance and Conceptual Art and New Media 793

- ARTISTS ON ART: Jackson Pollock on Easel and Mural Painting 749
- ARTISTS ON ART: Helen Frankenthaler on Color-Field Painting 753
- ARTISTS ON ART: David Smith on Outdoor Sculpture 754
- ARTISTS ON ART: Donald Judd on Sculpture and Industrial Materials 755
- ARTISTS ON ART: Roy Lichtenstein on Pop Art 759
- ARTISTS ON ART: Chuck Close on Portrait Painting and Photography 762
- ARTISTS ON ART: Judy Chicago on The Dinner Party 766
- ART AND SOCIETY: Public Funding of Controversial Art 772
- ART AND SOCIETY: Maya Lin's Vietnam Veterans Memorial 783
- ARTISTS ON ART: Philip Johnson on Postmodern Architecture 785
- ARTISTS ON ART: Frank Gehry on Architectural Design and Materials 788
- ART AND SOCIETY: Richard Serra's Tilted Arc 792
- ARTISTS ON ART: Carolee Schneemann on Painting, Performance Art, and Art History 794

THE BIG PICTURE 801

NOTES 802

GLOSSARY 805

BIBLIOGRAPHY 813

CREDITS 820

INDEX 823

PREFACE

When Helen Gardner published the first edition of *Art through* the Ages in 1926, she could not have imagined that more than 80 years later instructors all over the world would still be using her textbook in their classrooms. Indeed, if she were alive today, she would not recognize the book that long ago became—and remains—the most widely read introduction to the history of art and architecture in the English language. During the past half century, successive authors have constantly reinvented Helen Gardner's groundbreaking survey, always keeping it fresh and current, and setting an ever-higher standard in both content and publication quality with each new edition. I hope both professors and students will agree that this 13th edition lives up to that venerable tradition.

Certainly, this latest edition offers much that is fresh and new (enumerated below), but some things have not changed, including the fundamental belief that guided Helen Gardner—namely, that the primary goal of an introductory art history textbook should be to foster an appreciation and understanding of historically significant works of art of all kinds from all periods. Because of the longevity and diversity of the history of art, it is tempting to assign responsibility for telling its story to a large team of specialists. The Gardner publishers themselves took this approach for the first edition they produced after Helen Gardner's death, and it has now become the norm for introductory art history surveys. But students overwhelmingly say that the very complexity of the history of art makes it all the more important for the story to be told with a consistent voice if they are to master so much diverse material. I think Helen Gardner would be pleased to know that this new edition of Art through the Ages once again has a single storyteller.

Along with the late Richard Tansey and my more recent collaborator, Christin Mamiya, with whom I had the honor and pleasure of working on the 10th, 11th, and 12th editions, I continue to believe that the most effective way to tell the story of art through the ages, especially to someone studying art history for the first time, is to organize the vast array of artistic monuments according to the civilizations that produced them and to consider each work in roughly chronological order. This approach has not merely stood the test of time. It is the most appropriate way to narrate the *history* of art. The principle that underlies my approach to every period of art history is that the enormous variation in the form and meaning of the paintings, sculptures, buildings, and other artworks men and women have produced over the past 30,000 years is largely the result of the constantly changing contexts in which artists and architects worked. A historically based

narrative is therefore best suited for a comprehensive history of art because it permits the author to situate each work discussed in its historical, social, economic, religious, and cultural context. That is, after all, what distinguishes art history from art appreciation.

In the first (1926) edition of Art through the Ages, Helen Gardner discussed Henri Matisse and Pablo Picasso in a chapter entitled "Contemporary Art in Europe and America." Since then many other artists have emerged on the international scene, and the story of art through the ages has grown longer and even more complex. More important, perhaps, the discipline of art history has changed markedly in recent decades, and so too has Helen Gardner's book. The 13th edition fully reflects the latest art historical research emphases while maintaining the traditional strengths that have made previous editions of Art through the Ages so popular. While sustaining attention to style, chronology, iconography, and technique, I also ensure that issues of patronage, function, and context loom large in every chapter. I treat artworks not as isolated objects in sterile 21stcentury museum settings but with a view toward their purpose and meaning in the society that produced them at the time they were produced. I examine not only the role of the artist or architect in the creation of a work of art or a building, but also the role of the individuals or groups who paid the artists and influenced the shape the monuments took. Further, I devote more space than previously to the role of women and women artists in diverse societies over time. In every chapter, I have tried to choose artworks and buildings that reflect the increasingly wide range of interests of scholars today, while not rejecting the traditional list of "great" works or the very notion of a "canon." Consequently, the selection of works in this edition encompasses every artistic medium and almost every era and culture in the Western world, and includes many works that until recently art historians would not have considered to be "art" at all.

The 12th edition of *Art through the Ages* was the number-one choice for art history survey courses and the best-selling version of the book in its long history, and for this 13th edition I have retained all of the features that made its predecessor so successful. Once again, this edition, which contains 25 chapters on the Western tradition and its roots in the ancient Near East and Egypt, plus a chapter on Islamic art and architecture, boasts roughly 1,100 photographs, plans, and drawings, virtually all in color and reproduced according to the highest standards of clarity and color fidelity. The 13th edition, however, also features hundreds of new or upgraded photos by a host of new photographers as well as redesigned maps and plans

and an extraordinary new set of architectural drawings prepared exclusively for *Art through the Ages* by John Burge.

The captions to the illustrations in this edition of Art through the Ages, as before, contain a wealth of information, including the name of the artist or architect, if known; the formal title (printed in italics), if assigned, description of the work, or name of the building; the provenance or place of production of the object or location of the building; the date; the material(s) used; the size; and the current location if the work is in a museum or private collection. As in previous editions, scales accompany all plans, but for the first time scales now also appear next to each photograph of a painting, statue, or other artwork. The works illustrated vary enormously in size, from colossal sculptures carved into mountain cliffs and paintings that cover entire walls or ceilings to tiny figurines, coins, and jewelry that one can hold in the hand. Although the captions contain the pertinent dimensions, it is hard for students who have never seen the paintings or statues in person to translate those dimensions into an appreciation of the real size of the objects. The new scales provide an effective and direct way to visualize how big or how small a given artwork is and its relative size compared with other objects in the same chapter and throughout the book.

Also new to this edition are the Quick-Review Captions that students found so useful when these were introduced in 2006 in the first edition of Art through the Ages: A Concise History. These brief synopses of the most significant aspects of each artwork or building illustrated accompany the captions to all images in the book. They have proved invaluable to students preparing for examinations in onesemester art history survey courses, and I am confident they will be equally useful to students enrolled in yearlong courses. In the 13th edition, however, I have provided two additional tools to aid students in reviewing and mastering the material. Each chapter now ends with a full-page feature called The Big Picture, which sets forth in bulletpoint format the most important characteristics of each period or artistic movement discussed in the chapter. Small illustrations of characteristic works discussed accompany the summary of major points. Finally, I have attempted to tie all of the chapters together by providing with each copy of Art through the Ages a poster-size Global Timeline. This too features illustrations of key monuments of each age and geographical area as well as a brief enumeration of the most important art historical developments during that period. The timeline is global in scope to permit students in Western art courses to place developments in Europe and America in a worldwide context. The poster has four major horizontal bands corresponding to Europe, the Americas, Asia, and Africa, and 34 vertical columns for the successive chronological periods from 30,000 BCE to the present.

Another pedagogical tool not found in any other introductory art history textbook is the *Before 1300* section that appears at the beginning of the second volume of the paperbound version of the 13th edition. Because many students taking the second half of a yearlong survey course will not have access to volume one, I have provided a special set of concise primers on religion and mythology and on architectural terminology and construction methods in the ancient and medieval worlds—information that is essential for understanding the history of Western art after 1300. The subjects of these special boxes are The Gods and Goddesses of Mount Olympus; The Life of Jesus in Art; Greco-Roman Temple Design and the Classical Orders; Arches and Vaults; and Medieval Church Design.

Boxed essays once again appear throughout the book as well. This popular feature first appeared in the 11th edition of *Art through the Ages*, which won both the Texty and McGuffey Prizes of the Text and Academic Authors Association for the best college textbook of 2001 in the humanities and social sciences. In this edition the essays are

more closely tied to the main text than ever before. Consistent with that greater integration, most boxes now incorporate photographs of important artworks discussed in the text proper that also illustrate the theme treated in the boxed essays. These essays fall under six broad categories, one of which is new to the 13th edition.

Architectural Basics boxes provide students with a sound foundation for the understanding of architecture. These discussions are concise explanations, with drawings and diagrams, of the major aspects of design and construction. The information included is essential to an understanding of architectural technology and terminology. The boxes address questions of how and why various forms developed, the problems architects confronted, and the solutions they used to resolve them. Topics discussed include how the Egyptians built the pyramids, the orders of classical architecture, Roman concrete construction, and the design and terminology of mosques and Gothic cathedrals.

Materials and Techniques essays explain the various media artists employed from prehistoric to modern times. Since materials and techniques often influence the character of artworks, these discussions contain essential information on why many monuments appear as they do. Hollow-casting bronze statues; fresco painting; Islamic tile work; embroidery and tapestry; perspective; engraving, etching, and lithography; and daguerreotype and calotype photography are among the many subjects treated.

Religion and Mythology boxes introduce students to the principal elements of great religions, past and present, and to the representation of religious and mythological themes in painting and sculpture of all periods and places. These discussions of belief systems and iconography give readers a richer understanding of some of the greatest artworks ever created. The topics include the gods and goddesses of Egypt, Mesopotamia, Greece, and Rome; the life of Jesus in art; and Muhammad and Islam.

Art and Society essays treat the historical, social, political, cultural, and religious context of art and architecture. In some instances, specific monuments are the basis for a discussion of broader themes, as when the Hegeso stele serves as the springboard for an exploration of the role of women in ancient Greek society. Another essay discusses how people's evaluation today of artworks can differ from those of the society that produced them by examining the problems created by the contemporary market for undocumented archaeological finds. Other subjects include Egyptian mummification, Etruscan women, Byzantine icons and iconoclasm, artistic training in Renaissance Italy, 19th-century academic salons and independent art exhibitions, and public funding of controversial art.

Written Sources present and discuss key historical documents illuminating important monuments of art and architecture throughout the Western world. The passages quoted permit voices from the past to speak directly to the reader, providing vivid and unique insights into the creation of artworks in all media. Examples include Bernard of Clairvaux's treatise on sculpture in medieval churches, Giovanni Pietro Bellori's biographies of Annibale Carracci and Caravaggio, Jean François Marmontel's account of 18th-century salon culture, as well as texts that bring the past to life, such as eyewitness accounts of the volcanic eruption that buried Roman Pompeii and of the fire that destroyed Canterbury Cathedral in medieval England.

A new category is *Artists on Art* in which artists and architects throughout history discuss both their theories and individual works. Examples include Sinan the Great discussing the mosque he designed for Selim II, Leonardo da Vinci and Michelangelo debating the relative merits of painting and sculpture, Artemisia Gentileschi talking about the special problems she confronted as a woman artist, Jacques-Louis David on Neoclassicism, Gustave Courbet on Realism, Henri

Matisse on color, Pablo Picasso on Cubism, Diego Rivera on art for the people, and Judy Chicago on her seminal work *The Dinner Party*.

Instructors familiar with previous editions of Art through the Ages will also find that many of the chapters in the 13th edition have been reorganized, especially in volume two. For example, the treatment of European 17th-century art now appears in two discrete chapters, one devoted to Baroque Italy and Spain, the other to Northern Europe. A single chapter is devoted to the 18th century, another to the period from 1800 to 1870, and a third to 1870 to 1900. In addition, in recognition that different instructors at different colleges and universities end the first semester and begin the second semester at different points, for the first time both volumes of Art through the Ages include Chapter 14 on Italian art from 1200 to 1400. And The Western Perspective is now also available in a special backpack edition consisting of four, rather than the traditional two, paperback volumes: Book A (Antiquity: chapters 1–7), Book B (The Middle Ages: chapters 8–14), Book C (Renaissance and Baroque: chapters 14-20), and Book D (Modern Europe and America: chapters 21-25). These books can also be purchased separately.

Rounding out the features in the book itself is a Glossary containing definitions of all terms introduced in the text in italics and a Bibliography of books in English, including both general works and a chapter-by-chapter list of more focused studies. In this edition I have also taken care to italicize and define in the text all Glossary terms that appear in volume two even if they have been used and defined in volume one, because many students enrolled in the second semester of a yearlong course will not have taken the first semester and will not be familiar with those terms.

The 13th edition of *Art through the Ages* is not, however, a standalone text, but one element of a complete package of learning tools. In addition to the Global Timeline, every new copy of the book comes with a password to *ArtStudy Online*, a web site with access to a host of multimedia resources that students can employ throughout the entire course, including image flashcards, tutorial quizzes, podcasts, vocabulary, and more. Instructors have access to a host of teaching materials, including digital images with zoom capabilities, video, and Google Earth™ coordinates.

A work as extensive as this history of art could not be undertaken or completed without the counsel of experts in all areas of Western art. As with previous editions, the publisher has enlisted more than a hundred art historians to review every chapter in order to ensure that the text lived up to the Gardner reputation for accuracy as well as readability. I take great pleasure in acknowledging here the invaluable contributions to the 13th edition of Art through the Ages: The Western Perspective made by the following for their critiques of various chapters: Charles M. Adelman, University of Northern Iowa; Kirk Ambrose, University of Colorado-Boulder; Susan Ashbrook, Art Institute of Boston; Zainab Bahrani, Columbia University; Susan Bakewell, University of Texas-Austin; James J. Bloom, Florida State University; Suzaan Boettger, Bergen Community College; Colleen Bolton, Mohawk Valley Community College; Angi Elsea Bourgeois, Mississippi State University; Kimberly Bowes, Fordham University; Elizabeth Bredrup, St. Christopher's School; Lawrence E. Butler, George Mason University; Alexandra Carpino, Northern Arizona University; Jane Carroll, Dartmouth College; Hipolito Rafael Chacon, The University of Montana; Catherine M. Chastain, North Georgia College & State University; Violaine Chauvet, Johns Hopkins University; Daniel Connolly, Augustana College; Michael A. Coronel, University of Northern Colorado; Nicole Cox, Rochester Institute of Technology; Jodi Cranston, Boston University; Giovanna De Appolonia, Boston University; Marion de Koning, Grossmont College; John J. Dobbins, University of Virginia; Erika Doss, University of Colorado-Boulder;

B. Underwood DuRette, Thomas Nelson Community College; Lisa Farber, Pace University; James Farmer, Virginia Commonwealth University; Sheila ffolliott, George Mason University; Ferdinanda Florence, Solano Community College; William B. Folkestad, Central Washington University; Jeffery Fontana, Austin College; Mitchell Frank, Carleton University; Sara L. French, Wells College; Norman P. Gambill, South Dakota State University; Elise Goodman, University of Cincinnati; Kim T. Grant, University of Southern Maine; Elizabeth ten Grotenhuis, Silk Road Project; Sandra C. Haynes, Pasadena City College; Valerie Hedquist, The University of Montana; Susan Hellman, Northern Virginia Community College; Marian J. Hollinger, Fairmont State University; Cheryl Hughes, Alta High School; Heidrun Hultgren, Kent State University; Joseph M. Hutchinson, Texas A&M University; Julie M. Johnson, Utah State University; Sandra L. Johnson, Citrus College; Deborah Kahn, Boston University; Fusae Kanda, Harvard University; Catherine Karkov, Miami University; Wendy Katz, University of Nebraska-Lincoln; Nita Kehoe-Gadway, Central Wyoming College; Nancy L. Kelker, Middle Tennessee State University; Cathie Kelly, University of Nevada-Las Vegas; Katie Kempton, Ohio University; John F. Kenfield, Rutgers University; Herbert L. Kessler, Johns Hopkins University; Monica Kjellman-Chapin, Emporia State University; Ellen Konowitz, State University of New York-New Paltz; Kathryn E. Kramer, State University of New York-Cortland; Carol Krinsky, New York University; Lydia Lehr, Atlantic Cape Community College; Krist Lien, Shelton State Community College; Ellen Longsworth, Merrimack College; David A. Ludley, Clayton State University; Henry Luttikhuizen, Calvin College; Christina Maranci, University of Wisconsin-Milwaukee; Dominic Marner, University of Guelph; Jack Brent Maxwell, Blinn College; Anne McClanan, Portland State University; Brian McConnell, Florida Atlantic University; Heather McPherson, University of Alabama-Birmingham; Cynthia Millis, Houston Community College-Southwest; Cynthia Taylor Mills, Brookhaven College; Keith N. Morgan, Boston University; Johanna D. Movassat, San Jose State University; Helen Nagy, University of Puget Sound; Heidi Nickisher, Rochester Institute of Technology; Bonnie Noble, University of North Carolina-Charlotte; Abigail Noonan, Rochester Institute of Technology; Marjorie Och, University of Mary Washington; Karen Michelle O'Day, University of Wisconsin-Eau Claire; Edward J. Olszewski, Case Western Reserve University; Allison Lee Palmer, University of Oklahoma; Martin Patrick, Illinois State University; Glenn Peers, University of Texas-Austin; Jane Peters, University of Kentucky; Julie Anne Plax, University of Arizona; Frances Pohl, Pomona College; Virginia C. Raguin, College of the Holy Cross; Donna Karen Reid, Chemeketa Community College; Albert W. Reischuch, Kent State University; Jonathan Ribner, Boston University; Cynthea Riesenberg, Washington Latin School; James G. Rogers Jr., Florida Southern College; Carey Rote, Texas A&M University-Corpus Christi; David J. Roxburgh, Harvard University; Conrad Rudolph, University of California-Riverside; Catherine B. Scallen, Case Western Reserve University; Denise Schmandt-Besserat, University of Texas-Austin; Natasha Seaman, Berklee College of Music; Malia E. Serrano, Grossmont College; Laura Sommer, Daemen College; Natasha Staller, Amherst College; Nancy Steele-Hamme, Midwestern State University; Andrew Stewart, University of California-Berkeley; Francesca Tronchin, Ohio State University; Frances Van Keuren, University of Georgia; Kelly Wacker, University of Montevallo; Carolynne Whitefeather, Utica College; Nancy L. Wicker, University of Mississippi; Alastair Wright, Princeton University; John G. Younger, University of Kansas; Michael Zell, Boston University.

I am also happy to have this opportunity to express my gratitude to the extraordinary group of people at Wadsworth involved with the editing, production, and distribution of *Art through the Ages*. Some of them I have now worked with on various projects for more than a decade and feel privileged to count among my friends. The success of the Gardner series in all of its various permutations depends in no small part on the expertise and unflagging commitment of these dedicated professionals: Sean Wakely, executive vice president, Cengage Arts and Sciences; P. J. Boardman, vice president, editor-in-chief of Cengage Learning Arts and Sciences; Clark Baxter, publisher; Sharon Adams Poore, senior development editor; Helen Triller-Yambert, development editor; Lianne Ames, senior content project manager; Wendy Constantine, senior media editor; Kimberly Apfelbaum, assistant editor; Nell Pepper, editorial assistant; Cate Rikard Barr, senior art director; Scott Stewart, vice president managing director sales; Diane Wenckebach, senior marketing manager; as well as Kim Adams, Heather Baxley, William Christy, Doug Easton, tani hasegawa, Cara Murphy, Ellen Pettengell, Kathryn Stewart, and Joy Westberg.

I am also deeply grateful to the following for their significant contributions to the 13th edition of *Art through the Ages:* Joan Keyes, Dovetail Publishing Services; Ida May Norton, copy editor; Sarah

Evertson and Stephen Forsling, photo researchers; Pete Shanks and Jon Peck, accuracy readers; Pat Lewis, proofreader; John Pierce, Thompson Type; Rick Stanley, Digital Media Inc., U.S.A; Don Larson, Mapping Specialists; Anne Draus, Scratchgravel; Cindy Geiss, Graphic World; and, of course, John Burge, for his superb architectural drawings. I also wish to acknowledge my debt to Edward Tufte for an illuminating afternoon spent discussing publication design and production issues and for his invaluable contribution to the creation of the scales that accompany all reproductions of paintings, sculptures, and other artworks in this edition.

Finally, I owe thanks to my colleagues at Boston University and to the thousands of students and the scores of teaching fellows in my art history courses during the past three decades. From them I have learned much that has helped determine the form and content of *Art through the Ages* and made it a much better book than it otherwise might have been.

Fred S. Kleiner

About the Author

FRED S. KLEINER (Ph.D., Columbia University) is the co-author of the 10th, 11th, and 12th editions of *Art through the Ages* and more than a hundred publications on Greek and Roman art and architecture, including *A History of Roman Art*, also published by Wadsworth. He has taught the art history survey course for more than three decades, first at the University of Virginia and, since 1978, at Boston University, where he is currently Professor of Art History and Archaeology and Chair of the Art History Department. Long recognized for his inspiring lectures and devotion to students, Professor Kleiner won Boston University's Metcalf Award for Excellence in Teaching as well as the College Prize for Undergraduate Advising in the Humanities in 2002 and is a two-time winner of the Distinguished Teaching Prize in the College of Arts and Sciences Honors Program. He was Editor-in-Chief of the *American Journal of Archaeology* from 1985 to 1998.

Also by Fred Kleiner: *A History of Roman Art* (Wadsworth 2007; ISBN 0534638465), winner of the 2007 Texty Prize as the best new college textbook in the humanities and social sciences. In this authoritative and lavishly illustrated volume, Professor Kleiner traces the development of Roman art and architecture from Romulus' foundation of Rome in the eighth century BCE to the death of Constantine in the fourth century CE, with special chapters devoted to Pompeii and Herculaneum, Ostia, funerary and provincial art and architecture, and the earliest Christian art.

RESOURCES

FOR FACULTY

PowerLecture with Digital Image Library and JoinIn™ on Turning Point®

ISBN 0495792888

Bring digital images into the classroom with this one-stop lecture and class presentation tool that makes it easy to assemble, edit, and present customized lectures for your course using Microsoft Power-Point™. Available on the PowerLecture DVD, the Digital Image Library provides high-resolution images (maps, illustrations, and fine art images from the text) for lecture presentations, either in an easyto-use PowerPoint presentation format, or in individual file formats compatible with other image-viewing software. The zoom feature allows you to magnify selected portions of an image for more detailed display, and another setting enables you to show images side by side for purposes of comparison. You can readily customize your classroom presentation by adding your personal visuals to those from the text. The PowerLecture also includes Google™Earth coordinates that allow you to zoom in on an entire city, as well as key monuments and buildings within it. Also included are panoramic video clips of architectural landmarks in New York City discussed in the text. Using a navigation bar on the video, you can move around the structure and zoom in/out, and right/left, to add a three-dimensional experience to your presentation.

This PowerLecture DVD also includes a Resource Integration Guide, an electronic Instructor's Manual, and a Test Bank with multiple-choice, matching, short-answer, and essay questions in ExamView® computerized format.

Text-specific Microsoft PowerPoint slides have been created for use with $JoinIn^{TM}$ software for classroom personal response systems ("clickers").

WebTutor on Blackboard or WebCT

WebCT ISBN: 0495792608 BlackBoard ISBN: 0495792586

This package allows you to assign preformatted, text-specific content that is available as soon as you log on, or customize the learning environment in any way you choose—from uploading images and other resources, to adding Web links to create your own practice materials.

Contact your Wadsworth representative.

FOR STUDENTS

ArtStudy Online

This tool gives access to a host of multimedia resources, including **flashcards** of works in the text, and a compare-and-contrast feature, where two works are displayed side by side for more in-depth analysis. Other features include critical-thinking questions, interactive maps, architectural basics materials, big picture overviews, multi-

media mini-lectures, video clips of select architectural monuments, museum guide with links, **Google™Earth** coordinates, Student Test Packet, audio study tools, vocabulary of art history, a guide to researching art history online, tips on becoming a successful student and links to beneficial Web sites on art, artists, architecture and more, and tips on becoming a successful student of art and art history.

Slide Guide Contact your Wadsworth representative.

This lecture companion allows students to take notes alongside representations of the art images shown in class. New to this edition's slide guide are two features—the use of **Google™Earth** coordinates to link satellite images of historic sites and images to textual references, and end-of-chapter questions.

Web Site

Instructors and students have access to a comprehensive array of teaching and learning resources, including chapter-by-chapter online tutorial quizzes, a final exam, chapter reviews, chapter-by-chapter Web links, glossary flashcards, and more.

If you are interested in bundling any of the preceding student resources with the text, contact your Wadsworth sales representative.

To order student editions packaged with the Timeline and ArtStudy Online at no extra cost to students, use the following ISBNs:

Gardner's Art through the Ages: The Western Perspective, 13e

ISBN: 0495573558

Gardner's Art through the Ages: The Western Perspective, 13e

Volume I

ISBN: 0495573604

Gardner's Art through the Ages: The Western Perspective, 13e

Volume II

ISBN: 0495573647

Gardner's Art through the Ages: The Western Perspective, 13e

Backpack edition ISBN: 049579442

To order the Backpack edition (Books A, B, C, and D) packaged with the Timeline and ArtStudy Online use ISBN: 0495794422. To order the Backpack edition books separately:

Gardner's Art through the Ages: The Western Perspective, 13e

Book A Antiquity ISBN: 0495794481

Gardner's Art through the Ages: The Western Perspective, 13e

Book B The Middle Ages

ISBN: 049579452X

Gardner's Art through the Ages: The Western Perspective, 13e

Book C Renaissance and Baroque

ISBN: 0495794562

Gardner's Art through the Ages: The Western Perspective, 13e

Book D Modern Europe and America

ISBN: 0495794627

BEFORE 1300

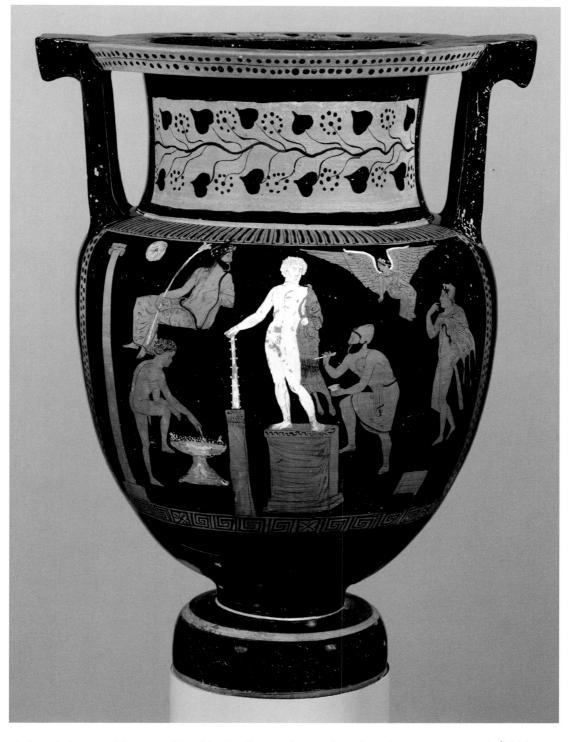

Artist painting a marble statue of Herakles (Apulian red-figure column krater), ca. 350–320 BCE. $1'8\frac{1}{4}''$ high. Metropolitan Museum of Art, New York (Rogers Fund, 1950).

BEFORE 1300 Contents

IRELIGION AND MYTHOLOGY

The Gods and Goddesses of Mount Olympus xv The Life of Jesus in Art xvi

ARCHITECTURAL BASICS

Greco-Roman Temple Design and the Classical Orders xviii

Arches and Vaults xx

Medieval Church Design xxii

The Gods and Goddesses of Mount Olympus

he chief deities of the Greeks ruled the world from their home on Mount Olympus, Greece's highest peak. They figure prominently not only in Greek, Etruscan, and Roman art but also in art from the Renaissance to the present.

The 12 Olympian gods (and their Roman equivalents) were

- **Zeus** (**Jupiter**) King of the gods, Zeus ruled the sky and allotted the sea to his brother Poseidon and the Underworld to his other brother Hades. His weapon was the thunderbolt. Jupiter was also the chief god of the Romans.
- Hera (Juno) Wife and sister of Zeus, Hera was the goddess of marriage.
- *Poseidon (Neptune)* Poseidon was lord of the sea. He controlled waves, storms, and earthquakes with his three-pronged pitchfork (*trident*).
- *Hestia* (*Vesta*) Sister of Zeus, Poseidon, and Hera, Hestia was goddess of the hearth.
- *Demeter* (*Ceres*) Third sister of Zeus, Demeter was the goddess of grain and agriculture.
- *Ares* (*Mars*) God of war, Ares was the son of Zeus and Hera and the lover of Aphrodite, and the father of the twin founders of Rome, Romulus and Remus.
- Athena (Minerva) Goddess of wisdom and warfare, Athena was a virgin born from the head of Zeus.

- Hephaistos (Vulcan) God of fire and of metalworking, Hephaistos was the son of Zeus and Hera. Born lame and, uncharacteristically for a god, ugly, he married Aphrodite, who was unfaithful to him.
- *Apollo* (*Apollo*) God of light and music and son of Zeus, the young, beautiful Apollo was sometimes identified with the sun (*Helios/Sol*).
- Artemis (Diana) Sister of Apollo, Artemis was goddess of the hunt. She was occasionally equated with the moon (Selene/Luna).
- *Aphrodite* (*Venus*) Daughter of Zeus and a *nymph* (goddess of springs and woods), Aphrodite was the goddess of love and beauty.
- Hermes (Mercury) Son of Zeus and another nymph, Hermes was the fleet-footed messenger of the gods. He carried the caduceus, a magical herald's rod.

Other important Greek gods and goddesses were

- Hades (Pluto), lord of the Underworld and god of the dead. Although the brother of Zeus and Poseidon, Hades never resided on Mount Olympus.
- Dionysos (Bacchus), god of wine.
- *Eros* (*Amor* or *Cupid*), the winged child-god of love, son of Aphrodite and Ares.
- **Asklepios** (*Aesculapius*), god of healing. His serpent-entwined staff is the emblem of modern medicine.

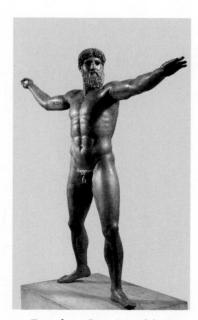

Zeus, from Cape Artemision, ca. 460–450 BCE

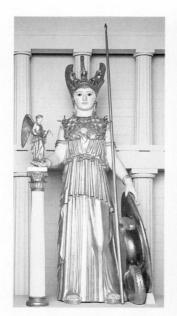

Athena, by Phidias, ca. 438 BCE

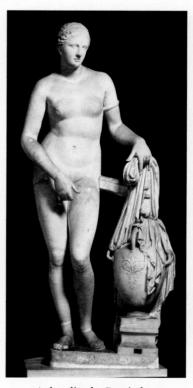

Aphrodite, by Praxiteles, ca. 350–340 BCE

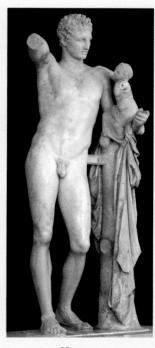

Hermes and infant Dionysos, by Praxiteles, ca. 340 BCE

The Life of Jesus in Art

hristians believe that Jesus of Nazareth is the son of God, the Messiah (Savior, Christ) of the Jews prophesied in the Old Testament. His life—his miraculous birth from the womb of a virgin mother, his preaching and miracle working, his execution by the Romans and subsequent ascent to Heaven—has been the subject of countless artworks from Roman times through the present day.

INCARNATION AND CHILDHOOD

The first "cycle" of the life of Jesus consists of the events of his conception (Incarnation), birth, infancy, and childhood.

- **Annunciation to Mary** The archangel Gabriel announces to the Virgin Mary that she will miraculously conceive and give birth to God's son Jesus.
- *Visitation* The pregnant Mary visits her cousin Elizabeth, who is pregnant with John the Baptist. Elizabeth is the first to recognize that Mary is bearing the Son of God.
- Nativity, Annunciation to the Shepherds, and Adoration of the Shepherds Jesus is born at night in Bethlehem and placed in a basket. Mary and her husband Joseph marvel at the newborn, while an angel announces the birth of the Savior to shepherds in the field, who rush to adore the child.
- Adoration of the Magi A bright star alerts three wise men (magi) in the East that the King of the Jews has been born. They travel 12 days to present precious gifts to the infant Jesus.
- Presentation in the Temple In accordance with Jewish tradition, Mary and Joseph bring their firstborn son to the temple in Jerusalem, where the aged Simeon recognizes Jesus as the prophesied Savior of humankind.
- Massacre of the Innocents and Flight into Egypt King Herod, fearful that a rival king has been born, orders the massacre of all infants, but the Holy Family escapes to Egypt.

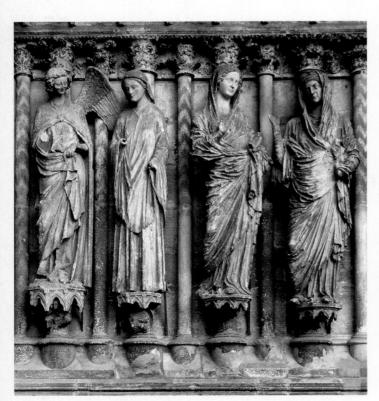

Annunciation and Visitation, Reims Cathedral, ca. 1230

■ *Dispute in the Temple* Joseph and Mary travel to Jerusalem for the feast of Passover. Jesus, only a boy, debates the astonished Jewish scholars in the temple, foretelling his ministry.

PUBLIC MINISTRY

The public-ministry cycle comprises the teachings of Jesus and the miracles he performed.

- **Baptism** The beginning of Jesus' public ministry is marked by his baptism at age 30 by John the Baptist in the Jordan River. God's voice is heard proclaiming Jesus as his son.
- Calling of Matthew Jesus summons Matthew, a tax collector, to follow him, and Matthew becomes one of his 12 disciples, or apostles (from the Greek for "messenger").
- *Miracles* Jesus performs many miracles, revealing his divine nature. These include acts of healing and raising the dead, turning water into wine, walking on water and calming storms, and creating wondrous quantities of food.
- *Delivery of the Keys to Peter* Jesus chooses the fisherman Peter (whose name means "rock") as his successor. He declares that Peter is the rock on which his church will be built and symbolically delivers to Peter the keys to the kingdom of Heaven.
- *Transfiguration* Jesus scales a mountain and, in the presence of Peter and two other disciples, is transformed into radiant light. God announces from a cloud that Jesus is his son.
- Cleansing of the Temple Jesus returns to Jerusalem, where he finds money changers and merchants conducting business in the temple. He rebukes them and drives them out.

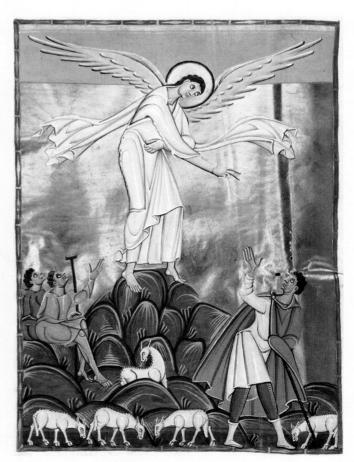

Annunciation to the Shepherds, Lectionary of Henry II, 1002-1014

PASSION

The Passion (Latin *passio*, "suffering") cycle includes the events leading to Jesus' death, Resurrection, and ascent to Heaven.

- **Entry into Jerusalem** On the Sunday before his Crucifixion (Palm Sunday), Jesus rides into Jerusalem on a donkey.
- **Last Supper** In Jerusalem, Jesus celebrates Passover with his disciples. During this Last Supper, Jesus foretells his imminent betrayal, arrest, and death and invites the disciples to remember him when they eat bread (symbol of his body) and drink wine (his blood). This ritual became the celebration of *Mass (Eucharist)*.
- **Agony in the Garden** Jesus goes to the Mount of Olives in the Garden of Gethsemane, where he struggles to overcome his human fear of death by praying for divine strength.
- **Betrayal** and **Arrest** The disciple Judas Iscariot betrays Jesus to the Jewish authorities for 30 pieces of silver. Judas identifies Jesus to the soldiers by kissing him, and Jesus is arrested.
- *Trials of Jesus* Jesus is brought before Caiaphas, the Jewish high priest, who interrogates Jesus about his claim to be the Messiah. Jesus is then brought before the Roman governor of Judaea, Pontius Pilate, on the charge of treason because he had proclaimed himself King of the Jews. Pilate asks the crowd to choose between freeing Jesus or Barabbas, a murderer. The people choose Barabbas, and the judge condemns Jesus to death.
- Flagellation The Roman soldiers who hold Jesus captive whip (flagellate) him and mock him by dressing him as King of the Jews and placing a crown of thorns on his head.
- Carrying of the Cross, Raising of the Cross, and Crucifixion The Romans force Jesus to carry the cross on which he will be crucified from Jerusalem to Mount Calvary. Soldiers erect the cross and nail Jesus' hands and feet to it. Jesus' mother, John the Evangelist, and

- Mary Magdalene mourn at the foot of the cross, while soldiers torment Jesus. One of them stabs Jesus in the side with a spear. After suffering great pain, Jesus dies on Good Friday.
- Deposition, Lamentation, and Entombment Two disciples, Joseph of Arimathea and Nicodemus, remove Jesus' body from the cross (Deposition) and take him to his tomb. Joseph, Nicodemus, the Virgin Mary, Saint John the Evangelist, and Mary Magdalene mourn over the dead Jesus (Lamentation). (When in art the isolated figure of the Virgin Mary cradles her dead son in her lap, it is called a Pietà—Italian for "pity.") Then his followers lower Jesus into a sarcophagus in the tomb (Entombment).
- Descent into Limbo During the three days he spends in the tomb, Jesus (after death, Christ) descends into Hell, or Limbo, and frees the souls of the righteous, including Adam, Eve, Moses, David, Solomon, and John the Baptist.
- Resurrection and Three Marys at the Tomb On the third day (Easter Sunday), Christ rises from the dead and leaves the tomb. The Virgin Mary, Mary Magdalene, and Mary, the mother of James, visit the tomb, find it empty, and learn from an angel that Christ has been resurrected.
- Noli Me Tangere, Supper at Emmaus, and Doubting of Thomas
 During the 40 days between Christ's Resurrection and his ascent
 to Heaven, he appears on several occasions to his followers. Christ
 warns Mary Magdalene, weeping at his tomb, with the words
 "Don't touch me" (Noli me tangere in Latin). At Emmaus he eats
 supper with two astonished disciples. Later, Thomas, who cannot
 believe that Christ has risen, touches the wound in his side inflicted at the Crucifixion.
- **Ascension** On the 40th day, on the Mount of Olives, with his mother and apostles as witnesses, Christ gloriously ascends to Heaven in a cloud.

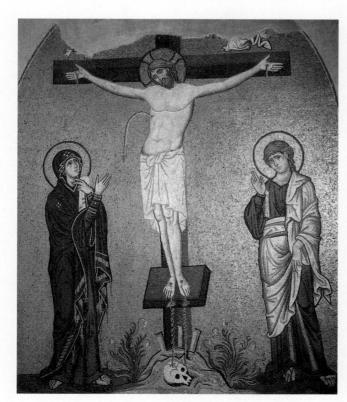

Crucifixion, Church of the Dormition, Daphni, ca. 1090–1100

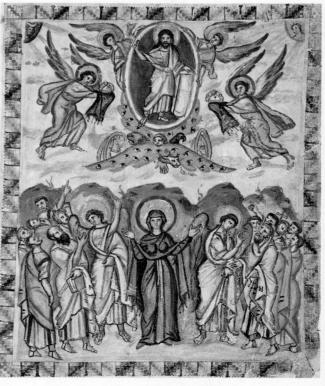

Ascension, Rabbula Gospels, 586

Greco-Roman Temple Design and the Classical Orders

The gable-roofed columnar stone temples of the Greeks and Romans have had more influence on the later history of architecture in the Western world than any other building type ever devised. Many of the elements of classical temple architecture are present in buildings from the Renaissance to the present day. The basic design principles of Greek and Roman temples and the most important components of the classical orders can be summarized as follows.

- Temple design The core of a Greco-Roman temple was the cella, a room with no windows that usually housed the statue of the god or goddess to whom the shrine was dedicated. Generally, only the priests, priestesses, and chosen few would enter the cella. Worshipers gathered in front of the building, where sacrifices occurred at open-air altars. In most Greek temples, for example, the second temple erected in honor of Hera at Paestum, a colonnade was erected all around the cella to form a peristyle. In contrast, Roman temples, for example, the Temple of Portunus in Rome, usually have freestanding columns only in a porch at the front of the building. Sometimes, as in the Portunus temple, engaged (attached) half-columns adorn three sides of the cella to give the building the appearance of a peripteral temple. Architectural historians call this a pseudoperipteral design.
- Classical orders The Greeks developed two basic architectural orders, or design systems: the *Doric* and the *Ionic*. The forms of

the columns and *entablature* (superstructure) generally differentiate the orders. Classical columns have two or three parts, depending on the order: the shaft, which is usually marked with vertical channels (*flutes*); the *capital*; and, in the Ionic order, the *base*. The Doric capital consists of a round *echinus* beneath a square abacus block. Spiral *volutes* constitute the distinctive feature of the Ionic capital. Classical entablatures have three parts: the *architrave*, the *frieze*, and the triangular *pediment* of the gabled roof, framed by the *cornice*. In the Doric order, the frieze is subdivided into *triglyphs* and *metopes*, whereas in the Ionic, the frieze is left open.

The *Corinthian capital*, a later Greek invention very popular in Roman times, is more ornate than either the Doric or Ionic. It consists of a double row of acanthus leaves, from which tendrils and flowers emerge. Although this capital often is cited as the distinguishing element of the Corinthian order, in strict terms no Corinthian order exists. Architects simply substituted the new capital type for the volute capital in the Ionic order, as in the *tholos* (round temple) at Epidauros.

Sculpture played a major role on the exterior of classical temples, partly to embellish the deity's shrine and partly to tell something about the deity to those gathered outside. Sculptural ornament was concentrated on the upper part of the building, in the pediment and frieze.

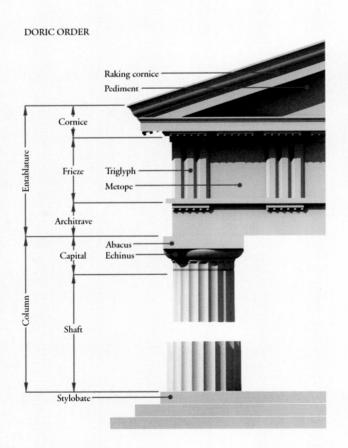

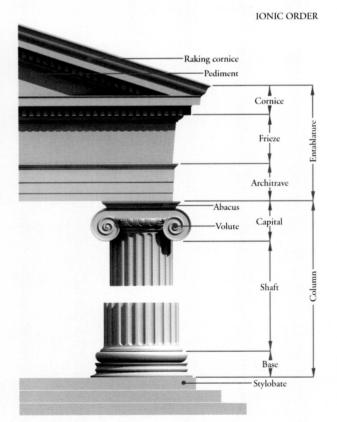

Doric and Ionic orders

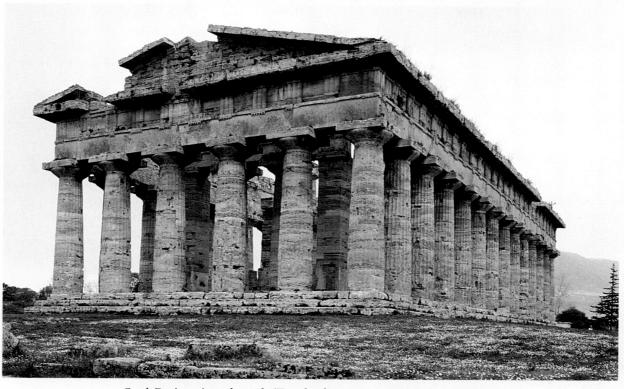

Greek Doric peripteral temple (Temple of Hera II, Paestum, Italy, ca. 460 $_{\rm BCE})$

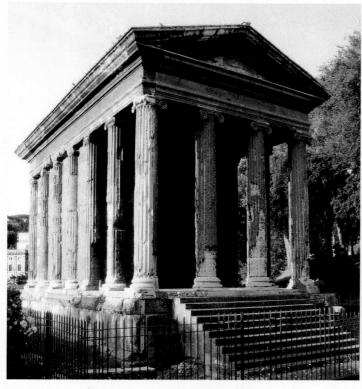

Roman Ionic pseudoperipteral temple (Temple of Portunus, Rome, ca. 75 BCE)

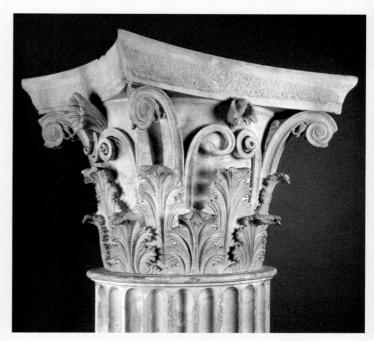

Corinthian capital (Tholos, Epidauros, Greece, ca. 350 BCE)

Arches and Vaults

Ithough earlier architects used both arches and vaults, the Romans employed them more extensively and effectively than any other ancient civilization. The Roman forms became staples of architectural design from the Middle Ages until today.

- Arch The arch is one of several ways of spanning a passageway. The Romans preferred it to the post-and-lintel (column-and-architrave) system used in the Greek orders. Builders construct arches using wedge-shaped stone blocks called voussoirs. The central voussoir is the arch's keystone.
- Barrel vault Also called the tunnel vault, the barrel vault is an extension of a simple arch, creating a semicylindrical ceiling over parallel walls.
- **Groin vault** The groin vault, or *cross vault*, is formed by the intersection at right angles of two barrel vaults of equal size. When a

- series of groin vaults covers an interior hall, the open lateral arches of the vaults function as windows admitting light to the building.
- **Dome** The hemispherical dome may be described as a round arch rotated around the full circumference of a circle, usually resting on a cylindrical *drum*. The Romans normally constructed domes using *concrete*, a mix of lime mortar, volcanic sand, water, and small stones, instead of with large stone blocks. Concrete dries to form a solid mass of great strength, which allowed the Romans to puncture the apex of a concrete dome with an *oculus* (eye), so that much-needed light could reach the interior of the building.

Barrel vaults, as noted, resemble tunnels, and groin vaults are usually found in a series covering a similar *longitudinally* oriented interior space. Domes, in contrast, crown *centrally* planned buildings, so named because the structure's parts are of equal or almost equal dimensions around the center.

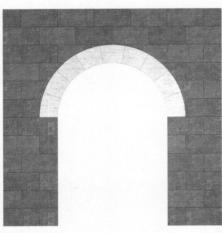

Arch

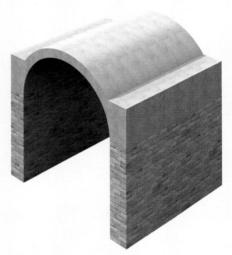

Barrel vault

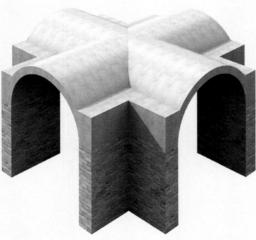

Groin vault

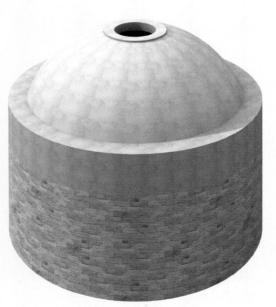

Hemispherical dome with oculus

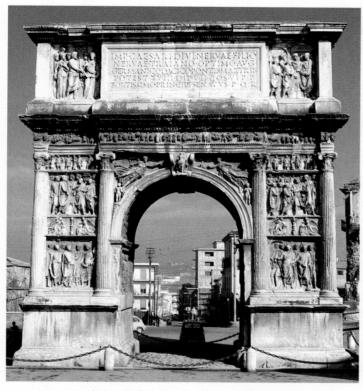

Roman arch (Arch of Trajan, Benevento, Italy, ca. 114–118)

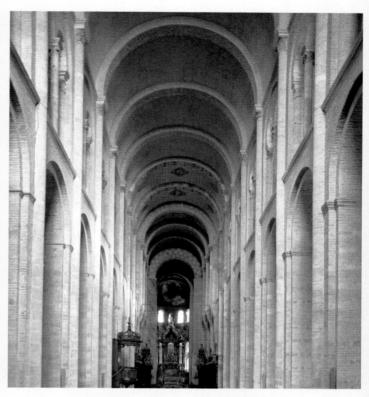

Medieval barrel-vaulted church (Saint-Sernin, Toulouse, France, ca. 1070–1120)

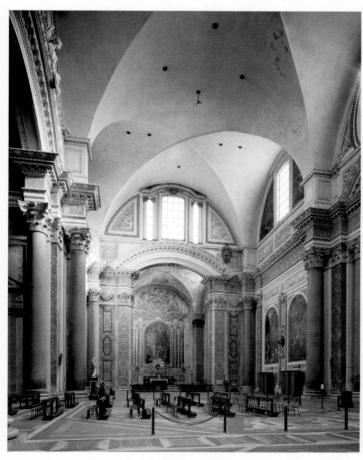

Roman hall with groin vaults (Baths of Diocletian [Santa Maria degli Angeli], Rome, Italy, ca. 298–306)

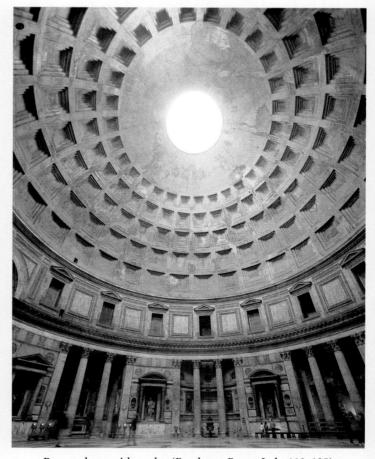

Roman dome with oculus (Pantheon, Rome, Italy, 118–125)

Medieval Church Design

hurch design during the Middle Ages set the stage for ecclesiastical architecture from the Renaissance to the present. Both the longitudinal- and central-plan building types of antiquity had a long postclassical history.

■ Basilican churches In Western Christendom, the typical medieval church had a basilican plan, which evolved from the Roman columnar hall, or basilica. The great European cathedrals of the Gothic age, which were the immediate predecessors of the churches of the Renaissance and Baroque eras, shared many elements with the earliest basilican churches constructed during the fourth century, including a wide central nave flanked by aisles and ending in an apse. Some basilican churches also have a transept, an area perpendicular to the nave. The nave and transept intersect at the crossing. Gothic

churches, however, have many additional features. The key components of Gothic design are labeled in the drawing of a typical French Gothic cathedral and the plan of Chartres Cathedral.

Gothic architects frequently extended the aisles around the apse to form an *ambulatory*, onto which opened *radiating chapels* housing sacred relics. Groin vaults formed the ceiling of the nave, aisles, ambulatory, and transept alike, replacing the timber roof of the typical Early Christian basilica. These vaults rested on *diagonal* and *transverse ribs* in the form of pointed arches. On the exterior, *flying buttresses* held the nave vaults in place. These masonry struts transferred the thrust of the nave vaults across the roofs of the aisles to tall piers frequently capped by pointed ornamental *pinnacles*. This structural system made it possible to open up the walls above the *nave arcade* with huge *stained-glass* windows in the nave *clerestory*.

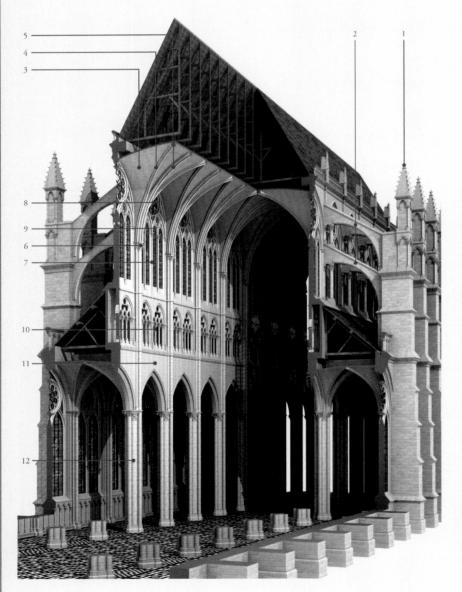

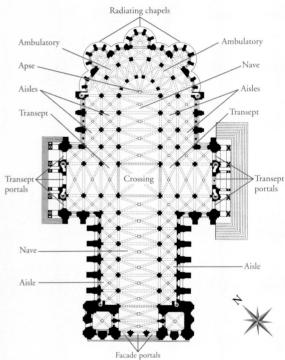

Plan of Chartres Cathedral, Chartres, France, rebuilt after 1194

Left: Cutaway view of a typical French Gothic cathedral

- (1) pinnacle, (2) flying buttress, (3) vaulting web,
- (4) diagonal rib, (5) transverse rib, (6) springing,
- (7) clerestory, (8) oculus, (9) lancet, (10) triforium,
- (11) nave arcade, (12) compound pier with responds

■ Central-plan churches The domed central plan of classical antiquity dominated the architecture of the Byzantine Empire but with important modifications. Because the dome covered the crossing of a Byzantine church, architects had to find a way to erect domes on square bases instead of on the circular bases (cylindrical drums) of Roman buildings. The solution was pendentive construction in which the dome rests on what is in effect a second, larger dome. The top portion and four segments around the rim of the larger dome are omitted, creating four curved triangles, or pendentives. The pendentives join to form a ring and four arches

whose planes bound a square. The first use of pendentives on a grand scale occurred in the sixth-century church of Hagia Sophia (Holy Wisdom) in Constantinople.

The interiors of Byzantine churches differed from those of basilican churches in the West not only in plan and the use of domes but also in the manner in which they were adorned. The original mosaic decoration of Hagia Sophia is lost, but at Saint Mark's in Venice, some 40,000 square feet of mosaics cover all the walls, arches, vaults, and domes.

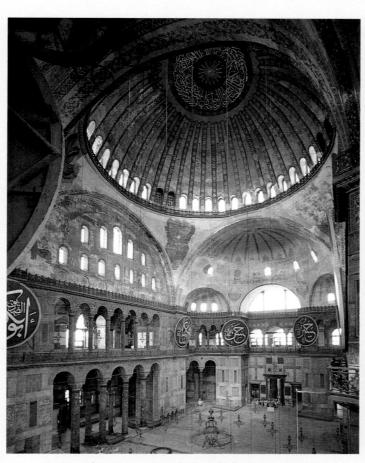

Hagia Sophia, Constantinople (Istanbul), Turkey, 532-537

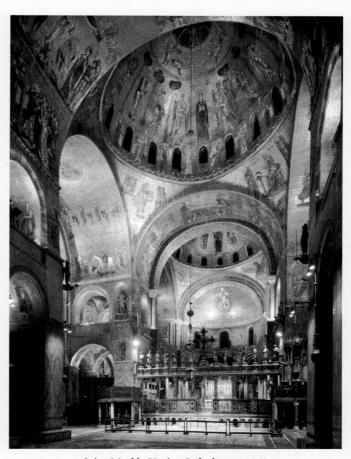

Saint Mark's, Venice, Italy, begun 1063

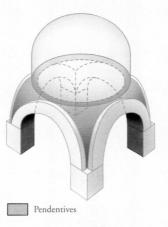

Dome on pendentives

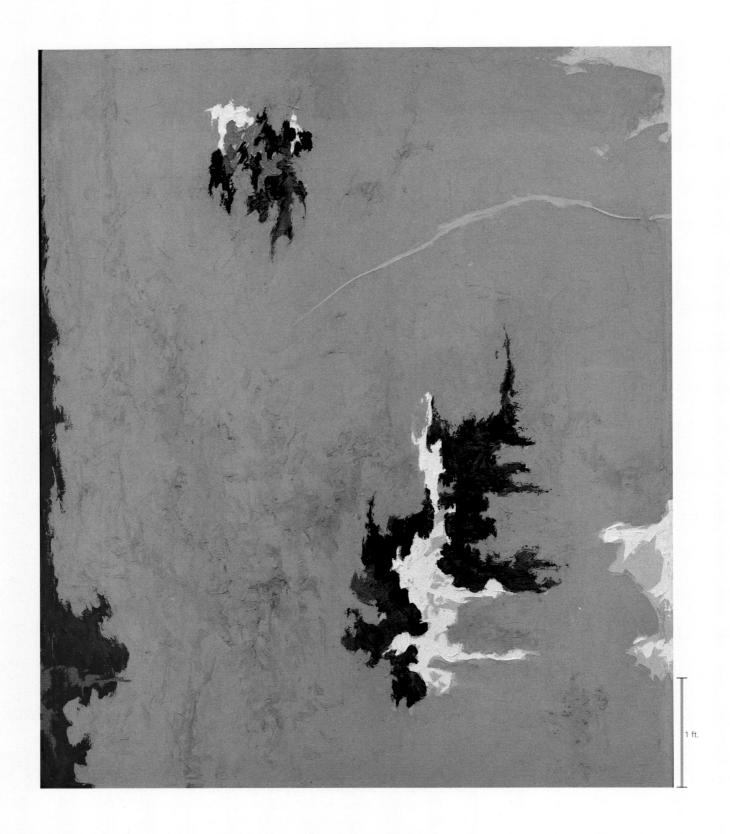

I-1 Clyfford Still, 1948-C, PH-15, 1948. Oil on canvas, 6' $8\frac{7}{8}$ " \times 5' $10\frac{3}{4}$ ". Hirshhorn Museum and Sculpture Garden, Smithsonian Institution, Washington, D.C. (purchased with funds of Joseph H. Hirshhorn, 1992).

Clyfford Still painted this abstract composition without knowing who would purchase it or where it would be displayed, but throughout history most artists created works for specific patrons and settings.

INTRODUCTION: WHAT IS ART HISTORY?

Except when referring to the modern academic discipline, people do not often juxtapose the words "art" and "history." They tend to think of history as the record and interpretation of past human actions, particularly social and political actions. Most think of art, quite correctly, as part of the present—as something people can see and touch. Of course, people cannot see or touch history's vanished human events, but a visible, tangible artwork is a kind of persisting event. One or more artists made it at a certain time and in a specific place, even if no one today knows just who, when, where, or why. Although created in the past, an artwork continues to exist in the present, long surviving its times. The first painters and sculptors died 30,000 years ago, but their works remain, some of them exhibited in glass cases in museums built only a few years ago.

Modern museum visitors can admire these objects from the remote past—and countless others humankind has produced over the millennia—without any knowledge of the circumstances that led to the creation of those works. The beauty or sheer size of an object can impress people, the artist's virtuosity in the handling of ordinary or costly materials can dazzle them, or the subject depicted can move them. Viewers can react to what they see, interpret the work in the light of their own experience, and judge it a success or a failure. These are all valid responses to a work of art. But the enjoyment and appreciation of artworks in museum settings are relatively recent phenomena, as is the creation of artworks solely for museum-going audiences to view.

Today, it is common for artists to work in private studios and to create paintings, sculptures, and other objects commercial art galleries will offer for sale. This is what the American painter Clyfford Still (1904–1980) did when he created large canvases of pure color (FIG. I-1) titled simply with the year of their creation. Usually, someone the artist has never met will purchase the artwork and display it in a setting the artist has never seen. This practice is not a new phenomenon in the history of art—an ancient potter decorating a vase for sale at a village market stall probably did not know who would buy the pot or where it would be housed—but it is not at all typical. In fact, it is exceptional. Throughout history, most artists created paintings, sculptures, and other objects for specific patrons and settings and to fulfill a specific purpose, even if today no one knows the original contexts of most of those works. Museum visitors can appreciate the visual and tactile qualities of these objects, but they cannot understand why

they were made or why they appear as they do without knowing the circumstances of their creation. Art *appreciation* does not require knowledge of the historical context of an artwork (or a building). Art *history* does.

Thus, a central aim of art history is to determine the original context of artworks. Art historians seek to achieve a full understanding not only of why these "persisting events" of human history look the way they do but also of why the artistic events happened at all. What unique set of circumstances gave rise to the erection of a particular building or led an individual patron to commission a certain artist to fashion a singular artwork for a specific place? The study of history is therefore vital to art history. And art history is often very important to the study of history. Art objects and buildings are historical documents that can shed light on the peoples who made them and on the times of their creation in a way other historical documents cannot. Furthermore, artists and architects can affect history by reinforcing or challenging cultural values and practices through the objects they create and the structures they build. Thus, the history of art and architecture is inseparable from the study of history, although the two disciplines are not the same.

The following pages introduce some of the distinctive subjects art historians address and the kinds of questions they ask, and explain some of the basic terminology they use when answering these questions. Readers armed with this arsenal of questions and terms will be ready to explore the multifaceted world of art through the ages.

ART HISTORY IN THE 21ST CENTURY

Art historians study the visual and tangible objects humans make and the structures humans build. Scholars traditionally have classified such works as architecture, sculpture, the pictorial arts (painting, drawing, printmaking, and photography), and the craft arts, or arts of design. The craft arts comprise utilitarian objects, such as ceramics, metalwork, textiles, jewelry, and similar accessories of ordinary living. Artists of every age have blurred the boundaries among these categories, but this is especially true today, when multimedia works abound.

From the earliest Greco-Roman art critics on, scholars have studied objects that their makers consciously manufactured as "art" and to which the artists assigned formal titles. But today's art historians also study a vast number of objects that their creators and owners almost certainly did not consider to be "works of art." Few ancient Romans, for example, would have regarded a coin bearing their emperor's portrait as anything but money. Today, an art museum may exhibit that coin in a locked case in a climate-controlled room, and scholars may subject it to the same kind of art historical analysis as a portrait by an acclaimed Renaissance or modern sculptor or painter.

The range of objects art historians study is constantly expanding and now includes, for example, computer-generated images, whereas in the past almost anything produced using a machine would not have been regarded as art. Most people still consider the performing arts—music, drama, and dance—as outside art history's realm because these arts are fleeting, impermanent media. But recently even this distinction between "fine art" and "performance art" has become blurred. Art historians, however, generally ask the same kinds of questions about what they study, whether they employ a restrictive or expansive definition of art.

The Questions Art Historians Ask

HOW OLD IS IT? Before art historians can construct a history of art, they must be sure they know the date of each work they study. Thus, an indispensable subject of art historical inquiry is *chronology*,

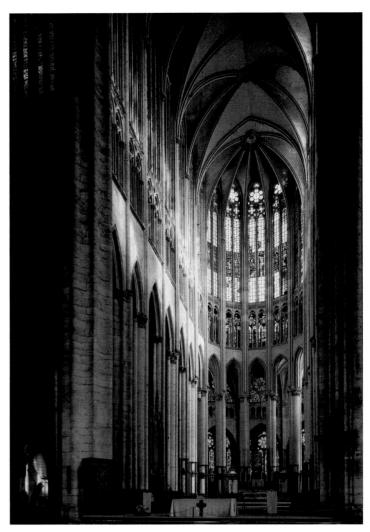

1-2 Choir of Beauvais Cathedral, Beauvais, France, rebuilt after 1284.

The style of an object or building often varies from region to region. This cathedral has towering stone vaults and large stained-glass windows typical of 13th-century French architecture.

the dating of art objects and buildings. If researchers cannot determine a monument's age, they cannot place the work in its historical context. Art historians have developed many ways to establish, or at least approximate, the date of an artwork.

Physical evidence often reliably indicates an object's age. The material used for a statue or painting—bronze, plastic, or oil-based pigment, to name only a few—may not have been invented before a certain time, indicating the earliest possible date someone could have fashioned the work. Or artists may have ceased using certain materials—such as specific kinds of inks and papers for drawings—at a known time, providing the latest possible dates for objects made of those materials. Sometimes the material (or the manufacturing technique) of an object or a building can establish a very precise date of production or construction. Studying tree rings, for instance, usually can help scholars determine within a narrow range the date of a wood statue or a timber roof beam.

Documentary evidence can help pinpoint the date of an object or building when a dated written document mentions the work. For example, official records may note when church officials commissioned a new altarpiece—and how much they paid to which artist.

Internal evidence can play a significant role in dating an artwork. A painter might have depicted an identifiable person or a kind of hairstyle, clothing, or furniture fashionable only at a certain

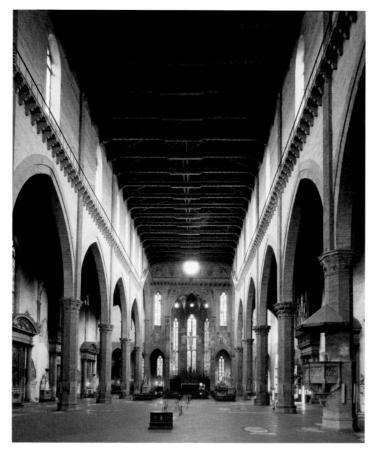

1-3 Interior of Santa Croce, Florence, Italy, begun 1294.

In contrast to Beauvais Cathedral (FIG. I-2), this contemporaneous Florentine church conforms to the quite different regional style of Italy. The building has a low timber roof and small windows.

time. If so, the art historian can assign a more accurate date to that painting.

Stylistic evidence is also very important. The analysis of style—an artist's distinctive manner of producing an object—is the art historian's special sphere. Unfortunately, because it is a subjective assessment, stylistic evidence is by far the most unreliable chronological criterion. Still, art historians find style a very useful tool for establishing chronology.

WHAT IS ITS STYLE? Defining artistic style is one of the key elements of art historical inquiry, although the analysis of artworks solely in terms of style no longer dominates the field as it once did. Art historians speak of several different kinds of artistic styles.

Period style refers to the characteristic artistic manner of a specific time, usually within a distinct culture, such as "Archaic Greek" or "Late Byzantine." But many periods do not manifest any stylistic unity at all. How would someone define the artistic style of the opening decade of the new millennium in North America? Far too many crosscurrents exist in contemporary art for anyone to describe a period style of the early 21st century—even in a single city such as New York.

Regional style is the term art historians use to describe variations in style tied to geography. Like an object's date, its provenance, or place of origin, can significantly determine its character. Very often two artworks from the same place made centuries apart are more similar than contemporaneous works from two different regions. To cite one example, usually only an expert can distinguish between an Egyptian statue carved in 2500 BCE and one made in 500 BCE. But no

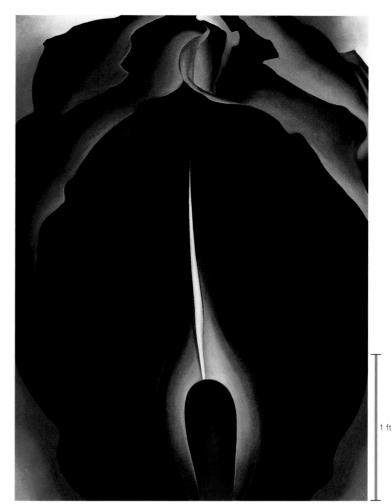

I-4 GEORGIA O'KEEFFE, *Jack-in-the-Pulpit No. 4*, 1930. Oil on canvas, $3' 4'' \times 2' 6''$. National Gallery of Art, Washington, D.C. (Alfred Stieglitz Collection, bequest of Georgia O'Keeffe).

O'Keeffe's paintings feature close-up views of petals and leaves in which the organic forms become powerful abstract compositions. This approach to painting typifies the artist's distinctive personal style.

one would mistake an Egyptian statue of 500 BCE for one of the same date made in Greece or Mexico.

Considerable variations in a given area's style are possible, however, even during a single historical period. In late medieval Europe, French architecture differed significantly from Italian architecture. The interiors of Beauvais Cathedral (FIG. I-2) and the Florentine church of Santa Croce (FIG. I-3) typify the architectural styles of France and Italy, respectively, at the end of the 13th century. The rebuilding of the east end of Beauvais Cathedral began in 1284. Construction commenced on Santa Croce only 10 years later. Both structures employ the *pointed arch* characteristic of this era, yet the two churches differ strikingly. The French church has towering stone ceilings and large expanses of colored windows, whereas the Italian building has a low timber roof and small, widely separated windows. Because the two contemporaneous churches served similar purposes, regional style mainly explains their differing appearance.

Personal style, the distinctive manner of individual artists or architects, often decisively explains stylistic discrepancies among monuments of the same time and place. In 1930 the American painter Georgia O'Keeffe (1887–1986) produced a series of paintings of flowering plants. One of them was Jack-in-the-Pulpit No. 4 (Fig. 1-4), a sharply focused close-up view of petals and leaves. O'Keeffe captured the growing plant's slow, controlled motion while converting

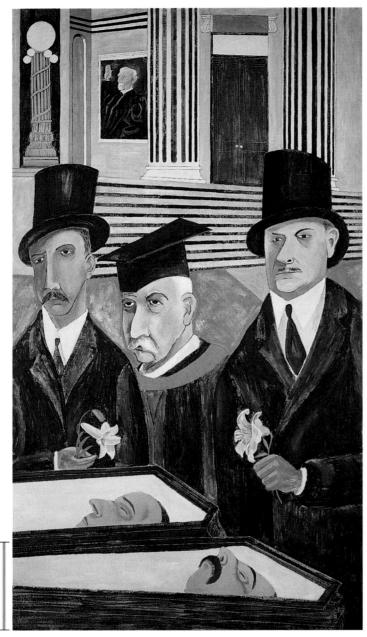

I-5 Ben Shahn, *The Passion of Sacco and Vanzetti*, 1931–1932. Tempera on canvas, $7'\frac{1}{2}'' \times 4'$. Whitney Museum of American Art, New York (gift of Edith and Milton Lowenthal in memory of Juliana Force).

A contemporary of O'Keeffe's, Shahn developed a style of painting that differed markedly from hers. His paintings are often social commentaries on current events and incorporate readily identifiable people.

the plant into a powerful abstract composition of lines, forms, and colors (see the discussion of art historical vocabulary in the next section). Only a year later, another American artist, Ben Shahn (1898–1969), painted *The Passion of Sacco and Vanzetti* (Fig. 1-5), a stinging commentary on social injustice inspired by the trial and execution of two Italian anarchists, Nicola Sacco and Bartolomeo Vanzetti. Many people believed Sacco and Vanzetti had been unjustly convicted of killing two men in a holdup in 1920. Shahn's painting compresses time in a symbolic representation of the trial and its aftermath. The two executed men lie in their coffins. Presiding over them are the three members of the commission (headed by a college president wearing academic cap and gown) that declared the original trial fair and cleared the way for the executions. Behind, on the wall of a stately government building, hangs the framed portrait of the judge who pronounced the

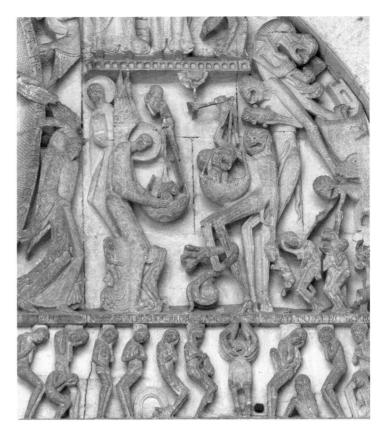

I-6 GISLEBERTUS, The weighing of souls, detail of Last Judgment (FIG. 12-12), west tympanum of Saint-Lazare, Autun, France, ca. 1120–1135.

In this high relief portraying the weighing of souls on Judgment Day, Gislebertus used disproportion and distortion to dehumanize the devilish figure yanking on the scales of justice.

initial sentence. Personal style, not period or regional style, sets Shahn's canvas apart from O'Keeffe's. The contrast is extreme here because of the very different subjects the artists chose. But even when two artists depict the same subject, the results can vary widely. The way O'Keeffe painted flowers and the way Shahn painted faces are distinctive and unlike the styles of their contemporaries. (See the "Who Made It?" discussion on page xxxix.)

The different kinds of artistic styles are not mutually exclusive. For example, an artist's personal style may change dramatically during a long career. Art historians then must distinguish among the different period styles of a particular artist, such as the "Blue Period" and the "Cubist Period" of the prolific 20th-century artist Pablo Picasso.

WHAT IS ITS SUBJECT? Another major concern of art historians is, of course, subject matter, encompassing the story, or narrative; the scene presented; the action's time and place; the persons involved; and the environment and its details. Some artworks, such as modern abstract paintings (FIG. I-1), have no subject, not even a setting. The "subject" is the artwork itself. But when artists represent people, places, or actions, viewers must identify these aspects to achieve complete understanding of the work. Art historians traditionally separate pictorial subjects into various categories, such as religious, historical, mythological, *genre* (daily life), portraiture, *landscape* (a depiction of a place), *still life* (an arrangement of inanimate objects), and their numerous subdivisions and combinations.

Iconography—literally, the "writing of images"—refers both to the content, or subject of an artwork, and to the study of content in art. By extension, it also includes the study of *symbols*, images that stand for other images or encapsulate ideas. In Christian art, two intersecting

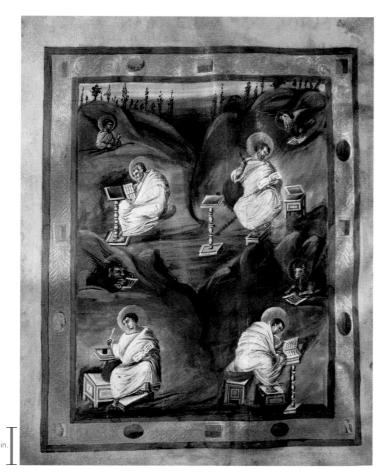

I-7 The four evangelists, folio 14 verso of the *Aachen Gospels*, ca. 810. Ink and tempera on vellum, $1' \times 9\frac{1}{2}''$. Cathedral Treasury, Aachen.

Artists depict figures with attributes in order to identify them for viewers. The authors of the four gospels have distinctive attributes—John an eagle, Luke an ox, Mark a lion, and Matthew a winged man.

lines of unequal length or a simple geometric cross can serve as an emblem of the religion as a whole, symbolizing the cross of Jesus Christ's crucifixion. A symbol also can be a familiar object the artist imbued with greater meaning. A balance or scale, for example, may symbolize justice or the weighing of souls on Judgment Day (FIG. I-6).

Artists may depict figures with unique *attributes* identifying them. In Christian art, for example, each of the authors of the New Testament Gospels, the four evangelists (FIG. I-7), has a distinctive attribute. People can recognize Saint John by the eagle associated with him, Luke by the ox, Mark by the lion, and Matthew by the winged man.

Throughout the history of art, artists have used *personifications*—abstract ideas codified in human form. Worldwide, people visualize Liberty as a robed woman with a torch because of the fame of the colossal statue set up in New York City's harbor in the 19th century. *The Four Horsemen of the Apocalypse* (FIG. I-8) is a terrifying late-15th-century depiction of the fateful day at the end of time when, according to the Bible's last book, Death, Famine, War, and Pestilence will annihilate the human race. The German artist Albrecht Dürer (1471–1528) personified Death as an emaciated old man with a pitchfork. Dürer's Famine swings the scales that will weigh human souls (compare FIG. I-6), War wields a sword, and Pestilence draws a bow.

Even without considering style and without knowing a work's maker, informed viewers can determine much about the work's period and provenance by iconographical and subject analysis alone. In *The Passion of Sacco and Vanzetti* (FIG. I-5), for example, the two

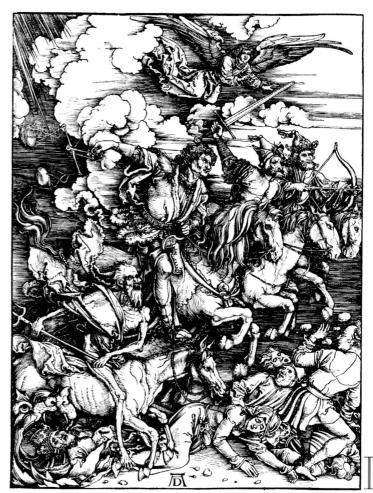

I-8 Albrecht Dürer, *The Four Horsemen of the Apocalypse*, ca. 1498. Woodcut, 1' $3\frac{1}{4}$ " × 11". Metropolitan Museum of Art, New York (gift of Junius S. Morgan, 1919).

Personifications are abstract ideas codified in human form. Here, Albrecht Dürer represented Death, Famine, War, and Pestilence as four men on charging horses, each carrying an identifying attribute.

coffins, the trio headed by an academic, and the robed judge in the background are all pictorial clues revealing the painting's subject. The work's date must be after the trial and execution, probably while the event was still newsworthy. And because the two men's deaths caused the greatest outrage in the United States, the painter–social critic was probably American.

WHO MADE IT? If Ben Shahn had not signed his painting of Sacco and Vanzetti, an art historian could still assign, or attribute (make an attribution of), the work to him based on knowledge of the artist's personal style. Although signing (and dating) works is quite common (but by no means universal) today, in the history of art countless works exist whose artists remain unknown. Because personal style can play a large role in determining the character of an artwork, art historians often try to attribute anonymous works to known artists. Sometimes they assemble a group of works all thought to be by the same person, even though none of the objects in the group is the known work of an artist with a recorded name. Art historians thus reconstruct the careers of artists such as "the Achilles Painter," the anonymous ancient Greek vase painter whose masterwork is a depiction of the hero Achilles. Scholars base their attributions on internal evidence, such as the distinctive way an artist draws or carves drapery folds, earlobes, or flowers. It requires a keen, highly trained eye and long experience to become a connoisseur, an expert in

I-9 Augustus wearing the corona civica, early first century CE. Marble, 1' 5" high. Glyptothek, Munich.

Patrons frequently dictate the form their portraits will take. The Roman emperor Augustus demanded that he always be portrayed as a young, godlike head of state even though he lived to age 76.

assigning artworks to "the hand" of one artist rather than another. Attribution is subjective, of course, and ever open to doubt. At present, for example, international debate rages over attributions to the famous 17th-century Dutch painter Rembrandt.

Sometimes a group of artists works in the same style at the same time and place. Art historians designate such a group as a *school*. "School" does not mean an educational institution. The term connotes only chronological, stylistic, and geographic similarity. Art historians speak, for example, of the Dutch school of the 17th century and, within it, of subschools such as those of the cities of Haarlem, Utrecht, and Leyden.

WHO PAID FOR IT? The interest many art historians show in attribution reflects their conviction that the identity of an artwork's maker is the major reason the object looks the way it does. For them, personal style is of paramount importance. But in many times and places, artists had little to say about what form their work would take. They toiled in obscurity, doing the bidding of their *patrons*, those who paid them to make individual works or employed them on a continuing basis. The role of patrons in dictating the content and shaping the form of artworks is also an important subject of art historical inquiry.

In the art of portraiture, to name only one category of painting and sculpture, the patron has often played a dominant role in deciding how the artist represented the subject, whether that person was the patron or another individual, such as a spouse, son, or mother. Many Egyptian pharaohs and some Roman emperors, for example, insisted that artists depict them with unlined faces and perfect youthful bodies no matter how old they were when portrayed. In these cases, the state employed the sculptors and painters, and the artists had no choice but to depict their patrons in the officially approved manner. This is why Augustus, who lived to age 76, looks so young in his portraits (FIG. I-9). Although Roman emperor for more than 40 years, Augustus demanded that artists always represent him as a young, godlike head of state.

All modes of artistic production reveal the impact of patronage. Learned monks provided the themes for the sculptural decoration of medieval church portals (FIG. I-6). Renaissance princes and popes dictated the subject, size, and materials of artworks destined for buildings constructed according to their specifications. An art historian could make a very long list of commissioned works, and it would indicate that throughout the history of art, patrons have had diverse tastes and needs and demanded different kinds of art. Whenever a patron contracts an artist or architect to paint, sculpt, or build in a prescribed manner, personal style often becomes a very minor factor in the ultimate appearance of the painting, statue, or building. In these cases, the identity of the patron reveals more to art historians than does the identity of the artist or school. The portrait of Augustus wearing a corona civica, or civic crown (FIG. I-9), was the work of a virtuoso sculptor, a master wielder of hammer and chisel. But scores of similar portraits of that emperor exist today. They differ in quality but not in kind from this one. The patron, not the artist, determined the character of these artworks. Augustus's public image never varied.

The Words Art Historians Use

Like all specialists, art historians have their own specialized vocabulary. That vocabulary consists of hundreds of words, but certain basic terms are indispensable for describing artworks and buildings of any time and place. They make up the essential vocabulary of *formal analysis*, the visual analysis of artistic form. Definitions of the most important of these art historical terms follow.

FORM AND COMPOSITION *Form* refers to an object's shape and structure, either in two dimensions (for example, a figure painted on a canvas) or in three dimensions (such as a statue carved from a marble block). Two forms may take the same shape but may differ in their color, texture, and other qualities. *Composition* refers to how an artist organizes (*composes*) forms in an artwork, either by placing shapes on a flat surface or by arranging forms in space.

MATERIAL AND TECHNIQUE To create art forms, artists shape materials (pigment, clay, marble, gold, and many more) with tools (pens, brushes, chisels, and so forth). Each of the materials and tools available has its own potentialities and limitations. Part of all artists' creative activity is to select the *medium* and instrument most suitable to the artists' purpose—or to develop new media and tools, such as bronze and concrete in antiquity and cameras and computers in modern times. The processes artists employ, such as applying paint to canvas with a brush, and the distinctive, personal ways they handle materials constitute their *technique*. Form, material, and technique interrelate and are central to analyzing any work of art.

LINE Among the most important elements defining an artwork's shape or form is *line*. A line can be understood as the path of a point moving in space, an invisible line of sight. More commonly, however, artists and architects make a line tangible by drawing (or chiseling) it

on a *plane*, a flat surface. A line may be very thin, wirelike, and delicate. It may be thick and heavy. Or it may alternate quickly from broad to narrow, the strokes jagged or the outline broken. When a continuous line defines an object's outer shape, art historians call it a *contour line*. All of these line qualities are present in Dürer's *Four Horsemen of the Apocalypse* (FIG. I-8). Contour lines define the basic shapes of clouds, human and animal limbs, and weapons. Within the forms, series of short broken lines create shadows and textures. An overall pattern of long parallel strokes suggests the dark sky on the frightening day when the world is about to end.

COLOR Light reveals all colors. Light in the world of the painter and other artists differs from natural light. Natural light, or sunlight, is whole or *additive light*. As the sum of all the wavelengths composing the visible *spectrum*, natural light may be disassembled or fragmented into the individual colors of the spectral band. The painter's light in art—the light reflected from pigments and objects—is *subtractive light*. Paint pigments produce their individual colors by reflecting a segment of the spectrum while absorbing all the rest. Green pigment, for example, subtracts or absorbs all the light in the spectrum except that seen as green.

Hue is the property that gives a color its name. Although the spectrum colors merge into each other, artists usually conceive of their hues as distinct from one another. Color has two basic variables—the apparent amount of light reflected and the apparent purity. A change in one must produce a change in the other. Some terms for these variables are value, or tonality (the degree of lightness or darkness), and intensity, or saturation (the purity of a color, or its brightness or dullness).

Artists call the three basic colors—red, yellow, and blue—the *primary colors*. The *secondary colors* result from mixing pairs of primaries: orange (red and yellow), purple (red and blue), and green (yellow and blue). *Complementary colors* represent the pairing of a primary color and the secondary color created from mixing the two other primary colors—red and green, yellow and purple, and blue and orange. They "complement," or complete, each other, one absorbing colors the other reflects.

Artists can manipulate the appearance of colors, however. One artist who made a systematic investigation of the formal aspects of art, especially color, was Josef Albers (1888-1976), a German-born artist who emigrated to the United States in 1933. In connection with his studies, Albers created the series *Homage to the Square*—hundreds of paintings, most of which are color variations on the same composition of concentric squares, as in the illustrated example (FIG. I-10). The series reflected Albers's belief that art originates in "the discrepancy between physical fact and psychic effect." Because the composition in most of these paintings remains constant, the works succeed in revealing the relativity and instability of color perception. Albers varied the hue, saturation, and value of each square in the paintings in this series. As a result, the sizes of the squares from painting to painting appear to vary (although they remain the same), and the sensations emanating from the paintings range from clashing dissonance to delicate serenity. Albers explained his motivation for focusing on color juxtapositions:

They [the colors] are juxtaposed for various and changing visual effects.... Such action, reaction, interaction... is sought in order to make obvious how colors influence and change each other; that the same color, for instance—with different grounds or neighbors—looks different.... Such color deceptions prove that we see colors almost never unrelated to each other.²

Albers's quotation is only one example of how artists' comments on their own works are often invaluable to art historians. In *Art through*

I-10 Josef Albers, *Homage to the Square: "Ascending,*" 1953. Oil on composition board, 3' $7\frac{1}{2}'' \times 3'$ $7\frac{1}{2}''$. Whitney Museum of American Art, New York.

Josef Albers painted hundreds of canvases with the same composition but employed variations in hue, saturation, and value in order to reveal the relativity and instability of color perception.

the Ages: The Western Perspective, artist commentaries appear frequently in boxed features called "Artists on Art."

TEXTURE The term *texture* refers to the quality of a surface, such as rough or shiny. Art historians distinguish between true texture, or the tactile quality of the surface, and represented texture, as when painters depict an object as having a certain texture even though the pigment is the true texture. Sometimes artists combine different materials of different textures on a single surface, juxtaposing paint with pieces of wood, newspaper, fabric, and so forth. Art historians refer to this mixed-media technique as *collage*. Texture is, of course, a key determinant of any sculpture's character. A viewer's first impulse is usually to handle a piece of sculpture—even though museum signs often warn "Do not touch!" Sculptors plan for this natural human response, using surfaces varying in texture from rugged coarseness to polished smoothness. Textures are often intrinsic to a material, influencing the type of stone, wood, plastic, clay, or metal sculptors select.

SPACE, MASS, AND VOLUME *Space* is the bounded or boundless "container" of objects. For art historians, space can be the literal three-dimensional space occupied by a statue or a vase or contained within a room or courtyard. Or space can be *illusionistic*, as when painters depict an image (or illusion) of the three-dimensional spatial world on a two-dimensional surface.

Mass and volume describe three-dimensional objects and space. In both architecture and sculpture, mass is the bulk, density, and weight of matter in space. Yet the mass need not be solid. It can be the exterior form of enclosed space. Mass can apply to a solid Egyptian pyramid or stone statue, to a church, synagogue, or mosque—architectural shells enclosing sometimes vast spaces—and to a hollow metal statue or baked clay pot. Volume is the space that mass organizes, divides, or encloses. It may be a building's interior spaces, the

I-11 CLAUDE LORRAIN, Embarkation of the Queen of Sheba, 1648. Oil on canvas, 4' $10'' \times 6'$ 4''. National Gallery, London.

To create the illusion of a deep landscape, Claude Lorrain employed perspective, reducing the size of and blurring the most distant forms. Also, all diagonal lines converge on a single point.

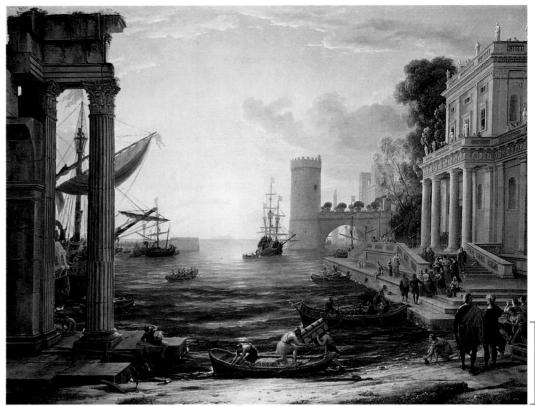

1 ft.

intervals between a structure's masses, or the amount of space occupied by three-dimensional objects such as sculpture, pottery, or furniture. Volume and mass describe both the exterior and interior forms of a work of art—the forms of the matter of which it is composed and the spaces immediately around the work and interacting with it.

PERSPECTIVE AND FORESHORTENING *Perspective* is one of the most important pictorial devices for organizing forms in space. Throughout history, artists have used various types of perspec-

tive to create an illusion of depth or space on a two-dimensional surface. The French painter Claude Lorrain (1600–1682) employed several perspectival devices in *Embarkation of the Queen of Sheba* (FIG. I-11), a painting of a biblical episode set in a 17th-century European harbor with a Roman ruin in the left foreground. For example, the figures and boats on the shoreline are much larger than those in the distance. Decreasing the size of an object makes it appear farther away. Also, the top and bottom of the port building at the painting's right side are not parallel horizontal lines, as they are

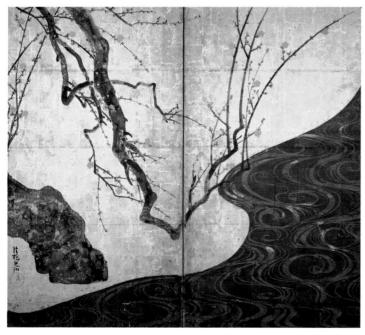

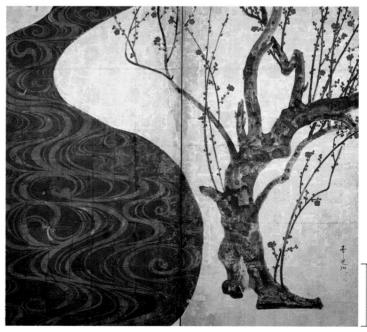

1 ft.

I-12 OGATA KORIN, White and Red Plum Blossoms, Edo period, ca. 1710–1716. Pair of twofold screens. Ink, color, and gold leaf on paper, each screen $5' 1\frac{5}{8}'' \times 5' 7\frac{7}{8}''$. MOA Art Museum, Shizuoka-ken.

Ogata Korin was more concerned with creating an interesting composition of shapes on a surface than with locating objects in space. Asian artists rarely employed Western perspective.

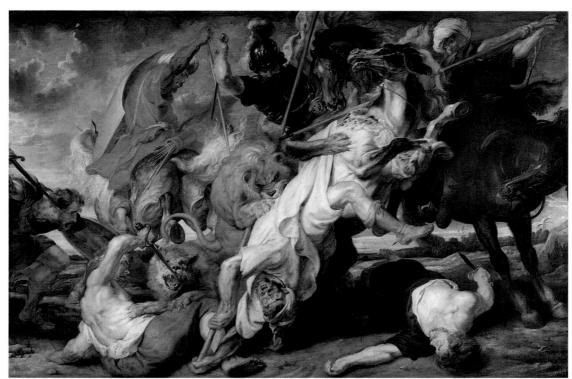

I-13 PETER PAUL RUBENS, Lion Hunt, 1617–1618. Oil on canvas, 8' 2" × 12' 5". Alte Pinakothek, Munich.

Foreshortening—the representation of a figure or object at an angle to the picture plane—is a common device in Western art for creating the illusion of depth. Foreshortening is a type of perspective.

1 1

in a real building. Instead, the lines converge beyond the structure, leading viewers' eyes toward the hazy, indistinct sun on the horizon. These perspectival devices—the reduction of figure size, the convergence of diagonal lines, and the blurring of distant forms—have been familiar features of Western art since the ancient Greeks. But it is important to note at the outset that all kinds of perspective are only pictorial conventions, even when one or more types of perspective may be so common in a given culture that people accept them as "natural" or as "true" means of representing the natural world.

In White and Red Plum Blossoms (FIG. I-12), a Japanese land-scape painting on two folding screens, Ogata Korin (1658–1716) used none of these Western perspective conventions. He showed the two plum trees as seen from a position on the ground, but viewers look down on the stream between them from above. Less concerned with locating the trees and stream in space than with composing shapes on a surface, the painter played the water's gently swelling curves against the jagged contours of the branches and trunks. Neither the French nor the Japanese painting can be said to project "correctly" what viewers "in fact" see. One painting is not a "better" picture of the world than the other. The European and Asian artists simply approached the problem of picture-making differently. Claude Lorrain's approach is, however, one of the most distinctive features of the Western tradition in art examined exclusively in this book.

Artists also represent single figures in space in varying ways. When the Flemish artist Peter Paul Rubens (1577–1640) painted Lion Hunt (FIG. I-13), he used foreshortening for all the hunters and animals—that is, he represented their bodies at angles to the picture plane. When in life one views a figure at an angle, the body appears to contract as it extends back in space. Foreshortening is a kind of perspective. It produces the illusion that one part of the body is farther away than another, even though all the forms are on the same surface. Especially noteworthy in Lion Hunt are the gray horse at the left, seen from behind with the bottom of its left rear hoof facing viewers and most of its head hidden by its rider's shield, and the fallen hunter at the painting's lower right corner, whose barely visible legs and feet recede into the distance.

The artist who carved the portrait of the ancient Egyptian official Hesire (FIG. I-14) did not employ foreshortening. That artist's purpose was to present the various human body parts as clearly as possible, without overlapping. The lower part of Hesire's body is in

1-14 Hesire, relief from his tomb at Saqqara, Egypt, Third Dynasty, ca. 2650 BCE. Wood, 3′ 9″ high. Egyptian Museum, Cairo.

Egyptian artists combined frontal and profile views to give a precise picture of the parts of the human body, as opposed to depicting how an individual body appears from a specific viewpoint.

1 ft.

I-15 King on horseback with attendants, from Benin, Nigeria, ca. 1550–1680. Bronze, 1' $7\frac{1}{2}$ " high. Metropolitan Museum of Art, New York (Michael C. Rockefeller Memorial Collection, gift of Nelson A. Rockefeller).

This African artist used hierarchy of scale to distinguish the relative rank of the figures, making the king the largest. The sculptor created the relief by casting (pouring bronze into a mold).

profile to give the most complete view of the legs, with both the heels and toes of the foot visible. The frontal torso, however, allows viewers to see its full shape, including both shoulders, equal in size, as in nature. (Compare the shoulders of the hunter on the gray horse or those of the fallen hunter in *Lion Hunt's* left foreground.) The result, an "unnatural" 90-degree twist at the waist, provides a precise picture of human body parts. Rubens and the Egyptian sculptor used very different means of depicting forms in space. Once again, neither is the "correct" manner, although foreshortening, like perspective, is one of the characteristic features of the Western artistic tradition.

PROPORTION AND SCALE *Proportion* concerns the relationships (in terms of size) of the parts of persons, buildings, or objects. People can judge "correct proportions" intuitively ("that statue's head seems the right size for the body"). Or proportion can be a mathematical relationship between the size of one part of an artwork or building and the other parts within the work. Proportion in art implies using a *module*, or basic unit of measure. When an artist or architect uses a formal system of proportions, all parts of a building, body, or other entity will be fractions or multiples of the module. A module might be a *column*'s diameter, the height of a human head, or any other component whose dimensions can be multiplied or divided to determine the size of the work's other parts.

In certain times and places, artists have formulated *canons*, or systems, of "correct" or "ideal" proportions for representing human fig-

ures, constituent parts of buildings, and so forth. In ancient Greece, many sculptors devised canons of proportions so strict and allencompassing that they calculated the size of every body part in advance, even the fingers and toes, according to mathematical ratios.

Proportional systems can differ sharply from period to period, culture to culture, and artist to artist. Part of the task art history students face is to perceive and adjust to these differences. In fact, many artists have used disproportion and distortion deliberately for expressive effect. In the medieval French depiction of the weighing of souls on Judgment Day (FIG. I-6), the devilish figure yanking down on the scale has distorted facial features and stretched, lined limbs with animal-like paws for feet. Disproportion and distortion make him appear "inhuman," precisely as the sculptor intended.

In other cases, artists have used disproportion to focus attention on one body part (often the head) or to single out a group member (usually the leader). These intentional "unnatural" discrepancies in proportion constitute what art historians call hierarchy of scale, the enlarging of elements considered the most important. On a bronze plaque from Benin, Nigeria (FIG. I-15), the sculptor enlarged all the heads for emphasis and also varied the size of each figure according to its social status. Central, largest, and therefore most important is the Benin king, mounted on horseback. The horse has been a symbol of power and wealth in many societies from prehistory to the present. That the Benin king is disproportionately larger than his horse, contrary to nature, further aggrandizes him. Two large attendants fan the king. Other figures of smaller size and status at the Benin court stand on the king's left and right and in the plaque's upper corners. One tiny figure next to the horse is almost hidden from view beneath the king's feet.

One problem that students of art history—and professional art historians too—confront when studying illustrations in art history books is that although the relative sizes of figures and objects in a painting or sculpture are easy to discern, it is impossible to determine the absolute size of the works reproduced because they all appear at approximately the same size on the page. Readers of *Art through the Ages* can learn the size of all artworks from the dimensions given in the captions and, more intuitively, from the scales that appear—for the first time in this 13th edition—at the lower left or right corner of the illustration.

CARVING AND CASTING Sculptural technique falls into two basic categories, *subtractive* and *additive*. *Carving* is a subtractive technique. The final form is a reduction of the original mass of a block of stone, a piece of wood, or another material. Wooden statues were once tree trunks, and stone statues began as blocks pried from mountains. An unfinished marble statue of a bound slave (FIG. I-16) by the Italian artist MICHELANGELO BUONARROTI (1475–1564) clearly reveals the original shape of the stone block. Michelangelo thought of sculpture as a process of "liberating" the statue within the block. All sculptors of stone or wood cut away (subtract) "excess material." When they finish, they "leave behind" the statue—in this example, a twisting nude male form whose head Michelangelo never freed from the stone block.

In additive sculpture, the artist builds up the forms, usually in clay around a framework, or *armature*. Or a sculptor may fashion a *mold*, a hollow form for shaping, or *casting*, a fluid substance such as bronze or plaster. The ancient Greek sculptor who made the bronze statue of a warrior found in the sea near Riace, Italy, cast the head (FIG. I-17), limbs, torso, hands, and feet in separate molds and then *welded* them together (joined them by heating). Finally, the artist added features, such as the pupils of the eyes (now missing), in other materials. The warrior's teeth are silver, and his lower lip is copper.

I-16 MICHELANGELO BUONARROTI, unfinished captive, 1527–1528. Marble, 8' $7\frac{1}{2}$ " high. Galleria dell'Accademia, Florence.

Carving a freestanding figure from stone or wood is a subtractive process. Michelangelo thought of sculpture as a process of "liberating" the statue within the block of marble.

RELIEF SCULPTURE *Statues* that exist independent of any architectural frame or setting and that viewers can walk around are *freestanding* sculptures, or *sculptures in the round*, whether the artist produced the piece by carving (FIG. I-9) or casting (FIG. I-17). In *relief* sculpture, the subjects project from the background but remain part of it. In *high-relief* sculpture, the images project boldly. In the medieval weighing-of-souls scene (FIG. I-6), the relief is so high that not only do the forms cast shadows on the background, but some parts are even in the round, which explains why some pieces, for example the arms of the scale, broke off centuries ago. In *low relief*, or *basrelief*, such as the portrait of Hesire (FIG. I-14), the projection is slight. Relief sculpture, like sculpture in the round, can be produced either by carving or casting. The plaque from Benin (FIG. I-15) is an example of bronze casting in high relief.

ARCHITECTURAL DRAWINGS Buildings are groupings of enclosed spaces and enclosing masses. People experience architecture both visually and by moving through and around it, so they

I-17 Head of a warrior, detail of a statue (FIG. 5-35) from the sea off Riace, Italy, ca. 460–450 BCE. Bronze, full statue 6′ 6″ high. Museo Nazionale della Magna Grecia, Reggio Calabria.

The sculptor of this life-size statue of a bearded Greek warrior cast the head, limbs, torso, hands, and feet in separate molds, then welded the pieces together and added the eyes in a different material.

perceive architectural space and mass together. Architects can represent these spaces and masses graphically in several ways, including as plans, sections, elevations, and cutaway drawings.

A plan, essentially a map of a floor, shows the placement of a structure's masses and, therefore, the spaces they circumscribe and enclose. A section, like a vertical plan, depicts the placement of the masses as if someone cut through the building along a plane. Drawings showing a theoretical slice across a structure's width are lateral sections. Those cutting through a building's length are longitudinal sections. Illustrated here are the plan and lateral section of Beauvais Cathedral (FIG. I-18), which may be compared to the photograph of the church's choir (FIG. I-2). The plan shows not only the choir's shape and the location of the piers dividing the aisles and supporting the vaults above but also the pattern of the crisscrossing vault ribs. The lateral section shows both the interior of the choir with its vaults and tall stained-glass windows as well as the roof structure and the form of the exterior flying buttresses that hold the vaults in place.

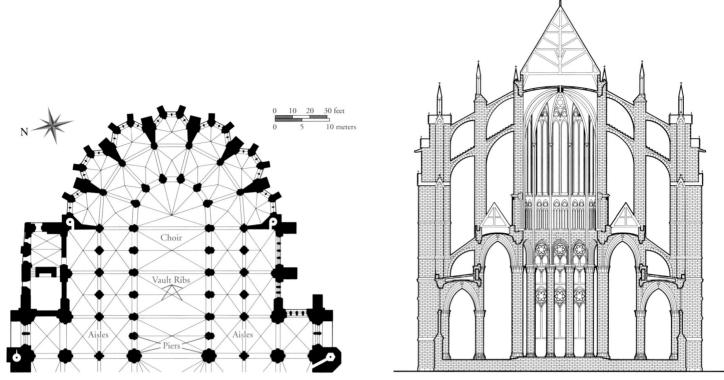

I-18 Plan (left) and lateral section (right) of Beauvais Cathedral, Beauvais, France, rebuilt after 1284.

Architectural drawings are indispensable aids for the analysis of buildings. Plans are maps of floors, recording the structure's masses. Sections are vertical "slices," across either a building's width or length.

Other types of architectural drawings appear throughout this book. An *elevation* drawing is a head-on view of an external or internal wall. A *cutaway* combines in a single drawing an exterior view with an interior view of part of a building.

This overview of the art historian's vocabulary is not exhaustive, nor have artists used only painting, drawing, sculpture, and architecture as media over the millennia. Ceramics, jewelry, textiles, photography, and computer art are just some of the numerous other arts. All of them involve highly specialized techniques described in distinct vocabularies. As in this introductory chapter, new terms are in *italics* where they first appear. The comprehensive Glossary at the end of the book contains definitions of all italicized terms.

Art History and Other Disciplines

By its very nature, the work of art historians intersects with that of others in many fields of knowledge, not only in the humanities but also in the social and natural sciences. To do their job well today, art historians regularly must go beyond the boundaries of what the public and even professional art historians of previous generations traditionally considered the specialized discipline of art history. In short, art historical research in the 21st century is typically interdisciplinary in nature. To cite one example, in an effort to unlock the secrets of a particular statue, an art historian might conduct archival research hoping to uncover new documents shedding light on who paid for the work and why, who made it and when, where it originally stood, how its contemporaries viewed it, and a host of other questions. Realizing, however, that the authors of the written documents often were not objective recorders of fact but rather observers with their own biases and agendas, the art historian may also use methodologies developed in

such fields as literary criticism, philosophy, sociology, and gender studies to weigh the evidence the documents provide.

At other times, rather than attempt to master many disciplines at once, art historians band together with other specialists in multidisciplinary inquiries. Art historians might call in chemists to date an artwork based on the composition of the materials used or might ask geologists to determine which quarry furnished the stone for a particular statue. X-ray technicians might be enlisted in an attempt to establish whether a painting is a forgery. Of course, art historians often reciprocate by contributing their expertise to the solution of problems in other disciplines. A historian, for example, might ask an art historian to determine—based on style, material, iconography, and other criteria—if any of the portraits of a certain king date to after his death. That would help establish the ruler's continuing prestige during the reigns of his successors. (Some portraits of Augustus, FIG. I-9, the founder of the Roman Empire, postdate his death by decades, even centuries.)

DIFFERENT WAYS OF SEEING

The history of art can be a history of artists and their works, of styles and stylistic change, of materials and techniques, of images and themes and their meanings, and of contexts and cultures and patrons. The best art historians analyze artworks from many viewpoints. But no art historian (or scholar in any other field), no matter how broad-minded in approach and no matter how experienced, can be truly objective. Like artists, art historians are members of a society, participants in its culture. How can scholars (and museum visitors and travelers to foreign locales) comprehend cultures unlike their own? They can try to reconstruct the original cultural contexts of artworks, but they are limited by their distance from the thought

I-19 *Left:* John Henry Sylvester, *Portrait of Te Pehi Kupe* (detail), 1826. Watercolor, $8\frac{1}{4}'' \times 6\frac{1}{4}''$. National Library of Australia, Canberra (Rex Nan Kivell Collection). *Right:* Te Pehi Kupe, *Self-Portrait*, 1826. From Leo Frobenius, *The Childhood of Man* (New York: J. B. Lippincott, 1909).

These strikingly different portraits of the same Maori chief reveal how differently Western and non-Western artists "see" a subject. Understanding the cultural context of artworks is vital to art history.

patterns of the cultures they study and by the obstructions to understanding—the assumptions, presuppositions, and prejudices peculiar to their own culture—their own thought patterns raise. Art historians may reconstruct a distorted picture of the past because of culture-bound blindness.

A single instance underscores how differently people of diverse cultures view the world and how various ways of seeing can cause sharp differences in how artists depict the world. Illustrated here are two contemporaneous portraits of a 19th-century Maori chieftain (FIG. I-19)—one by an Englishman, John Sylvester (active early 19th century), and the other by the New Zealand chieftain himself, Te Pehi Kupe (d. 1829). Both reproduce the chieftain's facial tattooing. The European artist (FIG. I-19, *left*) included the head and shoulders and underplayed the tattooing. The tattoo pattern is one aspect of the likeness among many, no more or less important than the chieftain's European attire. Sylvester also recorded his subject's momentary glance toward the right and the play of light on his hair, fleeting aspects that have nothing to do with the figure's identity.

In contrast, Te Pehi Kupe's self-portrait (FIG. I-19, *right*)—made during a trip to Liverpool, England, to obtain European arms to take back to New Zealand—is not a picture of a man situated in space and

bathed in light. Rather, it is the chieftain's statement of the supreme importance of the tattoo design that symbolizes his rank among his people. Remarkably, Te Pehi Kupe created the tattoo patterns from memory, without the aid of a mirror. The splendidly composed insignia, presented as a flat design separated from the body and even from the head, is Te Pehi Kupe's image of himself. Only by understanding the cultural context of each portrait can viewers hope to understand why the English representation differs so strikingly from the Maori representation.

As noted at the outset, the study of the context of artworks and buildings is one of the central concerns of art historians. Western art differs in many fundamental ways from other artistic traditions, but even within the Western world, each culture and each period is distinctive. Paintings, sculptures, buildings—indeed, all art forms—changed dramatically with each change of culture, locale, and date. *Art through the Ages: The Western Perspective* seeks to present a history of art and architecture that will help readers understand not only the subjects, styles, and techniques of paintings, sculptures, buildings, and other art forms created in the Western world across 30 millennia but also their cultural and historical contexts. That story now begins.

14-1 GIOTTO DI BONDONE, Arena Chapel (Cappella Scrovegni; interior looking west), Padua, Italy, 1305–1306.

Giotto, widely regarded as the first Renaissance painter, was a pioneer in pursuing a naturalistic approach to representation based on observation. The frescoes in the Arena Chapel show his art at its finest.

ITALY, 1200 TO 1400

When the Italian humanists of the 16th century condemned the art of the late Middle Ages in northern Europe as "Gothic" (see Chapter 13), they did so by comparing it with the contemporary art of Italy, which was a conscious revival of classical* art. Italian artists and scholars regarded medieval artworks as distortions of the noble art of the Greeks and Romans. But interest in the art of classical antiquity was not entirely absent during the medieval period, even in France, the center of the Gothic style. For example, on the west front of Reims Cathedral, the statues of Christian saints and angels (FIG. 13-24) reveal the unmistakable influence of Roman art on French sculptors. However, the classical revival that took root in Italy during the 13th and 14th centuries (MAP 14-1) was much more pervasive and long-lasting.

THE 13TH CENTURY

Italian admiration for classical art surfaced early on at the court of Frederick II, king of Sicily (r. 1197–1250) and Holy Roman Emperor (r. 1220–1250). Frederick's nostalgia for the past grandeur of Rome fostered a revival of Roman sculpture in Sicily and southern Italy not unlike the neoclassical *renovatio* (renewal) that Charlemagne encouraged in Germany four centuries earlier (see Chapter 11).

Sculpture

NICOLA PISANO The sculptor Nicola d'Apulia (Nicholas of Apulia), better known as NICOLA PISANO (active ca. 1258–1278) after his adopted city (see "Italian Artists' Names," page 376), received his early training in southern Italy under Frederick's rule. In 1250, Nicola traveled northward and eventually settled in Pisa. Then at the height of its political and economic power, Pisa was a magnet for artists seeking lucrative commissions. Nicola specialized in carving marble reliefs and ornamentation for large *pulpits* (raised platforms from which priests lead church services), completing the first (FIG. **14-2**) in 1260 for Pisa's baptistery (FIG. **12-25**, *left*). Some elements of the pulpit's design carried on medieval traditions (for example, the *trefoil arches* and the lions supporting some of the *columns*), but Nicola also incorporated

^{*} In *Art through the Ages* the adjective "Classical," with uppercase *C*, refers specifically to the Classical period of ancient Greece, 480–323 BCE. Lowercase "classical" refers to Greco-Roman antiquity in general, that is, the period treated in Chapters 5, 6, and 7.

Italian Artists' Names

n contemporary societies, people have become accustomed to a standardized method of identifying individuals, in part because of the proliferation of official documents such as driver's licenses, passports, and student identification cards. Given names are coupled with family names, although the order of the two (or more) names varies from country to country. This kind of regularity in names was not, however, the norm in premodern Italy. Many individuals were known by their place of birth or adopted hometown. Nicola Pisano was known as "Nicholas the Pisan," Giulio Romano was "Julius the Roman," and Domenico Veneziano was "the Venetian." Leonardo da Vinci ("Leonard from Vinci") hailed from the small town of Vinci.

Art historians therefore refer to these artists by their given name, not the name of their town: "Leonardo," not "da Vinci."

Nicknames were also common. Giorgione was "Big George." People usually referred to Tommaso di Cristoforo Fini as Masolino ("Little Thomas") to distinguish him from his more famous pupil Masaccio ("Brutish Thomas"). Guido di Pietro was called Fra Angelico (the Angelic Friar). Cenni di Pepo is remembered as Cimabue ("bull's head"). Names were also impermanent and could be changed at will. This flexibility has resulted in significant challenges for historians, who often must deal with archival documents and records that refer to the same artist by different names.

classical elements. The large, bushy *capitals* are a Gothic variation of the highly ornate *Corinthian capital*. The arches are round, as in Roman architecture, rather than pointed (*ogival*) as in Gothic buildings. And each of the large rectangular relief panels resembles the sculptured front of a Roman *sarcophagus*, or coffin (for example, FIG. 7-70).

The densely packed large-scale figures of the individual panels also seem to derive from the compositions found on Roman sarcophagi. One of these panels (FIG. 14-3) depicts scenes from the Infancy cycle of Christ (see "The Life of Jesus in Art," Chapter 8,

pages 216–217, or in the "Before 1300" section), including the *Annunciation* (top left), the *Nativity* (center and lower half), and the *Adoration of the Shepherds* (top right). Mary appears twice, and her size varies. The focus of the composition is the reclining Virgin of the *Nativity*, whose posture and drapery are reminiscent of those of the lid figures on Etruscan (FIGS. 6-5 and 6-15) and Roman (FIG. 7-61) sarcophagi. The face types, beards, and coiffures as well as the bulk and weight of Nicola's figures also reveal the influence of classical relief sculpture. Scholars have even been able to pinpoint the models of some of the pulpit figures on Roman sarcophagi in Pisa.

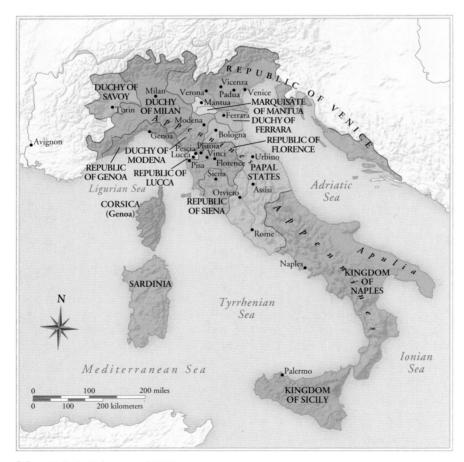

MAP 14-1 Italy around 1400.

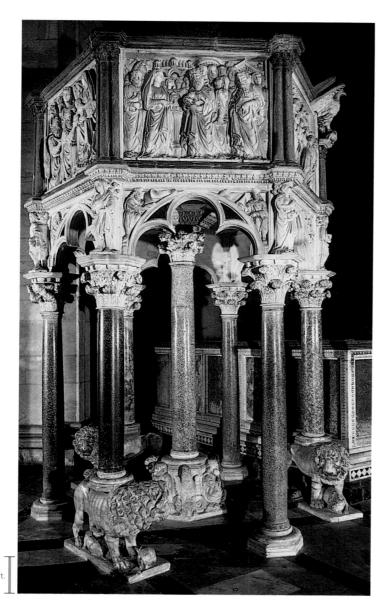

14-2 NICOLA PISANO, pulpit of the baptistery, Pisa, Italy, 1259–1260. Marble, 15' high.

Nicola Pisano's baptistery pulpit at Pisa retains many medieval design elements, for example, the trefoil arches and the lions supporting columns, but the panels draw on ancient Roman sarcophagus reliefs.

GIOVANNI PISANO Nicola Pisano's son, GIOVANNI PISANO (ca. 1250-1320), likewise became a sought-after sculptor of church pulpits. Giovanni's pulpit in Sant'Andrea at Pistoia also has a panel (FIG. 14-4) featuring the Nativity and related scenes. The son's version of the subject is in striking contrast to his father's thick carving and placid, almost stolid, presentation of the religious narrative. Giovanni arranged the figures loosely and dynamically. They twist and bend in excited animation, and the spaces that open deeply between them suggest their motion. In the Annunciation episode (top left), the Virgin shrinks from the angel's sudden appearance in a posture of alarm touched with humility. The same spasm of apprehension contracts her supple body as she reclines in the Nativity scene (center). The drama's principals share in a peculiar nervous agitation, as if they all suddenly are moved by spiritual passion. Only the shepherds and the sheep (right) do not yet experience the miraculous event. The swiftly turning, sinuous draperies, the slender figures they enfold, and the general emotionalism of the scene are features not found in Nicola Pisano's interpretation. The father worked in the classical tradition, the son in a style derived from French Gothic. Both styles were important ingredients in the formation of the distinctive and original art of 14th-century Italy.

Painting and Architecture

A third contributing component of 14th-century Italian art was the Byzantine tradition (see Chapter 9). Throughout the Middle Ages, the Byzantine style dominated Italian painting, but its influence was especially strong after the fall of Constantinople in 1204, which precipitated a migration of Byzantine artists to Italy.

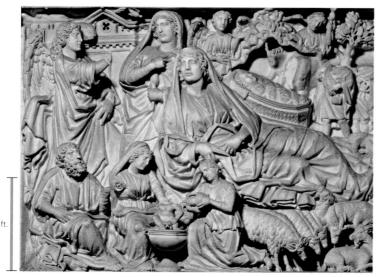

14-3 NICOLA PISANO, *Annunciation, Nativity, and Adoration of the Shepherds*, relief panel on the baptistery pulpit, Pisa, Italy, 1259–1260. Marble, $2' 10'' \times 3' 9''$.

Classical sculpture inspired the face types, beards, coiffures, and draperies, as well as the bulk and weight of Nicola's figures. The Madonna of the *Nativity* resembles lid figures on Roman sarcophagi.

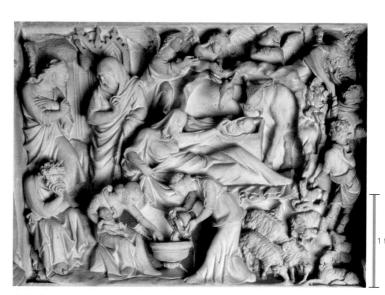

14-4 GIOVANNI PISANO, *Annunciation, Nativity, and Adoration of the Shepherds*, relief panel on the pulpit of Sant'Andrea, Pistoia, Italy, 1297–1301. Marble, $2'10'' \times 3'4''$.

The French Gothic style had a greater influence on Giovanni Pisano, Nicola's son. Giovanni arranged his figures loosely and dynamically. They display a nervous agitation, as if moved by spiritual passion.

377

14-5 Bonaventura Berlinghieri, panel from the *Saint Francis Altarpiece*, San Francesco, Pescia, Italy, 1235. Tempera on wood, $5' \times 3' \times 6'$.

Berlinghieri was one of the leading painters working in the Italo-Byzantine style, or *maniera greca*. The frontal pose of Saint Francis and the use of gold leaf reveal the painter's Byzantine sources.

BONAVENTURA BERLINGHIERI

One of the leading painters working in the Italo-Byzantine style, or maniera greca (Greek style), was Bonaventura Berlin-GHIERI (active ca. 1235–1244) of Lucca. He created the Saint Francis Altarpiece (FIG. 14-5) for the church of San Francesco (Saint Francis) in Pescia in 1235. Painted in tempera on wood panel (see "Tempera and Oil Painting," Chapter 15, page 401), the altarpiece honors Saint Francis of Assisi (ca. 1181–1226). Francis wears the coarse clerical robe, tied at the waist with a rope, which became the costume of Franciscan monks. The saint displays the stigmata marks resembling Christ's wounds-that appeared on his hands and feet. Flanking Francis are two angels, whose frontal poses, prominent halos, and lack of modeling reveal the Byzantine roots of Berlinghieri's style. So too does his use of gold leaf (gold beaten into tissue-paper-thin sheets, then applied to surfaces), which emphasizes the image's flatness and spiritual nature. The narrative scenes that run along the sides of the panel provide an active contrast to the stiff formality of the large central image of Francis. At the upper left, taking pride of

place at the saint's right, Francis miraculously acquires the stigmata. Directly below, the saint preaches to the birds. These and the scenes depicting Francis's miracle cures strongly suggest that Berlinghieri's source was one or more Byzantine *illuminated manuscripts* (compare FIG. 9-17) having biblical narrative scenes.

Berlinghieri's Saint Francis Altarpiece also highlights the increasingly prominent role of religious orders in late medieval Italy (see "The Great Schism, Mendicant Orders, and Confraternities," page 379). Saint Francis's Franciscan order worked diligently to impress on the public the saint's valuable example and to demonstrate its monks' commitment to teaching and to alleviating suffering. Berlinghieri's Pescia altarpiece, painted nine years after Francis's death, is the earliest known signed and dated representation of the saint. Appropriately, the panel focuses on the aspects of the saint's life that the Franciscans wanted to promote, thereby making visible (and thus more credible) the legendary life of this holy man. Saint Francis believed he could get closer to God by rejecting worldly

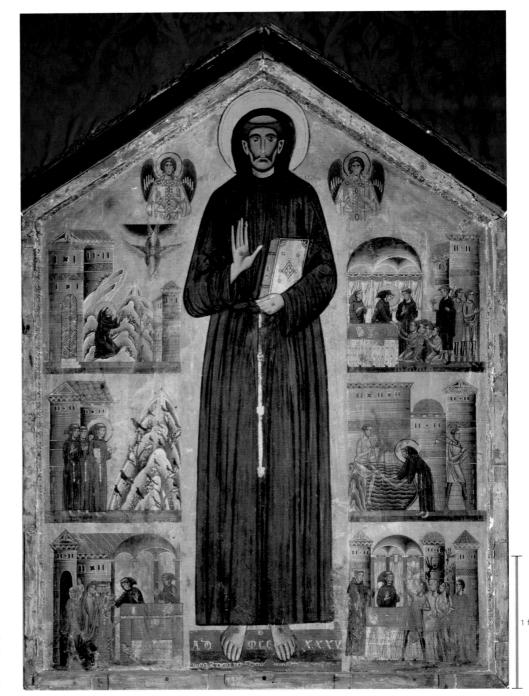

goods, and to achieve this he stripped himself bare in a public square and committed himself to a strict life of fasting, prayer, and meditation. The appearance of stigmata on his hands and feet (clearly visible in the saint's frontal image, which resembles an *icon*) was perceived as God's blessing and led some followers to see Francis as a second Christ. Fittingly, four of the six narrative scenes on the altarpiece depict miraculous healings, connecting him more emphatically to Christ.

SANTA MARIA NOVELLA The increased importance of the mendicant orders during the 13th century led to the construction of large churches in Florence by the Franciscans (Santa Croce; FIG. I-3) and the Dominicans. The Florentine government and contributions from private citizens subsidized the commissioning of the Dominicans' Santa Maria Novella (FIG. 14-6) around 1246. The large congregations these orders attracted necessitated the expansive scale of this church. Small *oculi* (round windows) and marble striping along

The Great Schism, Mendicant Orders, and Confraternities

n 1305 the College of Cardinals (the collective body of all cardinals) elected a French pope, Clement V, who settled in Avignon. Subsequent French popes remained in Avignon, despite their announced intentions to return to Rome. Understandably, this did not please the Italians, who saw Rome as the rightful capital of the universal church. The conflict between the French and Italians resulted in the election in 1378 of two popes— Clement VII, who resided in Avignon (and who does not appear in the Catholic Church's official list of popes), and Urban VI (r. 1378-1389), who remained in Rome. Thus began what became known as the Great Schism. After 40 years, the Holy Roman Emperor Sigismund (r. 1410-1437) convened a council that managed to resolve this crisis by electing a new Roman pope, Martin V (r. 1417-1431), who was acceptable to all.

The pope's absence from Italy during much of the 14th century (the Avignon papacy) contributed to an increase in prominence of monastic orders. The Augustinians, Carmelites, and Servites became very active, ensuring a constant religious presence in the daily life of Italians, but the largest and most influential monastic orders were the mendicants (begging friars)—the Franciscans, founded by Francis of Assisi (FIG. 14-5), and the Dominicans, founded by the Spaniard Dominic de Guzman (ca. 1170-1221). These mendicants renounced all worldly goods and committed themselves to spreading God's word, performing good deeds, and ministering to the sick and dying. The Dominicans, in particular, contributed significantly to establishing urban educational institutions. The Franciscans and Dominicans became very popular among Italian citizens because of their devotion to their faith and the more personal relationship with God they encouraged. Although both mendicant orders were working for the same purpose—the glory of God—a degree of rivalry nevertheless existed between the two. They established their churches on opposite sides of Florence—Santa Croce (FIG. I-3), the Franciscan church, on the eastern side, and the Dominicans' Santa Maria Novella (FIG. 14-6) on the western (MAP 16-1).

Confraternities, organizations consisting of laypersons who dedicated themselves to strict religious observance, also grew in popularity during the 14th and 15th centuries. The mission of confraternities included tending the sick, burying the dead, singing hymns, and per-

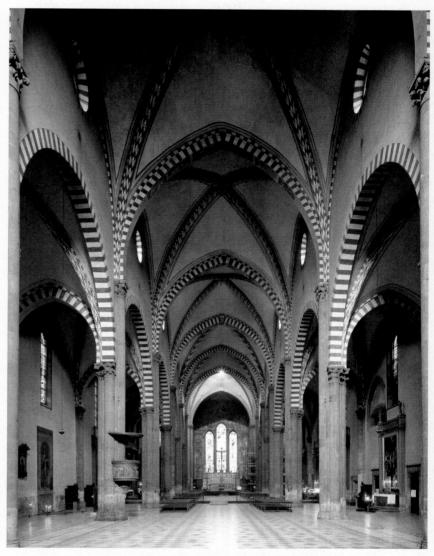

14-6 Nave of Santa Maria Novella, Florence, Italy, ca. 1246–1470.

The basilicas of Santa Maria Novella and Santa Croce (FIG. I-3) testify to the growing influence of the Dominican and Franciscan mendicant orders, respectively, in 13th-century Florence.

forming other good works. The confraternities as well as the mendicant orders continued to play an important role in Italian religious life through the 16th century. Further, the numerous artworks and monastic churches they commissioned ensured their enduring legacy.

the ogival arches punctuate the *nave*, or central *aisle*. (For the nomenclature of *basilican* church architecture, see FIG. **8-9** or in the "Before 1300" section.) Originally, a screen (*tramezzo*) placed across the nave separated the friars from the lay audience. The priests performed the *Mass* at separate altars on each side of the screen. Church officials removed this screen in the mid-16th century to encourage greater lay participation in the Mass.

CIMABUE One of the first artists to begin to break away from the Italo-Byzantine style that dominated 13th-century Italian painting was Cenni di Pepo, better known as CIMABUE (ca. 1240–1302). Although his works reveal the unmistakable influence of Gothic sculpture, Cimabue challenged some of the conventions that dominated late medieval art in pursuit of a new *naturalism*, the close observation of the natural world that was at the core of the classical

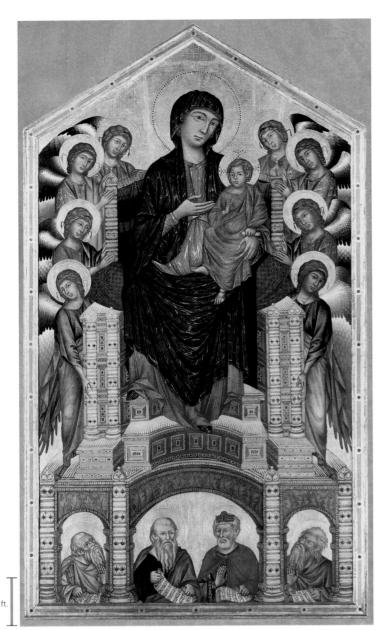

14-7 CIMABUE, *Madonna Enthroned with Angels and Prophets*, from Santa Trinità, Florence, Italy, ca. 1280–1290. Tempera and gold leaf on wood, 12' $7'' \times 7'$ 4". Galleria degli Uffizi, Florence.

Cimabue was one of the first artists to break away from the Italo-Byzantine style. Although he relied on Byzantine models, Cimabue depicted the Madonna's massive throne as receding into space.

tradition. Cimabue's Madonna Enthroned with Angels and Prophets (FIG. 14-7), created for the church of Santa Trinità (Holy Trinity) in Florence, nonetheless reveals the painter's reliance on Byzantine models for the composition as well as the gold background (compare FIG. 9-18). Cimabue used the gold embellishments common to Byzantine art for the folds of the Madonna's robe, but they are no longer merely decorative patterns. Here they enhance the three-dimensionality of the drapery. Cimabue also constructed a deeper space for the Madonna and the surrounding figures to inhabit than is common in Byzantine art. The Virgin's throne, for example, is a massive structure that Cimabue convincingly depicted as receding into space. The overlapping bodies of the angels on each side of the throne and the half-length prophets who look outward or upward from beneath it reinforce the sense of depth.

THE 14TH CENTURY

In the 14th century, Italy consisted of numerous independent *city-states*, each corresponding to a geographic region centered on a major city (MAP 14-1). Most of the city-states, such as Venice, Florence, Lucca, and Siena, were republics. These republics were constitutional oligarchies—governed by executive bodies, advisory councils, and special commissions. Other powerful 14th-century states included the Papal States, the Kingdom of Naples, and the Duchies of Milan, Modena, Ferrara, and Savoy. As their names indicate, these states were politically distinct from the republics, but all the states shared in the prosperity of the period. The sources of wealth varied from state to state. Italy's port cities expanded maritime trade, whereas the economies of other cities depended on banking or the manufacture of arms or textiles.

The eruption of the Black Death (bubonic plague) in the late 1340s threatened this prosperity, however. Originating in China, the Black Death swept across the entire European continent. The most devastating natural disaster in European history, the plague killed between 25 and 50 percent of Europe's population in about five years. Italy was particularly hard hit. In large cities, where people lived in relatively close proximity, the death tolls climbed as high as 50 or 60 percent of the population. The Black Death had a significant effect on art. It stimulated religious bequests and encouraged the commissioning of devotional images. The focus on sickness and death also led to a burgeoning in hospital construction.

Another significant development in 14th-century Italy was the blossoming of a vernacular (commonly spoken) literature, which dramatically affected Italy's intellectual and cultural life. Latin remained the official language of church liturgy and state documents. However, the creation of an Italian vernacular literature (based on the Tuscan dialect common in Florence) expanded the audience for philosophical and intellectual concepts because of its greater accessibility. Dante Alighieri (1265–1321; author of *The Divine Comedy*), poet and scholar Francesco Petrarch (1304–1374), and Giovanni Boccaccio (1313–1375; author of *Decameron*) were among those most responsible for establishing this vernacular literature.

RENAISSANCE HUMANISM The development of a vernacular literature was one important sign that the essentially religious view of the world that dominated medieval Europe was about to change dramatically in what historians call the Renaissance. Although religion continued to occupy a primary position in the lives of Europeans, a growing concern with the natural world, the individual, and humanity's worldly existence characterized the Renaissance period the 14th through the 16th centuries. The word renaissance in French and English (rinascità in Italian) refers to a "rebirth" of art and culture. A revived interest in classical cultures—indeed, the veneration of classical antiquity as a model—was central to this rebirth. The notion that the Renaissance represented the restoration of the glorious past of Greece and Rome gave rise to the concept of the "Middle Ages" as the era spanning the time between antiquity and the Renaissance. The transition from the medieval to the Renaissance, though dramatic, did not come about abruptly, however. In fact, much that is medieval persisted in the Renaissance and in later periods.

Fundamental to the development of the Italian Renaissance was humanism, a concept that emerged during the 14th century and became a central component of Italian art and culture in the 15th and 16th centuries. Humanism was more a code of civil conduct, a theory of education, and a scholarly discipline than a philosophical system. As their name suggests, Italian humanists were concerned chiefly with human values and interests as distinct from—but not opposed to—religion's otherworldly values. Humanists pointed to

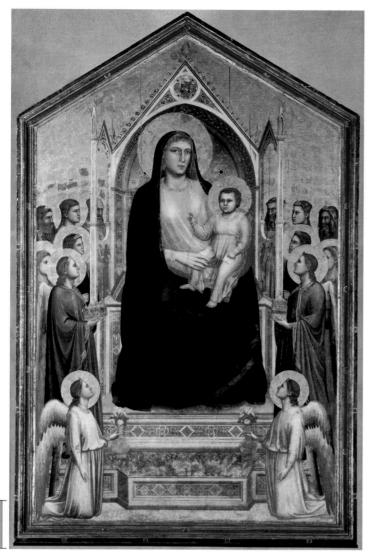

14-8 Giotto di Bondone, *Madonna Enthroned*, from the Church of Ognissanti, Florence, Italy, ca. 1310. Tempera and gold leaf on wood, 10' 8" \times 6' 8". Galleria degli Uffizi, Florence.

Giotto displaced the Byzantine style in Italian painting and revived the naturalism of classical art. His figures have substance, dimensionality, and bulk and give the illusion that they could throw shadows.

classical cultures as particularly praiseworthy. This enthusiasm for antiquity, represented by the elegant Latin of Cicero (106–43 BCE) and the Augustan age, involved study of Latin literature and a conscious emulation of what proponents thought were the Roman civic virtues. These included self-sacrificing service to the state, participation in government, defense of state institutions (especially the administration of justice), and stoic indifference to personal misfortune in the performance of duty. With the help of a new interest in and knowledge of Greek, the humanists of the late 14th and 15th centuries recovered a large part of the Greek as well as the Roman literature and philosophy that had been lost, left unnoticed, or cast aside in the Middle Ages. Indeed, classical cultures provided humanists with a model for living in this world, a model primarily of human focus that derived not from an authoritative and traditional religious dogma but from reason.

Ideally, humanists sought no material reward for services rendered. The sole reward for heroes of civic virtue was fame, just as the reward for leaders of the holy life was sainthood. For the educated, the lives of heroes and heroines of the past became as edifying as the lives of the saints. Petrarch wrote a book on illustrious men, and his colleague Boccaccio complemented it with biographies of famous women—from Eve to his contemporary, Joanna, queen of Naples. Both Petrarch and Boccaccio were famous in their own day as poets, scholars, and men of letters—their achievements equivalent in honor to those of the heroes of civic virtue. In 1341 in Rome, Petrarch received the laurel wreath crown, the ancient symbol of victory and merit. The humanist cult of fame emphasized the importance of creative individuals and their role in contributing to the renown of the city-state and of all Italy.

Giotto

GIOTTO DI BONDONE (ca. 1266-1337) of Florence made a much more radical break with the past than did Cimabue. Art historians from Giorgio Vasari[†] to the present day have regarded Giotto as the first Renaissance painter, a pioneer in pursuing a naturalistic approach to representation based on observation. Scholars still debate the sources of Giotto's style, however. One formative influence must have been the work of the man Vasari said was his teacher, Cimabue, although Vasari lauded Giotto as having eclipsed Cimabue by abandoning the "crude maniera greca." Some late-13th-century murals in Rome with fully modeled figures of saints may also have influenced the young Giotto. French Gothic sculpture (which Giotto may have seen, but certainly familiar to him from the work of Giovanni Pisano, who had spent time in Paris) and ancient Roman art must also have contributed to Giotto's artistic education. Yet no mere synthesis of these varied influences could have produced the significant shift in artistic approach that has led some scholars to describe Giotto as the father of Western pictorial art. Renowned in his own day, he established a reputation that has never faltered. Regardless of the other influences on his artistic style, his true teacher was nature—the world of visible things.

Giotto's revolution in painting did not consist only of displacing the Byzantine style, establishing painting as a major art form for the next seven centuries, and restoring the naturalistic approach the ancients developed and medieval artists largely abandoned. He also inaugurated a method of pictorial expression based on observation and initiated an age that might be called "early scientific." By stressing the preeminence of sight for gaining knowledge of the world, Giotto and his successors contributed to the foundation of empirical science. They recognized that the visual world must be observed before it can be analyzed and understood. Praised in his own and later times for his fidelity to nature, Giotto was more than a mere imitator of it. He revealed nature while observing it and divining its visible order. In fact, he showed his generation a new way of seeing. With Giotto, Western artists turned resolutely toward the visible world as their source of knowledge of nature.

MADONNA ENTHRONED On nearly the same great scale as Cimabue's enthroned Madonna (FIG. 14-7) is Giotto's panel (FIG. 14-8) depicting the same subject, painted for the high altar of the Ognissanti (All Saints) church in Florence. Although still seen against the traditional gold background, Giotto's Madonna rests within her Gothic throne with the unshakable stability of an ancient

†Giorgio Vasari (1511–1574) established himself as both a painter and architect during the 16th century. However, people today usually associate him with his landmark book *Lives of the Most Eminent Painters, Sculptors, and Architects,* first published in 1550. Scholars long have considered this book a major source of information about Italian art and artists, although many of the details have proven inaccurate. Regardless, Vasari's *Lives* remains a tour de force—an ambitious, comprehensive book dedicated to recording the biographies of artists.

resco painting has a long history, particularly in the Mediterranean region, where the Minoans (FIGS. 4-7 to 4-9) used it as early as 1650 BCE. Fresco (Italian for "fresh") is a mural-painting technique that involves applying permanent limeproof pigments, diluted in water, on freshly laid lime plaster. Because the surface of the wall absorbs the pigments as the plaster dries, fresco is one of the most permanent painting techniques. The stable condition of frescoes such as those in the Arena Chapel (FIGS. 14-1 and 14-9) and in the Sistine Chapel (FIGS. 17-1, 17-18, and 17-19), now hundreds of years old, attest to the longevity of this painting method. The colors have remained vivid (although dirt and soot have necessitated cleaning) because of the chemically inert pigments the artists used. In addition to this buon fresco ("true" fresco) technique, artists used fresco secco (dry fresco). Fresco secco involves painting on dried lime plaster. Although the finished product visually approximates buon fresco, the plaster wall does not ab-

The buon fresco process is time-consuming and demanding and requires several layers of plaster. Although buon fresco methods vary, generally the artist prepares the wall with a rough layer of lime plaster called the *arriccio* (brown coat). The artist then transfers the composition to the wall, usually by drawing directly on the arriccio with a burnt-orange pigment called *sinopia* (most popular during the 14th century) or by transferring a

sorb the pigments, which simply adhere to the surface. Thus fresco secco does not have buon

fresco's longevity.

cartoon (a full-sized preparatory drawing). Cartoons increased in usage in the 15th and 16th centuries, largely replacing sinopia underdrawings. Finally, the painter lays the *intonaco* (painting coat) smoothly over the drawing in sections (called *giornate*, Italian for "days") only as large as the artist expects to complete in that session. The buon fresco painter must apply the colors fairly quickly, because once the plaster is dry, it will no longer absorb the pigment. Any

Fresco Painting

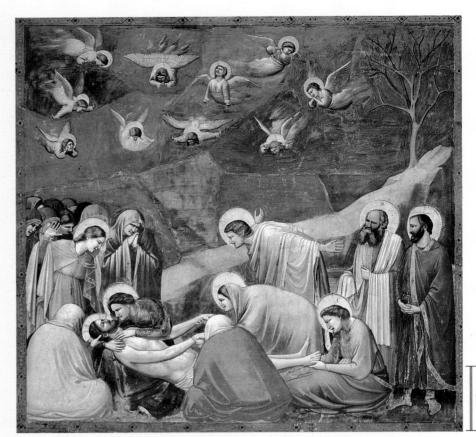

14-9 GIOTTO DI BONDONE, *Lamentation*, Arena Chapel (Cappella Scrovegni), Padua, Italy, ca. 1305. Fresco, 6′ $6\frac{3}{4}'' \times 6' \frac{3}{4}''$.

In this fresco painted in several sections, Giotto used the diagonal slope of the rocky landscape to direct the viewer's attention toward the head of the sculpturesque figure of the dead Christ.

areas of the intonaco that remain unpainted after a session must be cut away so that fresh plaster can be applied for the next giornata.

In areas of high humidity, such as Venice, fresco was less appropriate because moisture is an obstacle to the drying process. Over the centuries, fresco became less popular, although it did experience a revival in the 1930s with the Mexican muralists (FIGS. 24-67 and 24-68).

marble goddess. Giotto replaced Cimabue's slender Virgin, fragile beneath the thin ripplings of her drapery, with a weighty, queenly mother. In Giotto's painting, the Madonna's body is not lost. It is asserted. Giotto even shows Mary's breasts pressing through the thin fabric of her white undergarment. Gold highlights have disappeared from her heavy robe. Giotto aimed, before all else, to construct a figure that has substance, dimensionality, and bulk—qualities suppressed in favor of a spiritual immateriality in Byzantine and Italo-Byzantine art. Works painted in the new style portray sculpturesque figures—projecting into the light and giving the illusion that they could throw shadows. Giotto's *Madonna Enthroned* marks the end of medieval painting in Italy and the beginning of a new naturalistic approach to art.

ARENA CHAPEL, PADUA To project onto a flat surface the illusion of solid bodies moving through space presents a double challenge. Constructing the illusion of a body also requires constructing the illusion of a space sufficiently ample to contain that body. In his *fresco* cycles (see "Fresco Painting," above), Giotto constantly strove to reconcile these two aspects of illusionistic painting. His murals in the Arena Chapel (Cappella Scrovegni; FIG. 14-1) at Padua show his art at its finest. Enrico Scrovegni, a wealthy Paduan banker, built the chapel on a site adjacent to his now-razed palace. Consecrated in 1305, the Arena Chapel takes its name from an ancient Roman amphitheater nearby. Scrovegni erected the chapel, which he intended for his family's private use, in part to expiate the bankers' sin of usury. Some scholars have suggested that Giotto him-

self may have been the chapel's architect because its design is so perfectly suited to its interior decoration.

The rectangular barrel-vaulted hall has six narrow windows only in its south wall (FIG. 14-1, left), which left the entire north wall an unbroken and well-illuminated surface for painting. The building seems to have been designed to provide Giotto with as much flat surface as possible for presenting one of the most impressive and complete Christian pictorial cycles ever rendered. In 38 framed pictures, arranged on three levels, the artist related the most poignant incidents from the lives of the Virgin and her parents, Joachim and Anna (top level), the life and mission of Christ (middle level), and his Passion, Crucifixion, and Resurrection (bottom level). These three pictorial levels rest on a coloristically neutral base. Imitation marble veneer—reminiscent of ancient Roman decoration (FIG. 7-51), which Giotto may have seen—alternates with the Virtues and Vices painted in grisaille (monochrome grays, often used for modeling in paintings) to resemble sculpture. The climactic event of the cycle of human salvation, the Last Judgment, covers most of the west wall above the chapel's entrance (FIG. 14-1).

The hall's vaulted ceiling is blue, an azure sky dotted with golden stars symbolic of Heaven. Medallions bearing images of Christ, Mary, and various prophets also appear on the vault. Giotto painted the same blue in the backgrounds of the narrative panels on the walls below. The color thereby functions as a unifying agent for the entire decorative scheme and renders the scenes more realistic.

Decorative borders frame the individual panels. They offer a striking contrast to the sparse simplicity of the images they surround. Subtly scaled to the chapel's space (only about half life-size), Giotto's stately and slow-moving actors present their dramas convincingly and with great restraint. Lamentation (FIG. 14-9) reveals the essentials of his style. In the presence of boldly foreshortened angels, seen head-on with their bodies receding into the background and darting about in hysterical grief, a congregation mourns over the dead body of the Savior just before its entombment. Mary cradles her son's body, while Mary Magdalene looks solemnly at the wounds in Christ's feet and Saint John the Evangelist throws his arms back dramatically. Giotto arranged a shallow stage for the figures, bounded by a thick diagonal rock incline that defines a horizontal ledge in the foreground. Though narrow, the ledge provides firm visual support for the figures, and the steep slope indicates the picture's dramatic focal point at the lower left. The rocky setting, which recalls that of a 12th-century Byzantine mural (FIG. 9-27), also links this scene with the adjoining one. Giotto connected the framed scenes throughout the fresco cycle with such formal elements. The figures are sculpturesque, simple, and weighty, but this mass did not preclude motion and emotion. Postures and gestures that might have been only rhetorical and mechanical convey, in Lamentation, a broad spectrum of grief. They range from Mary's almost fierce despair to the passionate outbursts of Mary Magdalene and John to the philosophical resignation of the two disciples at the right and the mute sorrow of the two hooded mourners in the foreground. Giotto constructed a kind of stage that served as a model for artists who depicted human dramas in many subsequent paintings. His style broke sharply from the isolated episodes and figures seen in art until the late 13th century. In Lamentation, a single event provokes an intense response. Painters before Giotto rarely attempted, let alone achieved, this combination of compositional complexity and emotional resonance.

The formal design of the *Lamentation* fresco—the way the figures are grouped within the constructed space—is worth close study. Each group has its own definition, and each contributes to the

rhythmic order of the composition. The strong diagonal of the rocky ledge, with its single dead tree (the tree of knowledge of good and evil, which withered at the fall of Adam), concentrates the viewer's attention on the group around the head of Christ, whose positioning is dynamically off center. The massive bulk of the seated mourner in the painting's left corner arrests and contains all movement beyond this group. The seated mourner to the right establishes a relation with the center figures, who, by gazes and gestures, draw the viewer's attention back to Christ's head. Figures seen from the back, which are frequent in Giotto's compositions, represent an innovation in the development away from the formal Italo-Byzantine style. These figures emphasize the foreground, aiding the visual placement of the intermediate figures farther back in space. This device, the very contradiction of the old frontality, in effect puts viewers behind the "observer figures," who, facing the action as spectators, reinforce the sense of stagecraft as a model for painting.

Giotto's new devices for depicting spatial depth and body mass could not, of course, have been possible without his management of light and shade. He shaded his figures to indicate both the direction of the light that illuminates them and the shadows (the diminished light), giving the figures volume. In *Lamentation*, light falls upon the upper surfaces of the figures (especially the two central bending figures) and passes down to dark in their draperies, separating the volumes one from the other and pushing one to the fore, the other to the rear. The graded continuum of light and shade, directed by an even, neutral light from a single steady source—not shown in the picture—was the first step toward the development of *chiaroscuro* (the use of contrasts of dark and light to produce modeling) in later Renaissance painting.

The stagelike settings made possible by Giotto's innovations in perspective (the depiction of three-dimensional objects in space on a two-dimensional surface) and lighting suited perfectly the dramatic narrative the Franciscans emphasized then as a principal method for educating the faithful in their religion. In the age of humanism, the old stylized presentations of the holy mysteries had evolved into what were called mystery plays. The drama of the Mass was extended into one- and two-act tableaus and scenes and then into simple narratives offered at church portals and in city squares. (Eventually, confraternities also presented more elaborate religious dramas called sacre rappresentazioni—holy representations.) The great increase in popular sermons addressed to huge city audiences prompted a public taste for narrative, recited as dramatically as possible. The arts of illusionistic painting, of drama, and of sermon rhetoric with all their theatrical flourishes developed simultaneously and were mutually influential. Giotto's art masterfully synthesized dramatic narrative, holy lesson, and truth to human experience in a visual idiom of his own invention, accessible to all. Not surprisingly, Giotto's frescoes served as textbooks for generations of Renaissance painters.

Siena

Among 14th-century Italian city-states, the Republics of Siena and Florence were the most powerful. Both Siena and Florence (the major cities of these two republics) were urban centers of bankers and merchants with widespread international contacts and large sums available for the commissioning of artworks (see "Artists' Guilds, Commissions, and Contracts," page 384).

DUCCIO The works of Duccio di Buoninsegna (active ca. 1278–1318) represent Sienese art in its supreme achievement. His most famous painting, the immense altarpiece called the *Maestà*

Artists' Guilds, Commissions, and Contracts

The structured organization of economic activity during the 14th century, when Italy had established a thriving international trade and held a commanding position in the Mediterranean world, extended to many trades and professions. *Guilds* (associations of master craftspeople, apprentices, and tradespeople), which had emerged during the 12th century, became prominent. These associations not only protected members' common economic interests against external pressures, such as taxation, but also provided them with the means to regulate their internal operations (for example, work quality and membership training).

Because of today's international open art market, the notion of an "artists' union" may seem strange. The general public tends to see art as the creative expression of an individual artist. However, artists did not always enjoy this degree of freedom. Historically, artists rarely undertook major artworks without a patron's concrete commission. The patron could be a civic group, religious entity, private individual, or even the artists' guild itself. Guilds, although primarily economic commercial organizations, contributed to their city's religious and artistic life by subsidizing the building and decoration of numerous churches and hospitals. For example, the Arte della Lana (wool manufacturers' guild) oversaw the start of Florence Cathedral (FIGS. 14-18 and 14-19) in 1296, and the Arte di Calimala (wool merchants' guild) supervised the completion of its dome.

Monastic orders, confraternities, and the popes were also major art patrons. In addition, wealthy families and individuals commissioned artworks for a variety of reasons. Besides the aesthetic pleasure these patrons derived from art, the images often served as testaments to the patron's wealth, status, power, and knowledge. Because artworks during this period were the product of what was, in effect, a service contract, a patron's needs or wishes played a crucial role in the final form of any painting, sculpture, or building. Some contracts between patrons and artists are preserved in European municipal and church archives. The patrons normally asked artists to submit drawings or models for approval, and they expected the artists they hired to adhere to the approved designs fairly closely. These contracts usually stipulated certain conditions, such as the insistence on the artist's own hand in the production of the work, the quality of pigment and amount of gold or other precious items to be used, completion date, payment terms, and penalties for failure to meet the contract's terms.

A few extant 13th- and 14th-century painting contracts are especially illuminating. Although they may specify the subject to be represented, the focus of these binding legal documents is always the financial aspects of the commission and the responsibilities of the painter to the patron (and vice versa). In a contract dated November 1, 1301, between Cimabue and another artist and the Hospital of Santa Chiara in Pisa, the artists agree to supply an altarpiece

with colonnettes, tabernacles, and predella, painted with histories of the divine majesty of the Blessed Virgin Mary, of the apostles, of

the angels, and with other figures and pictures, as shall be seen fit and shall please the said master of or other legitimate persons for the hospital.*

Other contract terms specify the size of the panel and require that gold and silver gilding be used for parts of the altarpiece.

The contract for the construction of an altarpiece was usually a separate document, for that required the services of a master carpenter. For example, Duccio's April 15, 1285, contract with the rectors of the Confraternity of the Laudesi, the lay group associated with the Dominican church of Santa Maria Novella (FIG. 14-6) in Florence, specifies only that he is to provide the painting, not its frame—and it imposes conditions that he must meet if he is to be paid.

[The rectors] promise . . . to pay the same Duccio . . . as the payment and price of the painting of the said panel that is to be painted and done by him in the way described below . . . 150 lire of the small florins [Duccio, in turn, promises] to paint and embellish the panel with the image of the blessed Virgin Mary and of her omnipotent Son and other figures, according to the wishes and pleasure of the lessors, and to gild [the panel] and do everything that will enhance the beauty of the panel, his being all the expenses and the costs If the said panel is not beautifully painted and it is not embellished according to the wishes and desires of the same lessors, they are in no way bound to pay him the price or any part of it. †

Sometimes patrons furnished the materials and paid artists by the day instead of a fixed amount. That was the arrangement Duccio made on October 9, 1308, when he agreed to paint the *Maestà* (FIG. 14-10) for the high altar of Siena Cathedral.

Duccio has promised to paint and make the said panel as well as he can and knows how, and he further agreed not to accept or receive any other work until the said panel is done and completed.... [The church officials promise] to pay the said Duccio sixteen solidi of the Sienese denari as his salary for the said work and labor for each day that the said Duccio works with his own hands on the said panel... [and] to provide and give everything that will be necessary for working on the said panel so that the said Duccio need contribute nothing to the work save his person and his effort. ‡

In all cases, the artists worked for their patrons and could count on being compensated for their talents and efforts only if the work they delivered met the standards of those who ordered it.

^{*} Translated by John White, *Duccio: Tuscan Art and the Medieval Workshop* (London: Thames & Hudson, 1979), 34.

[†] Translated by James H. Stubblebine, *Duccio di Buoninsegna and His School* (Princeton, N.J.: Princeton University Press, 1979), 1: 192.

[‡] Stubblebine, *Duccio*, 1: 201.

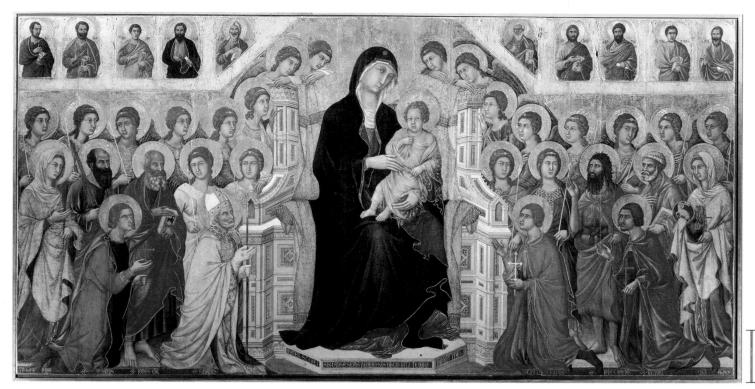

14-10 Duccio di Buoninsegna, *Virgin and Child Enthroned with Saints*, principal panel of the *Maestà* altarpiece, from Siena Cathedral, Siena, Italy, 1308–1311. Tempera and gold leaf on wood, $7' \times 13'$ (center panel). Museo dell'Opera del Duomo, Siena.

Duccio derived the formality and symmetry of his composition from Byzantine tradition, but relaxed the rigidity and frontality of the figures, softened the drapery, and individualized the faces.

(*Virgin Enthroned in Majesty;* FIG. 14-10), replaced a much smaller painting of the Virgin Mary on the high altar of Siena Cathedral. The Sienese believed the Virgin had brought them their victory over the Florentines at the battle of Monteperti in 1260, and she was the focus of the religious life of the republic. Duccio and his assistants began work on the prestigious commission in 1308 and completed the *Maestà* in 1311. As originally executed, it consisted of a seven-foothigh central panel (FIG. 14-10), surmounted by seven *pinnacles* above, and a *predella*, or raised shelf, of panels at the base, altogether some 13 feet high. Painted in tempera front and back, the work unfortunately is no longer viewable in its entirety because of its dismantling in subsequent centuries. Many of Duccio's panels are now scattered as single masterpieces among the world's museums.

The main panel of the front side represents the Virgin enthroned as Queen of Heaven amid choruses of angels and saints. Duccio derived the composition's formality and symmetry, along with the figures and facial types of the principal angels and saints, from Byzantine tradition. But the artist relaxed the strict frontality and rigidity of the figures. They turn to each other in quiet conversation. Further, Duccio individualized the faces of the four saints kneeling in the foreground, who perform their ceremonial gestures without stiffness. Similarly, he softened the usual Byzantine hard body outlines and drapery patterning. The drapery, particularly that of the female saints at both ends of the panel, falls and curves loosely. This is a feature familiar in northern Gothic works (FIG. 13-37) and is a mark of the artistic dialogue between Italy and the north in the 14th century.

Despite these changes that reveal Duccio's interest in the new naturalism, he respected the age-old requirement that as an altarpiece, the *Maestà* would be the focus of worship in Siena's largest

and most important church, its *cathedral*, the seat of the bishop of Siena. As such, Duccio knew the *Maestà* should be an object holy in itself—a work of splendor to the eyes, precious in its message and its materials. Duccio thus recognized that he could not be too radical—that the function of this work naturally limited experimentation with depicting narrative action and producing illusionistic effects (such as Giotto's) by modeling forms and adjusting their placement in pictorial space.

Instead, the Queen of Heaven panel is a miracle of color composition and texture manipulation, unfortunately not apparent in a photograph. Close inspection of the original reveals what the Sienese artist learned from other sources. In the 13th and 14th centuries, Italy was the distribution center for the great silk trade from China and the Middle East. After processing the silk in city-states such as Lucca and Florence, the Italians exported the precious fabric throughout Europe to satisfy an immense market for sumptuous dress. (Dante, Petrarch, and many of the humanists decried the appetite for luxury in costume, which to them represented a decline in civic and moral virtue.) People throughout Europe (Duccio and other artists among them) prized fabrics from China, Persia, Byzantium, and the Islamic realms. In the Maestà panel, Duccio created the glistening and shimmering effects of textiles, adapting the motifs and design patterns of exotic materials. Complementing the luxurious fabrics and the (lost) gilded wood frame are the gold haloes of the holy figures, which feature tooled decorative designs in gold leaf (punchwork). But Duccio, like Giotto (FIG. 14-8), eliminated almost all the gold patterning of the figures' garments in favor of creating three-dimensional volume. Traces remain only in the Virgin's red dress.

14-11 DUCCIO DI BUONINSEGNA, Betrayal of Jesus, detail from the back of the Maestà altarpiece, from Siena Cathedral, Siena, Italy, 1309–1311. Tempera and gold leaf on wood, detail $1'10\frac{1}{2}" \times$ 3'4". Museo dell'Opera del Duomo, Siena.

On the back of the *Maestà*, Duccio painted a religious drama in which the actors display a variety of individual emotions. Duccio here took a decisive step toward the humanization of religious subject matter.

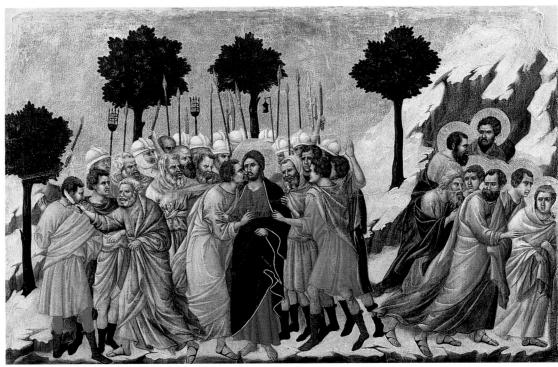

T_{1 in}

On the front panel of the Maestà, Duccio showed himself as the great master of the formal altarpiece. However, he allowed himself greater latitude for experimentation in the small accompanying panels, front and back. (Both sides of the altarpiece were always on view because the high altar stood at the very center of the sanctuary.) These images reveal Duccio's powers as a narrative painter. In the numerous panels on the back, he illustrated the later life of Christ—his ministry (on the predella), his Passion (on the main panel), and his Resurrection and appearances to the disciples (on the pinnacles). On one of the small panels, Betrayal of Jesus (FIG. 14-11), the artist represented several episodes of the event—the betrayal of Jesus by Judas's false kiss, the disciples fleeing in terror, and Peter cutting off the ear of the high priest's servant. Although the background, with its golden sky and rock formations, remains traditional, the style of the figures before it has changed quite radically. The bodies are not the flat frontal shapes of Italo-Byzantine art. Duccio imbued them with mass, modeled them with a range from light to dark, and arranged their draperies around them convincingly. Even more novel and striking is the way the figures seem to react to the central event. Through posture, gesture, and even facial expression, they display a variety of emotions. Duccio carefully differentiated among the anger of Peter, the malice of Judas (echoed in the faces of the throng about Jesus), and the apprehension and timidity of the fleeing disciples. These figures are actors in a religious drama that the artist interpreted in terms of thoroughly human actions and reactions. In this and similar narrative panels, Duccio took a decisive step toward the humanization of religious subject matter.

ORVIETO CATHEDRAL While Duccio was working on the *Maestà* for Siena Cathedral, a Sienese architect, LORENZO MAITANI, was called to Orvieto to design that city's cathedral (FIG. **14-12**). The Orvieto *facade* imitates some elements of the French Gothic

14-12 LORENZO MAITANI, west facade of Orvieto Cathedral, Orvieto, Italy, begun 1310.

The pointed gables over the doorways, the rose window, and the large pinnacles derive from French architecture, but the facade of Orvieto Cathedral is merely a Gothic overlay masking a timber-roofed basilica.

architectural vocabulary (see Chapter 13), especially the pointed gables over the three doorways, the *rose window* and statues in niches in the upper zone, and the four large *pinnacles* that divide the facade into three bays. The outer pinnacles serve as miniature substitutes for the large northern European west-front towers. Maitani's facade, however, is merely a Gothic overlay masking a marble-revetted basil-

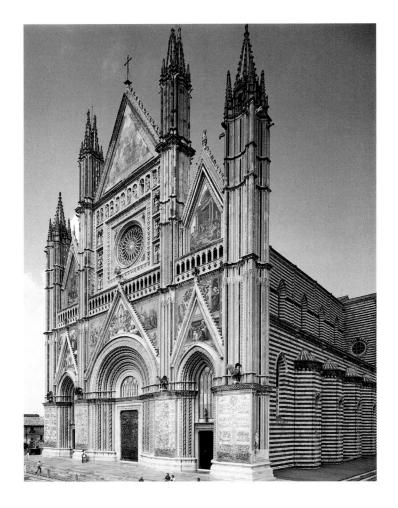

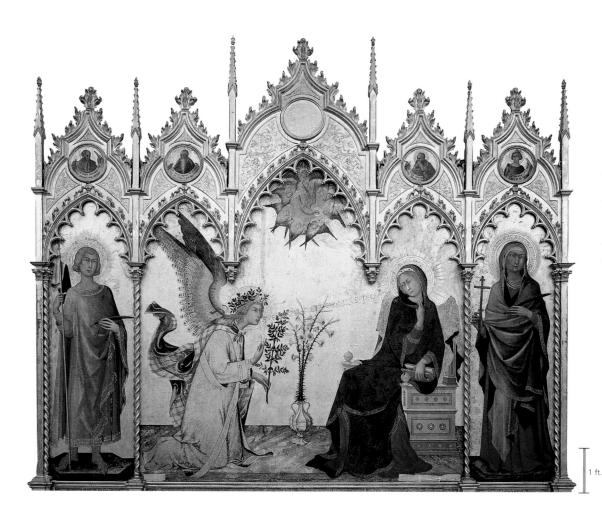

14-13 SIMONE MARTINI and LIPPO MEMMI(?), Annunciation altarpiece, from Siena Cathedral, Siena, Italy, 1333 (frame reconstructed in the 19th century). Tempera and gold leaf on wood, center panel $10' 1'' \times 8' 8\frac{3}{4}''$. Galleria degli Uffizi, Florence.

A pupil of Duccio, Martini was instrumental in the creation of the International Style. Its hallmarks are elegant shapes, radiant color, flowing line, and weightless figures in golden, spaceless settings.

ican structure in the Tuscan Romanesque tradition, as the three-quarter view of the cathedral in Fig. 14-12 reveals. Few Italian architects fully accepted the northern Gothic style. Some architectural historians even have questioned whether it is proper to speak of late medieval Italian buildings as Gothic structures. The Orvieto facade resembles a great altar screen, its single plane covered with carefully placed carved and painted ornament. In principle, Orvieto belongs with Pisa Cathedral (Fig. 12-25) and other Italian buildings rather than with the French cathedrals at Amiens (Fig. 13-21) and Reims (Fig. 13-23). Inside, Orvieto Cathedral has a timber-roofed nave with a two-story elevation (columnar *arcade* and *clerestory*) in the Early Christian manner. Both the *chancel arch* framing the semicircular *apse* and the nave arcade's arches are round as opposed to pointed.

SIMONE MARTINI Duccio's successors in the Sienese school also produced innovative works. Simone Martini (ca. 1285–1344) was a pupil of Duccio and may have assisted him in painting the Maestà. Martini was a close friend of Petrarch, and the poet praised him highly for his portrait of "Laura" (the woman to whom Petrarch dedicated his sonnets). Martini worked for the French kings in Naples and Sicily and, in his last years, produced paintings for the papal court at Avignon, where he came in contact with Northern European painters. By adapting the insubstantial but luxuriant patterns of the French Gothic manner to Sienese art and, in turn, by acquainting painters north of the Alps with the Sienese style, Martini was instrumental in creating the so-called International Style. This new style swept Europe during the late 14th and early 15th centuries because it appealed to the aristocratic taste for brilliant colors, lavish costumes, intricate ornamentation, and themes involving splendid processions.

Martini's Annunciation altarpiece (FIG. 14-13) features elegant shapes and radiant color, fluttering line, and weightless figures in a spaceless setting—all hallmarks of the artist's style. The complex etiquette of the European chivalric courts probably dictated the presentation. The angel Gabriel has just alighted, the breeze of his passage lifting his mantle, his iridescent wings still beating. The gold of his sumptuous gown is representative of the celestial realm from which he has descended to deliver his message. The Virgin, putting down her book of devotions, shrinks demurely from Gabriel's reverent genuflection, an appropriate gesture in the presence of royalty. She draws about her the deep blue, golden-hemmed mantle, the heraldic colors she wears as Queen of Heaven. Between the two figures is a vase of white lilies, symbolic of the Virgin's purity. Despite the Virgin's modesty and diffidence and the tremendous import of the angel's message, the scene subordinates drama to court ritual, and structural experimentation to surface splendor. The intricate *tracery* of the richly tooled (reconstructed) French Gothic-inspired frame and the elaborate punchwork halos, now a characteristic feature of Sienese panel painting, enhance the tactile magnificence of the Annunciation.

Simone Martini and his student and assistant, Lippo Memmi (active ca. 1317–1350), signed the altarpiece and dated it (1333). The latter's contribution to the *Annunciation* is still a matter of debate, but art historians now generally agree he painted the two lateral saints. These figures, which are reminiscent of the jamb statues of Gothic church portals, have greater solidity and lack the linear elegance of Martini's central pair. Given the nature of medieval and Renaissance workshop practices, it is often next to impossible to distinguish the master's hand from that of an assistant, especially if the master corrected or redid part of the latter's work (see "Artistic Training in Renaissance Italy," page 388).

Artistic Training in Renaissance Italy

In 14th- through 16th-century Italy, training to become a professional artist (earning membership in the appropriate guild) was a laborious and lengthy process. Because Italians perceived art as a trade, they expected artists to be trained as they would be in any other profession. Accordingly, aspiring artists started their training at an early age, anywhere from 7 to 15 years old. Their fathers would negotiate arrangements with specific master artists whereby each youth lived with a master for a specified number of years, usually five or six. During that time, they served as apprentices to the masters in the workshop, learning the trade. (This living arrangement served as a major obstacle for aspiring female artists, as it was considered inappropriate for young girls to live in a master's household.)

The skills apprentices learned varied with the type of studio they joined. Those apprenticed to painters learned to grind pigments, draw, prepare wood panels for painting, gild, and lay plaster for fresco. Sculptors in training learned to manipulate different materials (for example, wood, stone, *terracotta* [baked clay], wax, bronze, or stucco), although many sculpture workshops specialized in only one or two of these materials. For stone carving, apprentices learned their craft by blocking out the master's designs for statues.

The guilds supervised this rigorous training. They wanted not only to ensure their professional reputations by admitting only the most talented members but also to control the number of artists (to limit undue competition). Toward this end they frequently tried to regulate the number of apprentices working under a single master. Surely, the quality of the apprentices a master trained reflected the master's competence. When encouraging a prospective apprentice to join his studio, the Paduan painter Francesco Squarcione (1397–1468) boasted he could teach "the true art of perspective and everything necessary to the art of painting. . . . I made a man of Andrea Mantegna [see Chapter 16] who stayed with me and I will also do the same to you."*

As their skills developed, apprentices took on increasingly difficult tasks. After completing their apprenticeships, artists entered the appropriate guilds. For example, painters, who ground pigments, joined the guild of apothecaries; sculptors were members of the guild of stoneworkers; and goldsmiths entered the silk guild, because gold often was stretched into threads wound around silk for weaving. Such memberships served as certification of the artists' competence. Once "certified," artists often affiliated themselves with established workshops, as assistants to master artists. This was largely for practical reasons. New artists could not expect to receive many commissions, and the cost of establishing their own workshops was high. In any case, this arrangement was not permanent, and workshops were not necessarily static enterprises. Although well-established and respected studios existed, workshops could be organized around individual masters (with no set studio locations) or organized for a specific project, especially an extensive decoration program.

Generally, assistants were responsible for gilding frames and backgrounds, completing decorative work, and, occasionally, rendering architectural settings. Artists regarded figures, especially those central to the represented subject, as the most important and difficult parts of a painting, and the master therefore reserved these for himself. Sometimes assistants painted secondary or marginal figures, but only under the master's close supervision.

Eventually, of course, artists hoped to attract patrons and establish themselves as masters. Artists, who were largely anonymous during the medieval period, began to enjoy greater emancipation during the 15th and 16th centuries, when they rose in rank from artisan to artist-scientist. The value of their individual skills—and their reputations—became increasingly important to their patrons and clients.

* Quoted in Giuseppe Fiocco, Mantegna: La cappella Ovetari nella chiesa degli Eremitani (Milan: A. Pizzi, 1974), 7.

PIETRO LORENZETTI One of Duccio's students, PIETRO LORENZETTI (active 1320-1348), contributed significantly to the general experiments in pictorial realism that characterized the 14th century. Going well beyond his master, Lorenzetti achieved a remarkable degree of spatial illusionism in his large triptych (three-part panel painting) Birth of the Virgin (FIG. 14-14), created for the altar of Saint Savinus in Siena Cathedral. Lorenzetti painted the wooden architectural members that divide the panel as though they extend back into the painted space. Viewers seem to look through the wooden frame (apparently added later) into a boxlike stage, where the event takes place. That one of the vertical members cuts across one of the figures, blocking part of it from view, strengthens the illusion. In subsequent centuries, artists exploited this use of architectural elements to enhance the pictorial illusion that the painted figures are acting out a drama just a few feet away. This kind of pictorial illusionism characterized ancient Roman mural painting (FIGS. 7-18 and 7-19, right), but had not been practiced in Italy for a thousand years.

Lorenzetti's setting for his holy subject also represented a marked step in the advance of worldly realism. Saint Anne—who, like Nicola Pisano's Virgin of the *Nativity* (FIG. 14-3), resembles a reclining figure on the lid of a Roman sarcophagus (FIG. 7-61)—props herself up

wearily as the midwives wash the child and the women bring gifts. She is the center of an episode that occurs in an upper-class Italian house of the period. A number of carefully observed domestic details and the scene at the left, where Joachim eagerly awaits the news of the delivery, place the event in an actual household, as if viewers had moved the panels of the walls back and peered inside. Lorenzetti joined structural innovation in illusionistic space with the new curiosity that led to careful inspection and recording of what lay directly before the artist's eye in the everyday world.

PALAZZO PUBBLICO Not all Sienese painting of the early 14th century was religious in character. One of the most important fresco cycles of the period (discussed next) was a civic commission for Siena's Palazzo Pubblico ("public palace" or city hall). Siena was a proud commercial and political rival of Florence. As the secular center of the community, the civic meeting hall in the main square (the Campo, or Field; FIG. 14-15) was almost as great an object of civic pride as the city's cathedral. The Palazzo Pubblico has a slightly concave facade (to conform to the irregular shape of the Campo) and a gigantic tower visible from miles around. The imposing building and tower must have earned the admiration of Siena's citizens as well as of

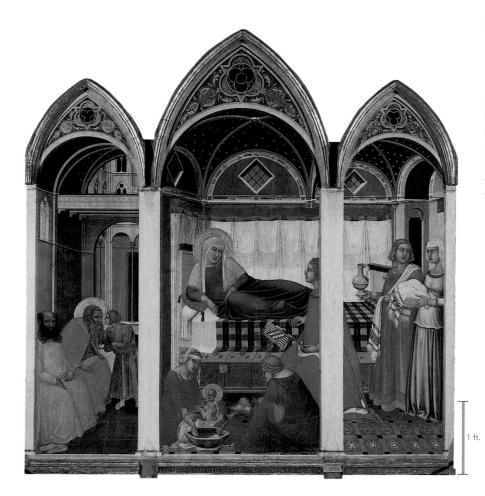

14-14 PIETRO LORENZETTI, *Birth of the Virgin*, from the altar of Saint Savinus, Siena Cathedral, Siena, Italy, 1342. Tempera on wood, $6'\ 1'' \times 5'\ 11''$. Museo dell'Opera del Duomo, Siena.

In this triptych, Pietro Lorenzetti revived the pictorial illusionism of ancient Roman murals and painted the architectural members that divide the panel as though they extend back into the painted space.

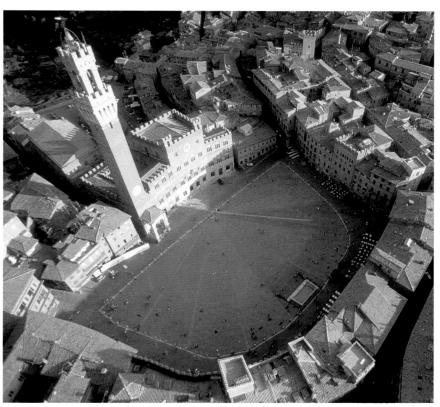

14-15 Aerial view of the Campo with the Palazzo Pubblico, Siena, Italy, 1288–1309.

Siena's Palazzo Pubblico has a slightly concave facade and a gigantic tower visible from miles around. The tower served both as a defensive lookout over the countryside and a symbol of the city-state's power.

visitors to the city, inspiring in them respect for the republic's power and success. The tower served as lookout over the city and the countryside around it and as a bell tower (*campanile*) for ringing signals of all sorts to the populace. Siena, like other Italian city-states, had to defend itself against neighboring cities and often against kings and emperors. In addition, it had to be secure against the internal upheavals

common in the history of the Italian city-republics. Class struggle, feuds between rich and powerful families, and even uprisings of the whole populace against the city governors were constant threats. The heavy walls and *battlements* (fortified *parapets*) of the Italian town hall eloquently express how frequently the city governors needed to defend themselves against their own citizens. The Sienese tower, out

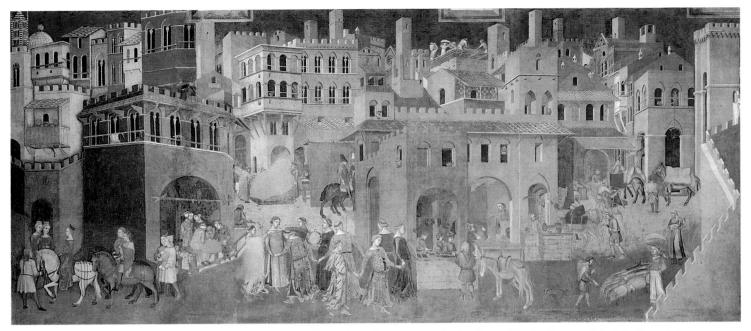

14-16 Ambrogio Lorenzetti, *Peaceful City*, detail from *Effects of Good Government in the City and in the Country*, Sala della Pace, Palazzo Pubblico, Siena, Italy, 1338–1339. Fresco.

In the Hall of Peace of Siena's city hall, Ambrogio Lorenzetti painted an illusionistic panorama of the bustling city. The fresco served as an allegory of good government in the Sienese republic.

of reach of most missiles, includes *machicolated galleries* (galleries with holes in their floors to allow the dumping of stones or hot liquids on enemies below) built out on *corbels* (projecting supporting architectural members) for defense of the tower's base.

AMBROGIO LORENZETTI The painter entrusted with the vast fresco program in Siena's Palazzo Pubblico was Pietro Lorenzetti's brother, Ambrogio Lorenzetti (active 1319–1348), who both elabo-

rated Pietro's advances in illusionistic representation in spectacular fashion and gave visual form to Sienese civic concerns. Ambrogio produced three frescoes for the walls of the Sala della Pace (Hall of Peace) in the Palazzo Pubblico: Allegory of Good Government, Bad Government and the Effects of Bad Government in the City, and Effects of Good Government in the City and in the Country. The turbulent politics of the Italian cities—the violent party struggles, the overthrow and reinstatement of governments—certainly would have called for solemn

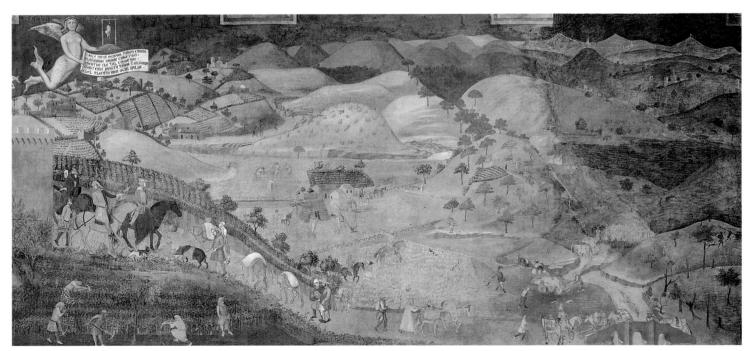

14-17 Ambrogio Lorenzetti, Peaceful Country, detail from Effects of Good Government in the City and in the Country, Sala della Pace, Palazzo Pubblico, Siena, Italy, 1338–1339. Fresco.

This sweeping view of the Sienese countryside is one of the first appearances of landscape in Western art since antiquity. An allegorical figure of winged Security promises safety to all who live under the rule of law.

reminders of fair and just administration. And the city hall was just the place for paintings such as Ambrogio Lorenzetti's. Indeed, the leaders of the Sienese government who commissioned this fresco series had undertaken the "ordering and reformation of the whole city and countryside of Siena."

In Effects of Good Government in the City and in the Country, the artist depicted the urban and rural effects of good government. Peaceful City (FIG. 14-16) is a panoramic view of Siena, with its clustering palaces, markets, towers, churches, streets, and walls, reminiscent of the townscapes of ancient Roman murals (FIG. 7-19, left). The city's traffic moves peacefully, guild members ply their trades and crafts, and several radiant maidens, hand in hand, perform a graceful circling dance. Dancers were regular features of festive springtime rituals. Here, their presence also serves as a metaphor for a peaceful commonwealth. The artist fondly observed the life of his city, and its architecture gave him an opportunity to apply Sienese artists' rapidly growing knowledge of perspective.

As an entourage passes through the city gate to the countryside beyond its walls, Ambrogio Lorenzetti's *Peaceful Country* (FIG. **14-17**) presents a bird's-eye view of the undulating Tuscan countryside—its villas, castles, plowed farmlands, and peasants going about their seasonal occupations. An allegorical figure of Security hovers above the landscape, unfurling a scroll that promises safety to all who live under the rule of law. In this sweeping view of an actual countryside, *Peaceful Country* represents one of the first appearances of *landscape* in Western art since antiquity (FIG. **7-20**). Whereas earlier depictions were fairly generic, Lorenzetti particularized the landscape—as well as the city view—by careful observation and endowed the painting with the character of a specific place and environment.

The Black Death may have ended the careers of both Lorenzettis. They disappear from historical records in 1348, the year that brought so much horror to defenseless Europe.

Florence

Like Siena, the Republic of Florence was a dominant city-state during the 14th century. The historian Giovanni Villani (ca. 1270–1348), for example, described Florence as "the daughter and the creature of Rome," suggesting a preeminence inherited from the Roman Empire. Florentines were fiercely proud of what they perceived as their economic and cultural superiority. Florence controlled the textile industry in Italy, and the republic's gold *florin* was the standard coin of exchange everywhere in Europe.

FLORENCE CATHEDRAL Florentines translated their pride in their predominance into landmark buildings, such as Florence Cathedral (FIG. 14-18), recognized as the center for the most important religious observances in the city. Arnolfo di Cambio (ca. 1245–1302) began work on the cathedral in 1296. Intended as the "most beautiful and honorable church in Tuscany," this structure reveals the competitiveness Florentines felt with cities such as Siena and Pisa. Cathedral authorities planned for the church to hold the city's entire population, and although it holds only about 30,000 (Florence's population at the time was slightly less than 100,000), it seemed so large that even the noted architect Leon Battista Alberti (see Chapter 16) commented that it seemed to cover "all of Tuscany with its shade." The builders ornamented the church's surfaces, in the old Tuscan fashion, with marble-encrusted geometric designs, matching the cathedral's revetment (decorative wall paneling) to that

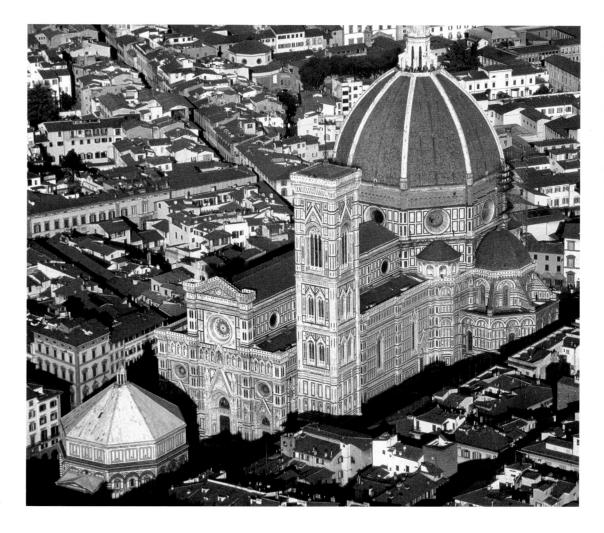

14-18 Arnolfo di Cambio and others, Florence Cathedral (aerial view looking northeast), Florence, Italy, begun 1296.

This basilican church with its marble-encrusted walls carries on the Tuscan Romanesque architectural tradition, linking Florence Cathedral more closely to Early Christian Italy than to contemporaneous France.

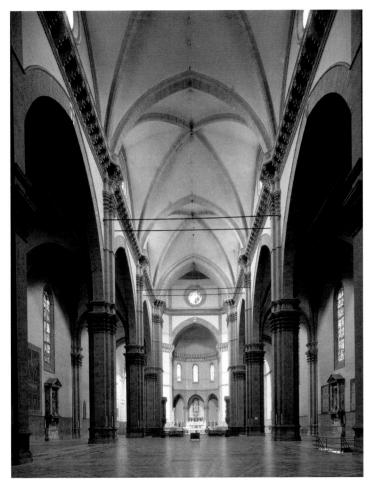

14-19 Arnolfo di Cambio and others, interior of Florence Cathedral (looking east), Florence, Italy, begun 1296.

Designed to hold 30,000 worshipers, Florence Cathedral has fewer but wider and deeper nave and aisle bays than do northern Gothic cathedrals. The result is an interior of unmatched spaciousness.

of the neighboring 11th-century Romanesque baptistery of San Giovanni (FIGS. 12-26 and 14-18, bottom left).

The vast gulf that separates Florence Cathedral from its northern European counterparts becomes evident in a comparison between the Italian church and a full-blown German representative of the High Gothic style, such as Cologne Cathedral (FIG. 13-45). Cologne Cathedral's emphatic stress on the vertical produces an awe-inspiring upward rush of almost unmatched vigor and intensity. The building has the character of an organic growth shooting heavenward, its toothed upper portions engaging the sky. The pierced, translucent stone tracery of the spires merges with the atmosphere. Florence Cathedral, in contrast, clings to the ground and has no aspirations toward flight. All emphasis is on the horizontal elements of the design, and the building rests firmly and massively earthbound. The clearly defined simple geometric volumes of the cathedral show no tendency to merge either into each other or into the sky.

Giotto di Bondone designed the cathedral's campanile in 1334. In keeping with Italian tradition (FIGS. 12-20 and 12-25), it stands apart from the church. In fact, it is essentially self-sufficient and could stand anywhere else in Florence without looking out of place. The same hardly can be said of the Cologne towers. They are essential elements of the building behind them, and it would be unthinkable to detach one of them and place it elsewhere. No individual element in the Cologne grouping seems capable of an independent existence. One form merges into the next in a series of rising movements that pull the

eye ever-upward and never permit it to rest until it reaches the sky. The Italian tower is entirely different. Neatly subdivided into cubic sections, Giotto's tower is the sum of its component parts. Not only could this tower be removed from the building without adverse effects, but also each of the parts—cleanly separated from each other by continuous moldings—seems capable of existing independently as an object of considerable aesthetic appeal. This compartmentalization is reminiscent of the Romanesque style, but it also forecasts the ideals of Renaissance architecture. Artists hoped to express structure in the clear, logical relationships of the component parts and to produce self-sufficient works that could exist in complete independence. Compared with Cologne's towers, Giotto's campanile has a cool and rational quality that appeals more to the intellect than to the emotions.

In Florence Cathedral's plan, the nave (FIG. 14-19) appears to have been added to the *crossing* complex almost as an afterthought. In fact, the nave was the first section to be built, mostly according to Arnolfo di Cambio's original plans (except for the vaulting). Midway through the 14th century, the Florentines redesigned the crossing to increase the cathedral's interior space. In its present form, the area beneath the *dome* is the design's focal point, and the nave leads to it. To visitors from north of the Alps, the nave may have seemed as strange as the plan. Neither has a northern European counterpart. The Florence nave *bays* are twice as deep as those of Amiens (FIG. 13-19), and the wide arcades permit the shallow aisles to become part of the central nave. The result is an interior of unmatched spaciousness. The accent here, as it is on the exterior, is on the horizontal elements. The substantial capitals of the *piers* prevent them from soaring into the vaults and emphasize their function as supports.

The facade of Florence Cathedral was not completed until the 19th century and then in a form much altered from its original design. In fact, until the 17th century, Italian builders exhibited little concern for the facades of their churches, and dozens remain unfinished to this day. One reason for this may be that Italian architects did not conceive the facades as integral parts of the structures but, as in the case of Orvieto Cathedral (FIG. 14-12), as screens that could be added to the church exterior at any time.

Pisa, Venice, and Milan

Italy's port cities—Genoa, Pisa, and Venice—controlled the ever busier and more extended avenues of maritime commerce that connected the West with the lands of Islam, with Byzantium and Russia, and overland with China. As a port city, Pisa established itself as a major shipping power and thus as a dominant Italian city-state. Yet Pisa was not immune from the disruption that the Black Death wreaked across all of Italy and Europe in the late 1340s. Concern with death was a significant theme in art even before the onset of the plague and became more prominent in the years after midcentury.

CAMPOSANTO, PISA Triumph of Death (FIG. 14-20) is a tour de force of death imagery. The creator of this large-scale (over 18 × 49 feet) fresco remains disputed. Some attribute the work to Francesco Traini (active ca. 1321–1363), while others argue for Buonamico Buffalmacco (active 1320–1336). Painted on the wall of the Camposanto (Holy Field), the enclosed burial ground adjacent to Pisa's cathedral (FIG. 12-25), the fresco captures the horrors of death and forces viewers to confront their mortality. In the left foreground (FIG. 14-20, left), young aristocrats, mounted in a stylish cavalcade, encounter three coffin-encased corpses in differing stages of decomposition. As the horror of the confrontation with death strikes them, the ladies turn away with delicate disgust, while a gentleman holds his nose (the animals, horses and dogs, sniff excitedly). At the far left, the hermit Saint Macarius unrolls a scroll bearing an inscription commenting on

14-20 Francesco Traini or Buonamico Buffalmacco, two details of *Triumph of Death*, 1330s. Full fresco, 18' 6" × 49' 2". Camposanto, Pisa. Befitting its location on a wall in Pisa's Camposanto, the enclosed burial ground adjacent to the city's cathedral, this fresco captures the horrors of death and forces viewers to confront their mortality.

the folly of pleasure and the inevitability of death. On the far right (FIG. 14-20, *right*), ladies and gentlemen ignore dreadful realities, occupying themselves in an orange grove with music and amusements while all around them angels and demons struggle for the souls of the corpses heaped in the foreground.

In addition to these direct and straightforward scenes, the mural contains details that convey more subtle messages. For example, the painter depicted those who appear unprepared for death—and thus unlikely to achieve salvation—as wealthy and reveling in luxury. Given that the Dominicans—an order committed to a life of poverty—participated in the design for this fresco program, the imagery surely was a warning against greed and lust. Although *Triumph of Death* is a compilation of disparate scenes, the artist rendered each scene with natural-

ism and emotive power. It is an irony of history that as Western humanity drew both itself and the world into ever sharper visual focus, it perceived ever more clearly that corporeal things were perishable.

DOGE'S PALACE, VENICE One of the wealthiest cities of late medieval Italy—and of Europe—was Venice, renowned for its streets of water. Situated on a lagoon on the northeastern coast of Italy, Venice was secure from land attack and could rely on a powerful navy for protection against invasion from the sea. Internally, Venice was a tight corporation of ruling families who, for centuries, provided stable rule and fostered economic growth. The Venetian republic's seat of government was the Doge's (Duke's) Palace (FIG. **14-21**). Begun around 1340–1345 and significantly remodeled

14-21 Doge's Palace, Venice, Italy, begun ca. 1340-1345; expanded and remodeled, 1424-1438.

The delicate patterning in cream- and rose-colored marbles, the pointed and ogee arches, and the quatrefoil medallions of the Doge's Palace constitute a distinctive Venetian variation of northern Gothic architecture.

14-22 Milan Cathedral, Milan, Italy, begun 1386.

Milan Cathedral's elaborate facade is a confused mixture of Late Gothic pinnacles and tracery and Renaissance pediment-capped rectilinear portals. It marks the waning of the Gothic style.

after 1424, it was the most ornate public building in medieval Italy. In a stately march, the first level's short and heavy columns support rather severe pointed arches that look strong enough to carry the weight of the upper structure. Their rhythm doubles in the upper arcades, where slimmer columns carry ogee arches (made up of double-curving lines), which terminate in flamelike tips between medallions pierced with quatrefoils (cloverleaf-shaped). Each story is taller than the one beneath it, the topmost as high as the two lower arcades combined. Yet the building does not look top-heavy. This is due in part to the complete absence of articulation in the top story and in part to the walls' delicate patterning, in cream- and rose-colored marbles, which makes them appear paper-thin. The Doge's Palace represents a delightful and charming variant of Late Gothic architecture. Colorful, decorative, light and airy in appearance, the Venetian Gothic is ideally suited to Venice, which floats between water and air.

MILAN CATHEDRAL Since Romanesque times, northern European influences had been felt more strongly in Lombardy than in

the rest of Italy. When Milan's citizens decided to build their own cathedral (FIG. 14-22) in 1386, they invited experts from France, Germany, and England, as well as from Italy. These masters argued among themselves and with the city council, and no single architect ever played a dominant role. The result of this attempt at "architecture by committee" was, not surprisingly, a compromise. The building's proportions, particularly the nave's, became Italian (that is, wide in relation to height), and the surface decorations and details remained Gothic. Clearly derived from France are the cathedral's multitude of pinnacles and the elaborate tracery on the facade, flank, and transept. But long before the completion of the building, the new classical style of the Italian Renaissance had been well launched (see Chapter 16), and the Gothic design had become outdated. Thus, Milan Cathedral's elaborate facade represents a confused mixture of Late Gothic and Renaissance elements. With its pediment-capped rectilinear portals amid Gothic pinnacles, the cathedral stands as a symbol of the waning of the Gothic style and the advent of the Renaissance.

ITALY, 1200 TO 1400

THE 13TH CENTURY

- Diversity of style characterizes the art of 13th-century Italy, with some artists working in the newly revived classical tradition, some in the mode of Gothic France, and others in the maniera greca, or Italo-Byzantine style.
- Trained in southern Italy in the court style of Frederick II (r. 1197–1250), Nicola Pisano was a master sculptor who settled in Pisa and carved pulpits incorporating marble panels that, both stylistically and in individual motifs, depend on ancient Roman sarcophagi.
- Nicola's son, Giovanni Pisano, also was a sculptor of church pulpits, but his work more closely reflects the Gothic sculpture of France.
- The leading painters working in the Italo-Byzantine style were Bonaventura Berlinghieri and Cimabue. Both artists drew inspiration from Byzantine icons and illuminated manuscripts. Berlinghieri's Saint Francis Altarpiece is the earliest dated portrayal of Saint Francis of Assisi, who died in 1226.

THE 14TH CENTURY

- During the 14th century, Italy suffered the most devastating natural disaster in European history the Black Death that swept through Europe—but it was also the time when Renaissance humanism took root. Although religion continued to occupy a primary position in Italian life, scholars and artists became much more concerned with the natural world.
- Giotto di Bondone of Florence, widely regarded as the first Renaissance painter, was a pioneer in pursuing a naturalistic approach to representation based on observation, which was at the core of the classical tradition in art. The Renaissance marked the rebirth of classical values in art and society.
- The greatest master of the Sienese school of painting was Duccio di Buoninsegna, whose *Maestà* still incorporates many elements of the *maniera greca*. He relaxed the frontality and rigidity of his figures, however, and in narrative scenes took a decisive step toward humanizing religious subject matter by depicting actors displaying individual emotions.
- Secular themes also came to the fore in 14th-century Italy, most notably in Ambrogio Lorenzetti's frescoes for Siena's Palazzo Pubblico. His depictions of the city and its surrounding countryside are among the first landscapes in Western art since antiquity.
- The 14th-century architecture of Italy underscores the regional character of late medieval art. Some architectural historians even have questioned whether it is proper to speak of Italian buildings of this period as Gothic structures. Orvieto Cathedral's facade, for example, imitates some elements of the French Gothic vocabulary, but it is merely an overlay masking a traditional timber-roofed structure with round arches in the nave arcade.

Nicola Pisano, Pisa baptistery pulpit, 1259–1260

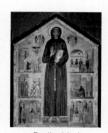

Berlinghieri, Saint Francis Altarpiece, 1235

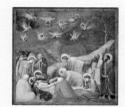

Giotto, Arena Chapel, Padua, ca. 1305

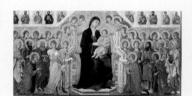

Duccio, *Maestà*, Siena Cathedral, 1308–1311

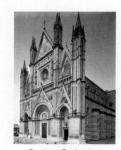

Orvieto Cathedral, begun 1310

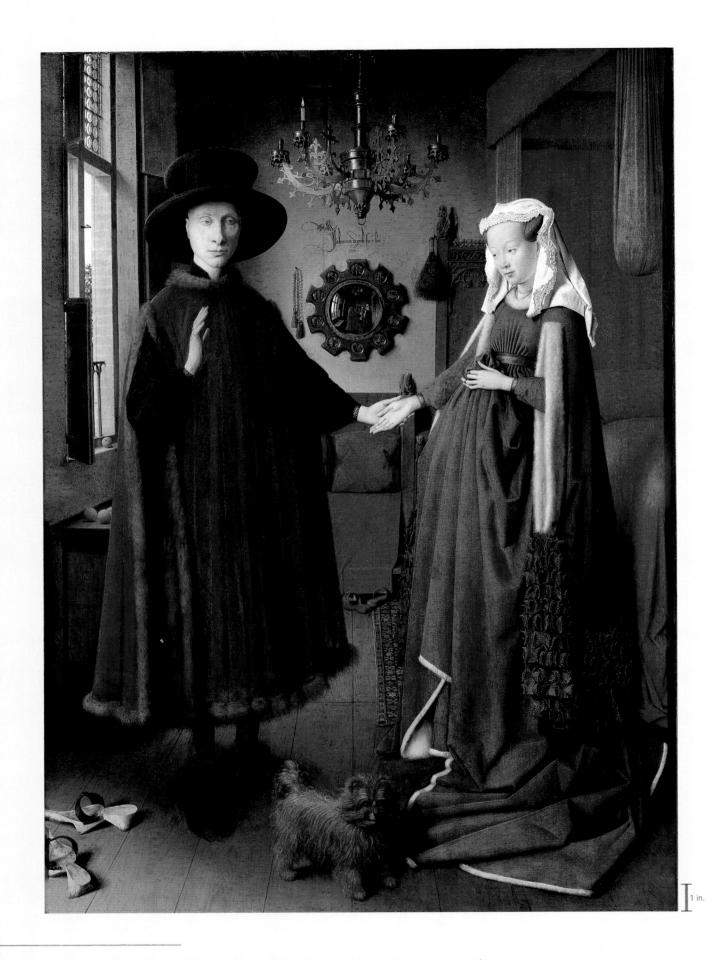

15-1 Jan van Eyck, Giovanni Arnolfini and His Bride, 1434. Oil on wood, 2' 9" \times 1' $10\frac{1}{2}$ ". National Gallery, London.

Van Eyck played a major role in popularizing oil painting and in establishing portraiture as an important art form. In this portrait of an Italian financier and his wife, he also portrayed himself in the mirror.

NORTHERN EUROPE, 1400 TO 1500

As the 15th century opened, two competing popes still resided in Rome and Avignon during the Great Schism (1378–1417), and France and England still fought each other in the Hundred Years' War (1337–1453). Social turmoil accompanied dying *feudalism* as the widespread European movement toward centralized royal governments, begun in the 12th century, continued apace. But out of conflict and turmoil also emerged a new economic system—the early stage of European capitalism. In response to the financial requirements of trade, new credit and exchange systems created an economic network of enterprising European cities. Trade in money accompanied trade in commodities, and the former financed industry. Both were in the hands of international trading companies such as those of Jacques Coeur in Bourges (see Chapter 13) and the Medici in Florence (see Chapter 16). In 1460 the Flemish established the first international commercial stock exchange in Antwerp. In fact, the French word for stock market (*bourse*) comes from the name of the van der Beurse family of Bruges, the wealthiest city in 15th-century Flanders—a region corresponding to what is today Belgium, the Netherlands, Luxembourg, and part of northern France (MAP 15-1).

Art also thrived in Northern Europe during this time under royal, ducal, church, and private patronage. Two developments in particular were of special significance: the adoption of oil-based pigment as the leading medium for painting and the blossoming of printmaking as a major art form, which followed the invention of movable type. These new media had a dramatic impact on artistic production worldwide.

BURGUNDY AND FLANDERS

In the 15th century, Flanders was not an independent state but a region under the control of the duke of Burgundy, the ruler of the fertile east-central region of France still famous for its wines. Duke Philip the Bold (r. 1363–1404) was one of four sons of King John II (r. 1350–1364) of France. In 1369, Philip married Margaret of Mâle, the daughter of the count of Flanders, and acquired territory in the Netherlands. Thereafter, the major source of Burgundian wealth was Bruges, the city that made Burgundy a dangerous rival of France, which then, as in the Gothic age, was a smaller kingdom geographically than the modern nation-state. Bruges initially derived its wealth from the wool trade and soon expanded into banking, becoming the financial clearinghouse for all of Northern Europe. Indeed, Bruges so dominated Flanders that the duke of Burgundy eventually chose to make the city his capital and moved his court there from Dijon in the early 15th century.

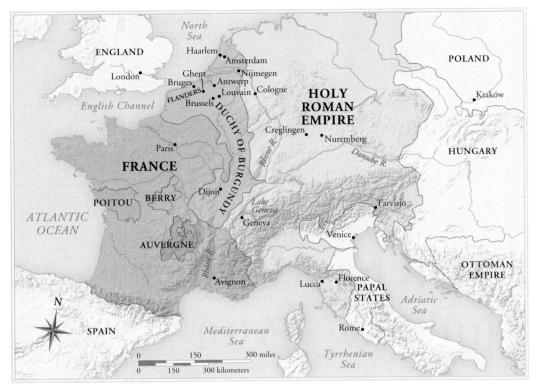

MAP 15-1 France, the duchy of Burgundy, and the Holy Roman Empire in 1477.

Due to the expanded territory and the prosperity of the duchy of Burgundy, Philip the Bold and his successors were probably the most powerful rulers in Northern Europe during the first three-quarters of the 15th century. Although members of the French royal family, they usually supported England (on which they relied for the raw materials used in their wool industry) during the Hundred Years' War and, at times, controlled much of northern France, including Paris, the seat of the French monarchy. At the height of Burgundian power, the reigning duke's lands stretched from the Rhône River to the North Sea.

Chartreuse de Champmol

The dukes of Burgundy were major patrons of the arts and understood how art could support their dynastic and political goals as well as adorn their castles and town houses. Philip the Bold's grandest artistic enterprise was the building of the Chartreuse de Champmol, near Dijon. A chartreuse ("charter house" in English) is a Carthusian monastery. The Carthusian order, founded by Saint Bruno in the late 11th century at Chartreuse, near Grenoble in southeastern France, consisted of monks who devoted their lives to solitary living and prayer. Unlike monastic orders that earned income from farming and other work, the Carthusians generated no revenues. Philip's generous endowment at Champmol was therefore the sole funding for an ambitious artistic program. Inspired by Saint-Denis, the royal abbey of France and burial site of the French kings (see Chapter 13), Philip intended the Dijon chartreuse to become a ducal mausoleum and serve both as a means of securing salvation in perpetuity for the Burgundian dukes (the monks prayed continuously for the souls of the ducal family) and as a dynastic symbol of Burgundian power.

CLAUS SLUTER In 1389, Philip the Bold placed the Haarlem (Netherlands) sculptor Claus Sluter (active ca. 1380–1406) in charge of the sculptural program for the Chartreuse de Champmol. For the cloister of the Carthusian monastery, Sluter designed a large sculptural fountain located in a well. The well served as a water source for the monastery. It seems improbable, however, that the fountain actually

spouted water, because the Carthusian commitment to silence and prayer would have precluded anything that produced sound. Although the sculptor died before completing the entire fountain, he did finish Well of Moses (FIG. 15-2). Moses and five other prophets (David, Daniel, Isaiah, Jeremiah, and Zachariah) surround a base that once supported a 25-foot-tall group of Christ on the Cross, the Virgin Mary, John the Evangelist, and Mary Magdalene. The Well of Moses is a modern name. The Carthusians called it a fons vitae, a fountain of everlasting life. The blood of the crucified Christ symbolically flowed down over the grieving angels and Old Testament prophets, spilling into the well below, washing over Christ's prophetic predecessors and redeeming anyone who would drink water from the well. The inspiration for the well may have come in part from contemporaneous mystery plays in which actors portraying prophets frequently delivered commentaries on events in Christ's life.

Although the six figures recall the jamb statues (FIGS. 13-17 and 13-24) of Gothic portals, they are much more realistically rendered, and the prophets have almost portraitlike features and distinct individual personalities and costumes. David is an elegantly garbed Gothic king, Moses an elderly horned prophet (compare FIG. 12-36) with a waist-length beard. Sluter's intense observation of natural appearance provided him with the information necessary to sculpt the figures in minute detail. Heavy draperies with voluminous folds swathe the lifesize figures. The artist succeeded in making their difficult, complex surfaces seem remarkably naturalistic. He enhanced this effect by skillfully differentiating textures, from coarse drapery to smooth flesh and silky hair. Originally, paint, much of which has flaked off, further augmented the naturalism of the figures. (The painter was Jean Malouel [ca. 1365–1415], another Netherlandish master.) This fascination with the specific and tangible in the visible world became one of the chief characteristics of 15th-century Flemish art.

MELCHIOR BROEDERLAM Philip the Bold also commissioned a major altarpiece for the main altar in the chapel of the Chartreuse. A collaborative project between two Flemish artists, this altarpiece consisted of a large sculptured shrine by Jacques de Baerze (active ca. 1384–1399) and a pair of exterior panels painted by MELCHIOR BROEDERLAM (active ca. 1387–1409).

Altarpieces were a major art form north of the Alps in the late 14th and 15th centuries. From their position behind the altar, they served as backdrops for the Mass. The Mass represents a ritual celebration of the Holy *Eucharist*. At the Last Supper, Christ commanded that his act of giving to his apostles his body to eat and his blood to drink be repeated in memory of him. This act serves as the nucleus of the Mass. The ritual of the Mass involves prayer, contemplation of the Word of God, and the reenactment of the Eucharistic sacrament. Because the Mass involves not only a memorial rite but complex Christian doctrinal tenets as well, art has traditionally played an important role in giving visual form to these often intricate theological concepts for the Christian faithful. Like sculpted

15-2 Claus Sluter, *Well of Moses*, Chartreuse de Champmol, Dijon, France, 1395–1406. Limestone with traces of paint, Moses 6' high.

The Well of Moses, a symbolic fountain of life made for the duke of Burgundy, originally supported a Crucifixion group. Sluter's figures recall the jamb statues of French Gothic portals but are far more realistic.

medieval church portals, these altarpieces had a didactic role, especially for the illiterate. They also reinforced Church doctrines for viewers and stimulated devotion.

Given their function as backdrops to the Mass, it is not surprising that many altarpieces depict scenes directly related to Christ's sacrifice. The Champmol altarpiece, or retable, for example, features sculpted Passion scenes on the interior. These public altarpieces most often took the form of polyptychs (hinged multipaneled paintings) or carved relief panels. The hinges allowed the clergy to close the polyptych's side wings over the central panel(s). Artists decorated both the exterior and interior of the altarpieces. This multi-image format provided artists the opportunity to construct narratives through a sequence of images, somewhat as in manuscript illustration. Although scholars do not have concrete information about when the clergy opened and closed these altarpieces, evidence suggests they remained closed on regular days and were opened on Sundays and feast days. This schedule would have allowed viewers to see both the interior and exterior—diverse imagery at various times according to the liturgical calendar. Over time, however, differing Protestant conceptions of the Eucharist (see Chapter 18) ultimately led to a decline of the altarpiece as a dominant art form in Northern Europe.

The painted wings of the Retable de Champmol (FIG. 15-3) depict the Annunciation and Visitation on the left panel and the

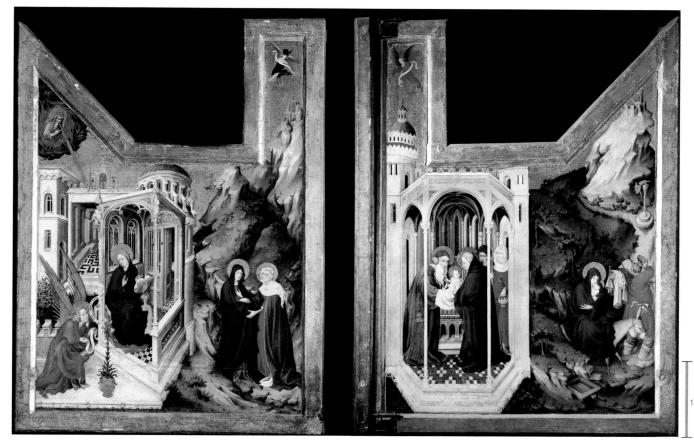

15-3 Melchior Broederlam, *Retable de Champmol*, from the chapel of the Chartreuse de Champmol, Dijon, France, installed 1399. Oil on wood, each wing 5′ $5\frac{3}{4}'' \times 4'$ $1\frac{1}{4}''$. Musée des Beaux-Arts, Dijon.

This early example of oil painting reveals an attempt to represent the three-dimensional world on a two-dimensional surface, but the gold background and flat halos recall medieval pictorial conventions.

Presentation in the Temple and Flight into Egypt on the right panel (see "The Life of Jesus in Art," Chapter 8, pages 216-217, or in the "Before 1300" section). Broederlam's painted images on the altarpiece's exterior deal with Christ's birth and infancy and set the stage for de Baerze's interior sculpted Passion scenes (not illustrated). The exterior panels are an unusual amalgam of different styles, locales, and religious symbolism. The two paintings include both landscape and interior scenes. The style of the buildings Broederlam depicted varies from Romanesque to Gothic (see Chapters 12 and 13). Scholars have suggested that the juxtaposition of different architectural styles in the left panel is symbolic. The rotunda (round building, usually with a dome) refers to the Old Testament, whereas the Gothic porch relates to the New Testament. In the right panel, a statue of a pagan god falls from the top of a column as the Holy Family approaches. These and other details symbolically announce the coming of the new order under Christ. Stylistically, Broederlam's representation of parts of the landscape and architecture reveals an attempt to render the three-dimensional world on a two-dimensional surface. Yet the gold background and the flat halos of the figures, regardless of the positions of their heads, recall medieval pictorial conventions. Despite this interplay of various styles and diverse imagery, the altarpiece was a precursor of many of the artistic developments (such as the illusionistic depiction of three-dimensional objects and the representation of landscape) that preoccupied European artists throughout the 15th century.

Robert Campin, Jan van Eyck, and Rogier van der Weyden

Melchior Broederlam's Champmol retable also foreshadowed another significant development in 15th-century art—the widespread adoption of oil paints. Oil paints facilitated the exactitude in rendering details so characteristic of Northern European painting. Although the Italian biographer Giorgio Vasari and other 16thcentury commentators credited Jan van Eyck with the invention of oil painting, recent evidence has revealed that oil paints had been known for some time, well before Melchior Broederlam used oils in his work for Philip the Bold. Flemish painters built up their pictures by superimposing translucent paint layers on a layer of underpainting, which in turn had been built up from a carefully planned drawing made on a panel prepared with a white ground. With the oil medium, artists created richer colors than previously had been possible, giving their paintings an intense tonality, the illusion of glowing light, and enamel-like surfaces. These traits differed significantly from the high-keyed color, sharp light, and rather matte (dull) surface of tempera (see "Tempera and Oil Painting," page 401). The brilliant and versatile oil medium suited perfectly the formal intentions of the generation of Flemish painters after Broederlam, including Robert Campin, Jan van Eyck, and Rogier van der Weyden, who aimed for sharply focused clarity of detail in their representation of thousands of objects ranging in scale from large to almost invisible.

ROBERT CAMPIN One of the earliest masters of oil painting was the artist known as the "Master of Flémalle," who scholars generally agree was ROBERT CAMPIN (ca. 1378–1444), the leading painter of the city of Tournai. His most famous work is the *Mérode Altarpiece* (FIG. **15-4**). Similar in format to, but much smaller than, the Champmol retable, the *Mérode Altarpiece* was a private commission for household prayer. It was not unusual in that respect. Based on an accounting of extant Flemish religious paintings, lay patrons outnumbered clerical patrons by a ratio of two to one. At the time, various reform movements advocated personal devotion, and in the

years leading up to the Protestant Reformation in the early 16th century, private devotional exercises and prayer grew in popularity. One of the more prominent features of these images commissioned for private use is the integration of religious and secular concerns. For example, artists often presented biblical scenes as taking place in a Flemish house. Although this might seem inappropriate or even sacrilegious today, religion was such an integral part of Flemish life that separating the sacred from the secular became virtually impossible. Moreover, the presentation in religious art of familiar settings and objects no doubt strengthened the direct bond the patron or viewer felt with biblical figures.

The popular Annunciation theme, as prophesied in Isaiah 7:14, occupies the Mérode triptych's central panel. The archangel Gabriel approaches Mary, who sits reading. The artist depicted a well-kept middle-class Flemish home as the site of the event. The carefully rendered architectural scene in the background of the right wing confirms this identification of the locale. The depicted accessories, furniture, and utensils contribute to the identification of the setting as Flemish. However, the objects represented are not merely decorative. They also function as religious symbols. The book, extinguished candle, and lilies on the table, the copper basin in the corner niche, the towels, fire screen, and bench all symbolize, in different ways, the Virgin's purity and her divine mission. In the right panel, Joseph has made a mousetrap, symbolic of the theological tradition that Christ is bait set in the trap of the world to catch the Devil. Campin completely inventoried a carpenter's shop. The ax, saw, and rod in the foreground not only are tools of the carpenter's trade but also are mentioned in Isaiah 10:15.

In the left panel, the closed garden is symbolic of Mary's purity, and the flowers depicted all relate to Mary's virtues, especially humility. The altarpiece's donor, Peter Inghelbrecht, a wealthy merchant, and his wife kneel in the garden and witness the momentous event through an open door. *Donor portraits*—portraits of the individual(s) who commissioned (or "donated") the work—became very popular in the 15th century. In this instance, in addition to asking to be represented in their altarpiece, the Inghelbrechts probably specified the subject. Inghelbrecht means "angel bringer," a reference to the *Annunciation* theme of the central panel. The wife's name, Scrynmakers, means "cabinet- or shrine-makers," referring to the workshop scene in the right panel.

JAN VAN EYCK The first Netherlandish painter to achieve international fame was JAN VAN EYCK (ca. 1390-1441), who in 1425 became the court painter of Philip the Good, duke of Burgundy (r. 1419-1467). The artist moved his studio to Bruges, where the duke maintained his official residence, in 1432, the year he completed the Ghent Altarpiece (FIGS. 15-5 and 15-6). This retable is one of the largest (nearly 12 feet tall) of the 15th century. Jodocus Vyd, diplomat-retainer of Philip the Good, and his wife Isabel Borluut commissioned this polyptych as the centerpiece of the chapel Vyd built in the church originally dedicated to Saint John the Baptist (since 1540 Saint Bavo Cathedral). Vyd's largesse and the political and social connections that the Ghent Altarpiece revealed to its audience contributed to Vyd's appointment as burgomeister (chief magistrate) of Ghent shortly after the unveiling of the work. Two of the exterior panels (FIG. 15-5) depict the donors. The husband and wife, painted in illusionistically rendered niches, kneel with their hands clasped in prayer. They gaze piously at illusionistic stone sculptures of Ghent's patron saints, Saint John the Baptist and Saint John the Evangelist (who was probably also Vyd's patron saint). An Annunciation scene appears on the upper register, with a careful representation of a Flemish town outside the painted window of the center

Tempera and Oil Painting

he generic words "paint" and "pigment" encompass a wide range of substances artists have used over the years. Fresco aside (see "Fresco Painting," Chapter 14, page 382), during the 14th century, egg tempera was the material of choice for most painters, both in Italy and Northern Europe.

Tempera consists of egg combined with a wet paste of ground pigment. In his influential guidebook *Il libro dell'arte* (*The Artist's Handbook*, 1437), Cennino Cennini mentioned that artists mixed only the egg yolk with the ground pigment, but analyses of paintings from this period have revealed that some artists used the whole egg. Images painted with tempera have a velvety sheen. Artists usually applied tempera to the painting surface with a light touch because thick application of the pigment mixture results in premature cracking and flaking.

Scholars have discovered that artists used oil paints as far back as the 8th century, but not until the early 15th century did oil painting become widespread. Flemish artists such as Melchior Broederlam (FIG. 15-3) were among the first to employ oils extensively (often mixing them with tempera), and Italian painters quickly followed suit. The discovery of better drying components in the early 15th century enhanced the setting capabilities of oils. Rather than apply these oils in the light, flecked brushstrokes that tempera encouraged, artists laid the oils down in transparent layers, or *glazes*, over opaque

or semiopaque underlayers. In this manner, painters could build up deep tones through repeated glazing. Unlike tempera, whose surface dries quickly due to water evaporation, oils dry more uniformly and slowly, providing the artist time to rework areas. This flexibility must have been particularly appealing to artists who worked very deliberately, such as Robert Campin (FIG. 15-4), Jan van Eyck (FIGS. 15-1, 15-5 to 15-7), and other Flemish masters discussed in this chapter and the Italian Leonardo da Vinci (see Chapter 17). Leonardo also preferred oil paint because its gradual drying process and consistency permitted him to blend the pigments, thereby creating the impressive *sfumato* (smoky effect) that contributed to his fame.

Both tempera and oils can be applied to various surfaces. Through the early 16th century, wooden panels served as the foundation for most paintings. Italians painted on poplar. Northern European artists used oak, lime, beech, chestnut, cherry, pine, and silver fir. Availability of these timbers determined the choice of wood. Linen canvas became increasingly popular in the late 16th century. Although evidence suggests that artists did not intend permanency for their early images on canvas, the material proved particularly useful in areas such as Venice where high humidity warped wood panels and made fresco unfeasible. Further, until artists began to use wooden bars to stretch the canvas to form a taut surface, canvas paintings were more portable than wood panels.

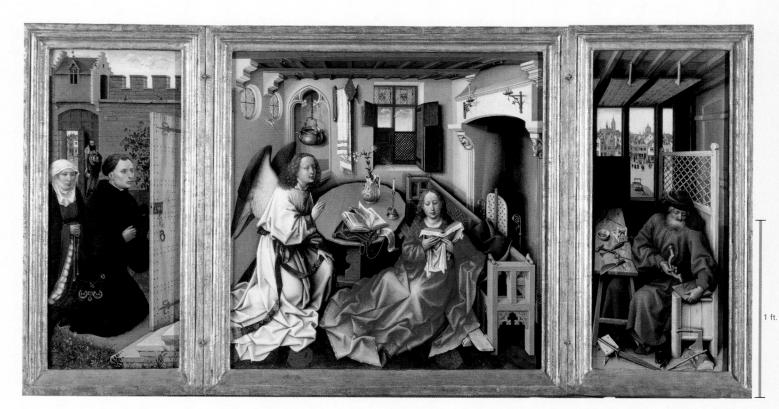

15-4 ROBERT CAMPIN (MASTER OF FLÉMALLE), *Mérode Altarpiece* (open), ca. 1425–1428. Oil on wood, center panel 2' $1\frac{3}{8}'' \times 2'\frac{7}{8}''$, each wing 2' $1\frac{3}{8}'' \times 10\frac{7}{8}''$. Metropolitan Museum of Art, New York (The Cloisters Collection, 1956).

Campin set the *Annunciation* in a Flemish merchant's home in which the everyday objects represented have symbolic significance. Oil paints permitted Campin to depict all the details with loving fidelity.

401

panel. In the uppermost arched panels, van Eyck depicted images of the Old Testament prophets Zachariah and Micah, along with *sibyls*, Greco-Roman mythological prophetesses whose writings the Christian Church interpreted as prophecies of Christ.

When opened (FIG. 15-6), the altarpiece reveals a sumptuous, superbly colored painting of humanity's redemption through Christ. In the upper register, God the Father-wearing the pope's triple tiara, with a worldly crown at his feet, and resplendent in a deep-scarlet mantle—presides in majesty. To God's right is the Virgin, represented, as in the Gothic age, as the Queen of Heaven, with a crown of 12 stars upon her head. Saint John the Baptist sits to God's left. To either side is a choir of angels, with an angel playing an organ on the right. Adam and Eve appear in the far panels. The inscriptions in the arches above Mary and Saint John extol the Virgin's virtue and purity and Saint John's greatness as the forerunner of Christ. The inscription above the Lord's head translates as "This is God, allpowerful in his divine majesty; of all the best, by the gentleness of his goodness; the most liberal giver, because of his infinite generosity." The step behind the crown at the Lord's feet bears the inscription "On his head, life without death. On his brow, youth without age. On his right, joy without sadness. On his left, security without fear." The entire altarpiece amplifies the central theme of salvation. Even though humans, symbolized by Adam and Eve, are sinful, they will be saved because God, in his infinite love, will sacrifice his own son for this purpose.

The panels of the lower register extend the symbolism of the upper. In the central panel, the community of saints comes from the four corners of the earth through an opulent, flower-spangled landscape. They proceed toward the altar of the Lamb and the octagonal fountain of life (compare FIG. 15-2). The Revelation passage recounting the Adoration of the Lamb is the main reading on All Saints' Day (November 1). The Lamb symbolizes the sacrificed Son of God, whose heart bleeds into a chalice, while into the fountain spills the "pure river of water of life, clear as crystal, proceeding out of the throne of God and of the Lamb" (Rev. 22:1). On the right, the 12 apostles and a group of martyrs in red robes advance. On the left appear prophets. In the right background come the virgin martyrs, and in the left background the holy confessors approach. On the lower wings, her-

mits, pilgrims, knights, and judges approach from left and right. They symbolize the four cardinal virtues: Temperance, Prudence, Fortitude, and Justice, respectively. The altarpiece celebrates the whole Christian cycle from the Fall to the Redemption, presenting the Church triumphant in heavenly Jerusalem.

Van Eyck used oil paints to render the entire altarpiece in a shimmering splendor of color that defies reproduction. No small detail escaped the painter. With pristine specificity, he revealed the beauty of the most insignificant object as if it were a work of piety as much as a work of art. He captured the soft texture of hair, the glitter of gold in the heavy brocades, the luster of pearls, and the flashing of gems, all with loving fidelity to appearance. This kind of meticulous attention to recording the exact surface appearance of humans, animals, objects, and landscapes, already evident in the *Mérode Altarpiece* (FIG. 15-4), became the hallmark of Flemish panel painting in the 15th century.

GIOVANNI ARNOLFINI Emerging capitalism led to an urban prosperity that fueled the growing bourgeois market for art objects, particularly in Bruges, Antwerp, and, later, Amsterdam. This prosperity contributed to a growing interest in secular art in addition to

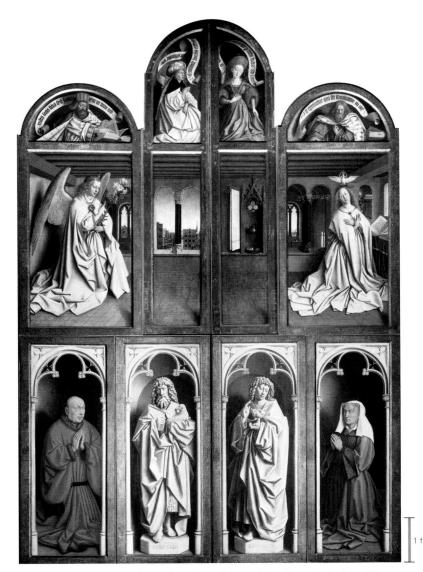

15-5 Jan van Eyck, Ghent Altarpiece (closed), Saint Bavo Cathedral, Ghent, Belgium, completed 1432. Oil on wood, 11' 5" \times 7' 6".

Monumental painted altarpieces were popular in 15th-century Flemish churches. Artists decorated both the interiors and exteriors of these hinged polyptychs, which often, as here, included donor portraits.

religious artworks. Both the *Mérode Altarpiece* and the *Ghent Altarpiece* include painted portraits of their donors. These paintings marked a significant revival of portraiture, a genre that had languished since antiquity.

A purely secular portrait, but one with religious overtones, is Jan van Eyck's oil painting Giovanni Arnolfini and His Bride (FIG. 15-1). Van Eyck depicted the Lucca financier (who had established himself in Bruges as an agent of the Medici family) and his betrothed in a Flemish bedchamber that is simultaneously mundane and charged with the spiritual. As in the Mérode Altarpiece, almost every object portrayed conveys the sanctity of the event, specifically, the holiness of matrimony. Arnolfini and his bride, Giovanna Cenami, hand in hand, take the marriage vows. The cast-aside clogs indicate that this event is taking place on holy ground. The little dog symbolizes fidelity (the common canine name Fido originated from the Latin fido, "to trust"). Behind the pair, the curtains of the marriage bed have been opened. The bedpost's finial (crowning ornament) is a tiny statue of Saint Margaret, patron saint of childbirth. (Giovanna is not yet pregnant, although the fashionable costume she wears makes her appear so.) From the finial hangs a whisk broom, symbolic of domestic care. The oranges on the chest below the window may refer to fertility. The single

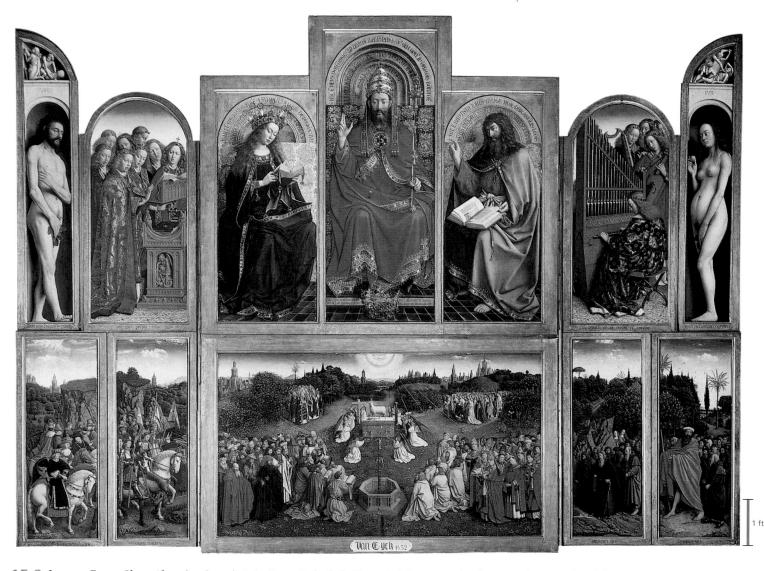

15-6 Jan van Eyck, *Ghent Altarpiece* (open), Saint Bavo Cathedral, Ghent, Belgium, completed 1432. Oil on wood, 11' 5" × 15' 1".

In this sumptuous painting of salvation from the Original Sin of Adam and Eve, God the Father presides in majesty. Van Eyck rendered every figure.

candle burning in the left rear holder of the ornate chandelier and the mirror, in which the viewer sees the entire room reflected, symbolize the all-seeing eye of God. The small medallions set into the mirror frame show tiny scenes from the Passion of Christ and represent God's promise of salvation for the figures reflected on the mirror's convex surface. Flemish viewers would have been familiar with many of the objects included in the painting because of traditional Flemish customs. Husbands traditionally presented brides with clogs, and the solitary lit candle in the chandelier was part of Flemish marriage practices. Van Eyck's placement of the two figures suggests conventional gender

roles—the woman stands near the bed and well into the room, whereas

garment, and object with loving fidelity to appearance.

the man stands near the open window, symbolic of the outside world. Van Eyck enhanced the documentary nature of this scene by exquisitely painting each object. He carefully distinguished textures and depicted the light from the window on the left reflecting off various surfaces. He augmented the scene's credibility by including the convex mirror (complete with its spatial distortion, brilliantly recorded), because viewers can see not only the principals, Arnolfini and his wife, but also two persons who look into the room through the door. (Arnolfini's raised right hand may be a gesture of greeting to the two men.) One of these must be the artist himself, as the florid inscription above the mirror, "Johannes de Eyck fuit hic" (Jan van Eyck was here),

announces he was present. The picture's purpose, then, seems to have been to record and sanctify this marriage. However, some scholars have taken issue with this traditional reading of the painting, suggesting instead that Arnolfini is conferring legal privileges on his wife to conduct business in his absence. In either case, the artist functions as a witness. The self-portrait of van Eyck in the mirror also underscores the painter's self-consciousness as a professional artist whose role deserves to be recorded and remembered. (Compare the 12th-century monk Eadwine's self-portrait as "prince of scribes" [FIG. 12-37], a very early instance of an artist engaging in "self-promotion.")

MAN IN A RED TURBAN In 15th-century Flanders, artists also painted secular portraits without the layer of religious interpretation present in the Arnolfini double portrait. These private commissions began to multiply as both artists and patrons became interested in the reality (both physical and psychological) that portraits could reveal. For various reasons, great patrons embraced the opportunity to have their likenesses painted. They wanted to memorialize themselves in their dynastic lines and to establish their identities, ranks, and stations with images far more concrete than heraldic coats of arms. Portraits also served to represent state officials at events they could not attend. Sometimes, royalty, nobility, and the very rich would send artists to

Framed Paintings

Intil recent decades, when painters began to be content with simply affixing canvas to wooden *stretcher bars* to provide a taut painting surface devoid of any ornamentation, artists considered the frame an integral part of the painting. Frames served a number of functions, some visual, others conceptual. For paintings such as large-scale altarpieces that were part of a larger environment, frames often served to integrate the painting with its surroundings. Frames could also be used to reinforce the illusionistic nature of the painted image. For example, the

15-7 Jan van Eyck, *Man in a Red Turban*, 1433. Oil on wood, $1' 1\frac{1}{8}'' \times 10\frac{1}{4}''$. National Gallery, London.

Man in a Red Turban seems to be the first Western painted portrait in a thousand years in which the sitter looks directly at the viewer. The inscribed frame suggests it is a selfportrait of Jan van Eyck.

Italian painter Giovanni Bellini duplicated the carved pilasters of the architectural frame in his *San Zaccaria Altarpiece* (FIG. 17-33) in the painting itself, thereby enhancing the illusion of space and giving the painted figures an enhanced physical presence. In Jan van Eyck's *Ghent Altarpiece*, the frame seems to cast shadows on the floor between the angel and Mary in the *Annunciation* scene (FIG. 15-5, *top*.) More commonly, artists used frames specifically to distance the viewer from the (often otherworldly) scene by calling attention to the separation of the image from the viewer's space.

Most 15th- and 16th-century paintings included elaborate frames that the artists themselves helped design and construct. Frequently, the artists painted or gilded the frames, adding to the expense. Surviving contracts reveal that the frame accounted for as much as half the cost of an altarpiece. For small works, artists sometimes affixed the frames to the panels before painting, creating an insistent visual presence as they worked. Occasionally, a single piece of wood served as both panel and frame, and the artist carved the painting surface from the wood, leaving the edges as a frame. Larger images with elaborate frames, such as altarpieces, required the services of a woodcarver or stonemason. The painter worked closely with the individual constructing the frame to ensure its appropriateness for the image(s) produced.

Unfortunately, over time, many frames have been removed from their paintings. For instance, in 1566 church officials dismantled the *Ghent Altarpiece* and detached its elaborately carved frame in order to protect the sacred work from Protestant *iconoclasts* (see "Protes-

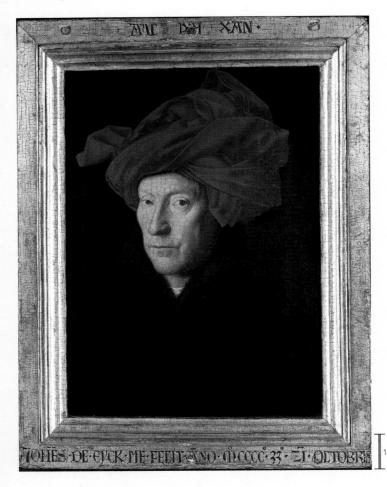

tantism and Iconoclasm," Chapter 18, page 510). As ill luck would have it, when the panels were reinstalled in 1587, no one could find the frame. Sadly, the absence of many of the original frames of old paintings deprives viewers today of the complete artistic vision of the artists. Conversely, when the original frames exist, they sometimes provide essential information, such as the subject, name of the painter, and date. For example, the inscriptions on the frame of Jan van Eyck's *Man in a Red Turban* (FIG. 15-7) state that he painted it on October 21, 1433, and the inclusion of "As I can" and the omission of the sitter's name suggest that the painting is a self-portrait.

paint the likeness of a prospective bride or groom. When young King Charles VI (r. 1380–1422) of France sought a bride, a painter journeyed to three different royal courts to make portraits of the candidates for the king to use in making his choice.

In *Man in a Red Turban* (FIG. **15-7**), the man van Eyck portrayed looks directly at the viewer. This seems to be the first Western painted portrait in a thousand years where the sitter does so. The level, composed gaze, directed from a true three-quarter head pose, must have impressed observers deeply. The painter created the illusion that from whatever angle a viewer observes the face, the eyes return that gaze. Van Eyck, with his considerable observational skill and controlled painting style, injected a heightened sense of speci-

ficity into this portrait by including beard stubble, veins in the bloodshot left eye, and weathered and aged skin. Although a definitive identification of the sitter has yet to be made, most scholars consider *Man in a Red Turban* to be a self-portrait, which van Eyck painted by looking at his image in a mirror (as he depicted himself in the mirror in the Arnolfinis' bedroom). The inscriptions on the frame (see "Framed Paintings," above) reinforce this identification. Across the top, van Eyck wrote "As I can" in Flemish using Greek letters, and across the bottom in Latin appears the statement "Jan van Eyck made me" and the date. The use of both Greek and Latin suggests the artist's view of himself as a successor to the fabled painters of antiquity.

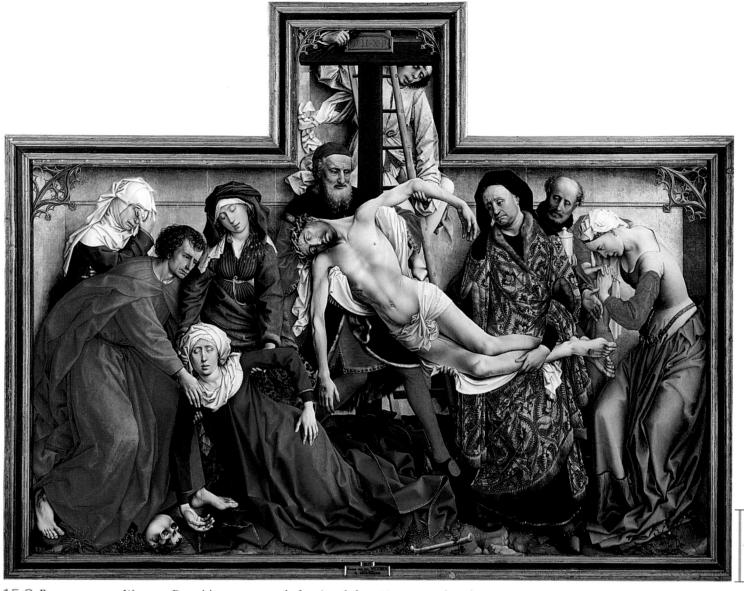

15-8 Rogier van der Weyden, *Deposition*, center panel of a triptych from Notre-Dame hors-les-murs, Louvain, Belgium, ca. 1435. Oil on wood, $7' 2\frac{5''}{8} \times 8' 7\frac{1''}{8}$. Museo del Prado, Madrid.

Deposition resembles a relief carving in which the biblical figures act out a drama of passionate sorrow as if on a shallow theatrical stage. The emotional impact of the painting is unforgettable.

ROGIER VAN DER WEYDEN When Jan van Eyck received the commission for the *Ghent Altarpiece*, ROGIER VAN DER WEYDEN (ca. 1400–1464) was an assistant in the workshop of Robert Campin, but the younger painter's fame eventually rivaled van Eyck's. Rogier soon became renowned for his dynamic compositions stressing human action and drama. He concentrated on Christian themes such as the Crucifixion and the *Pietà* (the Virgin Mary cradling the dead body of her son), moving observers emotionally by relating the sufferings of Christ.

An early masterwork is his 1435 *Deposition* (FIG. **15-8**), the center panel of a triptych the Archers Guild of Louvain commissioned for the church of Notre-Dame hors-les-murs (Notre-Dame "outside the [town] walls") in Louvain. Rogier acknowledged the patrons of this large painting by incorporating the crossbow (the guild's symbol) into the decorative tracery in the corners. Instead of creating a deep landscape setting, as van Eyck might have, Rogier compressed the figures and action onto a shallow stage, imitating the large sculptured shrines so popular in the 15th century, especially in

the Holy Roman Empire (FIGS. 15-18 and 15-19). The device admirably served his purpose of expressing maximum action within a limited space. The painting, with the artist's crisp drawing and precise modeling of forms, resembles a stratified relief carving. A series of lateral undulating movements gives the group a compositional unity, a formal cohesion the artist strengthened by depicting the desolating anguish that many of the figures share. The similar poses of Christ and the Virgin Mary further unify the composition.

Few painters have equaled Rogier van der Weyden in the rendering of passionate sorrow as it vibrates through a figure or distorts a tearstained face. His depiction of the agony of loss is among the most authentic in religious art. The emotional impact on the viewer is immediate and unforgettable. It was probably Rogier van der Weyden that Michelangelo had in mind when, according to the Portuguese painter Francisco de Hollanda (1517–1584), the Italian master observed that "Flemish painting [will] please the devout better than any painting of Italy, which will never cause him to shed a tear, whereas that of Flanders will cause him to shed many." I

The Artist's Profession in Flanders

s in Italy (see "Artistic Training," Chapter 14, page 388), guilds controlled the Flemish artist's profession. To pursue a craft, individuals had to belong to the guild controlling that craft. Painters, for example, sought admission to the Guild of Saint Luke, the patron saint of painters (FIG. 15-9), as well as saddlers, glassworkers, and mirror-workers. The path to eventual membership in the guild began, for men, at an early age, when the father apprenticed his son in boyhood to a master, with whom the young aspiring painter lived. The master taught the fundamentals of his craft—how to make implements, prepare panels with gesso (plaster mixed with a binding material), and mix colors, oils, and varnishes. Once the youth mastered these procedures and learned to work in the master's traditional manner, he usually spent several years working as a journeyman in various cities, observing and absorbing ideas from other masters. He then was eligible to become a master and to apply for admission to the guild. Through the guild, he obtained commissions. The guild inspected his paintings to ensure that he used quality materials and to evaluate workmanship. It also secured him adequate payment for his labor. As a result of this quality control, Flemish artists soon gained a favorable reputation for their solid artisanship.

Women clearly had many fewer opportunities than men to train as artists, in large part because of social and moral constraints that would have forbidden women's apprenticeship in the homes of male masters. Moreover, from the 16th century, when academic training courses supplemented and then replaced guild training, until the 20th century, women would not as a rule expect or be permitted instruction in figure painting, insofar as it involved dissection of cadavers and study of the nude male model. Flemish women interested in pursuing art as a career, for example, Caterina van Hemessen (FIG. 18-17),

most often received tutoring from fathers and husbands who were professionals and whom the women assisted in all the technical procedures of the craft. Despite these obstacles, membership records of the art guilds of cities such as Bruges reveal that a substantial number of

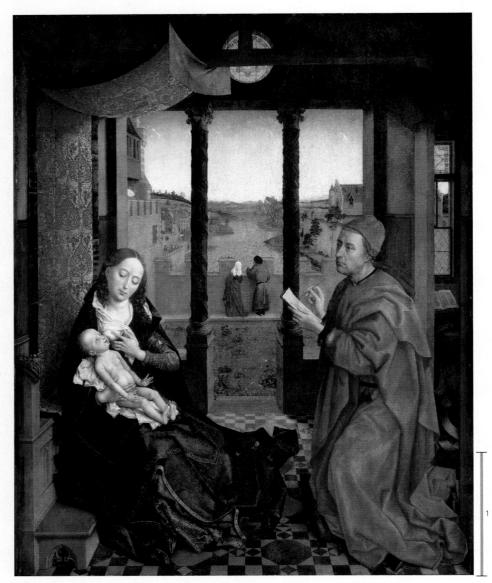

15-9 ROGIER VAN DER WEYDEN, *Saint Luke Drawing the Virgin*, ca. 1435–1440. Oil and tempera on wood, $4' 6\frac{1}{8}'' \times 3' 7\frac{5}{8}''$. Museum of Fine Arts, Boston. (Gift of Mr. and Mrs. Henry Lee Higginson)

Probably commissioned by the painters guild in Brussels, this panel honors the first Christian artist and the profession of painting. Saint Luke may be a self-portrait of Rogier van der Weyden.

Flemish women in the 15th century were able to establish themselves as artists. That they succeeded in negotiating the difficult path to acceptance as professionals is a testament to both their tenacity and their artistic skill.

SAINT LUKE Slightly later in date is Rogier's *Saint Luke Drawing the Virgin* (FIG. **15-9**), probably painted for the Guild of Saint Luke, the artists guild in Brussels. The panel depicts the patron saint of painters drawing the Virgin Mary using a *silverpoint* (a sharp *stylus* that creates a fine line). The theme paid tribute to the profession of painting in Flanders (see "The Artist's Profession in Flanders," above) by drawing attention to the venerable history of the painter's craft. Many scholars believe that Rogier's *Saint Luke* is a self-portrait, iden-

tifying the Flemish painter with the first Christian artist and underscoring the holy nature of painting. Here, Rogier shares with Jan van Eyck the aim of recording every detail of the scene with loving fidelity to optical appearance, from the rich fabrics to the floor pattern to the landscape seen through the window. And, like Campin and van Eyck, Rogier imbued much of the representation with symbolic significance. At the right, the ox identifies the figure recording the Virgin's features as Saint Luke (see "The Four Evangelists," Chapter 11,

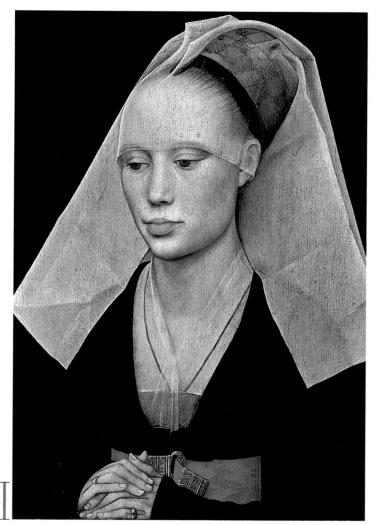

15-10 ROGIER VAN DER WEYDEN, *Portrait of a Lady*, ca. 1460. Oil on panel, $1' 1\frac{3''}{8} \times 10\frac{1}{16}$ ". National Gallery, Washington, D.C. (Andrew W. Mellon Collection).

Rogier van der Weyden won renown for his penetrating portrayals of character. The lowered eyes, tightly locked thin fingers, and fragile physique convey this unnamed lady's reserved demeanor.

page 290). The carved armrest of the Virgin's bench depicts Adam, Eve, and the serpent, reminding the viewer that Mary is the new Eve and Christ the new Adam who will redeem humanity from the Original Sin.

PORTRAIT OF A LADY Rogier, like van Eyck, also painted private portraits. The identity of the young woman he portrayed in FIG. 15-10 is unknown. Her dress and bearing imply noble rank. The portrait also reveals the lady's individual character. Her lowered eyes, tightly locked thin fingers, and fragile physique bespeak a reserved and pious demeanor. This style contrasted with the formal Italian approach (FIG. 16-25), derived from the profiles common to coins and medallions, which was sterner and conveyed little of the sitter's personality. Rogier was perhaps chief among the Flemish in his penetrating readings of his subjects. As a great pictorial composer, he made beautiful use here of flat, sharply pointed angular shapes that so powerfully suggest this subject's composure. In this portrait, unlike in his Saint Luke, the artist placed little emphasis on minute description of surface detail. Instead, he defined large, simple planes and volumes and focused on capturing the woman's dignity and elegance.

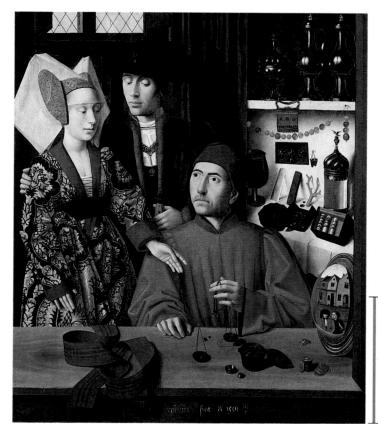

15-11 Petrus Christus, *A Goldsmith in His Shop*, 1449. Oil on wood, 3' $3'' \times 2'$ 10''. Metropolitan Museum of Art, New York (Robert Lehman Collection, 1975).

Once thought to depict Eligius, the patron saint of goldsmiths, Christus's painting, made for the Bruges goldsmiths' guild chapel, is more likely a generic scene of a couple shopping for a wedding ring.

Later Flemish Panel Painters

Robert Campin, Jan van Eyck, and Rogier van der Weyden were the leading figures of the first generation of "Northern Renaissance" painters. (Art historians usually transfer to Northern Europe, with less validity than in its original usage, the term "Renaissance," coined to describe the conscious revival of classical art in Italy.) The second generation of Flemish masters, active during the latter half of the 15th century, shared many of the concerns of their illustrious predecessors, especially the use of oil paints to create naturalistic representations, often, although not always, of traditional Christian subjects for installation in churches.

PETRUS CHRISTUS One work of uncertain Christian content is A Goldsmith in His Shop (FIG. 15-11) by Petrus Christus (ca. 1410-1472), who settled in Bruges in 1444. According to the traditional interpretation, A Goldsmith in His Shop portrays Saint Eligius (who was initially a master goldsmith before committing his life to God) sitting in his stall, showing an elegantly attired couple a selection of rings. The bride's betrothal girdle lies on the table as a symbol of chastity, and the woman reaches for the ring the goldsmith weighs. The artist's inclusion of a crystal container for Eucharistic wafers (on the lower shelf to the right of Saint Eligius) and the scales (a reference to the Last Judgment) supports a religious interpretation of this painting and continues the Flemish habit of imbuing everyday objects with symbolic significance. A halo once circled the goldsmith's head, seemingly confirming the religious nature of this scene, but when scientific analysis revealed that the halo was a later addition by an artist other than Christus, restorers removed it.

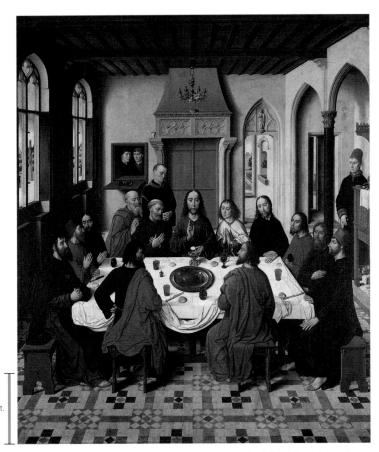

15-12 DIRK BOUTS, Last Supper, center panel of the Altarpiece of the Holy Sacrament, Saint Peter's, Louvain, Belgium, 1464–1468. Oil on wood, $6' \times 5'$.

One of the earliest Northern European paintings to employ singlevanishing-point perspective, this *Last Supper* includes four servants in Flemish attire, probably portraits of the altarpiece's patrons.

More recent scholarship has argued that this painting, although not devoid of religious content, should be seen in the context of the tradition of vocational paintings produced for installation in guild chapels. Although the couple's presence suggests a marriage portrait, most scholars now believe that the goldsmiths' guild in Bruges commissioned this painting. Saint Eligius was the patron saint of gold- and silversmiths, blacksmiths, and metalworkers, all of whom shared a chapel in a building adjacent to their meetinghouse. The reconsecration of this chapel took place in 1449, the same date as this painting. Therefore, it seems probable that Christus painted *A Goldsmith in His Shop*, which depicts an economic transaction and focuses on the goldsmith's profession, specifically for the guild chapel.

Christus went to great lengths to produce a historically credible image. For example, the variety of objects depicted in the painting serves as advertisement for the goldsmiths guild. Included are the profession's raw materials—precious stones, beads, crystal, coral, and seed pearls—scattered among finished products—rings, buckles, and brooches. The pewter vessels on the upper shelves are donation pitchers, which town leaders gave to distinguished guests. All these meticulously painted objects attest to the centrality and importance of the goldsmiths to both the secular and sacred communities as well as enhance the naturalism of the painting. The convex mirror in the foreground showing another couple and a street with houses serves to extend the painting's space into the viewer's space, further creating the illusion of reality.

DIRK BOUTS A different means of suggesting spatial recession is evident in *Last Supper* (FIG. **15-12**) by DIRK BOUTS (ca. 1415–1475), who became the official painter of Louvain in 1468. The painting is the central panel of *Altarpiece of the Holy Sacrament*, which the Louvain Confraternity of the Holy Sacrament commissioned in 1464. It is one of the earliest Northern European paintings to demonstrate the use of a single *vanishing point* (see "Renaissance Perspectival Systems," Chapter 16, page 425) for creating *perspective*. All of the central room's *orthogonals* (converging diagonal lines imagined to be behind and perpendicular to the picture plane) lead to a single vanishing point in the center of the mantelpiece above Christ's head. However, the small side room has its own vanishing point, and neither it nor the vanishing point of the main room falls on the horizon of the landscape seen through the windows, as in Italian Renaissance paintings.

In *Last Supper*, Bouts did not focus on the biblical narrative itself but instead presented Christ in the role of a priest performing a ritual from the liturgy of the Christian Church—the consecration of the Eucharistic wafer. This contrasts strongly with other Last Supper depictions, which often focused on Judas's betrayal or on Christ's comforting of John. Bouts also added to the complexity of this image by including four servants (two in the pass-through window and two standing), all dressed in Flemish attire. These servants are most likely portraits of the confraternity's members responsible for commissioning the altarpiece, continuing the Flemish tradition of inserting into biblical representations portraits of the painting's patrons, first noted in the *Mérode Altarpiece* (FIG. 15-4).

HUGO VAN DER GOES By the mid-15th century, Flemish art had achieved renown throughout Europe. The Portinari Altarpiece (FIG. 15-13), for example, is a large-scale Flemish work in a family chapel in Florence, Italy. The artist who received the commission was Hugo VAN DER GOES (ca. 1440–1482), the dean of the painters guild of Ghent from 1468 to 1475. Hugo painted the triptych for Tommaso Portinari, an Italian shipowner and agent for the powerful Medici family of Florence. Portinari appears on the wings of the altarpiece with his family and their patron saints. The central panel depicts the Adoration of the Shepherds. On this large surface, Hugo displayed a scene of solemn grandeur, muting the high drama of the joyous occasion. The Virgin, Joseph, and the angels seem to brood on the suffering to come rather than to meditate on the Nativity miracle. Mary kneels, somber and monumental, on a tilted ground that has the expressive function of centering the main actors. The composition may also reflect the tilted stage floors of contemporary mystery plays. From the right rear enter three shepherds, represented with powerful realism in attitudes of wonder, piety, and gaping curiosity. Their lined faces, work-worn hands, and uncouth dress and manner seem immediately familiar.

The symbolic architecture and a continuous wintry northern landscape unify the three panels. Symbols surface throughout the altarpiece. Iris and columbine flowers symbolize the Sorrows of the Virgin. The 15 angels represent the Fifteen Joys of Mary. A sheaf of wheat stands for Bethlehem (the "house of bread" in Hebrew), a reference to the Eucharist. The harp of David, emblazoned over the building's portal in the middle distance (just to the right of the Virgin's head), signifies the ancestry of Christ. To stress the meaning and significance of the depicted event, Hugo revived medieval pictorial devices. Small scenes shown in the background of the altarpiece represent (from left to right) the flight into Egypt, the annunciation to the shepherds, and the arrival of the magi. Hugo's variation in the scale of his figures to differentiate them by their importance to the central event also reflects older traditions. Still, he put a vigorous, penetrating realism to work in a new direction, characterizing human beings according to their social level while showing their common humanity.

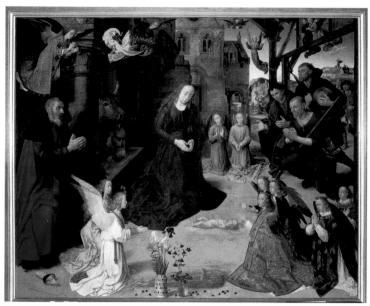

15-13 Hugo van der Goes, *Portinari Altarpiece* (open), from Sant'Egidio, Florence, Italy, ca. 1476. Tempera and oil on wood, center panel 8' $3\frac{1}{2}'' \times 10'$, each wing 8' $3\frac{1}{2}'' \times 4'$ $7\frac{1}{2}''$. Galleria degli Uffizi, Florence.

This altarpiece is a rare instance of the awarding of a major commission in Florence to a Flemish painter. The Italians admired the incredibly realistic details and Hugo's brilliant portrayal of human character.

After Portinari placed his altarpiece in the family chapel in the Florentine church of Sant'Egidio, it created a considerable stir among Italian artists. Although the painting as a whole may have seemed unstructured to them, Hugo's masterful technique and what the Florentines regarded as extraordinary realism in representing drapery, flowers, animals, and, above all, human character and emotion made a deep impression on them. At least one Florentine artist, Domenico Ghirlandaio (see Chapter 16), paid tribute to the Northern European master by using Hugo's most striking motif, the adoring shepherds, in one of his own Nativity paintings.

HANS MEMLING A contemporary of Hugo van der Goes was HANS MEMLING (ca. 1430–1494), who became a citizen of Bruges in 1465 and received numerous commissions from the city's wealthy merchants, Flemish and foreign alike. Memling specialized in portraits and images of the Madonna. The many that survive depict young, slight, pretty princesses, each holding a doll-like infant Christ. The center panel of the *Saint John Altarpiece* depicts the *Virgin with Saints and Angels* (FIG. 15-14). The patrons of this altarpiece—two brothers and two sisters of the order of the Hospital of Saint John in Bruges—appear on the exterior side panels (not illustrated). In the central panel, two

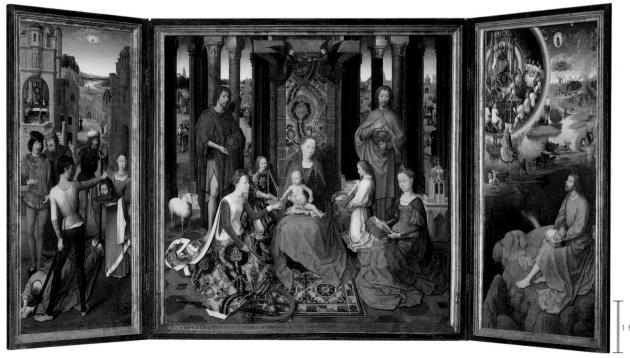

15-14 Hans Memling, *Virgin with Saints and Angels*, center panel of the *Saint John Altarpiece*, Hospitaal Sint Jan, Bruges, Belgium, 1479. Oil on wood, $5'7\frac{3}{4}'' \times 5'7\frac{3}{4}''$ (center panel), $5'7\frac{3}{4}'' \times 2'7\frac{1}{8}''$ (each wing).

Memling specialized in images of the Madonna. His Saint John Altarpiece exudes an opulence that results from the sparkling and luminous colors and the realistic depiction of rich tapestries and brocades.

angels, one playing a musical instrument and the other holding a book, flank the Virgin. To the sides of Mary's throne stand Saint John the Baptist on the left and Saint John the Evangelist on the right, and seated in the foreground are Saints Catherine and Barbara. This gathering celebrates the mystic marriage of Saint Catherine of Alexandria, one of many virgin saints who were believed to have entered into a special spiritual marriage with Christ. As one of the most revered virgins of Christ, Saint Catherine provided a model of devotion especially resonant with women viewers (particularly nuns). The altarpiece exudes an opulence that results from the rich colors, carefully depicted tapestries and brocades, and the serenity of the figures. The composition is balanced and serene, the color sparkling and luminous, and the execution of the highest technical quality-all characteristics of 15th-century Flemish painting in general.

FRANCE

In contrast to the prosperity and peace Flanders enjoyed during the 15th century, in France the Hundred Years' War crippled economic enterprise and brought political instability. The anarchy of war and the weakness of the kings gave rise to a group of duchies, each with significant power. The strongest and wealthiest of these was the duchy of Burgundy, which controlled Flanders and where artists prospered. But the dukes of Berry, Bourbon, and Nemours, as well as members of the French royal court, were also major art patrons.

Manuscript Painting

During the 15th century, French artists built on the achievements of Gothic painters (see Chapter 13) and produced exquisitely refined *illuminated manuscripts*. Among the most significant developments in French manuscript painting was a new conception and presentation of space. Paintings in manuscripts took on more pronounced characteristics as illusionistic scenes. Increased contact with Italy, where Renaissance artists had revived the pictorial principles of classical antiquity, may have influenced French painters' interest in illusionism.

LIMBOURG BROTHERS Among the early-15th-century artists who furthered the maturation of manuscript painting were the three LIMBOURG BROTHERS—POL, HERMAN, and JEAN—from Nijmegen in the Netherlands. They were nephews of Jean Malouel, the court artist of Philip the Bold. Following in the footsteps of earlier illustrators such as Jean Pucelle (Fig. 13-36), the Limbourg brothers expanded the illusionistic capabilities of illumination. Trained in the Netherlands, the brothers moved to Paris no later than 1402, and between 1405 and their death in 1416, probably from the plague, they worked in Paris and Bourges for Jean, duke of Berry (r. 1360–1416)

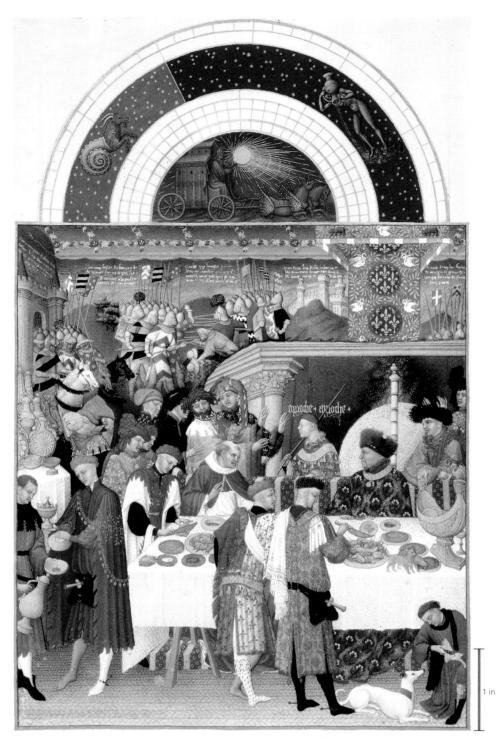

15-15 LIMBOURG BROTHERS (POL, JEAN, HERMAN), January, from Les Très Riches Heures du Duc de Berry, 1413–1416. Ink on vellum, $8\frac{7}{8}$ " $\times 5\frac{3}{8}$ ". Musée Condé, Chantilly.

The sumptuous pictures in *Les Très Riches Heures* depict characteristic activities of each month and give unusual prominence to genre subjects, reflecting the increasing integration of religious and secular art.

and brother of King Charles V (r. 1364–1380) of France and of Philip the Bold of Burgundy. The duke ruled the western French regions of Berry, Poitou, and Auvergne. He was an avid art patron and focused much of his collecting energy on manuscripts, jewels, and rare artifacts. An inventory of the duke's libraries revealed that he owned more than 300 manuscripts, including Pucelle's *Belleville Breviary* (FIG. 13-36) and the *Hours of Jeanne d'Évreux*. For Jean, the Limbourg brothers produced a gorgeously illustrated Book of Hours, *Les Très Riches Heures du Duc de Berry (The Very Sumptuous*

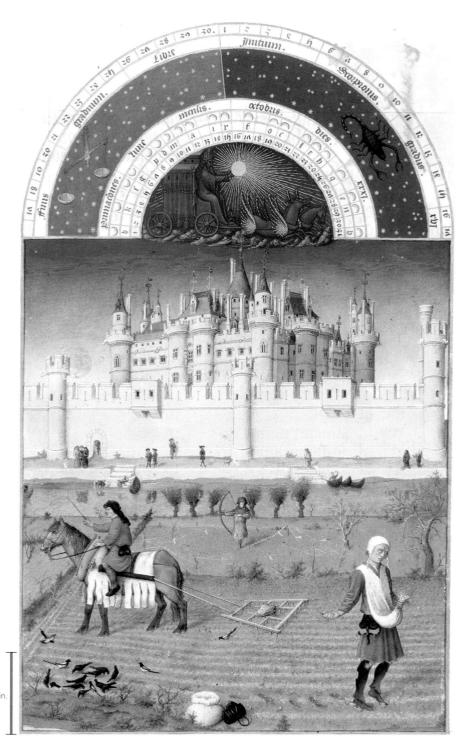

15-16 Limbourg Brothers (Pol, Jean, Herman), October, from Les Très Riches Heures du Duc de Berry, 1413–1416. Ink on vellum, $8\frac{7}{8}$ " $\times 5\frac{3}{8}$ ". Musée Condé, Chantilly.

The Limbourg brothers expanded the illusionistic capabilities of manuscript painting with their care in rendering architectural detail and convincing depiction of shadows cast by people and objects.

Hours of the Duke of Berry). A Book of Hours, like a breviary, was a book used for reciting prayers (see "Medieval Books," Chapter 11, page 289). As prayer books, they replaced the traditional psalters (book of Psalms), which were the only liturgical books in private hands until the mid-13th century. The centerpiece of a Book of Hours was the "Office [prayer] of the Blessed Virgin," which contained liturgical passages to be read privately at set times during the day, from matins (dawn prayers) to compline (the last of the prayers recited daily). An illustrated calendar listing local religious feast

days usually preceded the Office of the Blessed Virgin. Penitential Psalms, devotional prayers, litanies to the saints, and other prayers, including those of the dead and of the Holy Cross, followed the centerpiece. Such books became favorite possessions of the Northern European aristocracy during the 14th and 15th centuries. They eventually became available to affluent burghers and contributed to the decentralization of religious practice that was one factor in the Protestant Reformation in the early 16th century (see Chapter 18).

The calendar pictures of *Les Très Riches Heures* are perhaps the most famous in the history of manuscript illumination. They represent the 12 months in terms of the associated seasonal tasks, alternating scenes of nobility and peasantry. Above each picture is a lunette (semicircular frame) in which the Limbourgs depicted the chariot of the sun as it makes its yearly cycle through the 12 months and zodiac signs. Beyond its function as a religious book, Les Très Riches Heures also visually captures the power of the duke and his relationship to the peasants. The colorful calendar picture for January (FIG. 15-15) depicts a New Year's reception at court. The duke appears as magnanimous host, his head circled by the fire screen, almost halolike, behind him. His chamberlain stands next to him, urging the guests forward with the words "aproche, aproche." The lavish spread of food on the table and the large tapestry on the back wall augment the richness and extravagance of the setting and the occasion.

In contrast, the illustration for October (FIG. 15-16) focuses on the peasantry. Here, the Limbourg brothers depicted a sower, a harrower on horseback, and washerwomen, along with city dwellers, who promenade in front of the Louvre (the French king's residence at the time, now one of the world's great art museums). The peasants do not appear particularly disgruntled as they go about their tasks. Surely, this imagery flattered the duke's sense of himself as a compassionate master. The growing artistic interest in naturalism is evident here in the careful way the brothers recorded the architectural details of the Louvre and in their convincing depiction of the shadows of the people and objects (such as the archer scarecrow and the horse) in the scene.

As a whole, *Les Très Riches Heures* reinforced the image of the duke of Berry as a devout man, cultured bibliophile, sophisticated art patron, and powerful and magnanimous leader. Further, the expanded range of subject matter, especially the prominence of *genre* subjects in a religious book, reflected the in-

creasing integration of religious and secular concerns in both art and life at the time. Although all three Limbourg brothers worked on *Les Très Riches Heures*, art historians have never been able to ascertain definitively which brother painted which images. Given the common practice of collaboration on artistic projects at this time, this determination of specific authorship is not very important. The Limbourg brothers died before completing this Book of Hours, and another court illustrator finished the manuscript about 70 years later.

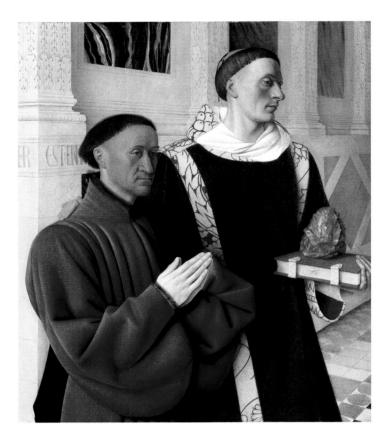

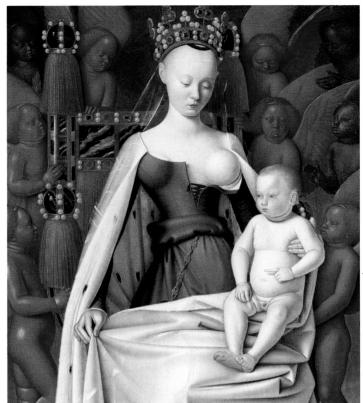

15-17 Jean Fouquet, *Melun Diptych. Étienne Chevalier and Saint Stephen* (left wing), ca. 1450. Oil on wood, $3'\frac{1}{2}'' \times 2'9\frac{1}{2}''$. Gemäldegalerie, Staatliche Museen, Berlin. *Virgin and Child* (right wing), ca. 1451. Oil on wood, $3'1\frac{1}{4}'' \times 2'9\frac{1}{2}''$. Koninklijk Museum voor Schone Kunsten, Antwerp.

Fouquet's meticulous representation of a pious kneeling donor with a standing patron saint recalls Flemish painting, as do the three-quarter stances and the sharp focus of the portraits.

Panel Painting

Images for private devotional use were popular in France, as in Flanders, and the preferred medium was oil paint on wooden panels.

JEAN FOUQUET Among the French artists whose paintings were in demand was Jean Fouquet (ca. 1420-1481), who worked for King Charles VII (r. 1422-1461, the patron and client of Jacques Coeur; FIG. 18-30) and for the duke of Nemours. Fouquet painted a diptych (two-paneled painting; FIG. 15-17) for Étienne Chevalier, who, despite his lowly origins, became Charles VII's treasurer in 1452. In the left panel, Chevalier appears with his patron saint, Saint Stephen (Étienne in French). Appropriately, Fouquet's donor portrait of Chevalier depicts his prominent patron as devout—kneeling, with hands clasped in prayer. The representation of the pious donor with his standing saint recalls Flemish art, as do the three-quarter stances and the sharp, clear focus of the portraits. The artist depicted Saint Stephen holding the stone of his martyrdom (death by stoning) atop a volume of the Scriptures, thereby ensuring that viewers properly identify the saint. Fouquet rendered the entire image in meticulous detail and included a highly ornamented architectural setting.

In its original diptych form (the two panels are now in different museums), the viewer would follow the gaze of Chevalier and Saint Stephen over to the right panel, which depicts the Virgin Mary and Christ Child. The juxtaposition of these two images allowed the patron to bear witness to the sacred. The integration of sacred and secular (especially the political or personal) prevalent in other Northern European artworks also emerges here, complicating the reading of this diptych. Agnès Sorel, the mistress of King Charles VII, was Fouquet's model for the Virgin Mary. Sorel was a pious individual,

and according to an inscription, Chevalier commissioned this painting to fulfill a vow he made after Sorel's death in 1450. Thus, in addition to the religious interpretation of this diptych, there is surely a personal narrative here as well.

HOLY ROMAN EMPIRE

Because the Holy Roman Empire (whose core was Germany) did not participate in the long, drawn-out saga of the Hundred Years' War, its economy remained stable and prosperous. Without a dominant court culture to commission artworks, wealthy merchants and clergy became the primary German patrons during the 15th century.

Sculpture

The art of the early "Northern Renaissance" in the Holy Roman Empire displays a pronounced stylistic diversity. Although some artists followed developments in Flemish painting, the works of artists who specialized in carving large wooden retables reveal most forcefully the power of the lingering Late Gothic style.

VEIT STOSS The sculptor VEIT STOSS (1447–1533) trained in the Upper Rhine region but settled in Kraków (in present-day Poland) in 1477. In that year, he began work on a great altarpiece (FIG. 15-18) for the church of Saint Mary in Kraków. In the central boxlike shrine, huge carved and painted figures, some nine feet high, represent *Death and Assumption of the Virgin*. On the wings, Stoss portrayed scenes from the lives of Christ and Mary. The altar expresses the intense piety of Gothic culture in its late phase, when artists used every figural and ornamental design resource from the vocabulary of Gothic art to heighten the emotion and to glorify the

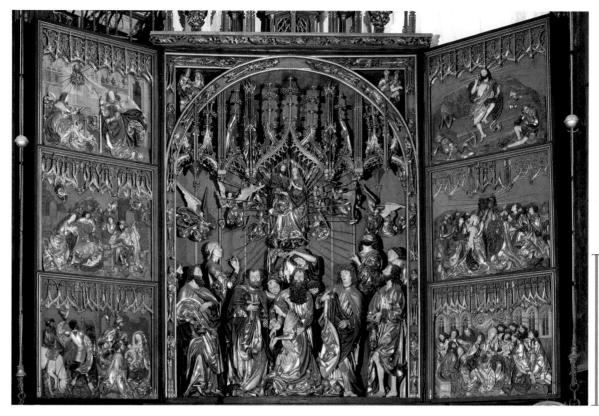

15-18 VEIT STOSS, Death and Assumption of the Virgin (wings open), altar of the Virgin Mary, church of Saint Mary, Kraków, Poland, 1477–1489. Painted and gilded wood, central panel 23′ 9″ high.

In this huge sculptured and painted altarpiece, Veit Stoss used every figural and ornamental element from the vocabulary of Gothic art to heighten the emotion and to glorify the sacred event.

10 ft.

sacred event. In the Kraków altarpiece, the disciples of Christ congregate around the Virgin, who sinks down in death. One of them supports her, while another, just above her, wrings his hands in grief. Stoss posed others in attitudes of woe and psychic shock, striving for realism in every minute detail. Moreover, he engulfed the figures in restless, twisting, and curving swaths of drapery whose broken and writhing lines unite the whole tableau in a vision of agitated emotion. The artist's massing of sharp, broken, and pierced forms that dart flamelike through the composition—at once unifying and animating it—recalls the design principles of Late Gothic architecture (FIG. 13-27). Indeed, in the Kraków altarpiece, Stoss merged sculpture and architecture, enhancing their union with paint and gilding.

TILMAN RIEMENSCHNEIDER The Virgin's Assumption also appears in the center panel (FIG. 15-19) of the *Creglingen Altarpiece*, created by TILMAN RIEMENSCHNEIDER (ca. 1460–1531) of Würzburg for a parish church in Creglingen, Germany. He also incorporated intricate Gothic forms, especially in the altarpiece's elaborate canopy, but unlike Stoss, he did not paint the figures or the background. By employing an endless and restless line that runs through the garments of the figures, Riemenschneider succeeded in setting the whole design into fluid motion, and no individual element functions without the rest. The draperies float and flow around bodies lost within them, serving not as descriptions but as design elements that tie the figures to one another and to the framework. A look of psychic strain, a facial expression common in Riemenschneider's work, heightens the spirituality of the figures, immaterial and weightless as they appear.

15-19 TILMAN RIEMENSCHNEIDER, *The Assumption of the Virgin*, center panel of the *Creglingen Altarpiece*, Herrgottskirche, Creglingen, Germany, ca. 1495–1499. Lindenwood, 6′ 1″ wide.

Tilman Riemenschneider specialized in carving large wooden retables. His works feature intricate Gothic tracery and religious figures whose bodies are almost lost within their swirling garments.

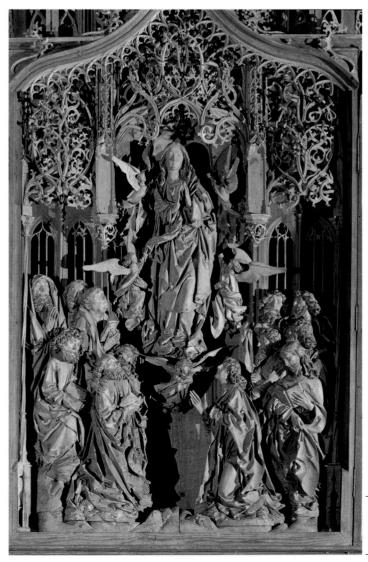

1 ft

15-20 Konrad Witz, Miraculous Draught of Fish, from the Altarpiece of Saint Peter, from the Chapel of Notre-Dame des Maccabées, Cathedral of Saint Peter, Geneva, Switzerland, 1444. Oil on wood, 4′ 3″ × 5′ 1″. Musée d'Art et d'Histoire, Geneva.

Konrad Witz set this Gospel episode on Lake Geneva. The painting is one of the first 15th-century works depicting a specific landscape and is noteworthy for the painter's skill in rendering water effects.

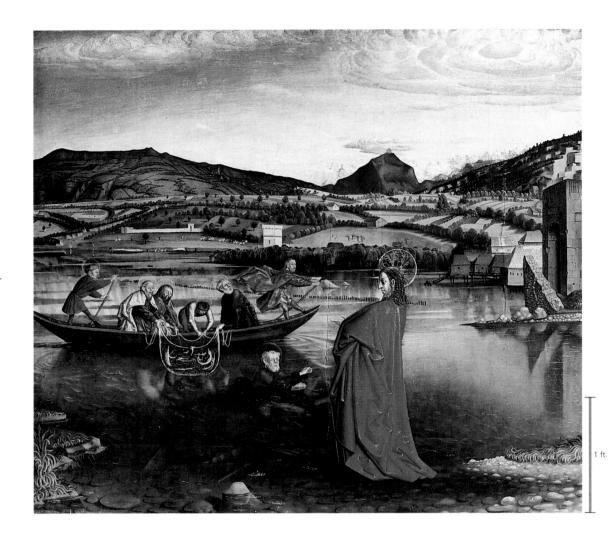

Panel Painting

As in Flanders, large-scale altarpieces featuring naturalistically painted biblical themes were familiar sights in the Holy Roman Empire.

KONRAD WITZ Among the most notable 15th-century German altarpieces is the Altarpiece of Saint Peter, painted in 1444 for the chapel of Notre-Dame des Maccabées in the Cathedral of Saint Peter in Geneva, Switzerland. Konrad Witz (ca. 1400–1446), whose studio was in Basel, painted one exterior wing of this triptych with a representation of the Miraculous Draught of Fish (FIG. 15-20). The other exterior wing (not illustrated) depicts the release of Saint Peter from prison. The central panel is lost. On the interior wings, Witz painted scenes of the adoration of the magi and of Saint Peter's presentation of the donor (Bishop François de Mies) to the Virgin and Child. Miraculous Draught of Fish shows Peter, the first pope, unsuccessfully trying to emulate Christ walking on water. Some scholars think the detail is a subtle commentary on the limited power of the pope in Rome on the part of the Swiss cardinal who commissioned the work. The painting is particularly significant because of the landscape's prominence. Witz showed precocious skill in the study of water effects—the sky glaze on the slowly moving lake surface, the mirrored reflections of the figures in the boat, and the transparency of the shallow water in the foreground. He observed and depicted the landscape so carefully that art historians have determined the exact location shown. Witz presented a view of the shores of Lake Geneva, with the town of Geneva on the right and Le Môle Mountain in the distance behind Christ's head. This painting is one of the first 15th-century works depicting a specific site.

Graphic Arts

A new age blossomed in the 15th century with a sudden technological advance that had widespread effects—the invention by Johannes Gutenberg (ca. 1400–1468) of movable type around 1450 and the development of the printing press. Printing had been known in China centuries before but had never fostered, as it did in 15th-century Europe, a revolution in written communication and in the generation and management of information. Printing provided new and challenging media for artists, and the earliest form was the woodcut (see "Woodcuts, Engravings, and Etchings," page 415). Using a gouging instrument, artists remove sections of wood blocks, sawing along the grain. They ink the ridges that carry the designs, and the hollows remain dry of ink and do not print. Artists produced woodcuts well before the development of movable-type printing. But when a rise in literacy and the improved economy necessitated production of illustrated books on a grand scale, artists met the challenge of bringing the woodcut picture onto the same page as the letterpress.

MICHEL WOLGEMUT The so-called *Nuremberg Chronicle*, a history of the world produced in Nuremberg by Anton Koberger (ca. 1445–1513) with more than 650 illustrations by the workshop of Michel Wolgemut (1434–1519), documents this achievement. The hand-colored page illustrated here (fig. 15-21) represents Tarvisium (modern Tarvisio), a town in the extreme northeast of Italy, as it was in the "fourth age of the world" according to the Latin inscription at the top. The blunt, simple lines of the woodcut technique give a detailed perspective of Tarvisium, its harbor and shipping, its walls and towers, its churches and municipal buildings, and the baronial

Woodcuts, Engravings, and Etchings

ith the invention of movable type in the 15th century and the new widespread availability of paper from commercial mills, the art of printmaking developed rapidly in Europe. A *print* is an artwork on paper, usually produced in multiple impressions. The set of prints an artist creates from a single print surface is called an *edition*. (The same term is used to describe a single printed version of a book. This is the 13th edition of *Art through the Ages*.) As with books manufactured on a press, the printmaking process involves the transfer of ink from a printing surface to paper. This can be accomplished in several ways. During the 15th and 16th centuries, artists most commonly used the *relief* and *intaglio* methods of printmaking.

Artists produce relief prints, the oldest and simplest of the printing methods, by carving into a surface, usually wood. Relief printing requires artists to conceptualize their images negatively—that is, they remove the surface areas around the images. Thus, when the printmaker inks the surface, the carved-out areas remain clean, and a positive image results when the artist presses the printing block against paper. Because artists produce *woodcuts* through a subtractive process (removing parts of the material), it is difficult to create very thin, fluid, and closely spaced lines. As a result, woodcut prints (for example, FIG. 15-21) tend to exhibit stark contrasts and sharp edges.

In contrast to the production of relief prints, the intaglio method involves a positive process. The artist incises (cuts) an image on a metal plate, often copper. The image can be created on the plate manually (engraving or drypoint; for example, FIG. 15-22) using a tool (a burin or stylus) or chemically (etching; for example, FIG. 20-16). In the latter process, an acid bath eats into the exposed parts of the plate where the artist has drawn through an acid-resistant coating. When the artist inks the surface of the intaglio plate and wipes it clean, the ink is forced into the incisions. Then the artist runs the plate and paper through a roller press, and the paper absorbs the remaining ink, creating the print. Because the artist "draws" the image onto the plate, intaglio prints differ in character from relief prints. Engravings, drypoints, and etchings generally present a wider variety of linear effects. They also often reveal to a greater extent evidence of the artist's touch, the result of the hand's changing pressure and shifting directions.

The paper and inks artists use also affect the finished look of the printed image. During the 15th and 16th centuries, European printmakers used papers produced from cotton and linen rags that papermakers mashed with water into a pulp. The papermakers then applied a thin layer of this pulp to a wire screen and allowed it to dry to create the paper. As contact with Asia increased, printmakers made greater use of what was called Japan paper (of mulberry fibers) and China paper. Artists, then as now, could select from a wide variety of inks. The type and proportion of the ink ingredients affect the consistency, color, and oiliness of inks, which various

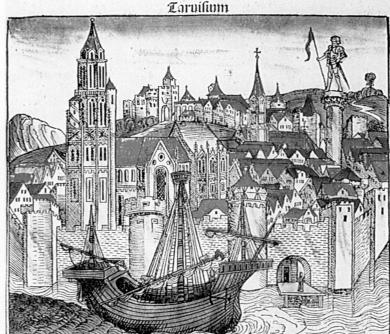

Arusin ipius Darchte Tarusiane cui tas : et ipia per bec tempora (vr Dieardo Fremonéii episcopo placs) a quibridam troy anis fundata fuit. Ablumir aute; imo pomus binidiru Silo flunto qui er ipius peo pinquiocibus monthè etijt. alijiga vbernimis aquis in ea quali featurientibus irrigatur, ac filus in mediterrancis Tarusium vrbem binidir Luius nomen paro inter vetifios babet plini) us. Per tempora vero Offrogotborum dignitate indo affe videt qua nue babet. Eo qi Torila qi poftea quimis fuit Offrogotborure 7 qde pilantilimi tarusii nate educantique et. Potte iliq qo pottea quimis fuit Offrogotborure 7 qde pilantilimi tarusii nate educantique et. Potte o getto primi vata incerate eterrativi que distince ante eterrativi que en iliqui podei que qui intico quom albomi rete o getto primi vatali effet ingrefius. Adletanqo qi iis tune erat etercate regionis vrbes produci onime epifet. Larusini qi eti incole vedito ytari diuficule obinishen, poltare ac bruce cofitue ratinifi felix ipli vrbis efus (vi Gregori feritivi) diir timorat rancina oriundi regis barbare fua pundetra a preci inflantia velinifet. Prinatagi ut ea ciutas altero prefitic efo bermo los barbaro. Qui ficut vece epin pplo mas] p

reffe adutebat of precile. Do ait ab bac vrbe vinuerfaregio Larunfana marchia renomiciur facti crevo a miori nomica abiurditate vr bec ap pellatio marchie Larunfane in spa maferit: cun at in regione sint amplissime cuntates Gerona at phatauni. Que semp e dignitate at gepote ratu necio e opuleta Larunsio antecirint: Lon gobard en in cay talke parte martine qua obti nebant regiones babucrunt quattuoz a ducib administratas in quibus nullum succissome babucrunt quattuoz a ducib administratas in quibus nullum succissoma sus shipe reportibus competedat, beneuetana spoleranam: taurinessem e sociolitensem: dua opolernam: amplitudine superioribus pares Bucontianam at quatufanam esse voluerum. La affectas legis conditione, vi qui regum aut gentis longobardorum concisi pinissione e volucreto impetrasset, as ships at quagnatis successi one possidendas relinquendi uns facultatem quagnitarium in longobarda, barbarie marchio natus est appellatum. Decetiam vrbs ecclini e Alberti est gennam ve rumano scutt paranus; verannete non carutt. Aquibus impuneras qui tre calanitates.

15-21 MICHEL WOLGEMUT and shop, *Tarvisium*, page from the *Nuremberg Chronicle*, 1493. Woodcut, $1'2'' \times 9''$. Printed by Anton Koberger.

The *Nuremberg Chronicle* is an early example of woodcut illustrations in printed books. The more than 650 pictures include detailed views of towns, but they are generic rather than specific portrayals.

papers absorb differently. Paper is lightweight, and the portability of prints has appealed to artists over the years. The opportunity to produce multiple impressions from the same print surface also made printmaking attractive to 15th- and 16th-century artists. In addition, prints can be sold at cheaper prices than paintings or sculptures. Consequently, prints can reach a much wider audience than one-of-a-kind artworks can. The number and quality of existing 15th- and 16th-century European prints attest to the importance of the new print medium.

1 in.

15-22 Martin Schongauer, *Saint Anthony Tormented by Demons*, ca. 1480–1490. Engraving, $1'\frac{1}{4}'' \times 9''$. Fondazione Magnani Rocca, Corte di Mamiano.

Martin Schongauer was the most skilled of the early masters of metal engraving. By using a burin to incise lines in a copper plate, he was able to create a marvelous variety of tonal values and textures.

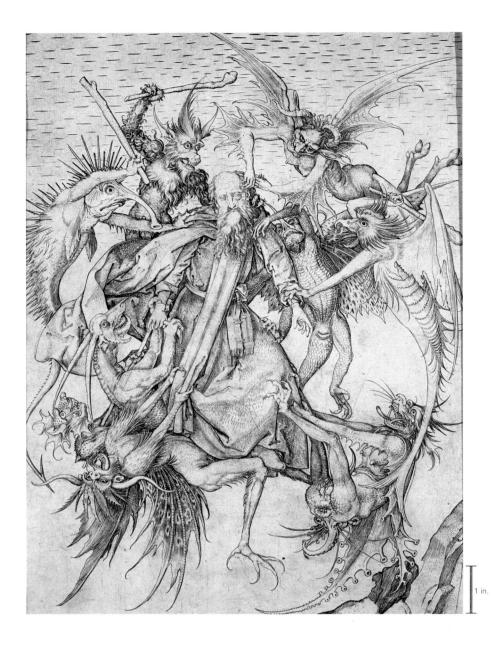

castle on the hill. Despite the numerous architectural structures, historians cannot determine whether this illustration represents the artist's accurate depiction of the city or his fanciful imagination. Artists often reprinted the same image as illustrations of different cities, and this depiction of Tarvisium is very likely a generic view. Regardless, the work is a monument to a new craft, which expanded in concert with the art of the printed book.

MARTIN SCHONGAUER The woodcut medium hardly had matured when the technique of *engraving* (inscribing on a hard surface), begun in the 1430s and well developed by 1450, proved much more flexible. Predictably, in the second half of the century, engraving began to replace the woodcut process, for making both book illustrations and widely popular single prints. Metal engraving produces an *intaglio* (incised) surface for printing. The incised lines (hollows) of the design, rather than the ridges, take the ink. It is the reverse of the woodcut technique.

Martin Schongauer (ca. 1430–1491) was the most skilled and subtle Northern European master of metal engraving. His *Saint Anthony Tormented by Demons* (FIG. **15-22**) shows both the versatility of the medium and the artist's mastery of it. The stoic saint is caught in a revolving thornbush of spiky demons, who claw and tear at him

furiously. With unsurpassed skill and subtlety, Schongauer created marvelous distinctions of tonal values and textures—from smooth skin to rough cloth, from the furry and feathery to the hairy and scaly. The use of *cross-hatching* to describe forms, which Schongauer probably developed, became standard among German graphic artists. The Italians preferred *parallel hatching* (FIG. 16-29) and rarely adopted cross-hatching, which, in keeping with the general Northern European approach to art, tends to describe the surfaces of things rather than their underlying structures.

Schongauer probably engraved *Saint Anthony* between 1480 and 1490. By then, the political geography of Europe had changed dramatically. Charles the Bold, who had assumed the title of duke of Burgundy in 1467, died in 1477, bringing to an end the Burgundian dream of forming a strong middle kingdom between France and the Holy Roman Empire. After Charles's death at the battle of Nancy, the French monarchy reabsorbed the southern Burgundian lands, and the Netherlands passed to the Holy Roman Empire by virtue of the dynastic marriage of Charles's daughter, Mary of Burgundy, to Maximilian of Habsburg. Thus was inaugurated a new political and artistic era in Northern Europe (see Chapter 18). The next two chapters, however, explore Italian developments in painting, sculpture, and architecture during the 15th and 16th centuries.

NORTHERN EUROPE, 1400 TO 1500

BURGUNDY AND FLANDERS

- The most powerful rulers north of the Alps during the first three-quarters of the 15th century were the dukes of Burgundy. They controlled Flanders, which derived its wealth from wool and banking.
- Duke Philip the Bold (r. 1363–1404) was the great patron of the Carthusian monastery at Champmol, near Dijon. He employed Claus Sluter, whose *Well of Moses* features innovative statues of prophets with portraitlike features and realistic costumes.
- Flemish painters popularized the use of oil paints on wooden panels. By superimposing translucent glazes, they created richer colors than possible using tempera or fresco. One of the earliest examples of oil paintng is Melchior Broederlam's *Retable de Champmol* (1399).
- A major art form in churches and private homes alike was the altarpiece with folding wings. Robert Campin's Mérode Altarpiece is an early example painted in oils, in which the Annunciation takes place in a Flemish home. The work's donors are present as witnesses to the sacred event. Typical of "Northern Renaissance" painting, the everyday objects depicted often have symbolic significance.
- Jan van Eyck, Rogier van der Weyden, and others established portraiture as an important art form in 15th-century Flanders. Van Eyck's self-portrait, Man in a Red Turban, and Rogier's Saint Luke Drawing the Virgin reveal the growing self-awareness of Renaissance artists.
- Among the other major Flemish painters were Petrus Christus, Dirk Bouts, Hans Memling, and Hugo van der Goes. Hugo achieved such renown that he won a commission to paint an altarpiece for a church in Florence. The Italians marveled at the Flemish painter's masterful technique and extraordinary realism.

Sluter, Well of Moses, 1395–1406

Campin, *Mérode Altarpiece*, ca. 1425–1428

van Eyck, *Man in a Red Turban*, 1433

FRANCE

- During the 15th century, the Hundred Years' War crippled the French economy, but dukes and members of the royal court still commissioned some notable artworks.
- The Limbourg brothers expanded the illusionistic capabilities of manuscript illumination in the Book of Hours they produced for Jean, duke of Berry (r. 1360–1416) and brother of King Charles V (r. 1364–1380). Their full-page calendar pictures alternately represent the nobility and the peasantry, always in naturalistic settings with realistically painted figures.
- French court art—for example, Jean Fouquet's Melun Diptych—owes a large debt to Flemish painting in style and technique as well as in the integration of sacred and secular themes.

Limbourg brothers, Les Très Riches Heures du Duc de Berry, 1413–1416

HOLY ROMAN EMPIRE

- The Late Gothic style remained popular in 15th-century Germany for large carved wooden retables featuring highly emotive figures amid Gothic tracery.
- The major German innovation of the 15th century was the development of the printing press, which soon was used to produce books with woodcut illustrations. Woodcuts are relief prints in which the artist carves out the areas around the printed lines, a method that requires the images to be conceptualized negatively.
- German artists such as Martin Schongauer were also the earliest masters of engraving. This intaglio technique allows for a wider variety of linear effects because the artist incises the image directly onto a metal plate.

Schongauer,
Saint Anthony Tormented by Demons,
ca. 1480–1490

16-1 Piero della Francesca, detail of *Flagellation of Christ* (Fig. 16-43), ca. 1455–1465. Galleria Nazionale delle Marche, Urbino.

One hallmark of Italian Renaissance painting is the representation of architecture using the new mathematically based science of linear perspective. Piero della Francesca was a master of perspective painting.

ITALY, 1400 TO 1500

The humanism that Petrarch and Boccaccio promoted during the 14th century (see Chapter 14) fully blossomed in the 15th century. Increasingly, Italians in elite circles embraced the tenets underlying humanism—an emphasis on education and on expanding knowledge (especially of classical antiquity), the exploration of individual potential and a desire to excel, and a commitment to civic responsibility and moral duty. Italy in the 1400s also enjoyed an abundance of artistic talent. The fortunate congruence of artistic genius, the spread of humanism, and economic prosperity nourished a significantly new and expanded artistic culture—the Renaissance. Artistic developments in 15th-century Italy forever changed the direction and perception of art in the Western world.

For the Italian humanists, the quest for knowledge began with the legacy of the Greeks and Romans—the writings of Socrates, Plato, Aristotle, Ovid, and others. The development of a literature based on the commonly spoken Tuscan dialect expanded the audience for humanist writings. Further, the invention of movable metal type in Germany around 1450 (see Chapter 15) facilitated the printing and widespread distribution of books. Italians enthusiastically embraced this new printing process. By 1464 Subiaco (near Rome) boasted a press, and by 1469 Venice had established one as well. Among the first books printed in Italy using this new press was Dante's vernacular epic about Heaven, Purgatory, and Hell, *Divine Comedy*. The production of editions in Foligno (1472), Mantua (1472), Venice (1472), Naples (1477 and 1478–1479), and Milan (1478) testifies to the extensive popularity of Dante's work.

The humanists also avidly acquired information in a wide range of subjects, including botany, geology, geography, optics, medicine, and engineering. Leonardo da Vinci's phenomenal expertise in many fields—from art and architecture to geology, aerodynamics, hydraulics, botany, and military science, among others—still defines the modern notion of a "Renaissance man." Humanism also fostered a belief in individual potential and encouraged individual achievement as well as civic responsibility. Whereas people in medieval society accorded great power to divine will in determining the events that affected lives, those in Renaissance Italy adopted a more secular stance. Humanists not only encouraged individual improvement but also rewarded excellence with fame and honor. Achieving and excelling through hard work became moral imperatives.

Fifteenth-century Italy witnessed constant fluctuations in its political and economic spheres, including shifting power relations among the numerous city-states and the rise of princely courts (see "Italian Princely Courts and Artistic Patronage," page 447). *Condottieri* (military leaders) with large numbers of mercenary

MAP 16-1 Renaissance Florence.

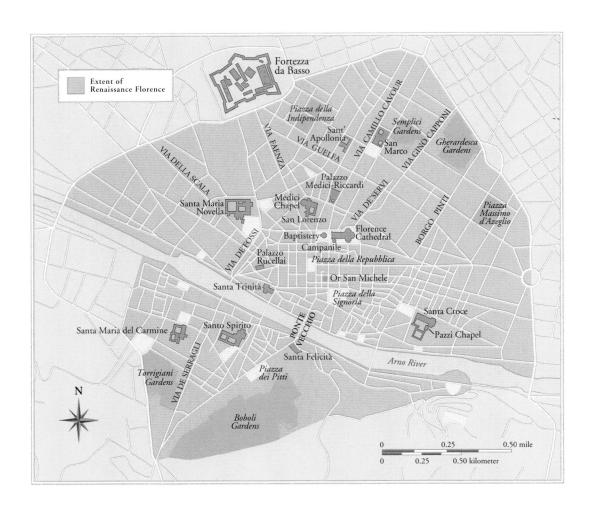

troops at their disposal played a major role in the ongoing struggle for power. Princely courts, such as those in Urbino and Mantua, emerged as cultural and artistic centers alongside the great art centers of the 14th century, especially the Republic of Florence. The association of humanism with education and culture appealed to accomplished individuals of high status, and humanism had its greatest impact among the elite and powerful, whether in the republics or the princely courts. These individuals were in the best position to commission art. As a result, humanist ideas permeate Italian Renaissance art. The intersection of art with humanist doctrines during the Renaissance is evident in the popularity of subjects selected from classical history or mythology; the increased concern with developing perspectival systems and depicting anatomy accurately; the revival of portraiture and other self-aggrandizing forms of patronage; and citizens' extensive participation in civic and religious art commissions.

FLORENCE

Because high-level patronage required significant accumulated wealth, the individuals and families who had managed to prosper economically, whether princes or merchants, came to the fore in artistic circles. The best-known Italian Renaissance art patrons were the Medici of the Republic of Florence (MAP 16-1). Early in the 15th century, the banker Giovanni de' Medici (ca. 1360–1429) had established the family fortune. His son Cosimo (1389–1464) expanded his family's dominance in financial circles, which led to considerable political power as well. This consolidation of power in a city that prided itself on its republicanism did not go unchallenged. In the early 1430s, a power struggle with other elite families led to the family's expulsion from Florence. In 1434 the Medici returned and used their tremendous wealth to commission art and architecture on a scale rarely seen.

The Medici were avid humanists. Cosimo began the first public library since the ancient world, and historians estimate that in some 30 years he and his descendants expended the equivalent of more than \$20 million for manuscripts and books. Scarcely a great architect, painter, sculptor, philosopher, or humanist scholar escaped the family's notice. Cosimo was the very model of the cultivated humanist. His grandson Lorenzo (1449–1492), called "the Magnificent," was a talented poet himself and gathered about him a galaxy of artists and gifted men in all fields, extending the library Cosimo had begun and revitalizing his academy for instructing artists. Lorenzo also participated in what some have called the Platonic Academy of Philosophy (most likely an informal reading group), and lavished funds (often the city's own) on splendid buildings, festivals, and pageants. The Medici were such grand patrons of art and learning that, to this day, a generous benefactor of the fine arts is often called "a Medici."

Sculpture

The earliest important artistic commission in 15th-century Florence was not, however, a Medici project, but a guild-sponsored competition in 1401 for a design for the east doors of the city's baptistery (FIG. 12-26). Artists and public alike considered this commission particularly prestigious because of the intended placement of the doors on the building's east side, facing Florence Cathedral (FIG. 14-18). Several traits associated with mature Renaissance art already characterized the baptistery competition: patronage as both a civic imperative and a form of self-promotion, the esteem accorded to individual artists, and the development of a new pictorial illusionism.

SACRIFICE OF ISAAC Andrea Pisano (ca. 1290–1348), unrelated to the two 13th-century Pisan sculptors Nicola and Giovanni discussed in Chapter 14, had designed the south doors of Florence's

baptistery between 1330 and 1335. The wool merchants' guild sponsored the 1401 competition for the second set of doors, requiring each entrant to submit a relief panel depicting the sacrifice of Isaac. This biblical event centers on God's order to Abraham that he sacrifice his son Isaac as a demonstration of Abraham's devotion to God (see "Jewish Subjects in Christian Art," Chapter 8, page 213). Just as Abraham is about to comply, an angel intervenes and stops him from plunging the knife into his son's throat. Because of the parallel between Abraham's willingness to sacrifice Isaac and God's sacrifice of his son Jesus to redeem mankind, the sacrifice of Isaac was often linked to the Crucifixion. Both refer to covenants, and given that the sacrament of baptism initiates the newborn or the convert into the possibilities of these covenants, Isaac's sacrifice was certainly appropriate for representation on a baptistery.

Contemporary events, however, may have been an important factor in the selection of this theme. In the late 1390s, Giangaleazzo Visconti, the first duke of Milan (r. 1378–1395), began a military campaign to take over the Italian peninsula. By 1401, when the cathedral's art directors initiated the baptistery competition, Visconti's troops had surrounded Florence, and its independence was in serious jeopardy. Despite dwindling water and food supplies, Florentine officials exhorted the public to defend the city's freedom. For example, the humanist chancellor Coluccio Salutati (1331–1406) urged his fellow citizens to adopt the republican ideal of civil and political liberty associated with ancient Rome and to identify themselves with its spirit. To be Florentine was to be Roman. Freedom was the distinguishing virtue of both republics. The story of Abraham and Isaac, with its

theme of sacrifice, paralleled the message city officials had conveyed to inhabitants. It is certainly plausible that the wool merchants, asserting both their preeminence among Florentine guilds and their civic duty, selected the subject with this in mind. The Florentines' reward for their faith and sacrifice came in 1402 when Visconti died suddenly, ending the invasion threat.

BRUNELLESCHI AND GHIBERTI The jury selected seven semifinalists from among the many who entered the widely advertised competition for the baptistery commission. Only the panels of the two finalists, Filippo Brunelleschi (1377–1446) and Lorenzo Ghiberti (1378–1455), have survived. As instructed, both artists used the same French Gothic quatrefoil frames Andrea Pisano had used for the baptistery's south doors and depicted the same moment of the narrativethe angel's halting of the action. Brunelleschi's panel (FIG. 16-2) shows a sturdy and vigorous interpretation of the theme, with something of the emotional agitation of Giovanni Pisano's relief sculptures (FIG. 14-4). Abraham seems suddenly to have summoned the dreadful courage needed to kill his son at God's command. He lunges forward, robes flying, exposing Isaac's throat to the knife. Matching Abraham's energy, the saving angel darts in from the left, grabbing Abraham's arm to stop the killing. Brunelleschi's figures demonstrate his ability to observe carefully and represent faithfully all the elements in the biblical narrative.

Whereas Brunelleschi imbued his image with dramatic emotion, Ghiberti, the youngest artist in the competition, emphasized grace and smoothness. In Ghiberti's panel (FIG. 16-3), Abraham

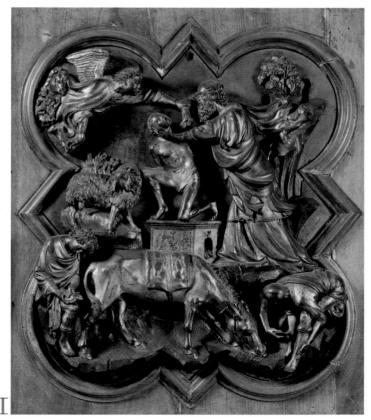

16-2 FILIPPO BRUNELLESCHI, *Sacrifice of Isaac*, competition panel for east doors of the baptistery, Florence, Italy, 1401–1402. Gilded bronze, 1' 9" \times 1' $5\frac{1}{2}$ ". Museo Nazionale del Bargello, Florence.

Brunelleschi's entry in the competition to create new bronze doors for the Florentine baptistery shows a frantic angel about to halt an emotional, lunging Abraham clothed in swirling Gothic robes.

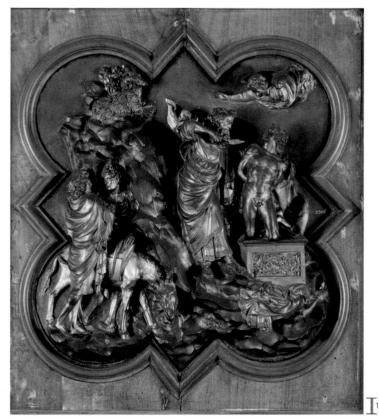

16-3 Lorenzo Ghiberti, *Sacrifice of Isaac*, competition panel for east doors of the baptistery, Florence, Italy, 1401–1402. Gilded bronze, 1' 9" \times 1' $5\frac{1}{2}$ ". Museo Nazionale del Bargello, Florence.

In contrast to Brunelleschi's panel (FIG. 16-2), Ghiberti's entry in the baptistery competition features gracefully posed figures that recall classical statuary. Even Isaac's altar has a Roman acanthus frieze.

appears in a typically Gothic pose with outthrust hip (compare FIG. 13-26) and seems to contemplate the act he is about to perform, even as he draws his arm back to strike. The figure of Isaac, beautifully posed and rendered, recalls Greco-Roman statuary and could be regarded as the first classical nude since antiquity. (Compare, for example, the torsion of Isaac's body and the dramatic turn of his head with those of the Hellenistic statue of a Gaul plunging a sword into his own chest, FIG. 5-80). Unlike his medieval predecessors, Ghiberti revealed a genuine appreciation of the nude male form and a deep interest in how the muscular system and skeletal structure move the human body. Even the altar on which Isaac kneels displays Ghiberti's emulation of antique models. Decorating it are acanthus scrolls of a type that commonly adorned Roman temple friezes in Italy and throughout the former Roman Empire (for example, FIG. 7-32). These classical references reflect the increasing influence of humanism in the 15th century. Ghiberti's entry in the baptistery competition is also noteworthy for the artist's interest in spatial illusion. The rocky landscape seems to emerge from the blank panel toward the viewer, as does the strongly foreshortened angel. Brunelleschi's image, in contrast, emphasizes the planar orientation of the surface.

Ghiberti's training included both painting and metalwork. His careful treatment of the gilded bronze surfaces, with their sharply and accurately incised detail, proves his skill as a goldsmith. That Ghiberti cast his panel in only two pieces (thereby reducing the amount of bronze needed) no doubt impressed the selection committee. Brunelleschi's panel consists of several cast pieces. Thus, not only would Ghiberti's doors, as proposed, be lighter and more impervious to the elements, but they also represented a significant cost savings. The younger artist's submission clearly had much to recommend it, both stylistically and technically, and the judges awarded the commission to him. Ghiberti's pride in winning is evident in his description of the award, which also reveals the fame and glory increasingly accorded to individual achievement during the Early Renaissance:

To me was conceded the palm of the victory by all the experts and by all who had competed with me. To me the honor was conceded universally and with no exception. To all it seemed that I had at that time surpassed the others without exception, as was recognized by a great council and an investigation of learned men. . . . There were thirty-four judges from the city and the other surrounding countries. The testimonial of the victory was given in my favor by all. ¹

OR SAN MICHELE A second major Florentine sculptural project of the early 1400s was the decoration of Or San Michele, an early-14th-century building prominently located on the main street connecting the Palazzo della Signoria (seat of the signoria, Florence's governing body) and the cathedral (MAP 16-1). At various times Or San Michele housed a church, a granary, and the headquarters of Florence's guilds. After construction of the building, city officials assigned each of the niches on the exterior to a specific guild for decoration with a sculpture of its patron saint. By 1406 the guilds had placed statues in only 5 of the 14 niches, so the officials issued a dictum requiring the guilds to comply with the original plan and fill their assigned niches. A few years later, Florence was once again under siege, this time by King Ladislaus (r. 1399–1414) of Naples. Ladislaus had marched north, occupied Rome and the Papal States (MAP 14-1) by 1409, and threatened to overrun Florence. As they had previously, Florentine officials urged citizens to stand firm and defend their city-state from tyranny. Once again,

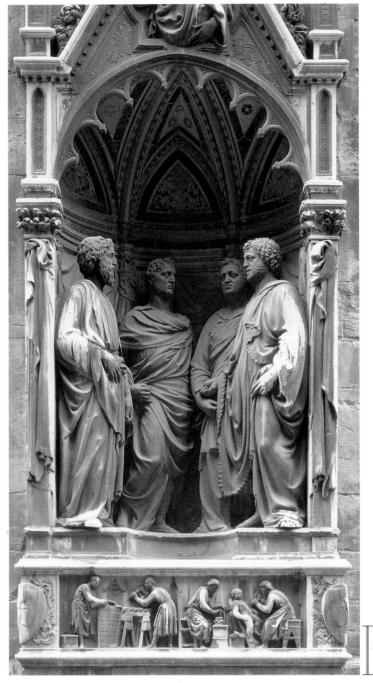

16-4 Nanni di Banco, *Four Crowned Saints*, Or San Michele, Florence, Italy, ca. 1410–1416. Marble, figures 6' high. Modern copy in exterior niche. Original sculpture in museum on second floor of Or San Michele, Florence.

Nanni's group representing the four martyred patron saints of Florence's sculptors' guild is an early example of Renaissance artists' attempt to liberate statuary from its architectural setting.

Florence escaped unscathed. Ladislaus, on the verge of military success in 1414, fortuitously died. The guilds may well have viewed this new threat as an opportunity to perform their civic duty by rallying their fellow Florentines while also promoting their own importance and position in Florentine society. By 1423 statues by Ghiberti and other leading Florentine artists filled the nine remaining niches of Or San Michele.

NANNI DI BANCO Among the niches filled during the Neapolitan king's attempted siege was that assigned to the Florentine guild

16-5 DONATELLO, *Saint Mark*, Or San Michele, Florence, Italy, ca. 1411–1413. Marble, 7′ 9″ high. Modern copy in exterior niche. Original sculpture in museum on second floor of Or San Michele, Florence.

In this statue carved for the guild of linen drapers, Donatello introduced the classical principle of contrapposto into Early Renaissance sculpture. The drapery falls naturally and moves with the body.

of stone- and woodworkers. They chose one of their members, Nanni di Banco (ca. 1380–1421), to create four life-size marble statues of the guild's martyred patron saints. These four Christian sculptors had defied an order from the Roman emperor Diocletian to carve a statue of a pagan deity. In response, the emperor ordered

them put to death. Because they placed their faith above all else, these saints were perfect role models for the 15th-century Florentines whom city leaders exhorted to stand fast in the face of the armies of Ladislaus.

Nanni's sculptural group, Four Crowned Saints (FIG. 16-4), is an early attempt to solve the problem of integrating figures and space on a monumental scale. The artist's positioning of the figures, which stand in a niche that is in but confers some separation from the architecture, furthered the gradual emergence of sculpture from its architectural setting. This process began with works such as the 13th-century jamb statues (FIG. 13-24) on the west front of Reims Cathedral. At Or San Michele, the niche's spatial recess permitted a new and dramatic possibility for the interrelationship of the figures. By placing them in a semicircle within their deep niche and relating them to one another by their postures and gestures, as well as by the arrangement of robes, Nanni arrived at a unified spatial composition. A remarkable psychological unity also connects these unyielding figures, whose bearing expresses the discipline and integrity necessary to face adversity. As the figure on the right speaks, pointing to his right, the two men opposite listen, and the one next to him looks out into space, pondering the meaning of the words and reinforcing the formal unity of the figural group with psychological cross-references.

In *Four Crowned Saints*, Nanni also displayed a deep respect for and close study of Roman portrait statues. The emotional intensity of the faces of the two inner saints owes much to the extraordinarily moving portrayals in stone of third-century Roman emperors (FIG. 7-68), and the bearded heads of the outer saints reveal a familiarity with second-century imperial portraiture (FIG. 7-59). Often, when Renaissance artists sought to portray individual personalities, they turned to ancient Roman models for inspiration, but they did not simply copy them. Rather, they strove to interpret or offer commentary on their classical models in the manner of humanist scholars dealing with classical texts.

DONATELLO Another sculptor who carved statues for Or San Michele's facade was Donato di Niccolo Bardi, or Donatello (ca. 1386–1466), who incorporated Greco-Roman sculptural principles in his Saint Mark (FIG. 16-5), executed for the guild of linen drapers. In this sculpture, Donatello took a fundamental step toward depicting motion in the human figure by recognizing the principle of weight shift, or *contrapposto*. Greek sculptors of the fifth century BCE were the first to grasp that the act of standing requires balancing the position and weight of the different parts of the human body, as they demonstrated in works such as the Kritios Boy (FIG. 5-34) and the Doryphoros (FIG. 5-40). In contrast to earlier sculptors, they recognized that the human body is not a rigid mass but a flexible structure that moves by continuously shifting its weight from one supporting leg to the other, its constituent parts moving in consonance. Donatello reintroduced this concept into Renaissance statuary. As the saint's body "moves," his garment "moves" with it, hanging and folding naturally from and around different body parts so that the viewer senses the figure as a clothed nude human, not a stone statue with arbitrarily incised drapery. Donatello's Saint Mark is the first Renaissance statue whose voluminous cloth garment (the pride of the Florentine guild that paid for the statue) does not conceal but accentuates the movement of the arms, legs, shoulders, and hips. This development further contributed to the sculpted figure's independence from its architectural setting. Saint Mark's stirring limbs, shifting weight, and mobile drapery suggest impending movement out of the niche.

16-6 DONATELLO, Saint George, Or San Michele, Florence, Italy, ca. 1410–1415. Marble, 6′ 10″ high. Museo Nazionale del Bargello, Florence.

Donatello's statue for the armorers' guild once had a bronze sword and helmet. The warrior saint stands defiantly, ready to spring from his niche to defend Florence, his sword pointed at the spectator.

SAINT GEORGE For the Or San Michele niche of the armorers' and swordmakers' guild, Donatello made a statue of Saint George (FIG. 16-6). The saintly knight stands proudly with his shield in front of him. He once held a bronze sword in his right hand and wore a bronze helmet on his head, both fashioned by the sponsoring guild. The statue continues the Gothic tradition of depicting warrior saints on church facades, as seen in the statue of Saint Theodore (FIG. 13-18) on the south-transept portal

of Chartres Cathedral, but here it has a civic role to play. Saint George stands in a defiant manner—ready to spring out of his niche to defend Florence against attack from another Visconti or Ladislaus, his sword jutting out threateningly at all passersby. The saint's body is taut, and Donatello has given him a face filled with nervous energy.

Directly below the statue's base is Donatello's marble relief representing *Saint George and the Dragon* (FIG. **16-7**). Commissioned about two years after he installed the statue in its niche, the relief marks a turning point in Renaissance sculpture. Even the landscapes

16-8 Donatello, *Feast of Herod*, panel on the baptismal font of Siena Cathedral, Siena, Italy, 1423–1427. Gilded bronze, $1' 11\frac{1}{2}'' \times 1' 11\frac{1}{2}''$.

Donatello's *Feast of Herod* marked the advent of rationalized perspective space in Renaissance relief sculpture. Two arched courtyards of diminishing size open the space of the action well into the distance.

in the baptistery competition reliefs (FIGS. 16-2 and 16-3) are modeled forms seen against a blank background. In *Saint George and the Dragon*, Donatello took a painterly approach to representation, creating an atmospheric effect by using incised lines. It is impossible to talk about a background plane in this work. The landscape recedes into distant space. The depth of that space cannot be measured. The relief is a window onto an infinite vista.

FEAST OF HEROD Donatello's mastery of relief sculpture is also evident in *Feast of Herod* (FIG. **16-8**), a bronze relief on the baptismal font in Siena Cathedral. Some of the figures, especially the dancing Salome (to the right), derive from classical reliefs, but nothing in Greco-

Roman art can match the illusionism of Donatello's rendition of this New Testament scene. In Donatello's relief, Salome has already delivered the severed head of John the Baptist, which the kneeling executioner offers to King Herod. The other figures recoil in horror in two groups. At the right, one man covers his face with his

16-7 DONATELLO, *Saint George and the Dragon*, relief below the statue of Saint George (FIG. 16-6), Or San Michele, Florence, Italy, ca. 1417. Marble, $1' 3\frac{1}{4}'' \times 3' 11\frac{1}{4}''$. Museo Nazionale del Bargello, Florence.

Donatello's relief marked a turning point in Renaissance sculpture. He took a painterly approach, creating an atmospheric effect by using incised lines. The depth of the background cannot be measured.

Renaissance Perspectival Systems

cholars long have noted the Renaissance fascination with perspective. In essence, portraying perspective involves constructing a convincing illusion of space in two-dimensional imagery while unifying all objects within a single spatial system. Renaissance artists were not the first to focus on depicting illusionistic space. Both the Greeks and the Romans were well versed in perspectival rendering. Many frescoes of buildings and colonnades (for example, FIG. 7-19, *right*) using a Renaissance-like system of converging lines survive on the walls of Roman houses. However, the Renaissance rediscovery of and interest in perspective contrasted sharply with the portrayal of space during the Middle Ages, when spiritual concerns superseded the desire to depict objects illusionistically.

Renaissance perspectival systems included both linear perspective and atmospheric perspective. Developed by Filippo Brunelleschi, *linear perspective* allows artists to determine mathematically the relative size of rendered objects to correlate them with the visual recession into space. Linear perspective can be either one-point or two-point.

■ In one-point linear perspective (FIG. 16-9a), the artist first must identify a horizontal line that marks, in the image, the horizon in the distance (hence the term *horizon line*). The artist then selects a *vanishing point* on that horizon line (often located at the exact center of the line). By drawing *orthogonals* (diagonal lines) from the edges of the picture to the vanishing point, the artist creates a

structural grid that organizes the image and determines the size of objects within the image's illusionistic space. Among the works that provide clear examples of one-point linear perspective are Masaccio's *Holy Trinity* (FIG. 16-20), Leonardo da Vinci's *Last Supper* (FIG. 17-4), and Raphael's *School of Athens* (FIG. 17-9). All of these are representations of figures in architectural settings, but linear perspective can also be applied to single figures. An especially dramatic example of the use of one-point perspective to depict a body receding into the background is Andrea Mantegna's *Foreshortened Christ* (FIG. 16-49).

- Two-point linear perspective (FIG. 16-9b) also involves the establishment of a horizon line. Rather than using a single vanishing point along this horizon line, the artist identifies two of them. The orthogonals that result from drawing lines from an object to each of the vanishing points create, as in one-point perspective, a grid that indicates the relative size of objects receding into space. An example of two-point perspective is Titian's *Madonna of the Pesaro Family* (FIG. 17-38).
- Unlike linear perspective, which relies on a structured mathematical system, *atmospheric perspective* involves optical phenomena. Artists using atmospheric (sometimes called *aerial*) perspective exploit the principle that the farther back the object is in space, the blurrier, less detailed, and bluer it appears. Further, color saturation and value contrast diminish as the image recedes into the distance. Leonardo da Vinci used atmospheric perspective to great effect, as seen in works such as *Madonna of the Rocks* (FIG. 17-2) and *Mona Lisa* (FIG. 17-5).

These two methods of creating the illusion of space in pictures are not exclusive, and Renaissance artists often used both linear and atmospheric perspective in the same work to heighten the sensation of three-dimensional space, as in Raphael's *Marriage of the Virgin* (FIG. 17-7).

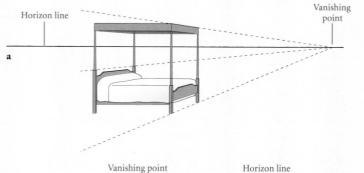

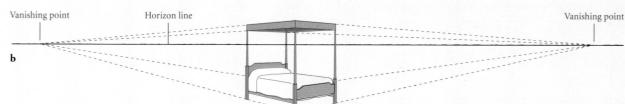

16-9 One-point (a) and two-point (b) linear perspective.

Linear perspective reflected the emergence of modern science itself. With its mathematical certitude, perspective also elevated the stature of painting by making pictures rational and measurable.

hand. At the left, Herod and two terrified children shrink back in dismay. The psychic explosion drives the human elements apart, leaving a gap across which the emotional electricity crackles. This masterful stagecraft obscures another drama Donatello was playing out on the stage itself. His *Feast of Herod* marks the advent of rationalized perspective space, long prepared for in 14th-century Italian art. As in *Saint George and the Dragon* (FIG. 16-7), Donatello opened the space of the action well into the distance. But here he employed the new mathematically based science of linear perspective to depict two arched courtyards and the groups of attendants in the background.

RENAISSANCE PERSPECTIVE In the 14th century, Italian artists, such as Duccio and the Lorenzetti brothers, had used several devices to indicate distance, but with the development of *linear perspective* (FIG. 16-9), Early Renaissance artists acquired a way to make the illusion of distance certain and consistent (see "Renaissance Perspectival Systems," above). In effect, they conceived the picture plane as a transparent window through which the observer looks to see the constructed pictorial world. This discovery was enormously important, for it made possible what has been called the "rationalization of sight." It brought all random and infinitely various visual

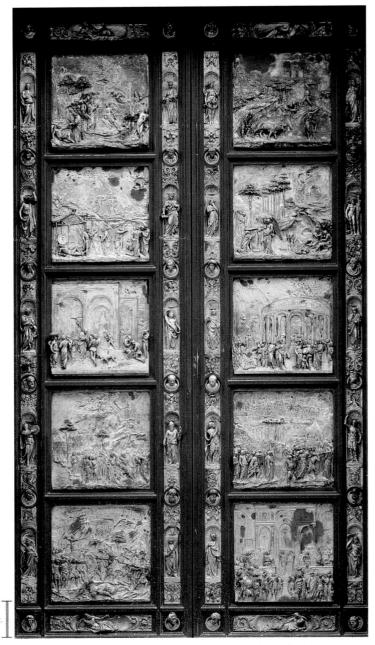

16-10 LORENZO GHIBERTI, east doors (*Gates of Paradise*), baptistery, Florence, Italy, 1425–1452. Gilded bronze, 17' high. Modern copy, ca. 1980. Original panels in Museo dell'Opera del Duomo, Florence.

In Ghiberti's later doors for the Florentine baptistery, the sculptor abandoned the Gothic quatrefoil frames for the biblical scenes (compare FIG. 16-3) and employed painterly illusionistic devices.

sensations under a simple rule that could be expressed mathematically. Indeed, Renaissance artists' interest in perspective reflects the emergence at this time of modern science itself. Of course, 15th-century artists were not primarily scientists. They simply found perspective an effective way to order and clarify their compositions. Nonetheless, there can be little doubt that perspective, with its new mathematical certitude, conferred a kind of aesthetic legitimacy on painting by making the picture measurable and exact. According to Plato, measure is the basis of beauty, and Classical Greek art reflects this belief (see "Polykleitos," Chapter 5, page 110). In the Renaissance, when humanists rediscovered Plato and eagerly read his works, artists once again exalted the principle of measure as the foundation of the beautiful in the fine arts. The projection of measurable objects on flat surfaces influenced the character of Renais-

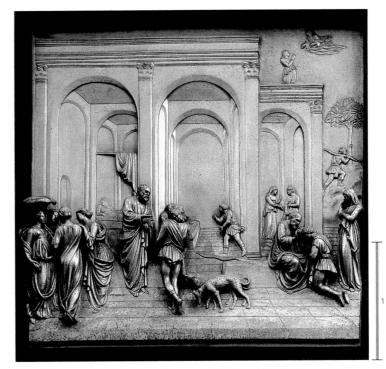

16-11 LORENZO GHIBERTI, *Isaac and His Sons* (detail of FIG. 16-10), east doors (*Gates of Paradise*), baptistery, Florence, Italy, 1425–1452. Gilded bronze, $2' 7\frac{1}{2}'' \times 2' 7\frac{1}{2}''$. Museo dell'Opera del Duomo, Florence.

In this relief, Ghiberti employed linear perspective to create the illusion of distance, but he also used sculptural aerial perspective, with forms appearing less distinct the deeper they are in space.

sance paintings and made possible scale drawings, maps, charts, graphs, and diagrams—means of exact representation that laid the foundation for modern science and technology. Mathematical truth and formal beauty united in the minds of Renaissance artists.

GATES OF PARADISE Ghiberti was among the first Italian artists in the 15th century to embrace a unified system for representing space. His enthusiasm for perspectival illusion is particularly evident in the famous east doors (FIG. 16-10) that in 1425 church officials commissioned him to make for the Florentine baptistery (FIG. 12-26). Michelangelo later declared these as "so beautiful that they would do well for the gates of Paradise." Three sets of doors provide access to the building. Andrea Pisano created the first set, on the south side, between 1330 and 1335. Ghiberti made his first pair of doors (1403–1424), the result of the competition, for the east portal, but church officials moved those doors to the north entrance so that his second pair of doors (1425–1452) could be placed on the east side. In the Gates of Paradise, Ghiberti abandoned the quatrefoil pattern that frames the reliefs on the south and north doors and reduced the number of panels from 28 to 10. Each panel contains a relief set in plain moldings and depicts a scene from the Old Testament. The complete gilding of the reliefs creates an effect of great splendor and elegance.

The individual panels, such as *Isaac and His Sons* (FIG. 16-11), clearly recall painting techniques in their depiction of space as well as in their treatment of the narrative. Some exemplify more fully than painting many of the principles the architect and theorist Leon Battista Alberti formulated in his 1435 treatise, *On Painting.* In his relief, Ghiberti created the illusion of space partly through the use of pictorial perspective and partly by sculptural means. He represented buildings according to a painter's one-point perspective construction, but the figures (in the bottom section of the relief, which

actually projects slightly toward the viewer) appear almost fully in the round, some of their heads standing completely free. As the eye progresses upward, the relief increasingly flattens, concluding with the architecture in the background, which Ghiberti depicted in barely raised lines. In this manner, the artist created a sort of sculptor's aerial perspective, with forms appearing less distinct the deeper they are in space. Ghiberti described the east doors as follows:

I strove to imitate nature as closely as I could, and with all the perspective I could produce [to have] excellent compositions rich with many figures. In some scenes I placed about a hundred figures, in some less, and in some more. . . . There were ten stories, all [sunk] in frames because the eye from a distance measures and interprets the scenes in such a way that they appear round. The scenes are in the lowest relief and the figures are seen in the planes; those that are near appear large, those in the distance small, as they do in reality. I executed this entire work with these principles.³

In these panels, Ghiberti achieved a greater sense of depth than had previously seemed possible in a relief. His principal figures do not occupy the architectural space he created for them. Rather, the artist arranged them along a parallel plane in front of the grandiose architecture. (According to Leon Battista Alberti, in his On the Art of Building, the grandeur of the architecture reflects the dignity of the events shown in the foreground.) Ghiberti's figure style mixes a Gothic patterning of rhythmic line, classical poses and motifs, and a new realism in characterization, movement, and surface detail. Ghiberti retained the medieval narrative method of presenting several episodes within a single frame. In Isaac and His Sons, the women in the left foreground attend the birth of Esau and Jacob in the left background. In the central foreground, Isaac sends Esau and his dogs to hunt game. In the right foreground, Isaac blesses the kneeling Jacob as Rebecca looks on. Yet viewers experience little confusion because of Ghiberti's careful and subtle placement of each scene. The figures, in varying degrees of projection, gracefully twist and turn, appearing to occupy and move through a convincing stage space, which Ghiberti deepened by showing some figures from behind. The classicism derives from the artist's close study of ancient art. Ghiberti admired and collected classical sculpture, bronzes, and coins. Their influence appears throughout the panel, particularly in the figure of Rebecca, which Ghiberti based on a popular Greco-Roman statuary type. The emerging practice of collecting classical art in the 15th century had much to do with the incorporation of classical motifs and the emulation of classical style in Renaissance art.

DONATELLO, *DAVID* The use of perspectival systems in relief sculpture and painting represents only one aspect of the Renaissance revival of classical principles and values in the arts. Another was the revival of the freestanding nude statue. The first Renaissance sculptor to portray the nude male figure in statuary was Donatello. The date of his bronze David (FIG. 16-12) is unknown, but he probably cast it sometime between 1440 and 1460 for display in the courtyard (FIG. 16-37) of the Medici palace in Florence. In the Middle Ages, the clergy regarded nude statues as both indecent and idolatrous, and nudity in general appeared only rarely in art—and then only in biblical or moralizing contexts, such as the story of Adam and Eve or depictions of sinners in Hell. With David, Donatello reinvented the classical nude. His subject, however, was not a pagan god, hero, or athlete but the youthful biblical slayer of Goliath who had become the symbol of the independent Florentine republic—and therefore an ideal choice of subject for the residence of the most powerful family in Florence. The Medici were aware of Donatello's earlier David in the Palazzo della Signoria, Florence's town hall. The artist had produced it during the threat of invasion by King Ladislaus. Their selection of the same subject suggests that the Medici identified themselves with Florence or, at the very least, saw themselves as responsible for Florence's prosperity and freedom. The invoking of classical poses and formats also appealed to the humanist Medici. Donatello's *David* possesses both the relaxed classical contrapposto stance and the proportions and sensuous beauty of the gods (FIG. 5-63) of Praxiteles, a famous Greek sculptor. These qualities were, not surprisingly, absent from medieval figures.

VERROCCHIO Another *David* (FIG. **16-13**), by ANDREA DEL VERROCCHIO (1435–1488), one of the most important sculptors during the second half of the century, reaffirms the Medici family's identification with Florence. A painter as well as a sculptor, Verrocchio

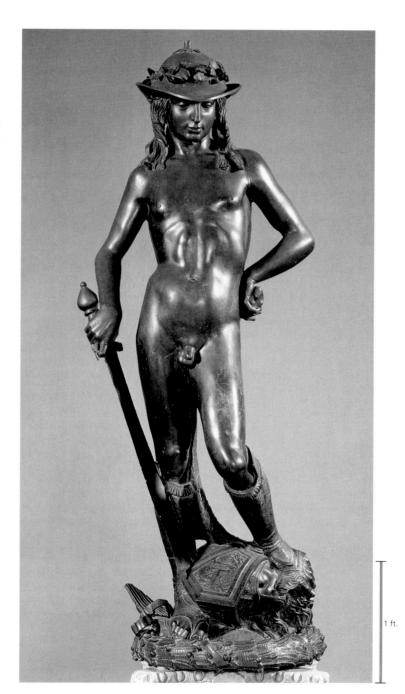

16-12 Donatello, *David*, ca. 1440–1460. Bronze, 5' $2\frac{1}{4}$ " high. Museo Nazionale del Bargello, Florence.

Donatello's *David* possesses both the relaxed contrapposto and the sensuous beauty of nude Greek gods (FIG. **5-60**). The revival of classical statuary style appealed to the sculptor's patrons, the Medici.

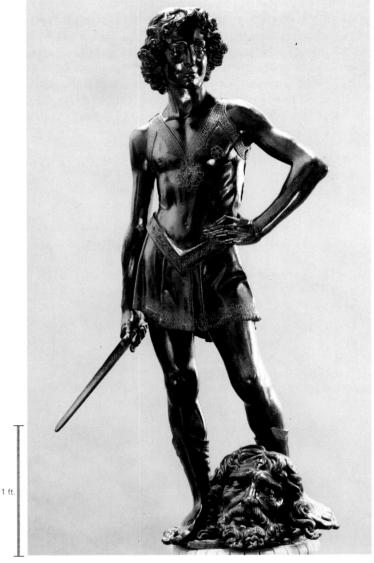

16-13 Andrea del Verrocchio, *David*, ca. 1465–1470. Bronze, 4' $1\frac{1}{2}$ " high. Museo Nazionale del Bargello, Florence.

Verrocchio's *David*, also made for the Medici, displays a brash confidence. The statue's narrative realism contrasts strongly with the quiet classicism of Donatello's *David* (FIG. 16-12).

directed a flourishing bottega (studio-shop) in Florence that attracted many students, among them Leonardo da Vinci. Verrocchio, like Donatello, also had a broad repertoire. His David contrasts strongly in its narrative realism with the quiet classicism of Donatello's David. Verrocchio's David is a sturdy, wiry, young apprentice clad in a leathern doublet who stands with a jaunty pride. As in Donatello's version, Goliath's head lies at David's feet. He poses like a hunter with his kill. The easy balance of the weight and the lithe, still thinly adolescent musculature, with prominent veins, show how closely Verrocchio read the biblical text and how clearly he knew the psychology of brash young men. The Medici eventually sold Verrocchio's bronze David to the Florentine government for placement in the Palazzo della Signoria. After the expulsion of the Medici from Florence, officials appropriated Donatello's David for civic use and moved it to the city hall as well.

POLLAIUOLO The Renaissance interest in classical culture naturally also led to the revival of Greco-Roman mythological themes in art. The Medici were leading patrons in this sphere as well. Around 1470, Antonio del Pollaiuolo (ca. 1431–1498), who was also important as a painter and engraver (FIG. 16-29), received a Medici com-

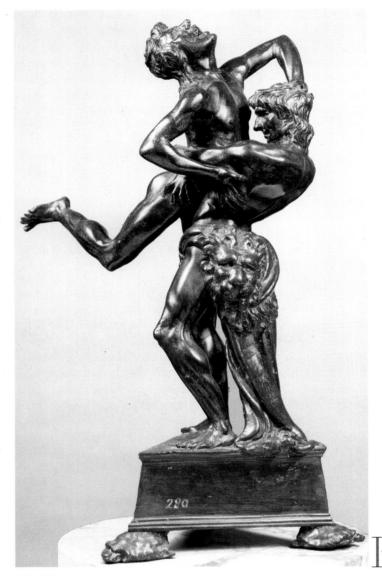

16-14 Antonio del Pollaiuolo, *Hercules and Antaeus*, ca. 1470–1475. Bronze, 1' 6" high with base. Museo Nazionale del Bargello, Florence.

The Renaissance interest in classical culture led to the revival of Greco-Roman mythological themes in art. *Hercules and Antaeus* exhibits the stress and strain of the human figure in violent action.

mission to produce a small-scale sculpture, *Hercules and Antaeus* (FIG. **16-14**). The subject matter, derived from Greek mythology, and the emphasis on human anatomy reflect the Medici preference for humanist imagery. Even more specifically, the state seal of Florence had featured Hercules since the end of the 13th century. As commissions such as the two *David* sculptures demonstrate, the Medici clearly embraced every opportunity to associate themselves with the glory of the Florentine Republic, surely claiming much of the credit for it.

In contrast to the placid presentation of Donatello's *David* (FIG. 16-12), Pollaiuolo's *Hercules and Antaeus* exhibits the stress and strain of the human figure in violent action. This sculpture departs dramatically from the convention of frontality that had dominated statuary during the Middle Ages and the Early Renaissance. Only 18 inches high, *Hercules and Antaeus* embodies the ferocity and vitality of elemental physical conflict. The group illustrates the wrestling match between Antaeus (Antaios), a giant and son of the goddess Earth, and Hercules (Herakles), a theme the Greek painter Euphronios had represented on an ancient Greek vase (FIG. 5-23) 2,000 years before. According to the Greek myth, each time Hercules threw him down, Antaeus sprang up again, his strength renewed by

contact with the earth. Finally, Hercules held him aloft so that he could not touch the ground, and strangled him around the waist. Pollaiuolo strove to convey the final excruciating moments of the struggle—the straining and cracking of sinews, the clenched teeth of Hercules, and the kicking and screaming of Antaeus. The figures intertwine and interlock as they fight, and the flickering reflections of light on the dark gouged bronze surface contribute to a fluid play of planes and the effect of agitated movement.

GATTAMELATA Given the increased emphasis on individual achievement and recognition that humanism fostered, it is not surprising that portraiture enjoyed a revival in the 15th century. Commemorative portraits of the deceased were common, and patrons also commissioned portraits of themselves. In 1443, Donatello left Florence for northern Italy to accept a rewarding commission from the Republic of Venice to create a commemorative monument in honor of the recently deceased Venetian condottiere Erasmo da Narni (1370-1443), nicknamed Gattamelata ("honeyed cat," a wordplay on his mother's name, Melania Gattelli). Although Gattamelata's family paid for the general's portrait (FIG. 16-15), the Venetian senate formally authorized its erection in the square in front of the church of Sant'Antonio in Padua, the condottiere's birthplace. Equestrian statues occasionally had been set up in Italy in the late Middle Ages, but Donatello's Gattamelata was the first to rival the grandeur of the mounted portraits of antiquity, such as that of Marcus Aurelius (FIG. 7-59), which the artist must have

seen in Rome. Donatello's contemporaries, one of whom described Gattamelata as sitting "there with great magnificence like a triumphant Caesar,"4 recognized this reference to antiquity. The statue stands on a lofty elliptical base, set apart from its surroundings, and almost celebrates sculpture's liberation from architecture. Massive and majestic, the great horse bears the armored general easily, for, unlike the sculptor of Marcus Aurelius, Donatello did not represent the Venetian commander as superhuman and more than life-size. Gattamelata dominates his mighty steed by force of character rather than sheer size. The Italian rider, his face set in a mask of dauntless resolution and unshakable will, is the very portrait of the Renaissance individualist. Such a man-intelligent, courageous, ambitious, and frequently of humble origin—could, by his own resourcefulness and on his own merits, rise to a commanding position in the world. Together, man and horse convey an overwhelming image of irresistible strength and unlimited power-an impression Donatello reinforced visually by placing the left forehoof of the horse on an orb, reviving a venerable ancient symbol for hegemony over the earth (compare FIG. 11-12). The imperial imagery is all the more remarkable because Erasmo da Narni was not a head of state.

BARTOLOMMEO COLLEONI Verrocchio also received a commission to make an equestrian statue of a Venetian condottiere, Bartolommeo Colleoni (1400–1475). His portrait (FIG. 16-16) provides a counterpoint to Donatello's statue. Eager to garner the same fame

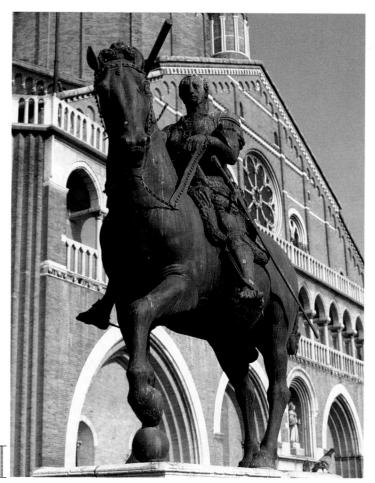

16-15 Donatello, *Gattamelata* (equestrian statue of Erasmo da Narni), Piazza del Santo, Padua, Italy, ca. 1445–1453. Bronze, 12′ 2″ high.

Donatello based his giant portrait of a Venetian general on equestrian statues of ancient Roman emperors (FIG. 7-59). Together, man and horse convey an overwhelming image of irresistible strength.

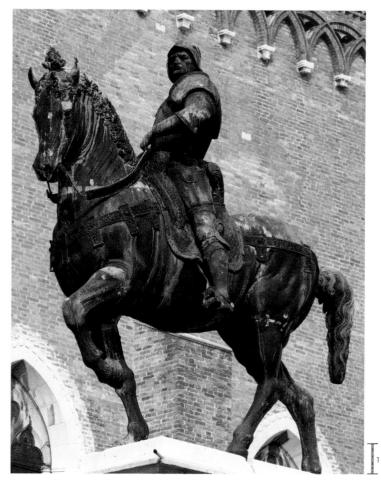

16-16 Andrea del Verrocchio, *Bartolommeo Colleoni* (equestrian statue), Campo dei Santi Giovanni e Paolo, Venice, Italy, ca. 1481–1496. Bronze, 13' high.

Eager to compete with Donatello's *Gattamelata* (FIG. 16-15), Colleoni provided the funds for his own equestrian statue in his will. The statue stands on a pedestal even taller than Gattamelata's.

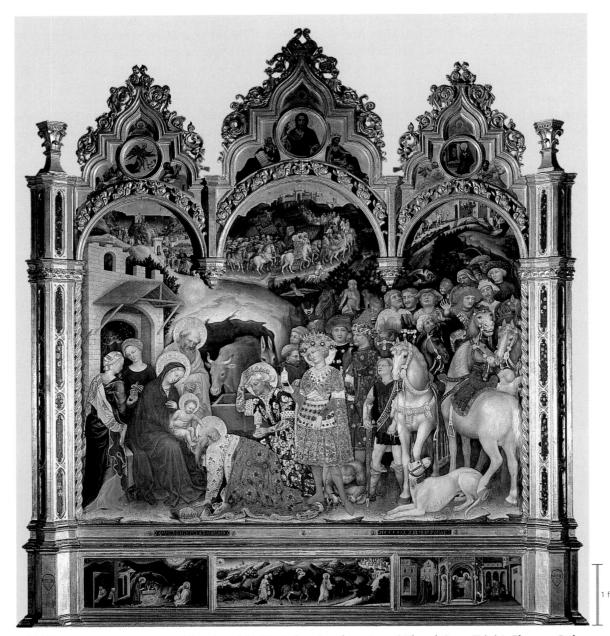

16-17 Gentile da Fabriano, Adoration of the Magi, altarpiece from Strozzi Chapel, Santa Trinità, Florence, Italy, 1423. Tempera on wood, 9' $11'' \times 9'$ 3". Galleria degli Uffizi, Florence.

Gentile was the leading Florentine painter working in the International Style, but he successfully blended naturalistic details with Late Gothic splendor in color, costume, and framing ornament.

the Gattamelata portrait achieved, Colleoni provided funds in his will for his own statue. Since both Donatello and Verrocchio executed their statues after the deaths of their subjects, neither artist knew personally the individual he portrayed. The result is a fascinating difference of interpretation (like that between their two Davids) as to the demeanor of a professional captain of armies. Verrocchio placed the statue of the bold equestrian general on a pedestal even higher than that Donatello used for Gattamelata so that viewers could see the dominating, aggressive figure from all major approaches to the piazza (the Campo dei Santi Giovanni e Paolo). In contrast to the near repose of the Gattamelata steed and rider, the Colleoni horse moves in a prancing stride, arching and curving its powerful neck, while the commander seems suddenly to shift his whole weight to the stirrups and rise from the saddle with a violent twist of his body. The artist depicted the figures with an exaggerated tautness—the animal's bulging muscles and the man's fiercely erect and rigid body together convey brute strength. In Gattamelata, Donatello created a portrait of grim sagacity. Verrocchio's *Bartolommeo Colleoni* is a portrait of merciless might. Niccolò Machiavelli wrote in his famous political treatise of 1513, *The Prince*, that the successful ruler must combine the traits of the lion and the fox. Donatello's *Gattamelata* approaches the latter, whereas Verrocchio's *Bartolommeo Colleoni* tilts toward the former.

Painting

In 15th-century Italy, humanism and the celebration of classical artistic values also characterized panel and mural painting. The new Renaissance style did not, however, immediately displace all vestiges of the Late Gothic style. In particular, the International Style, the dominant mode in painting around 1400 (see Chapter 14) persisted well into the century.

GENTILE DA FABRIANO The leading Florentine master of the International Style was GENTILE DA FABRIANO (ca. 1370–1427), who in 1423 painted *Adoration of the Magi* (FIG. 16-17) as the

Cennino Cennini on Imitation and Emulation in Renaissance Art

he familiar premium that contemporary Western society places on artistic originality is actually a fairly recent phenomenon. Among the concepts Renaissance artists most valued were imitation and emulation. Although many Renaissance artists did develop unique, recognizable styles, convention, in terms of both subject matter and representational practices, predominated. In a review of Italian Renaissance art, certain themes, motifs, and compositions surface with great regularity, and the traditional training practices reveal the importance of imitation and emulation to aspiring Renaissance artists.

- Imitation Imitation was the starting point in a young artist's training (see "Artistic Training in Renaissance Italy," Chapter 19, page 510). Italian Renaissance artists believed that the best way to learn was to copy the works of masters. Accordingly, much of an apprentice's training consisted of copying exemplary artworks. Leonardo da Vinci filled his sketchbooks with drawings of well-known sculptures and frescoes, and Michelangelo spent days sketching artworks in churches around Florence and Rome.
- **Emulation** The next step was emulation, which involved modeling one's art after that of another artist. Although imitation still provided the foundation for this practice, an artist used features of another's art only as a springboard for improvements or innovations. Thus, developing artists went beyond previous artists and attempted to prove their own competence and skill by improving on established and recognized masters. Comparison and a degree of competition were integral to emulation. To evaluate the "improved" artwork, viewers had to know the original "model."

Renaissance artists believed that developing artists would ultimately arrive at their own unique style through this process of imitation and emulation. Cennino Cennini (ca. 1370–1440) explained the value of this training procedure in a book he published in 1400, *Il Libro dell'Arte* (*The Artist's Handbook*), which served as a practical guide to producing art:

Having first practiced drawing for a while, . . . take pains and pleasure in constantly copying the best things which you can find done by the hand of great masters. And if you are in a place where many good masters have been, so much the better for you. But I give you this advice: take care to select the best one every time, and the one who has the greatest reputation. And, as you go on from day to day, it will be against nature if you do not get some grasp of his style and of his spirit. For if you undertake to copy after one master today and after another one tomorrow, you will not acquire the style of either one or the other, and you will inevitably, through enthusiasm, become capricious, because each style will be distracting your mind. You will try to work in this man's way today, and in the other's tomorrow, and so you will not get either of them right. If you follow the course of one man through constant practice, your intelligence would have to be crude indeed for you not to get some nourishment from it. Then you will find, if nature has granted you any imagination at all, that you will eventually acquire a style individual to yourself, and it cannot help being good; because your hand and your mind, being always accustomed to gather flowers, would ill know how to pluck thorns.*

* Translated by Daniel V. Thompson Jr., *Cennino Cennini, The Artist's Handbook (Il Libro dell'Arte*), (New York: Dover Publications, 1960; reprint of 1933 ed.), 14–15.

altarpiece for the family chapel of Palla Strozzi (1372–1462) in the church of Santa Trinità in Florence. At the beginning of the 15th century, the Strozzi family was the wealthiest in Florence. The altarpiece, with its elaborate gilded Gothic frame, is testimony to Strozzi's lavish tastes. So too is the painting itself, with its gorgeous surface and sumptuously costumed kings, courtiers, captains, and retainers accompanied by a menagerie of exotic animals. Gentile portrayed all these elements in a rainbow of color with extensive use of gold. The painting presents all the pomp and ceremony of chivalric etiquette in a scene that sanctifies the aristocracy in the presence of the Madonna and Child. Although the style is fundamentally Late Gothic, Gentile inserted striking naturalistic details. For example, the artist depicted animals from a variety of angles and foreshortened the forms convincingly, most notably the horse at the far right seen in a three-quarter rear view. Gentile did the same with human figures, such as the kneeling man removing the spurs from the standing magus in the center foreground. In the left panel of the predella, Gentile painted what may have been the very first nighttime Nativity with the central light source—the radiant Christ Child—introduced into the picture itself. Although predominantly conservative, Gentile demonstrated that he was not oblivious to contemporary experimental trends and that he could blend naturalistic and

inventive elements skillfully and subtly into a traditional composition without sacrificing Late Gothic splendor in color, costume, and framing ornament.

MASACCIO The artist who epitomizes the innovative spirit of early-15th-century Florentine painting was Tommaso di ser Giovanni di Mone Cassai, known as Masaccio (1401-1428). Although his presumed teacher, Masolino da Panicale (see "Italian Artists' Names," Chapter 14, page 376), had worked in the International Style, Masaccio broke sharply from the normal practice of imitating his master's style (see "Imitation and Emulation in Renaissance Italy," above). He moved suddenly, within the short span of six years, into unexplored territory. Most art historians recognize no other painter in history to have contributed so much to the development of a new style in so short a time as Masaccio, whose untimely death at age 27 cut short his brilliant career. Masaccio was the artistic descendant of Giotto (see Chapter 14), whose calm, monumental style he revolutionized with a whole new repertoire of representational devices that generations of Renaissance painters later studied and developed. Masaccio also knew and understood the innovations of his great contemporaries, Ghiberti, Brunelleschi, and Donatello, and he introduced new possibilities for both form and content.

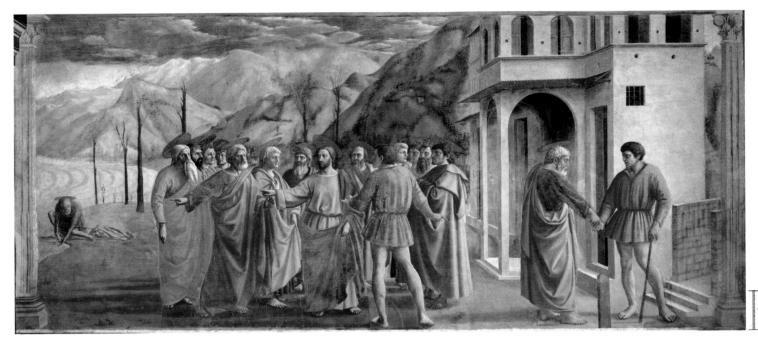

16-18 Masaccio, Tribute Money, Brancacci Chapel, Santa Maria del Carmine, Florence, Italy, ca. 1424–1427. Fresco, 8' $4\frac{1}{8}'' \times 19'$ $7\frac{1}{8}''$.

Masaccio's figures recall Giotto's in their simple grandeur, but they convey a greater psychological and physical credibility. He modeled his figures with light coming from a source outside the picture.

BRANCACCI CHAPEL The frescoes Masaccio painted in the Brancacci family chapel of Santa Maria del Carmine in Florence provide excellent examples of his innovations. In Tribute Money (FIG. 16-18), painted shortly before his death, Masaccio depicted a seldom-represented narrative from the Gospel of Matthew (17:24–27). As the tax collector confronts Christ at the entrance to the Roman town of Capernaum, Christ directs Saint Peter to the shore of Lake Galilee. There, as Christ foresaw, Peter finds the tribute coin in the mouth of a fish and returns to pay the tax. Art historians have debated why Felice Brancacci (1382-1447), the chapel's patron, selected this obscure biblical narrative. Some scholars have suggested that Tribute Money, in which Christ condones taxation, served as a commentary on the income tax the Florentine republic was considering implementing at the time. However, Brancacci's considerable wealth makes it unlikely he would have supported a tax on income. Moreover, this fresco's placement in a private family chapel meant that the public had only limited access. Therefore, because this fresco lacked the general audience enjoyed by, for example, the Or San Michele niche sculptures, it seems ill-suited for public statements.

Whatever the reason for the choice of subject, Masaccio decided to divide the story into three episodes within the fresco. In the center, Christ, surrounded by his disciples, tells Saint Peter to retrieve the coin from the fish, while the tax collector stands in the foreground, his back to spectators and hand extended, awaiting payment. At the left, in the middle distance, Saint Peter extracts the coin from the fish's mouth, and, at the right, he thrusts the coin into the tax collector's hand. Masaccio's figures recall Giotto's in their simple grandeur, but they convey a greater psychological and physical credibility. Masaccio created the bulk of the figures by modeling not with a flat, neutral light lacking an identifiable source but with a light coming from a specific source outside the picture. The light comes from the right and strikes the figures at an angle, illuminating the parts of the solids that obstruct its path and leaving the rest in shadow, producing the illusion of deep sculptural relief. Between the extremes of light and dark, the light appears as a constantly active but fluctuating force highlighting the

scene in varying degrees, almost a tangible substance independent of the figures. In his frescoes, Giotto used light only to model the masses. In Masaccio's works, light has its own nature, and the masses are visible only because of its direction and intensity. The viewer can imagine the light as playing over forms—revealing some and concealing others, as the artist directs it. The individual figures in Tribute Money are solemn and weighty, but they also move freely and reveal body structure, as do Donatello's statues. Masaccio's representations adeptly suggest bones, muscles, and the pressures and tensions of joints. Each figure conveys a maximum of contained energy. Tribute Money helps the viewer understand Giorgio Vasari's comment: "[T]he works made before his [Masaccio's] day can be said to be painted, while his are living, real, and natural."5

Masaccio's arrangement of the figures is equally inventive. They do not appear as a stiff screen in the foreground. Instead, the artist grouped them in circular depth around Christ, and he placed the whole group in a spacious landscape, rather than in the confined stage space of earlier frescoes. The group itself generates the foreground space that the architecture on the right amplifies. Masaccio depicted the building in one-point perspective, locating the vanishing point, where all the orthogonals converge, at Christ's head. Atmospheric perspective—the diminishing of light and the blurring of outlines as the distance increases (see "Renaissance Perspectival Systems," page 425)—unites the foreground with the background. Although ancient Roman painters used atmospheric perspective (FIG. 7-20), medieval artists had abandoned it. Thus, it virtually disappeared from art until Masaccio and his contemporaries rediscovered it. They came to realize that the light and air interposed between viewers and what they see are two parts of the visual experience called "distance."

In an awkwardly narrow space at the entrance to the Brancacci Chapel, Masaccio painted Expulsion of Adam and Eve from Eden (FIG. 16-19), another fresco displaying the representational innovations of Tribute Money. For example, the sharply slanted light from an outside source creates deep relief, with lights placed alongside darks, and acts as a strong unifying agent. Masaccio also presented the figures

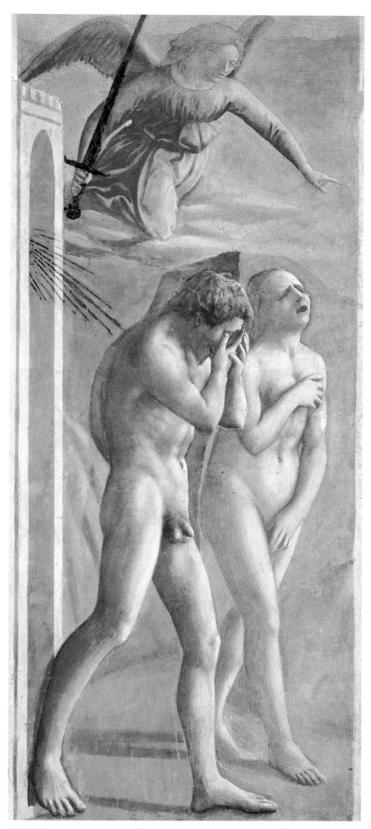

16-19 Masaccio, Expulsion of Adam and Eve from Eden, Brancacci Chapel, Santa Maria del Carmine, Florence, Italy, ca. 1424–1427. Fresco, $7'\times 2'$ 11".

Adam and Eve, expelled from Eden, stumble on blindly, driven by the angel's will and their own despair. The hazy background specifies no locale but suggests a space around and beyond the figures.

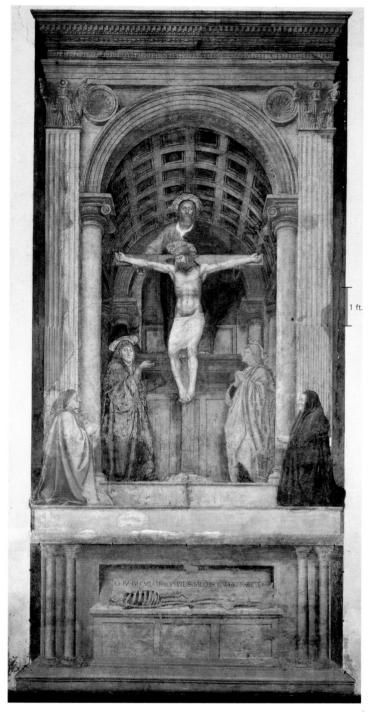

16-20 Masaccio, *Holy Trinity*, Santa Maria Novella, Florence, Italy, ca. 1424–1427. Fresco, 21' $10\frac{5}{8}$ " \times 10' $4\frac{3}{4}$ ".

Masaccio's *Holy Trinity* is the premier early-15th-century example of the application of mathematics to pictorial organization in Brunelleschi's new science of perspective. The illusionism is breathtaking.

the cry issuing from Eve's mouth voices her anguish. The angel does not force them physically from Eden. Rather, they stumble on blindly, the angel's will and their own despair driving them. The composition is starkly simple, its message incomparably eloquent.

HOLY TRINITY Masaccio's Holy Trinity fresco (FIG. 16-20) in Santa Maria Novella is another of the young artist's masterworks and the premier early-15th-century example of the application of mathematics to the depiction of space. Masaccio painted the composition on two levels of unequal height. Above, in a coffered barrel-vaulted chapel reminiscent of a Roman triumphal arch

16-21 Fra Angelico, *Annunciation*, San Marco, Florence, Italy, ca. 1438–1447. Fresco, 7' 1" \times 10' 6".

Painted for the Dominican monks of San Marco, Fra Angelico's fresco is simple and direct. Its figures and architecture have a pristine clarity that befits the fresco's function as a devotional image.

(FIG. 7-39), the Virgin Mary and Saint John appear on either side of the crucified Christ. God the Father emerges from behind Christ, supporting the arms of the cross and presenting his Son to the worshiper as a devotional object. The dove of the Holy Spirit hovers between God's head and Christ's head. Masaccio also included portraits of the donors of the painting, Lorenzo Lenzi and his wife, who kneel just in front of the *pilasters* that frame the chapel's entrance. Below, the artist painted a tomb containing

a skeleton. An inscription in Italian painted above the skeleton reminds the spectator that "I was once what you are, and what I am you will become."

The illusionism of *Holy Trinity* is breathtaking. In this fresco, Masaccio brilliantly demonstrated the principles and potential of Brunelleschi's new science of perspective. Indeed, some historians have suggested Brunelleschi may have collaborated with Masaccio. The vanishing point of the composition is at the foot of the cross. With this point at eye level, spectators look up at the Trinity and down at the tomb. About five feet above the floor level, the vanishing point pulls the two views together, creating the illusion of an actual structure that transects the wall's vertical plane. Whereas the tomb appears to project forward into the church, the chapel recedes visually behind the wall and appears as an extension of the spectator's space. This adjustment of the pictured space to the viewer's position was an important innovation in illusionistic painting that other artists of the Renaissance and the later Baroque period would develop further. Masaccio was so exact in his metrical proportions that it is possible to calculate the dimensions of the chapel (for example, the span of the painted vault is seven feet and the depth of the chapel is nine feet). Thus, he achieved not only a successful illusion but also a rational measured coherence that is responsible for the unity and harmony of the fresco. Holy Trinity is, however, much more than a demonstration of Brunelleschi's perspective or of the painter's ability to represent fully modeled figures bathed in light. In this painting, Masaccio also powerfully conveyed one of the central tenets of Christian faith. The ascending pyramid of figures leads viewers from the despair of death to the hope of resurrection and eternal life through Christ's crucifixion.

FRA ANGELICO As Masaccio's *Holy Trinity* clearly demonstrates, humanism and religion were not mutually exclusive, but for many 15th-century Italian artists, humanist concerns were not a primary consideration. The art of FRA ANGELICO (ca. 1400–1455) focused on serving the Roman Catholic Church. In the late 1430s, the abbot of the Dominican monastery of San Marco (Saint Mark) in Florence asked Fra Angelico to produce a series of frescoes for the monastery. The Dominicans (see "The Great Schism," Chapter 14, page 379) of San Marco had dedicated themselves to lives of prayer

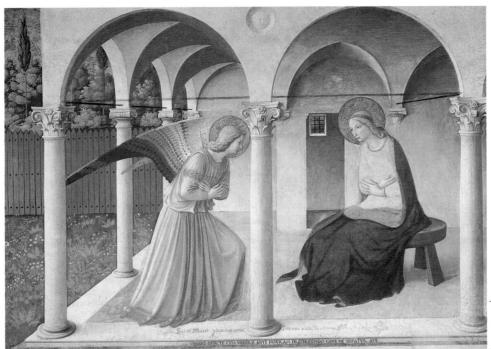

1 ft.

and work, and the religious compound was mostly spare and austere to encourage the monks to immerse themselves in their devotional lives. Fra Angelico's *Annunciation* (FIG. 16-21) appears at the top of the stairs leading to the friars' cells. Appropriately, Fra Angelico presented the scene of the Virgin Mary and the Archangel Gabriel with simplicity and serenity. The two figures appear in a plain *loggia* resembling San Marco's *portico*, and the artist painted all the fresco elements with a pristine clarity. As an admonition to heed the devotional function of the images, Fra Angelico included a small inscription at the base of the image: "As you venerate, while passing before it, this figure of the intact Virgin, beware lest you omit to say a Hail Mary." Like most of Fra Angelico's paintings, *Annunciation*'s simplicity and directness still have an almost universal appeal and fully reflect the artist's simple, humble character.

ANDREA DEL CASTAGNO Like Fra Angelico, Andrea del Castagno (ca. 1421-1457) accepted a commission to produce a series of frescoes for a religious establishment. His Last Supper (FIG. **16-22**) in the *refectory* (dining hall) of Sant'Apollonia in Florence, a convent for Benedictine nuns, manifests both a commitment to the biblical narrative and an interest in perspective. The lavishly painted room that Christ and his 12 disciples occupy suggests Castagno's absorption with creating the illusion of three-dimensional space. However, close scrutiny reveals inconsistencies, such as the fact that Renaissance perspectival systems make it impossible to see both the ceiling from inside and the roof from outside, as Castagno depicted. The two side walls also do not appear parallel. The artist chose a conventional compositional format, with the figures seated at a horizontally placed table. Castagno derived the apparent self-absorption of most of the disciples and the malevolent features of Judas (who sits alone on the outside of the table) from the Gospel of Saint John, rather than the more familiar version of the Last Supper recounted in the Gospel of Saint Luke. Castagno's dramatic and spatially convincing depiction of the event no doubt was a powerful presence for the nuns during their daily meals.

FRA FILIPPO LIPPI A younger contemporary of Fra Angelico, Fra Filippo Lippi (ca. 1406–1469), was also a friar—but there all resemblance ends. Fra Filippo seems to have been unsuited for

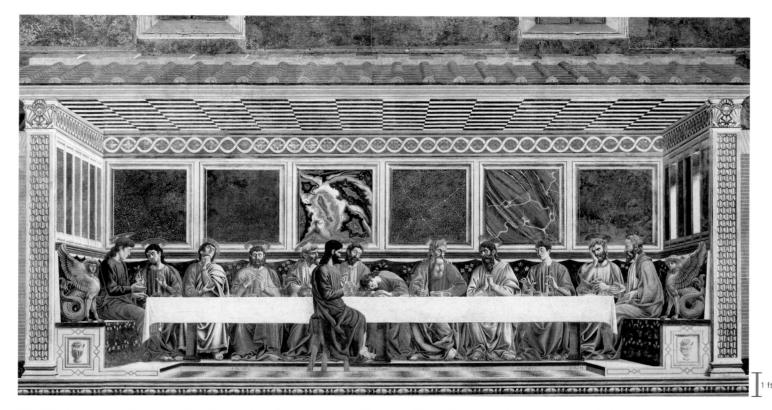

16-22 Andrea del Castagno, Last Supper, the refectory, convent of Sant'Apollonia, Florence, Italy, 1447. Fresco, 15' 5" × 32'.

Judas sits isolated in this Last Supper fresco based on the Gospel of Saint John. The figures are small compared to the setting, reflecting Castagno's preoccupation with the new science of perspective.

monastic life. He indulged in misdemeanors ranging from forgery and embezzlement to the abduction of a pretty nun, Lucretia, who became his mistress and the mother of his son, the painter Filippino Lippi (1457–1504). Only the intervention of the Medici on his behalf at the papal court saved Fra Filippo from severe punishment and total disgrace. An orphan, Fra Filippo spent his youth in a monastery adjacent to the church of Santa Maria del Carmine. When he was still in his teens, he must have met Masaccio there and witnessed the decoration of the Brancacci Chapel. Fra Filippo's early work survives only in fragments, but these show that he tried to work with Masaccio's massive forms. Later, probably under the influence of Ghiberti's and Donatello's relief sculptures, he developed a linear style that emphasized the contours of his figures and permitted him to suggest movement through flying and swirling draperies.

A painting from Fra Filippo's later years, *Madonna and Child with Angels* (FIG. **16-23**), shows his skill in employing a wonderfully fluid line, which unifies the composition and contributes to the precise and smooth delineation of forms. Fra Filippo interpreted his subject in a surprisingly worldly manner. The Madonna, a beautiful young mother, is not at all spiritual or fragile, and neither is the Christ Child, whom two angels hold up. One of the angels turns with the mischievous, puckish grin of a boy refusing to behave for the pious occasion. Significantly, all figures reflect the use of live models (perhaps even Lucretia for the Madonna). Fra Filippo plainly relished the charm of youth and beauty as he found it in this world. He

16-23 Fra Filippo Lippi, *Madonna and Child with Angels*, ca. 1455. Tempera on wood, 2' $11\frac{1}{2}$ " \times 2' 1". Galleria degli Uffizi, Florence.

Fra Filippo, a monk guilty of many misdemeanors, represented the Virgin and Christ Child in a distinctly worldly manner, carrying the humanization of the holy family further than ever before.

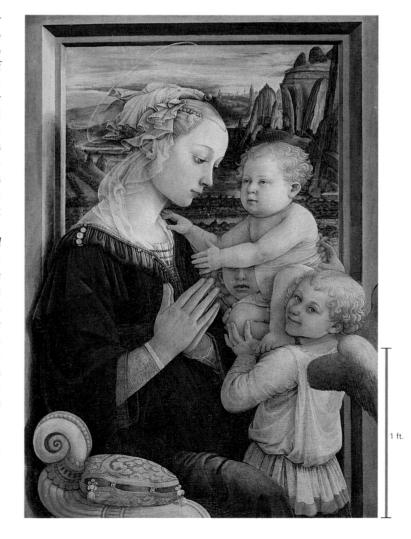

16-24 Domenico Ghirlandaio, *Birth* of the Virgin, Cappella Maggiore, Santa Maria Novella, Florence, Italy, ca. 1485–1490. Fresco, $24' 4'' \times 14' 9''$.

Ludovica Tornabuoni holds as prominent a place in Ghirlandaio's fresco as she must have held in Florentine society—evidence of the secularization of sacred themes in 15th-century Italian painting.

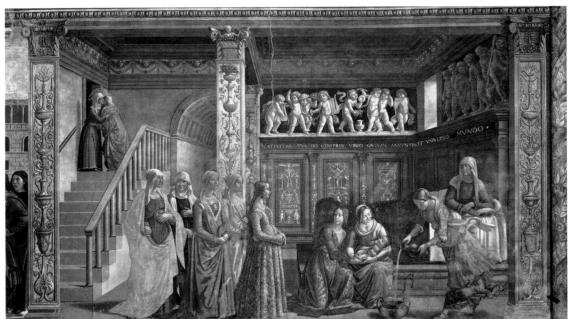

T_{1 ft.}

preferred the real in landscape also. The background, seen through the window, incorporates recognizable features of the Arno River valley. Compared with the earlier Madonnas by Giotto (FIG. 14-8) and Duccio (FIG. 14-10), this work shows how far artists had carried the humanization of the religious theme. Whatever the ideals of spiritual perfection may have meant to artists in past centuries, Renaissance artists realized those ideals in terms of the sensuous beauty of this world.

DOMENICO GHIRLANDAIO Toward the end of the 15th century, Domenico Ghirlandaio (1449–1494) received an important commission from Giovanni Tornabuoni, one of the wealthiest Florentines of his day. Tornabuoni asked Ghirlandaio to paint a cycle of frescoes depicting scenes from the lives of the Virgin and Saint John the Baptist for the choir of Santa Maria Novella, the Dominican church where Masaccio had earlier painted his revolutionary Holy Trinity (FIG. 16-20). In Birth of the Virgin (FIG. 16-24), Mary's mother, Saint Anne, reclines in a palatial Renaissance room embellished with fine wood inlay and sculpture, while midwives prepare the infant's bath. From the left comes a grave procession of women led by a young Tornabuoni family member, probably Ludovica, Giovanni's daughter. Ghirlandaio's composition epitomizes the achievements of 15th-century Florentine painting: clear spatial representation, statuesque figures, and rational order and logical relations among all figures and objects. If anything of earlier artistic traits remains here, it is the arrangement of the figures, who still cling somewhat rigidly to layers parallel to the picture plane. New, however, and in striking contrast to the dignity and austerity of Fra Angelico's frescoes (FIG. 16-21) for the Dominican monastery of San Marco, is the dominating presence of the donor's family in the religious tableau. Ludovica holds as prominent a place in the composition (close to the central axis) as she must have held in Florentine society.

16-25 Domenico Ghirlandaio, *Giovanna Tornabuoni*(?), 1488. Oil and tempera on wood, 2' $6'' \times 1'$ 8''. Museo Thyssen-Bornemisza, Madrid.

Renaissance artists revived the ancient art of portraiture. This portrait reveals the great wealth, courtly manners, and humanistic interest in classical literature that lie behind much 15th-century Florentine art.

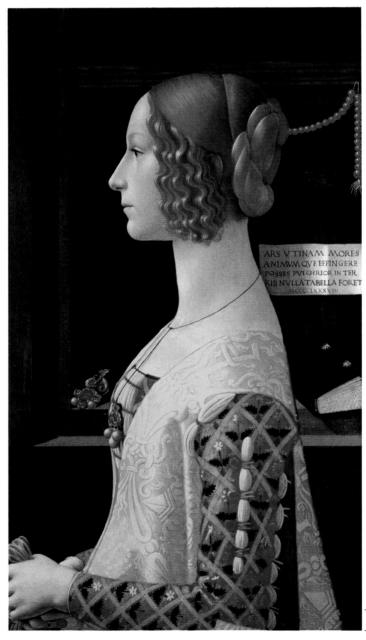

1 in

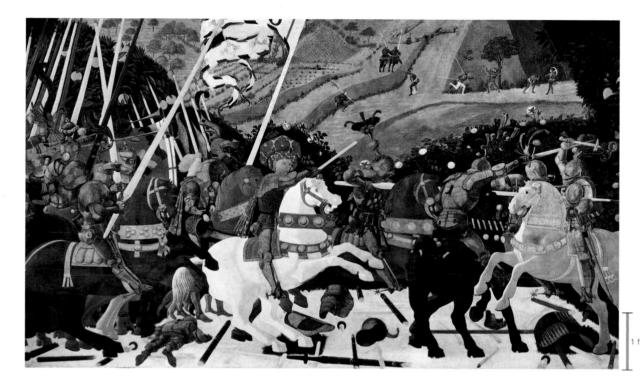

16-26 PAOLO UCCELLO, Battle of San Romano, ca. 1455 (?). Tempera on wood, $6' \times 10'$ 5". National Gallery, London.

In this panel once in the bedchamber of Lorenzo de' Medici, Niccolò da Tolentino leads the charge against the Sienese. The foreshortened spears and figures reveal Uccello's fascination with perspective.

around 1455, the traditional dat panel illustrated, Niccolò da Tol

Her appearance in the painting (a different female member of the house appears in each fresco) is conspicuous evidence of the secularization of sacred themes. Artists depicted living persons of high rank not only as being present at biblical dramas (as Masaccio did in *Holy Trinity*) but also as even stealing the show—as here, where the Florentine women upstage the Virgin and Child. The display of patrician elegance tempers the biblical narrative and subordinates the fresco's devotional nature.

Ghirlandaio also painted individual portraits of wealthy Florentines. His 1488 panel painting (FIG. 16-25) of an aristocratic young woman is probably a portrait of Giovanna Tornabuoni (1468–1488), a member of the powerful Albizzi family and wife of Lorenzo Tornabuoni. Although artists at this time were beginning to employ three-quarter and full-face views for portraits in place of the more traditional profile pose, Ghirlandaio used the conventional format. This did not prevent him from conveying a character reading of the sitter. His portrait reveals the proud bearing of a sensitive and beautiful young woman. It also tells viewers much about the advanced state of culture in Florence, the value and careful cultivation of beauty in life and art, the breeding of courtly manners, and the great wealth behind it all. In addition, the painting shows the powerful attraction classical literature held for Italian humanists. In the background, an epitaph (Giovanna Tornabuoni died in childbirth) quotes the ancient Roman poet Martial.

PAOLO UCCELLO This secular side of Florentine art is on display in *Battle of San Romano* (FIG. **16-26**) by PAOLO UCCELLO (1397–1475), a Florentine painter trained in the International Style. The panel painting is one of a series of three that Lorenzo de' Medici acquired for his bedchamber in the palatial family residence (FIGS. **16-36** and **16-37**) in Florence. There is some controversy about the date of the painting because recently discovered documents suggest that Lorenzo may have purchased at least two of the paintings from a previous owner instead of commissioning the full series himself. The scenes commemorate the Florentine victory over the Sienese in 1432 and must have been painted no earlier than the mid-1430s if

not around 1455, the traditional date assigned to the commission. In the panel illustrated, Niccolò da Tolentino (ca. 1350–1435), a friend and supporter of Cosimo de' Medici, leads the charge against the Sienese. Although the painting focuses on Tolentino's military exploits, it also acknowledges the Medici, albeit in symbolic form. The bright orange fruit (appropriately placed) behind the unbroken and sturdy lances on the left were known as "mela medica" (Italian, "medicinal apples"). Given that the name Medici means "doctors," this fruit was a fitting symbol (one of many) of the family. It also suggests that at least this panel was a Medici commission.

Uccello was one of many 15th-century painters (and patrons) obsessed with the new science of perspective. The development of perspectival systems intrigued the humanists, because perspective represented the rationalization of vision. As staunch humanists, the Medici pursued all facets of expanding knowledge. In Battle of San Romano, Uccello created a composition that recalls the International Style processional splendor of Gentile's Adoration of the Magi (FIG. 16-17). But in contrast with Gentile, who emphasized surface decoration, Uccello painted immobilized solid forms. He foreshortened broken spears, lances, and a fallen soldier and carefully placed them along the converging orthogonals of the perspectival system to create a base plane like a checkerboard, on which he then placed the larger volumes in measured intervals. This diligently created space recedes to a landscape that resembles the low cultivated hillsides between Florence and Lucca. The rendering of three-dimensional form, used by other painters for representational or expressive purposes, became for Uccello a preoccupation. For him, it had a magic of its own, which he exploited to satisfy his inventive and original imagination.

SANDRO BOTTICELLI Of all the Florentine painters the Medici employed, perhaps the most famous today is SANDRO BOTTICELLI (1444–1510), a pupil of Fra Filippo Lippi (FIG. 16-23), who must have taught him the method of using firm, pure outlines with light shading within the contours. Art historians universally recognize Botticelli as one of the great masters of line. He was, however, a

16-27 SANDRO BOTTICELLI, *Primavera*, ca. 1482. Tempera on wood, 6' 8" × 10' 4". Galleria degli Uffizi, Florence.

Probably intended to commemorate the May 1482 wedding of Lorenzo di Pierfrancesco de' Medici, Botticelli's lyrical painting celebrates love in spring, with Venus and Cupid at the center of the composition.

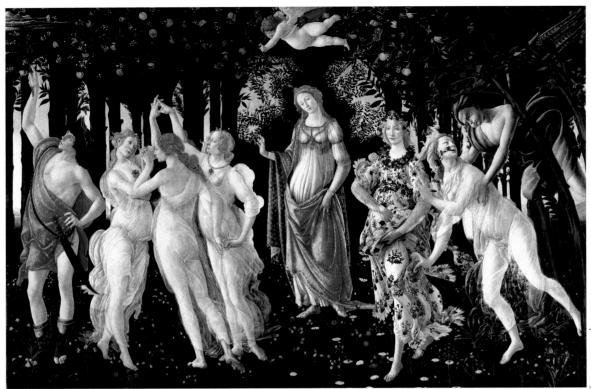

1 ft.

brilliant colorist as well, as is evident in Primavera (Spring; FIG. 16-27), one of the most popular paintings among a host of other extraordinary works in the collection of the Uffizi Gallery in Florence. The precise meaning of this painting continues to elude scholars. Created for Lorenzo di Pierfrancesco de' Medici, one of Lorenzo the Magnificent's cousins, it features a friezelike series of classically inspired figures in the foreground and a lush backdrop of orange trees in honor of the patron (compare FIG. 16-26). Venus stands just to the right of center with her son Cupid hovering above her head. Botticelli drew attention to the goddess of love by opening the landscape behind her to reveal a portion of sky that forms a kind of halo around her head. To Venus's right, seemingly the target of Cupid's arrow, are the dancing Three Graces, based closely on ancient prototypes but clothed, albeit in thin, transparent garments. At the right, the blue ice-cold Zephyrus, the west wind, is about to carry off and then marry the nymph Chloris, whom he transforms into Flora, goddess of spring, appropriately shown wearing a rich floral gown. At the far left, the enigmatic figure of Mercury turns away from all the others and reaches up with his distinctive staff, the caduceus, perhaps to dispel storm clouds. The sensuality of the representation, the appearance of Venus in springtime, and the abduction and marriage of Chloris all suggest that the painting was commissioned on the occasion of young Lorenzo's May 1482 wedding.

BIRTH OF VENUS Rivaling Primavera in fame is Botticelli's tempera on canvas Birth of Venus (FIG. 16-28), which the painter also created for the Medici family. The theme was the subject of a poem by Angelo Poliziano (1454–1494), a leading humanist of the day. In Botticelli's lyrical painting of the poet's retelling of the Greek myth, Zephyrus, carrying Chloris, blows Venus, born of sea foam and carried on a cockle shell, to her sacred island, Cyprus. There, the nymph Pomona runs to meet her with a brocaded mantle. The lightness and bodilessness of the winds propel all the figures without effort. Draperies undulate easily in the gentle gusts, perfumed by rose petals that fall on the whitecaps. In this painting, unlike Primavera, Botticelli depicted Venus as nude. As noted earlier, the nude, especially the female nude, was exceedingly rare during the Middle Ages. The artist's

use (particularly on such a large scale) of an ancient Venus statue (a Hellenistic variant of Praxiteles' famous *Aphrodite of Knidos*, FIG. **5-62**) as a model could have drawn the charge of paganism. But in the more accommodating Renaissance culture and under the protection of the powerful Medici, the depiction went unchallenged.

Botticelli's style is clearly distinct from the earnest search many other artists pursued to comprehend humanity and the natural world through a rational, empirical order. Indeed, Botticelli's elegant and beautiful style seems to have ignored all of the scientific knowledge 15th-century artists had gained in the areas of perspective and anatomy. For example, the seascape in Birth of Venus is a flat backdrop devoid of atmospheric perspective. Botticelli's style paralleled the Florentine allegorical pageants that were chivalric tournaments structured around allusions to classical mythology. The same trend is evident in the poetry of the 1470s and 1480s. Artists and poets at this time did not directly imitate classical antiquity but used the myths, with delicate perception of their charm, in a way still tinged with medieval romance. Ultimately, Botticelli created a style of visual poetry parallel to the love poetry of Lorenzo de' Medici. His paintings possess a lyricism and courtliness that appealed to cultured Florentine patrons.

MEDICI PATRONAGE The wide range of Medici commissions illustrated in this chapter makes clear that the Florentine banking family did not restrict its collecting to any specific style or artist. Medici acquisitions ranged from mythological to biblical to contemporary historical subject matter and included both paintings and sculptures. Collectively, the art of the Medici reveals their wide and eclectic tastes and sincere love of art and learning and makes a statement about the patrons themselves as well. Careful businessmen that they were, the Medici were not sentimental about their endowment of art and scholarship. Cosimo acknowledged that his good works were not only for the honor of God but also to construct his own legacy. Fortunately, the Medici desired to promote their own fame, and this led to the creation of many of the most cherished masterpieces in the history of Western art.

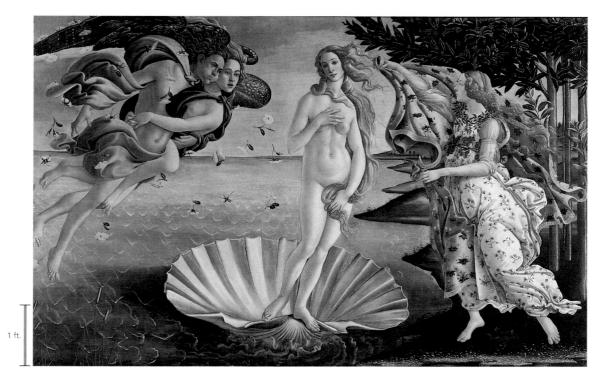

16-28 SANDRO BOTTICELLI, Birth of Venus, ca. 1484–1486. Tempera on canvas, 5' 9" × 9' 2". Galleria degli Uffizi, Florence.

Inspired by an Angelo
Poliziano poem and classical
statues of Aphrodite (FIG. 5-62),
Botticelli revived the theme of
the female nude in this elegant
and romantic representation
of Venus born of sea foam.

ENGRAVING Although the most prestigious commissions in 15th-century Florence were for large-scale panel paintings and frescoes and for monumental statues and reliefs, some artists also produced important small-scale works, such as Pollaiuolo's *Hercules and Antaeus* (FIG. 16-14). Pollaiuolo also experimented with the new medium of engraving, which Northern European artists had pioneered around the middle of the century. But whereas German graphic artists, such as Martin Schongauer (FIG. 15-22), used cross hatching that followed the forms, Italian engravers, such as Pollaiuolo, preferred parallel hatching. The former method was in keeping with the general Northern European approach to art, which tended to describe surfaces of forms rather than their underlying structures, whereas the latter better suited the anatomical studies that preoccupied Pollaiuolo and his Italian contemporaries.

Pollaiuolo's *Battle of the Ten Nudes* (FIG. **16-29**), like his *Hercules and Antaeus*, reveals the artist's interest in the realistic presentation of human figures in action. Earlier artists, such as Donatello and Masaccio, had dealt effectively with the problem of rendering human anatomy, but they usually depicted their figures at rest or in restrained motion. As is evident in his engraving as well as in his sculpture, Pollaiuolo took delight in showing violent action. He conceived the body as a powerful machine and liked to display its mechanisms, such as knotted muscles and taut sinews that activate the skeleton as ropes pull levers. To show this to best effect, Pollaiuolo developed a figure so lean and muscular that it appears *écorché* (as if without skin), with strongly accentuated delineations at the wrists, elbows, shoulders, and knees. *Battle of the Ten Nudes* shows this figure type in a variety of poses and from numerous

16-29 Antonio del Pollaiuolo, Battle of the Ten Nudes, ca. 1465. Engraving, 1' $3\frac{1}{8}'' \times 1'$ $11\frac{1}{4}''$. Metropolitan Museum of Art, New York (bequest of Joseph Pulitzer, 1917).

Pollaiuolo was fascinated by how muscles and sinews activate the human skeleton. He delighted in showing nude figures in violent action and from numerous foreshortened viewpoints.

1 in.

viewpoints, allowing Pollaiuolo to demonstrate his prowess in rendering the nude male figure. In this, he was a kindred spirit of late-sixth-century Greek vase painters, such as Euthymides (FIG. 5-24), who had experimented with foreshortening for the first time in history. Even though Pollaiuolo's figures hack and slash at each other without mercy, they nevertheless seem somewhat stiff and frozen, because Pollaiuolo depicted *all* the muscle groups at maximum tension. Not until several decades later did an even greater anatomist, Leonardo da Vinci, observe that only part of the body's muscle groups participate in any one action, while the others remain relaxed.

Architecture

Filippo Brunelleschi's ability to codify a system of linear perspective derived in part from his skill as an architect. Although in a biography of him written around 1480, Antonio Manetti (1423–1497) reported that Brunelleschi turned to architecture out of disappointment over the loss of the commission for Florence's baptistery doors, he continued to work as a sculptor for several years and received commissions for sculpture as late as 1416. It is true, however, that as the 15th century progressed, Brunelleschi's interest turned increasingly toward architecture. Several trips to Rome (the first in 1402, probably with his friend Donatello), where the ruins of the ancient city captivated him, heightened his fascination with architecture. His close study of Roman monuments and his effort to make an accurate record of what he saw may well have been the catalyst that led Brunelleschi to develop his revolutionary system of geometric linear perspective.

FLORENCE CATHEDRAL Brunelleschi's broad knowledge of Roman construction principles, combined with an analytical and inventive mind, permitted him to solve an engineering problem that no other 15th-century architect could tackle. The challenge was the design and construction of a *dome* for the huge *crossing* of the unfinished Florence Cathedral (FIG. 14-18). The problem was staggering. The space to be spanned (140 feet) was much too wide to permit construction with the aid of traditional wooden centering. Nor was it possible (because of the crossing plan) to support the dome with *buttressed* walls. Brunelleschi began work on the problem about 1417. In 1420 the officials overseeing cathedral projects awarded Brunelleschi and Ghiberti a joint commission. The latter, however, soon retired from the project.

With exceptional ingenuity, Brunelleschi not only discarded traditional building methods and devised new ones but also invented much of the machinery necessary for the job. Although he might have preferred the hemispheric shape of Roman domes, Brunelleschi raised the center of his dome and designed it around an *ogival* (pointed arch) section (FIG. 16-30), which is inherently more stable because it reduces the outward thrust around the dome's base. To minimize the structure's weight, he designed a relatively thin double shell (the first in history) around a skeleton of 24 ribs. The eight most important are visible on the exterior. Finally, in almost paradoxical fashion, Brunelleschi anchored the structure at the top with a heavy lantern, built after his death but from his design. Despite Brunelleschi's knowledge of and admiration for Roman building techniques, and even though Florence Cathedral's dome was his most outstanding engineering achievement, he solved this critical structural problem through what were essentially Gothic building principles. Thus, the dome, which also had to harmonize in formal terms with the century-old building, does not express Brunelleschi's Renaissance architectural style.

SANTO SPIRITO Santo Spirito (FIGS. **16-31** and **16-32**), begun around 1436 and completed, with some changes, after Brunel-

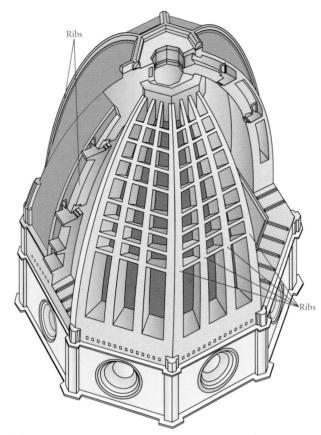

16-30 FILIPPO BRUNELLESCHI, cutaway view of the dome of Florence Cathedral, Florence, Italy, 1420–1436 (after Piero Sanpaolesi).

Brunelleschi solved the problem of placing a dome over the 140-footwide crossing of Florence Cathedral by designing a thin double shell that was ogival in section. A heavy lantern anchors the dome at the top.

leschi's death, is one of two basilican churches the architect built in Florence. It showcases the clarity and classically inspired rationality that characterize Brunelleschi's mature designs. Brunelleschi laid out this cruciform building in either multiples or segments of the domecovered crossing square. The aisles, subdivided into small squares covered by shallow, saucer-shaped vaults, run all the way around the flat-roofed central space. They have the visual effect of compressing the longitudinal design into one comparable to a central plan, because the various aspects of the interior resemble one another, no matter where an observer stands. Originally, this centralization effect would have been even stronger. Brunelleschi had planned to extend the aisles across the front of the nave as well, as shown on the plan (FIG. 16-32, *left*). However, adherence to that design would have required four entrances in the facade, instead of the traditional and symbolic three, a feature hotly debated during Brunelleschi's lifetime and changed after his death. Successor builders later also modified the appearance of the exterior walls (compare the two plans in FIG. 16-32) by filling in the recesses between the projecting semicircular chapels to convert the original highly sculpted wall surface into a flat one.

The major features of Santo Spirito's interior (FIG. 16-31), however, are much as Brunelleschi designed them. In this *modular* scheme, a mathematical unit served to determine the dimensions of every aspect of the church. This unit, repeated throughout the interior, creates a rhythmic harmony. For example, the nave is twice as high as it is wide, and the arcade and clerestory are of equal height, which means that the height of the arcade equals the nave's width.

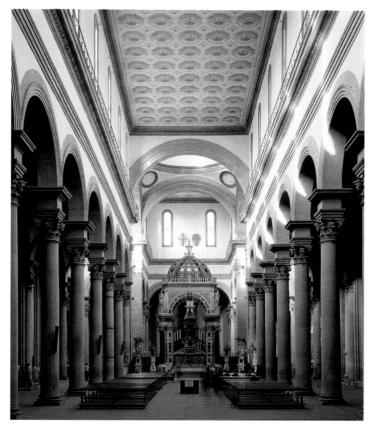

16-31 FILIPPO BRUNELLESCHI, interior of Santo Spirito (looking northeast), Florence, Italy, designed 1434–1436; begun 1446.

The austerity of the decor and the mathematical clarity of the interior of Santo Spirito contrast sharply with the soaring drama and spirituality of the nave arcades and vaults of Gothic churches.

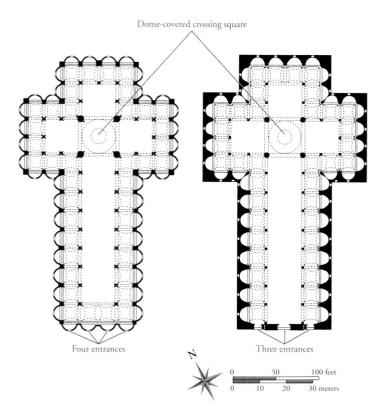

16-32 FILIPPO BRUNELLESCHI, early plan (*left*) and plan as constructed (*right*) of Santo Spirito, Florence, Italy, designed 1434–1436; begun 1446.

Santo Spirito displays the classically inspired rationality of Brunelleschi's mature architectural style in its all-encompassing modular scheme based on the dimensions of the dome-covered crossing square.

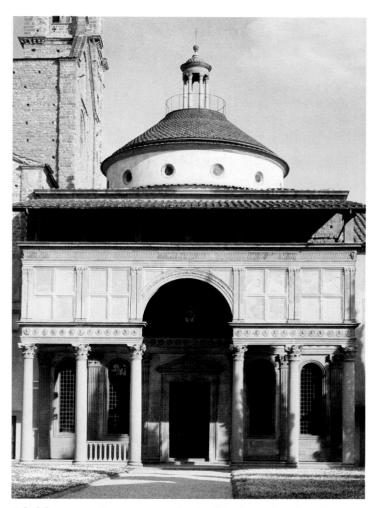

16-33 FILIPPO BRUNELLESCHI, facade of the Pazzi Chapel, Santa Croce, Florence, Italy, designed ca. 1423, begun 1442.

The Pazzi family erected this chapel as a gift to the Franciscan church of Santa Croce. One of the first independent Renaissance central-plan buildings, it served as the monks' chapter house.

Astute observers can read the proportional relationships among the interior's parts as a series of mathematical equations. The austerity of the decor enhances the rationality of the design and produces a restful and tranquil atmosphere. Brunelleschi left no space for expansive wall frescoes that only would interrupt the clarity of his architectural scheme. The calculated logic of the design echoes that of ancient Roman buildings, such as the Pantheon (FIG. 7-50, *right*). The rationality of Santo Spirito contrasts sharply, however, with the soaring drama and spirituality of the nave arcades and vaults of Gothic churches (for example, FIGS. 13-19 and 13-20). It even deviates from the design of Florence Cathedral's nave (FIG. 14-19), whose verticality is restrained compared with its Northern European counterparts. Santo Spirito fully expresses the new Renaissance spirit that placed its faith in reason rather than in the emotions.

PAZZI CHAPEL Brunelleschi's apparent effort to impart a centralized effect to the interior of Santo Spirito suggests that the compact and self-contained qualities of earlier central-plan buildings, such as the Roman Pantheon (FIGS. 7-49 to 7-51), intrigued him. The Pazzi Chapel (FIG. 16-33) presented Brunelleschi with the opportunity to explore this interest, in a structure much better suited to a centralized design than a basilican church. The chapel was the Pazzi family's gift to the Franciscan church of Santa Croce in Florence (see "Renaissance Family Chapel Endowments," page 442) and served as

Renaissance Family Chapel Endowments

uring the 14th through 16th centuries in Italy, wealthy families regularly endowed chapels in or adjacent to major churches. These family chapels were usually on either side of the choir near the altar at the church's east end. Particularly wealthy families endowed chapels in the form of separate buildings constructed adjacent to churches. For example, the Medici Chapel (Old Sacristy) abuts San Lorenzo in Florence. Powerful banking families, such as the Baroncelli, Bardi, and Peruzzi, each sponsored chapels in the Florentine church of Santa Croce. The Pazzi commissioned a chapel (FIGS. 16-33 to 16-35) adjacent to Santa Croce, and the Brancacci family sponsored the decorative program (FIGS. 16-18 and 16-19) of their chapel in Santa Maria del Carmine.

These families endowed chapels to ensure the well-being of the souls of individual family members and ancestors. The chapels served as burial sites and as spaces for liturgical celebrations and commemorative services. Chapel owners sponsored Masses for the dead, praying to the Virgin Mary and the saints for intercession on behalf of their deceased loved ones. Changes in Christian doctrine

prompted these concerted efforts to improve donors' chances for eternal salvation. Until the 13th century, Christians believed that after death, souls went either to Heaven or to Hell. After that time, the concept of Purgatory—a way station between Heaven and Hell where souls could atone for sins before Judgment Day—increasingly won favor. Pope Innocent III (1198–1216) recognized the existence of such a place in 1215. Because Purgatory represented an opportunity for the faithful to improve their chances of eventually gaining admission to Heaven, they eagerly embraced this opportunity. When they extended this idea to improving their chances while alive, charitable work, good deeds, and devotional practices proliferated. Family chapels provided the space necessary for the performance of devotional rituals. Most chapels included altars as well as chalices, vestments, candlesticks, and other objects used in the Mass. Most patrons also commissioned decorations, such as painted altarpieces, frescoes on the walls, and sculptural objects. The chapels were therefore expressions of piety and devotion but also opportunities for the donors to burnish their images in the larger community.

the monk's *chapter house* (meeting hall). Brunelleschi began to design the Pazzi Chapel around 1423, but work continued until the 1460s, long after his death. The exterior (FIG. **16-33**) probably does not reflect Brunelleschi's original design. The loggia, admirable as it is, seems to have been added as an afterthought, perhaps by the sculptor-architect Giuliano da Maiano (1432–1490). Historians have

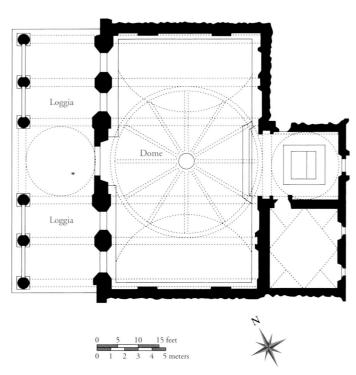

16-34 FILIPPO BRUNELLESCHI, plan of the Pazzi Chapel, Santa Croce, Florence, Italy, designed ca. 1423, begun 1442.

Although the Pazzi Chapel is rectangular, rather than square or round, Brunelleschi created a central plan by placing all emphasis on the dome-covered space at the heart of the building.

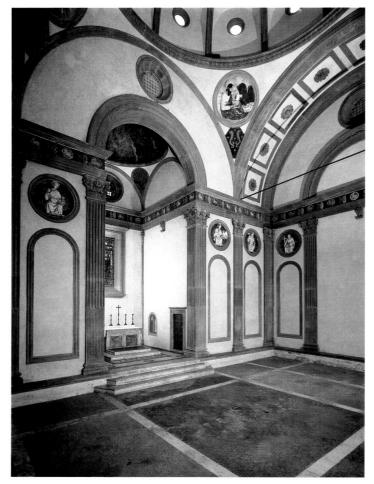

16-35 FILIPPO BRUNELLESCHI, interior of the Pazzi Chapel (looking northeast), Santa Croce, Florence, Italy, designed ca. 1423, begun 1442, with glazed terracotta roundels by Luca Della Robbia.

The interior trim of the Pazzi Chapel is gray pietra serena, which stands out against the white stuccoed walls and crisply defines the modular relationships of Brunelleschi's plan and elevation.

16-36 MICHELOZZO DI BARTOLOMMEO, facade of the Palazzo Medici-Riccardi, Florence, Italy, begun 1445.

The Medici palace, with its combination of dressed and rusticated masonry and classical moldings, draws heavily on ancient Roman architecture, but Michelozzo creatively reinterpreted his models.

suggested that the local chapter of Franciscan monks who held meetings in the chapel needed the expansion. Behind the loggia stands one of the first independent Renaissance buildings conceived basically as a central-plan structure. Although the plan (FIG. 16-34) is rectangular, rather than square or round, the architect placed all emphasis on the central dome-covered space. The short barrel-vaulted sections that brace the dome on two sides appear to be incidental appendages. The interior trim (FIG. 16-35) is gray pietra serena ("serene stone"), which stands out against the white stuccoed walls and crisply defines the modular relationships of plan and elevation. As he did in his design for Santo Spirito, Brunelleschi used a basic unit that allowed him to construct a balanced, harmonious, and regularly proportioned

Circular medallions, or *tondi*, in the dome's *pendentives* (see "Pendentives and Squinches," Chapter 9, page 235) consist of *glazed terracotta* reliefs representing the four evangelists. The technique for manufacturing these baked clay reliefs was of recent invention. Around 1430, Luca Della Robbia (1400–1482) perfected the application of vitrified (heat-fused) colored potters' glazes to sculpture. Inexpensive and durable, these colorful sculptures became extremely popular and provided the basis for a flourishing family business. Luca's nephew Andrea della Robbia (1435–1525) and Andrea's sons, Giovanni della Robbia (1469–1529) and Girolamo della Robbia

(1488–1566), carried on this tradition well into the 16th century. Most of the *roundels* in the Pazzi Chapel are the work of Luca della Robbia himself. Together with the images of the 12 apostles on the pilaster-framed wall panels, they add striking color accents to the tranquil interior.

PALAZZO MEDICI It seems curious that Brunelleschi, the most renowned architect of his time, did not participate in the upsurge of palace building that Florence experienced in the 1430s and 1440s. This proliferation of palazzi testified to the stability of the Florentine economy and to the affluence and confidence of the city's leading citizens. Brunelleschi, however, confined his efforts in this field to work on the Palazzo di Parte Guelfa (headquarters of Florence's then-ruling "party") and to a rejected model for a new palace that Cosimo de' Medici intended to build. When the Medici returned to Florence in 1434 after their short-lived exile, Cosimo, aware of the importance of public perception, attempted to maintain a lower profile and to wield his power from behind the scenes. In all probability, this attitude accounted for his rejection of Brunelleschi's design for the Medici residence, which he evidently found

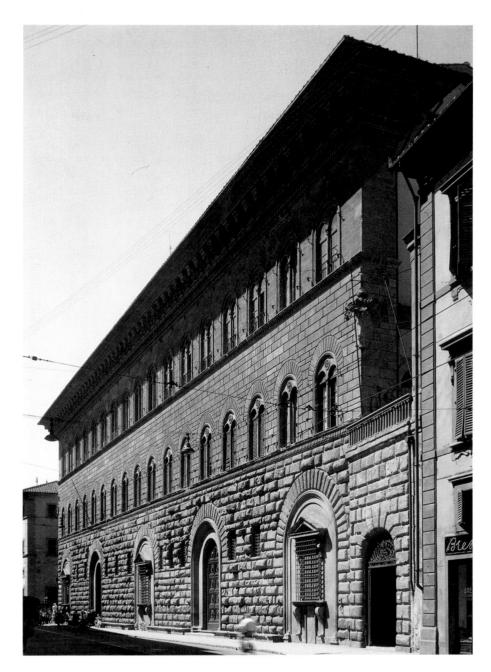

too imposing and ostentatious to be politically wise. Cosimo eventually awarded the commission to Michelozzo di Bartolommeo (1396–1472), a young architect who had collaborated with Donatello in several sculptural enterprises. Although Cosimo passed over Brunelleschi, his architectural style in fact deeply influenced Michelozzo. To a limited extent, the Palazzo Medici (Fig. 16-36) reflects Brunelleschian principles.

Later bought by the Riccardi family (hence the name Palazzo Medici-Riccardi), who almost doubled the facade's length in the 18th century, the palace, both in its original and extended form, is a simple, massive structure. Heavy rustication (rough unfinished masonry) on the ground floor accentuates its strength. Michelozzo divided the building block into stories of decreasing height by using long, unbroken stringcourses (horizontal bands), which give it coherence. Dressed (smooth, finished) masonry on the second level and an even smoother surface on the top story modify the severity of the ground floor and make the building appear progressively lighter as the eye moves upward. The extremely heavy cornice, which Michelozzo related not to the top story but to the building as a whole, dramatically reverses this effect. Like the ancient Roman cornices that served as

16-37 MICHELOZZO DI BARTOLOMMEO, interior court of the Palazzo Medici-Riccardi, Florence, Italy, begun 1445.

The Medici palace's interior court surrounded by a round-arched colonnade was the first of its kind, but the austere design clearly reveals Michelozzo's debt to Brunelleschi (FIG. 16-31).

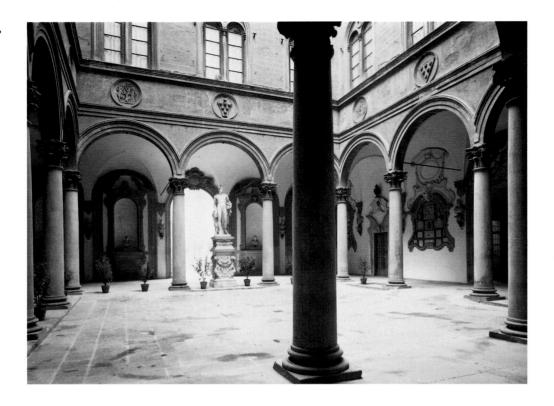

Michelozzo's models (compare FIGS. 7-32, 7-39, and 7-47), the Palazzo Medici-Riccardi cornice is an effective lid for the structure, clearly and emphatically defining its proportions. Michelozzo also may have drawn inspiration from the many extant examples of Roman rusticated masonry, and Roman precedents even existed for the juxtaposition of rusticated and dressed stone masonry on the same facade (FIG. 7-34). However, nothing in the ancient world precisely compares to Michelozzo's design. The Palazzo Medici exemplifies the simultaneous respect for and independence from the antique that characterize the Early Renaissance in Italy.

The heart of the Palazzo Medici is an open colonnaded court (FIG. 16-37) that clearly shows Michelozzo's debt to Brunelleschi. The round-arched colonnade, although more massive in its proportions, closely resembles other buildings Brunelleschi designed. This internal court surrounded by an arcade was the first of its kind and influenced a long line of descendants in Renaissance domestic architecture.

LEON BATTISTA ALBERTI Although he entered the profession of architecture rather late in life, LEON BATTISTA ALBERTI (1404-1472) nevertheless made a remarkable contribution to architectural design. He was the first to study seriously the ancient Roman architectural treatise of Vitruvius, and his knowledge of it, combined with his own archaeological investigations, made him the first Renaissance architect to understand classical architecture in depth. Alberti's most influential theoretical work, On the Art of Building (written about 1450, published 1486), although inspired by Vitruvius, contains much original material. Alberti advocated a system of ideal proportions and believed that the central plan was the ideal form for a Christian church. He also considered incongruous the combination of column and arch, which had persisted since Roman times and throughout the Middle Ages. He argued that the arch is a wall opening that should be supported only by a section of wall (a pier), not by an independent sculptural element (a column) as in Brunelleschi's and Michelozzo's buildings (FIGS. 16-31, 16-33, and 16-37).

PALAZZO RUCELLAI Alberti's own architectural style represents a scholarly application of classical elements to contemporary buildings. He designed the Palazzo Rucellai (FIG. 16-38) in Flor-

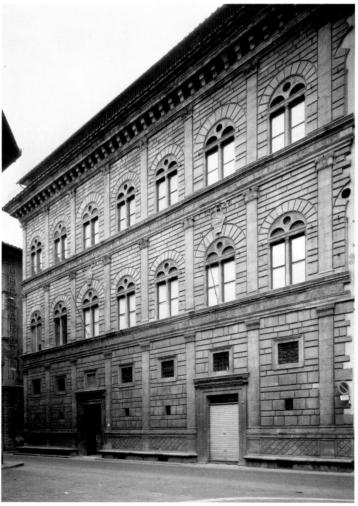

16-38 Leon Battista Alberti and Bernardo Rossellino, Palazzo Rucellai, Florence, Italy, ca. 1452–1470.

Alberti was an ardent student of classical architecture. He created the illusion that the Palazzo Rucellai becomes lighter toward its top by adapting the Roman manner of using different capitals for each story.

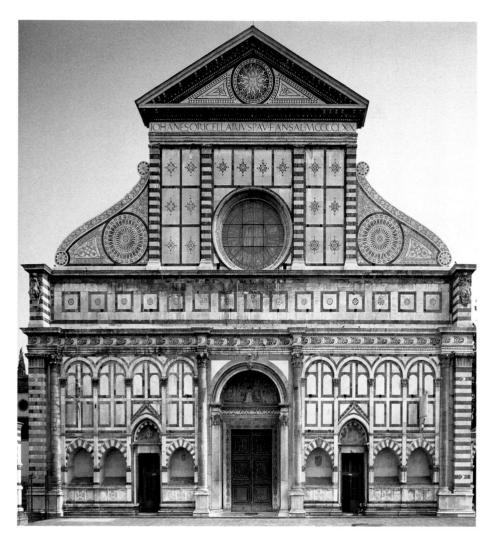

16-39 Leon Battista Alberti, west facade of Santa Maria Novella, Florence, Italy, 1456–1470.

Alberti's design for the facade of this Gothic church features a pediment-capped temple front and pilaster-framed arcades. Numerical ratios are the basis of the proportions of all parts of the facade

his cue from a Romanesque design—that of the Florentine church of San Miniato al Monte (FIG. 12-27). Following his medieval model, he designed a small, pseudoclassical, pediment-capped temple front for the facade's upper part and supported it with a pilaster-framed arcade that incorporates the six tombs and three doorways of the Gothic building. But in the organization of these elements, Alberti applied Renaissance principles. The height of Santa Maria Novella (to the pediment tip) equals its width so that the entire facade can be inscribed in a square. Throughout the facade, Alberti defined areas and related them to one another in terms of proportions that can be expressed in simple numerical ratios. For example, the upper structure can be encased in a square one-fourth the size of the main square. The cornice separating the two levels divides the major square in half so that the lower portion of the building is a rectangle twice as wide as it is high. In his treatise,

Alberti wrote at length about the necessity of employing harmonic proportions to achieve beautiful buildings. Alberti shared this conviction with Brunelleschi, and this fundamental dependence on classically derived mathematics distinguished their architectural work from that of their medieval predecessors. They believed in the eternal and universal validity of numerical ratios as the source of beauty. In this respect, Alberti and Brunelleschi revived the true spirit of the High Classical age of ancient Greece, as epitomized by the sculptor Polykleitos and the architect Iktinos, who produced canons of proportions for the perfect statue and the perfect temple (see Chapter 5). But it was not only a desire to emulate Vitruvius and the Greek masters that motivated Alberti to turn to mathematics in his quest for beauty. His contemporary, the Florentine humanist Giannozzo Manetti (1396–1459), had argued that Christianity itself possessed the order and logic of mathematics. In his 1452 treatise, On the Dignity and Excellence of Man, Manetti stated that Christian religious truths were as self-evident as mathematical axioms.

The Santa Maria Novella facade was an ingenious solution to a difficult design problem. On the one hand, it adequately expressed the organization of the structure attached to it. On the other hand, it subjected preexisting and quintessentially medieval features, such as the large round window on the second level, to a rigid geometrical order that instilled a quality of classical calm and reason. This facade also introduced a feature of great historical consequence—the scrolls that simultaneously unite the broad lower and narrow upper level and screen the sloping roofs over the aisles. With variations, similar spirals appeared in literally hundreds of church facades throughout the Renaissance and Baroque periods.

ence, although his pupil and collaborator, Bernardo Rossellino (1409–1464), actually constructed the building using Alberti's plans and sketches. The facade of the palace is much more severe than that of the Palazzo Medici-Riccardi (FIG. 16-36). Pilasters define each story, and a classical cornice crowns the whole. Between the smooth pilasters are subdued and uniform wall surfaces. Alberti created the sense that the structure becomes lighter in weight toward its top by adapting the ancient Roman manner of using different capitals for each story. He chose Tuscan (the Etruscan variant of the Greek Doric order; FIG. 5-14 or in the "Before 1300" section) for the ground floor, Composite (the Roman combination of *Ionic volutes* with the acanthus leaves of the Corinthian; FIG. 5-73 or in the "Before 1300" section) for the second story, and Corinthian for the third floor. Alberti modeled his facade on the most imposing Roman ruin of all, the Colosseum (FIG. 7-1), but he was no slavish copyist. On the Colosseum's facade, the capitals employed are, from the bottom up, Tuscan, Ionic, and Corinthian. Moreover, Alberti adapted the Colosseum's varied surface to a flat facade, which does not allow the deep penetration of the building's mass that is so effective in the Roman structure. By converting his ancient model's engaged columns (half-round columns attached to a wall) into shallow pilasters that barely project from the wall, Alberti created a large-meshed linear net. Stretched tightly across the front of his building, it not only unifies the three levels but also emphasizes the wall's flat, two-dimensional qualities.

SANTA MARIA NOVELLA The Rucellai family also commissioned Alberti to design the facade (FIG. **16-39**) of the 13th-century Gothic church of Santa Maria Novella in Florence. Here, Alberti took

GIROLAMO SAVONAROLA In the 1490s, Florence underwent a political, cultural, and religious upheaval. Florentine artists and their fellow citizens responded then not only to humanist ideas but also to the incursion of French armies and especially to the preaching of the Dominican monk Girolamo Savonarola (1452–1498), the reforming priest-dictator who denounced the paganism of the Medici and their artists, philosophers, and poets. Savonarola exhorted the people of Florence to repent their sins, and when Lorenzo de' Medici died in 1492, he prophesied the downfall of the city and of Italy and assumed absolute control of the state. Together with a large number of citizens, Savonarola believed that the Medici's political, social, and religious power had corrupted Florence and had invited the scourge of foreign invasion. Savonarola denounced humanism and encouraged citizens to burn their classical texts, scientific treatises, and philosophical publications. The Medici fled in 1494. Scholars still debate the significance of Savonarola's brief span of power. Apologists for the undoubtedly sincere monk deny that his actions played a role in the decline of Florentine culture at the end of the 15th century. But the puritanical spirit that moved Savonarola must have dampened considerably the neopagan enthusiasm of the Florentine Early Renaissance. Certainly, his condemnation of humanism as heretical nonsense, and his banishing of the Medici, Tornabuoni, and other wealthy families from Florence, deprived local artists of some of their major patrons. There were, however, abundant commissions for artists elsewhere in Italy.

THE PRINCELY COURTS

Although Florentine artists led the way in creating the Renaissance in art and architecture, art production flourished throughout Italy in the 15th century. The papacy in Rome and the princely courts in Urbino, Mantua, and elsewhere also deserve credit for nurturing Renaissance art (see "Italian Princely Courts and Artistic Patronage," page 447). These princely courts consisted of the prince (whose title varied from city to city), his consort and children, courtiers, household staff, and administrators. The considerable wealth these princes possessed, coupled with their desire for recognition, fame, and power, resulted in major art commissions.

Rome and the Papal States

Although not a secular ruler, the pope in Rome was the head of a court with enormous wealth at his disposal. In the 16th and 17th centuries, the popes became the major patrons of art and architecture in Italy (see Chapters 17 and 19), but even in the 15th century, the papacy was the source of some significant artistic commissions.

PERUGINO Between 1481 and 1483, Pope Sixtus IV (r. 1414–1484) summoned a group of artists, including Botticelli and Ghirlandaio, to Rome to decorate the walls of the newly completed Sistine Chapel (MAP 19-1). Pietro Vannucci of Perugia in Umbria, who was known as Perugino (ca. 1450–1523), was among the painters the pope em-

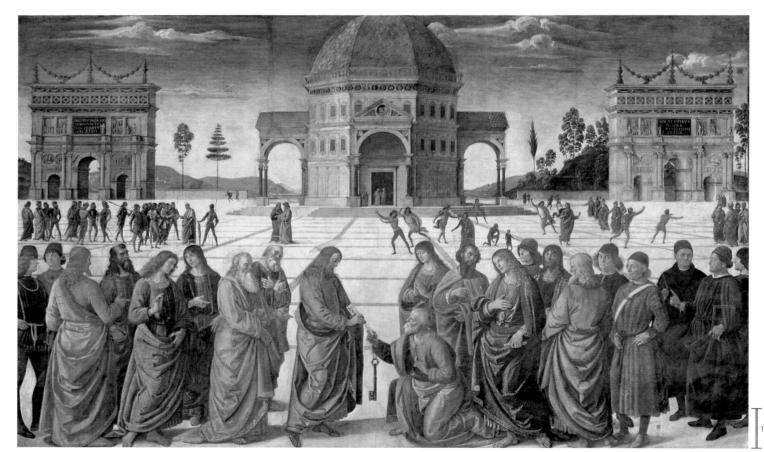

16-40 Perugino, Christ Delivering the Keys of the Kingdom to Saint Peter, Sistine Chapel, Vatican, Rome, Italy, 1481–1483. Fresco, $11' 5\frac{1}{2}'' \times 18' 8\frac{1}{2}''$.

Painted for the Vatican, this fresco depicts the event on which the papacy bases its authority. The converging lines of the pavement connect the action in the foreground with the background.

Italian Princely Courts and Artistic Patronage

he absence of a single sovereign ruling all of Italy and the fragmented nature of the independent city-states (MAP 14-1) provided a fertile breeding ground for the ambitions of the power-hungry. In the 15th century, Italian society witnessed the expansion of princely courts throughout the peninsula. A prince was in essence the lord of a territory, and despite this generic title, he could have been a duke, marquis, tyrant, cardinal, pope, or papal vicar. At this time, major princely courts emerged in papal Rome, Milan, Naples, Ferrara, Savoy, Urbino, and Mantua. Rather than denoting a specific organizational structure or physical entity, the term "princely court" refers to a power relationship between the prince and the territory's inhabitants based on imperial models. Each prince worked tirelessly to preserve and extend his control and authority, seeking to establish a societal framework of people who looked to him for jobs, favors, protection, prestige, and leadership. The importance of these princely courts derived from their role as centers of power and culture.

The efficient functioning of a princely court required a sophisticated administrative structure. Each prince employed an extensive household staff, ranging from counts, nobles, cooks, waiters, stewards, footmen, stable hands, and ladies-in-waiting to dog handlers, leopard keepers, pages, and runners. The duke of Milan had more than 40 chamberlains to attend to his personal needs alone. Each prince also needed an elaborate bureaucracy to oversee political, economic, and military operations and to ensure his continued control. These officials included secretaries, lawyers, captains, ambassadors, and condottieri. Burgeoning international diplomacy and trade made each prince the center of an active and privileged sphere. The princes' domains extended to the realm of culture, for they saw themselves as more than political, military, and economic leaders. They felt responsible for the vitality of cultural life in their territories, and art was a major component for developing a cultured populace. Visual imagery also appealed to them as effective propaganda for reinforcing their control. As the wealthiest individuals in their regions, princes possessed the means to commission numerous artworks and buildings. Thus, art functioned in several capacities—as evidence of princely sophistication and culture, as a form of prestige or commemoration, as public education and propaganda, as a demonstration of wealth, and as a source of visual pleasure.

Princes often researched in advance the reputations and styles of the artists and architects they commissioned. Such assurances of excellence were necessary, because the quality of the work reflected not just on the artist but on the patron as well. Yet despite the importance of individual style, princes sought artists who also were willing, at times, to subordinate their personal styles to work collaboratively on large-scale projects.

Princes bestowed on selected individuals the title of "court artist." Serving as a court artist had its benefits, among them a guaranteed salary (not always forthcoming), living quarters in the palace, liberation from guild restrictions, and, on occasion, status as a member of the prince's inner circle, perhaps even a knighthood. For artists struggling to elevate their profession from the ranks of craftspeople, working for a prince presented a marvelous opportunity. Until the 16th century, artists had limited status and were in the same class as small shopkeepers and petty merchants. Indeed, at court dinners, artists most often sat with the other members of the salaried household: tailors, cobblers, barbers, and upholsterers. Thus, the possibility of advancement was a powerful and constant incentive.

Princes demanded a great deal from court artists. Artists not only created the frescoes, portraits, and sculptures that have become their legacies but also designed tapestries, seat covers, costumes, masks, and decorations for various court festivities. Because princes constantly entertained, received ambassadors and dignitaries, and needed to maintain a high profile to reinforce their authority, lavish social functions were the norm. Artists often created gifts for visiting nobles and potentates. Recipients judged such gifts on the quality of both the work and the materials. By using expensive materials—gold leaf, silver leaf, lapis lazuli (a rich azure-blue stone imported from Afghanistan), silk, and velvet brocade—princes could impress others with their wealth and good taste.

ployed. His contribution to the fresco cycle of the Sistine Chapel was *Christ Delivering the Keys of the Kingdom to Saint Peter* (FIG. **16-40**). The papacy had, from the beginning, based its claim to infallible and total authority over the Roman Catholic Church on this biblical event, and therefore the subject was one of obvious appeal to Sixtus IV. In Perugino's version, Christ hands the keys to Saint Peter, who stands amid an imaginary gathering of the 12 apostles and Renaissance contemporaries. These figures occupy the apron of a great stage space that extends into the distance to a point of convergence in the doorway of a central-plan temple. (Perugino used parallel and converging lines in the pavement to mark off the intervening space.) Figures in the middle distance complement the near group, emphasizing its density and order by their scattered arrangement. At the corners of the great piazza, duplicate triumphal arches serve as the base angles of a distant compositional triangle whose apex is in the central building. Perugino modeled the arches very closely on the Arch of Constantine (FIG. 7-75) in Rome. Although an anachronism in a painting depicting a scene from Christ's life, the arches served to underscore the close ties between Saint Peter and Constantine, the first Christian emperor and the builder of the great basilica (FIG. 8-9) over Saint Peter's tomb in Rome. Christ and Peter flank the triangle's central axis, which runs through the temple's doorway, the perspective's vanishing point. Thus, the composition interlocks both two-dimensional and three-dimensional space, and the placement of central actors emphasizes the axial center. This spatial science allowed the artist to organize the action systematically. Perugino, in this single picture, incorporated the learning of generations.

LUCA SIGNORELLI Another Umbrian artist that Sixtus IV employed for the decoration of the Sistine Chapel was Luca Signorelli (ca. 1445–1523), in whose work the fiery passion of the sermons of Savonarola found its pictorial equal. Signorelli further developed Pollaiuolo's interest in the depiction of muscular bodies in violent action in a wide variety of poses and foreshortenings. In the San Brizio Chapel in the cathedral of the papal state of Orvieto (MAP 14-1), Signorelli painted for Pope Alexander VI (r. 1492–1503)

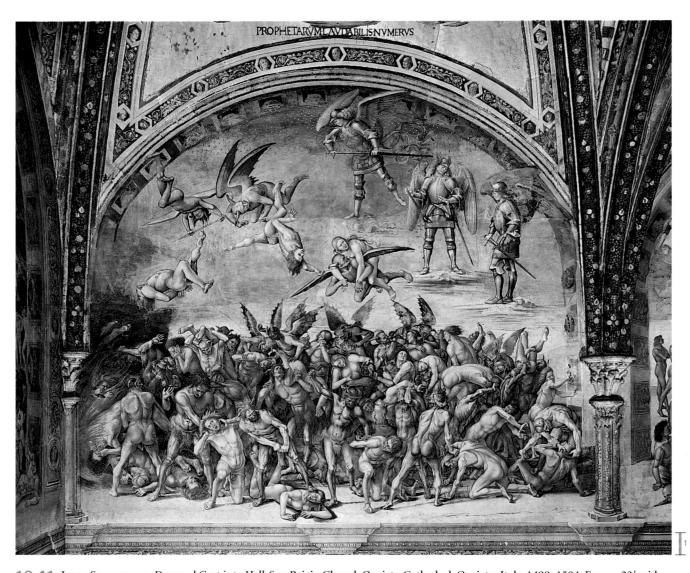

16-41 Luca Signorelli, *Damned Cast into Hell*, San Brizio Chapel, Orvieto Cathedral, Orvieto, Italy, 1499–1504. Fresco, 23' wide. Few figure compositions of the 15th century have the same psychic impact as Luca Signorelli's Orvieto Cathedral fresco of writhing, foreshortened muscular bodies tortured by demons in Hell.

scenes depicting the end of the world, including *Damned Cast into Hell* (FIG. **16-41**). Few figure compositions of the 15th century have the same psychic impact. Saint Michael and the hosts of Heaven hurl the damned into Hell, where, in a dense, writhing mass, they are vigorously tortured by demons. The horrible consequences of a sinful life had not been so graphically depicted since Gislebertus carved his vision of the Last Judgment (FIGS. **I-6** and **12-12**) in the west *tympanum* of Saint-Lazare at Autun around 1130. The figures—nude, lean, and muscular—assume every conceivable posture of anguish. Signorelli's skill at foreshortening the human figure was equaled by his mastery of its action, and although each figure is clearly a study from a model, he fit his theme to the figures in an entirely convincing manner. Terror and rage explode like storms through the wrenched and twisted bodies. The fiends, their hair flaming and their bodies the color of putrefying flesh, lunge at their victims in ferocious frenzy.

Urbino

Under the patronage of Federico da Montefeltro (1422–1482), Urbino, southeast of Florence across the Appennines (MAP 14-1), became an important center of Renaissance art and culture. In fact, the humanist writer Paolo Cortese (1465–1540) described Federico as

one of the two greatest artistic patrons of the 15th century (the other was Cosimo de' Medici). Federico was a condottiere so renowned for his military expertise that he was in demand by popes and kings, and soldiers came from across Europe to study under his direction.

PIERO DELLA FRANCESCA One artist who received several commissions from Federico was Piero della Francesca (ca. 1420–1492) of San Sepolcro in Tuscany, who had earlier painted for the Medici, among others. One of Piero's major works at the Urbino court was Enthroned Madonna and Saints Adored by Federico da Montefeltro, also called the Brera Altarpiece (FIG. 16-42). Federico, clad in armor, kneels piously at the Virgin's feet. Directly behind him stands Saint John the Evangelist, his patron saint. Where the viewer would expect to see Federico's wife, Battista Sforza (on the lower left, kneeling and facing her husband), no figure is present. Battista had died in 1472, shortly before Federico commissioned this painting. Thus, her absence clearly announces his loss. Piero further called attention to it by depicting Saint John the Baptist, Battista's patron saint, at the far left. The ostrich egg that hangs suspended from a shell over the Virgin's head was common over altars dedicated to Mary. The figures appear in an illusionistically painted, coffered barrel vault, which may have resembled part of the interior of the church of

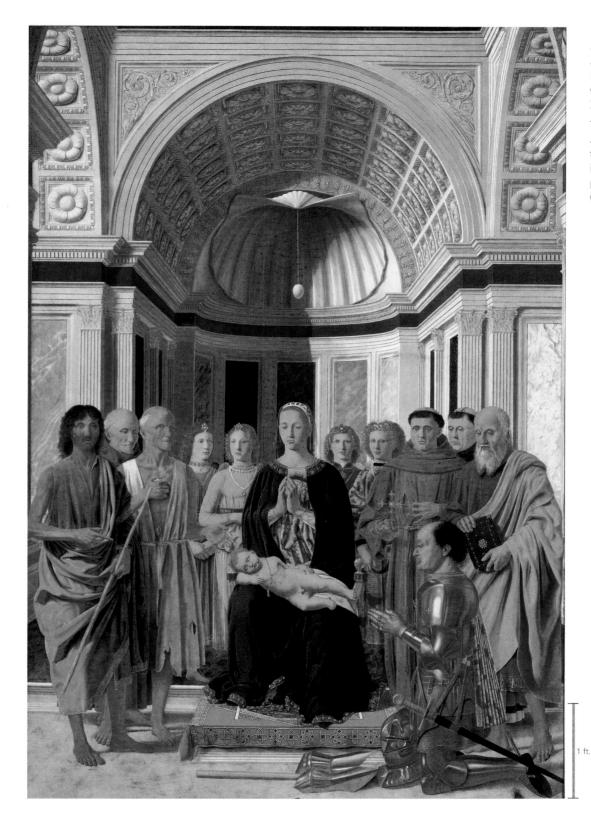

16-42 PIERO DELLA FRANCESCA, Enthroned Madonna and Saints Adored by Federico da Montefeltro (Brera Altarpiece), ca. 1472–1474. Oil on wood, 8' $2'' \times 5'$ 7''. Pinacoteca di Brera, Milan.

The illusionism of Piero's *Brera*Altarpiece is so convincing that
the viewer is compelled to believe
in Federico da Montefeltro's
presence before the Virgin Mary,
Christ Child, and saints.

San Bernadino degli Zoccolanti near Urbino, the painting's intended location. If so, the viewer would be compelled to believe in Federico's presence in the church before the Virgin, Christ Child, and saints. That Piero depicted Federico in left profile was undoubtedly a concession to his patron. The right side of Federico's face had sustained severe injury in a tournament, and the resulting deformity made him reluctant to show that side.

The *Brera Altarpiece* reveals Piero's deep interest in the properties of light and color. In his effort to make the clearest possible dis-

tinction among forms, he flooded his pictures with light, imparting a silver-blue tonality. To avoid heavy shadows, he illuminated the dark sides of his forms with reflected light. By moving the darkest tones of his modeling toward the centers of his volumes, he separated them from their backgrounds. Because of this technique, Piero's paintings lack some of Masaccio's relieflike qualities but gain in spatial clarity, as each shape forms an independent unit surrounded by an atmospheric envelope and movable to any desired position, like a figure on a chessboard.

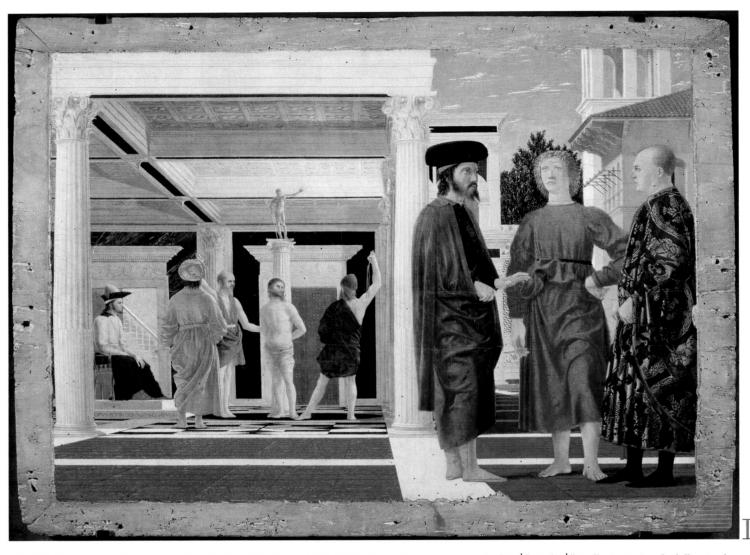

16-43 Piero della Francesca, Flagellation of Christ, ca. 1455–1465. Oil and tempera on wood, 1' $11\frac{1}{8}'' \times 2'$ $8\frac{1}{4}''$. Galleria Nazionale delle Marche, Urbino.

The identification of the foreground figures continues to elude scholars. They appear to discuss the biblical tragedy that takes place in Pilate's palace (FIG. 16-1), which Piero rendered in perfect perspective.

FLAGELLATION Piero's most enigmatic painting is Flagellation of Christ (FIG. 16-43), a small panel painting perhaps also produced for Federico da Montefeltro. The setting for the New Testament drama is the portico of Pontius Pilate's palace in Jerusalem. Curiously, the focus of the composition is not Christ but the group of three large figures in the foreground, whose identity scholars still debate. Some have identified the bearded figure as a Turk and interpreted the painting as a commentary on the capture in 1453 of Christian Constantinople by the Muslims (see Chapter 9). Other scholars, however, identify the three men as biblical figures, including the Old Testament's King David, one of whose psalms theologians believed predicted the conspiracy against Christ. In any case, the three men appear to discuss the event in the background. As Pilate, the seated judge, watches, Christ, bound to a column topped by a classical statue, is about to be whipped (FIG. 16-1). Piero's perspective is so meticulous that the floor pattern can be reconstructed perfectly as a central porphyry (purple marble) circle with surrounding squares composed of various geometric shapes. Whatever the solution is to the iconographical puzzle of Piero's Flagellation, the panel reveals a mind cultivated by mathematics. The careful delineation of the setting suggests an architect's vision, certainly that of a man entirely familiar with compass and straightedge.

Piero planned his compositions almost entirely by his sense of the exact and lucid structures defined by mathematics. He believed that the highest beauty resides in forms that have the clarity and purity of geometric figures. Toward the end of his long career, Piero, a skilled geometrician, wrote the first theoretical treatise on systematic perspective, after having practiced the art with supreme mastery for almost a lifetime. His association with the architect Alberti at Ferrara and at Rimini around 1450–1451 probably turned his attention fully to perspective (a science in which Alberti was an influential pioneer) and helped determine his later, characteristically architectonic compositions. This approach appealed to Federico, a patron fascinated by architectural space and its depiction.

Mantua

Marquis Ludovico Gonzaga (1412–1478) ruled the court of Mantua in northeastern Italy (MAP 14-1). A famed condottiere like Federico da Montefeltro, Gonzaga established his reputation as a fierce military general while commanding the Milanese armies. The visit of Pope Pius II (r. 1458–1464) to Mantua in 1459 stimulated the marquis's determination to transform Mantua into a city that all Italy would envy.

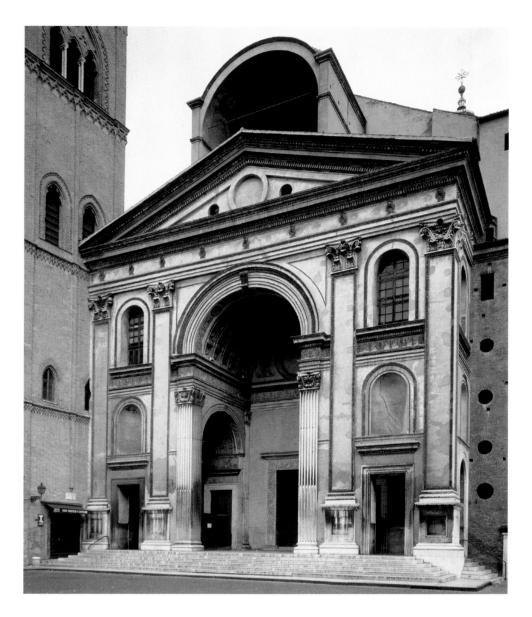

16-44 LEON BATTISTA ALBERTI, west facade of Sant'Andrea, Mantua, Italy, designed 1470, begun 1472.

Alberti's design for Sant'Andrea reflects his study of ancient Roman architecture. Employing a colossal order, the architect locked together a triumphal arch and a Roman temple front with pediment.

SANT'ANDREA One of the major projects Gonzaga instituted was the redesigning of the church of Sant'Andrea to replace an 11th-century church. Gonzaga turned to the renowned architect Leon Battista Alberti for this important commission. The facade (FIG. 16-44) Alberti designed locked together two complete ancient Roman architectural motifs—the temple front and the triumphal arch. The combination was already a familiar feature of Roman buildings still standing in Italy. For example, many triumphal arches incorporated a pediment over the arcuated passageway and engaged columns, but there is no close parallel in antiquity for Alberti's eclectic and

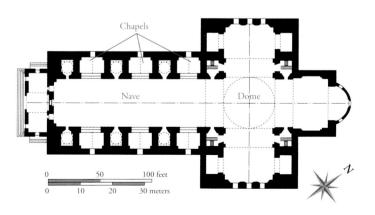

ingenious design. The Renaissance architect's concern for proportion led him to equalize the vertical and horizontal dimensions of the facade, which left it considerably shorter than the church behind it. Because of the primary importance of visual appeal, many Renaissance architects made this concession not only to the demands of a purely visual proportionality in the facade but also to the facade's relation to the small square in front of it, even at the expense of continuity with the body of the building. Yet structural correspondences to the building do exist in Sant'Andrea's facade. The pilasters are the same height as those on the nave's interior walls, and the central barrel vault over the main exterior entrance, with smaller barrel vaults branching off at right angles, introduces on a smaller scale the arrangement of the nave and aisles (FIG. 16-45). The facade pilasters, as part of the wall, run uninterrupted through three stories in an early application of the colossal or giant order that became a favorite motif of Michelangelo.

16-45 LEON BATTISTA ALBERTI, plan of Sant'Andrea, Mantua, Italy, designed 1470, begun 1472.

In his architectural treatise, Alberti criticized the traditional basilican plan as impractical and designed Sant'Andrea as a single huge hall with independent chapels branching off at right angles.

16-46 Leon Battista Alberti, interior of Sant'Andrea (looking northeast), Mantua, Italy, designed 1470, begun 1472.

Alberti abandoned the medieval columnar arcade for the nave of Sant'Andrea. The tremendous vaults suggest that he may have been inspired by Constantine's Basilica Nova (FIG. 7-78) in Rome.

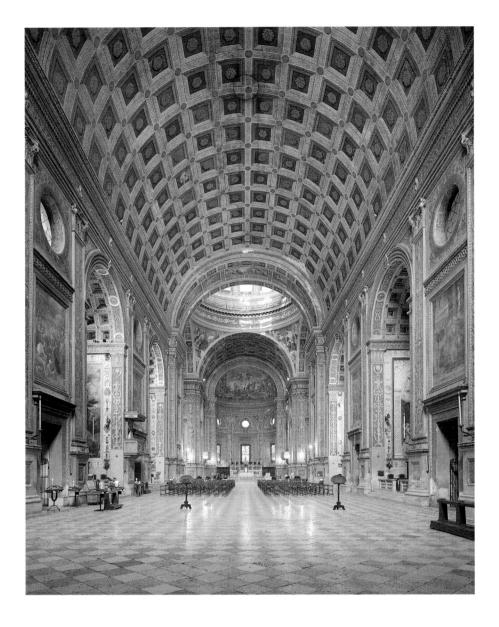

The tremendous vaults in the interior of Sant'Andrea suggest that Alberti's model may have been Constantine's Basilica Nova (FIG. 7-78) in Rome—erroneously thought in the Middle Ages and Renaissance to be a Roman temple. Consistent with his belief that arches should not be used with freestanding columns, Alberti abandoned the medieval columned arcade Brunelleschi still used in Santo Spirito (FIG. 16-31). Thick walls alternating with vaulted chapels, interrupted by a massive dome over the crossing, support the huge coffered barrel vault. Because Filippo Juvara (1678–1736) added the present dome in the 18th century, the effect may be somewhat different from what Alberti planned. Regardless, the vault calls to mind the vast interior spaces and dense enclosing masses of Roman architecture. In his treatise, Alberti criticized the traditional basilican plan (with continuous aisles flanking the central nave) as impractical because the colonnades conceal the ceremonies from the faithful in the aisles. For this reason, he designed a single huge hall (FIG. 16-46) with independent chapels branching off at right angles. This break with a Christian building tradition that had endured for a thousand years was extremely influential in later Renaissance and Baroque church planning.

ANDREA MANTEGNA Like other princes, Ludovico Gonzaga believed an impressive palace was an important visual expres-

sion of his authority. One of the most spectacular rooms in the Palazzo Ducale (Ducal Palace) is the duke's bedchamber and audience hall, the so-called Camera degli Sposi (Room of the Newlyweds), originally the Camera Picta (Painted Room; FIGS. 16-47 and 16-48). Andrea Mantegna (ca. 1431–1506) of Padua, near Venice, took almost nine years to complete the extensive fresco program in which he sought to aggrandize Ludovico Gonzaga and his family. The particulars of each scene are still a matter of scholarly debate, but any viewer standing in the Camera Picta surrounded by the spectacle and majesty of courtly life cannot help but be thoroughly impressed by both the commanding presence and elevated status of the patron and the dazzling artistic skills of Mantegna.

In the Camera Picta, Mantegna performed a triumphant feat by producing the first completely consistent illusionistic decoration of an entire room. By integrating real and painted architectural elements, Mantegna dissolved the room's walls in a manner that fore-told later Baroque decoration (see Chapter 19). It recalls the efforts of Italian painters more than 15 centuries earlier at Pompeii and elsewhere to merge mural painting and architecture in frescoes of the so-called Second Style of Roman painting (FIGS. 7-18 and 7-19). Mantegna's *trompe l'oeil* (French, "deceives the eye") design, however, went far beyond anything preserved from ancient Italy.

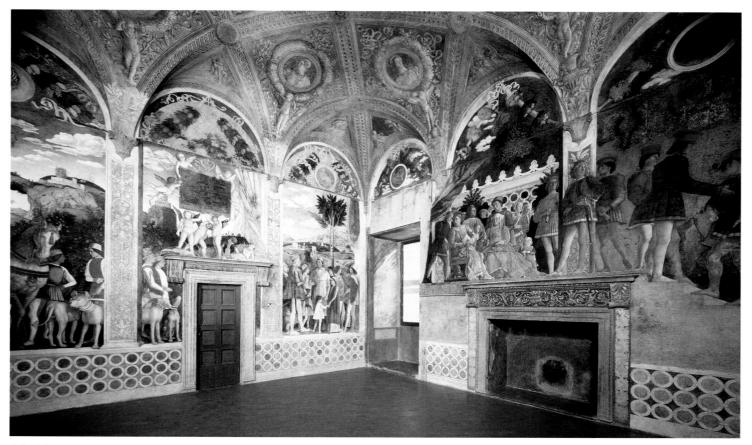

16-47 Andrea Mantegna, interior of the Camera Picta (Painted Chamber), Palazzo Ducale, Mantua, Italy, 1465-1474.

Working for Ludovico Gonzaga, who established Mantua as a great art city, Mantegna produced for the duke's palace the first completely consistent illusionistic fresco decoration of an entire room.

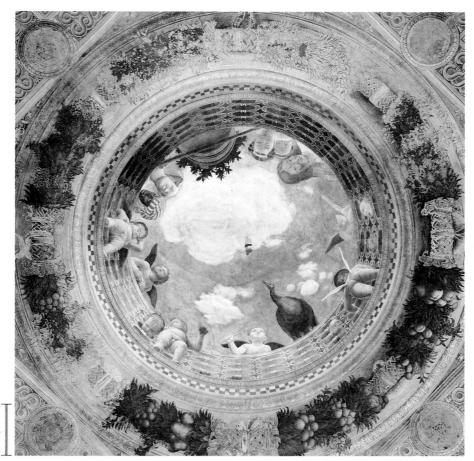

The Renaissance painter's daring experimentalism led him to complete the room's decoration with the first perspective of a ceiling (FIG. 16-48) seen from below (called, in Italian, di sotto in sù, "from below upward"). Baroque ceiling decorators later broadly developed this technique. Inside the Camera Picta, the viewer becomes the viewed as figures look down into the room from the painted oculus ("eye"). Seen against the convincing illusion of a cloud-filled blue sky, several putti (cupids), strongly foreshortened, set the amorous mood of the Room of the Newlyweds, as the painted spectators (who are not identified) smile down on the scene. The prominent peacock is an attribute of Juno, Jupiter's bride, who oversees lawful marriages. This brilliant feat of illusionism climaxes almost a century of experimentation with perspective.

16-48 Andrea Mantegna, ceiling of the Camera Picta (Painted Chamber), Palazzo Ducale, Mantua, Italy, 1465–1474. Fresco, 8′ 9″ in diameter.

Inside the Camera Picta, the viewer becomes the viewed as figures look down into the room from a painted oculus opening onto a blue sky. This is the first perspectival view of a ceiling from below.

16-49 Andrea Mantegna, Foreshortened Christ, ca. 1500. Tempera on canvas, $2' \, 2\frac{3}{4}'' \times 2' \, 7\frac{7}{8}''$. Pinacoteca di Brera, Milan. In this work of overwhelming emotional power, Mantegna presented both a harrowing study of a strongly foreshortened cadaver and an intensely poignant depiction of a biblical tragedy.

FORESHORTENED CHRIST One of Mantegna's later paintings (FIG. **16-49**) is another example of the artist's mastery of perspective. In fact, Mantegna seems to have set up for himself difficult problems in perspective simply for the joy in solving them. The painting popularly known as *Dead Christ*, but recorded under the name *Foreshortened Christ* at the time of Mantegna's death, is a work of overwhelming power. At first glance, as its 16th-century title implies, this painting seems to be a strikingly realistic study in foreshortening. Careful scrutiny, however, reveals that Mantegna reduced

the size of the figure's feet, which, as he must have known, would cover much of the body if properly represented. Thus, tempering naturalism with artistic license, Mantegna presented both a harrowing study of a strongly foreshortened cadaver and an intensely poignant depiction of a biblical tragedy. The painter's harsh, sharp line seems to cut the surface as if it were metal and conveys, by its grinding edge, the theme's corrosive emotion. Remarkably, in the hands of Andrea Mantegna all the scientific learning of the 15th century serves the purpose of devotion.

ITALY, 1400 TO 1500

FLORENCE

- The fortunate congruence of artistic genius, the spread of humanism, and economic prosperity nourished the flowering of the new artistic culture that historians call the Renaissance—the rebirth of classical values in art and life. The greatest center of Renaissance art in the 15th century was Florence, home of the powerful Medici, who were among the most ambitious art patrons in history.
- Some of the earliest examples of the new Renaissance style in sculpture are the statues Nanni di Banco and Donatello made for the facade niches of Or San Michele. Donatello's Saint Mark reintroduced the classical concept of contrapposto into Renaissance statuary. His later David was the first nude male statue since antiquity. Donatello was also a pioneer in relief sculpture, the first to incorporate the principles of linear and atmospheric perspective, devices also employed brilliantly by Lorenzo Ghiberti in his Gates of Paradise for the Florence baptistery.
- The Renaissance interest in classical culture naturally also led to the revival of Greco-Roman mythological themes in art, for example, Antonio del Pollaiuolo's *Hercules and Antaeus*, and to the revival of equestrian portraits, such as Donatello's *Gattamelata* and Andrea del Verrocchio's *Bartolommeo Colleoni*.
- Although some painters continued to work in the Late Gothic International Style, others broke fresh ground by exploring new modes of representation. Masaccio's figures recall Giotto's but have a greater psychological and physical credibility, and the light shining on Masaccio's figures comes from a source outside the picture. His Holy Trinity epitomizes Early Renaissance painting in its convincing illusionism, achieved through Filippo Brunelleschi's new science of linear perspective, yet it remains effective as a devotional painting in a church setting.
- The secular side of 15th-century Italian painting is on display in historical works, such as Paolo Uccello's *Battle of San Romano* and Domenico Ghirlandaio's portrait *Giovanna Tornabuoni*. The humanist love of classical themes comes to the fore in the works of Sandro Botticelli, whose lyrical *Primavera* and *Birth of Venus* were inspired by contemporaneous poetry and scholarship.
- Italian architects also revived the classical style. Brunelleschi's Santo Spirito showcases the clarity and Roman-inspired rationality of 15th-century Florentine architecture. The model for Leon Battista Alberti's influential treatise *On the Art of Building* was a similar work by the ancient Roman architect Vitruvius.

THE PRINCELY COURTS

- Although Florentine artists led the way in creating the Renaissance in art and architecture, the papacy in Rome and the princely courts in Urbino, Mantua, and elsewhere also were major art patrons.
- Among the important papal commissions of the 15th century was the decoration of the walls of the Sistine Chapel with frescoes, including Perugino's *Christ Delivering the Keys of the Kingdom to Saint Peter*, a prime example of linear perspective.
- Under the patronage of Federico da Montefeltro, Urbino became a major center of Renaissance art and culture. The leading painter in Federico's employ was Piero della Francesca, a master of color and light and the author of the first theoretical treatise on perspective.
- Mantua became an important art center under Marquis Ludovico Gonzaga, who brought in Alberti to rebuild the church of Sant'Andrea. Alberti applied the principles he developed in his architectural treatise to the project and freely adapted forms from Roman religious, triumphal, and civic architecture.
- Gonzaga hired Andrea Mantegna to decorate the Camera Picta of his Ducal Palace, in which the painter produced the first completely consistent illusionistic decoration of an entire room.

Donatello, Saint Mark, ca. 1411-1413

Masaccio, Holy Trinity, ca. 1424-1427

Brunelleschi, Santo Spirito, Florence, designed 1434–1436

Perugino, Christ Delivering the Keys to Saint Peter, 1481–1483

Alberti, Sant'Andrea, Mantua, designed 1470

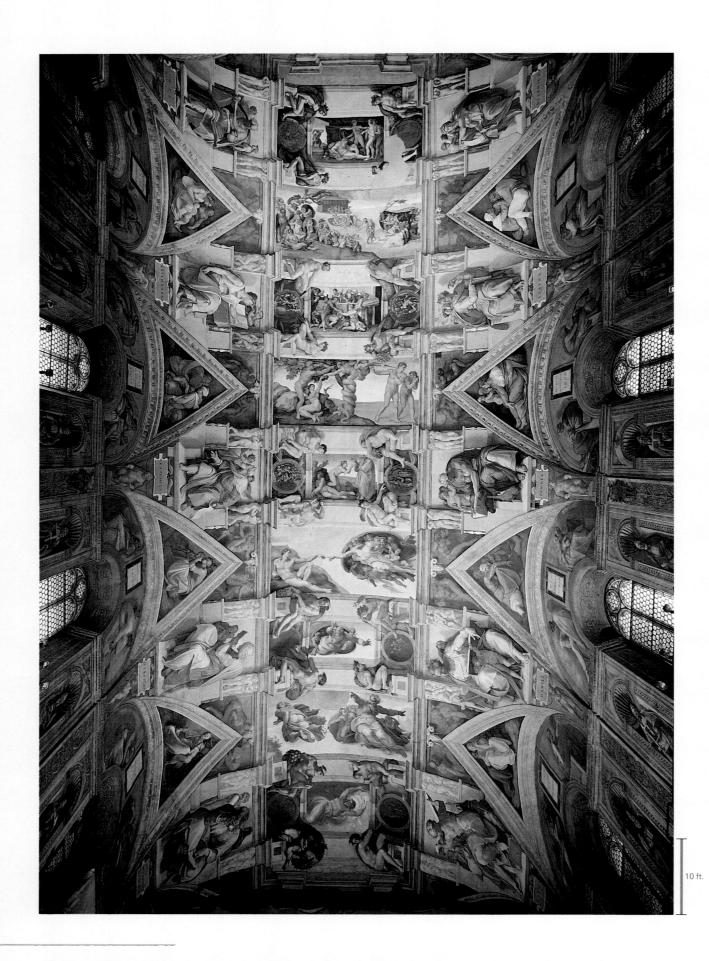

17-1 Michelangelo Buonarroti, ceiling of the Sistine Chapel, Vatican City, Rome, Italy, 1508–1512. Fresco, $128' \times 45'$.

Michelangelo, the Renaissance genius who was also a sculptor and architect, labored almost four years in the Sistine Chapel painting more than 300 biblical figures illustrating the creation and fall of humankind.

ITALY, 1500 TO 1600

The 15th-century artistic developments in Italy (for example, the interest in perspective, anatomy, and classical cultures) matured during the early 16th century in the brief era that art historians call the High Renaissance—the period between 1495 and the deaths of Leonardo da Vinci in 1519 and Raphael in 1520. The Renaissance style, however, dominated the remainder of the 16th century (the Late Renaissance), although a new style, called Mannerism, challenged it almost as soon as Raphael had been laid to rest (in the ancient Roman Pantheon, FIG. 7-51). Thus, no singular artistic style characterizes 16th-century Italy. Nonetheless, Italian art of this period uniformly exhibits an astounding mastery, both technical and aesthetic.

HIGH AND LATE RENAISSANCE

The High Renaissance produced a cluster of extraordinary geniuses and found in divine inspiration the rationale for the exaltation of the artist-genius. The Neo-Platonists read in Plato's *Ion* his famous praise of the poet: "All good poets . . . compose their beautiful poems not by art, but because they are inspired and possessed. . . . For not by art does the poet sing, but by power divine." And what the poet could claim, the Renaissance claimed also, raising visual art to the status formerly held only by poetry. Thus, painters, sculptors, and architects came into their own, successfully advocating for their work a high place among the fine arts. During the High Renaissance, the masters in essence created a new profession, one having its own rights of expression, its own venerable character, and its own claims to recognition by the great. The "fine" artist today lives, often without realizing it, on the accumulated prestige won by preceding artists, beginning with those who made the first great gains of the High Renaissance.

As in many other artistic eras, regional differences abounded in the 16th century, not only between Northern Europe (discussed in Chapter 18) and Italy but within Italy itself. The leading artistic centers of Central Italy were Florence and Rome, where three of the greatest artists who ever lived—Leonardo da Vinci, Raphael, and Michelangelo—created works whose appeal has endured for 500 years.

Leonardo da Vinci

Born in the small town of Vinci, near Florence, Leonardo da Vinci (1452-1519) trained in the studio of Andrea del Verrocchio (FIG. 16-13). The quintessential "Renaissance man," Leonardo had prodigious talent and an unbridled imagination. Art was but one of his innumerable interests. The scope and depth of these interests were without precedent—so great as to frustrate any hopes Leonardo might have had of realizing all that his extraordinarily inventive mind could conceive. Still, he succeeded in mapping the routes that both art and science were to take for generations. Although the discussion here focuses on Leonardo as an artist, exploring his art in conjunction with his other pursuits considerably enhances an understanding of his artistic production. Leonardo revealed his unquenchable curiosity in his voluminous notes, liberally interspersed with sketches dealing with botany, geology, geography, cartography, zoology, military engineering, animal lore, anatomy, and aspects of physical science, including hydraulics and mechanics. These studies informed his art. In his notes, he stated repeatedly that all his scientific investigations made him a better painter. For example, Leonardo's in-depth exploration of optics gave him an understanding of perspective, light, and color. His scientific drawings (FIG. 17-6) are themselves artworks.

Leonardo's great ambition in his painting, as well as in his scientific endeavors, was to discover the laws underlying the processes and flux of nature. With this end in mind, he also studied the human body and contributed immeasurably to the fields of physiology and psychology. Leonardo believed that reality in an absolute sense was inaccessible and that humans could know it only through its changing images. He considered the eyes the most vital organs and sight the most essential function. Better to be deaf than blind, he argued, because through the eyes individuals could grasp reality most directly and profoundly.

Around 1481, Leonardo left Florence after offering his services to Ludovico Sforza (1451–1508), the son and heir apparent of the ruler of Milan. The political situation in Florence was uncertain, and Leonardo may have felt that his particular skills would be in greater demand in Milan, providing him with the opportunity for increased financial security. He devoted most of a letter to Ludovico to advertising his competence and his qualifications as a military engineer, mentioning only at the end his abilities as a painter and sculptor. The letter illustrates the relationship between Renaissance artists and their patrons, as well as Leonardo's breadth of competence. That he should select expertise in military engineering as his primary attraction to the Sforzas is an index of the period's instability.

And in short, according to the variety of cases, I can contrive various and endless means of offence and defence. . . . In time of peace I believe I can give perfect satisfaction and to the equal of any other in architecture and the composition of buildings, public and private; and in guiding water from one place to another. . . . I can carry out sculpture in marble, bronze, or clay, and also I can do in painting whatever may be done, as well as any other, be he whom he may.²

Ludovico accepted Leonardo's offer, and the Florentine artist remained in Milan for almost 20 years.

MADONNA OF THE ROCKS Shortly after settling in Milan, Leonardo painted Madonna of the Rocks (FIG. 17-2) as the central panel of an altarpiece for the chapel of the Confraternity of the Immaculate Conception in San Francesco Grande. The painting builds on Masaccio's understanding and usage of chiaroscuro, the subtle play of light and dark. Modeling with light and shadow and expressing emotional states were, for Leonardo, the heart of painting:

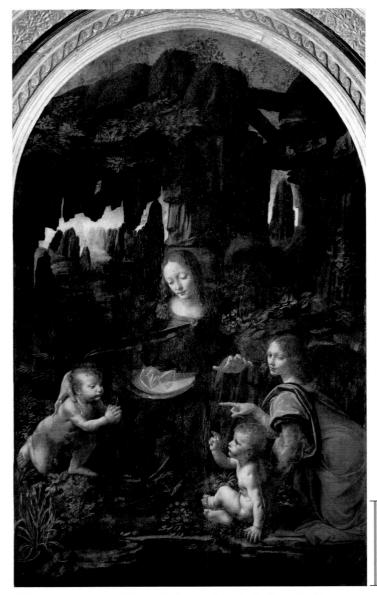

17-2 Leonardo da Vinci, *Madonna of the Rocks*, from San Francesco Grande, Milan, Italy, begun 1483. Oil on wood (transferred to canvas), $6' 6\frac{1}{2}'' \times 4'$. Louvre, Paris.

In this groundbreaking work, Leonardo used gestures and a pyramidal composition to unite the Virgin, Saint John the Baptist, the Christ Child, and an angel. The figures share the same light-infused environment.

A good painter has two chief objects to paint—man and the intention of his soul. The former is easy, the latter hard, for it must be expressed by gestures and the movement of the limbs.... A painting will only be wonderful for the beholder by making that which is not so appear raised and detached from the wall.³

Leonardo presented the figures in *Madonna of the Rocks* in a pyramidal grouping and, more notably, as sharing the same environment. This groundbreaking achievement—the unified representation of objects in an atmospheric setting—was a manifestation of his scientific curiosity about the invisible substance surrounding things. The Madonna, Christ Child, infant John the Baptist, and angel emerge through nuances of light and shade from the half-light of the cavernous visionary landscape. Light simultaneously veils and reveals the forms, immersing them in a layer of atmosphere. Leonardo's

Renaissance Drawings

n the 16th century in Italy, drawing (or *disegno*) assumed a position of greater prominence than ever before in artistic production. Until the late 15th century, the expense of drawing surfaces and their lack of availability limited the production of preparatory sketches. Most artists drew on parchment (prepared from the skins of calves, sheep, and goats) or on vellum (made from the skins of young animals and therefore very expensive). Because of the cost of these materials, drawings in the 14th and 15th centuries tended to be extremely detailed and meticulously executed. Artists often drew using silverpoint (a stylus made of silver) because of the fine line it produced and the sharp point it maintained. The introduction in the late 15th century of less expensive paper made of fibrous pulp produced for the developing printing industry (see "Woodcuts, Engravings, and Etchings," Chapter 15, page 415) allowed artists to experiment more and to draw with greater freedom. As a result, sketches abounded. Artists executed these drawings in pen and ink (FIG. 17-6), chalk, charcoal (FIG. 17-3), brush, and graphite or lead.

The importance of drawing transcended the mechanical or technical possibilities it afforded artists, however. The term *disegno* referred also to design, an integral component of good art. Design was the foundation of art, and drawing was the fundamental element of design. The painter Federico Zuccaro (1542–1609) summed up this philosophy when he stated that drawing is the external physical manifestation (*disegno esterno*) of an internal intellectual idea or design (*disegno interno*).

The design dimension of art production became increasingly important as artists cultivated their own styles. The early stages of artistic training largely focused on imitation and emulation (see "Cennino Cennini on Imitation and Emulation," Chapter 16, page 431), but to achieve widespread recognition, artists had to develop their own styles. Although the artistic community and public at large acknowledged technical skill, the conceptualization of the artwork—its theoretical and formal development—was paramount. Disegno—or design in this case—represented an artist's conception and intention. In the literature of the period, the terms writers and critics often invoked to praise esteemed artists included *invenzione* (invention), *ingegno* (innate talent), *fantasia* (imagination), and *capriccio* (originality).

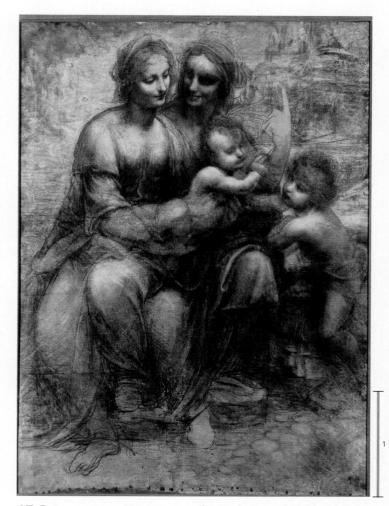

17-3 Leonardo da Vinci, cartoon for *Madonna and Child with Saint Anne and the Infant Saint John*, ca. 1505–1507. Charcoal heightened with white on brown paper, $4' 6'' \times 3' 3''$. National Gallery, London.

The introduction of less expensive paper in the late 15th century allowed artists to draw more frequently. In this cartoon, Leonardo depicted monumental figures in a scene of tranquil grandeur and balance.

effective use of atmospheric perspective is the result in large part of his mastery of the relatively new medium of oil painting, which had previously been used mostly by Northern European painters (see "Tempera and Oil Painting," Chapter 15, page 401). The figures pray, point, and bless, and these acts and gestures, although their meanings are not certain, visually unite the individuals portrayed. The angel points to the infant John and, through his outward glance, involves the viewer in the tableau. John prays to the Christ Child, who blesses him in return. The Virgin herself completes the series of interlocking gestures, her left hand reaching toward the Christ Child and her right hand resting protectively on John's shoulder. The melting mood of tenderness, which the caressing light enhances, suffuses the entire composition. By creating an emotionally compelling, visually unified, and spatially convincing image, Leonardo succeeded in expressing "the intention of his soul."

MADONNA AND CHILD CARTOON Leonardo's style fully emerges in Madonna and Child with Saint Anne and the Infant Saint John (FIG. 17-3), a preliminary drawing for a painting (see "Renaissance Drawings," above) he made in 1505 or shortly thereafter. Here, the glowing light falls gently on the majestic forms in a scene of tranquil grandeur and balance. Leonardo ordered every part of his cartoon with an intellectual pictorial logic that results in an appealing visual unity. The figures are robust and monumental, the stately grace of their movements reminiscent of the Greek statues of goddesses (FIG. 5-49) in the pediments of the Parthenon. Leonardo's infusion of the principles of classical art into his designs, however, cannot be attributed to specific knowledge of Greek monuments. He and his contemporaries never visited Greece. Their acquaintance with classical art extended only to Etruscan and Roman monuments and Roman copies of Greek statues in Italy.

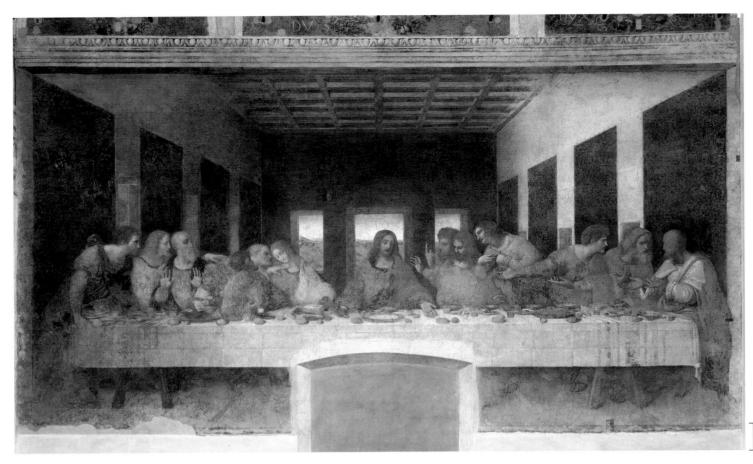

17-4 Leonardo da Vinci, *Last Supper*, ca. 1495–1498. Oil and tempera on plaster, 13' $9'' \times 29'$ 10''. Refectory, Santa Maria delle Grazie, Milan.

Christ has just announced that one of his disciples will betray him, and each one reacts. Christ is both the psychological focus of Leonardo's fresco and the focal point of all the converging perspective lines.

LAST SUPPER For the refectory of the church of Santa Maria delle Grazie in Milan, Leonardo painted Last Supper (FIG. 17-4). Cleaned and restored in 1999, the mural is still in a poor state, in part because of the painter's unfortunate experiments with his materials (see "Restoring Renaissance Paintings," page 473). Nonetheless, the painting is both formally and emotionally Leonardo's most impressive work. Christ and his 12 disciples sit at a long table placed parallel to the picture plane in a simple, spacious room. The austere setting amplifies the painting's highly dramatic action. Christ, with outstretched hands, has just said, "One of you is about to betray me" (Matt. 26:21). A wave of intense excitement passes through the group as each disciple asks himself and, in some cases, his neighbor, "Is it I?" (Matt. 26:22). Leonardo visualized a sophisticated conjunction of the dramatic "One of you is about to betray me" with the initiation of the ancient liturgical ceremony of the Eucharist, when Christ, blessing bread and wine, said, "This is my body, which is given for you. Do this for a commemoration of me. . . . This is the chalice, the new testament in my blood, which shall be shed for you" (Luke 22:19-20).

In the center, Christ appears isolated from the disciples and in perfect repose, the calm eye of the stormy emotion swirling around him. The central window at the back, whose curved pediment arches above his head, frames his figure. The pediment is the only curve in the architectural framework, and it serves here, along with the diffused light, as a halo. Christ's head is the focal point of all converging perspective lines in the composition. Thus, the still, psychological

focus and cause of the action is also the perspectival focus, as well as the center of the two-dimensional surface. The two-dimensional, the three-dimensional, and the psychodimensional focuses are the same.

Leonardo presented the agitated disciples in four groups of three, united among and within themselves by the figures' gestures and postures. The artist sacrificed traditional iconography to pictorial and dramatic consistency by placing Judas on the same side of the table as Jesus and the other disciples (compare FIG. 16-22). The light source in the painting corresponds to the windows in the Milanese refectory. Judas's face is in shadow and he clutches a money bag in his right hand as he reaches his left forward to fulfill the Master's declaration: "But yet behold, the hand of him that betrayeth me is with me on the table" (Luke 22:21). The two disciples at the table ends are quieter than the others, as if to bracket the energy of the composition, which is more intense closer to Christ, whose serenity both halts and intensifies it. The disciples register a broad range of emotional responses, including fear, doubt, protestation, rage, and love. Leonardo's numerous preparatory studies—using live models—suggest that he thought of each figure as carrying a particular charge and type of emotion. Like a stage director, he read the Gospel story carefully, and scrupulously cast his actors as the New Testament described their roles. In this work, as in his other religious paintings, Leonardo revealed his extraordinary ability to apply his voluminous knowledge about the observable world to the pictorial representation of a religious scene, resulting in a psychologically complex and compelling painting.

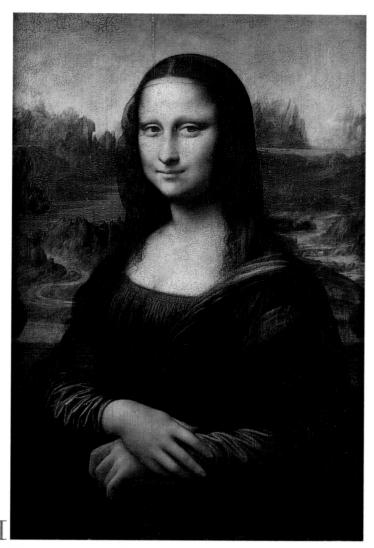

17-5 Leonardo da Vinci, *Mona Lisa*, ca. 1503–1505. Oil on wood, 2′ $6\frac{1}{4}'' \times 1′$ 9″. Louvre, Paris.

Leonardo's skill with chiaroscuro and atmospheric perspective is on display in this new kind of portrait depicting the sitter as an individual personality who engages the viewer psychologically.

MONA LISA Leonardo's Mona Lisa (FIG. 17-5) is probably the world's most famous portrait. The sitter's identity is still the subject of scholarly debate, but in his biography of Leonardo, Giorgio Vasari asserted she was Lisa di Antonio Maria Gherardini, the wife of Francesco del Giocondo, a wealthy Florentine-hence, "Mona (an Italian contraction of ma donna, "my lady") Lisa." Despite the uncertainty of this identification, Leonardo's portrait is a convincing representation of an individual. Unlike earlier portraits, it does not serve solely as an icon of status. Indeed, Mona Lisa neither wears jewelry nor holds any attribute associated with wealth. She sits quietly, her hands folded, her mouth forming a gentle smile, and her gaze directed at the viewer. Renaissance etiquette dictated that a woman should not look directly into a man's eyes. Leonardo's portrayal of this self-assured young woman without the trappings of power but engaging the audience psychologically is thus quite remarkable. The painting is darker today than 500 years ago, and the colors are less vivid, but Mona Lisa still reveals the artist's fascination and skill with chiaroscuro and atmospheric perspective. Mona Lisa is a prime example of Leonardo's famous smoky sfumato (misty haziness)—his subtle adjustment of light and blurring of precise planes.

The lingering appeal of *Mona Lisa* derives in large part from Leonardo's decision to set his subject against the backdrop of a mysterious uninhabited landscape. This landscape, with roads and bridges that seem to lead nowhere, recalls his *Madonna of the Rocks* (FIG. 17-2). The composition also resembles Fra Filippo Lippi's *Madonna and Child with Angels* (FIG. 16-23) with figures seated in front of a window through which the viewer sees a distant landscape. Originally, the artist represented Mona Lisa in a *loggia* (columnar gallery). When the painting was trimmed (not by Leonardo), these columns were eliminated, but the remains of the column bases may still be seen to the left and right of Mona Lisa's shoulders.

ANATOMICAL STUDIES Leonardo completed very few paintings. His perfectionism, relentless experimentation, and far-ranging curiosity diffused his efforts. However, the drawings in his notebooks preserve an extensive record of his ideas. His interests focused increasingly on science in his later years, and he embraced knowledge of all facets of the natural world. His investigations in anatomy yielded drawings of great precision and beauty of execution. *The Fetus and Lining of the Uterus* (FIG. 17-6), although it does not meet 21st-century standards for accuracy (for example, Leonardo regularized the uterus's shape to a sphere, and his characterization of the

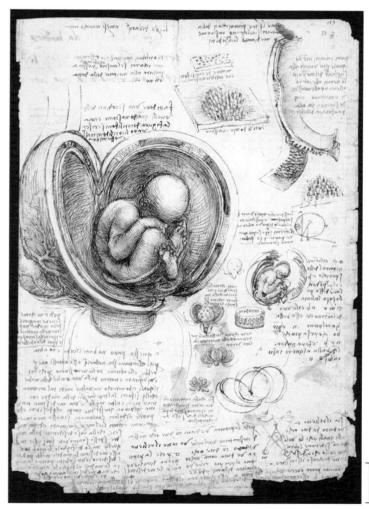

17-6 LEONARDO DA VINCI, *The Fetus and Lining of the Uterus*, ca. 1511–1513. Pen and ink with wash, over red chalk and traces of black chalk on paper, $1' \times 8\frac{5}{8}"$. Royal Library, Windsor Castle.

Leonardo's analytical anatomical studies epitomize the scientific spirit of the Renaissance, establishing that era as a prelude to the modern world and setting it in sharp contrast to the preceding Middle Ages.

17-7 RAPHAEL, *Marriage of the Virgin*, from the Chapel of Saint Joseph, San Francesco, Città di Castello, Italy, 1504. Oil on wood, 5' $7'' \times 3'$ $10\frac{1}{2}''$. Pinacoteca di Brera, Milan.

In this early work depicting the marriage of the Virgin to Saint Joseph, Raphael demonstrated his mastery of foreshortening and of the perspective system he learned from his teacher, Perugino (FIG. 16-40).

lining is incorrect), was an astounding achievement in its day. Analytical anatomical studies such as this epitomize the scientific spirit of the Renaissance, establishing that era as a prelude to the modern world and setting it in sharp contrast to the preceding Middle Ages. Although Leonardo may not have been the first scientist of the modern world (at least not in the modern sense of the term), he certainly originated a method of scientific illustration, especially *cutaway* views. Scholars have long recognized the importance of these drawings for the development of anatomy as a science, especially in an age predating photographic methods such as X-rays.

Leonardo also won renown in his time as both architect and sculptor, although no surviving buildings or sculptures can be definitively attributed to him. From his many drawings of central-plan buildings, it appears he shared the interest of other Renaissance architects in this building type. As for sculpture, Leonardo left numerous drawings of monumental equestrian statues, and also made a full-scale model for a monument to Francesco Sforza (1401–1466; Ludovico's father). The French used the statue as a target and shot it to pieces when they occupied Milan in 1499. Due to the French presence, Leonardo left Milan and served for a while as a military engi-

neer for Cesare Borgia (1476–1507), who, with the support of his father, Pope Alexander VI (r. 1492–1503), tried to conquer the cities of the Romagna region in north-central Italy and create a Borgia duchy. Leonardo eventually returned to Milan in the service of the French. At the invitation of King Francis I (FIG. 18-10), he then went to France, where he died at the château of Cloux in 1519.

Raphael

Alexander VI's successor was Julius II (r. 1503-1513). In addition to his responsibility as the spiritual leader of Christendom, the new pope extended his quest for authority to the temporal realm, as other medieval and Renaissance popes had done. An immensely ambitious man, Julius II indulged his enthusiasm for engaging in battle, which earned him a designation as the "warrior-pope." Further, his selection of the name Julius, after Julius Caesar, reinforced the perception that the Roman Empire served as his governmental model. Julius II's 10year papacy, however, was most notable for his contributions to the arts. He was an avid art patron and understood well the propagandistic value of visual imagery. After his election, he immediately commissioned artworks that would present an authoritative image of his rule and reinforce the primacy of the Catholic Church. Among the many projects he commissioned were a new design for Saint Peter's basilica (FIGS. 17-23 and 17-24), the painting of the Sistine Chapel ceiling (FIG. 17-1), the decoration of the papal apartments (FIG. 17-9), and the construction of his tomb (FIGS. 17-15 and 17-16).

17-8 RAPHAEL, *Madonna in the Meadow*, 1505–1506. Oil on wood, $3' \ 8\frac{1}{2}'' \times 2' \ 10\frac{1}{4}''$. Kunsthistorisches Museum, Vienna.

Emulating Leonardo's pyramidal composition (FIG. 17-2) but rejecting his dusky modeling and mystery, Raphael set his Madonna in a well-lit landscape and imbued her with grace, dignity, and beauty.

17-9 RAPHAEL, Philosophy (School of Athens), Stanza della Segnatura, Vatican Palace, Rome, Italy, 1509–1511. Fresco, 19' × 27'.

Raphael included himself in this gathering of great philosophers and scientists whose self-assurance conveys calm reason. The setting resembles the interior of the new Saint Peter's (FIG. 19-5).

In 1508, Julius II called Raffaello Santi (or Sanzio), known as Raphael (1483–1520) in English, to the papal court in Rome. Born in a small town in Umbria near Urbino, Raphael probably learned the rudiments of his art from his father, Giovanni Santi, a painter connected with the ducal court of Federico da Montefeltro (see Chapter 16), before entering the studio of Perugino in Perugia. Although strongly influenced by Perugino, Leonardo, and others, Raphael developed an individual style that exemplifies the ideals of High Renaissance art.

MARRIAGE OF THE VIRGIN Among Raphael's early works is Marriage of the Virgin (FIG. 17-7), which he painted for the Chapel of Saint Joseph in the church of San Francesco in Città di Castello, southeast of Florence. The subject is a fitting one for a chapel dedicated to Saint Joseph. According to the Golden Legend (a 13th-century collection of stories about the lives of the saints), Joseph competed with other suitors for Mary's hand. The high priest was to give the Virgin to whichever suitor presented to him a rod that had miraculously bloomed. Raphael depicted Joseph with his flowering rod in his left hand. In his right hand Joseph holds the wedding ring he is about to place on Mary's finger. Other virgins congregate at the left, and the unsuccessful suitors stand on the right. One of them breaks his rod in half over his knee in frustration, giving Raphael an opportunity to demonstrate his mastery of foreshortening. The perspective system he

used is the one he learned from Perugino (FIG. 16-40). The temple in the background is Raphael's version of a centrally planned building (FIG. 17-22), featuring Brunelleschian arcades (FIG. 16-31).

MADONNA IN THE MEADOW Raphael spent the four years from 1504 to 1508 in Florence. There, still in his early 20s, he discovered that the painting style he had learned so painstakingly from Perugino was already outmoded (as was Brunelleschi's architectural style). Florentine crowds flocked to the church of Santissima Annunziata to see Leonardo's recently unveiled cartoon of the Virgin, Christ Child, Saint Anne, and Saint John (probably an earlier version of FIG. 17-3). Under Leonardo's influence, Raphael began to modify the Madonna compositions he had learned in Umbria. In Madonna in the Meadow (FIG. 17-8) of 1505–1506, Raphael adopted Leonardo's pyramidal composition and modeling of faces and figures in subtle chiaroscuro. Yet the Umbrian artist placed the large, substantial figures in a Peruginesque landscape, with his former master's typical feathery trees in the middle ground. Although Raphael experimented with Leonardo's dusky modeling, he tended to return to Perugino's lighter tonalities and blue skies. Raphael preferred clarity to obscurity, not fascinated, as Leonardo was, with mystery.

SCHOOL OF ATHENS Three years after completing Madonna in the Meadow, Raphael received one of the most important painting commissions (FIG. 17-9) Julius II awarded—the decoration of

17-10 RAPHAEL, *Galatea*, Sala di Galatea, Villa Farnesina, Rome, Italy, ca. 1513. Fresco, $9' 8'' \times 7' 5''$.

Based on a poem by Poliziano, Raphael's fresco depicts Galatea fleeing from Polyphemus. The painting, made for the banker Agostino Chigi's private palace, celebrates human beauty and zestful love.

the papal apartments in the Apostolic Palace of the Vatican (MAP 19-1). Of the suite's several rooms (stanze), Raphael painted the Stanza della Segnatura (Room of the Signature—the papal library, where Julius II signed official documents) and the Stanza d'Eliodoro (Room of Heliodorus-the pope's private audience room, named for one of the paintings). His pupils completed the others, following his sketches. On the four walls of the Stanza della Segnatura, under the headings Theology, Law (Justice), Poetry, and Philosophy, Raphael presented images that symbolized and summed up Western learning as Renaissance

society understood it. The frescoes refer to the four branches of human knowledge and wisdom while pointing out the virtues and the learning appropriate to a pope. Given Julius II's desire for recognition as both a spiritual and temporal leader, it is appropriate that the *Theology* and *Philosophy* frescoes face each other. The two images present a balanced picture of the pope—as a cultured, knowledgeable individual and as a wise, divinely ordained religious authority.

In Raphael's *Philosophy* mural (commonly known as *School of Athens*, FIG. 17-9) the setting is not a "school" but a congregation of the great philosophers and scientists of the ancient world. Raphael depicted these luminaries, revered by Renaissance humanists, conversing and explaining their various theories and ideas. The setting is a vast hall covered by massive vaults that recall ancient Roman architecture—and approximate the appearance of the new Saint Peter's (FIG. 19-5) in 1509, when Raphael began the fresco. Colossal statues of Apollo and Athena, patron deities of the arts and of wisdom, oversee the interactions. Plato and Aristotle serve as the central

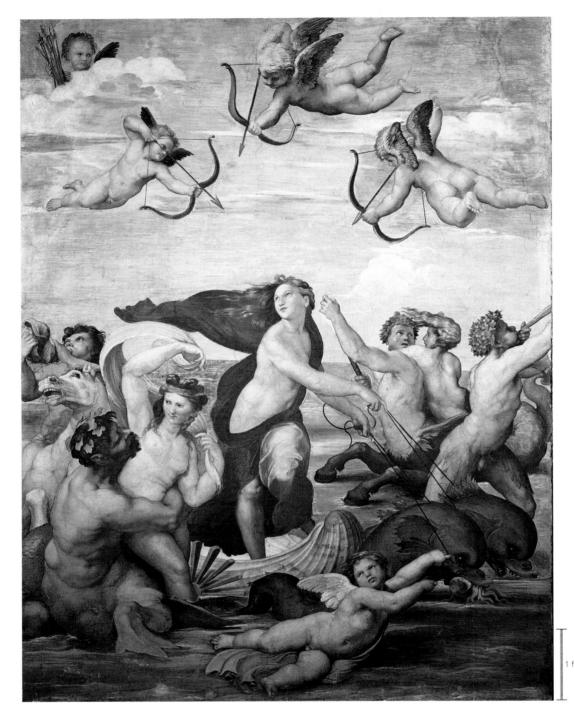

figures around whom Raphael carefully arranged the others. Plato holds his book Timaeus and points to Heaven, the source of his inspiration, while Aristotle carries his book Nicomachean Ethics and gestures toward the earth, from which his observations of reality sprang. Appropriately, ancient philosophers, men concerned with the ultimate mysteries that transcend this world, stand on Plato's side. On Aristotle's side are the philosophers and scientists interested in nature and human affairs. At the lower left, Pythagoras writes as a servant holds up the harmonic scale. In the foreground, Heraclitus (probably a portrait of Raphael's great contemporary, Michelangelo) broods alone. Diogenes sprawls on the steps. At the right, students surround Euclid, who demonstrates a theorem. Euclid may be a portrait of the architect Bramante, whom Julius II had recently commissioned to design a new Saint Peter's (FIGS. 17-23 and 17-24) to replace the Constantinian basilica (FIG. 8-9). At the extreme right, just to the right of the astronomers Zoroaster and Ptolemy, both holding globes, Raphael included his own portrait.

The groups appear to move easily and clearly, with eloquent poses and gestures that symbolize their doctrines and present an engaging variety of figural positions. Their self-assurance and natural dignity convey the very nature of calm reason, that balance and measure the great Renaissance minds so admired as the heart of philosophy. Significantly, in this work Raphael placed himself among the mathematicians and scientists rather than the humanists. Certainly the evolution of pictorial science came to its perfection in *School of Athens*. Raphael's convincing depiction of a vast perspectival space on a two-dimensional surface was the consequence of the union of mathematics with pictorial science, here mastered completely.

The artist's psychological insight matured along with his mastery of the problems of physical representation. All the characters in Raphael's School of Athens, like those in Leonardo's Last Supper (FIG. 17-4), communicate moods that reflect their beliefs, and the artist's placement of each figure tied these moods together. Raphael carefully considered his design devices for relating individuals and groups to one another and to the whole. These compositional elements demand close study. From the center, where Plato and Aristotle stand, Raphael arranged the groups of figures in an ellipse with a wide opening in the foreground. Moving along the floor's perspectival pattern, the viewer's eye penetrates the assembly of philosophers and continues, by way of the reclining Diogenes, up to the here-reconciled leaders of the two great opposing camps of Renaissance philosophy. The perspectival vanishing point falls on Plato's left hand, drawing attention to Timaeus. In the Stanza della Segnatura, Raphael reconciled and harmonized not only the Platonists and Aristotelians but also paganism and Christianity, surely a major factor in his appeal to Julius II.

GALATEA Pope Leo X (r. 1513–1521), the second son of Lorenzo de' Medici, succeeded Julius II as Raphael's patron. Leo was a worldly, pleasure-loving prince who, as a true Medici, spent huge sums on the arts. Raphael moved in the highest circles of the papal court, the star of a brilliant society. He was young, handsome, wealthy, and admired, not only by his followers but also by Rome and all of Italy. Genial, even-tempered, generous, and high-minded, Raphael had a personality that contrasted strikingly with that of the aloof, mysterious Leonardo or the tormented and obstinate Michelangelo (so depicted in *School of Athens*).

The pope was not Raphael's sole patron. Agostino Chigi (1465–1520), an immensely wealthy banker who managed the papal state's financial affairs, commissioned Raphael to decorate his palace on the Tiber River with scenes from classical mythology. Outstanding among the frescoes Raphael painted in the small but splendid Villa Farnesina is Galatea (FIG. 17-10), which Raphael based on Stanzas for the Joust of Giuliano de' Medici by the poet Angelo Poliziano (1454-1494). In Raphael's fresco, Galatea flees on a shell drawn by leaping dolphins as she escapes from her uncouth lover, the Cyclops Polyphemus (painted on another wall by a different artist). Sea creatures and playful cupids surround her. The painting erupts in unrestrained pagan joy and exuberance, an exultant song in praise of human beauty and zestful love. Compositionally, Raphael enhanced the liveliness of the image by arranging the sturdy figures around Galatea in bounding and dashing movements that always return to her as the energetic center. The cupids, skillfully foreshortened, repeat the circling motion. Raphael conceived his figures sculpturally, and Galatea's body—supple, strong, and vigorously in motion—contrasts with Botticelli's delicate, hovering, almost dematerialized Venus (FIG. 16-28) while suggesting the spiraling compositions of Hellenistic statuary (FIG. 5-80). In Galatea, pagan myth presented here in monumental form, in vivacious movement, and

in a spirit of passionate delight—resurrects the naturalistic art and poetry of the classical world.

BALDASSARE CASTIGLIONE Raphael also excelled at portraiture. His subjects were the illustrious scholars and courtiers who surrounded Leo X, among them the pope's close friend Count Baldassare Castiglione (1478-1529), the author of a handbook on genteel behavior. In Book of the Courtier, Castiglione enumerated the attributes of the perfect Renaissance courtier: impeccable character, noble birth, military achievement, classical education, and knowledge of the arts. Castiglione then described a way of life based on cultivated rationality in imitation of the ancients. In Raphael's portrait of the count (FIG. 17-11), Castiglione, splendidly yet soberly garbed, looks directly at the viewer with a philosopher's grave and benign expression, clear-eyed and thoughtful. The figure is in halflength (the lower part with the hands was later cut off) and threequarter view, a pose Leonardo made popular with Mona Lisa (FIG. 17-5). Both portraits exhibit the increasing attention High Renaissance artists paid to the subject's personality and psychic state. The muted and low-keyed tones befit the temper and mood of this reflective middle-aged man—the background is entirely neutral, without the usual landscape or architecture. The head and the hands wonderfully reveal the man, who himself had written so eloquently in Courtier of enlightenment through the love of beauty. This kind of love animated Raphael, Castiglione, and other artists and writers of their age, and Michelangelo's poetry suggests he shared in the widespread appreciation for the beauty found in the natural world.

17-11 Raphael, Baldassare Castiglione, ca. 1514. Oil on canvas, 2' $6\frac{1}{4}$ " \times 2' $2\frac{1}{2}$ ". Louvre, Paris.

Raphael's painting of the famed courtier Count Baldassare Castiglione typifies High Renaissance portraiture in the increasing attention the artist paid to the subject's personality and psychic state.

Leonardo and Michelangelo on Painting versus Sculpture

eonardo da Vinci and Michelangelo each produced work in a variety of artistic media, earning enviable reputations not just as painters and sculptors but as architects and draftsmen as well. The two disagreed, however, on the relative merits of the different media. In particular, Leonardo, with his intellectual and analytical mind, preferred painting to sculpture, which he denigrated as manual labor. In contrast, Michelangelo, who worked in a more intuitive manner, regarded himself primarily as a sculptor. Two excerpts from their writings reveal their positions on the relationship between the two media.

Leonardo da Vinci wrote the following in his so-called *Treatise* on *Painting*:

Painting is a matter of greater mental analysis, of greater skill, and more marvelous than sculpture, since necessity compels the mind of the painter to transform itself into the very mind of nature, to become an interpreter between nature and art. Painting justifies by reference to nature the reasons of the pictures which follow its laws: in what ways the images of objects before the eye come together in the pupil of the eye; which, among objects equal in size, looks larger to the eye; which, among equal colors, will look more or less dark or more or less bright; which, among things at the same depth, looks more or less low; which, among those objects placed at equal height, will look more or less high, and why, among objects placed at various distances, one will appear less clear than the other.

This art comprises and includes within itself all visible things such as colors and their diminution which the poverty of sculpture cannot include. Painting represents transparent objects but the sculptor will show you the shapes of natural objects without artifice. The painter will show you things at different distances with variation of color due to the air lying between the objects and the eye; he shows you mists through which visual images penetrate with difficulty; he shows you rain which discloses within it clouds with mountains

and valleys; he shows the dust which discloses within it and beyond it the combatants who stirred it up; he shows streams of greater or lesser density; he shows fish playing between the surface of the water and its bottom; he shows the polished pebbles of various colors lying on the washed sand at the bottom of rivers, surrounded by green plants; he shows the stars at various heights above us, and thus he achieves innumerable effects which sculpture cannot attain.*

In response, although decades later, Michelangelo wrote these excerpts in a letter to Benedetto Varchi (1502–1565), a Florentine poet best known for his 16-volume history of Florence:

I believe that painting is considered excellent in proportion as it approaches the effect of relief, while relief is considered bad in proportion as it approaches the effect of painting.

I used to consider that sculpture was the lantern of painting and that between the two things there was the same difference as that between the sun and the moon. But . . . I now consider that painting and sculpture are one and the same thing.

Suffice that, since one and the other (that is to say, both painting and sculpture) proceed from the same faculty, it would be an easy matter to establish harmony between them and to let such disputes alone, for they occupy more time than the execution of the figures themselves. As to that man [Leonardo] who wrote saying that painting was more noble than sculpture, if he had known as much about the other subjects on which he has written, why, my serving-maid would have written better!

Michelangelo

Pope Julius II had a keen eye for talent and during his decade-long papacy also entrusted highly coveted commissions to MICHELANGELO BUONARROTI (1475–1564). Although Michelangelo was an architect, sculptor, painter, poet, and engineer, he thought of himself first as a sculptor, regarding that calling as superior to that of a painter because the sculptor shares in something like the divine power to "make man" (see "Leonardo and Michelangelo on Painting versus Sculpture," above). Drawing a conceptual parallel to Plato's ideas, Michelangelo believed that the image the artist's hand produces must come from the idea in the artist's mind. The idea, then, is the reality that the artist's genius has to bring forth. But artists are not the creators of the ideas they conceive. Rather, they find their ideas in the natural world, reflecting the absolute idea, which, for the artist, is beauty. One of Michelangelo's best-known observations about sculpture is that the artist must proceed by finding the idea—the image locked in the stone. By removing the excess stone, the sculptor extricates the idea from the block (FIG. I-16), bringing forth the living form. The artist, Michelangelo felt, works many years at this unceasing process of revelation and "arrives late at novel and lofty things."4

Michelangelo did indeed arrive "at novel and lofty things," for he broke sharply from the lessons of his predecessors and contemporaries in one important respect. He mistrusted the application of mathematical methods as guarantees of beauty in proportion. Measure and proportion, he believed, should be "kept in the eyes." Vasari quoted Michelangelo as declaring that "it was necessary to have the compasses in the eyes and not in the hand, because the hands work and the eye judges."5 Thus, Michelangelo set aside the ancient Roman architect Vitruvius, Alberti, Leonardo, and others who tirelessly sought the perfect measure, asserting that the artist's inspired judgment could identify other pleasing proportions. In addition, Michelangelo argued that the artist must not be bound, except by the demands made by realizing the idea. This insistence on the artist's own authority was typical of Michelangelo and anticipated the modern concept of the right to a self-expression of talent limited only by the artist's judgment. The artistic license to aspire far beyond the "rules" was, in part, a manifestation of the pursuit of fame and success that humanism fostered. In this context, Michelangelo created works in architecture, sculpture, and painting that departed from High Renaissance regularity. He put in its stead a style of vast, expressive

^{*} Leonardo da Vinci, *Treatise on Painting*, 51, in Robert Klein and Henri Zerner, *Italian Art 1500–1600: Sources and Documents* (Evanston, Ill.: Northwestern University Press, 1966), 7–8.

[†] Michelangelo to Benedetto Varchi, Rome, 1549; in Klein and Zerner, 13–14.

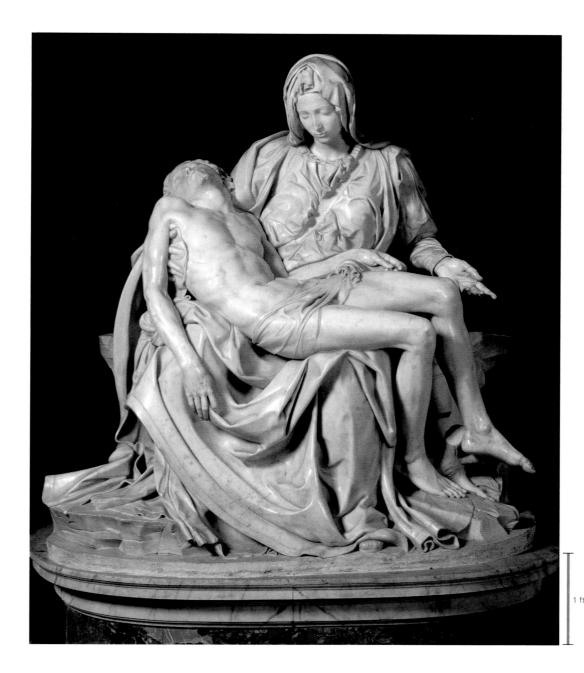

17-12 MICHELANGELO BUONARROTI, *Pietà*, ca. 1498–1500. Marble, 5' $8\frac{1}{2}$ " high. Saint Peter's, Vatican City, Rome.

Michelangelo's representation of Mary cradling Christ's corpse brilliantly captures the sadness and beauty of the young Virgin but was controversial because the Madonna seems younger than her son

strength conveyed through complex, eccentric, and often titanic forms that loom before the viewer in tragic grandeur. Michelangelo's self-imposed isolation, creative furies, proud independence, and daring innovations led Italians to speak of the dominating quality of the man and his works in one word—*terribilità*, the sublime shadowed by the awesome and the fearful.

As a youth, Michelangelo was an apprentice in the studio of the painter Domenico Ghirlandaio, whom he left before completing his training. Although Michelangelo later claimed that in his art he owed nothing to anyone, he made detailed drawings in the manner of the great Florentines Giotto and Masaccio. Early on, he came to the attention of Lorenzo the Magnificent and studied sculpture under one of Lorenzo's favorite artists, Bertoldo di Giovanni (ca. 1420–1491), a former collaborator of Donatello. When the Medici fell in 1494, Michelangelo fled from Florence to Bologna, where the sculptures of the Sienese artist Jacopo della Quercia (1367–1438) impressed him.

PIETÀ Michelangelo's wanderings took him to Rome, where, around 1498, still in his early 20s, he produced his first masterpiece, a *Pietà* (FIG. 17-12), for the French cardinal Jean de Bilhères La-

graulas (1439-1499). The cardinal commissioned the statue to adorn the chapel in Old Saint Peter's (FIG. 8-9) in which he was to be buried. (The work is now on view in the new church that replaced the fourth-century basilica.) The theme—Mary cradling the dead body of Christ in her lap—was a staple in the repertoire of French and German artists (FIG. 13-51), and Michelangelo's French patron doubtless chose the subject. The Italian, however, rendered the Northern theme in an unforgettable manner. Michelangelo transformed marble into flesh, hair, and fabric with a sensitivity for texture that is almost without parallel. The polish and luminosity of the exquisite marble surface cannot be captured fully in photographs and can be appreciated only in the presence of the original. Breathtaking too is the tender sadness of the beautiful and youthful Mary as she mourns the death of her son. In fact, her age—seemingly less than that of Christ—was a subject of controversy from the moment of the unveiling of the statue. Michelangelo explained Mary's ageless beauty as an integral part of her purity and virginity. Beautiful too is the son whom she holds. Christ seems less to have died than to have drifted off into peaceful sleep in Mary's maternal arms. His wounds are barely visible.

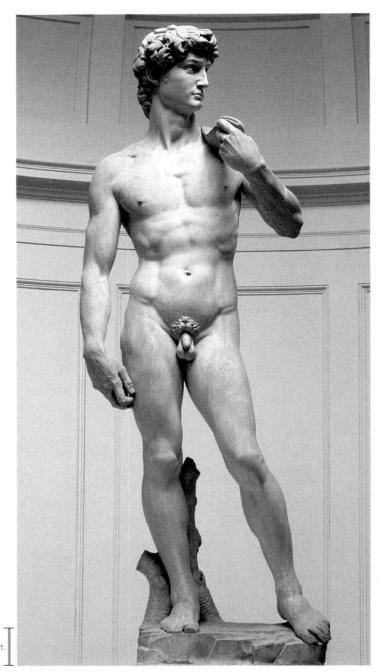

17-13 MICHELANGELO BUONARROTI, *David*, from Piazza della Signoria, Florence, Italy, 1501–1504. Marble, 17' high. Galleria dell'Accademia, Florence.

In this colossal statue, Michelangelo represented David in heroic classical nudity, capturing the tension of Lysippan athletes (FIG. 5-65) and the emotionalism of Hellenistic statuary (FIGS. 5-80 and 5-81).

DAVID Michelangelo returned to Florence in 1501, seven years after the exile of the Medici (see Chapter 16). In 1495 the Florentine Republic had ordered the transfer of Donatello's *David* (FIG. **16-12**) from the Medici palace to the Palazzo della Signoria to join Verrocchio's *David* (FIG. **16-13**) there. The importance of David as a civic symbol led the Florence Cathedral building committee to invite Michelangelo to work a great block of marble left over from an earlier aborted commission into still another statue of *David* (FIG. **17-13**). The colossal statue—Florentines referred to it as "the Giant"—Michelangelo created from that block assured his reputation then and now as an extraordinary talent. Only 40 years after *David*'s completion, Vasari extolled the work, which had been set up near the

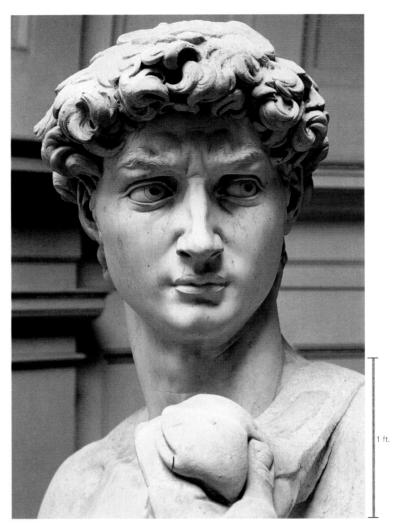

17-14 MICHELANGELO BUONARROTI, head of *David* (detail of Fig. 17-13), 1501–1504. Galleria dell'Accademia, Florence.

In contrast to earlier Renaissance depictions (FIGS. 16-12 and 16-13) of this Old Testament drama, Michelangelo portrayed David *before* the battle with Goliath, as he sternly watches his gigantic foe.

west door of the Palazzo della Signoria, and claimed that "without any doubt the figure has put in the shade every other statue, ancient or modern, Greek or Roman—this was intended as a symbol of liberty for the Palace, signifying that just as David had protected his people and governed them justly, so whoever ruled Florence should vigorously defend the city and govern it with justice." 6

Despite the traditional association of David with heroism, Michelangelo chose to represent the young biblical warrior not after his victory, with Goliath's head at his feet, but turning his head (FIG. 17-14) to his left, sternly watchful of the approaching foe. *David* exhibits the characteristic representation of energy in reserve that imbues Michelangelo's later figures with the tension of a coiled spring. The anatomy of David's body plays an important part in this prelude to action. His rugged torso, sturdy limbs, and large hands and feet alert viewers to the strength to come. The swelling veins and tightening sinews amplify the psychological energy of David's pose.

Michelangelo doubtless had the classical nude in mind when he conceived his *David*. Like many of his colleagues, he greatly admired Greco-Roman statues, in particular the skillful and precise rendering of heroic physique. Without strictly imitating the antique style, the Renaissance sculptor captured in his portrayal of the biblical hero the tension of Lysippan athletes (FIG. 5-65) and the psychological

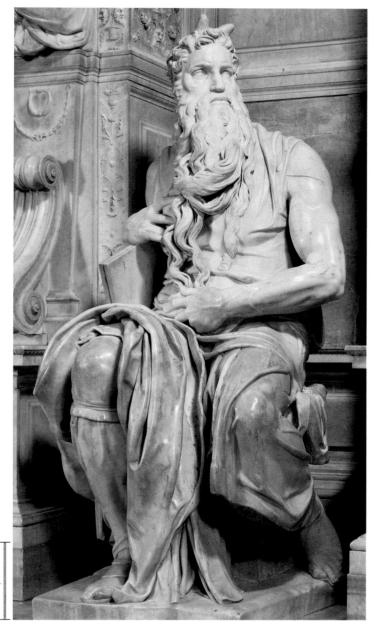

17-15 MICHELANGELO BUONARROTI, *Moses*, from the tomb of Pope Julius II, Rome, Italy, ca. 1513–1515. Marble, 7' 8 $\frac{1}{2}''$ high. San Pietro in Vincoli, Rome.

Not since Hellenistic times had a sculptor captured as much pent-up energy, both emotional and physical, in a seated statue as Michelangelo did in the over-life-size *Moses* he carved for Julius II's tomb.

insight and emotionalism of Hellenistic statuary (FIGS. 5-80 and 5-81). His *David* differs from those of Donatello and Verrocchio in much the same way later Hellenistic statues departed from their Classical predecessors (see Chapter 5). Michelangelo abandoned the self-contained compositions of the 15th-century *David* statues by abruptly turning the hero's head (FIG. 17-14) toward his gigantic adversary. This *David* is compositionally and emotionally connected to an unseen presence beyond the statue, a feature also of Hellenistic sculpture (FIG. 5-85). As early as 1501, then, Michelangelo invested his efforts in presenting towering, pent-up emotion rather than calm, ideal beauty. He transferred his own doubts, frustrations, and passions into the great figures he created or planned.

TOMB OF JULIUS II The formal references to classical antiquity in *David* surely appealed to Julius II, who associated himself with

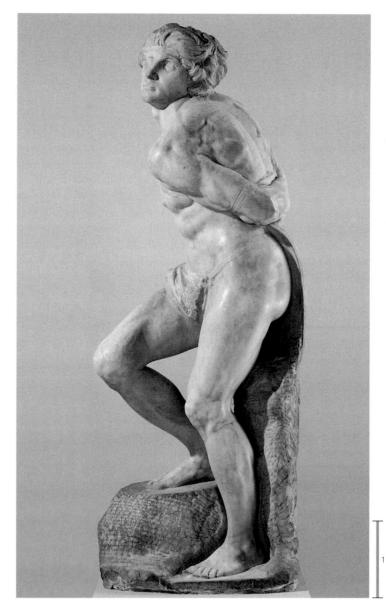

17-16 MICHELANGELO BUONARROTI, Bound Slave (Rebellious Captive), from the tomb of Pope Julius II, Rome, Italy, ca. 1513–1516. Marble, $7'\frac{5}{8}''$ high. Louvre, Paris.

For Pope Julius II's grandiose tomb, Michelangelo planned a series of statues of captives or slaves in various attitudes of revolt and exhaustion. This defiant figure exhibits a violent contrapposto.

the humanists and with Roman emperors. Thus, this sculpture and the fame that accrued to Michelangelo on its completion called the artist to the pope's attention, leading shortly thereafter to major papal commissions. The first project Julius II commissioned from Michelangelo was the pontiff's own tomb, to be placed in Old Saint Peter's. The original 1505 design called for a freestanding two-story structure with some 28 statues (FIGS. 17-15 and 17-16). This colossal monument would have given Michelangelo the latitude to sculpt numerous human figures while providing Julius II with a grandiose memorial that would associate the 16th-century pope with the first pope, Peter himself. Shortly after Michelangelo began work on this project, the pope, for unknown reasons, interrupted the commission, possibly because funds had to be diverted to the rebuilding of Saint Peter's. After Julius II's death in 1513, Michelangelo reluctantly reduced the scale of the project step-by-step until, in 1542, a final contract specified a simple wall tomb with fewer than one-third of the originally planned figures. Michelangelo completed the tomb in 1545 and saw it placed in San Pietro in Vincoli, Rome, where Julius II had served as a cardinal before his accession to the papacy. Given Julius's ambitions, it is safe to say that had he seen the final design of his tomb, or known where it would eventually be located, he would have been bitterly disappointed.

The spirit of the tomb may be summed up in *Moses* (FIG. 17-15), which Michelangelo completed during one of his sporadic resumptions of the work. Meant to be seen from below and to be balanced with seven other massive forms related to it in spirit, Moses in its final comparatively paltry setting does not convey the impact originally intended. Michelangelo depicted the Old Testament prophet seated, the Tablets of the Law under one arm and his hands gathering his voluminous beard. The horns that appear on Moses's head were a convention in Christian art (based on a mistranslation of the Hebrew word for "rays") and helped Renaissance viewers identify the prophet (compare FIGS. 12-36 and 15-2). Here again, Michelangelo used the turned head, which concentrates the expression of awful wrath that stirs in the mighty frame and eyes. The muscles bulge, the veins swell, and the great legs seem to begin slowly to move. Not since Hellenistic times had a sculptor captured so much pent-up energy—both emotional and physical—in a seated statue (FIG. 5-85).

Originally, Michelangelo intended the tomb to have some 20 statues of captives, popularly known as slaves, in various attitudes of re-

volt and exhaustion. One is *Bound Slave*, or *Rebellious Captive* (FIG. 17-16). Another is shown in FIG. I-16. Considerable scholarly uncertainty exists about these statues. Although art historians have traditionally connected them with Julius's tomb, some now doubt the association. Some scholars even reject their identification as "slaves" or "captives." Despite these unanswered questions, the statues, like *David* and *Moses*, represent definitive statements. Michelangelo created figures that do not so much represent an abstract concept, as in medieval allegory, as they embody powerful emotional states associated with oppression. Indeed, Michelangelo communicated his expansive imagination through every plane and hollow of the stone. In

Bound Slave, the defiant figure's violent contrapposto is the image of frantic but impotent struggle. Michelangelo based his whole art on his conviction that whatever can be said greatly through sculpture and painting must be

TOMB OF GIULIANO DE' MEDICI Following the death of Julius II, Michelangelo, like Raphael, went into the service of the Medici popes, Leo X and his successor Clement VII (r. 1523–1534). These Medici chose not to perpetuate their predecessor's fame by let-

said through the human figure.

17-17 MICHELANGELO BUONARROTI, tomb of Giuliano de' Medici, New Sacristy (Medici Chapel), San Lorenzo, Florence, Italy, 1519–1534. Marble, central figure 5′ 11″ high.

Michelangelo's portrait of Giuliano de' Medici clad in ancient Roman armor depicts the deceased as the model of the active and decisive man. Below are the anguished and twisting figures of Night and Day. ting Michelangelo complete Julius's tomb. Instead, they (Pope Leo X and the then-cardinal Giulio de' Medici) commissioned him in 1519 to build a funerary chapel, the New Sacristy, in San Lorenzo in Florence. At opposite sides of the New Sacristy stand Michelangelo's sculpted tombs of Giuliano (1478–1516), duke of Nemours (south of Paris), and Lorenzo (1492–1519), duke of Urbino, son and grandson of Lorenzo the Magnificent. Giuliano's tomb (FIG. 17-17) is compositionally the twin of Lorenzo's. Michelangelo finished neither tomb. Most scholars believe he intended to place pairs of recumbent river gods at the bottom of the sarcophagi, balancing the pairs of figures that rest on the sloping sides, but Michelangelo's grand design for the tombs remains a puzzle.

The traditional interpretation is that the arrangement Michelangelo planned, but never completed, mirrors the soul's ascent through the levels of the Neo-Platonic universe. Neo-Platonism, a school of thought based on Plato's idealistic, spiritualistic philosophy, experienced a renewed popularity in the 16th-century humanist community. The lowest level of the tomb, which the river gods represent, would have signified the Underworld of brute matter, the source of evil. The two statues on the sarcophagi would symbolize the realm of time—the specifically human world of the cycles of dawn, day, evening, and night. Humanity's state in this world of time was one of pain and anxiety, of frustration and exhaustion. At left, the female figure of Night and, at right, the male figure of Day ap-

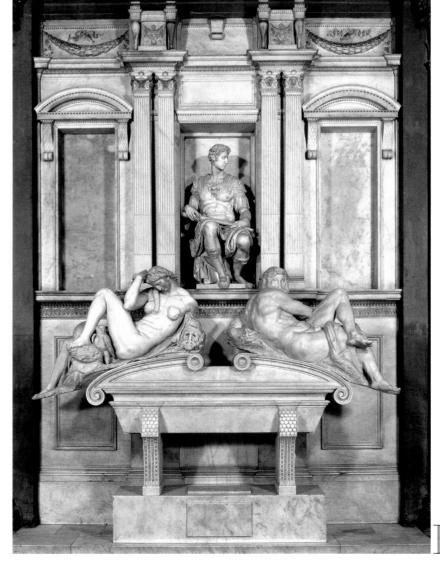

pear to be chained into never-relaxing tensions. Both exhibit that anguished twisting of the body's masses in contrary directions, seen also in Michelangelo's *Bound Slave* (FIG. 17-16) and in his Sistine Chapel paintings (FIG. 17-19). This contortion is a staple of Michelangelo's figural art. Day, with a body the thickness of a great tree and the anatomy of Hercules (or of a reclining Greco-Roman river god that may have inspired Michelangelo's statue), strains his huge limbs against each other, his unfinished visage rising menacingly above his shoulder. Night, the symbol of rest, twists as if in troubled sleep, her posture wrenched and feverish. The artist surrounded her with an owl, poppies, and a hideous mask symbolic of nightmares. Some scholars argue, however, that the personifications Night and Day allude not to humanity's pain but to the life cycle and the passage of time leading ultimately to death.

On their respective tombs, sculptures of Lorenzo and Giuliano appear in niches at the apex of the structures. Transcending worldly existence, they represent the two ideal human types—the contemplative man (Lorenzo) and the active man (Giuliano). Giuliano (FIG. 17-17) sits clad in the armor of a Roman emperor and holds a commander's baton, his head turned alertly as if in council (he looks toward the statue of the Virgin at one end of the chapel). Across the room, Lorenzo appears wrapped in thought, his face in deep shadow. Together, they symbolize the two ways human beings might achieve union with God—through meditation or through the active

life fashioned after that of Christ. In this sense, they are not individual portraits. Indeed, Michelangelo declined to make likenesses of Lorenzo and Giuliano. Who, he asked, would care what the two dukes looked like in a thousand years? This attitude is consistent with Michelangelo's interests. Throughout his career he demonstrated less concern for facial features and expressions than for the overall human form. The rather generic visages of the two Medici captains of the Church attest to this. For the artist, more important was the contemplation of what lies beyond the corrosion of time.

SISTINE CHAPEL CEILING When Julius II suspended work on his tomb, the pope gave the bitter Michelangelo the commission to paint the ceiling (FIG. 17-1) of the Sistine Chapel (FIG. 17-18) in 1508. The artist, insisting that painting was not his profession (a protest that rings hollow after the fact, but Michelangelo's major works until then had been in sculpture, and painting was of secondary interest to him), assented in the hope that the tomb project could be revived. Michelangelo faced enormous difficulties in painting the Sistine ceiling. He had to address the ceiling's dimensions (some 5,800 square feet), its height above the pavement (almost 70 feet), and the complicated perspective problems the vault's height and curve presented, as well as his inexperience in the fresco technique. (The first section Michelangelo completed had to be redone because of faulty preparation of the intonaco; see "Fresco Painting," Chapter 14, page 382.) Yet,

in less than four years, Michelangelo produced an unprecedented work—a monumental fresco incorporating his patron's agenda, Church doctrine, and the artist's interests. Depicting the most august and solemn themes of all, the creation, fall, and redemption of humanity—themes most likely selected by Julius II with input from Michelangelo and a theological adviser, probably Cardinal Marco Vigerio della Rovere (1446–1516)—Michelangelo spread a colossal decorative scheme across the vast surface. He succeeded in weaving together more than 300 figures in an ultimate grand drama of the human race.

A long sequence of narrative panels describing the creation, as recorded in Genesis, runs along the crown of the vault, from *God's Separation of Light and Darkness* (above the altar) to *Drunkenness of Noah* (nearest the entrance to the chapel). Thus, as viewers enter the chapel, look up, and walk toward the altar, they review, in reverse order, the history of the fall of humankind. The Hebrew prophets and pagan sibyls who foretold the coming of Christ appear seated in large thrones on both sides of the central row of scenes

17-18 Interior of the Sistine Chapel (looking east), Vatican City, Rome, Italy, built 1473.

Michelangelo reluctantly agreed to paint the ceiling (FIG. 17-1) of the Sistine Chapel for Pope Julius II. He had to overcome the complicated perspective problems that the height and curve of the vault presented.

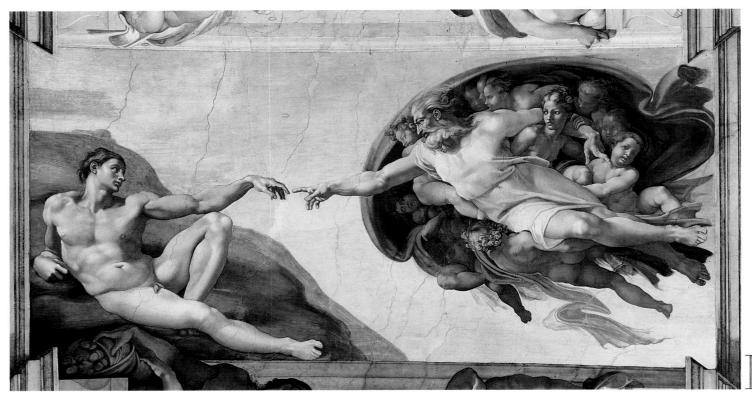

17-19 MICHELANGELO BUONARROTI, *Creation of Adam*, detail of the ceiling (FIG. 17-1) of the Sistine Chapel, Vatican City, Rome, Italy, 1511–1512. Fresco, 9' 2" × 18' 8".

Life leaps to Adam like a spark from the extended hand of God in this fresco, which recalls the communication between gods and heroes in the classical myths Renaissance humanists admired so much.

from Genesis, where the vault curves down. In the four corner *pendentives*, Michelangelo placed four Old Testament scenes with David, Judith, Haman, and Moses and the Brazen Serpent. Scores of lesser figures also appear. The ancestors of Christ fill the triangular compartments above the windows, nude youths punctuate the corners of the central panels, and small pairs of putti in *grisaille* (monochrome painting using shades of gray to imitate sculpture) support the painted cornice surrounding the entire central corridor. The overall conceptualization of the ceiling's design and narrative structure not only presents a sweeping chronology of Christianity but also is in keeping with Renaissance ideas about Christian history. These ideas included interest in the conflict between good and evil and between the energy of youth and the wisdom of age. The conception of the entire ceiling was astounding in itself, and the articulation of it in its thousands of details was a superhuman achievement.

Unlike Andrea Mantegna's decoration of the Camera Picta (FIGS. 16-47 and 16-48) in Mantua, the strongly marked unifying architectural framework in the Sistine Chapel does not produce "picture windows" enframing illusions just within. Rather, the viewer focuses on figure after figure, each sharply outlined against the neutral tone of the architectural setting or the plain background of the panels. Here, as in his sculpture, Michelangelo relentlessly concentrated his expressive purpose on the human figure. To him, the body was beautiful not only in its natural form but also in its spiritual and philosophical significance. The body was the manifestation of the soul or of a state of mind and character. Michelangelo represented the body in its most simple, elemental aspect—in the nude or simply draped, with no background and no ornamental embellishment. He always painted with a sculptor's eye for how light and shadow communicate volume and surface. It is no coincidence that many of the figures seem to be tinted reliefs or freestanding statues.

CREATION OF ADAM One of the ceiling's central panels is Creation of Adam (FIG. 17-19). Michelangelo did not paint the traditional representation but instead produced a bold humanistic interpretation of the momentous event. God and Adam confront each other in a primordial unformed landscape of which Adam is still a material part, heavy as earth. The Lord transcends the earth, wrapped in a billowing cloud of drapery and borne up by his powers. Life leaps to Adam as if a spark flashed from the extended, mighty hand of God. The communication between gods and heroes, so familiar in classical myth, is here concrete. This blunt depiction of the Lord as ruler of Heaven in the Olympian pagan sense indicates how easily High Renaissance thought joined classical and Christian traditions. Yet the classical trappings do not obscure the essential Christian message.

Beneath the Lord's sheltering left arm is a female figure, apprehensively curious but as yet uncreated. Scholars traditionally believed her to represent Eve, but many now think she is the Virgin Mary (with the Christ Child at her knee). If the second identification is correct, it suggests that Michelangelo incorporated into his fresco one of the essential tenets of Christian faith—the belief that Adam's Original Sin eventually led to the sacrifice of Christ, which in turn made possible the redemption of all humankind.

As God reaches out to Adam, the viewer's eye follows the motion from right to left, but Adam's extended left arm leads the eye back to the right, along the Lord's right arm, shoulders, and left arm to his left forefinger, which points to the Christ Child's face. The focal point of this right-to-left-to-right movement—the fingertips of Adam and the Lord—is dramatically off-center. Michelangelo replaced the straight architectural axes found in Leonardo's compositions with curves and diagonals. For example, the bodies of the two great figures are complementary—the concave body of Adam fitting the convex body and billowing "cloak" of God. Thus, motion directs

Restoring Renaissance Paintings

The year 1989 marked the culmination of a 12-year project to clean the Sistine Chapel ceiling (FIG. 17-1). Cleaning of Michelangelo's *Last Judgment* (FIG. 17-21) behind the altar followed during the next five years. Restorers removed centuries of accumulated grime, overpainting, and protective glue, uncovering much of Michelangelo's original form, color, style, and procedure.

The before-and-after details (FIG. 17-20) of one of the lunettes over the windows reveal the stark contrast in the appearance of the frescoes in 1977 and today. In these semicircular spaces, Michelangelo painted figures representing the ancestors of Christ (Matt. 1:1–17). After computer assessment of the damage (including use of infrared and ultraviolet lights), the restorers worked carefully and slowly to clean the fresco of soot, dirt, dissolved salts, and various types of gums and varnishes made of animal glues. Over the centuries, restorers had used various varnishes to brighten the darkening fresco. Unfortunately, over time the varnishes deteriorated, darkening the painting even more. For the latest cleaning effort, the restorers first wet a small section of the fresco with distilled, deionized water. The application of a cleaning solution made of bicarbonates of sodium and ammonium and supplemented with an antibacterial, antifungal agent followed. Adding carboxymethyl cellulose and water to this solution created a gel that clung to the ceiling fresco. After three minutes, restorers removed the gel.

Michelangelo's figures, once thought purposefully dark, now show brilliant colors of high intensity, brushed on with an astonishing freedom and verve. The fresh, luminous hues, boldly joined in unexpected harmonies, seemed uncharacteristically dissonant to some experts when first revealed and aroused brisk controversy. Some scholars believed that the restorers removed Michelangelo's work along with the accumulated layers and that the apparently strident coloration could not possibly be his. Most art historians, however, now agree that the restoration effort has revealed to modern eyes the artist's real intentions and effects—and that in the Sistine Chapel, Michelangelo already had paved the way for the Mannerist reaction to the High Renaissance, examined later in this chapter.

The restoration of Leonardo's Last Supper (FIG. 17-4), which took more than two decades, presented conservators with an even greater challenge. Leonardo had mixed oil and tempera, applying much of it a secco (to dried, rather than wet, plaster) in order to create a mural that more closely approximated oil painting on canvas or wood instead of fresco. But because the wall did not absorb the pigment as in the buon fresco technique, the paint quickly began to flake (see "Fresco Painting," Chapter 14, page 382). Milan's humidity further accelerated the deterioration. Restoration efforts, completed in May 1999, were painstaking and slow, as were those in the Sistine Chapel, and involved extensive scholarly, chemical, and computer analysis. Like other restorations, this one was not without controversy. One scholar has claimed that 80 percent of what is visible today is the work of the modern restorers, not Leonardo. The controversies surrounding the cleanings of the Sistine Chapel ceiling and Santa Maria delle Grazie have not put a damper on other restoration projects. After the cleaning of Last Judgment, the Vatican continued the restoration of the remaining frescoes in the Sistine Chapel (FIG. 17-18), including Perugino's Christ Delivering the Keys of the Kingdom to Saint Peter (FIG. 16-40), completing the project in December 1999. Restorers have also cleaned the frescoes in the Stanza della Segnatura in the Vatican Apartments in Rome, including Raphael's School of Athens (FIG. 17-9).

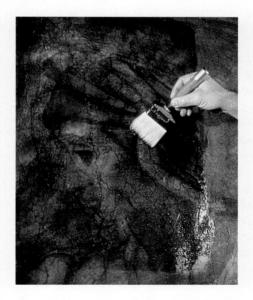

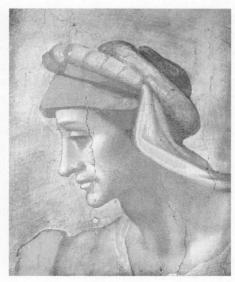

17-20 Detail of the Azor-Sadoch lunette over one of the Sistine Chapel windows (FIG. 17-18) at the beginning (*left*) and final stage (*right*) of the restoration process.

The 1977–1989 restoration of the frescoes on the Sistine Chapel ceiling removed centuries of accumulated grime and revealed the original bright and luminous colors of Michelangelo's figures.

not only the figures but also the whole composition. The reclining positions of the figures, the heavy musculature, and the twisting poses are all intrinsic parts of Michelangelo's style.

The photographs of the Sistine Chapel reproduced here record the appearance of Michelangelo's frescoes after the completion of a 12-year cleaning project (1977–1989). The painstaking restoration (FIG. 17-20) elicited considerable controversy because it revealed vivid colors that initially shocked art historians, producing accusations that the restorers were destroying Michelangelo's masterpieces (see "Restoring Renaissance Paintings," above). That reaction, however, was largely attributable to the fact that for centuries no one had ever seen Michelangelo's frescoes except covered with soot and grime.

Religious Art in Counter-Reformation Italy

oth Catholics and Protestants took seriously the role of devotional imagery in religious life. However, their views differed dramatically. Whereas Catholics deemed art as valuable for cultivating piety, Protestants believed visual imagery could produce idolatry and could distract the faithful from their goal—developing a personal relationship with God (see "Protestantism and Iconoclasm," Chapter 18, page 510). As part of the Counter-Reformation effort, Pope Paul III convened the Council of Trent in 1545 to review controversial Church doctrines. At its conclusion in 1563, the Council issued the following edict:

The holy council commands all bishops and others who hold the office of teaching and have charge of the *cura animarum* [literally, "cure of souls"—the responsibility of laboring for the salvation of souls], that in accordance with the usage of the Catholic and Apostolic Church, received from the primitive times of the Christian religion, and with the unanimous teaching of the holy Fathers and the decrees of sacred councils, they above all instruct the faithful diligently in matters relating to intercession and invocation of the saints, the veneration of relics, and the legitimate use of images. . . . Moreover, that the images of Christ, of the Virgin Mother of God, and of the other saints are to be placed and retained especially in the churches, and that due honor and veneration is to be given them; . . . because the honor which is shown them is referred to the prototypes which they represent, so that by means of the images which we kiss

and before which we uncover the head and prostrate ourselves, we adore Christ and venerate the saints whose likeness they bear. That is what was defined by the decrees of the councils, especially of the Second Council of Nicaea, against the opponents of images.

Moreover, let the bishops diligently teach that by means of the stories of the mysteries of our redemption portrayed in paintings and other representations the people are instructed and confirmed in the articles of faith, which ought to be borne in mind and constantly reflected upon; also that great profit is derived from all holy images, not only because the people are thereby reminded of the benefits and gifts bestowed on them by Christ, but also because through the saints the miracles of God and salutary examples are set before the eyes of the faithful, so that they may give God thanks for those things, may fashion their own life and conduct in imitation of the saints and be moved to adore and love God and cultivate piety. . . .

That these things may be the more faithfully observed, the holy council decrees that no one is permitted to erect or cause to be erected in any place or church, howsoever exempt, any unusual image unless it has been approved by the bishop.*

THE COUNTER-REFORMATION Paul III (r. 1534–1549) succeeded Clement VII as pope in 1534 at a time of widespread dissatisfaction with the leadership and policies of the Roman Catholic Church. Led by clerics such as Martin Luther (1483–1546) and John Calvin (1509–1564) in the Holy Roman Empire, early-16th-century reformers directly challenged papal authority, especially regarding secular issues. Disgruntled Catholics voiced concerns about the sale of indulgences (pardons for sins, reducing the time a soul spent in Purgatory), about nepotism (the appointment of relatives to important positions), and about how high Church officials were pursuing personal wealth. This Reformation movement resulted in the establishment of Protestantism, with sects such as Lutheranism and Calvinism (see Chapter 18). Central to Protestantism was a belief in personal faith rather than adherence to decreed Church practices and doctrines. Because the Protestants believed that the only true religious relationship was the personal relationship between an individual and God, they were, in essence, eliminating the need for Church intercession, which is central to Catholicism.

The Catholic Church, in response, mounted a full-fledged campaign to counteract the defection of its members to Protestantism. Led by Paul III, this response, the Counter-Reformation, consisted of numerous initiatives. The Council of Trent, which met intermittently from 1545 through 1563, was a major element of this effort. Composed of cardinals, archbishops, bishops, abbots, and theologians, the Council of Trent dealt with issues of Church doctrine, including many the Protestants contested. Many papal commissions during this period can be viewed as an integral part of the Counter-Reformation effort. Popes long had been aware of the power of visual imagery to

construct and reinforce ideological claims, and 16th-century popes exploited this capability (see "Religious Art in Counter-Reformation Italy," above).

LAST JUDGMENT Among Paul III's first papal commissions was an enormous (48 feet tall) fresco for the Sistine Chapel. Michelangelo agreed to paint the Last Judgment fresco (FIG. 17-21) on the chapel's altar wall. Here, the artist depicted Christ as the stern judge of the world—a giant who raises his mighty right arm in a gesture of damnation so broad and universal as to suggest he will destroy all creation. The choirs of Heaven surrounding him pulse with anxiety and awe. Crowded into the space below are trumpeting angels, the ascending figures of the just, and the downward-hurtling figures of the damned. On the left, the dead awake and assume flesh. On the right, demons, whose gargoyle masks and burning eyes revive the demons of Romanesque tympana (FIG. 1-6), torment the damned.

Michelangelo's terrifying vision of the fate that awaits sinners goes far beyond even Signorelli's gruesome images (FIG. 16-41). Martyrs who suffered especially agonizing deaths crouch below the Judge. One of them, Saint Bartholomew, who was skinned alive, holds the flaying knife and the skin, its face a grotesque self-portrait of Michelangelo. The figures are huge and violently twisted, with small heads and contorted features. Although this immense fresco impresses on viewers Christ's wrath on Judgment Day, it also holds out hope. A group of saved souls—the elect—crowd around Christ, and on the far right appears a figure with a cross, most likely the Good Thief (crucified with Christ) or a saint martyred by crucifixion, such as Saint Andrew.

^{*} Canons and Decrees of the Council of Trent, December 3–4, 1563, in Robert Klein and Henri Zerner, Italian Art 1500–1600: Sources and Documents (Evanston, Ill.: Northwestern University Press, 1966), 120–121.

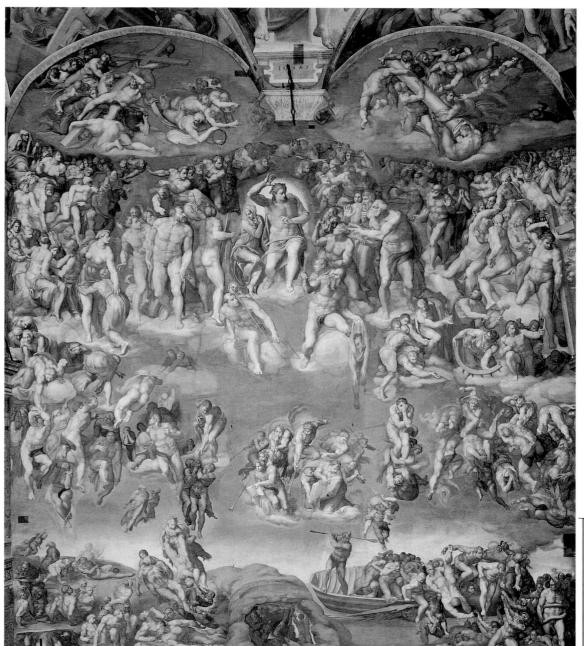

17-21 MICHELANGELO BUONARROTI, *Last Judgment*, altar wall of the Sistine Chapel (FIG. 17-18), Vatican City, Rome, Italy, 1536–1541. Fresco, $48' \times 44'$.

Michelangelo completed his fresco cycle in the Sistine Chapel with this terrifying vision of the fate that awaits sinners. Near the center, he placed his own portrait on the flayed skin Saint Bartholomew holds.

10 ft.

Architecture: Rome

The Sistine Chapel was but a small part of the vast Vatican palace complex on the west side of the Tiber River (MAPS 17-1 and 19-1), construction of which began under Constantine with the erection of a church over the site of Saint Peter's burial place (Old Saint Peter's, FIG. 8-9). By the 15th century, it was obvious that the millennium-old basilica was insufficient for the needs and aspirations of the Renaissance papacy. Rebuilding the fourth-century church would occupy some of the leading architects of Italy for more than a century.

BRAMANTE The first in the distinguished line of architects of the new Saint Peter's was Donato d'Angelo Bramante (1444–1514). Born in Urbino and trained as a painter (perhaps by Piero della Francesca), Bramante went to Milan in 1481 and, like Leonardo, stayed there until the French arrived in 1499. In Milan, he abandoned painting to become one of his generation's most renowned architects. Under the influence of Filippo Brunelleschi, Leon Battista Alberti, and perhaps Leonardo, all of whom strongly favored the art

and architecture of classical antiquity, Bramante developed the High Renaissance form of the central-plan church.

TEMPIETTO The architectural style Bramante championed was, consistent with the humanistic values of the day, based on ancient Roman models. This style is on display in the small architectural gem known as the Tempietto (FIG. 17-22) on the Janiculum hill overlooking the Vatican. The building received its name because, to contemporaries, it had the look of a small ancient temple. "Little Temple" is, in fact, a perfect nickname for the structure, because the round temples of Roman Italy (FIG. 7-4) directly inspired Bramante's design. King Ferdinand and Queen Isabella of Spain commissioned the Tempietto to mark the presumed location of Saint Peter's crucifixion. The patrons asked Bramante to undertake the project in 1502, but work may not have commenced until the end of the decade. Today the Tempietto stands inside the rectangular cloister alongside the church of San Pietro in Montorio, but Bramante planned, although never executed, a circular colonnaded courtyard

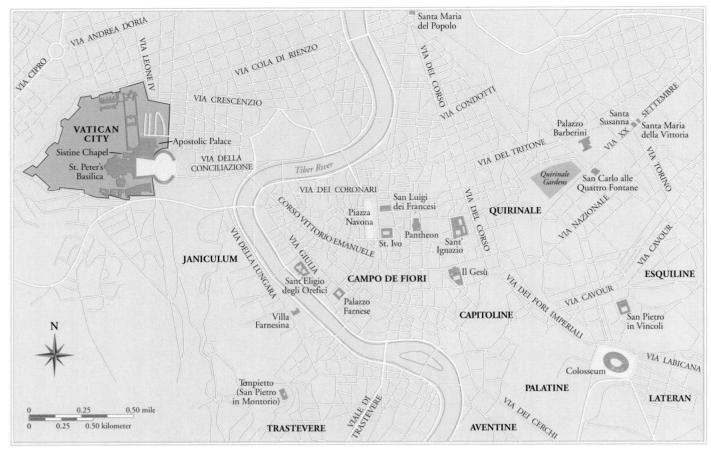

MAP 17-1 Rome with Renaissance and Baroque monuments.

to frame the "temple." His intent was to coordinate the Tempietto and its surrounding portico by aligning the columns of the two structures

At first glance, the Tempietto (FIG. 17-22) may seem severely rational with its sober circular *stylobate* (stepped temple platform) and the austere Tuscan style of the colonnade, neither feature giving any indication of the placement of an interior altar or of the entrance. However, Bramante achieved a truly wonderful balance and harmony in the relationship of the parts (dome, drum, and base) to one another and to the whole. Conceived as a tall, domed cylinder projecting from the lower, wider cylinder of its colonnade, this small building incorporates all the qualities of a sculptured monument. Bramante's sculptural eye is most evident in the rhythmical play of light and shadow seen around the columns and balustrade and across the deep-set rectangular windows alternating with shallow shellcapped niches in the cella (central room of a temple), walls, and drum. Although the Tempietto, superficially at least, may resemble a Greek tholos (a circular shrine; FIG. 5-72), and although antique models provided the inspiration for all its details, the combination of parts and details was new and original. (Classical tholoi, for instance, had neither drum nor balustrade.)

17-22 DONATO D'ANGELO BRAMANTE, Tempietto, San Pietro in Montorio, Rome, Italy, 1502(?).

Contemporaries celebrated Bramante as the first to revive the classical style in architecture. Roman round temples (FIG. 7-4) inspired this "little temple," but Bramante combined the classical parts in new ways.

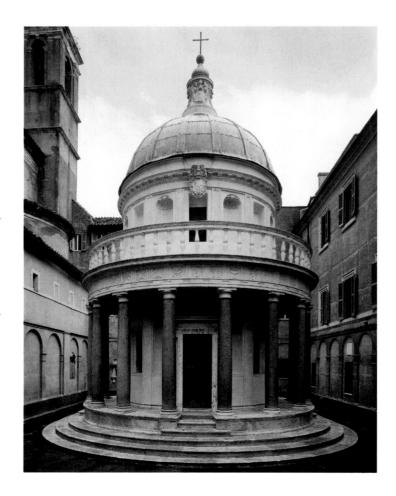

One of the main differences between the Early and High Renaissance styles of architecture is the former's emphasis on detailing flat wall surfaces versus the latter's sculptural handling of architectural masses. Bramante's Tempietto initiated the High Renaissance era. Andrea Palladio, a brilliant theorist as well as a major later 16th-century architect (FIGS. 17-29 and 17-32), included the Tempietto in his survey of ancient temples because Bramante was "the first to bring back to light the good and beautiful architecture that from antiquity to that time had been hidden." Round in plan and elevated on a base that isolates it from its surroundings, the Tempietto conforms to Alberti's and Palladio's strictest demands for an ideal church.

NEW SAINT PETER'S As noted, Bramante was the architect Julius II selected to design a replacement for the Constantinian basilican church of Old Saint Peter's (FIG. 8-9). The earlier building had fallen into considerable disrepair and, in any event, did not suit this ambitious pope's taste for the colossal. Julius wanted to gain control over the whole of Italy and to make the Rome of the popes reminiscent of (if not more splendid than) the Rome of the caesars. As the symbolic seat of the papacy, Saint Peter's represented the history of the Church.

Bramante originally designed the new Saint Peter's (FIG. 17-23) to consist of a cross with arms of equal length, each terminating in an apse. Julius II intended the new building to serve as a *martyrium* to mark Saint Peter's grave and also hoped to have his own tomb in it. A large dome would have covered the crossing, and smaller domes over subsidiary chapels would have covered the diagonal axes of the roughly square plan. Thus, Bramante's ambitious design called for a

boldly sculptural treatment of the walls and piers under the dome. His organization of the interior space was complex in the extreme, with the intricate symmetries of a crystal. It is possible to detect in the plan some nine interlocking crosses, five of them supporting domes. The scale was titanic. According to sources, Bramante boasted he would place the dome of the Pantheon (FIGS. 7-49 to 7-51) over the Basilica Nova (FIG. 7-78).

A commemorative medal (FIG. 17-24) by Cristoforo Foppa Caradosso (ca. 1452–1526) shows how Bramante's scheme would have attempted to do just that. The dome is hemispherical, as is that of the Pantheon, but the massive unity of that building is broken up here by two towers and a medley of domes and porticos. In light of Julius II's interest in the Roman Empire, using the Pantheon as a model was entirely appropriate. That Bramante's design for the new Saint Peter's was commemorated on a medal is in itself significant. Such medals proliferated in the 15th century, reviving the ancient Roman practice of placing images of important imperial building projects on the reverses of Roman coins and portraits of the emperors who commissioned them on the coins' fronts. Julius II appears on the front of the Caradosso medal.

During Bramante's lifetime, the actual construction of the new Saint Peter's did not advance beyond the building of the crossing piers and the lower choir walls. After his death, the work passed from one architect to another and, in 1546, to Michelangelo. With the Church facing challenges to its supremacy, Pope Paul III surely felt a sense of urgency about the completion of this project. Michelangelo's work on Saint Peter's became a long-term show of dedication, thankless and without pay. Among Michelangelo's difficulties was his struggle to preserve and carry through Bramante's original plan

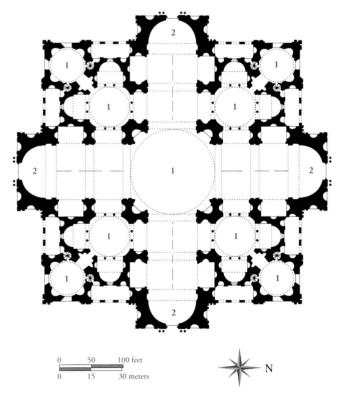

17-23 Donato d'Angelo Bramante, plan for the new Saint Peter's, the Vatican, Rome, Italy, 1505. (1) dome, (2) apse.

Bramante's design for the new church to replace the Constantinian basilica of Saint Peter's (FIG. 8-9) featured a central plan consisting of a cross with arms of equal length, each terminating in an apse.

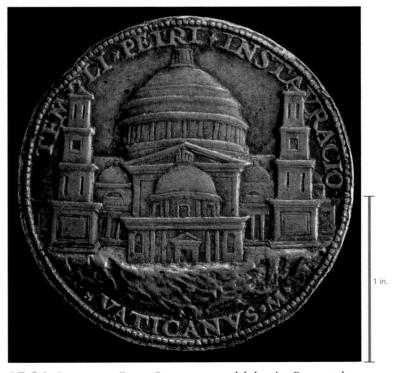

17-24 Cristoforo Foppa Caradosso, medal showing Bramante's design for the new Saint Peter's, 1506. Bronze, $2\frac{1}{4}$ " diameter. British Museum, London.

Bramante's unexecuted 1506 design for Saint Peter's called for a large dome over the crossing, smaller domes over the subsidiary chapels, and a boldly sculptural treatment of the walls and piers.

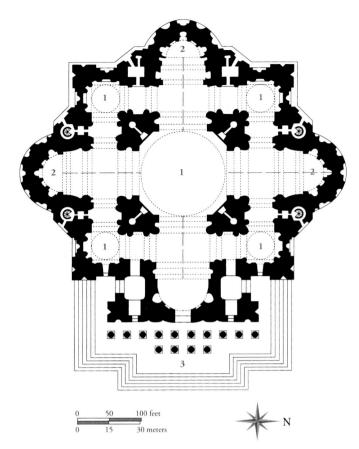

17-25 MICHELANGELO BUONARROTI, plan for Saint Peter's, Vatican City, Rome, Italy, 1546. (1) dome, (2) apse, (3) portico.

In his modification of Bramante's plan (FIG. 17-23), Michelangelo reduced the central component from a number of interlocking crosses to a compact domed Greek cross inscribed in a square.

(FIG. 17-23), which he praised and chose to retain as the basis for his own design (FIG. 17-25). Michelangelo shared Bramante's conviction that a central plan was the ideal form for a church. Always a sculptor first and foremost, Michelangelo carried his obsession with human form over to architecture and reasoned that buildings should follow the form of the human body. This meant organizing their

17-26 MICHELANGELO BUONARROTI, Saint Peter's (looking northeast), Vatican City, Rome, Italy, 1546–1564. Dome completed by GIACOMO DELLA PORTA, 1590.

The west end of Saint Peter's offers the best view of Michelangelo's intentions. The giant pilasters of his colossal order march around the undulating wall surfaces of the central-plan building.

units symmetrically around a central and unique axis, as the arms relate to the body or the eyes to the nose. "For it is an established fact," he wrote, "that the members of architecture resemble the members of man. Whoever neither has been nor is a master at figures, and especially at anatomy, cannot really understand architecture."

In his modification of Bramante's plan, Michelangelo reduced the central component from a number of interlocking crosses to a compact domed *Greek cross* inscribed in a square and fronted with a double-columned portico. Without destroying the centralizing features of Bramante's plan, Michelangelo, with a few strokes of the pen, converted its snowflake complexity into massive, cohesive unity. His treatment of the building's exterior further reveals his interest in creating a unified and cohesive design. Because of later changes to the front of the church, the west (apse) end (FIG. 17-26) offers the best view of his style and intention. Michelangelo's design incorporated the colossal order, the two-story pilasters first seen in more reserved fashion in Alberti's Mantuan church of Sant'Andrea (FIG. 16-44). The giant pilasters seem to march around the undulating wall surfaces, confining the movement without interrupting it. The architectural sculpturing here extends up from the ground through the attic stories and into the *drum* and the dome (FIG. 19-4), unifying the whole building from base to summit. Baroque architects later learned much from this kind of integral design, which Michelangelo based on his conviction that architecture is one with the organic beauty of the human form.

The domed west end—as majestic as it is today and as influential as it has been on architecture throughout the centuries—is not quite as Michelangelo intended it. Originally, he had planned a dome with an ogival section, like that of Florence Cathedral (Fig. 14-18). But in his final version he decided on a hemispherical dome to temper the verticality of the design of the lower stories and to establish a balance between dynamic and static elements. However, when Giacomo della Porta (ca. 1533–1602) executed the dome (Fig. 19-4) after Michelangelo's death, he restored the earlier high design, ignoring Michelangelo's later version. Giacomo's reasons were probably the same ones that had impelled Brunelleschi to use an ogival section for his Florentine dome—greater stability and ease of construction. The result is that the dome seems to rise from its base, rather than rest firmly on it—an effect Michelangelo might not have approved. Nevertheless, Saint Peter's dome is probably the most impressive in the world.

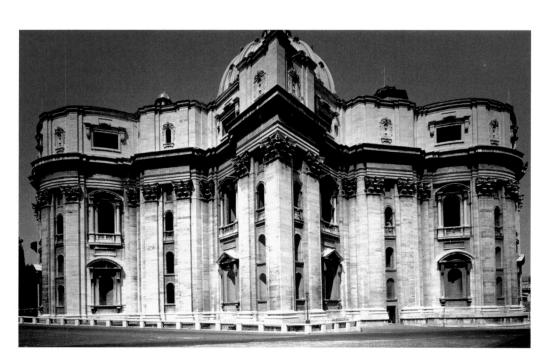

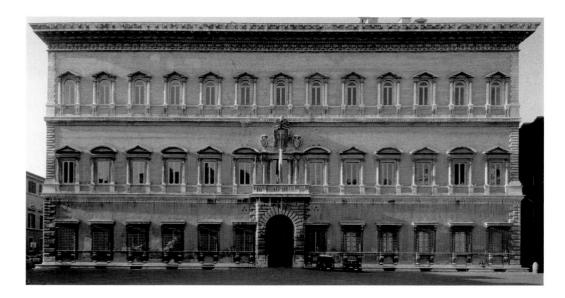

17-27 Antonio da Sangallo the Younger, Palazzo Farnese (looking southeast), Rome, Italy, 1517–1546; completed by Michelangelo Buonarroti, 1546–1550.

Pope Paul III's decision to construct a lavish private palace in Rome reflects his ambitions for his papacy. The facade features a rusticated central doorway and alternating triangular and segmental pediments.

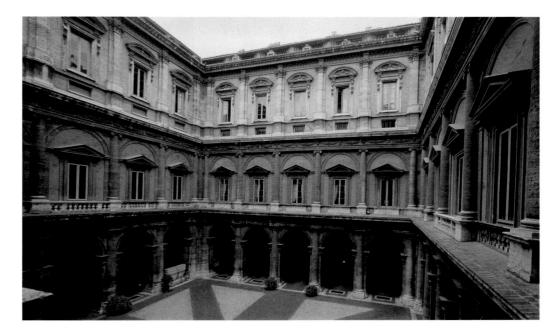

17-28 Antonio da Sangallo The Younger, courtyard of the Palazzo Farnese, Rome, Italy, ca. 1517–1546. Third story and attic by Michelangelo Buonarroti, 1546–1550.

The interior courtyard of the Palazzo Farnese set the standard for later Italian palaces. It fully expresses the classical order, regularity, simplicity, and dignity of the High Renaissance style in architecture.

PALAZZO FARNESE Another architectural project Michelangelo took over at the request of Paul III was the construction of the lavish private palace the pope had commissioned when he was still Cardinal Alessandro Farnese. The future pope had selected Antonio da Sangallo the Younger (1483–1546) to design the Palazzo Farnese (Fig. 17-27) in Rome. (At Antonio's death in 1546, Michelangelo assumed control of the building's completion.) Antonio, the youngest of a family of architects, went to Rome around 1503 and became Bramante's draftsman and assistant. He is the perfect example of the professional architect. Indeed, his family constituted an architectural firm, often planning and drafting for other architects.

The broad, majestic front of the Palazzo Farnese asserts to the public the exalted station of a great family. This impressive facade encapsulates the aristocratic epoch that followed the stifling of the nascent middle-class democracy of European cities (especially the Italian cities) by powerful rulers heading centralized states. It is thus significant that Paul chose to enlarge greatly the original rather modest palace to its present form after his accession to the papacy in 1534, reflecting his ambitions both for his family and for the papacy. Facing a spacious paved square, the facade is the very essence of princely dignity in architecture. The *quoins* (rusticated building corners) and cornice firmly anchor the rectangle of the smooth front,

and lines of windows (the central row with alternating triangular and segmental pediments, in Bramante's fashion) mark a majestic beat across it. The window frames are not flush with the wall, as in the Palazzo Medici-Riccardi (FIG. 16-36), but project from its surface, so instead of being a flat, thin plane, the facade is a spatially active three-dimensional mass. The rusticated doorway and second-story balcony, surmounted by the Farnese coat of arms, emphasize the central axis and bring the design's horizontal and vertical forces into harmony. This centralizing feature, absent from the palaces of Michelozzo (FIG. 16-36) and Alberti (FIG. 16-38), is the external opening of a central corridor axis that runs through the entire building and continues in the garden beyond. Around this axis, Antonio arranged the rooms with strict regularity.

The interior courtyard (FIG. 17-28) displays stately columnenframed arches on the first two levels, as in the Roman Colosseum (FIG. 7-1). On the third level, Michelangelo incorporated his sophisticated variation on that theme (based in part on the Colosseum's fourth-story Corinthian pilasters), with overlapping pilasters replacing the weighty columns of Antonio's design. The Palazzo Farnese set the standard for Italian Renaissance palaces and fully expresses the classical order, regularity, simplicity, and dignity of the High Renaissance. 17-29 Andrea Palladio, Villa Rotonda (formerly Villa Capra), near Vicenza, Italy, ca. 1550–1570.

Andrea Palladio's Villa Rotonda has four identical facades, each one resembling a Roman temple with a columnar porch. In the center is a great dome-covered rotunda modeled on the Pantheon (FIG. 7-49).

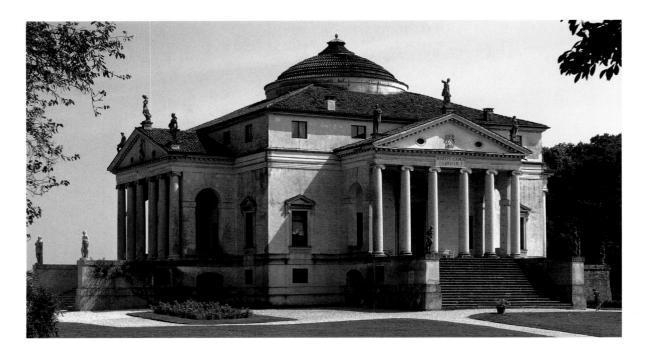

Architecture: Venice

Venice long had been a major Mediterranean coastal port and served as the gateway to the Orient. Reaching the height of its commercial and political power during the 15th century, the city saw its fortunes decline in the 16th century. Even so, Venice and the Papal States were the only Italian sovereignties to retain their independence during the century of strife. Either France or Spain dominated all others. Although the discoveries in the New World and the economic shift from Italy to areas such as the Netherlands were largely responsible for the decline of Venice, even more immediate and pressing events drained its wealth and power. After their conquest of Constantinople, the Turks began to vie with the Venetians for control of the eastern Mediterranean. The Ottoman Empire evolved into a constant threat to Venice. Early in the century, the European powers of the League of Cambrai also attacked the Italian port city. Formed and led by Pope Julius II, who coveted Venetian holdings on Italy's mainland, the league included Spain, France, and the Holy Roman Empire, in addition to the Papal States. Despite these challenges, Venice developed a flourishing, independent, and influential school of artists.

ANDREA PALLADIO The chief architect of the Venetian Republic from 1570 until his death a decade later was Andrea di Pietro, known as Andrea Palladio (1508–1580). (The surname derives from Pallas Athena, Greek goddess of wisdom, an appropriate reference for an architect schooled in the classical tradition of Alberti and Bramante.) Palladio began his career as a stonemason and decorative sculptor in Vicenza, but at age 30 he turned to architecture, the ancient literature on architecture, engineering, topography, and military science. In order to study the ancient buildings firsthand, Palladio made several trips to Rome. In 1556 he illustrated Daniele Barbaro's edition of Vitruvius's De architectura and later wrote his own treatise on architecture, I quattro libri dell'architettura (The Four Books of Architecture), originally published in 1570. That work had a wide-ranging influence on succeeding generations of architects throughout Europe. Palladio's influence outside Italy, most significantly in England and in colonial America (see Chapter 21), was stronger and more lasting than that of any other architect.

Palladio accrued his significant reputation from his many designs for villas, built on the Venetian mainland. Nineteen still stand, and they especially influenced later architects. The same spirit that prompted the

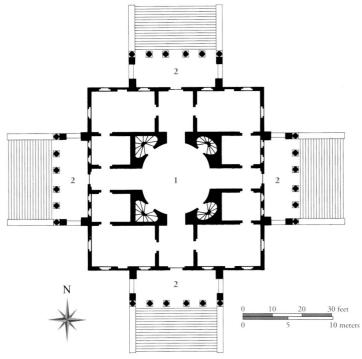

17-30 Andrea Palladio, plan of the Villa Rotonda (formerly Villa Capra), near Vicenza, Italy, ca. 1550–1570. (1) dome, (2) porch.

Palladio published an influential treatise on architecture in 1570. Consistent with his design theories, all the parts of the Villa Rotonda relate to one another in terms of calculated mathematical ratios.

ancient Romans to build villas in the countryside motivated a similar villa-building boom in 16th-century Venice, which, with its very limited space, was highly congested. But a longing for the countryside was not the only motive. Declining fortunes prompted the Venetians to develop their mainland possessions with new land investment and reclamation projects. Citizens who could afford it set themselves up as aristocratic farmers and developed swamps into productive agricultural land. Wealthy families could look on their villas as providential investments. The villas were thus aristocratic farms surrounded by service outbuildings (like the much later American plantations, which emulated many aspects of Palladio's architectural style). Palladio generally

arranged the outbuildings in long, low wings branching out from the main building and enclosing a large rectangular court area.

VILLA ROTONDA Palladio's most famous villa, Villa Rotonda (FIG. 17-29), near Vicenza, is exceptional because the architect did not build it for an aspiring gentleman farmer but for a retired monsignor who wanted a villa for social events. Palladio planned and designed Villa Rotonda, located on a hilltop, as a kind of *belvedere* (literally "beautiful view"; in architecture, a structure with a view of the countryside or the sea), without the usual wings of secondary buildings. It has a central plan (FIG. 17-30) with four identical facades and projecting porches oriented to the four compass points. Each facade of the Villa Rotonda resembles a Roman Ionic temple. In placing a traditional temple porch in front of a dome-covered interior, Palladio doubtless had the Pantheon (FIG. 7-49) in mind as a model. But, as Bramante did in his Tempietto (FIG. 17-22), Palladio transformed his model into a new design that has no parallel in antiquity. Each of the villa's four porches can be used as a platform for enjoying a different

view of the surrounding landscape. In this design, the central dome-covered rotunda logically functions as a kind of circular platform from which visitors may turn in any direction for the preferred view. The result is a building with functional parts systematically related to one another in terms of calculated mathematical relationships. Villa Rotonda embodies all the qualities of self-sufficiency and formal completeness most Renaissance architects sought.

SAN GIORGIO MAGGIORE One of the most dramatically placed buildings in Venice is San Giorgio Maggiore (FIG. 17-31), directly across the Grand Canal from Piazza San Marco. Dissatisfied with earlier solutions to the problem of integrating a high central nave and lower aisles into a unified facade design, Palladio solved it by superimposing a tall and narrow classical porch on a low broad one. This solution reflects the building's interior arrangement (FIG. 17-32) and in that sense is strictly logical, but the intersection of two temple facades is irrational and ambiguous, consistent with contemporaneous developments in Mannerist architecture, discussed

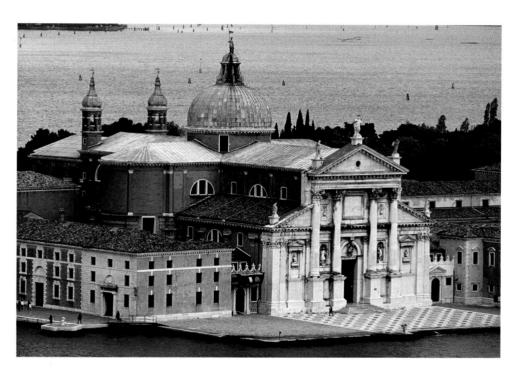

17-31 Andrea Palladio, aerial view of San Giorgio Maggiore, Venice, Italy, begun 1566.

Dissatisfied with earlier solutions to the problem of integrating a high central nave and lower aisles into a unified facade, Palladio superimposed a tall and narrow classical porch on a low broad one.

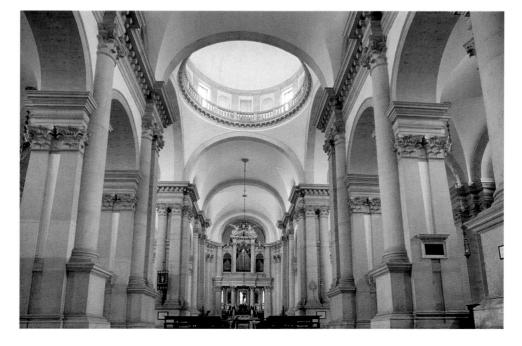

17-32 Andrea Palladio, interior of San Giorgio Maggiore, Venice, Italy, begun 1566.

In contrast to the somewhat irrational intersection of two temple facades on the exterior of San Giorgio Maggiore, Palladio's interior is strictly logical, consistent with classical architectural theory.

later. Palladio's design also created the illusion of three-dimensional depth, an effect intensified by the strong projection of the central columns and the shadows they cast. The play of shadow across the building's surfaces, its reflection in the water, and its gleaming white against sea and sky create a remarkably colorful effect. The interior of the church lacks the ambiguity of the facade and exhibits strong roots in High Renaissance architectural style. Light floods the interior and crisply defines the contours of the rich wall decorations, all beautifully and "correctly" profiled—the exemplar of what classical architectural theory meant by "rational" organization.

Venetian Painting

In the 16th century the Venetians developed a distinctive painting style. Artists in the maritime republic showed a special interest in recording the effect of Venice's soft-colored light on figures and landscapes, and Venetian paintings of the High and Late Renaissance are easy to distinguish from contemporaneous works in Florence and Rome.

GIOVANNI BELLINI One artist who contributed significantly to creating the High Renaissance painting style in Venice was GIOVANNI BELLINI (ca. 1430–1516). Trained in the International

Style (see Chapter 14) by his father Jacopo, a student of Gentile da Fabriano, Bellini worked in the family shop and did not develop his own style until after his father's death in 1470. His early independent works show the dominant influence of his brother-in-law Andrea Mantegna. But in the late 1470s, he came into contact with the work of the Sicilian-born painter Antonello da Messina (ca. 1430–1479). Antonello received his early training in Naples, where he must have become familiar with Flemish painting and mastered using mixed oil (see "Tempera and Oil Painting," Chapter 15, page 401). This more flexible medium is wider in coloristic range than either tempera or fresco. Antonello arrived in Venice in 1475 and during his two-year stay introduced his Venetian colleagues to the possibilities the new oil technique offered. As a direct result of contact with Antonello, Bellini abandoned Mantegna's harsh linear style and developed a sensuous coloristic manner that was to characterize Venetian painting for a century.

SAN ZACCARIA ALTARPIECE Bellini earned great recognition for his many Madonnas, which he painted both in half-length (with or without accompanying saints) on small devotional panels and in full-length on large, monumental altarpieces of the sacra conversazione (holy conversation) type. In the sacra conversazione,

which gained great popularity as a theme for religious paintings from the middle of the 15th century on, saints from different epochs occupy the same space and seem to converse either with each other or with the audience. (Raphael employed much the same conceit in his School of Athens, FIG. 17-9, where he gathered Greek philosophers of different eras.) Bellini carried on the tradition in one of his earliest major commissions, the San Zaccaria Altarpiece (FIG. 17-33). As was conventional, the Virgin Mary sits enthroned, holding the Christ Child, with saints flanking her. Bellini placed the group in a carefully painted shrine. Attributes aid the identification of all the saints: Saint Lucy holding a tray with her plucked-out eyes displayed on it; Saint Peter with his key and book; Saint Catherine with the palm of martyrdom and the broken wheel; and Saint Jerome with a book (representing his translation of the Bible into Latin). At the foot of the throne sits an angel playing a viol. The painting radiates a feeling of serenity and spiritual calm. Viewers derive this sense less from the figures (no interaction occurs among them) than from Bellini's harmonious and balanced presentation of color and light. Line is not the chief agent of form, as it generally is in paintings produced in Rome and Florence. Indeed, outlines dissolve in light and shadow. Glowing color produces a soft radiance that envelops the forms with an atmospheric haze and enhances their majestic serenity.

17-33 GIOVANNI BELLINI, *San Zaccaria Altarpiece*, 1505. Oil on wood transferred to canvas, 16' $5\frac{1}{2}'' \times 7'$ 9". San Zaccaria, Venice.

In this sacra conversazione uniting saints from different eras, Bellini created a feeling of serenity and spiritual calm through the harmonious and balanced presentation of color and light.

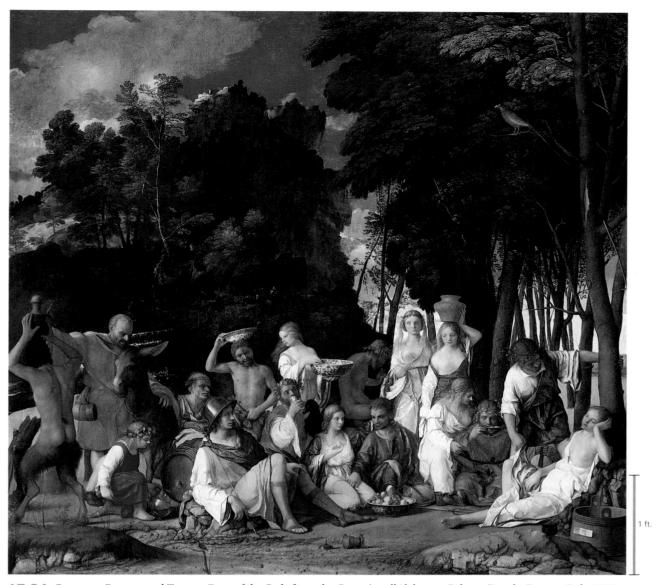

17-34 GIOVANNI BELLINI and TITIAN, *Feast of the Gods*, from the Camerino d'Alabastro, Palazzo Ducale, Ferrara, Italy, 1529. Oil on canvas, 5' $7'' \times 6'$ 2''. National Gallery of Art, Washington, D.C. (Widener Collection).

In Feast of the Gods, based on Ovid's Fasti, Bellini developed a new kind of mythological painting in which the Olympian deities appear as peasants enjoying a picnic in the soft afternoon light.

FEAST OF THE GODS In painting Feast of the Gods (FIG. 17-34), Bellini drew from the work of one of his students, Giorgione da Castelfranco (discussed next), who developed his master's landscape backgrounds into poetic Arcadian reveries. Derived from Arcadia, a region in southern Greece, the term Arcadian referred, by the time of the Renaissance, to an idyllic place of rural, rustic peace and simplicity. After Giorgione's premature death, Bellini embraced his student's interests and, in Feast of the Gods, developed a new kind of mythological painting. The duke of Ferrara, Alfonso d'Este, commissioned this work for a room in the Palazzo Ducale. Although Bellini drew some of the figures from the standard repertoire of Greco-Roman art—most notably, the nymph carrying a vase on her head and the sleeping nymph in the lower right corner—the Olympian gods appear as peasants enjoying a picnic in a shady glade. Bellini's source was Ovid's Fasti, which describes a banquet of the gods. The artist spread the figures across the foreground. Satyrs attend the gods, nymphs bring jugs of wine, a child draws from a keg, couples engage in love play, and the sleeping nymph with exposed breast receives amorous attention. The mellow light of a long afternoon glows softly

around the gathering, caressing the surfaces of colorful fabrics, smooth flesh, and polished metal. Here, Bellini communicated the delight the Venetian school took in the beauty of texture revealed by the full resources of gently and subtly harmonized color. Behind the warm, lush tones of the figures, a background of cool green tree-filled glades extends into the distance. At the right, a screen of trees creates a verdant shelter. The atmosphere is idyllic, a lush countryside providing a setting for the never-ending pleasure of the immortal gods.

With Bellini, Venetian art became the great complement of the schools of Florence and Rome. The Venetians' instrument was color, that of the Florentines and Romans sculpturesque form. Scholars often distill the contrast between these two approaches down to *colorito* (colored or painted) versus *disegno* (drawing and design). Whereas most central Italian artists emphasized careful design preparation based on preliminary drawing (see "Renaissance Drawings," page 459), Venetian artists focused on color and the process of paint application. In addition, the general thematic focus of their work differed. Venetian artists painted the poetry of the senses and delighted in nature's beauty and the pleasures of humanity. Artists in Florence and

17-35 GIORGIONE DA CASTELFRANCO (and/or TITIAN), *Pastoral Symphony*, ca. 1508–1510. Oil on canvas, 3' $7\frac{1}{4}'' \times 4'$ $6\frac{1}{4}''$. Louvre, Paris.

Venetian art is often described as poetic. In this painting, Giorgione so eloquently evoked the pastoral mood that the uncertainty about the picture's meaning is not distressing. The mood and rich color are enough.

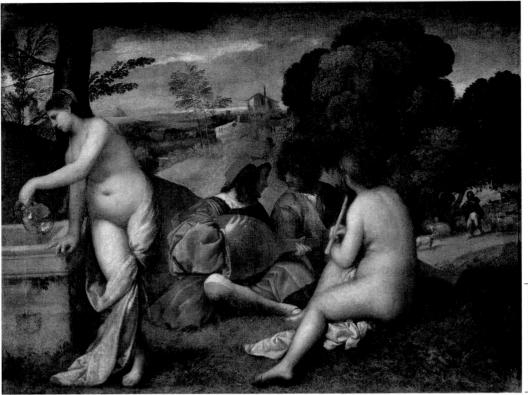

1 ft

17-36 GIORGIONE DA CASTELFRANCO, *The Tempest*, ca. 1510. Oil on canvas, 2' $8\frac{1}{4}'' \times 2' 4\frac{3}{4}''$. Galleria dell'Accademia, Venice.

The subject of this painting set in a lush landscape beneath a stormy sky has never been identified.

The uncertainty contributes to the painting's enigmatic quality and intriguing air and may have been intentional.

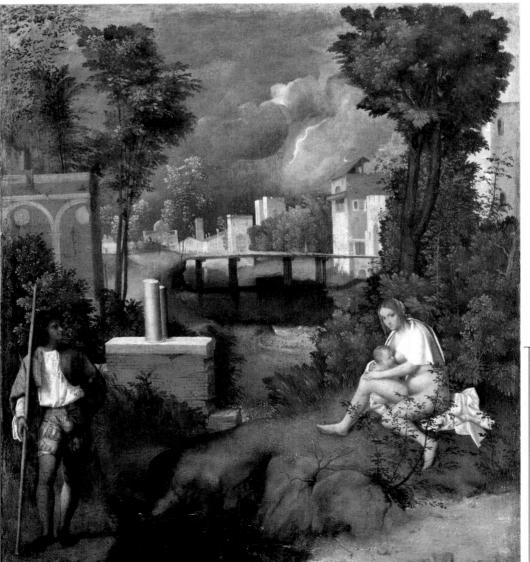

1 ft.

Rome gravitated toward more intellectual themes—the epic of humanity, the masculine virtues, the grandeur of the ideal, and the lofty conceptions of religion involving the heroic and sublime. Much of the history of later Western art involves a dialogue between these two traditions.

Describing Venetian art as "poetic" is particularly appropriate, given the development of *poesia*, or painting meant to evoke moods in a manner similar to poetry. Both classical and Renaissance poetry inspired Venetian artists, and their paintings focused on the lyrical and sensual. Thus, in many Venetian artworks, discerning concrete narratives or subjects (in the traditional sense) is virtually impossible.

GIORGIONE The Venetian artist who deserves much of the credit for developing this poetic manner of painting was GIORGIONE DA CASTELFRANCO (ca. 1477-1510). Giorgione's so-called Pastoral Symphony (FIG. 17-35; many scholars believe it is an early work of his student Titian) exemplifies poesia and surely inspired the late Arcadian scenes by Bellini, his teacher. Out of dense shadow emerge the soft forms of figures and landscape. Giorgione cast a mood of tranquil reverie and dreaminess over the entire scene, evoking the landscape of a lost but never-forgotten paradise. The theme is as enigmatic as the lighting. Two nude women, accompanied by two clothed young men, occupy the rich, abundant landscape through which a shepherd passes. In the distance, a villa crowns a hill. The artist so eloquently evoked the pastoral mood that the viewer does not find the uncertainty about the picture's precise meaning distressing. The mood is enough. The shepherd symbolizes the poet. The pipes and lute symbolize his poetry. The two women accompanying the young men may be thought of as their invisible inspiration, their muses. One turns to lift water from the sacred well of poetic inspiration. The voluptuous bodies of the women, softly modulated by the smoky shadow, became the standard in Venetian art. The fullness of their figures contributes to their effect as poetic personifications of nature's abundance. As a pastoral poet in the pictorial medium and one of the greatest masters in the handling of light and color, Giorgione praised the beauty of nature, music, women, and pleasure. Vasari reported that Giorgione was an accomplished lutenist and singer, and adjectives from poetry and music seem well suited for describing the pastoral air and muted chords of his painting.

The Tempest (FIG. 17-36) displays this same interest in the poetic qualities of the natural landscape inhabited by humans. Dominating the scene is a lush landscape. Stormy skies and lightning in the middle background threaten the tranquility of the pastoral setting. Pushed off to both sides are the human figures—a young woman nursing a baby in the right foreground and a man carrying a halberd (a combination spear and battle-ax) on the left. Although the attribution of this work to Giorgione seems secure, much scholarly debate has centered on the painting's subject, fueled by the fact that X-rays of the canvas have revealed that a nude woman originally stood where Giorgione subsequently placed the man. This flexibility in subject has led many art historians to believe that Giorgione did not intend the painting to have a definitive narrative, which is appropriate for a Venetian poetic rendering. Other scholars have suggested mythological and biblical narratives. This uncertainty about the subject contributes to the painting's enigmatic quality and intriguing air.

TITIAN Giorgione's Arcadianism passed not only to his much older yet constantly inquisitive master, Bellini, but also to Tiziano Vecelli, called TITIAN (ca. 1490–1576) in English. Titian was a supreme colorist and the most extraordinary and prolific of the great Venetian painters. His remarkable coloristic sense and ability

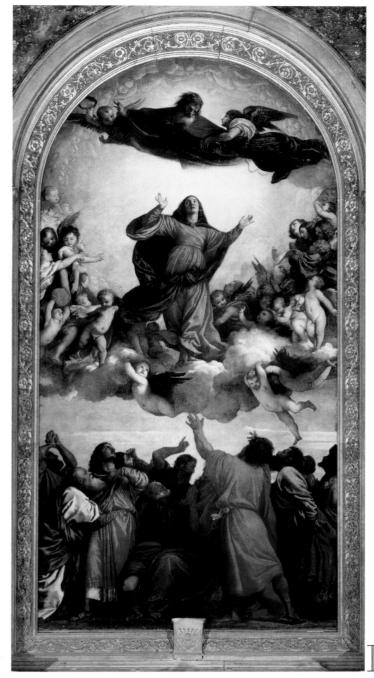

17-37 TITIAN, Assumption of the Virgin, 1516–1518. Oil on wood, $22' 7\frac{1}{2}'' \times 11' 10''$. Santa Maria Gloriosa dei Frari, Venice.

Titian won renown for his ability to convey light through color. In this dramatic depiction of the Virgin Mary's ascent to Heaven, the golden clouds seem to glow and radiate light into the church.

to convey light through color emerge in a major altarpiece, *Assumption of the Virgin* (FIG. **17-37**), painted in oils for the main altar of Santa Maria Gloriosa dei Frari in Venice. Commissioned by the prior of this Franciscan basilica, the monumental altarpiece (close to 23 feet high) depicts the glorious ascent of the Virgin's body to Heaven on a great white cloud borne aloft by putti. Above, golden clouds, so luminous they seem to glow and radiate light into the church, envelop the Virgin. God the Father appears above, awaiting Mary with open arms. Below, apostles gesticulate wildly as they witness this momentous event. Through vibrant color, Titian infused the image with a drama and intensity that assured his lofty reputation, then and now.

17-38 TITIAN, *Madonna of the Pesaro Family*, 1519–1526. Oil on canvas, 15' $11'' \times 8'$ 10''. Pesaro Chapel, Santa Maria dei Frari, Venice.

In this dynamic composition presaging a new kind of pictorial design, Titian placed the figures on a steep diagonal, positioning the Madonna, the focus of the composition, well off the central axis.

PESARO MADONNA Trained by both Bellini and Giorgione, Titian learned so well from them that even today scholars cannot concur about the degree of his participation in their later works. However, it is clear that Titian completed several of Bellini's and Giorgione's unfinished paintings, including the background of Bellini's Feast of the Gods (FIG. 17-34). On Bellini's death in 1516, the Republic of Venice appointed Titian its official painter. Shortly thereafter, Bishop Jacopo Pesaro commissioned him to paint Madonna of the Pesaro Family (FIG. 17-38) and presented it to the church of the Frari, which already housed Titian's Assumption of the Virgin. This new work, with its rich surface textures and dazzling display of color in all its nuances, furthered Titian's reputation and established his personal style.

Pesaro, bishop of Paphos in Cyprus and commander of the papal fleet, had led a successful expedition in 1502 against the Turks during the Venetian-Turkish war and commissioned this painting in gratitude. In a stately sunlit setting in what may be the Madonna's palace in Heaven, Mary receives the commander, who kneels dutifully at the foot of her throne. A soldier (Saint George?) behind the commander carries a banner with the escutcheons (shields with coats of arms) of the Borgia (Pope Alexander VI) and of Pesaro. Behind him is a turbaned Turk, a prisoner of war of the Christian forces. Saint Peter appears seated on the steps of the throne, and Saint Francis introduces other Pesaro family members (all male—Italian depictions of donors in this era typically excluded women and children), who kneel solemnly in the right foreground. Thus, Titian entwined the human and the heavenly, depicting the Madonna and saints honoring the achievements of a specific man in this particular world. A quite worldly transaction takes place (albeit

beneath a heavenly cloud bearing angels) between a queen and her court and loyal servants. Titian constructed this tableau in terms of Renaissance protocol and courtly splendor.

A prime characteristic of High Renaissance painting is the massing of monumental figures, singly and in groups, within a weighty and majestic architecture. But here Titian did not compose a horizontal and symmetrical arrangement, as did Leonardo in *Last Supper* (FIG. 17-4) and Raphael in *School of Athens* (FIG. 17-9). Rather, he placed the figures on a steep diagonal, positioning the Madonna, the focus of the composition, well off the central axis. Titian drew attention to her with the perspective lines, the inclination of the figures, and the directional lines of gaze and gesture. The banner inclining toward the left beautifully brings the design into equilibrium, balancing the rightward and upward tendencies of its main direction. This kind of composition is more dynamic than most High Renaissance examples and presaged a new kind of pictorial design—one built on movement rather than repose.

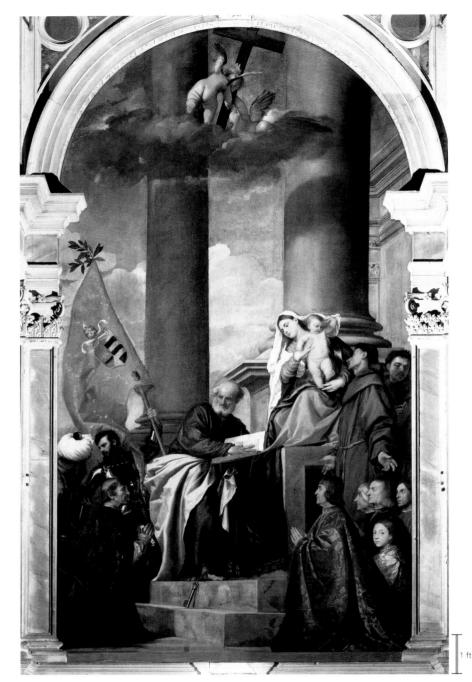

BACCHUS AND ARIADNE In 1511 the duke of Ferrara, Alfonso d'Este (r. 1505-1534), asked Titian to produce a painting for his Camerino d'Alabastro (small room of alabaster). The patron had requested one bacchanalian scene each from Titian, Bellini, Raphael, and Fra Bartolommeo. Both Raphael and Fra Bartolommeo died before fulfilling the commission, and Bellini painted only one scene (FIG. 17-34), leaving Titian to produce three. One of these three paintings is Meeting of Bacchus and Ariadne (FIG. 17-39). Bacchus, accompanied by a boisterous and noisy group, arrives in a leoparddrawn chariot to save Ariadne, whom Theseus abandoned on the island of Naxos. In this scene, Titian revealed his debt to classical art. He derived one of the figures, entwined with snakes, from the recently unearthed Laocoön (FIG. 5-88), which also made an indelible impression on Michelangelo and many others. Titian's rich and luminous colors (see "Palma il Giovane on Titian," page 487) add greatly to the sensuous appeal of this painting, making it perfect for Alfonso's "pleasure chamber."

Palma il Giovane on Titian

n important change occurring in Titian's time was the almost universal adoption of canvas, with its rough-textured surface, in place of wood panels for paintings. Titian's works (FIGS. 17-38 to 17-41) established oil color on canvas as the typical medium of the Western pictorial tradition thereafter. One of Titian's students and collaborators was Jacopo Negretti, known as Palma il Giovane (ca. 1548–1628), or "Palma the Younger." He wrote a valuable account of his teacher's working methods and described how he used the new medium to great advantage:

Titian [employed] a great mass of colors, which served . . . as a base for the compositions. . . . I too have seen some of these, formed with bold strokes made with brushes laden with colors, sometimes of a pure red earth, which he used, so to speak, for a middle tone, and at other times of white lead; and with the same brush tinted with red, black and yellow he formed a highlight; and observing these princi-

ples he made the promise of an exceptional figure appear in four brushstrokes. . . . Having constructed these precious foundations he used to turn his pictures to the wall and leave them there without looking at them, sometimes for several months. When he wanted to apply his brush again he would examine them with the utmost rigor . . . to see if he could find any faults. . . . In this way, working on the figures and revising them, he brought them to the most perfect symmetry that the beauty of art and nature can reveal. . . . [T]hus he gradually covered those quintessential forms with living flesh, bringing them by many stages to a state in which they lacked only the breath of life. He never painted a figure all at once and . . . in the last stages he painted more with his fingers than his brushes.*

* Quoted in Francesco Valcanover, "An Introduction to Titian," in Susanna Biadene and Mary Yakush, eds., *Titian: Prince of Painters* (Venice: Marsilio Editori, 1990), 23–24.

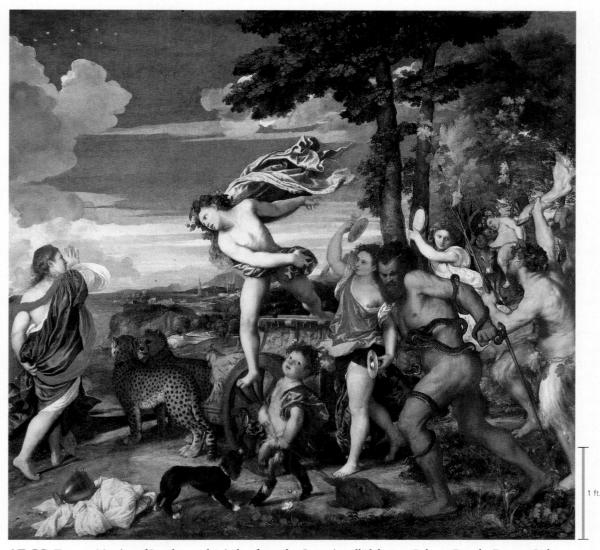

17-39 TITIAN, Meeting of Bacchus and Ariadne, from the Camerino d'Alabastro, Palazzo Ducale, Ferrara, Italy, 1522–1523. Oil on canvas, 5' $9'' \times 6'$ 3''. National Gallery, London.

Titian's rich and luminous colors add greatly to the sensuous appeal of this mythological painting in which he based one of the figures on the recently unearthed ancient statue of *Laocoön* (Fig. 5-88).

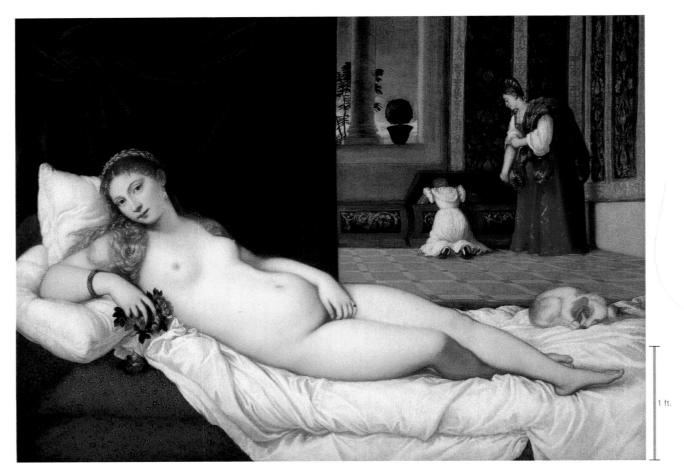

17-40 TITIAN, Venus of Urbino, 1538. Oil on canvas, 3' 11" × 5' 5". Galleria degli Uffizi, Florence.

Titian established oil-based pigments on canvas as the preferred painting medium in Western art. Here, he also set the standard for representations of the reclining female nude, whether divine or mortal.

VENUS OF URBINO In 1538, at the height of his powers, Titian painted the so-called Venus of Urbino (FIG. 17-40) for Guidobaldo II, who became the duke of Urbino the following year (r. 1539-1574). The title (given to the painting later) elevates to the status of classical mythology what is actually a representation of an Italian woman in her bedchamber. Indeed, no evidence suggests that Guidobaldo intended the commission as anything more than a female nude for his private enjoyment—the embodiment of womanly beauty and of the qualities he sought in a bride. Whether the subject is divine or mortal, Titian based his version on an earlier (and pioneering) painting of Venus (not illustrated) by Giorgione. Here, Titian established the compositional elements and the standard for paintings of the reclining female nude, regardless of the many variations that ensued. This "Venus" reclines on the gentle slope of her luxurious pillowed couch, the linear play of the draperies contrasting with her body's sleek continuous volume. At her feet is a pendant (balancing) figure—in this case, a slumbering lapdog. Behind her, a simple drape both places her figure emphatically in the foreground and indicates a vista into the background at the right half of the picture. Two servants bend over a chest, apparently searching for garments (Renaissance households stored clothing in carved wooden chests called cassoni) to clothe "Venus." Beyond them, a smaller vista opens into a landscape. Titian masterfully constructed the view backward into space and the division of the space into progressively smaller units.

As in other Venetian paintings, color plays a prominent role in *Venus of Urbino*. The red tones of the matron's skirt and the muted reds of the tapestries against the neutral whites of the matron's sleeves and the kneeling girl's gown echo the deep Venetian reds set

off against the pale neutral whites of the linen and the warm ivory gold of the flesh. The viewer must study the picture carefully to realize the subtlety of color planning. For instance, the two deep reds (in the foreground cushions and in the background skirt) play a critical role in the composition as a gauge of distance and as indicators of an implied diagonal opposed to the real one of the reclining figure. Here, Titian used color not simply to record surface appearance but also to organize his placement of forms.

ISABELLA D'ESTE Titian was also a highly esteemed portraitist and in great demand. More than 50 portraits by his hand survive. Among the best is Isabella d'Este (FIG. 17-41), Titian's portrait of one of the most prominent women of the Renaissance (see "Women in the Renaissance Art World," page 489). Isabella was the daughter of the duke of Ferrara. At 16, she married Francesco Gonzaga, marquis of Mantua, and through her patronage of art and music, she was instrumental in developing the Mantuan court into an important cultural center. Portraits by Titian generally emphasize his psychological reading of the subject's head and hands. Thus, Titian sharply highlighted Isabella's face, whereas her black dress fades into the undefined darkness of the background. The unseen light source also illuminates Isabella's hands, and Titian painted her sleeves with incredible detail to further draw viewers' attention to her hands. This portrait reveals not only Titian's skill but the patron's wish as well. Painted when Isabella was 60 years old, at her request it depicts her in her 20s. Titian used an earlier portrait of her as his guide, but his portrait is no copy. Rather, it is a distinctive portrayal of his poised and self-assured patron that owes little to its model.

Women in the Renaissance Art World

he Renaissance art world was decidedly male-dominated. Few women could become professional artists because of the obstacles they faced. In particular, for centuries, art-training practices mandating residence at a master's house (see "Artists' Guilds," Chapter 14, page 384) precluded women from acquiring the necessary experience. In addition, social proscriptions, such as those preventing women from drawing from nude models, further hampered an aspiring female artist's advancement through the accepted avenues of artistic training.

Still, there were determined women who surmounted these barriers and were able to develop not only considerable bodies of work but enviable reputations as well. One was Sofonisba Anguissola (FIG. 17-46), who was so accomplished that she can be considered the first Italian woman to have ascended to the level of international art celebrity. Lavinia Fontana (1552–1614) also achieved notable success, and her paintings constitute the largest surviving body of work by any woman artist before 1700. Fontana learned her craft from her father, a leading Bolognese painter. (Paternal training was the norm for aspiring women artists.) She was in demand as a portraitist and received commissions from important patrons, including members of the dominant Habsburg family. She even spent time as an official painter to the papal court in Rome.

Perhaps more challenging for women than the road to becoming a professional painter was the mastery of sculpture, made more difficult by the physical demands of the medium. Yet Properzia de' Rossi (ca. 1490–1530) established herself as a professional sculptor and was the only woman artist that Giorgio Vasari included in his comprehensive publication, *Lives of the Most Eminent Painters, Sculptors, and Architects*. Active in the early 16th century, she died of the plague in 1530, bringing her promising career to an early end.

Beyond the realm of art production, Renaissance women had a significant impact as art patrons. Scholars only recently have begun to explore systematically the role of women as patrons. As a result, current knowledge is sketchy at best but suggests that women played a much more extensive role than previously acknowledged. Among the problems researchers face in their quest to clarify women's participation as patrons is that women often wielded their influence and decision-making power behind the scenes. Many of them acquired their positions through marriage. Their power was thus indirect and provisional, based on their husbands' wealth and status. Thus, documentation of the networks within which women patrons operated and of the processes they used to exert power in a male-dominated society is less substantive than that available for male patrons.

One of the most important Renaissance patrons, male or female, was Isabella d'Este (1474–1539), marchioness of Mantua. Brought up in the cultured princely court of Ferrara (southwest of Venice), Isabella married Francesco Gonzaga (1466–1519), marquis of Mantua, in 1490. The marriage gave Isabella access to the position and wealth necessary to pursue her interest in becoming a major art patron. An avid collector, she enlisted the aid of agents who scoured Italy for appealing objects. Isabella did not limit her collection to painting and sculpture but included ceramics, glassware, gems, cameos, medals, classical texts, musical manuscripts, and musical instruments.

Isabella was undoubtedly a proud and ambitious woman well aware of how art could boost her fame and reputation. Accordingly, she commissioned several portraits of herself from the most esteemed artists of her day—Leonardo da Vinci, Andrea Mantegna, and Titian

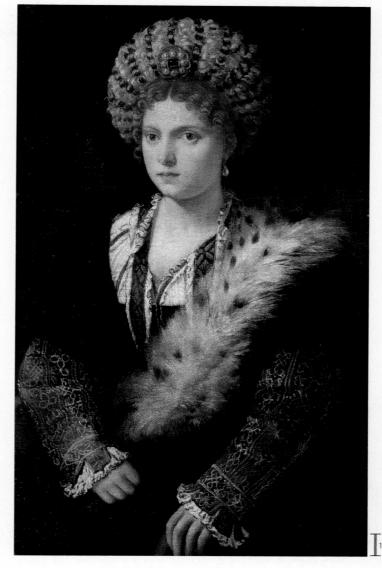

17-41 TITIAN, *Isabella d'Este*, 1534–1536. Oil on canvas, 3′ $4\frac{1}{8}$ ″ × 2′ $1\frac{3}{16}$ ″. Kunsthistorisches Museum, Vienna.

Isabella d'Este was one of the most powerful women of the Renaissance era. When, at age 60, she commissioned Titian to paint her portrait, she insisted that the artist depict her in her 20s.

(FIG. 17-41). The detail and complexity of many of her contracts with artists reveal her insistence on control over the artworks.

Other Renaissance women positioned themselves as serious art patrons. One was Caterina Sforza (1462–1509), daughter of Galeazzo Maria Sforza (heir to the duchy of Milan), who married Girolamo Riario in 1484. The death in 1488 of her husband, lord of Imola and count of Forlì, gave Caterina Sforza access to power denied most women. Another female art patron was Lucrezia Tornabuoni (married to Piero di Cosimo de' Medici), one of many Medici, both men and women, who earned reputations as unparalleled art patrons. Further archival investigation of women's roles in Renaissance Italy undoubtedly will produce more evidence of how women established themselves as patrons and artists and the extent to which they contributed to the flourishing of Renaissance art.

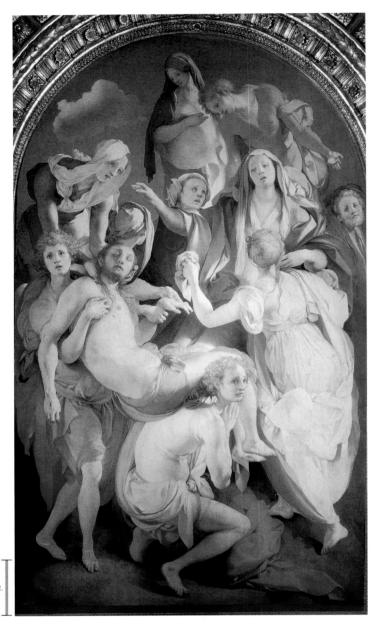

17-42 Јасоро да Ронтовмо, Entombment of Christ, Capponi Chapel, Santa Felicità, Florence, Italy, 1525–1528. Oil on wood, 10' $3'' \times 6'$ 4''.

Mannerist paintings such as this one represent a departure from the compositions of the earlier Renaissance. Instead of concentrating masses in the center of the painting, Pontormo left a void.

MANNERISM

The Renaissance style of Rome, Florence, and Venice dominated Italian painting, sculpture, and architecture for most of the 16th century, but already in the 1520s another style—Mannerism—emerged in reaction to it. *Mannerism* is a term derived from the Italian word *maniera*, meaning "style" or "manner." In the field of art history, the term *style* usually refers to a characteristic or representative mode, especially of an artist or period (for example, Leonardo's style or Gothic style). Style also can refer to an absolute quality of fashion (for example, someone has "style"). Mannerism's style (or representative mode) is characterized by style (being stylish, cultured, elegant).

Painting

Among the features most closely associated with Mannerism is artifice. Of course, all art involves artifice, in the sense that art is not

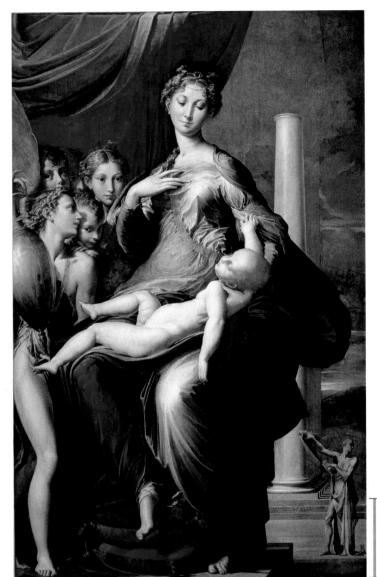

17-43 PARMIGIANINO, *Madonna with the Long Neck*, from the Baiardi Chapel, Santa Maria dei Servi, Parma, Italy, 1534–1540. Oil on wood, $7'\ 1'' \times 4'\ 4''$. Galleria degli Uffizi, Florence.

Parmigianino's Madonna displays the stylish elegance that was a principal aim of Mannerism. Mary has a small oval head, a long slender neck, attenuated hands, and a sinuous body.

"natural"—it is a representation of a scene or idea. But many artists, including High Renaissance painters such as Leonardo and Raphael, chose to conceal that artifice by using such devices as perspective and shading to make their art look natural. In contrast, Mannerist painters consciously revealed the constructed nature of their art. In other words, Renaissance artists generally strove to create art that appeared natural, whereas Mannerist artists were less inclined to disguise the contrived nature of art production. This is why artifice is a central feature of discussions about Mannerism, and why Mannerist works can seem, appropriately, "mannered." The conscious display of artifice in Mannerism often reveals itself in imbalanced compositions and unusual complexities, both visual and conceptual. Ambiguous space, departures from expected conventions, and unique presentations of traditional themes also surface frequently in Mannerist art.

PONTORMO *Entombment of Christ* (FIG. 17-42) by JACOPO DA PONTORMO (1494–1557) exhibits almost all the stylistic features char-

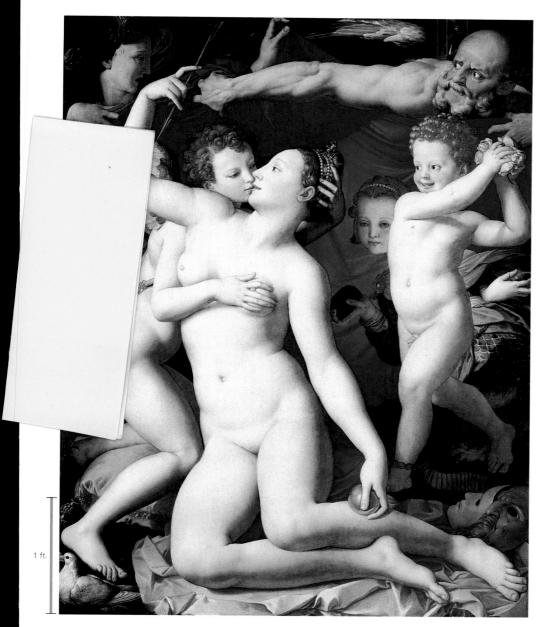

17-44 Bronzino, *Venus*, *Cupid*, *Folly*, *and Time*, ca. 1546. Oil on wood, 5' $1'' \times 4'$ $8\frac{1}{4}''$. National Gallery, London.

In this painting of Cupid fondling his mother Venus, Bronzino demonstrated a fondness for learned allegories with lascivious undertones. As in many Mannerist paintings, the meaning here is ambiguous.

tions (for example, the torso of the fore-ground figure bends in an anatomically impossible way), elastic elongation of the limbs, and heads rendered as uniformly small and oval. The contrasting colors, primarily light blues and pinks, add to the dynamism and complexity of the work. The painting represents a departure from the balanced, harmoniously structured compositions of the High Renaissance.

PARMIGIANINO Girolamo Francesco Maria Mazzola of Parma, known as Parmi-Gianino (1503–1540), achieved in his best-known work, *Madonna with the Long Neck* (Fig. 17-43), the elegant stylishness that was a principal aim of Mannerism. In Parmigianino's hands, this traditional, usually sedate, religious subject became a picture of exquisite grace and precious sweetness. The Madonna's small oval head, her long and slender neck, the otherworldly attenuation and delicacy of her hand, and the sinuous, swaying elongation of her frame—all are marks of the aristocratic, sumptuously courtly taste of a later phase of Mannerism. Parmigianino amplified

this elegance by expanding the Madonna's form as viewed from head to toe. On the left stands a bevy of angelic creatures, melting with emotions as soft and smooth as their limbs. On the right, the artist included a line of columns without capitals and an enigmatic figure with a scroll, whose distance from the foreground is immeasurable and ambiguous—the antithesis of rational Renaissance perspectival diminution of size with distance.

Although the elegance and sophisticated beauty of the painting are due in large part to the Madonna's attenuated limbs, that exaggeration is not solely decorative in purpose. *Madonna with the Long Neck* takes its subject from a simile in medieval hymns that compared the Virgin's neck to a great ivory tower or column, such as that which Parmigianino depicted to the right of the Madonna. Thus, the work contains religious meaning in addition to the power derived from its beauty alone.

BRONZINO *Venus, Cupid, Folly, and Time* (FIG. **17-44**), by Agnolo di Cosimo, called Bronzino (1503–1572), also displays all the chief features of Mannerist painting. A pupil of Pontormo, Bronzino was a Florentine and painter to the first grand duke of Tuscany, Cosimo I de' Medici (r. 1537–1574). In this painting, which Cosimo I commissioned as a gift for King Francis I of France,

acteristic of Mannerism's early phase in painting. Christ's descent from the cross and subsequent entombment had frequently been depicted in art (see "The Life of Jesus in Art," Chapter 8, pages 216–217, or in the "Before 1300" section), and Pontormo exploited the familiarity that 16th-century viewers would have had by playing off their expectations. For example, he omitted from the painting both the cross and Christ's tomb, so that scholars continue to debate whether he meant to represent the Descent from the Cross or the Entombment. And instead of presenting the action as occurring across the perpendicular picture plane, as artists such as Raphael and Rogier van der Weyden (FIG. 15-8) had done in their paintings of these episodes from Christ's Passion, Pontormo rotated the conventional figural groups along a vertical axis. As a result, the Virgin Mary falls back (away from the viewer) as she releases her dead son's hand. Unlike High Renaissance artists, who had concentrated their masses in the center of the painting, Pontormo left a void. This emptiness accentuates the grouping of hands that fill that hole, calling attention to the void—symbolic of loss and grief. The artist enhanced the painting's ambiguity with the curiously anxious glances the figures cast in all directions. (The bearded young man at the upper right who looks out at the viewer is probably a self-portrait of Pontormo.) Athletic bending and twisting characterize many of the figures, with distor-

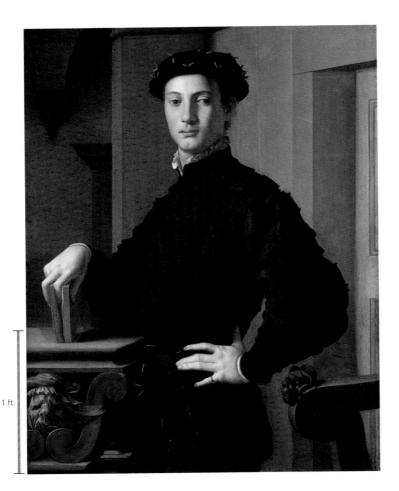

17-45 Bronzino, *Portrait of a Young Man*, ca. 1530–1545. Oil on wood, $3'1\frac{1}{2}''\times2'5\frac{1}{2}''$. Metropolitan Museum of Art, New York (H. O. Havemeyer Collection, bequest of Mrs. H. O. Havemeyer, 1929).

This depiction of a young intellectual with a calculated attitude of nonchalance is typical of Mannerist portraiture. Bronzino recorded the rank and station but not the personality of his subject.

Bronzino demonstrated the Mannerists' fondness for learned allegories that often had lascivious undertones, a shift from the simple and monumental statements and forms of the High Renaissance. Bronzino depicted Cupid fondling his mother Venus, while Folly prepares to shower them with rose petals. Time, who appears in the upper right corner, draws back the curtain to reveal the playful incest in progress. Other figures in the painting represent other human qualities and emotions, including Envy. The masks, a favorite device of the Mannerists, symbolize deceit. The picture seems to suggest that love-accompanied by envy and plagued by inconstancy-is foolish and that lovers will discover its folly in time. But as in many Mannerist paintings, the meaning here is ambiguous, and interpretations of the painting vary. Compositionally, Bronzino placed the figures around the front plane, and they almost entirely block the space. The contours are strong and sculptural, the surfaces of enamel smoothness. Of special interest are the heads, hands, and feet, for the Mannerists considered the extremities the carriers of grace, and the clever depiction of them as evidence of artistic skill.

Mannerist painters most often achieved in portraiture the sophisticated elegance they sought. Bronzino's *Portrait of a Young Man* (FIG. **17-45**) exemplifies Mannerist portraiture. The subject is a

17-46 SOFONISBA ANGUISSOLA, Portrait of the Artist's Sisters and Brother, ca. 1555. Oil on panel, 2' 5 $\frac{1}{4}$ " × 3' 1 $\frac{1}{2}$ ". Methuen Collection, Corsham Court, Wiltshire.

Anguissola was the leading female artist of her time. Her contemporaries greatly admired her use of relaxed poses and expressions in intimate and informal group portraits like this one of her own family.

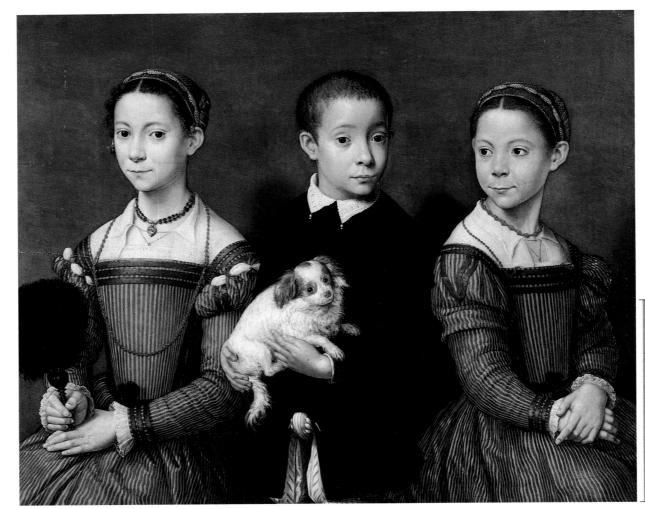

1 ft

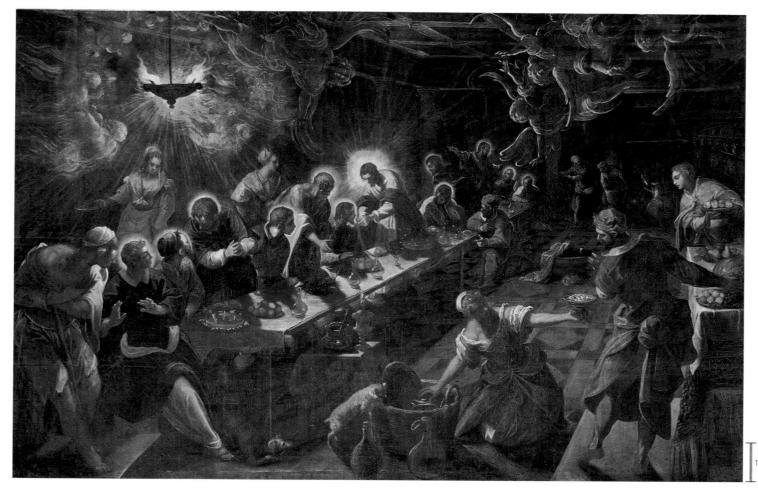

17-47 TINTORETTO, Last Supper, 1594. Oil on canvas, $12' \times 18'$ 8". San Giorgio Maggiore, Venice.

Tintoretto adopted many Mannerist pictorial devices to produce oil paintings imbued with emotional power, depth of spiritual vision, glowing Venetian color schemes, and dramatic lighting.

proud youth—a man of books and intellectual society, rather than a merchant or lowly laborer. His cool demeanor seems carefully affected, a calculated attitude of nonchalance. This staid and reserved formality is a standard component of Mannerist portraits. It asserts the rank and station but not the personality of the subject. In Bronzino's portrait, the haughty poise, the graceful long-fingered hands, the book, the carved faces of the furniture, and the severe architecture all suggest the traits and environment of the highbred, disdainful patrician. The somber black of the young man's Spanish doublet and cap and the room's slightly acid, olive-green walls make for a deeply restrained color scheme. Bronzino created a muted background for the man's sharply defined, asymmetrical silhouette that contradicts his impassive pose.

SOFONISBA ANGUISSOLA The aloof formality of Bronzino's portrait is much relaxed in the portraiture of SOFONISBA ANGUISSOLA (ca. 1532–1625). A northern Italian from Cremona, Anguissola introduced a new kind of group portrait of irresistible charm, characterized by an informal intimacy and subjects that are often moving, conversing, or engaged in activities. Like many of the other works she did before moving to Spain in 1559, the portrait illustrated here (FIG. 17-46) represents members of her family. Against a neutral ground, Anguissola placed her two sisters and brother in an affectionate pose meant not for official display but for private showing. The sisters, wearing matching striped gowns, flank their brother, who caresses a lapdog. The older sister (at the left) summons the dignity required

for the occasion, while the boy looks quizzically at the portraitist with an expression of naive curiosity, and the other girl diverts her attention toward something or someone to the painter's left.

Anguissola's use of relaxed poses and expressions, her sympathetic personal presentation, and her graceful treatment of the forms did not escape the attention of her contemporaries, who praised her highly (see "Women in the Renaissance Art World," page 489). Her recognized talents allowed her to consort with esteemed individuals. She knew and learned from the aged Michelangelo, was court painter to Philip II (r. 1556–1598) of Spain, and, at the end of her life, gave advice on art to a young admirer of her work, Anthony Van Dyck, the great Flemish master (see Chapter 20).

TINTORETTO Venetian painting of the later 16th century built on established High Renaissance ideas but incorporated many elements of the Mannerist style. Jacopo Robusti, known as TINTORETTO (1518–1594), claimed to be a student of Titian and aspired to combine Titian's color with Michelangelo's drawing, but art historians consider Tintoretto the outstanding Venetian representative of Mannerism. He adopted many Mannerist pictorial devices, which he employed to produce works imbued with dramatic power, depth of spiritual vision, and glowing Venetian color schemes.

Toward the end of Tintoretto's life, his art became spiritual, even visionary, as solid forms melted away into swirling clouds of dark shot through with fitful light. In Tintoretto's *Last Supper* (FIG. 17-47), painted for the right wall next to the high altar in Andrea Palladio's

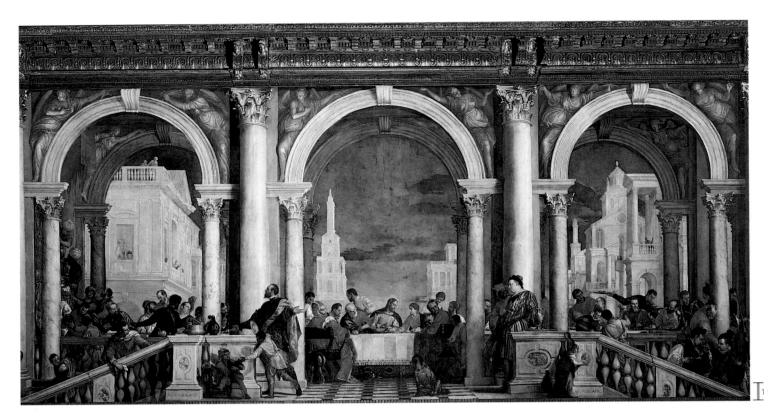

17-48 PAOLO VERONESE, *Christ in the House of Levi*, from the refectory of Santi Giovanni e Paolo, Venice, Italy, 1573. Oil on canvas, 18′ 3″ × 42′. Galleria dell'Accademia, Venice.

Veronese's paintings feature superb color and majestic classical settings. The Catholic Church accused him of impiety for including dogs and dwarfs near Christ in this work originally titled Last Supper.

church of San Giorgio Maggiore (FIG. 17-32), the figures appear in a dark interior illuminated by a single light in the upper left of the image. The shimmering halos establish the biblical nature of the scene. The ability of this dramatic scene to engage viewers was well in keeping with Counter-Reformation ideals (see "Religious Art in Counter-Reformation Italy," page 474) and the Catholic Church's belief in the didactic nature of religious art.

Last Supper incorporates many Mannerist elements, including an imbalanced composition and visual complexity. In terms of design, the contrast with Leonardo's Last Supper (FIG. 17-4) is both extreme and instructive. Leonardo's composition, balanced and symmetrical, parallels the picture plane in a geometrically organized and closed space. The figure of Christ is the tranquil center of the drama and the perspectival focus. In Tintoretto's painting, Christ is above and beyond the converging perspective lines that race diagonally away from the picture surface, creating disturbing effects of limitless depth and motion. The viewer locates Tintoretto's Christ via the light flaring, beaconlike, out of darkness. The contrast of the two works reflects the direction Renaissance painting took in the 16th century, as it moved away from architectonic clarity of space and neutral lighting toward the dynamic perspectives and dramatic chiaroscuro of the coming Baroque.

VERONESE Among the great Venetian masters was Paolo Caliari of Verona, called Paolo Veronese (1528–1588). Whereas Tintoretto gloried in monumental drama and deep perspectives, Veronese specialized in splendid pageantry painted in superb color and set within majestic classical architecture. Like Tintoretto, Veronese painted on a huge scale and often produced canvases as large as 20 by 30 feet or more for the refectories of wealthy monasteries. He painted *Christ in*

the House of Levi (FIG. 17-48), originally called Last Supper, for the dining hall of Santi Giovanni e Paolo in Venice. In a great open loggia framed by three monumental arches, Christ sits at the center of the splendidly garbed elite of Venice. In the foreground, with a courtly gesture, the very image of gracious grandeur, the chief steward welcomes guests. Robed lords, their colorful retainers, dogs, and dwarfs crowd into the spacious loggia. Painted during the Counter-Reformation, this depiction prompted criticism from the Catholic Church. The Holy Office of the Inquisition accused Veronese of impiety for painting such creatures so close to the Lord, and it ordered him to make changes at his own expense. Reluctant to do so, he simply changed the painting's title, converting the subject to a less solemn one. As Palladio looked to the example of classically inspired High Renaissance architecture, so Veronese returned to High Renaissance composition, its symmetrical balance, and its ordered architectonics. His shimmering colors span the whole spectrum, although he avoided solid colors for half shades (light blues, sea greens, lemon yellows, roses, and violets), creating veritable flower beds of tone.

The Venetian Republic employed both Tintoretto and Veronese to decorate the grand chambers and council rooms of the Doge's Palace (FIG. 14-21). A great and popular decorator, Veronese revealed himself a master of imposing illusionistic ceiling compositions, such as *Triumph of Venice* (FIG. 17-49). Here, within an oval frame, he presented Venice, crowned by Fame, enthroned between two great twisted columns in a balustraded loggia, garlanded with clouds, and attended by figures symbolic of its glories. Unlike Mantegna's *di sotto in sù* (FIG. 16-48) perspective, Veronese's projection is not directly up from below but at a 45-degree angle to spectators, a technique many later Baroque decorators used (see Chapter 19).

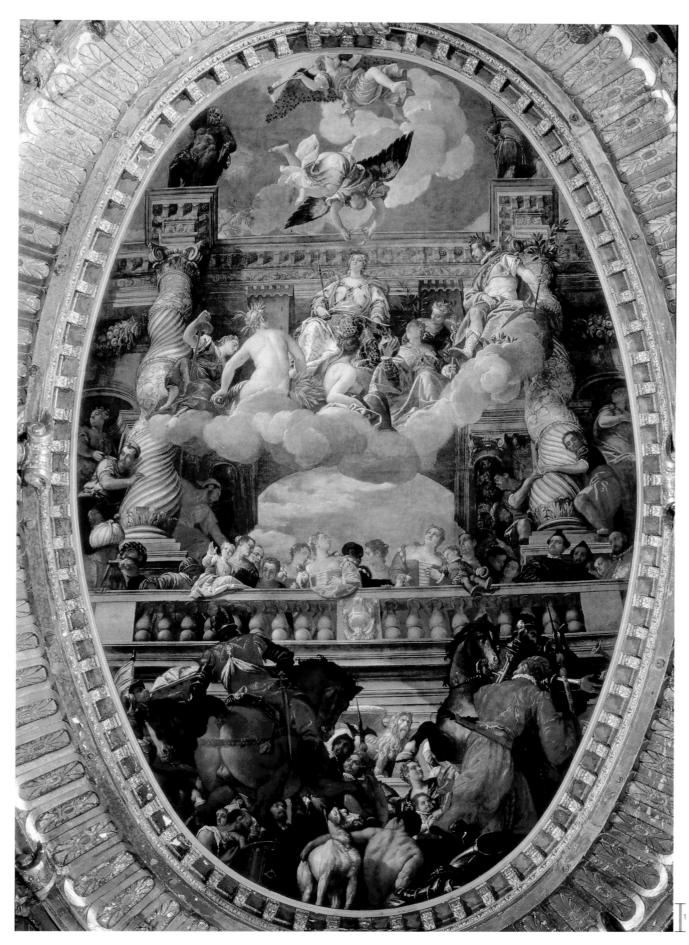

17-49 Paolo Veronese, *Triumph of Venice*, ca. 1585. Oil on canvas, $29' 8'' \times 19'$. Ceiling of the Hall of the Grand Council, Doge's Palace, Venice.

Within an immense oval frame, Veronese presented an illusionistic tableau of Venice crowned by Fame amid columns, clouds, and personifications. Baroque painters adopted this 45-degree view from the ground.

17-50 Correggio, Assumption of the Virgin, 1526–1530. Fresco, 35' $10'' \times 37'$ 11''. Parma Cathedral, Parma.

Working long before Veronese, Correggio, the teacher of Parmigianino, won little fame in his day, but his illusionistic ceiling designs, like this one in Parma Cathedral, inspired many 17th-century painters.

CORREGGIO One painter who developed a unique personal style that is almost impossible to classify was Antonio Allegri, known as Correg-GIO (ca. 1489-1534) from his birthplace, near Parma. The teacher of Parmigianino, Correggio, working more than a half century before Veronese, pulled together many stylistic trends, including those of Leonardo, Raphael, and the Venetians. Correggio's most enduring artistic contribution was his development of illusionistic ceiling perspectives. In Parma Cathedral, he painted away the entire dome with his Assumption of the Virgin (FIG. 17-50). Opening up the cupola, Correggio showed worshipers a view of the sky, with concentric rings of clouds where hundreds of soaring figures perform a wildly pirouetting dance in celebration of the Assumption. Versions of these an-

gelic creatures became permanent tenants of numerous Baroque churches in later centuries. Correggio was also an influential painter of religious panels, anticipating in them many other Baroque compositional devices. Correggio's contemporaries expressed little appreciation for his art. Later, during the 17th century, Baroque painters recognized him as a kindred spirit.

Sculpture

Mannerism extended beyond painting. Artists translated its principles into sculpture and architecture as well.

BENVENUTO CELLINI Among those who made their mark as Mannerist sculptors was Benvenuto Cellini (1500–1571), the author of a fascinating autobiography. It is difficult to imagine a medieval artist composing an autobiography. Only in the Renaissance, with the birth of the notion of individual artistic genius, could a work such as Cellini's (or Vasari's *Lives*) have been conceived and written. Cellini's literary self-portrait presents him not only as a highly accomplished artist, but also as a statesman, soldier, and lover, among many other roles. He was, first of all, a goldsmith, but only one of his major

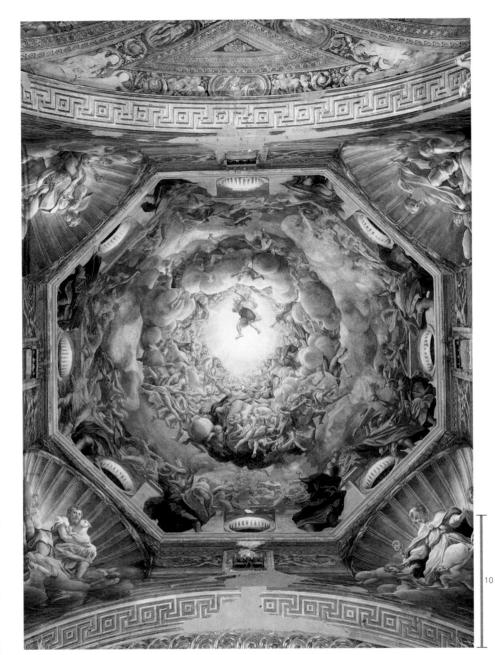

works in that medium survives, the saltcellar (FIG. 17-51) he made for Francis I (FIG. 18-10), who had hired Cellini with a retainer of an annual salary, supplemented by fees for the works he produced. The price paid for this luxurious gold-and-enamel item destined for the French royal table was almost 50 percent greater than Cellini's salary for the year. Neptune and Tellus (or, as Cellini named them, the Sea—the source of salt—and the Land) recline atop an ebony base decorated with relief figures of Dawn, Day, Twilight, Night, and the four winds—some based on Michelangelo's statues in the Medici Chapel (FIG. 17-17) in San Lorenzo. The boat next to Neptune's right leg contained the salt, and the triumphal arch (compare FIG. 7-75) next to the right leg of the earth goddess, the pepper. The elongated proportions of the figures, especially the slim, small-breasted figure of Tellus, whom ancient artists always represented as a matronly woman (FIG. 7-30), reveal Cellini's Mannerist approach to form.

GIOVANNI DA BOLOGNA The lure of Italy drew a brilliant young Flemish sculptor, Jean de Boulogne, to Italy, where he practiced his art under the equivalent Italian name of GIOVANNI DA BOLOGNA (1529–1608). Giovanni's Abduction of the Sabine Women

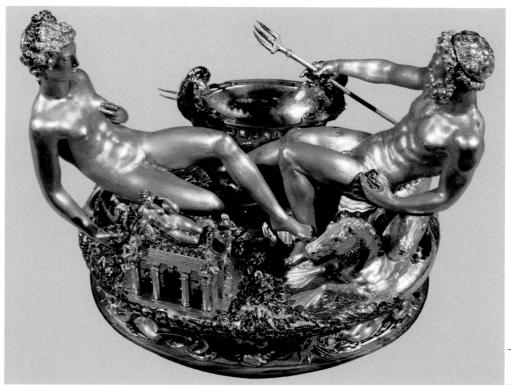

17-51 Benvenuto Cellini, *Saltcellar of Francis I*, 1540–1543. Gold, enamel, and ebony, $10\frac{1}{4}'' \times 1' 1\frac{1}{8}''$. Kunsthistorisches Museum, Vienna.

Famed as a master goldsmith, Cellini fashioned this costly saltcellar for the table of Francis I of France. The elongated proportions of the figures clearly reveal Cellini's Mannerist approach to form.

1 in

(FIG. 17-52) exemplifies Mannerist principles of figure composition. Drawn from the legendary history of early Rome, the group received its present title—relating how the Romans abducted wives for themselves from the neighboring Sabines—only after its exhibition. Earlier, it was Paris Abducting Helen, among other mythological titles. In fact, Giovanni had no interest in depicting any particular subject. He created the group as a demonstration piece. His goal was to achieve a dynamic spiral figural composition involving an old man, a young man, and a woman, all nude in the tradition of ancient statues portraying mythological figures. Although Giovanni would have known Antonio Pollaiuolo's Hercules and Antaeus (FIG. 16-14), whose Greek hero lifts his opponent off the ground, he turned directly to ancient sculpture for inspiration. Abduction of the Sabine Women includes references to Laocoön (FIG. 5-88)—once in the crouching old man and again in the woman's up-flung arm. The three bodies interlock on a vertical axis, creating an ascending spiral movement.

To appreciate the sculpture fully, the viewer must walk around it, because the work changes radically according to the viewing point. One factor contributing to the shifting imagery is the prominence of open spaces that pass through the masses (for example, the space between an arm and a body), giving the spaces an effect equal to that of the solids. This sculpture was the first large-scale group since classical antiquity designed to be seen from multiple viewpoints, in striking contrast to Pollaiuolo's group, which the artist intended to be seen from the angle shown in FIG. 16-14. Giovanni's figures do not break out of this spiral vortex but remain as if contained within a cylinder. Nonetheless, they display athletic flexibility and Michelangelesque potential for action.

17-52 GIOVANNI DA BOLOGNA, Abduction of the Sabine Women, Loggia dei Lanzi, Piazza della Signoria, Florence, Italy, 1579–1583. Marble, 13' $5\frac{1}{2}''$ high.

This sculpture was the first large-scale group since classical antiquity designed to be seen from multiple viewpoints. The three bodies interlock to create a vertical spiral movement.

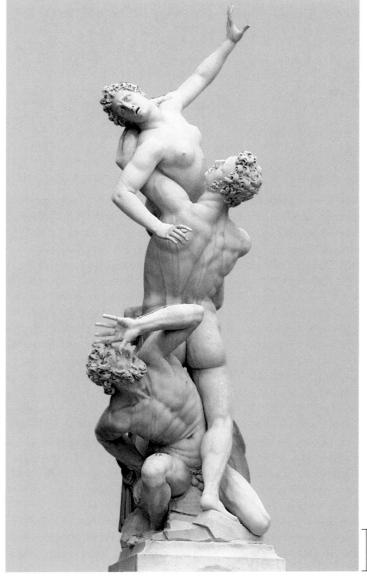

1 ft.

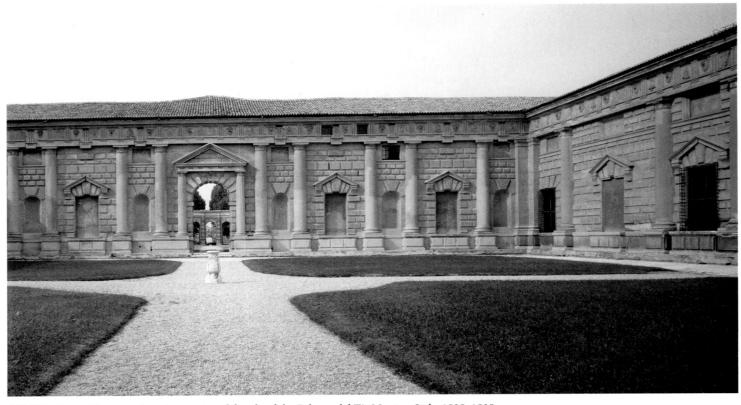

17-53 GIULIO ROMANO, interior courtyard facade of the Palazzo del Tè, Mantua, Italy, 1525-1535.

The Mannerist divergences from architectural convention, for example, the slipping triglyphs, are so pronounced in the Palazzo del Tè that they constitute a parody of Bramante's classical style.

Architecture

Mannerist architects used classical architectural elements in a highly personal and unorthodox manner, rejecting the balance, order, and stability that were the hallmarks of the High Renaissance style with the specific aim of revealing the contrived nature of architectural design.

GIULIO ROMANO Applying that anticlassical principle was the goal of GIULIO ROMANO (ca. 1499-1546) when he designed the Palazzo del Tè (FIG. 17-53) in Mantua and, with it, formulated almost the entire architectural vocabulary of Mannerism. Giulio became Raphael's chief assistant in decorating the Vatican stanze. After Raphael's premature death in 1520, Giulio served as his master's artistic executor, completing Raphael's unfinished frescoes and panel paintings. In 1524, he went to Mantua, where he found a patron in Duke Federigo Gonzaga (r. 1530-1540), for whom Giulio built and decorated the Palazzo del Tè between 1525 and 1535. Gonzaga intended the Palazzo del Tè to serve as both suburban summer palace and stud farm for the duke's famous stables. Originally planned as a relatively modest country villa, Giulio's building so pleased his patron that Gonzaga soon commissioned the architect to enlarge the structure. In a second building campaign, Giulio expanded the villa to a palatial scale by adding three wings, which he placed around a square central court. This once-paved court, which functions both as a passage and as the focal point of the design, has a nearly urban character. Its surrounding buildings form a self-enclosed unit with a large garden, flanked by a stable, attached to it on the east side.

Giulio exhibited his Mannerist style in the facades that face the palace's interior courtyard (FIG. 17-53), where the divergences from architectural convention are quite pronounced. Indeed, they consti-

tute an enormous parody of Bramante's classical style, thereby announcing the artifice of the palace design. In a building laden with structural surprises and contradictions, the design of these facades is the most unconventional of all. The keystones (central voussoirs), for example, either have not fully settled or seem to be slipping from the arches—and, more eccentric still, Giulio even placed voussoirs in the pediments over the rectangular niches, where no arches exist. The massive Tuscan columns that flank these niches carry incongruously narrow architraves. That these architraves break midway between the columns stresses their apparent structural insufficiency, and they seem unable to support the weight of the triglyphs of the Doric frieze above (see "Doric and Ionic Orders," Chapter 5, page 110, or in the "Before 1300" section), which threaten to crash down on the head of anyone foolish enough to stand below them. To be sure, appreciating Giulio's witticism requires a highly sophisticated audience, and recognizing some quite subtle departures from the norm presupposes a thorough familiarity with the established rules of classical architecture. It speaks well for the duke's sophistication that he accepted Giulio's form of architectural inventiveness.

LAURENTIAN LIBRARY Although he personifies the High Renaissance artist, Michelangelo, like Giulio Romano, also experimented with architectural designs that flouted most of the classical rules of order and stability. Michelangelo's restless genius is on display in the vestibule (FIG. 17-54) he designed for the Medici library adjoining the Florentine church of San Lorenzo. The Laurentian Library had two contrasting spaces that Michelangelo had to unite: the long horizontal of the library proper and the vertical of the vestibule. The need to place the vestibule windows up high (at the level

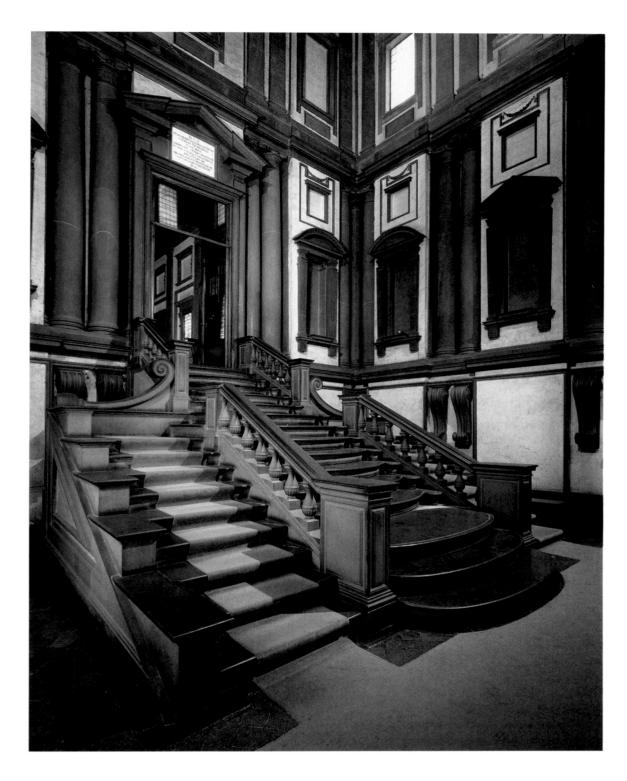

17-54 MICHELANGELO BUONARROTI, vestibule of the Laurentian Library, Florence, Italy, 1524–1534; staircase, 1558–1559.

With his customary independence of spirit, Michelangelo, working in a Mannerist mode in the vestibule of the Laurentian Library, disposed willfully of almost all the rules of classical architecture.

of the reading room) determined the narrow verticality of the vestibule's elevation and proportions. Much taller than it is wide, the vestibule gives the impression of a vertically compressed, shaftlike space. Anyone schooled exclusively in the classical architecture of Bramante and the High Renaissance would have been appalled by Michelangelo's indifference here to classical norms in the use of the orders and in proportion. He used columns in pairs and sank them into the walls, where they perform no supporting function. He also split columns in halves around corners. Elsewhere, he placed scroll corbels on the walls beneath columns. They seem to hang from the moldings, holding up nothing. He arbitrarily broke through pediments as well as through cornices and stringcourses. He sculpted pilasters that taper downward instead of upward. In short, the High

Renaissance master, working in a Mannerist mode, disposed willfully and abruptly of classical architecture. Moreover, in the vast, flowing stairway (the latest element of the vestibule) that protrudes tonguelike into the room from the "mouth" of the doorway to the library, Michelangelo foreshadowed the dramatic movement of Baroque architecture (see Chapter 19). With his customary trailblazing independence of spirit, Michelangelo created an interior space that conveyed all the strains and tensions found in his statuary and in his painted figures. Michelangelo's art began in the style of the 15th century, developed into the epitome of High Renaissance art, and, at the end, moved toward Mannerism. He was 89 when he died in 1564, still hard at work on Saint Peter's and other projects. Few artists, then or since, could escape his influence.

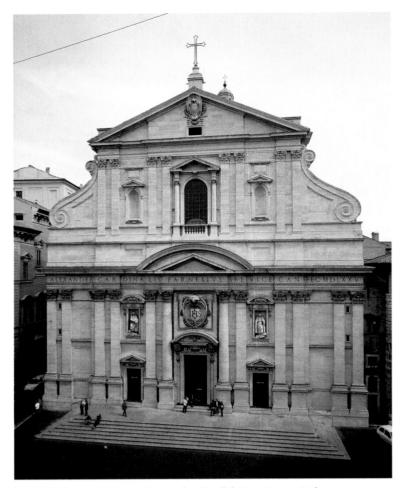

17-55 GIACOMO DELLA PORTA, facade of Il Gesù, Rome, Italy, ca. 1575–1584.

In Giacomo della Porta's innovative design, the march of pilasters and columns builds to a dramatic climax at the central bay. Many 17th-century Roman church facades are architectural variations of II Gesù.

IL GESÙ Probably the most influential building of the second half of the 16th century was the mother church of the Jesuit order. The activity of the Society of Jesus, known as the Jesuits, was an important component of the Counter-Reformation. Ignatius of Loyola (1491–1556), a Spanish nobleman who dedicated his life to the service of God, founded the Jesuit order. He attracted a group of followers, and in 1540 Pope Paul III formally recognized this group as a religious order. The Jesuits were the papacy's invaluable allies in its quest to reassert the supremacy of the Catholic Church. Particularly successful in the field of education, the order established numerous schools. In addition, its members were effective missionaries and carried the message of Catholicism to the Americas, Asia, and Africa.

As a major participant in the Counter-Reformation, the Jesuit order needed a church appropriate to its new prominence. Because Michelangelo was late in providing the plans for this church, called Il Gesù, or Church of Jesus, in 1568 the Jesuits turned to Giacomo della Porta, who was responsible for the facade (FIG. 17-55)—and later designed the dome of Saint Peter's (FIG. 19-3)—and GIACOMO DA VIGNOLA (1507–1573), who designed the ground plan (FIG. 17-56).

The plan of Il Gesù reveals a monumental expansion of Alberti's scheme for Sant'Andrea (FIGS. 16-45 and 16-46) in Mantua. In the new Jesuit church, the nave takes over the main volume of space, making the structure a great hall with side chapels. A dome empha-

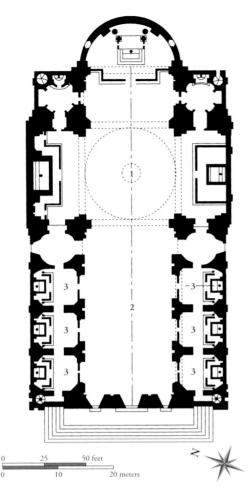

17-56 GIACOMO DA VIGNOLA, plan of Il Gesù, Rome, Italy, 1568. (1) dome, (2) nave, (3) chapel.

Giacomo da Vignola's plan for II Gesù, with its exceptionally wide nave with side chapels instead of aisles, won wide acceptance in the Catholic world. It is an ideal space for grand processions.

sizes the approach to the altar. The wide acceptance of the Gesù plan in the Catholic world, even until modern times, speaks to its ritual efficacy. The opening of the church building into a single great hall provides an almost theatrical setting for large promenades and processions (which seemed to combine social with priestly functions). Above all, the space is adequate to accommodate the great crowds that gathered to hear the eloquent preaching of the Jesuits.

The facade of Il Gesù was also not entirely original, but it too had an enormous impact on later church design. The union of the lower and upper stories, effected by scroll buttresses, harks back to Alberti's Santa Maria Novella (FIG. 16-39). Its classical pediment is familiar in Alberti's work (FIG. 16-44) as well as in that of Palladio (FIGS. 17-29 and 17-31). The paired pilasters appear in Michelangelo's design for Saint Peter's (FIG. 17-26). Giacomo della Porta skillfully synthesized these existing motifs and unified the two stories. The horizontal march of the pilasters and columns builds to a dramatic climax at the central bay, and the bays of the facade snugly fit the nave-chapel system behind them. Many Roman church facades of the 17th century are architectural variations on Giacomo della Porta's design. Chronologically and stylistically, Il Gesù belongs to the Late Renaissance, but its enormous influence on later churches marks it as a significant monument for the development of Italian Baroque church architecture, discussed in Chapter 19.

ITALY, 1500 TO 1600

HIGH AND LATE RENAISSANCE, 1495-1600

- During the High (1500–1520) and Late (1520–1600) Renaissance periods in Italy, artists, often in the employ of the papacy, further developed the interest in perspective, anatomy, and classical cultures that had characterized 15th-century Italian art.
- The major regional artistic centers were Florence and Rome in central Italy and Venice in the north. Whereas most Florentine and Roman artists emphasized careful design preparation based on preliminary drawing (disegno), Venetian artists focused on color and the process of paint application (colorito).
- Leonardo da Vinci was a master of chiaroscuro and atmospheric perspective. He was famous for his hazy sfumato and for his psychological insight in depicting biblical narrative (*Last Supper*) and contemporary personalities (*Mona Lisa*). His anatomical drawings are the first modern scientific illustrations.
- Raphael favored lighter tonalities than Leonardo and clarity over obscurity. His sculpturesque figures appear in landscapes under blue skies (*Madonna of the Meadows*) or in grandiose architectural settings rendered in perfect perspective (*School of Athens*).
- Michelangelo, a temperamental genius, was a pioneer in several media, including architecture, but his first love was sculpture. His carved (*David, Moses*) and painted (*Creation of Adam*) figures have heroic physiques and great emotional impact. He preferred pent-up energy to Raphael's calm, ideal beauty.
- The leading architect of the early 16th century was Bramante, who championed the classical style of the ancients. He based his pioneering design for the Tempietto on antique models, but the combination of parts was new and original.
- Andrea Palladio, an important theorist as well as architect, carried on Bramante's classical style during the Late Renaissance. Famed for his villa designs, he had a lasting impact upon later European and American architecture.
- One of the great masters of the Venetian painting school was Giorgione, who developed the concept of poesia, poetical painting. The subjects of his paintings (Pastoral Symphony, The Tempest) are often impossible to identify. His primary goal was to evoke a pastoral mood.
- Titian, the official painter of the Venetian Republic, won renown for his rich surface textures and dazzling display of color in all its nuances. In paintings such as *Venus of Urbino*, he established oil color on canvas as the typical medium of the Western pictorial tradition.

MANNERISM, 1520-1600

- Mannerism emerged in the 1520s in reaction to the High Renaissance style. A prime feature of Mannerist art is artifice. Renaissance artists generally strove to create art that appeared natural, whereas Mannerist artists were less inclined to disguise the contrived nature of art production. Ambiguous space, departures from expected conventions, and unique presentations of traditional themes are common features of Mannerist art.
- Parmigianino's *Madonna with the Long Neck* epitomizes the elegant stylishness of Mannerist painting. The elongated proportions of the figures, the enigmatic line of columns without capitals, and the ambiguous position of the figure with a scroll are the antithesis of High Renaissance classical proportions, clarity of meaning, and rational perspective.
- Mannerism was also a sculptural style. Giovanni da Bologna's *Abduction of the Sabine Women,* which does not really have a subject, is typical. The sculptor's goal was to depict elegant nude figures in a dynamic spiral composition that presaged the movement of Baroque sculpture.
- The leading Mannerist architect was Giulio Romano, who rejected the balance, order, and stability that were hallmarks of the High Renaissance style. In the Palazzo del Tè in Mantua, the divergences from architectural convention parody Bramante's classical style and include triglyphs that slip out of the Doric frieze.

Michelangelo, David, 1501–1504

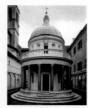

Bramante, Tempietto, Rome, 1502(?)

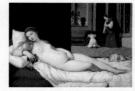

Titian, Venus of Urbino, 1538

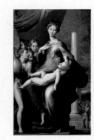

Parmigianino, Madonna with the Long Neck, 1534-1540

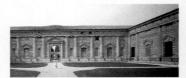

Giulio Romano, Palazzo del Tè, Mantua, 1525–1535

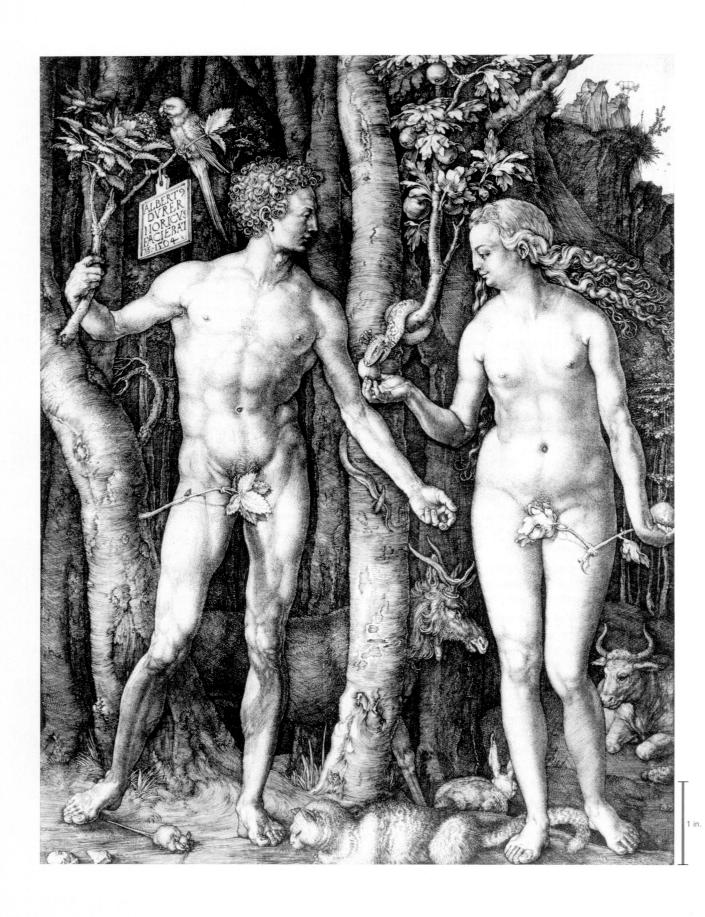

18-1 Albrecht Dürer, Fall of Man (Adam and Eve), 1504. Engraving, $9\frac{7}{8}$ × $7\frac{5}{8}$. Museum of Fine Arts, Boston (centennial gift of Landon T. Clay).

Albrecht Dürer was the first Northern European artist to become an international celebrity. *Fall of Man,* with two figures based on ancient statues, reflects his studies of the Vitruvian theory of human proportions.

NORTHERN EUROPE AND SPAIN, 1500 TO 1600

The dissolution of the Burgundian Netherlands in 1477 led in the early 16th century to a realignment in the European geopolitical landscape (MAP 18-1). France and the Holy Roman Empire absorbed the former Burgundian territories and increased their power. But by the end of the century, through calculated marriages, military exploits, and ambitious territorial expansion, Spain was the dominant European state. Throughout the continent, monarchs gained additional prestige and cultivated a stronger sense of cultural and political unity among their subjects, thereby laying the foundation for today's European nations. Yet a momentous crisis in the Christian Church overshadowed these power shifts. Concerted attempts to reform the Church led to the Reformation and the establishment of Protestantism (as distinct from Catholicism), which in turn prompted the Catholic Church's response, the Counter-Reformation (see Chapter 17). Ultimately, the Reformation split Christendom in half and produced a hundred years of civil war between Protestants and Catholics.

Despite the tumultuous religious conflict engulfing 16th-century Europe, the exchange of intellectual and artistic ideas continued to thrive. Catholic Italy and the (mostly) Protestant Holy Roman Empire shared in a lively commerce—economic and cultural—and 16th-century art throughout Europe was a major beneficiary of that exchange. Humanism filtered up from Italy and spread throughout Northern Europe. Northern humanists, like their southern counterparts, cultivated a knowledge of classical cultures and literature. Because they focused more on reconciling humanism with Christianity, later scholars applied the general label "Christian humanists" to describe them.

Among the most influential Christian humanists were the Dutch-born Desiderius Erasmus (1466–1536) and the Englishman Thomas More (1478–1535). Erasmus demonstrated his interest in both Italian humanism and religion with his "philosophy of Christ," emphasizing education and scriptural knowledge. Both an ordained priest and avid scholar, Erasmus published his most famous essay, *The Praise of Folly*, in 1509. In this widely read work, he satirized not just the Church but various social classes as well. His ideas were to play an important role in the development of the Reformation, but he consistently declined to join any of the Reformation sects. Equally well educated was Thomas More, who served King Henry VIII (r. 1509–1547). Henry eventually ordered More executed because of his

MAP 18-1 Europe in the early 16th century.

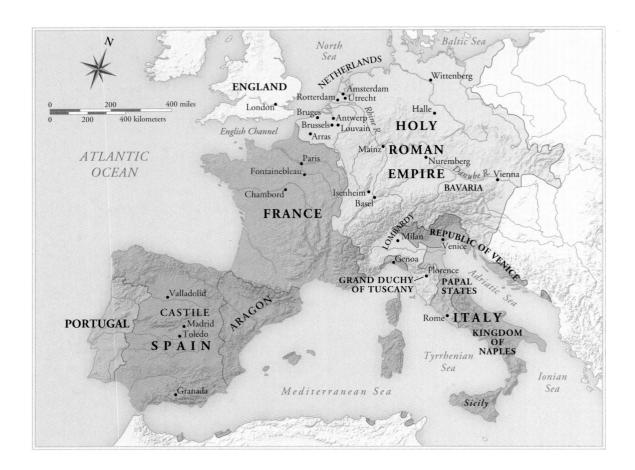

opposition to England's break with the Catholic Church. In France, François Rabelais (ca. 1494–1553), a former monk who advocated rejecting stagnant religious dogmatism, disseminated the humanist spirit.

The turmoil emerging during the 16th century lasted well into the 17th century and permanently affected the face of Europe. The concerted challenges to established authority and the persistent philosophical inquiry eventually led to the rise of new political systems (for example, the nation-state) and new economic systems (such as capitalism).

HOLY ROMAN EMPIRE

Although at the opening of the 16th century many in the Holy Roman Empire were expressing dissatisfaction with the Church in Rome, Martin Luther had not yet posted the *Ninety-five Theses* that launched the Protestant Reformation. The Catholic clergy in Germany still offered artists important commissions to adorn churches and other religious institutions.

MATTHIAS GRÜNEWALD Matthias Neithardt, known conventionally as MATTHIAS GRÜNEWALD (ca. 1480–1528), worked for the archbishops of Mainz from 1511 on in several capacities, from court painter and decorator to architect, hydraulic engineer, and superintendent of works. Grünewald eventually moved to northern Germany, where he settled at Halle in Saxony. Around 1510, he began work on the *Isenheim Altarpiece* (FIG. 18-2), a complex and fascinating monument that reflects Catholic beliefs and incorporates several references to Catholic doctrines, such as the lamb (symbol of the Son of God), whose wound spurts blood into a chalice in the *Crucifixion* scene (FIG. 18-2, *top*) on the exterior of the altarpiece.

Created for the monastic hospital order Saint Anthony of Isenheim, the *Isenheim Altarpiece* consists of a wooden shrine (carved by

NIKOLAUS HAGENAUER in 1490) that includes gilded and polychromed statues of Saints Anthony Abbot, Augustine, and Jerome (FIG. 18-2, bottom) in addition to Grünewald's two pairs of movable wings that open at the center. Hinged together at the sides, one pair stands directly behind the other. Grünewald painted the exterior panels of the first pair (visible when the altarpiece is closed, FIG. 18-2, top) between 1510 and 1515: Crucifixion in the center, Saint Sebastian on the left, Saint Anthony on the right, and Lamentation in the predella. When these exterior wings are open, four additional scenes (not illustrated)—Annunciation, Angelic Concert, Madonna and Child, and Resurrection—appear. Opening this second pair of wings exposes Hagenauer's interior shrine, flanked by Grünewald's panels depicting Meeting of Saints Anthony and Paul and Temptation of Saint Anthony (FIG. 18-2, bottom).

The placement of this altarpiece in the choir of a church adjacent to the monastery hospital dictated much of the imagery. Saints associated with the plague and other diseases and with miraculous cures, such as Saints Anthony and Sebastian, appear prominently in the *Isenheim Altarpiece*. Grünewald's panels specifically address the themes of dire illness and miraculous healing and accordingly emphasize the suffering of the order's patron saint, Anthony. The painted images served as warnings, encouraging increased devotion from monks and hospital patients. They also functioned therapeutically by offering some hope to the afflicted. Indeed, Saint Anthony's legend encompassed his role as both vengeful dispenser of justice (by inflicting disease) and benevolent healer. Grünewald brilliantly used color to enhance the impact of the altarpiece. He intensified the contrast of horror and hope by playing subtle tones and soft harmonies against shocking dissonance of color.

One of the most memorable scenes is *Temptation of Saint Anthony* (FIG. 18-2, *bottom right*). It is a terrifying image of the five temptations, depicted as an assortment of ghoulish and bestial creatures in a dark landscape, attacking the saint. In the foreground, Grünewald

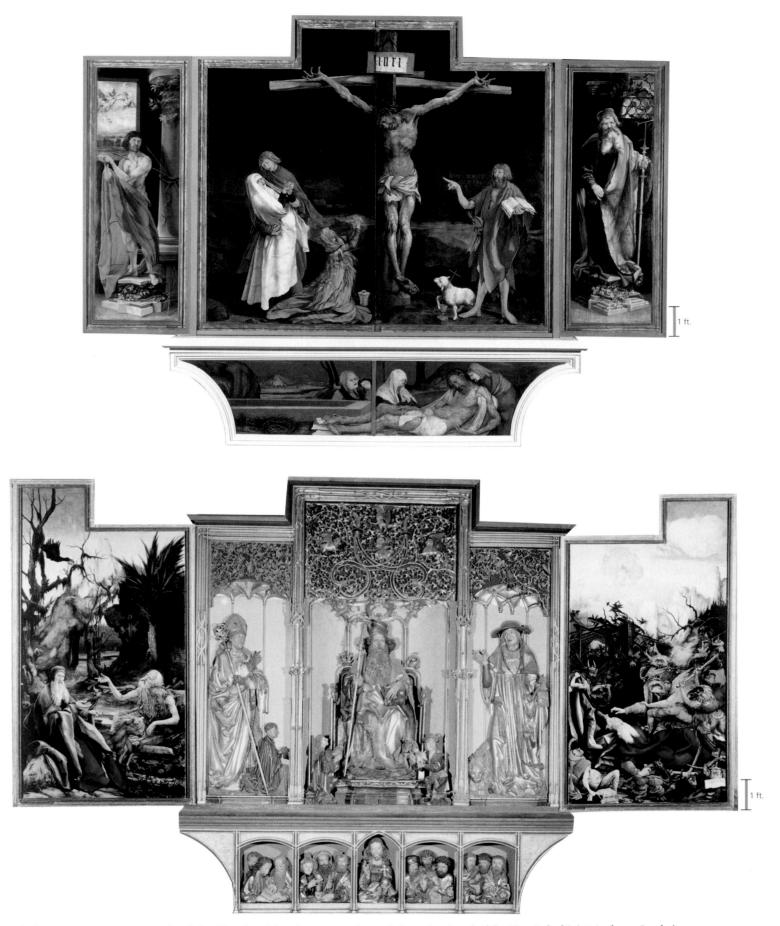

18-2 Matthias Grünewald, *Isenheim Altarpiece* (closed, *top*; open, *bottom*), from the chapel of the Hospital of Saint Anthony, Isenheim, Germany, ca. 1510–1515. Oil on wood, 9′ $9\frac{1}{2}'' \times 10'$ 9″ (center panel), 8′ $2\frac{1}{2}'' \times 3'$ $\frac{1}{2}''$ (each wing), 2′ $5\frac{1}{2}'' \times 11'$ 2″ (predella). Shrine carved by Nikolaus Hagenauer in 1490. Painted and gilt limewood, 9′ $9\frac{1}{2}'' \times 10'$ 9″. Musée d'Unterlinden, Colmar.

Befitting its setting in a monastic hospital, Matthias Grünewald's *Isenheim Altarpiece* includes painted panels depicting suffering and disease but also miraculous healing, hope, and salvation.

painted a grotesque image of a man, whose oozing boils, withered arm, and distended stomach all suggest a horrible disease. Medical experts have connected these symptoms with ergotism (a disease caused by ergot, a fungus that grows especially on rye). Although doctors did not discover the cause of ergotism until about 1600, people lived in fear of its recognizable symptoms (convulsions and gangrene). The public referred to this illness as "Saint Anthony's Fire," and it was one of the major diseases treated at the Isenheim hospital. The gangrene often compelled amputation, and scholars have noted that the two movable halves of the altarpiece's predella (FIG. 18-2, *top*), if slid apart, make it appear as if Christ's legs have been amputated. The same observation can be made with regard to the two main exterior panels. Due to the off-center placement of the cross, opening the left panel "severs" one arm from the crucified figure.

Thus, Grünewald carefully selected and presented his altarpiece's iconography to be particularly meaningful for viewers at this hospital. In the interior shrine, the artist balanced the horrors of the disease and the punishments that awaited those who did not repent with scenes such as *Meeting of Saints Anthony and Paul*, depicting the two saints, healthy and aged, conversing peacefully. Even the exterior panels (the closed altarpiece; FIG. 18-2, *top*) convey these same concerns. *Crucifixion* emphasizes Christ's pain and suffering, but the knowledge that this act redeemed humanity tempers the misery. In addition, Saint Anthony appears in the right wing as a devout follower of Christ who, like Christ and for Christ, endured intense suffering for his faith. Saint Anthony's presence on the exterior thus reinforces the themes Grünewald intertwined throughout this entire altarpiece—themes of pain, illness, and death, as well as those of hope, comfort, and salvation.

HANS BALDUNG GRIEN Very different in size, technique, and subject, but equally dramatic, is *Witches' Sabbath* (FIG. 18-3), a *chiaroscuro woodcut* that Hans Baldung Grien (ca. 1484–1545) produced in 1510. Chiaroscuro woodcuts were a recent German innovation. The technique requires the use of two blocks of wood instead of one. The printmaker carves and inks one block in the usual way in order to produce a traditional black-and-white print (see "Woodcuts, Engravings, and Etchings," Chapter 15, page 415). Then the artist cuts a second block consisting of broad highlights that can be inked in gray or color and printed over the first block's impression. Chiaroscuro woodcuts therefore incorporate some of the qualities of painting and feature tonal subtleties absent in traditional woodcuts.

Witchcraft was a counter-religion in the 15th and 16th centuries that involved magical rituals, secret potions, and devil worship. Witches prepared brews that they inhaled or rubbed into their skin, sending them into hallucinogenic trances in which they allegedly flew through the night sky on broomsticks or goats. The popes condemned all witches, and Church inquisitors vigorously pursued these demonic heretics and subjected them to torture to wrest confessions from them. Witchcraft fascinated Baldung, and he turned to the subject repeatedly. For him and his contemporaries, witches were evil forces in the world, threats to man—as was Eve herself, whom Baldung also frequently depicted as a temptress responsible for Original Sin.

In Witches' Sabbath, Baldung depicted a night scene in a forest in which a coven of nude witches—both young seductresses and old hags—gathers around a covered jar from which a fuming concoction escapes into the air. One young witch rides through the night sky on a goat. She sits backward—Baldung's way of suggesting that witchcraft is the inversion of the true religion, Christianity.

ALBRECHT DÜRER The dominant artist of the early 16th century in the Holy Roman Empire was Albrecht Dürer (1471–1528) of Nuremberg. Dürer was the first artist outside Italy to become an

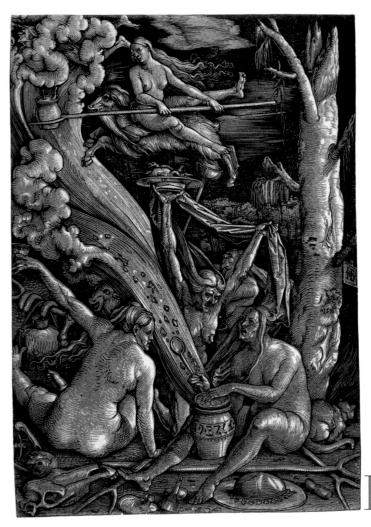

18-3 Hans Baldung Grien, *Witches' Sabbath*, 1510. Chiaroscuro woodcut, 1' $2\frac{7}{8}$ " \times $10\frac{1}{4}$ ". British Museum, London.

Baldung's chiaroscuro woodcut depicts witches gathered around a secret potion. One witch on a goat flies through the night sky mounted backward—suggesting witchcraft is the inversion of Christianity.

international celebrity. He traveled extensively, visiting and studying in Colmar, Basel, Strasbourg, Venice, Antwerp, and Brussels, among other locales. As a result of these travels, Dürer met many of the leading humanists and artists of his time, including Erasmus of Rotterdam and the Venetian master Giovanni Bellini (FIGS. 17-33 and 17-34). A man of exceptional talents and tremendous energy, Dürer achieved widespread fame in his own time and has enjoyed a lofty reputation ever since.

Fascinated with classical ideas as passed along by Italian Renaissance artists, Dürer was among the first Northern European artists to travel to Italy expressly to study Italian art and its underlying theories at their source. After his first journey in 1494–1495 (the second was in 1505–1506), he incorporated many Italian Renaissance developments into his art. Art historians have acclaimed Dürer as the first Northern European artist to understand fully the basic aims of the Renaissance in Italy. Like Leonardo da Vinci, Dürer wrote theoretical treatises on a variety of subjects, such as perspective, fortification, and the ideal in human proportions. Unlike Leonardo, he both finished and published his writings. Dürer also was the first Northern European artist to leave a record of his life and career through several self-portraits, through his correspondence, and through a carefully kept, quite detailed, and eminently readable diary.

18-4 Albrecht Dürer, *Great Piece of Turf*, 1503. Watercolor, 1' $3\frac{3}{4}'' \times 1' \frac{3}{8}''$. Albertina, Vienna.

Albrecht Dürer, who visited Italy twice, shared Leonardo da Vinci's belief that sight reveals scientific truth. Botanists have been able to identify each plant and grass variety in this watercolor.

GREAT PIECE OF TURF Dürer allied himself with Leonardo's scientific studies when he painted an extremely precise watercolor study of a piece of turf (FIG. 18-4). For both artists, observation yielded truth. Sight, sanctified by mystics such as Nicholas of Cusa (1401–1464) and artists such as Jan van Eyck (see Chapter 15), became the secularized instrument of modern knowledge. Dürer agreed with Aristotle (and Leonardo) that "sight is the noblest sense of man." Nature holds the beautiful, Dürer said, for the artist who has the insight to extract it. Thus, beauty lies even in humble, perhaps ugly, things, and the ideal, which bypasses or improves on nature, may not be truly beautiful in the end. Disordered and ordinary nature might be a reasonable object of an artist's interest, quite as much as its composed and measured aspect. The remarkable Great Piece of Turf is as scientifically accurate as it is poetic. Botanists can distinguish each plant and grass variety—dandelions, great plantain, yarrow, meadow grass, and heath rush. "[D]epart not from nature according to your fancy," Dürer said, "imagining to find aught better by yourself; . . . For verily 'art' is embedded in nature; he who can extract it, has it."2

FALL OF MAN Dürer's fame in his own day, as today, rested more on his achievements as a printmaker than as a painter. Trained as a goldsmith by his father before he took up painting and printmaking, he developed an extraordinary proficiency in handling the burin, the engraving tool. This technical ability, combined with a feeling for the form-creating possibilities of line, enabled him to produce a body of

graphic work in woodcut (FIG. I-8) and engraving (FIGS. 18-1 and 18-5) that few artists have rivaled for quality and number. Dürer created numerous book illustrations. He also circulated and sold prints in single sheets, which people of ordinary means could buy, expanding his audience considerably. Aggressively marketing his prints with the aid of an agent, Dürer became a wealthy man from the sale of these works. His wife, who served as his manager, and his mother also sold his prints at markets. Through his graphic works, he exerted strong influence throughout Europe (Hans Baldung Grien trained in Dürer's workshop), especially in Flanders but also in Italy. The lawsuit Dürer brought in 1506 against an Italian artist for copying his prints reveals his business acumen. Scholars generally regard this lawsuit as the first in history over artistic copyright.

An engraving, Fall of Man (Adam and Eve; FIG. 18-1), one of Dürer's early masterpieces, represents the first distillation of his studies of the Vitruvian theory of human proportions, a theory based on arithmetic ratios. Clearly outlined against the dark background of a northern forest, the two idealized figures of Adam and Eve stand in poses reminiscent of specific classical statues probably known to Dürer through graphic representations. Preceded by numerous geometric drawings in which the artist attempted to systematize sets of ideal human proportions in balanced contrapposto poses, the final print presents Dürer's concept of the "perfect" male and female figures. Yet he tempered this idealization with naturalism, demonstrating his well-honed observational skills in his rendering of the background foliage and animals. The gnarled bark of the trees and the feathery leaves authenticate the scene, as do the various creatures skulking underfoot. The animals populating the print are symbolic. The choleric cat, the melancholic elk, the sanguine rabbit, and the phlegmatic ox represent humanity's temperaments based on the "four humors," body fluids that were the basis of theories of the human body's function developed by the ancient Greek physician Hippocrates and practiced in medieval physiology. The tension between cat and mouse in the foreground symbolizes the relation between Adam and Eve at the crucial moment in Fall of Man.

KNIGHT, DEATH, AND THE DEVIL Dürer's lifelong interest in both idealization and naturalism surfaces again in Knight, Death, and the Devil (FIG. 18-5), in which he carried the art of engraving to the highest degree of excellence. Dürer used his burin to render differences in texture and tonal values that would be difficult to match even in the much more flexible medium of etching, which artists developed later in the century (see "Woodcuts, Engravings, and Etchings," Chapter 15, page 415). Knight, Death, and the Devil depicts a mounted armored knight who rides fearlessly through a foreboding landscape. Accompanied by his faithful retriever, the knight represents a Christian knight—a soldier of God. Armed with his faith, this warrior can repel the threats of Death, who appears as a crowned decaying cadaver wreathed with snakes and shaking an hourglass as a reminder of time and mortality. The knight is equally impervious to the Devil, a pathetically hideous horned creature who follows him. The knight triumphs because he has "put on the whole armor of God that [he] may be able to stand against the wiles of the devil," as urged in Saint Paul's Epistle to the Ephesians (Eph. 6:11).

The monumental knight and his mount display the strength, movement, and proportions of the Italian Renaissance equestrian statue. Dürer was familiar with Donatello's *Gattamelata* (FIG. 16-15) and Verrocchio's *Bartolommeo Colleoni* (FIG. 16-16) and had copied a number of Leonardo's sketches of horses. Dürer based the engraving on his observation of the real world, however, not other artworks, as seen in his meticulous rendering of myriad details—the knight's armor and weapons, the horse's anatomy, the textures of the

18-5 Albrecht Dürer, *Knight, Death, and the Devil,* 1513. Engraving, $9\frac{5}{8}'' \times 7\frac{3}{8}''$. Metropolitan Museum of Art, New York.

Dürer's Christian knight, armed with his faith, rides fearlessly through a meticulously rendered landscape, challenging both Death and the Devil. The engraving rivals the tonal range of painting.

18-6 Albrecht Dürer, Four Apostles, 1526. Oil on wood, each panel 7' 1" \times 2' 6". Alte Pinakothek, Munich.

Dürer's support for Lutheranism surfaces in his portraitlike depictions of four saints on two painted panels. Peter, representative of the pope in Rome, plays a secondary role behind John the Evangelist.

loathsome features of Death and the Devil, the rock forms and rugged foliage. Dürer realized this great variety of imagery with the dense hatching of fluidly engraved lines that rival the tonal range of painting. Erasmus appropriately praised Dürer as the "Apelles [the famous ancient Greek painter] of black lines."

FOUR APOSTLES Dürer was a phenomenally gifted artist. His impressive technical facility with different media extended also to oil painting. Four Apostles (FIG. 18-6) is a two-panel oil painting he produced without commission and presented to the city fathers of Nuremberg in 1526 to be hung in the city hall. Saints John and Peter appear on the left panel, Mark and Paul on the right. In addition to showcasing Dürer's mastery of the oil technique, of his brilliant use of color and light and shade, and of his ability to imbue the four saints with individual personalities and portraitlike features, Four Apostles documents Dürer's support for the German theologian Martin Luther (1483–1546), who sparked the Protestant Reformation. Dürer conveyed his Lutheran sympathies by his positioning of the figures. He relegated Saint Peter (as representative of the pope in Rome) to a secondary role by placing him behind John the Evangelist. John assumed particular prominence for Luther because of the evangelist's focus on Christ's person in his Gospel. In addition, Peter and John both read from the Bible, the single authoritative source of religious truth, according to Luther. Dürer emphasized the Bible's centrality by depicting it open to the passage "In the beginning was the Word, and

the Word was with God, and the Word was God" (John 1:1). At the bottom of the panels, Dürer included quotations from each of the four apostles' books, using Luther's German translation. The excerpts warn against the coming of perilous times and the preaching of false prophets who will distort God's word.

LUTHER AND THE REFORMATION The Protestant Reformation, which came to fruition in the early 16th century, had its roots in long-term, growing dissatisfaction with Church leadership. The deteriorating relationship between the faithful and the Church hierarchy stood as an obstacle for the millions who sought a meaningful religious experience. Particularly damaging was the perception that the Roman popes concerned themselves more with temporal power and material wealth than with the salvation of Church members. The fact that many 15th-century popes and cardinals came from wealthy families, such as the Medici, intensified this perception. It was not only those at the highest levels who seemed to ignore their spiritual duties. Upper-level clergy (such as archbishops, bishops, and abbots) began to accumulate numerous offices, thereby increasing their revenues but also making it more difficult for them to fulfill all of their responsibilities. By 1517 dissatisfaction with the Church had grown so widespread that Luther felt free to challenge papal authority openly by posting in Wittenberg his Ninety-five Theses, in which he enumerated his objections to Church practices, especially the sale of indulgences. Indulgences were Church-sanctioned remittances (or reductions) of

Catholic and Protestant Views of Salvation

central concern of the Protestant reformers was the question of how Christians achieve salvation. Martin Luther did not perceive salvation as something for which weak and sinful humans must constantly strive through good deeds performed under the watchful eye of a punitive God. Instead, he argued, faithful individuals attained redemption solely by God's bestowal of his grace. Therefore, people cannot earn salvation. Further, no ecclesiastical machinery with all its miraculous rites and indulgent forgivenesses could save sinners face-to-face with God. Only absolute faith in Christ could justify sinners and ensure salvation. Justification by faith alone, with the guidance of scripture, was the fundamental doctrine of Protestantism.

In *Allegory of Law and Grace* (FIG. 18-7), Lucas Cranach the Elder gave pictorial form to these doctrinal differences between Protestantism and Catholicism. Cranach was a follower and close friend of Martin Luther. (They were godfathers to each other's children.) Many scholars, in fact, call Cranach "the painter of the Reformation." Cranach produced his allegorical woodcut about a dozen years after

Luther set the Reformation in motion with his Ninety-five Theses. In Allegory of Law and Grace, Cranach depicted the differences between Catholicism (based on Old Testament law, according to Luther) and Protestantism (based on a belief in God's grace) in two images separated by a centrally placed tree. On the left half, Judgment Day has arrived, as represented by Christ's appearance at the top of the scene, hovering amid a cloud halo and accompanied by angels and saints. Christ raises his left hand in the traditional gesture of damnation, and, below, a skeleton drives off a terrified person to burn for eternity in Hell. This person tried to live a good and honorable life, but despite his efforts, he fell short. Moses stands to the side, holding the Tablets of the Law—the commandments Catholics follow in their attempt to attain salvation. In contrast to this Catholic reliance on good works and clean living, Protestants emphasized God's grace as the source of redemption. Accordingly, God showers the sinner in the right half of the print with grace, as streams of blood flow from the crucified Christ. On the far right, Christ emerges from the tomb and promises salvation to all who believe in him.

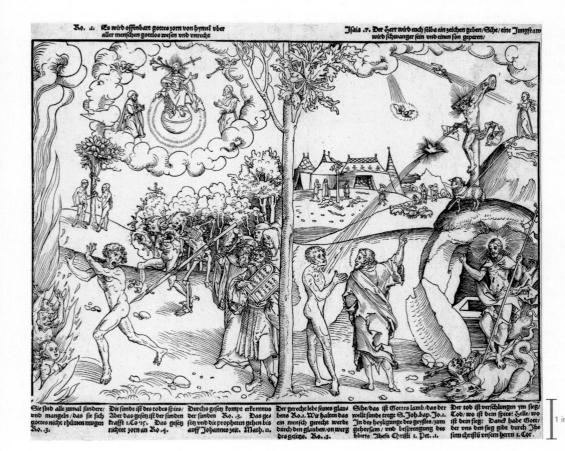

18-7 LUCAS CRANACH THE ELDER, Allegory of Law and Grace, ca. 1530. Woodcut, $10\frac{5}{8}'' \times 1'\frac{3}{4}''$. British Museum, London.

Lucas Cranach was a close friend of Martin Luther, whose *Ninety-five Theses* launched the Reformation in 1517. In this woodcut Cranach contrasted Catholic and Protestant views of how to achieve salvation.

time spent in Purgatory. The increasing frequency of their sale suggested that people were buying their way into Heaven.

Luther's goal was significant reform and clarification of major spiritual issues, but his ideas ultimately led to the splitting of Christendom. According to Luther, the Catholic Church's extensive ecclesiastical structure needed to be cast out, for it had no basis in scripture. Only the Bible—nothing else—could serve as the foundation

for Christianity. Luther declared the pope the Antichrist (for which the pope excommunicated him), called the Church the "whore of Babylon," and denounced ordained priests. He also rejected most of Catholicism's sacraments, decrying them as pagan obstacles to salvation (see "Catholic and Protestant Views of Salvation," above, and FIG. 18-7). Luther maintained that for Christianity to be restored to its original purity, the Church must be cleansed of all the doctrinal

Protestantism and Iconoclasm

The Protestant concern over the role of religious imagery at times progressed to outright *iconoclasm*—the objection to and destruction of religious imagery (see "Icons and Iconoclasm," Chapter 9, page 246). In encouraging a more personal relationship with God, Protestant leaders spoke out against much of the religious art being produced. In his 1525 tract *Against the Heavenly Prophets in the Matter of Images and Sacraments*, Martin Luther explained his attitude toward religious imagery:

I approached the task of destroying images by first tearing them out of the heart through God's Word and making them worthless and despised.... For when they are no longer in the heart, they can do no harm when seen with the eyes.... I have allowed and not forbidden the outward removal of images.... And I say at the outset that according to the law of Moses no other images are forbidden than an image of God which one worships. A crucifix, on the other hand, or any other holy image is not forbidden.*

Ulrich Zwingli (1484–1531), leader of the Zwinglians (a Protestant sect based in Switzerland), concurred with Luther and cautioned his followers about the potentially dangerous nature of religious imagery. Although Zwingli's ideas had much in common with those of Luther, he was more intent than Luther on simplifying religious belief and practices and rejected all sacraments (unlike Luther, who accepted both baptism and communion).

The Protestant Ten Commandments, which, although also excerpted from the Bible, differ slightly from those of the Catholic

Church, further reinforced the Protestant condemnation of possibly idolatrous religious imagery. For Protestants, this is the Second Commandment:

Thou shalt not make unto thee any graven image, or any likeness of any thing that is in heaven above, or that is in the earth beneath, or that is in the water under the earth. Thou shalt not bow down thyself to them, nor serve them, for I the Lord thy God am a jealous God, visiting the iniquity of the fathers upon the children unto the third and fourth generation of them that hate me. And showing mercy unto thousands of them that love me, and keep my commandments.

These many Protestant proscriptions against religious imagery often led to eruptions of iconoclasm. Particularly violent waves of iconoclastic fervor swept Basel, Zurich, Strasbourg, and Wittenberg in the 1520s. In an episode known as the Great Iconoclasm, bands of Calvinists visited Catholic churches in the Netherlands in 1566, shattering stained-glass windows, smashing statues, and destroying paintings and other artworks that they perceived as idolatrous. These strong reactions to art not only reflect the religious fervor of the time but also serve as dramatic demonstrations of the power of art—and of how much art mattered.

* Translated by Bernhard Erling, in Wolfgang Stechow, *Northern Renaissance Art* 1400–1600: Sources and Documents (Englewood Cliffs, N.J.: Prentice Hall, 1966), 129–130.

impurities that had collected through the ages. Luther advocated the Bible as the source of all religious truth. The Bible—the sole scriptural authority—was the word of God, and the Church's councils, law, and rituals carried no weight. Luther facilitated the lay public's access to biblical truths by producing the first translation of the Bible in a vernacular language. Luther's teachings found visual expression in *Allegory of Law and Grace* (FIG. 18-7) by Lucas Cranach the Elder (1472–1553).

VISUAL IMAGERY AND THE REFORMATION In addition to doctrinal differences, Catholics and Protestants took divergent stances on the role of visual imagery in religion. Catholics embraced church decoration as an aid to communicating with God, as seen in Italian ceiling frescoes (FIG. 17-1; see "Religious Art in Counter-Reformation Italy," Chapter 17, page 474) and German and Polish altarpieces (FIGS. 15-18, 15-19, and 18-2). In contrast, Protestants believed such imagery could lead to idolatry and would distract viewers from focusing on the real reason for their presence in church—to communicate directly with God (see "Protestantism and Iconoclasm," above). Because of this belief, Protestant churches were relatively austere and unadorned, and the extensive church decoration programs found especially in Italy were not as prominent in Protestant churches. This does not suggest that Protestants had no use for visual images. Art, especially prints (which were inexpensive and easily circulated), was a useful and effective teaching tool and facilitated the private devotional exercises that were fundamental to Protestantism. The popularity of prints both contributed to and received impetus from the transition from handwritten manuscripts to print media in Northern Europe during the 16th century.

ALBRECHT ALTDORFER Some 16th-century artists in the Holy Roman Empire addressed historical and political issues in their work. Albrecht Altdorfer (ca. 1480-1538), for example, painted Battle of Issus (FIG. 18-8) in 1529, a depiction of Alexander the Great's defeat of King Darius III of Persia in 333 BCE at a town called Issus on the Pinarus River. Altdorfer announced the subject (which the Greek painter Philoxenos of Eretria [FIG. 5-70] had represented two millennia before) in the Latin inscription that hangs in the sky. The duke of Bavaria, Wilhelm IV (r. 1508–1550), commissioned Battle of Issus at the commencement of his military campaign against the invading Turks. The parallels between the historical and contemporary conflicts were no doubt significant to the duke. Both involved societies that deemed themselves progressive as being engaged in battles against infidels—the Persians in antiquity and the Turks in 1528. Altdorfer reinforced this connection by attiring the figures in 16thcentury armor and depicting them embroiled in contemporary military alignments.

The scene also reveals Altdorfer's love of landscape. The battle takes place in an almost cosmological setting. From a bird's-eye view, the clashing armies swarm in the foreground. In the distance, craggy mountain peaks rise next to still bodies of water. Amid swirling clouds, a blazing sun descends. Although the spectacular topography may appear imaginary or invented, Altdorfer derived his depiction of the landscape from maps. Specifically, he set the scene

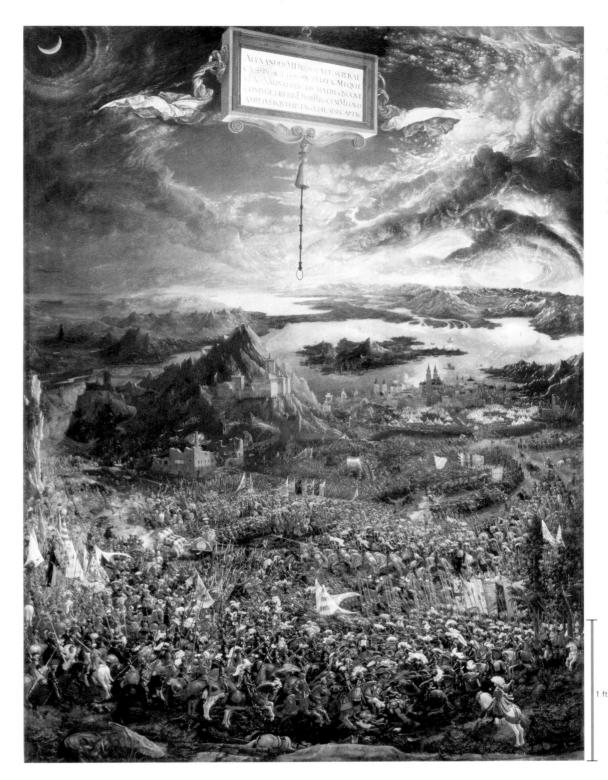

18-8 Albrecht Altdorfer, Battle of Issus, 1529. Oil on wood, 5' $2\frac{1}{4}'' \times$ 3' $11\frac{1}{4}''$. Alte Pinakothek, Munich.

Interweaving history and 16th-century politics, Albrecht Altdorfer painted Alexander the Great's defeat of the Persians for a patron who had just embarked on a military campaign against the Turks.

in the eastern Mediterranean with a view from Greece to the Nile in Egypt. In addition, Altdorfer may have acquired his information about this battle from the German scholar Johannes Aventinus (1477–1534). In his account, Aventinus described the bloody daylong battle and Alexander's ultimate victory. Appropriately, given Alexander's designation as the "sun god," the sun sets over the victorious Greeks on the right, while a small crescent moon (a symbol of the Near East) hovers in the upper left corner over the retreating Persians.

HANS HOLBEIN Choosing less dramatic scenes, Hans Holbein The Younger (ca. 1497–1543) excelled as a portraitist. Trained by his

father, Holbein produced portraits reflecting the Northern European tradition of close realism that had emerged in 15th-century Flemish art (see Chapter 15). Yet he also incorporated Italian ideas about monumental composition and sculpturesque form. The surfaces of his paintings are as lustrous as enamel, his detail is exact and exquisitely drawn, and his contrasts of light and dark are never heavy.

Holbein began his artistic career in Basel, where he knew Erasmus of Rotterdam. Because of the immediate threat of a religious civil war in Basel, Erasmus suggested that Holbein leave for England and gave him a recommendation to Thomas More, chancellor of England under Henry VIII. Holbein did move and became painter to the English court. While there, he produced a superb double portrait of the French

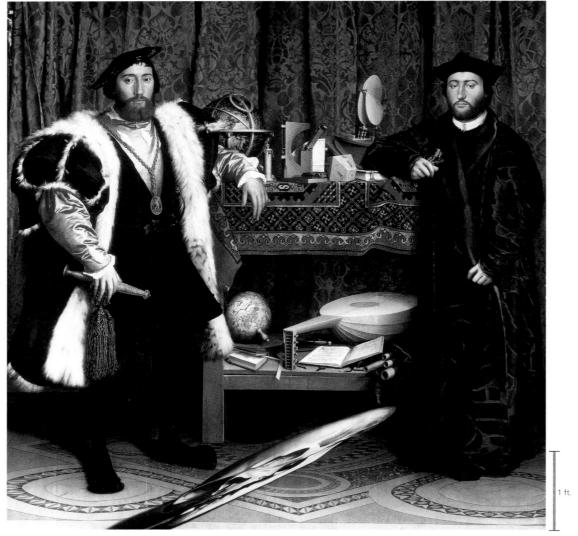

18-9 Hans Holbein the Younger, *The French Ambassadors*, 1533. Oil and tempera on wood, 6' $8'' \times 6'$ $9\frac{1}{2}''$. National Gallery, London.

In this double portrait, Holbein depicted two humanists with a collection of objects reflective of their worldliness and learning, but he also included an anamorphic skull, a reminder of death.

ambassadors to England, Jean de Dinteville (at *left*) and Georges de Selve. *The French Ambassadors* (FIG. **18-9**) exhibits Holbein's considerable talents—his strong sense of composition, his subtle linear patterning, his gift for portraiture, his marvelous sensitivity to color, and his faultlessly firm technique. The two men, both ardent humanists, stand at opposite ends of a side table covered with an oriental rug and a collection of objects reflective of their worldliness and their interest in learning and the arts. These include mathematical and astronomical models and implements, a lute with a broken string, compasses, a sundial, flutes, globes, and an open hymnbook with Luther's translation of *Veni, Creator Spiritus* and of the Ten Commandments.

Of particular interest is the long gray shape that slashes diagonally across the picture plane and interrupts the stable, balanced, and serene composition. This form is an *anamorphic image*, a distorted image recognizable only when viewed with a special device, such as a cylindrical mirror, or by looking at the painting at an acute angle. In this case, if the viewer stands off to the right, the gray slash becomes a skull. Although scholars do not agree on the skull's meaning, at the very least it certainly refers to death. Artists commonly incorporated skulls into paintings as reminders of mortality. Indeed, Holbein depicted a skull on the metal medallion on Jean de Dinteville's hat. Holbein may have intended the skulls, in conjunction with the cruci-

fix that appears half hidden behind the curtain in the upper left corner, to encourage viewers to ponder death and resurrection.

This painting may also allude to the growing tension between secular and religious authorities. Jean de Dinteville was a titled landowner, Georges de Selve a bishop. The inclusion of Luther's translations next to the lute with the broken string (a symbol of discord) may subtly refer to this religious strife. Despite scholars' uncertainty about the precise meaning of *The French Ambassadors*, it is a painting of supreme artistic achievement. Holbein rendered the still-life objects with the same meticulous care as the men themselves, the woven design of the deep emerald curtain behind them, and the floor tiles, constructed in faultless perspective. He surely hoped this painting's elegance and virtuosity of skill (produced shortly after Holbein arrived in England) would impress Henry VIII.

FRANCE

As *The French Ambassadors* illustrates, France in the early 16th century continued its efforts to secure widespread recognition as a political power and cultural force. The French kings were major patrons of art and architecture.

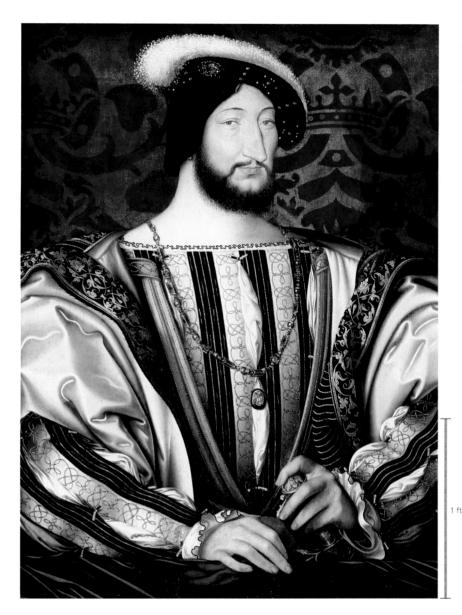

18-10 Jean Clouet, *Francis I*, ca. 1525–1530. Tempera and oil on wood, 3' $2'' \times 2'$ 5''. Louvre, Paris.

Clouet's portrait of Francis I in elegant garb reveals the artist's attention to detail but also the flattening of features and disproportion between head and body, giving the painting a formalized quality.

FRANCIS I Under the rule of Francis I (r. 1515–1547), the French established a firm foothold in Milan and its environs. Francis waged a campaign (known as the Habsburg-Valois Wars) against Charles V (the Spanish king and Holy Roman Emperor; r. 1516–1558), which occupied him from 1521 to 1544. These wars involved disputed territories—southern France, the Netherlands, the Rhinelands, northern Spain, and Italy—and reflected France's central role in the shifting geopolitical landscape.

The French king also took a strong position in the religious controversies of his day. By the mid-16th century, the split between Catholics and Protestants had become so pronounced that subjects often felt compelled either to accept the religion of their sovereign or to emigrate to a territory where the sovereign's religion corresponded with their own. France was predominantly Catholic, and in 1534 Francis declared Protestantism illegal. The state persecuted its Protestants, the Huguenots, and drove them underground. The Huguenots' commitment to Protestantism eventually led to one of the bloodiest religious massacres in European history when the Protestants and Catholics clashed in Paris on August 24, 1572, with the violence quickly spreading throughout France.

Francis I also endeavored to elevate his country's cultural profile. To that end, he invited several esteemed Italian artists, including Leonardo da Vinci, to his court. Francis's attempt to glorify the state

and himself meant the religious art that dominated the Middle Ages no longer prevailed, for the king and not the Christian Church held the power.

The portrait (FIG. 18-10) JEAN CLOUET (ca. 1485–1541) painted of Francis I about a decade after he became king shows a worldly ruler magnificently bedecked in silks and brocades, wearing a gold chain with a medallion of the Order of Saint Michael, a French order Louis XI founded in 1469. Legend has it that the "merry monarch" was a great lover and the hero of hundreds of "gallant" deeds. Appropriately, he appears suave and confident, with his hand resting on the pommel of a dagger. Despite the careful detail, the portrait also exhibits an elegantly formalized quality, the result of Clouet's suppression of modeling, which flattens features, seen particularly in Francis's neck. The disproportion between the king's small head and his broad body, swathed in heavy layers of fabric, adds to the formalized nature.

Francis and his court favored art that was at once elegant, erotic, and unorthodox. Appropriately, Mannerism appealed to them most, and Francis thus brought Benvenuto Cellini (FIG. 17-51) to France with the promise of a lucrative retainer (see Chapter 17). He also put two prominent Florentine Mannerists—Rosso Fiorentino and Francesco Primaticcio—in charge of decorating the new royal palace at Fontainebleau.

18-11 Château de Chambord, Chambord, France, begun 1519.

French Renaissance châteaux, which developed from medieval castles, served as country houses for royalty. King Francis I's Château de Chambord reflects Italian palazzo design but features a Gothic roof.

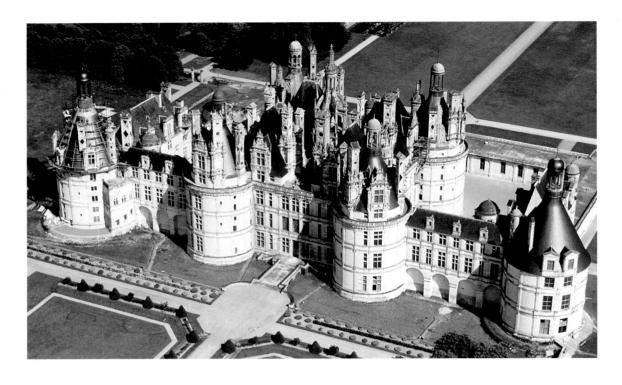

CHÂTEAU DE CHAMBORD Francis I indulged his passion for building by commissioning several large châteaux, among them the Château de Chambord (FIG. 18-11). Reflecting more peaceful times, these châteaux, developed from medieval castles, served as country houses for royalty, who usually built them near forests for use as hunting lodges. Construction of Chambord began in 1519, but Francis I never saw its completion. Chambord's plan, originally drawn by a pupil of Giuliano da Sangallo, includes a central square block with four corridors, in the shape of a cross, and a broad, central staircase that gives access to groups of rooms—ancestors of the modern suite of rooms or apartments. At each of the four corners, a round tower punctuates the square plan, and a moat surrounds the whole. From the exterior, Chambord presents a carefully contrived horizontal accent on three levels, with continuous moldings separating its floors. Windows align precisely, one exactly over another. The Italian Renaissance palazzo served as the model for this matching of horizontal and verti-

cal features, but above the third level the structure's lines break chaotically into a jumble of high dormers, chimneys, and lanterns that recall soaring ragged Gothic silhouettes on the skyline.

LOUVRE, PARIS Chambord essentially retains French architectural characteristics. During the reign of Francis's successor, Henry II (r. 1547–1559), however, translations of Italian architectural treatises appeared, and Italian architects themselves came to work in France.

18-12 PIERRE LESCOT, west wing of the Cour Carré (Square Court) of the Louvre, Paris, France, begun 1546.

Lescot's design for the Louvre palace reflects the Italian Renaissance classicism of Bramante, but the decreasing height of the stories, large scale of the windows, and steep roof are Northern European features.

Moreover, the French turned to Italy for study and travel. These exchanges caused a more extensive revolution in style than earlier, although certain French elements derived from the Gothic tradition persisted. This incorporation of Italian architectural ideas characterizes the redesigned Louvre in Paris, originally a medieval palace and fortress (FIG. 15-16). Since Charles V's renovation of the Louvre in the mid-14th century, the castle had languished relatively empty and fallen into a state of disrepair. Francis I initiated the project to update and expand the royal palace, but he died before the work was well under way. His architect, PIERRE LESCOT (1510–1578), continued under Henry II and produced the classical style later associated with 16th-century French architecture.

Although Chambord incorporated the formal vocabulary of the Early Renaissance, particularly from Lombardy, Lescot and his associates were familiar with the architectural style of Bramante and his school. In the west wing of the Cour Carré (Square Court; FIG. 18-12)

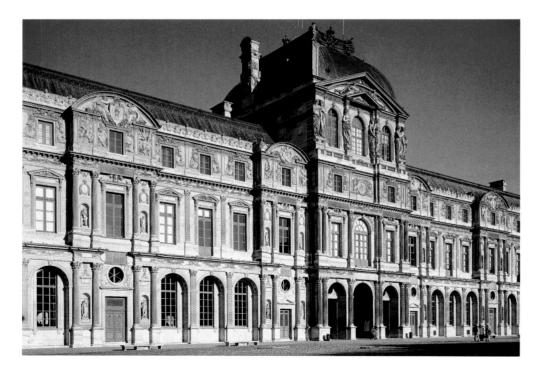

of the Louvre, each of the stories forms a complete order, and the cornices project enough to furnish a strong horizontal accent. The arcading on the ground story reflects the ancient Roman use of arches and produces more shadow than in the upper stories due to its recessed placement, thereby strengthening the design's visual base. On the second story, the pilasters rising from bases and the alternating curved and angular pediments supported by consoles have direct antecedents in several High Renaissance palaces (for example, FIG. 17-27). Yet the decreasing height of the stories, the scale of the windows (proportionately much larger than in Italian Renaissance buildings), and the steep roof suggest Northern European models. Especially French are the pavilions jutting from the wall. A feature the French long favored—double columns framing a niche—punctuates the pavilions. The building's vertical lines assert themselves. Openings deeply penetrate the wall, and sculptures by Jean Goujon (ca. 1510-1565) abound. Other Northern European countries imitated this French classical manner—its doublecolumned pavilions, tall and wide windows, profuse statuary, and steep roofs—although with local variations. The modified classicism the French produced was the only classicism to serve as a model for Northern European architects through most of the 16th century.

THE NETHERLANDS

With the demise of the Duchy of Burgundy in 1477 and the division of that territory between France and the Holy Roman Empire, the Netherlands at the beginning of the 16th century consisted of 17 provinces (corresponding to modern Holland, Belgium, and Luxembourg). The Netherlands was among the most commercially advanced and prosperous European countries. Its extensive network of rivers and easy access to the Atlantic Ocean provided a setting con-

ducive to overseas trade, and shipbuilding was one of the most profitable businesses. The region's commercial center shifted geographically toward the end of the 15th century, partly because of buildup of silt in the Bruges estuary. Traffic relocated to Antwerp, which became the hub of economic activity in the Netherlands after 1510. As many as 500 ships a day passed through Antwerp's harbor, and large trading companies from England, the Holy Roman Empire, Italy, Portugal, and Spain established themselves in the city.

During the second half of the 16th century, the Netherlands was under the political control of Philip II of Spain (r. 1556–1598), who had inherited the region from his father Charles V. The economic prosperity of the Netherlands served as a potent incentive for Philip II to strengthen his control over the territory. However, his heavy-handed tactics and repressive measures led in 1579 to revolt, resulting in the formation of two federations. The Union of Arras, a Catholic confederation of southern Netherlandish provinces, remained under Spanish dominion, and the Union of Utrecht, consisting of Protestant northern provinces, became the Dutch Republic (MAP 20-1).

The increasing number of Netherlandish citizens converting to Protestantism affected the arts and resulted in a corresponding decrease in large-scale altarpieces and religious works (although grand works continued to be commissioned for Catholic churches). Much of Netherlandish art of this period provides a wonderful glimpse into the lives of various strata of society, from nobility to peasantry, capturing their activities, environment, and values.

HIERONYMOUS BOSCH The most famous Netherlandish painter at the turn of the 16th century was HIERONYMUS BOSCH (ca. 1450–1516), whose most famous work is *Garden of Earthly Delights* (FIG. 18-13). Bosch is one of the most fascinating and puzzling

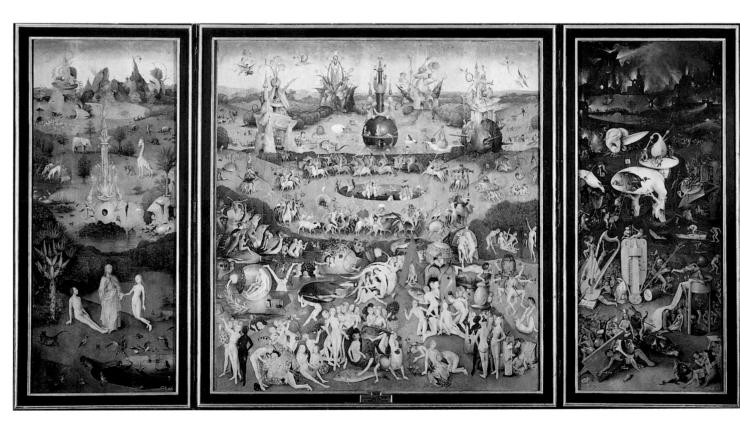

18-13 HIERONYMUS BOSCH, *Garden of Earthly Delights*, 1505–1510. Oil on wood, center panel 7' $2\frac{5}{8}$ " \times 6' $4\frac{3}{4}$ ", each wing 7' $2\frac{5}{8}$ " \times 3' $2\frac{1}{4}$ ". Museo del Prado, Madrid.

Bosch was the most imaginative and enigmatic painter of his era. In this triptych, which may commemorate a wedding, he created a fantasy world filled with nude men and women and bizarre creatures and objects.

18-14 JAN GOSSAERT, *Neptune and Amphitrite*, ca. 1516. Oil on wood, 6' $2'' \times 4'$ $\frac{3}{4}''$. Gemäldegalerie, Staatliche Museen, Berlin.

Dürer's Fall of Man (FIG. 18-1) inspired the poses of Gossaert's classical deities, but the architectural setting is probably based on sketches of ancient buildings Gossaert made during his trip to Rome.

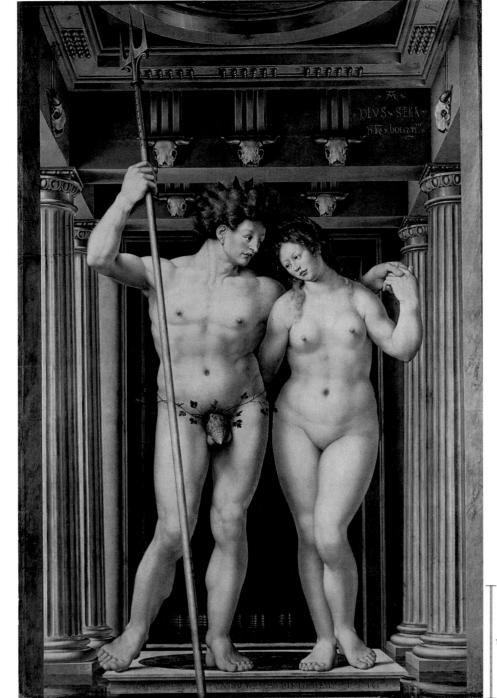

painters in history. Interpretations of Bosch differ widely. Scholars debate whether he was a satirist, an irreligious mocker, or a pornographer, a heretic or an orthodox fanatic like Girolamo Savonarola, his Italian contemporary (see Chapter 16).

Garden of Earthly Delights is Bosch's most enigmatic, and no interpretation has ever won universal acceptance. This large-scale work

takes the familiar form of a monumental triptych. The format suggests a religious function for Bosch's painting, but *Garden of Earthly Delights* resided in the palace of Henry III of Nassau, regent of the Netherlands, seven years after its completion. This location suggests a secular commission for private use. Some scholars have proposed that, given the work's central themes of marriage, sex, and procreation, the painting probably commemorates a wedding, a theme seen earlier in *Giovanni Arnolfini and His Bride* (FIG. 15-1) and in *A Goldsmith in His Shop* (FIG. 15-11). Any similarity to these paintings ends there, however. Whereas Jan van Eyck and Petrus Christus grounded their depictions of betrothed couples in 15th-century life and custom, Bosch's image portrays a visionary world of fantasy and intrigue.

In the left panel, God presents Eve to Adam in a landscape, presumably the Garden of Eden. Bosch placed the event in a wildly imaginative setting that includes an odd pink fountainlike structure in a body of water and an array of fanciful and unusual animals. These details may hint at an interpretation involving *alchemy*—the medieval study of seemingly magical changes, especially chemical changes. (Witchcraft also involved alchemy.) The right panel, in contrast, bombards viewers with the horrors of Hell. Beastly creatures devour people, while others are impaled or strung on musical instruments, as if on a medieval rack. A gambler is nailed to his own table. A spidery monster embraces a girl while toads bite her. A sea of inky darkness envelops all of these horrific scenes. Observers must search through the hideous enclosure of Bosch's Hell to take in its fascinating though repulsive details.

Sandwiched between Paradise and Hell is the huge central panel, in which nude people blithely cavort in a landscape dotted with bizarre creatures and unidentifiable objects. The numerous

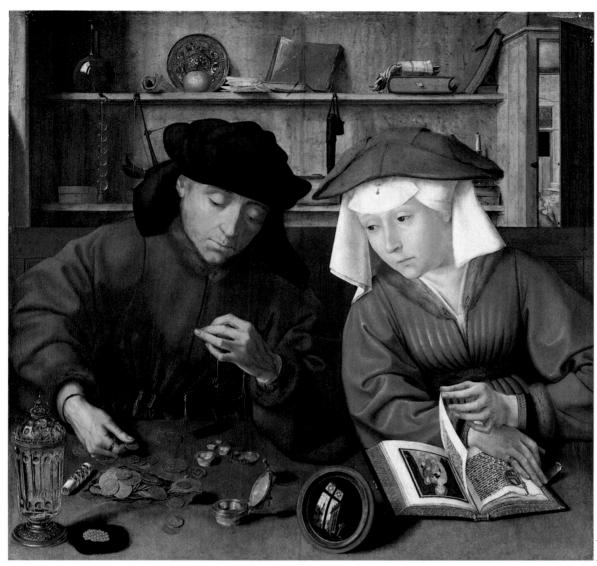

18-15 QUINTEN MASSYS, Money-Changer and His Wife, 1514. Oil on wood, $2'3\frac{3}{4}'' \times 2'2\frac{3}{8}''$. Louvre, Paris.

Massys's painting depicting a secular financial transaction is also a commentary on 16th-century Netherlandish values. The banker's wife shows more interest in the money-weighing than in her prayer book.

1 in

fruits and birds (fertility symbols) in the scene suggest procreation, and, indeed, many of the figures are paired off as couples. The orgiastic overtones of this panel, in conjunction with the terrifying image of Hell, have led some scholars to interpret this triptych as they have other Last Judgment images—as a warning to viewers of the fate awaiting the sinful, decadent, and immoral.

JAN GOSSAERT As in the Holy Roman Empire and France, developments in Italian Renaissance art interested many Netherlandish artists. Jan Gossaert (ca. 1478–1535) associated with humanist scholars and visited Italy, where he became fascinated with classical antiquity and its mythological subjects. Giorgio Vasari, the Italian artist and biographer and Gossaert's contemporary, wrote about him: "Jean Gossart [sic] of Mabuse was almost the first who took from Italy into Flanders the true method of making scenes full of nude figures and poetical inventions," although it is obvious Gossaert derived much of his classicism from Dürer.

Indeed, Dürer's *Fall of Man* (FIG. 18-1) inspired the composition and poses in Gossaert's *Neptune and Amphitrite* (FIG. 18-14). However, unlike Dürer's exquisitely small engraving, Gossaert's painting is more than six feet tall and four feet wide. The artist executed the painting with expected Netherlandish polish, skillfully drawing and carefully modeling the figures. Gossaert depicted the sea god with his

traditional attribute, the trident, and wearing a laurel wreath and an ornate conch shell rather than Dürer's fig leaf. Amphitrite is fleshy and, like Neptune, stands in a contrapposto stance. The architectural frame, which resembles the cella of a classical temple (FIG. 5-46), is an unusual mix of Doric and Ionic elements, including *bucrania* (ox skull decorations), a common motif in ancient architectural ornament. Gossaert likely based the classical setting on sketches he had made of ancient buildings while in Rome. He had traveled to Italy with Philip, bastard of Burgundy, this painting's patron. A Burgundian admiral (hence the Neptune reference), Philip became a bishop and kept this work in the innermost room of his castle.

QUINTEN MASSYS Antwerp's growth and prosperity, along with its wealthy merchants' propensity for collecting and purchasing art, attracted artists to the city. Among them was QUINTEN MASSYS (ca. 1466–1530), who became Antwerp's leading master after 1510. Son of a Louvain blacksmith, Massys demonstrated a willingness to explore the styles and modes of a variety of models, from Jan van Eyck to Bosch and from Rogier van der Weyden to Dürer and Leonardo. Yet his eclecticism was subtle and discriminating, enriched by an inventiveness that gave a personal stamp to his paintings.

In Money-Changer and His Wife (FIG. 18-15), Massys presented a professional man transacting business. He holds scales,

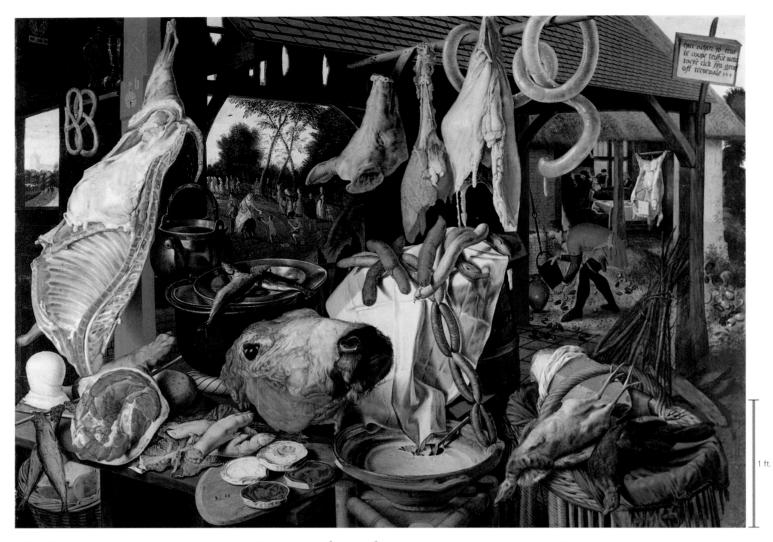

18-16 Pieter Aertsen, Butcher's Stall, 1551. Oil on wood, $4'\frac{3}{8}'' \times 6'5\frac{3}{4}''$. Uppsala University Art Collection, Uppsala.

At first glance *Butcher's Stall* appears to be a genre painting, but in the background Joseph leads a donkey carrying Mary and the Christ Child. Aertsen balanced images of gluttony with allusions to salvation.

checking the weight of coins on the table. The artist's detailed rendering of the figures, setting, and objects suggests a fidelity to observable fact. Thus, this work provides the viewer with insight into developing commercial practices. But Money-Changer and His Wife is also a commentary on Netherlandish values and mores. The painting highlights the financial transactions that were an increasingly prominent part of secular life in the 16th-century Netherlands and that distracted Christians from their religious duties. The banker's wife, for example, shows more interest in watching her husband weigh money than in reading her prayer book. Massys incorporated into his painting numerous references to the importance of a moral, righteous, and spiritual life, including a carafe with water and a candlestick, traditional religious symbols. The couple ignores them, focusing solely on money. On the right, through a window, an old man talks with another man, suggesting idleness and gossip. The reflected image in the convex mirror on the counter offsets this image of sloth and foolish chatter. There, a man reads what is most likely a Bible or prayer book. Behind him is a church steeple. An inscription on the original frame (now lost) read, "Let the balance be just and the weights equal" (Lev. 19:36), a caution that applies both to the money-changer's professional conduct and the eventual Last

Judgment. The couple in this painting, however, have tipped the balance in favor of the pursuit of wealth.

PIETER AERTSEN This tendency to inject reminders about spiritual well-being emerges in Butcher's Stall (FIG. 18-16) by PIETER AERTSEN (ca. 1507–1575), who worked in Antwerp for more than three decades. At first glance, this painting appears to be a descriptive genre scene (one from everyday life). On display is an array of meat products—a side of a hog, chickens, sausages, a stuffed intestine, pig's feet, meat pies, a cow's head, a hog's head, and hanging entrails. Also visible are fish, pretzels, cheese, and butter. Like Massys, Aertsen embedded strategically placed religious images in his painting. In the background, Joseph leads a donkey carrying Mary and the Christ Child. The Holy Family stops to offer alms to a beggar and his son, while the people behind the Holy Family wend their way toward a church. Furthermore, the crossed fishes on the platter and the pretzels and wine in the rafters on the upper left all refer to "spiritual food" (pretzels often served as bread during Lent). Aertsen accentuated these allusions to salvation through Christ by contrasting them to their opposite—a life of gluttony, lust, and sloth. He represented this degeneracy with the oyster and mussel shells

18-17 CATERINA VAN HEMESSEN, Self-Portrait, 1548. Oil on panel, $1'\frac{3}{4}'' \times 9\frac{7}{8}''$. Kunstmuseum, Öffentliche Kunstsammlung Basel. In this first known Northern European self-portrait by a woman,

In this first known Northern European self-portrait by a woman, Caterina van Hemessen represented herself as a confident artist momentarily interrupting her work to look out at the viewer.

18-18 Attributed to Levina Teerling, *Elizabeth I as a Princess*, ca. 1559. Oil on wood, 3' $6\frac{3}{4}'' \times 2'$ $8\frac{1}{4}''$. The Royal Collection, Windsor Castle, Windsor.

Teerlinc received greater compensation for her work for the English court than did her male contemporaries. Her considerable skill is evident in this life-size portrait of Elizabeth I as a young princess.

(which Netherlanders believed possessed aphrodisiacal properties) scattered on the ground on the painting's right side, along with the people seen eating and carousing nearby under the roof.

CATERINA VAN HEMESSEN With the accumulation of wealth in the Netherlands, portraits increased in popularity. The self-portrait (FIG. 18-17) by CATERINA VAN HEMESSEN (1528–1587) is the first known Northern European self-portrait by a woman. Here, she confidently presented herself as an artist who interrupts her work to look toward the viewer. She holds brushes, a palette, and a *maulstick* (a stick used to steady the hand while painting) in her left hand and delicately applies pigment to the canvas with her right hand. Van Hemessen's father, Jan Sanders van Hemessen, a well-known painter, trained her. Caterina ensured proper identification (and credit) through the inscription in the painting: "Caterina van Hemessen painted me / 1548 / her age 20."

LEVINA TEERLINC Another female painter, Levina Teerlinc (1515–1576) of Bruges, established herself as such a respected artist that Henry VIII and his successors invited her to England to paint miniatures for them. There, she was a formidable rival of some of her male contemporaries at the court, such as Hans Holbein, and received greater compensation for her work than they did for theirs. Teerlinc's considerable skill is evident in a life-size portrait (FIG. 18-18) attributed to her, which depicts Elizabeth I (1533–1603, r. 1558–1603) as a

composed, youthful princess. Daughter of Henry VIII and Anne Boleyn, Elizabeth was probably in her late 20s when she sat for this portrait. Appropriate to her station in life, she wears an elegant brocaded gown, extravagant jewelry, and a headdress based on a style her mother popularized.

That female artists such as van Hemessen and Teerlinc were able to achieve such success is a testament to their determination and skill. Despite the difficulties for women in obtaining artistic training (see "The Artist's Profession in Flanders," Chapter 15, page 406), women contributed significantly to the lofty reputation Flemish artists enjoyed. In addition to participating as artists, women also played an important role as patrons in the 16th-century art world. Politically powerful women such as Margaret of Austria (regent of the Netherlands during the early 16th century; 1480–1530) and Mary of Hungary (queen consort of Hungary; 1505–1558) were avid collectors and patrons, and contributed substantially to the thriving state of the arts. Like other art patrons, these women collected and commissioned art not only for the aesthetic pleasure it provided but also for the status it bestowed on them and the cultural sophistication it represented.

JOACHIM PATINIR Landscape painting also flourished in the Netherlands. Particularly well known for his landscapes was JOACHIM PATINIR (d. 1524). According to one scholar, the word

18-19 JOACHIM PATINIR, Landscape with Saint Jerome, ca. 1520–1524. Oil on wood, $2' 5\frac{1}{8}'' \times 2' 11\frac{7}{8}''$. Museo del Prado, Madrid.

Joachim Patinir, a renowned Netherlandish landscape painter, subordinated the story of Saint Jerome to the depiction of craggy rock formations, verdant rolling fields, and expansive bodies of water.

Landschaft (landscape) first emerged in German literature as a characterization of an artistic genre (category of art) when Dürer described Patinir as a "good landscape painter." In Landscape with Saint Ierome (FIG. 18-19), Patinir subordinated the saint, who removes a thorn from a lion's paw in the foreground, to the exotic and detailed landscape. Craggy rock formations, verdant rolling fields, villages with church steeples, expansive bodies of water, and a dramatic sky fill most of the panel. Patinir amplified the sense of distance by masterfully using color to enhance the visual effect of recession and advance.

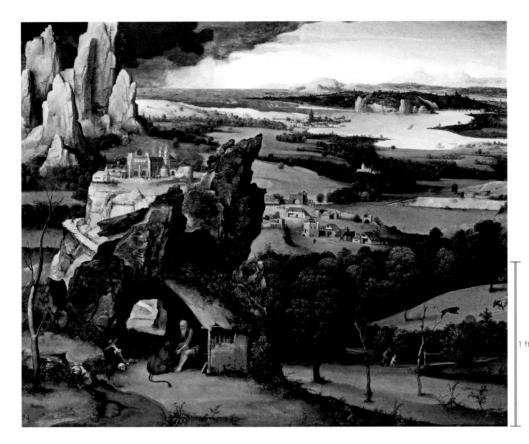

PIETER BRUEGEL THE ELDER The greatest Netherlandish painter of the mid-16th century was PIETER BRUEGEL THE ELDER (ca. 1528–1569), whose works reveal both an interest in the interrelationship of human beings and nature and Patinir's influence. But in Bruegel's paintings, no matter how huge a slice of the

world the artist shows, human activities remain the dominant theme. Like many of his contemporaries, Bruegel traveled to Italy, where he seems to have spent almost two years, venturing as far south as Sicily. Unlike other artists, however, Bruegel chose not to incorporate classical elements into his paintings.

18-20 PIETER BRUEGEL THE ELDER, Netherlandish Proverbs, 1559. Oil on wood, 3' $10'' \times 5' 4\frac{1}{8}''$. Gemäldegalerie, Staatliche Museen, Berlin.

In this painting of a crowded Netherlandish village, Bruegel indulged his audience's obsession with proverbs and passion for clever imagery, and demonstrated his deep understanding of human nature.

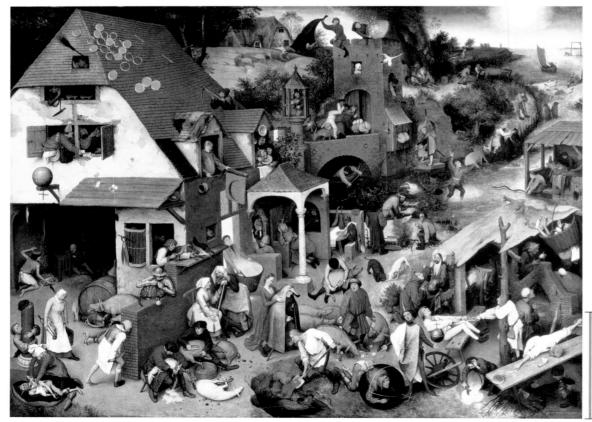

1 ft.

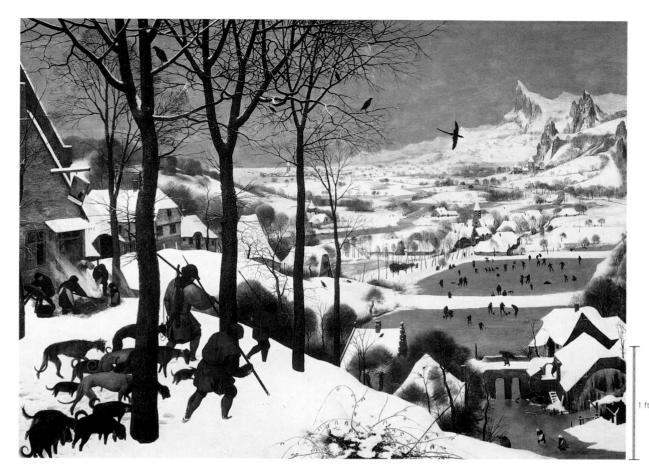

18-21 PIETER BRUEGEL THE ELDER, Hunters in the Snow, 1565. Oil on wood, $3' 10\frac{1}{8}'' \times 5' 3\frac{3}{4}''$. Kunsthistorisches Museum, Vienna.

In Hunters in the Snow, one of a series of paintings illustrating annual seasonal changes, Bruegel draws the viewer diagonally deep into the landscape by his mastery of line, shape, and composition.

Bruegel's Netherlandish Proverbs (FIG. 18-20) depicts a Netherlandish village populated by a wide range of people (nobility, peasants, and clerics). From a bird's-eye view, the spectator encounters a mesmerizing array of activities reminiscent of the topsy-turvy scenes of Bosch (FIG. 18-13), but the purpose and meaning of Bruegel's anecdotal details are clear. By illustrating more than a hundred proverbs in this one painting, the artist indulged his Netherlandish audience's obsession with proverbs and passion for detailed and clever imagery. As the viewer scrutinizes the myriad vignettes within the painting, Bruegel's close observation and deep understanding of human nature become apparent. The proverbs depicted include, on the far left, a man in blue gnawing on a pillar ("He bites the column"—an image of hypocrisy). To his right, a man "beats his head against a wall" (an ambitious idiot). On the roof a man "shoots one arrow after the other, but hits nothing" (a shortsighted fool). In the far distance, the "blind lead the blind"—a subject to which Bruegel returned several years later in one of his most famous paintings.

In contrast to Patinir's Saint Jerome, lost in the landscape, the myriad, raucous characters of Bruegel's *Netherlandish Proverbs* fill the panel, so much so that the artist almost shut out the sky. *Hunters in the Snow* (FIG. 18-21) is very different in character and illustrates the dynamic variety of Bruegel's work. One of a series of six paintings (some scholars think there were originally 12) illustrating seasonal changes in the year, *Hunters* refers back to older traditions of depicting seasons and peasants in Books of Hours (FIGS. 15-15 and 15-16). The painting shows human figures and landscape locked in winter cold, reflecting the particularly severe winter of 1565, when Bruegel produced the painting. The weary hunters return with their hounds, women build fires, skaters skim the frozen pond, and the town and its church huddle in their mantle of snow. Bruegel rendered the landscape in an optically accurate manner. It develops

smoothly from foreground to background and draws the viewer diagonally into its depths. The painter's consummate skill in using line and shape and his subtlety in tonal harmony make this one of the great landscape paintings and an occidental counterpart of the masterworks of classical Chinese landscape.

SPAIN

Spain's ascent to power in Europe began in the mid-15th century with the marriage of Isabella of Castile (1451-1504) and Ferdinand of Aragon (1452–1516) in 1469. By the end of the 16th century, Spain had emerged as the dominant European power. Under the Habsburg rulers Charles V and Philip II, the Spanish Empire controlled a territory greater in extent than any ever known—a large part of Europe, the western Mediterranean, a strip of North Africa, and vast expanses in the New World. Spain acquired many of its New World colonies through aggressive overseas exploration. Among the most notable conquistadors sailing under the Spanish flag were Christopher Columbus (1451-1506), Vasco Nuñez de Balboa (ca. 1475-1517), Ferdinand Magellan (1480–1521), Hernán Cortés (1485–1547), and Francisco Pizarro (ca. 1470-1541). The Habsburg Empire, enriched by New World plunder, supported the most powerful military force in Europe. Spain defended and then promoted the interests of the Catholic Church in its battle against the inroads of the Protestant Reformation. Indeed, Philip II earned the title "Most Catholic King." Spain's crusading spirit, nourished by centuries of war with Islam, engaged body and soul in forming the most Catholic civilization of Europe and the Americas. In the 16th century, for good or for ill, Spain left the mark of Spanish power, religion, language, and culture on two hemispheres.

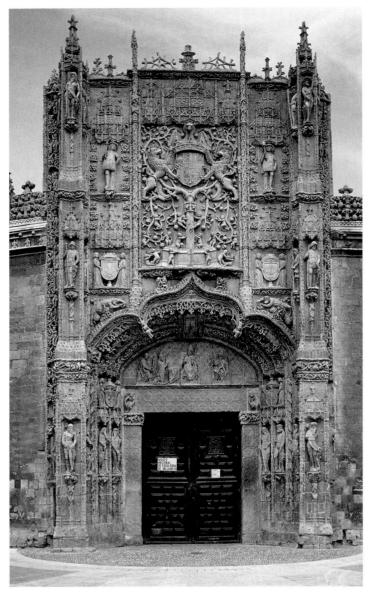

18-22 Portal, Colegio de San Gregorio, Valladolid, Spain, ca. 1498.

The Plateresque architectural style takes its name from *platero* ("silversmith" in Spanish). At the center of this Valladolid portal's Late Gothic tracery is the coat of arms of King Ferdinand and Queen Isabella.

COLEGIO DE SAN GREGORIO During the 15th century and well into the 16th, a Late Gothic style of architecture, the Plateresque, prevailed in Spain. Plateresque derives from the Spanish word platero, meaning "silversmith," and the Plateresque style in architecture is characterized by the delicate execution of its ornamentation, which resembles elegant metalwork. The Colegio de San Gregorio (Seminary of Saint Gregory; FIG. 18-22) in the Castilian city of Valladolid handsomely exemplifies the Plateresque manner. Great carved retables, like the German altarpieces that influenced them (FIGS. 15-18, 15-19, and 18-2, bottom), appealed to church patrons and architects in Spain. They thus made such retables a conspicuous decorative feature of their exterior architecture, dramatizing a portal set into an otherwise blank wall. The Plateresque entrance of San Gregorio is a lofty sculptured stone screen that bears no functional relation to the architecture behind it. On the entrance level, lacelike tracery reminiscent of Moorish design hems the flamboyant ogival arches. A great screen, paneled into sculptured compartments, rises above the tracery. In the center, the branches of a huge pomegranate

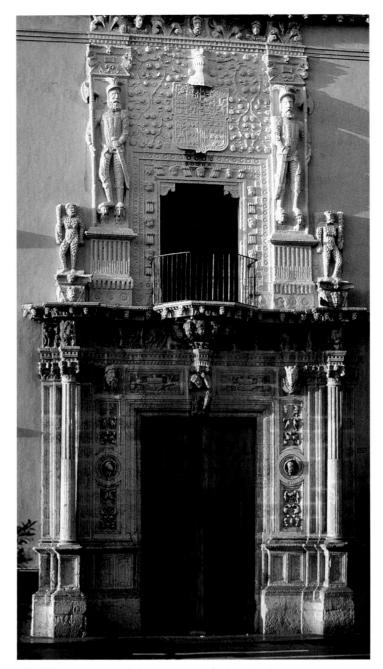

18-23 Portal, Casa de Montejo, Mérida, Mexico, 1549.

Spanish expansion brought the Plateresque style to the New World. The portal decoration of the home of the Yucatán's conqueror includes Spanish soldiers standing on the severed heads of Maya natives.

tree (symbolizing Granada, the Moorish capital of Spain the Habsburgs captured in 1492) wreathe the coat of arms of King Ferdinand and Queen Isabella. Cupids play among the tree branches, and, flanking the central panel, niches frame armed pages of the court, heraldic wild men symbolizing aggression, and armored soldiers, attesting to Spain's proud new militancy. In typical Plateresque and Late Gothic fashion, the activity of a thousand intertwined motifs unifies the whole design, which, in sum, creates an exquisitely carved panel greatly expanded in scale from the retables that inspired it.

NEW SPAIN Spanish expansion into the Western Hemisphere brought the Plateresque style to "New Spain" as well. A mid-16th-century gem of Plateresque architecture is the portal (FIG. 18-23) of the Casa de Montejo in Mérida, Mexico. The house, built in 1549,

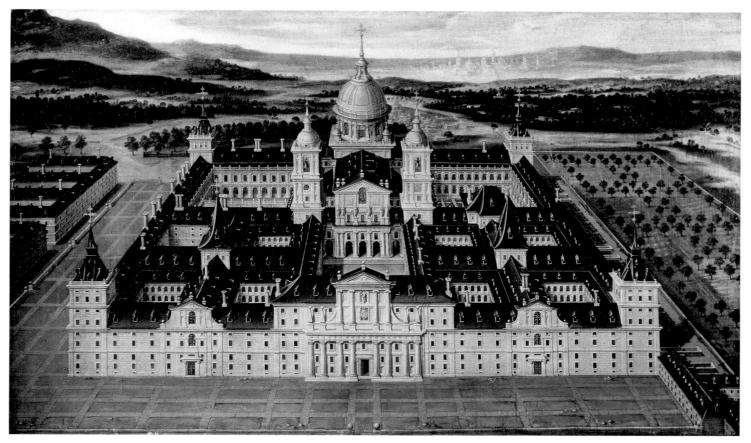

18-24 Juan de Herrera and Juan Bautista de Toledo, El Escorial, near Madrid, Spain, 1563–1584 (detail of an anonymous 18th-century painting).

Conceived by Charles V and built by Philip II, El Escorial is a combined royal mausoleum, church, monastery, and palace. The complex is classical in style with severely plain walls and massive towers.

was the palatial residence of Francisco de Montejo the Younger (1508–1565), the Spanish conqueror of the Yucatán who founded Mérida in 1542. The lower story features engaged classical columns on projecting pedestals and sculptured portrait busts of Montejo and his wife in roundels. The upper story is much more fanciful and fully Plateresque in style with a central coat of arms, as at Valladolid. The four statues of the second level are of special interest. The larger pair depicts bearded and armored Spanish soldiers standing on the severed heads of the Maya natives they conquered. Smaller in scale are two sheepskin-clad wild men holding clubs (also seen at Valladolid), probably personifications of the defeated indigenous population. The triumphal imagery is, ironically, the work of Maya sculptors from nearby Maní. In fact, the very stones used to build the Montejo house were taken from dismantled Maya temples in the area.

EL ESCORIAL In Spain itself, the Plateresque style gave way under Philip II to an Italian-derived classicism. The Italian style is on display in the expansive complex called El Escorial (FIG. 18-24), which Juan Bautista de Toledo (d. 1567) and Juan de Herrera (ca. 1530–1597), principally the latter, constructed for Philip II. In his will, Charles V stipulated that a "dynastic pantheon" be constructed to house the remains of past and future monarchs of Spain. Philip II, obedient to his father's wishes, chose a site some 30 miles northwest of Madrid in rugged terrain with barren mountains. There he built El Escorial, not only a royal mausoleum but also a church, a monastery, and a palace. Legend has it that the gridlike plan for the enormous complex, 625 feet wide and 520 feet deep,

symbolized the gridiron on which Saint Lawrence, El Escorial's patron saint, suffered his martyrdom.

The vast structure is in keeping with Philip's austere and conscientious character, his passionate Catholic religiosity, his proud reverence for his dynasty, and his stern determination to impose his will worldwide. He insisted that in designing El Escorial, the architects focus on simplicity of form, severity in the whole, nobility without arrogance, and majesty without ostentation. The result is a classicism of Doric severity, ultimately derived from Italian architecture and with the grandeur of Saint Peter's (FIG. 19-4) implicit in the scheme, but unique in Spanish and European architecture.

Only the three entrances, with the dominant central portal framed by superimposed orders and topped by a pediment in the Italian fashion, break the long sweep of the structure's severely plain walls. Massive square towers punctuate the four corners. The stress on the central axis, with its subdued echoes in the two flanking portals, anticipates the three-part organization of later Baroque facades (see Chapter 19). The construction material for the entire complex (including the church)—granite, a difficult stone to work—conveys a feeling of starkness and gravity. The church's massive facade and the austere geometry of the interior complex, with its blocky walls and ponderous arches, produce an effect of overwhelming strength and weight. The entire complex is a monument to the collaboration of a great king and remarkably understanding architects. El Escorial stands as the overpowering architectural expression of Spain's spirit in its heroic epoch and of the character of Philip II, the extraordinary ruler who directed it.

18-25 EL Greco, Burial of Count Orgaz, 1586. Oil on canvas, $16' \times 12'$. Santo Tomé, Toledo.

El Greco's art is a blend of Byzantine and Italian Mannerist elements. His intense emotional content captured the fervor of Spanish Catholicism, and his dramatic use of light foreshadowed the Baroque style.

EL GRECO Doménikos Theotokópoulos, called EL GRECO (ca. 1547–1614), was born on Crete but emigrated to Italy as a young man. In his youth, he absorbed the traditions of Late Byzantine frescoes and mosaics. While still young, El Greco went to Venice, where he worked in Titian's studio, although Tintoretto's painting apparently made a stronger impression on him. A brief trip to Rome explains the influences of Roman and Florentine Mannerism on his work. By 1577 he had left for Spain to spend the rest of his life in Toledo.

El Greco's art is a strong personal blending of Byzantine and Mannerist elements. The intense emotionalism of his paintings, which naturally appealed to Spanish piety, and a great reliance on and mastery of color bound him to 16th-century Venetian art and to Mannerism. El Greco's art was not strictly Spanish (although it appealed to certain sectors of that society), for it had no Spanish antecedents and little effect on later Spanish painters. Nevertheless, El Greco's hybrid style captured the fervor of Spanish Catholicism.

A vivid expression of this fervor is the artist's masterpiece, *Burial of Count Orgaz* (FIG. **18-25**), painted in 1586 for the

church of Santo Tomé in Toledo. El Greco based the painting on the legend that the count of Orgaz, who had died some three centuries before and who had been a great benefactor of Santo Tomé, was buried in the church by Saints Stephen and Augustine, who miraculously descended from Heaven to lower the count's body into its sepulcher. In the painting, El Greco carefully distinguished the terrestrial and celestial spheres. The brilliant Heaven that opens above irradiates the earthly scene. The painter represented the terrestrial realm with a firm realism, whereas he depicted the celestial, in his quite personal manner, with elongated undulating figures, fluttering draperies, and a visionary swirling cloud. Below, the two saints lovingly lower the count's armor-clad body, the armor and heavy robes painted with all the rich sensuousness of the Venetian school. A solemn chorus of black-clad Spanish personages fills the background. In the carefully individualized features of these figures, El Greco demonstrated that he was also a great portraitist. These men call to mind both the conquistadors of the early 16th century and the Spanish naval officers who, two years after the completion of this painting, led the Great Armada against both Protestant England and the Netherlands.

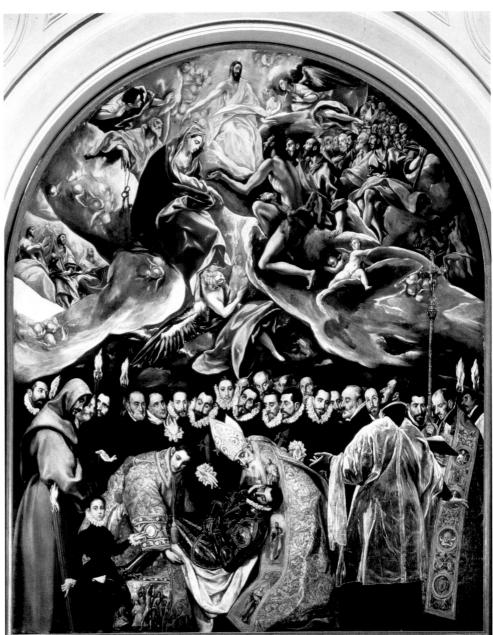

1 f

The upward glances of some of the figures below and the flight of an angel above link the painting's lower and upper spheres. The action of the angel, who carries the count's soul in his arms as Saint John and the Virgin intercede for it before the throne of Christ, reinforces this connection. El Greco's deliberate change in style to distinguish between the two levels of reality gives the viewer an opportunity to see the artist's early and late manners in the same work, one below the other. His relatively sumptuous and realistic presentation of the earthly sphere still has strong roots in Venetian art, but the abstractions and distortions El Greco used to show the immaterial nature of the heavenly realm characterized his later style. His elongated figures existing in undefined spaces, bathed in a cool light of uncertain origin, explain El Greco's usual classification as a Mannerist, but it is difficult to apply that label to him without reservations. Although he used Mannerist formal devices, El Greco's primary concerns were emotion and conveying his religious passion or arousing that of observers. The forcefulness of his paintings is the result of his unique, highly developed expressive style. His strong sense of movement and use of light prefigured the Baroque style of the 17th century, examined next in Chapter 19.

NORTHERN EUROPE AND SPAIN, 1500 TO 1600

HOLY ROMAN EMPIRE

- Widespread dissatisfaction with the Church in Rome led to the Protestant Reformation, splitting Christendom in half. Protestants objected to the sale of indulgences and rejected most of the sacraments of the Catholic Church. They also condemned ostentatious church decoration as a form of idolatry that distracted the faithful from communication with God.
- As a result, Protestant churches were relatively bare, but art, especially prints, still played a role in Protestantism. Lucas Cranach, for example, effectively used visual imagery to contrast Catholic and Protestant views of salvation in his woodcut Allegory of Law and Grace.
- The greatest printmaker of the Holy Roman Empire was Albrecht Dürer, who was also a painter. Dürer was the first artist outside Italy to become an international celebrity. His work ranged from biblical subjects to botanical studies. Fall of Man reflects Dürer's studies of the Vitruvian theory of human proportions and of classical statuary. Dürer's engravings rival painting in tonal quality.
- Other German artists, such as Albrecht Altdorfer, achieved fame as landscape painters. Hans Holbein was a renowned portraitist who became court painter in England. Holbein's *The French Ambassadors* portrays two worldly humanists and includes a masterfully rendered anamorphic skull.

Dürer, Fall of Man, 1504

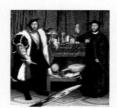

Holbein, The French Ambassadors, 1533

FRANCE

- King Francis I fought against the Holy Roman Emperor Charles V and declared Protestantism illegal in France. An admirer of Italian art, he invited several prominent Mannerists to work at his court and decorate his palace at Fontainebleau.
- French architecture of the 16th century is an eclectic mix of Italian and Northern European elements, as seen in Pierre Lescot's design of the renovated Louvre palace in Paris and Francis's château at Chambord. The château combines classical motifs derived from Italian palazzi with a Gothic roof silhouette.

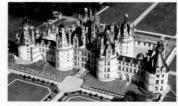

Château de Chambord, Chambord, begun 1519

THE NETHERLANDS

- The Netherlands was one of the most commercially advanced and prosperous countries in 16th-century Europe. Much of Netherlandish art of this period provides a picture of contemporary life and values.
- Pieter Aertsen of Antwerp, for example, painted *Butcher's Stall*, which seems to be a straightforward genre scene but includes the Holy Family offering alms to a beggar in the background. The painting provides a stark contrast between gluttony and religious piety.
- Landscapes were the specialty of Joachim Patinir. Pieter Bruegel's repertory also included landscape painting. His *Hunters in the Snow* is one of a series of paintings depicting the seasonal changes of the year and the activities associated with them, as in traditional Books of Hours.
- Prominent female artists of the period include Caterina van Hemessen, who painted the first known Northern European self-portrait of a woman, and Levina Teerlinc, who painted portraits for the English court.

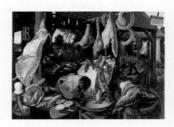

Aertsen, *Butcher's Stall,* 1551

SPAIN

- At the end of the 16th century, Spain was the dominant power in Europe and ruled an empire greater in extent than any ever known, including vast territories in the New World.
- The Spanish Plateresque style of architecture takes its name from *platero* ("silversmith") and features delicate ornamentation resembling metalwork.
- Under Philip II the Plateresque style gave way to an Italian-derived classicism, seen at its best in El Escorial, a royal mausoleum, monastery, and palace complex near Madrid.
- The leading painter of 16th-century Spain was the Greek-born El Greco, who combined Byzantine style, Italian Mannerism, and the religious fervor of Catholic Spain in works such as *Burial of Count Orgaz*.

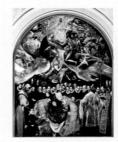

El Greco, Burial of Count Orgaz, 1586

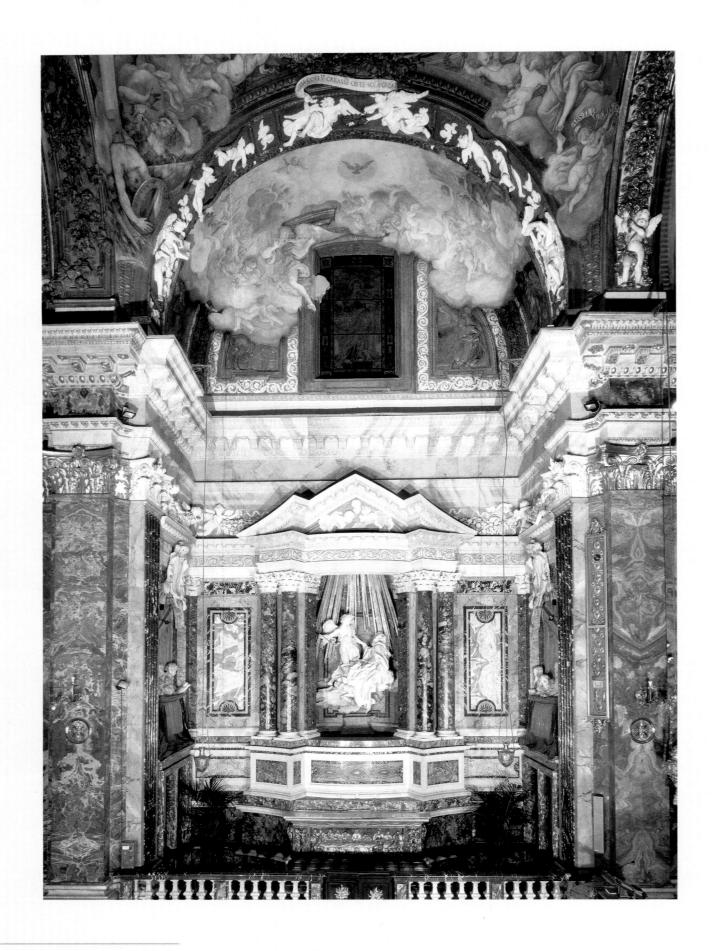

19-1 GIANLORENZO BERNINI, interior of the Cornaro Chapel, Santa Maria della Vittoria, Rome, Italy, 1645–1652.

Bernini was the quintessential Baroque artist. For the Cornaro Chapel, he drew on the full capabilities of architecture, sculpture, and painting to create an intensely emotional experience for worshipers.

ITALY AND SPAIN, 1600 TO 1700

Art historians traditionally describe 17th-century European art as *Baroque*, but the term is problematic because the period encompasses a broad range of styles and genres. Although its origin is unclear, "Baroque" may have come from the Portuguese word *barroco*, meaning an irregularly shaped pearl. Use of the term emerged in the late 18th and early 19th centuries, when critics disparaged the Baroque period's artistic production, in large part because of perceived deficiencies in comparison with the art of the Italian Renaissance. Over time, this negative connotation faded, but the term is still useful to describe the distinctive new style that emerged during the 17th century—a style of complexity and drama seen especially in Italian art of this period. Whereas Renaissance artists reveled in the precise, orderly rationality of classical models, Baroque artists embraced dynamism, theatricality, and elaborate ornamentation, all used to spectacular effect, often on a grandiose scale.

ITALY

Although in the 16th century the Catholic Church launched the Counter-Reformation in response to—and as a challenge to—the Protestant Reformation, the considerable appeal of Protestantism continued to preoccupy the popes throughout the 17th century. The Treaty of Westphalia (see Chapter 20) in 1648 had formally recognized the principle of religious freedom, serving to validate Protestantism (predominantly in the German states). With the Church in Rome as the leading art patron in 17th-century Italy, the aim of much of Italian Baroque art was to restore Catholicism's predominance and centrality. The Council of Trent, one 16th-century Counter-Reformation initiative, firmly resisted Protestant objections to using images in religious worship, insisting on their necessity for teaching the laity (see "Religious Art in Counter-Reformation Italy," Chapter 17, page 474). Baroque art in Italy was therefore often overtly didactic.

Architecture and Sculpture

Italian 17th-century art and architecture, especially in Rome, embodied the renewed energy of the Catholic Counter-Reformation and communicated it to the populace. At the end of the 16th century, Pope Sixtus V (r. 1585–1590) had played a key role in the Roman Catholic Church's lengthy campaign to

19-2 Carlo Maderno, facade of Santa Susanna, Rome, Italy, 1597–1603.

Maderno's facade of Santa Susanna is one of the earliest manifestations of the Baroque spirit. The rhythm of the columns and pilasters mounts dramatically toward the emphatically stressed vertical axis.

19-3 Carlo Maderno, facade of Saint Peter's, Vatican City, Rome, Italy, 1606–1612.

For the facade of Saint Peter's, Maderno elaborated on his design for Santa Susanna (FIG. 19-2), but the two outer bays with bell towers were not part of his plan and detract from the verticality he sought. reestablish its preeminence. He augmented the papal treasury and intended to rebuild Rome as an even more magnificent showcase of Church power. Between 1606 and 1667, several strong and ambitious popes—Paul V, Urban VIII, Innocent X, and Alexander VII—brought many of Sixtus V's dreams to fruition. Rome still bears the marks of their patronage everywhere.

SANTA SUSANNA The facade (FIG. 19-2) that CARLO MADERNO (1556–1629) designed at the turn of the century for the Roman church of Santa Susanna stands as one of the earliest manifestations of the Baroque artistic spirit. In its general appearance, Maderno's facade resembles Giacomo della Porta's immensely influential design for Il Gesù (FIG. 17-55). But Maderno's later facade has a greater verticality that concentrates and dramatizes the major features of its model. The tall central section projects forward from the horizontal lower story, and the scroll buttresses that connect the two levels are narrower and set at a sharper angle. The elimination of an arch framing the pediment over the doorway further enhances the design's vertical thrust. The rhythm of Santa Susanna's vigorously projecting columns and pilasters mounts dramatically toward the emphatically stressed central axis. The recessed niches, which contain statues and create pockets of shadow, heighten the sculptural effect.

MADERNO AND SAINT PETER'S The drama inherent in Santa Susanna's facade appealed to Pope Paul V (r. 1605–1621), who commissioned Maderno in 1606 to complete Saint Peter's in Rome. As the symbolic seat of the papacy, the church Constantine originally built over the first pope's tomb (see Chapter 8) radiated enormous symbolic presence. In light of Counter-Reformation concerns, the Baroque popes wanted to conclude the already century-long rebuilding project and reestablish the force embodied in the mammoth structure. In many ways Maderno's facade (FIG. 19-3) is a gigantic expansion of the elements of Santa Susanna's first level. But the compactness and verticality of the smaller church's facade are not as prominent because Saint Peter's enormous breadth counterbalances them. Mitigating circumstances must be considered when assessing this design, however. The preexisting core of an incomplete building restricted Maderno, so he did not have the luxury of formulating a

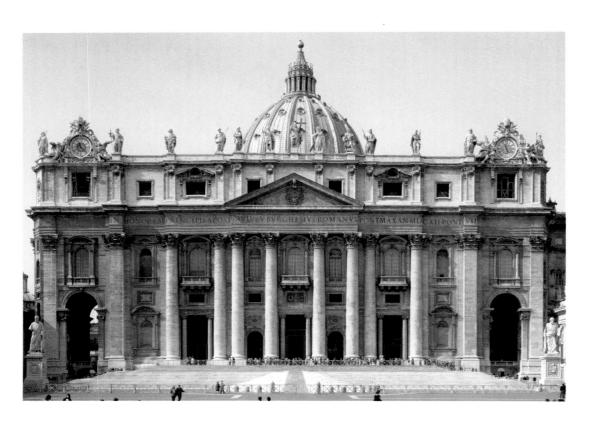

VATICAN
CITY

Vatican Gardens

Vatican Gardens

St. Peter's Chapel Scalia Regia

St. Peter's Plazza

Obelisk

longitudinal basilican plan used for the original fourth-century church (FIG. 8-9) reinforced the symbolic distinction between clergy and laity and provided a space for the processions of ever-growing assemblies. Lengthening the nave, unfortunately, pushed the dome farther back from the facade and all but destroyed the effect Michelangelo had planned—a structure pulled together and dominated by its dome. When viewed at close range, the dome barely emerges above the facade's soaring frontal plane. Seen from farther back (FIG. 19-3), it appears to have no drum. Visitors must move back quite a distance from the front (or fly over the church, FIG. 19-4) to see the dome and drum together. Today, viewers can appreciate the effect Michelangelo intended only by observing the church from the back (FIG. 17-26).

totally new concept for Saint Peter's. Moreover, the two outer bays with bell towers were not part of his original concept. Hence, had the facade been constructed according to the architect's initial design, the result would have been greater verticality and visual coherence.

Maderno's plan for Saint Peter's (MAP 19-1) also departed from the central plans designed for it during the Renaissance by Bramante (FIG. 17-23) and, later, by Michelangelo (FIG. 17-25). Paul V commissioned Maderno to add three nave bays to the earlier nucleus because Church officials had decided the central plan was too closely associated with pagan buildings, such as the Pantheon (FIG. 7-51). Moreover, the

BERNINI AND SAINT PETER'S Old Saint Peter's had a large forecourt, or *atrium* (FIG. 8-9, no. 6), in front of the church proper, and in the mid-17th century, GIANLORENZO BERNINI (1598–1680) received the prestigious commission to construct a monumental colonnade-framed *piazza* (plaza; FIG. 19-4) in front of Maderno's facade. Architect, painter, and sculptor, Bernini was one of the most important and imaginative artists of the Italian Baroque era and its most characteristic, sustaining spirit. Bernini's design had to accommodate two preexisting structures on the site—an ancient obelisk the Romans brought from Egypt (which

Pope Sixtus V had moved to its present location in 1585 as part of his vision of Christian triumph in Rome) and a fountain Maderno designed. Bernini co-opted these features to define the long axis of a vast oval embraced by two colonnades joined to Maderno's facade. Four rows of huge Tuscan columns make up the two colonnades, which terminate in classical temple fronts. The colonnades extend a dramatic gesture of embrace to all who enter the piazza, symbolizing the welcome the Roman Catholic Church gave its members

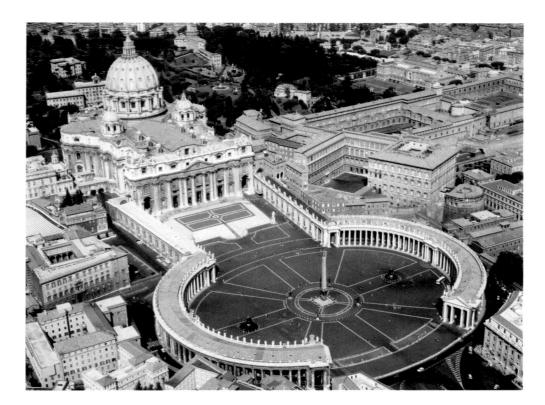

19-4 Aerial view of Saint Peter's, Vatican City, Rome, Italy. Piazza designed by Gianlorenzo Bernini, 1656–1667.

The dramatic gesture of embrace that Bernini's colonnade makes as worshipers enter Saint Peter's piazza symbolizes the welcome the Roman Catholic Church extended its members during the Counter-Reformation.

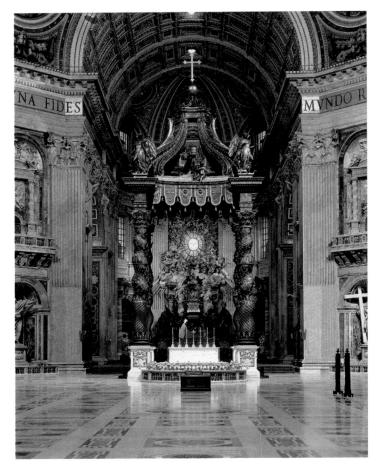

19-5 GIANLORENZO BERNINI, baldacchino, Saint Peter's, Vatican City, Rome, Italy, 1624–1633. Gilded bronze, 100′ high.

Bernini's baldacchino serves both functional and symbolic purposes. It marks Saint Peter's tomb and the high altar of the church, and it visually bridges human scale to the lofty vaults and dome above.

during the Counter-Reformation. Bernini himself referred to his colonnades as the welcoming arms of the church. Beyond their symbolic resonance, the colonnades served visually to counteract the natural perspective and bring the facade closer to the viewer. By emphasizing the facade's height in this manner, Bernini subtly and effectively compensated for its extensive width. Thus, a Baroque transformation expanded the compact central designs of Bramante and Michelangelo into a dynamic complex of axially ordered elements that reach out and enclose spaces of vast dimension. By its sheer scale and theatricality, the completed Saint Peter's fulfilled the desire of the Counter-Reformation Catholic Church to present an aweinspiring, authoritative vision of itself.

BALDACCHINO, SAINT PETER'S Long before being invited to design the piazza, Bernini had been at work decorating the interior of Saint Peter's. His first commission, completed between 1624 and 1633, called for the design and erection of a gigantic bronze *baldacchino* (FIG. **19-5**) under the great dome. The canopy-like structure (*baldacco* is Italian for "silk from Baghdad," such as for a cloth canopy) stands 100 feet high (the height of an average eight-story building). The baldacchino serves both functional and symbolic purposes. It marks the high altar and the tomb of Saint Peter, and it visually bridges human scale to the lofty vaults and dome above. Further, for worshipers entering the nave of the huge church, it provides a dramatic, compelling presence at the crossing. Its columns also create a visual frame for the elaborate sculpture representing the throne of Saint Peter (the Cathedra Petri) at the far end of Saint Peter's (FIG. **19-5**,

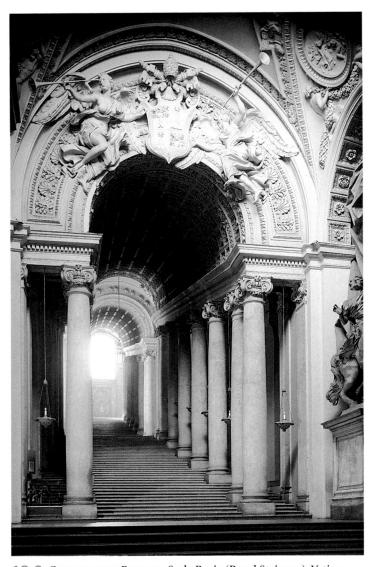

19-6 GIANLORENZO BERNINI, Scala Regia (Royal Stairway), Vatican City, Rome, Italy, 1663–1666.

By gradually reducing the distance between the columns and walls as the stairway ascends, Bernini created the illusion that the Scala Regia is of uniform width and that the aisles continue for its full length.

rear). On a symbolic level, the structure's decorative elements speak to the power of the Catholic Church and of Pope Urban VIII (r. 1623–1644). Partially fluted and wreathed with vines, the baldacchino's four spiral columns recall those of the ancient baldacchino over the same spot in Old Saint Peter's, thereby invoking the past to reinforce the primacy of the Roman Catholic Church in the l7th century. At the top of the columns, four colossal angels stand guard at the upper corners of the canopy. Forming the canopy's apex are four serpentine brackets that elevate the orb and the cross. Since the time of Constantine (FIG. 7-81, right), the orb and the cross had served as symbols of the Church's triumph. The baldacchino also features numerous bees, symbols of Urban VIII's family, the Barberini. The structure effectively gives visual form to the triumph of Christianity and the papal claim to doctrinal supremacy.

The construction of the baldacchino was itself a remarkable feat. Each of the bronze columns consists of five sections cast from wooden models using the *lost-wax process* (see "Hollow-Casting Life-Size Bronze Statues," Chapter 5, page 108). Although Bernini did some of the hands-on work himself, for example, cleaning and repairing the wax molds and doing the final *chasing* (engraving and

embossing) of the bronze casts, he contracted out much of the work for the project to experienced bronzecasters and sculptors. The super-structure is predominantly cast bronze, although some of the sculptural elements are brass or wood. The enormous scale of the baldacchino required a considerable amount of bronze. On Urban VIII's orders, workers dismantled the portico of the Pantheon (FIG. 7-49) to acquire the bronze for the baldacchino—ideologically appropriate, given the Church's rejection of paganism.

The concepts of triumph and grandeur permeate every aspect of the 17th-century design of Saint Peter's. Suggesting a great and solemn procession, the main axis of the complex traverses the piazza (marked by the central obelisk) and enters Maderno's nave. It comes to a temporary halt at the altar beneath Bernini's baldacchino, but it continues on toward its climactic destination at another great altar in the apse.

SCALA REGIA Bernini demonstrated his impressive skill at transforming space in another project he undertook for the papacy, the Scala Regia (Royal Stairway; FIG. 19-6), that connects the papal apartments to Saint Peter's. Because the original passageway was irregular, dark, and dangerous to descend, Pope Alexander VII (r. 1655–1667) commissioned Bernini to replace it. A sculptural group of trumpeting angels and the papal arms crowns the entrance to the stairway, where columns carrying a barrel vault (built in two sections) form aisles flanking the central corridor. By gradually reducing the distance between the columns and walls as the stairway ascends, Bernini eliminated the aisles on the upper levels while creating the illusion that the whole stairway is of uniform width and that the aisles continue for its entire length. Likewise, the space between the colonnades narrows with ascent, reinforcing the natural perspective and making the stairs appear longer than they are. To minimize this effect, Bernini brightened the lighting at the top of the stairs, exploiting the natural human inclination to move from darkness toward light. To make the long ascent more tolerable, he inserted an illuminated landing that provides a midway resting point. The result is a highly sophisticated design, both dynamic and dramatic, that repeats on a smaller scale, perhaps even more effectively, the processional sequence found inside Saint Peter's. The challenge of this difficult assignment must have intrigued Bernini. The biographer Filippo Baldinucci (1625-1696) reported that Bernini "said the highest merit lay not in making beautiful and commodious buildings, but in being able to make do with little, to make use of a deficit in such a way that if it had not existed one would have to invent it."1

BERNINI, DAVID Although Bernini was a great and influential Baroque architect, his fame rests primarily on his sculpture, which also energetically expresses the Italian Baroque spirit. Baldinucci asserted: "[T]here was perhaps never anyone who manipulated marble with more facility and boldness. He gave his works a marvelous softness . . . making the marble, so to say, flexible." Bernini's sculpture is expansive and theatrical, and the element of time usually plays an important role in it. A sculpture that predates his work on Saint Peter's is his David (FIG. 19-7). Bernini surely knew the Renaissance statues by Donatello (FIG. 16-12), Verrocchio (FIG. 16-13), and Michelangelo (FIG. 17-13) portraying the young biblical hero. Bernini's David fundamentally differs from those earlier masterpieces, however. Donatello and Verrocchio depicted David after his triumph over Goliath. Michelangelo portrayed David before his encounter with his gigantic adversary. Bernini chose to represent the combat itself. Unlike his Renaissance predecessors, the Baroque sculptor aimed to catch the split-second of maximum action. Bernini's David, his muscular legs widely and firmly planted, begins the violent, pivoting motion that will launch the stone from his sling. (A bag full of stones is

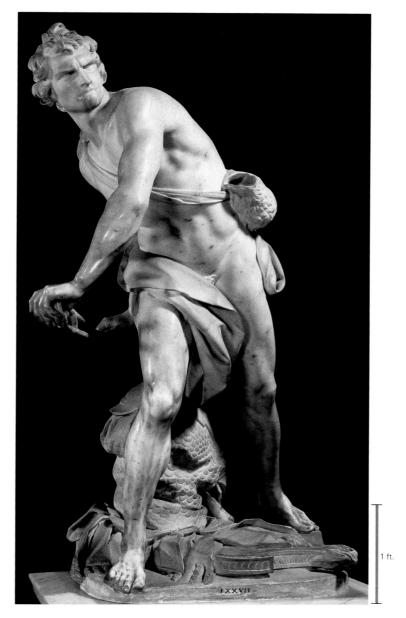

19-7 GIANLORENZO BERNINI, *David*, 1623. Marble, 5' 7" high. Galleria Borghese, Rome.

Bernini's sculptures are expansive and theatrical, and the element of time plays an important role in them. His emotion-packed *David* seems to be moving through both time and space.

at David's left hip, suggesting that he thought the fight would be tough and long.) Unlike Myron, the fifth-century BCE Greek sculptor who froze his *Diskobolos* (FIG. 5-39) at a fleeting moment of inaction, Bernini selected the most dramatic of an implied sequence of poses, so that the viewer has to think simultaneously of the continuum and of this tiny fraction of it. The suggested continuum imparts a dynamic quality to the statue that conveys a bursting forth of the energy seen confined in Michelangelo's figures (FIGS. 17-15 and 17-16). Bernini's David seems to be moving through time and through space. This kind of sculpture cannot be inscribed in a cylinder or confined in a niche. Its dynamic action demands space around it. Nor is the statue self-sufficient in the Renaissance sense, as its pose and attitude direct attention beyond it to the unseen Goliath. Bernini's sculpted figure moves out into the space that surrounds it. Further, the expression of intense concentration on David's face contrasts vividly with the classically placid visages of Donatello's and

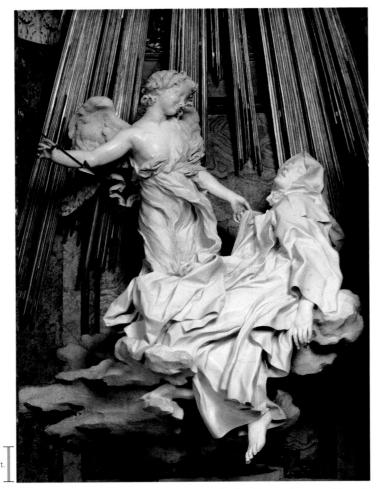

19-8 GIANLORENZO BERNINI, *Ecstasy of Saint Teresa*, Cornaro Chapel, Santa Maria della Vittoria, Rome, Italy, 1645–1652. Marble, height of group 11′ 6″.

The passionate drama of Bernini's depiction of Saint Teresa correlated with the ideas of Ignatius Loyola, who argued that the re-creation of spiritual experience would do much to increase devotion and piety.

Verrocchio's Davids and is more emotionally charged even than Michelangelo's (FIG. 17-14). The tension in David's face augments the dramatic impact of Bernini's sculpture.

ECSTASY OF SAINT TERESA Another work that displays the motion and emotion of Italian Baroque art and exemplifies Bernini's refusal to limit his statues to firmly defined spatial settings is Ecstasy of Saint Teresa in the Cornaro Chapel (FIG. 19-1) of the Roman church of Santa Maria della Vittoria. For this chapel, Bernini marshaled the full capabilities of architecture, sculpture, and painting to charge the entire area with palpable tension. He accomplished this by drawing on the considerable knowledge of the theater he absorbed from writing plays and producing stage designs. The marble sculpture (FIG. 19-8) that serves as the chapel's focus depicts Saint Teresa, a nun of the Carmelite order and one of the great mystical saints of the Spanish Counter-Reformation. Her conversion occurred after the death of her father, when she fell into a series of trances, saw visions, and heard voices. Feeling a persistent pain, she attributed it to the fire-tipped arrow of divine love that an angel had thrust repeatedly into her heart. In her writings, Saint Teresa described this experience as making her swoon in delightful anguish. In Bernini's hands, the entire Cornaro Chapel became a theater for the production of this mystical drama. The niche in which it takes place appears as a shallow

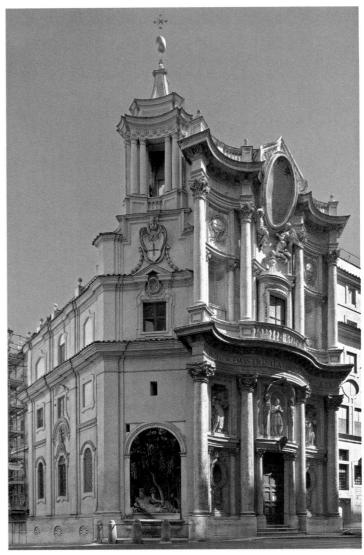

19-9 Francesco Borromini, facade of San Carlo alle Quattro Fontane, Rome, Italy, 1665–1667.

Borromini rejected the traditional notion that a building's facade should be a flat frontispiece. He set San Carlo's facade in undulating motion, creating a dynamic counterpoint of concave and convex elements.

proscenium (the part of the stage in front of the curtain) crowned with a broken Baroque pediment and ornamented with polychrome marble. On either side of the chapel, sculpted portraits of the family of Cardinal Federico Cornaro (1579–1673) watch the heavenly drama unfold from choice balcony seats. Bernini depicted the saint in ecstasy, unmistakably a mingling of spiritual and physical passion, swooning back on a cloud, while the smiling angel aims his arrow. The sculptor's supreme technical virtuosity is evident in the visual differentiation in texture among the clouds, rough monk's cloth, gauzy material, smooth flesh, and feathery wings—all carved from the same white marble. Light from a hidden window of yellow glass pours down on golden rays that suggest the radiance of Heaven, whose painted representation covers the vault.

The passionate drama of Bernini's *Ecstasy of Saint Teresa* correlated with the ideas disseminated earlier by Ignatius Loyola (1491–1556), who founded the Jesuit order in 1534 and whom the Church canonized as Saint Ignatius in 1622. In his book *Spiritual Exercises*, Ignatius argued that the re-creation of spiritual experiences in artworks would do much to increase devotion and piety. Thus,

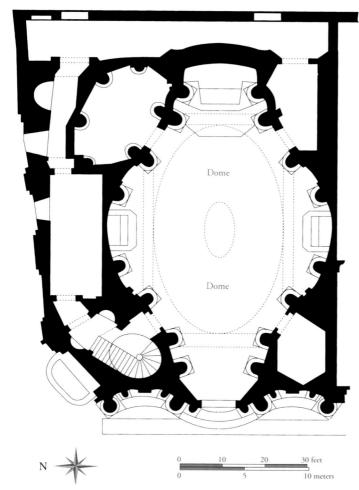

19-10 Francesco Borromini, plan of San Carlo alle Quattro Fontane, Rome, Italy, 1638–1641.

The plan of San Carlo is a hybrid of a Greek cross and an oval. The side walls pulsate in a way that reverses the facade's movement. The molded, dramatically lit space appears to flow from entrance to altar.

theatricality and sensory impact were useful vehicles for achieving Counter-Reformation goals. Bernini was a devout Catholic, which undoubtedly contributed to his understanding of those goals. His inventiveness, technical skill, sensitivity to his patrons' needs, and energy account for his position as the quintessential Italian Baroque artist.

SAN CARLO ALLE QUATTRO FONTANE As gifted as Bernini was as an architect, Francesco Borromini (1599–1667) took Italian Baroque architecture to even greater dramatic heights. In the little church of San Carlo alle Quattro Fontane (Saint Charles at the Four Fountains; FIG. 19-9), Borromini went well beyond any of his predecessors or contemporaries in emphasizing a building's sculptural qualities. Although Maderno incorporated sculptural elements in his designs for the facades of Santa Susanna (FIG. 19-2) and Saint Peter's (FIG. 19-3), they still develop along relatively lateral planes. Borromini set his facade in undulating motion, creating a dynamic counterpoint of concave and convex elements on two levels (for example, the sway of the cornices). He emphasized the threedimensional effect with deeply recessed niches. This facade is not the traditional flat frontispiece that defines a building's outer limits. It is a pulsating, engaging component inserted between interior and exterior space, designed not to separate but to provide a fluid transi-

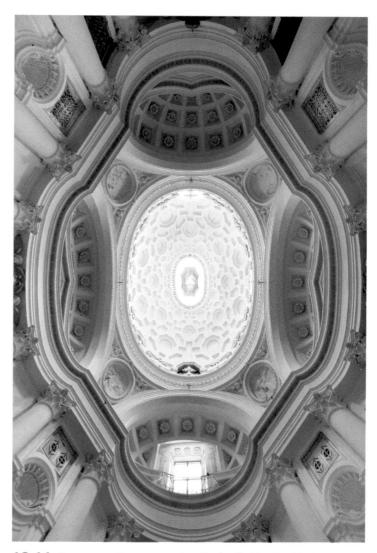

19-11 Francesco Borromini, San Carlo alle Quattro Fontane (view into dome), Rome, Italy, 1638–1641.

In place of a traditional round dome, Borromini capped the interior of San Carlo with a deeply coffered oval dome that seems to float on the light entering through windows hidden in its base.

tion between the two. Underscoring this functional interrelation of the building and its environment is the curious fact that the church has not one but two facades. The second, a narrow bay crowned with its own small tower, turns away from the main facade and, tracking the curve of the street, faces an intersection. (The upper facade dates seven years after Borromini's death, and it is uncertain to what degree the present design reflects his original intention.)

The interior is not only an ingenious response to an awkward site but also a provocative variation on the theme of the centrally planned church. In plan (FIG. 19-10), San Carlo is a hybrid of a *Greek cross* (a cross with four arms of equal length) and an oval, with a long axis between entrance and apse. The side walls move in an undulating flow that reverses the facade's motion. Vigorously projecting columns define the space into which they protrude just as much as they accent the walls attached to them. Capping this molded interior space is a deeply coffered oval dome (FIG. 19-11) that seems to float on the light entering through windows hidden in its base. Rich variations on the basic theme of the oval, dynamic relative to the static circle, create an interior that flows from entrance to altar, unimpeded by the segmentation so characteristic of Renaissance buildings.

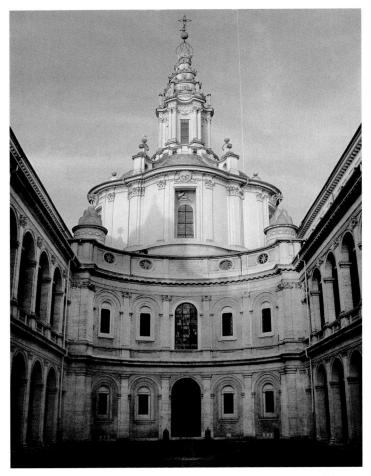

19-12 Francesco Borromini, Chapel of Saint Ivo, College of the Sapienza, Rome, Italy, begun 1642.

In characteristic fashion, Borromini played concave against convex forms on the upper level of the Roman Chapel of Saint Ivo. Pilasters restrain the forces that seem to push the bulging forms outward.

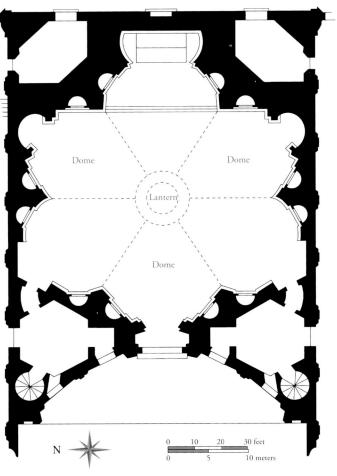

19-13 Francesco Borromini, plan of the Chapel of Saint Ivo, College of the Sapienza, Rome, Italy, begun 1642.

The interior elevation fully reflects all the elements of the highly complex plan of Borromini's chapel in the College of the Sapienza, which is star-shaped with rounded points and apses on all sides.

CHAPEL OF SAINT IVO Borromini carried the unification of interior space even further in the Chapel of Saint Ivo (FIG. 19-12) in the courtyard of the College of the Sapienza (Wisdom) in Rome. In his characteristic manner, Borromini played concave against convex forms on the upper level of this chapel's exterior. The lower stories of the court, which frame the bottom facade, had already been constructed when Borromini began work. Above the facade's inward curve—its design adjusted to the earlier arcades of the court—rises a convex drumlike structure that supports the dome's lower parts.

19-14 Francesco Borromini, Chapel of Saint Ivo (view into dome), College of the Sapienza, Rome, Italy, begun 1642.

Unlike Renaissance domes, Borromini's Saint Ivo dome is an organic part that evolves out of and shares the qualities of the supporting walls, and it cannot be separated from them.

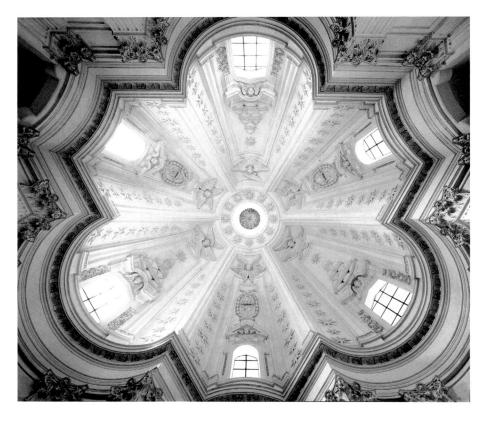

Powerful pilasters restrain the forces that seem to push the bulging forms outward. Buttresses above the pilasters curve upward to brace a tall, ornate lantern topped by a spiral that, screwlike, seems to fasten the structure to the sky.

The centralized plan (FIG. 19-13) of the Saint Ivo chapel is that of a star having rounded points and apses on all sides. Indentations and projections along the angled curving walls create a highly complex plan, with all the elements fully reflected in the interior elevation. From floor to lantern, the wall panels rise in a continuously tapering sweep halted only momentarily by a single horizontal cornice (FIG. 19-14). Thus, the dome is not a separate unit placed on a supporting block, as in Renaissance buildings. It is an organic part that evolves out of and shares the qualities of the supporting walls, and it cannot be separated from them. This carefully designed progression up through the lantern creates a dynamic and cohesive shell that encloses and energetically molds a scalloped fragment of space. Few architects have matched Borromini's ability to translate extremely complicated designs into such masterfully unified structures as Saint Ivo.

Painting

Although architecture and sculpture provided the most obvious vehicles for manipulating space and creating theatrical effects, painting continued to be an important art form, as it was in previous centuries. Among the most noted Italian Baroque painters were Annibale Carracci and Caravaggio, whose styles, although different, were both thoroughly in accord with the period.

ANNIBALE CARRACCI A native of Bologna, Annibale Carracci (1560–1609) received much of his training at an academy of art founded cooperatively by his family members, among them

his cousin Ludovico Carracci (1555–1619) and brother Agostino Carracci (1557–1602). The Bolognese academy was the first significant institution of its kind in the history of Western art. The Carracci founded it on the premises that art can be taught—the basis of any academic philosophy of art—and that its instruction must include the classical and Renaissance traditions in addition to the study of anatomy and life drawing.

In Flight into Egypt (FIG. 19-15), based on the biblical narrative from Matthew 2:13-14, Annibale Carracci created the "ideal" or "classical" landscape, in which nature appears ordered by divine law and human reason. Tranquil hills and fields, quietly gliding streams, serene skies, unruffled foliage, shepherds with their flocks-all the props of the pastoral scene and mood familiar in Venetian Renaissance paintings (FIG. 17-35)—expand to fill the picture space in Flight into Egypt and similar paintings. Carracci regularly included screens of trees in the foreground, dark against the sky's even light. In contrast to many Renaissance artists, he did not create the sense of deep space by employing linear perspective but rather by varying light and shadow to suggest expansive atmosphere. In Flight into Egypt, streams or terraces, carefully placed one above the other and narrowed, zigzag through the terrain, leading the viewer's eye back to the middle ground. There, many Venetian Renaissance landscape artists depicted architectural structures (as Carracci did in Flight into Egypt)—walled towns or citadels, towers, temples, monumental tombs, and villas. These constructed environments captured idealized antiquity and the idyllic life. Although the artists often took the subjects for these classically rendered scenes from religious or heroic stories, they favored the pastoral landscapes over the narratives. Here, the painter greatly diminished the size of Mary, the Christ Child, and Saint Joseph, who simply become part of the landscape as they wend their way slowly to Egypt after having been ferried across a stream.

19-15 Annibale Carracci, Flight into Egypt, 1603-1604. Oil on canvas, 4' × 7' 6". Galleria Doria Pamphili, Rome.

Carracci's landscapes idealize antiquity and the idyllic life. Here, the pastoral setting takes precedence over the narrative of Mary, the Christ Child, and Saint Joseph wending their way slowly to Egypt.

19-16 Annibale Carracci, Loves of the Gods, ceiling frescoes in the gallery, Palazzo Farnese, Rome, Italy, 1597–1601.

On the shallow curved vault of this gallery in the Palazzo Farnese, Carracci arranged the mythological scenes in a *quadro riportato* format—a fresco resembling easel paintings on a wall.

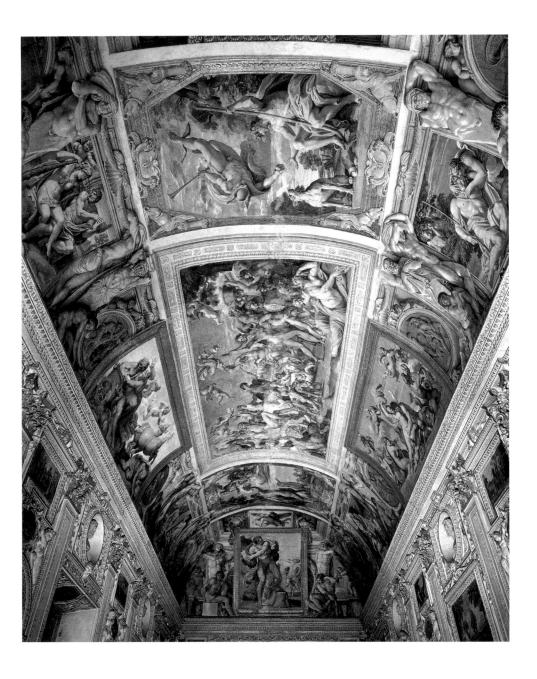

LOVES OF THE GODS Among Carracci's most notable works is his decoration of the Palazzo Farnese gallery (FIG. **19-16**) in Rome. Cardinal Odoardo Farnese (1573–1626), a wealthy descendant of Pope Paul III, commissioned this ceiling fresco to celebrate the wedding of the cardinal's brother. Appropriately, the title of its iconographic program is *Loves of the Gods*—interpretations of the varieties of earthly and divine love in classical mythology.

Carracci arranged the scenes in a format resembling framed easel paintings on a wall, but here he painted them on the surfaces of a shallow curved vault. This type of simulation of easel painting for ceiling design is called *quadro riportato* (transferred framed painting). By adapting the Northern European and Venetian tradition of oil painting to the central Italian fresco tradition, Carracci reoriented the direction of painting in Florence and Rome. His great influence made quadro riportato fashionable for more than a century.

Flanking the framed pictures are polychrome seated nude youths, who turn their heads to gaze at the scenes around them, and standing Atlas figures painted to resemble marble statues. Carracci derived these motifs from the Sistine Chapel ceiling (FIG. 17-1), but he did not copy Michelangelo's figures. Notably, the chiaroscuro of

the Farnese gallery frescoes differs for the pictures and the figures surrounding them. Carracci modeled the figures inside the quadri in an even light. In contrast, light from beneath seems to illuminate the outside figures, as if they were tangible, three-dimensional beings or statues lit by torches in the gallery below. This interest in illusion, already manifest in the Renaissance, continued in the grand ceiling compositions (FIGS. 19-21 to 19-24) of the 17th century. In the crown of the vault, a long panel representing the *Triumph of Bacchus* is an ingenious mixture of Raphael's drawing style and lighting and Titian's more sensuous and animated figures. It reflects Carracci's adroitness in adjusting their authoritative styles to create something of his own.

CARAVAGGIO Michelangelo Merisi, known as Caravaggio (1573–1610) after the northern Italian town from which he came, developed a unique style that had tremendous influence throughout Europe. His outspoken disdain for the classical masters (probably more vocal than real) drew bitter criticism from many painters, one of whom denounced him as the "anti-Christ of painting." Giovanni Pietro Bellori, the most influential critic of the age and an admirer of

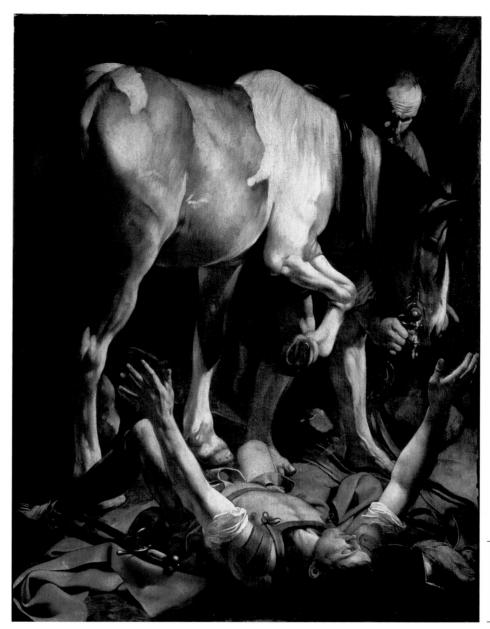

19-17 Caravaggio, *Conversion of Saint Paul*, ca. 1601. Oil on canvas, $7' 6'' \times 5' 9''$. Cerasi Chapel, Santa Maria del Popolo, Rome.

Caravaggio used perspective, chiaroscuro, and dramatic lighting to bring viewers into this painting's space and action, almost as if they were participants in Saint Paul's conversion to Christianity.

1 ft.

Annibale Carracci, felt that Caravaggio's refusal to emulate the models of his distinguished predecessors threatened the whole classical tradition of Italian painting that had reached its zenith in Raphael's work (see "Giovanni Pietro Bellori on Annibale Carracci and Caravaggio," page 538). Yet despite this criticism and the problems in Caravaggio's troubled life (reconstructed from documents such as police records), Caravaggio received many commissions, both public and private, and numerous artists paid him the supreme compliment of borrowing from his innovations. His influence on later artists, as much outside Italy as within, was immense. In his art, Caravaggio injected a naturalism into both religion and the classics, reducing them to human dramas played out in the harsh and dingy settings of his time and place. His unidealized figures selected from the fields and the streets of Italy, however, were effective precisely because of their familiarity.

CONVERSION OF SAINT PAUL Caravaggio painted Conversion of Saint Paul (FIG. 19-17) for the Cerasi Chapel in the Roman church of Santa Maria del Popolo. He depicted the saint-to-be at the moment of his conversion, flat on his back with his arms

thrown up. In the background, an old hostler seems preoccupied with caring for the horse. At first inspection, little here suggests the momentous significance of the spiritual event in progress. The viewer of the painting could well be witnessing a mere stable accident, not a man overcome by a great miracle. Although many of his contemporaries criticized Caravaggio for departing from traditional depictions of religious scenes, the eloquence and humanity with which he imbued his paintings impressed many others.

To compel interest and involvement in Paul's conversion, Caravaggio employed a variety of formal devices. Here, as elsewhere, he used a perspective and a chiaroscuro intended to bring viewers as close as possible to the scene's space and action, almost as if they were participating in them. The low horizon line augments the sense of inclusion. Caravaggio designed *Conversion of Saint Paul* for its location on the chapel wall, positioned at the line of sight of an average-height person standing at the chapel entrance. The sharply lit figures emerge from the dark background as if lit by the light from the chapel's windows. The lighting resembles that of a stage production and is analogous to the rays in Bernini's *Ecstasy of Saint Teresa* (FIG. 19-8).

Giovanni Pietro Bellori on Annibale Carracci and Caravaggio

The written sources to which art historians turn as aids in understanding the art of the past are invaluable, but they reflect the personal preferences and prejudices of the writers. Pliny the Elder, for example, writing in the first century CE, reported that "art ceased"* after the death of Alexander the Great—a remark usually interpreted as expressing his disapproval of Hellenistic art in contrast to Classical art (see Chapter 5). Giorgio Vasari, the biographer and champion of Italian Renaissance artists, condemned Gothic art as "monstrous and barbarous,"† and considered medieval art in general as a distortion of the noble art of the Greeks and Romans (see Chapter 13). Giovanni Pietro Bellori (1613–1696), the leading biographer of Baroque artists, similarly recorded his admiration for Renaissance classicism as well as his distaste for Mannerism and realism in his opposing evaluations of Annibale Carracci and Caravaggio.

In the opening lines of his *Vita* of Carracci, Bellori praised "the divine Raphael . . . [whose art] raised its beauty to the summit, restoring it to the ancient majesty of . . . the Greeks and the Romans" and lamented that soon after, "artists, abandoning the study of nature, corrupted art with the *maniera*, that is to say, with the fantastic idea based on practice and not on imitation." But fortunately, Bellori observed, just "when painting was drawing to its end," Annibale Carraccci rescued "the declining and extinguished art." ‡

Bellori especially lauded Carracci's Palazzo Farnese frescoes (FIG. 19-16):

No one could imagine seeing anywhere else a more noble and magnificent style of ornamentation, obtaining supreme excellence in the compartmentalization and in the figures and executed with the grandest manner in the design with the just proportion and the great strength of chiaroscuro. . . . Among modern works they have no comparison. §

In contrast, Bellori characterized Caravaggio as talented and widely imitated but misguided in his rejection of classicism in favor of realism.

[Caravaggio] began to paint according to his own inclinations; not only ignoring but even despising the superb statuary of antiquity and the famous paintings of Raphael, he considered nature to be the only subject fit for his brush. As a result, when he was shown the most famous statues of [the ancient Greek masters] Phidias and Glykon in order that he might use them as models, his only answer was to point toward a crowd of people, saying that nature had given him an abundance of masters. . . . [W]hen he came upon someone in town who pleased him he made no attempt to improve on the creations of nature.**

[Caravaggio] claimed that he imitated his models so closely that he never made a single brushstroke that he called his own, but said rather that it was nature's. Repudiating all other rules, he considered the highest achievement not to be bound to art. For this innovation he was greatly acclaimed, and many talented and educated artists seemed compelled to follow him.... Nevertheless he lacked *invenzione*, decorum, *disegno*, or any knowledge of the science of painting. The moment the model was taken from him, his hand and his mind became empty.... Thus, as Caravaggio suppressed the dignity of art, everybody did as he pleased, and what followed was contempt for beautiful things, the authority of antiquity and Raphael destroyed.... Now began the imitation of common and vulgar things, seeking out filth and deformity.#

Caravaggio's figures are still heroic with powerful bodies and clearly delineated contours in the Renaissance tradition, but the stark and dramatic contrast of light and dark, which at first shocked and then fascinated his contemporaries, obscures the more traditional aspects of his style. Art historians call Caravaggio's use of dark settings enveloping their occupants—which profoundly influenced European art, especially in Spain and the Netherlands—tenebrism, from the Italian word tenebroso, or "shadowy" manner. In Caravaggio's work, tenebrism also contributed greatly to the essential meaning of his pictures. In Conversion of Saint Paul, the dramatic spotlight shining down upon the fallen Paul is the light of divine revelation converting him to Christianity.

CALLING OF SAINT MATTHEW A piercing ray of light illuminating a world of darkness and bearing a spiritual message is also a central feature of one of Caravaggio's early masterpieces, Calling of Saint Matthew (FIG. 19-18). It is one of two large canvases honoring Saint Matthew that the artist painted for the side walls of the Contarelli Chapel in San Luigi dei Francesi in Rome. The commonplace setting of the painting—a tavern with unadorned walls—is typical of Caravag-

gio. Into this mundane environment, cloaked in mysterious shadow and almost unseen, Christ, identifiable initially only by his indistinct halo, enters from the right. With a commanding gesture that recalls the Lord's hand in Michelangelo's *Creation of Adam* (FIG. 17-19), he summons Levi, the Roman tax collector, to a higher calling. The astonished Levi—his face highlighted for the viewer by the beam of light emanating from an unspecified source above Christ's head and outside the picture—points to himself in disbelief. Although Christ's extended arm is reminiscent of the Lord's in *Creation of Adam*, the position of Christ's hand and wrist is similar to that of Adam's. This reference was highly appropriate, because the Church considered Christ to be the second Adam. Whereas Adam was responsible for the Fall of Man, Christ is responsible for human redemption. The conversion of Levi (who became Matthew) brought his salvation.

ENTOMBMENT In 1603, Caravaggio produced a large-scale painting, *Entombment* (FIG. 19-19), for the Chapel of Pietro Vittrice at Santa Maria in Vallicella in Rome. This work includes all the hallmarks of Caravaggio's distinctive style: the plebeian figure types (particularly visible in the scruffy, worn face of Nicodemus, who

^{*} Pliny, Natural History, 25.52.

[†] Giorgio Vasari, Introduzione alle tre arti del disegno (1550), ch. 3.

[‡] Giovanni Pietro Bellori, *Le vite de' pittori, scultori e architetti moderni* (Rome, 1672). Translated by Catherine Enggass, *The Lives of Annibale and Agostino Carracci by Giovanni Pietro Bellori* (University Park: Pennsylvania University Press, 1968), 5–6. [§] Ibid., 33.

^{**} Translated by Howard Hibbard, *Caravaggio* (New York: Harper & Row, 1983), 362.

[#] Ibid., 371–372.

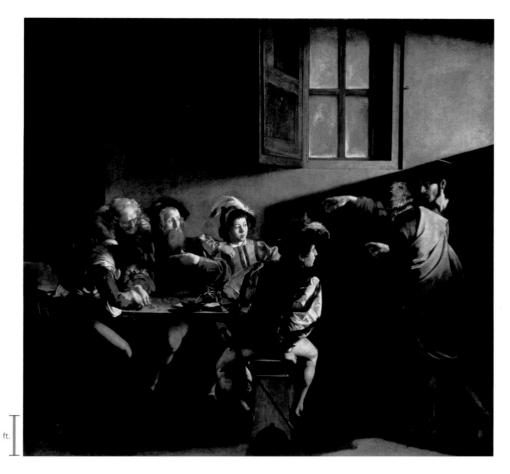

19-18 Caravaggio, *Calling of Saint Matthew*, ca. 1597–1601. Oil on canvas, $11'1'' \times 11'5''$. Contarelli Chapel, San Luigi dei Francesi, Rome.

The stark contrast of light and dark was a key feature of Caravaggio's style. Here, Christ, cloaked in mysterious shadow and almost unseen, summons Levi the tax collector (Saint Matthew) to a higher calling.

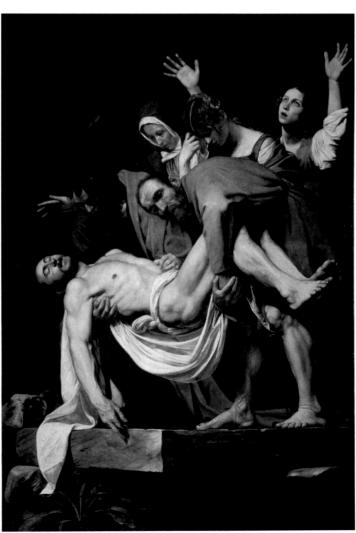

here holds Christ's legs in the foreground), the stark use of darks and lights, and the invitation to the viewer to participate in the scene. As in *Conversion of Saint Paul*, the action takes place in the foreground. Caravaggio positioned the figures on a stone slab the corner of which appears to extend into the viewer's space. This suggests that Christ's body will be laid directly in front of the viewer.

Beyond its ability to move its audience, Caravaggio's composition also had theological implications. In light of the ongoing Counter-Reformation efforts at that time, these implications cannot be overlooked. To viewers in the chapel, the men seem to be laying Christ's body on the altar, which stands in front of the painting. This serves to give visual form to the doctrine of *transubstantiation* (the transformation of the Eucharistic bread and wine into the body and blood of Christ)—a doctrine central to Catholicism that Protestants rejected. By depicting Christ's body as though it were physically present during the Mass, Caravaggio visually articulated an abstract theological precept. Unfortunately, because this painting is now in a museum, viewers no longer can experience this effect.

ARTEMISIA GENTILESCHI Caravaggio's combination of naturalism and drama appealed both to patrons and artists, and he had many followers. One of the most accomplished was ARTEMISIA GENTILESCHI (ca. 1593–1653), whose father Orazio (1563–1639), her teacher, was himself strongly influenced by Caravaggio. The daughter's successful career, pursued in Florence, Venice, Naples, and

19-19 Caravaggio, *Entombment*, from the Chapel of Pietro Vittrice, Santa Maria in Vallicella, Rome, Italy, ca. 1603. Oil on canvas, 9' $10\frac{1}{8}$ " \times 6' $7\frac{15}{16}$ ". Pinacoteca, Musei Vaticani, Rome.

In *Entombment*, Caravaggio gave visual form to the doctrine of transubstantiation. The jutting painted stone slab makes it seem as if Christ's body will be laid on the actual altar of the chapel.

1 ft

The Letters of Artemisia Gentileschi

rtemisia Gentileschi (FIG. 19-20) was the most renowned woman painter in Europe during the first half of the 17th century and the first woman ever admitted to membership in Florence's Accademia del Disegno. Like other women who could not become apprentices in all-male studios (see "The Artist's Profession," Chapter 15, page 406), she learned her craft from her father. Never forgotten in subsequent centuries, Artemisia's modern fame stems from the seminal 1976 exhibition Women Artists: 1550-1950,* which opened a new chapter in feminist art history.

19-20 ARTEMISIA GENTILESCHI, Judith Slaying Holofernes, ca. 1614–1620. Oil on canvas, 6' $6\frac{1}{3}'' \times 5' 4''$. Galleria degli Uffizi, Florence.

Narratives involving heroic women were a favorite theme of Gentileschi. In *Judith Slaying Holofernes,* the controlled highlights on the action in the foreground recall Caravaggio's paintings and heighten the drama.

In addition to scores of paintings created for wealthy patrons that included the King of England and the Grand Duke of Tuscany, Gentileschi left behind 28 letters, some of which reveal that she believed patrons treated her differently because of her gender. Three 1649 letters written in Naples to Don Antonio Ruffo (1610–1678) in Messina make her feelings explicit.

I fear that before you saw the painting you must have thought me arrogant and presumptuous.... [I]f it were not for Your Most Illustrious Lordship...I would not have been induced to give it for one hundred and sixty, because everywhere else I have been I was paid one hundred *scudi* [Italian coins] per figure.... You think me pitiful, because a woman's name raises doubts until her work is seen.

I was mortified to hear that you want to deduct one third from the already very low price that I had asked. . . . It must be that in your heart Your Most Illustrious Lordship finds little merit in me. ‡

As for my doing a drawing and sending it, [tell the gentleman who wishes to know the price for a painting that] I have made a solemn vow never to send my drawings because people have cheated me. In particular, just today I found myself [in the situation] that, having done a drawing of souls in purgatory for the Bishop of St. Gata, he, in order to spend less, commissioned another painter to do the painting using my work. If I were a man, I can't imagine it would

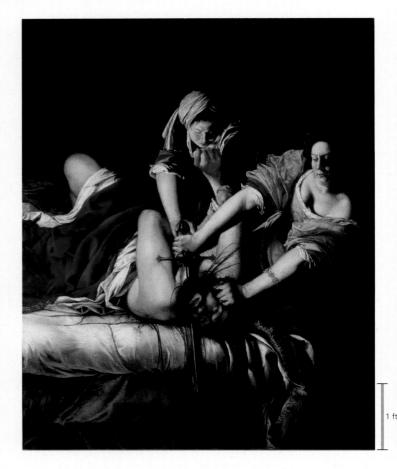

have turned out this way, because when the concept has been realized and defined with lights and darks, and established by means of planes, the rest is a trifle.§

* Ann Sutherland Harris and Linda Nochlin, *Women Artists:* 1550–1950 (Los Angeles, Calif.: Los Angeles County Museum of Art, 1976), 118–124. † Letter dated January 30, 1649. Translated by Mary D. Garrard, *Artemisia Gentileschi: The Image of the Female Hero in Italian Baroque Art* (Princeton, N.J.: Princeton University Press, 1989), 390.

[‡] Letter dated October 23, 1649. Ibid., 395-396.

§ Letter dated November 13, 1649. Ibid., 397–398.

Rome, helped disseminate Caravaggio's style throughout the peninsula (see "The Letters of Artemisia Gentileschi," above).

In her *Judith Slaying Holofernes* (FIG. **19-20**), Gentileschi used the tenebrism and what might be called the "dark" subject matter Caravaggio favored. Significantly, she chose a narrative involving a heroic female, a favorite theme of hers. The story, from the Old Testament Book of Judith, relates the delivery of Israel from its enemy, Holofernes. Having succumbed to Judith's charms, the Assyrian general Holofernes invited her to his tent for the night. When he fell asleep, Judith cut off his head. In this version of the scene (Gentileschi produced more than one painting of the subject), Judith and her maidservant behead Holofernes. Blood spurts everywhere as the two women summon all their strength to wield the heavy sword. The tension and strain are palpable. The controlled highlights on the

action in the foreground recall Caravaggio's work and heighten the drama here as well.

GUIDO RENI Caravaggio was not the only early-17th-century painter to win a devoted following. Guido Reni (1575–1642), known to his many admirers as "the divine Guido," trained in the Bolognese art academy founded by the Carracci family. The influence of Annibale Carracci and Raphael is evident in Reni's *Aurora* (Fig. **19-21**), a ceiling fresco in the Casino Rospigliosi in Rome. Aurora (Dawn) leads Apollo's chariot, while the Hours dance about it. The artist conceived *Aurora* as a quadro riportato, like the paintings in Carracci's *Loves of the Gods* (Fig. **19-16**), and painted a complex and convincing illusionistic frame. The fresco exhibits a fluid motion, soft modeling, and sure composition, although without Raphael's sculpturesque strength. It is

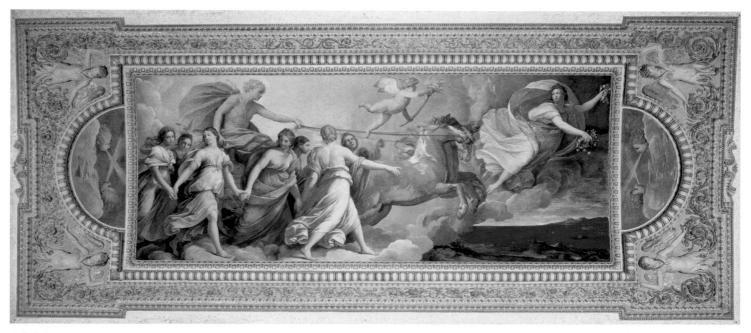

19-21 Guido Reni, Aurora, ceiling fresco in the Casino Rospigliosi, Rome, Italy, 1613-1614.

The "divine Guido" conceived Aurora as a quadro riportato, reflecting his training in the Bolognese art academy. The scene of Dawn leading Apollo's chariot derives from ancient Roman reliefs.

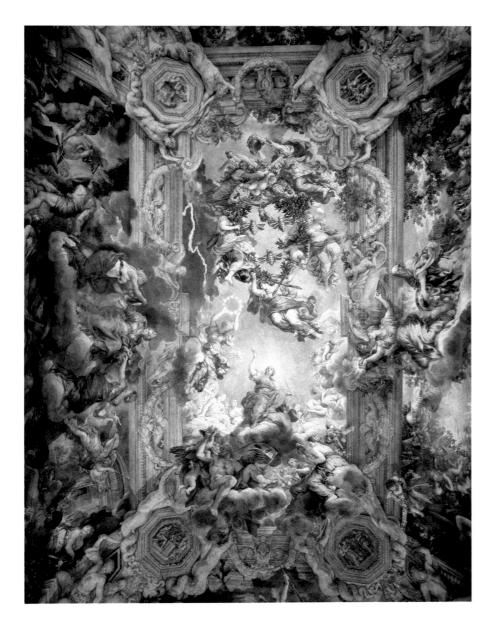

an intelligent interpretation of the Renaissance master's style. Reni, consistent with the precepts of the Bolognese academy, also looked to antiquity for his models. The ultimate sources for the *Au-rora* composition were Roman reliefs (FIG. 7-41) and coins depicting emperors in triumphal chariots accompanied by flying Victories and other personifications.

PIETRO DA CORTONA The experience of looking up at a painting is different from simply seeing a painting hanging on a wall. The considerable height and the expansive scale of most ceiling frescoes induce a feeling of awe. Patrons who wanted to burnish their public image or control their legacy found monumental ceiling frescoes to be perfect vehicles for such statements. In 1633, Pope Urban VIII commissioned a ceiling fresco for the Gran Salone of the Palazzo Barberini in Rome. The most important decorative commission of the 1630s, the job went to Pietro da Cor-TONA (1596–1669), a Tuscan architect and painter who had moved to Rome in about 1612. The grandiose and spectacular Triumph of the Barberini (FIG. 19-22) overwhelms spectators with the glory of the Barberini family (and Urban VIII

19-22 PIETRO DA CORTONA, *Triumph of the Barberini*, ceiling fresco in the Gran Salone, Palazzo Barberini, Rome, Italy, 1633–1639.

In this dramatic ceiling fresco, Divine Providence appears in a halo of radiant light directing Immortality, holding a crown of stars, to bestow eternal life on the family of Pope Urban VIII.

19-23 GIOVANNI BATTISTA GAULLI, *Triumph of the Name of Jesus*, ceiling fresco with stucco figures on the nave vault of Il Gesù, Rome, Italy, 1676–1679.

In the nave of II Gesù, gilded architecture opens up to offer the faithful a glimpse of Heaven. To heighten the illusion, Gaulli painted figures on stucco extensions that project outside the painting's frame.

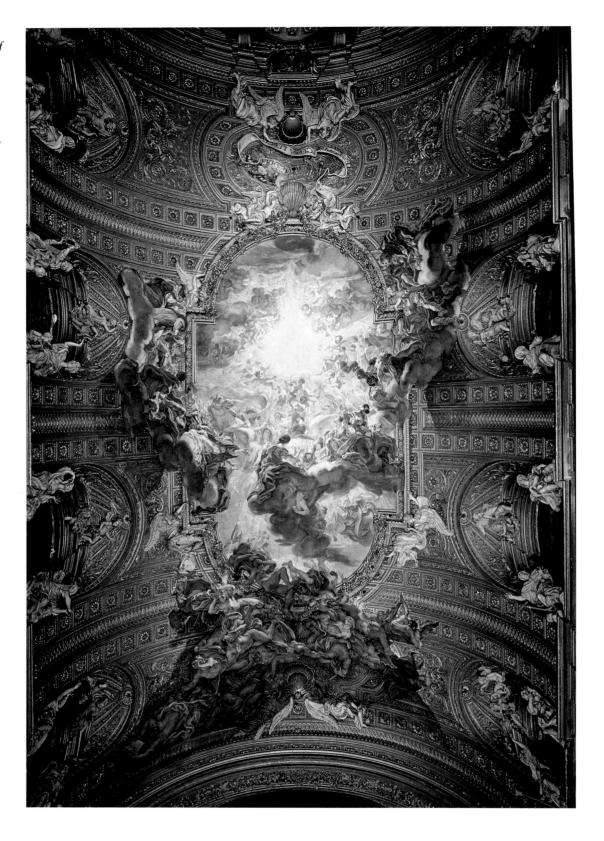

in particular). The iconographic program for this fresco, designed by the poet Francesco Bracciolini (1566–1645), centered on the accomplishments of the Barberini. Divine Providence appears in a halo of radiant light directing Immortality, holding a crown of stars, to bestow eternal life on the Barberini family. The virtues Faith, Hope, and Charity hold aloft a gigantic laurel wreath (also a symbol of immortality), which frames three bees (the family's symbols, which also appeared in Bernini's baldacchino, FIG. 19-5). Also present are the papal tiara and keys announcing the personal triumphs of Urban VIII.

GIOVANNI BATTISTA GAULLI The dazzling spectacle of ceiling frescoes also proved very effective for commissions illustrating religious themes. Church authorities realized that such paintings, high above the ground, offered perfect opportunities to impress on worshipers the glory and power of the Catholic Church. In conjunction with the theatricality of Italian Baroque architecture and sculpture, frescoes spanning church ceilings contributed to creating transcendent spiritual environments well suited to the Church's needs in Counter-Reformation Rome.

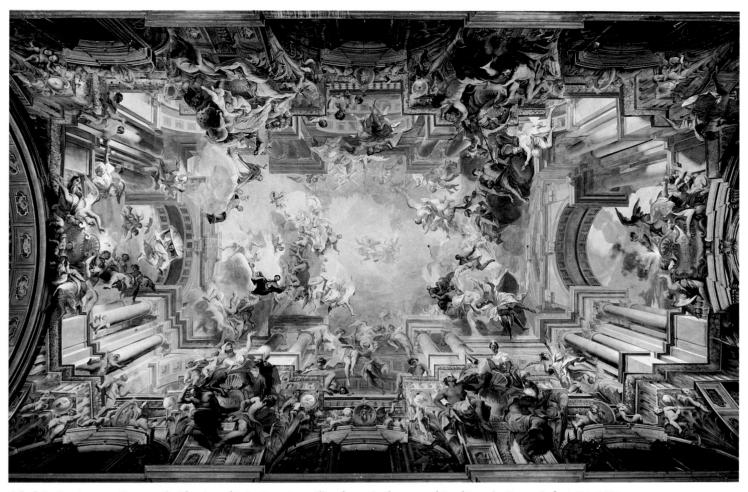

19-24 Fra Andrea Pozzo, Glorification of Saint Ignatius, ceiling fresco in the nave of Sant'Ignazio, Rome, Italy, 1691-1694.

Pozzo created the illusion that Heaven is opening up above the viewer's head by continuing the church's architecture into the painted vault. The fresco gives the appearance that the roof has been lifted off.

Triumph of the Name of Jesus (FIG. 19-23) in the nave of Il Gesù (FIGS. 17-55 and 17-56) in Rome vividly demonstrates the dramatic impact Baroque ceiling frescoes could have. As the mother church of the Jesuit order, Il Gesù played a prominent role in Counter-Reformation efforts. In this immense fresco by GIOVANNI BATTISTA GAULLI (1639–1709), gilded architecture opens up in the center of the ceiling to offer the faithful a stunning glimpse of Heaven. Gaulli represented Jesus as a barely visible monogram (IHS) in a blinding radiant light that floats heavenward. In contrast, sinners experience a violent descent back to Earth. The painter glazed the gilded architecture to suggest shadows, thereby enhancing the scene's illusionistic quality. To further heighten the effect, Gaulli painted many of the sinners on three-dimensional stucco extensions that project outside the painting's frame.

FRA ANDREA POZZO Another master of ceiling decoration was Fra Andrea Pozzo (1642–1709), a lay brother of the Jesuit order and a master of perspective, on which he wrote an influential treatise. Pozzo designed and executed the vast ceiling fresco *Glorification of Saint Ignatius* (FIG. 19-24) for the church of Sant'Ignazio in Rome. Like Il Gesù, Sant'Ignazio was a prominent church in Baroque Rome because of its dedication to the founder of the Jesuit order. The Jesuits played a major role in Counter-Reformation education and sent legions of missionaries to the New World and the Far East. As Gaulli did in Il Gesù, Pozzo created the illusion that Heaven

is opening up above the congregation. To accomplish this, the artist painted an extension of the church's architecture into the vault so that the roof seems to be lifted off. As Heaven and Earth commingle, Christ receives Saint Ignatius in the presence of figures personifying the four corners of the world. A disk in the nave floor marks the spot the viewer should stand to gain the whole perspectival illusion. For worshipers looking up from this point, the vision is complete. They find themselves in the presence of the heavenly and spiritual.

The effectiveness of Italian Baroque religious art depended on the drama and theatricality of individual images, as well as on the interaction and fusion of architecture, sculpture, and painting. Sound enhanced this experience. Architects designed churches with acoustical effect in mind, and, in an Italian Baroque church filled with music, the power of both image and sound must have been immensely moving. Through simultaneous stimulation of both the visual and auditory senses, the faithful might well have been transported into a trancelike state that would, indeed, as the great English poet John Milton (1608–1674) eloquently stated in *Il Penseroso* (1631), "bring all Heaven before [their] eyes."

SPAIN

During the 16th century, Spain had established itself as an international power. The Habsburg kings had built a dynastic state that encompassed Portugal, part of Italy, the Netherlands, and extensive

19-25 José de Ribera, *Martyrdom* of Saint Philip, ca. 1639. Oil on canvas, 7' 8" × 7' 8". Museo del Prado, Madrid.

Martyrdom scenes were popular in Counter-Reformation Spain. Scorning idealization of any kind, Ribera represented Philip's executioners hoisting him into position to die on a cross.

areas of the New World (see Chapter 18). By the beginning of the 17th century, however, the Habsburg Empire was struggling, and although Spain mounted an aggressive effort during the Thirty Years' War (see Chapter 20), by 1660 the imperial age of the Spanish Habsburgs was over. In part, the demise of the Spanish empire was due to economic woes. The military campaigns Philip III (r. 1598-1621) and his son Philip IV (r. 1621–1665) waged during the Thirty Years' War were costly and led to higher taxes. The increasing tax burden placed on Spanish subjects in turn incited revolts and civil war in Catalonia and Portugal in the 1640s, further straining an already fragile economy. Thus, the dawn of the Baroque period in Spain found the country's leaders struggling to maintain control of their dwindling empire. But realizing

the prestige that great artworks brought and the value of visual imagery in communicating to a wide audience, both Philip III and Philip IV continued to spend lavishly on art.

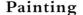

In the 17th century, Spain maintained its passionate commitment to Catholic orthodoxy, and as in Counter-Reformation Italy, Spanish Baroque artists sought ways to move viewers and to encourage greater devotion and piety. Particularly appealing in this regard were scenes of death and martyrdom, which provided Spanish artists with opportunities both to depict extreme feelings and to instill those feelings in viewers. Spain prided itself on its saints—Saint Teresa of Avila (FIG. 19-8) and Saint Ignatius Loyola (FIG. 19-24) were both Spanish-born—and martyrdom scenes surfaced frequently in Spanish Baroque art.

JOSÉ DE RIBERA As a young man, José (JUSEPE) DE RIBERA (ca. 1588–1652) emigrated to Naples and fell under the spell of Caravaggio, whose innovative style he introduced to Spain. Emulating

19-26 Francisco de Zurbarán, *Saint Serapion*, 1628. Oil on canvas, 3' $11\frac{1}{2}'' \times 3'$ $4\frac{3}{4}''$. Wadsworth Atheneum, Hartford (The Ella Gallup Sumner and Mary Catlin Sumner Collection Fund).

The light shining on Serapion calls attention to his tragic death and increases the painting's dramatic impact. The Spanish monk's coarse features label him as common, evoking empathy from a wide audience.

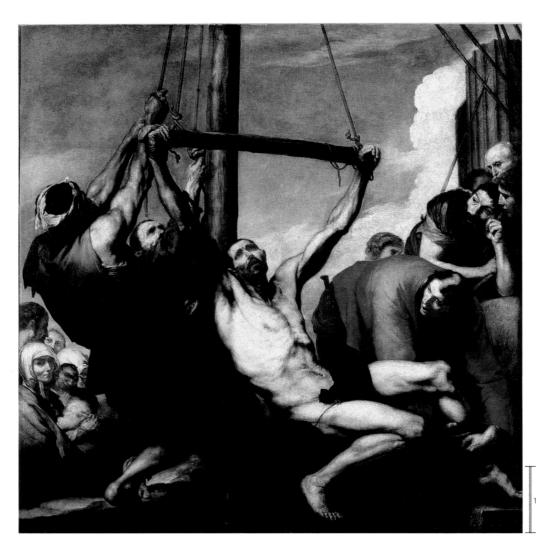

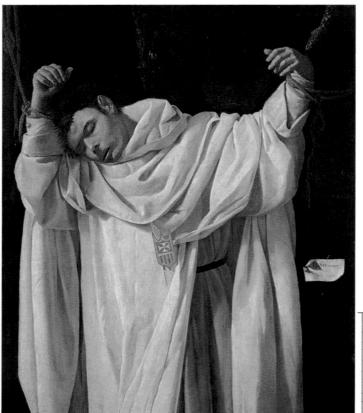

1 ft.

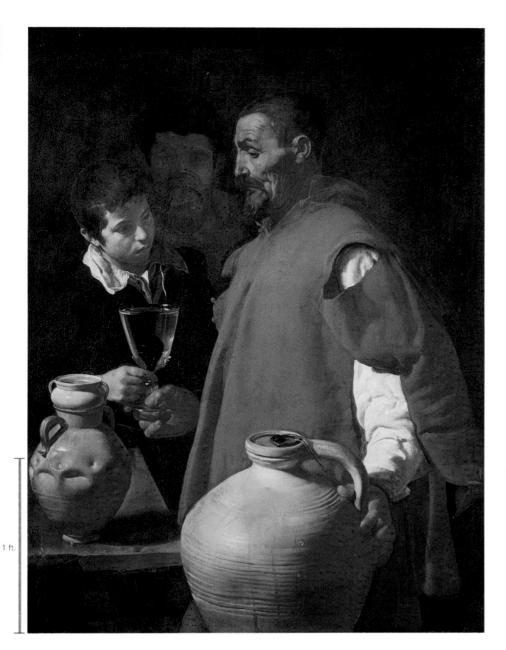

19-27 Diego Velázquez, Water Carrier of Seville, ca. 1619. Oil on canvas, $3' 5\frac{1}{2}'' \times 2' 7\frac{1}{2}''$. Victoria & Albert Museum, London.

In this early work—a genre scene that seems to convey a deeper significance—the contrast of darks and lights and the plebeian nature of the figures reveal Velázquez's indebtedness to Caravaggio.

Caravaggio, Ribera made naturalism and compelling drama primary ingredients of his paintings, which often embraced brutal themes, reflecting the harsh times of the Counter-Reformation and the Spanish taste for stories showcasing courage and devotion. Ribera's *Martyrdom of Saint Philip* (FIG. 19-25) is grim and dark in subject and form. Scorning idealization of any kind, Ribera represented Philip's executioners hoisting him into position after tying him to a cross, the instrument of Christ's own martyrdom. The saint's rough, heavy body and swarthy, plebeian features reveal a kinship between him and his tormentors, who are similar to the types of figures found in Caravaggio's paintings. The patron of this painting is unknown, but it is possible that Philip IV commissioned the work, because Saint Philip was the king's patron saint.

FRANCISCO DE ZURBARÁN Another prominent Spanish painter of dramatic works was Francisco de Zurbarán (1598–1664), whose primary patrons throughout his career were rich Spanish monastic orders. Many of his paintings are quiet and contemplative, appropriate for prayer and devotional purposes. Zurbarán painted Saint Serapion (FIG. 19-26) as a devotional image for the funerary

chapel of the monastic Order of Mercy in Seville. The saint, who participated in the Third Crusade of 1196, suffered martyrdom while preaching the Gospel to Muslims. According to one account, the monk's captors tied him to a tree and then tortured and decapitated him. The Order of Mercy dedicated itself to self-sacrifice, and Serapion's membership in this order amplified the resonance of Zurbarán's painting. In *Saint Serapion* the monk emerges from a dark background and fills the foreground. The bright light shining on him calls attention to the saint's tragic death and increases the dramatic impact of the image. In the background are two barely visible tree

branches. A small note next to the saint identifies him for viewers. The coarse features of the Spanish monk label him as common, no doubt evoking empathy from a wide audience.

DIEGO VELÁZQUEZ The greatest Spanish painter of the Baroque age was DIEGO VELÁZQUEZ (1599–1660). An early work, Water Carrier of Seville (FIG. 19-27), painted when Velázquez was only about 20, already reveals his impressive command of the painter's craft. Velázquez rendered the figures with clarity and dignity, and his careful and convincing depiction of the water jugs in the foreground, complete with droplets of water, adds to the credibility of the scene. The plebeian nature of the figures and the contrast of darks and lights again reveal the influence of Caravaggio, whose work Velázquez had studied.

SURRENDER OF BREDA Velázquez, like many other Spanish artists, produced religious pictures as well as genre scenes, but his renown in his day rested primarily on the works he painted for his major patron, King Philip IV (see "Velázquez and Philip IV," page 546). After the king appointed Velázquez as court painter, the artist largely abandoned both religious and genre subjects in favor of royal

545

Velázquez and Philip IV

rained in Seville, Diego Velázquez was quite young when he came to the attention of Philip IV. The painter's immense talent impressed Philip, and the king named him chief court artist and palace chamberlain, a position that also involved curating the king's rapidly growing art collection and advising him regarding acquisitions and display. Among the works in Philip IV's possession were paintings by Titian, Annibale Carracci, Guido Reni, Albrecht Dürer, and Velázquez's famous Flemish contemporary, Peter Paul Rubens (see Chapter 20).

With the exception of two extended trips to Italy and a few excursions, Veláz-

quez remained in Madrid for the rest of his life. His close relationship with Philip IV and his high office as chamberlain gave him prestige and a rare opportunity to fulfill the promise of his genius. One sign of Velázquez 's fertile imagination as well as mastery of the brush is that he was able to create timeless artworks out of routine assignments to commemorate the achievements of his patron, as he did in his record of the Spanish victory over the Dutch in 1625 (*Surrender of Breda*, FIG. 19-29).

Velázquez also painted dozens of portraits of Philip IV. One of the best is *King Philip IV of Spain* (FIG. 19-28), also known as the *Fraga Philip* because it was painted during the Aragonese campaign in the town of Fraga. Velázquez accompanied the king and his troops in their attempt to reconquer the territory, and during a three-month stay in Fraga, Philip ordered the artist to produce this portrait. In it, Philip IV appears as a military leader, arrayed in salmon and silver campaign dress but without military accourtements except his baton of command and sword. Because the king was not a commanding presence and because he had inherited the large Habsburg jaw, Velázquez had to find creative ways to "ennoble" the monarch. He succeeded by focusing attention on the exquisite attire Philip wears, particularly the elabo-

19-28 DIEGO VELÁZQUEZ, King Philip IV of Spain (Fraga Philip), 1644. Oil on canvas, $4' 3\frac{1}{8}'' \times 3' 3\frac{1}{8}''$. Frick Collection, New York.

Velázquez painted Philip IV during the king's campaign to reconquer Aragonese territory. The portrait is noteworthy for its faithful reproduction of the attire the king wore when reviewing troops.

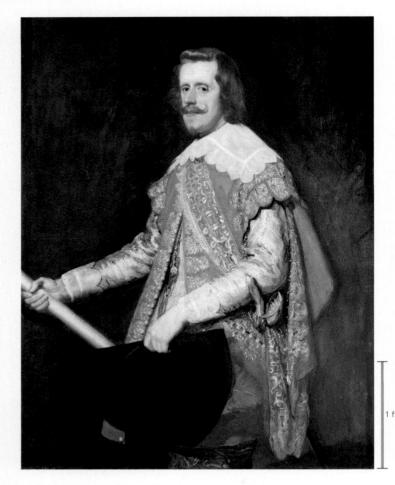

rately embroidered cloak and *baldric* (the sashlike belt worn over one shoulder and across the chest to support a sword). Velázquez managed to make the silver needlework on these vestments shimmer. Detailed written accounts attest that this is the costume the king wore when reviewing the troops, and the artist's fidelity in depicting Philip's elegant attire no doubt added to the authority of the image.

portraits (FIG. 19-28) and canvases recording historical events. In 1635 he painted Surrender of Breda (FIG. 19-29) as part of an extensive program of decoration for the Hall of Realms in Philip IV's Palace of Buen Retiro in Madrid. The huge canvas (more than 12 feet long and almost as tall) was one of 10 paintings celebrating recent Spanish military successes around the globe. It commemorates the Spanish victory over the Dutch at Breda in 1625. Among the most troublesome situations for Spain was the conflict in the Netherlands. Determined to escape Spanish control, the northern Netherlands broke from the Spanish empire in the late 16th century. Skirmishes continued to flare up along the border between the northern (Dutch) and southern (Spanish) Netherlands, and in 1625 Philip IV sent General Ambrogio di Spínola to Breda to reclaim the town for Spain. Velázquez depicted the victorious Spanish troops, organized and well armed, on the right side of the painting. In sharp contrast, the defeated Dutch on the left appear bedraggled and disorganized. In the

center foreground, the mayor of Breda, Justinus of Nassau, hands the city's keys to the Spanish general—although no encounter of this kind ever occurred. Velázquez's fictional record of the event glorifies not only the strength of the Spanish military but the benevolence of Spínola as well. Velázquez portrayed the general standing and magnanimously stopping Justinus from kneeling, rather than astride his horse, lording over the vanquished Dutch. Indeed, the terms of surrender were notably lenient, and the Spaniards allowed the Dutch to retain their arms—which they used to recapture the city in 1637.

LAS MENINAS After an extended visit to Rome from 1648 to 1651, Velázquez returned to Spain and painted his greatest masterpiece, *Las Meninas* (*The Maids of Honor*; FIG. 19-30). In it, Velázquez showed his mastery of both form and content. The painter represented himself in his studio standing before a large canvas. The young Infanta (Princess) Margarita appears in the foreground with her two

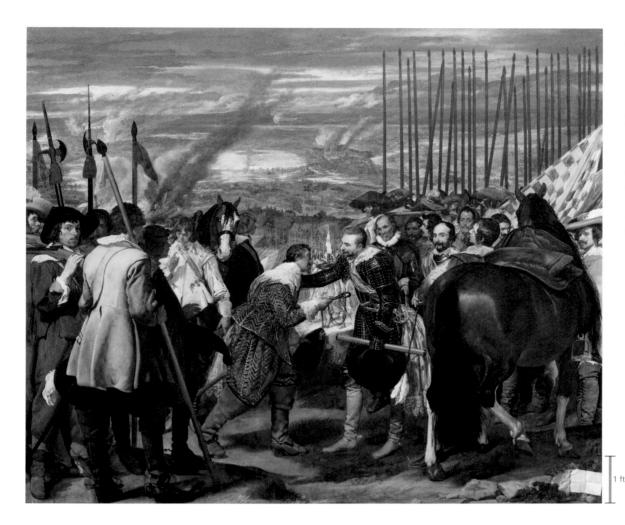

19-29 DIEGO VELÁZQUEZ, Surrender of Breda, 1634–1635. Oil on canvas, $10' \ 1'' \times 12' \frac{1}{2}''$. Museo del Prado, Madrid.

As Philip IV's court artist, Velázquez produced many history paintings, including fictional representations like this one depicting the Dutch mayor of Breda surrendering to the Spanish general.

maids-in-waiting, her favorite dwarfs, and a large dog. In the middle ground are a woman in widow's attire and a male escort. In the background, a chamberlain stands in a brightly lit open doorway. Scholars have been able to identify everyone in the room, including the two meninas and the dwarfs. The room was the artist's studio in the palace of the Alcázar in Madrid. After the death of Prince Baltasar Carlos in 1646, Philip IV ordered part of the prince's chambers converted into a studio for Velázquez.

Las Meninas is noteworthy for its visual and narrative complexity. Indeed, art historians have yet to agree on any particular reading or interpretation. A central issue preoccupying scholars has been what, exactly, is taking place in Las Meninas. What is Velázquez depicting on the huge canvas in front of him? He may be painting this very picture—an informal image of the infanta and her entourage. Alternately, Velázquez may be painting a portrait of King Philip IV and Queen Mariana, whose reflections appear in the mirror on the far wall. If so, that would suggest the presence of the king and queen in the viewer's space, outside the confines of the picture. Other scholars have proposed that the mirror image reflects not the physical appearance of the royal couple in Velázquez's studio but the image that he is in the process of painting on the canvas before him. This question has never been definitively resolved.

More generally, *Las Meninas* is Velázquez's attempt to elevate both himself and his profession. As first painter to the king and as chamberlain of the palace, Velázquez was conscious not only of the importance of his court office but also of the honor and dignity belonging to his profession as a painter. Throughout his career, Velázquez hoped to be ennobled by royal appointment to membership in

the ancient and illustrious Order of Santiago. Because he lacked a sufficiently noble background, he gained entrance only with difficulty at the very end of his life, and then only through the pope's dispensation. In the painting, he wears the order's red cross on his doublet, painted there, legend says, by the king himself. In all likelihood, the artist painted it. In Velázquez's mind, Las Meninas might have embodied the idea of the great king visiting his studio, as Alexander the Great visited the studio of the painter Apelles in ancient times. The figures in the painting all appear to acknowledge the royal presence. Placed among them in equal dignity is Velázquez, face-to-face with his sovereign. The location of the completed painting reinforced this act of looking-of seeing and being seen. Las Meninas hung in the personal office of Philip IV in another part of the palace. Thus, although occasional visitors admitted to the king's private quarters may have seen this painting, Philip IV was the primary audience. Each time he stood before the canvas, he again participated in the work as the probable subject of the painting within the painting and as the object of the figures' gazes. In Las Meninas, Velázquez elevated the art of painting, in the person of the painter, to the highest status. The king's presence enhanced this status—either in person as the viewer of Las Meninas or as a reflected image in the painting itself. The paintings that appear in Las Meninas further reinforced this celebration of the painter's craft. On the wall above the doorway and mirror, two faintly recognizable pictures have been identified as copies made by Velázquez's son-in-law, Juan del Mazo (ca. 1612-1667), of paintings by Peter Paul Rubens. The paintings depict the immortal gods as the source of art. Ultimately, Velázquez sought ennoblement not for himself alone but for his art.

19-30 DIEGO VELÁZQUEZ, Las Meninas (The Maids of Honor), 1656. Oil on canvas, 10′5″ × 9′. Museo del Prado, Madrid.

Velázquez intended this huge and visually complex work, with its cunning contrasts of true spaces, mirrored spaces, and picture spaces, to elevate both himself and the profession of painting.

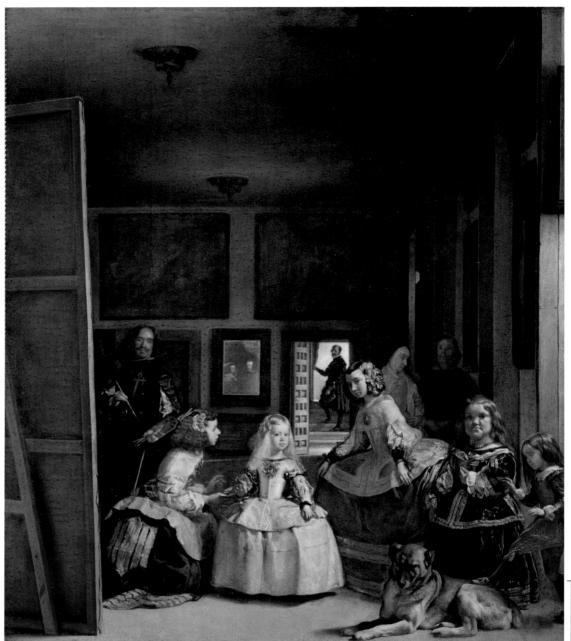

1 ft.

Las Meninas is extraordinarily complex visually. Velázquez's optical report of the event, authentic in every detail, pictorially summarizes the various kinds of images in their different levels and degrees of reality. He portrayed the realities of image on canvas, of mirror image, of optical image, and of the two painted images. This work—with its cunning contrasts of mirrored spaces, "real" spaces, picture spaces, and pictures within pictures—itself appears to have been taken from a large mirror reflecting the whole scene. This would mean that the artist did not paint the princess and her suite as the main subjects of Las Meninas but himself in the process of painting them. Las Meninas is a pictorial summary and a commentary on the essential mystery of the visual world, as well as on the ambiguity that results when different states or levels interact or are juxtaposed.

Velázquez achieved these results in several ways. The extension of the composition's pictorial depth in both directions is noteworthy. The open doorway and its ascending staircase lead the eye beyond the artist's studio, and the mirror device and the outward glances of several of the figures incorporate the viewer's space into the picture as well. (Compare how the mirror in Jan van Eyck's *Giovanni Arnolfini and His Bride*, FIG. 15-1, similarly incorporates the area in front of the canvas into the picture, although less obviously and without a comparable extension of space beyond the rear wall of the room.) Velázquez also masterfully observed and represented form and shadow. Instead of putting lights abruptly beside darks, following Caravaggio, Velázquez allowed a great number of intermediate values of gray to come between the two extremes. His matching of tonal gradations approached effects that were later discovered in the photography age.

The inclusion of the copies of two Rubens paintings hanging on the wall in Velázquez's studio is the Spanish master's tribute to the great Flemish painter, one of the towering figures who made the 17th century so important in the history of art in Northern Europe. The works of Rubens, Rembrandt, and the other leading Baroque painters, sculptors, and architects of Flanders, the Dutch Republic, France, and England are the subject of Chapter 20.

ITALY AND SPAIN, 1600 TO 1700

ITALY

- Art historians call the art of 17th-century Italy and Spain "Baroque," a term that probably derives from the Portuguese word for an irregularly shaped pearl. In contrast to the precision and orderly rationality of Italian Renaissance classicism, Baroque art and architecture are dynamic, theatrical, and highly ornate.
- Baroque architects emphatically rejected the classical style. Francesco Borromini emphasized the sculptural qualities of buildings. The facades of his churches, for example, San Carlo alle Quattro Fontane, are not flat frontispieces but undulating surfaces that provide a fluid transition from exterior to interior space. The interiors of his buildings pulsate with energy and feature complex domes that grow organically from curving walls.
- The greatest Italian Baroque sculptor was Gianlorenzo Bernini, who was also an important architect. In Ecstasy of Saint Teresa, he marshaled the full capabilities of architecture, sculpture, and painting to create an intensely emotional experience for worshipers, consistent with the Catholic Counter-Reformation principle of using artworks to inspire devotion and piety.
- In painting, Caravaggio broke new ground by employing stark and dramatic contrasts of light and dark (tenebrism) and by setting religious scenes in everyday locales filled with rough-looking common people. An early masterpiece, Calling of Saint Matthew, for example, takes place in an ordinary tavern.
- Caravaggio's combination of drama and realism attracted both loyal followers and harsh critics. The biographer Giovanni Pietro Bellori, for example, deplored Caravaggio's abandonment of the noble style of Raphael and the ancients and his "suppression of the dignity of art." He preferred the more classical style of Annibale Carracci and the Bolognese art academy.
- Illusionistic ceiling paintings were very popular in Baroque Italy. In Sant'Ignazio in Rome, Fra Andrea Pozzo created the illusion that Heaven is opening up above the viewer's head by continuing the church's architecture into the painted nave vault.

Borromini, San Carlo alle Quattro Fontane, Rome, 1665–1667

Bernini, Ecstasy of Saint Teresa, 1645–1652

Caravaggio, *Calling of Saint Matthew,* ca. 1597–1601

Pozzo, *Glorification of Saint Ignatius,* 1691–1694

SPAIN

- Although the power of the Habsburg kings of Spain declined over the course of the 17th century, the royal family, which was devoutly Catholic, continued to spend lavishly on art. Spanish artists eagerly embraced the drama and emotionalism of Italian Baroque art. Scenes of death and martyrdom were popular in Spain during the Counter-Reformation. Painters such as José de Ribera and Francisco de Zurbarán produced moving images of martyred saints that incorporated the lighting and realism of Caravaggio.
- The greatest Spanish Baroque painter was Diego Velázquez, court painter to Philip IV (r. 1621–1665). Velázquez painted a wide variety of themes ranging from religious subjects to royal portraits and historical events. His masterwork, *Las Meninas*, is extraordinarily complex visually and mixes true spaces, mirrored spaces, picture spaces, and pictures within pictures. It is a celebration of the art of painting itself.

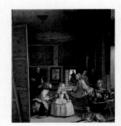

Velázquez, Las Meninas, 1656

20-1 Jan Vermeer, Allegory of the Art of Painting, 1670–1675. Oil on canvas, 4' 4" × 3' 8". Kunsthistorisches Museum, Vienna.

Dutch painters often specialized in domestic scenes, but Vermeer's mother-in-law described this work as "the Art of Painting." Vermeer's tribute to his craft includes a model holding the attributes of Clio.

NORTHERN EUROPE, 1600 TO 1700

uring the 17th and early 18th centuries, numerous geopolitical shifts occurred in Europe as the fortunes of the individual countries waxed and waned. Pronounced political and religious friction resulted in widespread unrest and warfare. Indeed, between 1562 and 1721, all of Europe was at peace for a mere four years. The major conflict of this period was the Thirty Years' War (1618-1648), which ensnared Spain, France, Sweden, Denmark, the Netherlands, Germany, Austria, Poland, the Ottoman Empire, and the Holy Roman Empire. Although the outbreak of the war had its roots in the conflict between militant Catholics and militant Protestants, the driving force quickly shifted to secular, dynastic, and nationalistic concerns. Among the major political entities vying for expanded power and authority in Europe were the Bourbon dynasty of France and the Habsburg dynasties of Spain and the Holy Roman Empire. The war, which concluded with the Treaty of Westphalia in 1648, was largely responsible for the political restructuring of Europe (MAP 20-1). As a result, the United Provinces of the Netherlands (the Dutch Republic), Sweden, and France expanded their authority. Spanish and Danish power diminished. In addition to reconfiguring territorial boundaries, the Treaty of Westphalia in essence granted freedom of religious choice throughout Europe. This treaty thus marked the abandonment of the idea of a united Christian Europe and accepted the practical realities of secular political systems. The building of today's nation-states was emphatically under way.

The 17th century also brought heightened economic competition to Europe. Much of the foundation for worldwide mercantilism—extensive voyaging and geographic exploration, improved cartography, and advances in shipbuilding—had been laid in the previous century. In the 17th century, however, changes in financial systems, lifestyles, and trading patterns, along with expanding colonialism, fueled the creation of a worldwide marketplace. The Dutch founded the Bank of Amsterdam in 1609, which eventually became the center of European transfer banking. By establishing a system in which merchant firms held money on account, the bank relieved traders of having to transport precious metals as payment. Trading practices became more complex. Rather than simple reciprocal trading, triangular trade (trade among three parties) allowed for a larger pool of desirable goods. Exposure to an ever-growing array of goods affected European diets and lifestyles. Coffee (from island colonies) and tea (from China)

MAP 20-1 Europe in 1648 after the Treaty of Westphalia.

became popular beverages during the early 17th century. Equally explosive was the growth of sugar use. Sugar, tobacco, and rice were slave crops, and the slave trade expanded to meet the demand for these goods. Traders captured and enslaved Africans and shipped them to European colonies and the Americas to provide the requisite labor force for producing these commodities.

The resulting worldwide mercantile system permanently changed the face of Europe. The prosperity international trade generated affected social and political relationships, necessitating new rules of etiquette and careful diplomacy. With increased disposable income, more of the newly wealthy spent money on art, expanding the number of possible sources of patronage.

FLANDERS

In the 16th century, the Netherlands had come under the crown of Habsburg Spain when the emperor Charles V retired, leaving the Spanish kingdoms, their Italian and American possessions, and the Netherlandish provinces to his only legitimate son, Philip II (r. 1556–1598). (Charles bestowed the imperial title and the German lands on his brother.) Philip's repressive measures against the Protestants led the northern provinces to break from Spain and to set up the Dutch Republic. The southern provinces remained under Spanish control, and they retained Catholicism as their official religion. The political distinction between modern Holland and Bel-

gium more or less reflects this original separation, which in the 17th century signaled not only religious but also artistic differences.

Painting

The leading art of 17th-century Flanders (the Spanish Netherlands) was painting. Flemish Baroque painters retained close connections to the Baroque art of Catholic Europe, whereas the Dutch schools of painting developed their own subjects and styles. This was consistent with their reformed religion and the new political, social, and economic structure of the Dutch Republic.

PETER PAUL RUBENS The renowned Flemish master Peter Paul Rubens (1577–1640) drew together the main contributions of the Italian Renaissance and Baroque masters to formulate the first truly pan-European painting style. Rubens's art is an original and powerful synthesis of the manners of many painters, especially Michelangelo, Titian, Carracci, and Caravaggio. His style had wide appeal, and his influence was international. Among the most learned individuals of his time, Rubens possessed an aristocratic education and a courtier's manner, diplomacy, and tact, which, with his facility for language, made him the associate of princes and scholars. He became court painter to the dukes of Mantua (descended from Mantegna's patrons), friend of King Philip IV (r. 1621–1665) of Spain and his adviser on art collecting, painter to Charles I (r. 1625–1649) of England and Marie de' Medici (1573–1642) of France, and permanent court painter to the Spanish governors of Flanders. Rubens

20-2 Peter Paul Rubens, *Elevation of the Cross*, from Saint Walburga, Antwerp, 1610. Oil on wood, 15' $1\frac{7}{8}'' \times 11'$ $1\frac{1}{2}''$ (center panel), 15' $1\frac{7}{8}'' \times 4'$ 11" (each wing). Antwerp Cathedral, Antwerp.

In this triptych, Rubens explored foreshortened anatomy and violent action. The composition seethes with a power that comes from heroic exertion. The tension is emotional as well as physical.

also won the confidence of his royal patrons in matters of state, and they often entrusted him with diplomatic missions of the highest importance. In the practice of his art, scores of associates and apprentices assisted Rubens, turning out numerous paintings for an international clientele. In addition, he functioned as an art dealer, buying and selling contemporary artworks and classical antiquities. His many enterprises made him a rich man, with a magnificent town house and a castle in the countryside. Rubens, like Raphael, was a successful and renowned artist, a consort of kings, a shrewd man of the world, and a learned philosopher.

ELEVATION OF THE CROSS Rubens became a master in 1598 and departed for Italy two years later, where he remained until 1608. During these years, he formulated the foundations of his style. Shortly after returning home, he painted Elevation of the Cross (FIG. 20-2) for the church of Saint Walburga in Antwerp. Later moved to the city's cathedral, the altarpiece is but one of many commissions for religious works that Rubens received at this time. By investing in sacred art, churches sought to affirm their allegiance to Catholicism and Spanish Habsburg rule after a period of Protestant iconoclastic fervor in the region.

The Saint Walburga triptych also reveals Rubens's interest in Italian art, especially the works of Michelangelo and Caravaggio. The scene brings together tremendous straining forces and counterforces

as heavily muscled men labor to lift the cross. Here, as in his *Lion Hunt* (FIG. I-13), Rubens used the subject as an opportunity to show foreshortened anatomy and the contortions of violent action reminiscent of the twisted figures that Michelangelo sculpted and painted. Rubens placed the body of Christ on the cross as a diagonal that cuts dynamically across the picture while inclining back into it. The whole composition seethes with a power that comes from genuine exertion, from elastic human sinew taut with effort. The tension is emotional as well as physical, as reflected not only in Christ's face but also in the features of his followers. Strong modeling in dark and light, which heightens the drama, marks Rubens's work at this stage of his career.

Although Rubens later developed a much subtler coloristic style, the human body in action, draped or undraped, male or female, remained the focus of his art. This interest, combined with his voracious intellect, led Rubens to copy the works of classical antiquity and of the Italian masters. When he was in Rome in 1606 to 1608, he made many black-chalk drawings of great artworks, including figures in Michelangelo's Sistine Chapel frescoes (FIG. 17-1) and the ancient marble group of Laocoön and his two sons (FIG. 5-88). In a Latin treatise he wrote titled *De imitatione statuarum* (*On the Imitation of Statues*), Rubens stated: "I am convinced that in order to achieve the highest perfection one needs a full understanding of the [ancient] statues, indeed a complete absorption in them; but one must make judicious use of them and before all avoid the effect of stone."

20-3 Peter Paul Rubens, Arrival of Marie de' Medici at Marseilles, 1622–1625. Oil on canvas, $12' 11\frac{1}{2}'' \times 9' 7''$. Louvre, Paris.

Marie de' Medici asked Rubens to paint 21 large canvases glorifying her career. In this historical-allegorical picture of robust figures in an opulent setting, the sea and sky rejoice at the queen's arrival in France.

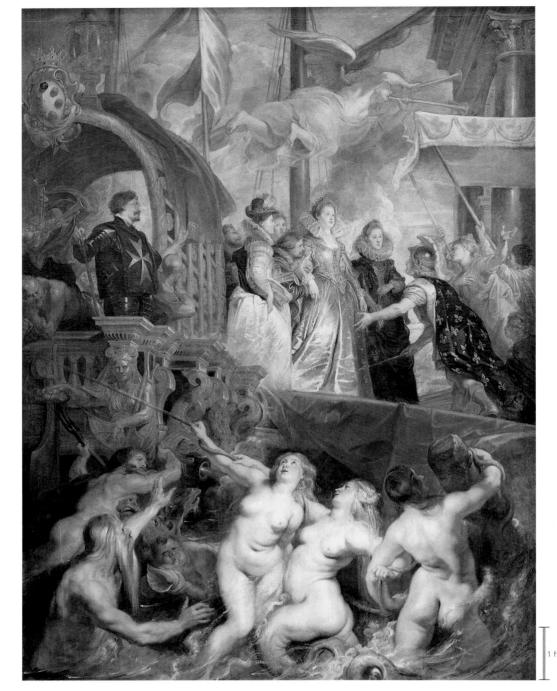

MARIE DE' MEDICI Rubens's interaction with royalty and aristocrats provided him with an understanding of the ostentation and spectacle of Baroque (particularly Italian) art that appealed to the wealthy and privileged. Rubens, the born courtier, reveled in the pomp and majesty of royalty. Likewise, those in power embraced the lavish spectacle that served the Catholic Church so well in Italy. The magnificence and splendor of Baroque imagery reinforced the

authority and right to rule of the highborn. Among Rubens's royal patrons was Marie de' Medici, a member of the famous Florentine house and widow of Henry IV (r. 1589–1610), the first Bourbon king of France. She commissioned Rubens to paint a series memorializing and glorifying her career. Between 1622 and 1626, Rubens, working with amazing creative energy, produced 21 huge historical-allegorical pictures designed to hang in the queen's new palace, the Luxembourg, in Paris.

In Arrival of Marie de' Medici at Marseilles (FIG. 20-3), Marie disembarks in France after her sea voyage from Italy. An allegorical personification of France, draped in a cloak decorated with the *fleur-de-lis* (the floral symbol of French royalty), welcomes her. The sea and sky rejoice at her safe arrival. Neptune and the Nereids (daughters of the sea god Nereus) salute her, and a winged, trumpeting Fame hovers overhead. Conspicuous in the galley's opulently carved stern-castle, under the Medici coat of arms, stands the imperious commander of the vessel, the only immobile figure in the composi-

tion. In black and silver, this figure makes a sharp accent amid the swirling tonality of ivory, gold, and red. Rubens enriched the surfaces with a decorative splendor that pulls the whole composition together. The audacious vigor that customarily enlivens the artist's figures, beginning with the monumental, twisting sea creatures, vibrates through the entire design.

CONSEQUENCES OF WAR Rubens's diplomatic missions gave him great insight into European politics, and he never ceased to promote peace. Throughout most of his career, war was constant. When commissioned in 1638 to produce a painting (FIG. 20-4) for Ferdinando II de' Medici, the grand duke of Tuscany (r. 1621–1670), Rubens took the opportunity to express his attitude toward the Thirty Years' War (see "Rubens on Consequences of War," page 555). The fluid articulation of human forms in this work and the energy that emanates from the chaotic scene are reminiscent of Rubens's other paintings.

Rubens on Consequences of War

n the ancient and medieval worlds, artists rarely wrote commentaries on the works they produced. Beginning with the Renaissance, however, the increased celebrity artists enjoyed and the ready availability of paper encouraged artists to record their intentions in letters to friends and patrons.

In March 1638, Peter Paul Rubens wrote a letter to Justus Sustermans (1597–1681), court painter to Grand Duke Ferdinando II de' Medici of Tuscany, explaining his *Consequences of War* (FIG. **20-4**) and his attitude toward the European military conflicts of his day.

The principal figure is Mars, who has left the open temple of Janus (which in time of peace, according to Roman custom, remained closed) and rushes forth with shield and blood-stained sword, threatening the people with great disaster. He pays little heed to Venus, his mistress, who, accompanied by Amors and Cupids, strives with caresses and embraces to hold him. From the other side, Mars is dragged forward by the Fury Alekto, with a torch in her hand. Near by are monsters personifying Pestilence and Famine, those inseparable partners of War. On the ground, turning her back, lies a woman with a broken lute, representing Harmony, which is incompatible with the discord of War. There is also a mother with her

child in her arms, indicating that fecundity, procreation and charity are thwarted by War, which corrupts and destroys everything. In addition, one sees an architect thrown on his back, with his instruments in his hand, to show that which in time of peace is constructed for the use and ornamentation of the City, is hurled to the ground by the force of arms and falls to ruin. I believe, if I remember rightly, that you will find on the ground, under the feet of Mars a book and a drawing on paper, to imply that he treads underfoot all the arts and letters. There ought also to be a bundle of darts or arrows, with the band which held them together undone; these when bound form the symbol of Concord. Beside them is the caduceus and an olive branch, attribute of Peace; these are also cast aside. That grief-stricken woman clothed in black, with torn veil, robbed of all her jewels and other ornaments, is the unfortunate Europe who, for so many years now, has suffered plunder, outrage, and misery, which are so injurious to everyone that it is unnecessary to go into detail. Europe's attribute is the globe, borne by a small angel or genius, and surmounted by the cross, to symbolize the Christian world.*

* Translated by Kristin Lohse Belkin, Rubens (London: Phaidon, 1998), 288-289.

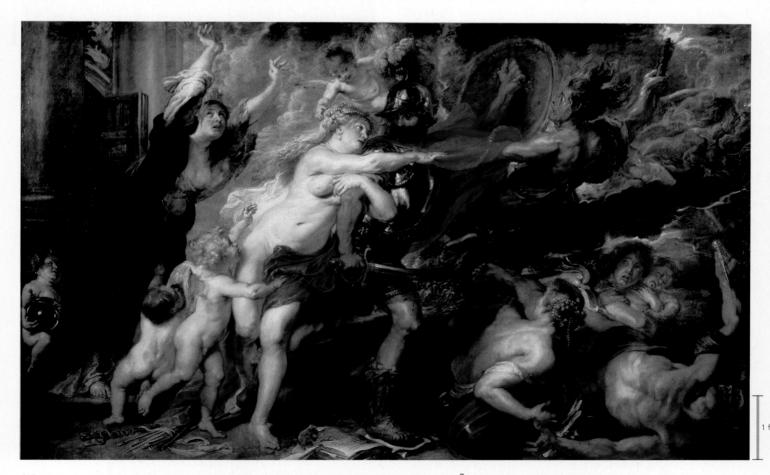

20-4 Peter Paul Rubens, Consequences of War, 1638–1639. Oil on canvas, 6' 9" \times 11' $3\frac{7}{8}$ ". Palazzo Pitti, Florence.

Beginning with the Renaissance, artists have left behind many writings shedding light on their life and work. In a 1638 letter, Rubens explained the meaning of each figure in this allegorical painting.

20-5 Anthony Van Dyck, *Charles I Dismounted*, ca. 1635. Oil on canvas, 8' 11" \times 6' 11 $\frac{1}{2}$ ". Louvre, Paris.

Van Dyck specialized in court portraiture. In this painting, he depicted the absolutist monarch Charles I at a sharp angle so that the king, a short man, appears to be looking down at the viewer.

ANTHONY VAN DYCK Most of Rubens's successors in Flanders were at one time his assistants. The most famous of these was Anthony Van Dyck (1599–1641). Early on, the younger man, unwilling to be overshadowed by the master's undisputed stature, left his native Antwerp for Genoa and then London, where he became court portraitist to Charles I. Although Van Dyck created dramatic compositions of high quality, his specialty became the portrait. He developed a courtly manner of great elegance that was influential internationally. In one of his finest works, Charles I Dismounted (FIG. 20-5), the ill-fated Stuart king stands in a landscape with the Thames River in the background. An equerry and a page attend him. The portrait is a stylish image of relaxed authority, as if the king is out for a casual ride in his park, but no one can mistake the regal poise and the air of absolute authority that his Parliament resented and was soon to rise against. Here, King Charles turns his back on his attendants as he surveys his domain. The king's placement in the composition is exceedingly artful. He stands off-center but balances the picture with a single keen glance at the viewer. Van Dyck even managed to portray Charles I in a position to look down on the observer. In reality, the monarch's short stature forced him to exert his

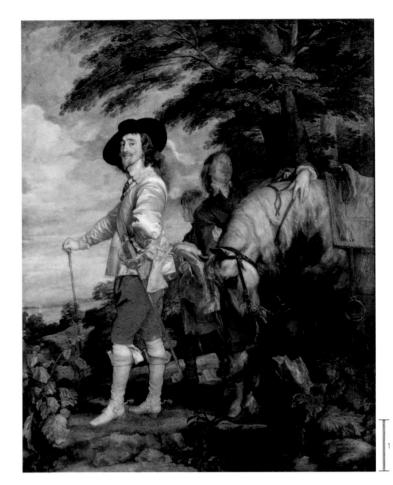

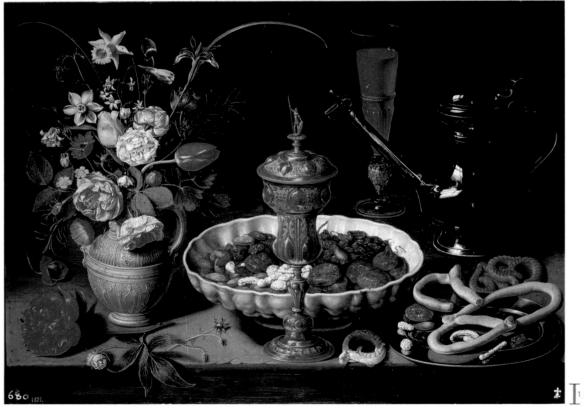

20-6 Clara Peeters, *Still Life with Flowers*, *Goblet, Dried Fruit, and Pretzels*, 1611. Oil on panel, $1'7\frac{3}{4}'' \times 2'1\frac{1}{4}''$. Museo del Prado, Madrid.

Clara Peeters was a pioneer of still-life painting. Although a Flemish artist, she spent time in Holland and laid the groundwork for many Dutch artists (FIGS. 20-21 to 20-23).

power in ways other than physical. Van Dyck's elegant style resounded in English portrait painting well into the 19th century.

CLARA PEETERS Some Flemish Baroque artists also explored still-life painting (inanimate objects artfully arranged). A pioneer of this genre was Clara Peeters (1594-ca. 1657), a Flemish artist who spent time in Holland and laid the groundwork for the Dutch artists Pieter Claesz (FIG. 20-21), William Kalf (FIG. 20-22), and Rachel Ruysch (FIG. 20-23). Peeters won renown for her depictions of food and flowers together, and for still lifes that included bread and fruit. Such still lifes became known as breakfast pieces. In the breakfast piece Still Life with Flowers, Goblet, Dried Fruit, and Pretzels (FIG. 20-6), Peeters's considerable skills are on full display. One of a series of four paintings, each of which depicts a typical early-17thcentury meal, Still Life reveals Peeters's virtuosity in painting a wide variety of objects convincingly, from the smooth, reflective surfaces of the glass and silver goblets to the soft petals of the blooms in the vase. Although Peeters often depicted the objects in her still lifes against a dark background, thereby negating any sense of deep space, in this painting she presented the leaves of the flower on the stone ledge as though they were encroaching into the viewer's space.

DUTCH REPUBLIC

The Dutch succeeded in securing their independence from the Spanish in the late 16th century. Not until 1648, however, after years of continual border skirmishes with the Spanish (as depicted in Diego Velázquez's *Surrender of Breda*, Fig. 19-29), did the northern Netherlands achieve official recognition as the United Provinces of the Netherlands (the Dutch Republic; MAP 20-1). The Dutch Republic owed its ascendance during the 17th century largely to its economic prosperity. With the founding of the Bank of Amsterdam in 1609, Amsterdam emerged as the financial center of the Continent. In the 17th century, the city had the highest per capita income in Europe. The Dutch economy also benefited enormously from the

country's expertise on the open seas, which facilitated establishing far-flung colonies. By 1650, Dutch trade routes extended to North America, South America, the west coast of Africa, China, Japan, Southeast Asia, and much of the Pacific. Due to this prosperity and in the absence of an absolute ruler, political power increasingly passed into the hands of an urban patrician class of merchants and manufacturers, especially in cities such as Amsterdam, Haarlem, and Delft. That all these bustling cities were located in Holland (the largest of the seven United Provinces) perhaps explains why historians informally use the name "Holland" to refer to the entire country.

Ter Brugghen, van Honthorst, Hals, Leyster

Religious differences were a major consideration during the northern Netherlands' insistent quest for independence during the 16th and early 17th centuries. Whereas Spain and the southern Netherlands were Catholic, the people of the northern Netherlands were predominantly Protestant. The prevailing Calvinism demanded a puritanical rejection of art in churches, and thus artists produced relatively little religious art in the Dutch Republic at this time (especially in comparison with that created in the wake of the Counter-Reformation in areas dominated by Catholicism; see Chapter 19).

HENDRICK TER BRUGGHEN Religious art was not unknown in the Dutch Republic, however. HENDRICK TER BRUGGHEN (1588–1629), for example, painted *Calling of Saint Matthew* (FIG. **20-7**) in 1621, after returning from a trip to Italy, selecting as his subject a theme Caravaggio had painted (FIG. **19-18**). The moment of the narrative depicted and the naturalistic presentation of the figures echo Caravaggio's work. But although ter Brugghen was an admirer of the Italian master, he dispensed with Caravaggio's stark contrasts of dark and light and instead presented the viewer with a more colorful palette of soft tints. Further, the Dutch painter compressed the figures into a small but well-lit space, creating an intimate effect that differs from Caravaggio's more spacious setting.

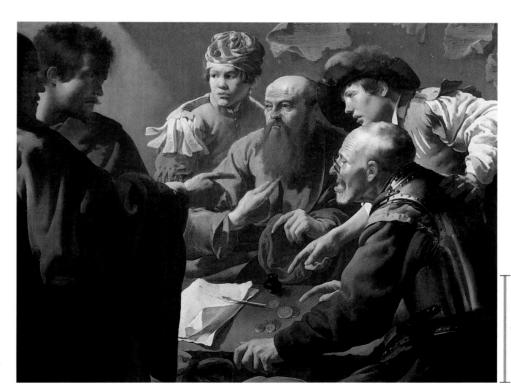

20-7 Hendrick ter Brugghen, Calling of Saint Matthew, 1621. Oil on canvas, 3' $4'' \times 4'$ 6". The Hague.

Although middle-class patrons in the Protestant Dutch Republic preferred genre scenes, still lifes, and portraits, some artists, including Hendrick ter Brugghen, also painted religious scenes.

1 ft.

Middle-Class Patronage and the Art Market in the Dutch Republic

Throughout history, the wealthy have been the most avid art collectors. Indeed, the money necessary to commission major artworks from esteemed artists can be considerable. During the 17th century in the Dutch Republic, however, the widespread prosperity a large proportion of the population enjoyed significantly expanded the range of art patrons. As a result, one of the distinguishing hallmarks of Dutch art production during the Baroque period was how it catered to the tastes of a middle-class audience. The term "middle class" is used broadly here. An aristocracy and an upper class of large-ship owners, rich businesspeople, high-ranking officers, and directors of large companies still existed. These groups continued to be major patrons of the arts. But with the expansion of the Dutch economy, traders, craftspeople, bureaucrats, and soldiers also commissioned and collected art.

Although steeped in the morality and propriety central to the Calvinist ethic, members of the Dutch middle class sought ways to announce their success and newly acquired status. House furnishings, paintings, tapestries, and porcelain were among the items they collected and displayed in their homes. The Dutch disdain for excessive ostentation, however, attributable to Calvinism, led these collectors to favor small, low-key works—portraits, still lifes, genre scenes, and landscapes. This contrasted with the Italian Baroque penchant for large-scale, dazzling ceiling frescoes and opulent room decoration (see Chapter 19).

Although it is risky to generalize about the spending and collecting habits of the Dutch middle class, probate records, contracts, and archived inventories reveal some interesting facts. These records suggest that an individual earning between 1,500 and 3,000 guilders a year would have been living comfortably. This individual might have spent 1,000 guilders for a house and another 1,000 guilders on furnishings, which would have included a significant amount of art, particularly paintings. Although there was, of course, considerable

variation in the prices of artworks, a great deal of art was very affordable. Prints were extremely cheap because of the quantity in which artists produced them. In terms of paintings, interior and genre scenes were relatively inexpensive, perhaps costing one or two guilders. Small landscapes fetched between three and four guilders. Commissioned portraits were the most costly. The size of the work and quality of the frame, as well as the reputation of the artist, were other factors in determining the price.

With the exception of portraits, Dutch artists produced most of their paintings for an anonymous market, hoping to appeal to a wide audience. To ensure success, artists in the United Provinces adapted to the changed conditions of art production and sales. They marketed their paintings in many ways, selling their works directly to buyers who visited their studios and through art dealers, exhibitions, fairs, auctions, and even lotteries. Because of the uncertainty of these sales mechanisms (as opposed to the certainty of an ironclad contract for a commission from a church or king), artists became more responsive to market demands. Specialization became common among Dutch artists. For example, painters might limit their practice to painting portraits, still lifes, or landscapes—the most popular genres among middle-class patrons.

Artists did not always sell their paintings. Frequently they used their work to pay off loans or debts. Tavern debts, in particular, could be settled with paintings, which may explain why many art dealers (such as Jan Vermeer and his father before him) were also innkeepers. This connection between art dealing and other businesses eventually solidified, and innkeepers, for example, often would mount art exhibitions in their taverns, hoping to make a sale. The institutions of today's open art market—dealers, galleries, auctions, and estate sales—owe their establishment to the emergence in the 17th century of a prosperous middle class in the Dutch Republic.

MERCANTILIST PATRONAGE Given the absence of an authoritative ruler and the Calvinist concern for the potential misuse of religious art, commissions from royalty or the Catholic Church, prominent in the art of other countries, were uncommon in the United Provinces. With the new prosperity, however, an expanding class of merchant patrons emerged, and this shift led to an emphasis on different pictorial content. Dutch Baroque art centered on genre scenes, landscapes, portraits, and still lifes, all of which appealed to the prosperous middle class (see "Middle-Class Patronage and the Art Market in the Dutch Republic," above).

GERRIT VAN HONTHORST Typical of 17th-century Dutch genre scenes is *Supper Party* (FIG. 20-8) by GERRIT VAN HONTHORST (1590–1656) of Utrecht. In this painting, van Honthorst presented an informal gathering of nonidealized human figures. While a musician serenades the group, his companions delight in watching a young woman feeding a piece of chicken to a man whose hands are both occupied—one holds a jug and the other a glass. Van Honthorst spent several years in Italy, and while there he carefully studied Caravaggio's work. The Italian artist's influence surfaces in the mun-

dane tavern setting and the nocturnal lighting. Fascinated by night-time effects, van Honthorst frequently placed a hidden light source in his pictures and used it as a pretext to work with dramatic and starkly contrasting dark and light effects. Seemingly lighthearted genre scenes such as *Supper Party* were popular in Baroque Holland, but Dutch viewers could also interpret them moralistically. For example, *Supper Party* can be read as a warning against the sins of gluttony (represented by the man on the right) and lust (the woman feeding the glutton is, in all likelihood, a prostitute with her aged procuress at her side). Or perhaps the painting represents the loose companions of the Prodigal Son (Luke 15:13)—panderers and prostitutes drinking, singing, strumming, and laughing. Strict Dutch Calvinists no doubt approved of such interpretations. Others simply took delight in the immediacy of the scenes and the skill of the artists.

FRANS HALS Dutch artists also excelled in portraiture. Frans Hals (ca. 1581–1666), the leading painter in Haarlem, made portraits his specialty. Portrait artists traditionally had relied heavily on convention—for example, specific poses, settings, attire, and accou-

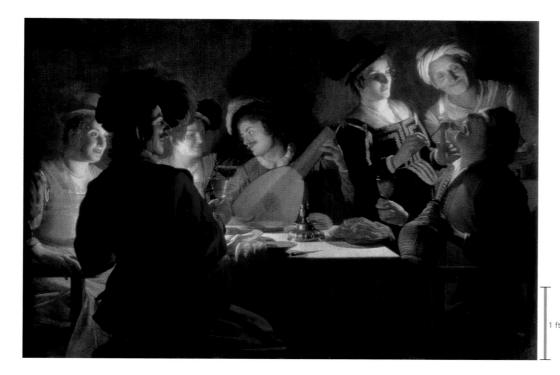

20-8 Gerrit van Honthorst, Supper Party, 1620. Oil on canvas, $4' 8'' \times 7'$. Galleria degli Uffizi, Florence.

Gerrit van Honthorst spent several years in Italy and studied the paintings of Caravaggio, whose influence is evident in the mundane tavern setting and the nocturnal light of *Supper Party*.

trements—to convey a sense of the sitter. Because the subject was usually someone of status or note, such as a pope, king, duchess, or wealthy banker, the artist's goal was to produce an image appropriate to the subject's station in life. With the increasing number of Dutch middle-class patrons, the tasks for portraitists became more challenging. The Calvinists shunned ostentation, instead wearing subdued and dark clothing with little variation or decoration, and the traditional conventions became inappropriate and thus unusable. Despite these difficulties, or perhaps because of them, Hals produced lively portraits that seem far more relaxed than traditional formulaic portraiture. He injected an engaging spontaneity into his images and conveyed the individuality of his sitters as well. His manner of execution intensified the casualness, immediacy, and intimacy in his paint-

ings. Because the touch of Hals's brush was as light and fleeting as the moment he captured the pose, the figure, the highlights on clothing, and the facial expression all seem instantaneously created.

ARCHERS OF SAINT HADRIAN Hals's group portraits reflect the widespread popularity in the Dutch Republic of vast canvases commemorating the participation of Dutch burghers in civic organizations. These commissions presented a far greater challenge to the painter than requests to depict a single sitter. Hals rose to the challenge and achieved great success with this new portrait genre. His Archers of Saint Hadrian (FIG. 20-9) is typical in that the subject is one of the many Dutch civic militia groups that claimed credit for liberating the Dutch Republic from Spain. Like other companies, the

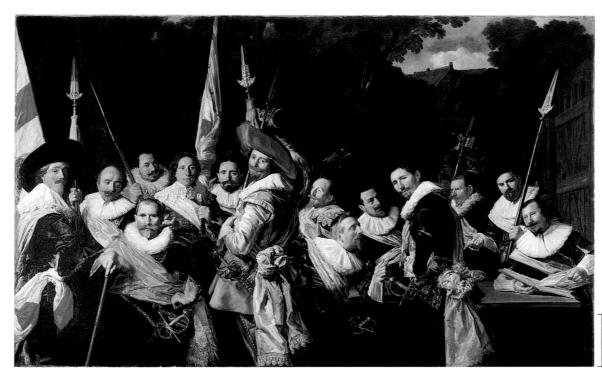

20-9 Frans Hals, Archers of Saint Hadrian, ca. 1633. Oil on canvas, 6' 9" × 11'. Frans Halsmuseum, Haarlem.

In this brilliant composition, Hals succeeded in solving the problem of adequately representing each individual in a group portrait while retaining action and variety in the painting as a whole.

1 ft

20-10 Frans Hals, The Women Regents of the Old Men's Home at Haarlem, 1664. Oil on canvas, 5' 7" × 8' 2". Frans Halsmuseum, Haarlem.

Dutch women played a major role in public life as regents of charitable institutions. A stern puritanical sensibility suffuses Hals's group portrait of the regents of Haarlem's old men's home.

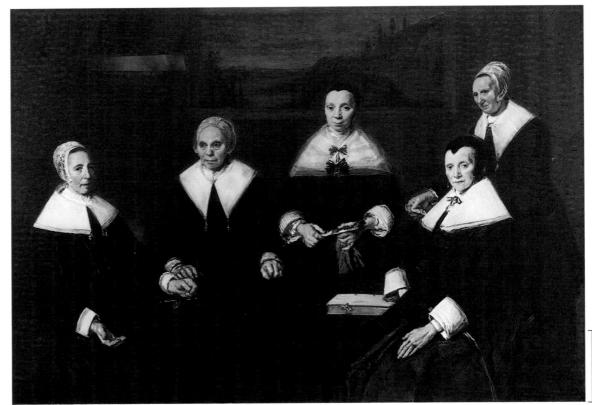

1 ft.

Archers met on their saint's feast day in dress uniform for a grand banquet. The celebrations sometimes lasted an entire week, prompting an ordinance limiting them to three or four days. These events often involved a group portrait.

In Archers of Saint Hadrian, Hals attacked the problem of how to represent each militia member adequately yet retain action and variety in the composition. Whereas earlier group portraits in the Netherlands were rather ordered, regimented images, Hals sought to enliven his depictions.

In the *Archers* portrait, for example, each man is both a troop member and an individual with a distinct physiognomy. The sitters' movements and moods vary enormously. Some engage the viewer directly. Others look away or at a companion. Whereas one is stern, another is animated. Each man is equally visible and clearly recognizable. The uniformity of attire—black military dress, white ruffs, and sashes—did not deter Hals from injecting spontaneity into the work. Indeed, he used those elements to create a lively rhythm that extends throughout the composition and energizes the portrait. The impromptu effect—the preservation of every detail and fleeting facial expression—is, of course, the result of careful planning. Yet Hals's vivacious brush appears to have moved instinctively, directed by a plan in his mind but not traceable in any preparatory scheme on the canvas.

WOMEN REGENTS OF HAARLEM In The Women Regents of the Old Men's Home at Haarlem (FIG. 20-10), Hals produced a group portrait of Calvinist women engaged in charitable work. Although Dutch women had primary responsibility for the welfare of the family and the orderly operation of the home, they also populated the labor force in the cities. Among the more prominent roles that educated women played in public life were regents of orphanages, hospitals, old-age homes, and houses of correction. In Hals's portrait, the regents sit quietly in a manner becoming of devout

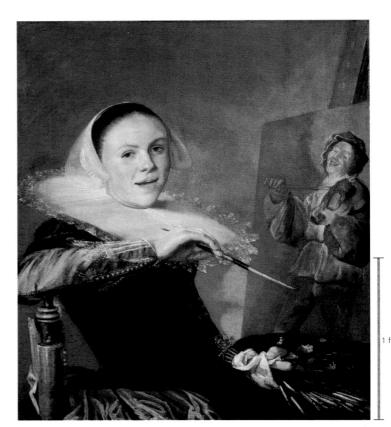

20-11 JUDITH LEYSTER, *Self-Portrait*, ca. 1630. Oil on canvas, $2' \, 5\frac{3''}{8} \times 2' \, 1\frac{5''}{8}$. National Gallery of Art, Washington, D.C. (gift of Mr. and Mrs. Robert Woods Bliss).

Although presenting herself as an artist specializing in genre scenes, Leyster wears elegant attire instead of a painter's smock, placing her socially as a member of a well-to-do family. Calvinists. Unlike the more relaxed, seemingly informal character of his other group portraits, a stern, puritanical, and composed sensibility suffuses Hals's portrayal of the Haarlem regents. The women—all carefully distinguished as individuals—gaze out from the painting with expressions ranging from dour disinterest to kindly concern. The somber and virtually *monochromatic* (one-color) palette, punctuated only by the white accents of the clothing, contributes to the painting's restraint. Both the coloration and the mood of Hals's portrait are appropriate for this commission. Portraying the Haarlem regents called for a very different kind of portrait from those Hals made of men at festive militia banquets.

JUDITH LEYSTER Some of Hals's students developed thriving careers of their own as portraitists. One was Judith Leyster (1609–1660), whose Self-Portrait (FIG. 20-11) suggests the strong training she received. The picture is detailed, precise, and accurate but also imbued with the spontaneity found in Hals's works. In this self-portrait, Leyster succeeded at communicating a great deal about herself. She depicted herself as an artist, seated in front of a painting resting on an easel. The palette in her left hand and brush in her right announce that the painting is her creation. She thus allows the viewer to evaluate her skill, which both the fiddler on the canvas and the image of herself demonstrate as considerable. Although she produced a wide range of paintings, including still lifes and floral pieces, her specialty was genre scenes such as the comic image seen on the easel. Her self-assurance is reflected in her quick smile and her relaxed pose as she stops her work to meet the viewer's gaze. Although presenting herself as an artist, Leyster did not portray herself wearing the traditional artist's smock, as Rembrandt did in his self-portrait (FIG. 20-15). Her elegant attire distinguishes her socially as a member of a well-to-do family, another important aspect of Leyster's identity.

Rembrandt

REMBRANDT VAN RIJN (1606–1669), Hals's younger contemporary, was an artist of great versatility, a master of light and shadow, and a unique interpreter of the Protestant conception of scripture. The leading Dutch painter of his time, Rembrandt was an undisputed genius. Born in Leiden, he moved to Amsterdam around 1631, which provided him with a more extensive clientele than possible in his native city. Rembrandt had trained as a history painter in Leiden, but in Amsterdam he immediately entered the lucrative market for portrait painting and soon became renowned for that genre.

ANATOMY LESSON OF DR. TULP In a painting he created shortly after he arrived in Amsterdam, Anatomy Lesson of Dr. Tulp (FIG. 20-12), Rembrandt deviated even further from the traditional staid group portrait than had Hals. Despite Hals's determination to enliven his portraits, he still evenly spread his subjects across the canvas. In contrast, Rembrandt chose to portray the members of the surgeons' guild (who commissioned this group portrait) clustered together on the painting's left side. In the foreground appears the corpse that Dr. Tulp, a noted physician, is in the act of dissecting. Rembrandt diagonally placed and foreshortened the corpse, activating the space by disrupting the strict horizontal, planar orientation found in traditional portraiture. He depicted each of the "students" specifically, and although they wear virtually identical attire, their poses and facial expressions suggest the varying degrees of intensity with which they watch Dr. Tulp's demonstration—or ignore it. One, at the apex of Rembrandt's triangular composition of bodies, looks out at the viewer instead of at the operating table. Another directs his attention at the open book (a manual of anatomy) at the corpse's feet. Rembrandt produced this painting when he was 26 and just beginning his career, a fact that makes his innovative approach to group portraiture all the more remarkable.

20-12 REMBRANDT VAN RIJN, Anatomy Lesson of Dr. Tulp, 1632. Oil on canvas, 5' $3\frac{3}{4}'' \times 7'$ $1\frac{1}{4}''$. Mauritshuis, The Hague.

In this early work, Rembrandt used an unusual composition, portraying members of Amsterdam's surgeons' guild clustered together on one side of the painting as they watch Dr. Tulp dissect a corpse.

l ft.

20-13 Rembrandt van Rijn, The Company of Captain Frans Banning Cocq (Night Watch), 1642. Oil on canvas, $11' 11'' \times 14' 4''$ (cropped from original size). Rijksmuseum, Amsterdam.

Rembrandt's dramatic use of light contributes to the animation of this militia group portrait in which the artist showed the company rushing about as they organize themselves for a parade.

NIGHT WATCH Rembrandt amplified the complexity and energy of the group portrait in *The Company of Captain Frans Banning Cocq* (FIG. **20-13**), better known as *Night Watch*. This more commonly used title is a misnomer, however—the painting is not of a nocturnal scene. Rembrandt used light in a masterful way, and dramatic lighting certainly enhances the image. Still, the painting's darkness (which

explains the commonly used title) is due more to the varnish the artist used, which darkened considerably over time, than to the subject depicted.

This painting was one of many civic-guard group portraits produced during this period. From the limited information available about the commission, it appears that the two officers, Captain Frans Banning Cocq and his lieutenant, Willem van Ruytenburch, along with 16 members of their militia, contributed to Rembrandt's fee. (Despite the prominence of the girl just to the left of center, scholars have yet to ascertain her identity.) Night Watch was one of six paintings by different artists that various groups commissioned around 1640 for the assembly and banquet room of Amsterdam's new Musketeers Hall, the largest and most prestigious interior space in the city. Unfortunately, in 1715, when city officials moved Rembrandt's painting to Amsterdam's town hall, they cropped it on all sides, leaving an incomplete record of the artist's final resolution of the challenge of portraying this group.

Even in its truncated form, *The Company of Captain Frans Banning Cocq* succeeds in capturing the excitement and frenetic activity of the men preparing for the parade. A comparison of this militia group portrait with Hals's *Archers of Saint Hadrian* (FIG. 20-9) reveals Rembrandt's inventiveness in enlivening what was, by then, becoming a conventional portrait format. Rather than present assembled men, posed in orderly fashion, the younger artist chose to portray the company scurrying about in the act of organizing themselves, thereby animating the image considerably. At the same time, he managed to record the three most important stages of using a musket—loading, firing, and readying the weapon for reloading—details that must have pleased his patrons.

RETURN OF THE PRODIGAL SON The Calvinist injunctions against religious art did not prevent Rembrandt from making a

series of religious paintings and prints. In the Dutch Republic, paintings depicting biblical themes were not objects of devotion, but they still brought great prestige, and Rembrandt and other artists vied to demonstrate their ability to narrate holy scripture in dramatic new ways. The Dutch images, however, are unlike the opulent, overwhelming art of Baroque Italy. Rather, Rembrandt's religious art is that of a committed Christian who desired to interpret biblical narratives in human (as opposed to lofty theological) terms. Rembrandt had a special interest in probing the states of the human soul. The spiritual stillness of his religious paintings is that of inward-turning contemplation, far from the choirs and trumpets and the heavenly tumult of Bernini (FIG. 19-1) or Pozzo (FIG. 19-24). The Dutch artist's psychological insight and his profound sympathy for human affliction produced, at the very end of his life, one of the most moving pictures in all religious art, Return of the Prodigal Son (FIG. 20-14). Tenderly embraced by his forgiving father, the son crouches before him in weeping contrition, while three figures, immersed to varying degrees in the soft shadows, note the lesson of mercy. The light, everywhere mingled with shadow, directs the viewer's attention by illuminating the father and son and largely veiling the witnesses. Its focus is the beautiful, spiritual face of the old man. Secondarily, the light touches the contrasting stern face of the foremost witness. The painting demonstrates the degree to which Rembrandt developed a personal style completely in tune with the simple eloquence of the biblical passage.

REMBRANDT'S LIGHT From the few paintings by Rembrandt discussed thus far, it should be clear that the artist's use of light is among the hallmarks of his style. Rembrandt's pictorial method involved refining light and shade into finer and finer nuances until they blended with one another. Earlier painters' use of abrupt lights and darks gave way to gradation in the work of artists

20-14 REMBRANDT VAN RIJN, Return of the Prodigal Son, ca. 1665. Oil on canvas, $8' 8'' \times 6' 9''$. Hermitage Museum, Saint Petersburg.

The spiritual stillness of Rembrandt's religious paintings is that of inward-turning contemplation, far from the choirs and trumpets and heavenly tumult of Italian Baroque Counter-Reformation works.

such as Rembrandt and Velázquez (see Chapter 19). Although these later artists may have sacrificed some of the dramatic effects of sharp chiaroscuro, a greater fidelity to actual appearances offset those sacrifices. This technique is closer to reality because the eyes perceive light and dark not as static but as always subtly changing.

In general, Renaissance artists represented forms and faces in a flat, neutral modeling light (even Leonardo's shading is of a standard kind). They represented the idea of light, rather than the real look of it. Artists such as Rembrandt discovered degrees of light and dark, degrees of differences in pose, in the movements of facial features, and in psychic states. They arrived at these differences optically, not conceptually or in terms of some ideal. Rembrandt found that by manipulating the direction, intensity, distance, and surface texture of light and shadow, he could render the most subtle nuances of character and mood, both in persons and in whole scenes. He discovered for the modern world that variation of light and shade, subtly modulated, can be read as emotional differences. In the visible world, light, dark, and the wide spectrum of values between the two are charged with meanings and feelings that sometimes are independent of the shapes and figures they modify. The theater and the photographic arts have used these discoveries to great dramatic effect.

REMBRANDT'S SELF-PORTRAITS Rembrandt carried over the spiritual quality of his religious works into his later portraits by the same means—what could be called the "psychology of

light." Light and dark are not in conflict in his portraits. They are reconciled, merging softly and subtly to produce the visual equivalent of quietness. Their prevailing mood is that of tranquil meditation, of philosophical resignation, of musing recollection—indeed, a whole cluster of emotional tones heard only in silence.

In a self-portrait (FIG. 20-15) produced late in Rembrandt's life, the light that shines from the upper left of the painting bathes the painter's face in soft highlights, leaving the lower part of his body in shadow. The artist depicted himself here as possessing dignity and strength, and the portrait serves as a summary of the many stylistic and professional concerns that occupied him throughout his career. Rembrandt's distinctive use of light is evident, as is the assertive brushwork that suggests a quiet confidence and self-assurance. He presented himself as a working artist holding his brushes, palette, and maulstick (compare FIG. 18-17) and wearing his studio garb—a smock and painter's turban. The circles on the wall behind him (the subject of much scholarly debate) may allude to a legendary sign of artistic virtuosity—the ability to draw a perfect circle freehand. Ultimately, Rembrandt's abiding interest in revealing the human soul emerged here in his careful focus on his expressive visage. His controlled use of light and the nonspecific setting contribute to this focus. Further, X-rays of the painting have revealed that Rembrandt originally depicted himself in the act of painting. His final resolution, with the viewer's attention drawn to his face, produced a portrait not just of the artist but of the man as well. Indeed, Rembrandt's nearly 70 self-portraits in various media have no parallel in sheer quantity. They reflect the artist's deeply personal connection to his craft.

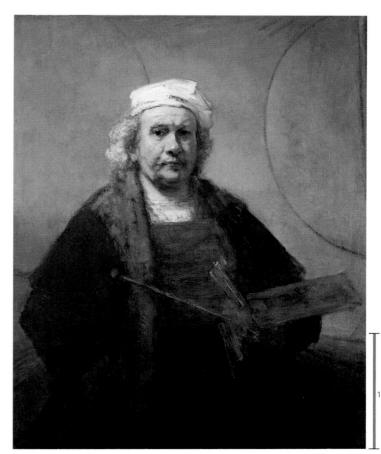

20-15 Rembrandt van Rijn, Self-Portrait, ca. 1659–1660. Oil on canvas, 3' $8\frac{3}{4}'' \times 3'$ 1". Kenwood House, London (Iveagh Bequest).

In this late self-portrait, Rembrandt's interest in revealing the human soul is evident in the attention given to his expressive face. The controlled use of light and the nonspecific setting contribute to this focus.

20-16 Rembrandt van Rijn, Christ with the Sick around Him, Receiving the Children (Hundred-Guilder Print), ca. 1649. Etching, $11'' \times 1' 3\frac{1}{4}''$. Pierpont Morgan Library, New York.

Rembrandt's mastery of the new printmaking medium of etching is evident in his expert use of light and dark to draw attention to Christ as he preaches compassionately to the blind and lame.

REMBRANDT'S ETCHINGS

Rembrandt's virtuosity also extended to the graphic media—in particular, to etching (see "Woodcuts, Engravings, and Etchings," Chapter 15, page 415). Many artists took up etching after its perfection early in the 17th century, because etching allowed greater freedom than engraving in drawing the design. For etching, the printmaker covers a copper plate with a layer of wax or var-

nish. The artist incises the design into this surface with a pointed tool, exposing the metal below but not cutting into its surface. The printer then immerses the plate in acid, which etches, or eats away, the exposed parts of the metal, acting the same as the burin in engraving. The medium's softness gives etchers greater carving freedom than woodcutters and engravers have working directly in their more resistant media of wood and metal. If Rembrandt had never painted, he still would be renowned, as he principally was in his lifetime, for his prints. Prints were a major source of income for Rembrandt, as they were for Albrecht Dürer (see Chapter 18), and he often reworked the plates so that they could be used to produce a new issue or edition. This constant reworking was unusual within the context of 17th-century printmaking practices.

HUNDRED-GUILDER PRINT One of Rembrandt's most celebrated etchings is Christ with the Sick around Him, Receiving the Children (FIG. 20-16). Indeed, the title by which this work has been known since the early 18th century, Hundred-Guilder Print, refers to the high price it brought during Rembrandt's lifetime. Christ with the Sick demonstrates the artist's mastery of all aspects of the printmaker's craft, for Rembrandt used both engraving and etching to depict the figures and the setting. As in his other religious works, Rembrandt suffused this print with a deep and abiding piety, presenting the viewer not the celestial triumph of the Catholic Church but the humanity and humility of Jesus. Christ appears in the center preaching compassionately to, and simultaneously blessing, the blind, the lame, and the young who are spread throughout the composition in a dazzling array of standing, kneeling, and lying positions. Also present is a young man in elegant garments with his head in his hand, lamenting Christ's insistence that the wealthy need to give their possessions to the poor in order to gain entrance to Heaven. The tonal range of the print is remarkable. At the right, the figures near the city gate are in deep shadow. At the left, the figures, some rendered almost exclusively in outline, are in bright light—not the light of day but the illumination radiating from Christ himself. A second, unseen source of light comes from the right and casts the shadow of the praying man's arms and head onto Christ's tunic. Technically and in terms of its humanity, the Hundred-Guilder *Print* is Rembrandt's supreme achievement as a printmaker.

Landscape and Interior Painting

Landscape scenes abound in 17th-century Dutch art. Due to topography and politics, the Dutch had a unique relationship to the terrain, one that differed from those of other European countries. After gaining independence from Spain, the Dutch undertook an extensive land reclamation project that lasted almost a century. Dikes and drainage systems cropped up across the countryside. Because of the effort expended on these endeavors, people developed a very direct relationship to the land. Further, the reclamation affected Dutch social and economic life. The marshy and swampy nature of much of the land made it less desirable for large-scale exploitation, so the extensive feudal landowning system that existed elsewhere in Europe never developed in the United Provinces. Most Dutch families owned and worked their own farms, cultivating a feeling of closeness to the terrain.

AELBERT CUYP One Dutch artist who established his reputation as a specialist in landscape painting was AELBERT CUYP (ca. 1620–1691). His works were the products of careful observation and a deep respect for and understanding of the Dutch terrain. *Distant View of Dordrecht, with a Milkmaid and Four Cows, and Other Figures* (FIG. 20-17) reveals Cuyp's substantial skills. Unlike the idealized classical landscapes that appear in many Italian Renaissance paintings, this landscape is particularized. In fact, the church in the background can be identified as the Grote Kerk in Dordrecht. The dairy cows, shepherds, and milkmaid in the foreground refer to a cornerstone of Dutch agriculture—the demand for dairy products such as butter and cheese, which increased with the development of urban centers. The credibility of this and similar paintings rests on Cuyp's pristine rendering of each detail.

JACOB VAN RUISDAEL Depicting the Dutch landscape with precision and sensitivity was also a specialty of JACOB VAN RUISDAEL (ca. 1628–1682). In *View of Haarlem from the Dunes at Overveen* (FIG. 20-18), van Ruisdael provided an overarching view of this major Dutch city. The specificity of the artist's image—the Saint Bavo church in the background, the numerous windmills that refer to the land reclamation efforts, and the figures in the foreground stretching linen

20-17 Aelbert Cuyp, Distant View of Dordrecht, with a Milkmaid and Four Cows, and Other Figures, late 1640s. Oil on canvas, 5' $1'' \times 6'$ $4\frac{7}{8}''$. National Gallery, London.

Unlike idealized Italian Renaissance classical landscapes, Cuyp's painting portrays a particular locale. The cows, shepherds, and milkmaid refer to the Dutch Republic's important dairy industry.

1 f

20-18 Jacob van Ruisdael, View of Haarlem from the Dunes at Overveen, ca. 1670. Oil on canvas, $1' 10'' \times 2' 1''$. Mauritshuis, The Hague.

In this painting, van Ruisdael succeeded in capturing a specific view of Haarlem, its windmills, and Saint Bavo church, but he also imbued the landscape with a quiet serenity that approaches the spiritual.

1 in.

20-19 JAN VERMEER, The Letter, 1666. Oil on canvas, 1' $5\frac{1}{4}$ " \times 1' $3\frac{1}{4}$ ". Rijksmuseum, Amsterdam.

Vermeer used both mirrors and the camera obscura to depict opulent 17th-century Dutch domestic interiors so convincingly. He was also far ahead of his time in understanding the science of color.

to be bleached (a major industry in Haarlem)—reflects the pride Dutch painters took in recording their homeland and the activities of their fellow citizens. Nonetheless, in this painting the inhabitants and dwellings are so minuscule that they blend into the land itself, unlike the figures in Cuvp's view of Dordrecht (FIG. 20-17). Further, the horizon line is low, so the sky fills almost three-quarters of the picture space, and the sun illuminates the landscape only in patches, where it has broken through the clouds above. In View of Haarlem, as in his other landscape paintings, van Ruisdael not only captured the appearance of a specific locale but also succeeded in imbuing the work with a quiet serenity that becomes almost spiritual.

JAN VERMEER The sense of peace, familiarity, and comfort that Dutch land-scape paintings exude also emerges in in-

terior scenes, another popular subject among middle-class patrons. These paintings offer the viewer glimpses into the lives of prosperous, responsible, and cultured citizens of the United Provinces. The foremost Dutch painter of interior scenes was JAN VERMEER (1632–1675) of Delft. Vermeer derived much of his income from his work as an innkeeper and art dealer (see "Middle-Class Patronage and the Art Market," page 558), and he painted no more than 35 paintings that can be definitively attributed to him. He began his career as a painter of biblical and historical themes but soon abandoned those traditional subjects in favor of domestic scenes. Flemish artists of the 15th century also had painted domestic interiors, but persons of sacred significance often occupied those scenes (FIG. 15-4). In contrast, Vermeer and his contemporaries composed neat, quietly opulent interiors of Dutch middle-class dwellings with men, women, and children engaging in household tasks or some little recreation. Women are the primary occupants of Vermeer's homes, and his paintings are highly idealized depictions of the social values of Dutch burghers.

THE LETTER A room of a well-appointed Dutch house is the scene of Vermeer's *The Letter* (FIG. **20-19**). The drawn curtain and open doorway through which viewers must peer reinforce their status as outsiders getting a glimpse of a private scene. The painting features two women. One wears elegant attire, suggesting that she is

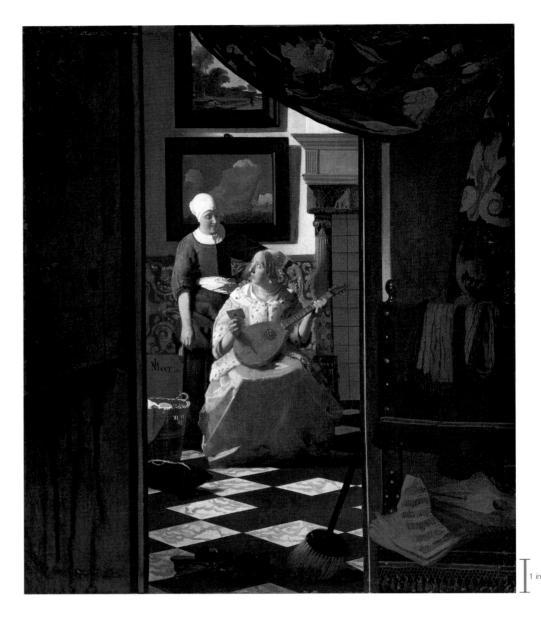

a woman of considerable means. A maid interrupts her lute playing to deliver a letter. The 17th-century Dutch audience would immediately recognize that it is a love letter, because the lute was a traditional symbol of the music of love, and the painting of a ship on a calm (as opposed to rough) sea on the back wall was a symbol of love requited. In Jan Harmensz Krul's book *Love Emblems*, published in Amsterdam in 1634, the author wrote, "Love may rightly be com-

pared to the sea, considering its changeableness . . . just so does it go with a lover as with a skipper embarking on the sea, one day good weather another day storm and howling wind "2

weather, another day storm and howling wind."2

Vermeer was a master of pictorial light and used it with immense virtuosity. He could render space so convincingly through his depiction of light that in his works, the picture surface functions as an invisible glass pane through which the viewer looks into the constructed illusion. Historians are confident that Vermeer used as tools both mirrors and the *camera obscura*, an ancestor of the modern camera based on passing light through a tiny pinhole or lens to project an image on a screen or the wall of a room. (In later versions, artists projected the image on a ground-glass wall of a box whose opposite wall contained the pinhole or lens.) This does not mean that Vermeer merely copied the image. Instead, these aids helped him obtain results he reworked compositionally, placing his figures and the furniture of a room in a beautiful stability of quadrilateral shapes. His designs have a matchless classical serenity. Enhancing

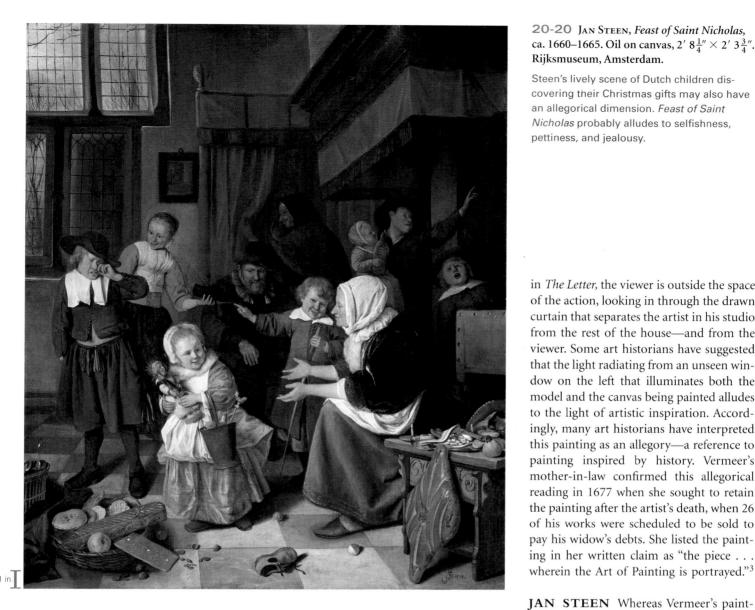

20-20 JAN STEEN, Feast of Saint Nicholas, ca. 1660–1665. Oil on canvas, 2' $8\frac{1}{4}$ " \times 2' $3\frac{3}{4}$ ". Rijksmuseum, Amsterdam.

Steen's lively scene of Dutch children discovering their Christmas gifts may also have an allegorical dimension. Feast of Saint Nicholas probably alludes to selfishness, pettiness, and jealousy.

in *The Letter*, the viewer is outside the space of the action, looking in through the drawn curtain that separates the artist in his studio from the rest of the house—and from the viewer. Some art historians have suggested that the light radiating from an unseen window on the left that illuminates both the model and the canvas being painted alludes to the light of artistic inspiration. Accordingly, many art historians have interpreted this painting as an allegory—a reference to painting inspired by history. Vermeer's mother-in-law confirmed this allegorical reading in 1677 when she sought to retain the painting after the artist's death, when 26 of his works were scheduled to be sold to pay his widow's debts. She listed the painting in her written claim as "the piece . . . wherein the Art of Painting is portrayed."3

ings reveal the charm and beauty of Dutch

domesticity, the works of Jan Steen (ca. 1625-1679) provide a counterpoint. In Feast of Saint Nicholas (FIG. 20-20), Steen rejected painting a tidy, calm Dutch household and opted instead for a scene of chaos and disruption. Saint Nicholas has just visited this residence, and the children are in an uproar as they search their shoes

for the Christmas gifts he has left. Some children are delighted. The little girl in the center clutches her gifts, clearly unwilling to share with the other children despite her mother's pleas. Others are disappointed. The boy on the left is in tears because he has received only a birch rod. An appropriately festive atmosphere reigns, which contrasts sharply with the decorum that prevails in Vermeer's works. Like the paintings of other Dutch artists, Steen's lively scenes often take on an allegorical dimension and moralistic tone. Steen fre-

adult behavior, and Feast of Saint Nicholas is not his only allusion to selfishness, pettiness, and jealousy.

Still-Life Painting

quently used children's activities as satirical comments on foolish

The prosperous Dutch were justifiably proud of their accomplishments, and the popularity of still-life paintings—particularly images of accumulated goods—reflected this pride. These still lifes, like Vermeer's interior scenes, are beautifully crafted images that are both scientific in their optical accuracy and poetic in their beauty and lyricism.

this quality are colors so true to the optical facts and so subtly modulated that they suggest Vermeer was far ahead of his time in color science. Close examination of his paintings shows that Vermeer realized shadows are not colorless and dark, that adjoining colors affect each other, and that light is composed of colors. Thus, he painted reflections off of surfaces in colors modified by others nearby. Some experts have suggested that Vermeer also perceived the phenomenon modern photographers call "circles of confusion," which appear on out-of-focus negatives. Vermeer could have seen them in images projected by the camera obscura's primitive lenses. He approximated these effects with light dabs that, in close view, give the impression of an image slightly "out of focus." When the observer draws back a step, however, as if adjusting the lens, the color spots cohere, giving an astonishingly accurate illusion of a third dimension.

THE ART OF PAINTING Vermeer's stylistic precision and commitment to his profession surface in Allegory of the Art of Painting (FIG. 20-1). The artist himself appears in the painting, with his back to the viewer and dressed in "historical" clothing (reminiscent of Burgundian attire). He is hard at work on a painting of the model who stands before him wearing a laurel wreath and holding a trumpet and book, traditional attributes of Clio, the muse of history. The map of the provinces (an increasingly common adornment in Dutch homes) on the back wall serves as yet another reference to history. As

20-21 PIETER CLAESZ, Vanitas Still Life, 1630s. Oil on panel, 1' 2" \times 1' $11\frac{1}{2}$ ". Germanisches Nationalmuseum, Nuremberg.

Vanitas still lifes reflect the pride Dutch citizens had in their material possessions, but Calvinist morality and humanity tempered that pride. The skull and timepiece remind the viewer of life's transience.

1 in

PIETER CLAESZ Many Dutch still-life paintings, such as Vanitas Still Life (FIG. 20-21) by PIETER CLAESZ (1597/98-1660), celebrate material possessions, here presented as if strewn across a tabletop or dresser. The ever-present morality and humility central to the Calvinist faith tempered Dutch pride in worldly goods, however. Thus, while Claesz fostered the appreciation and enjoyment of the beauty and value of the objects he depicted, he also reminded the viewer of life's transience by incorporating references to death. Paintings with such features are called vanitas (vanity) paintings. Each feature is referred to as a memento mori (reminder of death). In Vanitas Still Life, references to mortality include the skull, timepiece, tipped glass, and cracked walnut. All suggest the passage of time or a presence that has disappeared. Something or someone was here—and now is gone. Claesz emphasized this element of time (and demonstrated his technical virtuosity) by including a self-portrait, reflected in the glass ball on the left side of the table. He appears to be painting this still life. But in an apparent challenge to the message of inevitable mortality that vanitas paintings convey, the portrait serves to immortalize the subject—in this case, the artist himself.

WILLEM KALF As Dutch prosperity increased, precious objects and luxury items made their way into still-life paintings. Still Life with a Late Ming Ginger Jar (FIG. 20-22) by WILLEM KALF (1619–1693) reveals both the wealth Dutch citizens had accrued and the painter's exquisite skills, both technical and aesthetic. Kalf highlighted the breadth of Dutch maritime trade through his depiction of the Indian floral carpet and the Chinese jar used to store ginger (a luxury item). He delighted in recording the lustrous sheen of fabric and the light glinting off reflective surfaces. As is evident in this image, Kalf's works present an array of ornamental objects, such as the Venetian

20-22 WILLEM KALF, Still Life with a Late Ming Ginger Jar, 1669. Oil on canvas, 2' $6'' \times 2'$ $1\frac{3}{4}''$. Indianapolis Museum of Art, Indianapolis (gift in commemoration of the 60th anniversary of the Art Association of Indianapolis, in memory of Daniel W. and Elizabeth C. Marmon).

The opulent objects, especially the Indian carpet and Chinese jar, attest to the prosperous Dutch maritime trade. Kalf's inclusion of a watch suggests that this painting may also be a vanitas still life.

and Dutch glassware and the silver dish. The inclusion of the watch, Mediterranean peach, and peeled lemon suggests that this work is also a vanitas painting.

RACHEL RUYSCH As living objects that soon die, flowers, particularly cut blossoms, appeared frequently in vanitas paintings. However, floral painting as a distinct genre also flourished in the Dutch Republic. Among the leading practitioners of this art was RACHEL RUYSCH (1663–1750). Ruysch's father was a professor of botany and anatomy, which may account for her interest in and knowledge of plants and insects. She acquired an international reputation for lush paintings such as *Flower Still Life* (FIG. 20-23). In this image, the

11

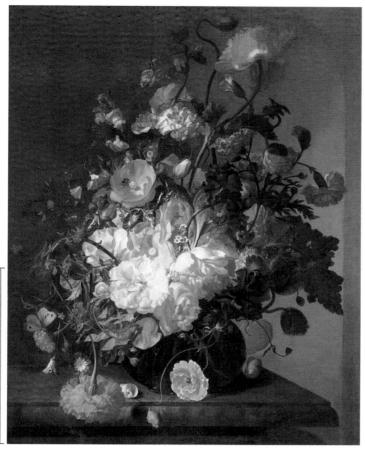

20-23 RACHEL RUYSCH, *Flower Still Life*, after 1700. Oil on canvas, $2' \, 5\frac{3}{4}'' \times 1' \, 11\frac{7}{8}''$. Toledo Museum of Art, Toledo (purchased with funds from the Libbey Endowment, gift of Edward Drummond Libbey).

Flower paintings were very popular in the Dutch Republic. Rachel Ruysch achieved international renown for her lush paintings of floral arrangements, noted also for their careful compositions.

lavish floral arrangement is so full that many of the blossoms seem to be spilling out of the vase. Ruysch carefully constructed her paintings. Here, for example, she positioned the flowers to create a diagonal that runs from the lower left of the painting to the upper right corner and that offsets the opposing diagonal of the table edge. Ruysch became famous for her floral paintings and still lifes, and from 1708 to 1716 she served as court painter to the elector Palatine (the ruler of the Palatinate, a former division of Bayaria) in Düsseldorf, Germany.

FRANCE

In France, monarchical authority had been increasing for centuries, culminating in the reign of Louis XIV (r. 1661–1715), who sought to determine the direction of French society and culture. Although its economy was not as expansive as that of the Dutch Republic, France became Europe's largest and most powerful country in the 17th century. Against this backdrop, the arts flourished.

Painting and Graphic Art

NICOLAS POUSSIN Rome's ancient and Renaissance monuments enticed many French artists to study there. Normandy-born NICOLAS POUSSIN (1594–1665), for example, spent most of his life in Rome, where he produced grandly severe paintings modeled on those of Titian and Raphael. He also carefully worked out a theoretical explanation of his method and was ultimately responsible for establishing classical painting as an important ingredient of 17th-century French art (see "Poussin's Notes for a Treatise on Painting," page 570). His classical style presents a striking contrast to the contemporaneous Baroque style of his Italian counterparts in Rome (see Chapter 19), underscoring the multifaceted character of the art of 17th-century Europe.

ET IN ARCADIA EGO Poussin's Et in Arcadia Ego (I, Too, in Arcadia, or Even in Arcadia, I [am present]; FIG. 20-24) draws on the rational order and stability of Raphael's paintings and on antique

20-24 NICOLAS POUSSIN, Et in Arcadia Ego, ca. 1655. Oil on canvas, $2' 10'' \times 4'$. Louvre, Paris.

Poussin was the leading proponent of classicism in 17th-century Rome. His works incorporate the rational order and stability of Raphael's compositions as well as figures inspired by ancient statuary.

1 ft

Poussin's Notes for a Treatise on Painting

s the leading exponent of classical painting in 17th-century Rome, Nicolas Poussin (FIGS. 20-24 and 20-25) outlined the principles of classicism in notes for an intended treatise on painting, left incomplete at his death. In those notes, Poussin described the essential ingredients necessary to produce a beautiful painting in "the grand manner":

The grand manner consists of four things: subject-matter or theme, thought, structure, and style. The first thing that, as the foundation of all others, is required, is that the subject-matter shall be grand, as are battles, heroic actions, and divine things. But assuming that the subject on which the painter is laboring is grand, his next consideration is to keep away from minutiae . . . [and paint only] things magnificent and grand Those who elect mean subjects take refuge in them because of the weakness of their talents.*

The idea of beauty does not descend into matter unless [a painting] is prepared as carefully as possible. This preparation consists of three things: arrangement, measure, and aspect or form. Arrangement means the relative position of the parts; measure refers to their size; and form consists of lines and colors. Arrangement and relative position of the parts and making every limb of the body hold its natural place are not sufficient unless measure is added, which gives to each limb its correct size, proportionate to that of the whole body [compare "Polykleitos's Prescription for the Perfect Statue," Chapter 5, page 110], and unless form joins in, so that the lines will be drawn with grace and with a harmonious juxtaposition of light and shadow.

 * Translated by Robert Goldwater and Marco Treves, eds., Artists on Art, 3d ed. (New York: Pantheon Books, 1958), 155.

† Ibid., 156.

20-25 NICOLAS POUSSIN, Burial of Phocion, 1648. Oil on canvas, $3' 11'' \times 5' 10''$. Louvre, Paris.

Poussin's landscapes do not represent a particular place and time but are idealized settings for noble themes, like this one based on Plutarch's biography of the Athenian general Phocion.

statuary. Landscape, of which Poussin became increasingly fond, provides the setting for the picture. Dominating the foreground, however, are three shepherds, living in the idyllic land of Arcadia, who study an inscription on a tomb as a statuesque female figure quietly places her hand on the shoulder of one of them. She may be the spirit of death, reminding these mortals, as does the inscription, that death is found even in Arcadia, supposedly a spot of paradisiacal bliss. The countless draped female statues surviving in Italy from Roman times supplied the models for this figure, and the posture of the youth with one foot resting on a boulder derives from Greco-Roman statues of Neptune, the sea god, leaning on his trident. The classically compact and balanced grouping of the figures, the even light, and the thoughtful and reserved mood complement Poussin's classical figure types.

BURIAL OF PHOCION Among Poussin's finest works is Burial of Phocion (FIG. 20-25), a subject the artist characteristically chose from the literature of antiquity. Poussin's source was Plutarch's Life of Phocion, a biography of the distinguished Athenian general whom his compatriots unjustly put to death for treason. Eventually, the state gave Phocion a public funeral and memorialized him. In the foreground of Poussin's painting, the hero's body is being taken away, his burial on Athenian soil initially forbidden. The two massive bearers and the bier are starkly isolated in a great landscape that throws them into solitary relief, eloquently expressive of the hero abandoned in death. The landscape's interlocking planes slope upward to the lighted sky at the left. Its carefully arranged terraces bear slowly moving streams, shepherds and their flocks, and, in the dis-

20-26 CLAUDE LORRAIN, Landscape with Cattle and Peasants, 1629. Oil on canvas, 3' $6'' \times 4'$ $10\frac{1}{2}''$. Philadelphia Museum of Art, Philadelphia (George W. Elkins Collection).

Claude used atmospheric and linear perspective to transform the rustic Roman countryside filled with peasants and animals into an idealized classical landscape bathed in sunlight in infinite space.

tance, whole assemblies of solid geometric structures (temples, towers, walls, villas, and a central grand sarcophagus). The skies are untroubled, and the light is even and revealing of form. The trees are few and carefully arranged, like curtains lightly drawn back to reveal a natural setting carefully cultivated for a single human action. Unlike van Ruisdael in *View of Haarlem* (FIG. 20-18), Poussin did not intend this scene to represent a particular place and time. It was the French artist's construction of an idea of a noble landscape to frame a noble theme, much like Annibale Carracci's classical landscape (FIG. 19-15). The *Phocion* landscape is nature subordinated to a rational plan.

CLAUDE LORRAIN Claude Gellée, called CLAUDE LORRAIN (1600–1682) after his birthplace in the duchy of Lorraine, which was technically independent from the French monarchy during this period, rivaled Poussin in fame. Claude modulated in a softer style the disciplined rational art of Poussin, with its sophisticated revelation of the geometry of landscape. Unlike the figures in Poussin's pictures, those in Claude's landscapes tell no dramatic story, point out no moral, and praise no hero. Indeed, they often appear to be added as mere excuses for the radiant landscape itself. For Claude, painting

involved essentially one theme—the beauty of a broad sky suffused with the golden light of dawn or sunset glowing through a hazy atmosphere and reflecting brilliantly off rippling water.

In Landscape with Cattle and Peasants (FIG. 20-26), the figures in the right foreground chat in animated fashion. In the left foreground, cattle relax contentedly. In the middle ground, cattle amble slowly away. The well-defined foreground, distinct middle ground, and dim background recede in serene orderliness, until all form dissolves in a luminous mist. Atmospheric and linear perspective reinforce each other to turn a vista into a typical Claudian vision, an ideal classical world bathed in sunlight in infinite space (compare FIG. I-11).

Claude's formalizing of nature with balanced groups of architectural masses, screens of trees, and sheets of water followed the great tradition of classical landscape. It began with the backgrounds of Venetian painting (FIGS. 17-34 and 17-35) and continued in the art of Annibale Carracci (FIG. 19-15) and Poussin (FIG. 20-25). Yet Claude, like the Dutch painters, studied the light and the atmospheric nuances of nature, making a unique contribution. He recorded carefully in hundreds of sketches the look of the Roman countryside, its gentle terrain accented by stone-pines, cypresses, and poplars and by the ever-present ruins of ancient aqueducts,

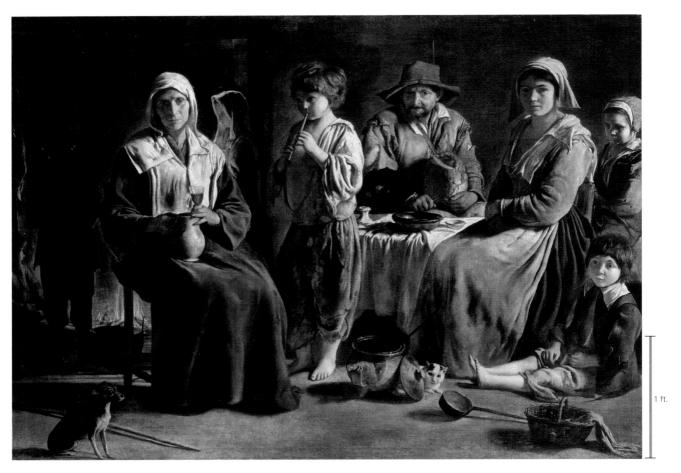

20-27 Louis Le Nain, Family of Country People, ca. 1640. Oil on canvas, 3' 8" × 5' 2". Louvre, Paris.

Le Nain's painting expresses the grave dignity of a peasant family made stoic by hardship. It reflects 17th-century French social theory, which celebrated the natural virtue of those who worked the soil.

tombs, and towers. He made these the fundamental elements of his compositions. Travelers could understand the picturesque beauties of the outskirts of Rome in Claude's landscapes.

The artist achieved his marvelous effects of light by painstakingly placing tiny value gradations, which imitated, though on a very small scale, the range of values of outdoor light and shade. Avoiding the problem of high-noon sunlight overhead, Claude preferred, and convincingly represented, the sun's rays as they gradually illuminated the morning sky or, with their dying glow, set the pensive mood of evening. Thus, he matched the moods of nature with those of human subjects. Claude's infusion of nature with human feeling and his recomposition of nature in a calm equilibrium greatly appealed to the landscape painters of the 18th and early 19th centuries.

LOUIS LE NAIN Although classicism was an important presence in French art during the 17th and early 18th centuries, not all artists pursued this direction. Louis Le Nain (ca. 1593–1648) bears comparison to the Dutch. Subjects that in Dutch painting were opportunities for boisterous good humor, the French treated with somber stillness. *Family of Country People* (Fig. 20-27) reflects the thinking of 17th-century French social theorists who celebrated the natural virtue of peasants who worked the soil. Le Nain's painting expresses the grave dignity of one peasant family made stoic and resigned by hardship. These drab country folk surely had little reason for merriment. The peasant's lot, never easy, was miserable during the Thirty Years' War. The anguish and frustration of the peasantry, suffering from the cruel depredations of unruly armies living off the

countryside, often broke out in violent revolts that the same armies savagely suppressed. This family, however, is pious, docile, and calm. Because Le Nain depicted peasants as dignified and subservient despite their harsh living conditions, some scholars have suggested he intended to please wealthy urban patrons with these paintings.

JACQUES CALLOT Two other prominent artists from Lorraine were Jacques Callot and Georges de La Tour. Jacques Callot (ca. 1592–1635) conveyed a sense of military life during these troubled times in a series of etchings called *Miseries of War*. Callot confined himself almost exclusively to the art of etching and was widely influential in his own time and since. (Rembrandt was among those who knew and learned from his work.) Callot perfected the medium and the technique of etching, developing a very hard surface for the copper plate to permit fine and precise delineation with the needle. His quick, vivid touch and faultless drawing produced panoramas sparkling with sharp details of life—and death. In the *Miseries of War* series, he observed these details coolly, presenting without comment images based on events he himself must have seen in the wars in Lorraine.

In *Hanging Tree* (FIG. **20-28**), Callot depicted a mass execution of thieves (identified in the text at the bottom of the etching). The event takes place in the presence of a disciplined army, drawn up on parade with banners, muskets, and lances, their tents in the background. Hanged men sway in clusters from the branches of a huge cross-shaped tree. A monk climbs a ladder, holding up a crucifix to a man while the executioner adjusts the noose around the man's neck. At the foot of the ladder, another victim kneels to receive absolution.

20-28 JACQUES CALLOT, Hanging Tree, from the Miseries of War series, 1629–1633. Etching, $3\frac{3}{4}'' \times 7\frac{1}{4}''$. Private collection.

Callot's *Miseries of War* etchings were among the first realistic pictorial records of the human disaster of military conflict. *Hanging Tree* depicts a mass execution of thieves in the presence of an army.

Under the crucifix tree, men roll dice on a drumhead for the belongings of the executed. (This may be an allusion to the soldiers who cast lots for the garments of the crucified Christ.) In the right foreground, a hooded priest consoles a bound man. Callot's *Miseries of War* etchings are among the first realistic pictorial records of the human disaster of armed conflict.

GEORGES DE LA TOUR France, unlike Flanders and the Dutch Republic, was a Catholic country, and religious themes, al-

though not as common as in Italian Baroque art, occupied some 17th-century French painters. Among the artists well known for their religious imagery was Georges de La Tour (1593–1652). His work, particularly his use of light, suggests a familiarity with Caravaggio's art. La Tour may have learned about Caravaggio from the Dutch school of Utrecht. Although La Tour used the devices of Caravaggio's northern followers, his effects are strikingly different from theirs. His *Adoration of the Shepherds* (FIG. 20-29) makes use of the night setting favored by that school, much as van Honthorst

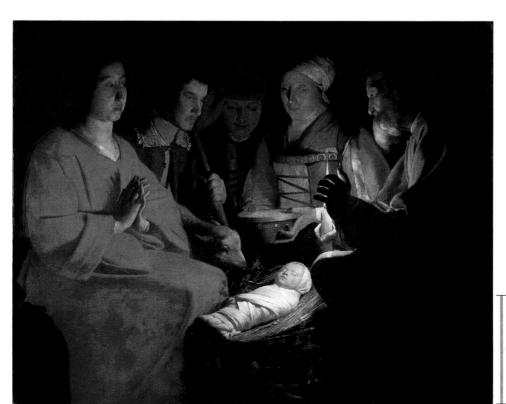

20-29 Georges de La Tour, *Adoration of the Shepherds*, 1645–1650. Oil on canvas, 3' $6'' \times 4'$ 6''. Louvre, Paris.

Without the aid of the title, Georges de la Tour's painting could be a genre piece instead of a biblical narrative. The French painter did not even paint halos around the heads of the holy figures.

1 ft.

20-30 Hyacinthe Rigaud, *Louis XIV*, 1701. Oil on canvas, 9' $2'' \times 6'$ 3". Louvre, Paris.

In this portrait set against a stately backdrop, Rigaud portrayed the 5' 4" Sun King wearing red high-heeled shoes and with his erminelined coronation robes thrown over his left shoulder.

portrayed it (FIG. 20-8). But here, the light, its source shaded by an old man's hand, falls upon a very different company in a very different mood. A group of humble men and women, coarsely clad, gather in prayerful vigil around a luminous baby Jesus. Without the aid of the title, this might be construed as a genre piece, a narrative of some event from peasant life. Nothing in the environment, placement, poses, dress, or attributes of the figures distinguishes them as the scriptural Virgin Mary, Joseph, Christ Child, or shepherds. The artist did not even paint halos. The light is not spiritual but material: It comes from a candle. La Tour's scientific scrutiny of the effects of light, as it throws precise shad-

ows on surfaces that intercept it, nevertheless had religious intention and consequence. The light illuminates a group of ordinary people held in a mystic trance induced by their witnessing the miracle of the Incarnation. In this timeless tableau of simple people, La Tour eliminated the dogmatic significance and traditional iconography of the Incarnation. Still, these people reverently contemplate something they regard as holy. The devout of any religious persuasion can read this painting, regardless of their familiarity with the New Testament.

The supernatural calm that pervades *Adoration of the Shepherds* is characteristic of the mood of Georges de La Tour's art. He achieved this tone by eliminating motion and emotive gesture (only the light is dramatic), by suppressing surface detail, and by simplifying body volumes. These stylistic traits are among those associated with classical and Renaissance art. Thus, several apparently contradictory elements meet in the work of La Tour: classical composure, fervent spirituality, and genre realism.

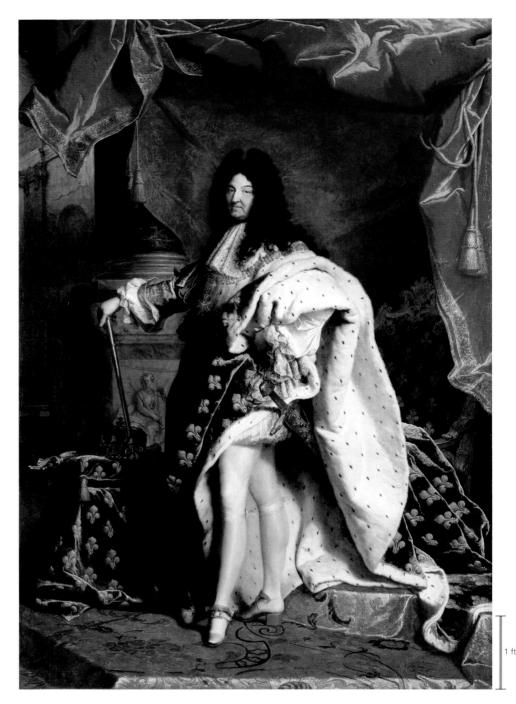

LOUIS XIV The preeminent French art patron of the 17th century was King Louis XIV. Determined to consolidate and expand his power, Louis was a master of political strategy and propaganda. He established a carefully crafted and nuanced relationship with the nobility, granting them sufficient benefits to keep them pacified but simultaneously maintaining rigorous control to avoid insurrection or rebellion. He also ensured subservience by anchoring his rule in divine right (a belief in a king's absolute power as God's will), rendering Louis's authority incontestable. So convinced was Louis of his importance and centrality to the French kingdom that he eagerly adopted the title "le Roi Soleil" ("the Sun King"). Like the sun, Louis XIV was the center of the universe.

Louis's desire for control extended to all realms of French life, including art. The king and his principal adviser, Jean-Baptiste Colbert (1619–1683), strove to organize art and architecture in the service of the state. They understood well the power of art as propa-

ganda and the value of visual imagery for cultivating a public persona, and they spared no pains to raise great symbols and monuments to the king's absolute power. Louis and Colbert sought to regularize taste and establish the classical style as the preferred French manner. The founding of the Royal Academy of Painting and Sculpture in 1648 served to advance this goal.

Louis XIV maintained a workshop of artists, each with a specialization—faces, fabric, architecture, landscapes, armor, or fur. Thus, many of the king's portraits were a group effort, but the finest is the work of one artist. The portrait of Louis XIV (FIG. 20-30) by HYACINTHE RIGAUD (1659–1743) successfully conveys the image of an absolute monarch. The king, age 63 when Rigaud painted this work, looks out at the viewer with directness. He stands with his left hand on his hip and with his elegant ermine-lined fleur-de-lis coronation robes (compare FIG. 20-3) thrown over his shoulder, suggesting an air of haughtiness. Louis also draws his garment back to expose his legs. (The king was a ballet dancer in his youth and was proud of his well-toned legs.) The portrait's majesty derives in large part from the composition. The Sun King is the unmistakable focal point of the image, and Rigaud placed him so that he seems to look down on the viewer. Given that Louis XIV was very short in stature—only five feet, four inches, a fact that drove him to invent the red-heeled shoes he wears in the portrait—the artist apparently catered to his patron's wishes. The carefully detailed environment in which the king stands also contributes to the painting's stateliness and grandiosity. Indeed,

when the king was not present, Rigaud's portrait, which hung over the throne, served in his place, and courtiers were not permitted to turn their backs on the painting.

Architecture and Sculpture

THE LOUVRE The first great architectural project Louis XIV and his adviser Colbert undertook was the closing of the east side of the Louvre's Cour Carré (FIG. 18-12), left incomplete by Pierre Lescot in the 16th century. The king summoned Gianlorenzo Bernini, as the most renowned architect of his day, from Rome to submit plans, but Bernini envisioned an Italian palace on a monumental scale that would have involved the demolition of all previous work. His plan rejected, Bernini indignantly returned to Rome. Louis then turned to three French architects—Claude Perrault (1613–1688), Louis Le Vau (1612-1670), and Charles Le Brun (1619-1690)—for the Louvre's east facade (FIG. 20-31). The design is a brilliant synthesis of French and Italian classical elements, culminating in a new and definitive formula. The facade has a central and two corner projecting columnar pavilions. The central pavilion is in the form of a classical temple front. To either side is a giant colonnade of paired columns, resembling the columned flanks of a temple folded out like wings. The whole rests on a stately podium. The designers favored an even roofline, balustraded and broken only by the central pediment, over the traditional French pyramidal roof of the Louvre's west wing

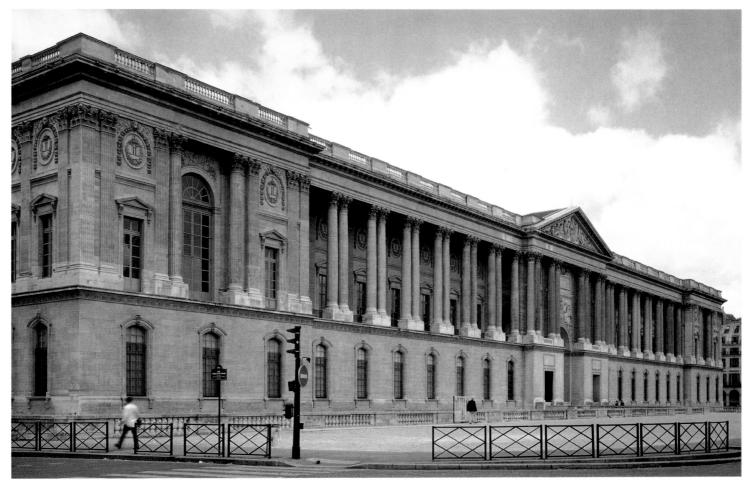

20-31 Claude Perrault, Louis Le Vau, and Charles Le Brun, east facade of the Louvre, Paris, France, 1667–1670.

The design of the Louvre's east facade is a brilliant synthesis of French and Italian classical elements, including a central pavilion that resembles an ancient temple front with a pediment.

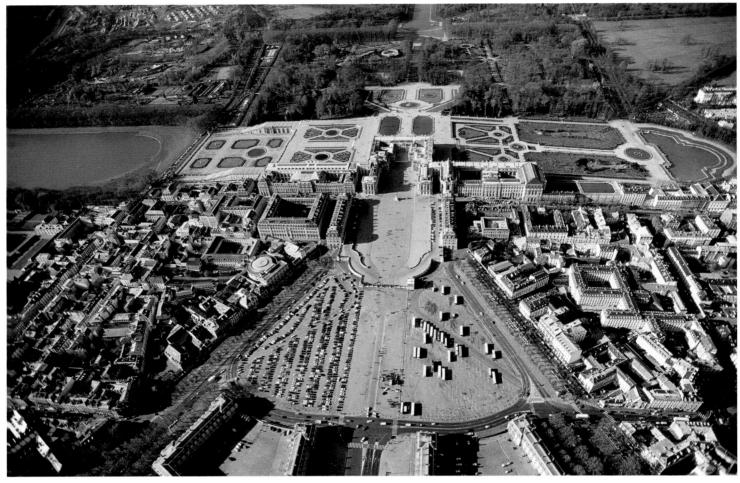

20-32 Aerial view (looking west) of the palace and gardens, Versailles, France, begun 1669.

Louis XIV ordered his architects to convert a royal hunting lodge at Versailles into a gigantic palace and park with a satellite city whose three radial avenues intersect in the king's bedroom.

(FIG. 18-12). The emphatically horizontal sweep of the 17th-century facade brushed aside all memory of Gothic verticality. Its stately proportions and monumentality were both an expression of the new official French taste and a symbol of centrally organized authority.

VERSAILLES PALACE Work on the Louvre had barely begun when Louis XIV decided to convert a royal hunting lodge at Versailles, a few miles outside Paris, into a great palace. He assembled a veritable army of architects, decorators, sculptors, painters, and landscape architects under the general management of Charles Le Brun. In their hands, the conversion of a simple lodge into the palace of Versailles (FIG. **20-32**) became the greatest architectural project of the age—a defining statement of French Baroque style and an undeniable symbol of Louis XIV's power and ambition.

Planned on a gigantic scale, the project called not only for a large palace flanking a vast park but also for the construction of a satellite city to house court and government officials, military and guard detachments, courtiers, and servants (undoubtedly to keep them all under the king's close supervision). Le Brun laid out this town to the east of the palace along three radial avenues that converge on the palace structure. Their axes, in a symbolic assertion of the ruler's absolute power over his domains, intersected in the king's spacious bedroom, which served as an official audience chamber. The palace itself, more than a quarter mile long, is perpendicular to the dominant eastwest axis that runs through the associated city and park.

Every detail of the extremely rich decoration of the palace's interior received careful attention. The architects and decorators designed

everything from wall paintings to doorknobs in order to reinforce the splendor of Versailles and to exhibit the very finest sense of artisanship. Of the literally hundreds of rooms within the palace, the most famous is the Galerie des Glaces, or Hall of Mirrors (FIG. 20-33), designed by JULES HARDOUIN-MANSART (1646–1708) and Le Brun. This hall overlooks the park from the second floor and extends along most of the width of the central block. Although deprived of its original sumptuous furniture, which included gold and silver chairs and bejeweled trees, the Galerie des Glaces retains much of its splendor today. Hundreds of mirrors, set into the wall opposite the windows, alleviate the hall's tunnel-like quality and illusionistically extend the width of the room. The mirror, that ultimate source of illusion, was a favorite element of Baroque interior design. Here, it also enhanced the dazzling extravagance of the great festivals Louis XIV was so fond of hosting.

VERSAILLES PARK The enormous palace might appear unbearably ostentatious were it not for its extraordinary setting in the vast park that makes it almost an adjunct. From the Galerie des Glaces, the king and his guests could gaze out on a sweeping vista down the park's tree-lined central axis and across terraces, lawns, pools, and lakes to the horizon. The park of Versailles (FIG. 20-32), designed by André Le Nôtre (1613–1700), must rank among the world's greatest artworks in both size and concept. Here, the French architect transformed an entire forest into a park. Although its geometric plan may appear stiff and formal, the park in fact offers an almost unlimited assortment of vistas, as Le Nôtre used not only the multiplicity of natural forms but also the terrain's slightly rolling contours with stunning effectiveness.

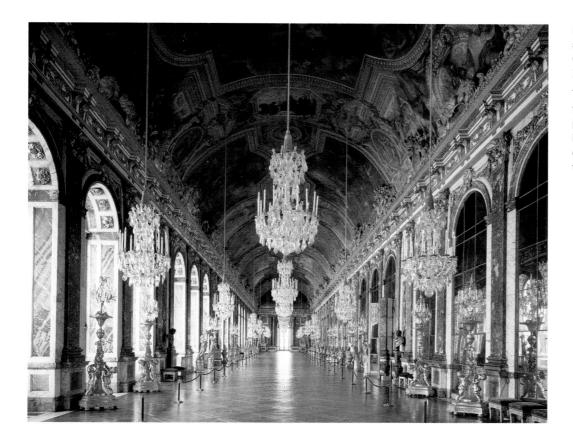

20-33 Jules Hardouin-Mansart and Charles Le Brun, Galerie des Glaces (Hall of Mirrors), palace of Louis XIV, Versailles, France, ca. 1680.

This hall overlooks the Versailles park from the second floor of Louis XIV's palace. Hundreds of mirrors illusionistically extend the room's width and once reflected gilded and jeweled furnishings.

The formal gardens near the palace provide a rational transition from the frozen architectural forms to the natural living ones. Here, the elegant shapes of trimmed shrubs and hedges define the tightly designed geometric units. Each unit is different from its neighbor and has a focal point in the form of a sculptured group, a pavilion, a reflecting pool, or perhaps a fountain. Farther away from the palace, the design loosens as trees, in shadowy masses, screen or frame views of open countryside. Le Nôtre carefully composed all vistas for maximum effect. Light and shadow, formal and informal, dense growth

and open meadows—all play against one another in unending combinations and variations. No photograph or series of photographs can reveal the design's full richness. The park unfolds itself only to people who actually walk through it. In this respect, it is a temporal artwork. Its aspects change with the time of day, the seasons, and the relative position of the observer.

For the Grotto of Thetis above a dramatic waterfall in the gardens of Versailles, François Girardon (1628–1715) designed *Apollo Attended by the Nymphs* (Fig. **20-34**). Both stately and graceful, the

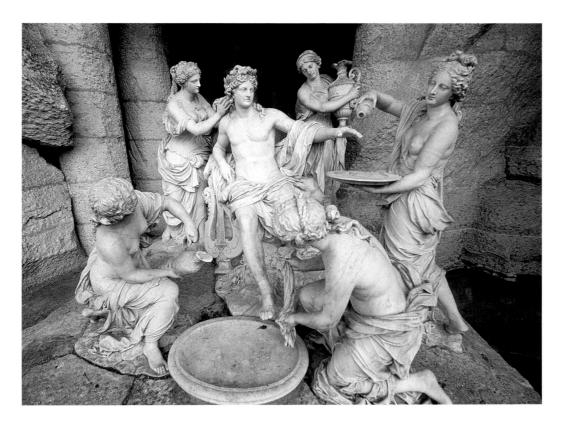

20-34 François Girardon and Thomas Regnaudin, *Apollo Attended by the Nymphs*, Grotto of Thetis, Versailles, France, ca. 1666–1672. Marble, life-size.

Girardon's study of ancient sculpture and Poussin's figure compositions influenced the design of this mythological group in a grotto above a dramatic waterfall in the gardens of Versailles.

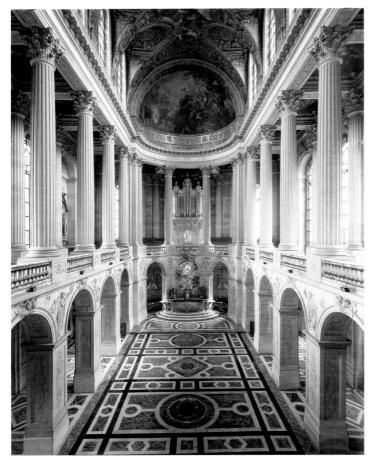

20-35 Jules Hardouin-Mansart, Royal Chapel, with ceiling decorations by Antoine Coypel, palace of Louis XIV, Versailles, France, 1698–1710.

Because the apse is as high as the nave, the central space of the Royal Chapel at Versailles has a curved Baroque quality. Louis XIV could reach the royal pew directly from his apartments.

nymphs display a compelling charm as they minister to the god Apollo at the end of the day. (The three nymphs in the background are the work of Thomas Regnaudin, 1622–1706.) Girardon's close study of Greco-Roman sculpture heavily influenced his design of the figures, and Poussin's figure compositions (Fig. 20-24) inspired their arrangement. Since Apollo was often equated with the sun god, the group refers obliquely to Louis XIV as the "god of the sun." This was bound to assure the work's success at court. Girardon's classical style and mythological symbolism were well suited to France's glorification of royal majesty.

VERSAILLES CHAPEL In 1698, Jules Hardouin-Mansart received the commission to add a Royal Chapel to the Versailles palace complex. The chapel's interior (FIG. **20-35**) is essentially rectangular, but because its apse is as high as the nave, the fluid central space takes on a curved Baroque quality. However, the light entering through the large clerestory windows lacks the directed dramatic effect of the Italian Baroque, instead illuminating the interior's precisely chiseled details brightly and evenly. Pier-supported arcades carry a majestic row of Corinthian columns that define the royal gallery. The royal pew occupies its rear, accessible directly from the king's apartments. Amid the restrained decoration, only the illusionistic ceiling paintings, added in 1708–1709 by Antoine Coypel (1661–1722), suggest the drama and complexity of Italian Baroque art.

As a symbol of the power of absolutism, Versailles has no equal. It also expresses, in the most monumental terms of its age, the ratio-

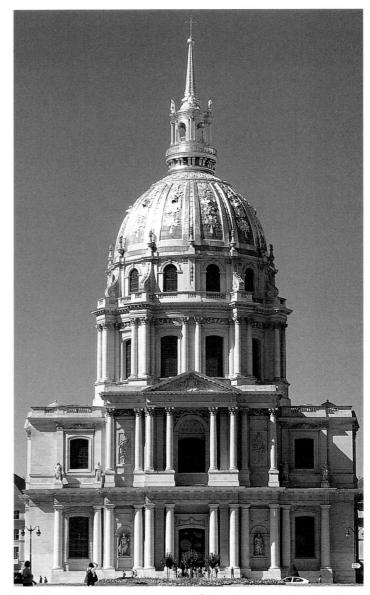

20-36 Jules Hardouin-Mansart, Église du Dôme, Church of the Invalides, Paris, France, 1676–1706.

Hardouin-Mansart's church marries the Italian and French architectural styles. The grouping of the orders is similar to the Italian Baroque manner but without the dramatic play of curved surfaces.

nalistic creed—based on scientific advances, such as the physics of Sir Isaac Newton (1642–1727) and the mathematical philosophy of René Descartes (1596–1650)—that all knowledge must be systematic and all science must be the consequence of the intellect imposed on matter. The whole spectacular design of Versailles proudly proclaims the mastery of human intelligence (and the mastery of Louis XIV) over the disorderliness of nature.

ÉGLISE DU DÔME, PARIS Another of Hardouin-Mansart's masterworks, the Église du Dôme (FIG. 20-36), or Church of the Invalides, in Paris, also marries the Italian Baroque and French classical architectural styles. An intricately composed domed square of great scale, the church adjoins the veterans hospital Louis XIV established for the disabled soldiers of his many wars. Two firmly separated levels, the upper one pedimented, compose the frontispiece. The grouping of the orders and of the bays they frame is not unlike that in Italian Baroque architecture but without the dramatic play of curved surfaces characteristic of many 17th-century Italian churches (FIG. 19-9). The compact facade is low and narrow in relation to the

vast drum and dome, seeming to serve simply as a base for them. The overpowering dome, conspicuous on the Parisian skyline, is itself expressive of the Italian Baroque love for dramatic magnitude, as is the way that its designer aimed for theatrical effects of light and space. The dome consists of three shells, the lowest cut off so that a visitor to the interior looks up through it to the one above, which is filled with light from hidden windows in the third, outermost dome. Charles de La Fosse (1636–1716) painted the interior of the second dome in 1705 with an Italian-inspired representation of the heavens opening up to receive Saint Louis, patron of France.

ENGLAND

In England, in sharp distinction to France, the common law and the Parliament kept royal power in check. England also differed from France (and Europe in general) in other significant ways. Although an important part of English life, religion was not the contentious issue it was on the Continent. The religious affiliations of the English included Catholicism, Anglicanism, Protestantism, and Puritanism (the English version of Calvinism). In the economic realm, England was the one country (other than the Dutch Republic) to take advantage of the opportunities overseas trade offered. As an island country, Britain (which after 1603 consisted of England, Wales, and Scotland), like the Dutch Republic, possessed a large and powerful navy as well as excellent maritime capabilities.

Architecture

In the realm of art, the most important English achievements were in the field of architecture, much of it, as in France, incorporating classical elements.

INIGO JONES The most notable English architect of the first half of the 17th century was INIGO JONES (1573-1652), architect to Kings James I (r. 1603–1625) and Charles I (FIG. 20-5). Jones spent considerable time in Italy. He greatly admired the classical authority and restraint of Andrea Palladio's structures and studied with great care his treatise on architecture (see Chapter 17). Jones took many motifs from Palladio's villas and palaces, and he adopted Palladio's basic design principles for his own architecture. The nature of his achievement is evident in the buildings he designed for his royal patrons, among them the Banqueting House (FIG. 20-37) at Whitehall in London. For this structure, a symmetrical block of great clarity and dignity, Jones superimposed two orders, using columns in the center and pilasters near the ends. The balustraded roofline, uninterrupted in its horizontal sweep, predates the Louvre's facade (FIG. 20-31) by more than 40 years. Palladio would have recognized and approved all of the design elements, but the building as a whole is not a copy of his work. Although relying on the revered Italian's architectural vocabulary and syntax, Jones retained his own independence as a designer. For two centuries his influence was almost as authoritative in English architecture as that of Palladio.

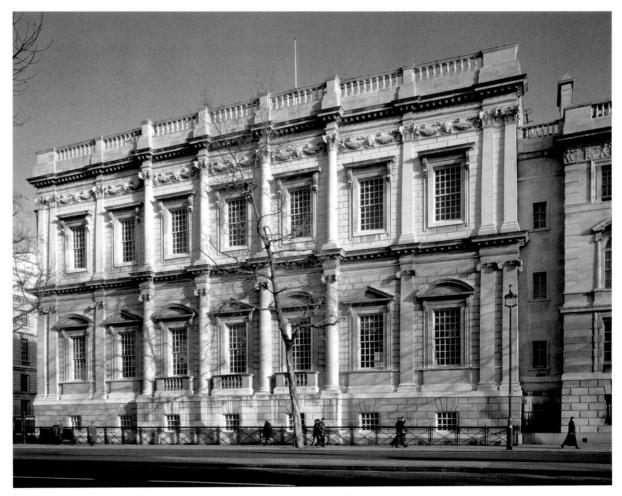

20-37 INIGO JONES, Banqueting House at Whitehall, London, England, 1619-1622.

Jones was a great admirer of the classical architecture of Palladio, and he adopted motifs from the Italian Renaissance architect's villas and palaces for the buildings he designed for his royal patrons.

20-38 SIR CHRISTOPHER WREN, Saint Paul's Cathedral, London, England, 1675–1710.

Wren's cathedral replaced an old Gothic church. The facade design owes much to Palladio (Fig. 17-31) and Borromini (Fig. 19-12). The great dome recalls Saint Peter's in Rome (Figs. 19-3 and 19-4).

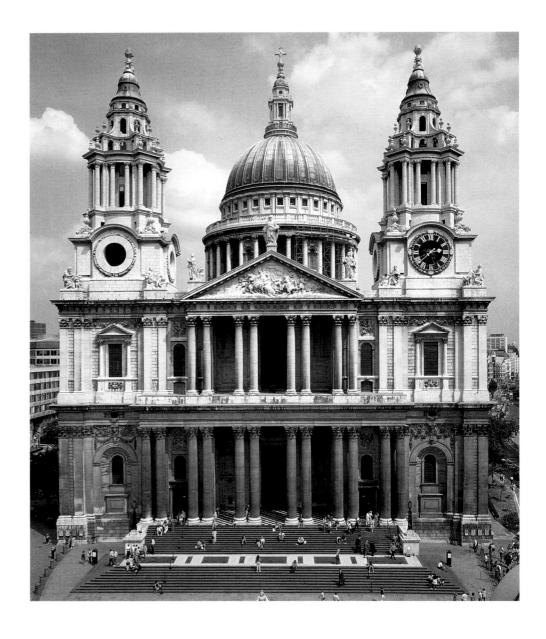

CHRISTOPHER WREN London's majestic Saint Paul's Cathedral (FIG. 20-38) is the work of England's most renowned architect, Christopher Wren (1632-1723). A mathematical genius and skilled engineer whose work won Isaac Newton's praise, Wren became professor of astronomy in London at age 25. Mathematics led to architecture, and Charles II (r. 1649–1685) asked Wren to prepare a plan for restoring the old Gothic church of Saint Paul. Wren proposed to remodel the building based on Roman structures. Within a few months, the Great Fire of London, which destroyed the old structure and many churches in the city in 1666, gave Wren his opportunity. Although Jones's work strongly influenced him, Wren also traveled in France, where the splendid palaces and state buildings being created in and around Paris at the time of the competition for the Louvre design must have impressed him. Wren also closely studied prints illustrating Baroque architecture in Italy. In Saint Paul's, he harmonized Palladian, French, and Italian Baroque features.

In view of its size, the cathedral was built with remarkable speed—in little more than 30 years—and Wren lived to see it com-

pleted. The building's form underwent constant refinement during construction, and Wren did not determine the final appearance of the towers until after 1700.

In the splendid skyline composition, two foreground towers act effectively as foils to the great dome. Wren must have known similar schemes that Italian architects devised for Saint Peter's (FIG. 19-4) in Rome to solve the problem of the relationship between the facade and dome. Certainly, the influence of Borromini (FIG. 19-12) appears in the upper levels and lanterns of the towers and that of Palladio (FIG. 17-31) in the lower levels. Further, the superposed paired columnar porticos recall the Louvre facade (FIG. 20-31). Wren's skillful eclecticism brought all these foreign features into a monumental unity.

Wren designed many other London churches after the Great Fire. Even today, his towers and domes punctuate the skyline of London. Saint Paul's dome is the tallest of all. Wren's legacy was significant and long-lasting, in both England and colonial America (see Chapter 21).

NORTHERN EUROPE, 1600 TO 1700

FLANDERS

- In the 17th century, Flanders remained Catholic and under Spanish control. Flemish Baroque art is more closely tied to the Baroque art of Italy than is the art of much of the rest of northern Europe.
- The leading Flemish painter of this era was Peter Paul Rubens, whose work and influence were international in scope. A diplomat as well as an artist, he counted kings and queens among his patrons and friends. His paintings of the career of Marie de' Medici exhibit Baroque splendor in color and ornament, and feature Rubens's characteristic robust and foreshortened figures in swirling motion.

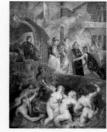

Rubens, Arrival of Marie de' Medici, 1622–1625

DUTCH REPUBLIC

- The Dutch Republic received official recognition of its independence from Spain in the Treaty of Westphalia of 1648. Worldwide trade and banking brought prosperity to its predominantly Protestant citizenry, which largely rejected church art in favor of private commissions of portraits, genre scenes, landscapes, and still lifes.
- Frans Hals produced innovative portraits of middle-class patrons in which a lively informality replaced the formulaic patterns of traditional portraiture. Aelbert Cuyp and Jacob van Ruisdael specialized in landscapes depicting specific places, not idealized Renaissance settings. Pieter Claesz, Willem Kalf, and others painted vanitas still lifes featuring meticulous depictions of worldly goods and reminders of death.

Jan Vermeer specialized in painting Dutch families in serenely opulent homes. Vermeer's convincing representation of interior spaces depended in part on his employment of the camera obscura. He was also a master of light and color and understood that shadows are not colorless.

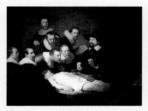

Rembrandt, Night Watch, 1642

Vermeer, The Letter, 1666

FRANCE AND ENGLAND

■ The major art patron in 17th-century France was the Sun King, the absolutist monarch Louis XIV, who expanded the Louvre and built a gigantic palace-and-garden complex at Versailles featuring sumptuous furnishings and sweeping vistas. Among the architects Louis employed were Charles Le Brun and Jules Hardouin-Mansart, who succeeded in marrying Italian Baroque and French classical styles.

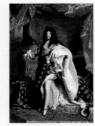

Rigaud, Louis XIV, 1701

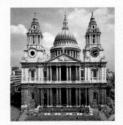

Wren, Saint Paul's, London, 1675–1710

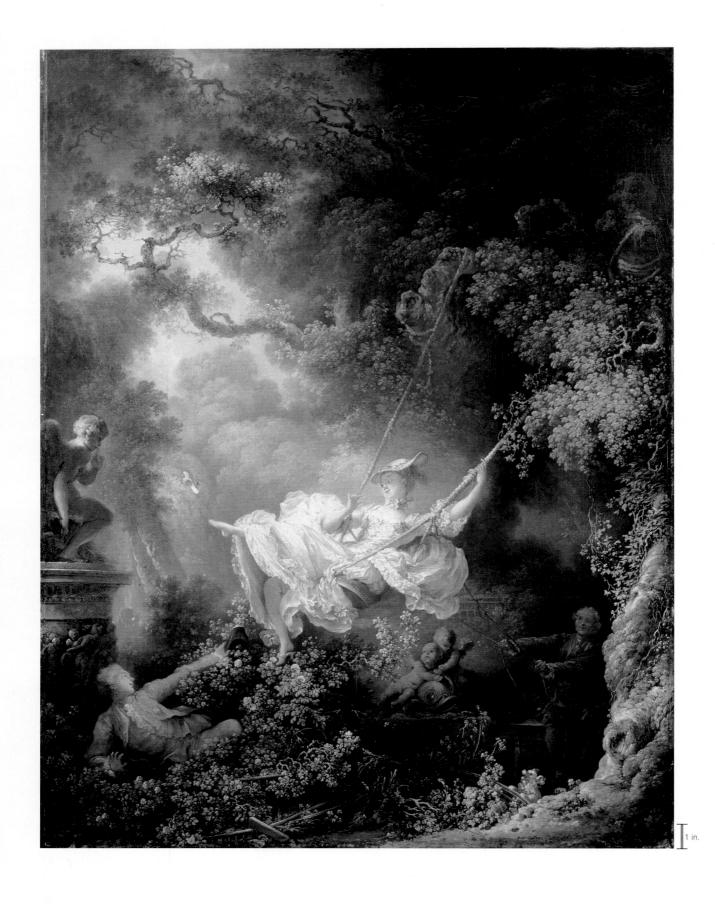

21-1 Jean-Honoré Fragonard, *The Swing*, 1766. Oil on canvas, 2' $8\frac{5}{8}'' \times 2'$ 2''. Wallace Collection, London.

In this painting epitomizing Rococo style, pastel colors and soft light complement a sensuous scene in which a young lady flirtatiously kicks off her shoe at a statue of Cupid while her lover watches.

EUROPE AND AMERICA, 1700 TO 1800

In 1700, Louis XIV still ruled as the Sun King of France, presiding over his realm and French culture from his palatial residence at Versailles (FIG. 20-32). By 1800, revolutions had overthrown the monarchy in France and achieved independence for the British colonies in America (MAP 21-1). The 18th century also gave birth to a revolution of a different kind—the Industrial Revolution, which began in England and soon transformed the economies of continental Europe and North America and eventually the world. Against this backdrop of revolutionary change, social as well as political, economic, and technological, came major transformations in the arts. Indeed, *Pilgrimage to Cythera* (FIG. 21-6), painted in 1717 and set in a lush landscape, celebrates the romantic dalliances of the moneyed elite. In contrast, the 1784 *Oath of the Horatii* (FIG. 21-23) takes place in an austere Doric hall and glorifies the civic virtue and heroism of an ancient Roman family. The two works have little in common other than that both are French oil paintings. In the 18th century, shifts in style and subject matter were both rapid and significant.

ROCOCO

The death of Louis XIV in 1715 brought many changes in French high society. The elite quickly abandoned the court of Versailles for the pleasures of town life. Although French citizens still owed allegiance to a monarch, the early 18th century brought a resurgence of aristocratic social, political, and economic power. Members of the nobility not only exercised their traditional privileges (for example, exemption from certain taxes and from forced labor on public works) but also sought to expand their power. In the cultural realm, aristocrats reestablished their predominance as art patrons. The *hôtels* (town houses) of Paris soon became the centers of a new, softer style called *Rococo*. Associated with the regency (1715–1723) that followed the death of Louis XIV and with the reign of Louis XV (r. 1723–1774), the Rococo style in art and architecture was the perfect expression of the sparkling gaiety the wealthy cultivated in their elegant homes (see "Femmes Savantes and Salon Culture," page 585).

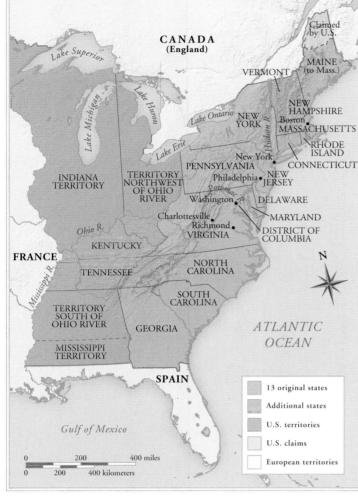

MAP 21-1 The United States in 1800.

Architecture

Rococo appeared in France in about 1700, primarily as a style of interior design. The French Rococo exterior was most often simple, or even plain, but Rococo exuberance took over the interior. The term derived from the French word *rocaille* (literally, "pebble"), but it referred especially to the small stones and shells used to decorate grotto interiors. Shells or shell forms were the principal motifs in Rococo ornament.

SALON DE LA PRINCESSE A typical French Rococo room is the Salon de la Princesse (FIG. 21-2) in the Hôtel de Soubise in Paris, designed by Germain Boffrand (1667–1754). Parisian salons of this sort were the center of Rococo social life. They usurped the role that Louis XIV's Versailles palace (FIG. 20-32) played in the 17th century, when the Sun King set the tone for French culture. In the early 18th century, the centralized and grandiose palace-based culture of Baroque France gave way to a much more intimate and decentralized culture based in private homes. The new architectural style mirrored this social and cultural shift. A comparison between the Salon de la Princesse and the Galerie des Glaces (FIG. 20-33) at Versailles reveals how Boffrand softened the strong architectural lines and panels of the earlier style into flexible, sinuous curves luxuriantly multiplied in mirror reflections. The walls melt into the vault. Irregular painted shapes, surmounted by sculpture and separated by the typical rocaille shells, replace the hall's cornices. Painting, architecture, and sculpture combine to form a single ensemble. The profusion of curving tendrils and sprays of foliage blends with the shell forms to give an effect of freely growing nature, suggesting that the designer permanently decked the Rococo room for a festival.

French Rococo interiors were lively total works of art. Exquisitely wrought furniture, enchanting small sculptures, ornamented mirror frames, delightful ceramics and silver, small paintings, and decorative *tapestries* complemented the architecture, relief sculptures, and mural paintings. The Salon de la Princesse no longer has most of the movable furnishings and decor that once contributed so much to its total ambience. Visitors can imagine, however, how this and similar Rococo rooms—with their alternating gilded moldings, vivacious relief sculptures, luxurious furniture, and daintily colored ornamentation of flowers and garlands—must have harmonized with the chamber music played in them, with the elaborate costumes of satin and brocade, and with the equally elegant etiquette and sparkling wit of the people who graced them.

AMALIENBURG The French Rococo style quickly spread beyond Paris. The Amalienburg, a small lodge the French architect François de Cuvilliés (1695–1768) built in the park of the Nymphenburg Palace in Munich, is a prime example of Germany's adoption of the Parisian style. The most spectacular room in the lodge is the circular Hall of Mirrors (FIG. 21-3), a silver-and-blue ensemble of architecture, stucco relief, silvered bronze mirrors, and crystal that represents the Rococo style at its zenith. The hall dazzles the eye with myriad scintillating motifs, forms, and figurations the designer borrowed from the full Rococo ornamental repertoire. Silvery light, reflected and amplified by windows and mirrors, bathes the room and creates shapes and contours that weave rhythmically around the upper walls and the ceiling coves. Everything seems organic, growing, and in motion, an ultimate refinement of illusion that the architect, artists, and artisans, all magically in command of their varied media, created with virtuoso flourishes.

21-2 Germain Boffrand, Salon de la Princesse, with painting by Charles-Joseph Natoire and sculpture by J. B. Lemoine, Hôtel de Soubise, Paris, France, 1737–1740.

Elegant Rococo rooms such as this salon, featuring sinuous curves, gilded moldings and mirrors, small sculptures and paintings, and floral ornament, were the center of Parisian social and intellectual life.

Femmes Savantes and Salon Culture

he feminine look of the Rococo style suggests that the taste and social initiative of women dominated the age—and, to a large extent, they did. Women—for example, Madame de Pompadour (1721–1764), mistress of Louis XV of France; Maria Theresa (1717–1780), archduchess of Austria and queen of Hungary and Bohemia; and Empresses Elizabeth (r. 1741–1762) and Catherine the Great (r. 1762–1796) of Russia—held some of the most influential positions in Europe. Female taste also had an impact in numerous smaller courts as well as in the private sphere.

In the early 18th century, Paris was the social capital of Europe, and the Rococo salon (FIG. 21-2) was the center of Parisian society. Wealthy, ambitious, and clever society hostesses competed to attract the most famous and the most accomplished people to their salons, whether in Paris or elsewhere in Europe (FIG. 21-3). The medium of social intercourse was conversation spiced with wit, repartee as quick and deft as a fencing match. Artifice reigned supreme, and participants considered enthusiasm or sincerity in bad taste.

The women who hosted these salons referred to themselves as *femmes savantes*, or learned women. Among them was Julie de Lespinasse (1732–1776), one of the most articulate, urbane, and intelligent French women of the time. She held daily salons from five o'clock until nine in the evening. The book *Memoirs of Marmontel* documented the liveliness of these gatherings and the remarkable nature of this hostess.

The circle was formed of persons who were not bound together. She had taken them here and there in society, but so well assorted were they that once there they fell into harmony like the strings of an instrument touched by an able hand. Following out that comparison, I may say that she played the instrument with an art that came of genius; she seemed to know what tone each string would yield before she touched it; I mean to say that our minds and our natures were so well known to her that in order to bring them into play she had but to say a word. Nowhere was conversation more lively, more brilliant, or better regulated than at her house. It was a rare phenomenon indeed, the degree of tempered, equable heat which she knew so well how to maintain, sometimes by moderating it, sometimes by quickening it. The continual activity of her soul was communicated to our souls, but measurably; her imagination was the mainspring, her reason the regulator. Remark that the brains she stirred at will were neither feeble nor frivolous.... Her talent for casting out a thought and giving it for discussion to men of that class, her own talent in discussing it with precision, sometimes with eloquence, her talent for bringing forward new ideas and varying the topic—always with the facility and ease of a fairy ... these talents, I say, were not those of an ordinary woman. It was not with the follies of fashion and vanity that daily, during four hours of conversation, without languor and without vacuum, she knew how to make herself interesting to a wide circle of strong minds.*

* Jean François Marmontel, Memoirs of Marmontel, translated by Brigit Patmore (London: Routledge, 1930), 270.

21-3 François de Cuvilliés, Hall of Mirrors, the Amalienburg, Nymphenburg Palace park, Munich, Germany, early 18th century.

Designed by a French architect, this circular hall in a German lodge displays the Rococo architectural style at its zenith, dazzling the eye with the organic interplay of mirrors, crystal, and stucco relief.

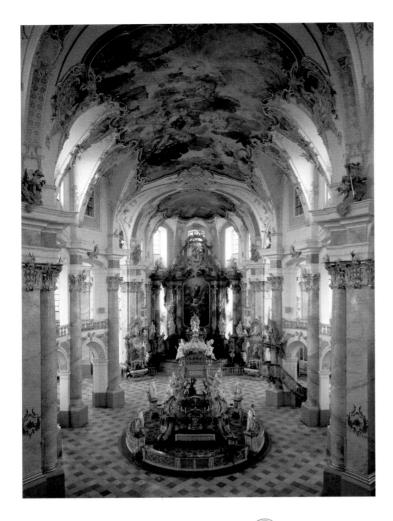

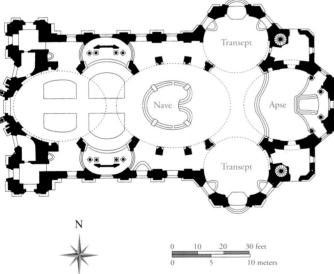

21-4 Balthasar Neumann, interior (*top*) and plan (*bottom*) of the pilgrimage church of Vierzehnheiligen, near Staffelstein, Germany, 1743–1772.

The Rococo style also appeared in ecclesiastical architecture. Vierzehnheiligen's interior is light and delicate. Its plan features undulating lines and a dynamic interplay of ovals and circles.

VIERZEHNHEILIGEN Rococo style was not exclusively a domestic phenomenon, however. One of the most splendid examples of Rococo ecclesiastical architecture is the pilgrimage church of Vierzehnheiligen (Fourteen Saints; FIG. 21-4) near Staffelstein (MAP 20-1), which the German architect Balthasar Neumann (1687–1753)

designed. The interior (FIG. 21-4, *top*) exhibits a vivacious play of architectural fantasy that retains the dynamic energy of Italian Baroque architecture (see Chapter 19) but not its drama. Numerous large windows in the richly decorated but continuous walls of Vierzehnheiligen flood the interior with an even, bright, and cheerful light. The feeling is one of lightness and delicacy.

Vierzehnheiligen's plan (FIG. 21-4, bottom) reveals the influence of Borromini (FIGS. 19-10 and 19-13) but is even more complex. Neumann seems deliberately to have banished all straight lines. The composition, made up of tangent ovals and circles, achieves a quite different interior effect within the essential outlines of a traditional rectilinear basilican church with a nave, transept, and apse. Undulating space is in continuous motion, creating unlimited vistas bewildering in their variety and surprise effects. The structural features pulse, flow, and commingle as if they were ceaselessly in the process of being molded. The design's fluidity of line, the floating and hovering surfaces, the interwoven spaces, and the dematerialized masses combine to suggest a "frozen" counterpart to the intricacy of voices in a Bach fugue. The church is a brilliant ensemble of architecture, painting, sculpture, and music that dissolves the boundaries of the arts in a visionary unity.

Painting and Sculpture

ANTOINE WATTEAU The painter whom scholars most associate with French Rococo is Antoine Watteau (1684–1721). The differences between the Baroque age in France and the Rococo age can be

21-5 Antoine Watteau, *L'Indifférent*, ca. 1716. Oil on canvas, $10'' \times 7''$. Louvre, Paris.

This small Rococo painting of a languid, gliding dancer exhibits lightness and delicacy in both color and tone. It contrasts sharply with Rigaud's majestic portrait (FIG. 20-30) of the pompous Louis XIV.

21-6 Antoine Watteau, *Pilgrimage to Cythera*, 1717. Oil on canvas, 4' $3'' \times 6'$ $4\frac{1}{2}''$. Louvre, Paris.

Watteau's fête galante paintings depict the outdoor amusements of French upper-class society. The haze of color, subtly modeled shapes, gliding motion, and air of suave gentility match Rocco taste.

seen clearly by contrasting Rigaud's portrait of Louis XIV (FIG. 20-30) with one of Watteau's paintings, L'Indifférent (The Indifferent One; FIG. 21-5). Rigaud portrayed pompous majesty in supreme glory, as if the French monarch were reviewing throngs of bowing courtiers at Versailles. Watteau's painting, in contrast, is more delicate and lighter in both color and tone. The artist presented a languid, gliding dancer whose stilted minuet could be a parody of the monarch's solemnity if the paintings were hung together. In Rigaud's portrait, stout architecture, bannerlike curtains, flowing ermine, and fleur-de-lis exalt the king. In Watteau's painting, the dancer moves in a rainbow shimmer of color, emerging onto the stage of the intimate comic opera to the silken sounds of strings. As in architecture, this contrast of paintings also highlights the different patronage of the eras. Whereas royal patronage, particularly that of Louis XIV, dominated the French Baroque period, Rococo was the culture of a wider aristocracy in which private patrons dictated taste.

PILGRIMAGE TO CYTHERA Watteau was largely responsible for creating a specific type of Rococo painting, called a *fête galante* (amorous festival) painting. These works depicted the outdoor entertainment or amusements of French high society. An example of a fête galante painting is Watteau's masterpiece (painted in two versions), *Pilgrimage to Cythera* (FIG. 21-6). The painting was the artist's entry for admission to the French Royal Academy of Painting and Sculpture (see "Academic Salons," Chapter 23, page 655). In 1717 the fête galante

was not an acceptable category for submission, but rather than reject Watteau's candidacy, the academy created a new category to accommodate his entry. At the turn of the century, two competing doctrines sharply divided the membership of the French academy. Many members followed Nicolas Poussin in teaching that form was the most important element in painting, whereas "colors in painting are as allurements for persuading the eyes"—additions for effect and not really essential. The other group took Peter Paul Rubens as its model and proclaimed the natural supremacy of color and the coloristic style as the artist's proper guide. Depending on which doctrine they supported, academy members were either *Poussinistes* or *Rubénistes*. Watteau was Flemish, and Rubens's coloristic style heavily influenced his work. With Watteau in their ranks, the Rubénistes carried the day, establishing Rococo painting as the preferred style of the early 18th century.

Watteau's *Pilgrimage to Cythera* (FIG. 21-6) portrays luxuriously costumed lovers who have made a "pilgrimage" to Cythera, the island of eternal youth and love, sacred to Aphrodite. The elegant figures move gracefully from the protective shade of a woodland park filled with amorous cupids and voluptuous statuary. Watteau's figural poses blend elegance and sweetness. He composed his generally quite small paintings from albums of superb drawings in which he sought to capture slow movement from difficult and unusual angles, obviously intending to find the smoothest, most poised, and most refined attitudes. As he experimented with nuances of posture and movement, Watteau also strove for the most exquisite shades of

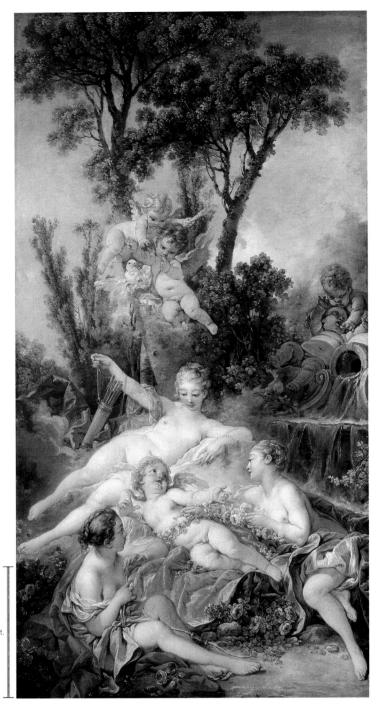

21-7 François Boucher, *Cupid a Captive*, 1754. Oil on canvas, 5' $6'' \times 2'$ 10''. Wallace Collection, London.

In this Rococo canvas, François Boucher, painter for Madame de Pompadour, portrayed a rosy pyramid of infant and female flesh and fluttering draperies set off against a cool, leafy background.

color difference, defining in a single stroke the shimmer of silk at a bent knee or the iridescence that touches a glossy surface as it emerges from shadow. The haze of color, the subtly modeled shapes, the gliding motion, and the air of suave gentility appealed greatly to the Rococo artist's wealthy patrons.

FRANÇOIS BOUCHER After Watteau's early death at 37, his follower, François Boucher (1703–1770), rose to dominance in French painting, in large part because of Madame de Pompadour's patronage. Although he was an excellent portraitist, Boucher's fame rested primarily on his graceful canvases depicting Arcadian shep-

21-8 GIAMBATTISTA TIEPOLO, *Apotheosis of the Pisani Family*, ceiling fresco in the Villa Pisani, Stra, Italy, 1761–1762. Fresco, 77' $1'' \times 44'$ 3".

A master of illusionistic ceiling painting in the Baroque tradition, Tiepolo adopted the bright, cheerful colors and weightless figures of Rococo easel paintings for huge frescoes.

herds, nymphs, and goddesses cavorting in shady glens engulfed in pink and sky-blue light. *Cupid a Captive* (FIG. 21-7) presents a rosy pyramid of infant and female flesh set off against a cool, leafy background, with fluttering draperies both hiding and revealing the nudity of the figures. Boucher used the full range of Italian and French Baroque devices—the dynamic play of crisscrossing diagonals, curvilinear forms, and slanting recessions—to create his masterly composition. But in his work he dissected powerful Baroque curves into a multiplicity of decorative flourishes, dissipating Baroque drama into sensual playfulness. Lively and lighthearted, Boucher's artful Rococo fantasies became mirrors for his patrons, the wealthy French, to behold the ornamental reflections of their cherished pastimes.

JEAN-HONORÉ FRAGONARD Boucher's greatest student, JEAN-HONORÉ FRAGONARD (1732–1806), was an outstanding colorist whose decorative skill almost surpassed his master's. An example of his manner can stand as characteristic not only of his work but also of the later Rococo style in general. In *The Swing* (FIG. 21-1), a young gentleman has managed an arrangement whereby an unsuspecting old bishop swings the young man's pretty sweetheart higher

21-9 CLODION, *Satyr Crowning a Bacchante*, 1770. Terracotta, $1'\frac{5}{8}''$ high. Louvre, Paris.

The erotic playfulness of Boucher's and Fragonard's paintings is evident in Clodion's tabletop terracotta sculptures representing sensuous fantasies often involving satyrs and bacchantes, the followers of Bacchus.

and higher, while her lover (and the work's patron), in the lower left corner, stretches out to admire her ardently from a strategic position on the ground. The young lady flirtatiously and boldly kicks off her shoe toward the little statue of Cupid. The infant love god holds his finger to his lips. The landscape setting is out of Watteau—a luxuriant perfumed bower in a park that very much resembles a stage scene for comic opera. The glowing pastel colors and soft light convey, almost by themselves, the theme's sensuality.

GIAMBATTISTA TIEPOLO The Swing is less than three feet in height, and Watteau's L'Indifférent (FIG. 21-5) barely 10 inches tall. But the intimate Rococo style could also be adopted for paintings of huge size, as the work of GIAMBATTISTA TIEPOLO (1696-1770) demonstrates. Of Venetian origin, Tiepolo worked for patrons in Austria, Germany, and Spain as well as in Italy. A master of illusionistic ceiling decoration in the Baroque tradition, Tiepolo favored the bright, cheerful colors and relaxed compositions of Rococo easel paintings. Apotheosis of the Pisani Family (FIG. 21-8), a ceiling fresco in the Villa Pisani at Stra in northern Italy (MAP 20-1), shows airy figures fluttering through vast sunlit skies and fleecy clouds, their forms casting dark accents against the brilliant light of high noon. Tiepolo here elevated the Pisani family members to the rank of gods in a heavenly scene that recalls the ceiling paintings of Pozzo (FIG. 19-24). But while retaining 17th-century illusionism, Tiepolo softened the rhetoric and created pictorial schemes of great elegance and grace, unsurpassed for their sheer effectiveness as decor.

CLODION Rococo was nonetheless a style best suited for small-scale works that projected a mood of sensual intimacy in elegant salons. Artists such as Claude Michel, called CLODION (1738–1814), specialized in small, lively sculptures representing sensuous Rococo

fantasies. Clodion lived in Rome for several years, and his work incorporates echoes of Italian Mannerist sculpture. His small group *Satyr Crowning a Bacchante* (FIG. **21-9**) depicts two mythological followers of Bacchus, the Roman god of wine. The languorous bacchante being crowned by the satyr with a floral wreath is reminiscent of the nude female personification in Benvenuto Cellini's *Saltcellar of Francis I* (FIG. **17-51**). The erotic playfulness of Boucher's and Fragonard's paintings is also evident in Clodion's sculpture. He captured the sensual exhilaration of the Rococo style in diminutive scale and inexpensive terracotta. As is true of so many Rococo artifacts, the artist designed this group for a tabletop.

THE ENLIGHTENMENT

The aristocratic culture celebrated in Rococo art did not go unchallenged during the 18th century. Indeed, the feudal system that served as the foundation of social and economic life in Europe dissolved, and the rigid social hierarchies that provided the basis for Rococo art and patronage relaxed. By the end of the 18th century, revolutions had erupted in France and America. A major factor in these political, social, and economic changes was the Enlightenment.

Philosophy and Science

The *Enlightenment* was in essence a new way of thinking critically about the world and about humankind, independently of religion, myth, or tradition. The basis of Enlightenment thought was empirical evidence. Enlightenment thinkers promoted the scientific questioning of all assertions and rejected unfounded beliefs about the nature of humankind and of the world. Thus, the Enlightenment encouraged and stimulated the habit and application of mind known as the scientific method.

This new approach to the acquisition of knowledge had its roots in the 17th century, with the mathematical and scientific achievements of René Descartes (1596–1650), Blaise Pascal (1623–1662), Isaac Newton (1642–1727), and Gottfried Wilhelm von Leibniz (1646–1716). England and France were the principal centers of the Enlightenment, though its dictums influenced the thinking of intellectuals throughout Europe and in the American colonies. Benjamin Franklin (1706–1790), Thomas Jefferson (1743–1826), and other American notables embraced its principles.

NEWTON AND LOCKE Of particular importance for Enlightenment thought was the work of Great Britain's Isaac Newton and John Locke (1632–1704). In his scientific studies, Newton insisted on empirical proof of his theories and encouraged others to avoid metaphysics and the supernatural—realms that extended beyond the natural physical world. This emphasis on both tangible data and concrete experience became a cornerstone of Enlightenment thought. In addition, Newton's experiments revealed a rationality in the physical world, and Enlightenment thinkers transferred that concept to the sociopolitical world by promoting a rationally organized society. Locke, whose works acquired the status of Enlightenment gospel, developed these ideas further. According to Locke's "doctrine of empiricism," knowledge comes to people through their sense perception of the material world. From these perceptions alone people form ideas. Locke asserted that human beings are born good, not cursed by Original Sin. The laws of Nature grant them the natural rights of life, liberty, and property as well as the right to freedom of conscience. Government is by contract, and its purpose is to protect these rights. If and when government abuses these rights, the citizenry has the further natural right of revolution. Locke's ideas empowered people to take control of their own destinies.

PHILOSOPHES The work of Newton and Locke also inspired many French intellectuals, or *philosophes*. These thinkers conceived of individuals and societies at large as parts of physical nature. They shared the conviction that the ills of humanity could be remedied by applying reason and common sense to human problems. They criticized the powers of church and state as irrational limits placed on political and intellectual freedom. They believed that by the accumulation and propagation of knowledge, humanity could advance by degrees to a happier state than it had ever known. This conviction matured into the "doctrine of progress" and its corollary doctrine of the "perfectibility of humankind." Previous societies, for the most part, perceived the future as inevitable—the cycle of life and death. Religious beliefs determined fate. The notion of progress—the systematic and planned improvement of society—first developed during the 18th century and continues to influence 21st-century thought.

DIDEROT Animated by their belief in human progress and perfectibility, the philosophes took on the task of gathering knowledge and making it accessible to all who could read. Their program was, in effect, the democratization of knowledge. Denis Diderot (1713-1784) greatly influenced the Enlightenment's rationalistic and materialistic thinking. He became editor of the pioneering Encyclopédie, a compilation of articles written by more than a hundred contributors, including all the leading philosophes. The Encyclopédie was truly comprehensive (its formal title was Systematic Dictionary of the Sciences, Arts, and Crafts) and included all available knowledge—historical, scientific, and technical as well as religious and moral—and political theory. The first volume appeared in 1751 and the last of the 35 volumes of text and illustrations in 1780. Other Enlightenment authors produced different compilations of knowledge. Diderot's contemporary, Comte de Buffon (1707-1788), undertook a kind of encyclopedia of the natural sciences. His Natural History, a monumental work of 44 volumes, was especially valuable for its zoological study. Buffon's contemporary, the Swedish botanist Carolus Linnaeus (1707-1778), established a system of plant classification. The political, economic, and social consequences of this increase in knowledge and the doctrine of progress were explosive. It is no coincidence that the French Revolution, the American Revolution, and the Industrial Revolution in England all occurred during this period. These upheavals precipitated yet other major changes, including the growth of cities, the emergence of an urban working class, and the expansion of colonialism as the demand for cheap labor and raw materials increased. This enthusiasm for growth gave birth to the doctrine of Manifest Destiny—the ideological justification for continued territorial expansion. Thus, the Age of Enlightenment ushered in a new way of thinking and affected historical developments worldwide.

VOLTAIRE François Marie Arouet, better known as Voltaire (1694-1778), became, and still is, the most representative figure almost the personification—of the Enlightenment spirit. Voltaire was instrumental in introducing Newton and Locke to the French intelligentsia. He hated, and attacked through his writings, the arbitrary despotic rule of kings, the selfish privileges of the nobility and the church, religious intolerance, and, above all, the injustice of the ancien régime (the "old order"). In his numerous books and pamphlets, which the authorities regularly condemned and burned, he protested against government persecution of the freedoms of thought and religion. Voltaire believed humankind could never be happy until an enlightened society removed the traditional obstructions to the progress of the human mind. His personal and public involvement in the struggle against established political and religious authority gave authenticity to his ideas. It converted a whole generation to the conviction that fundamental changes were necessary. This conviction paved the way for a revolution in France that Voltaire never intended, and he probably would never have approved of it. He was not convinced that "all men are created equal," the credo of Jean-Jacques Rousseau, Thomas Jefferson, and the American Declaration of Independence.

21-10 Joseph Wright of Derby, A Philosopher Giving a Lecture at the Orrery, ca. 1763–1765. Oil on canvas, 4′ 10″ × 6′ 8″. Derby Museums and Art Gallery, Derby.

Wright's celebration of the inventions of the Industrial Revolution was in tune with the Enlightenment doctrine of progress. In this dramatically lit scene, the wonders of science mesmerize everyone present.

1 ft.

INDUSTRIAL REVOLUTION The Enlightenment's emphasis on scientific investigation and technological invention opened up new possibilities for human understanding of the world and for control of its material forces. Research into the phenomena of electricity and combustion, along with the discovery of oxygen and the power of steam, had enormous consequences. Steam power as an adjunct to, or replacement for, human labor began a new era in world history, beginning with the Industrial Revolution in England. These technological advances, coupled with the celebration of "progress," gave rise to industrialization. Most scholars mark the beginning of the Industrial Revolution with the invention of steam engines in England for industrial production and, later, their use for transportation in the 1740s. By 1850, England had a manufacturing economy—a revolutionary development because for the first time in history, societies were capable of producing a seemingly limitless supply of goods and services. Within a century, the harnessed power of steam, coal, oil, iron, steel, and electricity working in concert transformed Europe. These scientific and technological developments also affected the arts, particularly the use of new materials for constructing buildings (FIG. 21-11) and the invention of photography (see Chapter 22).

JOSEPH WRIGHT Technological advance fueled a new enthusiasm for mechanical explanations about the wonders of the universe. The fascination science held for ordinary people as well as for the learned is the subject of A Philosopher Giving a Lecture at the Orrery (FIG. 21-10) by the English painter Joseph Wright of Derby (1734-1797). Wright specialized in painting dramatic candlelit and moonlit scenes. He loved subjects such as the orrery demonstration, which could be illuminated by a single light from within the picture. In the painting, a scholar demonstrates a mechanical model of the solar system called an orrery, in which each planet (represented by a metal orb) revolves around the sun (a lamp) at the correct relative velocity. Light from the lamp pours forth from in front of the boy silhouetted in the foreground to create dramatic light and shadows that heighten the drama of the scene. Awed children crowd close to the tiny orbs that represent the planets within the arcing bands that symbolize their orbits. An earnest listener makes notes, while the lone woman seated at the left and the two gentlemen at the right

look on with rapt attention. The wonders of scientific knowledge mesmerize everyone in Wright's painting. The artist visually reinforced the fascination with the orrery by composing his image in a circular fashion, echoing the device's orbital design. The postures and gazes of all the participants and observers focus attention on the cosmic model. Wright scrupulously rendered with careful accuracy every detail of the figures, the mechanisms of the orrery, and even the books and curtain in the shadowy background.

Wright's realism appealed to the great industrialists of his day. Scientific-industrial innovators, such as Josiah Wedgwood, who pioneered many techniques of mass-produced pottery, and Sir Richard Arkwright, whose spinning frame revolutionized the textile industry, often purchased works such as *Orrery*. To them, Wright's elevation of the theories and inventions of the Industrial Revolution to the plane of history painting was exciting and appropriately in tune with the future.

COALBROOKDALE BRIDGE Advances in engineering and the development of new industrial materials during the 18th century had a profound impact on the history of architecture, leading eventually to the steel-and-glass skyscrapers of cities all over the world today. The first use of iron in bridge design was in the cast-iron bridge (FIG. 21-11) built over the Severn River, near Coalbrookdale in England (MAP 22-1), where ABRAHAM DARBY III (1750–1789), one of the bridge's two designers, ran his family's cast-iron business. The Darby family had spearheaded the evolution of the iron industry in England, and they vigorously supported the investigation of new uses for the material. The fabrication of cast-iron rails and bridge elements inspired Darby to work with architect Thomas F. Pritchard (1723–1777) in designing the Coalbrookdale Bridge. The cast-iron armature that supports the roadbed springs from stone pier to stone pier until it leaps the final 100 feet across the Severn River gorge. The style of the graceful center arc echoes the grand arches of Roman aqueducts (FIG. 7-33). At the same time, the exposed structure of the bridge's cast-iron parts prefigured the skeletal use of iron and steel in the 19th century. Visible structural armatures became expressive factors in the design of buildings such as the Crystal Palace (FIG. 22-48) in England and the Eiffel Tower (FIG. 23-1) in France.

21-11 ABRAHAM DARBY III and THOMAS F. PRITCHARD, iron bridge, Coalbrookdale, England, 1776–1779.

The first use of iron in bridge design was in this bridge over the Severn River. The Industrial Revolution brought engineering advances and new materials that revolutionized architectural construction.

Diderot on Chardin and Naturalism

enis Diderot was a pioneer in the field of art criticism as well as in the encyclopedic compilation of human knowledge. Between 1759 and 1781 he contributed reviews of the biennial Salon of the French Royal Academy of Painting and Sculpture (see "Academic Salons," Chapter 23, page 655) to the Parisian journal Correspondence littéraire. In his review of the 1763 Salon, Diderot, a great admirer of Jean-Baptiste-Siméon Chardin (FIG. 21-12), had the following praise for that painter's still lifes and for naturalism in painting.

There are many small pictures by Chardin at the Salon, almost all of them depicting fruit with the accoutrements for a meal. This is nature itself. The objects stand out from the canvas and they are so real that my eyes are fooled by them. . . . In order to look at other people's paintings, I feel as though I need different eyes; but to look at Chardin's, I need only keep the ones nature gave me and use them properly. If I had painting in mind as a career for my child, I'd buy this one [and have him copy it].... Yet nature itself may be no more difficult to copy.... O Chardin, it's not white, red or black pigment that you grind on your palette but rather the very substance of objects; it's real air and light that you take onto the tip of your brush and transfer onto the canvas. . . . It's magic, one can't understand how it's done: thick layers of colour, applied one on top of the other, each one filtering through from underneath to create the effect.... Close up, everything blurs, goes flat and disappears. From a distance, everything comes back to life and reappears.*

* Translated by Kate Tunstall, in Charles Harrison, Paul Wood, and Jason Gaiger, eds., *Art in Theory 1648–1815: An Anthology of Changing Ideas* (Oxford: Blackwell, 2000), 604.

21-12 Jean-Baptiste-Siméon Chardin, Saying Grace, 1740. Oil on canvas, $1'7'' \times 1'3''$. Louvre, Paris.

Chardin embraced naturalism and celebrated the simple goodness of ordinary people, especially mothers and children, who lived in a world far from the frivolous Rococo salons of Paris.

"Natural" Art

ROUSSEAU The second key figure of the French Enlightenment, who was also instrumental in preparing the way ideologically for the French Revolution, was Jean-Jacques Rousseau (1712-1778). Voltaire believed the salvation of humanity was in the advancement of science and in the rational improvement of society. In contrast, Rousseau declared that the arts, sciences, society, and civilization in general had corrupted "natural man"—people in their primitive state—and that humanity's only salvation lay in a return to something like "the ignorance, innocence and happiness" of its original condition. According to Rousseau, human capacity for feeling, sensibility, and emotions came before reason: "To exist is to feel; our feeling is undoubtedly earlier than our intelligence, and we had feelings before we had ideas." Nature alone must be the guide: "All our natural inclinations are right." Fundamental to Rousseau's thinking was the notion that "Man by nature is good ... he is depraved and perverted by society." He rejected the idea of progress, insisting that "Our minds have been corrupted in proportion as the arts and sciences have improved." Rousseau's elevation of feelings above reason as the most primitive-and hence the most "natural"—of human expressions led him to exalt as the ideal the peasant's simple life, with its honest and unsullied emotions.

CHARDIN Rousseau's views, popular and widely read, were largely responsible for the turning away from the Rococo sensibility

and the formation of a taste for the "natural," as opposed to the artificial and frivolous. Reflecting Rousseau's values, JEAN-BAPTISTE-SIMÉON CHARDIN (1699-1779) painted quiet scenes of domestic life, which offered the opportunity to praise the simple goodness of ordinary people, especially mothers and young children, who in spirit, occupation, and environment lived far from corrupt society. In Saying Grace (FIG. 21-12), Chardin ushers the viewer into a modest room where a mother and her small daughters are about to dine. The mood of quiet attention is at one with the hushed lighting and mellow color and with the closely studied still-life accessories whose worn surfaces tell their own humble domestic history. The viewer witnesses a moment of social instruction, when mother and older sister supervise the younger sister in the simple, pious ritual of giving thanks to God before a meal. The simplicity of the composition reinforces the subdued charm of this scene, with the three figures highlighted against the dark background. Chardin was the poet of the commonplace and the master of its nuances. A gentle sentiment prevails in all his pictures, an emotion not contrived and artificial but born of the painter's honesty, insight, and sympathy. Chardin's paintings had wide appeal, even in unexpected places. Louis XV, the royal personification of the Rococo in his life and tastes, once owned Saying Grace. The painter was also a favorite of Diderot, the leading art critic of the day as well as the editor of the Encylopédie (see "Diderot on Chardin and Naturalism," above).

21-13 Jean-Baptiste Greuze, *Village Bride*, 1761. Oil on canvas, $3' \times 3' \cdot 10^{\frac{1}{2}''}$. Louvre, Paris.

Greuze was a master of sentimental narrative, which appealed to a new audience that admired "natural" virtue. Here, in an unadorned room, a father blesses his daughter and her husband-to-be.

JEAN-BAPTISTE GREUZE

The sentimental narrative in art became the specialty of French artist JEAN-BAPTISTE GREUZE (1725–1805), whose most popular work, *Village Bride* (FIG. **21-13**), sums up the characteristics of the genre. The setting is an unadorned room in a rustic dwelling. In a notary's presence, the elderly father has passed his daughter's dowry to her youthful husband-

to-be and blesses the pair, who gently take each other's arms. The old mother tearfully gives her daughter's arm a farewell caress, while the youngest sister melts in tears on the shoulder of the demure bride. An envious older sister broods behind her father's chair. Rosy-faced, healthy children play around the scene. The picture's story is simple—the happy climax of a rural romance. The painting's moral is just as clear—happiness is the reward of "natural" virtue.

Greuze produced this work at a time when the audience for art was expanding. The strict social hierarchy that provided the foundation for Rococo art and patronage gave way to a bourgeois economic and social system. Members of this bourgeois class increasingly embraced art, and paintings such as *Village Bride* particularly appealed to them. They carefully analyzed each gesture and each nuance of sentiment and reacted enthusiastically. At the 1761 Salon of the Royal Academy, Greuze's picture received enormous attention. Diderot, who reviewed the exhibition for *Correspondence littéraire*, declared that it was difficult to get near it because of the throngs of admirers.

VIGÉE-LEBRUN Self-Portrait (FIG. 21-14) by ÉLISABETH LOUISE VIGÉE-LEBRUN (1755–1842) is another variation of the "naturalistic" impulse in 18th-century French art. In this new mode of portraiture, Vigée-Lebrun looks directly at viewers and pauses in her work to return their gaze. Although her mood is lighthearted and her costume's details echo the serpentine curve Rococo artists and wealthy patrons loved, nothing about Vigée-Lebrun's pose or her mood speaks of Rococo frivolity. Hers is the self-confident stance of a woman whose art has won her an independent role in her society. She portrayed herself in a close-up, intimate view at work on one of the portraits that won her renown, that of Queen Marie Antoinette (1755–1793). Like many of her contemporaries, Vigée-Lebrun lived a life of extraordinary personal and economic independence, working for the nobility throughout Europe. She was famous for the force and grace of her portraits, especially those of highborn ladies and royalty. She was successful during the age of the late monarchy in France and was one of the few women admitted to the Royal Academy. After the French

21-14 ÉLISABETH LOUISE VIGÉE-LEBRUN, Self-Portrait, 1790. Oil on canvas, 8' $4'' \times 6'$ 9''. Galleria degli Uffizi, Florence.

Vigée-Lebrun was one of the few women admitted to France's Royal Academy of Painting and Sculpture. In this self-portrait, she depicted herself confidently painting the likeness of Queen Marie Antoinette.

21-15 WILLIAM HOGARTH, *Breakfast Scene*, from *Marriage à la Mode*, ca. 1745. Oil on canvas, 2′ 4″ × 3′. National Gallery, London.

Hogarth won fame for his paintings and prints satirizing 18th-century English life with comic zest. This is one of a series of six paintings in which he chronicled the marital immoralities of the moneyed class.

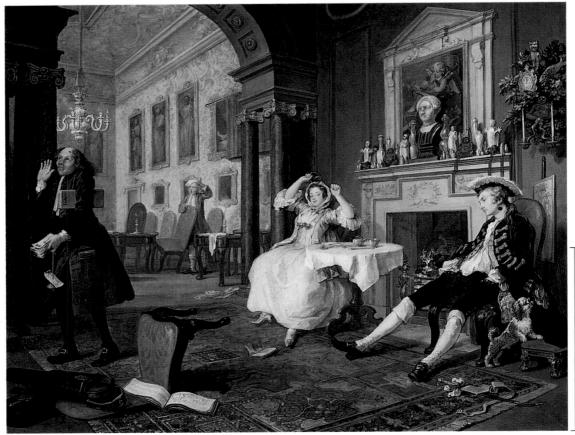

1 ft

Revolution, however, the Academy rescinded her membership, because women were no longer welcome, but she enjoyed continued success owing to her talent, wit, and ability to forge connections with those in power in the postrevolutionary period.

WILLIAM HOGARTH Across the Channel, a truly English style of painting emerged with WILLIAM HOGARTH (1697–1764), who satirized the lifestyle of the newly prosperous middle class with comic zest. Traditionally, the British imported painters from the Continent—Holbein, Rubens, and Van Dyck among them. Hogarth waged a lively campaign throughout his career against the English feeling of dependence on, and inferiority to, these artists. Although Hogarth would have been the last to admit it, his own painting owed much to the work of his contemporaries in France, the Rococo artists. Yet his subject matter, frequently moral in tone, was distinctively English. It was the great age of English satirical writing, and Hogarth—who knew and admired this genre and included Henry Fielding (1701–1754), the author of *Tom Jones*, among his closest friends—clearly saw himself as translating satire into the visual arts.

Hogarth's favorite device was to make a series of narrative paintings and prints, in a sequence like chapters in a book or scenes in a play, following a character or group of characters in their encounters with some social evil. *Breakfast Scene* (FIG. 21-15), from *Marriage à la Mode*, is one in a sequence of six paintings that satirize the marital immoralities of the moneyed classes in England. In it, the marriage of a young viscount is just beginning to founder. The husband and wife are tired after a long night spent in separate pursuits. While the wife stayed home for an evening of cards and music-making, her young husband had been away from the house for a night of suspicious business. He thrusts his hands deep into the empty money-pockets of his breeches, while his wife's small dog sniffs inquiringly at a woman's lacy cap protruding from his coat pocket. A steward, his hands full of unpaid bills, raises his eyes to Heaven in despair at the actions of his no-

ble master and mistress. The house is palatial, but Hogarth filled it with witty clues to the dubious taste of its occupants. For example, the row of pious religious paintings on the upper wall of the distant room concludes with a curtain-shielded work that undoubtedly depicts an erotic subject. According to the custom of the day, ladies could not view this discretely hidden painting, but at the pull of a cord, the master and his male guests could gaze at the cavorting figures. In *Breakfast Scene*, as in all his work, Hogarth proceeded as a novelist might, elaborating on his subject with carefully chosen detail, whose discovery heightens the comedy.

Hogarth designed the marriage series to be published as a set of engravings. The prints of this and his other moral narratives were so popular that unscrupulous entrepreneurs produced unauthorized versions almost as fast as the artist created his originals. The popularity of these prints speaks not only to the appeal of their subjects but also to the democratization of knowledge and culture the Enlightenment fostered and to the exploitation of new printing technologies that produced a more affordable and widely disseminated visual culture.

THOMAS GAINSBOROUGH A contrasting blend of "naturalistic" representation and Rococo setting is found in the portrait Mrs. Richard Brinsley Sheridan (FIG. 21-16) by the British painter Thomas Gainsborough (1727–1788). This painting shows a lovely woman, dressed informally, seated in a rustic landscape faintly reminiscent of Watteau (FIG. 21-6) in its soft-hued light and feathery brushwork. Gainsborough intended to match the natural, unspoiled beauty of the landscape with that of his sitter. Mrs. Sheridan's dark brown hair blows freely in the slight wind, and her clear "English" complexion and air of ingenuous sweetness contrast sharply with the pert sophistication of those that Continental Rococo artists portrayed. Gainsborough originally had planned to give the picture a more pastoral air by adding several sheep, but he did not live long enough to paint them. Even without this element, the painting

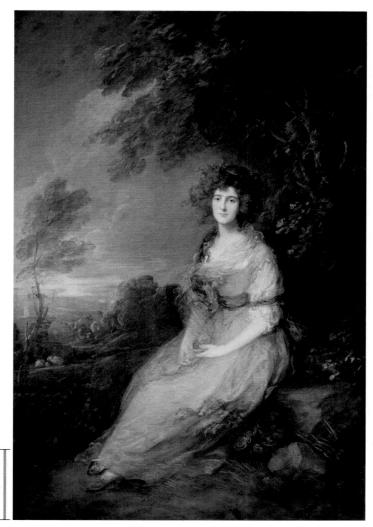

21-16 Thomas Gainsborough, *Mrs. Richard Brinsley Sheridan*, 1787. Oil on canvas, $7' 2\frac{5}{8}'' \times 5' \frac{5}{8}''$. National Gallery of Art, Washington, D.C. (Andrew W. Mellon Collection).

In this life-size portrait, Gainsborough sought to match the natural beauty of Mrs. Sheridan with that of the landscape. The rustic setting, soft-hued light, and feathery brushwork recall Rococo painting.

clearly expresses the artist's deep interest in the landscape setting. Although he won greater fame in his time for his portraits, he had begun as a landscape painter and always preferred painting scenes of nature to depicting human likenesses.

JOSHUA REYNOLDS Morality of a more heroic tone than that found in the work of Greuze, yet in harmony with "naturalness," included the virtues of honor, valor, and love of country. According to 18th-century Western thought, these virtues produced great people and exemplary deeds. The concept of "nobility," especially as discussed by Rousseau, referred to character, not to aristocratic birth. As the century progressed and people felt the tremors of coming revolutions, these virtues of courage and resolution, patriotism, and self-sacrifice assumed greater importance. Having risen from humble origins, the modern military hero, not the decadent aristocrat, brought the tumult of war into the company of the "natural" emotions.

SIR JOSHUA REYNOLDS (1723–1792) specialized in what became known as *Grand Manner portraiture* and often depicted contemporaries who participated in the great events of the latter part of the 18th century. Although clearly showing individualized people, Grand Manner portraiture also elevated the sitter by conveying refinement and elegance. Painters communicated a person's grace and class through

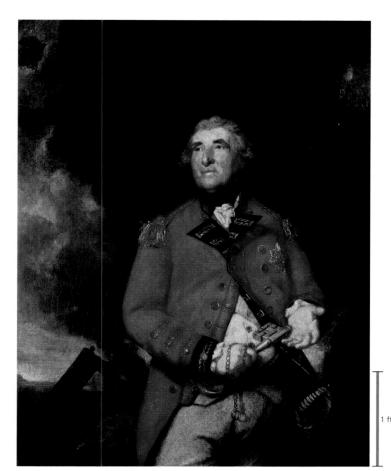

21-17 SIR JOSHUA REYNOLDS, *Lord Heathfield*, 1787. Oil on canvas, $4' 8'' \times 3' 9''$. National Gallery, London.

In this Grand Manner portrait, Reynolds depicted the English commander who defended Gibraltar. Typical of this genre, Heathfield is large in relation to the canvas size and stands in a dramatic pose.

certain standardized conventions, such as the large scale of the figure relative to the canvas, the controlled pose, the landscape setting, and the low horizon line. Reynolds painted his portrait of Lord Heathfield (FIG. 21-17) in 1787. This burly, ruddy English officer, commandant of the fortress at Gibraltar, was a perfect subject for a Grand Manner portrait. Heathfield had doggedly defended the British fortress against the Spanish and the French, and later received the honorary title Baron Heathfield of Gibraltar. Here, he holds the huge key to the fortress, the symbol of his victory. He stands in front of a curtain of dark smoke rising from the battleground, flanked by one cannon that points ineffectively downward and another whose tilted barrel indicates that it lies uselessly on its back. Reynolds portrayed the features of the general's heavy, honest face and his uniform with unidealized realism. But Lord Heathfield's posture and the setting dramatically suggest the heroic themes of battle and refer to the revolutions (American and French) then taking shape in deadly earnest, as the old regimes faded into the past.

BENJAMIN WEST Some American artists also became well known in England. Benjamin West (1738–1820), born in Pennsylvania on what was then the colonial frontier, traveled to Europe early in life to study art and then went to England, where he met with almost immediate success. A cofounder of the Royal Academy of Arts, West succeeded Reynolds as its president. He became official painter to King George III (r. 1760–1801) and retained that position during the strained period of the American Revolution.

21-18 Benjamin West, *Death of General Wolfe*, 1771. Oil on canvas, $4' 11\frac{1}{2}'' \times 7'$. National Gallery of Canada, Ottawa (gift of the Duke of Westminster, 1918).

West's great innovation was to blend contemporary subject matter and costumes with the grand tradition of history painting. Here, West likened General Wolfe's death to that of a martyred saint.

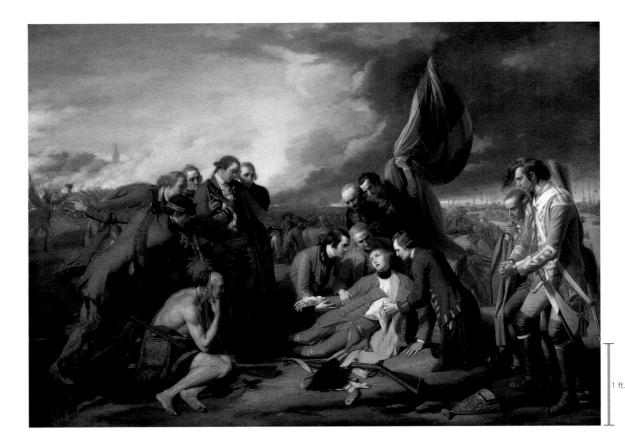

In *Death of General Wolfe* (FIG. **21-18**), West depicted the mortally wounded young English commander just after his defeat of the French in the decisive battle of Quebec in 1759, which gave Canada to Great Britain. In portraying a contemporary historical subject, he put his characters in contemporary costume (although the military uniforms are not completely accurate in all details). However, West blended this realism of detail with the grand tradition of history painting by arranging his figures in a complex, theatrically ordered composition. His modern hero dies among grieving officers on the field of victorious battle in a way that suggests the death of a great saint. West wanted to present this hero's death in the service of the state as a martyrdom charged with religious emotions. His innovative combination of the conventions of traditional heroic painting with a look of modern realism was so effective that it won viewers' hearts in his own day and continued to influence history painting well into the 19th century.

JOHN SINGLETON COPLEY American artist John Single-TON COPLEY (1738-1815) matured as a painter in the Massachusetts Bay Colony. Like West, Copley later emigrated to England, where he absorbed the fashionable English portrait style. But unlike Grand Manner portraiture, Copley's Portrait of Paul Revere (FIG. 21-19), painted before Copley left Boston, conveys a sense of directness and faithfulness to visual fact that marked the taste for honesty and plainness many visitors to America noticed during the 18th and 19th centuries. When Copley painted his portrait, Revere was not yet the familiar hero of the American Revolution. In the picture, he is working at his profession of silversmithing. The setting is plain, the lighting clear and revealing. Revere sits in his shirtsleeves, bent over a teapot in progress. He pauses and turns his head to look the observer straight in the eye. Copley treated the reflections in the polished wood of the tabletop with as much care as Revere's figure, his tools, and the teapot resting on its leather graver's pillow. Copley gave special prominence to Revere's eyes by reflecting intense reddish light onto the darkened side of his face and hands. The informality and the sense of the moment link this

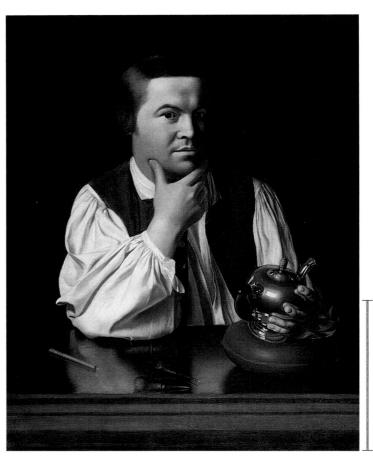

21-19 John Singleton Copley, *Portrait of Paul Revere*, ca. 1768–1770. Oil on canvas, 2' $11\frac{1}{8}'' \times 2'$ 4". Museum of Fine Arts, Boston (gift of Joseph W., William B., and Edward H. R. Revere).

In contrast to Grand Manner portraiture, Copley's *Paul Revere* emphasizes his subject's down-to-earth character, differentiating this American work from its European counterparts.

The Grand Tour and Veduta Painting

Ithough travel throughout Europe was commonplace in the 18th century, Italy became a particularly popular destination. This "pilgrimage" of aristocrats, the wealthy, politicians, and diplomats from France, England, Germany, Flanders, Sweden, the United States, Russia, Poland, and Hungary came to be known as the Grand Tour. Italy's allure fueled the revival of classicism, and the popularity of Neoclassical art drove this fascination with Italy. One British observer noted: "All our religion, all our arts, almost all that sets us above savages, has come from the shores of the Mediterranean."*

The Grand Tour was not simply leisure travel. The education available in Italy to the inquisitive mind made the trip an indispensable experience for anyone who wished to make a mark in society. The Enlightenment had made knowledge of ancient Rome and Greece imperative, and a steady stream of Europeans and Americans traveled to Italy in the late 18th and early 19th centuries. These tourists aimed to increase their knowledge of literature, the visual arts, architecture, theater, music, history, customs, and folklore. Given this extensive agenda, it is not surprising that a Grand Tour could take a number of years to complete, and most travelers moved from location to location, following an established itinerary.

The British were the most avid travelers, and they conceived the initial "tour code," including important destinations and required itineraries. Although they designated Rome early on as the primary destination, visitors traveled as far north as Venice and as far south as Naples. Eventually, Paestum, Sicily, Florence, Genoa, Milan, Siena, Pisa, Bologna, and Parma (MAP 20-1) all appeared in guidebooks and in paintings. Joseph Wright of Derby (FIG. 21-10) and Joseph Mallord William Turner (FIG. 22-23) were among the many British artists to undertake a Grand Tour.

Many of those who completed a Grand Tour returned home with a painting by Antonio Canaletto, the leading painter of scenic views (*vedute*) of Venice. It must have been very cheering on a gray winter afternoon in England to look up and see a sunny, panoramic view such as that in Canaletto's *Riva degli Schiavoni*, *Venice* (FIG. 21-20), with its cloud-studded sky, picturesque water traffic, and well-known Venetian landmarks (the Doge's Palace, FIG. 14-21, is at the left in *Riva degli Schiavoni*) painted in scrupulous perspective and minute detail. Canaletto usually made drawings "on location" to take back to his studio and use as sources for paintings. To help make the on-site draw-

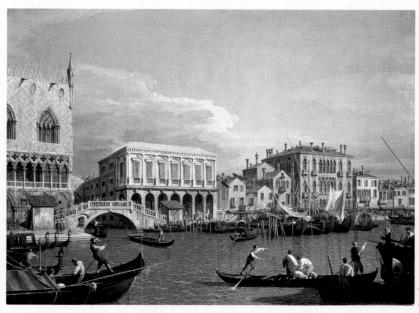

21-20 Antonio Canaletto, *Riva degli Schiavoni*, *Venice*, ca. 1735–1740. Oil on canvas, 1' $6\frac{1}{2}$ " \times 2' $\frac{7}{8}$ ". Toledo Museum of Art, Toledo.

Canaletto was the leading painter of Venetian *vedute*, which were treasured souvenirs for 18th-century travelers visiting Italy on a Grand Tour. He used a camera obscura for his on-site drawings.

ings true to life, he often used a camera obscura, as Vermeer (FIGS. 20-1 and 20-19) did before him. These instruments were darkened chambers (some of them virtually portable closets) with optical lenses fitted into a hole in one wall through which light entered to project an inverted image of the subject onto the chamber's opposite wall. The artist could trace the main details from this image for later reworking and refinement. The camera obscura allowed artists to create visually convincing paintings that included variable focus of objects at different distances. Canaletto's paintings give the impression of capturing every detail, with no omissions. In fact, he presented each site within Renaissance perspectival rules and exercised great selectivity about which details to include and which to omit to make a coherent and engagingly attractive veduta.

* Cesare de Seta, "Grand Tour: The Lure of Italy in the Eighteenth Century," in Andrew Wilton and Ilaria Bignamini, eds., *Grand Tour: The Lure of Italy in the Eighteenth Century* (London: Tate Gallery, 1996), 13.

painting to contemporaneous English and European portraits. But the spare style and the emphasis on the sitter's down-to-earth character differentiate this American work from its European counterparts.

THE GRAND TOUR The 18th-century public also sought "naturalness" in artists' depictions of landscapes. Documentation of particular places became popular, in part due to growing travel opportunities and expanding colonialism. These depictions of geographic settings also served the needs of the many scientific expeditions mounted during the century and satisfied the desires of genteel tourists for mementos of their journeys. By this time, a "Grand Tour" of the major

sites of Europe was an essential part of every well-bred person's education (see "The Grand Tour," above). Naturally, those on tour wished to return with items that would help them remember their experiences and impress those at home with the wonders they had seen. The English were especially eager collectors of pictorial souvenirs. Certain artists in Venice specialized in painting the most characteristic scenes, or *vedute* (views), of that city to sell to British visitors. Chief among the Venetian painters was Antonio Canaletto (1697–1768), whose works, for example *Riva degli Schiavoni*, *Venice* (Fig. **21-20**), English tourists avidly acquired as evidence of their visit to the city of the Grand Canal.

The Excavations of Herculaneum and Pompeii

mong the events that fueled the European fascination with classical antiquity were the excavations of two ancient Roman cities on the Bay of Naples-Herculaneum and Pompeii. The violent eruption of Mount Vesuvius in August 79 CE had buried both cities under volcanic ash and mud (see "An Eyewitness Account of the Eruption of Mount Vesuvius," Chapter 7, page 165). Although each city was "rediscovered" at various times during the ensuing centuries, systematic exploration of both sites did not begin until the mid-1700s. Because Vesuvius buried these cities under volcanic ash and lava, the excavations produced unusually rich evidence for reconstructing Roman art and life. The 18th-century excavators uncovered paintings, sculptures, furniture, vases, and silverware in addition to buildings. As a result, European interest in ancient Rome expanded tremendously. European collectors acquired many of the newly discovered objects. For example, Sir William Hamilton, British consul in Naples from 1764 to 1800, purchased numerous vases and small objects, which he sold to the British Museum in 1772. The finds at Pompeii and Herculaneum, therefore, quickly became available to a wide public.

"Pompeian" style soon became all the rage in England, as evident in the interior designs of Robert Adam, which were inspired by the slim, straight-lined, elegant frescoes of the Third and early Fourth Styles of Roman mural painting (FIGS. 7-21 and 7-22). The new Neoclassical style almost entirely displaced the curvilinear Rococo (FIGS. 21-2 and 21-3) after midcentury. In the Etruscan Room (FIG. 21-21) at Osterley Park House, Adam took decorative motifs (medallions, urns, vine scrolls, sphinxes, and tripods) from Roman art and arranged them sparsely within broad, neutral spaces and slender margins, as in his ancient models. Adam was an archaeologist as well, and he had explored and written accounts of the ruins of Diocletian's palace (FIG. 7-74) at Split. Kedleston House in Derbyshire, Adelphi Terrace in London, and a great many other structures he designed show the influence of the Split palace on his work.

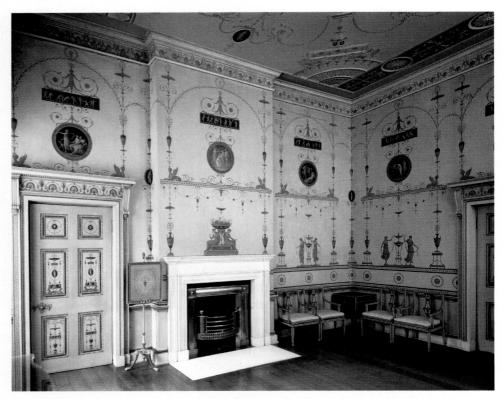

21-21 ROBERT ADAM, Etruscan Room, from Osterley Park House, Middlesex, England, begun 1761. Victoria & Albert Museum, London.

Inspired by the recent discoveries at Herculaneum and Pompeii, Adam incorporated classical decorative motifs into his Etruscan Room, which he based on Roman mural painting.

The archaeological finds from Herculaneum and Pompeii also affected garden and landscape design, fashion, and tableware. Clothing based on classical garb became popular, and Emma Hamilton, wife of Sir William Hamilton, often gave lavish parties dressed in floating and delicate Greek-style drapery. Neoclassical taste also determined the pottery designs of John Flaxman (1755–1826) and Josiah Wedgwood (1730–1795). Wedgwood established his reputation in the 1760s with his creamware inspired by ancient art. He eventually produced vases based on what were thought to be Etruscan designs (actually Greek vases found in Etruscan tombs) and expanded his business by producing small busts of classical figures as well as cameos and medallions adorned with copies of antique reliefs and statues.

NEOCLASSICISM

One of the defining characteristics of the late 18th century was a renewed admiration for classical antiquity, which the Grand Tour was instrumental in fueling. This interest gave rise to the artistic movement known as *Neoclassicism*, which incorporated the subjects and styles of ancient art. Painting, sculpture, and architecture, however, were only the most prominent manifestations of Neoclassicism. Fascination with Greek and Roman culture was widespread and extended to the public culture of fashion and home decor. The En-

lightenment's emphasis on rationality in part explains this classical focus, because the geometric harmony of classical art and architecture embodied Enlightenment ideals. In addition, classical cultures represented the pinnacle of civilized society, and Greece and Rome served as models of enlightened political organization. These cultures, with their traditions of liberty, civic virtue, morality, and sacrifice, were ideal models during a period of great political upheaval. Given these traditional associations, it is not coincidental that Neoclassicism was particularly appealing during the French and American Revolutions. Further whetting the public appetite for classicism

were the excavations of Herculaneum (begun in 1738) and Pompeii (1748), which the volcanic eruption of Mount Vesuvius had buried (see "The Excavations of Herculaneum and Pompeii," page 598). Soon, murals based on artwork unearthed in the excavations began to appear on the walls of rooms in European town houses, such as the "Etruscan Room" (FIG. 21-21) by ROBERT ADAM (1728–1792) in Osterley Park House in Middlesex, begun in 1761.

WINCKELMANN The enthusiasm for classical antiquity also permeated much of the scholarship of the time. In the late 18th century, the ancient world increasingly became the focus of scholarly attention. A visit to Rome stimulated Edward Gibbon (1737–1794) to begin his monumental *Decline and Fall of the Roman Empire*, which appeared between 1776 and 1788. Earlier, in 1755, Johann Joachim Winckelmann (1717–1768), the first modern art historian, published *Reflections on the Imitation of Greek Works in Painting and Sculpture*, uncompromisingly designating Greek art as the most perfect to come from human hands—and far preferable to "natural" art.

Good taste, which is becoming more prevalent throughout the world, had its origins under the skies of Greece.... The only way for us to become great... is to imitate the ancients.... In the masterpieces of Greek art, connoisseurs and imitators find not only nature at its most beautiful but also something beyond nature, namely certain ideal forms of its beauty.... A person enlightened enough to penetrate the innermost secrets of art will find beauties hitherto seldom revealed when he compares the total structure of Greek figures with most modern ones, especially those modelled more on nature than on Greek taste.³

In his *History of Ancient Art* (1764), Winckelmann described each monument and positioned it within a huge inventory of works organized by subject matter, style, and period. Before Winckelmann, art historians had focused on biography, as did Giorgio Vasari and

Giovanni Pietro Bellori in the 16th and 17th centuries. Winckelmann thus initiated one modern art historical method thoroughly in accord with Enlightenment ideas of ordering knowledge—a system of description and classification that provided a pioneering model for the understanding of stylistic evolution. His familiarity with classical art derived predominantly (as was the norm) from Roman works and Roman copies of Greek art in Italy. Yet he was instrumental in bringing to scholarly attention the distinctions between Greek and Roman art. Thus, he paved the way for more thorough study of the distinct characteristics of the art and architecture of these two cultures. Winckelmann's writings also laid a theoretical and historical foundation for the enormously widespread taste for Neoclassicism that lasted well into the 19th century.

Painting

ANGELICA KAUFFMANN One of the pioneers of Neoclassical painting was Angelica Kauffmann (1741-1807). Born in Switzerland and trained in Italy, Kauffmann spent many of her productive years in England. A student of Reynolds, and an interior decorator of many houses built by Adam, she was a founding member of the British Royal Academy of Arts and enjoyed an enviable reputation. Her Cornelia Presenting Her Children as Her Treasures, or Mother of the Gracchi (FIG. 21-22), is an exemplum virtutis (example or model of virtue) drawn from Greek and Roman history and literature. The moralizing pictures of Greuze (FIG. 21-13) and Hogarth (FIG. 21-15) already had marked a change in taste, but Kauffmann replaced the modern setting and character of their works. She clothed her actors in ancient Roman garb and posed them in statuesque attitudes within Roman interiors. The theme in this painting is the virtue of Cornelia, mother of the future political leaders Tiberius and Gaius Gracchus, who, in the second century BCE, attempted to reform the Roman Republic. Cornelia reveals her charac-

ter in this scene, which takes place after the seated visitor showed off her fine jewelry and then insisted haughtily that Cornelia show hers. Instead of rushing to get her own precious adornments, Cornelia brought her sons forward, presenting them as her jewels. The architectural setting is severely Roman, with no Rococo motif in evidence, and the composition and drawing have the simplicity and firmness of low-relief carving.

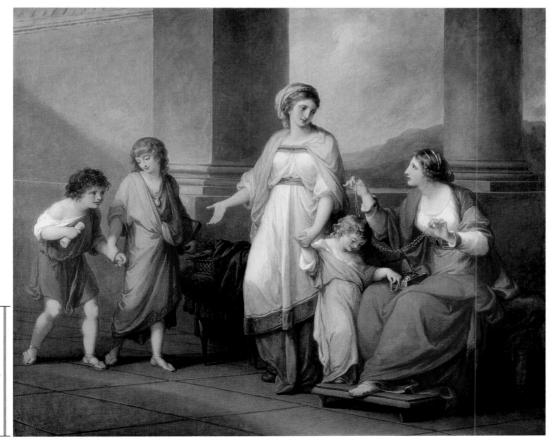

21-22 ANGELICA KAUFFMANN, Cornelia Presenting Her Children as Her Treasures, or Mother of the Gracchi, ca. 1785. Oil on canvas, 3' 4" × 4' 2". Virginia Museum of Fine Arts, Richmond (the Adolph D. and Wilkins C. Williams Fund).

Kauffmann's painting of a virtuous Roman mother who presented her children to a visitor as her jewels exemplifies the Enlightenment fascination with classical antiquity and with classical art.

David on Greek Style and Public Art

acques-Louis David was the leading Neoclassical painter in France at the end of the 18th century. He championed a return to Greek style and the painting of inspiring heroic and patriotic subjects. In 1796 he made the following statement to his pupils:

I want to work in a pure Greek style. I feed my eyes on antique statues, I even have the intention of imitating some of them. The Greeks had no scruples about copying a composition, a gesture, a type that had already been accepted and used. They put all their attention and all their art on perfecting an idea that had been already conceived. They thought, and they were right, that in the arts the way in which an idea is rendered, and the manner in which it is expressed, is much more important than the idea itself. To give a body and a perfect form to one's thought, this—and only this—is to be an artist.*

David also strongly believed that paintings depicting noble events in ancient history, such as Oath of the Horatii (FIG. 21-23),

would instill patriotism and civic virtue in the public at large in postrevolutionary France. In November 1793 he wrote:

[The arts] should help to spread the progress of the human spirit, and to propagate and transmit to posterity the striking examples of the efforts of a tremendous people who, guided by reason and philosophy, are bringing back to earth the reign of liberty, equality, and law. The arts must therefore contribute forcefully to the education of the public. . . . The arts are the imitation of nature in her most beautiful and perfect form. . . . [T]hose marks of heroism and civic virtue offered the eyes of the people [will] electrify the soul, and plant the seeds of glory and devotion to the fatherland.

* Translated by Robert Goldwater and Marco Treves, eds., Artists on Art, 3d ed. (New York: Pantheon Books, 1958), 206.

21-23 Jacques-Louis DAVID, Oath of the Horatii, 1784. Oil on canvas, 10' $10'' \times$ 13' 11". Louvre, Paris.

David was the Neoclassical painter-ideologist of the French Revolution. This huge canvas celebrating ancient Roman patriotism and sacrifice features statuesque figures and classical architecture.

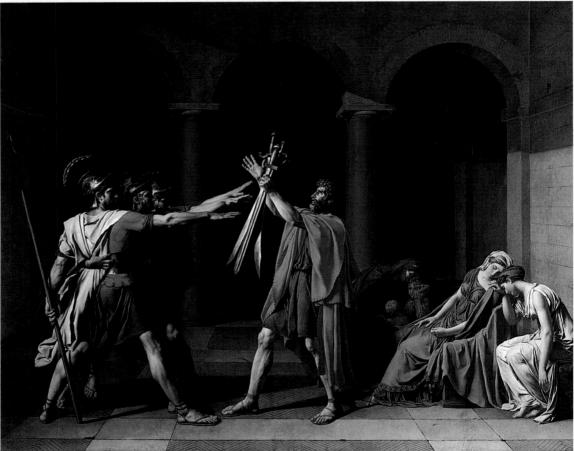

JACQUES-LOUIS DAVID The Enlightenment idea of a participatory and knowledgeable citizenry lay behind the revolt against the French monarchy in 1789, but the immediate causes of the French Revolution were the country's economic crisis and the clash between the Third Estate (bourgeoisie, peasantry, and urban and rural workers) and the First and Second Estates (the clergy and nobility, respectively). They fought over the issue of representation in the legislative body, the Estates-General, which had been convened to discuss taxation as a possible solution to the economic problem. However, the ensuing revolution revealed the instability of the monarchy and of French society's traditional structure and resulted in a succession of republics and empires as France struggled to find a way to adjust to these decisive changes.

[†] Ibid., 205.

Jacques-Louis David (1748–1825) became the Neoclassical painter-ideologist of the French Revolution. A distant relative of Boucher, he followed the Rococo painter's style until a period of study in Rome won the younger man over to the classical art tradition. David favored the academic teachings about using the art of the ancients and of the great Renaissance masters as models. He rebelled against Rococo style as an "artificial taste" and exalted the "perfect form" of Greek art (see "David on Greek Style and Public Art," page 600).

OATH OF THE HORATII David concurred with the Enlightenment belief that subject matter should have a moral and should be presented so that noble deeds in the past could inspire virtue in the present. A milestone painting in David's career, Oath of the Horatii (FIG. 21-23), depicts a story from pre-Republican Rome, the heroic phase of Roman history. The topic was not too arcane for David's audience. Pierre Corneille (1606-1684) had retold this story of conflict between love and patriotism, first recounted by the ancient Roman historian Livy, in a play performed in Paris several years earlier, making it familiar to David's viewing public. According to the story, the leaders of the warring cities of Rome and Alba decided to resolve their conflicts in a series of encounters waged by three representatives from each side. The Romans chose as their champions the three Horatius brothers, who had to face the three sons of the Curatius family from Alba. A sister of the Horatii, Camilla, was the bride-tobe of one of the Curatius sons, and the wife of the youngest Horatius was the sister of the Curatii.

David's painting shows the Horatii as they swear on their swords, held high by their father, to win or die for Rome, oblivious to the anguish and sorrow of their female relatives. In its form, Oath of the Horatii is a paragon of the Neoclassical style. Not only does the subject matter deal with a narrative of patriotism and sacrifice excerpted from Roman history, but the painter presented the image with force and clarity. David depicted the scene in a shallow space much like a stage setting, defined by a severely simple architectural framework. He deployed his statuesque and carefully modeled figures across the space, close to the foreground, in a manner reminiscent of ancient relief sculpture. The rigid, angular, and virile forms of the men on the left effectively contrast with the soft curvilinear shapes of the distraught women on the right. This pattern visually pits virtues the Enlightenment leaders ascribed to men (such as courage, patriotism, and unwavering loyalty to a cause) against the emotions of love, sorrow, and despair that the women in the painting express. The French viewing audience perceived such emotionalism as characteristic of the female nature. The message was clear and of a type readily identifiable to the prerevolutionary French public. The picture created a sensation at its first exhibition in Paris in 1785, and although David had painted it under royal patronage and did not intend the painting as a revolutionary statement, the Neoclassical style of Oath of the Horatii soon became the semiofficial voice of the French Revolution. David may have painted in the academic tradition, but he brought new impetus to it. He created a program for arousing his audience to patriotic zeal.

DEATH OF MARAT When the French Revolution broke out in 1789, David threw in his lot with the Jacobins, the radical and militant revolutionary faction. He accepted the role of de facto minister of propaganda, organizing political pageants and ceremonies that included floats, costumes, and sculptural props. David believed that art could play an important role in educating the public and that dramatic paintings emphasizing patriotism and civic virtue would prove

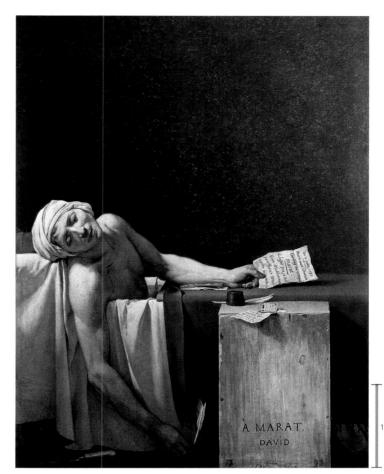

21-24 JACQUES-LOUIS DAVID, *Death of Marat*, 1793. Oil on canvas, $5' 5'' \times 4' 2\frac{1}{2}''$. Musées Royaux des Beaux-Arts de Belgique, Brussels.

David depicted the revolutionary Marat as a tragic martyr, stabbed to death in his bath. Although the painting displays severe Neoclassical spareness, its convincing realism conveys pain and outrage.

effective as rallying calls. However, rather than continuing to create artworks focused on scenes from antiquity, David began to portray scenes from the French Revolution itself. He intended Death of Marat (FIG. 21-24) not only to serve as a record of an important event in the struggle to overthrow the monarchy but also to provide inspiration and encouragement to the revolutionary forces. Jean-Paul Marat (1743-1793), a writer and David's friend, was tragically assassinated in 1793. David depicted the martyred revolutionary after Charlotte Corday (1768-1793), a member of a rival political faction, stabbed him to death in his medicinal bath. (Marat suffered from a painful skin disease.) David presented the scene with directness and clarity. The cold neutral space above Marat's figure slumped in the tub produces a chilling oppressiveness. The painter vividly placed narrative details—the knife, the wound, the blood, the letter with which the young woman gained entrance—to sharpen the sense of pain and outrage and to confront viewers with the scene itself. Death of Marat is convincingly real, yet David masterfully composed the painting to present Marat as a tragic martyr who died in the service of the revolution. David based the figure of Marat on Christ in Michelangelo's Pietà (FIG. 17-12) in Saint Peter's in Rome. The reference to Christ's martyrdom made the painting a kind of "altarpiece" for the new civic "religion," inspiring the French people with the saintly dedication of their slain leader.

21-25 Jacques-Germain Soufflot, Panthéon (Sainte-Geneviève), Paris, France, 1755–1792.

Soufflot's Panthéon is a testament to the Enlightenment admiration for Greece and Rome. It combines a portico based on an ancient Roman temple with a colonnaded dome and a Greek-cross plan.

Architecture in the Enlightenment era also exhibits a dependence on classical models. Early in the 18th century, architects began to turn away from the theatricality and ostentation of Baroque and Rococo design and embraced a more streamlined antique look.

PANTHÉON The portico of the Parisian church of Sainte-Geneviève,

now the Panthéon (FIG. 21-25), by Jacques-Germain Soufflot (1713–1780), stands as testament to the revived interest in Greek and Roman cultures. The Roman ruins at Baalbek in Lebanon, especially the titanic colonnade of the temple of Jupiter, provided much of the inspiration for Soufflot's design. The columns, reproduced with studied archaeological precision, stand out from walls that are severely blank, except for a repeated garland motif near the top. The colonnaded dome, a Neoclassical version of the domes of Saint Peter's (FIGS. 19-3 and 19-4) in Rome, the Église du Dôme (FIG. 20-36) in Paris, and Saint Paul's (FIG. 20-38) in London, rises above a Greek-cross plan. Both the dome and the vaults rest on an interior grid of splendid freestanding Corinthian columns, as if the portico's colonnade continued within. Although the overall effect, inside and out, is Roman, the structural principles employed are essentially Gothic. Soufflot was one of the first 18th-century builders to suggest that the logical engineering of Gothic cathedrals (see "The Gothic Cathedral," Chapter 13, page 347) could be applied to modern buildings. In his work, the curious, but not unreasonable, conjunction of Gothic and classical has a structural integration that laid the foundation for the 19th-century admiration of Gothic building principles.

CHISWICK HOUSE The appeal of classical antiquity extended well beyond French borders. The popularity of Greek and Roman

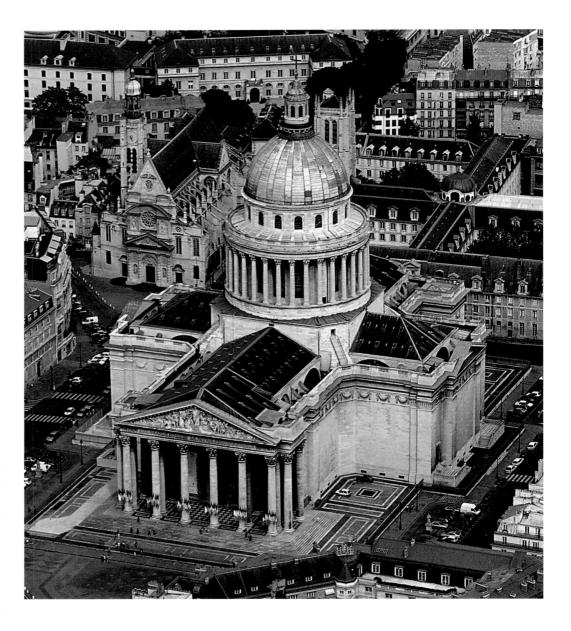

cultures was due not only to their association with morality, rationality, and integrity but also to their connection to political systems ranging from Athenian democracy to Roman imperial rule. Thus, parliamentary England joined revolutionary France in embracing Neoclassicism. In England, Neoclassicism's appeal also was due to its clarity and simplicity. These characteristics provided a stark contrast to the complexity and opulence of Baroque art, then associated with the flamboyant rule of absolute monarchy. In English architecture, the preference for a simple style derived indirectly from the authority of the classical Roman architect Vitruvius, through Andrea Palladio's work (FIGS. 17-29 to 17-32), and on through that of Inigo Jones (FIG. 20-37).

RICHARD BOYLE (1695–1753), earl of Burlington, strongly restated Jones's Palladian doctrine in a new style in Chiswick House (FIG. 21-26), which he built on London's outskirts with the help of WILLIAM KENT (ca. 1686–1748). The way had been paved for this shift in style by, among other things, the publication of Colin Campbell's *Vitruvius Britannicus* (1715), three volumes of engravings of ancient buildings, prefaced by a denunciation of Italian Baroque and high praise for Palladio and Jones. Chiswick House is a free variation on the theme of Palladio's Villa Rotonda (FIG. 17-29). The exterior design provided a clear alternative to the colorful splendors of Versailles (FIG. 20-32). In its simple symmetry, unadorned planes, right

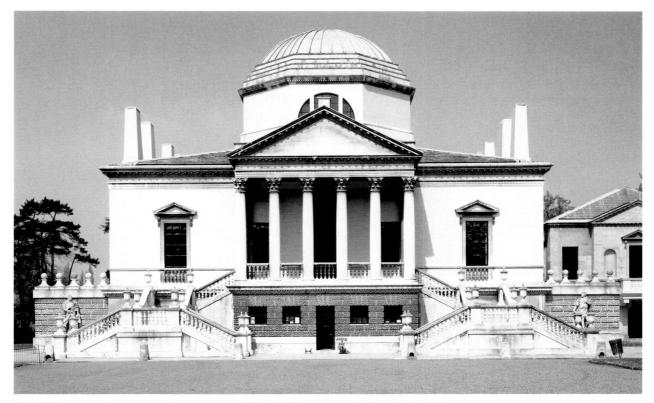

21-26 RICHARD BOYLE and WILLIAM KENT, Chiswick House, near London, England, begun 1725.

For this British villa, Boyle and Kent emulated the simple symmetry and unadorned planes of the Palladian architectural style. Chiswick House is a free variation on the Villa Rotonda (FIG. 17-29).

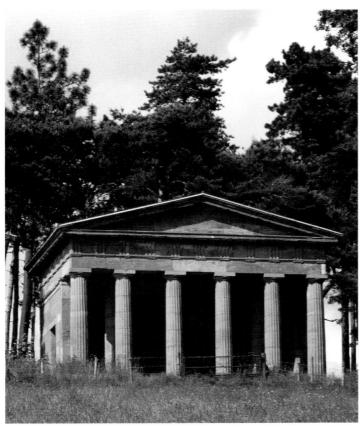

21-27 James Stuart, Doric portico, Hagley Park, Worcestershire, England, 1758.

Most Neoclassical architects used Roman buildings in Italy and France as models. Stuart, who spent four years in Greece, based his Doric portico on a fifth-century BCE temple in Athens.

angles, and precise proportions, Chiswick looks very classical and "rational." But the Palladian-style villa's setting within informal gardens, where a charming irregularity of layout and freely growing uncropped foliage dominate the scene, mitigates the classical severity and rationality. Just as the owners of English villas cultivated irregularity in the landscaping surrounding their homes, they sometimes preferred interiors ornamented in a style more closely related to Rococo decoration. At Chiswick, the interior design creates a luxurious Baroque foil to the stern symmetry of the exterior and the plan. Palladian classicism prevailed in English architecture until about 1760, when it began to evolve into Neoclassicism.

STUART AND REVETT British painters and architects James STUART (1713-1788) and Nicholas Revett (1720-1804) introduced to Europe the splendor and originality of Greek art in their enormously influential Antiquities of Athens, the first volume of which appeared in 1762. These volumes firmly distinguished Greek art from the "derivative" Roman style that had served as the model for classicism since the Renaissance. Stuart and Revett fostered a new preference for Greek art and architecture over Roman antiquities, despite the fact that in the 18th century, familiarity with Greek art continued to be based primarily on Roman copies of Greek originals. Notwithstanding the popularity of the Grand Tour (see "The Grand Tour," page 597), travel to Greece was hazardous, making firsthand inspection of Greek monuments difficult. Stuart and Revett spent four years visiting Greece in the early 1750s, where they formed their preference for Greek art. When Stuart received the commission to design a portico (FIG. 21-27) for Hagley Park in Worcestershire, he used as his model the fifth-century BCE Doric temple in Athens known as the Theseion. His Doric portico is consequently much more severe (and authentic) than any contemporaneous Neoclassical building in Europe based on Roman or Renaissance designs.

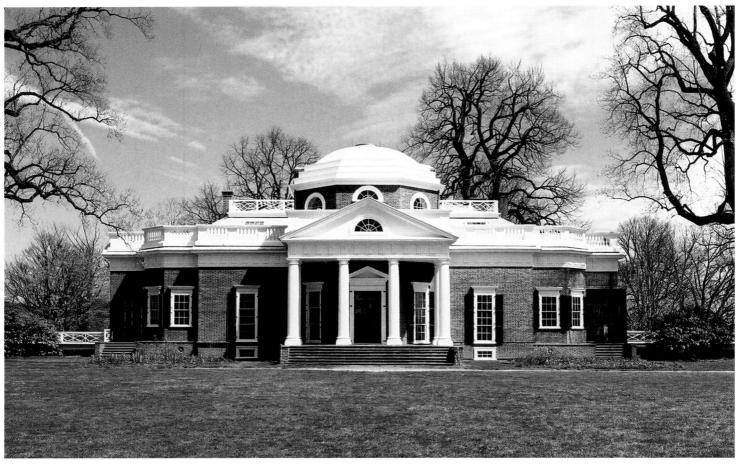

21-28 Thomas Jefferson, Monticello, Charlottesville, Virginia, 1770–1806.

Jefferson led the movement to adopt Neoclassicism as the architectural style of the United States. Although built of local materials, his Palladian Virginia home recalls Chiswick House (Fig. 21-26).

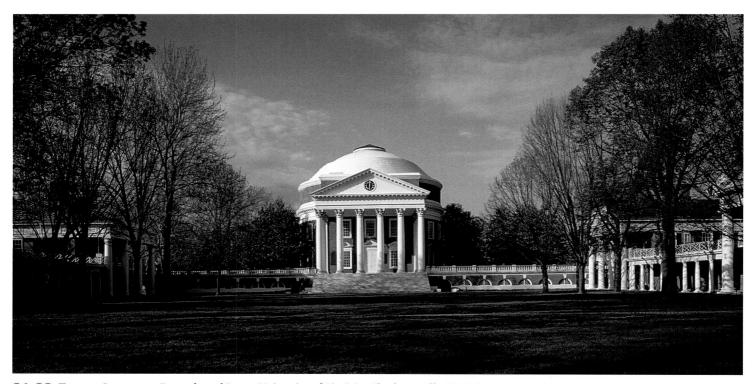

21-29 Thomas Jefferson, Rotunda and Lawn, University of Virginia, Charlottesville, Virginia, 1819–1826.

Modeled on the Pantheon (Fig. 7-49), Jefferson's Rotunda, like a temple in a Roman forum, sits on an elevated platform overlooking the colonnaded Lawn of the University of Virginia.

THOMAS JEFFERSON Part of the appeal of Neoclassicism was due to the values with which it was connected—morality, idealism, patriotism, and civic virtue. Thus, it is not surprising that in the new American republic (MAP 21-1), Thomas Jefferson (1743-1826) scholar, economist, educational theorist, statesman, and gifted amateur architect—spearheaded a movement to adopt Neoclassicism as the national architectural style. Jefferson admired Palladio immensely and read carefully the Italian architect's Four Books of Architecture. Later, while minister to France, he studied French 18th-century classical architecture and city planning and visited the Maison Carrée (FIG. 7-32), a Roman temple at Nîmes. After his European trip, Jefferson completely remodeled his own home, Monticello (FIG. 21-28), near Charlottesville, Virginia, which he first had designed in a different style. The final version of Monticello is somewhat reminiscent of Palladio's Villa Rotonda (FIG. 17-29) and of Chiswick House (FIG. 21-26), but its materials are the local wood and brick used in Virginia.

UNIVERSITY OF VIRGINIA Jefferson's Neoclassicism was an extension of the Enlightenment belief in the perfectibility of human beings and in the power of art to help achieve that perfection. When he became president, he selected Benjamin Latrobe (1764–1820) to build the United States Capitol in Washington, D.C., specifying that Latrobe use a Roman style. Jefferson's choice in part reflected his admiration for the beauty of the Roman buildings he had seen in Europe

GEORGE WASHINGTON

and in part his association of those buildings with an idealized Roman republican government and, through that, with the democracy of ancient Greece.

In his own designs for public buildings, Jefferson also looked to Rome for models. He modeled the State Capitol in Richmond, Virginia, on the Maison Carrée (FIG. 7-32). For the University of Virginia, which he founded, Jefferson turned to the Pantheon (FIG. 7-49). The Rotunda (FIG. 21-29) is the centerpiece of Jefferson's "academical village" in Charlottesville. It sits on an elevated platform at one end of a grassy quadrangle ("the Lawn"), framed by Neoclassical pavilions and colonnades—just as temples in Roman forums (FIGS. 7-12 and 7-43) stood at one short end of a colonnaded square. Each of the ten pavilions (five on each side) resembles a small classical temple. No two are exactly alike. Jefferson experimented with variations of all the different classical orders in their designs. Jefferson was no mere copyist. He had absorbed all the principles of classical architecture and clearly delighted in borrowing from major buildings in his own designs, which were nonetheless highly original—and, in turn, frequently emulated.

JEAN-ANTOINE HOUDON Neoclassicism also became the preferred style for public sculptural commissions in the new American republic. When the Virginia legislature wanted to erect a life-size marble statue of Virginia-born George Washington, the commission

turned to the leading French Neoclassical sculptor of the late 18th century, Jean-Antoine Houdon (1741–1828). Houdon had already carved a bust portrait of Benjamin Franklin when he was U.S. ambassador to France. His portrait of Washington (FIG. 21-30) is the sculptural equivalent of a painted Grand Manner portrait (FIG. 21-18). But although both Washington and West's General Wolfe (FIG. 21-18) wear contemporary garb, the Houdon statue makes overt reference to the Roman Republic. The "column" on which Washington leans is a bundle of rods with an ax attached—the ancient Roman fasces, an emblem of authority (used much later as the emblem of Mussolini's Fascist-the term derives from "fasces"-government in 20th-century Italy). The 13 rods symbolize the 13 original states. The plow behind Washington and the fasces alludes to Cincinnatus, a patrician of the early Roman Republic who was elected dictator during a time of war and resigned his position as soon as victory had been achieved in order to return to his farm. Washington wears the badge of the Society of the Cincinnati (visible beneath the bottom of his waistcoat), an association founded in 1783 for officers in the revolutionary army who had resumed their peacetime roles. Tellingly, Washington no longer holds his sword in Houdon's statue.

21-30 Jean-Antoine Houdon, *George Washington*, 1788–1792. Marble, 6′ 2″ high. State Capitol, Richmond.

Houdon portrayed Washington in contemporary garb, but he incorporated the Roman *fasces* and Cincinnatus's plow in the statue, because Washington had returned to his farm after his war service.

21-31 HORATIO GREENOUGH, George Washington, 1840. Marble, 11' 4" high. Smithsonian American Art Museum, Washington, D.C.

In this posthumous portrait, Greenough likened Washington to a god by depicting him seminude and enthroned in the manner of Phidias's Olympian statue of Zeus, king of the Greek gods.

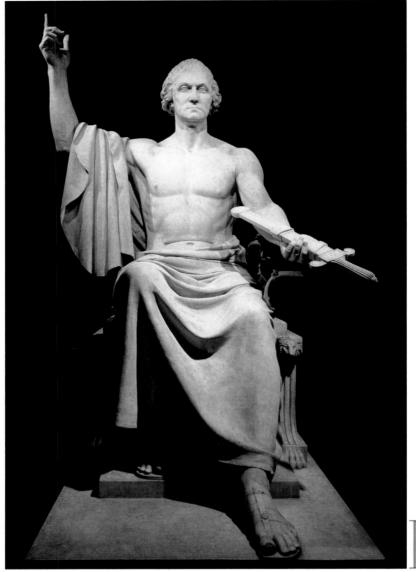

1 ft.

HORATIO GREENOUGH After his death, Washington gradually acquired almost godlike stature as the "father of his country." In 1840 the United States Congress commissioned the American sculptor Horatio Greenough (1805–1852) to make a statue (FIG. 21-31) of the country's first president for the Capitol. Greenough used Houdon's portrait as his model for the head, but he portrayed Washington as seminude and enthroned, like the famous lost statue of Zeus that Phidias made for the god's temple at Olympia in ancient

Greece. The statue, which epitomizes the Neoclassical style, did not, however, win favor with either the Congress that commissioned it or the public. Although no one ever threw Greenough's statue into the Potomac River, as one congressman suggested, the legislators never placed it in its intended site beneath the Capitol dome. In fact, by 1840 the Neoclassical style itself was no longer in vogue. The leading artists of Europe and America had embraced a new style, Romanticism, examined in the next chapter.

EUROPE AND AMERICA, 1700 TO 1800

ROCOCO

- In the early 18th century, the centralized and grandiose palace-based culture of Baroque France gave way to the much more intimate Rococo culture based in the town houses of Paris. There, aristocrats and intellectuals gathered for witty conversation in salons featuring delicate colors, sinuous lines, gilded mirrors, elegant furniture, and small paintings and sculptures.
- The leading Rococo painter was Antoine Watteau, whose usually small canvases feature light colors and elegant figures in ornate costumes moving gracefully through lush landscapes. His *fête galante* paintings depict the outdoor amusements of French high society.
- Watteau's successors included François Boucher and Jean-Honoré Fragonard, who carried on the Rococo style late into the 18th century. In Italy, Giambattista Tiepolo adapted the Rococo manner to huge ceiling frescoes in the Baroque tradition.

Watteau, *Pilgrimage to Cythera*, 1717

THE ENLIGHTENMENT

- By the end of the 18th century, revolutions had overthrown the monarchy in France and achieved independence for the British colonies in America. A major factor was the Enlightenment, a new way of thinking critically about the world independently of religion and tradition.
- The Enlightenment promoted scientific questioning of all assertions and embraced the doctrine of progress. The first modern encyclopedias appeared during the 18th century. The Industrial Revolution began in England in the 1740s. Engineers and architects developed new building materials. Iron was first used in bridge construction at Coalbrookdale, England, in 1776.

■ The taste for naturalism also led to the popularity of portrait paintings set against landscape backgrounds, a specialty of Thomas Gainsborough, among others, and to a reawakening of an interest in realism. Benjamin West represented the protagonists in his history paintings wearing contemporary costumes.

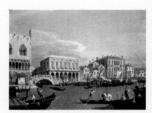

Canaletto, *Riva degli Schiavoni,* Venice, ca. 1735–1740

Greuze, Village Bride, 1761

NEOCLASSICISM

■ The Enlightenment revival of interest in Greece and Rome, which spurred systematic excavations at Herculaneum and Pompeii, also gave rise in the late 18th century to the artistic movement known as Neoclassicism, which incorporated the subjects and styles of ancient art.

David, Oath of the Horatii, 1784

Jefferson, Monticello, Charlottesville, 1770–1806

22-1 NADAR, *Eugène Delacroix*, ca. 1855. Modern print, $8\frac{1}{2}'' \times 6\frac{2}{3}''$, from the original negative. Bibliothèque Nationale, Paris. Eugène Delacroix, the great Romantic painter, was one of many 19th-century artists intrigued by how photography presented reality. Here, he sat for Nadar, one of the earliest portrait photographers.

EUROPE AND AMERICA, 1800 TO 1870

The revolution of 1789 initiated a new era in France, but the overthrow of the monarchy also opened the door for Corsican-born Napoleon Bonaparte (1769–1821) to exploit the resulting disarray and establish a different kind of monarchy with himself at its head. In 1799, after serving in various French army commands, including leading major campaigns in Italy and Egypt, Napoleon became first consul of the French Republic, a title with clear and intentional links to the ancient Roman Republic (see Chapter 7). During the next 15 years, the ambitious general gained control of almost all of continental Europe in name or through alliances (MAP 22-1). In May 1804, for example, he became king of Italy. Later that year, the pope journeyed to Paris for Napoleon's coronation as Emperor of the French (FIG. 22-2). But in 1812, Napoleon launched a disastrous invasion of Russia that ended in retreat, and in 1815 he suffered a devastating loss at the hands of the British at Waterloo in present-day Belgium. Forced to abdicate the imperial throne, Napoleon went into exile on the island of Saint Helena in the South Atlantic, dying there six years later.

Following Napoleon's exile, the political geography of Europe changed dramatically (MAP 22-2), but in many ways the more significant changes during the first half of the 19th century were technological and economic. The Industrial Revolution caused a population boom in European cities, and railroads spread to many parts of the Continent, facilitating the transportation of both goods and people. During this period, the arts also underwent important changes. The century opened with Neoclassicism still supreme, but by 1870 Romanticism and Realism in turn had captured the imagination of artists and public alike. New construction techniques had a major impact on architectural design, and the invention of photography revolutionized picture making of all kinds.

ART UNDER NAPOLEON

At the fall of the French revolutionary Maximilien Robespierre (1758–1794) and his party in 1794, Jacques-Louis David, who had aligned himself personally and through his work with the revolutionary forces (see Chapter 21), barely escaped with his life. He stood trial and went to prison. After his release in

MAP 22-1 The Napoleonic Empire in 1815.

MAP 22-2 Europe around 1850.

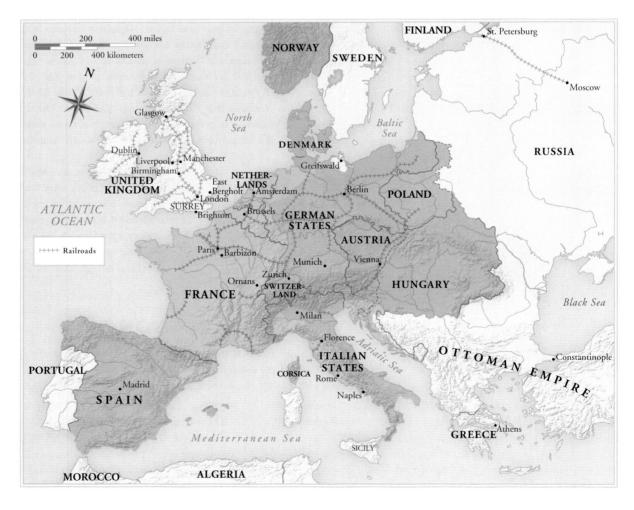

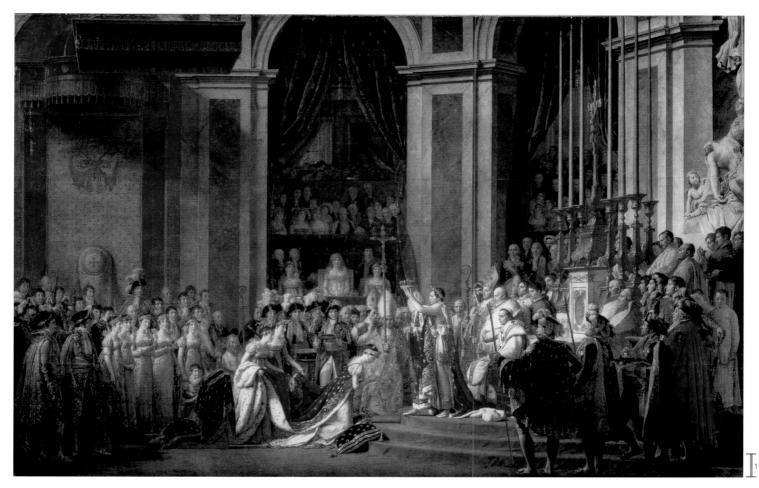

22-2 Jacques-Louis David, Coronation of Napoleon, 1805–1808. Oil on canvas, $20' 4\frac{1}{2}'' \times 32' 1\frac{3}{4}''$. Louvre, Paris.

As First Painter of the Empire, David recorded Napoleon at his December 1804 coronation crowning his wife with the pope as witness, thus underscoring the authority of the state over the church.

1795, he worked hard to resurrect his career. When Napoleon Bonaparte approached David in 1804 and offered him the position of First Painter of the Empire, David seized the opportunity. It was not just the artist's personal skill but Neoclassicism in general that appealed to Napoleon. The emperor embraced all links with the classical past as symbolic sources of authority. Classical associations, particularly connections to the Roman Empire, served Napoleon well, since he aspired to rule an empire that might one day rival ancient Rome's.

CORONATION OF NAPOLEON One of the major paintings David produced for Napoleon was Coronation of Napoleon (FIG. 22-2), a monumental painting (20 by 32 feet) that documented the pomp and pageantry of the new emperor's coronation in December 1804. Napoleon was well aware of the power of art for constructing a public image and of David's ability to produce inspiring patriotic images. To a large extent, David adhered to historical fact regarding the coronation, duly recording the appearance of the interior of Paris's Notre-Dame Cathedral as Napoleon's architects, Charles Percier (1764–1838) and Pierre-François-Léonard Fontaine (1762–1853), had decorated it for the occasion. David also faithfully portrayed those in attendance. In addition to Napoleon, his wife Josephine (1763–1814; kneeling to receive her crown), and Pope Pius VII (r. 1800-1823; seated behind Napoleon), others present at the occasion and in the painting included Joseph (1768–1814) and Louis (1778–1846) Bonaparte, Napoleon's ministers, the retinues of the emperor and empress, and a representative group of the clergy, as well as David himself, seated among the rows of spectators in the balconies. Despite the

artist's apparent fidelity to historical fact, preliminary studies and drawings reveal that David made changes at Napoleon's request. For example, Napoleon insisted that the painter depict the pope with his hand raised in blessing. Further, Napoleon's mother appears prominently in the center background, yet she had refused to attend the coronation.

Although David had to incorporate numerous figures and lavish pageantry in his painting, he retained the structured composition central to the Neoclassical style. As in his Oath of the Horatii (FIG. 21-23), David presented the action as if on a theater stagewhich in this instance was literally the case, even if the stage Percier and Fontaine constructed was inside a church. In addition, as he did in his arrangement of the men and women in Oath of the Horatii, David conceptually divided the painting to reveal polarities. The pope, prelates, and priests representing the Catholic Church appear on the right, contrasting with members of Napoleon's imperial court on the left. The relationship between church and state was one of this period's most contentious issues. Napoleon's decision to crown himself, rather than to allow the pope to perform the coronation, as was traditional, reflected Napoleon's concern about the power relationship between church and state. For the painting commemorating the occasion, the emperor insisted that David depict the moment when, having already crowned himself, Napoleon places a crown on his wife's head, further underscoring his authority. Thus, although this painting represents an important visual document in the tradition of history painting, it is also a more complex statement about the changing politics in Napoleonic France.

22-3 PIERRE VIGNON, La Madeleine, Paris, France, 1807–1842.

Napoleon constructed La Madeleine as a "temple of glory" for his armies. Based on ancient temples (FIG. 7-32) and Neoclassical in style, Vignon's design linked the Napoleonic and Roman empires.

LA MADELEINE Napoleon also embraced Neoclassical architecture as an ideal vehicle for expressing his imperial authority. For example, the emperor resumed construction of the church of La Madeleine (FIG. 22-3) in Paris, which had begun in 1764 but ceased in 1790. However, he converted the building to a "temple of glory" for France's imperial armies. The structure reverted again to a church after Napoleon's defeat and long before its completion in 1842. Designed by PIERRE VIGNON (1763–1828), the grandiose Napoleonic temple includes a high podium and broad flight of stairs leading to a deep porch in the front. These architectural features, coupled with the Corinthian columns, recall Roman temples in France, such as the Maison Carrée (FIG.

7-32) at Nîmes, making La Madeleine a symbolic link between the Napoleonic and Roman empires. Curiously, the building's classical shell surrounds an interior covered by a sequence of three domes, a feature found in Byzantine and Romanesque churches. It is as though Vignon clothed a traditional church in the costume of pagan Rome.

ANTONIO CANOVA Neoclassical sculpture also was in vogue under Napoleon. His favorite sculptor was ANTONIO CANOVA (1757–1822), who somewhat reluctantly left a successful career in Italy to settle in Paris and serve the emperor. Once in France, Canova became Napoleon's admirer and made numerous portraits, all in the Neoclassical style, of the emperor and his family. Perhaps the best

known of these works is the marble portrait (FIG. 22-4) of Napoleon's sister, Pauline Borghese, as Venus. Initially, Canova had suggested depicting Borghese as Diana, goddess of the hunt. Pauline, however, demanded to be shown as Venus, the goddess of love. Thus, she appears reclining on a divan and gracefully holding the golden apple, the symbol of the goddess's triumph in the judgment of Paris. Canova clearly based his work on Greek statuary—the sensuous pose and seminude body recall Hellenistic works such as Venus de Milo (FIG. 5-83)-and the reclining figure has parallels on Roman sarcophagus lids (FIG. 7-61; compare FIG. 6-5).

22-4 Antonio Canova, *Pauline Borghese as Venus*, 1808. Marble, 6' 7" long. Galleria Borghese, Rome.

Canova was Napoleon's favorite sculptor. Here, the artist depicted the emperor's sister nude—at her request—as the Roman goddess of love in a marble statue inspired by classical models.

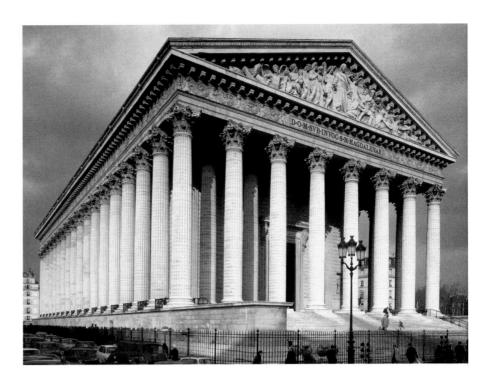

The French public never got to admire Canova's portrait, however. Napoleon had arranged the marriage of his sister to an heir of the noble Roman Borghese family. Once Pauline was in Rome, her behavior was less than dignified, and the public gossiped extensively about her affairs. Her insistence on being portrayed as the goddess of love reflected her self-perception. Due to his wife's questionable reputation, Prince Camillo Borghese (1775–1832), the work's official patron, kept the sculpture sequestered in the Villa Borghese in Rome, where it remains today. Borghese allowed relatively few people to see it (and then only by torchlight). Still, knowledge of the existence of the sculpture was widespread and increased the notoriety of both artist and subject.

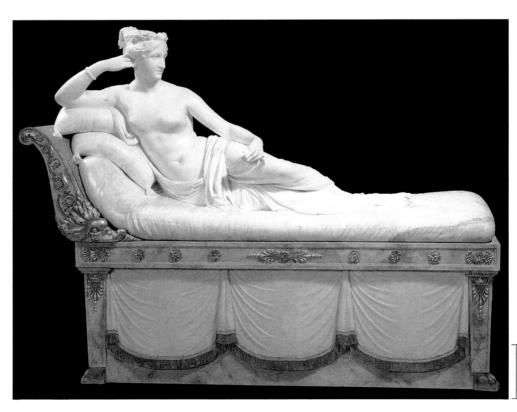

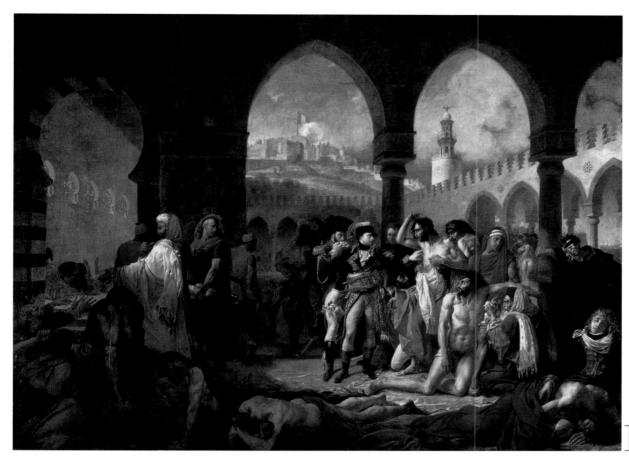

22-5 ANTOINE-JEAN GROS, Napoleon at the Pesthouse at Jaffa, 1804. Oil on canvas, 17' 5" × 23' 7". Louvre, Paris.

Gros's huge painting glorifies Napoleon as possessing the miraculous power to heal and reflects David's compositional principles, but Gros's fascination with the exotic Near East presaged Romanticism.

1 ft

DAVID'S STUDENTS Given Jacques-Louis David's stature and prominence as an artist in Napoleonic France, along with the popularity of Neoclassicism, it is not surprising that he attracted numerous students and developed an active and flourishing teaching studio. David gave practical instruction to and deeply influenced many important artists of the period. So strong was David's commitment to classicism that he encouraged all his students to learn Latin, the better to immerse themselves in and understand classical culture. David even initially demanded that his pupils select their subjects from Plutarch, the ancient author of Lives of the Great Greeks and Romans and a principal source of Neoclassical subject matter. Due to this thorough classical foundation, David's students produced work that at its core retains Neoclassical elements. Yet David was open-minded and far from authoritarian in his teaching, and he encouraged his students to find their own artistic identities. The work of three of David's pupils-Antoine-Jean Gros, Anne-Louis Girodet-Trioson, and Jean-Auguste-Dominique Ingres—represents a departure from the structured confines of Neoclassicism. These artists laid the foundation for the Romantic movement, discussed in detail later. They explored the realm of the exotic and the erotic, and often turned to fictional narratives for the subjects of their paintings, as Romantic artists also did.

GROS Like his teacher David, Antoine-Jean Gros (1771–1835) was aware of the benefits that could accrue to artists whom the powerful favored. Following David's lead, Gros produced several paintings that contributed to the growing mythic status of Napoleon Bonaparte in the early 1800s. In *Napoleon at the Pesthouse at Jaffa* (Fig. 22-5), the artist, at Napoleon's request, recorded an incident during an outbreak of the bubonic plague that erupted in the course of the Near

Eastern campaigns of 1799. This fearsome disease struck Muslim and French forces alike, and in March 1799, Napoleon himself visited the pesthouse at Jaffa to quell the growing panic and hysteria. Gros depicted Napoleon's staff officers covering their noses against the stench of the place, whereas Napoleon, amid the dead and dying, is fearless and in control. He comforts those still alive, who are clearly awed by his presence and authority. Indeed, by depicting the French leader touching the sores of a plague victim, Gros implied that Napoleon possessed the miraculous power to heal. This exaltation of the French leader was necessary to counteract the negative publicity he was subject to at the time. Apparently, two months after his visit to the pesthouse, Napoleon ordered all plague-stricken French soldiers poisoned so as to relieve him of having to return them to Cairo or abandon them to the Turks. Some of the soldiers survived, and from their accounts highly critical stories about Napoleon began to circulate. Gros's painting was an attempt at damage control—to resurrect the event and rehabilitate Napoleon's compromised public image.

Gros structured his composition in a manner reminiscent of David's major paintings, with the horseshoe arches and Moorish arcades of the mosque courtyard providing a backdrop for the unfolding action. In addition, Gros's placement of Muslim doctors ministering to plague-stricken Muslims on the left contrasts them with Napoleon and his soldiers on the right, bathed in radiant light. David had used this polarized compositional scheme to great effect in works such as *Oath of the Horatii* (FIG. 21-23). However, Gros's fascination with the exoticism of the Near East, as is evident in his attention to the unique architecture, attire, and terrain, represented a departure from Neoclassicism. This interest in the exotic, along with the artist's emphasis on death, suffering, and an emotional rendering of the scene, foreshadowed prominent aspects of Romanticism.

22-6 Anne-Louis Girodet-Trioson, *Burial of Atala*, 1808. Oil on canvas, 6' 11" × 8' 9". Louvre, Paris.

Girodet's depiction of Native American lovers in the Louisiana wilderness appealed to the French public's fascination with what it perceived as the passion and primitivism of tribal life in the New World.

GIRODET-TRIOSON Another of David's students, Anne-Louis Girodet-TRIOSON (1767-1824), also produced paintings that conjured images of exotic locales and cultures. He moved further into the domain of Romanticism with Burial of Atala (FIG. 22-6), based on The Genius of Christianity, a novel by French writer François René de Chateaubriand (1768-1848). The section of the novel dealing with Atala appeared as an excerpt a year before the publication of the entire book in 1802. Both the excerpt and the novel were enormously successful, and as a result, Atala became almost a cult figure. The exoticism and eroticism integral to the narrative ac-

counted in large part for the public's interest in *The Genius of Christianity*. Set in Louisiana, Chateaubriand's work focuses on two young Native Americans, Atala and Chactas. The two, from different tribes, fall in love and run away together through the wilderness. Erotic passion permeates the story, and Atala, sworn to lifelong virginity, finally commits suicide rather than break her oath. Girodet's painting depicts this tragedy. Atala's grief-stricken lover, Chactas, buries the heroine in the shadow of a cross. Assisting in the burial is a cloaked priest, whose presence is appropriate given Chateaubriand's emphasis on

the revival of Christianity (and the Christianization of the New World) in his novel. Like Gros's depiction of the foreign Muslim world, Girodet's representation of American Indian lovers in the Louisiana wilderness appealed to the public's fascination (whetted by the Louisiana Purchase in 1803) with what it perceived as the passion and primitivism of Native American tribal life. *Burial of Atala* speaks here to emotions,

22-7 Jean-Auguste-Dominique Ingres, *Apotheosis of Homer*, 1827. Oil on

Inspired by *School of Athens* (FIG. 17-9) by Ingres's favorite painter, Raphael, this monumental canvas is a Neoclassical celebration of Homer and other ancient worthies, Dante, and select French authors.

canvas, $12' 8'' \times 16' 10\frac{3}{4}''$. Louvre, Paris.

rather than inviting philosophical meditation or revealing some grand order of nature and form. Unlike David's appeal in *Oath of the Horatii* (FIG. 21-23) to feelings that manifest themselves in public action, the appeal here is to the viewer's private world of fantasy and emotion.

INGRES JEAN-AUGUSTE-DOMINIQUE INGRES (1780–1867) arrived at David's studio in the late 1790s after Girodet-Trioson had left to establish an independent career. Ingres's study there was to be short-

1 f

22-8 Jean-Auguste-Dominique Ingres, Grande Odalisque, 1814. Oil on canvas, 2' $11\frac{7}{8}$ " \times 5' 4". Louvre, Paris.

The reclining female nude was a Greco-Roman subject, but Ingres converted his Neoclassical figure into an odalisque in a Turkish harem, consistent with the new Romantic taste for the exotic.

lived, however, as he soon broke with David on matters of style. This difference of opinion involved Ingres's embrace of what he believed to be a truer and purer Greek style than what David employed. The younger artist adopted flat and linear forms approximating those found in Greek vase painting (see Chapter 5). In many of his works, Ingres placed the figure in the foreground, much like a piece of low-relief sculpture.

Ingres exhibited his huge composition Apotheosis of Homer (FIG. 22-7) at the Salon of 1827 (see "Academic Salons," Chapter 23, page 655). The painting presented in a single statement the doctrines of ideal form and of Neoclassical taste, and generations of academic painters remained loyal to that style. Raphael's School of Athens (FIG. 17-9) served as the inspiration for *Apotheosis of Homer*. Enthroned before an Ionic temple, the epic poet Homer receives a crown from Fame or Victory. At the poet's feet are two statuesque women, who personify the *Iliad* and the *Odyssey*, the offspring of his imagination. Symmetrically grouped about him is a company of the "sovereign geniuses"—as Ingres called them—who expressed humanity's highest ideals in philosophy, poetry, music, and art. To Homer's left are the Greek poet Anacreon with his lyre, Phidias with his sculptor's hammer, the philosophers Plato and Socrates, and other ancient worthies. To his far right are the Roman poets Horace and Vergil, and two Italian greats: Dante and, conspicuously, Raphael, the painter Ingres most admired. Among the forward group on the painting's left side are Poussin (pointing) and Shakespeare (half concealed), and at the right are French writers Jean Baptiste Racine, Molière, Voltaire, and François de Salignac de la Mothe Fénelon. Ingres had planned a much larger and more inclusive group, but he never completed the project. For years he agonized over whom to choose for this select company of heroes in various humanistic disciplines.

GRANDE ODALISQUE As a true Neoclassical painter, Ingres condemned "modern" styles such as Romanticism. But despite his commitment to ideal form and careful compositional structure, Ingres also produced works that, like those of Gros and Girodet, his contemporaries saw as departures from Neoclassicism. One of those paintings was *Grande Odalisque* (FIG. 22-8). Ingres's subject, the reclining nude figure, followed the tradition of Giorgione and Titian (FIG. 17-40). The work also shows Ingres's admiration for Raphael in his borrowing of that master's type of female head (FIGS. 17-7 and 17-8). The figure's languid pose, small head and elongated limbs, and the generally cool color scheme reveal his debt to Parmigianino (FIG. 17-43) and the Italian Mannerists. However, by converting the figure to an *odalisque* (woman in a Turkish harem), the artist made a strong concession to the contemporary Romantic taste for the exotic.

This rather strange mixture of artistic allegiances—the combination of precise classical form and Romantic themes—prompted confusion, and when Ingres first exhibited *Grande Odalisque* in 1814, the painting drew acid criticism. Critics initially saw Ingres as a rebel in terms of both the form and content of his works. They did not cease their attacks until the mid-1820s, when another enemy of the official style, Eugène Delacroix, appeared on the scene. Then they suddenly perceived that Ingres's art, despite its innovations and deviations, still contained many elements that adhered to the official Neoclassicism—the taste for the ideal. Ingres soon led the academic forces in their battle against the "barbarism" of Delacroix, Théodore Géricault, and the Romantic movement. Gradually, Ingres warmed to the role his critics had cast for him, and he came to see himself as the conservator of good and true art, a protector of its principles against its would-be destroyers.

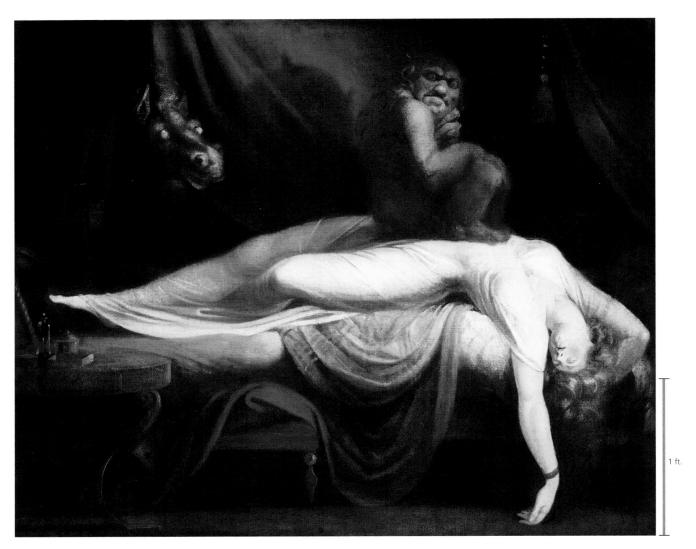

22-9 Henry Fusell, *The Nightmare*, 1781. Oil on canvas, $3' \, 3\frac{3}{4}'' \times 4' \, 1\frac{1}{2}''$. Detroit Institute of the Arts (Founders Society Purchase with funds from Mr. and Mrs. Bert L. Smokler and Mr. and Mrs. Lawrence A. Fleishman).

The transition from Neoclassicism to Romanticism marked a shift in emphasis from reason to feeling. Fuseli was among the first painters to depict the dark terrain of the human subconscious.

ROMANTICISM

Whereas Neoclassicism's rationality reinforced Enlightenment thought (see Chapter 21), particularly Voltaire's views, Rousseau's ideas contributed to the rise of *Romanticism*. Rousseau's exclamation "Man is born free, but is everywhere in chains!"—the opening line of his *Social Contract* (1762)—summarizes a fundamental Romantic premise. Romanticism emerged from a desire for freedom—not only political freedom but also freedom of thought, of feeling, of action, of worship, of speech, and of taste. Romantics asserted that freedom was the right and property of all. They believed the path to freedom was through imagination rather than reason and functioned through feeling rather than through thinking.

The allure of the Romantic spirit grew dramatically during the late 18th century. The term originated toward the end of that century among German literary critics, who aimed to distinguish peculiarly "modern" traits from the Neoclassical traits that already had displaced Baroque and Rococo design elements. Consequently, many scholars refer to Romanticism as a phenomenon that began around 1750 and ended about 1850, but most use the term more narrowly to denote a movement that flourished from about 1800 to 1840, between Neoclassicism and Realism.

Roots of Romanticism

The transition from Neoclassicism to Romanticism represented a shift in emphasis from reason to feeling, from calculation to intuition, and from objective nature to subjective emotion. Among Romanticism's manifestations were the interests in the medieval period and in the sublime. For people living in the 18th century, the Middle Ages were the "dark ages," a time of barbarism, superstition, dark mystery, and miracle. The Romantic imagination stretched its perception of the Middle Ages into all the worlds of fantasy open to it, including the ghoulish, the infernal, the terrible, the nightmarish, the grotesque, the sadistic, and all the imagery that emerges from the chamber of horrors when reason sleeps. Related to the imaginative sensibility was the period's notion of the sublime. Among the individuals most involved in studying the sublime was the British politician and philosopher Edmund Burke (1729–1797). In his 1757 publication A Philosophical Enquiry into the Origins of Our Ideas of the Sublime and Beautiful, Burke articulated his definition of the sublime—feelings of awe mixed with terror. Burke observed that pain or fear evoked the most intense human emotions and that these emotions could also be thrilling. Thus, raging rivers and great storms at sea could be sublime to their viewers. Accompanying this taste for

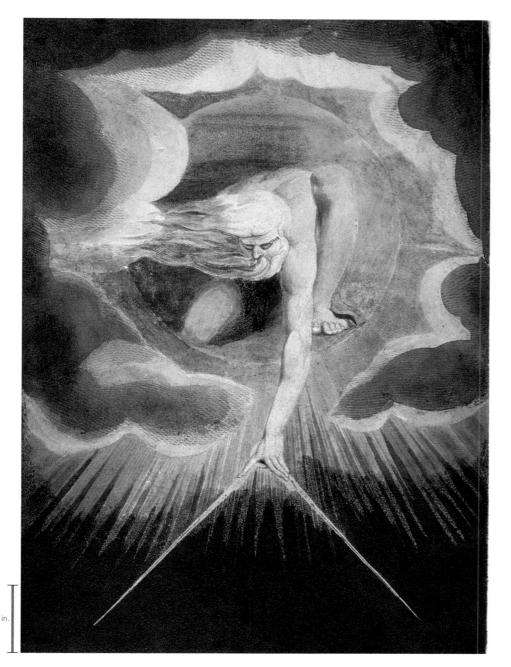

22-10 William Blake, *Ancient of Days*, frontispiece of *Europe: A Prophecy*, 1794. Metal relief etching, hand colored, $9\frac{1}{2}'' \times 6\frac{3}{4}''$. Pierpont Morgan Library, New York.

Although art historians classify Blake as a Romantic artist, he incorporated classical references in his works. Here, ideal classical anatomy merges with the inner dark dreams of Romanticism.

to depict the dark terrain of the human subconscious that became fertile ground for later artists to sow.

WILLIAM BLAKE In their images of the sublime and the terrible, Romantic artists often combined Baroque dynamism with naturalistic details in their quest for grippingly moving visions. These preferences became the mainstay of Romantic art and contrasted with the more intellectual, rational Neoclassical themes and presentations. The two were not mutually exclusive, however. Gros, Girodet-Trioson, and Ingres effectively integrated elements of Neoclassicism with Romanticism. So too did the visionary English poet, painter, and engraver William Blake (1757-1827). Blake greatly admired ancient Greek art because it exemplified for him the mathematical and thus the eternal, and his work often incorporated classical references. Yet Blake did not align himself with prominent Enlightenment figures. Like many other Romantic artists, he also found the art of the Middle Ages appealing. Blake derived the inspiration for many of his paintings and poems from his dreams. The importance he attached to these nocturnal experi-

ences led him to believe that the rationalist search for material explanations of the world stifled the spiritual side of human nature. He also believed that the stringent rules of behavior imposed by orthodox religions killed the individual's creative impulse.

Blake's vision of the Almighty in Ancient of Days (FIG. 22-10) combines his ideas and interests in a highly individual way. For Blake, this figure united the concept of the Creator with that of wisdom as a part of God. He chose Ancient of Days as the frontispiece for his book Europe: A Prophecy, and juxtaposed it with a quotation ("When he set a compass upon the face of the deep") from Proverbs 8:27 in the Old Testament. The speaker in that Bible chapter is Wisdom, who tells the reader how she was with the Lord through all the time of the Creation (Prov. 8:22–23, 27–30). Energy fills Blake's composition. The Almighty leans forward from a fiery orb, peering toward earth and unleashing power through his outstretched left arm into twin rays of light. These emerge between his spread fingers as might an architect's measuring instrument. A strong wind surges through his thick hair and beard. Only the strength of his Michelangelesque physique keeps him firmly planted on his heavenly perch. Here, ideal classical anatomy merges with the inner dark dreams of Romanticism.

the sublime was the taste for the fantastic, the occult, and the macabre—for the adventures of the soul voyaging into the dangerous reaches of consciousness.

HENRY FUSELI The concept of the nightmare is the subject of a 1781 painting (FIG. 22-9) by HENRY FUSELI (1741-1825). Swiss by birth, Fuseli settled in England and eventually became a member of the Royal Academy and an instructor there. Largely self-taught, he contrived a distinctive manner to express the fantasies of his vivid imagination. Fuseli specialized in night moods of horror and in dark fantasies—in the demonic, in the macabre, and often in the sadistic. In The Nightmare, a beautiful young woman lies asleep, draped across the bed with her limp arm dangling over the side. An incubus, a demon believed in medieval times to prey, often sexually, on sleeping women, squats ominously on her body. In the background, a ghostly horse with flaming eyes bursts into the scene from beyond the curtain. Despite the temptation to see the painting's title as a pun because of this horse, the word "nightmare" actually derives from "night" and "Mara." Mara was a spirit in Northern European mythology that people thought tormented and suffocated sleepers. Fuseli was among the first to attempt

Spain and France

From its roots in the work of Fuseli, Blake, and other late-18th-century artists, Romanticism gradually displaced Neoclassicism as the dominant painting style of the first half of the 19th century. Romantic artists, including Francisco Goya in Spain and Théodore Géricault and Eugène Delacroix in France, explored the exotic, erotic, and fantastic in their paintings.

FRANCISCO GOYA The Spaniard Francisco José de Goya y Lucientes (1746–1828) was David's contemporary, but their work has little in common. Goya did not arrive at his general dismissal of Neoclassicism without considerable thought about the Enlightenment and the Neoclassical penchant for rationality and order. This reflection emerges in such works as *The Sleep of Reason Produces Monsters* (Fig. 22-11) from a series titled *Los Caprichos* (*The Caprices*). In this print, Goya depicted himself asleep, slumped onto a table or writing stand, while threatening creatures converge on him. Seemingly poised to attack the artist are owls (symbols of folly) and bats (symbols of ignorance). The viewer might read this as a portrayal of what emerges when reason is suppressed and, therefore, as an espousal of Enlightenment ideals. However, it also can be interpreted as Goya's commitment to the creative process and the Romantic spirit—the unleashing of imagination, emotions, and even nightmares.

FAMILY OF CHARLES IV The emotional art Goya produced during his long career stands as testimony not only to the allure of the Romantic vision but also to the turmoil in Spain and to the conflicts in Goya's life. His art is multifaceted in character, however, and many of his works deal with traditional religious subjects. Others are royal portraits painted after 1786, when Goya became Pintor del Rey (Painter to the King). Charles IV (r. 1788-1808) promoted him to First Court Painter in 1799. In his official capacity, Goya produced paintings very different in character from his Caprichos, such as Family of Charles IV (FIG. 22-12). Goya greatly admired the achievements of his predecessor Diego Velázquez, and Velázquez's Las Meninas (FIG. 19-30) was the inspiration for this image of the king and his queen, Maria Luisa, surrounded by their children. As in Las Meninas, the royal family appears facing the viewer in an interior space while the artist included himself on the left, dimly visible, in the act of painting on a large canvas. Goya's portrait of the royal family has been subjected to intense scholarly scrutiny, resulting in a variety of interpretations. Some scholars see this painting as a naturalistic depiction of Spanish royalty. Others believe it to be a pointed commentary in a time of Spanish turmoil. It is clear that his patrons authorized the painting's basic elements—the king and his family, their attire, and Goya's inclusion. Little evidence exists as to how the royal family reacted to this painting. Although some scholars have argued that they disliked the portrait, others have suggested that the painting confirmed the Spanish monarchy's continuing presence and strength and thus elicited a positive response from the patrons.

As dissatisfaction with the rule of Charles IV and Maria Luisa increased, the political situation grew more tenuous. The Spanish people eventually threw their support behind Ferdinand VII, son of the royal couple, in the hope that he would initiate reform. To overthrow his father and mother, Ferdinand VII enlisted the aid of Napoleon Bonaparte, who possessed uncontested authority and military expertise at that time. Napoleon had designs on the Spanish throne and thus willingly sent French troops to Spain. Not surprisingly, as soon as he ousted Charles IV, Napoleon revealed his plan to rule Spain himself by installing his brother Joseph Bonaparte (r. 1808–1813) on the Spanish throne.

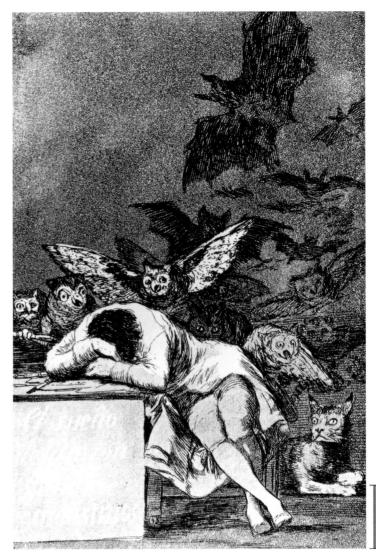

22-11 Francisco Goya, *The Sleep of Reason Produces Monsters*, from *Los Caprichos*, ca. 1798. Etching and aquatint, $8\frac{1}{2}" \times 5\frac{7}{8}"$. Metropolitan Museum of Art, New York (gift of M. Knoedler & Co., 1918).

In this print, Goya depicted himself asleep while threatening creatures converge on him, revealing his commitment to the Romantic spirit—the unleashing of imagination, emotions, and nightmares.

THIRD OF MAY, 1808 The Spanish people, finally recognizing the French as invaders, sought a way to expel the foreign troops. On May 2, 1808, in frustration, the Spanish attacked Napoleon's soldiers in a chaotic and violent clash. In retaliation and as a show of force, the French responded the next day by executing numerous Spanish citizens. This tragic event is the subject of Goya's most famous painting, Third of May, 1808 (FIG. 22-13). In emotional fashion, Goya depicted the anonymous murderous wall of French soldiers ruthlessly executing the unarmed and terrified Spanish peasants. The artist encouraged empathy for the Spanish by portraying horrified expressions and anguish on their faces, endowing them with a humanity absent from the firing squad. Moreover, the peasant about to be shot throws his arms out in a cruciform gesture reminiscent of Christ's position on the cross. Goya enhanced the emotional drama of this tragic event through his stark use of darks and lights and by extending the time frame depicted. Although Goya captured the specific moment when one man is about to be executed, he also

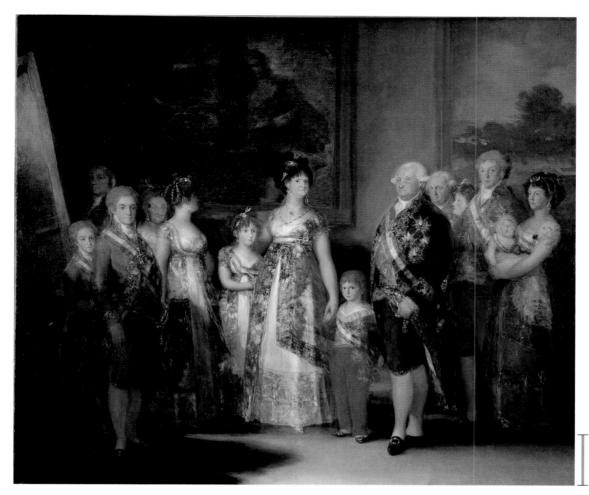

22-12 Francisco Goya, Family of Charles IV, 1800. Oil on canvas, 9' $2'' \times 11'$. Museo del Prado, Madrid.

Goya painted the family of the Spanish king Charles IV while serving as Pintor del Rey. Goya's model for the portrait was Velázquez's *Las Meninas* (FIG. 19-30), which also included the artist in the painting.

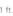

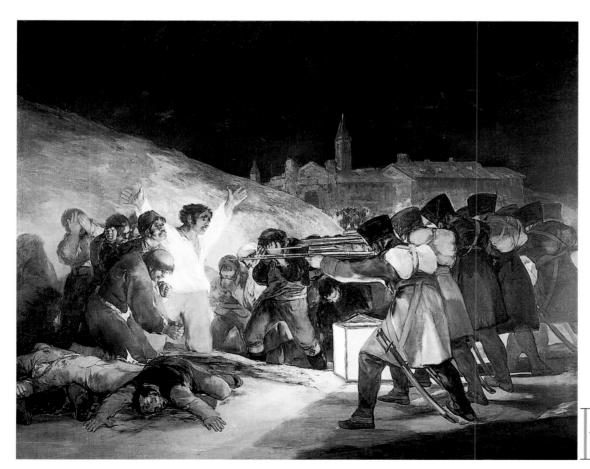

22-13 Francisco Goya, *Third of May, 1808*, 1814–1815. Oil on canvas, $8'\ 9'' \times 13'\ 4''$. Museo del Prado, Madrid.

Goya encouraged empathy for the massacred Spanish peasants by portraying horrified expressions and anguish on their faces, endowing them with a humanity lacking in the French firing squad. depicted the bloody bodies of others already lying dead on the ground. Still others have been herded together to be shot in a few moments. Its depiction of the resistance and patriotism of the Spanish people notwithstanding, *Third of May, 1808*, was a royal commission, painted in 1814 for Ferdinand VII (r. 1813–1833), who had reclaimed the throne after the ouster of the French.

SATURN Over time, Goya became increasingly disillusioned and pessimistic, and his declining health only contributed to this state of mind. Among his later works are the Black Paintings, frescoes he painted on the walls of his farmhouse in Quinta del Sordo, outside Madrid. Because Goya created these works solely on his terms and for his private viewing, they provide great insight into the artist's outlook, which is terrifying and disturbing. Saturn Devouring One of His Children (FIG. 22-14) depicts the raw carnage and violence of Saturn (the Greek god Kronos; see "The Gods and Goddesses of Mount Olympus," Chapter 5, page 87, or in the "Before 1300" section), wildeyed and monstrous, as he consumes one of his children. Because of the similarity of Kronos and khronos (Greek for "time"), Saturn has come to be associated with time. This has led some scholars to interpret Goya's painting as an expression of the artist's despair over the passage of time. Despite the simplicity of the image, it conveys a wildness, boldness, and brutality that cannot help but evoke an elemental response from any viewer. Goya's work, rooted both in personal and national history, presents darkly emotional images well in keeping with Romanticism.

THÉODORE GÉRICAULT In France one of the artists most closely associated with the Romantic movement was Théodore Géricault (1791–1824), who studied with an admirer of David, P. N. Guérin (1774–1833). Although Géricault retained an interest in the heroic and the epic and was well trained in classical drawing, he chafed at the rigidity of the Neoclassical style, instead producing works that captivate the viewer with their drama, visual complexity, and emotional force.

Géricault's most ambitious project was a gigantic canvas (approximately 16 by 23 feet) titled *Raft of the Medusa* (FIG. **22-15**). In this depiction of a historical event, the artist abandoned the idealism of Neoclassicism and instead invoked the theatricality of Romanticism. The painting's subject is a shipwreck that occurred in 1816 off the African coast. The French frigate *Medusa* ran aground on a reef due to the incompetence of the captain, a political appointee. In an attempt to survive, 150 remaining passengers built a makeshift raft from pieces of the disintegrating ship. The raft drifted for 12 days, and the number of survivors dwindled to 15. Finally, a ship spotted the raft and rescued the emaciated survivors. This horrendous event was political dynamite once it became public knowledge.

In Raft of the Medusa, which Géricault took eight months to complete, the artist sought to capture the horror, chaos, and emotion of the tragedy yet invoke the grandeur and impact of large-scale history painting. Géricault went to great lengths to ensure the accuracy of his representation. He visited hospitals and morgues to examine corpses, interviewed the survivors, and had a model of the raft constructed in his studio. In the painting, the few despairing survivors summon what little strength they have left to flag down the passing ship far on the horizon. Géricault departed from the straightforward organization of Neoclassical compositions and instead presented a jumble of writhing bodies. He arranged the survivors and several corpses in a powerful X-shaped composition, and piled one body on another in every attitude of suffering, despair, and death (recalling the plague-stricken bodies in Gros's Napoleon at Jaffa, Fig. 22-5). One light-filled diagonal axis stretches from bodies

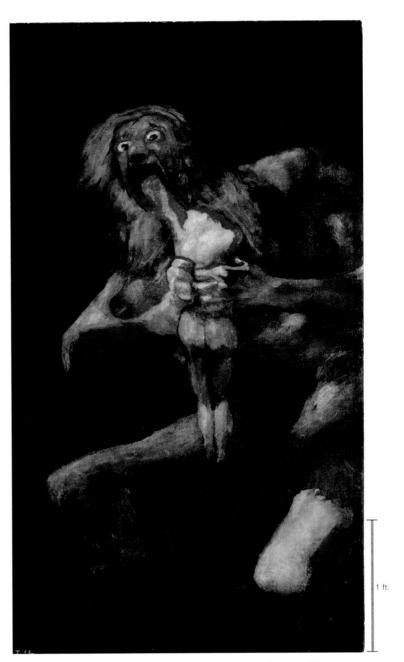

22-14 Francisco Goya, Saturn Devouring One of His Children, 1819–1823. Detached fresco mounted on canvas, 4' $9\frac{1}{8}'' \times 2'$ $8\frac{5}{8}''$. Museo del Prado, Madrid.

This disturbing fresco in Goya's farmhouse uses a mythological tale perhaps to express the aging artist's despair over the passage of time. Saturn's Greek name Kronos is similar to the Greek word for time.

at the lower left up to the black man raised on his comrades' shoulders and waving a piece of cloth toward the horizon. The cross axis descends from the storm clouds and the dark, billowing sail at the upper left to the shadowed upper torso of the body trailing in the open sea. Géricault's decision to place the raft at a diagonal so that a corner juts outward further compels viewers' participation in this scene. Indeed, it seems as though some of the corpses are sliding off the raft into the viewing space. The subdued palette and prominent shadows lend an ominous pall to the scene.

Géricault also took this opportunity to insert a comment on the practice of slavery. The artist was a member of an abolitionist group that sought ways to end the slave trade in the colonies. Given his

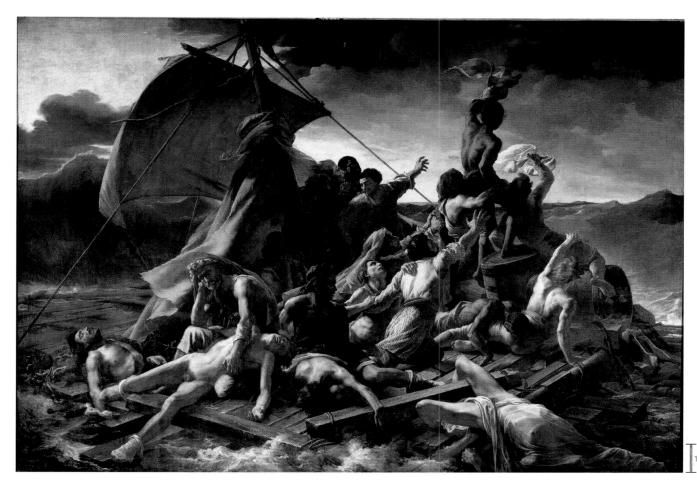

22-15 Théodore Géricault, Raft of the Medusa, 1818-1819. Oil on canvas, 16' 1" × 23' 6". Louvre, Paris.

In this gigantic history painting, Géricault rejected Neoclassical compositional principles and, in the Romantic spirit, presented a jumble of writhing bodies in every attitude of suffering, despair, and death.

antipathy to slavery, it is appropriate that Géricault placed Jean Charles, a black soldier and one of the few survivors, at the top of the pyramidal heap of bodies.

INSANE WOMAN Mental aberration and irrational states of mind could not fail to interest the rebels against Enlightenment rationality. Géricault, like many of his contemporaries, examined the influence of mental states on the human face and believed, as others did, that a face accurately revealed character, especially in madness and at the moment of death. He made many studies of the inmates of hospitals and institutions for the criminally insane, and he studied the severed heads of guillotine victims. Scientific and artistic curiosity often accompanied the morbidity of the Romantic interest in derangement and death. Géricault's Insane Woman (FIG. 22-16)—her mouth tense, her eyes red-rimmed with suffering—is one of several of his portraits of the insane that have a peculiar hypnotic power. These portraits present the psychic facts with astonishing authenticity, especially in contrast to earlier idealized commissioned portraiture.

22-16 Théodore Géricault, *Insane Woman*, 1822–1823. Oil on canvas, 2' $4'' \times 1'$ 9''. Musée des Beaux-Arts, Lyons.

The insane and the influence of aberrant states of mind on the appearance of the human face fascinated Géricault and other Romantic artists, who rebelled against Enlightenment rationality.

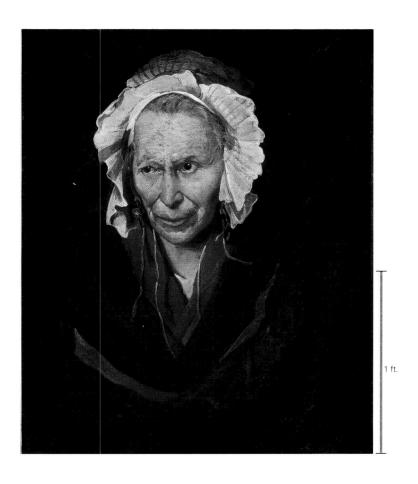

The Romantic Spirit in Art, Music, and Literature

The appeal of Romanticism, with its emphasis on freedom and feeling, extended well beyond the realm of the visual arts. The imagination and vision that characterized Romantic paintings and sculptures were equally moving and riveting in musical or written form. In European music, literature, and poetry, the Romantic spirit was a dominant presence during the late 18th and early 19th centuries. These artistic endeavors rejected classicism's structured order in favor of the emotive and expressive. In music, the compositions of Franz Schubert (1797–1828), Franz Liszt (1811–1886), Frédéric Chopin (1810–1849), and Johannes Brahms (1833–1897) all emphasized the melodic or lyrical. For these composers, music had the power to express the unspeakable and to communicate the subtlest and most powerful human emotions.

In literature, Romantic poets such as John Keats (1795–1821), William Wordsworth (1770–1850), and Samuel Taylor Coleridge (1772–1834) published volumes of poetry that serve as manifestations

of the Romantic interest in lyrical drama. Ozymandias, by Percy Bysshe Shelley (1792-1822), speaks of faraway, exotic locales. The setting of Lord Byron's Sardanapalus is the ancient Assyrian Empire (see Chapter 2). Byron's poem conjures images of eroticism and fury unleashed images that appear in Delacroix's painting Death of Sardanapalus (FIG. 22-17). One of the best examples of the Romantic spirit is the engrossing novel Frankenstein, written in 1818 by Shelley's wife, Mary Wollstonecraft Shelley (1797-1851). This tale of a monstrous creature run amok remains popular to the present day. As was true of many Romantic artworks, the novel not only embraced the emotional but also rejected the rationalism that underlay Enlightenment thought. Dr. Frankenstein's monster was a product of science, and the novel is an indictment of the tenacious belief in science that Enlightenment thinkers such as Voltaire promoted. Frankenstein served as a cautionary tale of the havoc that could result from unrestrained scientific experimentation and from the arrogance of scientists like Dr. Frankenstein.

22-17 EUGÈNE DELACROIX, Death of Sardanapalus, 1827. Oil on canvas, $12' 1\frac{1}{2}'' \times 16' 2\frac{7}{8}''$. Louvre, Paris.

Inspired by Byron's 1821 poem, Delacroix painted the Romantic spectacle of an Assyrian king on his funeral pyre. The richly colored and emotionally charged canvas is filled with exotic figures.

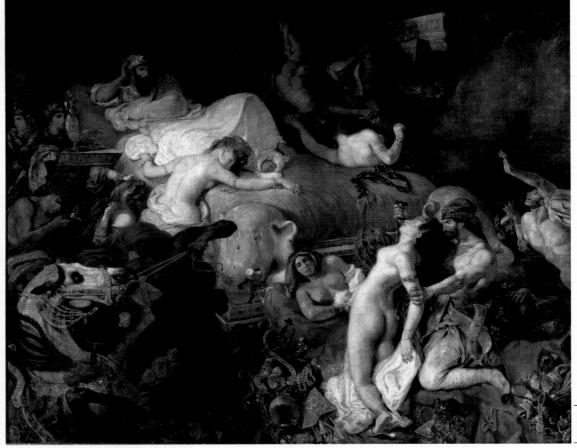

1 ft.

EUGÈNE DELACROIX Art historians often present the history of painting during the first half of the 19th century as a contest between two major artists—Ingres, the Neoclassical draftsman, and EUGÈNE DELACROIX (1798–1863), the Romantic colorist. Their dialogue recalls the quarrel between the Poussinistes and the Rubénistes

at the end of the 17th century and into the 18th (see Chapter 21). The Poussinistes were conservative defenders of academism who regarded drawing as superior to color, whereas the Rubénistes proclaimed the importance of color over line (line quality being more intellectual and thus more restrictive than color). Delacroix's works

were products of his view that the artist's powers of imagination would in turn capture and inflame the viewer's imagination. Literature of imaginative power served Delacroix (and many of his contemporaries) as a useful source of subject matter. Théophile Gautier (1811–1872), the prominent Romantic critic and novelist, recalled:

In those days painting and poetry fraternized. The artists read the poets, and the poets visited the artists. We found Shakespeare, Dante, Goethe, Lord Byron and Walter Scott in the studio as well as in the study. There were as many splashes of color as there were blots of ink in the margins of those beautiful books which we endlessly perused. Imagination, already excited, was further fired by reading those foreign works, so rich in color, so free and powerful in fantasy.¹

DEATH OF SARDANAPALUS Delacroix's Death of Sardanapalus (FIG. 22-17) is grand Romantic pictorial drama. Although inspired by the 1821 narrative poem Sardanapalus by Lord Byron (1788-1824), the painting does not illustrate that text (see "The Romantic Spirit in Art, Music, and Literature," page 622). Instead, Delacroix depicted the last hour of the Assyrian king (who had just received news of his armies' defeat and the enemies' entry into his city) in a much more tempestuous and crowded setting than Byron described. Here, orgiastic destruction replaces the sacrificial suicide found in the poem. In the painting, the king reclines on his funeral pyre, soon to be set alight, and gloomily watches the destruction of all of his most precious possessions—his women, slaves, horses, and treasure. Sardanapalus's favorite concubine throws herself on the bed, determined to go up in flames with her master. The king presides like a genius of evil over the tragic scene. Most conspicuous are the tortured and dying bodies of the harem women. In the foreground, a muscular

slave plunges his knife into the neck of one woman. Delacroix filled this awful spectacle of suffering and death with the most daringly difficult and tortuous poses, and chose the richest intensities of hue. With its exotic and erotic overtones, *Death of Sardanapalus* tapped into the Romantic fantasies of 19th-century viewers.

LIBERTY LEADING THE PEOPLE Although Death of Sardanapalus is a seventh-century BCE drama, Delacroix, like Géricault, also turned to current events, particularly tragic or sensational ones, for his subject matter. For example, he produced several images based on the Greek war for independence (1821-1829). Certainly, the French perception of the Greeks locked in a brutal struggle for freedom from the cruel and exotic Ottoman Turks generated great interest in Romantic circles. Closer to home, Delacroix captured the passion and energy of the 1830 revolution in France in his painting Liberty Leading the People (FIG. 22-18). Based on the Parisian uprising against Charles X (r. 1824-1830) at the end of July 1830, it depicts the allegorical personification of Liberty defiantly thrusting forth the republic's tricolor banner as she urges the masses to fight on. The scarlet Phrygian cap (the symbol of a freed slave in antiquity) she wears reinforces the urgency of this struggle. Arrayed around Liberty are bold Parisian types—the street boy brandishing his pistols, the menacing worker with a cutlass, and the intellectual dandy in top hat with sawed-off musket. As in Géricault's Raft of the Medusa (FIG. 22-15), dead bodies lie all around. In the background, the towers of Notre-Dame rise through the smoke and haze. The painter's inclusion of this recognizable Parisian landmark announces the specificity of locale and event, balancing contemporary historical fact with poetic allegory.

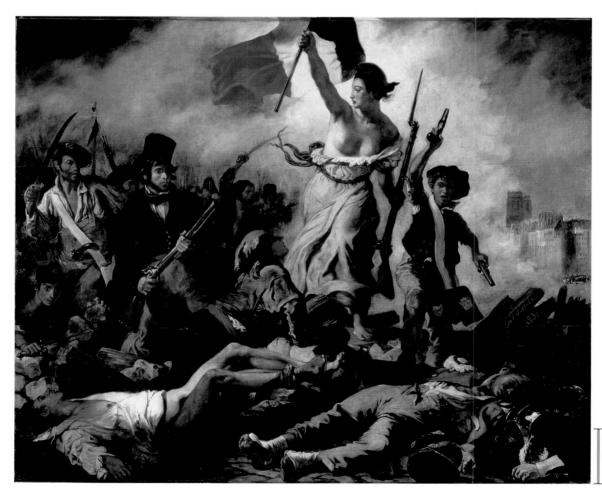

22-18 EUGÈNE
DELACROIX, *Liberty Leading the People*, 1830.
Oil on canvas, 8′ 6″ ×
10′ 8″. Louvre, Paris.

Balancing contemporaneous historical fact with poetic allegory, Delacroix captured the passion and energy of the 1830 revolution in this painting of Liberty leading the Parisian uprising against Charles X.

1 ft.

Delacroix in Morocco

omantic painters often depicted exotic faraway places they had never seen, but Eugène Delacroix journeyed to Morocco in 1832 and discovered in the sun-drenched landscape—and in the hardy and colorful Moroccans dressed in robes reminiscent of the Roman toga—new insights into a culture built on proud virtues. He found there a culture more classical than anything European Neoclassicism could conceive. In a letter to his friend Fréderic Villot dated February 29, 1832, he wrote:

This place is made for painters. . . . [B] eauty abounds here; not the over-praised beauty of fashionable paintings. The heroes of David and Co. with their rose-pink limbs would cut a sorry figure beside these children of the sun, who moreover wear the dress of classical antiquity with a nobler air, I dare assert.*

In a second letter, written June 4, 1832, he reported to Auguste Jal:

You have seen Algiers and you can imagine what the natives of these regions are like. Here there is something even simpler and more primitive; there is less of the Turkish alloy; I have Romans

and Greeks on my doorstep: it makes me laugh heartily at David's Greeks, apart, of course, from his sublime skill as a painter. I know now what they were really like; . . . If painting schools persist in [depicting classical subjects], I am convinced, and you will agree with me, that they would gain far more from being shipped off as cabin boys on the first boat bound for the Barbary coast than from

spending any more time wearing out the classical soil of Rome. Rome is no longer to be found in Rome. †

The gallantry, valor, and fierce love of liberty of the Moroccans made them, in Delacroix's eyes, unspoiled heroes uncontaminated by European decadence. The Moroccan journey renewed Delacroix's Romantic conviction that beauty exists in the fierceness of nature, natural processes, and natural beings, especially animals. After Morocco, more and more of Delacroix's subjects involved combats between beasts and between beasts and men. He painted snarling tangles of lions and tigers, battles between horses, and clashes of Muslims with great cats in swirling hunting scenes using compositions reminiscent of those of Rubens (FIG. 1-13), as in his 1854 painting *Tiger Hunt* (FIG. 22-19), which clearly speaks to the Romantic interest in faraway lands and exotic cultures.

* Translated by Jean Stewart, in Charles Harrison, Paul Wood, and Jason Gaiger, eds., *Art in Theory 1815–1900: An Anthology of Changing Ideas* (Oxford: Blackwell, 1998), 87.

† Ibid., 88.

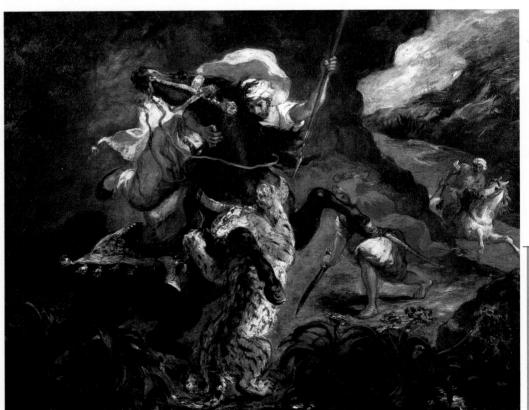

22-19 Eugène Delacroix, *Tiger Hunt*, 1854. Oil on canvas, 2' $5'' \times 3'$. Musée d'Orsay, Paris.

Tiger Hunt reflects Delacroix's 1832 trip to Morocco, which had a lasting impact on his art. His paintings of men battling ferocious beasts are consistent with the Romantic interest in exotic places.

TIGER HUNT An enormously influential event in Delacroix's life that affected his art in both subject and form was his visit to North Africa in 1832 (see "Delacroix in Morocco," above). Things he saw there shocked his imagination with fresh impressions that lasted throughout his life and resulted in paintings such as *Tiger Hunt* (FIG. 22-19), which he completed more than two decades after his trip.

Delacroix's African experience also further heightened his already considerable awareness of the expressive power of color and light. What Delacroix knew about color he passed on to later painters of the 19th century, particularly the Impressionists (see Chapter 23). He observed that pure colors are as rare in nature as lines and that color appears only in an infinitely varied scale of different tones,

shadings, and reflections, which he tried to re-create in his paintings. He recorded his observations in his journal, which became for later painters and scholars a veritable handbook of pre-Impressionist color theory. Delacroix anticipated the later development of Impressionist color science. But that art-science had to await the discoveries by Michel Eugène Chevreul (1786–1889) and Hermann von Helmholtz (1821–1894) of the laws of light decomposition and the properties of complementary colors before the problems of color perception and juxtaposition in painting could be properly formulated (see "19th-Century Color Theory," Chapter 23, page 664). Nevertheless, Delacroix's observations were significant, and he advised other artists not to fuse their brush strokes, as those strokes would appear to fuse naturally from a distance.

No other painter of the time explored the domain of Romantic subject and mood as thoroughly and definitively as Delacroix. His technique was impetuous, improvisational, and instinctive, rather than deliberate, studious, and cold. It epitomized Romantic colorist painting, catching the impression quickly and developing it in the execution process. His contemporaries commented on how furiously Delacroix worked once he had an idea, keeping the whole painting progressing at once. The fury of his attack matched the fury of his imagination and his subjects.

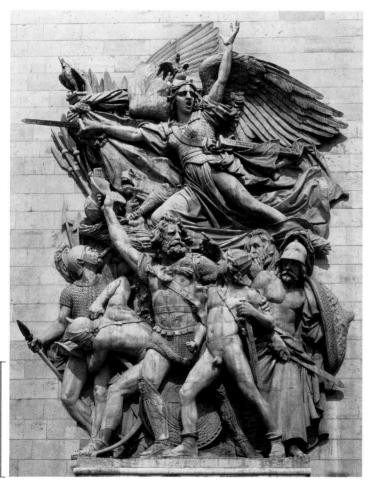

22-20 François Rude, *Departure of the Volunteers of 1792 (La Marseillaise)*, Arc de Triomphe, Paris, France, 1833–1836. Limestone, 41' 8" high.

In this historical-allegorical sculpture, the figures wear classical costumes, but the violent motion, jagged contours, and densely packed masses relate more closely to the compositions of Romantic paintings.

FRANÇOIS RUDE The Romantic spirit pervaded all media during the early 19th century. Many sculptors, like the painters of the period, produced work that incorporated both Neoclassical and Romantic elements. The colossal sculptural group Departure of the Volunteers of 1792 (FIG. 22-20), also called La Marseillaise, is one example. The limestone relief by François Rude (1784–1855) decorates one of the gigantic piers of the Arc de Triomphe in Paris. This French landmark was commissioned by Napoleon in 1806 and designed by Jean François Thérèse Chalgrin (1739–1811) on the model of the triumphal arches of ancient Rome (FIGS. 7-39, 7-47, and 7-75). Work on the arch stopped after Napoleon's defeat but resumed in 1833. Three years later, workers inserted Rude's group (and three similar ones by other sculptors) into the completed arch. The sculpture depicts the volunteers of 1792 departing to defend France's borders against the foreign enemies of the revolution. The Roman goddess of war, Bellona (who here personifies Liberty as well as the "Marseillaise," the revolutionary hymn that is now France's national anthem), soars above patriots of all ages, exhorting them forward with her thundering battle cry. The figures recall David's classically armored (FIG. 21-23) or nude heroes, as do the rhetorical gestures of the wide-flung arms and the striding poses. Yet the violent motion, the jagged contours, and the densely packed, overlapping masses relate more closely to the compositional method of dramatic Romanticism, as found in Géricault (FIG. 22-15) and Delacroix (FIG. 22-18), whose Liberty is the spiritual sister of the allegorical figure in La Marseillaise. Rude's stone figure shares the same Phrygian cap, the badge of liberty, with Delacroix's earlier painted figure, but Rude's soldiers wear classical costumes or are heroically nude, whereas those in Delacroix's painting appear in modern Parisian dress. Both works are allegorical, but one looks to the past and the other to the present.

Landscape Painting

Landscape painting came into its own in the 19th century as a fully independent and respected genre. Briefly eclipsed at the century's beginning by the taste for ideal form, which favored figural composition and history, landscape painting flourished as leading painters made it their profession. Increasing tourism, which came courtesy of improved and expanded railway systems both in Europe (MAP 22-2) and America, contributed to the popularity of landscape painting.

The notion of the picturesque became particularly resonant in the Romantic era. Already in the 18th century, artists had regarded the pleasurable, aesthetic mood that natural landscape inspired as making the landscape itself "picturesque"—that is, worthy of being painted. Rather than simply describe nature, Romantic poets and artists often used nature as allegory. In this manner, artists commented on spiritual, moral, historical, or philosophical issues. Landscape painting was a particularly effective vehicle for such commentary.

In the early 19th century, most Northern European (especially German) landscape painting to some degree expressed the Romantic view (first extolled by Rousseau) of nature as a "being" that included the totality of existence in organic unity and harmony. In nature— "the living garment of God," as German poet and dramatist Johann Wolfgang von Goethe (1749–1832) called it—artists found an ideal subject to express the Romantic theme of the soul unified with the natural world. As all nature was mysteriously permeated by "being," landscape artists had the task of interpreting the signs, symbols, and emblems of universal spirit disguised within visible material things. Artists no longer merely beheld a landscape but rather participated in its spirit, becoming translators of nature's transcendent meanings.

625

22-21 CASPAR DAVID FRIEDRICH, Abbey in the Oak Forest, 1810. Oil on canvas, $3' 7\frac{1}{2}'' \times 5' 7\frac{1}{4}''$. Nationalgalerie, Staatliche Museen zu Berlin,

Friedrich was a master of the Romantic transcendental landscape. The reverential mood of this winter scene with the ruins of a Gothic church and cemetery demands the silence appropriate to sacred places.

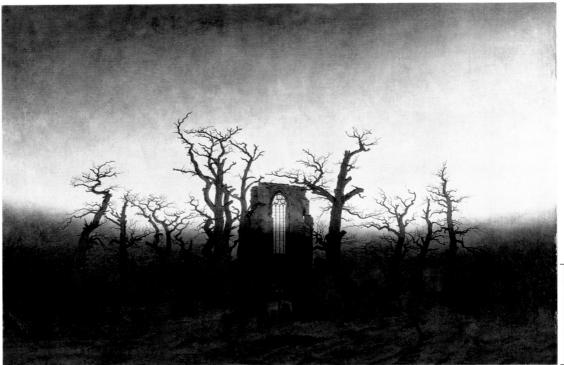

1 ft.

CASPAR DAVID FRIEDRICH Among the first Northern European artists to depict the Romantic transcendental landscape was Caspar David Friedrich (1774-1840). For Friedrich, landscapes were temples and his paintings were altarpieces. The reverential mood of his works demands from the viewer the silence appropriate to sacred places filled with a divine presence. Abbey in the Oak Forest (FIG. 22-21) serves as a solemn requiem. Under a winter sky, through the leafless oaks of a snow-covered cemetery, a funeral procession bears a coffin into the ruins of a Gothic church that Friedrich based on the remains of Eldana Abbey in Greifswald. The emblems of death are everywhere—the season's desolation, the leaning crosses and tombstones, the black of mourning that the grieving wear, the skeletal trees, the destruction time has wrought on the church. The painting is a meditation on human mortality. As Friedrich himself remarked: "Why, it has often occurred to me to ask myself, do I so frequently choose death, transience, and the grave as subjects for my paintings? One must submit oneself many times to death in order some day to attain life everlasting." The artist's sharp-focused rendering of details demonstrates his keen perception of everything in the physical environment relevant to his message. Friedrich's work balances inner and outer experience. "The artist," he wrote, "should not only paint what he sees before him, but also what he sees within him. If he does not see anything within him, he should give up painting what he sees before him." Although Friedrich's works may not have the theatrical energy of the paintings of Géricault or Delacroix, a resonant and deep emotion pervades them.

JOHN CONSTABLE One of the most momentous developments in Western history—the Industrial Revolution—influenced the evolution of Romantic landscape painting in England. Although discussion of the Industrial Revolution invariably focuses on technological advances, factory development, and growth of urban centers, its effect on the countryside and the land itself was no less severe. The detrimental economic impact industrialization had on the prices for agrarian products produced significant unrest in the English countryside. In particular, increasing numbers of displaced farmers could no longer afford to farm their small land plots.

JOHN CONSTABLE (1776–1837) addressed the agrarian situation in his landscape paintings. *The Haywain* (FIG. 22-22) is representative of Constable's art and reveals much about his outlook. A small cottage sits on the left of this placid, picturesque scene of the countryside, and in the center foreground a man leads a horse and wagon across the stream. Billowy clouds float lazily across the sky. The muted greens and golds and the delicacy of Constable's brush strokes augment the scene's tranquility. The artist portrayed the oneness with nature that the Romantic poets sought. The relaxed figures are not observers but participants in the landscape's being.

Constable made countless studies from nature for each of his canvases, which helped him produce in his paintings the convincing sense of reality that won so much praise from his contemporaries. In his quest for the authentic landscape, Constable studied it as a meteorologist (which he was by avocation). His special gift was for capturing the texture that the atmosphere (the climate and the weather, which delicately veil what is seen) gave to landscape. Constable's use of tiny dabs of local color, stippled with white, created a sparkling shimmer of light and hue across the canvas surface—the vibration itself suggestive of movement and process.

The Haywain is also significant for precisely what it does not show—the civil unrest of the agrarian working class and the outbreaks of violence and arson that resulted. The people who populate Constable's landscapes blend into the scenes and are at one with nature. Rarely does the viewer see workers engaged in tedious labor. Indeed, this painting has a nostalgic, wistful air to it, and reflects Constable's memories of a disappearing rural pastoralism. The artist's father was a rural landowner of considerable wealth, and many of the scenes Constable painted (*The Haywain* included) depict his family's property near East Bergholt in Suffolk, East Anglia. This nostalgia, presented in such naturalistic terms, renders Constable's works Romantic in tone. That Constable felt a kindred spirit with the Romantic artists is revealed by his comment "painting is but another word for feeling."⁴

J.M.W. TURNER Constable's contemporary in the English school of landscape painting, Joseph Mallord William Turner (1775–1851), produced work that also responded to encroaching in-

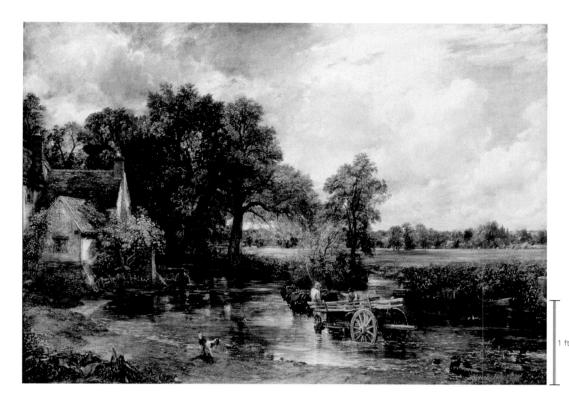

22-22 John Constable, *The Haywain*, 1821. Oil on canvas, $4' 3'' \times 6' 2''$. National Gallery, London.

The Haywain is a nostalgic view of the disappearing English countryside during the Industrial Revolution. Constable had a special gift for capturing the texture that climate and weather give to landscape.

dustrialization. However, where Constable's paintings are serene and precisely painted, Turner's feature turbulent swirls of frothy pigment. The passion and energy of Turner's works reveal the Romantic sensibility that was the foundation for his art and also clearly illustrate Edmund Burke's concept of the sublime—awe mixed with terror.

Among Turner's most notable works is *The Slave Ship* (FIG. 22-23). Its subject is a 1783 incident reported in an extensively read book titled *The History of the Abolition of the Slave Trade*, by Thomas Clarkson. Because the book had just been reprinted in

1839, Clarkson's account probably prompted Turner's choice of subject for this 1840 painting. The incident involved the captain of a slave ship who, on realizing that his insurance company would reimburse him only for slaves lost at sea but not for those who died en route, ordered the sick and dying slaves thrown overboard. Appropriately, the painting's full title is *The Slave Ship (Slavers Throwing Overboard the Dead and Dying, Typhoon Coming On)*. Turner's frenzied emotional depiction of this act matches its barbaric nature. The artist transformed the sun into an incandescent comet amid flying

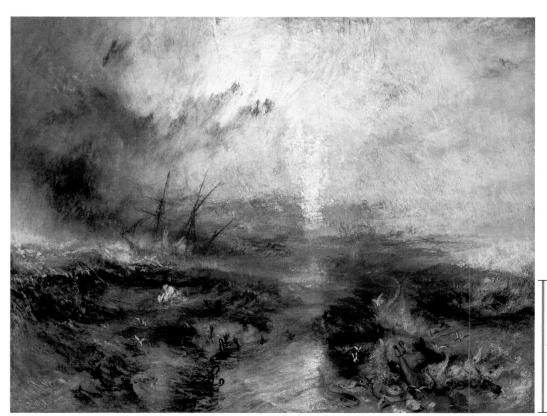

22-23 Joseph Mallord William Turner, The Slave Ship (Slavers Throwing Overboard the Dead and Dying, Typhoon Coming On), 1840. Oil on canvas, 2' $11\frac{11}{16}" \times 4'\frac{5}{16}"$. Museum of Fine Arts, Boston (Henry Lillie Pierce Fund).

The essence of Turner's innovative style is the emotive power of color. He released color from any defining outlines to express both the forces of nature and the painter's emotional response to them.

1 ft.

22-24 Thomas Cole, The Oxbow (View from Mount Holyoke, Northampton, Massachusetts, after a Thunderstorm), 1836. Oil on canvas, 4' $3\frac{1}{2}$ " \times 6' 4". Metropolitan Museum of Art, New York (gift of Mrs. Russell Sage, 1908).

Cole divided his canvas into dark wilderness on the left and sunlit civilization on the right. The minuscule painter at the bottom center seems to be asking for advice about America's future course.

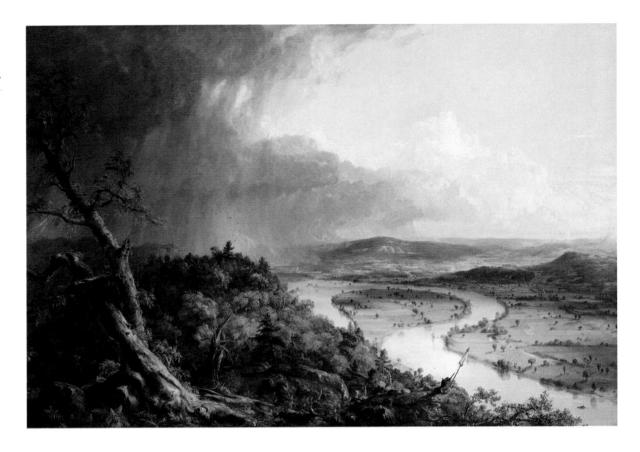

scarlet clouds. The slave ship moves into the distance, leaving in its wake a turbulent sea choked with the bodies of slaves sinking to their deaths. The relative scale of the minuscule human forms compared with the vast sea and overarching sky reinforces the sense of the sublime, especially the immense power of nature over humans. Almost lost in the boiling colors are the event's particulars, but on close inspection, the viewer can discern the iron shackles and manacles around the wrists and ankles of the drowning slaves, cruelly denying them any chance of saving themselves.

A key ingredient of Turner's highly personal style is the emotive power of pure color. The haziness of the painter's forms and the indistinctness of his compositions intensify the colors and energetic brush strokes. Turner's innovation in works such as *The Slave Ship* was to release color from any defining outlines so as to express both the forces of nature and the painter's emotional response to them. In his paintings, the reality of color is at one with the reality of feeling. Turner's methods had an incalculable effect on the later development of painting. His discovery of the aesthetic and emotive power of pure color and his pushing of the medium's fluidity to a point where the paint itself is almost the subject were important steps toward 20th-century abstract art, which dispensed with shape and form altogether (see Chapter 25).

THOMAS COLE In America, landscape painting was the specialty of a group of artists known as the Hudson River School, so named because its members drew their subjects primarily from the uncultivated regions of New York State's Hudson River Valley, although many of these painters depicted scenes from across the country. Like the early-19th-century landscape painters in Germany and England, the artists of the Hudson River School not only presented Romantic panoramic landscape views but also participated in the ongoing exploration of the individual's and the country's relationship to the land. American landscape painters frequently focused on identifying qualities that made America unique. One American painter of

English birth, Thomas Cole (1801–1848), often referred to as the leader of the Hudson River School, articulated this idea:

Whether he [an American] beholds the Hudson mingling waters with the Atlantic—explores the central wilds of this vast continent, or stands on the margin of the distant Oregon, he is still in the midst of American scenery—it is his own land; its beauty, its magnificence, its sublimity—all are his; and how undeserving of such a birthright, if he can turn towards it an unobserving eye, an unaffected heart!⁵

Another issue that surfaced frequently in Hudson River School paintings was the moral question of America's direction as a civilization. Cole addressed this question in *The Oxbow* (*View from Mount Holyoke, Northampton, Massachusetts, after a Thunderstorm;* FIG. **22-24**). A splendid scene opens before the viewer, dominated by the lazy oxbow-shaped curve of the Connecticut River. Cole divided the composition in two, with the dark, stormy wilderness on the left and the more developed civilization on the right. The minuscule artist in the bottom center of the painting (wearing a top hat), dwarfed by the land-scape's scale, turns to the viewer as if to ask for input in deciding the country's future course. Cole's depictions of expansive wilderness incorporated reflections and moods romantically appealing to the public.

ALBERT BIERSTADT Other Hudson River artists used the landscape genre as an allegorical vehicle to address moral and spiritual concerns. Albert Bierstadt (1830–1902) traveled west in 1858 and produced many paintings depicting the Rocky Mountains, Yosemite Valley, and other dramatic sites. His works, such as *Among the Sierra Nevada Mountains, California* (FIG. 22-25), present breathtaking scenery and natural beauty. This panoramic view (the painting is 10 feet wide) is awe-inspiring. Deer and waterfowl appear at the edge of a placid lake, and steep and rugged mountains soar skyward on the left and in the distance. A stand of trees, uncultivated and wild, frames the lake on the right. To underscore the almost transcendental nature of this scene, Bierstadt depicted the sun's rays

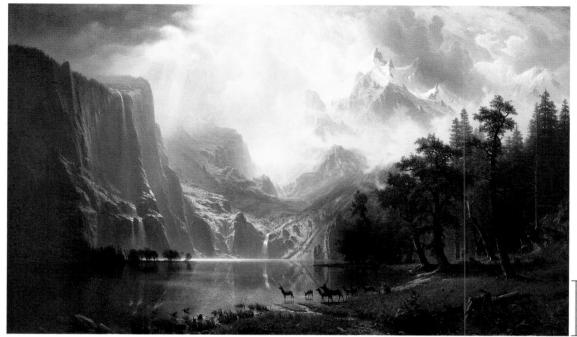

22-25 Albert Bierstadt, Among the Sierra Nevada Mountains, California, 1868. Oil on canvas, $6' \times 10'$. National Museum of American Art, Smithsonian Institution, Washington, D.C.

Bierstadt's panoramic landscape presents the breathtaking natural beauty of the American West. His paintings reinforced the 19th-century doctrine of Manifest Destiny, which justified western expansion.

1 ft.

breaking through the clouds overhead, which suggests a heavenly consecration of the land. That Bierstadt focused attention on the West is not insignificant. By calling national attention to the splendor and uniqueness of the regions beyond the Rocky Mountains, Bierstadt's paintings reinforced the idea of Manifest Destiny. This popular 19th-century doctrine held that westward expansion across the continent was the logical destiny of the United States. As John L. O'Sullivan (1813–1895) expounded in the earliest known use of the term in 1845, "Our manifest destiny [is] to overspread the continent allotted by Providence for the free development of our yearly multiplying millions." Paintings of the scenic splendor of the American West helped to mute growing concerns about the realities of conquest, the displacement of the Native Americans, and the exploitation of the environment. It should come as no surprise that among those most eager to purchase Bierstadt's work were mail-service

magnates and railroad builders—the very entrepreneurs and financiers involved in westward expansion.

FREDERIC CHURCH Another painter usually associated with the Hudson River School was Frederic Edwin Church (1826–1900), but his interest in landscape scenes extended beyond America. During his life he traveled to South America, Mexico, Europe, the Middle East, Newfoundland, and Labrador. Church's paintings are firmly in the idiom of the Romantic sublime, yet they also reveal contradictions and conflicts in the constructed mythology of American providence and character. *Twilight in the Wilderness* (FIG. 22-26) presents a panoramic view of the sun setting over the majestic landscape. Beyond Church's precise depiction of the aweinspiring spectacle of nature, the painting is remarkable for what it does not depict. Like Constable, Church and the other Hudson River

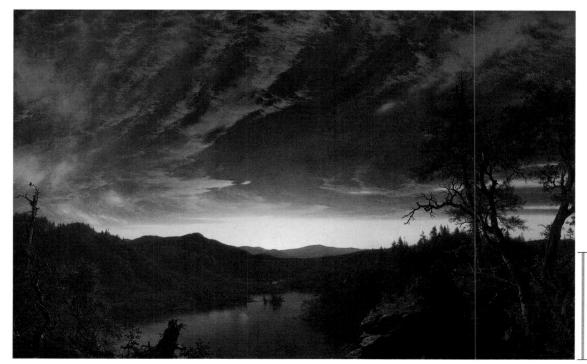

22-26 Frederic Edwin Church, *Twilight in the Wilderness*, 1860s. Oil on canvas, $3' 4'' \times 5' 4''$. Cleveland Museum of Art, Cleveland (Mr. and Mrs. William H. Marlatt Fund, 1965.233).

Church's paintings eloquently express the Romantic notion of the sublime. Painted during the Civil War, this wilderness landscape presents an idealistic view of America free of conflict.

1 ft.

School painters worked in a time of great upheaval. *Twilight in the Wilderness* dates to the 1860s, when the Civil War was tearing apart the country. Yet this painting does not display evidence of turbulence or discord. Indeed, it does not include even a trace of humanity. By constructing such an idealistic and comforting view, Church contributed to the national mythology of righteousness and divine providence—a mythology that had become increasingly difficult to maintain in the face of conflict.

Landscape painting was immensely popular in the late 18th and early 19th centuries, in large part because it provided viewers with breathtaking and sublime spectacles of nature. Artists also could allegorize nature, and it was rare for a landscape painting not to touch on spiritual, moral, historical, or philosophical issues. Landscape painting became the perfect vehicle for artists (and the viewing public) to "naturalize" conditions, rendering debate about contentious issues moot and eliminating any hint of conflict.

REALISM

Realism was a movement that developed in France around midcentury against the backdrop of an increasing emphasis on science. Advances in industrial technology during the early 19th century reinforced the Enlightenment's foundation of rationalism. The connection between science and progress seemed obvious to many, both in intellectual circles and among the general public, and people increasingly embraced empiricism (the search for knowledge based on observation and direct experience). Indicative of the widespread faith in science was the influence of positivism, a Western philosophical model developed by the French philosopher Auguste Comte (1798–1857). Positivists promoted science as the mind's highest achievement and advocated a purely empirical approach to nature and society. Comte believed that scientific laws governed the environment and human activity and could be revealed through careful recording and analysis of observable data. Like the empiricists and positivists, Realist artists argued that only the things of one's own time—what people could see for themselves—were "real." Accordingly, Realists focused their attention on the experiences and sights of everyday contemporary life and disapproved of historical and fictional subjects on the grounds that they were neither real and visible nor of the present.

22-27 Gustave Courbet, The Stone Breakers, 1849. Oil on canvas, 5' 3" \times 8' 6". Formerly Gemäldegalerie, Dresden (destroyed in 1945).

Courbet was the leading figure in the Realist movement. Using a palette of dirty browns and grays, he conveyed the dreary and dismal nature of menial labor in mid-19th-century France.

France

GUSTAVE COURBET The leading figure of the Realist movement in 19th-century art was GUSTAVE COURBET (1819–1877). In fact, Courbet used the term *Realism* when exhibiting his works, even though he shunned labels (see "Courbet on Realism," page 631). The Realists' sincerity about scrutinizing their environment led them to portray objects and images that in recent centuries artists had deemed unworthy of depiction—the mundane and trivial, working-class laborers and peasants, and so forth. Moreover, the Realists depicted these scenes on a scale and with an earnestness and seriousness previously reserved for grand history painting.

STONE BREAKERS Courbet presented a glimpse into the life of rural menial laborers in *The Stone Breakers* (FIG. 22-27), capturing on canvas in a straightforward manner two men—one about 70, the other quite young—in the act of breaking stones, traditionally the lot of the lowest in French society. By juxtaposing youth and age, Courbet suggested that those born to poverty remain poor their entire lives. The artist neither romanticized nor idealized the men's work but depicted their thankless toil with directness and accuracy. Courbet's palette of dirty browns and grays conveys the dreary and dismal nature of the task, while the angular positioning of the older stone breaker's limbs suggests a mechanical monotony.

This interest in the working poor as subject matter had special meaning for the mid-19th-century French audience. In 1848 laborers rebelled against the bourgeois leaders of the newly formed Second Republic and against the rest of the nation, demanding better working conditions and a redistribution of property. The army quelled the revolution in three days, but not without long-lasting trauma and significant loss of life. That uprising thus raised the issue of labor as a national concern and placed workers center stage, both literally and symbolically. Courbet's depiction of stone breakers in 1849 was very timely and populist.

BURIAL AT ORNANS Also representative of Courbet's work is Burial at Ornans (FIG. 22-28), which depicts a funeral set in a bleak provincial landscape outside his home town. Attending the funeral are the types of ordinary people Honoré de Balzac (1799–1850) and Gustave Flaubert (1821–1880) presented in their novels. While an officious clergyman reads the Office of the Dead, those attending

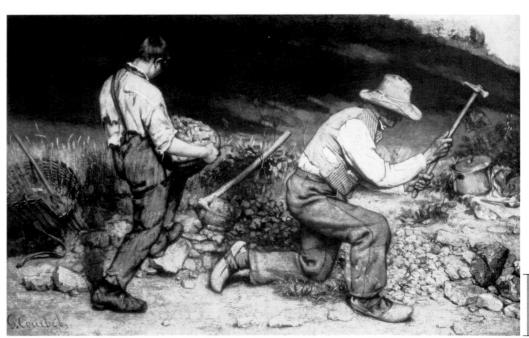

1 ft

Courbet on Realism

he Parisian academic jury selecting work for the 1855 Salon (part of the Exposition Universelle in that year) rejected two paintings by Gustave Courbet on the grounds that his subjects and figures were too coarse (so much so as to be plainly "socialistic") and too large (*Burial at Ornans*, FIG. 22-28, is almost 22 feet long). In response, Courbet withdrew all of his works and set up his own exhibition outside the grounds, calling it the Pavilion of Realism. Courbet was the first artist ever to stage a private exhibition of his own work. His pavilion and the statement he issued to explain the paintings shown there amounted to the new movement's manifestos. Although Courbet maintained that he founded no school and was of no school, he did, as the name of his pavilion suggests, accept the term *Realism* as descriptive of his art. The statement Courbet distributed at his pavilion reads in part:

The title of "realist" has been imposed upon me Titles have never given a just idea of things; were it otherwise, the work would be superfluous. . . . I have studied the art of the moderns, avoiding any preconceived system and without prejudice. I have no more wanted to imitate the former than to copy the latter; nor have I thought of achieving the idle aim of "art for art's sake." No! I have simply wanted to draw from a thorough knowledge of tradition the reasoned and free sense of my own individuality. . . . To be able to translate the customs, ideas, and appearances of my time as I see them—in a word, to create a living art—this has been my aim.*

Six years later, on Christmas Day, 1861, Courbet wrote an open letter, published a few days later in the *Courier du dimanche*, addressed to prospective students. In the letter, the painter reflected on the nature of his art.

[An artist must apply] his personal faculties to the ideas and the events of the times in which he lives. . . . [A]rt in painting should consist only of the representation of things that are visible and tangible to the artist. Every age should be represented only by its own artists, that is to say, by the artists who have lived in it. I also maintain that painting is an essentially concrete art form and can consist only of the representation of both real and existing things. . . . An abstract object, not visible, nonexistent, is not within the domain of painting. †

Courbet's most famous statement, however, is his blunt dismissal of academic painting, in which he concisely summed up the core principle of Realist painting:

I have never seen an angel. Show me an angel, and I'll paint one.‡

- * Translated by Robert Goldwater and Marco Treves, eds., *Artists on Art from the XIV to the XX Century*, 3rd ed. (New York: Pantheon, 1958), 295.
- † Translated by Petra ten-Doesschate Chu, *Letters of Gustave Courbet* (Chicago: University of Chicago Press, 1992), 203–204.
- [‡] Quoted by Vincent van Gogh in a July 1885 letter to his brother Theo. Ronald de Leeuw, *The Letters of Vincent van Gogh* (New York: Penguin, 1996), 302.

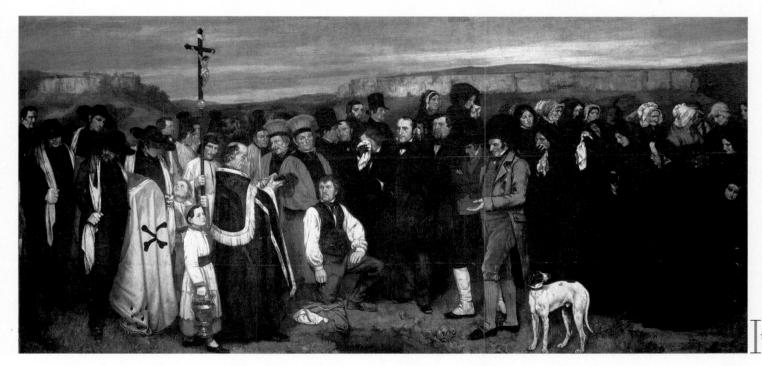

22-28 Gustave Courbet, Burial at Ornans, 1849. Oil on canvas, $10' 3\frac{1}{2}'' \times 21' 9\frac{1}{2}''$. Musée d'Orsay, Paris.

Although as monumental in scale as a traditional history painting, *Burial at Ornans* horrified critics because of the ordinary nature of the subject and Courbet's starkly antiheroic composition.

cluster around the excavated grave site, their faces registering all degrees of response to the situation. Although the painting has the monumental scale of a traditional history painting, the subject's ordinariness and the starkly antiheroic composition horrified contem-

poraneous critics. Arranged in a wavering line extending across the broad horizontal width of the canvas are three groups—the somberly clad women at the back right, a semicircle of similarly clad men by the open grave, and assorted churchmen at the left. This wall of

22-29 JEAN-FRANÇOIS MILLET, The Gleaners, 1857. Oil on canvas, 2' 9" × 3' 8". Musée d'Orsay, Paris.

Millet and the Barbizon School painters specialized in depictions of French country life. Here, Millet portrayed three impoverished women gathering the remainders left in the field after a harvest.

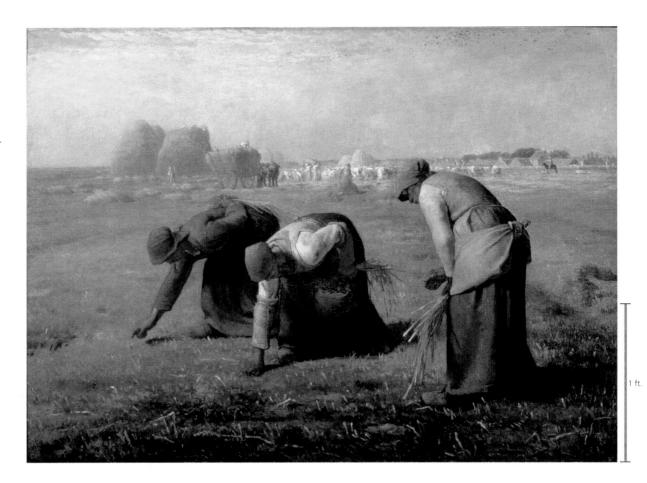

figures, seen at eye level in person, blocks any view into deep space. The faces are portraits. Some of the models were Courbet's sisters (three of the women in the front row, toward the right) and friends. Behind and above the figures are bands of overcast sky and barren cliffs. The dark pit of the grave opens into the viewer's space in the center foreground. Despite the unposed look of the figures, Courbet controlled the composition in a masterful way by his sparing use of bright color. In place of the heroic, the sublime, and the dramatic, Courbet aggressively presents the viewer with the mundane realities of daily life and death. In 1857, Jules-François-Félix Husson Champfleury (1821–1889), one of the first critics to recognize and appreciate Courbet's work, wrote of *Burial at Ornans*, "[I]t represents a smalltown funeral and yet reproduces the funerals of *all* small towns." Unlike the theatricality of Romanticism, Realism captured the ordinary rhythms of daily existence.

Of great importance for the later history of art, Realism also involved a reconsideration of the painter's primary goals and departed from the established priority on illusionism. Accordingly, Realists called attention to painting as a pictorial construction by the ways they applied pigment or manipulated composition. Courbet's intentionally simple and direct methods of expression in composition and technique seemed unbearably crude to many of his more traditional contemporaries, who called him a primitive. Although his bold, somber palette was essentially traditional, Courbet often used the *palette knife* for quickly placing and unifying large daubs of paint, producing a roughly wrought surface. His example inspired the young artists who worked for him (and later Impressionists such as Claude Monet and Auguste Renoir; see Chapter 23), but the public accused him of carelessness and critics wrote of his "brutalities."

JEAN-FRANÇOIS MILLET Like Courbet, JEAN-FRANÇOIS MILLET (1814-1878) found his subjects in the people and occupations of the everyday world. Millet was one of a group of French painters of country life who, to be close to their rural subjects, settled near the village of Barbizon in the forest of Fontainebleau. This Barbizon School specialized in detailed pictures of forest and countryside. Millet, perhaps their most prominent member, was of peasant stock and identified with the hard lot of the country poor. In *The* Gleaners (FIG. 22-29), he depicted three peasant women performing the backbreaking task of gleaning the last wheat scraps. These impoverished women were members of the lowest level of peasant society. Landowning nobles traditionally permitted them to glean to pick up the remainders left in the field after the harvest. Millet characteristically placed his monumental figures in the foreground, against a broad sky. Although the field stretches back to a rim of haystacks, cottages, trees, and distant workers and a flat horizon, the gleaners quietly doing their tedious and time-consuming work dominate the canvas.

Although Millet's works have a sentimentality absent from those of Courbet, the French public still reacted to his paintings with disdain and suspicion. In the aftermath of the 1848 revolution, for Millet to invest the poor with solemn grandeur did not meet with the approval of the prosperous classes. In particular, middle-class landowners resisted granting gleaning rights, and thus Millet's relatively dignified depiction of gleaning did not gain their favor. The middle class also linked the poor with the dangerous, newly defined working class, which was finding outspoken champions in men such as Karl Marx (1818–1883), Friedrich Engels (1820–1895), and the novelists Émile Zola (1840–1902) and Charles Dickens (1812–1870).

Lithography

n 1798 the German printmaker Alois Senefelder (1771–1834) created the first prints using stone instead of metal plates or wooden blocks. In contrast to earlier printing techniques (see "Woodcuts, Engravings, and Etchings," Chapter 15, page 415) in which the artist applied ink to either a raised or incised surface, in *lithography* (Greek, "stone writing") the printing and nonprinting areas of the plate are on the same plane.

The chemical phenomenon fundamental to lithography is the repellence of oil and water. The lithographer uses a greasy, oil-based

crayon to draw directly on a stone plate and then wipes water onto the stone, which clings only to the areas the drawing does not cover. Next, the artist rolls oil-based ink onto the stone, which adheres to the drawing but is repelled by the water. When the artist presses the stone against paper, only the inked areas—the drawing—transfer to the paper. Color lithography requires multiple plates, one for each color, and the printmaker must take special care to make sure that each impression lines up perfectly with the previous one so that each color prints in its proper place.

One of the earliest masters of this new printmaking process was Honoré Daumier (FIG. 22-30), whose politically biting lithographs published in a widely read French journal reached an audience of unprecedented size.

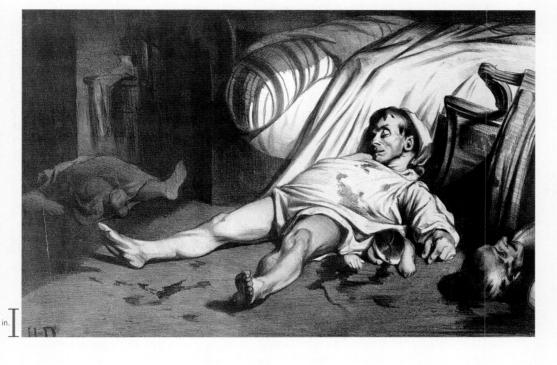

22-30 Honoré Daumier, Rue Transnonain, 1834. Lithograph, $1' \times 1' 5\frac{1}{2}''$. Philadelphia Museum of Art, Philadelphia (bequest of Fiske and Marie Kimball).

Daumier used the recent invention of lithography to reach a wide audience for his social criticism and political protest. This print records the horrific 1834 massacre in a workers' housing block.

Socialism was a growing movement, and both its views on property and its call for social justice, even economic equality, frightened the bourgeoisie. In Millet's sympathetic portrayal of the poor, many saw a political manifesto.

HONORÉ DAUMIER Because people widely recognized the power of art to serve political means, the political and social agitation accompanying the violent revolutions in France and the rest of Europe in the later 18th and early 19th centuries prompted the French people to suspect artists of subversive intention. A person could be jailed for too bold a statement in the press, in literature, in art—even in music and drama. Realist artist Honoré Daumier (1808–1879) was a defender of the urban working classes, and in his art he boldly confronted authority with social criticism and political protest. In response, the authorities imprisoned the artist. A painter, sculptor, and, like Dürer, Rembrandt, and Goya, one of the world's great printmakers, Daumier produced lithographs (see "Lithography," above) that allowed him to create an unprecedented number of prints, thereby reaching a broader audience. In addition to producing individual lithographs for sale, Daumier also contributed satirical lithographs to the widely read, liberal French Republican journal Caricature. In these prints, he mercilessly lampooned the foibles and

misbehavior of politicians, lawyers, doctors, and the rich bourgeoisie in general. His in-depth knowledge of the acute political and social unrest in Paris during the revolutions of 1830 and 1848 endowed his work with truthfulness and, therefore, with power.

RUE TRANSNONAIN Daumier's lithograph Rue Transnonain (FIG. 22-30) depicts an atrocity with the same shocking impact as Goya's Third of May, 1808 (FIG. 22-13). The title refers to a street in Paris where an unknown sniper killed a civil guard, part of a government force trying to repress a worker demonstration. Because the fatal shot had come from a workers' housing block, the remaining guards immediately stormed the building and massacred all of its inhabitants. With Goya's power, Daumier created a view of the slaughter from a sharp, realistic angle of vision. He depicted not the dramatic moment of execution but the terrible, quiet aftermath. The broken, scattered forms lie amid violent disorder, as if newly found. The print's significance lies in its factualness. It is an example of the period's increasing artistic bias toward using facts as subject, and not always illusionistically. Daumier's pictorial manner is rough and spontaneous. How it carries expressive exaggeration is part of its remarkable force. Daumier's work is true to life in content, but his style is uniquely personal.

22-31 Honoré Daumier, *Third-Class Carriage*, ca. 1862. Oil on canvas, $2' 1\frac{3}{4}'' \times 2' 11\frac{1}{2}''$. Metropolitan Museum of Art, New York (H. O. Havemeyer Collection, bequest of Mrs. H. O. Havemeyer, 1929).

Daumier frequently depicted the plight of the disinherited masses of 19th-century industrialism. Here, he portrayed the anonymous poor cramped together in a grimy third-class railway carriage.

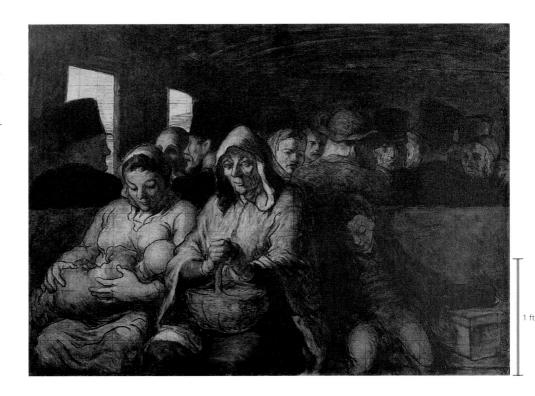

THIRD-CLASS CARRIAGE Daumier brought the same convictions exhibited in his graphic work to his paintings as well, especially after 1848. His unfinished *Third-Class Carriage* (FIG. 22-31) provides a glimpse into the cramped and grimy railway carriage of the 1860s. The riders are poor and can afford only third-class tickets. While first- and second-class carriages had closed compartments, third-class passengers were crammed together on hard benches that filled the carriage. The disinherited masses of 19th-century industrialism were Daumier's indignant concern, and he made them his

subject repeatedly. He showed them in the unposed attitudes and unplanned arrangements of the millions thronging the modern cities—anonymous, insignificant, dumbly patient with a lot they could not change. Daumier saw people as they ordinarily appeared, their faces vague, impersonal, and blank—unprepared for any observers. He tried to achieve the real by isolating a random collection of the unrehearsed details of human existence from the continuum of ordinary life. Daumier's vision anticipated the spontaneity and candor of scenes captured with the camera by the end of the century.

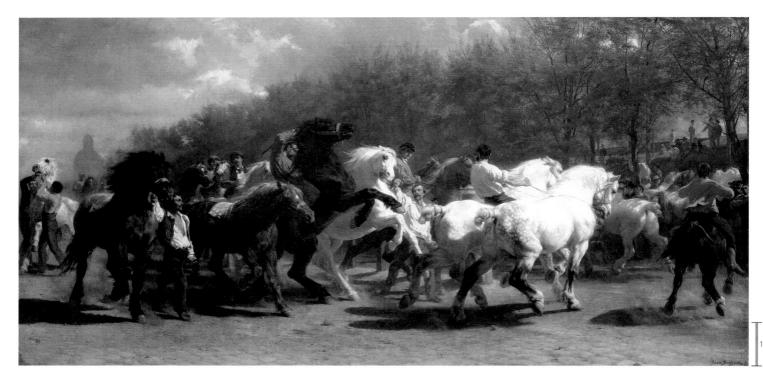

22-32 Rosa Bonheur, *The Horse Fair*, 1853–1855. Oil on canvas, $8'\frac{1}{4}'' \times 16'7\frac{1}{2}''$. Metropolitan Museum of Art, New York (gift of Cornelius Vanderbilt, 1887).

Bonheur was the most celebrated woman artist of the 19th century. A Realist, she went to great lengths to record accurately the anatomy of living horses, even studying carcasses in slaughterhouses.

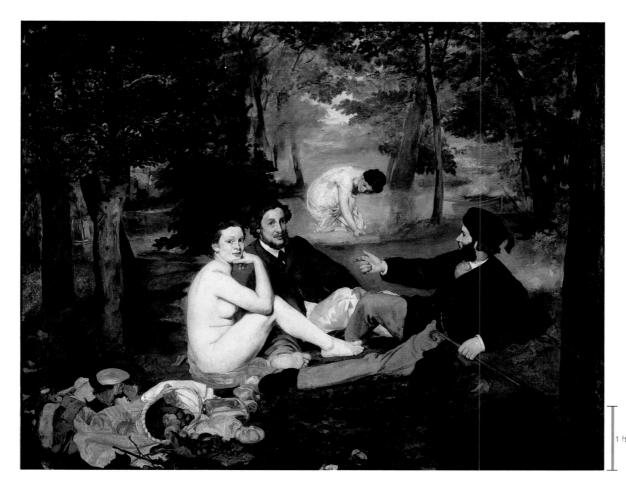

22-33 ÉDOUARD MANET, Le Déjeuner sur l'Herbe (Luncheon on the Grass), 1863. Oil on canvas, 7' × 8' 8". Musée d'Orsay, Paris.

Manet was widely criticized for both his shocking subject matter and his manner of painting. Moving away from illusionism, he used colors to flatten form and to draw attention to the painting surface.

ROSA BONHEUR The most celebrated woman artist of the 19th century was Marie-Rosalie (Rosa) Bonheur (1822–1899). The winner of the gold medal at the Salon of 1848, Bonheur became in 1894 the first woman officer in the French Legion of Honor. Bonheur received her artistic training from her father, who was a proponent of Saint-Simonianism, an early-19th-century utopian socialist movement that championed the education and enfranchisement of women. As a result of her father's influence, Bonheur launched her career believing that as a woman and an artist, she had a special role to play in creating a new and perfect society. A Realist passion for accuracy in painting drove Bonheur, but she resisted depicting the problematic social and political situations seen in the work of Courbet, Millet, Daumier, and other Realists. Rather, she turned to the animal world—not, however, to the exotic wild animals that so fascinated Delacroix (FIG. 22-19), but to animals common in the French countryside, especially horses, but also rabbits, cows, and sheep. She went to great lengths to observe the anatomy of living horses at the great Parisian horse fair and spent long hours studying the anatomy of carcasses in the Paris slaughterhouses. For her best-known work, The Horse Fair (FIG. 22-32), she adopted a panoramic composition similar to that in Courbet's Burial at Ornans (FIG. 22-28). Bonheur filled her broad canvas with the sturdy farm Percherons and their grooms seen on parade at the annual Parisian horse sale. Some horses, not quite broken, rear up. Others plod or trot, guided on foot or ridden by their keepers. Bonheur recorded the Percherons' uneven line of march, their thunderous pounding, and their seemingly overwhelming power based on her close observation of living animals, even though she acknowledged some inspiration from the Parthenon frieze (FIG. 5-50, top). The dramatic lighting, loose brushwork, and rolling sky also reveal her admiration of the style of Géricault (FIG. 22-15). The equine drama in The Horse Fair captivated viewers, who eagerly bought en-

graved reproductions of Bonheur's painting, making it one of the best-known artworks of the century.

ÉDOUARD MANET Like Gustave Courbet, ÉDOUARD MANET (1832-1883) was a pivotal artist during the 19th century. Not only was his work critical for the articulation of Realist principles, but his art also played an important role in the development of Impressionism in the 1870s (see Chapter 23). Manet's masterpiece, Le Déjeuner sur l'Herbe (Luncheon on the Grass; FIG. 22-33), depicts two women, one nude, and two clothed men enjoying a picnic of sorts. Consistent with Realist principles, Manet based all of the foreground figures on living people. The seated nude is Victorine Meurend (Manet's favorite model at the time), and the gentlemen are his brother Eugène (with cane) and probably the sculptor Ferdinand Leenhof, although scholars have suggested other identifications. The two men wear fashionable Parisian attire of the 1860s, and the foreground nude not only is a distressingly unidealized figure type but also seems disturbingly unabashed and at ease, gazing directly at the viewer without shame or flirtatiousness.

This audacious painting outraged the public—rather than a traditional pastoral scene, like the Renaissance *Pastoral Symphony* (FIG. 17-35), which featured anonymous idealized figures in an idyllic setting, *Le Déjeuner* seemed merely to represent ordinary men and promiscuous women in a Parisian park. One hostile critic, no doubt voicing public opinion, said: "A commonplace woman of the demimonde, as naked as can be, shamelessly lolls between two dandies dressed to the teeth. These latter look like schoolboys on a holiday, perpetrating an outrage to play the man. . . . This is a young man's practical joke—a shameful, open sore." Manet surely anticipated criticism of his painting, but shocking the public was not his primary aim. His goal was more complex and involved a reassessment of the entire range of

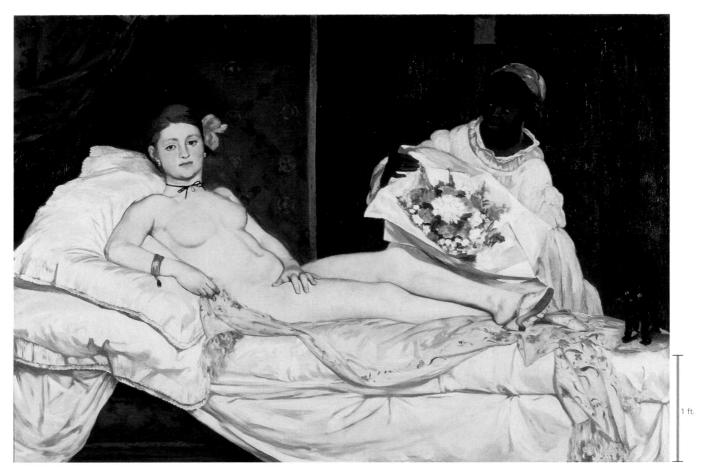

22-34 ÉDOUARD MANET, Olympia, 1863. Oil on canvas, 4' $3'' \times 6'$ $2\frac{1}{4}''$. Musée d'Orsay, Paris.

Manet scandalized the public with this painting of a nude prostitute and her black maid carrying a bouquet from a client. Critics also faulted him for using rough brush strokes and abruptly shifting tonality.

art. *Le Déjeuner* contains sophisticated references and allusions to many painting genres—history painting, portraiture, pastoral scenes, nudes, and even religious scenes. What *Le Déjeuner* thus represents is an impressive synthesis and critique of the history of painting.

The negative response to this painting by public and critics alike extended beyond subject matter. Manet's manner of presenting his figures also prompted severe criticism. He rendered them in soft focus and broadly painted the landscape, including the pool in which the second woman bathes. The loose manner of painting contrasts with the clear forms of the harshly lit foreground trio and the pile of discarded female attire and picnic foods at the lower left. The lighting creates strong contrasts between darks and highlighted areas. In the main figures, many values are summed up in one or two lights or darks. The effect is both to flatten the forms and to give them a hard snapping presence. Form, rather than a matter of line, is only a function of paint and light. Manet himself declared that the chief actor in the painting is the light. Manet used art to call attention to art. In other words, he was moving away from illusionism and toward open acknowledgment of painting's properties, such as the flatness of the painting surface, which would become a core principle of many later 19th- and 20th-century painters. The public, however, saw only a crude sketch without the customary finish. The style of the painting, coupled with the unorthodox subject matter, made this work exceptionally controversial.

OLYMPIA Even more scandalous to the French viewing public was Manet's 1863 painting *Olympia* (FIG. 22-34). This work depicts

a young white prostitute (Olympia was a common "professional" name for prostitutes in the 19th century) reclining on a bed that extends across the foreground. Entirely nude except for a thin black ribbon tied around her neck, a bracelet on her arm, an orchid in her hair, and fashionable mule slippers on her feet, Olympia meets the viewer's eyes with a look of cool indifference. Behind her appears a black maid, who presents her a bouquet of flowers from a client.

Olympia horrified public and critics alike. Although images of prostitutes were not unheard of during this period, the shamelessness of Olympia and her look that verges on defiance shocked viewers. The depiction of a black woman was also not new to painting, but the viewing public perceived Manet's inclusion of both a black maid and a nude prostitute as evoking moral depravity, inferiority, and animalistic sexuality. The contrast of the black servant with the fair-skinned courtesan also made reference to racial divisions. One critic described Olympia as "a courtesan with dirty hands and wrinkled feet . . . her body has the livid tint of a cadaver displayed in the morgue; her outlines are drawn in charcoal and her greenish, bloodshot eyes appear to be provoking the public, protected all the while by a hideous Negress."9 From this statement, it is clear that viewers were responding not just to the subject matter but to Manet's artistic style as well. Manet's brush strokes are rougher and the shifts in tonality are more abrupt than those found in traditional academic painting. This departure from accepted practice exacerbated the audacity of the subject matter.

ADOLPHE-WILLIAM BOUGUEREAU To understand better the public's reaction to Manet's radically new painting style, it is in-

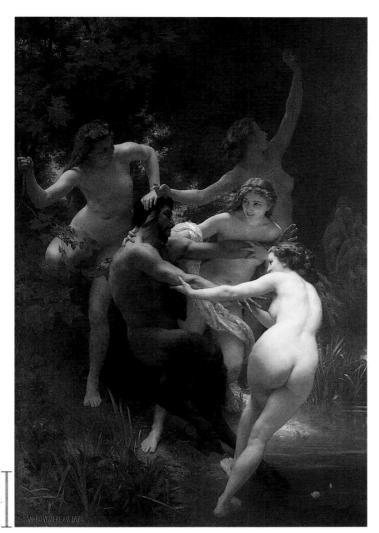

22-35 Adolphe-William Bouguereau, *Nymphs and a Satyr*, 1873. Oil on canvas, $9'\frac{3}{8}'' \times 5' \cdot 10\frac{7}{8}''$. Sterling and Francine Clark Art Institute, Williamstown.

More renowned than Manet in his own day, Bouguereau was an artist in the French academic tradition who specialized in depicting subjects from classical mythology with polished naturalism.

Structive to compare *Olympia* with a work by a highly acclaimed French academic artist of the time, Adolphe-William Bouguereau (1825–1905). In *Nymphs and a Satyr* (Fig. **22-35**), Bouguereau characteristically depicted a classical mythological subject with polished illusionism. The flirtatious and ideally beautiful nymphs strike graceful poses yet seem based as closely on nature as are the details of their leafy surroundings. They playfully pull in different directions the *satyr*, the mythical Greek beast-man, with a goat's hindquarters and horns, a horse's ears and tail, and a man's upper body. Although Bouguereau arguably depicted this scene in a very naturalistic manner, it is emphatically not Realist. His choice of a fictional theme and adherence to established painting conventions were staunchly traditional. In contrast to the daring and pioneering—and underappreciated—Manet, Bouguereau was immensely popular during the later 19th century, enjoying the favor of state patronage throughout his career.

Germany and the United States

Although French artists took the lead in promoting Realism and the notion that artists should depict the realities of modern life, this movement was not exclusively French. The Realist foundation in empiricism and positivism appealed to artists in many European countries and in the United States.

WILHELM LEIBL Three Women in a Village Church (FIG. 22-36) by WILHELM LEIBL (1844–1900) demonstrates the German artist's commitment to Realist principles and his mastery of the quaint and quiet details of country life. His painting records a sacred moment—the moment of prayer—in the life of three country women of different generations. Dressed in rustic costume, their Sunday best, they pursue their devotions unself-consciously, their prayer books held in large hands roughened by work. Their manners and dress reflect their unaffected nature, untouched by the refinements of urban life. Leibl highlighted their natural virtues: simplicity, honesty, steadfastness, patience.

Leibl spent three years working on this image of peasants in their village church, often under impossible conditions of lighting and temperature. Despite the meticulous application of paint and sharpness of focus, *Three Women* is a moving expression of the German artist's compassionate view of his subjects, a reading of character without sentimentality.

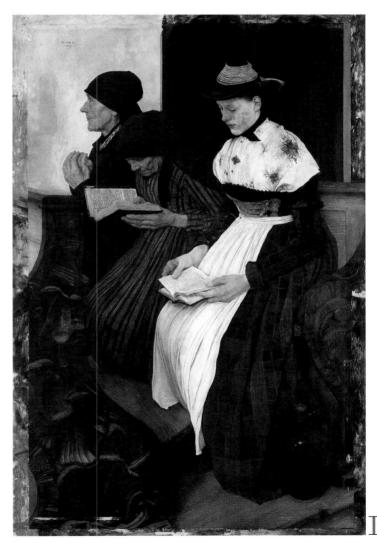

22-36 Wilhelm Leibl, Three Women in a Village Church, 1878–1882. Oil on canvas, 2' $5''\times 2'$ 1". Kunsthalle, Hamburg.

French Realism spread quickly to Germany, where Leibl painted this moving depiction of simple peasant women of different generations holding their prayer books in hands roughened by work.

637

22-37 WINSLOW HOMER, Veteran in a New Field, 1865. Oil on canvas, $2'\frac{1}{8}'' \times 3' 2\frac{1}{8}''$. Metropolitan Museum of Art, New York (bequest of Miss Adelaide Milton de Groot, 1967).

This veteran's productive work implies a smooth transition to peace after the Civil War, but Homer placed a singlebladed scythe in his hands, a symbol of the deaths of soldiers and of Abraham Lincoln.

WINSLOW HOMER Realism received an especially warm reception in the United States. One of the leading American Realist painters was WINSLOW HOMER (1836–1910) of Boston. Homer experienced at first hand the most momentous event of his lifetime—the Civil War. In 1860

he joined the Union campaign as an artist-reporter for Harper's Weekly. At the end of the war, he painted Veteran in a New Field (FIG. 22-37). Although it is fairly simple and direct, this painting provides significant commentary on the effects and aftermath of America's catastrophic national conflict. The painting depicts a man with his back to the viewer, harvesting wheat. Homer identified him as a veteran by the uniform and canteen carelessly thrown on the ground in the lower right corner, but the man's current occupation is as a farmer, and he has cast aside his former role as a soldier. The veteran's involvement in meaningful, productive work implies a smooth transition from war to peace. This postwar transition to work and the fate of disbanded soldiers were national concerns. Echoing the sentiments that lay behind Houdon's portrayal of George Washington as the new Cincinnatus (FIG. 21-30), the New York Weekly Tribune commented: "Rome took her great man from the plow, and made him a dictator—we must now take our soldiers from the camp and make them farmers." ¹⁰ America's ability to effect a smooth transition was seen as evidence of its national strength. "The peaceful and harmonious disbanding of the armies in the summer of 1865," poet Walt Whitman wrote, was one of the "immortal proofs of democracy, unequall'd in all the history of the past."11 Homer's painting thus reinforced the perception of the country's greatness.

Veteran in a New Field also comments symbolically about death. By the 1860s, farmers used cradled scythes to harvest wheat. In this instance, however, Homer rejected realism in favor of symbolism. He painted a single-bladed scythe, thereby transforming the veteran into a symbol of Death—the Grim Reaper himself—and the painting into an elegy to the thousands of soldiers who died in the Civil War and into a lamentation on the death of recently assassinated President Abraham Lincoln.

THOMAS EAKINS Even more resolutely a Realist than Homer was Philadelphia-born Thomas Eakins (1844–1916), who possessed a dedicated appetite for showing the realities of the human experience. Eakins studied both painting and medical anatomy in Philadelphia before undertaking further study under French artist Jean-Léon Gérôme (1824–1904). Eakins aimed to paint things as he saw them rather than as the public might wish them portrayed. This attitude was very much in tune with 19th-century American taste, combining an admiration for accurate depiction with a hunger for truth.

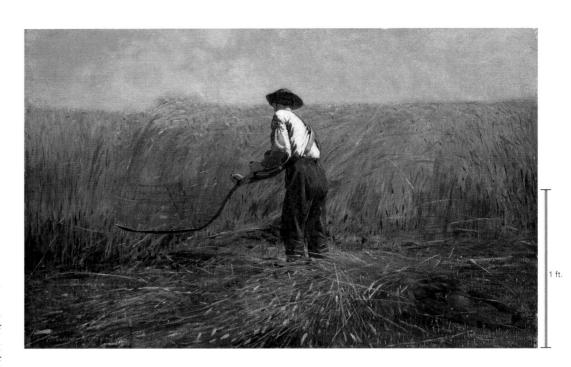

The too-brutal Realism of Eakins's early masterpiece, *Gross Clinic* (FIG. **22-38**), prompted the art jury to reject it for the Philadelphia exhibition that celebrated the American independence centennial in 1876. The work presents the renowned surgeon Dr. Samuel Gross in the operating amphitheater of the Jefferson Medical

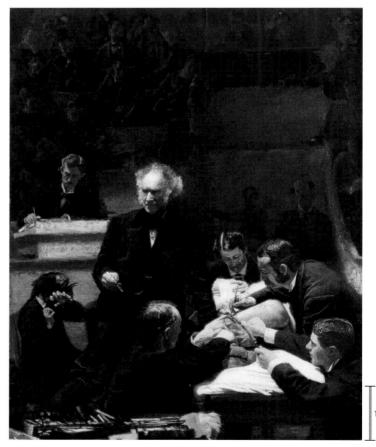

22-38 Thomas Eakins, *The Gross Clinic*, 1875. Oil on canvas, $8' \times 6'$ 6". Philadelphia Museum of Art, Philadelphia.

The too-brutal realism of Eakins's unsparing depiction of a medical college operating amphitheater caused rejection of this painting from the Philadelphia exhibition celebrating America's centennial.

College in Philadelphia, where the painting hung until its sale in 2006. That Eakins chose to depict this event testifies to the public's increasing faith in scientific and medical progress. Dr. Gross, with bloody fingers and scalpel, lectures about his surgery on a young man's leg. The patient suffered from osteomyelitis, a bone infection. Watching the surgeon, acclaimed for his skill in this particular operation, are several colleagues, all of whom historians have identified, and the patient's mother, who covers her face. Indicative of the contemporaneity of this scene is the anesthetist in the background holding the cloth over the patient's face. Anesthetics had been introduced in 1846, and their development eliminated a major obstacle to extensive surgery. The painting is an unsparing description of an unfolding event, with a good deal more reality than many viewers could endure. "It is a picture," one critic said, "that even strong men find difficult to look at long, if they can look at it at all." 12

Eakins believed that knowledge—and where relevant, scientific knowledge—was a prerequisite to his art. As a scientist (in his anatomical studies), Eakins preferred a slow, deliberate method of careful invention based on his observations of the perspective, the anatomy, and the details of his subject. This insistence on scientific fact corresponded to the dominance of empiricism during the latter half of the 19th century. Eakins's concern for anatomical correctness led him to investigate the human form and humans in motion, both with regular photographic apparatuses and with a special camera devised by the French kinesiologist (a person who studies the physiology of body movement) Étienne-Jules Marey (1830–1904). Eakins's later collaboration with Eadweard Muybridge (FIG. 22-54) in the photographic study of animal and human action of all types anticipated the motion picture.

JOHN SINGER SARGENT The expatriate American artist JOHN SINGER SARGENT (1856-1925), born in Florence, Italy, was a younger contemporary of Eakins. Sargent developed a looser, more dashing Realist portrait style, in contrast to Eakins's carefully rendered details. Sargent studied art in Paris before settling in London, where he won renown both as a cultivated and cosmopolitan gentleman and as a facile and fashionable portrait painter. He learned his adept brushing of paint in thin layers and his effortless achievement of quick and lively illusion from his study of Velázquez, whose masterpiece, Las Meninas (FIG. 19-30), may have influenced Sargent's portrait The Daughters of Edward Darley Boit (FIG. 22-39). The four girls (the children of one of Sargent's close friends) appear in a hall and small drawing room in their Paris home. The informal, eccentric arrangement of their slight figures suggests how much at ease they are within this familiar space and with objects such as the monumental Japanese vases, the red screen, and the fringed rug, whose scale subtly emphasizes the children's diminutive stature. Sargent must have known the Boit daughters well and liked them. Relaxed and trustful, they gave the artist an opportunity to record a gradation of young innocence. He sensitively captured the naive, wondering openness of the little girl in the foreground, the grave artlessness of the 10-year-old child, and the slightly self-conscious poise of the adolescents. Sargent's casual positioning of the figures and seemingly random choice of the setting communicate a sense of spontaneity. The children seem to be attending momentarily to an adult who has asked them to interrupt their activity. The painting embodies the Realist belief that the artist's business is to record modern people in modern contexts.

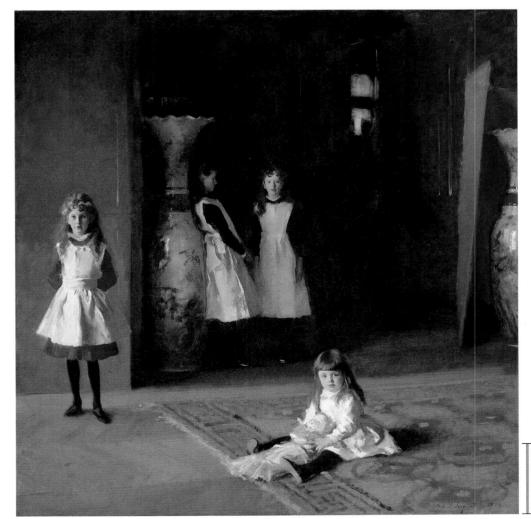

22-39 John Singer Sargent, *The* Daughters of Edward Darley Boit, 1882. Oil on canvas, $7' 3\frac{3}{8}'' \times 7' 3\frac{5}{8}''$. Museum of Fine Arts, Boston (gift of Mary Louisa Boit, Florence D. Boit, Jane Hubbard Boit, and Julia Overing Boit, in memory of their father, Edward Darley Boit).

Sargent's casual positioning of the Boit sisters creates a sense of the momentary and spontaneous, consistent with Realist painters' interest in recording modern people in modern contexts.

1 ft.

22-40 Henry Ossawa Tanner, *The Thankful Poor*, 1894. Oil on canvas, $2' 11\frac{1}{2}'' \times 3' 8\frac{1}{4}''$. Collection of William H. and Camille Cosby.

Tanner combined the Realists' belief in careful study from nature with a desire to portray with dignity the life of African American families. Expressive lighting reinforces the painting's reverent spirit.

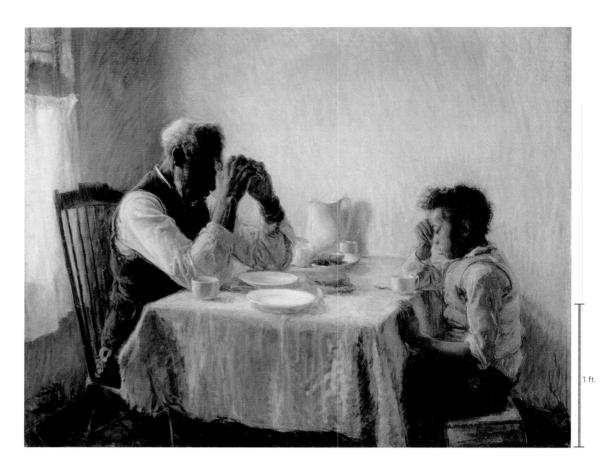

HENRY OSSAWA TANNER Typical of the Realist painter's desire to depict the lives of ordinary people is the early work of the American artist Henry Ossawa Tanner (1859-1937). Tanner studied art with Eakins before moving to Paris. There he combined Eakins's belief in careful study from nature with a desire to portray with dignity the life of the ordinary people he had been raised among as the son of an African American minister in Pennsylvania. The mood in *The Thankful Poor* (FIG. 22-40) is one of quiet devotion not far removed from the Realism of Millet (FIG. 22-29). Tanner painted the grandfather, grandchild, and main objects in the room with the greatest detail, while everything else dissolves into loose strokes of color and light. Expressive lighting reinforces the painting's reverent spirit, with deep shadows intensifying the man's devout concentration and golden light pouring in the window to illuminate the quiet expression of thanksgiving on the younger face. The deep sense of sanctity expressed here in terms of everyday experience became increasingly important for Tanner. Within a few years of completing The Thankful Poor, he began painting biblical subjects grounded in direct study from nature and in the love of Rembrandt that had inspired him from his days as a Philadelphia art student.

EDMONIA LEWIS About 15 years older than Tanner, the sculptor Edmonia Lewis (ca. 1845–after 1909) produced work that was stylistically indebted to Neoclassicism but depicted contemporary Realist themes. *Forever Free* (FIG. **22-41**) is a marble sculpture

22-41 EDMONIA LEWIS, *Forever Free*, 1867. Marble, $3' 5\frac{1}{4}''$ high. James A. Porter Gallery of Afro-American Art, Howard University, Washington, D.C.

Lewis was a sculptor whose work owes a stylistic debt to Neoclassicism but depicts contemporary Realist themes. She carved *Forever Free* four years after Lincoln's Emancipation Proclamation.

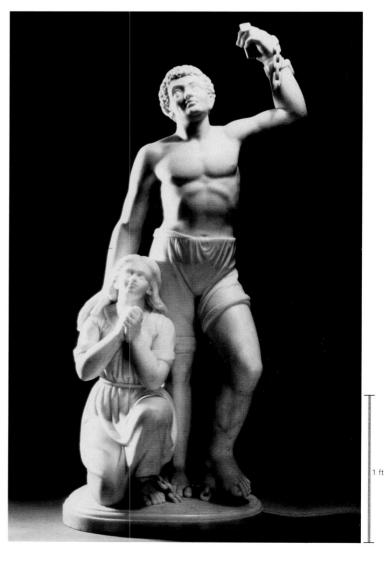

Lewis carved while living in Rome, surrounded by examples of both classical and Renaissance art. It represents two freed African American slaves. The man stands heroically in a contrapposto stance reminiscent of classical statues. His right hand rests on the shoulder of the kneeling woman, and his left hand holds aloft a broken manacle and chain as literal and symbolic references to his former servitude. Produced four years after President Lincoln's issuance of the Emancipation Proclamation, Forever Free (originally titled The Morning of Liberty) was widely perceived as an abolitionist statement. However, other factors caution against an overly simplistic reading. Because Lewis was female, African American, and Native American (she was the daughter of a Chippewa mother and African American father), scholars have debated the degree to which the sculptor attempted to inject a statement about African American gender relationships into this statue. For example, does the kneeling position of the woman represent Lewis's acceptance of female subordination?

Lewis's accomplishments as a sculptor speak to the increasing access to training that was available to women in the 19th century. Educated at Oberlin College (the first American college to grant degrees to women), Lewis financed her trip to Rome with the sale of medallions and marble busts. Her success in a field dominated by white male artists is a testament to both her skill and her determination.

Pre-Raphaelite Brotherhood

Realism did not appeal to all artists, however. In England a group of painters who called themselves the Pre-Raphaelite Brotherhood refused to be limited to the contemporary scenes strict Realists portrayed. These artists chose instead to represent fictional, historical, and fanciful subjects but with a significant degree of convincing illusion.

JOHN EVERETT MILLAIS One of the founders of the Pre-Raphaelite Brotherhood was JOHN EVERETT MILLAIS (1829–1896). So painstakingly careful was Millais in his study of visual facts

closely observed from nature that Charles Baudelaire (1821–1867) called him "the poet of meticulous detail." The Pre-Raphaelite Brotherhood, organized in 1848, wished to create fresh and sincere art, free from what its members considered the tired and artificial manner propagated in the academies by the successors of Raphael. Influenced by the well-known critic, artist, and writer John Ruskin (1819–1900), the Pre-Raphaelites agreed with his distaste for the materialism and ugliness of the contemporary industrializing world. They also expressed appreciation for the spirituality and idealism (as well as the art and artisanship) of past times, especially the Middle Ages and the Early Renaissance.

Millais's *Ophelia* (FIG. **22-42**) garnered enthusiastic praise when he exhibited it in the Exposition Universelle in Paris in 1855, where Courbet set up his Pavilion of Realism. The subject, from Shakespeare's *Hamlet* (4.7.176–179), is the drowning of Ophelia, who, in her madness, is unaware of her plight:

Her clothes spread wide, And mermaidlike awhile they bore her up— Which time she chanted snatches of old tunes, As one incapable of her own distress.

To make the pathos of the scene visible, Millais became a faithful and feeling witness of its every detail, reconstructing it with a lyricism worthy of the original poetry. Although the scene is fictitious, Millais worked diligently to present it with unswerving fidelity to visual fact. He painted the background on-site at a spot along the Hogsmill River in Surrey. For the figure of Ophelia, Millais had a friend lie in a heated bathtub full of water for hours at a stretch.

DANTE GABRIEL ROSSETTI Another founder of the Pre-Raphaelite Brotherhood was DANTE GABRIEL ROSSETTI (1828–1882), who established an enviable reputation as both a painter and poet. Like other members of the group, Rossetti focused on literary and biblical themes in his art. He also produced numerous portraits of

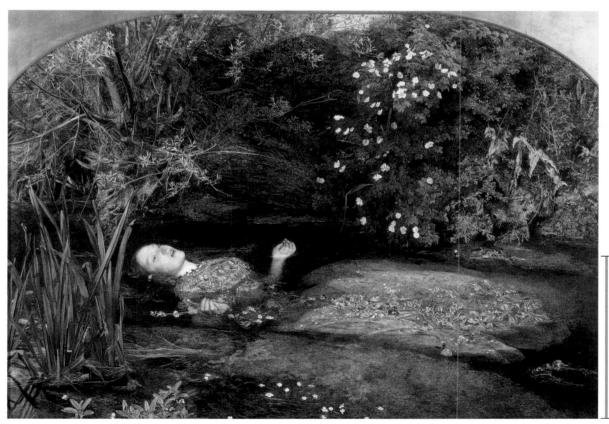

22-42 John Everett Millais, *Ophelia*, 1852. Oil on canvas, 2' $6'' \times 3'$ 8''. Tate Gallery, London.

Millet was a founder of the Pre-Raphaelite Brotherhood, whose members refused to be limited to the contemporary scenes strict Realists portrayed. The drowning of Ophelia is a Shakespearean subject.

1 ft.

Realism

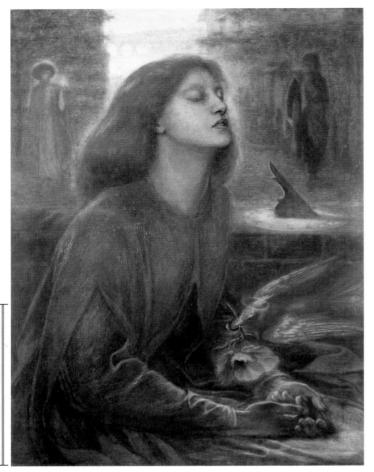

22-43 Dante Gabriel Rossetti, *Beata Beatrix*, ca. 1863. Oil on canvas, 2' $10'' \times 2'$ 2''. Tate Gallery, London.

This painting of a beautiful and sensuous woman is ostensibly a literary portrait of Dante's Beatrice, but the work also served as a memorial to Rossetti's wife, who died of an opium overdose.

women that projected an image of ethereal beauty and melded apparent opposites—a Victorian prettiness with sensual allure. His Beata Beatrix (FIG. 22-43) is ostensibly a portrait of a literary figure—Beatrice, from Dante's Vita Nuova—as she overlooks Florence in a trance after being mystically transported to Heaven. Yet the portrait also had personal resonance for Rossetti. It served as a memorial to his wife, Elizabeth Siddal (the model for Millais's Ophelia), who had died shortly before Rossetti began this painting in 1862. In the image, the woman (Siddal-Beatrice) sits in a trancelike state, while a red dove (a messenger of both love and death) deposits a poppy (symbolic of sleep and death) in her hands. Because Siddal died of an opium overdose, the presence of the poppy assumes greater significance.

ARCHITECTURE

As 19th-century scholars gathered the documentary materials of European history in extensive historiographic enterprises, each nation came to value its past as evidence of the validity of its ambitions and claims to greatness. Intellectuals appreciated the art of the remote past as a product of cultural and national genius. Italy, of course, had its Roman ruins, which had long inspired later architects. In France, Napoleon had co-opted the classical tradition, but even at the height of his power a reawakening of interest in Gothic architecture also surfaced. In 1802 the eminent French writer François-René de Chateaubriand (1768-1848) published his influential Genius of Christianity, which defended religion on the grounds of its beauty and mystery rather than on the grounds of truth. Gothic cathedrals, according to Chateaubriand, were translations of the sacred groves of the ancient Gauls into stone and should be cherished as manifestations of France's holy history. One result of this new nationalistic respect for the Gothic style was that Eugène Emmanuel Viollet-le-Duc (1814–1879) received a commission in 1845 to restore the inte-

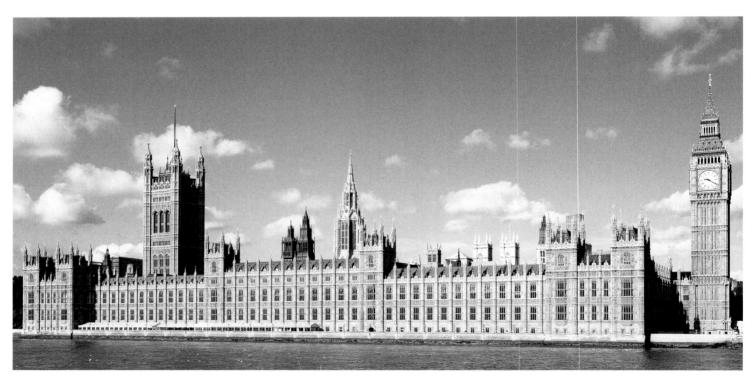

22-44 Charles Barry and A.W.N. Pugin, Houses of Parliament, London, England, designed 1835.

The 19th century brought the revival of many architectural styles, often reflecting nationalistic pride. The Houses of Parliament have an exterior veneer and towers that recall late English Gothic style.

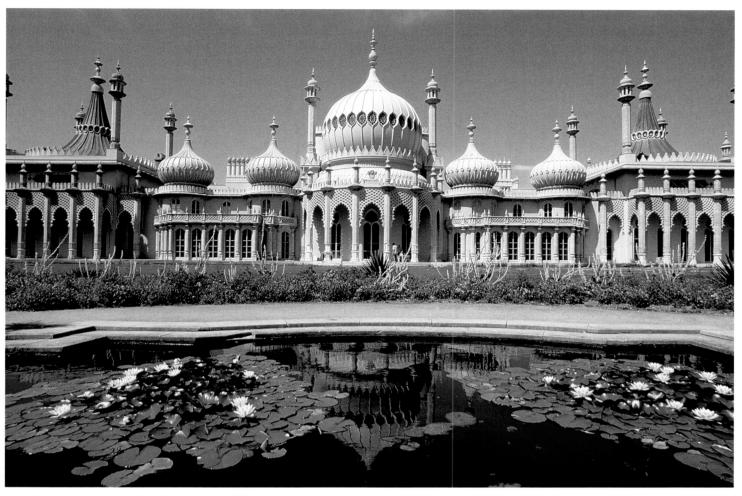

22-45 JOHN NASH, Royal Pavilion, Brighton, England, 1815-1818.

British territorial expansion brought a familiarity with many exotic styles. This palatial "Indian Gothic" seaside pavilion is a conglomeration of Islamic domes, minarets, and screens.

rior of Paris's Notre-Dame to its Gothic splendor after removing the Baroque and Napoleonic (FIG. 22-2) alterations.

HOUSES OF PARLIAMENT England also celebrated its medieval heritage with Neo-Gothic buildings. In London, after the old Houses of Parliament burned in 1834, the Parliamentary Commission decreed that designs for the new building be either Gothic or Elizabethan. Charles Barry (1795-1860), with the assistance of A.W.N. Pugin (1812–1852), submitted the winning design (FIG. 22-44) in 1835. By this time, style had become a matter of selection from the historical past. Barry had traveled widely in Europe, Greece, Turkey, Egypt, and Palestine, studying the architecture of each place. He preferred the classical Renaissance styles, but he had designed some earlier Neo-Gothic buildings, and Pugin successfully influenced him in the direction of English Late Gothic. Pugin was one of a group of English artists and critics who saw moral purity and spiritual authenticity in the religious architecture of the Middle Ages. They also glorified the careful medieval artisans who built the great cathedrals. The Industrial Revolution was flooding the market with cheaply made and ill-designed commodities, and machine work was replacing handicraft. Many, such as Pugin, believed in the necessity of restoring the old artisanship, which had honesty and quality. The design of the Houses of Parliament, however, is not genuinely Gothic, despite its picturesque tower groupings (the Clock Tower, containing Big Ben, at one end, and the Victoria Tower at the other). The building has a formal axial plan and a kind of Palladian regularity beneath its Neo-Gothic detail. Pugin himself said of it, "All Grecian, Sir. Tudor [late English Gothic] details on a classical body." ¹³

ROYAL PAVILION Although the Neoclassical and Neo-Gothic styles dominated early-19th-century architecture, exotic new styles of all types soon began to appear, due in part to European imperialism and in part to the Romantic spirit that permeated all the arts. Great Britain's forays throughout the world, particularly India, had exposed English culture to a broad range of non-Western artistic styles. The Royal Pavilion (FIG. 22-45), designed by John Nash (1752-1835), exhibits a wide variety of these styles. Nash was an established architect, known for Neoclassical buildings in London, when he was asked to design a royal pleasure palace in the seaside resort of Brighton for the prince regent (later King George IV). The structure's fantastic exterior is a conglomeration of Islamic domes, minarets, and screens that historians have called "Indian Gothic," and sources ranging from Greece and Egypt to China influenced the interior decor. Underlying the exotic facade is a cast-iron skeleton, an early (if hidden) use of this material in noncommercial building. Nash also put this metal to fanciful use, creating life-size palm-tree columns in cast iron to support the Royal Pavilion's kitchen ceiling. The building, an appropriate enough backdrop for gala throngs pursuing pleasure by the seaside, served as the prototype for numerous playful architectural exaggerations still found in European and American resorts.

22-46 CHARLES GARNIER, the Opéra, Paris, France, 1861–1874.

For Paris's opera house, Garnier chose a festive and spectacularly theatrical Neo-Baroque facade well suited to a gathering place for fashionable audiences in an age of conspicuous wealth.

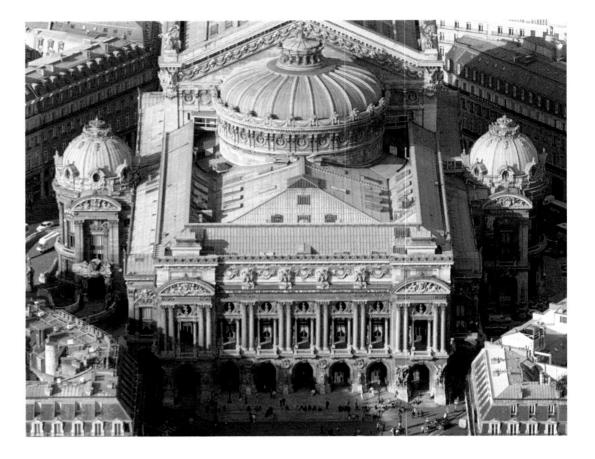

PARIS OPÉRA The Baroque style also found favor in 19thcentury architecture because it was well suited to conveying a grandeur worthy of the riches the European elite acquired during this age of expansion. The Paris Opéra (FIG. 22-46), designed by CHARLES GAR-NIER (1825–1898), mirrored the opulence that permeated the lives of these privileged few. The opera house has a festive and spectacularly theatrical Neo-Baroque front and two wings resembling Baroque domed central-plan churches. Inside, intricate arrangements of corridors, vestibules, stairways, balconies, alcoves, entrances, and exits facilitate easy passage throughout the building and provide space for entertainment and socializing at intermissions. The Baroque grandeur of the layout and of the building's ornamental appointments is characteristic of an architectural style called Beaux-Arts, which flourished in the late 19th and early 20th centuries in France. Based on ideas taught at the dominant École des Beaux-Arts (School of Fine Arts) in Paris, the Beaux-Arts style incorporated classical principles (such as symmetry in design, including interior spaces that extended radially from a central core or axis) and included extensive exterior ornamentation. As an example of a Beaux-Arts building, Garnier's Opéra proclaims, through its majesty and lavishness, its function as a gathering place for fashionable audiences in an era of conspicuous wealth. The style was so attractive to the moneyed classes who supported the arts that theaters and opera houses continued to reflect the Paris Opéra's design until World War I transformed society.

CAST-IRON CONSTRUCTION Work on Garnier's Opéra began in 1861, but by the middle of the 19th century, many architects had already abandoned sentimental and Romantic designs from the past. They turned to honest expressions of a building's purpose. Since the 18th century, bridges had been built of cast iron (FIG. 21-11), and most other utilitarian architecture—factories, warehouses, dockyard structures, mills, and the like—long had been built

simply and without historical ornamentation. Iron, along with other industrial materials, permitted engineering advancements in the construction of larger, stronger, and more fire-resistant structures than before. The tensile strength of iron (and especially of steel, available after 1860) permitted architects to create new designs involving vast enclosed spaces, as in the great train sheds of railroad stations and in exposition halls.

SAINTE-GENEVIÈVE LIBRARY The Bibliothèque Sainte-Geneviève (1843–1850), built by HENRI LABROUSTE (1801–1875), is an interesting mix of Renaissance revival style and modern cast-iron construction. Its two-story facade with arched windows recalls Renaissance palazzo designs, but Labrouste exposed the structure's metal skeleton on the interior. The lower story of the library housed the book stacks. The upper floor featured a spacious reading room (FIG. 22-47) consisting essentially of two barrel-vaulted halls, roofed in terracotta and separated by a row of slender cast-iron columns on concrete pedestals. The columns, recognizably Corinthian, support the iron roof arches pierced with intricate vine-scroll ornament out of the Renaissance architectural vocabulary. Labrouste's design highlights how the peculiarities of the new structural material aesthetically altered the forms of traditional masonry architecture. But it also makes clear how reluctant the 19th-century architect was to surrender traditional forms, even when fully aware of new possibilities for design and construction. Architects scoffed at "engineers' architecture" for many years and continued to clothe their steel-and-concrete structures in the Romantic "drapery" of a historical style.

CRYSTAL PALACE Completely "undraped" construction first became popular in the conservatories (greenhouses) of English country estates. JOSEPH PAXTON (1801–1865) built several such structures for his patron, the duke of Devonshire. In the largest—

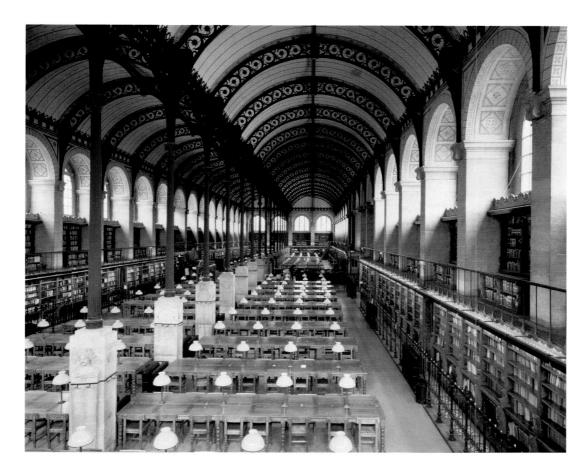

22-47 HENRI LABROUSTE, reading room of the Bibliothèque Sainte-Geneviève, Paris, France, 1843–1850.

The exterior of this Parisian library looks like a Renaissance palazzo, but the interior has an exposed cast-iron skeleton, which still incorporates classical Corinthian capitals and Renaissance scrolls.

300 feet long—he used an experimental system of glass-and-metal roof construction. Encouraged by the success of this system, Paxton submitted a winning glass-and-iron building plan to the design competition for the hall to house the Great Exhibition of 1851, organized to present "works of industry of all nations" in London. Paxton constructed the exhibition building, the Crystal Palace (FIG. **22-48**), with prefabricated parts. This allowed the vast structure to be erected in the then-unheard-of time of six months and dismantled at the exhibition's closing to avoid permanent obstruction of the park. The plan borrowed much from ancient Roman and Christian

basilicas, with a central flat-roofed "nave" and a barrel-vaulted crossing "transept." The design provided ample interior space to contain displays of huge machines as well as to accommodate decorative touches in the form of large working fountains and giant trees. The public admired the building so much that the workers who dismantled it erected an enlarged version of the Crystal Palace at a new location on the outskirts of London at Sydenham, where it remained until fire destroyed it in 1936. A few old black-and-white photographs and several color lithographs (FIG. 22-48) preserve a record of the Crystal Palace's appearance.

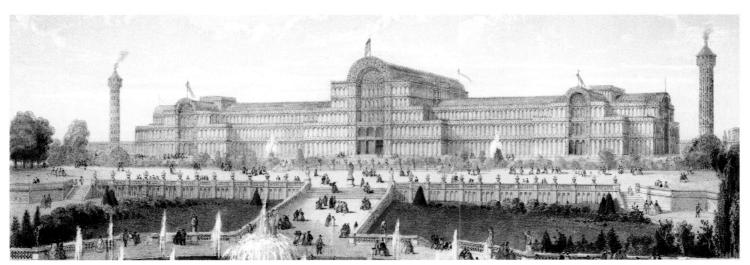

22-48 Joseph Paxton, Crystal Palace, London, England, 1850–1851; enlarged and relocated at Sydenham, England, 1852–1854. Detail of a color lithograph by Achille-Louis Martinet, ca. 1862. Private collection.

The tensile strength of iron permitted Paxton to experiment with a new system of glass-and-metal roof construction. Built with prefabricated parts, the vast Crystal Palace required only six months to erect.

Daguerreotype, Calotype, and Wet-Plate Photography

he earliest photographic processes were the daguerreotype, named after L.J.M. Daguerre (FIG. 22-50), and the calotype. Daguerre was an architect and theatrical set painter and designer. This background led Daguerre and a partner to open a popular entertainment called the Diorama. Audiences witnessed performances of "living paintings" created by changing the lighting effects on a "sandwich" composed of a painted backdrop and several layers of painted translucent front curtains. Daguerre used a camera obscura for the Diorama, but he wanted to find a more efficient and effective procedure. Through a mutual acquaintance, he met Joseph Nicéphore Niépce (1765-1833), who in 1826 had successfully made a permanent picture of the cityscape outside his upper-story window by exposing, in a camera obscura, a metal plate covered with a lightsensitive coating. Niépce's process, however, had the significant drawback that it required an eight-hour exposure time. After Niépce died in 1833, Daguerre continued his work, making two important discoveries. Latent development—that is, bringing out the image through treatment in chemical solutions—considerably shortened the length of time needed for exposure. Daguerre also discovered a better way to "fix" the image by chemically stopping the action of light on the photographic plate, which otherwise would continue to darken until the image turned solid black.

The daguerreotype reigned supreme in photography until the 1850s, but the second major photographic invention, the ancestor of the modern negative-print system, eventually replaced it. On January 31, 1839, less than three weeks after Daguerre unveiled his method in Paris, William Henry Fox Talbot presented a paper on his "photogenic drawings" to the Royal Institution in London. As early as 1835, Talbot made "negative" images by placing objects on sensitized paper and exposing the arrangement to light. This created a design of light-colored silhouettes recording the places where opaque or translucent objects had blocked light from darkening the paper's emulsion. In his experiments, Talbot next exposed sensitized papers inside simple cameras and, with a second sheet, created "positive" images. He further improved the process with more light-sensitive chemicals and a chemical development of the negative image. This technique allowed multiple prints. However, in Talbot's process, which he named the calotype (from the Greek word kalos, "beautiful"), the photographic images incorporated the texture of the paper. This produced a slightly blurred, grainy effect very different from the crisp detail and wide tonal range available with the daguerreotype. Also discouraging widespread adoption of the calotype were the stiff licensing and equipment fees charged for many years after Talbot patented his new process in 1841.

An early master of an improved kind of calotype photography was the multitalented Frenchman known as Nadar. He used glass negatives and albumen printing paper (prepared with egg white), which could record finer detail and a wider range of light and shadow than Talbot's calotype process. The new wet-plate technology (so named because the photographic plate was exposed, developed, and fixed while wet) almost at once became the universal way of making negatives until 1880. However, wet-plate photography had drawbacks. The plates had to be prepared and processed on the spot. Working outdoors

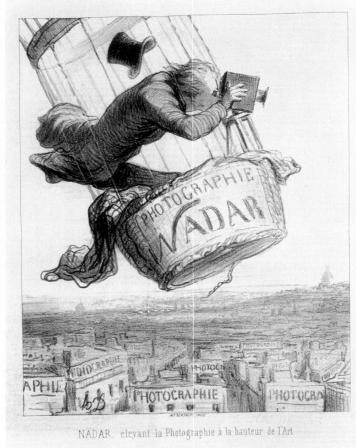

22-49 Honoré Daumier, *Nadar Raising Photography to the Height of Art*, 1862. Lithograph, $10\frac{3}{4}" \times 8\frac{3}{4}"$. Museum of Fine Arts, Boston.

Daumier's lithograph commemorates a court decision acknowledging photography as an art form protected by copyright law. Nadar (FIG. 22-1) was one of photography's early masters.

meant taking along a portable darkroom of some sort—a wagon, tent, or box with light-tight sleeves for the photographer's arms.

Nadar achieved so much fame for his wet-plate photographic portraits (FIG. 22-1) that he became the subject of a Daumier lithograph (FIG. 22-49) that provides incisive and amusing commentary about the struggle of photography to be recognized as a fine art. Daumier made his print in response to an 1862 court decision acknowledging that photography was indeed an art and therefore entitled to protection under copyright law. In the lithograph, Nadar energetically takes pictures with his camera as his balloon rises over Parisian rooftops—Daumier's literal representation of the elevation of photography's status that the court decision reaffirmed. The image also refers to the fact that Nadar was a staunch advocate of balloon transportation and aerial reconnaissance. He produced the first aerial photographs of Paris in 1858 from his balloon Le Géant (The Giant).

1 in.

PHOTOGRAPHY

A technological device of immense consequence for the modern experience was invented shortly before the mid-19th century: the camera, with its attendant art of photography. Ever since Frenchman Louis-Jacques-Mandé Daguerre (1789–1851) and Briton William Henry Fox Talbot (1800–1877) announced the first practical photographic processes in 1839, people have celebrated photography as a revelation of visible things. The relative ease of the process, even in its earliest and most primitive form, seemed a dream come true for 19th-century scientists and artists, who for centuries had grappled with less satisfying methods of capturing accurate images of their subjects. Photography also perfectly suited an age that saw artistic patronage continue to shift away from the elite few toward a broader base of support. The growing and increasingly powerful middle class embraced both the comprehensible images of the new medium and its lower cost.

For the traditional artist, photography suggested new answers to the great debate about what was real and how to represent the real in art. It also challenged the place of traditional modes of pictorial representation originating in the Renaissance. Artists as diverse as Delacroix, Ingres, Courbet, and the Impressionist Edgar Degas (see Chapter 23) welcomed photography as a helpful auxiliary to painting. In a memorable lithograph (FIG. 22-49), Daumier celebrated the new medium as a genuine art form, and many artists marveled at the ability of photography to translate three-dimensional objects onto a two-dimensional surface. Other artists, however, saw photography as a mechanism capable of displacing the painstaking work of skilled painters dedicated to representing the optical truth of chosen subjects. Photography's challenge to painting, both historically and technologically, seemed to some artists an expropriation of the realistic image, until then the exclusive property of painting. But just as some painters looked to the new medium of photography for answers on how best to render an image in paint, so too some photographers looked to painting for suggestions about ways to imbue the photographic image with qualities beyond simple reproduction.

Artists themselves were instrumental in the development of this new technology. The camera obscura was familiar to 18th-century artists. In 1807 the invention of the *camera lucida* (lighted room) replaced the enclosed chamber of the camera obscura. Now the photographer aimed a small prism lens, hung on a stand, downward at an object. The lens projected the image of the object onto a sheet of paper. Artists using either of these devices found the process long and arduous, no matter how accurate the resulting work. All yearned for a more direct way to capture a subject's image. Two very different scientific inventions that accomplished this—the *daguerreotype* (FIG. **22-50**) and the *calotype* (see "Daguerreotype, Calotype, and Wet-Plate Photography," page 646)—were announced almost simultaneously in France and England in 1839.

DAGUERREOTYPES The French government presented the new daguerreotype process at the Academy of Science in Paris on January 7, 1839, with the understanding that its details would be made available to all interested parties without charge (although the inventor received a large annuity in appreciation). Soon, people worldwide began taking pictures with the daguerreotype "camera" (a name shortened from camera obscura) in a process almost immediately christened "photography," from the Greek *photos* ("light") and *graphos* ("writing"). From the start, the possibilities of the process as a new art medium intrigued painters. Paul Delaroche (1797–1856), a leading academic painter of the day, wrote in an official report to the French government:

Daguerre's process completely satisfies all the demands of art, carrying certain essential principles of art to such perfection that it must become a subject of observation and study even to the most

22-50 LOUIS-JACQUES-MANDÉ DAGUERRE, *Still Life in Studio*, 1837. Daguerreotype, $6\frac{1}{4}'' \times 8\frac{1}{4}''$. Société Française de Photographie, Paris.

One of the first plates
Daguerre produced after
perfecting his new photographic process was this still
life, in which he was able to
capture amazing detail and
finely graduated tones from
black to white

in.

22-51 Josiah Johnson Hawes and Albert Sands Southworth, Early Operation under Ether, Massachusetts General Hospital, ca. 1847. Daguerreotype, $6\frac{1}{2}$ " \times $8\frac{1}{2}$ ". Massachusetts General Hospital Archives and Special Collections, Boston.

In this early daguerreotype, which predates Eakins's *Gross Clinic* FIG. 22-38) by almost 30 years, Hawes and Southworth demonstrated the documentary power of the new medium of photography.

1 in.

accomplished painters. The pictures obtained by this method are as remarkable for the perfection of the details as for the richness and harmony of the general effect. Nature is reproduced in them not only with truth, but also with art. ¹⁴

Each daguerreotype is a unique work with amazing detail and finely graduated tones from black to white. Still Life in Studio (FIG. 22-50) is one of the first successful plates Daguerre produced after perfecting his method. The process captured every detail—the subtle forms, the varied textures, the diverse tones of light and shadow—in Daguerre's carefully constructed tableau. The three-dimensional forms of the sculptures, the basket, and the bits of cloth spring into high relief and are convincingly represented. The inspiration for the composition came from 17th-century Dutch vanitas still lifes, such as those of Claesz (FIG. 20-21). Like Claesz, Daguerre arranged his objects to reveal their textures and shapes clearly. Unlike a painter, Daguerre could not alter anything within his arrangement to effect a stronger image. However, he could suggest a symbolic meaning through his choice of objects. Like the skull and timepiece in Claesz's painting, Daguerre's sculptural and architectural fragments and the framed print of an embrace suggest that even art is vanitas and will not endure forever.

HAWES AND SOUTHWORTH In the United States, photographers began to make daguerreotypes within two months of Daguerre's presentation in Paris. Two particularly avid and resourceful advocates of the new medium were Josiah Johnson Hawes (1808–1901), a painter, and Albert Sands Southworth (1811–1894), a pharmacist and teacher. Together, they ran a daguerreotype studio in Boston that specialized in portraiture, then popular due to the shortened exposure time required for the process (although it was still long enough to require head braces to help subjects remain motionless while photographers recorded their images).

The partners also took their equipment outside the studio to record places and events of particular interest to them. One resultant image is Early Operation under Ether, Massachusetts General Hospital (FIG. 22-51). This daguerreotype, taken from the gallery of a hospital operating room, put the viewer in the position of medical students looking down on a lecture-demonstration typical throughout the 19th century. An image of historical record, this early daguerreotype, which predates Eakins's Gross Clinic (FIG. 22-38) by almost three decades, gives the viewer a glimpse into the whole of Western medical practice. The focus of attention in Early Operation is the white-draped patient surrounded by a circle of darkly clad doctors. The details of the figures and the room's furnishings are in sharp focus, but the slight blurring of several of the figures betrays motion during the exposure. The elevated viewpoint flattens the spatial perspective and emphasizes the relationships of the figures in ways that the Impressionists, especially Degas, found intriguing.

NADAR Portraiture was one of the first photography genres to use a technology that improved the calotype. Making portraits was an important economic opportunity for most photographers, as Southworth and Hawes proved, but the greatest of the early portrait photographers was undoubtedly Gaspar-Félix Tournachon, known simply as NADAR (1828–1910), a French novelist, journalist, enthusiastic balloonist, caricaturist, and, later, photographer (see "Daguerreotype," page 646). Photographic studies for his caricatures led Nadar to open a portrait studio. So talented was he at capturing the essence of his subjects that the most important people in France, including Delacroix, Daumier, Courbet, and Manet, flocked to his studio to have their portraits made. Nadar said he sought in his work "that instant of understanding that puts you in touch with the model—helps you sum him up, guides you to his habits, his ideas,

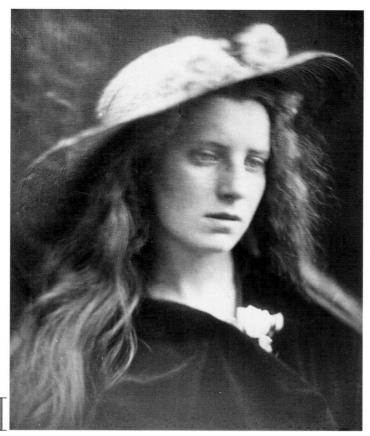

22-52 Julia Margaret Cameron, *Ophelia, Study No. 2*, 1867. Albumen print, $1' 1'' \times 10\frac{2''}{3}$. George Eastman House, Rochester (gift of Eastman Kodak Company; formerly Gabriel Cromer Collection).

Cameron was a prominent 19th-century photographer who often depicted her female subjects as characters in literary or biblical narratives. The slightly blurred focus is a distinctive feature of her work.

and character and enables you to produce . . . a really convincing and sympathetic likeness, an intimate portrait." ¹⁵

Nadar's *Eugène Delacroix* (FIG. **22-1**) shows the painter at the height of his career. In this photograph, the artist imparts remarkable

presence. Even in half-length, his gesture and expression create a mood that seems to reveal much about him. Perhaps Delacroix responded to Nadar's famous gift for putting his clients at ease by assuming the pose that best expressed his personality. The new photographic materials made possible the rich range of tones in Nadar's images.

JULIA MARGARET CAMERON Among the most famous portrait photographers in 19th-century England was Julia Margaret CAMERON (1815–1879), who did not take up photography seriously until age 48. Although she produced images of many well-known men of the period, including Charles Darwin, Alfred Tennyson, and Thomas Carlyle, she photographed more women than men, as was true of many women photographers. Ophelia, Study No. 2 (FIG. 22-52) typifies her portrait style. Cameron often depicted her female subjects as characters in literary or biblical narratives. The slightly blurred focus also became a distinctive feature of her work the byproduct of photographing with a lens having a short focal length, which allowed only a small area of sharp focus. The blurriness adds an ethereal, dreamlike tone to the photographs, appropriate for Cameron's fictional "characters." Her photograph of Ophelia has a mysterious, fragile quality reminiscent of Pre-Raphaelite paintings (FIG. 22-43) of literary heroines.

TIMOTHY O'SULLIVAN Photographers were quick to realize the documentary power of their new medium. Thus began the story of photography's influence on modern life and of the immense changes it brought to communication and information management. Historical events could be recorded in permanent form on the spot for the first time. The photographs taken of the Crimean War (1856) by Roger Fenton (1819–1869) and of the American Civil War by Mathew B. Brady (1823–1896), Alexander Gardner (1821–1882), and TIMOTHY O'SULLIVAN (1840–1882) remain unsurpassed as incisive accounts of military life, unsparing in their truthful detail and poignant as expressions of human experience.

Of the Civil War photographs, the most moving are the inhumanly objective records of combat deaths. Perhaps the most reproduced of these photographs is O'Sullivan's *A Harvest of Death, Gettysburg, Pennsylvania, July 1863* (FIG. **22-53**). Although viewers

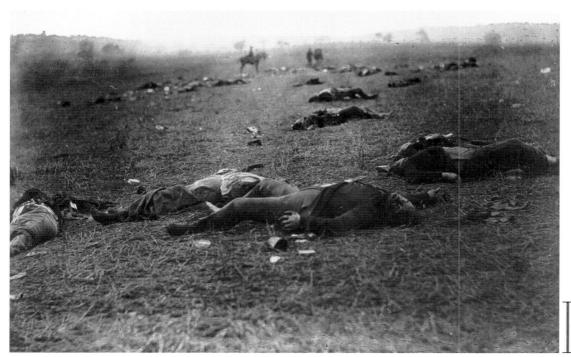

22-53 TIMOTHY O'SULLIVAN, A Harvest of Death, Gettysburg, Pennsylvania, July 1863, 1863. Negative by Timothy O'Sullivan. Albumen print by Alexander Gardner, $6\frac{3}{4}$ " \times $8\frac{3}{4}$ ". New York Public Library (Astor, Lenox and Tilden Foundations, Rare Books and Manuscript Division), New York.

Wet-plate technology enabled photographers to record historical events on the spot—and to comment on the high price of war, as in this photograph of dead Union soldiers at Gettysburg in 1863.

1 in.

22-54 Eadweard Muybridge, Horse Galloping, 1878. Calotype print, $9'' \times 12''$. George Eastman House, Rochester.

Muybridge specialized in photographic studies of the successive stages in human and animal motion—details too quick for the human eye to capture. Modern cinema owes a great deal to his work.

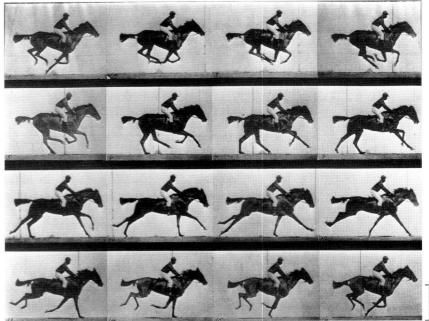

1 in.

could regard this image as simple news reportage, it also functions to impress on people the high price of the Civil War. Corpses litter the battlefield as far as the eye can see. O'Sullivan presented a scene stretching far to the horizon. As the photograph modulates from the precise clarity of the bodies of Union soldiers in the foreground, boots stolen and pockets picked, to the almost indistinguishable corpses in the distance, the suggestion of innumerable other dead soldiers is unavoidable. This "harvest" is far more sobering and depressing than that in Winslow Homer's Civil War painting, *Veteran in a New Field* (FIG. 22-37). Though it would be many years before photolithography could reproduce photographs like this in newspapers, photographers exhibited them publicly. They made an impression that newsprint engravings never could.

EADWEARD MUYBRIDGE The Realist photographer and scientist Eadweard Muybridge (1830–1904) came to the United States from England in the 1850s and settled in San Francisco, where he established a prominent international reputation for his photographs of the western United States. In 1872 the governor of California, Leland Stanford (1824–1893), sought Muybridge's assistance in settling a bet about whether, at any point in a stride, all four feet of a horse galloping at top speed were off the ground. Through his sequential photography, as seen in *Horse Galloping* (FIG. 22-54), Muybridge proved they were. This experience was the beginning of Muybridge's photographic studies of the successive stages in human

and animal motion—details too quick for the human eye to capture. These investigations culminated in 1885 at the University of Pennsylvania with a series of multiple-camera motion studies that recorded separate photographs of progressive moments in a single action. Muybridge's discoveries received extensive publicity through the book *Animal Locomotion* (1887), and his motion photographs earned him a place in the history of science as well as art. These sequential motion studies, along with those of Eakins and Marey, influenced many other artists, including their contemporary, the painter and sculptor Edgar Degas (FIG. 23-10), and 20th-century artists such as Marcel Duchamp (FIG. 24-1).

Muybridge presented his work to scientists and general audiences with a device called the *zoopraxiscope*, which he invented to project his sequences of images (mounted on special glass plates) onto a screen. The result was so lifelike that one viewer said it "threw upon the screen apparently the living, moving animals. Nothing was wanting but the clatter of hoofs upon the turf." The illusion of motion here was the result of an aspect of human eyesight called "persistence of vision." Stated simply, it means that the brain retains whatever the eye sees for a fraction of a second after the eye stops seeing it. Thus, viewers saw a rapid succession of different images merging one into the next, producing the illusion of continuous change. This illusion lies at the heart of the motion-picture industry that debuted in the 20th century, and thus was born cinema as a new art form.

EUROPE AND AMERICA, 1800 TO 1870

ART UNDER NAPOLEON

- As Emperor of the French from 1804 to 1815, Napoleon embraced the Neoclassical style in order to associate his regime with the empire of ancient Rome. Napoleon chose Jacques-Louis David as First Painter of the Empire. Roman temples were the models for La Madeleine in Paris, which Pierre Vignon built as a temple of glory for France's imperial armies.
- Napoleon's favorite sculptor was Antonio Canova, who carved marble Neoclassical portraits of the imperial family, including Napoleon's sister, Pauline Borghese, in the guise of Venus.
- The beginning of a break from Neoclassicism can already be seen in the work of some of David's students, including Gros, Girodet-Trioson, and Ingres, all of whom painted some exotic subjects that reflect Romantic taste.

Canova, Pauline Borghese as Venus, 1808

ROMANTICISM

- The roots of Romanticism are in the 18th century, but usually the term more narrowly denotes the artistic movement that flourished from 1800 to 1840, between Neoclassicism and Realism. Romantic artists gave precedence to feeling and imagination over Enlightenment reason. Romantic painters explored the exotic, erotic, and fantastic in their art. In Spain, Francisco Goya's *Caprichos* series celebrated the unleashing of imagination, emotions, and even nightmares.
- In France, Eugène Delacroix led the way in depicting Romantic narratives set in faraway places and distant times. He set his colorful *Death of Sardanapalus* in ancient Assyria.
- Romantic painters often chose landscapes as an ideal subject to express the Romantic theme of the soul unified with the natural world. Masters of the transcendental landscape include Friedrich in Germany, Constable and Turner in England, and Cole, Bierstadt, and Church in the United States.

Delacroix, Death of Sardanapalus, 1827

REALISM

- Realism developed as an artistic movement in mid-19th-century France. Its leading proponent was Gustave Courbet, whose paintings of menial labor and ordinary people exemplify his belief that painters should depict only their own time and place. Honoré Daumier boldly confronted authority with his satirical lithographs commenting on the plight of the working classes. Édouard Manet shocked the public with his paintings featuring promiscuous women and rough brush strokes, which emphasized the flatness of the painting surface, paving the way for modern abstract art.
- American Realists include Winslow Homer, Thomas Eakins, and John Singer Sargent. Eakins's painting of surgery in progress was too brutally realistic for the Philadelphia art jury that rejected it.

Courbet, The Stone Breakers, 1849

ARCHITECTURE

- Territorial expansion, the Romantic interest in exotic locales and earlier eras, and nationalistic pride led to the revival in the 19th century of older architectural styles, especially the Gothic.
- By the middle of the century, many architects had already abandoned sentimental and Romantic designs from the past in favor of exploring the possibilities of cast-iron construction, as in Henri Labrouste's Sainte-Geneviève Library in Paris and Joseph Paxton's Crystal Palace in London.

Labrouste, Bibliothèque Sainte-Geneviève, Paris, 1843–1850

PHOTOGRAPHY

■ In 1839, Daguerre in Paris and Talbot in London invented the first practical photographic processes. In 1862, a French court formally recognized photography as an art form subject to copyright protection. Many of the earliest photographers, including Nadar and Cameron, specialized in portrait photography, but others, including Hawes, Southworth, and O'Sullivan in the United States, quickly realized the documentary power of the new medium. Muybridge's sequential photos of human and animal motion were the forerunners of the modern cinema.

O'Sullivan, A Harvest of Death, 1863

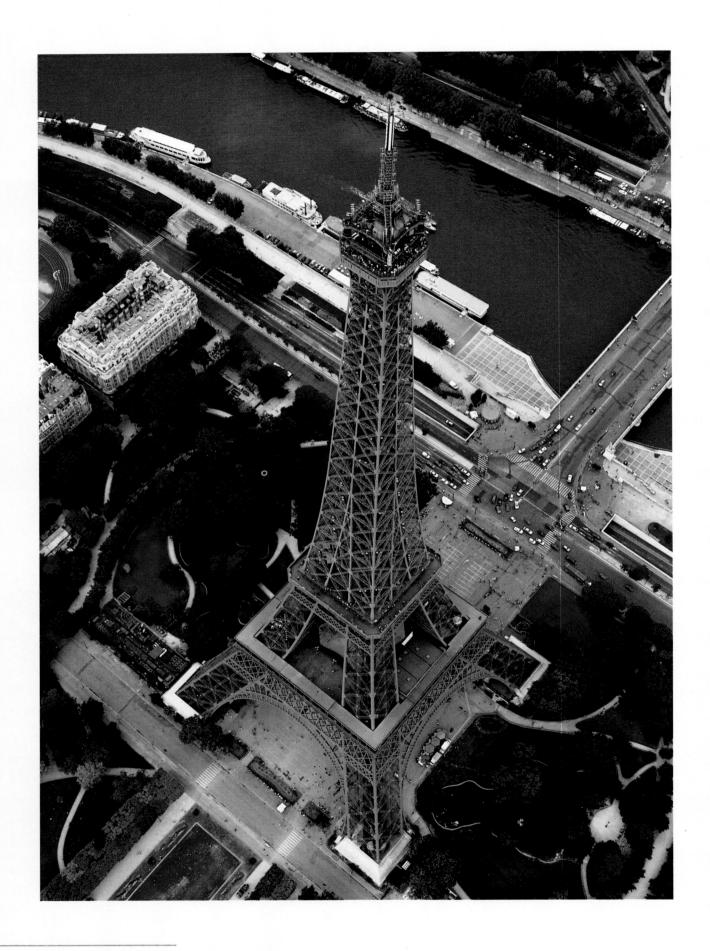

23-1 ALEXANDRE-GUSTAVE EIFFEL, Eiffel Tower, Paris, France, 1889.

New materials and technologies and the modernist aesthetic fueled radically new architectural designs in the late 19th century. Eiffel jolted the world with the exposed iron skeleton of his tower.

EUROPE AND AMERICA, 1870 TO 1900

The momentous Western developments of the early 19th century—industrialization, urbanization, and increased economic and political interaction worldwide—matured quickly during the latter half of the century. The Industrial Revolution in England spread to France (MAP 23-1) and the rest of Europe and to the United States. Because of this dramatic expansion, historians often refer to the third quarter of the 19th century as the second Industrial Revolution. Whereas the first Industrial Revolution centered on textiles, steam, and iron, the second focused on steel, electricity, chemicals, and oil. The discoveries in these fields provided the foundation for developments in plastics, machinery, building construction, and automobile manufacturing and paved the way for the invention of the radio, electric light, telephone, and electric streetcar.

One of the most significant consequences of industrialization was urbanization. The number and size of Western cities grew dramatically during the later 19th century, largely due to migration from rural regions. Rural dwellers relocated to urban centers because expanded agricultural enterprises squeezed the smaller property owners from the land. The widely available work opportunities in the cities, especially in the factories, were also a major factor in this migration. In addition, improving health and living conditions in the cities contributed to their explosive growth.

MARXISM AND DARWINISM The rise of the urban working class was fundamental to the ideas of Karl Marx (1818–1883), one of the era's dominant figures. Born in Trier, Marx received a doctorate in philosophy from the University of Berlin. After moving to Paris, he met fellow German Friedrich Engels (1820–1895), who became his lifelong collaborator. Together they wrote *The Communist Manifesto* (1848), which called for the working class to overthrow the capitalist system. Like other 19th-century empiricists, Marx believed that scientific, rational law governed nature and, indeed, all human history. For Marx, economic forces based on class struggle induced historical change. Throughout history, insisted Marx, those who controlled the means of production conflicted with those whose labor they exploited for their own enrichment. This constant opposition—a dynamic he called "dialectical materialism"—generated change. Marxism's ultimate goal was to create a socialist state in which the working class seized power and destroyed capitalism. Marxism held great appeal for the oppressed as well as many intellectuals.

Equally influential was the English naturalist Charles Darwin (1809–1882), whose theory of natural selection did much to increase interest in science. Darwin and his compatriot Alfred Russel Wallace (1823–1913), working independently, proposed a model for the process of evolution based on mechanistic laws, rather than attributing evolution to random chance or God's plan. They postulated a competitive system in which only the fittest survived. Darwin's controversial ideas, as presented in *On the Origin of Species by Means of Natural Selection* (1859), sharply contrasted with the biblical narrative of creation. By challenging traditional Christian beliefs, Darwinism contributed to a growing secular attitude.

Other theorists and social thinkers, most notably British philosopher Herbert Spencer (1820-1903), applied Darwin's principles to the rapidly changing socioeconomic realm. As in the biological world, they asserted, industrialization's intense competition led to the survival of the most economically fit companies, enterprises, and countries. The social Darwinists provided Western leaders with justification for the colonization of peoples and cultures that they deemed less advanced. By 1900 the major economic and political powers had divided up much of the world. The French had colonized most of North Africa and Indochina, while the British occupied India, Australia, and large areas of Africa, including Nigeria, Egypt, Sudan, Rhodesia, and the Union of South Africa. The Dutch were a major presence in the Pacific, and the Germans, Portuguese, Spanish, and Italians all established themselves in various areas of Africa.

MODERNISM The combination of extensive technological changes and increased exposure to other cultures, coupled with the rapidity of these changes, led to an acute sense in Western cultures of the world's impermanence. Darwin's ideas of evolution and Marx's emphasis on a continuing sequence of economic conflicts reinforced this awareness of a constantly shifting reality. These societal changes in turn fostered a new and multifaceted artistic approach that historians call *modernism*. Modernist artists seek to capture the images and sensibilities of their age, but modernism transcends the simple present to involve the artist's critical examination of or reflection on the premises of art itself. Modernism thus implies certain concerns about art and aesthetics that are internal to art production, regardless of whether the artist is producing scenes from contemporary social life. Clement Greenberg (1909–1994), an influential American art critic, explained:

The essence of Modernism lies . . . in the use of the characteristic methods of a discipline to criticize the discipline itself—not in order to subvert it, but to entrench it more firmly in its area of competence. . . . Realistic, illusionist art had dissembled the medium, using art to conceal art. Modernism used art to call attention to art. The limitations that constitute the medium of painting—the flat surface, the shape of the support, the properties of pigment—were treated by the Old Masters as negative factors that could be acknowledged only implicitly or indirectly. Modernist painting has come to regard these same limitations as positive factors that are to be acknowledged openly. ¹

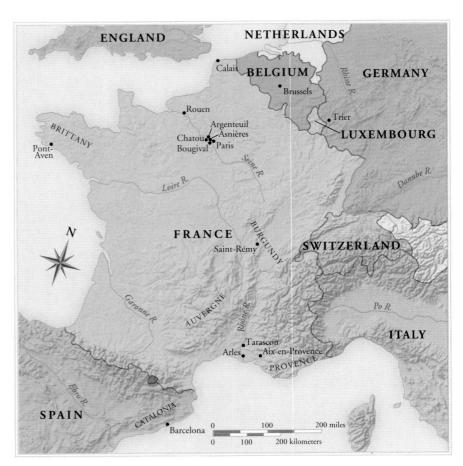

MAP 23-1 France around 1870.

The work of Gustave Courbet and the Realists (see Chapter 22) already expressed this modernist viewpoint, but modernism emerged even more forcefully in the late-19th-century movements that art historians call Impressionism, Post-Impressionism, and Symbolism.

IMPRESSIONISM

Impressionism, both in content and in style, was an art of industrialized, urbanized Paris, a reaction to the sometimes brutal and chaotic transformation of French life that occurred during the latter half of the 19th century. The rapidity of these changes made the world seem unstable and insubstantial. As the poet and critic Charles Baudelaire (1821–1867) observed in 1860 in his essay "The Painter of Modern Life": "[M]odernity is the transitory, the fugitive, the contingent." Accordingly, Impressionist works represent an attempt to capture a fleeting moment—not in the absolutely fixed, precise sense of a Realist painting but by conveying the elusiveness and impermanence of images and conditions.

CLAUDE MONET A hostile critic applied the term "Impressionism" in response to the painting *Impression: Sunrise* (FIG. 23-2) that CLAUDE MONET (1840–1926) exhibited in the first Impressionist show in 1874 (see "Academic Salons and Independent Art Exhibitions," page 655). Although the critic intended the label to be derogatory, by the third Impressionist show in 1878 the artists had embraced it and were calling themselves Impressionists. Artists and

Academic Salons and Independent Art Exhibitions

or both artists and art historians, modernist art stands in marked contrast—indeed in forceful opposition—to academic art, that is, to the art the established art schools such as the Royal Academy of Painting and Sculpture in France (founded 1648) and the Royal Academy of Arts in Britain (founded 1768) promoted. These academies provided instruction for art students and sponsored exhibitions, exerting tight control over the art scene. The annual exhibitions, called "Salons" in France, were highly competitive, as was membership in these academies. Subsidized by the government, the French Royal Academy supported a limited range of artistic expression, focusing on traditional subjects and highly polished technique. Because of the challenges modernist art presented to established artistic conventions, the juries for the Salons and other exhibitions often rejected the works more adventurous artists wished to display. As noted in the previous chapter, Gustave Courbet's reaction to the rejection of some of his paintings was to set up his own Pavilion of Realism in 1855 (see "Courbet on Realism," Chapter 22, page 631). Years later, he wrote:

[I]t is high time that someone have the courage to be an honest man and that he say that the Academy is a harmful, all-consuming institution, incapable of fulfilling the goal of its so-called mission.*

Growing dissatisfaction with the decisions of the French Academy's jurors prompted Napoleon III (r. 1852–1870) in 1863 to establish the Salon des Refusés (Salon of the Rejected) to show all of the works not accepted for exhibition in the regular Salon. Manet's *Le Déjeuner sur l'Herbe* (FIG. **22-33**) was among them. The public greeted it and the entire exhibition with derision. One reviewer of the rejected works summed up the prevailing attitude:

This exhibition, at once sad and grotesque, ... offers abundant proof ... that the jury always displays an unbelievable leniency. Save for one or two questionable exceptions there is not a painting which deserves the honor of the official galleries There is even something cruel about this exhibition; people laugh as they do at a farce. †

In 1867, after further rejections, Manet, following Courbet, mounted a private exhibition of 50 of his paintings outside the Paris World's Fair. Six years later, the Impressionists (FIG. 23-2) formed their own society and began mounting shows of their works in Paris. This decision gave the Impressionists much more freedom, for they did not have to contend with the Academy's authoritative and confining viewpoint, and thereafter they held exhibitions at one- or two-year intervals from 1874 until 1886.

Another group of artists unhappy with the Salon's conservative nature adopted the same renegade approach. In 1884 these artists formed the Société des Artistes Indépendants (Society of Independent Artists) and held annual Salons des Indépendants. Georges Seurat's *A Sunday on La Grande Jatte* (FIG. 23-15) was one of the paintings in the Independents' 1886 Salon.

As the art market expanded, venues for the exhibition of art increased. Art circles and societies sponsored private shows in which both amateurs and professionals participated. Dealers became more aggressive in promoting the artists they represented by mounting exhibitions in a variety of spaces, some fairly intimate and small, others large and grandiose. All of these proliferating opportunities for exhibition gave artists alternatives to the traditional constraints of the Salon and provided fertile breeding ground for the development of radically new art forms and styles.

* Letter to Jules-Antoine Castagnary, October 17, 1868. Translated by Petra ten-Doesschate Chu, Letters of Gustave Courbet (Chicago: University of Chicago Press, 1992), 346.

23-2 CLAUDE MONET, *Impression: Sunrise*, 1872. Oil on canvas, $1' 7\frac{1}{2}'' \times 2' 1\frac{1}{2}''$. Musée Marmottan, Paris.

A hostile critic applied the derogatory term "Impressionism" to this painting because of its sketchy quality and clearly evident brush strokes. Monet and his circle embraced the label for their movement.

[†] Maxime du Camp, in *Revue des deux mondes*, 1863, quoted in George Heard Hamilton, *Manet* and His Critics (New Haven: Yale University Press, 1986), 42–43.

critics had used the term before, but only in relation to sketches. Impressionist paintings do incorporate the qualities of sketches—abbreviation, speed, and spontaneity. This is apparent in *Impression: Sunrise*, in which Monet made no attempt to disguise the brush strokes or blend the pigment to create smooth tonal gradations and an optically accurate scene. This concern with acknowledging the paint and the canvas surface continued the modernist exploration that the Realists began. Beyond this connection to the sketch, Impressionism operated at the intersection of what the artists saw and what they felt. In other words, the "impressions" these artists recorded in their paintings were neither purely objective descriptions of the exterior world nor solely subjective responses but the interaction between the two. They were sensations—the artists' subjective and personal responses to nature.

In sharp contrast to traditional studio artists, Monet painted outdoors, which sharpened his focus on the roles light and color play in capturing an instantaneous representation of atmosphere and climate. Monet carried the systematic investigation of light and color further than any other Impressionist, but all of them recognized the importance of carefully observing and understanding how light and color operate. This thorough study permitted the Impressionists to present images that truly conveyed a sense of the momentary and transitory. Lila Cabot Perry (1848–1933), a student of Monet's late in his career, gave this description of Monet's approach:

I remember his once saying to me: "When you go out to paint, try to forget what objects you have before you—a tree, a house, a field, or whatever. Merely think, here is a little square of blue, here an oblong of pink, here a streak of yellow, and paint it just as it looks to you, the exact color and shape, until it gives your own naïve impression of the scene before you." 3

Scientific studies of light and the invention of chemically synthesized pigments increased artists' sensitivity to the multiplicity of colors in nature and gave them new colors for their work. After scrutinizing the effects of light and color on forms, the Impressionists concluded that local color—an object's true color in white light—becomes modified by the quality of the light shining on it, by reflections from other objects, and by the effects juxtaposed colors produce. Shadows do not appear gray or black, as many earlier painters thought, but are composed of colors modified by reflections or other conditions. If artists use complementary colors (see "19th-Century Color Theory," page 664) side by side over large enough areas, the colors intensify each other, unlike the effect of small quantities of adjoining mixed pigments, which blend into neutral tones. Furthermore, the "mixing" of colors by juxtaposing them on a canvas produces a more intense hue than the same colors mixed on the palette. It is not strictly true that the Impressionists used only primary hues, placing them side by side to create secondary colors (blue and yellow, for example, to create green). But they did achieve remarkably brilliant effects with their characteristically short, choppy brush strokes, which so accurately caught the vibrating quality of light. The fact that their canvas surfaces look incomprehensible at close range and their forms and objects appear only when the eye fuses the strokes at a certain distance accounts for much of the early adverse criticism leveled at their work. Some critics even accused the Impressionists of firing their paint at the canvas with pistols.

ROUEN CATHEDRAL Monet's intensive study of the phenomena of light and color is especially evident in several series of paintings he made of the same subject. In one series he painted some 40 views of Rouen Cathedral, northwest of Paris (MAP 23-1). For each canvas in the series, Monet observed the cathedral from nearly

23-3 CLAUDE MONET, Rouen Cathedral: The Portal (in Sun), 1894. Oil on canvas, $3' 3\frac{1}{4}'' \times 2' 1\frac{7}{8}''$. Metropolitan Museum of Art, New York (Theodore M. Davis Collection, bequest of Theodore M. Davis, 1915).

Monet painted some 40 views of Rouen Cathedral at different times of day and under various climatic conditions. The real subject of this painting is not the building but the sunlight shining on it.

the same viewpoint but at different times of the day or under various climatic conditions. In the painting illustrated here (FIG. 23-3), Monet depicted the church bathed in bright light. With scientific precision, he created an unparalleled record of the passing of time as seen in the movement of light over identical forms. In fact, the real subject of Monet's painting—as the title *Rouen Cathedral: The Portal* (*in Sun*) implies—is not the cathedral, which he shows only in part, but the sunlight on the building's main portal. Later critics accused Monet and his companions of destroying form and order for fleeting atmospheric effects, but Monet focused on light and color precisely to reach a greater understanding of the appearance of form.

SAINT-LAZARE Most of the Impressionists depicted scenes in and around Paris, the heart of modern life in France. Monet's Saint-Lazare Train Station (FIG. 23-4) shows a dominant aspect of the contemporary urban scene. The expanding railway network had made travel more convenient, bringing throngs of people into Paris. In this painting, Monet captured the energy and vitality of Paris's modern transportation hub. The train, emerging from the steam

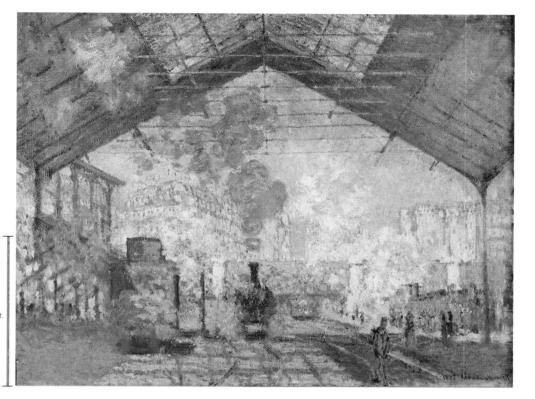

23-4 CLAUDE MONET, *Saint-Lazare Train Station*, 1877. Oil on canvas, 2' $5\frac{3}{4}$ " \times 3' 5". Musée d'Orsay, Paris.

Impressionist canvas surfaces are incomprehensible at close range, but the eye fuses the brush strokes at a distance.

Monet's agitated application of paint contributes to the sense of energy in this urban scene.

smoke, which lashes the glass roof of the main hall.... We see the vast and manic movements at the station where the ground shakes with every turn of the wheel. The platforms are sticky with soot, and the air is full of that bitter scent exuded by burning coal. As we look at this magnificent picture, we are overcome by the same feelings as if we were really there, and these feelings are perhaps even more powerful, because in the picture the artist has conveyed his own feelings as well.⁴

and smoke it emits, rumbles into the station. In the background haze are the tall buildings that were becoming a major component of the Parisian landscape. Monet's agitated paint application contributes to the sense of energy and conveys the atmosphere of urban life.

Georges Rivière (1855–1943), a critic and friend of some of the Impressionists, saw this painting in the third Impressionist exhibition and recorded the essence of what Monet had tried to achieve:

Like a fiery steed, stimulated rather than exhausted by the long trek that it has only just finished, [the locomotive] tosses its mane of GUSTAVE CAILLEBOTTE Other Impressionists also represented facets of city life, although not always using Monet's impressionistic brush strokes. The setting of *Paris: A Rainy Day* (FIG. 23-5) by GUSTAVE CAILLEBOTTE (1849–1893) is a junction of spacious boulevards that resulted from the redesigning of Paris that began in 1852. The city's population had reached nearly 1.5 million by midcentury. To accommodate this congregation of humanity—and to facilitate the movement of troops in the event of another revolution—Napoleon III ordered Paris rebuilt. The emperor named Baron Georges Haussmann (1809–1891), a city superintendent, to oversee

the entire project. In addition to new water and sewer systems, street lighting, and new residential and commercial buildings, a major component of the new Paris was the creation of the wide, open boulevards seen in Caillebotte's painting. These great avenues, whose construction caused the demolition of thousands of old buildings and streets, transformed medieval Paris into the present modern city, with its superb vistas and wide uninterrupted arteries for the flow of vehicular and pedestrian traffic. Caillebotte chose to focus on these markers of the city's rapid urbanization.

23-5 GUSTAVE CAILLEBOTTE, *Paris: A Rainy Day*, 1877. Oil on canvas, $6' 9'' \times 9' 9''$. Art Institute of Chicago, Chicago (Worcester Fund).

Although Caillebotte did not use Impressionistic broken brush strokes, the seemingly randomly placed figures and the arbitrary cropping of the vista suggest the transitory nature of modern life.

23-6 Camille Pissarro, La Place du Théâtre Français, 1898. Oil on canvas, $2' 4\frac{1''}{2} \times 3' \frac{1''}{2}$. Los Angeles County Museum of Art, Los Angeles (Mr. and Mrs. George Gard De Sylva Collection).

This Impressionist view of a crowded Paris square seen from several stories above street level has much in common with photographs, especially the flattening spatial effect resulting from the high viewpoint.

Although Caillebotte did not dissolve his image into the broken color and brushwork characteristic of Impressionism, he did use an informal and asymmetrical composition. The figures seem randomly placed, with the frame cropping them arbitrarily, suggesting the transitory nature of the street scene. Well-dressed Parisians of the leisure class share the viewer's space. Despite the sharp focus of *Paris: A Rainy Day*, the picture captures the artist's "impression" of urban life.

CAMILLE PISSARRO Other Impressionists also found the spacious boulevards and avenues that were the product of "Haussmannization" attractive subjects for paintings. *La Place du Théâtre Français* (FIG. **23-6**) is one of many panoramic scenes of Paris that CAMILLE PISSARRO (1830–1903) painted. The artist recorded the blurred dark accents against a light ground that constituted his visual sensations of a crowded Paris square viewed from several stories above street level. The moment Pissarro captured in this painting is not so

much of fugitive light effects as it is of the street life, achieved through a deliberate casualness in the arrangement of figures. To accomplish this sense of spontaneity, Pissarro, like many of his fellow Impressionists, sometimes used photography to record the places he wished to paint. Scholars have been quick to point out the visual parallels between Impressionist paintings and photographs. These parallels include, here, the arbitrary cutting off of figures at the frame's edge and the curious flattening spatial effect produced by the high viewpoint.

23-7 Berthe Morisot, *Villa at the Seaside*, 1874. Oil on canvas, $1' 7\frac{3}{4}'' \times 2' \frac{1}{8}''$. Norton Simon Art Foundation, Los Angeles.

In this informal view of a woman and child enjoying their leisure time at a fashionable seashore resort, Berthe Morisot used swift, sketchy strokes of light colors to convey a feeling of airiness.

BERTHE MORISOT Many Impressionist paintings depict scenes from resort areas on the seashore or along the Seine River, such as Argenteuil, Bougival, and Chatou. The railway line that carried people to and from Saint-Lazare Station connected Argenteuil to Paris, so transportation was not an obstacle. Parisians often would take the train out to these resort areas for a day of sailing, picnicking, and strolling along the Seine. Berthe Morisot (1841–1895), Édouard Manet's sister-in-law, regularly exhibited with the Impres-

1 in

Renoir on the Art of Painting

any 19th-century artists were concerned with the theoretical basis of picture making. One of the most cogent statements on this subject is Pierre-Auguste Renoir's concise summary of how he, as an Impressionist, painted pictures (for example, FIG. 23-8) and what he hoped to achieve as an artist.

I arrange my subject as I want it, then I go ahead and paint it, like a child. I want a red to be sonorous, to sound like a bell; if it doesn't turn

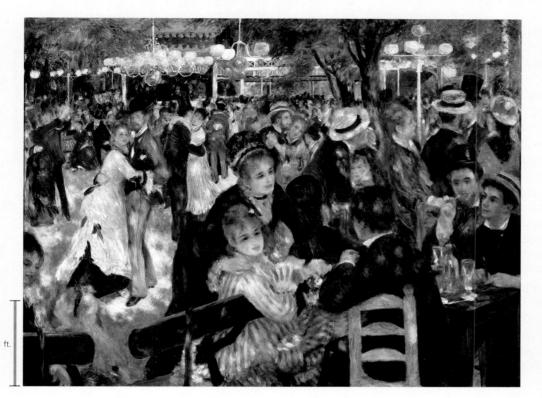

out that way, I add more reds and other colors until I get it. I am no cleverer than that. I have no rules and no methods; . . . I have no secrets. I look at a nude; there are myriads of tiny tints. I must find the ones that will make the flesh on my canvas live and quiver. . . .

[If viewers] could explain a picture, it wouldn't be art. Shall I tell you what I think are the two qualities of art? It must be indescribable and it must be inimitable. . . . The work of art must seize upon

you, wrap you up in itself, carry you away. It is the means by which the artist conveys his passions.... I want people to feel that neither the setting nor the figures are dull and lifeless.*

* Quoted in Eric Protter, ed., *Painters on Painting* (New York: Grosset & Dunlap, 1971), 145.

23-8 PIERRE-AUGUSTE RENOIR, Le Moulin de la Galette, 1876. Oil on canvas, 4' $3'' \times 5'$ 8''. Musée d'Orsay, Paris.

Renoir's painting of this popular Parisian dance hall is dappled by sunlight and shade, artfully blurred into the figures to produce the effect of floating and fleeting light that the Impressionists cultivated.

sionists. Most of her paintings focus on domestic subjects, the one realm of Parisian life where society allowed an upper-class woman such as Morisot free access, but she also produced many outdoor scenes. Morisot's considerable skills are evident in Villa at the Seaside (FIG. 23-7). Both the subject and style correlate well with Impressionist concerns. The setting is the shaded veranda of a summer hotel at a fashionable seashore resort. A woman elegantly but not ostentatiously dressed sits gazing out across the railing to a sunlit beach with its umbrellas and bathing cabins. Her child, its discarded toy boat a splash of red, is attentive to the passing sails on the placid sea. The mood is of relaxed leisure. Morisot used the open brushwork and the plein air (outdoor) lighting characteristic of Impressionism. Sketchy brush strokes record her quick perceptions. Nowhere did Morisot linger on contours or enclosed details. She presented the scene in a slightly filmy soft focus that conveys a feeling of airiness. The composition also recalls the work of other Impressionists. The figures fall informally into place, as someone who shared their intimate space would perceive them. Morisot was both immensely ambitious and talented, as her ability to catch the pictorial moment demonstrates. She escaped the hostile criticism directed at most of the other Impressionists. People praised her work for its sensibility, grace, and delicacy.

PIERRE-AUGUSTE RENOIR Another facet of the new industrialized Paris that drew the Impressionists' attention was the leisure activities of its inhabitants. Scenes of dining, dancing, the café-concerts, the opera, the ballet, and other forms of urban recreation were mainstays of Impressionism. Although seemingly unrelated, industrialization facilitated these pursuits. With the advent of set working hours, people's schedules became more regimented, allowing them to plan their favorite pastimes. Le Moulin de la Galette (FIG. 23-8) by Pierre-Auguste Renoir (1841–1919) depicts throngs of people gathered in a popular Parisian dance hall. Some crowd the tables and chatter, while others dance energetically. So lively is the atmosphere that the viewer can virtually hear the sounds of music, laughter, and tinkling glasses. The painter dappled the whole scene with sunlight and shade, artfully blurred into the figures to produce just the effect of floating and fleeting light the Impressionists so cultivated. Renoir's casual, unposed placement of the figures and the suggested continuity of space, spreading in all directions and only accidentally limited by the frame, position the viewer as a participant rather than as an outsider. Whereas classical art sought to express universal and timeless qualities, Impressionism attempted to depict just the opposite—the incidental, momentary, and passing aspects of reality (see "Renoir on the Art of Painting," above).

23-9 ÉDOUARD MANET, *Bar at the Folies-Bergère*, 1882. Oil on canvas, $3' 1'' \times 4' 3''$. Courtauld Institute of Art Gallery, London.

In this painting set in a Parisian café, Manet called attention to the canvas surface by creating spatial inconsistencies, such as the relationship between the barmaid and her apparent reflection in a mirror.

ÉDOUARD MANET Another artist who depicted Parisian nightlife was Édouard Manet, whose career bridged Realism (see Chapter 22) and Impressionism. One of his later paintings in the Impressionist mode is *Bar at the Folies-Bergère* (FIG. 23-9). The Folies-Bergère was a popular café with music-hall performances, one of the fashionable gathering places for Parisian revelers that many Impressionists frequented. In Manet's 1882 painting, a barmaid, centrally placed, looks out from the canvas but seems disinterested or lost in thought, divorced from her patrons as well as from the viewer. Manet blurred and roughly applied the brush strokes,

particularly those in the background, and the effects of modeling and perspective are minimal. This painting method further calls attention to the surface by forcing the viewer to scrutinize the work to make sense of the scene. On such scrutiny, visual discrepancies emerge. For example, what initially seems easily recognizable as a mirror behind the barmaid creates confusion throughout the rest of the painting. Is the woman on the right the barmaid's reflection? If so, it is impossible to reconcile the spatial relationship among the barmaid, the mirror, the bar's frontal horizontality, and the barmaid's seemingly displaced reflection. These visual contradictions reveal Manet's insistence on calling attention to the pictorial structure of his painting, in keeping with his modernist interest in examining the basic premises of the medium.

EDGAR DEGAS Impressionists also depicted more formal leisure activities. The fascination EDGAR DEGAS (1834–1917) had with patterns of motion brought him to the Paris Opéra (FIG. **22-46**) and

its ballet school. There, his great observational power took in the formalized movements of classical ballet, one of his favorite subjects. In *The Rehearsal* (FIG. **23-10**), Degas used several devices to bring the observer into the pictorial space. The frame cuts off the spiral stair, the windows in the background, and the group of figures in the right foreground. The figures are not at the center of a classically balanced composition. Instead, Degas arranged them in a

23-10 Edgar Degas, *The Rehearsal*, 1874. Oil on canvas, $1'11'' \times 2'9''$. Glasgow Art Galleries and Museum, Glasgow (Burrell Collection).

The arbitrarily cut-off figures, the patterns of light splotches, and the blurry images in this work reveal Degas's interest in reproducing fleeting moments, as well as his fascination with photography.

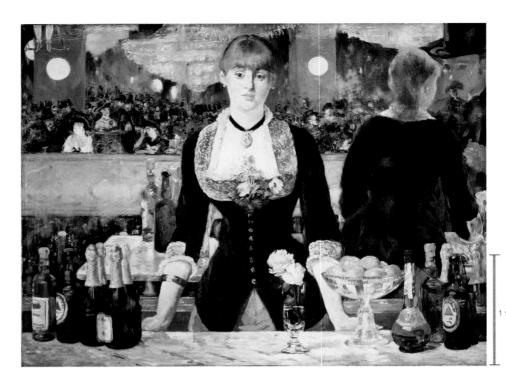

seemingly random manner. The prominent diagonals of the wall bases and floorboards carry the viewer into and along the directional lines of the dancers. Finally, as is customary in Degas's ballet pictures, a large, off-center, empty space creates the illusion of a continuous floor that connects the observer with the pictured figures.

The often arbitrarily cut-off figures, the patterns of light splotches, and the blurriness of the images in this and other Degas works indicate the artist's interest in reproducing single moments. Further, they reveal his fascination with photography. Degas not only studied the photography of others but also used the camera to make preliminary studies for his works, particularly photographing figures in interiors. Japanese woodblock prints (see "Japonisme," page 661) were another inspirational source for paintings such as *The Rehearsal*. The cunning spatial projections in Degas's paintings probably derived in part from Japanese prints, such as those by Suzuki Harunobu. Japanese artists used diverging lines not only to

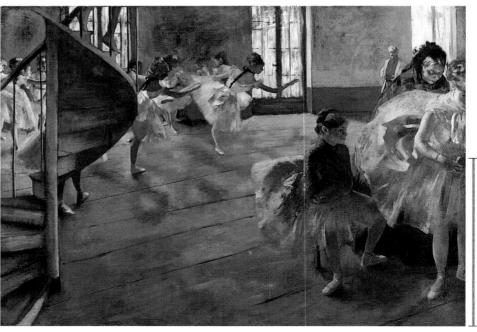

1 ft.

Japonisme

espite Europe's and America's extensive colonization during the 19th century, Japan avoided Western intrusion until 1853-1854, when Commodore Matthew Perry (1794-1858) and American naval forces exacted trading and diplomatic privileges from Japan. From the increased contact, Westerners became familiar with Japanese culture. So intrigued were the French with Japanese art and culture that they introduced a specific label—Japonisme—to describe the Japanese aesthetic, which, because of both its beauty and exoticism, greatly appealed to the fashionable segment of Parisian society. In 1867 at the Exposition Universelle in Paris, the Japanese pavilion garnered more attention than any other. Soon, Japanese kimonos, fans, lacquer cabinets, tea caddies, folding screens, tea services, and jewelry flooded Paris. Japanese-themed novels and travel books were immensely popular as well. As demand for Japanese merchandise grew in the West, the Japanese began to develop import-export businesses, and the foreign currency that flowed into Japan helped to finance much of its industrialization.

Artists in particular were great admirers of Japanese art. Among those the Japanese aesthetic influenced were the Impressionists and Post-Impressionists, especially Édouard Manet, Edgar Degas, Mary Cassatt, James Abbott McNeill Whistler, Henri de Toulouse-Lautrec, Vincent van Gogh, and Paul Gauguin. For the most part, the Japanese presentation of space in woodblock prints, which were more readily available in the West than any other art form, intrigued these artists. Because of the simplicity of the woodblock printing process, these prints feature broad areas of flat color with a limited amount of modulation or gradation. This flatness interested modernist painters, who sought ways to call attention to the picture surface. The right side of Degas's The Tub (FIG. 23-11, left), for example, has this two-dimensional quality. Degas, in fact, owned a print by Japanese artist Torii Kiyonaga (1752-1815) depicting eight women at a bath in various poses and states of undress. That print inspired Degas's painting. A comparison between Degas's bather and a detail (FIG. 23-11, right) of a bather from another of Kiyonaga's prints is striking, although Degas did not closely copy any of the Japanese artist's figures. Instead, he absorbed the essence of Japanese compositional style and the distinctive angles employed in representing human figures, and he translated them into the Impressionist mode.

The decorative quality of Japanese images also appealed to the artists associated with the Arts and Crafts movement in England. Artists such as William Morris (FIG. 23-34) and Charles Rennie Mackintosh (FIG. 23-35) found Japanese prints attractive because those artworks intersected nicely with two fundamental Arts and Crafts principles: Art should be available to the masses, and functional objects should be artistically designed.

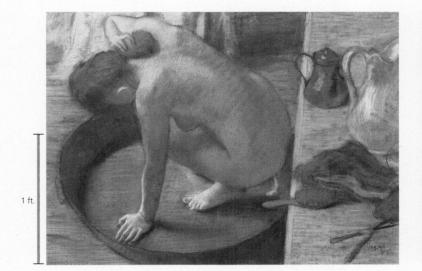

23-11 Left: Edgar Degas, The Tub, 1886. Pastel, $1'11\frac{1}{2}''\times2'8\frac{3}{8}''$. Musée d'Orsay, Paris. Right: Torii Kiyonaga, detail of Two Women at the Bath, ca. 1780. Color woodblock, full print $10\frac{1}{2}''\times7\frac{1}{2}''$, detail $3\frac{3}{4}''\times3\frac{1}{2}''$. Musée Guimet, Paris.

The Tub reveals the influence of Japanese prints, especially the distinctive angles artists such as Torii Kiyonaga used in representing figures. Degas translated his Japanese model into the Impressionist mode.

organize the flat shapes of figures but also to direct the viewer's attention into the picture space. The Impressionists, acquainted with these prints as early as the 1860s, greatly admired their spatial organization, familiar and intimate themes, and flat unmodeled color areas, and drew much instruction from them.

THE TUB Although color and light were major components of the Impressionist quest to capture fleeting sensations, these artists considered other formal elements as well. Degas, for example, became a superb master of line, so much so that his works often differ significantly from those of Monet and Renoir. Degas specialized in studies of figures in rapid and informal action, recording the quick impression of arrested motion, as is evident in The Rehearsal (FIG. 23-10). He often employed lines to convey this sense of movement. In The Tub (FIG. 23-11, left), inspired by a Japanese print similar to the one illustrated here (FIG. 23-11, right), a young woman crouches in a washing tub. The artist outlined the major objects in the painting the woman, tub, and pitchers—and covered all surfaces with linear

23-12 Mary Cassatt, *The Bath*, ca. 1892. Oil on canvas, $3' 3'' \times 2' 2''$. Art Institute of Chicago, Chicago (Robert A. Walker Fund).

Cassatt's style owed much to the compositional devices of Degas and of Japanese prints, but her subjects differed from those of most Impressionists, in part because, as a woman, she could not frequent cafés.

hatch marks. Degas achieved this leaner quality with *pastels*, his favorite medium. Using these dry sticks of powdered pigment, Degas drew directly on the paper, as one would with a piece of chalk, thus accounting for the linear basis of his work. Although the applied pastel is subject to smudging, the colors tend to retain their autonomy, so they appear fresh and bright.

The Tub also reveals how Degas's work, like that of the other Impressionists, continued the modernist exploration of the premises of painting by acknowledging the artwork's surface. Although the viewer clearly perceives the woman as a depiction of a three-dimensional form in space, the tabletop or shelf on the right of the image appears so severely tilted that it seems to parallel the picture plane. The two pitchers on the table complicate this visual conflict between the table's flatness and the illusion of the bathing woman's three-dimensional volume. The limited foreshortening of the pitchers and their shared edge, in conjunction with the rest of the image, create a visual perplexity for the viewer.

MARY CASSATT In the Salon of 1874, Degas admired a painting by a young American artist, MARY CASSATT (1844–1926), the

daughter of a Philadelphia banker. Degas befriended and influenced Cassatt, who exhibited regularly with the Impressionists. She had trained as a painter before moving to Europe to study masterworks in France and Italy. As a woman, she could not easily frequent the cafés with her male artist friends, and she had the responsibility of caring for her aging parents, who had moved to Paris to join her. Because of these restrictions, Cassatt's subjects, like Morisot's (FIG. 23-7), were principally women and children, whom she presented with a combination of objectivity and genuine sentiment. Works such as *The Bath* (FIG. 23-12) show the tender relationship between a mother and child. As in Degas's *The Tub*, the visual solidity of the mother and child contrasts with the flattened patterning of the wallpaper and rug. Cassatt's style in this work owed much to the compositional devices of Degas and of Japanese prints, but the painting's design has an originality and strength all its own.

JAMES WHISTLER Another American expatriate artist in Europe was James Abbott McNeill Whistler (1834–1903), who spent time in Paris before settling finally in London. He met many of the French Impressionists, and his art is a unique combination of some of their concerns and his own. Whistler shared the Impressionists' interests in the subject of contemporary life and the sensations color produces on the eye. To these influences he added his own desire to create harmonies paralleling those achieved in music.

23-13 James Abbott McNeill Whistler, *Nocturne in Black and Gold (The Falling Rocket)*, ca. 1875. Oil on panel, 1' $11\frac{5}{8}'' \times 1'$ $6\frac{1}{2}''$. Detroit Institute of Arts, Detroit (gift of Dexter M. Ferry Jr.).

In this painting, Whistler displayed an Impressionist's interest in conveying the atmospheric effects of fireworks at night, but he also emphasized the abstract arrangement of shapes and colors.

Nature contains the elements, in color and form, of all pictures, as the keyboard contains the notes of all music. But the artist is born to pick, and choose, and group with science, these elements, that the result may be beautiful—as the musician gathers his notes, and forms his chords, until he brings forth from chaos glorious harmony.⁵

To underscore his artistic intentions, Whistler began calling his paintings "arrangements" or "nocturnes." *Nocturne in Black and Gold*, or *The Falling Rocket* (FIG. **23-13**), is a daring painting with gold flecks and splatters that represent the exploded firework punctuating the darkness of the night sky. More interested in conveying the atmospheric effects than in providing details of the scene, Whistler emphasized creating a harmonious arrangement of shapes and colors on the rectangle of his canvas, an approach that appealed to many 20th-century artists. These works angered many 19th-century viewers, however. The British critic John Ruskin (1819–1900) responded to this painting with a scathing review accusing Whistler of "flinging a pot of paint in the public's face" with his style. In reply, Whistler sued Ruskin for libel. During the trial, Ruskin's attorney asked Whistler about the subject of *Nocturne*:

What is your definition of a Nocturne?

It is an arrangement of line, form, and colour first; ... Among my works are some night pieces; and I have chosen the word Nocturne because it generalizes and amplifies the whole set of them. ... The nocturne in black and gold is a night piece and represents the fireworks at Cremorne [Gardens in London].

Not a view of Cremorne?

If it were a view of Cremorne, it would certainly bring about nothing but disappointment on the part of the beholders. It is an artistic arrangement.⁶

The court transcript notes that the spectators in the courtroom laughed at that response, but Whistler won the case. However, his victory had sadly ironic consequences for him. The judge in the case,

showing where his—and the public's—sympathies lay, awarded the artist only one farthing (less than a penny) in damages and required him to pay all of the court costs, which ruined him financially.

POST-IMPRESSIONISM

By 1886 most critics and a large segment of the public accepted the Impressionists as serious artists. Just when their images of contemporary life no longer seemed crude and unfinished, however, some of these painters and a group of younger followers came to feel that the Impressionists were neglecting too many of the traditional elements of picture making in their attempts to capture momentary sensations of light and color on canvas. In a conversation with the influential art dealer Ambroise Vollard (1866-1939) in about 1883, Renoir commented: "I had wrung impressionism dry, and I finally came to the conclusion that I knew neither how to paint nor how to draw. In a word, impressionism was a blind alley, as far as I was concerned." By the 1880s, some artists were more systematically examining the properties and the expressive qualities of line, pattern, form, and color. Among them were Dutch-born Vincent van Gogh and the French painter Paul Gauguin, who focused their artistic efforts on exploring the expressive capabilities of formal elements, and Georges Seurat and Paul Cézanne, also from France, who were more analytical in orientation. Because their art had its roots in Impressionist precepts and methods, but is not stylistically homogeneous, these artists and others have become known as the Post-Impressionists.

HENRI DE TOULOUSE-LAUTREC Closest to the Impressionists in many ways was the French artist Henri de Toulouse-Lautrec (1864–1901), who deeply admired Degas and shared the Impressionists' interest in capturing the sensibility of modern life. His work, however, has an added satirical edge to it and often borders on caricature. Genetic defects that stunted his growth and in part crippled him led to Toulouse-Lautrec's self-exile from the high soci-

ety his ancient aristocratic name entitled him to enter. He became a denizen of the night world of Paris, consorting with a tawdry population of entertainers, prostitutes, and other social outcasts. He reveled in the energy of cheap music halls, cafés, and bordellos. At the Moulin Rouge (FIG. 23-14) reveals the influences of Degas, of the Japanese print, and of photography in the oblique and asymmetrical composition, the spatial diagonals, and the strong line patterns with added dissonant colors. But although Toulouse-Lautrec closely studied such scenes in real life and they were already familiar to viewers in the work of the earlier Impressionists, he so emphasized or exaggerated each element that

23-14 Henri de Toulouse-Lautrec, *At the Moulin Rouge*, 1892–1895. Oil on canvas, $4' \times 4'$ 7". Art Institute of Chicago, Chicago (Helen Birch Bartlett Memorial Collection).

The influences of Degas, Japanese prints, and photography show in this painting's oblique composition, but the glaring lighting, masklike faces, and dissonant colors are Toulouse-Lautrec's.

19th-Century Color Theory

In the 19th century, advances in the sciences contributed to changing theories about color and how people perceive it. Many physicists and chemists immersed themselves in studying optical reception and the behavior of the human eye in response to light of differing wavelengths. They also investigated the psychological dimension of color. These new ideas about color and its perception provided a framework within which artists such as Georges Seurat worked. Although historians do not know which publications on color Seurat himself read, he no doubt relied on aspects of these evolving theories to develop pointillism (FIG. 23-15).

Discussions of color often focus on hue (for example, red, yellow, and blue), but it is important to consider the other facets of color-saturation (the hue's brightness or dullness) and value (the hue's lightness or darkness). Most artists during the 19th century understood the concepts of primary colors (red, yellow, and blue), secondary colors (orange, purple, and green), and complementary colors (red and green, yellow and purple, blue and orange; see Introduction). Chemist Michel-Eugène Chevreul (1786-1889) extended artists' understanding of color dynamics by formulating the law of simultaneous contrasts of colors. Chevreul asserted that juxtaposed colors affect the eye's reception of each, making the two colors as dissimilar as possible, both in hue and in value. For example, placing light green next to dark green has the effect of making the light green look even lighter and the dark green darker. Chevreul further provided an explanation of successive contrasts—the phenomenon of colored afterimages. When a person looks intently at a color (green, for example) and then shifts to a white area, the fatigued eye momentarily perceives the complementary color (red).

Charles Blanc (1813–1882), who coined the term *optical mixture* to describe the visual effect of juxtaposed complementary colors, asserted that the smaller the areas of adjoining complementary colors, the greater the tendency for the eye to "mix" the colors, so that the viewer perceives a grayish or neutral tint. Seurat used this principle frequently in his paintings.

Also influential for Seurat was the work of physicist Ogden Rood (1831–1902), who published his ideas in *Modern Chromatics, with Applications to Art and Industry* in 1879. Expanding on the ideas of Chevreul and Blanc, Rood constructed an accurate and understandable diagram of contrasting colors. Further (and particularly significant to Seurat), Rood explored representing color gradation. He suggested that artists could achieve gradation by placing small dots or lines of color side by side, which he observed would blend in the eye of the beholder when viewed from a distance.

The color experiments of Seurat and other late-19th-century artists were also part of a larger discourse about human vision and how people see and understand the world. The theories of physicist Ernst Mach (1838–1916) focused on the psychological experience of sensation. He believed humans perceive their environments in isolated units of sensation that the brain then recomposes into a comprehensible world. Another scientist, Charles Henry (1859–1926), also pursued research into the psychological dimension of color—how colors affect people, and under what conditions. He went even further to explore the physiological effects of perception. Seurat's work, though characterized by a systematic and scientifically minded approach, also incorporated his concerns about the emotional tone of the images.

the tone is new. Compare, for instance, this painting's mood with the relaxed and casual atmosphere of Renoir's *Le Moulin de la Galette* (FIG. 23-8). Toulouse-Lautrec's scene is nightlife, with its glaring artificial light, brassy music, and assortment of corrupt, cruel, and masklike faces. (He included himself in the background—the tiny man with the derby accompanying the very tall man, his cousin.) Such distortions by simplification of the figures and faces anticipated Expressionism (see Chapter 24), when artists' use of formal elements—for example, brighter colors and bolder lines than ever before—increased the impact of the images on observers.

GEORGES SEURAT The themes GEORGES SEURAT (1859–1891) addressed in his paintings were also Impressionist subjects, but he depicted them in a resolutely intellectual way. He devised a disciplined and painstaking system of painting that focused on color analysis. Seurat was less concerned with the recording of immediate color sensations than he was with their careful and systematic organization into a new kind of pictorial order. He disciplined the free and fluent play of color that characterized Impressionism into a calculated arrangement based on scientific color theory (see "19th-Century Color Theory," above). Seurat's system, known as *pointillism* or *divisionism*, involves carefully observing color and separating it into its component parts. The artist then applies these pure component colors to the canvas in tiny dots (points) or daubs. Thus, the shapes, figures, and spaces in the

image become totally comprehensible only from a distance, when the viewer's eye blends the many pigment dots.

Pointillism was on view at the eighth and last Impressionist exhibition in 1886, when Seurat showed his A Sunday on La Grande Jatte (FIG. 23-15). The subject of the painting is consistent with Impressionist recreational themes, and Seurat also shared the Impressionists' interest in analyzing light and color. But Seurat's rendition is strangely rigid and remote, unlike the spontaneous representations of most Impressionists. Seurat applied pointillism to produce a carefully composed and painted image. By using meticulously calculated values, the painter carved out a deep rectangular space. He played on repeated motifs both to create flat patterns and to suggest spatial depth. Reiterating the profile of the female form, the parasol, and the cylindrical forms of the figures, Seurat placed each in space to set up a rhythmic movement in depth as well as from side to side. Sunshine fills the picture, but the painter did not break the light into transient patches of color. Light, air, people, and landscape are formal elements in an abstract design in which line, color, value, and shape cohere in a precise and tightly controlled organization. Seurat's orchestration of the many forms across the monumental (almost 7-by-10-foot) canvas created a rhythmic cadence that harmonizes the entire composition.

Seurat once stated: "They see poetry in what I have done. No, I apply my method, and that is all there is to it." Despite this claim,

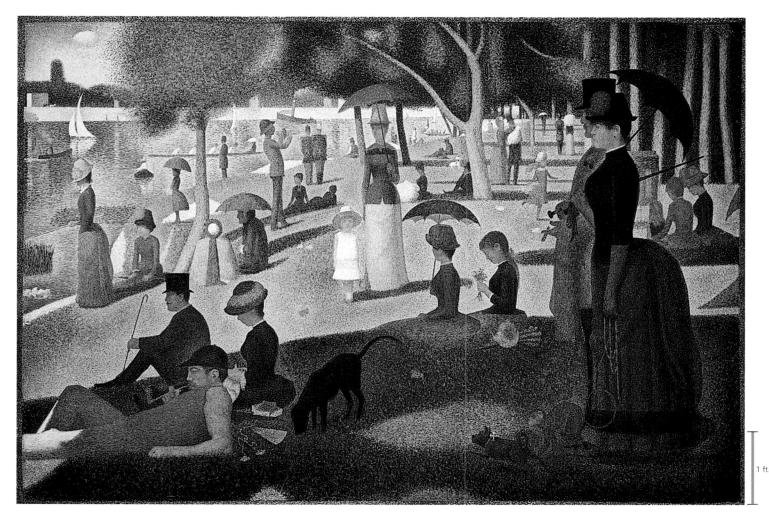

23-15 Georges Seurat, A Sunday on La Grande Jatte, 1884–1886. Oil on canvas, $6'9'' \times 10'$. Art Institute of Chicago, Chicago (Helen Birch Bartlett Memorial Collection, 1926).

Seurat's color system—pointillism—involved dividing colors into their component parts and applying those colors to the canvas in tiny dots. The forms become comprehensible only from a distance.

his art is much more than a scientifically based system. *La Grande Jatte* reveals Seurat's recognition of the tenuous and shifting social and class relationships at the time. La Grande Jatte (The Big Bowl) is an island in the Seine River near Asnières, one of Paris's rapidly growing industrial suburbs. Seurat's painting captures public life on a Sunday—a congregation of people from various classes, from the sleeveless worker lounging in the left foreground to the middle-class man and woman seated next to him. Most of the people wear their Sunday best, making class distinctions less obvious.

VINCENT VAN GOGH In marked contrast to Seurat, VINCENT VAN GOGH (1853–1890) explored the capabilities of colors and distorted forms to express his emotions as he confronted nature. The son of a Dutch Protestant pastor, van Gogh believed he had a religious calling and did missionary work in the coal-mining area of Belgium. Repeated professional and personal failures brought him close to despair. Only after he turned to painting did he find a way to communicate his experiences. When van Gogh died of a self-inflicted gunshot wound at age 37, he considered himself a failure as an artist. He felt himself an outcast not only from artistic circles but also from society at large. The hostile reception to his work, both from fellow artists and the general public, no doubt reinforced this

perception. He sold only one painting during his lifetime. Since his death, however, his reputation and the appreciation of his art have grown dramatically. Subsequent painters, especially the Fauves and German Expressionists (see Chapter 24), built on the use of color and the expressiveness of van Gogh's art. This kind of influence is an important factor in determining artistic significance, and it is no exaggeration to state that today van Gogh is one of the most revered artists in history.

NIGHT CAFÉ After relocating to Arles in southern France in 1888, van Gogh painted Night Café (Fig. 23-16). Although the subject is apparently benign, van Gogh invested it with a charged energy. As he stated in a letter to his brother Theo (see "The Letters of Vincent van Gogh," page 666), he wanted the painting to convey an oppressive atmosphere—"a place where one can ruin oneself, go mad, or commit a crime." The proprietor rises like a specter from the edge of the billiard table, which the painter depicted in such a steeply tilted perspective that it threatens to slide out of the painting into the viewer's space. Van Gogh communicated the "madness" of the place by selecting vivid hues whose juxtaposition augmented their intensity. His insistence on the expressive values of color led him to develop a corresponding expressiveness in his paint application. The

The Letters of Vincent van Gogh

hroughout his life, Vincent van Gogh wrote letters to his brother Theo van Gogh (1857-1891), a Parisian art dealer, on matters both mundane and philosophical. The letters are precious documents of the vicissitudes of the painter's life and reveal his emotional anguish. In many of the letters, van Gogh also forcefully stated his views about art. In one letter, he told Theo: "In both my life and in my painting, I can very well do without God but I cannot, ill as I am, do without something which is greater than I, . . . the power to create."* For van Gogh, the power to create involved the expressive use of color. "Instead of trying to reproduce exactly what I have before my eyes, I use color more arbitrarily so as to express myself forcibly."† Color in painting, he argued, is "not locally true from the point of view of the delusive realist, but color suggesting some emotion of an ardent temperament."‡

Some of van Gogh's letters contain vivid descriptions of his paintings, which are invaluable to art historians in gauging his intentions and judging his success. For example, about Night Café (FIG. 23-16), he wrote:

> I have tried to express the terrible passions of humanity by means of red and green. The room is blood red and dark yellow with a green billiard table in the middle; there are four citron-yellow lamps with a glow of orange and green. Everywhere there is a clash and contrast of the most disparate reds and greens in the figures of little sleeping hooligans, in the empty, dreary room, in violet and blue. The blood-red and the yellow-green of the billiard table, for instance, contrast with the soft, tender Louis XV green of the counter, on which there is a pink nosegay. The white coat of

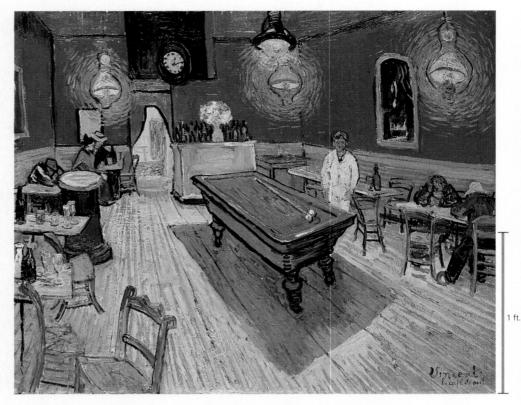

23-16 VINCENT VAN GOGH, Night Café, 1888. Oil on canvas, 2' $4\frac{1}{2}$ " \times 3'. Yale University Art Gallery, New Haven (bequest of Stephen Carlton Clark).

In Night Café, van Gogh explored the abilities of colors and distorted forms to express emotions. The thickness, shape, and direction of his brush strokes create a tactile counterpart to the intense colors.

> the landlord, awake in a corner of that furnace, turns citron-yellow, or pale luminous green.§

- * Vincent van Gogh to Theo van Gogh, September 3, 1888, in W. H. Auden, ed., Van Gogh: A Self-Portrait. Letters Revealing His Life as a Painter (New York: Dutton, 1963), 319.
- † August 11, 1888. Ibid., 313.
- [‡] September 8, 1888. Ibid., 321.
- § September 8, 1888. Ibid., 320.

thickness, shape, and direction of his brush strokes created a tactile counterpart to his intense color schemes. He often moved the brush vehemently back and forth or at right angles, giving a textilelike effect, even squeezing dots or streaks directly onto his canvas from his paint tube. This bold, almost slapdash attack enhanced the intensity of his colors.

STARRY NIGHT Similarly illustrative of van Gogh's "expressionist" method is Starry Night (FIG. 23-17), which the artist painted in 1889, the year before his death. At this time, van Gogh was living at Saint-Paul-de-Mausole, an asylum in Saint-Rémy, near Arles, where he had committed himself. In Starry Night, the artist did not represent the sky's appearance. Rather, he communicated his feelings about the electrifying vastness of the universe, filled with whirling and exploding stars and galaxies of stars, the earth and humanity huddling beneath it. The church nestled in the center of the village is perhaps van Gogh's attempt to express or reconcile his conflicted views about religion. Although the style in Starry Night suggests a very personal vision, this work does correspond in many ways to the view available to the painter from the window of his room in Saint-Paul-de-Mausole. The existence of cypress trees and the placement of the constellations have been confirmed as matching the view van Gogh would have had during his stay in the asylum. Still, the artist translated any visible objects into his unique vision. Given van Gogh's determination to "use color . . . to express [him]self forcibly," the dark, deep blue that suffuses the entire painting cannot be overlooked. Together with the turbulent brush strokes, the color suggests a quiet but pervasive depression. Van Gogh's written observation to his brother reveals his contemplative state of mind:

Perhaps death is not the hardest thing in a painter's life. . . . [L]ooking at the stars always makes me dream, as simply as I dream over the black dots representing towns and villages on a map. Why, I ask myself, shouldn't the shining dots of the sky be as accessible as the black dots on the map of France? Just as we take the train to get to Tarascon or Rouen, we take death to reach a star. 10

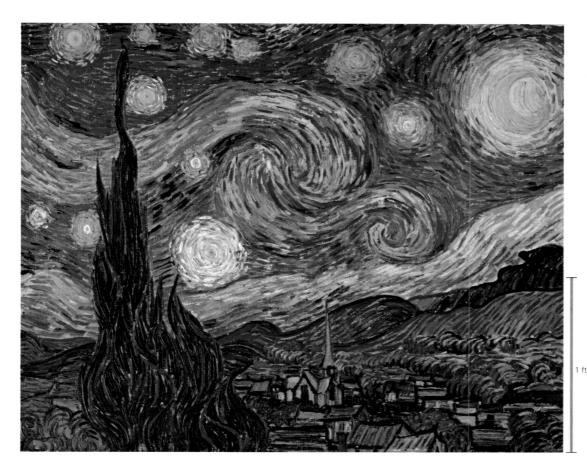

23-17 VINCENT VAN GOGH, Starry Night, 1889. Oil on canvas, $2' 5'' \times 3' \frac{1}{4}''$. Museum of Modern Art, New York (acquired through the Lillie P. Bliss Bequest).

In this late work, van Gogh painted the vast night sky filled with whirling and exploding stars, the earth huddled beneath it. The painting is an almost abstract pattern of expressive line, shape, and color.

PAUL GAUGUIN After painting as an amateur, Paul Gauguin (1848–1903) took lessons with Pissarro and then resigned from his prosperous brokerage business in 1883 to devote his time entirely to painting. Like van Gogh, he rejected objective representation in favor of subjective expression. He also broke with the Impressionists' studies of minutely contrasted hues because he believed that color above all must be expressive and that the artist's power to determine

the colors in a painting was a central element of creativity. However, whereas van Gogh's heavy, thick brush strokes were an important component of his expressive style, Gauguin's color areas appear flatter, often visually dissolving into abstract patches or patterns.

In 1886, attracted by Brittany's unspoiled culture, its ancient Celtic folkways, and the still-medieval Catholic piety of its people, Gauguin moved to Pont-Aven. Although in the 1870s and 1880s Brit-

tany had been transformed into a profitable market economy, Gauguin still viewed the Bretons as "natural" men and women, perfectly at ease in their unspoiled peasant environment. At Pont-Aven, he painted *Vision after the Sermon*, or *Jacob Wrestling with the Angel* (FIG. 23-18), a work that decisively rejects both Realism and Impressionism. The painting shows Breton women, wearing their starched white Sunday caps and black dresses, visualizing the sermon they have just heard at church on Jacob's encounter with the Holy

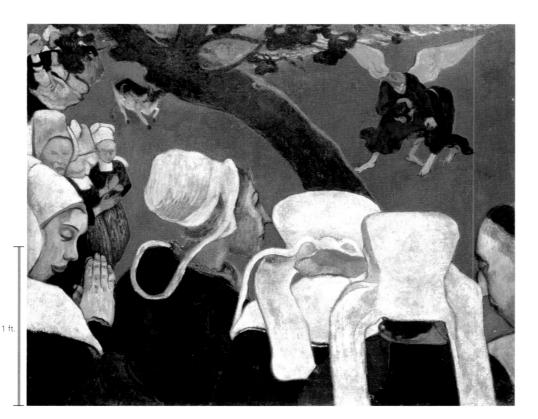

23-18 Paul Gauguin, *Vision after the Sermon*, or *Jacob Wrestling with the Angel*, 1888. Oil on canvas, $2' \, 4\frac{3}{4}'' \times 3' \, \frac{1}{2}''$. National Gallery of Scotland, Edinburgh.

Gauguin admired Japanese prints, stained glass, and cloisonné enamels. Their influences are evident in this painting of Breton women, in which firm outlines enclose large areas of unmodulated color.

Spirit (Gen. 32:24–30). The women pray devoutly before the apparition, as they would have before the roadside crucifix shrines that were familiar features of the Breton countryside. Gauguin departed from optical realism and composed the picture elements to focus the viewer's attention on the idea and intensify its message. The images are not what the Impressionist eye would have seen and replicated but what memory would have recalled and imagination would have modified. Thus the artist twisted the perspective and allotted the space to emphasize the innocent faith of the unquestioning women, and he shrank Jacob and the angel, wrestling in a ring enclosed by a Breton stone fence, to the size of fighting cocks. Wrestling matches were regular features at the entertainment held after high mass, so Gauguin's women are spectators at a contest that was, for them, a familiar part of their culture.

Gauguin did not unify the picture with a horizon perspective, light and shade, or a naturalistic use of color. Instead, he abstracted the scene into a pattern. Pure unmodulated color fills flat planes and shapes bounded by firm lines: white caps, black dresses, and the red field of combat. The shapes are angular, even harsh. The caps, the sharp fingers and profiles, and the hard contours suggest the austerity of peasant life and ritual. Gauguin admired Japanese prints, stained glass, and *cloisonné* metalwork (FIGS. 11-2 and 11-3). These art forms contributed to his own daring experiment to transform traditional painting and Impressionism into abstract, expressive patterns of line, shape, and pure color. His revolutionary method found its first authoritative expression in *Vision after the Sermon*.

WHERE DO WE COME FROM? After a brief period of association with van Gogh in Arles in 1888, Gauguin, in his restless search for provocative subjects and for an economical place to live, settled in Tahiti. The South Pacific island attracted Gauguin because it offered him a life far removed from materialistic Europe and an opportunity to reconnect with nature. Upon his arrival, he discovered that Tahiti, under French control since 1842, had been extensively colonized. Disappointed, Gauguin tried to maintain his vision of an untamed paradise by moving to the Tahitian countryside, where he expressed his fascination with primitive life and brilliant

color in a series of striking decorative canvases. Gauguin often based the design, although indirectly, on native motifs, and the color owed its peculiar harmonies of lilac, pink, and lemon to the tropical flora of the island.

Despite the allure of the South Pacific, Gauguin continued to struggle with life. His health suffered, and his art had a hostile reception. In 1897, worn down by these obstacles, Gauguin decided to take his own life, but not before painting a large canvas titled *Where Do We Come From? What Are We? Where Are We Going?* (FIG. 23-19). This painting can be read as a summary of Gauguin's artistic methods and of his views on life. The scene is a tropical landscape, populated with native women and children. Despite the setting, most of the canvas surface, other than the figures, consists of broad areas of flat color, which convey a lushness and intensity.

In a letter to his friend Charles Morice, Gauguin shed light on the meaning of this painting:

Where are we going? Near to death an old woman.... What are we? Day to day existence.... Where do we come from? Source. Child. Life begins.... Behind a tree two sinister figures, cloaked in garments of sombre colour, introduce, near the tree of knowledge, their note of anguish caused by that very knowledge in contrast to some simple beings in a virgin nature, which might be paradise as conceived by humanity, who give themselves up to the happiness of living. 11

Where Do We Come From? is, therefore, a sobering, pessimistic image of the life cycle's inevitability. Gauguin's attempt to commit suicide in Tahiti was unsuccessful, but he died a few years later, in 1903, in the Marquesas Islands, his artistic genius still unrecognized.

PAUL CÉZANNE Although a lifelong admirer of Eugène Delacroix, Paul CÉZANNE (1839–1906) allied himself early in his career with the Impressionists, especially Pissarro. He at first accepted their color theories and their faith in subjects chosen from everyday life, but his studies of the Old Masters in the Louvre persuaded him that Impressionism lacked form and structure. Cézanne declared he wanted to "make of Impressionism something solid and durable like the art of the museums." ¹²

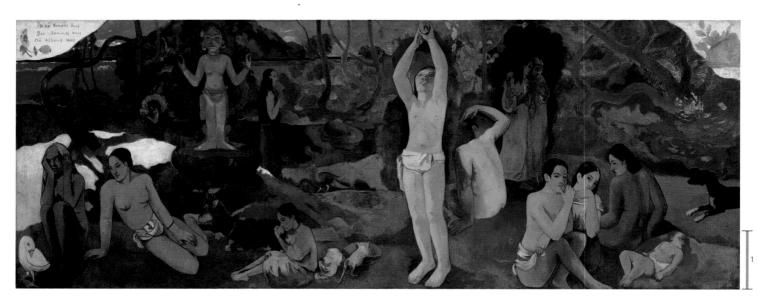

23-19 Paul Gauguin, Where Do We Come From? What Are We? Where Are We Going? 1897. Oil on canvas, $4' 6\frac{3}{4}'' \times 12' 3''$. Museum of Fine Arts, Boston (Tompkins Collection).

In search of a place far removed from European materialism, Gauguin moved to Tahiti, where he used native women and tropical colors to present a pessimistic view of the inevitability of the life cycle.

23-20 PAUL CÉZANNE, Mont Sainte-Victoire, 1902–1904. Oil on canvas, $2' 3\frac{1}{2}'' \times 2' 11\frac{1}{4}''$. Philadelphia Museum of Art, Philadelphia (The George W. Elkins Collection).

In his landscapes, Cézanne replaced the transitory visual effects of changing atmospheric conditions, a focus for the Impressionists, with careful analysis of the lines, planes, and colors of nature.

1 ft

The basis of Cézanne's art was his unique way of studying nature in works such as Mont Sainte-Victoire (FIG. 23-20), one of many views he painted of this mountain near his home in Aix-en-Provence. His aim was not truth in appearance, especially not photographic truth, nor was it the "truth" of Impressionism. Rather, he sought a lasting structure behind the formless and fleeting visual information the eye absorbs. Instead of employing the Impressionists' random approach when he was face-to-face with nature, Cézanne developed a more analytical style. He sought to order the lines, planes, and colors that comprised nature. He constantly and painstakingly checked his painting against the part of the real scene—he called it the "motif" he was studying at the moment. Cézanne wrote in March 1904 that his goal was "[to do] Poussin over entirely from nature . . . in the open air, with color and light, instead of one of those works imagined in a studio, where everything has the brown coloring of feeble daylight without reflections from the sky and sun." ¹³ He sought to achieve Poussin's effects of distance, depth, structure, and solidity not by using traditional perspective and chiaroscuro but by recording the color patterns an optical analysis of nature provides.

With special care, Cézanne explored the properties of line, plane, and color and their interrelationships. He studied the effect of every kind of linear direction, the capacity of planes to create the sensation of depth, the intrinsic qualities of color, and the power of colors to modify the direction and depth of lines and planes. To create the illusion of three-dimensional form and space, Cézanne focused on carefully selecting colors. He understood that the visual properties—hue, saturation, and value—of different colors vary (see "19th-Century Color Theory," page 664). Cool colors tend to recede, whereas warm ones advance. By applying to the canvas small patches of juxtaposed colors, some advancing and some receding, Cézanne

created volume and depth in his works. On occasion, the artist depicted objects chiefly in one hue and achieved convincing solidity by modulating the intensity (or saturation). At other times, he juxtaposed contrasting colors—for example, green, yellow, and red—of like saturation (usually in the middle range rather than the highest intensity) to compose specific objects, such as fruit or bowls.

In Mont Sainte-Victoire, he replaced the transitory visual effects of changing atmospheric conditions, effects that occupied Monet, with a more concentrated, lengthier analysis of the colors in large lighted spaces. The main space stretches out behind and beyond the canvas plane and includes numerous small elements, such as roads, fields, houses, and the viaduct at the far right, each seen from a slightly different viewpoint. Above this shifting, receding perspective rises the largest mass of all, the mountain, with an effect—achieved by equally stressing background and foreground contours—of being simultaneously near and far away. This portrayal approximates the real experience a person has when viewing a landscape's forms piecemeal. The relative proportions of objects vary rather than being fixed by a strict one- or twopoint perspective, such as that normally found in a photograph. Cézanne immobilized the shifting colors of Impressionism into an array of clearly defined planes that compose the objects and spaces in his scene. Describing his method in a letter to a fellow painter, he wrote:

[T] reat nature by the cylinder, the sphere, the cone, everything in proper perspective so that each side of an object or a plane is directed towards a central point. Lines parallel to the horizon give breadth . . . Lines perpendicular to this horizon give depth. But nature for us men is more depth than surface, whence the need of introducing into our light vibrations, represented by reds and yellows, a sufficient amount of blue to give the impression of air. 14

23-21 PAUL CÉZANNE, Basket of Apples, ca. 1895. Oil on canvas, $2'\frac{3}{8}'' \times 2'$ 7". Art Institute of Chicago, Chicago (Helen Birch Bartlett Memorial Collection, 1926).

Cézanne's analytical approach to painting is evident in his still lifes. He captured the solidity of bottles and fruit by juxtaposing color patches, but the resulting abstract shapes are not optically realistic.

BASKET OF APPLES Still life was another good vehicle for Cézanne's experiments, as he could arrange a limited number of selected objects to provide a well-ordered point of departure. So analytical was Cézanne in preparing, observing, and painting still lifes (in contrast to the Impressionist emphasis on the concept of spontaneity) that he had to abandon using real fruit and flowers because they tended to rot. In Basket of Apples (FIG. 23-21), the objects have lost something of their indi-

vidual character as bottles and fruit and almost become cylinders and spheres. Cézanne captured the solidity of each object by juxtaposing color patches. His interest in the study of volume and solidity is evident from the disjunctures in the painting—the table edges are discontinuous, and various objects seem to be depicted from different vantage points. In his zeal to understand three-dimensionality and to convey the placement of forms relative to the space around them, Cézanne explored his still-life arrangements from different viewpoints. This resulted in paintings that, although conceptually coherent, do not appear optically realistic. Cézanne created what might be called, paradoxically, an architecture of color.

In keeping with the modernist concern with the integrity of the painting surface, Cézanne's methods never allow the viewer to disregard the two-dimensionality of the picture plane. In this manner, Cézanne achieved a remarkable feat—presenting the viewer with two-dimensional and three-dimensional images simultaneously.

SYMBOLISM

The Impressionists and Post-Impressionists believed their emotions and sensations were important elements for interpreting nature, but the depiction of nature remained a primary focus of their efforts. By

23-22 PIERRE Puvis de Chavannes, Sacred Grove, 1884. Oil on canvas, 2' $11\frac{1}{2}'' \times 6'$ 10''. Art Institute of Chicago, Chicago (Potter Palmer Collection).

The Symbolists revered Puvis de Chavannes for his rejection of Realism. His statuesque figures in timeless poses inhabit a tranquil landscape, their gestures suggesting a symbolic ritual significance.

the end of the 19th century, the representation of nature became completely subjective. Artists no longer sought to imitate nature but created free interpretations of it, concerned solely with expressing their individual spirit. They rejected the optical world as observed in favor of a fantasy world, of forms they conjured in their free imagination, with or without reference to things conventionally seen. Color, line, and shape, divorced from conformity to the optical image, became symbols of personal emotions in response to the world. Deliberately choosing to stand outside of convention and tradition, artists spoke like prophets, in signs and symbols.

Many of the artists following this path adopted an approach to subject and form that associated them with a general European movement called Symbolism. Symbolists, whether painters or writers, disdained Realism as trivial. The task of Symbolist visual and verbal artists was not to see things but to see through them to a significance and reality far deeper than what superficial appearance gave. In this function, as the poet Arthur Rimbaud (1854–1891) insisted, artists became beings of extraordinary insight. (One group of Symbolist painters called itself the Nabis, the Hebrew word for "prophet.") Rimbaud, whose poems had great influence on the artistic community, went so far as to say, in his Letter from a Seer (1871), that to achieve the seer's insight, artists must become deranged. In effect, they must systematically unhinge and confuse the everyday faculties of sense and reason, which served only to blur artistic vision. The artists' mystical vision must convert the objects of the commonsense world into symbols of a reality beyond that world and, ultimately, a reality from within the individual. Elements of Symbolism appeared in the works of van Gogh and Gauguin, but their art differed from mainstream Symbolism in their insistence on showing unseen powers as linked to a physical reality, instead of attempting to depict an alternate, wholly interior life.

The extreme subjectivism of the Symbolists led them to cultivate all the resources of fantasy and imagination, no matter how deeply buried or obscure. Moreover, they urged artists to stand against the vulgar materialism and conventional mores of industrial and middle-class society. Above all, the Symbolists wished to purge literature and art of anything utilitarian, to cultivate an exquisite aesthetic sensitivity, and to make the slogan "art for art's sake" into a doctrine and a way of life. The subjects of the Symbolists, conditioned by this reverent attitude toward art and exaggerated aesthetic sensation, became increasingly esoteric and exotic, mysterious, visionary, dreamlike, and fantastic. Perhaps not coincidentally, contemporary with the Symbolists, Sigmund Freud (1856–1939), the founder of psychoanalysis, began the age of psychiatry with his *Interpretation of Dreams* (1900), an introduction to the concept and the world of unconscious experience.

PIERRE PUVIS DE CHAVANNES Although he never formally identified himself with the Symbolists, the French painter PIERRE PUVIS DE CHAVANNES (1824–1898) became the "prophet" of those artists. Puvis rejected Realism and Impressionism and went his own way in the 19th century, serenely unaffected by these movements. He produced an ornamental and reflective art—a dramatic rejection of Realism's noisy everyday world. In Sacred Grove (FIG. 23-22), which may have influenced Seurat's Grande Jatte (FIG. 23-15), he deployed statuesque figures in a tranquil landscape with a classical shrine. Suspended in timeless poses, the figures' contours are simple and sharp, and their modeling is as shallow as bas-relief. The calm and still atmosphere suggests some consecrated place, where all movements and gestures have a permanent ritual significance. The stillness and simplicity of the forms, the linear patterns their rhythmic contours create, and the suggestion of their symbolic weight constitute a type of anti-Realism. Puvis garnered support from a wide range of artists. The conservative French Academy and the government applauded his classicism. The Symbolists revered Puvis for his vindication of imagination and his independence from the capitalist world of materialism and the machine.

GUSTAVE MOREAU In keeping with Symbolist tenets, GUSTAVE MOREAU (1826–1898) gravitated toward subjects inspired by dreaming, which was as remote as possible from the everyday world. Moreau presented these subjects sumptuously, and his natural love of sensuous design led him to incorporate gorgeous color, intricate line, and richly detailed shape. *Jupiter and Semele* (FIG. 23-23) is one of the artist's rare finished works. The mortal girl Semele, one of Jupiter's loves, begged the god to appear to her in all his majesty. When he did, the sight was so powerful that she died from it.

23-23 Gustave Moreau, *Jupiter and Semele*, ca. 1875. Oil on canvas, $7' \times 3'$ 4". Musée Gustave Moreau, Paris.

Moreau favored subjects inspired by dreaming. In this painting, the apparition of Jupiter with his halo of thunderbolts overwhelms the mortal Semele, who dies upon seeing so powerful a sight.

671

Moreau presented the theme within an operalike setting, a towering opulent architecture. (Moreau loved the music of Richard Wagner [1813–1883] and, like that great composer, dreamed of a grand synthesis of the arts.) The painter depicted the royal hall of Olympus as shimmering in iridescent color, with tabernacles filled with the glowing shapes that enclose Jupiter like an encrustation of gems. In *Jupiter and Semele*, the rich color harmonizes with the exotic hues of Byzantine *mosaics*, medieval *enamels*, Indian *miniatures*, and the designs of exotic wares then influencing modern artists. The apparition of the god with his halo of thunderbolts overwhelms Semele, who sits in Jupiter's lap. Her languorous swoon and the suspended motion of all the entranced figures show the "beautiful inertia" that Moreau said he wished to render with all "necessary richness."

ODILON REDON Like Moreau, Odilon Redon (1840–1916) was a visionary. He had been aware of an intense inner world since childhood and later wrote of "imaginary things" that haunted him. Redon adapted the Impressionist palette and stippling brush stroke for a very different purpose. In The Cyclops (FIG. 23-24), Redon projected a figment of the imagination as if it were visible, coloring it whimsically with a rich profusion of fresh saturated hues that harmonized with the mood he felt fitted the subject. The fetal head of the shy, simpering Polyphemus, with its single huge loving eye, rises balloonlike above the sleeping Galatea. The image born of the dreaming world and the color analyzed and disassociated from the waking world come together here at the artist's will. The contrast with Raphael's representation of the same subject (FIG. 17-10) could hardly be more striking. As Redon himself observed: "All my originality consists . . . in making unreal creatures live humanly by putting, as much as possible, the logic of the visible at the service of the invisible." ¹⁵

HENRI ROUSSEAU The imagination of the French artist Henri Rousseau (1844–1910) engaged a different but equally powerful world of personal fantasy. Gauguin had journeyed to the South Seas in search of primitive innocence. Rousseau was a "primitive" without leaving Paris—an untrained amateur painter. Rousseau produced an art of dream and fantasy in a style that had its own sophistication and made its own departure from the artistic currency of the time. He compensated for his apparent visual, conceptual, and technical naïveté with a natural talent for design and an imagination teeming with exotic images of mysterious tropical landscapes. In

23-25 Henri Rousseau, Sleeping Gypsy, 1897. Oil on canvas, $4' 3'' \times 6' 7''$. Museum of Modern Art, New York (gift of Mrs. Simon Guggenheim).

In Sleeping Gypsy, Henri Rousseau depicted a doll-like but menacing lion sniffing at a recumbent dreaming figure in a mysterious landscape. The painting conjures the vulnerable subconscious during sleep.

23-24 Odilon Redon, *The Cyclops*, 1898. Oil on canvas, 2' 1" \times 1' 8". Kröller-Müller Foundation, Otterlo.

In *The Cyclops*, the Symbolist painter Odilon Redon projected a figment of the imagination as if it were visible, coloring it whimsically with a rich profusion of hues adapted from the Impressionist palette.

Sleeping Gypsy (FIG. 23-25), the recumbent figure occupies a desert world, silent and secret, and dreams beneath a pale, perfectly round moon. In the foreground, a lion that resembles a stuffed, but somehow menacing, animal doll sniffs at the gypsy. A critical encounter

1 ft

23-26 Aubrey Beardsley, *The Peacock Skirt*, 1894. Pen-and-ink illustration for Oscar Wilde's *Salomé*, $9'' \times 6\frac{5}{8}''$. Fogg Art Museum, Harvard University, Cambridge (bequest of Grenville L. Winthrop).

Banishing the Impressionist and Post-Impressionist emphasis on color, Aubrey Beardsley, a master of calligraphic line and curvilinear shapes, confined himself to patterns of black and white without shading.

impends—an encounter of the type that recalls the uneasiness of a person's vulnerable subconscious self during sleep.

AUBREY BEARDSLEY (1872–1898) was one of a circle of English artists whose work was at the intersection of Symbolism and Art Nouveau (see page 846). For *Salomé*, an illustration for a book by Oscar Wilde (1854–1900), Beardsley drew *The Peacock Skirt* (FIG. 23-26), a dazzlingly decorative composition perfectly characteristic of his style. The Japanese print influence is obvious, although Beardsley assimilated it into his unique manner. Banishing Realism as well as the Impressionists' and Post-Impressionists' emphasis on color, he confined himself to lines and to patterns of black and white, eliminating all shading. His tense, elastic line encloses sweeping curvilinear shapes that lie flat on the surface—some left almost vacant, others filled with swirling complexes of mostly organic motifs. Beardsley's unfailing sense of linear rhythms and harmonies supports his mastery of calligraphic line.

EDVARD MUNCH Also linked in spirit to the Symbolists was the Norwegian painter and graphic artist EDVARD MUNCH (1863–1944). Munch felt deeply the pain of human life. His belief that humans were powerless before the great natural forces of death and love and the emotions associated with them—jealousy, loneli-

ness, fear, desire, despair—became the theme of most of his art. Because Munch's goal was to describe the conditions of "modern psychic life," as he put it, Realist and Impressionist techniques were inappropriate, focusing as they did on the tangible world. In the spirit of Symbolism, Munch developed a style of putting color, line, and figural distortion to expressive ends. Influenced by Gauguin, Munch produced both paintings and prints whose high emotional charge was a major source of inspiration for the German Expressionists in the early 20th century (see Chapter 24).

Munch's The Scream (FIG. 23-27) exemplifies his style. The image—a man standing on a bridge or jetty in a landscape—comes from the real world, but Munch's treatment of the image departs significantly from visual reality. The Scream evokes a visceral, emotional response from the viewer because of the painter's dramatic presentation. The man in the foreground, simplified to almost skeletal form, emits a primal scream. The landscape's sweeping curvilinear lines reiterate the curvilinear shape of the mouth and head, almost like an echo, as the cry seems to reverberate through the setting. The fiery red and yellow stripes that give the sky an eerie glow also contribute to this work's resonance. Munch wrote a revealing epigraph to accompany the painting: "I stopped and leaned against the balustrade, almost dead with fatigue. Above the blue-black fjord hung the clouds, red as blood and tongues of fire. My friends had left me, and alone, trembling with anguish, I became aware of the vast, infinite cry of nature." ¹⁶ Appropriately, the original title of this work was *Despair*.

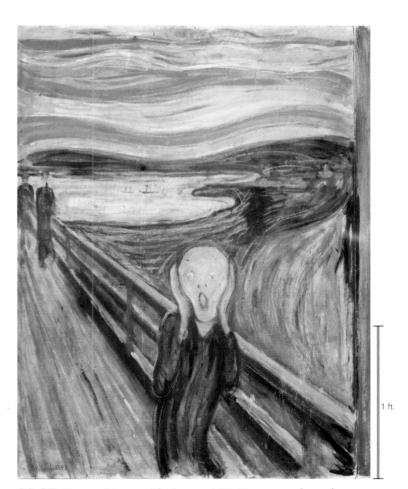

23-27 Edvard Munch, *The Scream*, 1893. Tempera and pastels on cardboard, 2' $11\frac{3}{4}'' \times 2'$ 5". National Gallery, Oslo.

Although grounded in the real world, *The Scream* departs significantly from visual reality. Munch used color, line, and figural distortion to evoke a strong emotional response from the viewer.

23-28 Gustav Klimt, The Kiss, 1907–1908. Oil on canvas, 5' $10\frac{3}{4}$ " \times 5' $10\frac{3}{4}$ ". Österreichische Galerie Belvedere, Vienna.

In this opulent Viennese finde-siècle painting, Gustav Klimt revealed only a small segment of each lover's body. The rest of his painting dissolves into shimmering, extravagant flat patterning.

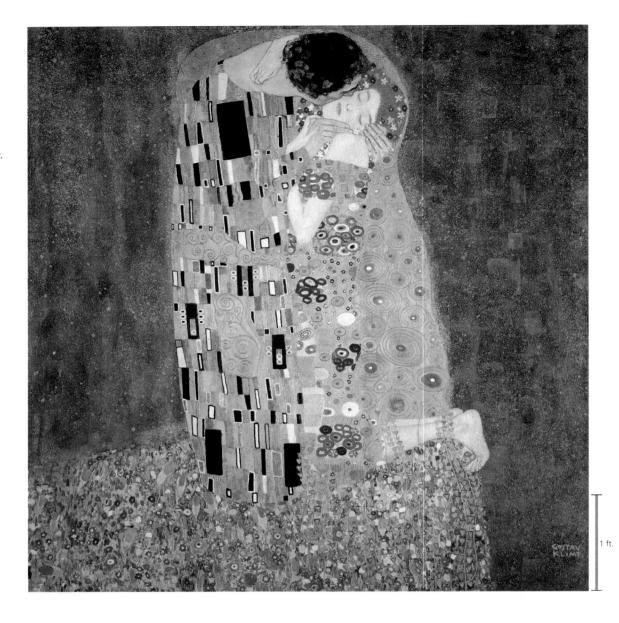

FIN-DE-SIÈCLE Historians have adopted the term *fin-de-siècle*, which means "end of the century," to describe the culture of the late 1800s. This designation is not merely chronological but also refers to a certain sensibility. The increasingly large and prosperous middle classes aspired to the advantages the aristocracy traditionally enjoyed. They too strove to live "the good life," which evolved into a culture of decadence and indulgence. Characteristic of the fin-de-siècle period was an intense preoccupation with sexual drives, powers, and perversions. People at the end of the century also immersed themselves in an exploration of the unconscious. This culture was unrestrained and freewheeling, but the determination to enjoy life masked an anxiety prompted by significant political upheaval and an uncertain future. The country most closely associated with fin-de-siècle culture was Austria.

GUSTAV KLIMT The Viennese artist Gustav Klimt (1863–1918) captured this period's flamboyance in his work but tempered it with unsettling undertones. In *The Kiss* (FIG. **23-28**), Klimt depicted a couple locked in an embrace. All that is visible of the couple, however, is a small segment of each person's body. The rest of the painting dissolves into shimmering, extravagant flat patterning. This patterning has clear ties to Art Nouveau and to the Arts and Crafts movement (see page 678) and also evokes the conflict between two- and three-dimensionality intrinsic to the work of Degas and other modernists.

Paintings such as *The Kiss* were visual manifestations of fin-de-siècle spirit because they captured a decadence conveyed by opulent and sensuous images.

GERTRUDE KÄSEBIER Photography, which during the 19th century most people regarded as the ultimate form of Realism, could also be manipulated by artists to produce effects more akin to painting than to factual records of contemporary life. After the first great breakthroughs, which bluntly showed what was before the eye, some photographers began to pursue new ways of using the medium as a vehicle of artistic expression. One of the leading practitioners of what might be called the pictorial style in photography was the American Gertrude Käsebier (1852–1934). Käsebier took up photography in 1897 after raising a family and working as a portrait painter. She soon became famous for photographs with symbolic themes, such as Blessed Art Thou among Women (FIG. 23-29). The title repeats the phrase the angel Gabriel used in the New Testament to announce to the Virgin Mary that she will be the mother of Jesus. In the context of Käsebier's photography, the words suggest a parallel between the biblical "Mother of God" and the modern mother in the image, who both protects and sends forth her daughter. The white setting and the mother's pale gown shimmer in soft focus behind the serious girl, who is dressed in darker tones and captured

23-29 Gertrude Käsebier, Blessed Art Thou among Women, 1899. Platinum print on Japanese tissue, $9\frac{3}{8}'' \times 5\frac{1}{2}''$. Museum of Modern Art, New York (gift of Mrs. Hermine M. Turner).

Gertrude Käsebier was able to inject a sense of the spiritual and the divine into scenes from everyday life. The soft focus of this photograph invests the whole scene with an aura of otherworldly peace.

with sharper focus. Käsebier deliberately combined an out-of-focus background with a sharp or almost-sharp foreground in order to achieve an expressive effect by blurring the entire image slightly. In *Blessed Art Thou*, the soft focus invests the whole scene with an aura of otherworldly peace. The photograph showcases Käsebier's ability to inject a sense of the spiritual and the divine into scenes from everyday life.

SCULPTURE

The three-dimensional art of sculpture was not suited to capturing the optical sensations many painters favored in the later 19th century. Its very nature—its tangibility and solidity—suggests permanence. Consequently, the sculptors of this period pursued artistic

23-30 Augustus Saint-Gaudens, Adams Memorial, Rock Creek Cemetery, Washington, 1891. Bronze, 5′ 10″ high. Smithsonian American Art Museum, Washington, D.C.

For the Adams Memorial, Augustus Saint-Gaudens chose a classical mode of representation. A woman of majestic bearing sits in mourning. The gesture of her right arm derives from ancient Roman statuary.

goals markedly different from those of contemporaneous painters and photographers.

AUGUSTUS SAINT-GAUDENS One artist who used sculpture to express timeless ideals rather than to depict transitory moments was the American Augustus Saint-Gaudens (1848–1907), who trained in France. When Saint-Gaudens received the commission to produce a memorial monument honoring Mrs. Henry Adams (FIG. 23-30), he chose a classical mode of representation, sculpting a woman of majestic bearing sitting in mourning. The voluminous garment that enfolds her body also partly shadows her classically beautiful face. The gesture of the woman's right arm, which reproduces a common motif in ancient Roman portraits of women, only slightly stirs the immobility of her form, set in an attitude of eternal vigilance.

23-31 JEAN-BAPTISTE CARPEAUX, *Ugolino and His Children*, 1865–1867. Marble, 6′ 5″ high. Metropolitan Museum of Art, New York (Josephine Bay Paul and C. Michael Paul Foundation, Inc., and the Charles Ulrich and Josephine Bay Foundation, Inc., gifts, 1967).

Based on Dante's *Inferno*, this group represents Ugolino biting his hands in despair as he and his sons await death by starvation. The twisted forms suggest the self-devouring torment of frustration.

JEAN-BAPTISTE CARPEAUX In France, JEAN-BAPTISTE CARPEAUX (1827–1875) combined an interest in Realism with a love of ancient, Renaissance, and Baroque sculpture. He based his group Ugolino and His Children (FIG. 23-31) on a passage in Dante's Inferno (33.58-75) in which Count Ugolino and his four sons starve to death while shut up in a tower. In Hell, Ugolino relates to Dante how, in a moment of extreme despair, he bit both his hands in grief. His children, thinking he did it because of his hunger, offered him their own flesh as food. In Carpeaux's statuary group, the powerful forms—twisted, intertwined, and densely concentrated—suggest the self-devouring torment of frustration and despair that wracks the unfortunate Ugolino. A careful student of Michelangelo's male figures, Carpeaux also said he had the *Laocoön* group (FIG. 5-88) in mind. Certainly, the storm and stress of Ugolino and His Children recall similar characteristics of that ancient work. Regardless of these influences, the sense of vivid reality in the anatomy of Carpeaux's figures shows the artist's interest in study from life.

AUGUSTE RODIN The leading French sculptor of the later 19th century was AUGUSTE RODIN (1840–1917), who conceived and executed his sculptures with a Realist sensibility. Like Muybridge and Eakins (see Chapter 22), Rodin was fascinated by the human body in motion (see "Rodin on Movement in Art and Photog-

raphy," page 677). He was also well aware of the innovations of the Impressionists. Although color was not a significant factor in Rodin's work, the influence of Impressionism is evident in the artist's abiding concern for the effect of light on the three-dimensional surface. When focusing on the human form, he joined his profound knowledge of anatomy and movement with special attention to the body's exterior, saying, "The sculptor must learn to reproduce the surface, which means all that vibrates on the surface, soul, love, passion, life. . . . Sculpture is thus the art of hollows and mounds, not of smoothness, or even polished planes." ¹⁷ Primarily a modeler of pliable material rather than a carver of hard wood or stone, Rodin worked his surfaces with fingers sensitive to the subtlest variations of surface, catching the fugitive play of constantly shifting light on the body. In his studio, he often would have a model move around in front of him while he modeled sketches with coils of clay.

In Walking Man (FIG. 23-32), a preliminary study for the sculptor's Saint John the Baptist Preaching, Rodin succeeded in representing the momentary in cast bronze. He portrayed the headless and armless figure in midstride at the moment when weight is transferred across the pelvis from the back leg to the front. In addition to

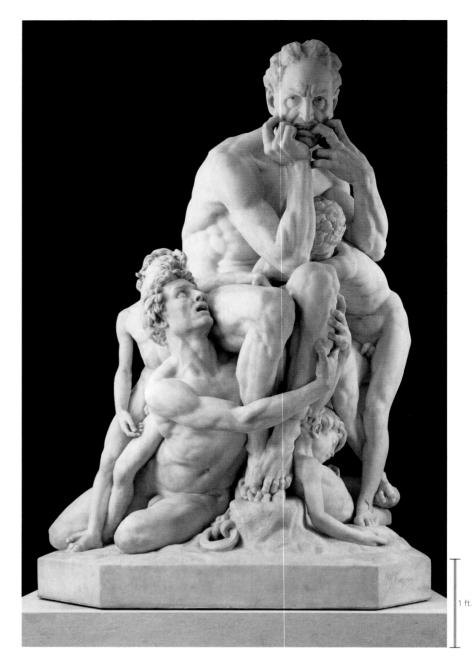

capturing the sense of the transitory, Rodin demonstrated his mastery of realistic detail in his meticulous rendition of muscle, bone, and tendon.

BURGHERS OF CALAIS Rodin also made many nude and draped studies for each of the figures in one of his most ambitious works—the life-size group Burghers of Calais (FIG. 23-33). This cast bronze monument commemorated a heroic episode in the Hundred Years' War. During the English siege of Calais, France, in 1347, six of the city's leading citizens agreed to offer their lives in return for the English king's promise to lift the siege and spare the rest of the populace. Each of the bedraggled-looking figures is a convincing study of despair, resignation, or quiet defiance. Rodin enhanced the psychic effects through his choreographic placement of the group members. Rather than clustering in a tightly formal composition, the burghers (middle-class citizens) seem to wander aimlessly. The roughly textured surfaces add to the pathos of the figures and compel the viewer's continued interest. Rodin designed the monument without the traditional high base in the hope that the citizens of Calais would be inspired by the sculptural representation of their ancestors stand-

Rodin on Movement in Art and Photography

hotography had a profound effect on 19th-century art, and many artists used photographs as an aid in capturing "reality" on canvas or in stone. Eadweard Muybridge's photographs of a galloping horse (FIG. 22-54), for example, definitively established that at certain times all four hooves of the animal are in the air. But not all artists believed that photography was "true to life." The sculptor Auguste Rodin (FIGS. 23-32 and 23-33) was one of the "doubters."

I have always sought to give some indication of movement [in my statues]. I have very rarely represented complete repose. I have always endeavoured to express the inner feelings by the mobility of the muscles. . . . The illusion of life is obtained in our art by good modelling and by movement. . . . [M] ovement is the transition from one attitude to another. . . . Have you ever attentively examined instantaneous photographs of walking figures? . . . [Photographs] present the odd appearance of a man suddenly stricken with paralysis and petrified in his pose. . . . If, in fact, in instantaneous photographs, the figures, though taken while moving, seem suddenly fixed in mid-air, it is because, all parts of the body being reproduced exactly at the same twentieth or fortieth of a second, there is no progressive development of movement as there is in art. . . . [I]t is the artist who is truthful and it is photography which lies, for in reality time does not stop.*

* Translated by Robin Fedden, in Elizabeth Gilmore Holt, ed., From the Classicists to the Impressionists: Art and Architecture in the 19th Century (New Haven: Yale University Press, 1966; reprint 1986), 406–409.

23-32 Auguste Rodin, *Walking Man*, 1905. Bronze, 6' $11\frac{3}{4}$ " high. Musée d'Orsay, Paris.

In this study for a statue of Saint John the Baptist, Rodin depicted a headless and armless figure in mid-stride. *Walking Man* demonstrates Rodin's mastery of anatomy and his ability to capture transitory motion.

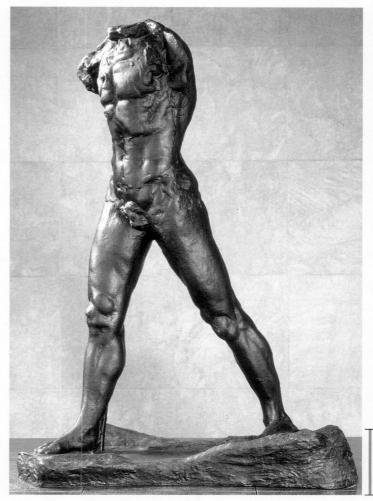

1 ft.

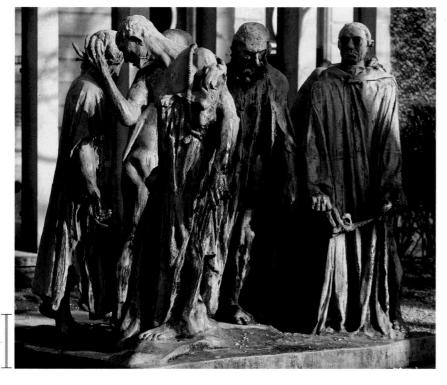

ing eye-level in the city center and preparing eternally to set off on their sacrificial journey. However, the city officials who commissioned the group found Rodin's Realist vision so offensive that they banished the monument to a remote site and modified the work's impact by placing it high on an isolating pedestal.

Rodin's ability to capture the quality of the transitory through his highly textured surfaces while revealing larger themes and deeper, lasting sensibilities is one of the reasons he had a strong influence on 20th-century artists. Because many of his works, such as *Walking Man*, were deliberate fragments, he was also instrumental in creating a taste for the incomplete, an aesthetic that many later sculptors embraced enthusiastically.

23-33 Auguste Rodin, *Burghers of Calais*, 1884–1889. Bronze, 6' $10\frac{1}{2}''$ high, 7' 11'' long, 6' 6'' deep. Musée Rodin, Paris

Rodin's bronze group commemorates an episode during the Hundred Years' War, when six Calais citizens offered their lives to save their city. Each highly textured figure is a convincing character study.

ARCHITECTURE AND DECORATIVE ARTS

The decisive effects of industrialization were impossible to ignore, and although many artists embraced this manifestation of "modern life" or at least explored its effects, other artists decried the impact of rampant industrialism. The latter response came from the Arts and Crafts movement in England. This movement, which developed during the last decades of the 19th century, was shaped by the ideas of John Ruskin, the critic who skewered Whistler's *Nocturne* (FIG. 23-13), and the artist William Morris. Both men shared a distrust of machines and industrial capitalism, which they believed alienated workers from their own nature. Accordingly, they advocated an art "made by the people for the people as a joy for the maker and the user." This condemnation of capitalism and support for manual laborers were compatible with socialism, and many artists in the Arts and Crafts movement, especially in England, considered themselves socialists and participated in the labor movement.

This democratic, or at least populist, attitude carried over to the art they produced as well. Members of the Arts and Crafts movement dedicated themselves to producing functional objects with high aesthetic value for a wide public. The style they advocated was based on natural, rather than artificial, forms and often consisted of repeated designs of floral or geometric patterns. For Ruskin, Morris, and others in the Arts and Crafts movement, high-quality artisanship and honest labor were crucial.

WILLIAM MORRIS In order to promote these ideals, WILLIAM MORRIS (1834–1896) formed a decorating firm dedicated to Arts and Crafts principles: Morris, Marshall, Faulkner, and Company, Fine Arts Workmen in Painting, Carving, Furniture, and Metals. His company did a flourishing business producing wallpaper, textiles, tiles, furni-

ture, books, rugs, stained glass, and pottery. In 1867, Morris received the commission to decorate the Green Dining Room (FIG. 23-34) at London's South Kensington Museum (now the Victoria & Albert Museum), the center of public art education and home of decorative art collections. The range of room features—windows, lights, and *wainscoting* (paneling on the lower part of interior walls)—that Morris decorated to create this unified, beautiful, and functional environment is all-encompassing. Nothing escaped his eye. Morris's design for this room also reveals the penchant of Arts and Crafts designers for intricate patterning.

CHARLES RENNIE MACKINTOSH Numerous Arts and Crafts societies in America, England, and Germany carried on this ideal of artisanship. In Scotland, Charles Rennie Mackintosh (1868–1929) designed a number of tearooms, including the Ladies Luncheon Room (Fig. 23-35) located in the Ingram Street Tea Room in Glasgow. The room decor is consistent with Morris's vision of a functional, exquisitely designed art. The chairs, stained-glass windows, and large panels of colored gesso with twine, glass beads, thread, mother-of-pearl, and tin leaf (made by Margaret Macdonald Mackintosh [1864–1933], an artist-designer and Mackintosh's wife, who collaborated with him on many projects) are all pristinely geometric and rhythmical in design.

ART NOUVEAU An important international architectural and design movement that developed out of the ideas the Arts and Crafts movement promoted was *Art Nouveau* (New Art), which took its name from a shop in Paris called L'Art Nouveau. Known by that name in France, Belgium, Holland, England, and the United States, the style had other names elsewhere: *Jugendstil* in Austria and Germany (after the magazine *Der Jugend*, "youth"), *Modernismo* in Spain, and *Floreale* in Italy. Proponents of this movement tried to

23-34 WILLIAM MORRIS, Green Dining Room, South Kensington Museum (now Victoria & Albert Museum), London, England, 1867.

William Morris was a founder of the Arts and Crafts movement. His Green Dining Room exemplifies the group's dedication to creating intricately patterned yet unified and functional environments.

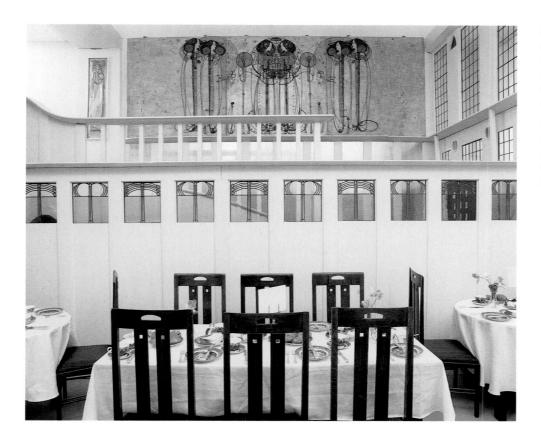

23-35 CHARLES RENNIE MACKINTOSH and MARGARET MACDONALD MACKINTOSH, reconstruction (1992–1995) of Ladies Luncheon Room, Ingram Street Tea Room, Glasgow, Scotland, 1900–1912. Glasgow Art Galleries and Museum, Glasgow.

Charles Mackintosh's Ladies Luncheon Room features functional and exquisitely designed decor, including stained-glass windows and pristinely geometric furnishings by Margaret Macdonald Mackintosh.

synthesize all the arts in a determined attempt to create art based on natural forms that could be mass-produced for a large audience. The Art Nouveau style adapted the twining-plant form to the needs of architecture, painting, sculpture, and all of the decorative arts.

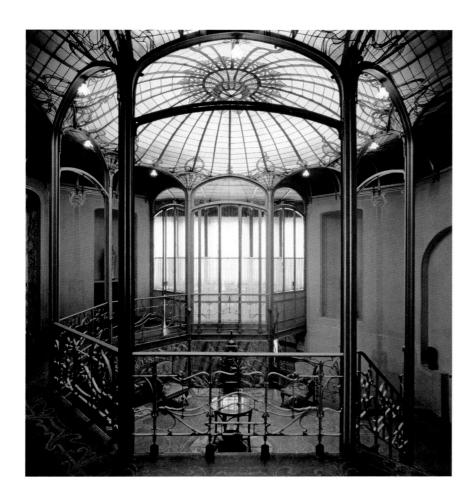

VICTOR HORTA The mature Art Nouveau style of the 1890s appears in the houses the Belgian architect VICTOR HORTA (1861–1947) designed. The staircase (FIG. 23-36) in the Van Eetvelde House, which Horta built in Brussels in 1895, is a characteristic example.

Every detail functions as part of a living whole. Furniture, drapery folds, veining in the lavish stone paneling, and the patterning of the door moldings join with real plants to provide graceful counterpoints for the twining-plant theme. Metallic tendrils curl around the railings and posts, delicate metal tracery fills the glass dome, and floral and leaf motifs spread across the fabric panels of the screen.

The Art Nouveau style reflects several influences. In addition to the rich, foliated two-dimensional ornament of Arts and Crafts design and that movement's respect for materials, the sinuous whiplash curve of Japanese print designs inspired Art Nouveau artists. Art Nouveau also borrowed from the expressively patterned styles of van Gogh (FIGS. 23-16 and 23-17), Gauguin (FIGS. 23-18 and 23-19), and their Post-Impressionist and Symbolist contemporaries.

23-36 VICTOR HORTA, staircase in the Van Eetvelde House, Brussels, Belgium, 1895.

The Art Nouveau movement was an attempt to create art and architecture based on natural forms. In this room, every detail conforms to the theme of the twining plant and functions as part of a living whole.

23-37 LOUIS COMFORT TIFFANY, lotus table lamp, ca. 1905. Leaded Favrile glass, mosaic, and bronze, $2' 10^{\frac{1}{2}''}$ high. Private collection.

Tiffany's lamps of leaded Favrile stained glass (a patented Tiffany technique), mosaic, and bronze, based on the curvilinear floral forms of the lotus, exemplify the sensuous opulence of the Art Nouveau style.

LOUIS COMFORT TIFFANY The sensuous opulence of Art Nouveau is also on display in the stained-glass lamps of Louis Comfort Tiffany (1848–1933). His lotus table lamp (FIG. 23-37), constructed of leaded glass (often *Favrile*, a type of glass Tiffany patented), mosaic, and bronze, is based on the curvilinear floral forms of the lotus. Intended for wealthy buyers, this was the most expensive lamp Tiffany Studios produced in 1906. Because of the careful attention to detail required to produce lamps of this type, Tiffany's workshop could make only one at a time. This ensured the high-quality artisanship the Arts and Crafts movement so prized.

ANTONIO GAUDI Art Nouveau achieved its most personal expression in the work of the Spanish architect Antonio Gaudi (1852–1926). Before becoming an architect, Gaudi had trained as an ironworker. Like many young artists of his time, he longed to create a style that was both modern and appropriate to his country. Taking inspiration from Moorish-Spanish architecture and from the simple architecture of his native Catalonia, Gaudi developed a personal aesthetic. He conceived a building as a whole and molded it almost as a sculptor might shape a figure from clay. Although work on his designs proceeded slowly under the guidance of his intuition and im-

agination, Gaudi was a master who invented many new structural techniques that facilitated construction of his visions. His Barcelona apartment house, Casa Milá (FIG. 23-38), is a wondrously free-form mass wrapped around a street corner. Lacy iron railings enliven the swelling curves of the cut-stone facade. Dormer windows peep from the undulating tiled roof, on which fantastically writhing chimneys poke energetically into the air above. The rough surfaces of the stone walls suggest naturally worn rock. The entrance portals look like eroded sea caves, but their design also may reflect the excitement that swept Spain following the 1879 discovery of Paleolithic cave paintings (FIG. 1-9) at Altamira. Gaudi felt that each of his buildings was symbolically a living thing. The passionate naturalism of his Casa Milá is the spiritual kin of early-20th-century Expressionist painting and sculpture (see Chapter 24).

23-38 Antonio Gaudi, Casa Milá, Barcelona, Spain, 1907.

The Spanish Art Nouveau architect Antonio Gaudi conceived this apartment house as if it were a gigantic sculpture to be molded from clay. Twisting chimneys cap the undulating roof and walls.

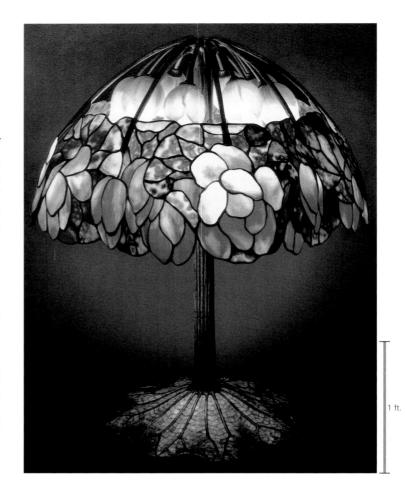

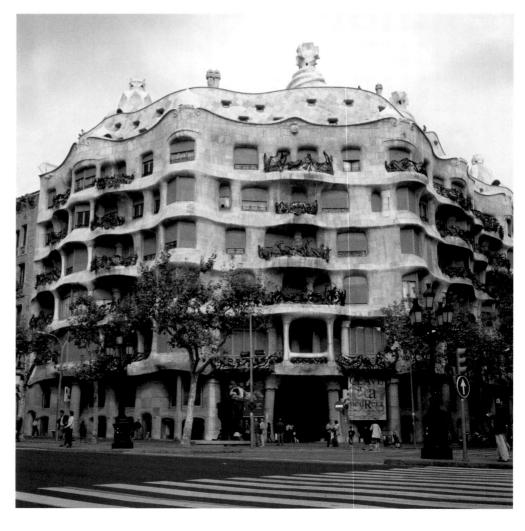

ALEXANDRE-GUSTAVE EIFFEL In the later 19th century, new technologies and the changing needs of urbanized, industrialized society affected architecture throughout the Western world. Since the 18th century, bridges had been built of cast iron (FIG. 21-11), which permitted engineering advancements in the construction of larger, stronger, and more fire-resistant structures. Steel, available after 1860, allowed architects to enclose ever larger spaces, such as those found in railroad stations (FIG. 23-4) and exposition halls. The Realist impulse also encouraged architectural designs that honestly expressed a building's purpose, rather than elaborately disguising its function. The elegant metal skeleton structures of the French engineer-architect Alexandre-Gustave Eiffel (1832-1923) constituted responses to this idea and were an important contribution to the development of the 20th-century skyscraper. A native of Burgundy, Eiffel trained in Paris before beginning a distinguished career designing exhibition halls, bridges, and the interior armature for France's anniversary gift to the United States-Frédéric Auguste Bartholdi's Statue of Liberty.

Eiffel designed his best-known work, the Eiffel Tower (FIG. 23-1), for a great exhibition in Paris in 1889. Originally seen as a symbol of modern Paris and still considered a symbol of 19thcentury civilization, the elegant iron tower thrusts its needle shaft 984 feet above the city, making it at the time of its construction (and for some time thereafter) the world's tallest structure. The tower rests on four giant supports connected by gracefully arching openframe skirts that provide a pleasing mask for the heavy horizontal girders needed to strengthen the legs. Visitors can take two elevators to the top, or they can use the internal staircase. Either way, the view of Paris and the Seine from the tower is incomparable, as is the design of the tower itself. The transparency of Eiffel's structure blurs the distinction between interior and exterior to an extent never before achieved or even attempted. This interpenetration of inner and outer space became a hallmark of 20th-century art and architecture. Eiffel's tower and the earlier iron skeletal frames designed by Labrouste (FIG. 22-47) and Paxton (FIG. 22-48) jolted the architectural profession into a realization that modern materials and processes could germinate a completely new style and a radically innovative approach to architectural design.

AMERICAN SKYSCRAPERS The desire for greater speed and economy in building, as well as for a reduction in fire hazards, prompted the use of cast and wrought iron for many building programs, especially commercial ones. Designers in both England and the United States enthusiastically developed cast-iron architecture until a series of disastrous fires in the early 1870s in New York, Boston, and Chicago demonstrated that cast iron by itself was far from impervious to fire. This discovery led to encasing the metal in masonry, combining the first material's strength with the second's fire resistance.

In cities, convenience required closely grouped buildings, and increased property values forced architects literally to raise the roof. Even an attic could command high rentals if the builders installed one of the new elevators, used for the first time in the Equitable Building in New York (1868–1871). Metal, which could support these towering structures, gave birth to the American skyscraper.

HENRY HOBSON RICHARDSON One of the pioneers in designing these modern commercial structures was Henry Hobson Richardson (1838–1886), but he also had profound respect for earlier architectural styles. Because Richardson had a special fondness for the Romanesque architecture of the Auvergne area in France, he frequently used heavy round arches and massive masonry walls. Architectural historians sometimes consider his work to constitute a

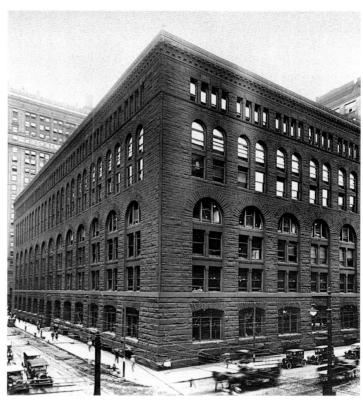

23-39 Henry Hobson Richardson, Marshall Field wholesale store, Chicago, 1885–1887 (demolished 1930).

Richardson was a pioneer in designing commercial structures using a cast-iron skeleton encased in fire-resistant masonry. This construction technique permitted him to open up the walls with large windows.

Romanesque revival related to the Neo-Gothic style (FIG. 22-44), but this designation does not do credit to the originality and quality of most of the buildings Richardson designed during his brief 18-year practice. Trinity Church in Boston and his smaller public libraries, residences, railroad stations, and courthouses in New England and elsewhere best demonstrate his vivid imagination and the solidity (the sense of enclosure and permanence) so characteristic of his style. However, his most important and influential building was the Marshall Field wholesale store (FIG. 23-39) in Chicago, begun in 1885 and later demolished. This vast building, occupying a city block and designed for the most practical of purposes, recalled historical styles without imitating them at all. The tripartite elevation of a Renaissance palace (FIG. 16-36) or of the Roman aqueduct (FIG. 7-33) near Nîmes, France, may have been close to Richardson's mind. Yet he used no classical ornament, made much of the massive courses of masonry, and, in the strong horizontality of the windowsills and the interrupted courses that defined the levels, stressed the long sweep of the building's lines as well as its ponderous weight. Although the structural frame still lay behind and in conjunction with the masonry screen, the great glazed arcades opened up the walls of the monumental store. They pointed the way to the modern total penetration of walls and the transformation of them into mere screens or curtains that serve both to echo the underlying structural grid and to protect it from the weather.

LOUIS HENRY SULLIVAN As skyscrapers proliferated, architects refined the visual vocabulary of these buildings. Louis Henry Sullivan (1856–1924), whom many architectural historians call the first truly modern architect, arrived at a synthesis of industrial structure and ornamentation that perfectly expressed the spirit

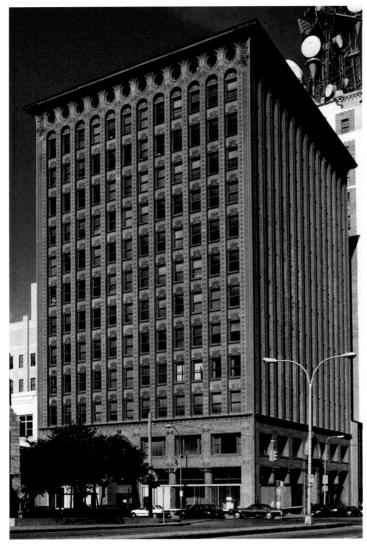

23-40 Louis Henry Sullivan, Guaranty (Prudential) Building, Buffalo, New York, 1894–1896.

Louis Sullivan used the latest technologies to create this light-filled, well-ventilated Buffalo office building. He added ornate surface embellishments to impart a sense of refinement and taste.

of late-19th-century commerce. To achieve this, he employed the latest technological developments to create light-filled, well-ventilated office buildings and adorned both exteriors and interiors with ornate embellishments. Such decoration served to connect commerce and culture and imbued these white-collar workspaces with a sense of refinement and taste. These characteristics are evident in the Guaranty (Prudential) Building (FIG. 23-40) in Buffalo, New York, built between 1894 and 1896. The structure is steel, sheathed with terracotta. The imposing scale of the building and the regularity of the window placements served as an expression of the large-scale, refined, and orderly office work that took place within. Sullivan tempered the severity of the structure with lively ornamentation, both on the piers and cornice on the exterior of the building and on the stairway balustrades, elevator cages, and ceiling in the interior. The

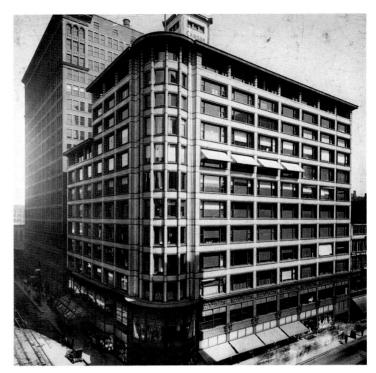

23-41 Louis Henry Sullivan, Carson, Pirie, Scott Building, Chicago, 1899–1904.

Sullivan's slogan was "form follows function." He tailored the design of this steel, glass, and stone Chicago department store to meet the needs of its employees and customers.

Guaranty Building illustrates Sullivan's famous dictum that "form follows function," which became the slogan of many early-20th-century architects. Still, Sullivan did not advocate a rigid and doctrinaire correspondence between exterior and interior design. Rather, he espoused a free and flexible relationship—one his pupil Frank Lloyd Wright (see Chapter 24) later described as similar to that between the hand's bones and tissue.

Sullivan also designed the Carson, Pirie, Scott Building (FIG. 23-41) in Chicago. Built between 1899 and 1904, this department store required broad, open, well-illuminated display spaces. Sullivan again used a minimal structural steel skeleton to achieve this goal. The architect gave over the lowest two levels of the building to an ornament in cast iron (of his invention) made of wildly fantastic motifs. He regarded the display windows as pictures and as such felt they merited elaborate frames. As in the Guaranty Building, Sullivan revealed his profound understanding of the maturing consumer economy and tailored the Chicago department store to meet the functional and symbolic needs of its users.

Thus, in architecture as well as in the pictorial arts, the late 19th century was a period during which artists challenged traditional modes of expression, often emphatically rejecting the past. Architects and painters as different as Sullivan, Monet, van Gogh, and Cézanne, each in his own way, contributed significantly to the entrenchment of modernism as the new cultural orthodoxy of the early 20th century (see Chapter 24).

EUROPE AND AMERICA, 1870 TO 1900

IMPRESSIONISM

- A hostile critic applied the term *Impressionism* to the paintings of Claude Monet because of their sketchy quality. The Impressionists—Monet, Pierre-Auguste Renoir, Edgar Degas, and others—strove to capture fleeting moments and transient effects of light and climate on canvas. Monet, for example, repeatedly painted Rouen Cathedral at different times of day.
- The Impressionists also focused on recording the contemporary urban scene in Paris. They frequently painted bars, dance halls, the ballet, wide boulevards, and railroad stations.
- Complementing the Impressionists' sketchy, seemingly spontaneous brush strokes are the compositions of their paintings. Reflecting the influence of Japanese prints and photography, Impressionist works often have arbitrarily cut-off figures and settings seen at sharply oblique angles.

- Post-Impressionism is not a unified style. The term refers to the group of late-19th-century artists who followed the Impressionists and took painting in new directions.
- Georges Seurat refined the Impressionist approach to color and light into pointillism—the disciplined application of pure color in tiny daubs that become recognizable forms only when seen from a distance. Vincent van Gogh explored the capabilities of colors and distorted forms to express emotions, as in his dramatic depiction of the sky in *Starry Night*. Paul Gauguin, another admirer of Japanese prints, moved away from Impressionism in favor of large areas of flat color bounded by firm lines. Paul Cézanne replaced the transitory visual effects of the Impressionists with a rigorous analysis of the lines, planes, and colors that make up landscapes and still lifes.

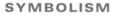

- The Symbolists disdained Realism as trivial and sought to depict a reality beyond that of the everyday world. They rejected materialism and celebrated fantasy and imagination. Their subjects were often mysterious, exotic, and sensuous.
- Gustave Moreau, Odilon Redon, and Henri Rousseau were the leading French Symbolists. Rousseau's Sleeping Gypsy, which depicts the world of the subconscious during sleep, is a characteristic example of Symbolist painting.

SCULPTURE

Sculpture is not suited to capturing transitory optical effects or exploring the properties of color and line, and late-19th-century sculptors pursued goals different from those of the Impressionists and Post-Impressionists. The leading figure of the era was Auguste Rodin, who explored Realist themes and the representation of movement, as in his moving portrayal of six leading citizens of Calais who sacrificed their lives for their countrymen. He also made statues that were deliberate fragments, creating a taste for the incomplete that appealed to many later sculptors.

ARCHITECTURE AND DECORATIVE ARTS

- Not all artists embraced the industrialization that transformed daily life during the 19th century. The Arts and Crafts movement in England and the international Art Nouveau style formed in opposition to modern mass production. Both schools advocated natural forms and high-quality craftsmanship.
- New technologies and the changing needs of industrialized society transformed Western architecture in the late 19th century. The exposed iron skeleton of the Eiffel Tower, which blurs the distinction between interior and exterior, jolted architects into a realization that modern materials and processes could revolutionize architectural design. In the United States, Henry Hobson Richardson and Louis Sullivan were pioneers in designing the first metal, stone, and glass skyscrapers.

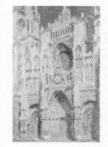

Monet, Rouen Cathedral, 1894

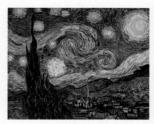

Van Gogh, Starry Night, 1889

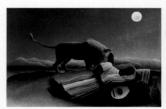

Rousseau, Sleeping Gypsy, 1897

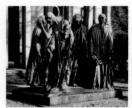

Rodin, *Burghers of Calais*, 1884–1889

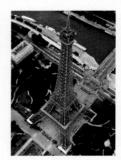

Eiffel, Eiffel Tower, Paris, 1889

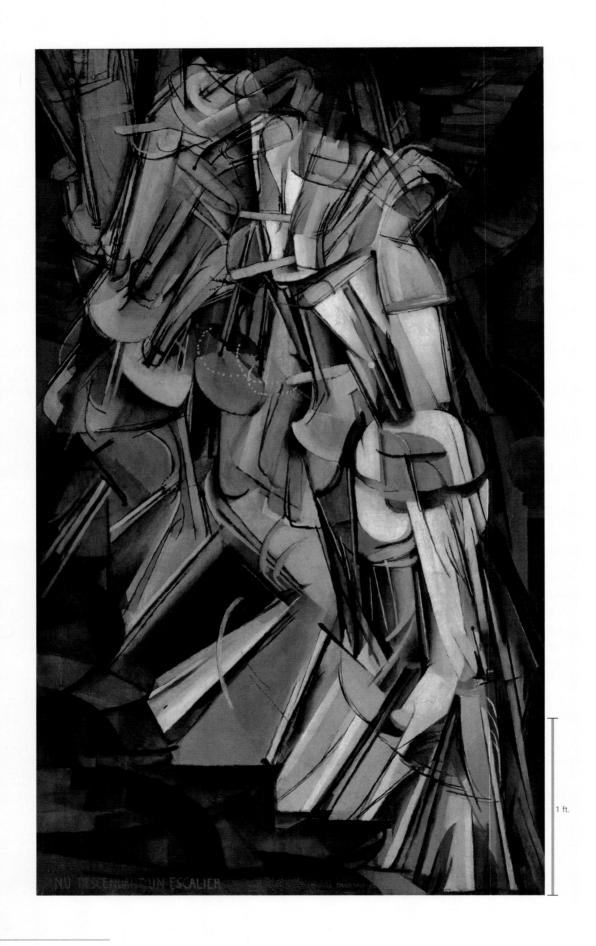

24-1 Marcel Duchamp, *Nude Descending a Staircase*, *No. 2*, 1912. Oil on canvas, $4'10'' \times 2'11''$. Philadelphia Museum of Art, Philadelphia (Louise and Walter Arensberg Collection).

The Armory Show of 1913 introduced European avant-garde art to America. Duchamp's figure in motion down a staircase in a time continuum reveals the artist's indebtedness to Cubism and Futurism.

EUROPE AND AMERICA, 1900 TO 1945

T he first half of the 20th century was a period of significant upheaval worldwide. Between 1900 and 1945, the major industrial powers expanded their colonial empires, fought two global wars, witnessed the rise of Communism, Fascism, and Nazism, and suffered the Great Depression. These decades were also a time of radical change in the arts when painters and sculptors challenged some of the most basic assumptions about the purpose of art and what form an artwork should take.

During the 19th century, the development of modern nation-states and advanced industrial societies in Europe and America had led to frenzied imperialist expansion. By the beginning of the 20th century (MAP 24-1), Britain, France, Germany, Belgium, Italy, Spain, and Portugal all had footholds in Africa. In Asia, Britain ruled India, the Dutch controlled Indonesia's vast archipelago, the French held power in Indochina, and the Russians ruled Central Asia and Siberia. Japan began rising as a new and formidable Pacific power that would stake its claims to empire in the 1930s. This imperialism was capitalist and expansionist, establishing colonies as raw-material sources, as manufacturing markets, and as territorial acquisitions. Early-20th-century colonialism also often had the missionary dimension of bringing the "light" of Christianity and civilization to "backward peoples" and educating "inferior races."

Nationalism and rampant imperialism also led to competition. Eventually, countries negotiated alliances to protect their individual state interests. The conflicts between the two major blocs—the Triple Alliance (Germany, Austria-Hungary, and Italy) and the Triple Entente (Russia, France, and Great Britain)—led to World War I, which began in 1914. The slaughter and devastation of the Great War lasted until 1918. Not only were more than nine million soldiers killed in battle, but the introduction of poison gas in 1915 added to the horror of humankind's inhumanity to itself. Although the United States tried to remain neutral, it finally felt compelled to enter the war in 1917. In 1919, the 27 Allied nations negotiated the official end of World War I, whose legacy was widespread misery, social disruption, and economic collapse—the ultimate effects of nationalism, imperialism, and expansionist goals.

The Russian Revolution exacerbated the global chaos when it erupted in 1917. Dissatisfaction with the regime of Tsar Nicholas II (r. 1894–1917) had led workers to stage a general strike, and the monarchy's rule ended with the tsar's abdication in March. In late 1917 the Bolsheviks wrested control of the country

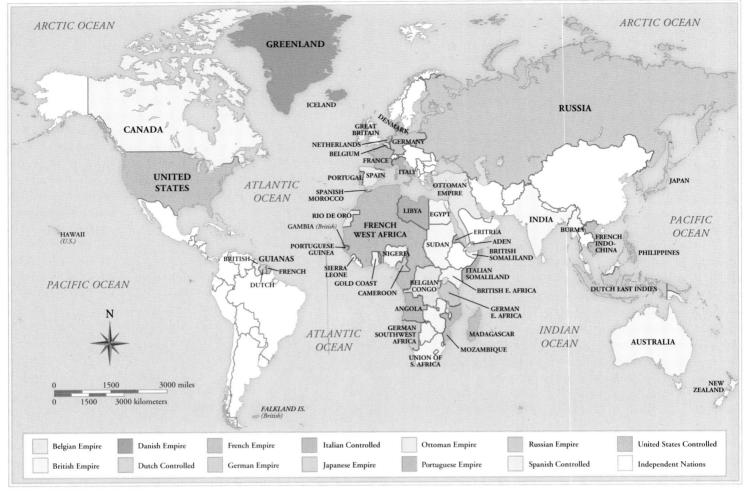

MAP 24-1 Colonial empires around 1900.

from the ruling provisional government. The Bolsheviks, a faction of Russian Social Democrats led by Vladimir Lenin (1870–1924), promoted violent revolution. Once in power, Lenin nationalized the land and turned it over to the local rural soviets (councils of workers and soldiers' deputies). After extensive civil war, the Communists, as they now called themselves, succeeded in retaining control of Russia and taking over an assortment of satellite countries in Eastern Europe. This new state took the official name the Union of Soviet Socialist Republics (USSR, or Soviet Union) in 1923.

Economic upheaval followed on the heels of war and revolution. The Great Depression of the 1930s dealt a serious blow to the stability of Western countries. Largely due to the international scope of banking and industrial capitalism, the economic depression deeply affected the United States and many European countries. By 1932 unemployment in the British workforce stood at 25 percent, and 40 percent of German workers were without jobs. Production in the United States plummeted by 50 percent.

This economic disaster, along with the failure of postwar treaties and the League of Nations to keep the peace, provided a fertile breeding ground for destabilizing forces to emerge once again. In the 1920s and 1930s, totalitarian regimes came to the fore in several European countries. Benito Mussolini (1883–1945) headed the nationalistic Fascist regime in Italy. Joseph Stalin (1879–1953) consolidated his control of the Soviet Union by 1929. Concurrently, in Germany Adolf Hitler (1889–1945) built the National Socialist German Workers Party (also known as the Nazi Party) into a mass political movement and eliminated all opposition.

These ruthless seizures of power led to the many conflicts that evolved into World War II. This catastrophic struggle erupted in 1939 when Germany invaded Poland, and Britain and France declared war on Germany. Eventually, the conflict earned its designation as a world war. While Germany and Italy fought most of Europe and the Soviet Union, Japan invaded China and occupied Indochina. After the Japanese bombing of Pearl Harbor in Hawaii in 1941, the United States declared war on Japan. Germany, in loose alliance with Japan, declared war on the United States, which joined the conflict in Europe on the side of Britain and France. Although most of the concerns of individual countries participating in World War II were territorial and nationalistic, other agendas surfaced as well. The Nazis, propelled by Hitler's staunch anti-Semitism, sought to build a racially exclusive Aryan state. This resolve led to the horror of the Holocaust, the killing of nearly two out of every three European Jews.

World War II drew to an end in 1945, when the Allied forces defeated Germany, and the United States dropped atomic bombs on Hiroshima and Nagasaki in Japan. The shock of the war's physical, economic, and psychological devastation immediately tempered the elation people felt at the conclusion of these global hostilities.

EUROPE, 1900 TO 1920

Like other members of society, artists deeply felt the effects of the political and economic disruptions of the early 20th century. As the old social orders collapsed and new ones, from communism to cor-

porate capitalism, took their places, artists searched for new definitions of and uses for art in a changed world.

Already in the 19th century, each successive modernist movement—Realism, Impressionism, and Post-Impressionism—had challenged artistic conventions with ever-greater intensity. This relentless challenge gave rise to the *avant-garde* ("front guard"), a term derived from 19th-century French military usage. The avant-garde were soldiers sent ahead of the army's main body to reconnoiter and make occasional raids on the enemy. Politicians who deemed themselves visionary and forward-thinking subsequently adopted the term. It then migrated to the art world in the 1880s, where it referred to artists who were ahead of their time and who transgressed the limits of established art forms.

These artists were the vanguard, or trailblazers. The avant-garde rejected the classical, academic, and traditional, and zealously explored the premises and formal qualities of painting, sculpture, and other media. The Post-Impressionists were the first artists labeled avant-garde. Although the general public found avant-garde art incomprehensible, the principles underlying late-19th-century modernism appealed to increasing numbers of artists as the 20th century dawned. Avant-garde artists in all their diversity became a major force during the first half of the 20th century and beyond.

Avant-garde principles emerged forcefully in European art of the early 1900s in the general movement that art historians call *Expressionism*, a term used over the years in connection with a wide range of art. At its essence, Expressionism refers to art that is the result of the artist's unique inner or personal vision and that often has an emotional dimension. This contrasts strongly with most Western art produced since the Renaissance that focused on visually describing the empirical world. The term "Expressionism" first gained currency after *Der Sturm*, an avant-garde periodical initially published in Munich, popularized it.

Fauvism

One of the first movements to tap into this pervasive desire for expression was *Fauvism*. In 1905, at the third Salon d'Automne in Paris, a group of young painters exhibited canvases so simplified in design and so shockingly bright in color that a startled critic, Louis Vauxcelles (1870–1943), described the artists as *fauves* (wild beasts). The Fauves were totally independent of the French Academy and the "official" Salon (see "Academic Salons and Independent Art Exhibitions," Chapter 23, page 655). Driving the Fauve movement was a desire to develop an art having the directness of Impressionism but also embracing intense color juxtapositions and their emotional capabilities.

Building on the legacy of artists such as van Gogh and Gauguin (see Chapter 23), Fauve artists went even further in liberating color from its descriptive function and using it for both expressive and structural ends. They produced portraits, landscapes, still lifes, and nudes of spontaneity and verve, with rich surface textures, lively linear patterns, and, above all, bold colors. The Fauves employed startling contrasts of vermilion and emerald green and of cerulean blue and vivid orange held together by sweeping brush strokes and bold patterns. Thus, these artists explored both facets of Expressionism. They combined outward expression, in the form of a bold release of internal feelings through wild color and powerful, even brutal, brushwork, and inward expression, awakening the viewer's emotions by these very devices.

The Fauve painters never officially organized, and the looseness of both personal connections and stylistic affinities caused the Fauve movement to begin to disintegrate almost as soon as it emerged. Within five years, most of the artists had departed from a strict adherence to Fauve principles and developed their own, more personal styles. During the brief existence of the movement, however, the Fauve artists made a remarkable contribution to the direction of painting by demonstrating color's structural, expressive, and aesthetic capabilities.

HENRI MATISSE The dominant figure of the Fauve group was Henri Matisse (1869–1954), who believed that color could play a primary role in conveying meaning and focused his efforts on developing this premise. In an early painting, *Woman with the Hat* (FIG. 24-2), Matisse depicted his wife Amélie in a rather conventional manner compositionally, but the seemingly arbitrary colors immediately startle the viewer, as does the sketchiness of the forms. The entire image—the woman's face, clothes, hat, and background—consists of patches and splotches of color juxtaposed in ways that sometimes produce jarring contrasts. Matisse explained his approach: "What characterized fauvism was that we rejected imitative colors, and that with pure colors we obtained stronger reactions." For Matisse and the Fauves, therefore, color became the formal element most responsible for pictorial coherence and the primary conveyor of meaning (see "Matisse on Color," page 688).

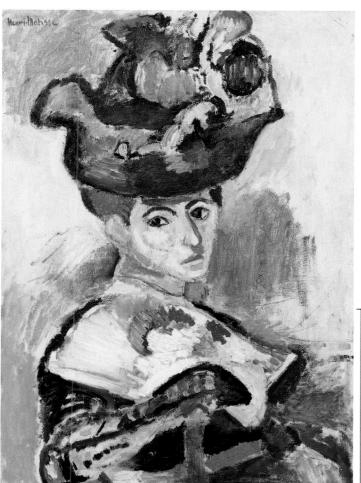

24-2 Henri Matisse, *Woman with the Hat*, 1905. Oil on canvas, $2' 7\frac{3}{4}'' \times 1' 11\frac{1}{2}''$. San Francisco Museum of Modern Art, San Francisco (bequest of Elise S. Haas).

Matisse portrayed his wife Amélie using patches and splotches of seemingly arbitrary colors. He and the other Fauve painters used color not to imitate nature but to produce a reaction in the viewer.

Matisse on Color

n an essay entitled "Notes of a Painter," published in the Parisian journal *La Grande Revue* on Christmas Day, 1908, Henri Matisse responded to his critics and set forth his principles and goals as a painter. The excerpts that follow help explain what Matisse was trying to achieve in paintings such as *Harmony in Red* (FIG. 24-3).

What I am after, above all, is expression. . . . Expression, for me, does not reside in passions glowing in a human face or manifested by violent movement. The entire arrangement of my picture is expressive: the place occupied by the figures, the empty spaces around them, the proportions, everything has its share. Composition is the art of arranging in a decorative manner the diverse elements at the painter's command to express his feelings. . . .

Both harmonies and dissonances of colour can produce agreeable effects.... Suppose I have to paint an interior: I have before me a cupboard; it gives me a sensation of vivid red, and I put down a red which satisfies me. A relation is established between this red and the white of the canvas. Let me put a green near the red, and make the floor yellow; and again there will be relationships between the green or yellow and the white of the canvas which will satisfy me.... A new combination of colours will succeed the first and render the totality

of my representation. I am forced to transpose until finally my picture may seem completely changed when, after successive modifications, the red has succeeded the green as the dominant colour. I cannot copy nature in a servile way; I am forced to interpret nature and submit it to the spirit of the picture. From the relationship I have found in all the tones there must result a living harmony of colours, a harmony analogous to that of a musical composition....

The chief function of colour should be to serve expression as well as possible.... My choice of colours does not rest on any scientific theory; it is based on observation, on sensitivity, on felt experiences. ... I simply try to put down colours which render my sensation. There is an impelling proportion of tones that may lead me to change the shape of a figure or to transform my composition. Until I have achieved this proportion in all parts of the composition I strive towards it and keep on working. Then a moment comes when all the parts have found their definite relationships, and from then on it would be impossible for me to add a stroke to my picture without having to repaint it entirely.*

* Translated by Jack D. Flam, Matisse on Art (London: Phaidon, 1973), 32-40.

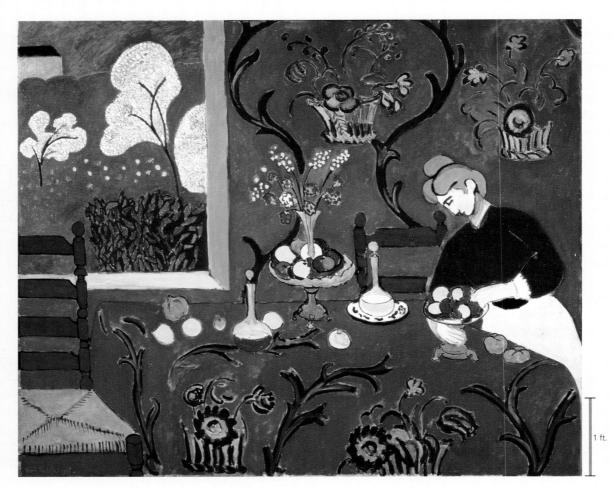

24-3 Henri Matisse, *Red Room* (*Harmony in Red*), 1908–1909. Oil on canvas, 5' $11'' \times 8'$ 1''. State Hermitage Museum, Saint Petersburg.

Matisse believed painters should choose compositions and colors that express their feelings. Here, the table and wall seem to merge because they are the same color and have identical patterning.

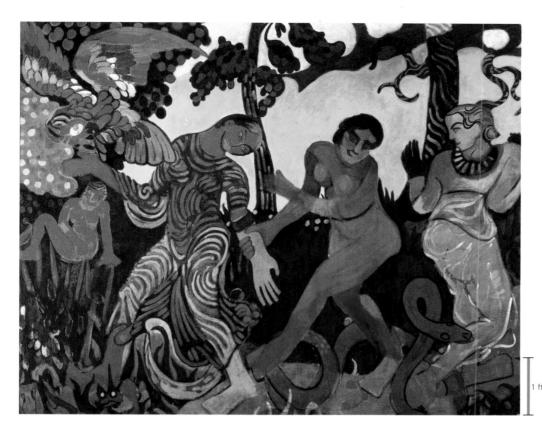

24-4 André Derain, *The Dance*, 1906. Oil on canvas, $6'\frac{7}{8}'' \times 6'$ $10\frac{1}{4}''$. Fridart Foundation, London.

Derain worked closely with Matisse, but the tropical setting and the bold colors of *The Dance* also reflect Derain's study of Gauguin's paintings (FIGS. 23-18 and 23-19), as does the flattened perspective.

HARMONY IN RED The maturation of Matisse's color discoveries coalesced in his Red Room (Harmony in Red; FIG. 24-3). The subject is the interior of a comfortable, prosperous household with a maid placing fruit and wine on the table, but Matisse's canvas is radically different from traditional paintings of domestic interiors (FIG. 20-19). The Fauve painter depicted objects in simplified and schematized fashion and flattened out the forms. For example, Matisse eliminated the front edge of the table, making the table, with its identical patterning, as flat as the wall behind it. The window at the upper left could also be a painting on the wall, further flattening the space. Everywhere, the colors contrast richly and intensely. Matisse's process of overpainting reveals the importance of color for striking the right chord in the viewer. Initially, this work was predominantly green, and then he repainted it blue. Neither seemed appropriate to Matisse, and not until he repainted this work in red did he feel he had found the right color for the "harmony" he wished to compose.

ANDRÉ DERAIN Another Fauve painter was André Derain (1880–1954), who worked closely with Matisse. Like Matisse, Derain worked to use color to its fullest potential—to produce aesthetic and compositional coherence, to increase luminosity, and to elicit emotional responses from the viewer. *The Dance* (Fig. 24-4), in which several figures, some nude, others clothed, frolic in a lush landscape, is typical of Derain's art. The tropical setting and the bold colors reflect in part Derain's study of Paul Gauguin's paintings (Figs. 23-18 and 23-19), as does the flattened perspective. Color delineates space, and Derain indicated light and shadow not by differences in value but by contrasts of hue. For the Fauves, as for Gauguin and van Gogh, color does not describe the local tones of objects but expresses the picture's content.

German Expressionism

The immediacy and boldness of the Fauve images appealed to many artists, including the German Expressionists. However, although color plays a prominent role in contemporaneous German painting, the expressiveness of the German images is due as much to wrenching distortions of form, ragged outline, and agitated brush strokes. This approach resulted in savagely powerful, emotional canvases in the years leading to World War I.

ERNST LUDWIG KIRCHNER The first group of German artists to explore Expressionist ideas gathered in Dresden in 1905 under the leadership of ERNST LUDWIG KIRCHNER (1880–1938). The group members thought of themselves as paving the way for a more perfect age by bridging the old age and the new. They derived their name, *Die Brücke* (The Bridge), from this concept. Kirchner's early studies in architecture, painting, and the graphic arts had instilled in him a deep admiration for German medieval art. Like the British artists associated with the Arts and Crafts movement, such as William Morris (FIG. 23-34), members of Die Brücke modeled themselves on their ideas of medieval craft guilds by living together and practicing all the arts equally. Kirchner described their lofty goals in a ringing statement published in the form of a woodcut in 1913 and titled *Chronik der Brücke*:

With faith in progress and in a new generation of creators and spectators we call together all youth. As youth, we carry the future and want to create for ourselves freedom of life and of movement against the long-established older forces. Everyone who reproduces that which drives him to creation with directness and authenticity belongs to us.²

These artists protested the hypocrisy and materialistic decadence of those in power. Kirchner, in particular, focused much of his attention on the detrimental effects of industrialization, such as the alienation of individuals in cities, which he felt fostered a mechanized and impersonal society. The tensions leading to World War I further exacerbated the discomfort and anxiety evidenced in the works of Die Brücke artists.

24-5 Ernst Ludwig Kirchner, *Street, Dresden,* 1908 (dated 1907). Oil on canvas, $4' 11\frac{1}{4}'' \times 6' 6\frac{7}{8}''$. Museum of Modern Art, New York.

Kirchner's perspectival distortions, disquieting figures, and color choices reflect the influence of the Fauves and of Edvard Munch (FIG. 23-27), who made similar expressive use of formal elements.

Kirchner's Street, Dresden (FIG. 24-5) provides a glimpse into the frenzied urban activity of a bustling German city before World War I. Rather than offering the distant, panoramic urban view of the Impressionists (FIG. 23-5), Kirchner's street scene is jarring and dissonant in both composition and color. The women in the foreground loom large, approaching somewhat menacingly. The steep perspective of the street, which threatens to push the women directly into the viewer's space, increases their confrontational nature. Harshly ren-

dered, the women's features make them appear ghoulish, and the garish, clashing colors—juxtapositions of bright orange, emerald green, chartreuse, and pink—add to the expressive impact of the image. Kirchner's perspectival distortions, disquieting figures, and color choices reflect the influence of the work of Edvard Munch, who made similar expressive use of formal elements in *The Scream* (FIG. 23-27).

EMIL NOLDE Much older than most Die Brücke artists was EMIL NOLDE (1867–1956), but because he pursued similar ideas in his

work, the younger artists invited him to join their group in 1906. (Die Brücke dissolved by 1913, and each member continued to work independently.) The content of Nolde's work centered, for the most part, on religious imagery. In contrast to the quiet spirituality and restraint of traditional religious images, however, Nolde's paintings, for example, Saint Mary of Egypt among Sinners (FIG. 24-6), are visceral and forceful. Mary, before her conversion, entertains lechers whose lust magnifies their brutal ugliness. The distortions of form and color (especially the jolting juxtaposition of blue and orange) and the rawness of the brush strokes amplify the harshness of the leering faces.

24-6 EMIL NOLDE, *Saint Mary of Egypt among Sinners*, 1912. Left panel of a triptych, oil on canvas, $2'10'' \times 3'3''$. Hamburger Kunsthalle, Hamburg.

In contrast to the quiet spirituality of traditional religious images, Nolde's paintings produce visceral emotions and feature distortions of form, jarring juxtapositions of color, and raw brush strokes.

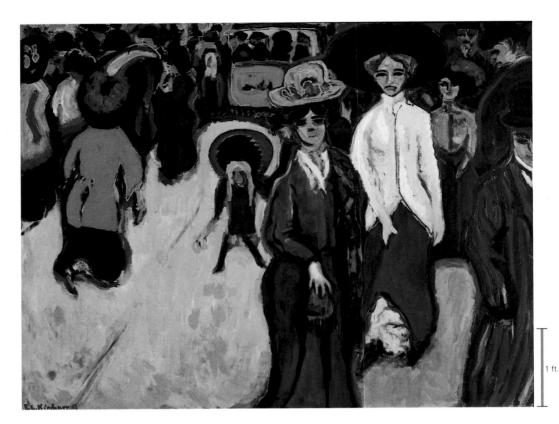

Borrowing ideas from van Gogh, Munch, the Fauves, and African and Oceanic art (see "Primitivism and Colonialism," page 696), Nolde and the other Die Brücke artists created images that derive much of their power from a dissonance and seeming lack of finesse. The harsh colors, aggressively brushed paint, and distorted forms expressed the artists' feelings about the injustices of society and their belief in a healthful union of human beings and nature. Their use of these diverse sources reflects the expanding scope of global contact brought about by colonialism and international capitalism.

1 ft.

Science and Art in the Early 20th Century

n the early 20th century, societies worldwide contended with discoveries and new ways of thinking in a wide variety of fields, including science. These new ideas forced people to revise radically how they understood their world. In particular, the values and ideals that were the legacy of the Enlightenment (see Chapter 21) began to yield to innovative views. Thus, intellectuals countered 18th- and 19thcentury assumptions about progress and reason with ideas challenging traditional notions about the physical universe, the structure of society, and human nature. Artists participated in this reassessment. Modernist artists, in particular, often acknowledged these new discoveries and shifting theoretical bases in their work. Accordingly, much of the history of early-20th-century Western art is a history of the rejection of traditional limitations and definitions both of art and of the universe.

One of the fundamental Enlightenment beliefs was faith in science. Because of its basis in empirical, or observable, fact, science provided a

mechanistic conception of the universe, which reassured a populace that was finding traditional religions less certain. As promoted in the classic physics of Isaac Newton (1642–1727), the universe was a huge machine consisting of time, space, and matter. The early 20th century witnessed an astounding burst of scientific activity challenging this model of the universe. It amounted to what has been called "the second scientific and technological revolution." Particularly noteworthy was the work of various physicists: Max Planck (1858–1947), Albert Einstein (1879–1955), Ernest Rutherford (1871–1937), and Niels Bohr (1885–1962). With their discoveries, each of these scientists shattered the existing faith in the objective reality of matter and, in so doing, paved the way for a new model of the universe. Planck's quantum theory (1900) raised questions about the emission of atomic energy. In his 1905 paper, "The Electrodynamics of Moving Bodies," Einstein carried

24-7 VASSILY KANDINSKY, *Improvisation 28* (second version), 1912. Oil on canvas, $3' 7\frac{7}{8}'' \times 5' 3\frac{7}{8}''$. Solomon R. Guggenheim Museum, New York (gift of Solomon R. Guggenheim, 1937).

The scientific theories of Einstein and Rutherford convinced Kandinsky that material objects had no real substance. He was one of the first painters to explore complete abstraction in his canvases.

Planck's work further by introducing his theory of relativity. He argued that space and time are not absolute, as postulated in Newtonian physics. Rather, Einstein explained, time and space are relative to the observer and linked in what he called a four-dimensional space-time continuum. He also concluded that matter, rather than a solid, tangible reality, was actually another form of energy. Einstein's famous equation $E = mc^2$, where E stands for energy, m for mass, and c for the speed of light, provided a formula for understanding atomic energy. Rutherford's and Bohr's exploration of atomic structure between 1906 and 1913 contributed to this new perception of matter and energy. Together, all these scientific discoveries constituted a changed view of physical nature and contributed to the growing interest in abstraction, as opposed to the mimetic representation of the world, among early-20th-century artists like Vassily Kandinsky (FIG. 24-7).

VASSILY KANDINSKY A second major German Expressionist group, *Der Blaue Reiter* (The Blue Rider), formed in Munich in 1911. The two founding members, Vassily Kandinsky and Franz Marc, whimsically selected this name because of their mutual interest in the color blue and horses. Like Die Brücke, this group produced paintings that captured their feelings in visual form while also eliciting intense visceral responses from viewers.

Born in Russia, Vassily Kandinsky (1866–1944) moved to Munich in 1896 and soon developed a spontaneous and aggressively avant-garde expressive style. Indeed, Kandinsky was one of the first artists to explore complete abstraction, as in *Improvisation 28* (FIG. 24-7), painted in 1912. Kandinsky fueled his elimination of repre-

sentational elements with his interest in theosophy (a religious and philosophical belief system incorporating a wide range of tenets from, among other sources, Buddhism and mysticism) and the occult, as well as with advances in the sciences. A true intellectual, widely read in philosophy, religion, history, and the other arts, especially music, Kandinsky was also one of the few early modernists to read with some comprehension the new scientific theories of the era (see "Science and Art in the Early 20th Century," above). Scientists' exploration of atomic structure, for example, convinced Kandinsky that material objects had no real substance, thereby shattering his faith in a world of tangible things. The painter articulated his ideas in an influential treatise, *Concerning the Spiritual in Art*, published in

24-8 Franz Marc, Fate of the Animals, 1913. Oil on canvas, 6' $4\frac{3}{4}$ " \times 8' $9\frac{1}{2}$ ". Kunstmuseum, Basel.

Marc developed a system of correspondences between specific colors and feelings or ideas. In this apocalyptic scene of animals trapped in a forest, the colors of severity and brutality dominate.

1 ft.

1912. Artists, Kandinsky believed, must express the spirit and their innermost feelings by orchestrating color, form, line, and space. He produced numerous works like *Improvisation 28*, conveying feelings with color juxtapositions, intersecting linear elements, and implied spatial relationships. Ultimately, Kandinsky saw these abstractions as evolving blueprints for a more enlightened and liberated society emphasizing spirituality.

FRANZ MARC Like many of the other German Expressionists, FRANZ MARC (1880–1916), the cofounder of Der Blaue Reiter, grew increasingly pessimistic about the state of humanity, especially as World War I loomed on the horizon. His perception of human beings as deeply flawed led him to turn to the animal world for his subjects. Animals, he believed, were more pure than humanity and thus more appropriate as a vehicle to express an inner truth. In his quest to imbue his paintings with greater emotional intensity, Marc focused on color and developed a system of correspondences between specific colors and feelings or ideas. In a letter to a fellow Blaue Reiter, Marc explained: "Blue is the *male* principle, severe and spiritual. Yellow is the *female* principle, gentle, happy and sensual. Red is *matter*, brutal and heavy." Marc's attempts to create, in a sense, an iconography (or representational system) of color linked him to other avant-garde artists struggling to redefine the practice of art.

Fate of the Animals (FIG. 24-8) represents the culmination of Marc's color explorations. Painted in 1913, when the tension of impending cataclysm had pervaded society, the animals appear trapped in a forest amid falling trees, some apocalyptic event destroying both the forest and the animals inhabiting it. The painter distorted the entire scene and shattered it into fragments. Significantly, the lighter and brighter colors—the passive, gentle, and cheerful ones—are absent, and the colors of severity and brutality dominate the work. On the back of the canvas Marc wrote "All being is flaming suffering." The artist discovered just how well his painting portended war's anguish and tragedy when he ended up at the front the following year.

His experiences in battle prompted him to write to his wife that *Fate of the Animals* "is like a premonition of this war—horrible and shattering. I can hardly conceive that I painted it." His contempt for people's inhumanity and his attempt to express that through his art ended, with tragic irony, in his death in action in 1916.

KÄTHE KOLLWITZ The emotional range of German Expressionism extends from passionate protest and satirical bitterness to the poignantly expressed pity for the poor in the prints of Käthe KOLLWITZ (1867-1945), who had no formal association with any Expressionist group. The graphic art of Gauguin and Munch stimulated a revival of the print medium in Germany, especially the woodcut, and these proved inspiring models. Kollwitz worked in a variety of printmaking techniques, including woodcut, lithography, and etching, and explored a range of issues from the overtly political to the deeply personal. One image she explored in depth, producing a number of print variations, was that of a mother with her dead child. Although she initially derived the theme from the Christian Pietà, she transformed it into a universal statement of maternal loss and grief. In Woman with Dead Child (FIG. 24-9), an etching and lithograph, she disavowed the reverence and grace that pervaded most Christian depictions of Mary holding the dead Christ (FIG. 17-12) and replaced those attributes with an animalistic passion, shown in the way the mother ferociously grips the body of her dead child. The primal nature of the image is in keeping with the aims of the Expressionists, and the scratchy lines the etching needle produced serve as evidence of Kollwitz's very personal touch. The impact of this image is undeniably powerful. Not since the Gothic age in Germany (FIG. 13-51) had any artist produced a mother-and-son group of comparable emotional power. That Kollwitz used her son Peter as the model for the dead child no doubt made the image all the more personal to her. The image stands as a poignant premonition. Peter died fighting in World War I at age 21.

WILHELM LEHMBRUCK The Great War also deeply affected WILHELM LEHMBRUCK (1881–1919). His figurative sculptures exude

24-9 KÄTHE KOLLWITZ, *Woman with Dead Child*, 1903. Etching and soft-ground etching, overprinted lithographically with a gold tone plate, $1' 4\frac{5''}{8} \times 1' 7\frac{1}{8}''$. British Museum, London.

The theme of the mother mourning over her dead child comes from images of the *Pietà* in Christian art, but Kollwitz transformed it into a powerful universal statement of maternal loss and grief.

a quiet mood but still possess a compelling emotional sensibility. Lehmbruck studied sculpture, painting, and the graphic arts in Düsseldorf before moving to Paris in 1910, where he developed the style of his *Seated Youth* (FIG. **24-10**). His sculpture combines the expressive qualities he much admired in the work of fellow sculptors,

especially the psychological energies of Rodin (FIGS. 23-32 and 23-33). In *Seated Youth*, the poignant elongation of human proportions, the slumped shoulders, and the hands that hang uselessly all impart an undertone of anguish to the rather classical figure. Lehmbruck's figure communicates by pose and gesture alone. Although its

extreme proportions may recall Mannerist attenuation (FIG. 17-43), its distortions announce a new freedom in interpreting the human figure. For Lehmbruck, as for Rodin, the human figure could express every human condition and emotion. The quiet, contemplative nature of this sculpture serves both as a personal expression of Lehmbruck's increasing depression and as a powerful characterization of the general sensibility in the wake of World War I. Appropriately, the original title of Seated Youth was The Friend, in reference to the artist's many friends who lost their lives in the war. After Lehmbruck's tragic suicide in 1919, officials placed this sculpture as a memorial in the soldiers' cemetery in Lehmbruck's native city of Duisburg.

24-10 WILHELM LEHMBRUCK, Seated Youth, 1917. Composite tinted plaster, $3' 4\frac{5}{8}'' \times 2' 6'' \times 3' 9''$. National Gallery of Art, Washington, D.C. (Andrew W. Mellon Fund).

The poignant elongation of human proportions, the slumped shoulders, and the hands that hang uselessly all impart an undertone of anguish to Lehmbruck's rather classical figure.

Gertrude and Leo Stein and the Avant-Garde

ne of the many unexpected developments in the history of art is that two Americans—Gertrude (1874–1946) and Leo (1872–1947) Stein—played pivotal roles in the history of the European avant-garde because they provided a hospitable environment in their Paris home. Artists, writers, musicians, collectors, and critics interested in progressive art and ideas could meet there to talk and socialize. Born in Pennsylvania, the Stein siblings moved to 27 rue de Fleurus in Paris in 1903. Gertrude's experimental writing stimulated her interest in the latest developments in the arts. Conversely, the avant-garde ideas discussed at the Steins' house influenced her unique poetry, plays, and other works. She is perhaps best known for *The Autobiography of Alice B. Toklas* (1933), a unique memoir written in the persona of her longtime lesbian companion.

The Steins' interest in the exciting, invigorating debates taking place in avant-garde circles led them to welcome visitors to their Saturday salons, which included lectures, thoughtful discussions, and spirited arguments. Often, these gatherings lasted until dawn and included not only their French friends but also visiting Americans, Britons, Swedes, Germans, Hungarians, Spaniards, Poles, and Russians. Among the hundreds who welcomed the opportunity to visit the Steins were artists Henri Matisse, Pablo Picasso, Georges Braque, Mary Cassatt, Marcel Duchamp, Alfred Stieglitz, and Arthur B. Davis; writers Ernest Hemingway, F. Scott Fitzgerald, John dos Passos, Jean Cocteau, and Guillaume Apollinaire; art dealers Daniel Kahnweiler and Ambroise Vollard; critics Roger Fry and Clive Bell; and collectors Sergei Shchukin and Ivan Morosov.

The Steins were avid art collectors, and the works decorating their walls attracted many visitors. One of the first paintings Leo purchased was Matisse's notorious *Woman with the Hat* (FIG. **24-2**), and he subsequently bought numerous important paintings by Matisse and Picasso, along with works by Gauguin, Cézanne, Renoir, and Braque. Picasso, who developed a close friendship with Gertrude, painted her portrait (FIG. **24-11**) in 1907. Gertrude loved the painting so much that she kept it by her all her life and donated it to the Metropolitan Museum of Art only upon her death in 1946.

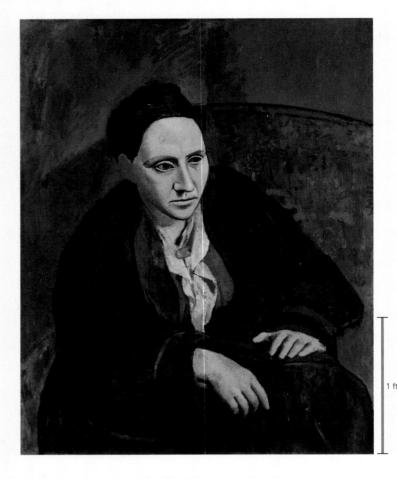

24-11 Pablo Picasso, *Gertrude Stein*, 1906–1907. Oil on canvas, $3' 3\frac{3''}{8} \times 2' 8''$. Metropolitan Museum of Art, New York (bequest of Gertrude Stein, 1947).

Picasso had left this portrait of his friend and patron unfinished until he decided to incorporate the planar simplicity of ancient Iberian stone sculptures into his depiction of her face.

Primitivism and Cubism

The Expressionist departure from any strict adherence to illusionism in art was a path that other artists followed. Among those who most radically challenged prevailing artistic conventions and moved most aggressively into the realm of abstraction was Pablo Picasso.

PABLO PICASSO Born in Spain four years after Gustave Courbet's death, Pablo Picasso (1881–1973) mastered all aspects of late-19th-century Realist technique by the time he entered the Barcelona Academy of Fine Art in the late 1890s. His prodigious talent led him to experiment with a wide range of visual expression, first in Spain and then in Paris, where he settled in 1904. An artist whose importance to the history of art is uncontested, Picasso made staggering contributions to new ways of representing the surrounding world. Perhaps the most prolific artist in history, he explored virtually every artistic medium during his lengthy career, but remained a traditional artist in making careful preparatory studies for each major work. Picasso epitomized modernism, however, in his enduring quest for innovation, which resulted in sudden shifts from one

style to another. By the time he settled permanently in Paris, Picasso's work had evolved from Spanish painting's sober Realism through an Impressionistic phase to the so-called Blue Period (1901–1904), when, in a melancholy state of mind, he used primarily blue colors to depict worn, pathetic, and alienated figures.

GERTRUDE STEIN By 1906, Picasso was searching restlessly for new ways to depict form. He found clues in the ancient Iberian sculpture of his homeland and other "primitive" cultures. Inspired by these sources, Picasso returned to a portrait of Gertrude Stein (FIG. 24-11), his friend and patron (see "Gertrude and Leo Stein and the Avant-Garde," above). Picasso had begun the painting earlier that year but left it unfinished after more than 80 sittings. When he resumed work on the portrait, Picasso painted Stein's head as a simplified planar form, incorporating aspects derived from Iberian stone heads. Although the disparity between the style of the face and the rest of Stein's image is striking, together they provide an insightful portrait of a forceful, vivacious woman. More important, Picasso had discovered a new approach to the representation of the human form.

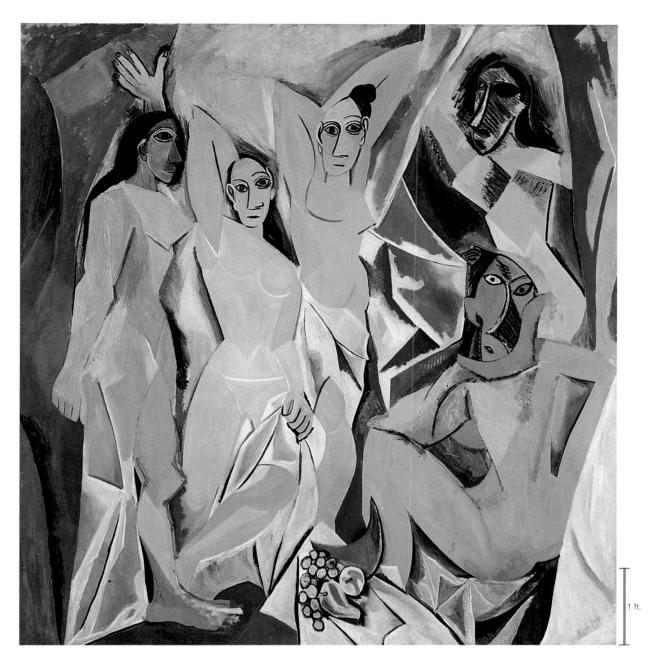

24-12 Pablo Picasso, Les Demoiselles d'Avignon, 1907. Oil on canvas, $8' \times 7'$ 8". Museum of Modern Art, New York (acquired through the Lillie P. Bliss Bequest).

African and ancient Iberian sculpture and the late paintings of Cézanne influenced this pivotal work, with which Picasso opened the door to a radically new method of representing forms in space.

DEMOISELLES D'AVIGNON The influence of "primitive" art also surfaces in *Les Demoiselles d'Avignon* (*The Young Ladies of Avignon*; FIG. **24-12**), which opened the door to a radically new method of representing form in space. Picasso began the work as a symbolic picture to be titled *Philosophical Bordello*, portraying two male clients (who, based on surviving drawings, had features resembling Picasso's) intermingling with women in the reception room of a brothel on Avignon Street in Barcelona. One was a sailor. The other carried a skull, an obvious reference to death. By the time the artist finished, he had eliminated the male figures and simplified the room's details to a suggestion of drapery and a schematic foreground still life. Picasso had become wholly absorbed in the problem of finding a new way to represent the five female figures in their interior space. Instead of depicting the figures as continuous volumes, he fractured their shapes and interwove them with the equally jagged planes that represent drapery and empty

space. Indeed, the space, so entwined with the bodies, is virtually illegible. Here Picasso pushed Cézanne's treatment of form and space (FIGS. 23-20 and 23-21) to a new level. The tension between Picasso's representation of three-dimensional space and his conviction that a painting is a two-dimensional design lying flat on the surface of a stretched canvas is a tension between representation and abstraction.

The artist extended the radical nature of *Les Demoiselles d'Avignon* even further by depicting the figures inconsistently. Ancient Iberian sculptures inspired the calm, ideal features of the three young women at the left, as they had the head of Gertrude Stein (FIG. **24-11**). The energetic, violently striated features of the two heads to the right emerged late in Picasso's production of the work and grew directly from his increasing fascination with the power of African sculpture (see "Primitivism and Colonialism," page 696), which the artist studied in Paris's Trocadéro ethnography museum as well as collected and kept in his

Primitivism and Colonialism

any scholars have noted that one major source for much of early-20th-century art is non-Western culture. Many modernist artists incorporated stylistic elements from the artifacts of Africa, Oceania, and the native peoples of the Americas—a phenomenon art historians call primitivism. Some of them, for example, Henri Matisse and Pablo Picasso (FIG. 24-13), were enthusiastic collectors of "primitive art," but all of them could view the numerous non-Western objects displayed in European and American collections and museums. During the second half of the 19th century, anthropological and ethnographic museums began to proliferate. In 1882, the Musée d'Ethnographie du Trocadéro (now the Musée du quai Branly) in Paris opened its doors to the public. The Musée Permanent des Colonies (now the Musée National des Arts d'Afrique et d'Océanie) in Paris also provided the public with a wide array of objects—weapons, tools, basketwork, headdresses—from colonial territories, as did the Musée Africain in Marseilles. In Berlin, the Museum für Völkerkunde housed close to 10,000 African objects by 1886, when it opened for public viewing. The Expositions Universelles, regularly scheduled exhibitions in France designed to celebrate industrial progress, included products from Oceania and Africa after 1851, familiarizing the public with these cultures. By the beginning of the 20th century, significant non-Western collections were on view in museums in Liverpool, Glasgow, Edinburgh, London, Hamburg, Stuttgart, Vienna, Berlin, Munich, Leiden, Copenhagen, and Chicago.

The formation of these collections was a by-product of the rampant colonialism central to the geopolitical dynamics of the 19th century and much of the 20th century. Most of the Western powers maintained colonies (MAP 24-1). For example, the United States, Holland, and France all kept a colonial presence in the Pacific. Britain, France, Germany, Belgium, Holland, Spain, and Portugal divided up the African continent. People often perceived these colonial cultures as "primitive" and referred to many of the non-Western artifacts displayed in museums as "artificial curiosities" or "fetish objects." Indeed, the exhibition of these objects collected during expeditions to the colonies served to reinforce the perceived "need" for a colonial presence in these countries. These objects, which often seemed to depict strange gods or creatures, bolstered the view that these peoples were "barbarians" who needed to be "civilized" or "saved," and this perception thereby justified colonialism—including its missionary dimension-worldwide.

Whether avant-garde artists were aware of the imperialistic implications of their appropriation of non-Western culture is unclear. Certainly, however, many artists reveled in the energy and freshness of non-Western images and forms. These different cultural products provided Western artists with new ways of looking at their own art. Matisse always maintained he saw African sculptures as simply "good sculptures . . . like any other."* Picasso, in contrast, believed "the masks weren't just like any other pieces of sculpture. Not at all.

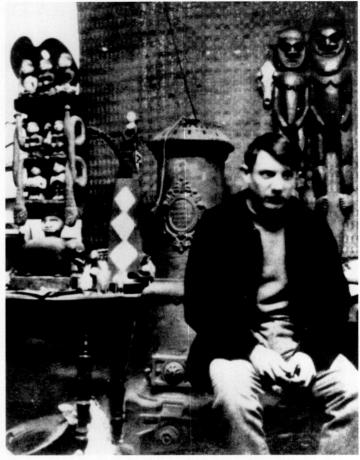

24-13 Frank Gelett Burgess, Pablo Picasso in his studio, Paris, France, 1908. Collection of the Musée Picasso, Paris.

Picasso was familiar with ancient Iberian art from his homeland and studied African and other "primitive" art in Paris's Trocadéro museum. He kept his own collection of primitive art in his studio.

They were magic things. . . . mediators" between humans and the forces of evil, and he sought to capture their power as well as their forms in his paintings. "[In the Trocadéro] I understood why I was a painter. . . . All alone in that awful museum, with masks, dolls . . . Les Demoiselles d'Avignon [FIG. 24-12)] must have come to me that day."† Further, "primitive" art seemed to embody a directness, closeness to nature, and honesty that appealed to modernist artists determined to reject conventional models. Non-Western art served as an important revitalizing and energizing force in Western art.

* Jean-Louis Paudrat, "From Africa," in William Rubin, ed., "*Primitivism*" in 20th Century Art: Affinity of the Tribal and the Modern (New York: Museum of Modern Art, 1984), 1:141.

† Ibid.

Paris studio (FIG. **24-13**). Perhaps responding to the energy of these two new heads, Picasso also revised their bodies. He broke them into more ambiguous planes suggesting a combination of views, as if the observer sees the figures from more than one place in space at once. The woman seated at the lower right shows these multiple angles most clearly, seeming to present the viewer simultaneously with a three-quarter back view from the left, another from the right, and a front

view of the head that suggests seeing the figure frontally as well. Gone is the traditional concept of an orderly, constructed, and unified pictorial space that mirrors the world. In its place are the rudimentary beginnings of a new representation of the world as a dynamic interplay of time and space. Clearly, *Les Demoiselles d'Avignon* represents a dramatic departure from the careful presentation of a visual reality. Explained Picasso: "I paint forms as I think them, not as I see them." 5

GEORGES BRAQUE AND CUBISM For many years, Picasso showed Les Demoiselles only to other painters. One of the first to see it was Georges Braque (1882-1963), a Fauve painter who found it so challenging that he began to rethink his own painting style. Using the painting's revolutionary ideas as a point of departure, together Braque and Picasso formulated Cubism around 1908. Cubism represented a radical turning point in the history of art, nothing less than a dismissal of the pictorial illusionism that had dominated Western art since the Renaissance. The Cubists rejected naturalistic depictions, preferring compositions of shapes and forms abstracted from the conventionally perceived world. These artists pursued the analysis of form central to Cézanne's artistic explorations, and they dissected life's continuous optical spread into its many constituent features, which they then recomposed, by a new logic of design, into a coherent aesthetic object. For the Cubists, the art of painting had to move far beyond the description of visual reality. This rejection of accepted artistic practice illustrates both the period's aggressive avantgarde critique of pictorial convention and the public's dwindling faith in a safe, concrete Newtonian world in the face of the physics of Einstein and others (see "Science and Art," page 691).

The new style received its name after Matisse described some of Braque's work to the critic Louis Vauxcelles as having been painted "with little cubes." In his review, Vauxcelles described the new paintings as "cubic oddities." The French writer and theorist Guillaume Apollinaire (1880–1918) summarized well the central concepts of Cubism in 1913:

Authentic cubism [is] the art of depicting new wholes with formal elements borrowed not from the reality of vision, but from that of conception. This tendency leads to a poetic kind of painting which stands outside the world of observation; for, even in a simple cubism, the geometrical surfaces of an object must be opened out in order to give a complete representation of it. . . . Everyone must agree that a chair, from whichever side it is viewed, never ceases to have four legs, a seat and a back, and that, if it is robbed of one of these elements, it is robbed of an important part.⁷

Art historians refer to the first phase of Cubism, developed jointly by Picasso and Braque, as *Analytic Cubism*. Because Cubists could not achieve Apollinaire's total view through the traditional method of drawing or painting models from one position, these artists began to dissect the forms of their subjects. They presented that dissection for the viewer to inspect across the canvas surface. In simplistic terms, Analytic Cubism involves analyzing the structure of forms.

THE PORTUGUESE Georges Braque's painting The Portuguese (FIG. 24-14) exemplifies Analytic Cubism. The artist derived the subject from his memories of a Portuguese musician seen years earlier in a bar in Marseilles. Braque concentrated his attention on dissecting the form and placing it in dynamic interaction with the space around it. Unlike the Fauves and German Expressionists, who used vibrant colors, the Cubists chose subdued hues—here solely brown tones—in order to focus the viewer's attention on form. In The Portuguese, the artist carried his analysis so far that the viewer must work diligently to discover clues to the subject. The construction of large intersecting planes suggests the forms of a man and a guitar. Smaller shapes interpenetrate and hover in the large planes. The way Braque treated light and shadow reveals his departure from conventional artistic practice. Light and dark passages suggest both chiaroscuro modeling and transparent planes that allow the viewer to see through one level to another. As the observer looks, solid forms emerge only to be canceled almost immediately by a different reading of the subject.

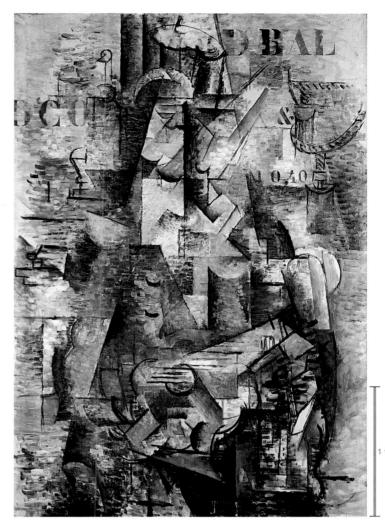

24-14 Georges Braque, *The Portuguese*, 1911. Oil on canvas, $3' 10\frac{1}{8}'' \times 2' 8''$. Kunstmuseum, Basel (gift of Raoul La Roche, 1952).

The Cubists rejected the pictorial illusionism that had dominated Western art for centuries. In this painting, Braque concentrated on dissecting form and placing it in dynamic interaction with space.

The stenciled letters and numbers add to the painting's complexity. Letters and numbers are flat shapes, but as elements of a Cubist painting such as The Portuguese, they allow the artist to play with the viewer's perception of two- and three-dimensional space. The letters and numbers lie flat on the painted canvas surface, yet the image's shading and shapes seem to flow behind and underneath them, pushing the letters and numbers forward into the viewing space. Occasionally, they seem attached to the surface of some object within the painting. Ultimately, the constantly shifting imagery makes it impossible to arrive at any definitive or final reading of the image. Examining this kind of painting is a disconcerting excursion into ambiguity and doubt, especially since the letters and numbers seem to anchor the painting in the world of representation, thereby exacerbating the tension between representation and abstraction. Analytical Cubist paintings radically disrupt expectations about the representation of space and time.

ROBERT DELAUNAY Artists and art historians generally have regarded the suppression of color as crucial to Cubism's success, but ROBERT DELAUNAY (1885–1941), a contemporary of Picasso and Braque, worked toward a kind of color Cubism. Apollinaire called this art style *Orphism*, after Orpheus, the Greek god with magical powers of music-making. Apollinaire believed art, like music, was

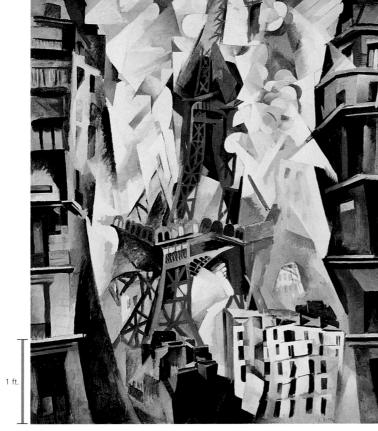

24-15 ROBERT DELAUNAY, *Champs de Mars*, or *The Red Tower*, 1911. Oil on canvas, 5' $3'' \times 4'$ 3''. Art Institute of Chicago, Chicago.

Orphism is a kind of color Cubism. Delaunay broke the Eiffel Tower into a kaleidoscopic array of colored pieces. Some scholars have interpreted the painting as a commentary on the collapse of society.

distinct from the representation of the visible world. Delaunay developed his ideas about color use in dialogue with his Russian-born wife, Sonia (1885–1974), also an artist. She created paintings, quilts, other textile arts, and book covers that exploited the expressive capabilities of color. As a result of their artistic explorations, both Delaunays became convinced that the rhythms of modern life could best be expressed through color harmonies and dissonances. *Champs de Mars*, or *The Red Tower* (FIG. **24-15**), is one of many paintings Delaunay produced between 1909 and 1912 depicting the Eiffel Tower (FIG. **23-1**). The title *Champs de Mars* refers to the Parisian field on which the Eiffel Tower stands, named after the Campus Martius (Field of Mars) located outside the walls of Republican Rome.

The artist broke Eiffel's tower into a kaleidoscopic array of colored pieces, which variously leap forward or pull back according to the relative hues and values of the broken shapes. The structure ambiguously rises and collapses. Delaunay's experiments with color dynamics strongly influenced the Futurists (discussed later) and the German Expressionists (he exhibited with Der Blaue Reiter as well as with Cubists). These artists found in his art a means for intensifying expression by suggesting violent motion through shape and color.

Some scholars have interpreted Delaunay's fragmentation of the Eiffel Tower in *Champs de Mars* in political terms as a commentary on societal collapse in the years leading to World War I. Delaunay himself described the collapsing-tower imagery as "the synthesis of a period of destruction; likewise a prophetic vision with social repercussions: war, and the base crumbles." This statement encapsulates well the social and artistic climate during these years—the destruction of old world

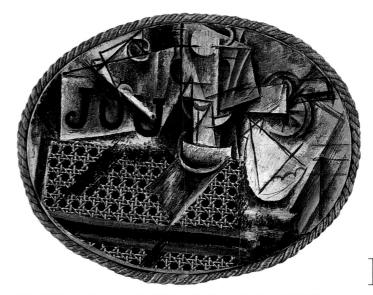

24-16 Pablo Picasso, *Still Life with Chair-Caning*, 1912. Oil and oilcloth on canvas, $10\frac{5}{8}'' \times 1' 1\frac{3}{4}''$. Musée Picasso, Paris.

This painting includes a piece of oilcloth imprinted with the photolithographed pattern of a cane chair seat. Framed with a piece of rope, the still life challenges the viewer's understanding of reality.

orders and of artistic practices deemed obsolete, as well as the avantgarde's prophetic nature and its determination to subvert tradition.

SYNTHETIC CUBISM In 1912, Cubism entered a new phase called Synthetic Cubism, in which artists constructed paintings and drawings from objects and shapes cut from paper or other materials to represent parts of a subject. The work marking the point of departure for this new style was Picasso's Still Life with Chair-Caning (FIG. 24-16), a painting in which the artist imprinted a photolithographed pattern of a cane chair seat on the canvas and then pasted a piece of oilcloth on it. Framed with a piece of rope, this work challenges the viewer's understanding of reality. The photographically replicated chair-caning seems so "real" that one expects the holes to break any brush strokes laid upon it. But the chair-caning, although optically suggestive of the real, is only an illusion or representation of an object. In contrast, the painted abstract areas do not refer to tangible objects in the real world. Yet the fact they do not imitate anything makes them more "real" than the chair-caning. No pretense exists. Picasso extended the visual play by making the letter U escape from the space of the accompanying J and O and partially covering it with a cylindrical shape that pushes across its left side. The letters JOU appear in many Cubist paintings. These letters formed part of the masthead of the daily French newspapers (journaux) often found among the objects represented. Picasso and Braque especially delighted in the punning references to jouer and jouir—the French verbs meaning "to play" and "to enjoy."

COLLAGE After Still Life with Chair-Caning, both Picasso and Braque continued to explore the medium of collage introduced into the realm of high art in that work. From the French word "coller" ("to stick"), a collage is a composition of bits of objects, such as newspaper or cloth, glued to a surface. Its possibilities can be seen in Braque's Bottle, Newspaper, Pipe, and Glass (FIG. 24-17), done in a variant of collage called papier collé ("stuck paper")—gluing assorted paper shapes to a drawing or painting. Here, charcoal lines and shadows provide clues to the Cubist multiple views of various surfaces and objects. Roughly rectangular strips of variously printed and colored paper dominate the composition. The paper imprinted with wood grain and

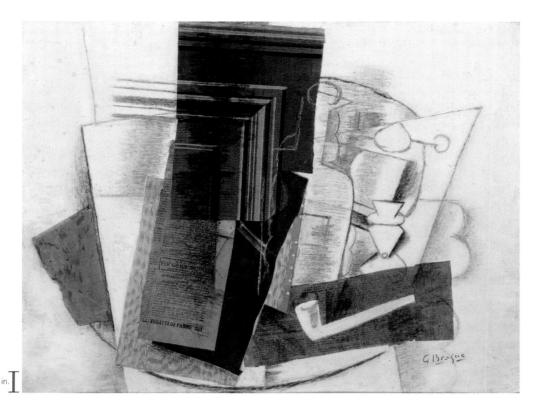

24-17 Georges Braque, *Bottle, Newspaper, Pipe, and Glass,* 1913. Charcoal and various papers pasted on paper, $1' 6\frac{7}{8}'' \times 2' 1\frac{1}{4}''$. Private collection, New York.

This Cubist collage of glued paper is a visual game to be deciphered. The pipe in the foreground, for example, seems to lie on the newspaper, but it is actually cut through the printed paper.

ety. Many artists and writers of the period allied themselves with various anarchist groups whose social critiques and utopian visions appealed to progressive thinkers. It was, therefore, not a far leap to see radical art, like Cubism, as having political ramifications. Indeed, many critics in the French press consistently equated Cubism with anarchism, revolution, and disdain for tradition. Picasso himself, however, never viewed Cubism as a protest movement or even different in kind from traditional painting (see "Picasso on Cubism," page 700).

moldings provides an illusion whose concreteness contrasts with the lightly rendered objects on the right. Five pieces of paper overlap each other in the center of the composition to create a layering of flat planes that both echo the space the lines suggest and establish the flatness of the work's surface. All shapes in the image seem to oscillate, pushing forward and dropping back in space. Shading carves space into flat planes in some places and turns planes into transparent surfaces in others. The pipe in the foreground illustrates this complex visual interplay especially well. Although it appears to lie on the newspaper, it is in fact a form cut through the printed paper to reveal the canvas surface, which Braque lightly modeled with charcoal. The artist thus kept his audience aware that *Bottle*, *Newspaper*, *Pipe*, *and Glass* is an artwork, a visual game to be deciphered, and not an attempt to reproduce nature. Picasso explained the goals of Cubist collage:

Not only did we try to displace reality; reality was no longer in the object.... [In] the *papier collé*... [w]e didn't any longer want to fool the eye; we wanted to fool the mind.... If a piece of newspaper can be a bottle, that gives us something to think about in connection with both newspapers and bottles, too.⁹

Like all collage, the papier collé technique was modern in its medium—mass-produced materials never before found in "high" art—and modern in the way the artist embedded the art's "message" in the imagery and in the nature of these everyday materials.

Although most discussions of Cubism and collage focus on the formal innovations they represented, it is important to note that the public also viewed the revolutionary and subversive nature of Cubism in sociopolitical terms. The public saw Cubism's challenge to artistic convention and tradition as an attack on 20th-century soci-

24-18 Pablo Picasso, maquette for *Guitar*, 1912. Cardboard, string, and wire (restored), $2' 1\frac{1}{4}'' \times 1' 1'' \times 7\frac{1}{2}''$. Museum of Modern Art, New York.

In this model for a sculpture of sheet metal, Picasso presented what is essentially a cutaway view of a guitar, allowing the viewer to examine both surface and interior space, both mass and void.

PICASSO, *GUITAR* Cubism did not just open new avenues for representing form on two-dimensional surfaces. It also inspired new approaches to sculpture. Picasso explored Cubism's possibilities in sculpture throughout the years he and Braque developed the style. Picasso created *Guitar* (FIG. **24-18**) in 1912. As in his Cubist paintings, this sculpture operates at the intersection of two- and three-dimensionality. Picasso took the form of a guitar (an image that

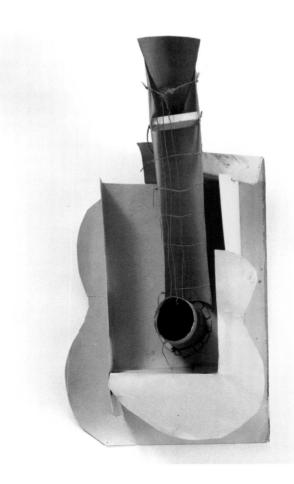

1 in

Picasso on Cubism

n 1923, Picasso granted an interview to the Mexican-born painter and critic Marius de Zayas (1880–1961), who had settled in New York City in 1907 and in 1911 had been instrumental in putting together the first exhibition in the United States of Picasso's paintings. In their conversation, the approved English translation of which appeared in the journal *The Arts* under the title "Picasso Speaks," the artist set forth his views about Cubism and the nature of art in general.

We all know that Art is not truth. Art is a lie that makes us realize truth, at least the truth that is given us to understand. The artist must know the manner whereby to convince others of the truthfulness of his lies. . . . They speak of naturalism in opposition to modern painting. I would like to know if anyone has ever seen a natural work of art. Nature and art, being two different things, cannot be the same thing. Through art we express our conception of what nature is not. . . .

Cubism is no different from any other school of painting. The same principles and the same elements are common to all.... Many think that Cubism is an art of transition, an experiment which is to bring

ulterior results. Those who think that way have not understood it. Cubism is not either a seed or a foetus, but an art dealing primarily with forms, and when a form is realized it is there to live its own life. . . . Mathematics, trigonometry, chemistry, psychoanalysis, music, and whatnot, have been related to Cubism to give it an easier interpretation. All this has been pure literature, not to say nonsense, . . . Cubism has kept itself within the limits and limitations of painting, never pretending to go beyond it. Drawing, design, and color are understood and practiced in Cubism in the spirit and manner that they are understood and practiced in all other schools. Our subjects might be different, as we have introduced into painting objects and forms that were formerly ignored. . . . [I]n our subjects, we keep the joy of discovery, the pleasure of the unexpected; our subject itself must be a source of interest.*

* Marius de Zayas, "Picasso Speaks," *The Arts* (May 1923), 315–326. Reprinted in Herschel B. Chipp, *Theories of Modern Art: A Source Book by Artists and Critics* (Berkeley and Los Angeles: University of California Press, 1968), 263–266.

surfaces in many of his paintings as well) and explored its volume via flat planar cardboard surfaces. (FIG. 24-18 reproduces the maquette, or model. The finished sculpture was to be made of sheet metal.) By presenting what is essentially a cutaway view of a guitar, Picasso allowed the viewer to examine both surface and interior space, both mass and void. This approach, of course, was completely in keeping with the Cubist program. Some scholars have suggested that Picasso derived the cylindrical form that serves as the sound hole on the guitar from the eyes on masks from the Ivory Coast of Africa. African masks were a continuing and persistent source of inspiration for the artist (see "Primitivism," page 696). Here, however, Picasso seems to have transformed the anatomical features of African masks into a part of a musical instrument—dramatic evidence of his unique, innovative artistic vision. Ironically—and intentionally—the sound hole, the central void in a real guitar, is, in Picasso's guitar, the only solid form.

JACQUES LIPCHITZ One of the most successful sculptors to adapt into three dimensions the planar, fragmented dissolution of form central to Analytic Cubist painting was Jacques Lipchitz (1891–1973). Born in Lithuania, Lipchitz resided for many years in France and the United States. He worked out his ideas for many of his sculptures in clay before creating them in bronze or in stone. Bather (FIG. 24-19) is typical of his Cubist style. Lipchitz broke the continuous form of the human body into cubic volumes and planes. The interlocking and gracefully intersecting irregular facets and curves recall the paintings of Picasso and Braque and represent a parallel analysis of dynamic form in space. Lipchitz later produced less volumetric sculptures that included empty spaces outlined by metal shapes. In these sculptures, Lipchitz pursued even further the Cubist notion of spatial ambiguity and the relationship between solid forms and space.

ALEKSANDR ARCHIPENKO The Russian sculptor Aleksandr Archipenko (1887–1964) explored similar ideas, as seen in *Woman Combing Her Hair* (FIG. **24-20**). In this statuette Archipenko introduced, in place of the head, a void with a shape of its

24-19 Jacques Lipchitz, Bather, 1917. Bronze, 2' $10\frac{3}{4}$ " \times 1' $1\frac{1}{4}$ " \times 1' 1". Nelson-Atkins Museum of Art, Kansas City (gift of the Friends of Art).

The interlocking and gracefully intersecting irregular facets and curves of Lipchitz's *Bather* recall the Cubist paintings of Picasso and Braque and represent a parallel analysis of dynamic form in space.

24-20 ALEKSANDR ARCHIPENKO, Woman Combing Her Hair, 1915. Bronze, 1' $1\frac{3}{4}'' \times 3\frac{1}{4}'' \times 3\frac{1}{8}''$. Museum of Modern Art, New York (acquired through the Lillie P. Bliss Bequest).

In this statuette Archipenko introduced, in place of the head, a void with a shape of its own that figures importantly in the whole design. The void is not simply the negative counterpart of the volume.

own that figures importantly in the whole design. Enclosed spaces have always existed in figurative sculpture—for example, the space between the arm and the body when the hand rests on the hip (FIG. 16-13). But here the space penetrates the figure's continuous mass and is a defined form equal in importance to the mass of the bronze. It is not simply the negative counterpart to the volume. Archipenko's figure shows the same fluid intersecting planes seen in Cubist painting, and the relation of the planes to each other is similarly complex. Thus, in both painting and sculpture, the Cubists broke through traditional limits and transformed the medium.

JULIO GONZÁLEZ A friend of Picasso, Julio González (1876–1942) shared his interest in the artistic possibilities of new materials and new methods borrowed from both industrial technology and traditional metalworking. Born into a family of metalworkers in Barcelona, González helped Picasso construct a number of welded sculptures. This contact with Picasso in turn allowed González

24-21 Julio González, *Woman Combing Her Hair*, 1936. Iron, $4' \ 4'' \times 1' \ 11 \frac{1}{2}'' \times 2' \frac{5}{8}''$. Museum of Modern Art, New York (Mrs. Simon Guggenheim Fund).

Using prefabricated metal pieces, González reduced his figure to an interplay of curves, lines, and planes—virtually a complete abstraction without any vestiges of traditional representational art.

to refine his own sculptural vocabulary. Using prefabricated bars, sheets, or rods of welded or wrought iron and bronze, González created dynamic sculptures with both linear elements and volumetric forms. A comparison between his *Woman Combing Her Hair* (FIG. **24-21**) and Archipenko's version of the same subject (FIG. **24-20**) is instructive. Archipenko's figure still incorporates the basic shapes of a woman's body. González reduced his figure to an interplay of curves, lines, and planes—virtually a complete abstraction without any vestiges of traditional representational art. Although González's sculpture received limited exposure during his lifetime, his work had a great impact on later abstract artists working in welded metal.

FERNAND LÉGER AND PURISM Le Corbusier is today best known as one of the most important modernist architects (FIG. 24-75), but he was also a painter. In 1918 he founded a movement called *Purism*, which opposed Synthetic Cubism on the grounds that it was becoming merely an esoteric, decorative art out of touch with

24-22 Fernand Léger, *The City*, 1919. Oil on canvas, $7' 7'' \times 9' 9\frac{1}{2}''$. Philadelphia Museum of Art, Philadelphia (A. E. Gallatin Collection).

Léger was a champion of the "machine aesthetic." In *The City*, he depicted the mechanical commotion of urban life, incorporating the effects of billboard advertisements, flashing lights, and noisy traffic.

the machine age. Purists maintained that machinery's clean functional lines and the pure forms of its parts should direct the artist's experiments in design, whether in painting, architecture, or industrially produced objects. This "machine aesthetic" inspired Fernand Léger (1881–1955), a French painter who early on had painted with the Cubists. He devised an effective compromise of tastes, bringing together meticulous Cubist analysis of form with Purism's broad simplification and machinelike finish of the design components. He retained from his Cubist practice a preference for cylindrical and tube-shaped motifs, suggestive of machined parts such as pistons and cylinders.

Léger's works have the sharp precision of the machine, whose beauty and quality he was one of the first artists to discover. For example, in his film *Ballet Mécanique* (1924), Léger contrasted inanimate objects such as functioning machines with humans in dancelike variations. Preeminently the painter of modern urban life, Léger incorporated into his work the massive effects of modern posters and billboard advertisements, the harsh flashing of electric lights, the noise of traffic, and the robotic movements of mechanized people. These effects appear in *The City* (FIG. **24-22**), an early work that incorporates the aesthetic of Synthetic Cubism. Its monumental scale suggests that Léger, had he been given the opportunity, would have been one of the great mural painters of his age. In a definitive way, he depicted the mechanical commotion of urban life.

Futurism

Artists associated with another major early-20th-century movement, *Futurism*, pursued many of the ideas the Cubists explored. Equally important to the Futurists, however, was their well-defined sociopolitical agenda. Inaugurated and given its name by the charismatic Italian poet and playwright Filippo Tommaso Marinetti (1876–1944) in 1909, Futurism began as a literary movement but soon encompassed the visual arts, cinema, theater, music, and architecture. Indignant over the political and cultural decline of Italy, the Futurists published numerous

manifestos in which they aggressively advocated revolution, both in society and in art. Like Die Brücke and other avant-garde artists, the Futurists aimed at ushering in a new, more enlightened era.

In their quest to launch Italian society toward a glorious future, the Futurists championed war as a means of washing away the stagnant past. Indeed, they saw war as a cleansing agent. Marinetti declared: "We will glorify war—the only true hygiene of the world." The Futurists agitated for the destruction of museums, libraries, and

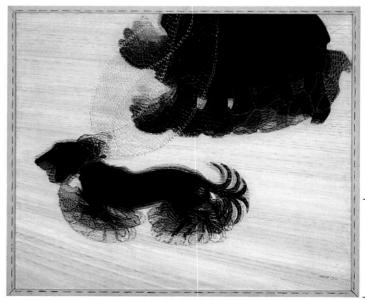

24-23 GIACOMO BALLA, *Dynamism of a Dog on a Leash*, 1912. Oil on canvas, $2'11\frac{3}{8}'' \times 3'7\frac{1}{4}''$. Albright-Knox Art Gallery, Buffalo (bequest of A. Conger Goodyear, gift of George F. Goodyear, 1964).

The Futurists' interest in motion and in the Cubist dissection of form is evident in Balla's painting of a passing dog and its owner. Simultaneity of views was central to the Futurist program.

Futurist Manifestos

n April 11, 1910, a group of young Italian artists published *Futurist Painting: Technical Manifesto* in Milan in an attempt to apply the writer Filippo Tommaso Marinetti's views on literature to the visual arts. Signed jointly by Umberto Boccioni (FIG. 24-24), Carlo Carrà, Luigi Russolo, Giacomo Balla (FIG. 24-23), and Gino Severini, the manifesto also appeared in an English translation supervised by Marinetti himself. It states in part:

On account of the persistency of an image on the retina, moving objects constantly multiply themselves [and] their form changes....

Thus a running horse has not four legs, but twenty....

What was true for the painters of yesterday is but a falsehood today....

To paint a human figure you must not paint it; you must render the whole of its surrounding atmosphere....[T]he vivifying current of science [must] soon deliver painting from academic tradition.... The shadows which we shall paint shall be more luminous than the highlights of our predecessors, and our pictures, next to those of the museums, will shine like blinding daylight compared with deepest night....

We declare . . . that all forms of imitation must be despised, all forms of originality glorified . . . that all subjects previously used must be swept aside in order to express our whirling life of steel, of pride, of fever and of speed . . . that movement and light destroy the materiality of bodies.*

Two years later, Boccioni published a *Technical Manifesto of Futurist Sculpture*, in which he argued that traditional sculpture was "a monstrous anachronism" and that modern sculpture should be

a translation, in plaster, bronze, glass, wood or any other material, of those atmospheric planes which bind and intersect things. . . . Let's . . . proclaim the absolute and complete abolition of finite lines and the contained statue. Let's split open our figures and place the environment inside them. We declare that the environment must form part of the plastic whole. †

Boccioni's own work (FIG. 24-24) is the perfect expression of these principles and goals.

24-24 UMBERTO BOCCIONI, Unique Forms of Continuity in Space, 1913 (cast 1931). Bronze, 3' $7\frac{7}{8}'' \times 2'$ $10\frac{7}{8}'' \times 1'$ $3\frac{3}{4}''$. Museum of Modern Art, New York (acquired through the Lillie P. Bliss Bequest).

Boccioni's Futurist manifesto for sculpture advocated abolishing the enclosed statue. This running figure is so expanded and interrupted that it almost disappears behind the blur of its movement.

* Futurist Painting: Technical Manifesto (Poesia, April 11, 1910). Translated by Filippo Tommaso Marinetti, in Umbro Apollonio, ed., Futurist Manifestos (Boston: Museum of Fine Arts, 1970), 27–31.

† Translated by Robert Brain, in ibid., 51-65.

similar repositories of accumulated culture, which they described as mausoleums. They also called for radical innovation in the arts. Of particular interest to the Futurists were the speed and dynamism of modern technology. Marinetti insisted that a racing "automobile adorned with great pipes like serpents with explosive breath . . . is more beautiful than the *Victory of Samothrace*" (FIG. 5-82, by then representative of classicism and the glories of past civilizations). ¹¹ Appropriately, Futurist art often focuses on motion in time and space, incorporating the Cubist discoveries derived from the analysis of form.

GIACOMO BALLA The Futurists' interest in motion and in the Cubist dissection of form is evident in *Dynamism of a Dog on a Leash* (FIG. **24-23**) by GIACOMO BALLA (1871–1958). Here, observers focus their gaze on a passing dog and its owner, whose skirts the artist placed just within visual range. Balla achieved the effect of motion by repeating shapes, as in the dog's legs and tail and in the swinging line of the leash. Simultaneity of views, as demonstrated here, was central to the Futurist program (see "Futurist Manifestos," above).

UMBERTO BOCCIONI One of the artists who cosigned the Futurist manifesto was UMBERTO BOCCIONI (1882-1916), who produced what is perhaps the definitive work of Futurist sculpture, Unique Forms of Continuity in Space (FIG. 24-24). This piece highlights the formal and spatial effects of motion rather than their source, the striding human figure. The figure is so expanded, interrupted, and broken in plane and contour that it almost disappears behind the blur of its movement. Boccioni's search for sculptural means for expressing dynamic action reached majestic expression here. In its power and sense of vital activity, this sculpture surpasses similar efforts in Futurist painting to create images symbolic of the dynamic quality of modern life. To be convinced by it, people need only reflect on how details of an adjacent landscape appear in their peripheral vision when they are traveling at great speed on a highway or in a low-flying airplane. Although Boccioni's figure bears a curious resemblance to the ancient Nike of Samothrace (FIG. 5-82), even a cursory comparison reveals how far the modern work departs from the ancient one.

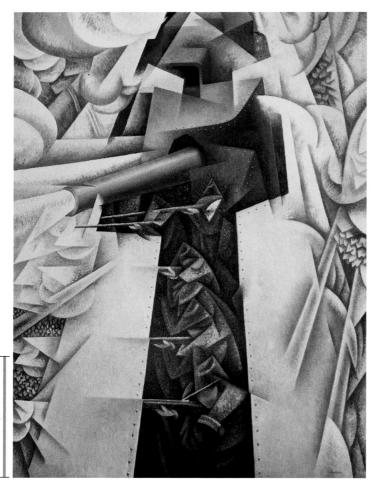

24-25 Gino Severini, *Armored Train*, 1915. Oil on canvas, $3'10'' \times 2'10\frac{1}{8}''$. Collection of Richard S. Zeisler, New York.

Severini's glistening armored train with protruding cannon reflects the Futurist faith in the cleansing action of war. The painting captures the dynamism and motion central to the Futurist manifesto.

This Futurist representation of motion in sculpture has its limitations. The eventual development of the motion picture, based on the rapid sequential projection of fixed images, produced more convincing illusions of movement. And several decades later in sculpture, Alexander Calder (FIG. 24-61) pioneered the development of kinetic sculpture—with parts that really move. However, in the early 20th century, Boccioni's sculpture was notable for its ability to capture the sensation of motion.

GINO SEVERINI The painting Armored Train (FIG. 24-25) by GINO SEVERINI (1883–1966) nicely encapsulates the Futurist program, both artistically and politically. The artist depicted a high-tech armored train with its rivets glistening and a huge booming cannon protruding from the top. Submerged in the bowels of the train, a row of soldiers train guns at an unseen target. Severini's painting reflects the Futurist faith in the cleansing action of war. Not only are the colors predominantly light and bright, but the artist also omitted death and destruction—the tragic consequences of war—from the image. This sanitized depiction of war contrasts sharply with Francisco Goya's Third of May, 1808 (FIG. 22-13), which also depicts a uniform row of anonymous soldiers in the act of shooting. Goya, however, graphically presented the dead and those about to be shot, and the dark tones of the work cast a dramatic and sobering pall. Armored Train captures the dynamism and motion central to Futurism.

In Cubist fashion, Severini depicted all of the objects, from the soldiers to the smoke emanating from the cannon, broken into facets and planes, suggesting action and movement. Once World War I broke out, the Futurist group began to disintegrate, largely because so many of them felt compelled (given the Futurist support for the war) to join the Italian army. Some of them, including Umberto Boccioni, died in the war. The ideas the Futurists promoted became integral to the Fascism that emerged in Italy shortly thereafter.

Dada

Although the Futurists celebrated World War I and the changes they hoped it would effect, the mass destruction and chaos that conflict unleashed horrified other artists. Humanity had never before witnessed such wholesale slaughter on so grand a scale over such an extended period. Millions died or sustained grievous wounds in great battles. For example, in 1916, the battle of Verdun (lasting five months) left 500,000 casualties. On another day in 1916, the British lost 60,000 men in the opening battle of the Somme. The new technology of armaments, bred of the age of steel, made it a "war of the guns" (as in Severini's Armored Train; FIG. 24-25). In the face of massed artillery hurling millions of tons of high explosives and gas shells and in the sheets of fire from thousands of machine guns, attack was suicidal, and battle movement congealed into the stalemate of trench warfare, stretching from the English Channel almost to Switzerland. The mud, filth, and blood of the trenches, the pounding and shattering of incessant shell fire, and the terrible deaths and mutilations were a devastating psychological, as well as physical, experience for a generation brought up with the doctrine of progress and a belief in the fundamental values of civilization.

With the war as a backdrop, many artists contributed to an artistic and literary movement that became known as Dada. This movement emerged, in large part, in reaction to what many of these artists saw as nothing more than an insane spectacle of collective homicide. Although Dada began independently in New York and Zurich, it also emerged in Paris, Berlin, and Cologne, among other cities. Dada was more a mind-set or attitude than a single identifiable style. As André Breton (1896-1966), founder of the slightly later Surrealist movement, explained: "Cubism was a school of painting, futurism a political movement: DADA is a state of mind."12 The Dadaists believed reason and logic had been responsible for the unmitigated disaster of global warfare, and they concluded that the only route to salvation was through political anarchy, the irrational, and the intuitive. Thus, an element of absurdity is a cornerstone of Dada, even reflected in the movement's name. There are many explanations for the choice of "Dada," but according to an often repeated anecdote, the Dadaists chose the word at random from a French-German dictionary. Dada is French for a child's hobbyhorse. The word satisfied the Dadaists' desire for something irrational and nonsensical.

The Dadaists' pessimism and disgust surfaced in their disdain for convention and tradition. These artists made a concerted and sustained attempt to undermine cherished notions and assumptions about art. Because of this destructive dimension, art historians often describe Dada as a nihilistic enterprise. Dada's nihilism and its derisive iconoclasm can be read at random from the Dadaists' numerous manifestos and declarations of intent:

Dada knows everything. Dada spits on everything. Dada says "knowthing," Dada has no fixed ideas. Dada does not catch flies. Dada is bitterness laughing at everything that has been accomplished, sanctified. . . . Dada is never right. . . . No more painters, no more writers, no more religions, no more royalists, no more anarchists, no more socialists, no more police, no more airplanes, no more urinary passages. . . . Like everything in life, Dada is useless, everything

happens in a completely idiotic way. . . . We are incapable of treating seriously any subject whatsoever, let alone this subject: ourselves. ¹³

Although cynicism and pessimism inspired the Dadaists, the movement they developed was phenomenally influential and powerful. By attacking convention and logic, the Dada artists unlocked new avenues for creative invention, thereby fostering a more serious examination of the basic premises of art than had prior movements. But the Dadaists could also be lighthearted in their subversiveness. Although horror and disgust about the war initially prompted Dada, an undercurrent of humor and whimsy—sometimes sardonic or irreverent—runs through much of the art. For example, Marcel Duchamp (see page 706) painted a mustache and goatee on a reproduction of Leonardo da Vinci's *Mona Lisa*. The French painter Francis Picabia (1879–1953), Duchamp's collaborator in setting up Dada in New York, nailed a toy monkey to a board and labeled it *Portrait of Cézanne*.

In its emphasis on the spontaneous and intuitive, Dada paralleled the views of Sigmund Freud (1856–1939) and Carl Jung (1875–1961). Freud was a Viennese doctor who developed the fundamental principles for what became known as psychoanalysis. In his book *The Interpretation of Dreams* (1900), Freud argued that the unconscious and inner drives (of which people are largely unaware) control human behavior. Jung, a Swiss psychiatrist who developed Freud's theories further, believed that the unconscious is composed of two facets, a personal unconscious and a collective unconscious. The collective unconscious comprises memories and associations all humans share, such as archetypes and mental constructions. According to Jung, the collective unconscious accounts for the development of myths, religions, and philosophies.

Particularly interested in the exploration of the unconscious as Freud advocated, the Dada artists believed that art was a powerfully practical means of self-revelation and catharsis, and that the images arising out of the subconscious mind had a truth of their own, independent of conventional vision. A Dada filmmaker, Hans Richter (1888–1976), summarized the attitude of the Dadaists:

Possessed, as we were, of the ability to entrust ourselves to "chance," to our conscious as well as our unconscious minds, we became a sort of public secret society. . . . We laughed at everything. . . . But laughter was only the expression of our new discoveries, not their essence and not their purpose. Pandemonium, destruction, anarchy, anti-everything of the World War? How could Dada have been anything but destructive, aggressive, insolent, on principle and with gusto? 14

JEAN ARP A Dada artist whose works illustrate Richter's element of chance was Zurich-based Jean (Hans) App (1887–1966). App pioneered the use of chance in composing his images. Tiring of the look of some Cubist-related collages he was making, he took some sheets of paper, tore them into roughly shaped squares, haphazardly dropped them onto a sheet of paper on the floor, and glued them into the resulting arrangement. The rectilinearity of the shapes guaranteed a somewhat regular design (which Arp no doubt enhanced by adjusting the random arrangement into a quasi-grid), but chance had introduced an imbalance that seemed to Arp to restore to his work a special mysterious vitality he wanted to preserve. Collage Arranged According to the Laws of Chance (FIG. 24-26) is a work he created by this method. The operations of chance were for Dadaists a crucial part of this kind of improvisation. As Richter stated: "For us chance was the 'unconscious mind' that Freud had discovered in 1900. . . . Adoption of chance had another purpose, a secret one. This was to restore to the work of art its primeval magic power and to find a way back to the immediacy it had lost through contact with ... classicism." ¹⁵ Arp's renunciation of artis-

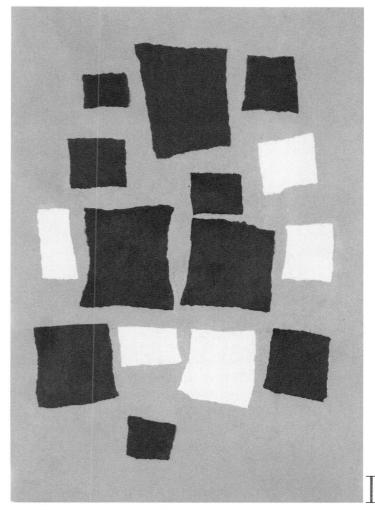

24-26 Jean (Hans) Arp, *Collage Arranged According to the Laws of Chance*, 1916–1917. Torn and pasted paper, 1' $7\frac{1}{8}$ " \times 1' $1\frac{5}{8}$ ". Museum of Modern Art, New York.

In this collage, Arp dropped torn paper squares onto a sheet of paper and then glued them into the resulting arrangement. His reliance on chance in composing images reinforced the anarchy inherent in Dada.

tic control and reliance on chance when creating his compositions reinforced the anarchy and subversiveness inherent in Dada.

CABARET VOLTAIRE Among the manifestations of Dada that matured in 1916 in Zurich were the performances presented at the Cabaret Voltaire, founded by Dadaist Hugo Ball (1886–1927), a poet, musician, and theatrical producer. The first Dada performances were fairly tame, consisting of musical presentations and poetry readings. In keeping with Dada thought, however, they quickly became more aggressive, anarchic, and illogical. Tristan Tzara (1896–1963) described one of these performances in characteristically absurd Dadaist language:

Boxing resumed: Cubist dance, costumes by Janco, each man his own big drum on his head, noise, Negro music/trabatgea bonoooooo oo ooooo/5 literary experiments; Tzara in tails stands before the curtain, stone sober for the animals, and explains the new aesthetic: gymnastic poem, concert of vowels, bruitist poem, static poem chemical arrangement of ideas, 'Biriboom biriboom' saust der Ochs im Kreis herum (the ox dashes round in a ring) (Huelsenbeck), vowel poem a a ò, i e o, a i ï, new interpretation of subjective folly of the arteries the dance of the heart on burning buildings and acrobatics in the audience.¹⁶

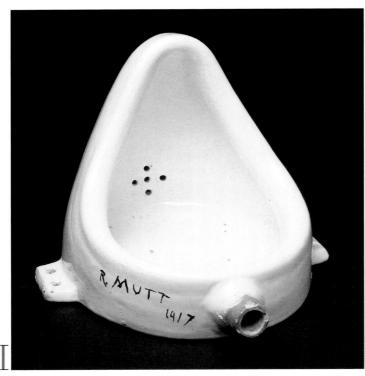

24-27 Marcel Duchamp, *Fountain* (second version), 1950 (original version produced 1917). Readymade glazed sanitary china with black paint, 1' high. Philadelphia Museum of Art, Philadelphia.

Duchamp's "readymade" sculptures were mass-produced objects that the Dada artist modified. In *Fountain*, he conferred the status of art on a urinal and forced people to see the object in a new light.

MARCEL DUCHAMP Perhaps the most influential Dadaist was MARCEL DUCHAMP (1887–1968), a Frenchman who became the central artist of New York Dada but was also active in Paris. In 1913 he exhibited his first "readymade" sculptures, which were mass-produced common objects—"found objects" the artist selected and sometimes "rectified" by modifying their substance or combining them with another object. The creation of readymades, he insisted, was free from any consideration of either good or bad taste, qualities shaped by a society he and other Dada artists found aesthetically bankrupt. Perhaps his most outrageous readymade was Fountain (FIG. 24-27), a porcelain urinal presented on its back, signed "R. Mutt," and dated. The "artist's signature" was, in fact, a witty pseudonym derived from the Mott plumbing company's name and that of the short half of the then-popular Mutt and Jeff comic-strip team. As with Duchamp's other readymades, he did not select this object for exhibition because of its aesthetic qualities. The "art" of this "artwork" lies in the artist's choice of object, which has the effect of conferring the status of art on it and forces the viewer to see the object in a new light. As he wrote in a "defense" published in 1917, after an exhibition committee rejected Fountain for display: "Whether Mr. Mutt with his own hands made the fountain or not has no importance. He CHOSE it. He took an ordinary article of life, placed it so that its useful significance disappeared under the new title and point of view—created a new thought for that object."17 It is hard to imagine a more aggressively avant-garde approach to art. Dada persistently presented staggering challenges to artistic conventions.

THE LARGE GLASS Among the most visually and conceptually challenging of Duchamp's works is *The Bride Stripped Bare by Her Bachelors, Even* (FIG. 24-28), often referred to as *The Large Glass.* Begun in 1915 and abandoned by Duchamp as unfinished in 1923,

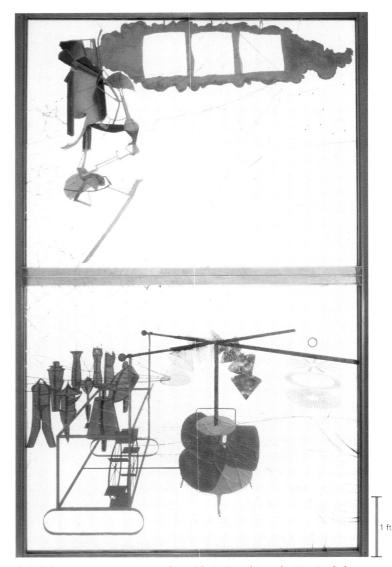

24-28 Marcel Duchamp, *The Bride Stripped Bare by Her Bachelors, Even* (*The Large Glass*), 1915–1923. Oil, lead, wire, foil, dust, and varnish on glass, 9' $1\frac{1}{2}'' \times 5'$ $9\frac{1}{8}''$. Philadelphia Museum of Art, Philadelphia (Katherine S. Dreier Bequest).

The Large Glass is a simultaneously playful and serious examination of humans as machines. The bride is a motor fueled by "love gasoline," and the male figures in the lower half also move mechanically.

The Large Glass is a simultaneously playful and serious examination of humans as machines. Consisting of oil paint, wire, and lead foil sandwiched in between two large glass panels, the artwork presents the viewer with an array of images, some apparently mechanical, others diagrammatic, and yet others seemingly abstract in nature. Duchamp provided some clues to the intriguing imagery in a series of notes that accompanied the work. The top half of the work represents "the bride," whom Duchamp has depicted as "basically a motor" fueled by "love gasoline." In contrast, the bachelors appear as uniformed male figures in the lower half of the work. They too move mechanically. The chocolate grinder in the center of the lower glass pane represents masturbation ("the bachelor grinds his own chocolate"). In The Large Glass, Duchamp provided his own whimsical but insightful ruminations into the ever-confounding realm of desire and sexuality. In true Dadaist fashion, chance completed the work. During the transportation of The Large Glass from an exhibition in 1927, the glass panes shattered. Rather than replace the broken glass, Duchamp painstakingly pieced together the glass fragments. After encasing the recon-

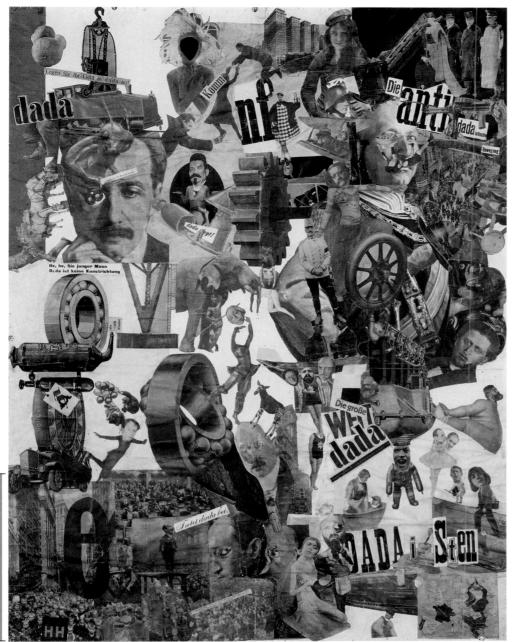

24-29 Hannah Höch, Cut with the Kitchen Knife Dada through the Last Weimar Beer Belly Cultural Epoch of Germany, 1919–1920. Photomontage, $3' 9'' \times 2' 11\frac{1}{2}''$. Neue Nationalgalerie, Staatliche Museen zu Berlin, Berlin.

In Höch's photomontage, photographs of some of her fellow Dadaists appear among images of Marx and Lenin, and the artist juxtaposed herself with a map of Europe showing the progress of women.

structed work, broken panes and all, between two heavier panes of glass, Duchamp declared the work completed "by chance."

Duchamp (and the generations of later artists who were profoundly influenced by his art and especially his attitude) considered life and art matters of chance and choice freed from the conventions of society and tradition. Within his approach to art and life, each act was individual and unique. Every person's choice of found objects would be different, for example, and each person's throw of the dice would be at a different instant and probably would yield a different number. This philosophy of utter freedom for artists was fundamental to the history of art in the 20th century. Duchamp spent much of World War I in New York, inspiring a group of American artists and collectors with his radical rethinking of the role of artists and of the nature of art.

HANNAH HÖCH Dada spread throughout much of western Europe, arriving as early as 1917 in Berlin, where it soon took on an activist political edge, partially in response to the economic, social, and political chaos in that city in the years at the end of and immediately after World War I. The Berlin Dadaists developed to a new inten-

sity a technique that had been used in private and popular arts long before the 20th century to create a composition by pasting together pieces of paper. A few years earlier, the Cubists had named the process "collage." The Berliners christened their version of the technique photomontage. Unlike Cubist collage (FIGS. 24-16 and 24-17), the parts of a Dada collage consisted almost entirely of "found" details, such as pieces of magazine photographs, usually combined into deliberately antilogical compositions. Collage lent itself well to the Dada desire to use chance when creating art and antiart, but not all Dada collage was as savagely aggressive as that of the Berlin photomontagists.

One of the Berlin Dadaists who perfected the photomontage technique was Hannah Höch (1889–1978). Höch's photomontages advanced the absurd illogic of Dada by presenting the viewer with chaotic, contradictory, and satiric compositions. They also provided insightful and scathing commentary on two of the most dramatic developments during the Weimar Republic (1918–1933) in Germany the redefinition of women's social roles and the explosive growth of mass print media. She revealed these combined themes in Cut with the Kitchen Knife Dada through the Last Weimar Beer Belly Cultural Epoch of Germany (FIG. 24-29). In this work Höch arranged an eclectic mixture of cutout photos in seemingly haphazard fashion. On closer inspection, however, the viewer can see that the artist carefully placed photographs of some of her fellow Dadaists among images of Marx, Lenin, and other revolutionary figures in the lower right section, aligning this movement with other revolutionary forces. She promoted Dada in prominently placed cutout lettering— "Die grosse Welt dada" (the great Dada world). Certainly, juxtaposing the heads of German military leaders with exotic dancers' bodies provided the wickedly humorous critique central to much of Dada. Höch also positioned herself in this topsy-turvy world she created.

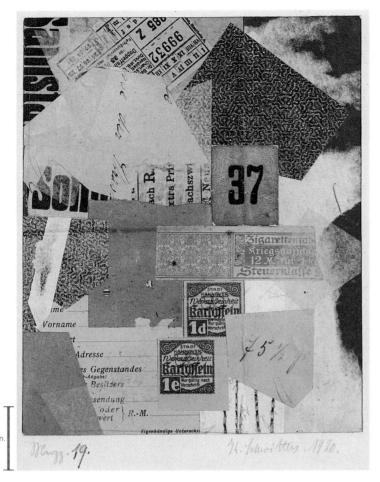

24-30 Kurt Schwitters, *Merz 19*, 1920. Paper collage, $7\frac{1}{4}'' \times 5\frac{7}{8}''$. Yale University Art Gallery, New Haven (gift of Collection Société Anonyme).

Inspired by Cubist collage but working nonobjectively, Schwitters found visual poetry in the cast-off junk of modern society, which he pasted and nailed together into striking Dada compositions.

24-31 John Sloan, Sixth Avenue and Thirtieth Street, New York City, 1907. Oil on canvas, $2'\frac{1}{4}'' \times 2'$ 8". Philadelphia Museum of Art, Philadelphia (gift of Meyer P. Potamkin and Vivian O. Potamkin, 2000)

A prominent member of the American Realist group called The Eight, Sloan captured in his paintings the bleak and seedy aspects of the rapidly changing urban landscape of New York City.

A photograph of her head appears in the lower right corner, juxtaposed with a map of Europe showing the progress of women's enfranchisement. Aware of the power both women and Dada had to destabilize society, Höch made forceful visual manifestations of that belief.

KURT SCHWITTERS The Hanover Dada artist Kurt Schwit-TERS (1887–1948) followed a gentler muse. Inspired by Cubist collage but working nonobjectively, Schwitters found visual poetry in the castoff junk of modern society and scavenged in trash bins for materials, which he pasted and nailed together into designs such as Merz 19 (FIG. 24-30). The term "Merz," which Schwitters used as a generic title for a whole series of collages, derived nonsensically from the German word Kommerzbank (commerce bank) and appeared as a word fragment in one of his compositions. Although nonobjective, his collages still resonate with the meaning of the fragmented found objects they contain. The recycled elements of Schwitters's collages, like Duchamp's readymades, acquire new meanings through their new uses and locations. Elevating objects that are essentially trash to the status of high art certainly fits within the parameters of the Dada program and parallels the absurd dimension of much of Dada art. Contradiction, paradox, irony, and even blasphemy are Dada's bequest. They are, in the view of Dada and its successors, the free and defiant artist's weapons in what has been called the hundred years' war with the public.

AMERICA, 1900 TO 1930

Avant-garde experiments in the arts were not limited to Europe. A wide range of artists engaged in a lively exchange of artistic ideas and significant transatlantic travel. In the latter part of the 19th century, American artists such as John Singer Sargent (see Chapter 22), James Abbott McNeil Whistler, and Mary Cassatt (see Chapter 23) spent much of their productive careers in Europe, whereas many European artists ended their careers in America, especially in anticipation of and, later, in the wake of World War I. Visionary patrons sup-

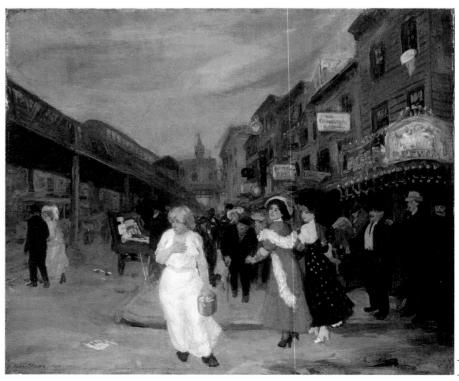

1 in

Art "Matronage" in America

Intil the 20th century, the dearth of women artists was often due to professional institutions that restricted women's access to artistic training. For example, the proscription against women participating in life-drawing classes, a staple of academic artistic training, in effect denied women the opportunity to become professional artists. Further, the absence of women from the art historical canon is also partly because art historians have not considered as "high art" many of the art objects women have traditionally produced (for example, quilts or basketry).

By the early 20th century, many of the impediments to women becoming recognized artists had been removed. Today, women are a major presence in the art world. One development in the early 20th century that laid the groundwork for this change was the prominent role women played as art patrons. These "art matrons" provided financial, moral, and political support to cultivate the advancement of the arts in America. Among these women were Gertrude Vanderbilt Whitney, Lillie P. Bliss, Mary Quinn Sullivan, Abby Aldrich Rockefeller, Isabella Stewart Gardner, Peggy Guggenheim, and Jane Stanford.*

Gertrude Vanderbilt Whitney (1875–1942) was a practicing sculptor and enthusiastic collector. To assist young American artists such as Robert Henri and John Sloan (FIG. 24-31) to exhibit their work, she opened the Whitney Studio in 1914. By 1929, dissatisfied with the recognition accorded young, progressive American artists, she offered her entire collection of 500 works to the Metropolitan Museum of Art. Her offer rejected, she founded her own museum, the Whitney Museum of American Art in New York City. She chose as the first director a visionary and energetic woman, Juliana Force (1876–1948), who inaugurated a pioneering series of monographs on living American artists and organized lecture series by influential art historians and critics. Through the efforts of these two women, the Whitney Museum became a major force in American art.

A trip to Paris in 1920 whetted the interest of Peggy Guggenheim (1898–1979) in avant-garde art. Like Whitney, she collected art and eventually opened a gallery in England to exhibit the work of in-

novative artists. She continued her support for avant-garde art after her return to the United States. Guggenheim's New York gallery, called Art of This Century, was instrumental in advancing the careers of many artists, including her husband, Max Ernst (FIG. 24-47). She eventually moved her art collection to a lavish Venetian palace, where the public can still view these important artworks.

Other women contributed significantly to the arts, including Lillie P. Bliss (1864–1931), Mary Quinn Sullivan (1877–1939), and Abby Aldrich Rockefeller (1874–1948). Philanthropists, art collectors, and educators, these visionary and influential women saw the need for a museum to collect and exhibit modernist art. Together they established the Museum of Modern Art in New York City in 1929, which became (and continues to be) the most influential museum of modern art in the world (see "The Museum of Modern Art," page 730).

Isabella Stewart Gardner (1840–1924) and Jane Stanford (1828–1905) also undertook the ambitious project of founding museums. The Isabella Stewart Gardner Museum in Boston, established in 1903, contains an impressive collection of art that is comprehensive in scope. The Stanford Museum, the first American museum west of the Mississippi, got its start in 1905 on the grounds of Stanford University, which Leland Stanford Sr. and Jane Stanford founded after the tragic death of their son. The Stanford Museum houses a wide range of objects, including archaeological and ethnographic artifacts. These two driven women committed much of their time, energy, and financial resources to ensure the success of these museums. Both were intimately involved in the day-to-day operations of their institutions.

The museums these women established flourish today, attesting to the extraordinary vision of these "art matrons" and the remarkable contributions they made to the advancement of art in the United States.

* Art historian Wanda Corn coined the term "art matronage" in the catalog Cultural Leadership in America: Art Matronage and Patronage (Boston: Isabella Stewart Gardner Museum, 1997).

ported the efforts of American artists to pursue modernist ideas (see "Art 'Matronage' in America," above).

Painting and Sculpture

The art scene in America before the establishment of a significant and consistent dialogue with European modernists was, of course, quite varied. However, many American artists active in the early 20th century were committed to presenting what they considered to be a realistic, unvarnished look at life. In this regard, their work parallels that of the French Realists in the mid-19th century (see Chapter 22).

JOHN SLOAN AND THE EIGHT One group of American Realist artists, The Eight, consisted of eight painters who gravitated into the circle of the influential and evangelical artist and teacher Robert Henri (1865–1929). Henri urged his followers to make "pictures from life," ¹⁸ and accordingly, these artists pursued with zeal the

production of images depicting the rapidly changing urban landscape of New York City. Because these vignettes often captured the bleak and seedy aspects of city life, The Eight eventually became known as the Ash Can School. Some critics referred to them as "the apostles of ugliness."

A prominent member of The Eight was John Sloan (1871–1951). A self-described "incorrigible window watcher," Sloan constantly wandered the streets of New York, observing human drama. He focused much of his attention on the working class, which he perceived as embodying the realities of life. So sympathetic was Sloan to the working class that he joined the Socialist Party in 1909 and eventually ran for public office on the Socialist ticket. In paintings such as Sixth Avenue and Thirtieth Street (FIG. 24-31), Sloan revealed his ability to capture both the visual and social realities of American urban life shortly after the turn of the century. When he painted this image in 1907, Sloan was living on West 23rd Street, on the outskirts

rom February 17 to March 15, 1913, the American public flocked in large numbers to view the International Exhibition of Modern Art (FIG. 24-32) at the 69th Regiment Armory in New York City. The "Armory Show," as it came universally to be called, was an ambitious endeavor organized primarily by two artists, Walt Kuhn (1877-1949) and Arthur B. Davies (1862-1928). The show contained more than 1,600 artworks by American and European artists. Among the European artists represented were Matisse, Derain, Picasso, Braque, Duchamp, Kandinsky, Kirchner, Lehmbruck, and Brancusi. In addition to exposing American artists and the public to the latest in European artistic developments, this show also provided American artists with a prime showcase for their work. The foreword to the exhibition catalogue spelled out the goals of the organizers:

The American artists exhibiting here consider the exhibition of equal importance for themselves as for the public. The less they find their work showing signs of the developments indicated in the Europeans, the more reason they will have to consider whether or not painters or sculptors here have fallen behind... the forces that have manifested themselves on the other side of the Atlantic.*

On its opening, this provocative exhibition served as a lightning rod for commentary, immediately attracting heated controversy. The *New York Times* described the show as "pathological" and called the modernist artists "cousins to the anarchists," while the magazine *Art and Progress* compared them to "bomb throwers, lunatics, depravers." Other critics demanded the exhibition be closed as a menace to public morality. The *New York Herald*, for example, asserted: "The United States is invaded by aliens, thousands of whom constitute so many perils to the health of the body politic. Modernism is of precisely the same heterogeneous alien origin and is imperiling the republic of art in the same way."

of the Tenderloin District, an area cluttered with brothels, dance halls, saloons, gambling dens, and cheap hotels. *Sixth Avenue* depicts a bustling intersection. Bracketing the throngs of people filling the intersection are elevated train tracks on the left and a row of storefronts and apartment buildings on the right side of the painting. These two defining elements of city life converge in the far center background. Sloan's paintings also capture a slice of American urban life in the cross-section of people depicted. In the foreground of *Sixth Avenue*, Sloan prominently placed three women. One, in a shabby white dress, is a drunkard, stumbling along with her pail of beer. Two streetwalkers stare at her. In turn, two well-dressed men gaze at the prostitutes. Sloan's depiction of the women allied him with reformers of the time, who saw streetwalkers not as immoral but as victims of an unfair social and economic system. At a time

The Armory Show

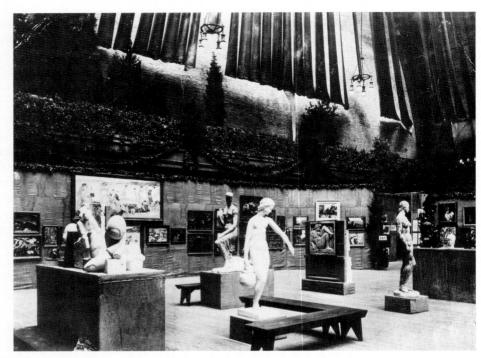

24-32 Installation photo of the Armory Show, New York National Guard's 69th Regiment, New York, 1913. Museum of Modern Art, New York.

The groundbreaking Armory Show introduced European modernism to the American public. Works like Duchamp's *Nude Descending a Staircase* (FIG. 24-1) received a hostile reception in the press.

Nonetheless, the exhibition was an important milestone in the history of art in the United States. The Armory Show traveled to Chicago and Boston after it closed in New York and was a significant catalyst for the reevaluation of the nature and purpose of American art.

when traditional art centered on genteel and proper society, Sloan's forthright depiction of prostitutes was categorically "Realist."

ARMORY SHOW One of the major vehicles for disseminating information about European artistic developments in the United States was the Armory Show (FIG. 24-32), held in early 1913 (see "The Armory Show," above). The exhibition received a hostile response from the press. The work the journalists and critics most maligned was Marcel Duchamp's *Nude Descending a Staircase*, *No. 2* (FIG. 24-1). The painting, a single figure in motion down a staircase in a time continuum, suggests the effect of a sequence of overlaid film stills. Unlike Duchamp's contributions to the Dada movement (FIGS. 24-27 and 24-28), *Nude Descending a Staircase* has much in common with the work of the Cubists and the Futurists.

^{*} Quoted in Herschel B. Chipp, *Theories of Modern Art: A Source Book by Artists and Critics* (Berkeley and Los Angeles: University of California Press, 1968), 503.

[†] Quoted in Sam Hunter, John Jacobus, and Daniel Wheeler, *Modern Art*, rev. 3d ed. (Upper Saddle Hill, N.J.: Prentice Hall, 2005), 250.

 $^{^{\}ddagger}$ Quoted in Francis K. Pohl, *Framing America: A Social History of American Art* (New York: Thames & Hudson, 2002), 321.

The monochromatic palette is reminiscent of Analytic Cubism, as is Duchamp's faceted presentation of the human form. The artist's interest in depicting the figure in motion reveals an affinity for the Futurists' ideas. One critic described this work as "an explosion in a shingle factory," and newspaper cartoonists had a field day lampooning the painting.

MAN RAY One American artist to incorporate the latest European trends in his work was Emmanuel Radnitzky, known as MAN RAY (1890-1976), who was a close associate of Duchamp in the 1920s. Man Ray produced art with a decidedly Dada spirit, often incorporating found objects in his paintings, sculptures, movies, and photographs. Trained as an architectural draftsman and engineer, Man Ray earned his living as a graphic designer and portrait photographer. He brought to his personal work an interest in massproduced objects and technology, as well as a dedication to exploring the psychological realm of human perception of the exterior world. Like Schwitters, Man Ray used chance and the dislocation of ordinary things from their everyday settings to surprise his viewers into new awareness. His displacement of found objects was particularly effective in works such as Cadeau (Gift; FIG. 24-33). For this sculpture, Man Ray—with characteristic Dada humor—equipped a laundry iron with a row of wicked-looking spikes, subverting its proper function of smoothing and pressing.

24-33 Man Ray, *Cadeau* (*Gift*), ca. 1958 (replica of 1921 original). Painted flatiron with row of 13 tacks with heads glued to the bottom, $6\frac{1}{8}$ " $\times 3\frac{5}{8}$ " $\times 4\frac{1}{2}$ ". Museum of Modern Art, New York (James Thrall Soby Fund).

With characteristic Dada humor, the American artist Man Ray equipped a laundry iron with a row of wicked-looking spikes, subverting its proper function of smoothing and pressing.

MARSDEN HARTLEY Other American artists developed personal styles that intersected with movements such as Cubism. MARSDEN HARTLEY (1877-1943) traveled to Europe in 1912, visiting Paris, where he became acquainted with the work of the Cubists, and Munich, where he gravitated to the Blaue Reiter circle. Kandinsky's work particularly impressed Hartley, and he developed a style he called "Cosmic Cubism." He took these influences with him when he landed in Berlin in 1913. With the heightened militarism in Germany and the eventual outbreak of World War I, Hartley immersed himself in military imagery. Among his most famous paintings of this period is Portrait of a German Officer (FIG. 24-34). It depicts an array of military-related images: German imperial flags, regimental insignia, badges, and emblems such as the Iron Cross. Although this image resonates in the general context of wartime militarism, elements in the painting did have personal significance for Hartley. In particular, the painting includes references to his lover, Lieutenant Karl von Freyberg, who lost his life in battle a few months before Hartley painted this work. Von Freyberg's initials appear in the lower

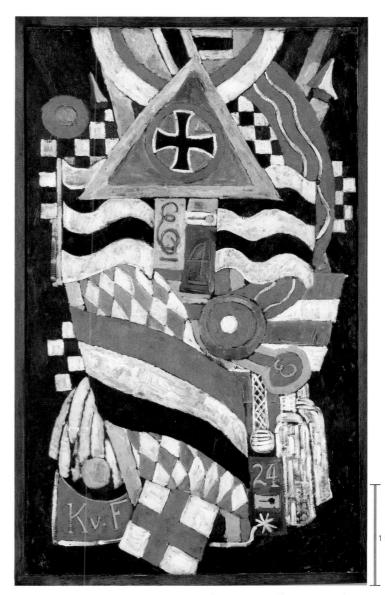

24-34 Marsden Hartley, Portrait of a German Officer, 1914. Oil on canvas, 5′ $8\frac{1}{4}$ ″ \times 3′ $5\frac{3}{8}$ ″. Metropolitan Museum of Art, New York (Alfred Stieglitz Collection).

In this elegy to a lover killed in battle, Hartley arranged military-related images against a somber black background. The flattened, planar presentation reveals the influence of Synthetic Cubism.

711

left corner. His age when he died (24) appears in the lower right corner, and his regiment number (4) appears in the center of the painting. Also incorporated is the letter *E* for von Freyberg's regiment, the Bavarian Eisenbahn. The influence of Synthetic Cubism is evident in the flattened, planar presentation of the elements, which almost appear as abstract patterns. The somber black background against which the artist placed the colorful stripes, patches, and shapes casts an elegiac pall over the painting.

STUART DAVIS Philadelphia-born STUART DAVIS (1894–1964) created what he believed was a modern American art style by combining the flat shapes of Synthetic Cubism with his sense of jazz tempos and his perception of the energy of fast-paced American culture.

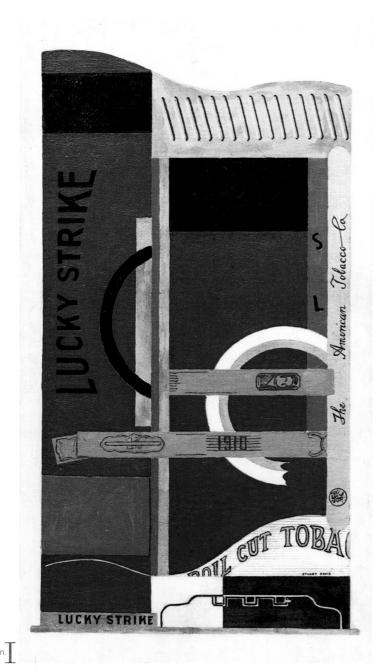

24-35 STUART DAVIS, *Lucky Strike*, 1921. Oil on canvas, $2' 9\frac{1}{4}'' \times 1' 6''$. Museum of Modern Art, New York (gift of the American Tobacco Company, Inc.). Art © Estate of Stuart Davis/Licensed by VAGA, New York.

Tobacco products fascinated Davis, a heavy smoker. In *Lucky Strike*, he depicted a cigarette package in fragmented form, reminiscent of Cubism, and imbued his painting with an American jazz rhythm.

Lucky Strike (FIG. 24-35) is one of several tobacco still lifes Davis began in 1921. Davis was a heavy smoker, and tobacco products and their packaging fascinated him. He insisted that the late-19th-century introduction of packaging was evidence of high civilization and therefore, he concluded, of the progressiveness of American culture. Davis depicted the Lucky Strike package in fragmented form, reminiscent of Synthetic Cubist collages. However, although the work does incorporate flat printed elements, these are illusionistically painted rather than glued onto the canvas surface. The discontinuities and the interlocking planes imbue Lucky Strike with a dynamism and rhythm not unlike American jazz or the pace of life in a lively American metropolis. This work is both resolutely American and modern.

AARON DOUGLAS Also deriving his personal style from Synthetic Cubism was African American artist AARON DOUGLAS (1898–1979), who used the style to represent symbolically the historical and cultural memories of African Americans. Born in Kansas, Douglas studied in Nebraska and Paris before settling in New York City, where he became part of the flowering of art and literature in the 1920s known as the Harlem Renaissance. Spearheaded by writers and editors Alain Locke and Charles Johnson, the Harlem Renaissance was a manifestation of the desire of African Americans to promote their cultural accomplishments. They also aimed to cultivate pride among fellow African Americans and to foster racial tolerance across the United States. Expansive and diverse, the fruits of the Harlem Renaissance included the writings of authors such as Langston Hughes, Countee Cullen, and Zora Neale Hurston; the jazz and blues of Duke Ellington, Bessie Smith, Eubie Blake, Fats Waller, and Louis Armstrong; the photographs of James Van Der Zee and Prentice H. Polk; and the paintings and sculptures of Meta Warrick Fuller and Augusta Savage.

Aaron Douglas arrived in New York City in 1924 and became one of the most sought-after graphic artists in the African American community. Encouraged to create art that would express the cultural history of his race, Douglas incorporated motifs from African sculpture into compositions painted in a version of Synthetic Cubism that stressed transparent angular planes. *Noah's Ark* (FIG. 24-36) was one of seven paintings based on a book of poems by James Weldon Johnson (1871-1938) called God's Trombones: Seven Negro Sermons in Verse. Douglas used flat planes to evoke a sense of mystical space and miraculous happenings. In Noah's Ark, lightning strikes and rays of light crisscross the pairs of animals entering the ark, while men load supplies in preparation for departure. The artist suggested deep space by differentiating the size of the large human head and shoulders of the worker at the bottom and the small person at work on the far deck of the ship. Yet the composition's unmodulated color shapes create a pattern on the Masonite surface that cancels any illusion of threedimensional depth. Here, Douglas used Cubism's formal language to express a powerful religious vision.

PRECISIONISM It is obvious from viewing American art in the period immediately after the Armory Show that the latest European avant-garde art, from Cubism to Dada, intrigued American artists. However, the Americans did not just passively absorb the ideas transported across the Atlantic. The challenge was to understand the ideas modernist European art presented and then filter them through an American sensibility. Ultimately, many American artists, including a group that became known as Precisionists, set as their goal the development of a uniquely American art.

Precisionism was not an organized movement, but the Precisionists did share certain thematic and stylistic traits in their art, which developed in the 1920s out of a fascination with the machine's precision and importance in modern life. Although many European

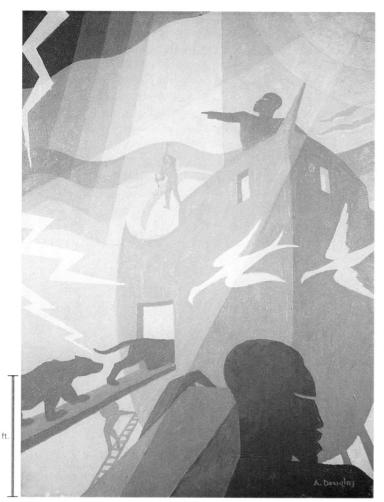

24-36 AARON DOUGLAS, *Noah's Ark*, ca. 1927. Oil on Masonite, $4' \times 3'$. Fisk University Galleries, University of Tennessee, Nashville.

In *Noah's Ark* and other paintings of the cultural history of African Americans, Douglas incorporated motifs from African sculpture and the transparent angular planes characteristic of Synthetic Cubism.

artists, especially the Futurists, had demonstrated interest in burgeoning technology, Americans generally seemed more enamored by the prospects of a mechanized society than did Europeans. Even the Frenchman Francis Picabia, Duchamp's collaborator, noted: "Since machinery is the soul of the modern world, and since the genius of machinery attains its highest expression in America, why is it not reasonable to believe that in America the art of the future will flower most brilliantly?" Precisionism, however, expanded beyond the exploration of machine imagery. Many artists associated with this group gravitated toward Synthetic Cubism's flat, sharply delineated planes as an appropriate visual idiom for their imagery, adding to the clarity and precision of their work. Eventually, Precisionism came to be characterized by a merging of a familiar native style in American architecture and artifacts with a modernist vocabulary derived largely from Synthetic Cubism.

CHARLES DEMUTH One of the leading Precisionists was Charles Demuth (1883–1935), who spent the years 1912–1914 in Paris and thus had firsthand exposure to Cubism and other avantgarde directions in art. He incorporated the spatial discontinuities characteristic of Cubism into his work, focusing much of it on industrial sites near his native Lancaster, Pennsylvania. *My Egypt* (FIG. **24-37**) is a prime example of Precisionist painting. Demuth depicted the John W. Eshelman and Sons grain elevators, which he

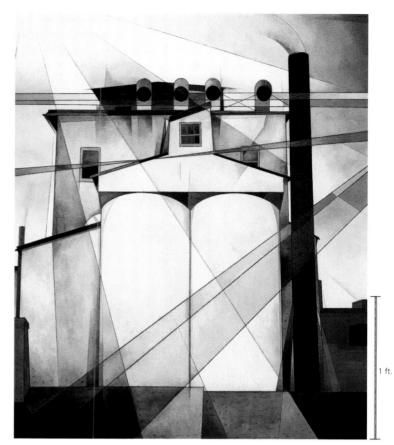

24-37 Charles Demuth, *My Egypt*, 1927. Oil on composition board, $2'11\frac{3}{4}'' \times 2'$ 6". Collection of Whitney Museum of American Art, New York (purchased with funds from Gertrude Vanderbilt Whitney).

Demuth was one of the leading Precisionists—American artists who extolled the machine age. This painting depicts grain elevators reduced to geometric forms amid Cubist transparent diagonal planes.

reduced to simple geometric forms. The grain elevators remain insistently recognizable and solid. However, the "beams" of transparent planes and the diagonal force lines threaten to destabilize the image and correspond to Cubist fragmentation of space. The degree to which Demuth intended to extol the American industrial scene is unclear. The title, *My Egypt*, is sufficiently ambiguous in tone to accommodate differing readings. On the one hand, Demuth could have been suggesting a favorable comparison between the Egyptian pyramids and American grain elevators as cultural icons. On the other hand, the title could be read cynically, as a negative comment on the limitations of American culture.

GEORGIA O'KEEFFE The work of Wisconsin-born Georgia O'Keeffe (1887–1986), like that of many artists, changed stylistically throughout her career. During the 1920s, O'Keeffe was a Precisionist. She had moved from the tiny town of Canyon to New York City in 1918, and although she had visited the city before, what she found there excited her. "You have to live in today," she told a friend. "Today the city is something bigger, more complex than ever before in history. And nothing can be gained from running away. I couldn't even if I could." While in New York, O'Keeffe met Alfred Stieglitz (FIG. 24-39), who played a major role in promoting the avant-garde in the United States. Stieglitz had established an art gallery at 291 Fifth Avenue in New York. In "291," as the gallery came to be called, he exhibited the latest in both European and American art. Thus, 291, like the Armory Show, played an important role in the history of early-20th-century art in America. Stieglitz had seen and exhibited some of O'Keeffe's earlier

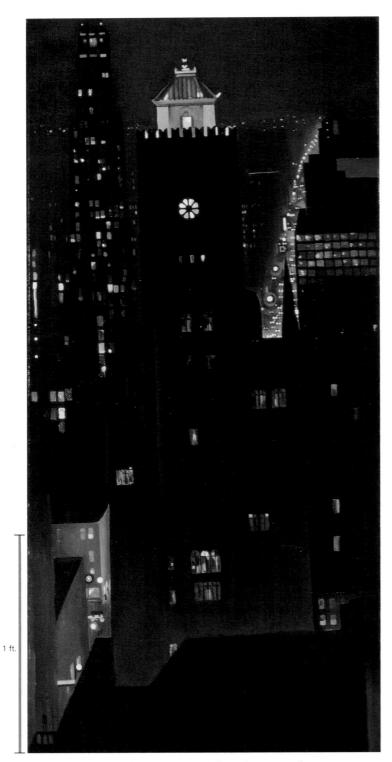

24-38 Georgia O'Keeffe, *New York, Night,* 1929. Oil on canvas, 3' $4\frac{1}{8}$ " \times 1' $7\frac{1}{8}$ ". Sheldon Memorial Art Gallery, Lincoln (Nebraska Art Association, Thomas C. Woods Memorial Collection).

O'Keeffe's Precisionist representation of New York's soaring skyscrapers reduces the buildings to large, simple, dark planes punctuated by small windows that add rhythm and energy to the image.

work and drew her into his circle of avant-garde painters and photographers. Stieglitz became one of O'Keeffe's staunchest supporters and, eventually, her husband. The interest of Stieglitz and his circle in capturing the sensibility of the machine age intersected with O'Keeffe's fascination with the fast pace of city life, and she produced paintings during this period, such as *New York*, *Night* (FIG. **24-38**), that depict the soaring skyscrapers dominating the city. Like other Precisionists,

O'Keeffe reduced her images to simple planes, here punctuated by small rectangular windows that add rhythm and energy to the image, countering the monolithic darkness of the looming buildings.

Despite O'Keeffe's affiliation with the Precisionist movement and New York, she is probably best known for her paintings of cow skulls and of flowers, for example, *Jack in the Pulpit No. 4* (FIG. I-4), which reveals her interest in stripping subjects to their purest forms and colors to heighten their expressive power. In this work, O'Keeffe reduced the incredible details of a flower to a symphony of basic colors, shapes, textures, and vital rhythms. Exhibiting the natural flow of curved planes and contour, O'Keeffe simplified the form almost to the point of complete abstraction. The fluid planes unfold like undulant petals from a subtly placed axis—the white jetlike streak—in a vision of the slow, controlled motion of growing life. O'Keeffe's painting, in its graceful, quiet poetry, reveals the organic reality of the object by strengthening its characteristic features.

Photography

ALFRED STIEGLITZ As an artist, ALFRED STIEGLITZ (1864–1946) is best known for his photographs. Taking his camera everywhere he went, he photographed whatever he saw around him, from the bustling streets of New York City to cloudscapes in upstate New York and the faces of friends and relatives. He believed in making only "straight, unmanipulated" photographs. Thus, he exposed and printed them using basic photographic processes, without resorting to techniques such as double-exposure or double-printing that would add information not present in the subject when he released the shutter. Stieglitz said he wanted the photographs he made with this direct technique "to hold a moment, to record something so completely that those who see it would relive an equivalent of what has been expressed." 23

Stieglitz began a lifelong campaign to win a place for photography among the fine arts while he was a student of photochemistry in Germany. Returning to New York, he founded the Photo-Secession group, which mounted traveling exhibitions in the United States and sent loan collections abroad, and he also published an influential journal titled Camera Work. In his own works, Stieglitz specialized in photographs of his environment and saw these subjects in terms of arrangements of forms and of the "colors" of his black-and-white materials. His aesthetic approach crystallized during the making of The Steerage (FIG. 24-39), taken during a voyage to Europe with his first wife and daughter in 1907. Traveling first class, Stieglitz rapidly grew bored with the company of the prosperous passengers in that section of the ship. He walked as far forward on the first-class level as he could, when the rail around the opening onto the lower deck brought him up short. This level was for the steerage passengers the government sent back to Europe after refusing them entrance into the United States. Later, Stieglitz described what happened next:

The scene fascinated me: A round hat; the funnel leaning left, the stairway leaning right; the white drawbridge, its railing made of chain; white suspenders crossed on the back of a man below; circular iron machinery; a mast that cut into the sky, completing a triangle. I stood spellbound. I saw shapes related to one another—a picture of shapes, and underlying it, a new vision that held me: simple people; the feeling of ship, ocean, sky; a sense of release that I was away from the mob called rich. Rembrandt came into my mind and I wondered would he have felt as I did. . . . I had only one plate holder with one unexposed plate. Could I catch what I saw and felt? I released the shutter. If I had captured what I wanted, the photograph would go far beyond any of my previous prints. It would be a picture based on related shapes and deepest human feeling—a step in my own evolution, a spontaneous discovery.²⁴

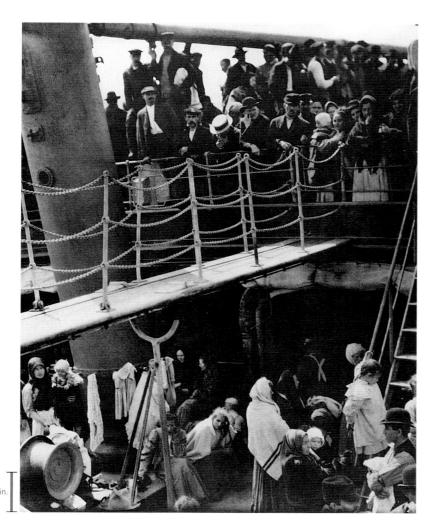

24-39 Alfred Stieglitz, *The Steerage*, 1907 (print 1915). Photogravure (on tissue), $1'\frac{3}{8}'' \times 10\frac{1}{8}''$. Amon Carter Museum, Fort Worth.

Stieglitz waged a lifelong campaign to win a place for photography among the fine arts. This 1907 image is a haunting mixture of found patterns of forms and human activity. It stirs deep emotions.

This description reveals Stieglitz's abiding interest in the formal elements of the photograph—an insistently modernist focus. The finished print fulfilled Stieglitz's vision so well that it shaped his future photographic work, and its haunting mixture of found patterns and human activity has continued to stir viewers' emotions to this day.

EDWARD WESTON Stieglitz's concern for positioning photography as an art form with the same fine-art status as painting and sculpture was also the aim of EDWARD WESTON (1886–1958). In addition to making "straight" photographs, like those of Stieglitz, Weston experimented with photographs that moved toward greater abstraction, paralleling developments in other media. *Nude* (FIG. **24-40**) is an example of the latter photographic style. The image's simplicity and the selection of a small segment of the human body as the subject result in a lyrical photograph of dark and light areas that at first glance suggests a landscape. Further inspection reveals the fluid curves and underlying skeletal armature of the human form. This photograph, in its reductiveness, formally expresses a study of the body that verges on the abstract.

24-40 EDWARD WESTON, *Nude*, 1925. Platinum print, $7\frac{1}{2}^{"} \times 9\frac{1}{2}^{"}$. Center for Creative Photography, University of Arizona, Tucson.

Weston experimented with photographs that moved toward abstraction. By selecting only a segment of a nude body as his subject, the artist converted the human form to a landscape.

EUROPE, 1920 TO 1945

Because World War I was fought entirely on European soil, European artists experienced its devastating effects to a much greater degree than did their American counterparts. The war had a profound impact on Europe's geopolitical terrain, on individual and national psyches, and on the art of the 1920s and 1930s.

Picasso in the 1930s

The previous discussion of Pablo Picasso focused on his immersion in aesthetic issues, but he was acutely aware of politics throughout his life. As Picasso watched his homeland descend into civil war in the late 1930s, his involvement in political issues grew even stronger. He declared: "[P]ainting is not made to decorate apartments. It is an instrument for offensive and defensive war against the enemy." 25

GUERNICA In January 1937, the Spanish Republican government-in-exile in Paris asked Picasso to produce a major work for the Spanish Pavilion at the Paris International Exposition that summer. Picasso was well aware of the immense visibility and large international audience this opportunity afforded him, but he did not formally accept this invitation until he received word that Guernica, capital of the Basque region (an area in southern France and northern Spain populated by Basque speakers), had been almost totally destroyed in an air raid on April 26 by Nazi bombers acting on behalf of the rebel general Francisco Franco (1892–1975). Not only did the Germans attack the city itself, but because they dropped their bombs at the busiest hour of a market day, they also killed or wounded many of Guernica's 7,000 citizens. The event jolted Picasso into action. By the end of June, he had completed Guernica (FIG. 24-41), a mural-sized canvas of immense power.

Despite the painting's title, Picasso made no specific reference to the event in *Guernica*—no bombs, no German planes. Rather, the collected images in *Guernica* combine to create a visceral outcry of human grief. In the center, along the lower edge of the painting, lies a slain warrior clutching a broken and useless sword. A gored horse tramples him and rears back in fright as it dies. On the left, a shrieking, anguished

woman cradles her dead child. On the far right, a woman on fire runs screaming from a burning building, while another woman flees mindlessly. In the upper right corner, a woman, represented by only a head, emerges from the burning building, thrusting forth a light to illuminate the horror. Overlooking the destruction is a bull, which, according to the artist, represents "brutality and darkness." ²⁶

Picasso used aspects of his Cubist discoveries to expressive effect in *Guernica*, particularly the fragmentation of objects and the dislocation of anatomical features. This Cubist fragmentation gave visual form to the horror. What happened to these figures in the artist's act of painting—the dissections and contortions of the human form—paralleled what happened to them in real life. To emphasize the scene's severity and starkness, Picasso reduced his palette to black, white, and shades of gray.

Revealing his political commitment and his awareness of the power of art, Picasso refused to allow exhibition of *Guernica* in Spain while Generalissimo Franco was in power. At the artist's request, *Guernica* hung in the Museum of Modern Art in New York City after the 1937 World's Fair concluded. Not until after Franco's death in 1975 did Picasso allow the mural to be exhibited in his homeland. It hangs today in the Centro de Arte Reina Sofia in Madrid as a testament to a tragic chapter in Spanish history.

Neue Sachlichkeit

In Germany, World War I gave rise to an artistic movement called *Neue Sachlichkeit* (New Objectivity). The artists associated with Neue Sachlichkeit served, at some point, in the German army, and their military experiences deeply influenced their worldviews and informed their art. "New Objectivity" captures the group's aim—to present a clear-eyed, direct, and honest image of the war and its effects.

GEORGE GROSZ One of the Neue Sachlichkeit artists was GEORGE GROSZ (1893–1958), who was, for a time, associated with the Dada group in Berlin. Grosz observed the onset of World War I with horrified fascination, but that feeling soon turned to anger and frustration. He reported:

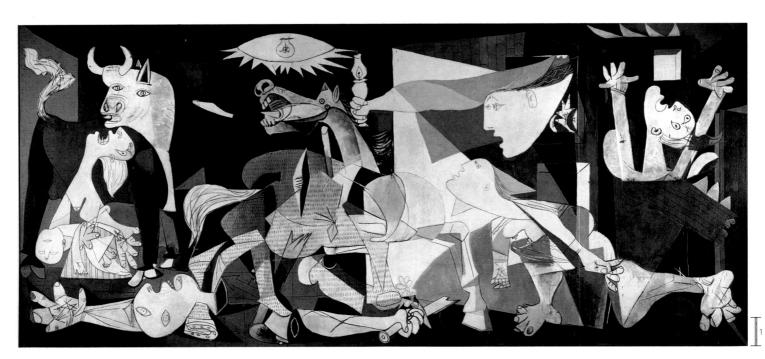

24-41 PABLO PICASSO, Guernica, 1937. Oil on canvas, $11' 5\frac{1}{2}'' \times 25' 5\frac{3}{4}''$. Museo Nacional Centro de Arte Reina Sofia, Madrid.

Picasso used Cubist techniques, especially the fragmentation of objects and dislocation of anatomical features, to expressive effect in this condemnation of the Nazi bombing of the Basque capital.

24-42 GEORGE GROSZ, *Fit for Active Service*, 1916–1917. Pen and brush and ink on paper, $1' 8'' \times 1' 2\frac{3}{8}''$. Museum of Modern Art, New York (gift of the American Tobacco Company, Inc.). Art © Estate of George Grosz/Licensed by VAGA, New York.

In a drawing that is an indictment of the German army and based on Grosz's personal experience, a doctor proclaims the skeleton before him "fit for service," and no one disputes his evaluation.

Of course, there was a kind of mass enthusiasm at the start. But this intoxication soon evaporated, leaving a huge vacuum. . . . And then after a few years when everything bogged down, when we were defeated, when everything went to pieces, all that remained, at least for me and most of my friends, were disgust and horror.²⁷

Grosz produced numerous paintings and drawings, such as Fit for Active Service (FIG. 24-42), that were caustic indictments of the military. In these works, he often depicted army officers as heartless or incompetent. This particular drawing may relate to Grosz's personal experience. On the verge of a nervous breakdown in 1917, he was sent to a sanatorium where doctors examined him and, much to his horror, declared him "fit for service." In this biting and sarcastic drawing, an army doctor proclaims the skeleton before him "fit for service." The other officers or doctors attending do not dispute this evaluation. The spectacles perched on the skeleton's face, very similar to the gold-rimmed glasses Grosz wore, further suggest he based this scene on his experiences. Grosz's searing wit is all the more evident upon comparing Fit for Active Service with Marsden Hartley's Portrait of a German Officer (FIG. 24-34). Although Hartley's painting deals with the death of his lover in battle, the incorporation of colorful German military insignia and emblems imbues the painting with a more heroic, celebratory tone. In contrast, the simplicity of Grosz's line drawing contributes to the directness and immediacy of the work, which scathingly portrays the German army.

MAX BECKMANN Like Grosz, Max Beckmann (1884–1950) enlisted in the German army and initially rationalized the war. He believed the chaos would lead to a better society, but over time the massive death and destruction increasingly disillusioned him. Soon his work began to emphasize the horrors of war and of a society he saw descending into madness. His disturbing view of society is evi-

dent in *Night* (FIG. **24-43**), which depicts a cramped room three intruders have forcibly invaded. A bound woman, apparently raped, is splayed across the foreground of the painting. Her husband appears on the left. One of the intruders hangs him, while another one twists his left arm out of its socket. An unidentified woman cowers in the background. On the far right, the third intruder prepares to flee with the child.

Although this image does not depict a war scene, the violence and wrenching brutality pervading the home are a searing and horrifying comment on society's condition. Beckmann also injected a personal

24-43 Max Beckmann, *Night*, 1918–1919. Oil on canvas, $4' \frac{4^3}{8}'' \times 5' \frac{1}{4}''$. Kunstsammlung Nordrhein-Westfalen, Düsseldorf.

Beckmann's treatment of forms and space in *Night* matched his view of the brutality of early-20th-century society. Objects seem dislocated and contorted, and the space appears buckled and illogical.

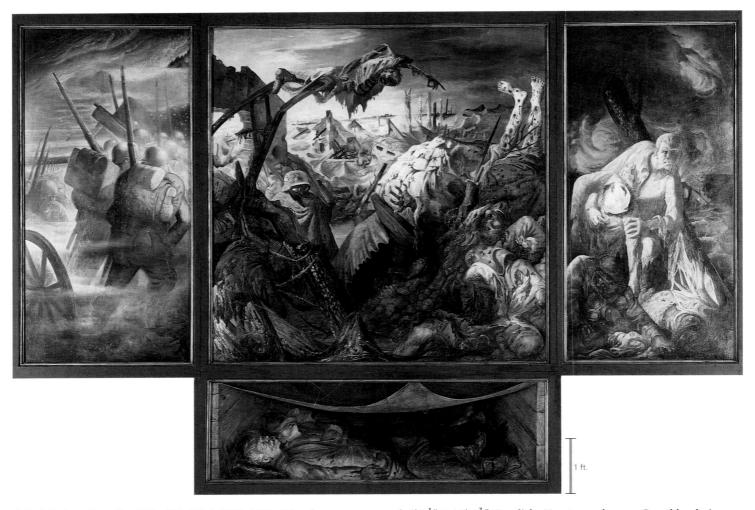

24-44 Otto Dix, *Der Krieg* (*The War*), 1929–1932. Oil and tempera on wood, $6' \ 8\frac{1}{3}'' \times 13' \ 4\frac{3}{4}''$. Staatliche Kunstsammlungen, Gemäldegalerie Neue Meister, Dresden.

In this triptych recalling earlier altarpieces, Dix captured the panoramic devastation that war inflicts on the terrain and on humans. He depicted himself as a soldier dragging a comrade to safety.

reference by using himself, his wife, and his son as the models for the three family members. The stilted angularity of the figures and the roughness of the paint surface contribute to the image's savageness. In addition, the artist's treatment of forms and space reflects the world's violence. Objects seem dislocated and contorted, and the space appears buckled and illogical. For example, the woman's hands are bound to the window that opens from the room's back wall, but her body appears to hang vertically, rather than lying across the plane of the intervening table.

OTTO DIX The third artist most closely associated with Neue Sachlichkeit was OTTO DIX (1891–1959). Having served as both a machine gunner and an aerial observer, Dix was well acquainted with war's effects. Like Grosz, he initially tried to find redeeming value in the apocalyptic event: "The war was a horrible thing, but there was something tremendous about it, too. . . . You have to have seen human beings in this unleashed state to know what human nature is. . . . I need to experience all the depths of life for myself, that's why I go out, and that's why I volunteered." This idea of experiencing the "depths of life" stemmed from Dix's interest in the philosophy of Friedrich Nietzsche (1844–1900). In particular, Dix avidly read Nietzsche's *The Joyous Science*, deriving from it a belief in life's cyclical nature—procreation and death, building up and tearing down, and growth and decay.

As the war progressed, however, Dix's faith in the potential improvement of society dissipated, and he began to produce unflinch-

ingly direct and provocative artworks. His Der Krieg (The War; FIG. 24-44) vividly captures the panoramic devastation that war inflicts, both on the terrain and on humans. In the left panel, armed and uniformed soldiers march off into the distance. Dix graphically displayed the horrific results in the center and right panels, where mangled bodies, many riddled with bullet holes, are scattered throughout the eerily lit apocalyptic landscape. As if to emphasize the intensely personal nature of this scene, the artist painted himself into the right panel as the ghostly but determined soldier who drags a comrade to safety. In the bottom panel, in a coffinlike bunker, lie soldiers asleep—or perhaps dead. Dix significantly chose to present this sequence of images in a triptych format, and the work recalls triptychs such as Matthias Grünewald's Isenheim Altarpiece (FIG. 18-2). However, Dix's work presents a bleaker outlook than that piece: The hope of salvation extended to viewers of the Isenheim Altarpiece through Christ's eventual Resurrection is absent from Der Krieg. Like his fellow Neue Sachlichkeit artists, Dix felt compelled to lay bare the realities of his time, which the war's violence dominated. Even years later, Dix still maintained:

You have to see things the way they are. You have to be able to say yes to the human manifestations that exist and will always exist. That doesn't mean saying yes to war, but to a fate that approaches you under certain conditions and in which you have to prove yourself. Abnormal situations bring out all the depravity, the bestiality of human beings. . . . I portrayed states, states that the war brought about, and the results of war, as states.²⁹

ERNST BARLACH A work more spiritual in its expression is the War Monument (FIG. 24-45), which the German sculptor Ernst Barlach (1870–1938) created for the cathedral in his hometown of Güstrow in 1927. Working often in wood, Barlach sculpted single figures usually dressed in flowing robes and portrayed in strong, simple poses that embody deep human emotions and experiences such as grief, vigilance, or self-comfort. Barlach's works combine sharp, smoothly planed forms with intense expression. The cast-bronze hovering figure of his War Monument is one of the most poignant memorials of World War I. Unlike traditional war memorials depicting heroic military figures, often engaged in battle, the hauntingly symbolic figure that Barlach created speaks to the experience of all caught in the conflict of war. The floating human form, suspended above a tomb inscribed with the dates 1914–1918 (and later also 1939-1945), suggests a dying soul at the moment when it is about to awaken to everlasting life—the theme of death and transfiguration. The rigid economy of surfaces concentrates attention on the simple but expressive head. So powerful was this sculpture that the Nazis had it removed from the cathedral in 1937 and melted down for ammunition. Luckily, a friend hid another version Barlach made. A Protestant parish in Cologne purchased this surviving cast, from which bronzeworkers made a new cast for the Güstrow cathedral.

24-45 ERNST BARLACH, *War Monument*, Cathedral, Güstrow, Germany, 1927. Bronze.

In this World War I memorial, a human form floating above a tomb suggests a dying soul at the moment when it is about to awaken to everlasting life. The Nazis melted down the piece for ammunition.

Surrealism

The exuberantly aggressive momentum of the Dada movement that emerged during World War I was of short duration. By 1924, with the publication in France of the First Surrealist Manifesto, most of the artists associated with Dada joined the Surrealism movement and its determined exploration of ways to express in art the world of dreams and the unconscious. Not surprisingly, the Surrealists incorporated many of the Dadaists' improvisational techniques. They believed these methods important for engaging the elements of fantasy and activating the unconscious forces that lie deep within every human being. The Surrealists sought to explore the inner world of the psyche, the realm of fantasy and the unconscious. Inspired in part by the ideas of the psychoanalysts Sigmund Freud and Carl Jung, the Surrealists had a special interest in the nature of dreams. They viewed dreams as occurring at the level connecting all human consciousness and as constituting the arena in which people could move beyond their environment's constricting forces to reengage with the deeper selves society had long suppressed. In the words of André Breton, one of the leading Surrealist thinkers:

Surrealism is based on the belief in the superior reality of certain forms of association heretofore neglected, in the omnipotence of dreams, in the undirected play of thought.... I believe in the future resolution of the states of dream and reality, in appearance so contradictory, in a sort of absolute reality, or surreality.³⁰

Thus, the Surrealists' dominant motivation was to bring the aspects of outer and inner "reality" together into a single position, in much the same way life's seemingly unrelated fragments combine in the vivid world of dreams. The projection in visible form of this new conception required new techniques of pictorial construction. The Surrealists adapted some Dada devices and invented new methods such as automatic writing (spontaneous writing using free association), not so much to reveal a world without meaning as to provoke reactions closely related to subconscious experience.

Surrealism developed along two lines. In *Naturalistic Surrealism*, artists present recognizable scenes that seem to have metamorphosed into a dream or nightmare image. The artists Salvador Dalí (FIG. **24-49**) and René Magritte (FIG. **24-50**) were the most famous practitioners of this variant of Surrealism. In contrast, some artists gravitated toward an interest in *Biomorphic Surrealism*. In Biomorphic (life forms) Surrealism, *automatism*—the creation of art without conscious control—predominated. Biomorphic Surrealists such as Joan Miró (FIG. **24-52**) produced largely abstract compositions, although the imagery sometimes suggests organisms or natural forms.

GIORGIO DE CHIRICO The Italian painter GIORGIO DE Chirico (1888–1978) produced emphatically ambiguous works that position him as a precursor of Surrealism. De Chirico's paintings of cityscapes and shop windows were part of a movement called Pittura Metafisica, or Metaphysical Painting. Returning to Italy after study in Munich, de Chirico found hidden reality revealed through strange juxtapositions, such as those seen on late autumn afternoons in the city of Turin, when the long shadows of the setting sun transformed vast open squares and silent public monuments into what the painter called "metaphysical towns." De Chirico translated this vision into paint in works such as Melancholy and Mystery of a Street (FIG. 24-46), where the spaces and buildings evoke a disquieting sense of foreboding. The choice of the term "metaphysical" to describe de Chirico's paintings suggests that these images transcend their physical appearances. Melancholy and Mystery of a Street, for all of its clarity and simplicity, takes on a rather sinister air. Only a few inexplicable and incongruous elements punctuate the scene's solitude—a small

24-46 GIORGIO DE CHIRICO, *Melancholy and Mystery of a Street*, 1914. Oil on canvas, $2' 10\frac{1}{4}'' \times 2' 4\frac{1}{2}''$. Private collection.

De Chirico's Metaphysical Painting movement was a precursor of Surrealism. In this street scene, filled with mysterious forms and shadows, the painter evoked a disquieting sense of foreboding.

girl with her hoop in the foreground, the empty van, and the ominous shadow of a man emerging from behind the building. The sense of strangeness de Chirico could conjure with familiar objects and scenes recalls Nietzsche's "foreboding that underneath this reality in which we live and have our being, another and altogether different reality lies concealed." ³¹

De Chirico's paintings were reproduced in periodicals almost as soon as he completed them, and his works quickly influenced artists outside Italy, including both the Dadaists and, later, the Surrealists. The incongruities in his work intrigued the Dadaists, whereas the eerie mood and visionary quality of paintings such as *Melancholy and Mystery of a Street* excited and inspired Surrealist artists who sought to portray the world of dreams.

MAX ERNST Originally a Dada activist in Germany, Max Ernst (1891–1976) became one of the early adherents of the Surrealist circle that André Breton anchored. As a child living in a small community near Cologne, Ernst had found his existence fantastic and filled with marvels. In autobiographical notes, written mostly in the third person, he said of his birth: "Max Ernst had his first contact with the world of sense on the 2nd April 1891 at 9:45 A.M., when he emerged from the egg which his mother had laid in an eagle's nest and which the bird had incubated for seven years." Ernst's service in the German army during World War I swept away his early success as an Expressionist. In his own words:

Max Ernst died on 1st August 1914. He returned to life on 11th November 1918, a young man who wanted to become a magician and

24-47 Max Ernst, *Two Children Are Threatened by a Nightingale*, 1924. Oil on wood with wood construction, $2' \ 3\frac{1}{2}'' \times 1' \ 10\frac{1}{2}'' \times 4\frac{1}{2}''$. Museum of Modern Art, New York.

In this early Surrealist painting with an intentionally ambiguous title, Ernst used traditional perspective to represent the setting, but the three sketchily rendered figures belong to a dream world.

find the central myth of his age. From time to time he consulted the eagle which had guarded the egg of his prenatal existence. The bird's advice can be detected in his work. 33

Before joining the Surrealists, Ernst explored every means to achieve the sense of the psychic in his art. Like other Dadaists, he set out to incorporate found objects and chance into his works. Using a process called *frottage*, he created some works by combining the patterns achieved by rubbing a crayon or another medium across a sheet of paper placed over a surface having a strong, evocative textural pattern. In other works, Ernst joined fragments of images he had cut from old books, magazines, and prints to form one hallucinatory collage.

Ernst soon began making paintings that shared the mysterious dreamlike effect of his collages. In 1920 his works brought him into contact with Breton, who instantly recognized Ernst's affinity with the Surrealist group. In 1922, Ernst moved to Paris. His *Two Children Are Threatened by a Nightingale* (FIG. **24-47**) manifests many of the creative bases of Surrealism. Here, Ernst displayed a private dream that challenged the post-Renaissance idea that a painting should resemble a window looking into a "real" scene rendered illusionistically three-dimensional through mathematical perspective. In *Two Children*, the artist painted the landscape, the distant city, and the tiny flying bird in conventional fashion, following all the established rules of linear and atmospheric perspective. The three sketchily rendered figures, however, clearly belong to a dream world, and the literally three-dimensional miniature gate, the odd button knob, and the strange

Degenerate Art

Ithough avant-garde artists often had to endure public ridicule both in Europe and America (see "The Armory Show," page 710), they suffered outright political persecution in Germany in the 1930s and 1940s. The most dramatic example of this abuse was the infamous *Entartete Kunst* (Degenerate Art) exhibition that Adolf Hitler (1889–1945) and the Nazis mounted in 1937.

Hitler aspired to become an artist himself and produced numerous drawings and paintings. These works reflected his firm belief that 19th-century realistic genre painting represented the zenith of Aryan art development. Accordingly, he denigrated anything that did not conform to that standard—in particular, avant-garde art. Turning his criticism into action, Hitler ordered the confiscation of more than 16,000 artworks he considered "degenerate." To publicize his condemnation of this art, he directed his minister for public enlightenment and propaganda, Joseph Goebbels (1897-1945), to organize a massive exhibition of this "degenerate art." Hitler defined it as works that "insult German feeling, or destroy or confuse natural form, or simply reveal an absence of adequate manual and artistic skill."* The term "degenerate" also had other specific connotations at the time. The Nazis used it to designate supposedly inferior racial, sexual, and moral types. Hitler's order to Goebbels to target 20th-century avantgarde art for inclusion in this exhibition aimed to impress on viewers the general inferiority of the artists producing this work. To make this point even more dramatically, Hitler mandated the organization of another exhibition, the Grosse Deutsche Kunstausstellung (Great German Art Exhibition), which ran concurrently and presented an extensive array of Nazi-approved conservative art.

Entartete Kunst opened in Munich on July 19, 1937, and included more than 650 paintings, sculptures, prints, and books. The exhibition was immensely popular. Roughly 20,000 viewers visited the show daily. By the end of its four-month run, it had attracted more than two million viewers, and nearly a million more viewed it as it traveled through Germany and Austria. Among the 112 artists whose works the Nazis presented for ridicule were Ernst Barlach, Max Beckmann, Otto Dix, Max Ernst, George Grosz, Vassily Kandinsky, Ernst Kirchner, Paul Klee, Wilhelm Lehmbruck, Franz Marc, Emil Nolde, and Kurt Schwitters. A memorable photograph (FIG. 24-48) recorded Hitler visiting the exhibition, pausing in front of the Dada wall where the organizers initially deliberately hung askew works by Schwitters, Klee, and Kandinsky. No avant-garde or even modernist artist was safe from Hitler's attack. (Only six of the artists in the exhibition were Jewish.) Indeed, despite his status as a charter member of the Nazi Party, Emil Nolde received particularly harsh treatment. The Nazis confiscated more than 1,000 of Nolde's works from German

24-48 Adolf Hitler, accompanied by Nazi commission members, including photographer Heinrich Hoffmann, Wolfgang Willrich, Walter Hansen, and painter Adolf Ziegler, viewing the *Entartete Kunst* show on July 16, 1937.

For Hitler's visit, the curators deliberately hung askew the works of Kandinsky, Klee, and Schwitters (although they subsequently straightened them for the duration of the exhibition).

museums and included 27 of them in the exhibition, more than for almost any other artist.

Clearly, artists needed considerable courage to defy tradition and produce avant-garde art. Especially in Germany in the 1930s and 1940s, in the face of Nazi persecution, commitment to the avant-garde demanded a resoluteness that extended beyond issues of aesthetics and beyond the confines of the art world. This persecution exacted an immense toll on these artists. Kirchner, for example, responded to the stress of Nazi pressure by destroying all his woodblocks and burning many of his works. A year later, in 1938, he committed suicide. Beckmann and his wife fled to Amsterdam on the exhibit's opening day, never to return to their homeland. Although *Entartete Kunst* was just a fragment of the tremendous destruction of life and spirit Hitler and the Nazis wrought, Hitler's insistence on suppressing and discrediting this art dramatically demonstrates art's power to affect viewers.

* Stephanie Barron, "Degenerate Art": The Fate of the Avant-Garde in Nazi Germany (Los Angeles: Los Angeles County Museum of Art, 1991), 19.

closed building "violate" the bulky frame's space. Additional dislocation occurs in the traditional museum identification label, which Ernst displaced into a cutaway part of the frame. Handwritten, it announces the work's title (taken from a poem Ernst wrote before he painted this), adding another note of irrational mystery.

As is true of many Surrealist works, the title, *Two Children Are Threatened by a Nightingale*, is ambiguous and relates uneasily to what the spectator sees. The viewer must struggle to decipher connections between the image and words. When Surrealists (and

Dadaists and Metaphysical artists before them) used such titles, they intended the seeming contradiction between title and picture to throw the spectator off balance with all expectations challenged. Much of the impact of Surrealist works begins with the viewer's sudden awareness of the incongruity and absurdity of what the artist pictured. These were precisely the qualities that subjected the Dadaists and Surrealists to public condemnation and, in Germany under Adolf Hitler (FIG. 24-48), to governmental persecution (see "Degenerate Art," above).

24-49 SALVADOR DALÍ, The Persistence of Memory, 1931. Oil on canvas, $9\frac{1}{2}^{"} \times 1'$ 1". Museum of Modern Art, New York.

Dalí aimed to paint "images of concrete irrationality." In this realistically rendered landscape featuring three "decaying" watches, he created a haunting allegory of empty space where time has ended.

SALVADOR DALÍ The Surrealists' exploration of the human psyche and dreams reached new heights in the works of Spain's SALVADOR DALÍ (1904–1989). In his paintings, sculptures, jewelry, and designs for furniture and movies, Dalí probed a deeply erotic dimension, studying the writings of Richard von Krafft-Ebing (1840–1902) and Sigmund

Freud and inventing what he called the "paranoiac-critical method" to assist his creative process. As he described it, in his painting he aimed "to materialize the images of concrete irrationality with the most imperialistic fury of precision . . . in order that the world of imagination and of concrete irrationality may be as objectively evident . . . as that of the exterior world of phenomenal reality." 34

All these aspects of Dalí's style appear in *The Persistence of Memory* (FIG. **24-49**), a haunting allegory of empty space where time has ended. In the painting, an eerie, never-setting sun illuminates the barren landscape. An amorphous creature draped with a limp pocket watch sleeps in the foreground. Another watch hangs from the branch of a dead tree that springs unexpectedly from a blocky architectural form. A third watch hangs half over the edge of the rectangular form, beside a small timepiece resting face down on the block's surface. Ants swarm mysteriously over the small watch, while a fly walks along the face of its large neighbor, almost as if this assembly of watches were decaying organic life—soft and sticky. Dalí rendered every detail of this dreamscape with precise control, striving to make the world of his paintings as convincingly real as the most meticulously rendered landscape based on a real scene from nature.

RENÉ MAGRITTE The Belgian painter René Magritte (1898–1967) also expressed in exemplary fashion the Surrealist idea and method—the dreamlike dissociation of image and meaning. His works administer disruptive shocks because they subvert the viewer's expectations based on logic and common sense. The danger of relying on rationality when viewing a Surrealist work is glaringly apparent in Magritte's *The Treachery (or Perfidy) of Images* (FIG. 24-50). Magritte presented a meticulously rendered *trompe l'oeil* depiction of a briar pipe. The caption beneath the image, however, contradicts what seems obvious: "Ceci n'est pas une pipe" ("This is not a pipe"). The discrepancy between image and caption clearly challenges the assumptions underlying the reading of visual art. Like the other Surrealists' work, this painting wreaks havoc on the viewer's reliance on the conscious and the rational.

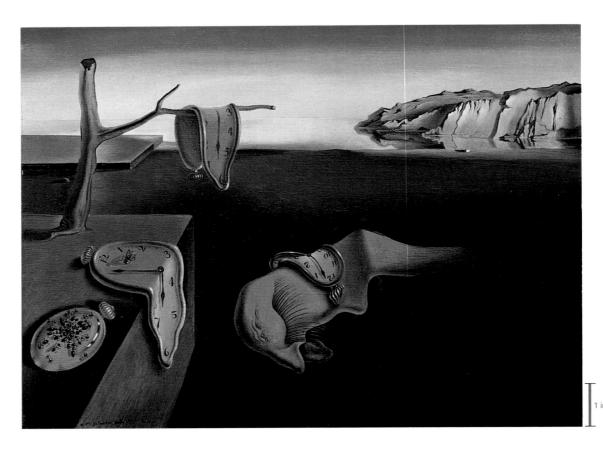

MERET OPPENHEIM Sculpture especially appealed to the Surrealists because its concrete tangibility made their art all the more disquieting. *Object* (FIG. **24-51**), also called *Le Déjeuner en fourrure* (*Luncheon in Fur*), by Swiss artist Meret Oppenheim (1913–1985) captures the incongruity, humor, visual appeal, and, often, eroticism characterizing Surrealism. The artist presented a furlined teacup inspired by a conversation she had with Picasso. After admiring a bracelet Oppenheim had made from a piece of brass covered with fur, Picasso noted that anything might be covered with fur. When her tea grew cold, Oppenheim responded to Picasso's com-

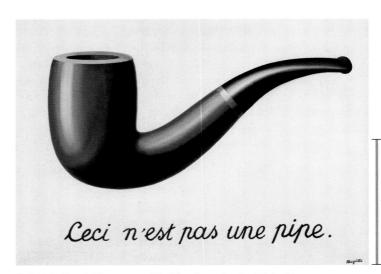

24-50 René Magritte, *The Treachery (or Perfidy) of Images*, 1928–1929. Oil on canvas, 1' $11\frac{5}{8}'' \times 3'$ 1". Los Angeles County Museum of Art, Los Angeles (purchased with funds provided by the Mr. and Mrs. William Preston Harrison Collection).

The discrepancy between Magritte's meticulously painted briar pipe and his caption, "This is not a pipe," challenges the viewer's reliance on the conscious and the rational in the reading of visual art.

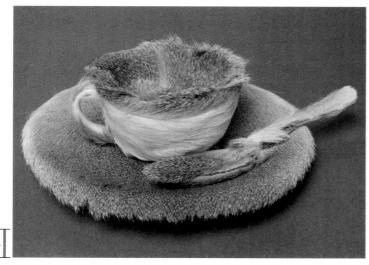

24-51 Мекет Орренным, *Object (Le Déjeuner en fourrure)*, 1936. Fur-covered cup, $4\frac{3}{8}$ " diameter; saucer, $9\frac{3}{8}$ " diameter; spoon, 8" long. Museum of Modern Art, New York.

The Surrealists loved the concrete tangibility of sculpture, which made their art even more disquieting. Oppenheim's functional fur-covered object captures the Surrealist flair for magical transformation.

ment by ordering "un peu plus de fourrure" (a little more fur), and the sculpture had its genesis. *Object* takes on an anthropomorphic quality, animated by the quirky combination of the fur with a functional object. Further, the sculpture captures the Surrealist flair for alchemical, seemingly magical or mystical, transformation. It incor-

porates a sensuality and eroticism (seen here in the seductively soft, tactile fur lining the concave form) that are also components of much of Surrealist art.

JOAN MIRÓ Like the Dadaists, the Surrealists used many methods to free the creative process from reliance on the kind of conscious control they believed society had shaped too much. Dalí used his paranoiac-critical approach to encourage the free play of association as he worked. Other Surrealists used automatism and various types of planned "accidents" to provoke reactions closely related to subconscious experience. The Spanish artist Joan Miró (1893-1983) was a master of this approach. Although Miró resisted formal association with any movement or group, including the Surrealists, André Breton identified him as "the most Surrealist of us all." 35 From the beginning, Miró's work contained an element of fantasy and hallucination. After Surrealist poets in Paris introduced him to the use of chance to create art, the young Spaniard devised a new painting method that allowed him to create works such as Painting (FIG. 24-52). Miró began this painting by making a scattered collage composition with assembled fragments cut from a catalogue for machinery. The shapes in the collage became motifs the artist freely reshaped to create black silhouettes—solid or in outline, with dramatic accents of white and vermilion. They suggest, in the painting, a host of amoebic organisms or constellations in outer space floating in an immaterial background space filled with soft reds, blues, and greens.

Miró described his creative process as a back-and-forth switch between unconscious and conscious image-making: "Rather than setting out to paint something, I begin painting and as I paint the picture begins to assert itself, or suggest itself under my brush. The form be-

comes a sign for a woman or a bird as I work.... The first stage is free, unconscious.... The second stage is carefully calculated." Seven the artist could not always explain the meanings of pictures such as *Painting*. They are, in the truest sense, spontaneous and intuitive expressions of the little-understood, submerged unconscious part of life.

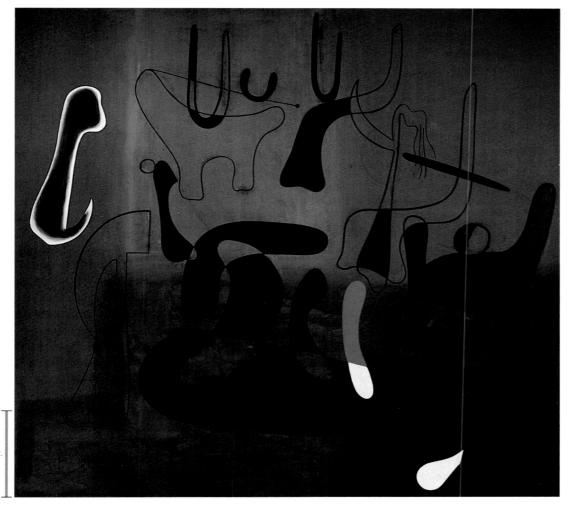

24-52 Joan Miró, *Painting*, 1933. Oil on canvas, 5′ 8″ × 6′ 5″. Museum of Modern Art, New York (Loula D. Lasker Bequest by exchange).

Miró promoted automatism, the creation of art without conscious control. He began this painting with a scattered collage and then added forms suggesting floating amoebic organisms.

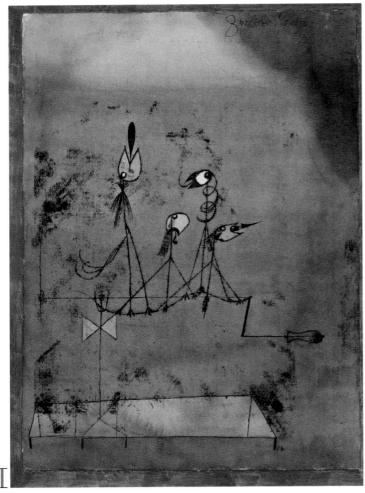

24-53 Paul Klee, *Twittering Machine*, 1922. Watercolor and pen and ink, on oil transfer drawing on paper, mounted on cardboard, $2' 1'' \times 1' 7''$. Museum of Modern Art, New York.

Although based on forms in the tangible world easily read as birds, Klee's *Twittering Machine* is a fanciful vision of a mysterious world presented in a simplified, almost childlike manner.

PAUL KLEE Perhaps the most inventive artist using fantasy images to represent the nonvisible world was the Swiss-German painter Paul Klee (1879–1940). Like Miró, he shunned formal association with groups such as the Dadaists and Surrealists but pursued their interest in the subconscious. Klee sought clues to humanity's deeper nature in primitive shapes and symbols. Like Jung, Klee seems to have accepted the existence of a collective unconscious that reveals itself in archaic signs and patterns and that is everywhere evident in the art of "primitive" cultures (see "Primitivism," page 696). The son of a professional musician and himself an accomplished violinist, Klee thought of painting as similar to music in its ability to express emotions through color, form, and line. In 1920, Klee set down his *Creative Credo*, which reads in part:

Art does not reproduce the visible; rather it makes visible. . . . The formal elements of graphic art are dot, line, plane, and space—the last three charged with energy of various kinds. . . . Formerly we used to represent things visible on earth, things we either liked to look at or would have liked to see. Today we reveal the reality that is behind visible things. ³⁷

To penetrate the reality behind visible things, Klee studied nature avidly, taking special interest in analyzing processes of growth and change. He coded these studies in diagrammatic form in notebooks. The root of his work was thus nature, but nature filtered

through his mind. Upon starting an image, he would allow the pencil or brush to lead him until an image emerged, to which he would then respond to complete the idea.

Twittering Machine (FIG. 24-53) reveals Klee's fanciful vision. The painting, although based on forms in the tangible world easily read as birds, is far from illusionistic. Klee presented the scene in a simplified, almost childlike manner, imbuing the work with a poetic lyricism. The small size of Klee's works enhanced their impact. A viewer must draw near to decipher the delicately rendered forms and enter this mysterious dream world. The inclusion of a crank-driven mechanism adds a touch of whimsy. Perhaps no other artist of the 20th century matched Klee's subtlety as he deftly created a world of ambiguity and understatement that draws each viewer into finding a unique interpretation of the work.

Suprematism, Constructivism, and De Stijl

The pessimism and cynicism of movements such as Dada reflect the historical circumstances of the early 20th century. However, not all artists reacted to the profound turmoil of the times by retreating from society. Some avant-garde artists promoted utopian ideals, believing staunchly in art's ability to contribute to improving society and all humankind. These efforts often surfaced in the face of significant political upheaval, illustrating the link established early on between revolution in politics and revolution in art. Among the art movements espousing utopian notions were Suprematism and Constructivism in Russia and De Stijl in Holland.

KAZIMIR MALEVICH Despite Russia's distance from Paris, the center of the international art world in the early 20th century, Russians had a long history of cultural contact and interaction with western Europe. Wealthy Russians, such as Ivan Morozov (1871–1921) and Sergei Shchukin (1854–1936), amassed extensive collections of Impressionist, Post-Impressionist, and avant-garde paintings. Shchukin became particularly enamored with the work of both Picasso and Matisse. By the mid-1910s, he had acquired 37 paintings by Matisse and 51 by Picasso. Because of their access to collections such as these, Russian artists were familiar with early-20th-century artistic developments, especially Fauvism, Cubism, and Futurism.

Among the Russian artists who pursued the avant-garde direction Cubism introduced was Kazimir Malevich (1878–1935). Malevich developed an abstract style to convey his belief that the supreme reality in the world is pure feeling, which attaches to no object. Thus, this belief called for new, nonobjective forms in art—shapes not related to objects in the visible world. Malevich had studied painting, sculpture, and architecture and had worked his way through most of the avant-garde styles of his youth before deciding none could express the subject he found most important—"pure feeling." He christened his new artistic approach *Suprematism*, explaining: "Under Suprematism I understand the supremacy of pure feeling in creative art. To the Suprematist, the visual phenomena of the objective world are, in themselves, meaningless; the significant thing is feeling, as such, quite apart from the environment in which it is called forth." 38

The basic form of Malevich's new Suprematist nonobjective art was the square. Combined with its relatives, the straight line and the rectangle, the square soon filled his paintings, such as *Suprematist Composition: Airplane Flying* (FIG. **24-54**). In this work, the brightly colored shapes float against and within a white space, and the artist placed them in dynamic relationship to one another. Malevich believed all people would easily understand his new art because of the universality of its symbols. It used the pure language of shape and color, to which everyone could respond intuitively.

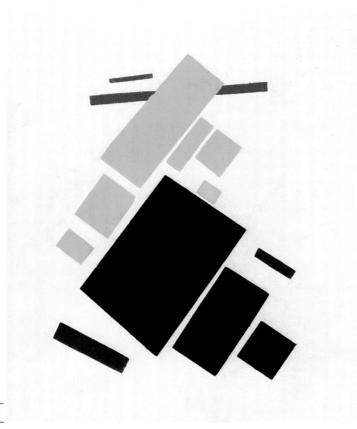

24-54 KAZIMIR MALEVICH, Suprematist Composition: Airplane Flying, 1915 (dated 1914). Oil on canvas, $1' 10\frac{7}{8}" \times 1' 7"$. Museum of Modern Art, New York.

Malevich developed an abstract style he called Suprematism to convey that the supreme reality in the world is pure feeling. In this work, the brightly colored rectilinear shapes float against white space.

Having formulated his artistic approach, Malevich welcomed the Russian Revolution, which broke out in 1917, as a political act that would wipe out past traditions and begin a new culture. He believed his art could play a major role because of its universal accessibility. In actuality, after a short period when the new regime heralded avant-garde art, the political leaders of the postrevolution Soviet Union decided the new society needed a more "practical" art. Soviet authorities promoted a "realistic," illusionistic art that they believed a wide public could understand and that they hoped would teach citizens about their new government. This horrified Malevich. To him, true art could never have a practical connection with life. As he explained, "Every social idea, however great and important it may be, stems from the sensation of hunger; every art work, regardless of how small and insignificant it may seem, originates in pictorial or plastic feeling. It is high time for us to realize that the problems of art lie far apart from those of the stomach or the intellect."39 Disappointed and unappreciated in his own country, Malevich eventually gravitated toward other disciplines, such as mathematical theory and geometry, logical fields given his interest in pure abstraction.

NAUM GABO Like Malevich, the Russian-born sculptor Naum GABO (1890–1977) wanted to create an innovative art to express a new reality, and, also like Malevich, Gabo believed art should spring from sources separate from the everyday world. For Gabo, the new reality was the space-time world described by early-20th-century scientists (see "Science and Art," page 691). As he wrote in *The Realistic Manifesto*, published with his brother Anton Pevsner (1886–1962) in 1920:

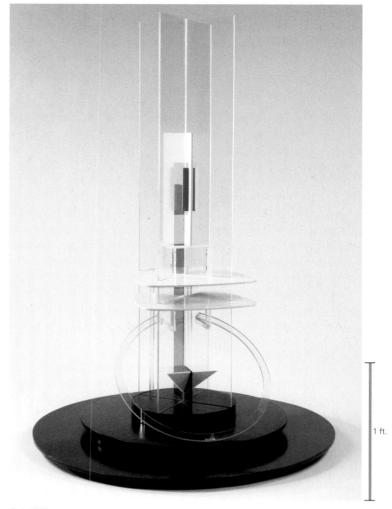

24-55 Naum Gabo, *Column*, ca. 1923 (reconstructed 1937). Perspex, wood, metal, glass, 3' $5'' \times 2'$ $5'' \times 2'$ 5''. Solomon R. Guggenheim Museum, New York.

Gabo's Constructivist sculptures rely on the relationship of mass and space to suggest the nature of space-time. Space seems to flow through as well as around the transparent materials he used.

Space and time are the only forms on which life is built and hence art must be constructed. . . . The realization of our perceptions of the world in the forms of space and time is the only aim of our pictorial and plastic art. . . . We renounce the thousand-year-old delusion in art that held the static rhythms as the only elements of the plastic and pictorial arts. We affirm in these arts a new element, the kinetic rhythms, as the basic forms of our perception of real time. ⁴⁰

Gabo was one of the Russian sculptors known as Constructivists. The name *Constructivism* may have come originally from the title *Construction*, which the Russian artist Vladimir Tatlin (FIG. **24-70**) used for some relief sculptures he made in 1913 and 1914. Gabo explained that he called himself a Constructivist partly because he built up his sculptures piece by piece in space, instead of carving or modeling them in the traditional way. Although Gabo experimented briefly with real motion in his work, most of his sculptures relied on the relationship of mass and space to suggest the nature of space-time. To indicate the volumes of mass and space more clearly in his sculpture, Gabo used some of the new synthetic plastic materials, including celluloid, nylon, and Lucite, to create constructions whose space seems to flow through as well as around the transparent materials. In works such as *Column* (FIG. **24-55**), the sculptor opened up the column's circular mass so that the viewer can experience the volume of space it

occupies. Two transparent planes extend through its diameter, crossing at right angles at the center of the implied cylindrical column shape. The opaque colored planes at the base and the inclined open ring set up counter-rhythms to the crossed upright planes. They establish the sense of dynamic kinetic movement that Gabo always sought to express as an essential part of reality.

DE STIJL The utopian spirit and ideals of the Suprematists and Constructivists extended beyond Russia. In Holland, a group of young artists formed a new movement in 1917 and began publishing a magazine, calling both movement and magazine *De Stijl* (The Style). The group's cofounders were the painters PIET MONDRIAN (1872–1944) and Theo van Doesburg (1883–1931). In addition to promoting utopian ideals, De Stijl artists believed in the birth of a new age in the wake of World War I. They felt it was a time of balance between individual and universal values, when the machine would assure ease of living. In their first manifesto of De Stijl, the artists declared: "There is an old and a new consciousness of time. The old is connected with the individual. The new is connected with the universal." The goal, according to van Doesburg and architect Cor van Eesteren (1897–1988), was a total integration of art and life:

We must realize that life and art are no longer separate domains. That is why the "idea" of "art" as an illusion separate from real life must disappear. The word "Art" no longer means anything to us. In its place we demand the construction of our environment in accordance with creative laws based upon a fixed principle. These laws, following those of economics, mathematics, technique, sanitation, etc., are leading to a new, plastic unity. 42

PIET MONDRIAN Toward this goal of integration, Mondrian created a new style based on a single ideal principle. The choice of the term "De Stijl" reflected Mondrian's confidence that this style the style—revealed the underlying eternal structure of existence. Accordingly, De Stijl artists reduced their artistic vocabulary to simple geometric elements. Time spent in Paris, just before World War I, introduced Mondrian to modes of abstraction such as Cubism. However, as his attraction to contemporary theological writings grew, Mondrian sought to purge his art of every overt reference to individual objects in the external world. He initially favored the teachings of theosophy, a tradition basing knowledge of nature and the human condition on knowledge of the divine nature or spiritual powers. (His fellow theosophist, Vassily Kandinsky [FIG. 24-7], pursued a similar path.) Mondrian, however, quickly abandoned the strictures of theosophy and turned toward a conception of nonobjective design—"pure plastic art"—that he believed expressed universal reality. He articulated his credo with great eloquence in 1914:

What first captivated us does not captivate us afterward (like toys). If one has loved the surface of things for a long time, later on one will look for something more. . . . The interior of things shows through the surface; thus as we look at the surface the inner image is formed in our soul. It is this inner image that should be represented. For the natural surface of things is beautiful, but the imitation of it is without life. . . . Art is higher than reality and has no direct relation to reality. . . . To approach the spiritual in art, one will make as little use as possible of reality, because reality is opposed to the spiritual. . . . [W]e find ourselves in the presence of an abstract art. Art should be above reality, otherwise it would have no value for man. ⁴³

Mondrian soon moved beyond Cubism because he felt "Cubism did not accept the logical consequences of its own discoveries; it was not developing towards its own goal, the expression of pure plastics." Caught by the outbreak of hostilities while on a visit to

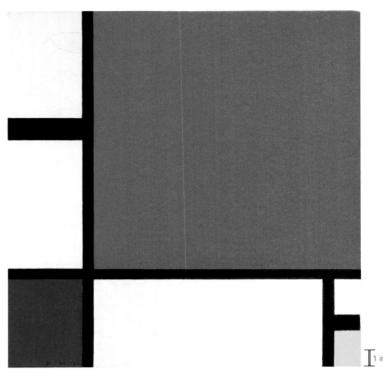

24-56 PIET MONDRIAN, *Composition with Red, Blue and Yellow,* 1930. Oil on canvas, 1' $6\frac{1}{8}$ ' × 1' $6\frac{1}{8}$ '. Kunsthaus, Zürich. © 2008 Mondrian/Holtzman Trust c/o HCR International, VA, USA.

Mondrian created numerous "pure plastic" paintings in which he locked primary colors into a grid of intersecting vertical and horizontal lines. By altering the grid patterns, he created a dynamic tension.

Holland, Mondrian remained there during World War I, developing his theories for what he called *Neoplasticism*—the new "pure plastic art." He believed all great art had polar but coexistent goals, the attempt to create "universal beauty" and the desire for "aesthetic expression of oneself."⁴⁵ The first goal is objective in nature, whereas the second is subjective, existing within the individual's mind and heart. To create such a universal expression, an artist must communicate "a real equation of the universal and the individual."⁴⁶

To express this vision, Mondrian eventually limited his formal vocabulary to the three primary colors (red, yellow, and blue), the three primary values (black, white, and gray), and the two primary directions (horizontal and vertical). Basing his ideas on a combination of teachings, he concluded that primary colors and values are the purest colors and therefore are the perfect tools to help an artist construct a harmonious composition. Using this system, he created numerous paintings locking color planes into a grid of intersecting vertical and horizontal lines, as in *Composition with Red, Blue, and Yellow* (FIG. **24-56**). In each of these paintings, Mondrian altered the grid patterns and the size and placement of the color planes to create an internal cohesion and harmony. This did not mean inertia. Rather, Mondrian worked to maintain a dynamic tension in his paintings from the size and position of lines, shapes, and colors.

Sculpture

It was impossible for early-20th-century artists to ignore the increasingly intrusive expansion of mechanization and growth of technology. However, not all artists embraced these developments, as had the Futurists. In contrast, many artists attempted to overcome the

Brancusi, Hepworth, and Moore on Abstract Sculpture

any early-20th-century sculptors rejected the notion that reproducing the physical world of nature was the purpose of sculpture. Instead, they championed abstraction as the sculptor's proper goal. Among those who not only produced enduring masterpieces of abstract sculpture but also wrote eloquently about the theoretical basis of their work were Constantin Brancusi (FIG. 24-57), Barbara Hepworth (FIG. 24-58), and Henry Moore (FIG. 24-59). Some excerpts from their writings on sculpture illustrate their commitment to abstraction as their guiding principle.

- Constantin Brancusi Simplicity is not an objective in art, but one achieves simplicity despite oneself by entering into the real sense of things.* What is real is not the external form but the essence of things. Starting from this truth it is impossible for anyone to express anything essentially real by imitating its exterior surface.†
- Barbara Hepworth The forms which have had special meaning for me since childhood have been the standing form (which is the translation of my feeling towards the human being standing in landscape); the two forms (which is the tender relationship of one living thing beside another); and the closed form, such as the oval, spherical, or pierced form (sometimes incorporating colour) which translates for me the association and meaning of gesture in the landscape. . . . In all these shapes the translation of what one feels about man and nature must be conveyed by the sculptor in terms of mass, inner tension, and rhythm, scale in relation to our human size, and the quality of surface which speaks through our hands and eyes. ‡
- Henry Moore Since the Gothic, European sculpture had become overgrown with moss, weeds—all sorts of surface excrescences which completely concealed shape. It has been Brancusi's special mission to get rid of this overgrowth, and to make us once more shape-conscious. To do this he has had to concentrate on very simple direct shapes. . . . Abstract qualities of design are essential to the value of a work. . . . Because a work does not aim at reproducing natural appearances, it is not, therefore, an escape from life—but may be a penetration into reality. . . . My sculpture is becoming

less representational, less an outward visual copy . . . but only because I believe that in this way I can present the human psychological content of my work with greatest directness and intensity.§

* Quoted in Herschel B. Chipp, *Theories of Modern Art: A Source Book by Artists and Critics* (Berkeley and Los Angeles: University of California Press, 1968), 364–365.

† Quoted in George Heard Hamilton, Painting and Sculpture in Europe, 1880–1940, 6th ed. (New Haven: Yale University Press, 1993), 426.

[‡] Barbara Hepworth, *A Pictorial Auto-biography* (London: Tate Gallery, 1978), 9, 53.

§ Quoted in Robert L. Herbert, *Modern Artists on Art*, 2d ed. (Mineola, N.Y.: Dover, 2000), 173–179.

24-57 Constantin Brancusi, *Bird in Space*, 1924. Bronze, 4' $2\frac{5}{16}$ " high. Philadelphia Museum of Art, Philadelphia (Louise and Walter Arensberg Collection, 1950).

Although not a literal depiction of 1 ft. a bird, Brancusi's softly curving, light-reflecting abstract sculpture in polished bronze suggests a bird about to soar in free flight through the heavens.

predominance of mechanization in society by immersing themselves in a search for the organic and natural.

CONSTANTIN BRANCUSI Romanian artist Constantin Brancusi (1876–1957) was one of many sculptors eager to produce works emphasizing the natural or organic. Often composed of softly curving surfaces and ovoid forms, his sculptures refer, directly or indirectly, to the cycle of life. Brancusi sought to move beyond surface appearances to capture the essence or spirit of the object depicted (see "Brancusi, Hepworth, and Moore on Abstract Sculpture," above). Brancusi's ability to design rhythmic, elegant sculptures conveying the essence of his subjects is evident in *Bird in Space* (FIG. **24-57**). Clearly not a literal depiction of a bird, the work is the final result of a long process. Brancusi started with the image of a bird at rest with its wings folded at its sides and ended with an abstract columnar form sharply tapered at each end. Despite the abstraction, the sculpture retains the suggestion of a bird about to soar in free flight

through the heavens. The highly reflective surface of the polished bronze does not allow the eye to linger on the sculpture itself (as do, for example, Rodin's agitated and textured surfaces; FIGS. 23-32 and 23-33). Instead, the viewer's eye follows the gleaming reflection along the delicate curves to glide right off the tip of the work, thereby inducing a feeling of flight. Brancusi stated, "All my life I have sought the essence of flight. Don't look for mysteries. I give you pure joy. Look at the sculptures until you see them. Those nearest to God have seen them." 47

BARBARA HEPWORTH British artist BARBARA HEPWORTH (1903–1975) developed her own kind of essential sculptural form, combining pristine shape with a sense of organic vitality. She sought a sculptural idiom that would express her sense both of nature and the landscape and of the person who is in and observes nature (see "Brancusi, Hepworth, and Moore," above). By 1929, Hepworth arrived at a breakthrough that evolved into an enduring and commanding

24-58 Barbara Hepworth, *Oval Sculpture (No. 2)*, 1943. Plaster cast, $11\frac{1}{4}'' \times 1'$ $4\frac{1}{4}'' \times 10''$. Tate Gallery, London.

Hepworth's major contribution to the history of sculpture was the introduction of the hole, or negative space, as an abstract element that is as integral and important to the sculpture as its mass.

element in her work from that point forward, and that represents her major contribution to the history of sculpture: the use of the hole, or void. Particularly noteworthy is that Hepworth introduced the hole, or negative space, in her sculpture as an abstract element—it does not represent anything specific—and one that is as integral and important to the sculpture as its mass. *Oval Sculpture* (*No. 2*) is a plaster cast (Fig. **24-58**) of an earlier wooden sculpture Hepworth carved in 1943. Pierced in four places, *Oval Sculpture* is as much defined by the smooth, curving holes as by the volume of white plaster. Like the forms in all of Hepworth's mature works, those in *Oval Sculpture* are basic and universal, expressing a sense of eternity's timelessness.

HENRY MOORE British sculptor Henry Moore (1898–1986) shared Hepworth's interest in the hole, or void, and Brancusi's profound love of nature and knowledge of organic forms and materials. Moore maintained that every "material has its own individual qualities" and that these qualities could play a role in the creative process: "It is only when the sculptor works direct, when there is an active relationship with his material, that the material can take its part in the shaping of an idea." Accordingly, the forms and lines of Moore's lead and stone sculptures tend to emphasize the material's hardness and solidity, whereas his fluid wood sculptures draw attention to the flow of the wood grain. One major recurring theme in Moore's work is the reclining female figure with simplified and massive forms. A tiny photograph of a Chacmool from ancient Mexico originally inspired this motif.

Although viewers can recognize a human figure in most of Moore's works, the artist simplified and abstracted the figure, attempting to express a universal truth beyond the physical world (see "Brancusi, Hepworth, and Moore," page 727). Reclining Figure (FIG. 24-59) reveals Moore's expressive handling of the human form and his responsiveness to his chosen material—here, elm wood. The contours of the sculpture follow the grain of the wood. The figure's massive shapes suggest Surrealist biomorphic forms (FIG. 24-52), but Moore's recumbent woman is also a powerful earth mother whose undulant forms and hollows suggest nurturing human energy. Similarly, they evoke the contours of the Yorkshire hills of Moore's childhood and the wind-polished surfaces of weathered wood and stone. The sculptor heightened the allusions to landscape and to Surrealist organic forms in his work by interplaying mass and void, based on the intriguing qualities of cavities in nature. As he explained, "The hole connects one side to the other, making it immediately more three-dimensional. . . . The mystery of the hole—the mysterious fascination of caves in hillsides and cliffs."49 The concern with the void—the holes—recalls the sculpture of artists such as Barbara Hepworth (FIG. 24-58), whose work influenced him, and Aleksandr Archipenko (FIG. 24-20). Above all, Reclining Figure combines the organic vocabulary central to Moore's philosophy—bone shapes, eroded rocks, and geologic formations—to communicate the human form's fluidity, dynamism, and evocative nature.

24-59 Henry Moore, *Reclining Figure*, 1939. Elm wood, $3' 1'' \times 6' 7'' \times 2' 6''$. Detroit Institute of Arts, Detroit (Founders Society purchase with funds from the Dexter M. Ferry Jr. Trustee Corporation).

The reclining female figure was a major theme in Moore's sculptures. He simplified and abstracted the massive form in a way that recalls Biomorphic Surrealism. The contours follow the grain of the wood.

24-60 VERA MUKHINA, *The Worker and the Collective Farm Worker*, Soviet Pavilion, Paris Exposition, 1937. Stainless steel, 78' high. Art © Estate of Vera Mukhina/RAO, Moscow/VAGA, New York.

In contrast to contemporaneous abstract sculpture, Mukhina's realistic representation of a male factory worker and a female farm worker glorifies the communal labor of the Soviet people.

VERA MUKHINA Not all sculptors of this period pursued abstraction, however. The Worker and the Collective Farm Worker (FIG. 24-60) by Russian artist Vera Mukhina (1889-1963) presents a vivid contrast to the work of Brancusi, Hepworth, and Moore. Produced in 1937 for the International Exposition in Paris the same venue in which Picasso displayed Guernica (FIG. 24-41)— Mukhina's monumental stainless-steel sculpture glorifies the communal labor of the Soviet people. Whereas Picasso employed Cubist abstraction to convey the horror of wartime bombing, Mukhina relied on realism to represent exemplars of the Soviet citizenry. Her sculpture, which stood atop the Soviet Pavilion at the exposition, depicts a male factory worker holding aloft the tool of his trade, the hammer. Alongside him is a female farm worker raising her sickle to the sky. The juxtaposed hammer and sickle, appearing as they do at the apex of the sculpture, replicate their appearance on the Soviet flag, thereby celebrating the Soviet system. The artist augmented the heroic tenor of this sculpture by emphasizing the solidity of the figures, who stride forward with their clothes billowing dramatically behind them. Mukhina had studied in Paris and was familiar with abstraction, especially Cubism, but felt that a commitment to realism produced the most powerful sculpture. The Soviet government officially approved this realist style, and Mukhina earned high praise for her sculpture. Indeed, Russian citizens celebrated the work as a national symbol for decades.

AMERICA, 1930 TO 1945

The Armory Show of 1913 (see "The Armory Show," page 710) was an important vehicle for exposing American artists to modernist European art. Equally significant was the emigration of European artists across the Atlantic Ocean. The havoc Hitler and the National Socialists wreaked in the early 1930s (see "Degenerate Art," page 721) forced artists to flee. The United States, among other countries, offered both survival and a more hospitable environment for producing their art. Léger, Lipchitz, Beckmann, Grosz, Ernst, and Dalí, among many others, all made their way to American cities.

Museums in the United States, wanting to demonstrate their familiarity and connection with the most progressive European art, mounted exhibitions centered on the latest European artistic developments. In 1938, for example, the City Art Museum of Saint Louis presented an exhibition of Beckmann's work, and the Art Institute of Chicago organized *George Grosz: A Survey of His Art from 1918–1938*. This interest in exhibiting the work of persecuted artists driven from their homelands also had political overtones. In the highly charged atmosphere of the late 1930s leading to the onset of World War II, people often perceived support for these artists and their work as support for freedom and democracy. In 1942, Alfred H. Barr Jr. (1902–1981), director of the Museum of Modern Art, stated:

Among the freedoms which the Nazis have destroyed, none has been more cynically perverted, more brutally stamped upon, than the Freedom of Art. For not only must the artist of Nazi Germany bow to political tyranny, he must also conform to the personal taste of that great art connoisseur, Adolf Hitler. . . . But German artists of spirit and integrity have refused to conform. They have gone into exile or slipped into anxious obscurity. . . . Their paintings and sculptures, too, have been hidden or exiled. . . . But in free countries they can still be seen, can still bear witness to the survival of a free German culture. ⁵⁰

Despite this moral support for exiled artists, once the United States formally entered the war, Germany officially became the enemy. Then it was much more difficult for the American art world to promote German artists, however persecuted. Many émigré artists, including Léger, Grosz, Ernst, and Dalí, returned to Europe after the war ended. Their collective presence in the United States until then, however, was critical for the development of American art and contributed to the burgeoning interest in the avant-garde among American artists.

Sculpture and Photography

ALEXANDER CALDER One American artist who rose to international prominence at this time was ALEXANDER CALDER (1898–1976). Both the artist's father and grandfather were sculptors, but Calder initially studied mechanical engineering. Fascinated all his life by motion, he explored that phenomenon and its relationship to three-dimensional form in much of his sculpture. As a young artist in Paris in the late 1920s, Calder invented a circus filled with wire-based miniature performers that he activated into realistic analogues of their real-life counterparts' motion. After a visit to Mondrian's studio in the early 1930s, Calder set out to put the Dutch painter's brightly colored rectangular shapes (FIG. 24-56) into motion. (Marcel Duchamp, intrigued by Calder's early motorized and hand-cranked examples of moving abstract pieces, named them *mobiles*.) Calder's

The Museum of Modern Art and the Avant-Garde

stablished in 1929, the Museum of Modern Art (often called MoMA) in New York City owes its existence to a trio of women—Lillie P. Bliss, Mary Quinn Sullivan, and Abby Aldrich Rockefeller (see "Art 'Matronage' in America," page 709). These women saw the need for a museum to collect and exhibit modernist art. Together they founded what quickly became the most influential museum of modern art in the world. Their success was extraordinary considering the skepticism and hostility greeting much of modernist art at the time of the museum's inception. Indeed, at that time, few American museums exhibited late-19th- and 20th-century art at all.

In its quest to expose the public to the energy and challenge of modernist, particularly avant-garde, art, MoMA developed unique and progressive exhibitions. Among those the museum mounted during the early years of its existence were *Cubism and Abstract Art* and *Fantastic Art*, *Dada, Surrealism* (1936). Two other noteworthy shows were *American Sources of Modern Art* (*Aztec, Maya, Inca*) in 1933 and *African Negro Art* in 1935, among the first exhibitions to deal with "primitive" artifacts in artistic rather than anthropological terms (see "Primitivism," page 696).

The organization of MoMA's administrative structure and the scope of the museum's early activities were also remarkable. MoMA's first director, Alfred H. Barr Jr., insisted on establishing departments not only for painting and sculpture but also for pho-

tography, prints and drawing, architecture, and the decorative arts. He developed a library of books on modern art and a film library, both of which have become world-class collections, as well as an extensive publishing program.

It is the museum's art collection, however, that has drawn the most attention. By cultivating an influential group of patrons, MoMA has developed an extensive and enviable collection of late-19th- and

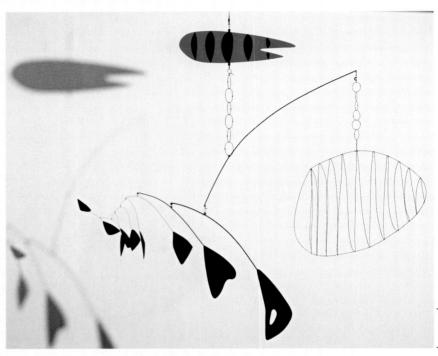

24-61 Alexander Calder, *Lobster Trap and Fish Tail*, 1939. Painted sheet aluminum and steel wire, $8' 6'' \times 9' 6''$. Museum of Modern Art, New York.

Using his thorough knowledge of engineering to combine nonobjective organic forms and motion, Calder created a new kind of sculpture—the mobile—that expressed reality's innate dynamism.

20th-century art. Its collection includes such important works as van Gogh's *Starry Night* (FIG. 23-17), Picasso's *Les Demoiselles d'Avignon* (FIG. 24-12), and Dali's *The Persistence of Memory* (FIG. 24-49), as well as many others illustrated in this book, including 19 in this chapter alone. MoMA has also served as an art patron itself, commissioning works like Calder's *Lobster Trap and Fish Tail* (FIG. 24-61) in 1939, just a decade after the institution's founding.

engineering skills soon helped him to fashion a series of balanced structures hanging from rods, wires, and colored, organically shaped plates. This new kind of sculpture, which combined nonobjective organic forms and motion, succeeded in expressing the innate dynamism of the natural world.

An early Calder mobile is *Lobster Trap and Fish Tail* (FIG. **24-61**), which the artist created in 1939 under a commission from the Museum of Modern Art in New York City for the stairwell of the museum's new building on 53rd Street (see "The Museum of Modern Art and the Avant-Garde," above). Calder carefully planned each non-mechanized mobile so that any air current would set the parts moving to create a constantly shifting dance in space. Mondrian's work may have provided the initial inspiration for the mobiles, but their organic

shapes resemble those in Joan Miro's Surrealist paintings (FIG. 24-52). Indeed, a viewer can read Calder's forms as either geometric or organic. Geometrically, the lines suggest circuitry and rigging, and the shapes derive from circles and ovoid forms. Organically, the lines suggest nerve axons, and the shapes resemble cells, leaves, fins, wings, and other bioforms.

GREAT DEPRESSION In the 1930s much of the Western world plunged into the Great Depression, which had particularly acute ramifications in the United States. The decade following the catastrophic stock market crash of October 1929 dramatically changed the nation, and artists were among the many economic victims. The limited art market virtually disappeared, and museums

curtailed both their purchases and exhibition schedules. Many artists sought financial support from the federal government, which established numerous programs to provide relief, assist recovery, and promote reform. Among the programs supporting artists were the Treasury Relief Art Project, founded in 1934 to commission art for federal buildings, and the Works Progress Administration (WPA), founded in 1935 to relieve widespread unemployment. Under the WPA, varied activities of the Federal Art Project paid artists, writers, and theater people a regular wage in exchange for work in their professions. Another important program was the Resettlement Administration (RA), better known by its later name, the Farm Security Administration. The RA oversaw emergency aid programs for farm families caught in the Depression.

DOROTHEA LANGE The RA hired American photographer DOROTHEA LANGE (1895–1965) in 1936 and dispatched her to photograph the rural poor attempting to survive the desperate conditions wrought by the Great Depression. At the end of an assignment to document the lives of migratory pea pickers in California, Lange stopped at a camp in Nipomo and found the migrant workers there starving because the crops had frozen in the fields. Among the pictures Lange made on this occasion was *Migrant Mother, Nipomo Valley* (FIG. **24-62**), in which she captured the mixture of strength and worry in the raised hand and careworn face of a young mother, who holds a baby on her lap. Two older children cling to their

24-62 DOROTHEA LANGE, Migrant Mother, Nipomo Valley, 1935. Gelatin silver print, $1'1'' \times 9''$. Oakland Museum of California, Oakland (gift of Paul S. Taylor).

While documenting the lives of migratory farm workers during the Depression, Lange made this unforgettable photograph of a mother in which she captured the woman's strength and worry.

mother trustingly while shunning the camera. Lange described how she got the picture:

[I] saw and approached the hungry and desperate mother, as if drawn by a magnet. I do not remember how I explained my presence or my camera to her, but I remember she asked me no questions. I made five exposures, working closer and closer from the same direction. . . . There she sat in that lean-to tent with her children huddled around her, and she seemed to know that my pictures might help her, and so she helped me. ⁵¹

Within days after Lange's photograph appeared in a San Francisco newspaper, people rushed food to Nipomo to feed the hungry workers.

Painting

The political, social, and economic developments of the 1930s and 1940s also had a profound effect on American painters.

BEN SHAHN Born in Lithuania, BEN SHAHN (1898–1969) came to the United States in 1906 and trained as a lithographer before broadening the media in which he worked to include easel painting, photography, and murals. He focused on the lives of ordinary people and the injustices often done to them by the structure of an impersonal, bureaucratic society. In the early 1930s, he completed a cycle of 23 paintings and prints inspired by the trial and execution of the two Italian anarchists Nicola Sacco and Bartolomeo Vanzetti. Accused of killing two men in a holdup in 1920 in South Braintree, Massachusetts, the Italians were convicted in a trial that many people thought resulted in a grave miscarriage of justice. Shahn felt he had found in this story a subject the equal of any in Western art history: "Suddenly I realized . . . I was living through another crucifixion."52 Basing many of the works in this cycle on newspaper photographs of the events, Shahn devised a style that adapted his knowledge of Synthetic Cubism and his training in commercial art to an emotionally expressive use of flat, intense color in figural compositions filled with sharp, dry, angular forms. He called the major work in the series The Passion of Sacco and Vanzetti (FIG. I-5), drawing a parallel to Christ's Passion. This tall, narrow painting condenses the narrative in terms of both time and space. The two executed men lie in coffins at the bottom of the composition. Presiding over them are the three members of the commission chaired by Harvard University president A. Laurence Lowell, who declared the original trial fair and cleared the way for the executions to take place. A framed portrait of Judge Webster Thayer, who handed down the initial sentence, hangs on the wall of a simplified government building. The gray pallor of the dead men, the stylized mask-faces of the mock-pious mourning commissioners, and the sanctimonious, distant judge all contribute to the mood of anguished commentary that makes this image one of Shahn's most powerful works.

EDWARD HOPPER Trained as a commercial artist, EDWARD HOPPER (1882–1967) studied painting and printmaking in New York and then in Paris. When he returned to the United States, he concentrated on scenes of contemporary American city and country life. His paintings depict buildings, streets, and landscapes that are curiously muted, still, and filled with empty spaces, evoking the national mind-set during the Depression era. Hopper did not paint historically specific scenes. He took as his subject the more generalized theme of the overwhelming loneliness and echoing isolation of modern life in the United States. In his paintings, motion is stopped

24-63 EDWARD HOPPER, *Nighthawks*, 1942. Oil on canvas, $2' 6'' \times 4' 8\frac{11}{16}''$. Art Institute of Chicago, Chicago (Friends of American Art Collection). The seeming indifference of Hopper's characters to one another, and the echoing spaces that surround them, evoke the overwhelming loneliness and isolation of Depression-era life in the United States.

and time suspended, as if the artist recorded the major details of a poignant personal memory. From the darkened streets outside a restaurant in *Nighthawks* (FIG. **24-63**), the viewer glimpses the lighted interior through huge plate-glass windows, which lend the inner space the paradoxical sense of being both a safe refuge and a vulnerable place for the three customers and the counterman. The seeming indifference of Hopper's characters to one another and the echoing spaces that surround them suggest the pervasive loneliness of modern humans. In *Nighthawks* and other works, Hopper created a Realist vision recalling that of 19th-century artists such as Thomas Eakins (FIG. **22-38**) and Henry Ossawa Tanner (FIG. **22-40**), but, consistent with more recent trends in painting, he simplified the shapes in a move toward abstraction.

JACOB LAWRENCE African American artist Jacob Lawrence (1917–2000) found his subjects in modern history, concentrating on the culture and history of his own people. Lawrence moved to Harlem, New York, in 1927 at about age 10. There, he came under the spell of the African art and the African American history he found in lectures and exhibitions and in the special programs sponsored by the 135th Street New York Public Library, which had outstanding collections of African American art and archival data. Inspired by the politically oriented art of Goya (FIG. 22-13), Daumier (FIG. 22-30), and Orozco (FIG. 24-67), and influenced by the many artists and writers of the Harlem Renaissance whom he met, including Aaron Douglas (FIG. 24-36), Lawrence found his subjects in the everyday life of Harlem and in African American history.

In 1941, Lawrence began a 60-painting series titled *The Migration of the Negro*, in which he defined his own vision of the continuing African American struggle against discrimination. Unlike his earlier historical paintings depicting important figures in American history,

such as the abolitionists Frederick Douglass and Harriet Tubman, this series called attention to a contemporaneous event—the ongoing exodus of black labor from the southern United States. Disillusioned with their lives in the South, hundreds of thousands of African Americans migrated north in the years following World War I, seeking improved economic opportunities and more hospitable political and social conditions. This subject had personal relevance to Lawrence:

I was part of the migration, as was my family, my mother, my sister, and my brother. . . . I grew up hearing tales about people "coming up," another family arriving. . . . I didn't realize what was happening until about the middle of the 1930s, and that's when the *Migration* series began to take form in my mind. ⁵³

The "documentation" of the period, such as the RA program, ignored African Americans, and thus this major demographic shift remained largely invisible to most Americans. Of course, the conditions African Americans encountered both during their migration and in the North were often as difficult and discriminatory as those they had left behind in the South.

Lawrence's series provides numerous vignettes capturing the experiences of these migrating people. Often, a sense of bleakness and of the degradation of African American life dominates the images. No. 49 (FIG. 24-64) of this series bears the caption "They also found discrimination in the North although it was much different from that which they had known in the South." The artist depicted a blatantly segregated dining room with a barrier running down the room's center separating the whites on the left from the African Americans on the right. To ensure a continuity and visual integrity among all 60 paintings, Lawrence interpreted his themes systematically in rhythmic arrangements of bold, flat, and strongly colored shapes. His style drew equally from his interest in the push-pull

24-64 Jacob Lawrence, *No. 49* from *The Migration of the Negro*, 1940–1941. Tempera on Masonite, 1' $6'' \times 1'$. Phillips Collection, Washington, D.C.

The 49th in a series of 60 paintings documenting African American life in the North, Lawrence's depiction of a segregated dining room underscored that the migrants had not left discrimination behind.

effects of Cubist space and his memories of the patterns made by the colored scatter rugs brightening the floors of his childhood homes. He unified the narrative with a consistent palette of bluish green, orange, yellow, and grayish brown throughout the entire series.

GRANT WOOD Although many American artists, such as the Precisionists (FIGS. 24-37 and 24-38), preferred to depict the city or rapidly developing technological advances, others avoided subjects tied to modern life. At a 1931 arts conference, Grant Wood (1891–1942) announced a new movement developing in the Midwest, known as *Regionalism*, which he described as focused on American subjects and as standing in reaction to the modernist abstraction of Europe and New York. Four years later, Wood published an essay "Revolt against the City" that underscored this new focus. Wood and the Regionalists, sometimes referred to as the American Scene Painters, turned their attention instead to rural life as America's cultural backbone. Wood's paintings, for example, focus on rural Iowa, where he was born and raised.

The work that catapulted Wood to national prominence was *American Gothic* (FIG. **24-65**), which became an American icon. The artist depicted a farmer and his spinster daughter standing in front of a

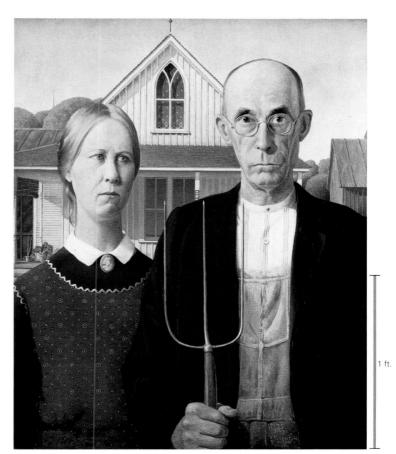

24-65 Grant Wood, *American Gothic*, 1930. Oil on beaverboard, $2' \, 5\frac{7}{8}'' \times 2' \, \frac{7}{8}''$. Art Institute of Chicago, Chicago (Friends of American Art Collection). Art © Estate of Grant Wood/Licensed by VAGA, New York.

In reaction to modernist abstract painting, the Midwestern Regionalism movement focused on American subjects. Wood's painting of an Iowa farmer and his daughter is an American icon.

neat house with a small *lancet* window, typically found on Gothic cathedrals. The man and woman wear traditional attire. He appears in worn overalls, and she in an apron trimmed with rickrack. The dour expression on both faces gives the painting a severe quality, which Wood enhanced with his meticulous brushwork. The public and professional critics agreed that *American Gothic* was "quaint, humorous, and AMERICAN" and embodied "strength, dignity, fortitude, resoluteness, integrity," qualities that represented the true spirit of America.⁵⁴

Wood's Regionalist vision involved more than his subjects. It extended to a rejection of avant-garde styles in favor of a clearly readable, Realist style. Surely this approach appealed to many people alienated by the increasing presence of abstraction in art. Interestingly enough, despite the accolades this painting received, it also attracted criticism. Not everyone saw the painting as a sympathetic portrayal of Midwestern life. Indeed, some in Iowa considered the depiction insulting. In addition, despite the seemingly reportorial nature of American Gothic, some viewed it as a political statement one of staunch nationalism. In light of the problematic nationalism in Germany at the time, many observers found Wood's nationalistic attitude disturbing. Nonetheless, during the Great Depression, Regionalist paintings had a popular appeal because they often projected a reassuring image of America's heartland. The public saw Regionalism as a means of coping with the national crisis through a search for cultural roots. Thus, people deemed acceptable any nostalgia implicit in Regionalist paintings or mythologies these works perpetuated because they served a larger purpose.

24-66 Thomas
Hart Benton, Pioneer
Days and Early Settlers,
State Capitol, Jefferson
City, Missouri, 1936.
Mural. Art ©
T. H. Benton and
R. P. Benton Testamentary Trusts/UMB
Bank Trustee/Licensed
by VAGA, New York.

Benton's mural for Missouri's State Capitol is one of the major Regionalist artworks. Part documentary and part invention, the images include both positive and negative aspects of state history.

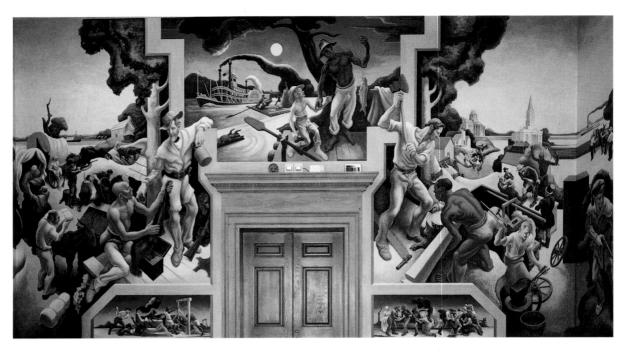

THOMAS HART BENTON Another major Regionalist artist was Thomas Hart Benton (1889-1975). Whereas Wood focused his attention on Iowa, Benton turned to scenes from his native Missouri. He produced one of his major works, a series of murals titled A Social History of the State of Missouri, in 1936 for the Missouri State Capitol. The murals depict a collection of images from the state's true and legendary history, such as primitive agriculture, horse trading, a vigilante lynching, and an old-fashioned political meeting. Other scenes portray the mining industry, grain elevators, Native Americans, and family life. One segment, Pioneer Days and Early Settlers (FIG. 24-66), shows a white man using whiskey as a bartering tool with a Native American (at left), along with scenes documenting the building of Missouri. Part documentary and part invention, Benton's images include both positive and negative aspects of Missouri's history, as these examples illustrate. Although the public perceived the Regionalists as dedicated to glorifying Midwestern life, that belief distorted their aims. Indeed, Grant Wood observed, "your true regionalist is not a mere eulogist; he may even be a severe critic." Benton, like Wood, championed a visually accessible style, but he developed a highly personal aesthetic that included complex compositions, a fluidity of imagery, and simplified figures depicted with a rubbery distortion.

JOSÉ CLEMENTE OROZCO During the period between the two world wars, three Mexican painters achieved international renown for their work both in Mexico and in the United States. The eldest of the three was José CLEMENTE OROZCO (1883–1949), one of a group of Mexican artists determined to base their art on the indigenous history and culture existing in Mexico before Europeans arrived. The movement these artists formed was part of the idealistic rethinking of society that occurred in conjunction with the Mexican Revolution (1910–1920) and the lingering political turmoil of the 1920s.

24-67 José Clemente Orozco, Epic of American Civilization: Hispano-America (panel 16), Baker Memorial Library, Dartmouth College, Hanover, New Hampshire, ca. 1932–1934. Fresco. Copyright © Orozco Valladares Family/SOMAAP, Mexico/Licensed by VAGA, New York.

One of 24 panels depicting the history of Mexico from ancient times, this scene focuses on a heroic peasant soldier of the Mexican Revolution surrounded by symbolic figures of his oppressors.

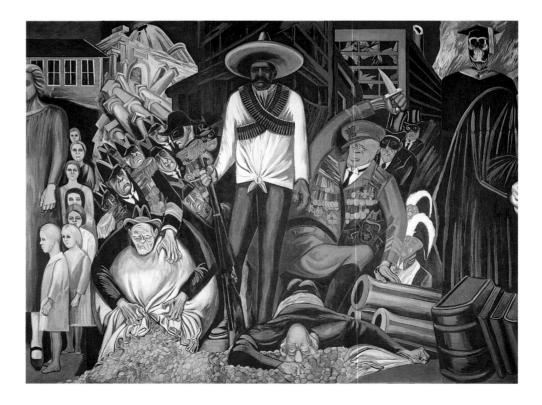

Rivera on Art for the People

iego Rivera was an avid proponent of a social and political role for art in the lives of common people and wrote passionately about the proper goals for an artist—goals he fully met in his murals depicting Mexican history (FIG. 24-68). Rivera's views stand in sharp contrast to the growing interest in abstraction on the part of many early-20th-century painters and sculptors.

Art has always been employed by the different social classes who hold the balance of power as one instrument of domination—hence, as a political instrument. One can analyze epoch after epoch—from the stone age to our own day-and see that there is no form of art which does not also play an essential political role. . . . What is it then that we really need? . . . An art with revolution as its subject: because the principal interest in the worker's life has to be touched first. It is necessary that he find aesthetic satisfaction and the highest pleasure appareled in the essential interest of his life. . . . The

subject is to the painter what the rails are to a locomotive. He cannot do without it. In fact, when he refuses to seek or accept a subject, his own plastic methods and his own aesthetic theories become his subject instead. . . . [H]e himself becomes the subject of his work. He be-

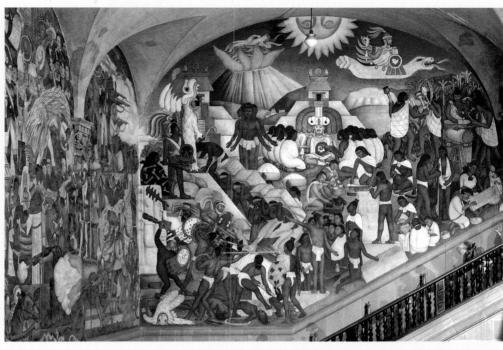

24-68 DIEGO RIVERA, Ancient Mexico, from the History of Mexico, Palacio Nacional, Mexico City, 1929-1935. Fresco.

A staunch Marxist, Rivera painted vast mural cycles in public buildings to dramatize the history of his native land. This fresco depicts the conflicts between indigenous Mexicans and the Spanish colonizers.

comes nothing but an illustrator of his own state of mind . . . That is the deception practiced under the name of "Pure Art."*

* Quoted in Robert Goldwater and Marco Treves, eds., Artists on Art from the XIV to the XX Century (New York: Pantheon, 1945), 475–477.

Among the projects these politically motivated artists undertook were vast mural cycles placed in public buildings to dramatize and validate the history of Mexico's native peoples. Orozco worked on one of the first major cycles, painted in 1922 on the walls of the National Training School in Mexico City. He carried the ideas of this mural revolution to the United States, completing many commissions for wall paintings between 1927 and 1934. From 1932 to 1934, he worked on one of his finest mural cycles in Baker Library at Dartmouth College in New Hampshire, partly in honor of its superb collection of books in Spanish. The college let him choose the subject. Orozco depicted, in 14 large panels and 10 smaller ones, a panoramic and symbolic history of ancient and modern Mexico, from the early mythic days of the feathered-serpent god Quetzalcoatl to a contemporary and bitterly satiric vision of modern education.

The imagery in panel 16, *Epic of American Civilization: Hispano-America* (FIG. **24-67**), revolves around the monumental figure of a heroic Mexican peasant armed to participate in the Mexican Revolution. Looming on either side of him are mounds crammed with symbolic figures of his oppressors—bankers, government soldiers, officials, gangsters, and the rich. Money-grubbers pour hoards of gold at the incorruptible peon's feet, cannons threaten him, and a bemedaled general raises a dagger to stab him in the back. Orozco's

training as an architect gave him a sense of the framed wall surface, which he easily commanded, projecting his clearly defined figures onto the solid mural plane in monumental scale. In addition, Orozco's early training as a maker of political prints and as a newspaper artist had taught him the rhetorical strength of graphic brevity, which he used here to assure that his allegory could be read easily. His special merging of the graphic and mural media effects gives his work an originality and force rarely seen in mural painting after the Renaissance and Baroque periods.

DIEGO RIVERA Like his countryman, DIEGO RIVERA (1886–1957) received great acclaim for his murals, both in Mexico and in the United States. A staunch Marxist, Rivera strove to develop an art that served his people's needs (see "Rivera on Art for the People," above). Toward that end, he sought to create a national Mexican style focusing on Mexico's history and incorporating a popular, generally accessible aesthetic in keeping with the socialist spirit of the Mexican Revolution. Rivera produced numerous large murals in public buildings, among them a series lining the staircase of the National Palace in Mexico City. In these images, painted between 1929 and 1935, he depicted scenes from Mexico's history, of which Ancient Mexico (FIG. 24-68) is one. This section of the mural represents the

24-69 Frida Kahlo, *The Two Fridas*, 1939. Oil on canvas, 5' $7'' \times 5'$ 7''. Museo de Arte Moderno, Mexico City.

Kahlo's deeply personal paintings touch sensual and psychological memories in her audience. Here, twin self-portraits linked by clasped hands and a common artery suggest different sides of her personality.

conflicts between the indigenous people and the Spanish colonizers. Rivera included portraits of important figures in Mexican history and, in particular, in the struggle for Mexican independence. Although complex, the decorative, animated murals retain the legibility of folklore, and the figures consist of simple monumental shapes and areas of bold color.

FRIDA KAHLO Born to a Mexican mother and German father, the painter Frida Kahlo (1907–1954), who married Diego Rivera, used the details of her life as powerful symbols for the psychological pain of human existence. Art historians often consider Kahlo a Surrealist due to the psychic and autobiographical issues she

dealt with in her art. Indeed, André Breton deemed her a Natural Surrealist, although Kahlo herself rejected any association with Surrealism. Kahlo began painting seriously as a young student, during convalescence from an accident that tragically left her in constant pain. Her life became a heroic and tumultuous battle for survival against illness and stormy personal relationships.

Typical of her long series of unflinching self-portraits is *The Two Fridas* (FIG. **24-69**), one of the few large-scale canvases Kahlo ever produced. The twin figures sit side by side on a low bench in a barren landscape under a stormy sky. The figures suggest different sides of the artist's personality, inextricably linked by the clasped hands and by the thin artery that stretches between them, joining their exposed hearts. The artery ends on one side in surgical forceps and on the other in a miniature portrait of her husband as a child. Her deeply personal paintings touch sensual and psychological memories in her audience.

However, to read Kahlo's paintings solely as autobiographical overlooks the powerful political dimension of her art. Kahlo was deeply nationalistic and committed to her Mexican heritage. Politically active, she joined the Communist Party in 1920 and participated in public political protests. *The Two Fridas* incorporates Kahlo's commentary on the struggle facing Mexicans in the early 20th century in defining their national cultural identity. The Frida on the right (representing indigenous culture) appears in a Tehuana dress, the traditional costume of Zapotec women from the Isthmus of Tehuantepec, whereas the Frida on the left (representing imperialist forces) wears a European-style white lace dress. The heart, depicted here in such dramatic fashion, was an important symbol in the art of the Aztecs, whom Mexican nationalists idealized as the last independent rulers of an indigenous political unit. Thus, *The Two Fridas* represents both Kahlo's personal struggles and the struggles of her homeland.

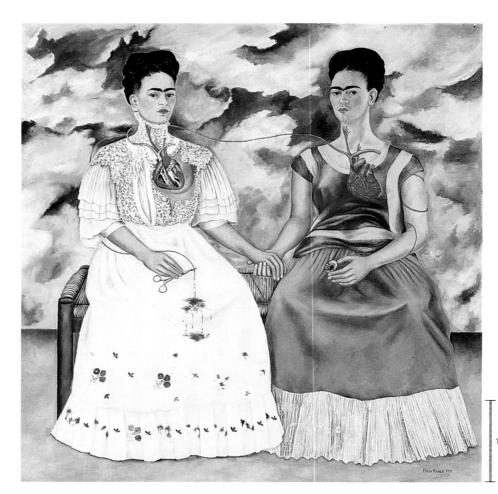

ARCHITECTURE

The first half of the 20th century was a time of great innovation in architecture too. As in painting, sculpture, and photography, new ideas came from both sides of the Atlantic.

Europe

In the years immediately following the Russian Revolution, a new art movement called *Productivism* emerged in the Soviet Union as an offshoot of the Constructivist movement. The Productivists devoted their talents to designing a better environment for human beings.

VLADIMIR TATLIN One of the most gifted leaders of the Productivism movement was VLADIMIR TATLIN (1885–1953). The revolution was the signal to Tatlin and other avant-garde artists in Russia that the hated old order was about to end. In utopian fashion, these artists aspired to play a significant role in creating a new world, one that would fully use the power of industrialization to benefit all the people. Initially, like Malevich (FIG. **24-54**) and Gabo (FIG. **24-55**), Tatlin believed that nonobjective art was ideal for the new society, free as such art was from any past symbolism. But after the 1917 revolution, Tatlin enthusiastically abandoned abstract art for "functional art" by designing products such as an efficient stove and a set of worker's clothing.

Tatlin's most famous work is his design for *Monument to the Third International* (FIG. **24-70**), commissioned by the Department of Artistic Work of the People's Commissariat for Enlightenment early in 1919 to honor the Russian Revolution. He envisioned a huge glass-and-iron building that—at 1,300 feet—would have been one-third taller than the Eiffel Tower (FIG. **23-1**). Widely influential, "Tatlin's Tower," as it became known, served as a model for those seeking to encourage socially committed and functional art. On its

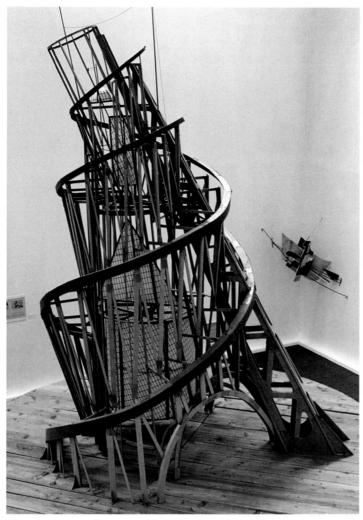

24-70 VLADIMIR TATLIN, Monument to the Third International, 1919–1920. Reconstruction of the lost model, 1992–1993. Kunsthalle, Düsseldorf.

"Tatlin's Tower" was an ambitious avant-garde design for a Soviet governmental building with three geometrically shaped chambers rotating at different speeds within a dynamically tilted spiral cage.

proposed site in the center of Moscow, it would have functioned as a propaganda and news center for the Soviet people. Within a dynamically tilted spiral cage, three geometrically shaped chambers were to rotate around a central axis, each chamber housing facilities for a different type of governmental activity and rotating at a different speed. The one at the bottom, a huge cylindrical glass structure for lectures and meetings, was to revolve once a year. Higher up was a coneshaped chamber intended for administrative functions and monthly rotations. At the top, a cubic information center would have revolved daily, issuing news bulletins and proclamations via the most modern means of communication. These included an open-air news screen (illuminated at night) and a special instrument designed to project words on the clouds on any overcast day. The decreasing size of the chambers as visitors ascended the monument paralleled the decisionmaking hierarchy in the political system, with the most authoritative, smallest groups near the building's apex. The design thus served as a visual reinforcement of a social and political reality.

Tatlin envisioned the whole complex as a dynamic communications center perfectly suited to the exhilarating pace of the new age. In addition, the design's reductive geometry demonstrates the architect's connection to the artistic programs of the Suprematists and the Constructivists. Due to Russia's desperate economic situation during these years, however, Tatlin's ambitious design never materialized as a building. It existed only in metal and wood models exhibited on various official occasions before disappearing. The only records of the models are a few drawings, photographs, and recent reconstructions (FIG. 24-70).

GERRIT RIETVELD Some European architects explored the ideas Mondrian and De Stijl artists advanced. One of the masterpieces of De Stijl architecture is the Schröder House (FIG. **24-71**) in Utrecht, built in 1924 by Gerrit Thomas Rietveld (1888–1964). Rietveld came to the group as a cabinetmaker and made De Stijl furnishings throughout his career. His architecture carries the same spirit into a larger integrated whole and perfectly expresses Theo van Doesburg's definition of De Stijl architecture:

The new architecture is anti-cubic, i.e., it does not strive to contain the different functional space cells in a single closed cube, but it throws the functional space (as well as canopy planes, balcony volumes, etc.) out from the centre of the cube, so that height, width, and depth plus time become a completely new plastic expression in open spaces. . . . The plastic architect . . . has to construct in the new field, time-space. ⁵⁶

The main living rooms of the Schröder House are on the second floor, with more private rooms on the ground floor. However, Rietveld's house has an open plan and a relationship to nature more like the houses of his contemporary, the American architect Frank Lloyd Wright (FIGS. 24-77 and FIG. 24-79). Rietveld designed the entire second floor with sliding partitions that can be closed to define separate rooms or pushed back to create one open space broken into units only by the furniture arrangement. This shifting quality appears also on the outside, where railings, free-floating walls, and long rectangular windows give the effect of cubic units breaking up before the viewer's eyes. Rietveld's design clearly links all the arts. Rectangular planes seem to slide across each other on the Schröder House facade like movable panels, making this structure a kind of three-dimensional projection of the rigid but carefully proportioned flat color rectangles in Mondrian's paintings (FIG. 24-56).

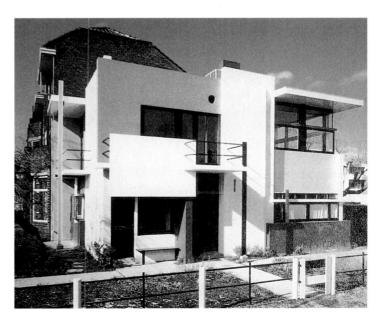

24-71 GERRIT THOMAS RIETVELD, Schröder House, Utrecht, the Netherlands, 1924.

The De Stijl Schröder House has an open plan and an exterior that is a kind of three-dimensional projection of the carefully proportioned flat color rectangles in Mondrian's paintings (FIG. 24-56).

WALTER GROPIUS De Stijl architects not only developed an appealing simplified geometric style but also promoted the notion that art should be thoroughly incorporated into living environments. As Mondrian had insisted, "[A]rt and life are one; art and life are both expressions of truth."57 In Germany, Walter Gropius (1883–1969) developed a particular vision of "total architecture." He made this concept the foundation of not only his own work but also the work of generations of pupils under his influence at a school called the Bauhaus. In 1919, Gropius became the director of the Weimar School of Arts and Crafts in Germany, founded in 1906. Under Gropius, the school assumed a new name—Das Staatliche Bauhaus (roughly translated as "State School of Building"). Gropius's goal was to train artists, architects, and designers to accept and anticipate 20th-century needs. He developed an extensive curriculum based on certain principles. First, Gropius staunchly advocated the importance of strong basic design (including principles of composition, two- and three-dimensionality, and color theory) and craftsmanship as fundamental to good art and architecture. He declared: "Architects, sculptors, painters, we must all go back to the crafts. . . . There is no essential difference between the artist and the craftsman."58 To achieve this integration of art and craft, both a technical instructor and a "teacher of form"—an artist—taught in each department. Among the teachers Gropius hired were Vassily Kandinsky (FIG. 24-7) and Paul Klee (FIG. 24-53).

Second, Gropius promoted the unity of art, architecture, and design. "Architects, painters, and sculptors," he insisted, "must recognize anew the composite character of a building as an entity." To encourage the elimination of boundaries that traditionally separated art from architecture and art from craft, the Bauhaus offered courses in a wide range of artistic disciplines. These included weaving, pottery, bookbinding, carpentry, metalwork, stained glass, mural painting, stage design, and advertising and typography, in addition to painting, sculpture, and architecture.

Third, because Gropius wanted the Bauhaus to produce graduates who could design progressive environments that satisfied 20th-century needs, he emphasized thorough knowledge of machine-age technologies and materials. He felt that to produce truly successful designs, the artist-architect-craftsperson had to understand industry and mass production. Ultimately, Gropius hoped for a marriage between art and industry—a synthesis of design and production.

Like the De Stijl movement, the Bauhaus philosophy had its roots in utopian principles. Gropius's declaration reveals the idealism of the

entire Bauhaus enterprise: "Together let us conceive and create the new building of the future, which will embrace architecture and sculpture and painting in one unity and which will rise one day toward heaven from the hands of a million workers like a crystal symbol of a new faith." In its reference to a unity of workers, this statement also reveals the undercurrent of socialism present in Germany at the time.

24-72 Walter Gropius, Shop Block, the Bauhaus, Dessau, Germany, 1925–1926.

Gropius constructed this Bauhaus building by sheathing a reinforced concrete skeleton in glass. The design followed his dictum that architecture should avoid "all romantic embellishment and whimsy." **BAUHAUS IN DESSAU** After encountering increasing hostility from a new government elected in 1924, the Bauhaus moved north to Dessau in early 1925. By this time, the Bauhaus program had matured. In a statement, Walter Gropius listed the school's goals more clearly:

- A decidedly positive attitude to the living environment of vehicles and machines.
- The organic shaping of things in accordance with their own current laws, avoiding all romantic embellishment and whimsy.
- Restriction of basic forms and colors to what is typical and universally intelligible.
- Simplicity in complexity, economy in the use of space, materials, time, and money.⁶¹

The building Gropius designed for the Bauhaus at Dessau visibly expressed these goals. It is, in fact, the Bauhaus's architectural manifesto. The Dessau Bauhaus consisted of workshop and class areas, a dining room, a theater, a gymnasium, a wing with studio apartments, and an enclosed two-story bridge housing administrative offices. Of the major wings, the most dramatic was the Shop Block (FIG. 24-72). Three stories tall, the Shop Block housed a printing shop and dye works facility, in addition to other work areas. The builders constructed the skeleton of reinforced concrete but set these supports well back, sheathing the entire structure in glass to create a streamlined and light effect. This design's simplicity followed Gropius's dictum that architecture should avoid "all romantic embellishment and whimsy." Further, he realized his principle of "economy in the use of space" in his interior layout of the Shop Block, which consisted of large areas of free-flowing undivided space. Gropius believed this kind of spatial organization encouraged interaction and the sharing of ideas.

MARCEL BREUER The interior decor of this Dessau building also reveals the comprehensiveness of the Bauhaus program. Because carpentry, furniture design, and weaving were all part of the Bauhaus curriculum, Gropius gave students and teachers the task of designing furniture and light fixtures for the building. One of the memorable furniture designs that emerged from the Bauhaus was the tubular steel "Wassily chair" (FIG. 24-73) crafted by Hungarian MARCEL BREUER (1902–1981) and named in honor of Bauhaus instructor Vassily

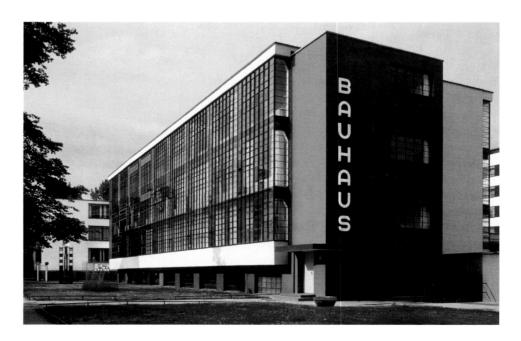

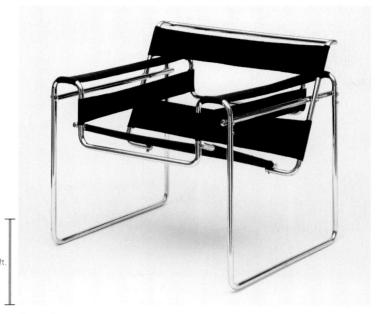

24-73 Marcel Breuer, Wassily chair, 1925. Chrome-plated tubular steel and canvas, $2' \frac{1}{4}'' \times 2' \frac{6^{3}}{4}'' \times 2' \frac{4''}{4}$. Museum of Modern Art, New York (gift of Herbert Bayer).

The Bauhaus advocated a comprehensive approach to architecture, which included furniture design. Breuer's chair has a simple geometric look in keeping with Bauhaus aesthetics.

(sometimes spelled Wassily) Kandinsky. Breuer supposedly got the inspiration to use tubular steel while riding his bicycle and admiring the handlebars. In keeping with Bauhaus aesthetics, his chairs have a simplified, geometric look, and the leather or cloth supports add to the furniture's comfort and functionality. These chairs could also easily be mass produced and thus epitomize the goals of the Bauhaus.

LUDWIG MIES VAN DER ROHE In 1928, Gropius left the Bauhaus, and Ludwig Mies van der Rohe (1886-1969) eventually took over the directorship, moving the school to Berlin. Taking as his motto "less is more" and calling his architecture "skin and bones," the new Bauhaus director had already fully formed his aesthetic when he conceived the model (FIG. 24-74) for a glass skyscraper building in 1921. In the glass model, which was on display at the first Bauhaus exhibition in 1923, three irregularly shaped towers flow outward from a central court designed to hold a lobby, a porter's room, and a community center. Two cylindrical entrance shafts rise at the ends of the court, each containing elevators, stairways, and toilets. Wholly transparent, the perimeter walls reveal the regular horizontal patterning of the cantilevered floor planes and their thin vertical supporting elements. The bold use of glass sheathing and inset supports was, at the time, technically and aesthetically adventurous. The weblike delicacy of the lines of the model, as well as the illusion of movement created by reflection and by light changes seen through the glass, appealed to many other architects. A few years later, Gropius pursued these principles in his design for the Bauhaus building (FIG. 24-72) in Dessau. The glass-and-steel skyscrapers found in major cities throughout the world today are the enduring legacy of Mies van der Rohe's design.

END OF THE BAUHAUS One of Hitler's first acts after coming to power was to close the Bauhaus in 1933. During its 14-year existence, the beleaguered school graduated fewer than 500 students, yet it achieved legendary status. Its phenomenal impact extended beyond painting, sculpture, and architecture to interior design, graphic design, and advertising. Moreover, art schools everywhere began to structure their curricula in line with the program the

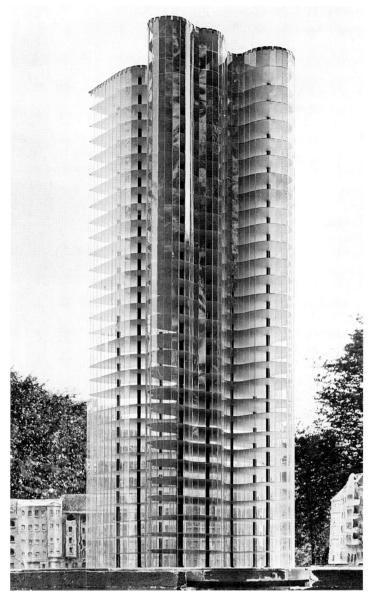

24-74 Ludwig Mies van der Rohe, model for a glass skyscraper, Berlin, Germany, 1922 (no longer extant).

In this technically and aesthetically adventurous design, the architect whose motto was "less is more" proposed a transparent building that revealed its cantilevered floor planes and thin supports.

Bauhaus pioneered. The numerous Bauhaus instructors who fled Nazi Germany disseminated the school's philosophy and aesthetic. Many Bauhaus members came to the United States. Gropius and Breuer ended up at Harvard University. Mies van der Rohe moved to Chicago and taught there.

LE CORBUSIER The simple geometric aesthetic that Gropius and Mies van der Rohe developed became known as the *International Style* because of its widespread popularity. The first and purest adherent of this style was the Swiss architect Charles-Edouard Jeanneret, who adopted his maternal grandfather's name—Le Corbusier (1887–1965). Trained in Paris and Berlin, he was also a painter, but Le Corbusier wielded greater influence as an architect and theorist on modern architecture. As such, he applied himself to designing a functional living space, which he described as a "machine for living." 62

Le Corbusier maintained that the basic physical and psychological needs of every human being were sun, space, and vegetation combined with controlled temperature, good ventilation, and insulation

24-75 Le Corbusier, Villa Savoye, Poissy-sur-Seine, France, 1929.

Steel and ferroconcrete made it possible for Le Corbusier to invert the traditional practice of placing light architectural elements above heavy ones and to eliminate weight-bearing walls on the ground story.

against harmful and undesirable noise. He also advocated basing dwelling designs on human scale, because the house is humankind's assertion within nature. All these qualities characterize Le Corbusier's Villa Savoye (FIG. 24-75), located at Poissy-sur-Seine near Paris. This country house sits conspicuously within its site, tending to dominate it, and has a broad view of the land-scape. Several colors appear on the exterior—originally, a dark-green base, cream walls, and a

rose-and-blue windscreen on top. They were a deliberate analogy for the colors in the contemporary machine-inspired Purist style of painting (FIG. 24-22) Le Corbusier practiced.

A cube of lightly enclosed and deeply penetrated space, the Villa Savoye has an only partially confined ground floor (containing a threecar garage, bedrooms, a bathroom, and utility rooms). Much of the house's interior is open space, with the thin columns supporting the main living floor and the roof garden area. The major living rooms in the Villa Savoye are on the second floor, wrapping around an open central court. Strip windows that run along the membranelike exterior walls provide illumination to the rooms. From the second-floor court, a ramp leads up to a flat roof-terrace and garden protected by a curving windbreak along one side. The Villa Savoye has no traditional facade. The ostensible approach to the house does not define an entrance. People must walk around and through the house to comprehend its layout. Spaces and masses interpenetrate so fluidly that inside and outside space intermingle. The machine-planed smoothness of the unadorned surfaces, the slender ribbons of continuous windows, and the buoyant lightness of the whole fabric—all combine to reverse the effect of traditional country houses (FIG. 17-29). By placing heavy elements above and light ones below, and by refusing to enclose the ground story of the Villa Savoye with masonry walls, Le Corbusier inverted traditional design practice. This openness, made possible by the use of steel and ferroconcrete as construction materials, makes the Villa Savoye's heavy upper stories appear to hover lightly on the slender column supports.

The Villa Savoye was a marvelous house for a single family, but like De Stijl architects, Le Corbusier dreamed of extending his ideas of the house as a "machine for living" to designs for efficient and humane cities. He saw great cities as spiritual workshops, and he proposed to correct the deficiencies in existing cities caused by poor traffic circulation, inadequate living units, and the lack of space for recreation and exercise. Le Corbusier suggested replacing traditional cities with three types of new communities. Vertical cities would house workers and the business and service industries. Linear-industrial cities would run as belts along the routes between the vertical cities and would serve as centers for the people and processes involved in manufacturing. Finally, separate centers would be constructed for people involved in intensive agricultural activity. Le Corbusier's cities would provide for human cultural needs in addition to serving every person's physical, mental, and emotional comfort needs.

Later in his career, Le Corbusier designed a few vertical cities, most notably the Unité d'Habitation in Marseilles (1945–1952). He also created the master plan for the entire city of Chandigarh, the

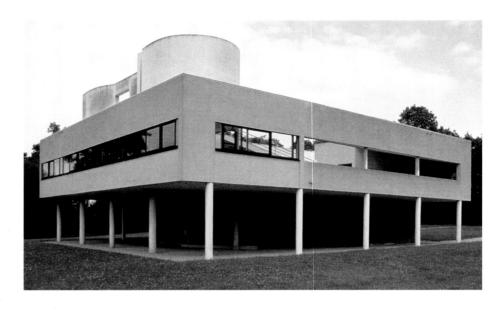

capital city of Punjab, India (1950–1957). He ended his career with a personal expressive style in his design of the Chapel of Notre Dame du Haut (FIGS. **25-56** and **25-57**) at Ronchamp.

America

America also embraced the new European architecture, particularly the Bauhaus style, which rejected ornament of any kind. But other styles also won wide followings, some of which were reactions against the severity of Bauhaus design.

ART DECO According to Bauhaus principles, pure form emerged from functional structure and required no decoration. Yet popular taste still favored ornamentation, especially in public architecture. A movement in the 1920s and 1930s sought to upgrade industrial design as a "fine art." Proponents wanted to work new materials into decorative patterns that could be either machined or handcrafted and that could, to a degree, reflect the simplifying trend in architecture. A remote descendant of Art Nouveau, this movement became known as Art Deco, which acquired its name at the Exposition des Arts Décoratifs et Industriels Modernes (Exposition of Modern Decorative and Industrial Arts), held in Paris in 1925. Art Deco had universal application—to buildings, interiors, furniture, utensils, jewelry, fashions, illustration, and commercial products of every sort. Art Deco products have a "streamlined," elongated symmetrical aspect. Simple flat shapes alternate with shallow volumes in hard patterns. The concept of streamlining predominated in industrial-design circles in the 1930s and involved the use of organic, tapered shapes and forms. Derived from nature, these simple forms are inherently aerodynamic, making them technologically efficient (because of their reduced resistance as they move through air or water) as well as aesthetically pleasing. Designers adopted streamlined shapes for trains and cars, and the popular appeal of these designs led to their use in an array of objects, from machines to consumer products.

Art Deco's exemplary masterpiece is the stainless-steel spire of the Chrysler Building (FIG. **24-76**) in New York City, designed by WILLIAM VAN ALEN (1882–1954). The building and spire are monuments to the fabulous 1920s, when American millionaires and corporations competed with one another to raise the tallest skyscrapers in the biggest cities. Built up of diminishing fan shapes, the spire glitters triumphantly in the sky, a resplendent crown honoring the business achievements of the great auto manufacturer. As a temple of commerce, the Chrysler Building celebrated the principles and success of American business before the onset of the Great Depression.

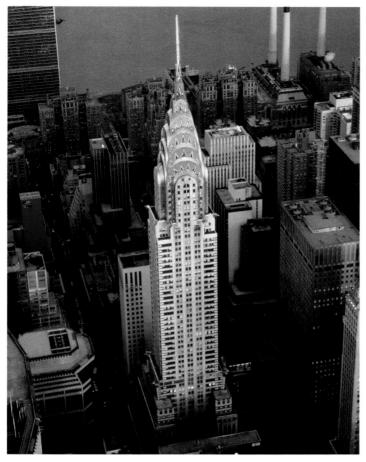

24-76 WILLIAM VAN ALEN, Chrysler Building, New York, New York, 1928–1930.

The Chrysler Building's stainless steel spire epitomizes Art Deco architecture. The skyscraper's glittering crown of diminishing fan shapes has a streamlined form that was popular during the 1920s.

FRANK LLOYD WRIGHT One of the most striking personalities in the development of early-20th-century architecture was Frank Lloyd Wright (1867–1959). Born in Wisconsin, Wright moved to Chicago, where he eventually joined the firm headed by Louis Sullivan (Figs. 23-40 and 23-41). Wright set out to create an "architecture of democracy." Always a believer in architecture as "natural" and "organic," Wright saw it as serving free individuals who have the right to move within a "free" space, envisioned as a nonsymmetrical design interacting spatially with its natural surroundings. He sought to develop an organic unity of planning, structure, materials, and site. Wright identified the principle of continuity as fundamental to understanding his view of organic unity:

Classic architecture was all fixation.... Now why not let walls, ceilings, floors become seen as component parts of each other? ... You may see the appearance in the surface of your hand contrasted with the articulation of the bony structure itself. This ideal, profound in its architectural implications ... I called ... continuity. 64

Wright manifested his vigorous originality early, and by 1900 he had arrived at a style entirely his own. In his work during the first decade of the 20th century, his cross-axial plan and his fabric of continuous roof planes and screens defined a new domestic architecture.

ROBIE HOUSE Wright fully expressed these elements and concepts in the Robie House (FIG. 24-77), built between 1907 and 1909. Like other buildings in the Chicago area he designed at about the same time, he called this home a "prairie house." Wright conceived the long, sweeping, ground-hugging lines, unconfined by abrupt wall limits, as reaching out toward and capturing the expansiveness of the Midwest's great flatlands. Abandoning all symmetry, the architect eliminated a facade, extended the roofs far beyond the walls, and all but concealed the entrance. Wright filled the house's "wandering" plan (FIG. 24-78) with intricately joined spaces (some large and open, others closed), grouped freely around a great central

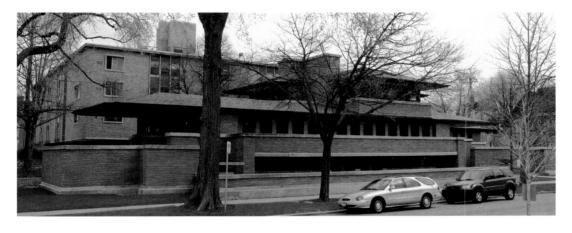

24-77 Frank Lloyd Wright, Robie House, Chicago, Illinois, 1907–1909.

The Robie House is an example of Wright's "architecture of democracy," in which free individuals move within a "free" space— a nonsymmetrical design interacting spatially with its natural surroundings.

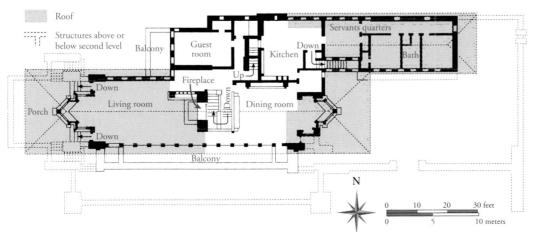

24-78 Frank Lloyd Wright, plan of the second (main) level of the Robie House, Chicago, Illinois, 1907–1909.

Typical of Wright's "prairie houses," the Robie House has a bold "wandering" asymmetrical plan with intricately joined open and closed spaces grouped freely around a great central fireplace.

24-79 Frank Lloyd Wright, Kaufmann House (Fallingwater), Bear Run, Pennsylvania, 1936–1939.

Perched on a rocky hillside over a waterfall, Wright's Fallingwater has long sweeping lines, unconfined by abrupt wall limits, reaching out and capturing the expansiveness of the natural environment.

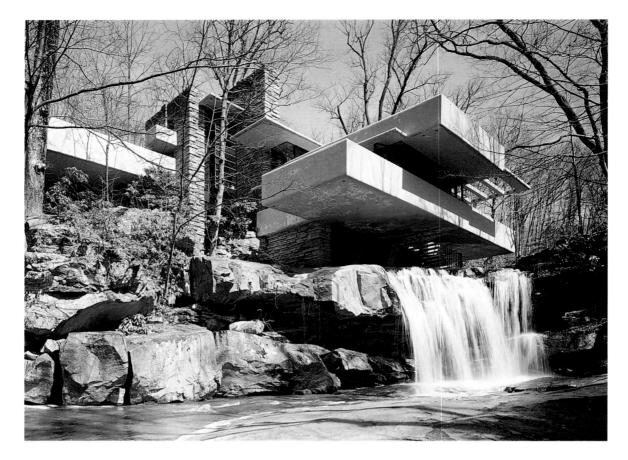

fireplace. (He believed strongly in the hearth's age-old domestic significance.) Wright designed enclosed patios, overhanging roofs, and strip windows to provide unexpected light sources and glimpses of the outdoors as the inhabitants moved through the interior space. These elements, together with the open ground plan, created a sense of space in motion, inside and out. Wright matched his new and fundamental interior spatial arrangement in his exterior treatment. The flow of interior space determined the sharp angular placement of exterior walls.

FALLINGWATER The Robie House is an example of Wright's "naturalism"—his adjustment of a building to its site. In this particular case, however, the confines of the city lot constrained the building-to-site relationship more than did the sites of some of Wright's more expansive suburban and country homes. The Kaufmann House, nicknamed "Fallingwater" (FIG. 24-79) and designed as a weekend retreat at Bear Run, Pennsylvania, for Pittsburgh department store magnate Edgar Kaufmann Sr., is a prime example of the latter. Perched on a rocky hillside over a small waterfall, this structure, which has become an icon of modernist architectural design, extends the Robie House's blocky masses in all four directions. Ever since the completion of this residence, architects and the public alike have marveled at the fluid interplay between interior and exterior. In designing Fallingwater, Wright, in keeping with his commitment to an "architecture of democracy," sought to incorporate the structure more fully into the site, thereby ensuring a fluid, dynamic exchange between the interior of the house and the natural environment outside. Rather than build the house overlooking or next to the waterfall, Wright decided to build it over the waterfall, because he believed the inhabitants would become desensitized to the waterfall's presence and power if they merely overlooked it. To take advantage of the location, Wright designed a series of terraces that extend on three levels from a central core structure. The contrast in textures between concrete, painted metal, and natural stones in the house's terraces and walls enlivens its shapes, as does Wright's use of full-length strip windows to create a stunning interweaving of interior and exterior space.

The implied message of Wright's new architecture was space, not mass—a space designed to fit the patron's life and enclosed and divided as required. Wright took special pains to meet his clients' requirements, often designing all the accessories of a house (including, in at least one case, gowns for his client's wife). In the late 1930s, he acted on a cherished dream to provide good architectural design for less prosperous people by adapting the ideas of his prairie house to plans for smaller, less-expensive dwellings. These residences, known as Usonian houses, became templates for suburban housing developments in the post–World War II housing boom.

The publication of Wright's plans brought him a measure of fame in Europe, especially in Holland and Germany. The issuance in Berlin in 1910 of a portfolio of his work and an exhibition of his designs the following year stimulated younger architects to adopt some of his ideas about open plans that afforded clients freedom. Some 40 years before his career ended, his work was already of revolutionary significance. Mies van der Rohe wrote in 1940 that the "dynamic impulse from [Wright's] work invigorated a whole generation. His influence was strongly felt even when it was not actually visible."

Frank Lloyd Wright's influence in Europe was exceptional, however, for any American artist before World War II. But in the decades following that global conflict, American painters, sculptors, and architects often took the lead in establishing new styles that artists elsewhere quickly emulated. This new preeminence of America in the arts is the subject of Chapter 25.

EUROPE AND AMERICA, 1900 TO 1945

EUROPE, 1900 to 1920

- During the early 20th century, avant-garde artists searched for new definitions of art in a changed world. Matisse and the Fauves used bold colors as the primary means of conveying feeling. German Expressionist paintings feature clashing colors, disquieting figures, and perspectival distortions.
- Pablo Picasso and Georges Braque radically challenged prevailing artistic conventions with Cubism, in which artists dissect forms and place them in interaction with the space around them.
- The Futurists focused on motion in time and space in their effort to create paintings and sculptures that captured the dynamic quality of modern life. The Dadaists celebrated the spontaneous and intuitive, often incorporating found objects in their artworks.

Picasso, Les Demoiselles d'Avignon,

AMERICA, 1900 to 1930

- The Armory Show of 1913 introduced avant-garde European art to American artists. Man Ray, for example, embraced Dada's fondness for chance and the displacement of ordinary items, and Stuart Davis adopted the Cubist interest in fragmented form.
- The Harlem Renaissance brought African American artists to the forefront, including Aaron Douglas, whose paintings drew on Cubist principles. Charles Demuth, Georgia O'Keeffe, and the Precisionists used European modernist techniques to celebrate contemporary American subjects.
- Photography emerged as an important American art form in the work of Alfred Stieglitz, who emphasized the careful arrangement of forms and patterns of light and dark. Edward Weston experimented with photographs of segments of the human body that verge on abstraction.

Weston, Nude, 1925

EUROPE, 1920 to 1945

- World War I gave rise to the Neue Sachlichkeit movement in Germany. "New Objectivity" artists depicted the horrors of war and explored the themes of death and transfiguration.
- The Surrealists investigated ways to express in art the world of dreams and the unconscious. Natural Surrealists aimed for "concrete irrationality" in their naturalistic paintings of dreamlike scenes.Biomorphic Surrealists experimented with automatism and employed abstract imagery.
- Many European modernists pursued utopian ideals. The Suprematists developed an abstract style to express pure feeling. The Constructivists used nonobjective forms to suggest the nature of spacetime. De Stijl artists employed simple geometric forms in their search for "pure plastic art."
- Sculptors, including Hepworth and Moore, also increasingly turned to abstraction and emphasized voids as well as masses in their work. Brancusi captured the essence of flight in *Bird in Space*, a glistening abstract sculpture that does not mimic the form of a bird.

Brancusi, Bird in Space, 1924

AMERICA, 1930 to 1945

- Although Calder created abstract works between the wars, other American artists favored figural art. Lange and Shahn chronicled social injustice. Hopper explored the loneliness of the Depression era. Lawrence recorded the struggle of African Americans. Wood depicted life in rural lowa.
- Mexican artists Orozco and Rivera painted epic mural cycles of the history of Mexico. Kahlo's powerful and frequently autobiographical paintings explored the human psyche.

Kahlo, The Two Fridas, 1939

ARCHITECTURE

- Under Walter Gropius, the Bauhaus in Germany promoted the vision of "total architecture," which called for the integration of all the arts in constructing modern living environments. Bauhaus buildings were simple glass and steel designs devoid of "romantic embellishment and whimsy."
- In France, Le Corbusier used modern construction materials in his "machines for living"—simple houses with open plans and unadorned surfaces.
- The leading American architect of the first half of the 20th century was Frank Lloyd Wright, who promoted the "architecture of democracy," in which free individuals move in a "free" space.
 Fallingwater is a bold asymmetrical design integrating the building with the natural environment.

Wright, Fallingwater, 1936-1939

25-1 Matthew Barney, Cremaster cycle, installation at the Solomon R. Guggenheim Museum, New York, 2003.

Barney's vast multimedia installations of drawings, photographs, sculptures, and videos typify the relaxation at the opening of the 21st century of the traditional boundaries among artistic media.

EUROPE AND AMERICA AFTER 1945

World War II, with the global devastation it unleashed on all dimensions of life—psychological, political, physical, and economic—set the stage for the second half of the 20th century. The dropping of atomic bombs by the United States on the Japanese cities of Hiroshima and Nagasaki in 1945 signaled a turning point not only in the war but in the geopolitical balance and the nature of international conflict as well. For the rest of the century, nuclear war became a very real threat. Indeed, the two nuclear superpowers, the United States and the Soviet Union, divided the post–World War II world into spheres of influence, and each regularly intervened politically, economically, and militarily wherever and whenever it considered its interests to be at stake.

Persistent conflict throughout the world in the later 20th century resulted in widespread disruption and dislocation. In 1947 the British left India, dividing the subcontinent into the new, still hostile nations of India and Pakistan. After a catastrophic war, Communists came to power in China in 1949. North Korea invaded South Korea in 1950 and fought a grim war with the United States and its allies that ended in 1953. The Soviet Union brutally suppressed uprisings in its subject nations—East Germany, Poland, Hungary, and Czechoslovakia. The United States intervened in disputes in Central and South America. Almost as soon as many previously colonized nations of Africa-Kenya, Uganda, Nigeria, Angola, Mozambique, the Sudan, Rwanda, and the Congo—won their independence, civil wars devastated them. In Indonesia civil conflict left more than 100,000 dead. Algeria expelled France in 1962 after the French waged a prolonged, vicious war with Algeria's Muslim natives. After 15 years of bitter war in Southeast Asia, the United States suffered defeat in Vietnam. From 1979 to 1989 the Soviets unsuccessfully tried to occupy Afghanistan. Arab nations fought wars with Israel in 1967, 1973, and the early 1980s. The Palestinian conflict remains the subject of almost daily newspaper headlines. A revitalized Islam, which inspired a fundamentalist religious revolution in Iran, has encouraged "holy war" with the West, using a new weapon, international terrorism-most dramatically in the attacks on New York City and Washington, D.C., on September 11, 2001. In response, the United States and allied Western nations launched invasions of Afghanistan and Iraq. Conflict and unrest continue to plague large areas of the globe today.

Upheaval has also characterized the cultural sphere in the decades since the end of World War II. In the United States, for example, various groups forcefully questioned the status quo. During the 1960s and 1970s, the struggle for civil rights for African Americans, for free speech on university campuses, and for disengagement from the Vietnam War led to a rebellion of the young, who took to the streets in often raucous demonstrations, with violent repercussions. The prolonged ferment produced a new system of values, a "youth culture," expressed in the radical rejection not only of national policies but often also of the society generating them. Young Americans derided their elders' lifestyles and adopted unconventional dress, manners, habits, and morals deliberately subversive of mainstream social standards. The youth era witnessed the sexual revolution, the widespread use and abuse of drugs, and the development of rock music, then an exclusively youthful art form. Young people "dropped out" of regulated society, embraced alternative belief systems, and rejected Western university curricula as irrelevant.

This counterculture had considerable societal impact and widespread influence beyond its political phase. The civil rights movement of the 1960s and later the women's liberation movement of the 1970s reflected the spirit of rebellion, coupled with the rejection of racism and sexism. In keeping with the growing resistance to established authority, women systematically began to challenge the maledominated culture, which they perceived as having limited their political power and economic opportunities for centuries. Feminists charged that the institutions of Western society, particularly the nuclear family headed by the patriarch, perpetuated male power and subordination of women. They further contended that monuments of Western culture—its arts and sciences as well as its political, social, and economic institutions—masked the realities of male power.

The central issue that fueled these rebellions and changes from international political conflicts to the rise of feminism—was power. Increasingly, individuals and groups sought not just to uncover the dynamics of power, but to combat actively the inappropriate exercise of power or change the balance of power. For example, following patterns developed first in the civil rights movement and later in feminism, various ethnic groups and gays and lesbians all mounted challenges to discriminatory policies and attitudes. These groups fought for recognition, respect, and legal protection and battled discrimination with political action. In addition, the growing scrutiny in numerous academic fields—cultural studies, literary theory, and colonial and postcolonial studies—of the dynamics and exercise of power also contributed to the dialogue on these issues. As a result of this concern for the dynamics of power, identity (both individual and group) has emerged as a potent arena for discussion and action. Explorations into the politics of identity now aim to increase personal and public understanding of how self-identifications, along with imposed or inherited identities, affect lives.

As has been true since human beings first began to make sculptures and paintings and erect buildings, European and American art and architecture since 1945 have reflected the changing cultural world in which artists and architects live and work.

PAINTING AND SCULPTURE, 1945 TO 1970

The end of World War II in 1945 left devastated cities, ruptured economies, and governments in chaos throughout Europe. These factors, coupled with the massive loss of life and the indelible horror of the Holocaust and of Hiroshima and Nagasaki, resulted in a pervasive sense of despair, disillusionment, and skepticism. Although

many groups (for example, the Futurists in Italy; see Chapter 24) had tried to find redemptive value in World War I, it was virtually impossible to do the same with World War II, coming as it did so soon after the war that was supposed to "end all wars." Additionally, World War I was largely a European conflict that left roughly 10 million people dead, whereas World War II was a truly global catastrophe that claimed 35 million lives.

Postwar Expressionism in Europe

The cynicism that emerged across Europe in the 1940s found voice in existentialism, a philosophy asserting the absurdity of human existence and the impossibility of achieving certitude. As existentialism gained widespread popularity, many adherents also promoted atheism and questioned the possibility of situating God within a systematic philosophy. Most scholars trace the roots of existentialism to the Danish theologian Søren Kierkegaard (1813–1855), but in the postwar period, the writings of French author Jean-Paul Sartre (1905–1980) most clearly captured the existentialist spirit. According to Sartre, if God does not exist, then individuals must constantly struggle in isolation with the anguish of making decisions in a world without absolutes or traditional values. This spirit of pessimism and despair emerged frequently in European art of the immediate postwar period.

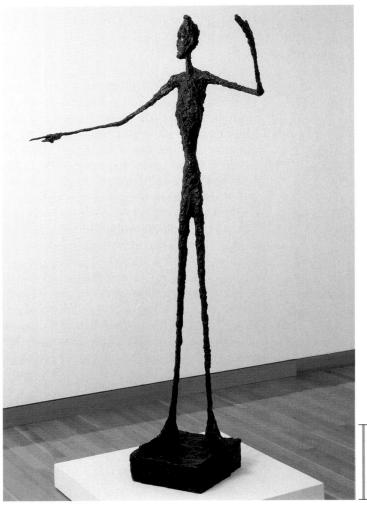

25-2 Alberto Giacometti, *Man Pointing* (no. 5 of 6), 1947. Bronze, $5' 10'' \times 3' 1'' \times 1' 5\frac{5}{8}''$. Des Moines Art Center, Des Moines (Nathan Emory Coffin Collection).

The writer Jean-Paul Sartre considered Giacometti's thin and virtually featureless sculpted figures as the epitome of existentialist humanity—alienated, solitary, and lost in the world's immensity.

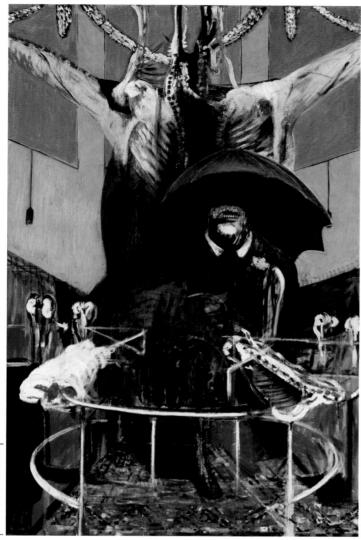

25-3 Francis Bacon, *Painting*, 1946. Oil and pastel on linen, 6' $5\frac{7}{8}$ " \times 4' 4". Museum of Modern Art, New York.

Painted in the aftermath of World War II, this intentionally revolting image of a powerful figure presiding over a slaughter is Bacon's indictment of humanity and a reflection of war's butchery.

A brutality or roughness appropriately expressing both the artist's state of mind and the larger cultural sensibility characterized the work of many European sculptors and painters.

ALBERTO GIACOMETTI The sculpture of Swiss artist Alberto Giacometti (1901–1966) perhaps best expresses the spirit of existentialism. Although Giacometti never claimed he pursued existentialist ideas in his art, his works capture the essence of that philosophy. Indeed, Sartre, Giacometti's friend, saw the artist's figural sculptures as the epitome of existentialist humanity—alienated, solitary, and lost in the world's immensity. Giacometti's sculptures of the 1940s, such as *Man Pointing* (Fig. 25-2), are thin, virtually featureless figures with rough, agitated surfaces. Rather than conveying the solidity and mass of conventional bronze sculpture, these severely attenuated figures seem swallowed up by the space surrounding them, imparting a sense of isolation and fragility. Giacometti's sculptures are evocative and moving, speaking to the pervasive despair in the aftermath of world war.

FRANCIS BACON Created in the year after World War II ended, Painting (FIG. 25-3) by British artist Francis Bacon (1910–1992) is an indictment of humanity and a reflection of war's butchery. The painting is a compelling and revolting image of a powerful, stocky man with a gaping mouth and a vivid red stain on his upper lip, as if he were a carnivore devouring the raw meat sitting on the railing surrounding him. Bacon may have based his depiction of this central figure on news photos of similarly dressed European and American officials. The umbrella in particular recalls images of Neville Chamberlain (1869–1940), the wartime British prime minister who frequently appeared in photographs with an umbrella. Bacon added to the visceral impact of the painting by depicting the flayed carcass hanging behind the central figure as if it were a crucified human form. Although the specific sources for the imagery in Painting may not be entirely clear, the work is unmistakably "an attempt to remake the violence of reality itself," as Bacon often described his art, based on what he referred to as "the brutality of fact."1

JEAN DUBUFFET Although less specific, the works of French artist Jean Dubuffet (1901–1985) also express a tortured vision of the world through manipulated materials. In works such as *Vie*

Inquiète (Uneasy Life; FIG. 25-4), Dubuffet presented a scene incised into thickly encrusted, parched-looking surfaces. He first built up an impasto (a layer of thickly applied pigment) of plaster, glue, sand, asphalt, and other common materials. Over that he painted or incised crude images of the type produced by children, the insane, and graffiti scrawlers. Scribblings interspersed with the images heighten the impression of smeared and gashed surfaces of crumbling walls and worn pavements marked by random individuals.

Dubuffet expressed a tortured vision of the world through thickly encrusted painted surfaces and crude images of the kind children and the insane produce. He called it "art brut"—untaught and coarse art.

Dubuffet believed the art of children, the mentally unbalanced, prisoners, and outcasts was more direct and genuine because those who created it did so unrestrained by conventional standards of art. He promoted "art brut"—untaught and coarse art.

Abstract Expressionism

In the 1940s, the center of the Western art world shifted from Paris to New York because of the devastation World War II had inflicted across Europe and the resulting influx of émigré artists escaping to the United States. American artists picked up the European avant-garde's energy, which movements such as Cubism and Dada had fostered, but in the postwar years, modernism increasingly became synonymous with a strict *formalism*—an emphasis on an artwork's visual elements rather than its subject. The most important champion of New York formalist painting was the American art critic Clement Greenberg (1909–1994), who wielded considerable influence from the 1940s through the 1970s. Greenberg helped redefine the parameters of modernism by advocating the rejection of illusionism and the exploration of the properties of each artistic medium. So dominant was Greenberg that scholars often refer to the general modernist tenets during this period as Greenbergian formalism.

Although Greenberg modified his complex ideas about art over the years, he consistently expounded certain basic concepts. In particular, he promoted the idea of purity in art. "Purity in art consists in the acceptance, willing acceptance, of the limitations of the medium of the specific art." In other words, Greenberg believed artists should strive for a more explicit focus on the properties exclusive to each

medium—for example, two-dimensionality or flatness in painting, and three-dimensionality in sculpture.

It follows that a modernist work of art must try, in principle, to avoid communication with any order of experience not inherent in the most literally and essentially construed nature of its medium. Among other things, this means renouncing illusion and explicit subject matter. The arts are to achieve concreteness, "purity," by dealing solely with their respective selves—that is, by becoming "abstract" or nonfigurative.³

Abstract Expressionism, the first major American avant-garde movement, emerged in New York in the 1940s. As the name suggests, the artists associated with the New York School of Abstract Expressionism produced paintings that are, for the most part, abstract but express the artist's state of mind with the goal also of striking emotional chords in the viewer. The Abstract Expressionists turned inward to create, and the resulting works convey a rough spontaneity and palpable energy. The New York School painters wanted the viewer to grasp the content of their art intuitively, in a state free from structured thinking. The artist Mark Rothko (FIG. 25-9) eloquently wrote:

We assert man's absolute emotions. We don't need props or legends. We create images whose realities are self evident. Free ourselves from memory, association, nostalgia, legend, myth. Instead of making cathedrals out of Christ, man or life, we make it out of ourselves, out of our own feelings. The image we produce is understood by anyone who looks at it without nostalgic glasses of history.⁴

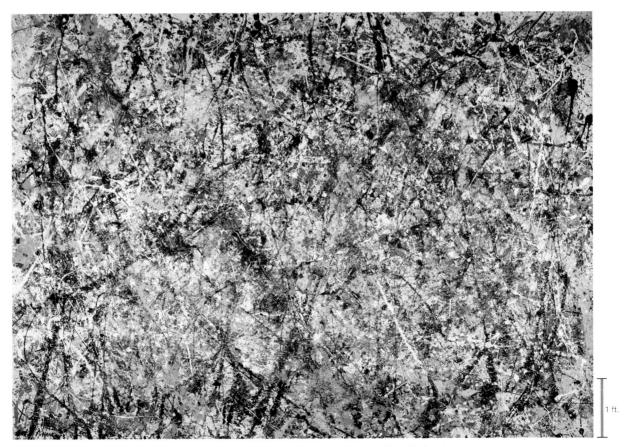

25-5 Jackson Pollock, *Number 1, 1950 (Lavender Mist)*, 1950. Oil, enamel, and aluminum paint on canvas, 7' 3" × 9' 10". National Gallery of Art, Washington, D.C. (Ailsa Mellon Bruce Fund).

Pollock's paintings emphasize the creative process. His mural-size canvases consist of rhythmic drips, splatters, and dribbles of paint that envelop viewers, drawing them into a lacy spider web.

Jackson Pollock on Easel and Mural Painting

n two statements made in 1947, one as part of his application for a Guggenheim Fellowship and one in a published essay, Jackson Pollock explained the motivations for his new kind of "action painting" and described the manner in which he applied pigment to canvas (FIG. 25-6).

I intend to paint large movable pictures which will function between the easel and mural....
I believe the easel picture to be a dying form, and the tendency of modern feeling is towards the wall picture or mural.*

25-6 HANS NAMUTH, Jackson Pollock painting in his studio in Springs, Long Island, New York, 1950. Center for Creative Photography, University of Arizona, Tucson.

"Gestural abstraction" nicely describes Pollock's working technique. Using sticks or brushes, he flung, poured, and dripped paint onto a section of canvas he simply unrolled across his studio floor.

My painting does not come from the easel. I hardly ever stretch my canvas before painting. I prefer to tack the unstretched canvas to the hard wall or the floor. I need the resistance of a hard surface. On the floor I am more at ease. I feel nearer, more a part of the painting, since this way I can walk around it, work from the four sides and literally be *in* the painting. This is akin to the method of the Indian sand painters of the West. I continue to get further away from the usual painter's tools such as easel, palette, brushes, etc. I prefer sticks, trowels, knives and dripping fluid paint or a heavy impasto with sand, broken glass and other foreign matter added. When I am *in* my painting, I'm not aware of what I'm doing. . . . [T]he painting has a life of its own. I try to let it come through. . . . The source of my painting is the unconscious. †

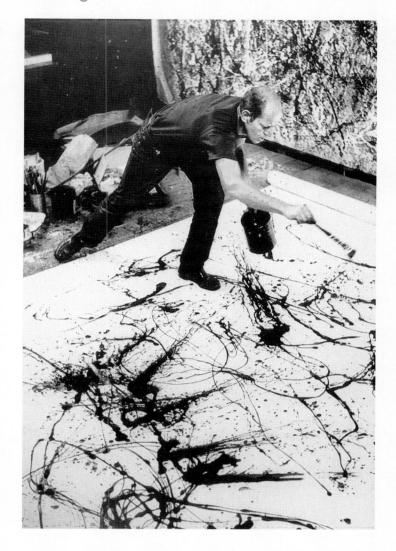

The Abstract Expressionist movement developed along two lines—gestural abstraction and chromatic abstraction. The gestural abstractionists relied on the expressiveness of energetically applied pigment. In contrast, the chromatic abstractionists focused on color's emotional resonance.

JACKSON POLLOCK The artist whose work best exemplifies gestural abstraction is Jackson Pollock (1912–1956), who developed his signature style in the mid-1940s. By 1950, Pollock had refined his technique and was producing large-scale abstract paintings such as *Number 1, 1950 (Lavender Mist;* FIG. 25-5). These works consist of rhythmic drips, splatters, and dribbles of paint. The mural-sized fields of energetic skeins of pigment envelop viewers, drawing them into a lacy spider web. Using sticks or brushes, Pollock flung, poured, and dripped paint (not only traditional oil paints but aluminum paints and household enamels as well) onto a section of canvas he simply unrolled across his studio floor (FIG. 25-6). This working method earned Pollock the derisive nickname "Jack the Dripper."

Responding to the image as it developed, he created art that was both spontaneous and choreographed. Pollock's painting technique highlights a particularly avant-garde aspect of gestural abstraction—its emphasis on the creative process. Indeed, Pollock literally immersed himself in the painting during its creation.

Art historians have linked Pollock's ideas about improvisation in the creative process to his interest in what psychiatrist Carl Jung called the collective unconscious. The improvisational nature of Pollock's work and his reliance on the subconscious also have parallels in the "psychic automatism" of Surrealism and the work of Vassily Kandinsky (FIG. 24-7), whom critics described as an "abstract expressionist" as early as 1919. In addition to Pollock's unique working methods and the expansive scale of his canvases, the lack of a well-defined compositional focus in his paintings significantly departed from conventional easel painting (see "Jackson Pollock on Easel and Mural Painting," above). A towering figure in 20th-century art, Pollock tragically died in a car accident at age 44, cutting short the development of his innovative artistic vision.

^{*} Quoted in Francis V. O'Connor, *Jackson Pollock* (New York: Museum of Modern Art, 1967), 39.

[†] Ibid., 39–40.

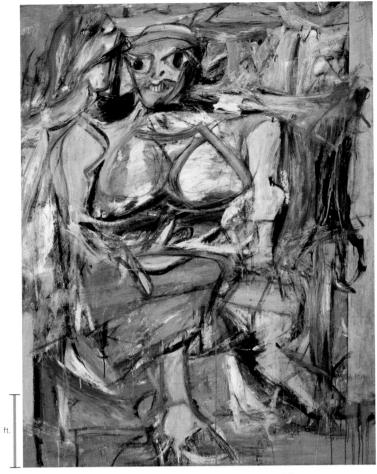

25-7 WILLEM DE KOONING, *Woman I*, 1950–1952. Oil on canvas, 6' $3\frac{7}{8}$ " × 4' 10". Museum of Modern Art, New York.

Although rooted in figuration, including pictures of female models on advertising billboards, de Kooning's *Woman I* displays the energetic application of pigment typical of gestural abstraction.

WILLEM DE KOONING Despite the public's skepticism about Pollock's art, other artists enthusiastically pursued similar avenues of expression. Dutch-born Willem De Kooning (1904–1997) also developed a gestural abstractionist style. Even images such as *Woman I* (FIG. 25-7), although rooted in figuration, display the sweeping gestural brush strokes and energetic application of pigment typical of gestural abstraction. Out of the jumbled array of slashing lines and agitated patches of color appears a ferocious-looking woman with staring eyes and ponderous breasts. Her toothy smile, modeled on an ad for Camel cigarettes, becomes a grimace. Female models on advertising billboards partly inspired *Woman I*, one of a series of female images, but de Kooning's female forms also suggest fertility figures and a satiric inversion of the traditional image of Venus, goddess of love.

Process was important to de Kooning, as it was to Pollock. Continually working on *Woman I* for almost two years, de Kooning painted an image and then scraped it away the next day and began anew. His wife Elaine, also a painter, estimated that he painted approximately 200 scraped-away images of women on this canvas before settling on the final one.

In addition to this *Woman* series, de Kooning created nonrepresentational works dominated by huge swaths and splashes of pigment. His images suggest rawness and intensity. His dealer, Sidney Janis (1896–1989), confirmed this impression, recalling that de Kooning occasionally brought him paintings with ragged holes in them, the result of overly vigorous painting. Like Pollock, de Kooning was very much "in" his paintings. That kind of physical interaction between the painter and the canvas led the critic Harold Rosenberg (1906–1978) to describe the work of the New York School as *action painting*. In his influential 1952 article "The American Action Painters," Rosenberg described the attempts of Pollock, de Kooning, and others to get "inside the canvas."

At a certain moment the canvas began to appear to one American painter after another as an arena in which to act—rather than as a space in which to reproduce, re-design, analyze or "express" an

25-8 Barnett Newman, Vir Heroicus Sublimis, 1950–1951. Oil on canvas, 7' $11\frac{3}{8}'' \times 17'$ $9\frac{1}{4}''$. Museum of Modern Art, New York (gift of Mr. and Mrs. Ben Heller).

Newman's canvases consist of a single slightly modulated color field split by "zips" (narrow bands) running from one edge of the painting to the other, energizing the color field and giving it scale.

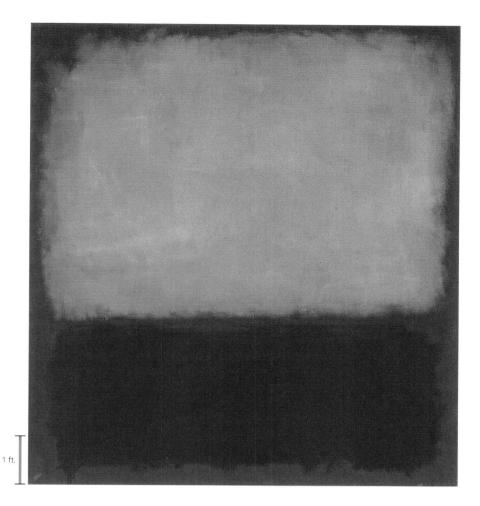

object, actual or imagined. What was to go on the canvas was not a picture but an event. The painter no longer approached his easel with an image in his mind; he went up to it with material in his hand to do something to that other piece of material in front of him. The image would be the result of this encounter.⁵

BARNETT NEWMAN In contrast to the aggressively energetic images of the gestural abstractionists, the work of the chromatic abstractionists exudes a quieter aesthetic, exemplified by the work of Barnett Newman and Mark Rothko. The emotional resonance of their works derives from their eloquent use of color. In his early paintings, BARNETT NEWMAN (1905-1970) presented organic abstractions inspired by his study of biology and his fascination with Native American art. He soon simplified his compositions so that each canvas, such as Vir Heroicus Sublimis (FIG. 25-8)—Latin, "sublime heroic man" consists of a single slightly modulated color field split by narrow bands the artist called "zips," which run from one edge of the painting to the other. As Newman explained it, "The streak was always going through an atmosphere; I kept trying to create a world around it." He did not intend the viewer to perceive the zips as specific entities, separate from the ground, but as accents energizing the field and giving it scale. By simplifying his compositions, Newman increased color's capacity to communicate and to express his feelings about the tragic condition of modern life and the human struggle to survive. He claimed that "the artist's problem . . . [is] the idea-complex that makes contact with mystery-of life, of men, of nature, of the hard black chaos that is death, or the grayer, softer chaos that is tragedy." Confronted by one of Newman's monumental colored canvases, viewers truly feel as if they are in the presence of the epic.

MARK ROTHKO The work of MARK ROTHKO (1903–1970) also deals with universal themes. Born in Russia, Rothko moved with

25-9 Макк Rothko, *No.* 14, 1960. Oil on canvas, $9'6'' \times 8'9''$. San Francisco Museum of Modern Art, San Francisco (Helen Crocker Russell Fund Purchase).

Rothko's chromatic abstractionist paintings—consisting of hazy rectangles of pure color hovering in front of a colored background—are compositionally simple but compelling visual experiences.

his family to the United States when he was 10. His early paintings were figural in orientation, but he soon arrived at the belief that references to anything specific in the physical world conflicted with the sublime idea of the universal, supernatural "spirit of myth," which he saw as the core of meaning in art. In a statement cowritten with Newman and artist Adolph Gottlieb (1903–1974), Rothko expressed his beliefs about art:

We favor the simple expression of the complex thought. We are for the large shape because it has the impact of the unequivocal.... We assert that... only that subject matter is valid which is tragic and timeless. That is why we profess spiritual kinship with primitive and archaic art.⁸

Rothko's paintings became compositionally simple, and he increasingly focused on color as the pri-

mary conveyor of meaning. In works such as No. 14 (FIG. 25-9), Rothko created compelling visual experiences consisting of two or three large rectangles of pure color with hazy, brushy edges that seem to float on the canvas surface, hovering in front of a colored background. These paintings appear as shimmering veils of intensely luminous colors suspended in front of the canvases. Although the color juxtapositions are visually captivating, Rothko intended them as more than decorative. He saw color as a doorway to another reality, and insisted that color could express "basic human emotions—tragedy, ecstasy, doom. . . . The people who weep before my pictures are having the same religious experience I had when I painted them. And if you, as you say, are moved only by their color relationships, then you miss the point." Like the other Abstract Expressionists, Rothko produced highly evocative, moving paintings that relied on formal elements rather than specific representational content to elicit emotional responses in the viewer.

Post-Painterly Abstraction

Post-Painterly Abstraction, another American art movement, developed out of Abstract Expressionism. Indeed, many of the artists associated with Post-Painterly Abstraction produced Abstract Expressionist work early in their careers. Yet Post-Painterly Abstraction, a term Clement Greenberg coined, manifests a radically different sensibility from Abstract Expressionism. Whereas Abstract Expressionism conveys a feeling of passion and visceral intensity, a cool, detached rationality emphasizing tighter pictorial control characterizes Post-Painterly Abstraction. Greenberg saw this art as contrasting with "painterly" art, characterized by loose, visible pigment application. Evidence of the artist's hand, so prominent in gestural abstraction, is conspicuously absent in Post-Painterly Abstraction. Greenberg championed this art form because it seemed to embody his idea of purity in art.

25-10 Ellsworth Kelly, Red Blue Green, 1963. Oil on canvas, 6' $11\frac{5}{8}'' \times 11'$ $3\frac{7}{8}''$. Museum of Contemporary Art, San Diego (gift of Dr. and Mrs. Jack M. Farris).

Hard-edge painting is one variant of Post-Painterly Abstraction. Kelly used razor-sharp edges and clearly delineated areas of color to distill painting to its essential two-dimensional elements.

ELLSWORTH KELLY Attempting to arrive at pure painting, the Post-Painterly Abstractionists distilled painting down to its essential elements, producing spare, elemental images. An example of one variant of Post-Painterly Abstraction, *hard-edge painting*, is *Red Blue Green* (FIG. **25-10**) by Ellsworth Kelly (b. 1923). With its razor-sharp edges and clearly delineated shapes, this work is completely abstract and extremely simple compositionally. Further, the painting contains no suggestion of the illusion of depth—the color shapes appear resolutely two-dimensional.

FRANK STELLA Another artist associated with the hard-edge painters of the 1960s is FRANK STELLA (b. 1936). In works such as *Mas o Menos (More or Less;* FIG. **25-11**), Stella eliminated many of

the variables associated with painting. His simplified images of thin, evenly spaced pinstripes on colored grounds have no central focus, no painterly or expressive elements, only limited surface modulation, and no tactile quality. Stella's systematic painting illustrates Greenberg's insistence on purity in art. The artist's famous comment on his work, "What you see is what you see," reinforces the notions that painters interested in producing advanced art must reduce their work to its essential elements and that the viewer must acknowledge that a painting is simply pigment on a flat surface.

HELEN FRANKENTHALER *Color-field painting*, another variant of Post-Painterly Abstraction, also emphasized painting's basic properties. However, rather than produce sharp, unmodulated

25-11 Frank Stella, *Mas o Menos* (*More or Less*), 1964. Metallic powder in acrylic emulsion on canvas, 9' $10'' \times 13'$ $8\frac{1}{2}''$. Musée National d'Art Moderne, Centre Georges Pompidou, Paris (purchase 1983 with participation of Scaler Foundation).

Stella tried to achieve purity in painting using evenly spaced pinstripes on colored grounds. His canvases have no central focus, no painterly or expressive elements, and no tactile quality.

Helen Frankenthaler on Color-Field Painting

n 1965 the art critic Henry Geldzahler interviewed Helen Frankenthaler about her work as an abstract painter. In the following excerpt, Frankenthaler describes her approach to placing color on canvas (FIG. 25-12) and compares her method with the way earlier modernist artists used color in their paintings.

I will sometimes start a picture feeling "What will happen if I work with three blues and another color, and maybe more or less of the other color than the combined blues?" And very often midway through the picture I have to change the basis of the experience....

25-12 HELEN FRANKENTHALER, *The Bay*, 1963. Acrylic on canvas, $6' 8\frac{7}{8}'' \times 6' 9\frac{7}{8}''$. Detroit Institute of Arts, Detroit.

Color-field painters like Frankenthaler poured paint onto unprimed canvas, allowing the pigments to soak into the fabric. Her works underscore that a painting is simply pigment on a flat surface.

When you first saw a Cubist or Impressionist picture there was a whole way of instructing the eye or the subconscious. Dabs of color had to stand for real things; it was an abstraction of a guitar or a hillside. The opposite is going on now. If you have bands of blue, green, and pink, the mind doesn't think sky, grass and flesh. These are colors and the question is what are they doing with themselves and with each other. Sentiment and nuance are being squeezed out.*

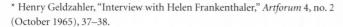

1 ft.

shapes as the hard-edge artists had done, the color-field painters poured diluted paint onto unprimed canvas, allowing the pigments to soak in. It is hard to conceive of another painting method that results in such literal flatness. The images created, such as *The Bay* (FIG. **25-12**) by Helen Frankenthaler (b. 1928), appear spontaneous and almost accidental (see "Helen Frankenthaler on Color-Field

Painting," above). These works differ from those of Rothko and Newman in that Frankenthaler subordinated the emotional component, so integral to Abstract Expressionism, to resolving formal problems.

MORRIS LOUIS Another artist who pursued color-field painting was Morris Louis (1912–1962). Clement Greenberg, an ad-

mirer of Frankenthaler's paintings, took Louis to her studio, and there she introduced him to the possibilities presented by the staining technique. Louis used this method of pouring diluted paint onto the surface of unprimed canvas in several series of paintings. *Saraband* (FIG. **25-13**) is one of the works in Louis's *Veils* series. By holding up the canvas edges and pouring on diluted acrylic resin, Louis created billowy, fluid, transparent shapes that run down the length of the canvas. Like Frankenthaler, Louis reduced painting to the concrete fact of the paint-impregnated material.

25-13 MORRIS LOUIS, *Saraband*, 1959. Acrylic resin on canvas, 8' $5\frac{1}{8}'' \times 12'$ 5". Solomon R. Guggenheim Museum, New York.

Louis created his color-field paintings by holding up the canvas edges and pouring diluted acrylic resin to produce billowy, fluid, transparent shapes that run down the length of the fabric.

David Smith on Outdoor Sculpture

rom ancient times, sculptors have frequently created statues for display in the open air, whether a portrait of a Roman emperor on horseback in a forum (FIG. 7-43, no. 6) or Michelangelo's *David* (FIG. 17-13) in Florence's Piazza della Signoria. But rarely have sculptors taken into consideration the effects of sunlight in the conception of their works. David Smith (FIG. 25-14) was an exception.

I like outdoor sculpture and the most practical thing for outdoor sculpture is stainless steel, and I make them and I polish them in such a way that on a dull day, they take on the dull blue, or the color of the sky in the late afternoon sun, the glow, golden like the rays, the colors of nature. And in a particular sense, I have used atmosphere in a reflective way on the surfaces. They are colored by the sky and the surroundings, the green or blue of water. Some are down by the water and some are by the mountains. They reflect the colors. They are designed for the outdoors.*

* Quoted in Cleve Gray, ed., *David Smith by David Smith* (New York: Holt, Rinehart, and Winston, 1968), 133.

25-14 DAVID SMITH, *Cubi XIX*, 1964. Stainless steel, 9' $4\frac{3}{4}'' \times 4'$ $10\frac{1}{4}'' \times 3'$ 4". Tate Gallery, London. Art © Estate of David Smith/Licensed by VAGA, New York.

David Smith designed his abstract metal sculptures of simple geometric forms to reflect the natural light and color of their outdoor settings, not the sterile illumination of a museum gallery.

1 ft.

CLYFFORD STILL Another American painter whose work art historians usually classify as Post-Painterly Abstraction was Clyfford Still (1904–1980), a pioneering abstract painter who produced a large series of canvases titled simply with their dates, underscoring his rejection of the very notion that the purpose of art is to represent places, people, or objects. Nonetheless, Still's paintings remind many viewers of vast landscapes seen from the air. But the artist's canvases make no reference to any forms in nature. His paintings, for example, 1948-C (FIG. I-1), are pure exercises in the expressive use of color, shape, and texture.

Sculpture

Painters were not the only artists interested in Greenberg's formalist ideas. American sculptors also aimed for purity in their medium. While painters worked to emphasize flatness, sculptors, understandably, chose to focus on three-dimensionality as the unique characteristic and inherent limitation of the sculptural idiom.

DAVID SMITH American sculptor David Smith (1906–1965) produced metal sculptures that have affinities with the Abstract Expressionist movement in painting. Smith learned to weld in an automobile plant in 1925 and later applied to his art the technical expertise in handling metals he gained from that experience. In addition, working in large scale at the factories helped him visualize the possibilities for monumental metal sculpture. After experimenting with a variety of sculptural styles and materials, Smith created his *Cubi* series in the early 1960s. These works, for example *Cubi XIX* (FIG. **25-14**), consist

of simple geometric forms—cubes, cylinders, and rectangular bars. Made of stainless steel sections piled atop one another and then welded together, these large-scale sculptures make a striking visual statement. Smith added gestural elements reminiscent of Abstract

25-15 Tony Smith, *Die*, 1962. Steel, $6' \times 6' \times 6'$. Museum of Modern Art, New York (gift of Jane Smith in honor of Agnes Gund).

By rejecting illusionism and symbolism and reducing sculpture to basic geometric forms, Minimalist sculptors like Tony Smith emphasized their art's "objecthood" and concrete tangibility.

Donald Judd on Sculpture and Industrial Materials

n a 1965 essay entitled "Specific Objects," the Minimalist sculptor Donald Judd described the advantages of sculpture over painting and the attractions of using industrial materials for his works (FIG. 25-16).

Three dimensions are real space. That gets rid of the problem of illusionism . . . one of the salient and most objectionable relics of European art. The several limits of painting are no longer present. A work can be as powerful as it can be thought to be. Actual space is intrinsically more powerful and specific than paint on a flat surface. . . . The use of three dimensions makes it possible to see all sorts of materials and colors. Most of [my] work involves new materials, either recent inventions or things not used before in art. Little was done until lately with the wide range of industrial products. . . . Materials vary greatly and are simply materials—formica, aluminum, cold-rolled steel, plexiglas, red and common brass, and so forth. They are specific. If they are used directly, they are more specific. Also, they are usually aggressive. There is an objectivity to the obdurate identity of a material. . . . The form of a work of art and its materials are closely related. In earlier work the structure and the imagery were executed in some neutral and homogeneous material.*

* Donald Judd, Complete Writings 1959–1975 (New York: New York University Press, 1975), 181–189.

25-16 Donald Judd, *Untitled*, 1969. Brass and colored fluorescent Plexiglas on steel brackets, 10 units, $6\frac{1}{8}'' \times 2' \times 2'$ 3" each, with 6" intervals. Hirshhorn Museum and Sculpture Garden, Smithsonian Institution, Washington, D.C. (gift of Joseph H. Hirshhorn, 1972). Art © Judd Foundation/Licensed by VAGA, New York.

Judd's Minimalist sculpture incorporates boxes fashioned from undisguised industrial materials. The artist used Plexiglas because its translucency gives the viewer access to the work's interior.

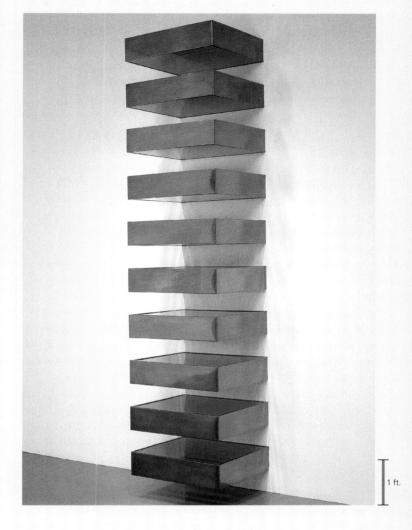

Expressionism by burnishing the metal with steel wool, producing swirling random-looking patterns that draw attention to the two-dimensionality of the sculptural surface. This treatment, which captures the light hitting the sculpture, activates the surface and imparts a texture to his pieces. Meant to be seen outdoors (see "David Smith on Outdoor Sculpture," page 754), Smith's sculptures unfortunately lose much of their character in the sterile lighting of a museum.

TONY SMITH A predominantly sculptural movement that emerged in the 1960s among artists seeking Greenbergian purity of form was *Minimalism*. One leading Minimalist was Tony Smith (1912–1980), who created simple volumetric sculptures such as *Die* (FIG. 25-15). Difficult to describe other than as three-dimensional objects, Minimalist artworks often lack identifiable subjects, colors, surface textures, and narrative elements. By rejecting illusionism and reducing sculpture to basic geometric forms, Minimalists emphatically stress their art's "objecthood" and concrete tangibility. In so doing, they reduce experience to its most fundamental level, preventing viewers from drawing on assumptions or preconceptions when dealing with the art before them.

DONALD JUDD Another Minimalist sculptor, Donald Judd (1928–1994), embraced a spare, universal aesthetic corresponding to

the core tenets of the movement. Judd's determination to arrive at a visual vocabulary that avoided deception or ambiguity propelled him away from representation and toward precise and simple sculpture. For Judd, a work's power derived from its character as a whole and from the specificity of its materials (see "Donald Judd on Sculpture and Industrial Materials," above). *Untitled* (FIG. **25-16**) presents basic geometric boxes constructed of brass and red Plexiglas, undisguised by paint or other materials. The artist did not intend the work to be metaphorical or symbolic but a straightforward declaration of sculpture's objecthood. Judd used Plexiglas because its translucency permits the viewer to access the interior, thereby rendering the sculpture both open and enclosed. This aspect of the design reflects Judd's desire to banish ambiguity or falseness from his works.

Interestingly, despite the ostensible connections between Minimalism and Greenbergian formalism, Greenberg did not embrace this direction in art. In his view,

Minimal Art remains too much a feat of ideation [the mental formation of ideas], and not enough anything else. Its idea remains an idea, something deduced instead of felt and discovered. The geometrical and modular simplicity may announce and signify the artistically furthest-out, but the fact that the signals are understood for

25-17 Louise Nevelson, *Tropical Garden II*, 1957–1959. Wood painted black, 5' $11\frac{1}{2}'' \times 10'$ $11\frac{3}{4}'' \times 1'$. Musée National d'Art Moderne, Centre Georges Pompidou, Paris.

The monochromatic color scheme unifies the diverse sculpted forms and found objects in Nevelson's "walls" and creates a mysterious field of shapes and shadows that suggest magical environments.

what they want to mean betrays them artistically. There is hardly any aesthetic surprise in Minimal Art.... Aesthetic surprise hangs on forever—it is there in Raphael as it is in Pollock—and ideas alone cannot achieve it. 10

LOUISE NEVELSON Although Minimalism was a dominant sculptural trend in the 1960s, many sculptors pursued other styles. Russian-born Louise Nevelson (1899–1988) created sculpture that combines a sense of the architectural fragment with the power of Dada and Surrealist found objects to express her personal sense of life's underlying significance. Multiplicity of meaning was important to Nevelson. She sought "the in-between place.... The dawns and the dusks" —the transitional realm between one

state of being and another. Beginning in the late 1950s, she assembled sculptures of found wooden objects and forms, enclosing small sculptural compositions in boxes of varied sizes, and joined the boxes to one another to form "walls," which she then painted in a single hue—usually black, white, or gold. This monochromatic color scheme unifies the diverse parts of pieces such as *Tropical Garden II* (FIG. **25-17**) and creates a mysterious field of shapes and shadows. The structures suggest magical environments resembling the treasured secret hideaways dimly remembered from childhood. Yet the boxy frames and the precision of the manufactured found objects create a rough geometric structure

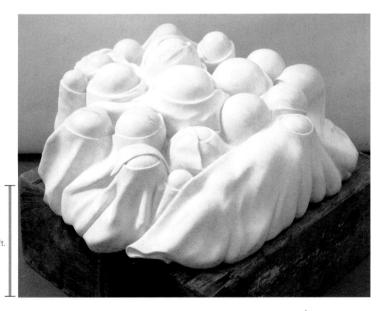

25-18 Louise Bourgeois, *Cumul I*, 1969. Marble, 1' $10\frac{3}{8}'' \times 4'$ 2" \times 4'. Musée National d'Art Moderne, Centre Georges Pompidou, Paris. Art © Louise Bourgeois/Licensed by VAGA, New York.

Bourgeois's sculptures consist of sensuous organic forms that recall the Biomorphic Surrealist forms of Miró (FIG. 24-52). Although the shapes remain abstract, they refer strongly to human figures.

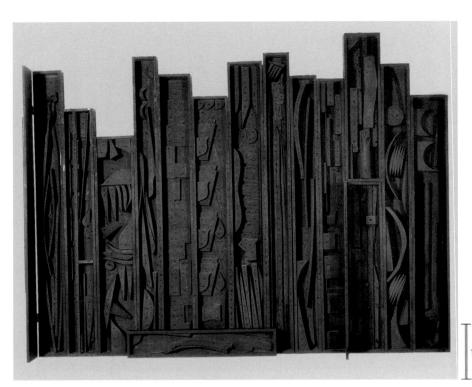

that the eye roams over freely, lingering on some details. The parts of a Nevelson sculpture and their interrelation recall the *Merz* constructions of Kurt Schwitters (FIG. **24-30**). The effect is also rather like viewing the side of an apartment building from a moving elevated train or like looking down on a city from the air.

LOUISE BOURGEOIS In contrast to the architectural nature of Nevelson's work, a sensuous organic quality recalling the evocative Biomorphic Surrealist forms of Joan Miró (FIG. 24-52) pervades the work of French-American artist Louise Bourgeois (b. 1911). *Cumul I* (FIG. 25-18) is a collection of round-headed units huddled, with their heads protruding, within a collective cloak dotted with holes. The units differ in size, and their position within the group lends a distinctive personality to each. Although the shapes remain abstract, they refer strongly to human bodies. Bourgeois uses a wide variety of materials in her works, including wood, plaster, latex, and plastics, in addition to alabaster, marble, and bronze. She exploits each material's qualities to suit the expressiveness of the piece.

In *Cumul I*, the alternating high gloss and matte finish of the marble increases the sensuous distinction between the group of swelling forms and the soft folds swaddling them. Like Barbara Hepworth (FIG. 24-58), Bourgeois connects her sculpture with the body's multiple relationships to landscape: "[My pieces] are anthropomorphic and they are landscape also, since our body could be considered from a topographical point of view, as a land with mounds and valleys and caves and holes." However, Bourgeois's sculptures are more personal and more openly sexual than those of Hepworth. *Cumul I* represents perfectly the allusions Bourgeois seeks: "There has always been sexual suggestiveness in my work. Sometimes I am totally concerned with female shapes—characters of breasts like clouds—but often I merge the activity—phallic breasts, male and female, active and passive." ¹³

EVA HESSE A Minimalist in the early part of her career, Eva HESSE (1936–1970) later moved away from the severity characterizing much of Minimalist art. She created sculptures that, although spare and simple, have a compelling presence. Using nontraditional sculptural materials such as fiberglass, cord, and latex, Hesse produced sculptures whose pure Minimalist forms appear to crumble,

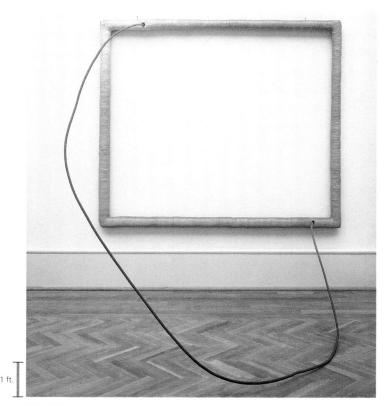

25-19 Eva Hesse, *Hang-Up*, 1965–1966. Acrylic on cloth over wood and steel, $6' \times 7' \times 6'$ 6". Art Institute of Chicago, Chicago (gift of Arthur Keating and Mr. and Mrs. Edward Morris by exchange).

Hesse created spare and simple sculptures with parts that extend into the room. She wanted her works to express the strangeness and absurdity that she considered the central conditions of modern life.

sag, and warp under the pressures of atmospheric force and gravity. Born Jewish in Hitler's Germany, the young Hesse hid with a Christian family when her parents and elder sister had to flee the Nazis. She did not reunite with them until the early 1940s, just before her parents divorced. Those extraordinary circumstances helped give her a lasting sense that the central conditions of modern life are strangeness and absurdity. Struggling to express these qualities in her art, she created informal sculptural arrangements with units often hung from the ceiling, propped against the walls, or spilled out along the floor. She said she wanted her pieces to be "non art, non connotative, non anthropomorphic, non geometric, non nothing, everything, but of another kind, vision, sort." ¹⁴

Hang-Up (FIG. **25-19**) fulfills these requirements. The piece looks like a carefully made empty frame sprouting a strange feeler that extends into the room and doubles back to the frame. Hesse wrote that in this work, for the first time, her "idea of absurdity or extreme feeling came through. . . . [Hang-Up] has a kind of depth I don't always achieve and that is the kind of depth or soul or absurdity of life or meaning or feeling or intellect that I want to get." The sculpture possesses a disquieting and touching presence, suggesting the fragility and grandeur of life amid the pressures of the modern age. Hesse was herself a touching and fragile presence in the art world. She died of a brain tumor at age 34.

Pop Art

Despite their differences, the Abstract Expressionists, Post-Painterly Abstractionists, and Minimalists all adopted an artistic vocabulary of resolute abstraction. Other artists, however, observing that the insular and introspective attitude of the avant-garde had alienated the

public, sought to harness the communicative power of art to reach a wide audience. However, they did not create reactionary or academic work. Their art still incorporated avant-garde elements, but their focus was not on the formalist issues characteristic of the modernist mindset.

The artists of the *Pop Art* movement reintroduced all of the devices the postwar avant-garde artists, in search of purity, had purged from their abstract and often reductive works. Thus, Pop artists revived the tools traditionally used to convey meaning in art, such as signs, symbols, metaphors, allusions, illusions, and figural imagery. They not only embraced representation but also produced an art firmly grounded in consumer culture and the mass media, thereby making it much more accessible and understandable to the average person. Indeed, the name "Pop Art" (credited to the British art critic Lawrence Alloway) is short for "popular art" and referred to the popular mass culture and familiar imagery of the contemporary urban environment. This was an art form rooted in the sensibilities and visual language of a late-20th-century mass audience.

RICHARD HAMILTON Art historians trace the roots of Pop Art to a group of young British artists, architects, and writers who formed the Independent Group at the Institute of Contemporary Art in London in the early 1950s. They sought to initiate fresh thinking in art, in part by sharing their fascination with the aesthetics and content of such facets of popular culture as advertising, comic books, and movies. In 1956 an Independent Group member, RICHARD HAMILTON (b. 1922), made a small collage, *Just What Is It That Makes Today's Homes So Different, So Appealing?* (FIG. **25-20**), which exemplifies many of the attitudes of British Pop Art. Trained as an engineering draftsman, exhibition designer, and painter, Hamilton studied the way advertising shapes public attitudes. Long intrigued by

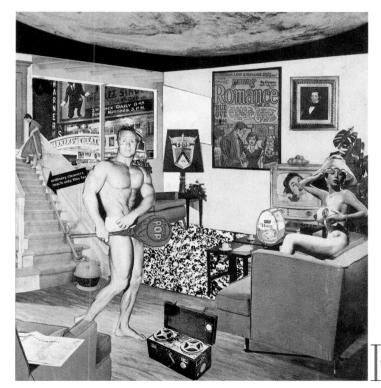

25-20 RICHARD HAMILTON, *Just What Is It That Makes Today's Homes So Different, So Appealing?* 1956. Collage, $10\frac{1}{4}$ " \times $9\frac{3}{4}$ ". Kunsthalle Tübingen, Tübingen.

The fantasy interior in Hamilton's collage reflects the values of modern consumer culture through figures and objects cut from glossy magazines. Toying with mass-media imagery typifies British Pop Art.

25-21 Jasper Johns, *Flag*, 1954–1955, dated on reverse 1954. Encaustic, oil, and collage on fabric mounted on plywood, 3' $6\frac{1}{4}'' \times 5'\frac{5}{8}''$. Museum of Modern Art, New York (gift of Philip Johnson in honor of Alfred H. Barr Jr.). Art © Jasper Johns/Licensed by VAGA, New York.

American Pop artist Jasper Johns wanted to draw attention to common objects that people view frequently but rarely scrutinize. He made several series of paintings of targets, flags, numbers, and alphabets.

Duchamp's ideas, Hamilton consistently combined elements of popular art and fine art, seeing both as belonging to the whole world of visual communication. He created *Just What Is It?* for the poster and catalogue of one section of an exhibition titled *This Is Tomorrow*, which included images from Hollywood cinema, science fiction, the mass media, and one reproduction of a van Gogh painting (to represent popular fine artworks).

The fantasy interior in Hamilton's collage reflects the values of modern consumer culture through figures and objects cut from glossy magazines. *Just What Is It*? includes references to mass media (the television, the theater marquee outside the window, the newspaper), advertising (Hoover vacuums, Ford cars, Armour hams, Tootsie Pops), and popular culture (the girlie magazine, bodybuilder Charles Atlas, romance comic books). Scholars have written much about the possible deep message of this piece, and few would deny the work's sardonic effect, whether or not the artist intended to make a pointed comment. Artworks of this sort stimulated the viewer's wide-ranging speculation about society's values, and this kind of intellectual toying with mass-media meaning and imagery typified Pop Art in England and Europe.

JASPER JOHNS Although Pop Art originated in England, the movement found its greatest articulation and success in the United States, in large part because the more fully matured American consumer culture provided a fertile environment in which the movement flourished through the 1960s. Indeed, Independent Group members claimed their inspiration came from Hollywood, Detroit, and New York's Madison Avenue, paying homage to America's predominance in the realms of mass media, mass production, and advertising. One of the artists pivotal to the early development of American Pop was JASPER JOHNS (b. 1930), who sought to draw attention to common objects in the world—what he called things "seen but not looked at." 16 To this end, he created several series of paintings of targets, flags, numbers, and alphabets. For example, Flag (FIG. 25-21) depicts an object people view frequently but rarely scrutinize. The highly textured surface of the work is the result of Johns's use of encaustic, an ancient method of painting with liquid

25-22 ROBERT RAUSCHENBERG, *Canyon*, 1959. Oil, pencil, paper, fabric, metal, cardboard box, printed paper, printed reproductions, photograph, wood, paint tube, and mirror on canvas, with oil on bald eagle, string, and pillow, $6' 9\frac{3}{4}'' \times 5' 10'' \times 2'$. Sonnabend Collection. Art © Robert Rauschenberg/Licensed by VAGA, New York.

Rauschenberg's "combines" intersperse painted passages with sculptural elements. *Canyon* incorporates pigment on canvas with pieces of printed paper, photographs, a pillow, and a stuffed eagle.

wax and dissolved pigment (see "Encaustic Painting," Chapter 7, page 195). First, the artist embedded a collage of newspaper scraps or photographs in wax. He then painted over them with the encaustic. Because the wax hardened quickly, Johns could work rapidly, and the translucency of the wax allows the viewer to see the layered painting process.

ROBERT RAUSCHENBERG Johns's friend ROBERT RAUSCH-ENBERG (1925-2008) began using mass-media images in his work in the 1950s. Rauschenberg set out to create works that would be open and indeterminate, and he began by making combines, which intersperse painted passages with sculptural elements. Combines are, in a sense, Rauschenberg's personal variation on assemblages, artworks constructed from already existing objects. At times, these combines seem to be sculptures with painting incorporated into certain sections. Others seem to be paintings with three-dimensional objects attached to the surface. In the 1950s, assemblages usually contained an array of art reproductions, magazine and newspaper clippings, and passages painted in an Abstract Expressionist style. In the early 1960s, Rauschenberg adopted the commercial medium of silk-screen printing, first in black and white and then in color, and began filling entire canvases with appropriated news images and anonymous photographs of city scenes.

Canyon (FIG. 25-22) is typical of Rauschenberg's combines. Pieces of printed paper and photographs cover parts of the canvas.

Roy Lichtenstein on Pop Art

n 1963, Roy Lichtenstein was one of eight painters interviewed for a profile on Pop Art in *Art News.* G. R. Swenson posed the questions. Part of Lichtenstein's response follows.

[Pop Art is] the use of commercial art as a subject matter in painting [Pop artists portray] what I think to be the most brazen and threatening characteristics of our culture, things we hate, but which are also so powerful in their impingement on us.... I paint directly ... [without] perspective or shading. It doesn't look like a painting of something, it looks like the thing itself. Instead of looking like a painting of a billboard . . . Pop Art seems to be the actual thing. It is an intensification, a stylistic intensification of the excitement which the subject matter has for me; but the style is . . . cool. One of the things a cartoon does is to express violent emotion and passion in a completely mechanized and removed style. To express this thing in a painterly style would dilute it.... Everybody has called Pop Art "American" painting, but it's actually industrial painting. America was hit by industrialism and capitalism harder and sooner . . . I think the meaning of my work is that it's industrial, it's what all the world will soon become. Europe will be the same way, soon, so it won't be American; it will be universal.*

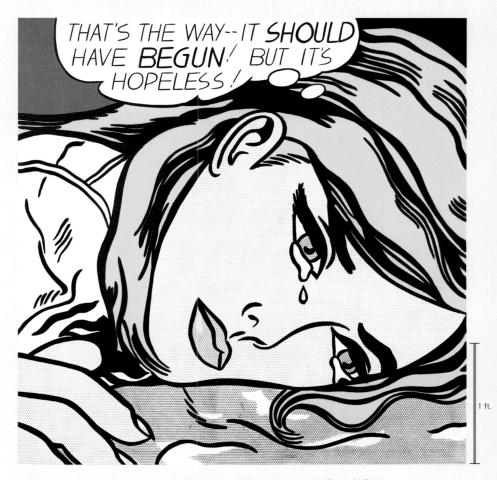

25-23 Roy Lichtenstein, *Hopeless*, 1963. Oil on canvas, 3' $8'' \times 3'$ 8''. Kunstmuseum, Basel. © Estate of Roy Lichtenstein.

Comic books appealed to Lichtenstein because they were a mainstay of American popular culture, meant to be read and discarded. The Pop artist immortalized their images on large canvases.

Much of the unevenly painted surface consists of pigment roughly applied in a manner reminiscent of de Kooning's work (FIG. 25-7). A stuffed bald eagle attached to the lower part of the combine spreads its wings as if lifting off in flight toward the viewer. Completing the combine, a pillow dangles from a string attached to a wood stick below the eagle. The artist presented the work's components in a jumbled fashion. He tilted or turned some of the images sideways, and each overlays part of another image. The compositional confusion may resemble that of a Dada collage, but the parts of Rauschenberg's combines maintain their individuality more than those in, for example, a Schwitters piece (FIG. 24-30). The eye scans a Rauschenberg canvas much as it might survey the environment on a walk through a city. The various recognizable images and objects seem unrelated and defy a consistent reading, although Rauschenberg chose all the elements of his combines with specific meanings in mind. For example, Rauschenberg based Canyon on a Rembrandt painting of Jupiter in the form of an eagle carrying the boy Ganymede heavenward. The photo in the combine is a reference to the Greek boy, and the hanging pillow is a visual pun on his buttocks.

ROY LICHTENSTEIN As the Pop movement matured, the images became more concrete and tightly controlled. American artist Roy Lichtenstein (1923-1997) turned his attention to commercial art and especially to the comic book as a mainstay of popular culture (see "Roy Lichtenstein on Pop Art," above). In paintings such as Hopeless (FIG. 25-23), Lichtenstein excerpted an image from a comic book, a form of entertainment meant to be read and discarded, and immortalized the image on a large canvas. Aside from that modification, Lichtenstein remained remarkably faithful to the original comic strip image. His subject was one of the melodramatic scenes common to popular romance comic books of the time. Lichtenstein also used the visual vocabulary of the comic strip, with its dark black outlines and unmodulated color areas, and retained the familiar square dimensions. Moreover, his printing technique, benday dots, called attention to the mass-produced derivation of the image. Named after its inventor, the newspaper printer Benjamin Day (1810-1889), the benday dot system involves the modulation of colors through the placement and size of colored dots. Lichtenstein thus transferred the visual shorthand language of the comic book to the realm of monumental painting.

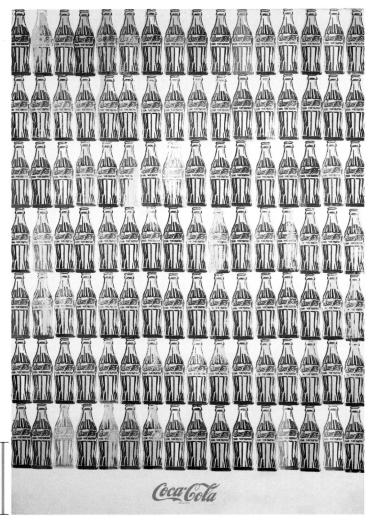

25-24 Andy Warhol, *Green Coca-Cola Bottles*, 1962. Oil on canvas, 6' $10\frac{1}{2}$ " \times 4' 9". Whitney Museum of American Art, New York.

Warhol was the quintessential American Pop artist. Here, he selected an icon of mass-produced consumer culture and then multiplied it, reflecting Coke's omnipresence in American society. ANDY WARHOL The quintessential American Pop artist was ANDY WARHOL (1928–1987). An early successful career as a commercial artist and illustrator grounded Warhol in the sensibility and visual rhetoric of advertising and the mass media, knowledge that proved useful for his Pop artworks. In paintings such as *Green Coca-Cola Bottles* (FIG. **25-24**), Warhol selected an icon of mass-produced, consumer culture of the time. The reassuringly familiar curved Coke bottle especially appealed to Warhol:

What's great about this country is that America started the tradition where the richest consumers buy essentially the same things as the poorest. You can be watching TV and see Coca-Cola, and you can know that the President drinks Coke, Liz Taylor drinks Coke, and just think, you can drink Coke, too. A Coke is a Coke and no amount of money can get you a better Coke. ¹⁷

As did other Pop artists, Warhol used a visual vocabulary and a printing technique that reinforced the image's connections to consumer culture. The repetition and redundancy of the Coke bottle reflect the omnipresence and dominance of this product in American society. The silk-screen technique allowed Warhol to print the image endlessly (although he varied each bottle slightly). So immersed was Warhol in a culture of mass production that he not only produced numerous canvases of the same image but also named his studio "the Factory."

Warhol often produced images of Hollywood celebrities, such as Marilyn Monroe. Like his other paintings, these works emphasize the commodity status of the subjects depicted. Warhol created *Marilyn Diptych* (FIG. **25-25**) in the weeks following the movie star's suicide in August 1962, capitalizing on the media frenzy her death prompted. Warhol selected a Hollywood publicity photo, one that provides no insight into the real Norma Jean Baker (the actress's name before she assumed the persona of Marilyn Monroe). Rather, the viewer sees only a mask—the image the Hollywood myth machine generated. The garish colors and the flat application of paint contribute to that image's masklike quality. The repetition of Monroe's face reinforces her status as a consumer product on a par with Coke bottles, her glamorous, haunting visage seemingly confront-

ing the viewer endlessly, as it did the American public in the aftermath of her death. The right half of this work, with its poor registration of pigment, suggests a sequence of film stills, a reference to the realm from which Monroe derived her fame.

Warhol's ascendance to the rank of celebrity artist underscored his remarkable and astute understanding of the dynamics and visual language of mass culture. He predicted

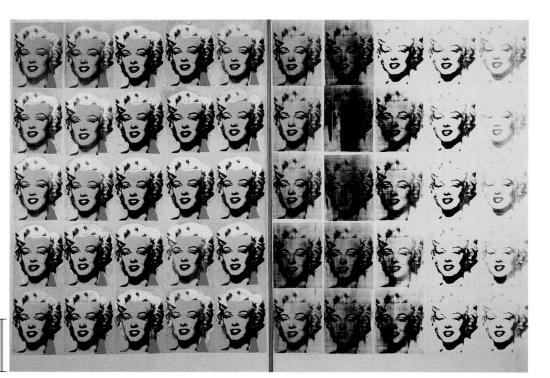

25-25 Andy Warhol, *Marilyn Diptych*, 1962. Oil, acrylic, and silkscreen enamel on canvas, each panel 6' $8'' \times 4'$ 9''. Tate Gallery, London.

Warhol's repetition of Monroe's face reinforced her status as a consumer product, her glamorous visage confronting the viewer endlessly, as it did the American public in the aftermath of her death.

1 ft.

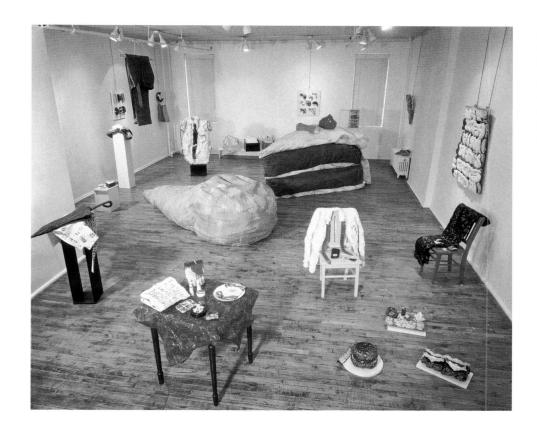

25-26 CLAES OLDENBURG, various works exhibited at the Green Gallery, New York, 1962.

Oldenburg's painted plaster and stuffed vinyl sculptures magnify familiar items of American consumer culture. The title of one of his shows, *The Store*, was a comment on art itself as a commodity.

that the age of mass media would enable everyone to become famous for 15 minutes. His own fame has lasted much longer.

CLAES OLDENBURG The Swedish-born Pop artist CLAES OLDENBURG (b. 1929) has produced sculptures that incisively comment on American consumer culture. His early works consisted of reliefs of food and clothing items. Oldenburg constructed these sculptures of plaster layered on chicken wire and muslin, painting them with cheap commercial house enamel. In later works, focused on the same subjects, he shifted to large-scale stuffed sculptures of sewn vinyl or canvas. Examples of both types of sculptures appear in the photograph (FIG. 25-26) of his one-person show at the Green Gallery in New York in 1962. Oldenburg had included many of the works in this exhibition in an earlier show he mounted titled The Store—an appropriate comment on the function of art as a commodity in a consumer society. Over the years, Oldenburg's sculpture has become increasingly monumental. In recent decades, he and his wife and collaborator, Dutch American Coosje van Bruggen (b. 1942), have become particularly well known for their mammoth outdoor sculptures of familiar, commonplace objects, such as cue balls, shuttlecocks, clothespins, and torn notebooks.

Superrealism

Like the Pop artists, the artists associated with *Superrealism* sought a form of artistic communication that was more accessible to the public than the remote, unfamiliar visual language of the Abstract Expressionists, Post-Painterly Abstractionists, and Minimalists. The Superrealists expanded Pop's iconography in both painting and sculpture by making images in the late 1960s and 1970s involving scrupulous fidelity to optical fact. Because many Superrealists used photographs as sources for their imagery, art historians also refer to this postwar art movement as *Photorealism*.

AUDREY FLACK American artist Audrey Flack (b. 1931) was one of Superrealism's pioneers. Her paintings, such as *Marilyn* (FIG. 25-27), were not simply technical exercises in recording objects in

minute detail but were also conceptual inquiries into the nature of photography and the extent to which photography constructs an understanding of reality. Flack observed that "[photography is] my whole life, I studied art history, it was always photographs, I never saw the paintings, they were in Europe. . . . Look at TV and at magazines

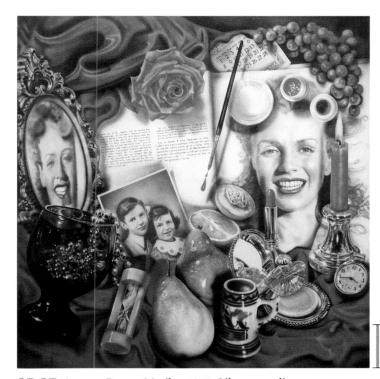

25-27 Audrey Flack, *Marilyn*, 1977. Oil over acrylic on canvas, $8' \times 8'$. University of Arizona Museum, Tucson (museum purchase with funds provided by the Edward J. Gallagher Jr. Memorial Fund).

Flack's pioneering Photorealist still lifes record objects with great optical fidelity. *Marilyn* alludes to Dutch vanitas paintings (FIG. 20-21) and incorporates multiple references to the transience of life.

Chuck Close on Portrait Painting and Photography

n a 1970 interview, the art critic Cindy Nemser asked Chuck Close about the scale of his huge portraits (FIG. 25-28) and the relationship of his paintings to the photographs that lie behind them. He answered in part:

The large scale allows me to deal with information that is overlooked in an eight-byten inch photograph . . . My large scale forces the viewer to focus on one area at a time. In that way he is made aware of the blurred areas that are seen with peripheral vision. Normally we never take those peripheral areas into account. When we focus on an area it is sharp. As we turn our attention to adjacent areas they sharpen up too. In my work, the blurred areas don't come into focus, but they are too large to be ignored. . . . In order to . . . make [my painted] information stack up with photo-

CLOSE, Big Self-Portrait, 1967–1968. Acrylic on canvas, 8' 11" × 6' 11". Walker Art Center, Minneapolis (Art Center Acquisition Fund, 1969).

25-28 Сниск

Close's goal was to translate photographic information into painted information. In his portraits, he deliberately avoided creative compositions, flattering lighting effects, and revealing facial expressions.

graphic information, I tried to purge my work of as much of the baggage of traditional portrait painting as I could. To avoid a painterly brush stroke and surface, I use some pretty devious means, such as razor blades, electric drills and airbrushes. I also work as thinly as possible and I don't use white paint as it tends to build up and become chalky and opaque. In fact, in a nine-by-seven foot picture, I only use a couple of tablespoons of black paint to cover the entire canvas.*

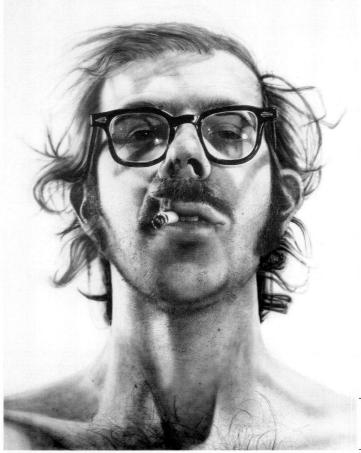

1 ft

and reproductions, they're all influenced by photo-vision." 18 The photograph's formal qualities also intrigued her, and she used photographic techniques by first projecting an image in slide form onto the canvas. By next using an airbrush (a device that uses compressed air to spray paint, originally designed as a photo-retouching tool), Flack could duplicate the smooth gradations of tone and color found in photographs. Most of her paintings are still lifes that present the viewer with a collection of familiar objects painted with great optical fidelity. Marilyn is a still life that incorporates photographs of the actress's face. Flack's commentary on Monroe's tragic death differs from that in Warhol's Marilyn Diptych (FIG. 25-25). Flack alludes to Dutch vanitas paintings (FIG. 20-21), and her still life includes multiple references to death. In addition to the black-and-white photographs of a youthful, smiling Monroe, fresh fruit, an hourglass, a burning candle, a watch, and a calendar all refer to the passage of time and the transience of life on earth.

CHUCK CLOSE Also usually considered a Superrealist is American artist Chuck Close (b. 1940), best known for his large-scale portraits, such as *Big Self-Portrait* (FIG. **25-28**). However, Close felt his connection to the Photorealists was tenuous, because for him realism, rather than an end in itself, was the result of an intellectually rigorous, systematic approach to painting. He based his paintings of

the late 1960s and early 1970s on photographs, and his main goal was to translate photographic information into painted information. Because he aimed simply to record visual information about his subject's appearance, Close deliberately avoided creative compositions, flattering lighting effects, and revealing facial expressions. Not interested in providing great insight into the personalities of those portrayed, Close painted anonymous and generic people, mostly friends. By reducing the variables in his paintings (even their canvas size is a constant 9 by 7 feet), he could focus on employing his methodical presentations of faces, thereby encouraging the viewer to deal with the formal aspects of his works. Indeed, because of the large scale of Close paintings, careful scrutiny causes the images to dissolve into abstract patterns (see "Chuck Close on Portrait Painting and Photography," above).

DUANE HANSON Not surprisingly, many sculptors also were Superrealists, including DUANE HANSON (1925–1996), who perfected a casting technique that allowed him to create life-size figural sculptures that many viewers initially mistake for real people. Hanson first made plaster molds from live models and filled the molds with polyester resin. After the resin hardened, the artist removed the outer molds and cleaned, painted with an airbrush, and decorated the sculptures with wigs, clothes, and other accessories. These works,

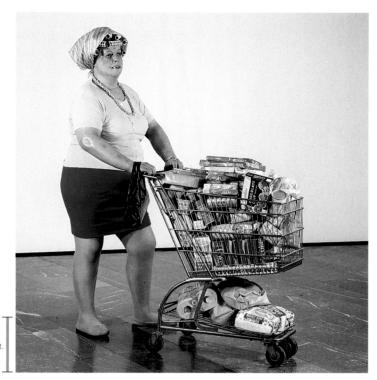

25-29 Duane Hanson, *Supermarket Shopper*, 1970. Polyester resin and fiberglass polychromed in oil, with clothing, steel cart, and groceries, life-size. Nachfolgeinstitut, Neue Galerie, Sammlung Ludwig, Aachen. Art © Estate of Duane Hanson/Licensed by VAGA, New York.

Hanson used molds from live models to create his Superrealistic lifesize painted plaster sculptures. His aim was to capture the emptiness and loneliness of average Americans in familiar settings.

such as *Supermarket Shopper* (FIG. **25-29**), depict stereotypical average Americans, striking chords with the public precisely because of their familiarity. Hanson explained his choice of imagery: "The subject matter that I like best deals with the familiar lower and middleclass American types of today. To me, the resignation, emptiness and loneliness of their existence captures the true reality of life for these people. . . . I want to achieve a certain tough realism which speaks of the fascinating idiosyncrasies of our time." ¹⁹

PAINTING AND SCULPTURE SINCE 1970

The Pop artists and Superrealists were not the only artists to challenge modernist formalist doctrine. By the 1970s, the range of art produced in both traditional and new media in reaction to Abstract Expressionism, Minimalism, and other formalist movements had become so diverse that only a broad general term can describe the phenomenon: postmodernism. There is no agreement about the definition of postmodern art. Some scholars, such as Fredric Jameson, assert that a major characteristic of postmodernism is the erosion of the boundaries between high culture and popular culture—a separation Clement Greenberg and the modernists had staunchly defended. With the appearance of Pop Art, that separation became more difficult to maintain. For Jameson, the intersection of high and mass culture is, in fact, a defining feature of the new postmodernism. He attributed the emergence of postmodernism to "a new type of social life and a new economic order—what is often euphemistically called modernization, postindustrial or consumer society, the society of the media or the spectacle, or multinational capitalism."²⁰

For many recent artists, postmodernism involves examining the process by which meaning is generated and the negotiation or dialogue that transpires between viewers and artworks. This kind of examination of the nature of art parallels the literary field of study known as critical theory. Critical theorists view art and architecture, as well as literature and the other humanities, as a culture's intellectual products, or "constructs." These constructs unconsciously suppress or conceal the true premises that inform the culture, primarily the values of those politically in control. Thus, cultural products function in an ideological capacity, obscuring, for example, racist or sexist attitudes. When revealed by analysis, the facts behind these constructs, according to critical theorists, contribute to a more substantial understanding of artworks, buildings, books, and the overall culture.

Many critical theorists use an analytical strategy called *deconstruction*, after a method developed in the 1960s and 1970s by French intellectuals, notably Michel Foucault (1926–1984) and Jacques Derrida (1930–2004). For those employing deconstruction, all cultural constructs are "texts." Acknowledging the lack of fixed or uniform meanings in these texts, critical theorists accept a variety of interpretations as valid. Further, as cultural products, how texts signify and what they signify are entirely conventional. They can refer to nothing outside of themselves, only to other texts. Thus, no extratextual reality exists that people can reference. The enterprise of deconstruction is to reveal the contradictions and instabilities of these texts, or cultural language (written or visual).

With primarily political and social aims, deconstructive analysis has the ultimate goal of effecting political and social change. Accordingly, critical theorists who employ this approach seek to uncover—to deconstruct—the facts of power, privilege, and prejudice underlying the practices and institutions of any given culture. In the process, deconstruction reveals the precariousness of structures and systems, such as language and cultural practices, along with the assumptions underlying them. Yet because of the lack of fixed meaning in texts, many politically committed thinkers assert that deconstruction does not provide a sufficiently stable basis for dissent.

Critical theorists do not agree upon any philosophy or analytical method, because in principle they oppose firm definitions. They do share a healthy suspicion of all traditional truth claims and value standards, all hierarchical authority and institutions. For them, deconstruction means destabilizing established meanings, definitions, and interpretations while encouraging subjectivity and individual differences.

Certainly, one thing all postmodern artists have in common is a self-consciousness about their place in the historical continuum of art. Consequently, many of them resurrect artistic traditions to comment on and reinterpret those styles or idioms. However defined, postmodern art comprises a dizzying array of artworks in different media. Only a representative sample can be presented here.

Neo-Expressionism

One of the first coherent movements to emerge during the postmodern era was *Neo-Expressionism*. This movement's name reflects postmodern artists' interest in reexamining earlier art production and connects this art to the powerful, intense works of the German Expressionists (see Chapter 24) and the Abstract Expressionists, among other artists.

SUSAN ROTHENBERG In the 1970s, Susan Rothenberg (b. 1945) produced a major series of large paintings with the horse as the central image. The horse theme resonates with history and metaphor—from the Parthenon frieze and Roman and Renaissance equestrian portraits to the paintings of German Expressionist Franz

25-30 Susan Rothenberg, *Tattoo*, 1979. Acrylic paint on canvas, 5′ 7″ × 8′ 7″. Walker Art Center, Minneapolis (purchased with the aid of funds from Mr. and Mrs. Edmond R. Ruben, Mr. and Mrs. Julius E. Davis, the Art Center Acquisition Fund, and the National Endowment for the Arts, 1979).

Rothenberg's Neo-Expressionist paintings feature loose brushwork, agitated surfaces, and hazy, semiabstract forms. This work's title refers to the horse's head drawn within the outline of its leg.

Marc (FIG. 24-8). Like Marc, Rothenberg saw horses as metaphors for humanity: "The horse was a way of not doing people, yet it was a symbol of people, a self-portrait, really." Rothenberg, however, distilled the image to a ghostly outline or hazy depiction that is more poetic than descriptive. As such, her works fall in the nebulous area between representation and abstraction. In paintings such as *Tattoo* (FIG. 25-30), the loose brushwork and agitated surface contribute to the expressiveness of the image and account for Rothenberg's cat-

egorization as a Neo-Expressionist. The title, *Tattoo*, refers to the horse's head drawn within the outline of its leg—"a tattoo or memory image," according to the artist.²²

JULIAN SCHNABEL The work of another American artist, Julian Schnabel (b. 1951), forcefully restates the premises of Abstract Expressionism. When executing his artworks in the 1980s, however, Schnabel experimented widely with materials and sup-

25-31 JULIAN SCHNABEL, *The Walk Home*, 1984–1985. Oil, plates, copper, bronze, fiberglass, and Bondo on wood, $9'\ 3'' \times 19'\ 4''$. Broad Art Foundation and the Pace Gallery, New York.

Schnabel's paintings recall the work of the gestural abstractionists, but he employs an amalgamation of media, bringing together painting, mosaic, and low-relief sculpture.

25-32 Anselm Kiefer, *Nigredo*, 1984. Oil paint on photosensitized fabric, acrylic emulsion, straw, shellac, relief paint on paper pulled from painted wood, 11' × 18'. Philadelphia Museum of Art, Philadelphia (gift of Friends of the Philadelphia Museum of Art).

Kiefer's paintings have thickly encrusted surfaces incorporating materials such as straw. Here, the German artist used perspective to pull the viewer into an incinerated landscape alluding to the Holocaust.

ports—from fragmented china plates bonded to wood, to paint on velvet and tarpaulin. He had a special interest in the physicality of the objects, and by attaching broken crockery, as in *The Walk Home* (FIG. **25-31**), he found an extension of what paint could do. Superficially, the painting recalls the work of the gestural abstractionists—the spontaneous drips of Pollock (FIG. **25-5**) and the energetic brush strokes of de Kooning (FIG. **25-7**). The thick, mosaic-like texture, an amalgamation of media, brings together painting, mosaic, and low-relief sculpture. In effect, Schnabel reclaimed older media for his expressionistic method, which considerably amplifies his bold, distinctive statement.

ANSELM KIEFER Neo-Expressionism was by no means a solely American movement. German artist Anselm Kiefer (b. 1945) has produced some of the most lyrical and engaging works of the contemporary period. Like Schnabel's, Kiefer's paintings, such as Nigredo (FIG. 25-32), are monumental in scale, recall Abstract Expressionist canvases, and draw the viewer to their textured surfaces, made more complex by the addition of materials such as straw and lead. It is not merely the impressive physicality of Kiefer's paintings that accounts for the impact of his work, however. His images function on a mythological or metaphorical level as well as on a historically specific one. Kiefer's works of the 1970s and 1980s often involve a reexamination of German history, particularly the painful Nazi era of 1933-1945, and evoke the feeling of despair. Kiefer believes that Germany's participation in World War II and the Holocaust left permanent scars on the souls of the German people and on the souls of all humanity.

Nigredo ("blackening") pulls the viewer into an expansive landscape depicted using Renaissance perspectival principles. This landscape, however, is far from pastoral or carefully cultivated. Rather, it is bleak and charred. Although it makes no specific reference to the Holocaust, this incinerated landscape indirectly alludes to the horrors of that event. More generally, the blackness of the landscape may refer to the notion of alchemical change or transformation, a concept of great interest to Kiefer. Black is one of the four symbolic colors of the alchemist—a color that refers both to death and to the molten, chaotic state of substances broken down by fire. The alchemist, however, focuses on the transformation of substances, and thus the emphasis on blackness is not absolute but can also be perceived as part of a process of renewal and redemption. Kiefer thus imbued his work with a deep symbolic meaning that, when combined with the intriguing visual quality of his parched, congealed surfaces, results in paintings of enduring power.

Feminist Art

With the renewed interest in representation that the Pop artists and Superrealists introduced in the 1960s and 1970s, painters and sculptors once again began to embrace the persuasive powers of art to communicate with a wide audience. In recent decades, artists have investigated more insistently the dynamics of power and privilege, especially in relation to issues of gender, race, ethnicity, class, and sexual orientation.

In the 1970s, the feminist movement focused public attention on the history of women and their place in society. In art, two women—Judy Chicago and Miriam Schapiro—largely spearheaded the American feminist art movement. Chicago and a group of students at California State University, Fresno, founded the Feminist Art Program, and Chicago and Schapiro coordinated it at the California Institute of the Arts in Valencia. In 1972, as part of this program, teachers and students joined to create projects such as Womanhouse, an abandoned house in Los Angeles they completely converted into a suite of "environments," each based on a different aspect of women's lives and fantasies.

JUDY CHICAGO In her own work in the 1970s, JUDY CHICAGO (Judy Cohen, b. 1939) wanted to educate viewers about women's role in history and the fine arts. She aimed to establish a respect for women and their art, to forge a new kind of art expressing women's experiences, and to find a way to make that art accessible to a large audience. Inspired early in her career by the work of Barbara Hepworth (FIG. 24-58), Georgia O'Keeffe (FIGS. I-4 and 24-38), and Louise Nevelson (FIG. 25-17), Chicago developed a personal painting style that consciously included abstract organic vaginal images. In the early 1970s, Chicago began planning an ambitious piece, *The*

Judy Chicago on The Dinner Party

ne of the acknowledged masterpieces of feminist art is Judy Chicago's *The Dinner Party* (FIG. **25-33**), which required a team of nearly 400 to create and assemble. In 1979, Chicago published a book explaining the genesis and symbolism of the work.

[By 1974] I had discarded [my original] idea of painting a hundred abstract portraits on plates, each paying tribute to a different historic female figure.... In my research I realized over and over again that women's achievements had been left out of history My new idea was to try to symbolize this.... [I thought] about putting the plates on a table with silver, glasses, napkins, and tablecloths, and over the next year and a half the concept of The Dinner Party slowly evolved. I began to think about the piece as a reinterpretation of the Last Supper from the point of view of women, who, throughout history, had prepared the meals and set the table. In my "Last Supper," however, the women would be the honored guests. Their repre-

sentation in the form of plates set on the table would express the way women had been confined, and the piece would thus reflect both women's achievements and their oppression.... My goal with *The Dinner Party* was... to forge a new kind of art expressing women's experience.... [It] seemed appropriate to relate our history through

25-33 Judy Chicago, *The Dinner Party*, 1979. Multimedia, including ceramics and stitchery, 48' long on each side. Brooklyn Museum, Brooklyn.

Chicago's *Dinner Party* honors 39 women from antiquity to 20th-century America. The triangular form and the materials—painted china and fabric—are traditionally associated with women.

art, particularly through techniques traditionally associated with women—china-painting and needlework.*

 * Judy Chicago, The Dinner Party: A Symbol of Our Heritage (Garden City, N.Y.: Anchor Press, 1979) 11–12.

Dinner Party (FIG. **25-33**), using craft techniques (such as china painting and needlework) traditionally practiced by women, to celebrate the achievements and contributions women made throughout history (see "Judy Chicago on *The Dinner Party*," above). She originally conceived the work as a feminist Last Supper for 13 "honored guests," as in the New Testament, but all women. There also are 13 women in a witches' coven, and Chicago's *Dinner Party* refers to witchcraft and the worship of the Mother Goddess. But because Chicago had uncovered so many worthy women in the course of her research, she expanded the number of guests threefold to 39 and placed them around a triangular table 48 feet long on each side. The triangular form refers to the ancient symbol for both woman and the Goddess. The notion of a dinner party also alludes to women's traditional role as homemakers.

The Dinner Party rests on a white tile floor inscribed with the names of 999 additional women of achievement to signify that the accomplishments of the 39 honored guests rest on a foundation other women laid. Among those with place settings at the table are O'Keeffe, the Egyptian pharaoh Hatshepsut (see "Hatshepsut," Chapter 3, page 54), the British writer Virginia Woolf, the Native American guide

Sacagawea, and the American suffragist Susan B. Anthony. Each woman's place has identical eating utensils and a goblet but a unique oversized porcelain plate and a long place mat or table runner covered with imagery that reflects significant facts about that woman's life and culture. The plates range from simple concave shapes with chinapainted imagery to dishes whose sculptured three-dimensional designs almost seem to struggle to free themselves. The designs on each plate incorporate both butterfly and vulval motifs—the butterfly as the ancient symbol of liberation and the vulva as the symbol of female sexuality. Each table runner combines traditional needlework techniques, including needlepoint, embroidery, crochet, beading, patchwork, and appliqué. *The Dinner Party* is, however, more than the sum of its parts. It provides viewers with a powerful launching point for considering broad feminist concerns.

MIRIAM SCHAPIRO After enjoying a thriving career as a hard-edge painter in California in the late 1960s, MIRIAM SCHAPIRO (b. 1923) became fascinated with the hidden metaphors for womanhood she then saw in her abstract paintings. Intrigued by the materials

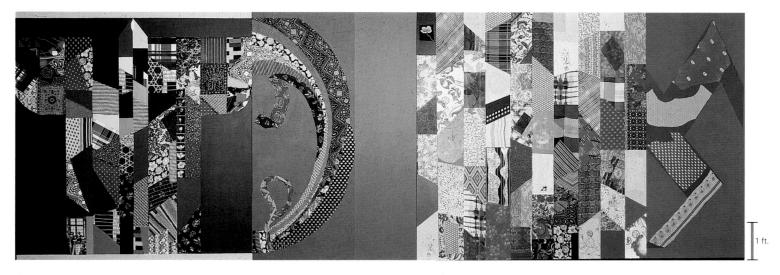

25-34 MIRIAM SCHAPIRO, Anatomy of a Kimono (section), 1976. Fabric and acrylic on canvas, 6' 8" high. Collection of Bruno Bishofberger, Zurich.

Schapiro calls her huge sewn collages *femmages* to make the point that women had been doing collages of fabric long before Picasso (FIG. 24-16). This femmage incorporates patterns from Japanese kimonos.

she had used to create a doll's house for her part in Womanhouse, in the 1970s Schapiro began to make huge sewn collages, assembled from fabrics, quilts, buttons, sequins, lace, and rickrack collected at antique shows. She called these works *femmages* to make the point that women had been doing collages using these materials long before Pablo Picasso (FIG. 24-16) introduced them to the art world. *Anatomy of a Kimono* (FIG. 25-34) is one of a series of monumental femmages based on the patterns of Japanese kimonos, fans, and robes. This vast composition repeats the kimono shape in a sumptuous array of fabric fragments.

CINDY SHERMAN Early attempts at dealing with feminist issues in art tended toward essentialism, emphasizing universal differences—either biological or experiential—between women and men. More recent discussions have gravitated toward the notion of gender as a socially constructed concept, and an extremely unstable one at that. Identity is multifaceted and changeable, making the discussion of feminist issues more challenging. Consideration of the many variables, however, results in a more complex understanding of gender roles.

American artist CINDY SHERMAN (b. 1954) addresses in her work the way much of Western art presents female beauty for the enjoyment of the "male gaze," a primary focus of contemporary feminist theory. Since 1977, Sherman has produced a series of more than 80 black-andwhite photographs titled Untitled Film Stills. She got the idea for the series after examining soft-core pornography magazines and noting the stereotypical ways they depicted women. She decided to produce her own series of photographs, designing, acting in, directing, and photographing the works. In so doing, she took control of her own image and constructed her own identity, a primary feminist concern. In works from the series, such as Untitled Film Still #35 (FIG. 25-35), Sherman appears, often in costume and wig, in a photograph that seems to be a film still. Most of the images in this series recall popular film genres but are sufficiently generic that the viewer cannot relate them to specific movies. Sherman often reveals the constructed nature of these images with the shutter release cable she holds in her hand to take the pictures. (The cord runs across the floor in #35.) Although the artist is still the object of the viewer's gaze in these images, the identity is one she alone chose to assume.

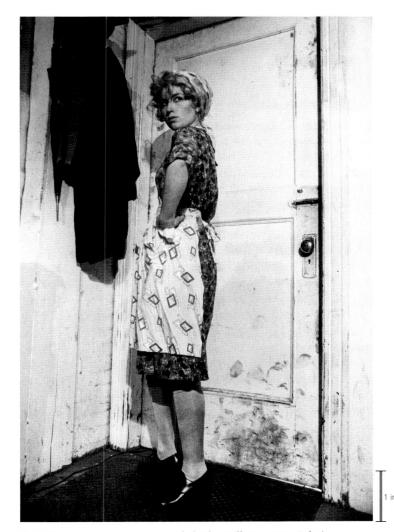

25-35 Cindy Sherman, *Untitled Film Still #35*, 1979. Gelatin silverprint, $10'' \times 8''$. Private collection.

Sherman here assumed a role for one of a series of 80 photographs resembling film stills in which she addressed the way women have been presented in Western art for the enjoyment of the "male gaze."

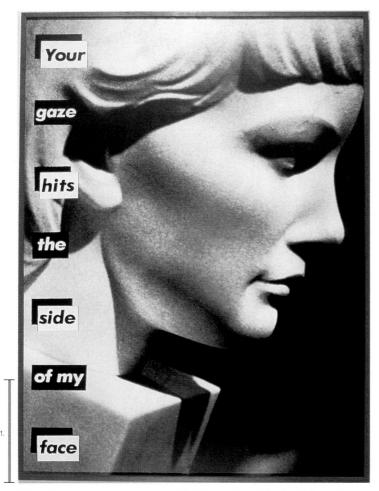

25-36 BARBARA KRUGER, *Untitled* (*Your Gaze Hits the Side of My Face*), 1981. Photograph, red painted frame, $4'7'' \times 3'5''$. Courtesy Mary Boone Gallery, New York.

Kruger, like Sherman, has explored the male gaze in her art. Using the layout techniques of mass media, she constructed this word-and-photograph collage to challenge culturally constructed notions of gender.

BARBARA KRUGER Another artist who has examined the male gaze and the culturally constructed notion of gender in her art is BARBARA KRUGER (b. 1945). Kruger's work explores the strategies and techniques of contemporary mass media and draws on her early training as a graphic designer who contributed to *Mademoiselle* magazine. *Untitled* (*Your Gaze Hits the Side of My Face*; Fig. 25-36) incorporates layout techniques the mass media use to sell consumer goods. Although Kruger favored the reassuringly familiar format and look of advertising, her goal was to subvert the typical use of such imagery. Rather, she aimed to expose the deceptiveness of the media messages the viewer complacently absorbs. Kruger wanted to undermine the myths—particularly those about women—the media constantly reinforce. Her huge (often 4 by 6 feet) word-and-photograph collages challenge the cultural attitudes embedded in commercial advertising.

In *Your Gaze*, Kruger overlaid a photograph of a classically beautiful sculpted head of a woman with a vertical row of text composed of eight words. The words cannot be taken in with a single glance, and reading them is a staccato exercise, with an overlaid cumulative quality that delays understanding and intensifies the meaning (rather like reading a series of roadside billboards from a speeding car). Kruger's use of text in her work is significant. Many cultural theorists have asserted that language is one of the most powerful vehicles for internalizing stereotypes and conditioned roles.

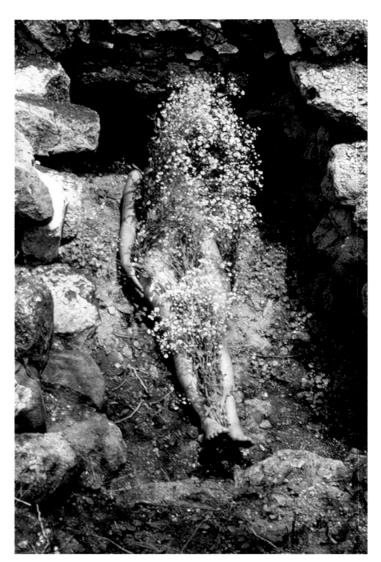

25-37 Ana Mendieta, *Flowers on Body*, 1973. Color photograph of earth/body work with flowers, executed at El Yagul, Mexico. Courtesy of the Estate of Ana Mendieta and Galerie Lelong, New York.

In this earth/body sculpture, Mendieta appears covered with flowers in a womblike cavity to address issues of birth and death as well as the human connection to the earth.

ANA MENDIETA Cuban-born artist Ana Mendieta (1948–1985), like Sherman, used her body as a component in her artworks. Although gender issues concerned her, Mendieta's art also dealt with issues of spirituality and cultural heritage. The artist's best-known series, *Silueta* (*Silhouettes*), consists of approximately 200 earth/body works completed between 1973 and 1980. These works represented Mendieta's attempt to carry on, as she described, "a dialogue between the landscape and the female body (based on my own silhouette)." ²³

Flowers on Body (FIG. 25-37) is a documentary photograph of the first of the earth/body sculptures in the Silueta series. In this work, Mendieta appears covered with flowers in an earthen, womblike cavity. Executed at El Yagul, a Mexican archaeological site, the work speaks to the issues of birth and death, the female experience of childbirth, and the human connection to the earth. Objects and locations from nature play an important role in Mendieta's art. She explained the centrality of this connection to nature:

I believe this has been a direct result of my having been torn from my homeland during my adolescence. I am overwhelmed by the

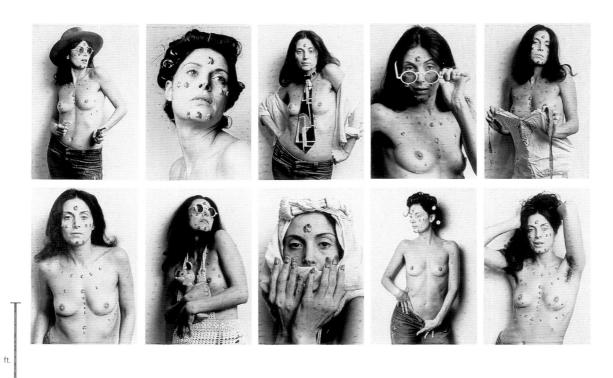

25-38 HANNAH WILKE, S.O.S.—Starification Object Series, 1974. Ten black-andwhite photographs with 15 chewing-gum sculptures in Plexiglas cases mounted on ragboard, from a series originally made for S.O.S. Mastication Box and used in an exhibition-performance at the Clocktower, January 1, 1975, 3' $5'' \times 5' 8''$. Courtesy Ronald Feldman Fine Arts, New York, Art @ Marsie, Emanuelle, Damon and Andrew Scharlatt/Licensed by VAGA, New York.

In this photographic series, Wilke posed topless decorated with chewinggum sculptures of vulvas that allude to female pleasure but also to pain, because they resemble scars.

feeling of having been cast from the womb (nature). My art is the way I re-establish the bonds that unite me to the universe. It is a return to the maternal source. Through my earth/body sculptures I become one with the earth.²⁴

Beyond their sensual, moving presence, Mendieta's works also generate a palpable spiritual force. In longing for her homeland, she sought the cultural understanding and acceptance of the spiritual powers inherent in nature that modern Western societies often seem to reject in favor of scientific and technological developments. Mendieta's art is lyrical and passionate and operates at the intersection of cultural, spiritual, physical, and feminist concerns.

HANNAH WILKE Like Mendieta, HANNAH WILKE (1940–1993) used her own nude body as her artistic material. In her 1974–1982 series S.O.S.—Starification Object Series (FIG. 25-38), Wilke's images of herself trigger readings that are simultaneously metaphorical and real, stereotypical and unique, erotic and disconcerting, and that deal with both pleasure and pain. In these 10 black-and-white photographs documenting a performance, Wilke appears topless in a variety of poses, some seductive and others more confrontational. In each, pieces of chewed gum shaped into small vulvas decorate her body. While these tiny vaginal sculptures allude to female pleasure, they also appear as scars, suggesting pain. Ultimately, Wilke hoped that women would "take control of and have pride in the sensuality of their own bodies and create a sexuality in their own terms, without deferring to concepts degenerated by culture." 25

GUERRILLA GIRLS Some feminist artists have taken the world of the woman artist as their subject, rather than women in society at large. The New York-based GUERRILLA GIRLS, formed in 1984, bill themselves as the "conscience of the art world." This group sees its duty as calling attention to injustice in the art world, especially what it perceives as the sexist and racist orientation of the major art institutions. The women who are members of the Guerrilla Girls have chosen to remain anonymous. To protect their identities, they wear

gorilla masks in public. The Guerrilla Girls employ guerrilla tactics by demonstrating in public, putting on performances, and placing posters and flyers in public locations. This distribution network expands the impact of their messages. One poster that reflects the Guerrilla Girls' agenda facetiously lists "the advantages of being a woman artist" (FIG. 25-39). In fact, the list itemizes the numerous obstacles women artists face in the contemporary art world. The Guerrilla Girls hope their publicizing of these obstacles will inspire improvements in the situation for women artists.

THE ADVANTAGES OF BEING A WOMAN ARTIST:

Working without the pressure of success

Not having to be in shows with men
Having an escape from the art world in your 4 free-lance jobs
Knowing your career might pick up after you're eighty
Being reassured that whatever kind of art you make it will be labeled feminine
Not being stuck in a tenured teaching position
Seeing your ideas live on in the work of others
Having the opportunity to choose between career and motherhood
Not having to choke on those big cigars or paint in Italian suits
Having more time to work when your mate dumps you for someone younger
Being included in revised versions of art history
Not having to undergo the embarrassment of being called a genius
Getting your picture in the art magazines wearing a gorilla suit

A PUBLIC SERVICE MESSAGE FROM GUERRILLA GIRLS CONSCIENCE OF THE ART WORLD

25-39 Guerrilla Girls, *The Advantages of Being a Woman Artist*, 1988. Offset print, $1'5'' \times 1'10''$. Collection of the artists.

The anonymous Guerrilla Girls wear gorilla masks in public performances and produce posters in which they call attention to injustice in the art world, especially what they perceive as sexist or racist treatment.

1 in.

Other Social and Political Art

Feminist issues are by no means the only social and political concerns that contemporary artists have addressed in their work. Race, ethnicity, and sexual orientation are among the other pressing issues that have given rise to important artworks during the past few decades.

KIKI SMITH American sculptor KIKI SMITH (b. 1954) has explored the question of who controls the human body, an interest that grew out of her training as an emergency medical service technician in New York City. Smith, however, also wants to reveal the socially constructed nature of the body, and she encourages the viewer to consider how external forces shape people's perceptions of their bodies. In works such as *Untitled* (FIG. 25-40), the artist dramatically departed from conventional representations of the body, both in art and in the media. She suspended two life-size wax figures, one male and one female, both nude, from metal stands. Smith marked each of the sculptures with long white drips—body

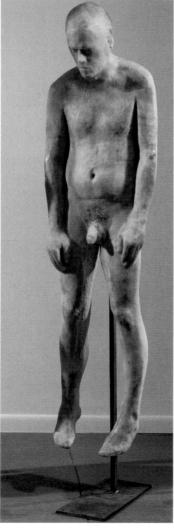

25-40 Kiki Smith, *Untitled*, 1990. Beeswax and microcrystalline wax figures on metal stands, female figure installed height 6' $1\frac{1}{2}''$; male figure 6' $4\frac{15}{16}''$. Whitney Museum of American Art, New York (purchased with funds from the Painting and Sculpture Committee).

Asking "who controls the body?" Kiki Smith sculpted two life-size wax figures of a nude man and woman with body fluids running from the woman's breasts and down the man's leg.

fluids running from the woman's breasts and down the man's leg. She commented:

Most of the functions of the body are hidden ... from society....
[W]e separate our bodies from our lives. But, when people are dying, they are losing control of their bodies. That loss of function can seem humiliating and frightening. But, on the other hand, you can look at it as a kind of liberation of the body. It seems like a nice metaphor—a way to think about the social—that people lose control despite the many agendas of different ideologies in society, which are trying to control the body(ies) ... medicine, religion, law, etc. Just thinking about control—who has control of the body? ... Does the mind have control of the body? Does the social?²⁶

FAITH RINGGOLD Other artists, reflecting their own identities and backgrounds, have used their art to address issues associated with African American women. Inspired by the civil rights movement, FAITH RINGGOLD (b. 1930) produced numerous works in the 1960s that provided incisive commentary on the realities of racial prejudice. She increasingly incorporated references to gender as well and, in the 1970s, turned to fabric as the predominant material in her art. Using fabric enabled her to make more pointed reference to the domestic sphere, traditionally associated with women, and to collaborate with her mother, Willi Posey, a fashion designer. After her mother's death in 1981, Ringgold created Who's Afraid of Aunt Jemima? (FIG. 25-41), a quilt composed of dyed, painted, and pieced fabric. A moving tribute to her mother, this work combines the personal and the political. The quilt includes a narrative—the witty story of the family of Aunt Jemima, most familiar as the stereotypical black "mammy" but here a successful African American businesswoman. Ringgold conveyed this

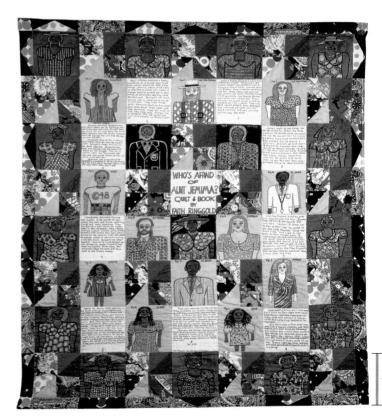

25-41 FAITH RINGGOLD, *Who's Afraid of Aunt Jemima?* 1983. Acrylic on canvas with fabric borders, quilted, 7' $6'' \times 6'$ 8''. Private collection.

In this quilt, a medium associated with women, Ringgold presented a tribute to her mother that also addresses African American culture and the struggles of women to overcome oppression.

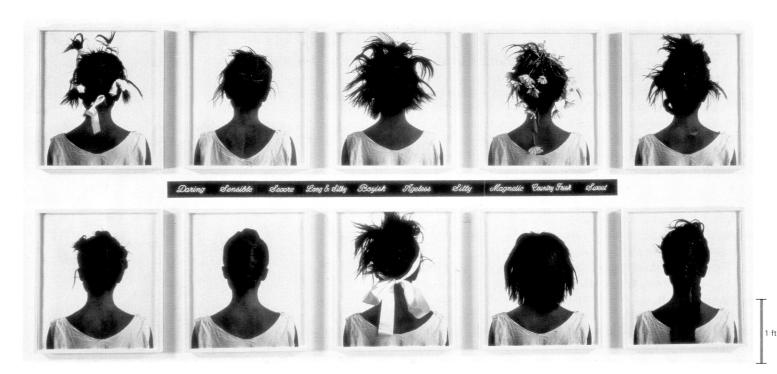

25-42 LORNA SIMPSON, Stereo Styles, 1988. 10 black-and-white Polaroid prints and 10 engraved plastic plaques, 5' $4'' \times 9'$ 8'' overall. Private collection.

In Stereo Styles, Simpson presents photographs of African American hairstyles as racial symbols associated with personality traits. She also comments on those coiffures as fashion commodities.

narrative using both text (written in black dialect) and embroidered portraits interspersed with traditional patterned squares. This work, while resonating with autobiographical references, also speaks to the larger issues of the history of African American culture and the struggles of women to overcome oppression.

LORNA SIMPSON The issues of racism and sexism are also central to the work of LORNA SIMPSON (b. 1960). Simpson has spent much of her career producing photographs that explore feminist and African American strategies to reveal and subvert conventional representations of gender and race. Like Sherman (FIG. 25-35), she deals with the issue of "the gaze," trying to counteract the process of objectification to which both women and African Americans are subject. In Stereo Styles (FIG. 25-42), a series of Polaroid photographs and engravings, Simpson focuses on African American hairstyles, often used to symbolize the entire race. Hair is a physical code tied to issues of social status and position. Kobena Mercer, who has studied the cultural importance of hair, observed that "Hair is never a straightforward biological 'fact' because it is almost always groomed, ... cut, ... and generally 'worked upon' by human hands. Such practices socialize hair, making it the medium of significant 'statements' about self and society."27 On the issue of race, Mercer argued, "where race structures social relations of power, hair—as visible as skin color, but also the most tangible sign of racial difference—takes on another forcefully symbolic dimension."28 In Stereo Styles, Simpson also commented on the appropriation of African-derived hairstyles as a fashion commodity, and the personality traits listed correlate with specific hairstyles.

MELVIN EDWARDS American Melvin Edwards (b. 1937) also has sought to reveal a history of collective oppression through his art. One of Edwards's major sculptural series focused on the metaphor of lynching to provoke thought about the legacy of racism. This *Lynch Fragment* series encompassed more than 150 welded-steel sculptures produced in the years after 1963. Lynching

as an artistic theme prompts an immediate and visceral response, conjuring chilling and gruesome images from the past. Edwards sought to extend this emotional resonance further in his art. He constructed the series' relatively small welded sculptures, such as *Tambo* (FIG. 25-43), from found metal objects—for example, chains, hooks, hammers, spikes, knife blades, and handcuffs. Although Edwards often intertwined or welded together the individual metal

25-43 Melvin Edwards, *Tambo*, 1993. Welded steel, $2' 4\frac{1}{8}'' \times 2' 1\frac{1}{4}''$. Smithsonian American Art Museum, Washington, D.C.

Edwards's welded sculptures of chains, spikes, knife blades, and other found objects allude to the lynching of African Americans and the continuing struggle for civil rights and an end to racism.

1 ft

Public Funding of Controversial Art

Ithough art can be beautiful and uplifting, throughout history art has also challenged and offended. Since the early 1980s, a number of heated controversies about art have surfaced in the United States. There have been many calls to remove the "offensive" works from public view (see "Richard Serra's *Tilted Arc*," page 792) and, in reaction, accusations of censorship. The central questions in all cases have been whether there are limits to what art can appropriately be exhibited, and whether governmental authorities have the right to monitor and pass judgment on creative endeavors. A related question is whether the acceptability of a work should be a criterion in determining the public funding of art.

Two exhibits in 1989 placed the National Endowment for the Arts (NEA), a government agency charged with distributing federal funds to support the arts, squarely in the middle of this debate. One of the exhibitions, devoted to recipients of the Awards for the Visual Arts (AVA), took place at the Southeastern Center for Contemporary Art in North Carolina. Among the award winners was Andres Serrano, whose Piss Christ, a photograph of a crucifix submerged in urine, sparked an uproar. Responding to this artwork, Reverend Donald Wildmon, an evangelical minister from Mississippi and head of the American Family Association, expressed outrage that such work was in an exhibition funded by the NEA and the Equitable Life Assurance Society (a sponsor of the AVA). He demanded that the work be removed and launched a letter-writing campaign that led Equitable Life to cancel its sponsorship of the awards. To Wildmon and other staunch conservatives, this exhibition, along with the Robert Mapplethorpe: The Perfect Moment show, served as evidence of cultural depravity and immorality, which they insisted should not be funded by government agencies such as the NEA. Mapplethorpe was a photographer well known for his elegant, spare photographs of flowers and vegetables as well as his erotic, homosexually oriented images. As a result of media furor over The Perfect Moment, the director of the Corcoran Museum of Art canceled the scheduled exhibition of this traveling show. But the director of the Contemporary Arts Center in Cincinnati decided to mount the show. The government indicted him on charges of obscenity, but a jury acquitted him six months later.

These controversies intensified public criticism of the NEA and its funding practices. The next year, the head of the NEA, John Frohnmayer, vetoed grants for four lesbian, gay, or feminist performance artists—Karen Finley, John Fleck, Holly Hughes, and Tim Miller—who became known as the "NEA Four." Infuriated by what they perceived as overt censorship, the artists filed suit, eventually settling the case and winning reinstatement of their grants. Congress responded by dramatically reducing the NEA's budget, and the agency no longer awards grants or fellowships to individual artists.

Controversies have also erupted on the municipal level. In 1999, Rudolph Giuliani, then mayor of New York, joined a number of individuals and groups protesting the inclusion of several artworks in the exhibition *Sensation: Young British Artists from the Saatchi Collec*-

25-44 Chris Ofili, *The Holy Virgin Mary*, 1996. Paper collage, oil paint, glitter, polyester resin, map pins, elephant dung on linen, $7'11'' \times 5'11\frac{5}{16}''$. Saatchi Collection, London.

Ofili, a British-born Catholic of Nigerian descent, represented the Virgin Mary with African elephant dung on one breast and surrounded by genitalia and buttocks. The painting produced a public outcry.

tion at the Brooklyn Museum. Chris Ofili's *The Holy Virgin Mary* (FIG. 25-44), a collage of Mary incorporating cutouts from pornographic magazines and shellacked clumps of elephant dung, became the flashpoint for public furor. Denouncing the show as "sick stuff," the mayor threatened to cut off all city subsidies to the museum.

Art that seeks to unsettle and challenge is critical to the cultural, political, and psychological life of a society. The regularity with which such art raises controversy suggests that it operates at the intersection of two competing principles: free speech and artistic expression on the one hand and a reluctance to impose images upon an audience that finds them repugnant or offensive on the other. What these controversies do demonstrate, beyond doubt, is the enduring power of art.

components so as to diminish immediate identifiability, the sculptures still retain a haunting connection to the overall theme. These works refer to a historical act that evokes a collective memory of oppression, but they also speak to the continuing struggle for civil rights and an end to racism. While growing up in Los Angeles,

Edwards experienced racial conflict firsthand. Among the metal objects incorporated into his *Lynch Fragments* sculptures are items he found in the streets in the aftermath of the Watts riots in 1965. The inclusion of these found objects imbued his disquieting, haunting works with an even greater intensity.

25-45 DAVID HAMMONS, *Public Enemy*, installation at Museum of Modern Art, New York, 1991. Photographs, balloons, sandbags, guns, and other mixed media.

Hammons intended this multimedia installation, with Theodore Roosevelt flanked by an African American and a Native American as servants, to reveal the racism embedded in America's cultural heritage.

CHRIS OFILI Another contemporary artist who has explored his ethnic and racial heritage in his art is CHRIS OFILI (b. 1968). One theme Ofili has treated is religion, interpreted through the eyes of a British-born Catholic of Nigerian descent. Ofili's The Holy Virgin Mary (FIG. 25-44) depicts Mary in a manner that departs radically from conventional Renaissance representations. Ofili's work presents the Virgin in simplified form, and she appears to float in an indeterminate space. The artist employed brightly colored pigments, applied to the canvas in multiple layers of beadlike dots (inspired by images from ancient caves in Zimbabwe). Surrounding the Virgin are tiny images of genitalia and buttocks cut from pornographic magazines, which, to the artist, parallel the putti that often surround Mary in Renaissance paintings. Another reference to Ofili's African heritage surfaces in the clumps of elephant dung—one attached to the Virgin's breast, and two more on which the canvas rests, serving as supports. The dung allowed Ofili to incorporate Africa into his work in a literal way. Still, he wants the viewer to move beyond the cultural associations of the materials and see those materials in new ways.

Not surprisingly, *The Holy Virgin Mary* has elicited strong reactions. Its inclusion in *Sensation* at the Brooklyn Museum in 1999 prompted indignant demands for cancellation of the show and countercharges of censorship (see "Public Funding of Controversial Art," page 772).

DAVID HAMMONS Nurturing viewer introspection is the driving force behind the art of DAVID HAMMONS (b. 1943). In his *installations* (artworks creating an artistic environment in a room or gallery), he combines sharp social commentary with beguiling sensory elements to push viewers to confront racism in American society. He created *Public Enemy* (FIG. **25-45**) for an exhibition at the Museum of Modern Art in New York in 1991. Hammons enticed viewers to interact with the installation by scattering fragrant autumn leaves on the floor and positioning helium-filled balloons

throughout the gallery. The leaves crunched underfoot, and the dangling strings of the balloons gently brushed spectators walking around the installation. Once drawn into the environment, viewers encountered the central element in *Public Enemy*—large black-and-white photographs of a public monument depicting President Theodore Roosevelt (1858–1919) triumphantly seated on a horse, flanked by an African American man and a Native American man, both appearing in the role of servants. Around the edge of the installation, circling the photographs of the monument, were piles of sandbags with both real and toy guns propped on top, aimed at the statue. By selecting evocative found objects and presenting them in a dynamic manner that encouraged viewer interaction, Hammons attracted an audience and then revealed the racism embedded in received cultural heritage. In this way, he prompted reexamination of American values and cultural emblems.

JAUNE QUICK-TO-SEE SMITH Another contemporary artist who has explored the politics of identity is JAUNE QUICK-TO-SEE SMITH (b. 1940), a Native American artist descended from the Shoshone, the Salish, and the Cree tribes and raised on the Flatrock Reservation in Montana. Quick-to-See Smith's native heritage has always informed her art, and her concern about the invisibility of Native American artists has led her to organize exhibitions of their art. Yet she has acknowledged a wide range of influences, including "pictogram forms from Europe, the Amur [the river between Russia and China], the Americas; color from beadwork, parfleches [hide cases], the landscape; paint application from Cobra art, New York expressionism, primitive art; composition from Kandinsky, Klee or Byzantine art." She has even compared her use of tribal images to that of the Abstract Expressionists.

Despite the myriad references and visual material in Quick-to-See Smith's art, her work displays coherence and power, and, like many other artists who have explored issues associated with identity, she 25-46 Jaune Quick-to-See Smith, *Trade* (*Gifts for Trading Land with White People*), 1992. Oil and mixed media on canvas, 5' × 14' 2". Chrysler Museum of Art, Norfolk.

Quick-to-See Smith's mixedmedia canvases are full of references to her Native American identity. Some of the elements refer to the controversy surrounding sports teams that have American Indian names.

1 ft.

challenges stereotypes and unacknowledged assumptions. *Trade* (*Gifts for Trading Land with White People*; FIG. **25-46**) is a large-scale painting with collage elements and attached objects, reminiscent of a Rauschenberg combine (FIG. **25-22**). The painting's central image, a canoe, appears in an expansive field painted in loose Abstract Expressionist fashion and covered with clippings from Native American newspapers. Above the painting, as if hung from a clothesline, is an array of objects. These include Native American artifacts, such as beaded belts and feather headdresses, and contemporary sports memorabilia from teams with American Indian—derived names—the Cleveland Indians, Atlanta Braves, and Washington Redskins. The inclusion of these contemporary objects immediately recalls the vocal opposition to these names and to acts such as the Braves' "tomahawk chop." Like Edwards, Quick-to-See Smith uses the past to comment on the present.

LEON GOLUB In his paintings, American artist LEON GOLUB (1922–2004) expressed a brutal vision of contemporary life through a sophisticated reading of the news media's raw data. His best-known work deals with violent events of recent decades—the narratives people have learned to extract from news photos of anonymous characters participating in atrocious street violence, terrorism, and

25-47 LEON GOLUB, *Mercenaries IV*, 1980. Acrylic on linen, 10′ × 19′ 2″. Courtesy Ronald Feldman Fine Arts. Art © Leon Golub/Licensed

The violence of contemporary life is the subject of Golub's huge paintings. Here, five mercenaries loom over the viewer, instilling a feeling of peril. The rough textures reinforce the raw imagery.

by VAGA, New York.

torture. Paintings in Golub's *Assassins* and *Mercenaries* series suggest not specific stories but a condition of being. As the artist said,

Through media we are under constant, invasive bombardment of images—from all over—and we often have to take evasive action to avoid discomforting recognitions.... The work [of art] should have an edge, veering between what is visually and cognitively acceptable and what might stretch these limits as we encounter or try to visualize the real products of the uses of power.³⁰

Mercenaries IV (FIG. 25-47), a huge canvas, represents a mysterious tableau of five tough freelance military professionals willing to fight, for a price, for any political cause. The three clustering at the right side of the canvas react with tense physical gestures to something one of the two other mercenaries standing at the far left is saying. The dark uniforms and skin tones of the four black fighters flatten their figures and make them stand out against the searing dark red background. The slightly modulated background seems to push their forms forward up against the picture plane and becomes an echoing void in the space between the two groups. Golub painted the mercenaries so that the viewer's eye is level with the menacing figures' knees. He placed the men so close to the front plane of the

1 ++

25-48 David Wojnarowicz, "When I put my hands on your body," 1990. Gelatin-silver print and silk-screened text on museum board, 2' 2" × 3' 2". Private collection.

In this disturbing yet eloquent print, Wojnarowicz overlaid typed commentary on a photograph of skeletal remains. He movingly communicated his feelings about watching a loved one die of AIDS.

work that the lower edge of the painting cuts off their feet, thereby trapping the viewer in the painting's compressed space. Golub emphasized both the scarred light tones of the white mercenary's skin and the weapons. Modeled with shadow and gleaming highlights, the guns contrast with the harshly scraped, flattened surfaces of the figures. The rawness of the canvas reinforces the rawness of the imagery. Golub often dissolved certain areas with solvent after applying pigment and scraped off applied paint with, among other tools, a meat cleaver. The feeling of peril confronts viewers mercilessly. They become one with all the victims caught in today's political battles.

DAVID WOJNAROWICZ As a gay activist and as someone who had lost many friends to AIDS (acquired immune deficiency syndrome), DAVID WOJNAROWICZ (1955–1992) created disturbing yet eloquent works about the tragedy of this disease. (Wojnarowicz himself died of AIDS.) In "When I put my hands on your body" (FIG. **25-48**), he overlaid a photograph of a pile of skeletal remains with evenly spaced typed commentary that communicated his feelings about watching a loved one dying of AIDS. Wojnarowicz movingly described the effects of AIDS on the human body and soul. He juxtaposed text with imagery, which, like the works of Barbara Kruger (FIG. **25-36**) and Lorna Simpson (FIG. **25-42**), paralleled the use of both words and images in advertising. The public's familiarity with this format ensured greater receptivity to the artist's message.

KRZYSZTOF WODICZKO When working in Canada in 1980, Polish-born artist Krzysztof Wodiczko (b. 1943) developed artworks involving outdoor slide images. He projected photographs on specific buildings to expose how civic buildings embody, legitimize, and perpetuate power. When Wodiczko moved to New York City in 1983, the pervasive homelessness troubled him, and he resolved to use his art to publicize this problem. In 1987 he produced *The Homeless Projection* (Fig. 25-49) as part of a New Year's celebration in Boston. The artist projected images of homeless people on all four sides of the Soldiers and Sailors Civil War Memorial on the Boston Common. In these photos, plastic bags filled with their few possessions flanked the people depicted. At the top of the monument, Wodiczko projected a local condominium construction site, which helped viewers make a connection between urban development and homelessness.

25-49 Krzysztof Wodiczko, *The Homeless Projection*, 1986. Outdoor slide projection at the Soldiers and Sailors Civil War Memorial, Boston.

To publicize their plight, Wodiczko projected on the walls of a monument on the Boston Common images of homeless people and their plastic bags filled with their few possessions.

25-50 MAGDALENA ABAKANOWICZ, 80 Backs, 1976–1980. Burlap and resin, each 2' 3" high. Museum of Modern Art, Dallas.

Polish fiber artist Abakanowicz explored the stoic, everyday toughness of the human spirit in this group of nearly identical sculptures that serve as symbols of distinctive individuals lost in the crowd.

MAGDALENA ABAKANOWICZ The stoic, everyday toughness of the human spirit has been the subject of Polish fiber artist Magdalena Abakanowicz (b. 1930). A leader in the recent exploration in sculpture of the expressive powers of weaving techniques, Abakanowicz gained fame with experimental freestanding pieces in both abstract and figural modes. For Abakanowicz, fiber materials are deeply symbolic:

I see fiber as the basic element constructing the organic world on our planet, as the greatest mystery of our environment. It is from fiber that all living organisms are built—the tissues of plants and ourselves. . . . Fabric is our covering and our attire. Made with our hands, it is a record of our souls.³¹

To all of her work, Abakanowicz brought the experiences of her early life as a member of an aristocratic family disturbed by the dislocations of World War II and its aftermath. Initially attracted to weaving as a medium that would adapt well to the small studio space she had available, Abakanowicz gradually developed huge abstract hangings she called Abakans that suggest organic spaces as well as giant pieces of clothing. She returned to a smaller scale with works based on human forms-Heads, Seated Figures, and Backs-multiplying each type for exhibition in groups as symbols for the individual in society lost in the crowd yet retaining some distinctiveness. This impression is especially powerful in an installation of 80 Backs (FIG. 25-50). Abakanowicz made each piece by pressing layers of natural organic fibers into a plaster mold. Every sculpture depicts the slumping shoulders, back, and arms of a figure of indeterminate sex and rests legless directly on the floor. The repeated pose of the figures in 80 Backs suggests meditation, submission, and anticipation. Although made from a single mold, the figures achieve a touch-

25-51 JEFF KOONS, *Pink Panther*, 1988. Porcelain, 3' $5'' \times 1'$ $8\frac{1}{2}'' \times 1'$ 7''. Museum of Contemporary Art, Chicago (Gerald S. Elliot Collection).

In the 1980s Koons created sculptures that highlight everything wrong with contemporary American consumer culture. In this work, he intertwined a centerfold nude and a cartoon character.

ing sense of individuality because each assumed a slightly different posture as the material dried and because the artist imprinted a different pattern of fiber texture on each.

JEFF KOONS While many contemporary artists have pursued personally meaningful agendas in their art, others have addressed society-wide concerns, for example, postmodern commodity culture. American Jeff Koons (b. 1955), who was a commodities broker before turning to art, first became prominent in the art world for a series of works in the early 1980s that involved exhibiting common purchased objects such as vacuum cleaners. Clearly following in the footsteps of artists such as Marcel Duchamp (FIG. 24-27) and Andy Warhol (FIG. 25-24), Koons made no attempt to manipulate or alter the objects. More recently, he has produced porcelain sculptures, such as Pink Panther (FIG. 25-51), in which he continued his immersion in contemporary mass culture by intertwining a magazine centerfold nude with a famous cartoon character. Koons reinforced the trite and kitschy nature of this imagery by titling the exhibition of which this work was a part The Banality Show. Some art critics have argued that Koons and his work instruct viewers because both

25-52 Robert Arneson, California Artist, 1982. Glazed stoneware, 5' $8\frac{1}{4}'' \times 2' 3\frac{1}{2}'' \times 1' 8\frac{1}{4}''$. San Francisco Museum of Modern Art, San Francisco (gift of the Modern Art Council). Art © Estate of Robert Arneson/Licensed by VAGA, New York.

Underscoring the importance of art critics in the contemporary art world, Arneson produced this self-portrait incorporating all the stereotypes a New York Times critic attributed to California artists.

artist and work serve as the most visible symbols of everything that is wrong with contemporary American society. Whether or not this is true, Koons's prominence in the art world indicates that he, like Warhol before him, has developed an acute understanding of the dynamics of consumer culture.

ROBERT ARNESON During his career, ROBERT ARNESON (1930–1992) developed a body of work of predominantly figural ceramic sculpture, often satirical or amusing and sometimes biting. In 1981 the influential New York Times art critic Hilton Kramer (b. 1928) published a review of an exhibition that included a scathing assessment of the artist's work. Arneson, who spent his life in a small town north of San Francisco, created California Artist (FIG. 25-52) as a direct response to Kramer, particularly to the critic's derogatory comments on the provincialism of California art. This ceramic sculpture, a half-length self-portrait, incorporates all of the stereotypes Kramer perpetuated. The artist placed the top half of his likeness on a pedestal littered with beer bottles, cigarette butts, and marijuana plants. Arneson appears clad only in a denim jacket and sunglasses, looking very defiant with his arms crossed. Of course, by creating an artwork that responded directly to Kramer's comments, Arneson validated the importance of art critics in the contemporary art world.

MARK TANSEY This kind of interaction between artists and critics also underscores the self-consciousness on the part of contemporary artists about their place in the continuum of art history. For many postmodern artists, referencing the past is much more than incorporating elements from earlier works and styles in their own art. It involves a critique of or commentary on fundamental art historical premises. In short, their art is about making art.

In his humorous A Short History of Modernist Painting (FIG. 25-53), American artist MARK TANSEY (b. 1949) provides viewers with a tongue-in-cheek summary of the various approaches to painting artists have embraced over the years. Tansey presents a sequence of three images, each visualizing a way of looking at art. At the far left, a glass window encapsulates the Renaissance ideal of viewing art as though one were looking through a window. In the

25-53 Mark Tansey, *A Short History of Modernist Painting*, 1982. Oil on canvas, three panels, each $4'10'' \times 3'4''$. Courtesy Gagosian Gallery, New York.

Tansey's tripartite history of painting includes the Renaissance window onto the world, the modernist insistence on a painting as a flat surface, and postmodern artists' reflections on their place in art history.

25-54 Hans Haacke, MetroMobiltan, 1985. Fiberglass construction, three banners, and photomural, 11' 8" × 20' × 5'. Musée National d'Art Moderne, Centre Georges Pompidou,

MetroMobiltan focuses attention on the connections between political and economic conditions in South Africa and the conflicted politics of corporate patronage of art exhibitions.

center image, a man pushing his head against a solid wall represents the thesis central to much of modernist formalism—that the painting should be acknowledged as an object in its own right. In the image on the right, Tansey summarizes the postmodern approach to art with a chicken pondering its reflection in the mirror. The chicken's action reveals postmodern artists' reflections on their place in the art historical continuum.

HANS HAACKE Along with a conscious reappraisal of the processes of art historical validation, postmodern artists have turned to assessing art institutions, such as museums and galleries, and their role in validating art. Many artists have also scrutinized the discriminatory policies and politics of these cultural institutions. German artist HANS HAACKE (b. 1936) has focused his attention on the politics of art museums and how acquisition and exhibition policies affect the public's understanding of art history. The specificity of his works, based on substantial research, makes them stinging indictments of the institutions whose practices he critiques. In MetroMobiltan (FIG. 25-54), Haacke illustrated the connection between the realm of art (more specifically, the Metropolitan Museum of Art in New York) and the "real" world of political and economic interests. MetroMobiltan is a large sculptural work that includes a photomural of a funeral for South African black people. This photomural serves as the backdrop for a banner for the 1980 Mobil Oil-sponsored Metropolitan Museum show Treasures of Ancient Nigeria. In 1980, Mobil was a principal U.S. investor in South Africa, and Haacke's work suggests that one of the driving forces behind Mobil's sponsorship of this exhibition was the fact that Nigeria was one of the richest oil-producing countries in Africa. In 1981 the public pressured Mobil's board of directors to stop providing oil to the white South African military and police. Printed on the blue banners hanging on either side of Metro-Mobiltan is the official corporate response refusing to comply with this demand. Haacke set the entire tableau in a fiberglass replica of the Metropolitan Museum's entablature. By bringing together these disparate visual and textual elements that make reference to the museum, Mobil Oil, and Africa, the artist forced viewers to think about the connections among multinational corporations, political and economic conditions in South Africa, and the conflicted politics of corporate patronage of art exhibitions, thereby undermining the public's view that cultural institutions are exempt from political and economic concerns.

ARCHITECTURE AND SITE-SPECIFIC ART

Some of the leading architects of the first half of the 20th century, most notably Frank Lloyd Wright (FIGS. 24-77 to 24-79), Le Corbusier (FIG. 24-75), and Ludwig Mies van der Rohe (FIG. 24-74), concluded their long and productive careers in the postwar period. At the same time, younger architects rose to international prominence, some working in the modernist idiom but others taking architectural design in new directions, including postmodernism and Deconstructivism. Still, one common denominator exists in the diversity of contemporary architectural design: the breaking down of national boundaries, with major architects pursuing projects on several continents (MAP 25-1), often simultaneously.

Modernism

In parallel with the progressive movement toward formal abstraction in painting and sculpture in the decades following World War II, modernist architects became increasingly concerned with a formalism that stressed simplicity. They articulated this in buildings that retained intriguing organic sculptural qualities, as well as in buildings that adhered to a more rigid geometry.

FRANK LLOYD WRIGHT The last great building Frank Lloyd Wright designed was the Solomon R. Guggenheim Museum (FIG. 25-55), built in New York City between 1943 and 1959. Using rein-

MAP 25-1 Modernist and postmodernist architecture in Europe and America.

forced concrete almost as a sculptor might use resilient clay, Wright, who often described his architecture as "organic," designed a structure inspired by the spiral of a snail's shell. Wright had introduced curves and circles into some of his plans in the 1930s, and, as the architectural historian Peter Blake noted, "The spiral was the next logical step; it is the circle brought into the third and fourth dimensions." Inside the building (FIGS. 25-1 and 25-85), the shape of the shell expands toward the top, and a winding interior ramp spirals to

connect the gallery bays. A skylight strip embedded in the museum's outer wall provides illumination to the ramp, which visitors can stroll up (or down, if they first take an elevator to the top of the building), viewing the artworks displayed along the gently sloping pathway. Thick walls and the solid organic shape give the building, outside and inside, the sense of turning in on itself, and the long interior viewing area opening onto a 90-foot central well of space creates a sheltered environment, secure from the bustling city outside.

25-55 FRANK LLOYD WRIGHT, Solomon R. Guggenheim Museum, (looking northeast) New York, 1943–1959.

Using reinforced concrete almost as a sculptor might use resilient clay, Wright designed a snail shell—shaped museum with a winding interior ramp for the display of artworks along its gently inclined path (FIGS. 25-1 and 25-85).

25-56 Le Corbusier, Notre-Dame-du-Haut, Ronchamp, France, 1950–1955.

The organic forms of Le Corbusier's mountaintop chapel present a fusion of architecture and sculpture. The architect based the shapes on praying hands, a dove's wings, and a ship's prow.

LE CORBUSIER Compared with his pristine geometric design for Villa Savoye (FIG. 24-75), the organic forms of Le Corbusier's Notre-Dame-du-Haut (FIG. 25-56) come as a startling surprise. Completed in 1955 at Ronchamp, France, the chapel attests to the boundless creativity of this great architect. A fusion of architecture and sculpture, the small chapel, which replaced a

building destroyed in World War II, occupies a pilgrimage site in the Vosges Mountains. The monumental impression of Notre-Damedu-Haut seen from afar is somewhat deceptive. Although one massive exterior wall contains a pulpit facing a spacious outdoor area for large-scale open-air services on holy days, the interior (FIG. **25-57**) holds at most 200 people. The intimate scale, stark and heavy walls, and mysterious illumination (jewel tones cast from the deeply recessed stained-glass windows) give this space an aura reminiscent of a sacred cave or a medieval monastery.

Notre-Dame-du-Haut's structure may look free-form to the untrained eye, but Le Corbusier based it, like the medieval cathedral, on an underlying mathematical system. The builders formed the fabric from a frame of steel and metal mesh, which they sprayed with concrete and painted white, except for two interior private chapel niches with colored walls and the roof, which Le Corbusier wished to have darken naturally with the passage of time. The roof appears to float freely above the sanctuary, intensifying the quality of mystery in the in-

terior space. In reality, a series of nearly invisible blocks holds up the roof. The mystery of the roof's means of support recalls the reaction to Hagia Sophia's miraculously floating dome (FIG. 9-4) a millennium and a half before. Le Corbusier's preliminary sketches for the building indicate he linked the design with the shape of praying hands, with the wings of a dove (representing both peace and the Holy Spirit), and with the prow

25-57 Le Corbusier, interior of Notre-Dame-du-Haut, Ronchamp, France, 1950–1955.

Constructed of concrete sprayed on a frame of steel and metal mesh, the heavy walls of the Ronchamp chapel enclose an intimate and mysteriously lit interior that has the aura of a sacred cave.

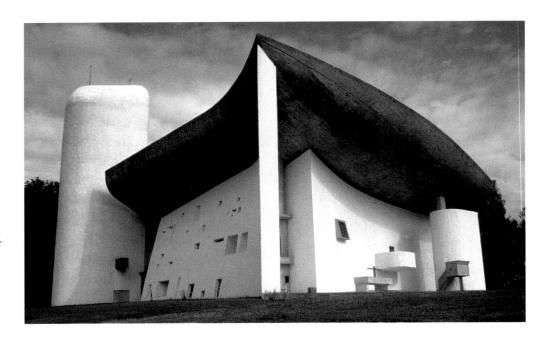

of a ship (a reminder that the Latin word used for the main gathering place in Christian churches is *nave*, meaning "ship"). The artist envisioned that in these powerful sculptural solids and voids, human beings could find new values—new interpretations of their sacred beliefs and of their natural environments.

EERO SAARINEN Dramatic, sweeping, curvilinear rooflines are characteristic features of the buildings designed by Finnish-born architect EERO SAARINEN (1910–1961). One of his signature buildings of the late 1950s is the former Trans World Airlines terminal (FIG. 25-58) at John F. Kennedy International Airport in New York, which Saarinen based on the theme of motion. The terminal consists of two immense concrete shells split down the middle and slightly rotated, giving the building a fluid curved outline that fits its corner site. The shells immediately suggest expansive wings and flight. Saarinen also designed everything on the interior, including the furniture, ventilation ducts, and signboards, with this same curvilinear vocabulary in mind.

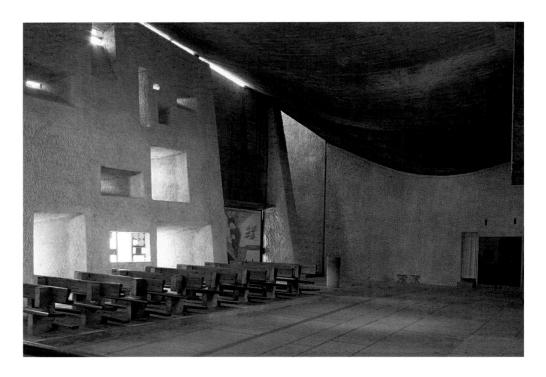

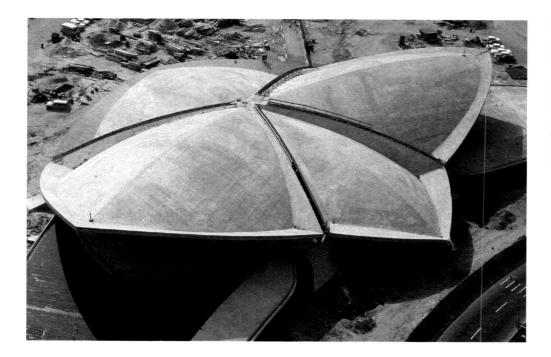

25-58 EERO SAARINEN, Trans World Airlines terminal (terminal 5), John F. Kennedy International Airport, New York, 1956–1962.

Saarinen based the design for this airline terminal on the theme of motion. The concrete-and-glass building's dramatic, sweeping, curvilinear rooflines appropriately suggest expansive wings and flight.

JOERN UTZON Saarinen was responsible for selecting the Danish architect Joern Utzon (b. 1918) to build the Sydney Opera House (FIG. 25-59) in Australia. Utzon's design is a bold composition of organic forms on a colossal scale. Utzon worked briefly with Frank Lloyd Wright at Taliesin (Wright's Wisconsin residence), and the style of the Sydney Opera House resonates distantly with the graceful curvature of Wright's Guggenheim Museum. Two clusters of immense concrete shells—the largest is 200 feet tall—rise from massive platforms and soar to delicate peaks. Recalling at first the ogival shapes of Gothic vaults, the shells also suggest both the buoyancy of seabird wings and the billowing sails of the tall ships that brought European settlers to Australia in the 18th and 19th centuries. These architectural metaphors are appropriate to the harbor surrounding Bennelong Point, whose bedrock foundations support the building. Utzon's matching of the structure with its site and atmosphere adds to the organic nature of the design.

Begun in 1959, completion of the opera house had to wait until 1972, primarily because Utzon's daring design required construc-

tion technology that had not yet been developed. Today the opera house is Sydney's defining symbol, a monument of civic pride that functions as the city's cultural center. In addition to the opera auditorium, the complex houses auxiliary halls and rooms for concerts, the performing arts, motion pictures, lectures, art exhibitions, and conventions.

MIES VAN DER ROHE Sculpturesque building design was not the only manifestation of postwar modernist architecture. From the mid-1950s through the 1970s, other architects created massive, sleek, and geometrically rigid buildings. They designed most of these structures following Bauhaus architect Mies van der Rohe's contention that "less is more." Many of these more "Minimalist" designs are powerful, heroic presences in the urban landscape that effectively symbolize the giant corporations that often inhabit them.

The "purest" example of these corporate skyscrapers is the mid-1950s rectilinear glass-and-bronze Seagram Building (FIG. **25-60**) in Manhattan, designed by Mies van der Rohe and American architect

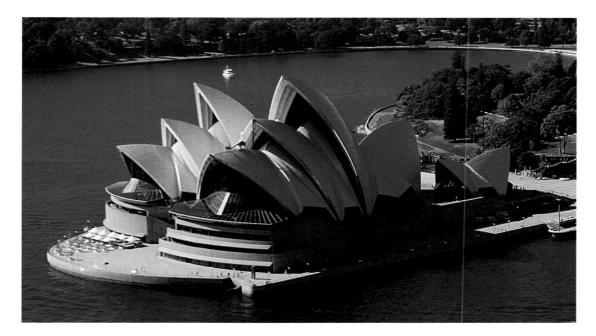

25-59 JOERN UTZON, Sydney Opera House, Sydney, Australia, 1959–1972.

The two soaring clusters of concrete shells of Utzon's opera house on an immense platform in Sydney's harbor suggest both the buoyancy of seabird wings and the billowing sails of tall ships.

25-60 Ludwig Mies van der Rohe and Philip Johnson, Seagram Building, New York, 1956–1958.

Massive, sleek, and geometrically rigid, this modernist skyscraper has a bronze and glass skin that masks its concrete and steel frame. The giant corporate tower appears to rise from the pavement on stilts.

Philip Johnson (FIG. 25-64). By this time, the concrete-steel-andglass towers pioneered by Louis Sullivan (FIGS. 23-40 and 23-41) and carried further by Mies van der Rohe (FIG. 24-74) had become a familiar sight in cities all over the world. Appealing in its structural logic and clarity, the style, easily imitated, quickly became the norm for postwar commercial high-rise buildings. The architects of the Seagram Building (FIG. 25-60) deliberately designed it as a thin shaft, leaving the front quarter of its midtown site as an open pedestrian plaza. The tower appears to rise from the pavement on stilts. Glass walls even surround the recessed lobby. The building's recessed structural elements make it appear to have a glass skin, interrupted only by the thin strips of bronze anchoring the windows. The bronze metal and the amber glass windows give the tower a richness found in few of its neighbors. Mies van der Rohe and Johnson carefully planned every detail of the Seagram Building, inside and out, to create an elegant whole. They even designed the interior and exterior lighting to make the edifice an impressive sight both day and night.

SKIDMORE, OWINGS, AND MERRILL The architectural firm SKIDMORE, OWINGS, AND MERRILL (SOM), perhaps the purest proponent of Miesian-inspired structures, designed a number of these simple rectilinear glass-sheathed buildings, and SOM's success indicates the popularity of this building type. By 1970 the company employed more than a thousand architects and had offices in New York, Chicago, San Francisco, Portland, and Washington, D.C. In 1974 the firm completed the Sears Tower (FIG. 25-61), a mammoth corporate building in Chicago. Consisting of nine clustered shafts

25-61 Skidmore, Owings and Merrill, Sears Tower, Chicago, 1974.

Consisting of nine black aluminum and smoked glass shafts soaring to 110 stories, the Sears Tower dominates Chicago's skyline. It was the tallest building in the world at the time of its erection.

soaring vertically, this 110-floor building houses more than 12,000 workers. Original plans called for 104 stories, but the architects acquiesced to Sears's insistence on making the building the tallest (measured to the structural top) in the world at the time. The tower's size, coupled with the black aluminum that sheathes it and the smoked glass, establish a dominant presence in a city of many corporate sky-scrapers—exactly the image Sears executives wanted to project.

MAYA YING LIN Often classified as a work of Minimalist sculpture rather than architecture is the Vietnam Veterans Memorial (FIG. 25-62) in Washington, D.C., designed in 1981 by MAYA YING LIN (b. 1960) when she was only 21. The austere, simple memorial, a V-shaped wall constructed of polished black granite panels, begins at ground level at each end and gradually ascends to a height of 10 feet at the center of the V. Each wing is 246 feet long. Lin set the wall into the landscape, enhancing visitors' awareness of descent as they walk along the wall toward the center. The names of the Vietnam War's

Maya Lin's Vietnam Veterans Memorial

aya Lin's design for the Vietnam Veterans Memorial (FIG. 25-62) is, like Minimalist sculptures (FIGS. 25-15 and 25-16), an unadorned geometric form. Yet the monument, despite its serene simplicity, actively engages viewers in a psychological dialogue, rather than standing mute. This dialogue gives visitors the opportunity to explore their feelings about the Vietnam War and perhaps arrive at some sense of closure.

The history of the Vietnam Veterans Memorial provides dramatic testimony to this monument's power. In 1981 a jury of architects, sculptors, and landscape architects selected Lin's design in a blind competition for a memorial to be placed in Constitution Gardens in Washington, D.C. Conceivably, the jury not only found her design compelling but also thought its simplicity would be the least likely to provoke controversy. But when the jury made its selection public, heated debate ensued. Even the wall's color came under attack. One veteran charged that black is "the universal color of shame, sorrow and degradation in all races, all societies worldwide."* But the sharpest protests concerned the form and siting of the monument. Because of the stark contrast between the massive white memorials (the Washington Monument and the Lincoln Memorial) bracketing Lin's sunken wall, some people saw her Minimalist design as minimizing the Vietnam War and, by extension, the efforts of those who fought in the conflict. Lin herself, however, described the wall as follows:

The Vietnam Veterans Memorial is not an object inserted into the earth but a work formed from the act of cutting open the earth and polishing the earth's surface—dematerializing the stone to pure surface, creating an interface between the world of the light and the quieter world beyond the names.

Due to the vocal opposition, a compromise was necessary to ensure the memorial's completion. The Commission of Fine Arts, the federal group overseeing the project, commissioned an additional memorial from artist Frederick Hart (1943–1999) in 1983. This larger-than-life-size realistic bronze sculpture of three soldiers, armed and in uniform, now stands approximately 120 feet from Lin's wall. Several years later, a group of nurses, organized as the Vietnam Women's Memorial Project, gained approval for a sculpture honoring women's service in the Vietnam War. The seven-foot-tall bronze statue by Glenna Goodacre (b. 1939) depicts three female figures, one cradling a wounded soldier in her arms. Unveiled in 1993, the work occupies a site about 300 feet south of the Lin memorial.

Whether celebrated or condemned, the Vietnam Veterans Memorial generates dramatic responses. Commonly, visitors react very emotionally, even those who know none of the soldiers named on the monument. The polished granite surface prompts individual soulsearching—viewers see themselves reflected among the names. Many visitors leave mementos at the foot of the wall in memory of loved ones they lost in the Vietnam War or make rubbings from the incised names. Arguably, much of this memorial's power derives from its Minimalist simplicity. Like Minimalist sculpture, it does not dictate response and therefore successfully encourages personal exploration.

[†] Excerpt from an unpublished 1995 lecture, quoted in Kristine Stiles and Peter Selz, *Theories and Documents of Contemporary Art: A Sourcebook of Artists' Writings* (Berkeley and Los Angeles: University of California Press, 1996), 525.

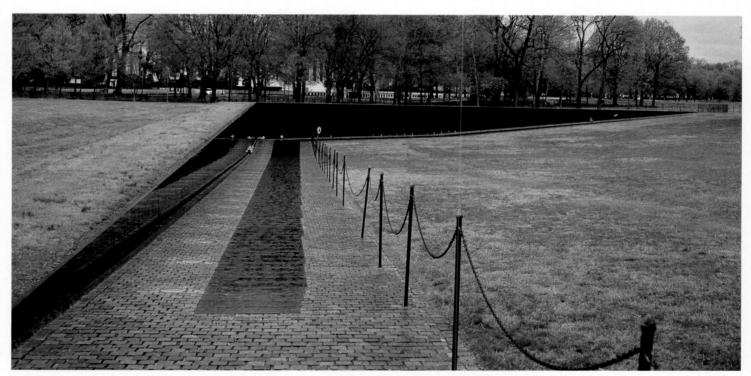

25-62 Maya Ying Lin, Vietnam Veterans Memorial (looking southwest), Washington, D.C., 1981-1983.

Like Minimalist sculpture, Lin's memorial to the veterans of Vietnam is a simple geometric form. Its inscribed polished walls actively engage the viewer in a psychological dialogue about the war.

^{*} Elizabeth Hess, "A Tale of Two Memorials," *Art in America* 71, no. 4 (April 1983),

57,939 casualties (and those still missing) incised on the memorial's walls, in the order of their deaths, contribute to the monument's dramatic effect.

When Lin designed this pristinely simple monument, she gave a great deal of thought to the purpose of war memorials. She concluded that a memorial

should be honest about the reality of war and be for the people who gave their lives. . . . [I] didn't want a static object that people would just look at, but something they could relate to as on a journey, or passage, that would bring each to his own conclusions. . . . I wanted to work with the land and not dominate it. I had an impulse to cut open the earth . . . an initial violence that in time would heal. The grass would grow back, but the cut would remain. 33

In light of the tragedy of the war, this unpretentious memorial's allusion to a wound and long-lasting scar contributes to its communicative ability (see "Maya Lin's Vietnam Veterans Memorial," page 783).

Postmodernism

The restrictiveness of modernist architecture and the impersonality and sterility of many modernist structures eventually led to a rejection of modernism's authority in architecture. Along with the apparent lack of responsiveness to the unique character of the cities and neighborhoods in which modernist architects erected their buildings, these reactions ushered in postmodernism, one of the most dramatic developments in later-20th-century architecture as in contemporary painting and sculpture. Postmodernism in architecture is also not a unified style. It is a widespread cultural phenomenon that is far more encompassing and accepting than the more rigid confines of modernist practice. In contrast to the simplicity of modernist architecture, the terms most often invoked to describe postmodern architecture are pluralism, complexity, and eclecticism. Whereas the modernist program was reductive, the postmodern vocabulary of the 1970s and 1980s was expansive and inclusive.

Among the first to explore this new direction in architecture were Jane Jacobs (1916–2006) and Robert Venturi (FIG. 25-66). In

their influential books *The Death and Life of Great American Cities* (Jacobs, 1961) and *Complexity and Contradiction in Architecture* (Venturi, 1966), Jacobs and Venturi argued that the uniformity and anonymity of modernist architecture (in particular, the corporate skyscrapers dominating many urban skylines) were unsuited to human social interaction and that diversity was the great advantage of urban life. Postmodern architects accepted, indeed embraced, the messy and chaotic nature of urban life.

When designing these varied buildings, many postmodern architects consciously selected past architectural elements or references and juxtaposed them with contemporary elements or fashioned them of high-tech materials, thereby creating a dialogue between past and present. Postmodern architecture incorporates not only traditional architectural references but references to mass culture and popular imagery as well. This was precisely the "complexity and contradiction" Venturi referred to in the title of his book.

CHARLES MOORE A clear example of the eclecticism and the dialogue between traditional and contemporary elements found in postmodern architecture is the Piazza d'Italia (FIG. **25-63**) by American architect Charles Moore (1925–1993). Designed in the late 1970s in New Orleans, the Piazza d'Italia is an open plaza dedicated to the city's Italian-American community. Appropriately, Moore selected elements relating specifically to Italian history, dating all the way back to ancient Roman culture.

Backed up against a contemporary high-rise and set off from urban traffic patterns, the Piazza d'Italia can be reached on foot from three sides through gateways of varied design. The approaches lead to an open circular area partially formed by short segments of colonnades arranged in staggered concentric arcs, which direct the eye to the focal point of the composition—an *exedra*. This recessed area on a raised platform serves as a *rostrum* (speaker's platform) during the annual festivities of Saint Joseph's Day. Moore inlaid the piazza's pavement with a map of Italy centered on Sicily, from which the majority of the city's Italian families originated. From there, the map's Italian "boot" moves in the direction of the steps that ascend the rostrum and correspond to the Alps.

25-63 CHARLES MOORE, Piazza d'Italia, New Orleans, Louisiana, 1976–1980.

Moore's circular postmodern Italian plaza incorporates elements drawn from ancient Roman architecture with the instability of Mannerist designs and modern stainless-steel columns with neon collars.

Philip Johnson on Postmodern Architecture

hilip Johnson, who died in 2005 at age 98, had a distinguished career that spanned almost the entire 20th century, during which he transformed himself from a modernist closely associated with Mies van der Rohe (FIG. 25-60) into one of the leading postmodernists, whose AT&T Building (FIG. 25-64) in New York City remains an early icon of postmodernism. The following remarks illustrate Johnson's thoughts about his early "Miesian" style and about the incorporation of various historical styles in postmodernist buildings.

My eyes are set by the Miesian tradition The continuity with my Miesian approach also shows through in my classicism. . . . [But in] 1952, about the same time that my whole generation did, I became very restless. . . . In the last decade there has been such a violent switch that it is almost embarrassing. But it isn't a switch, so much as a centrifugal splintering of architecture, to a degree that I don't think has been seen in the past few hundred years. Perfectly responsible architects build, even in one year, buildings that you cannot believe are done by the same person.*

Structural honesty seems to me one of the bugaboos that we should free ourselves from very quickly. The Greeks with their marble columns imitating wood, and covering up the roofs inside! The Gothic designers with their wooden roofs above to protect their delicate vaulting. And Michelangelo, the greatest architect in history, with his Mannerist column! There is only one absolute today and this is change. There are no rules, surely no certainties in any of the arts. There is only the feeling of a wonderful freedom, of endless possibilities to investigate, of endless past years of historically great buildings to enjoy.†

* Quoted in Paul Heyer, Architects on Architecture: New Directions in America (New York: Van Nostrand Reinhold, 1993), 285–286.

† Ibid., 279.

25-64 PHILIP JOHNSON and JOHN BURGEE (with SIMMONS ARCHI-TECTS), AT&T (now Sony) Building, New York, 1978–1984.

In a startling shift of style, modernist Johnson (FIG. 25-60) designed this postmodernist skyscraper with more granite than glass and with a variation on a classical pediment as the crowning motif.

The piazza's most immediate historical reference is to the Roman forum (FIGS. 7-12 and 7-43). However, its circular form alludes to the ideal geometric figure of the Renaissance (FIG. 17-22). The irregular placement of the concentrically arranged colonnade fragments inserts a note of instability into the design reminiscent of Mannerism (FIG. 17-54). Illusionistic devices, such as the continuation of the piazza's pavement design (apparently through a building and out into the street), are Baroque in character (FIG. 19-4). Moore incorporated all of the classical orders—most with whimsical modifications. Nevertheless, challenging the piazza's historical character are modern features, such as the stainless-steel columns and capitals, neon collars around the column necks, and neon lights that frame various parts of the exedra.

In sum, Moore designed the Piazza d'Italia as a complex conglomeration of symbolic, historical, and geographic allusions—some overt and others obscure. Although the piazza's specific purpose was to honor the Italian community of New Orleans, its more general purpose was to revitalize an urban area by becoming a focal point and an architectural setting for the social activities of neighborhood residents. Unfortunately, the piazza suffered extensive damage during Hurricane Katrina in 2005. PHILIP JOHNSON Even architects instrumental in the proliferation of the modernist idiom embraced postmodernism. Early in his career, Philip Johnson (1906–2005), for example, had been a leading proponent of modernism and worked with Mies van der Rohe on the design of the Seagram Building (FIG. 25-60). Johnson had even served as the director of the Department of Architecture at New York's Museum of Modern Art, the bastion of modernism, from 1930 to 1934 and from 1946 to 1954. Yet he made one of the most startling shifts of style in 20th-century architecture, eventually moving away from the severe geometric formalism exemplified by the Seagram Building to a classicizing transformation of it in his AT&T (American Telephone and Telegraph) Building (FIG. 25-64)—now the Sony Building—in New York City. Architect John Burgee (b. 1933) codesigned it with assistance from the firm SIMMONS ARCHITECTS. This structure was influential in turning architectural taste and practice away from modernism and toward postmodernism—from organic "concrete sculpture" and the rigid "glass box" to elaborate shapes, motifs, and silhouettes freely adapted from historical styles (see "Philip Johnson on Postmodernist Architecture," above).

The 660-foot-high slab of the AT&T Building is mostly granite. Johnson reduced the window space to some 30 percent of the building,

in contrast to modernist glass-sheathed skyscrapers. His design of its exterior elevation is classically tripartite, having an arcaded base and arched portal; a tall, shaftlike body segmented by slender *mullions* (vertical elements dividing a window); and a crowning pediment broken by an *orbiculum* (a disklike opening). The arrangement refers to the base, column, and entablature system of classical architecture (FIG. 5-14). More specifically, the pediment, indented by the circular space, resembles the crown of a typical 18th-century Chippendale high chest of drawers. It rises among the monotonously flattopped glass towers of the New York skyline as an ironic rebuke to the rigid uniformity of modernist architecture.

MICHAEL GRAVES Philip Johnson at first endorsed, then disapproved of, a building that rode considerably farther on the wave of postmodernism than did his AT&T tower. The Portland Building (FIG. 25-65) by American architect MICHAEL GRAVES (b. 1934) reasserts the wall's horizontality against the verticality of the tall, fenestrated shaft. Graves favored the square's solidity and stability, making it the main body of his composition (echoed in the windows), which rests upon a wider base and carries a set-back penthouse crown. Narrow vertical windows tying together seven stories open two paired facades. These support capital-like large hoods on one pair of opposite facades and a frieze of stylized Baroque roundels tied by bands on the other pair. A huge painted keystone motif joins five upper levels on one facade pair, and painted surfaces further define the building's base, body, and penthouse levels.

The modernist purist surely would not welcome the ornamental wall, color painting, or symbolic reference. These features, taken together, raised an even greater storm of criticism than that which greeted the Sydney Opera House or the AT&T Building. Various critics denounced Graves's Portland Building as "an enlarged jukebox," an "oversized Christmas package," a "marzipan monstrosity," a "histrionic masquerade," and a kind of "pop surrealism." Yet others approvingly noted its classical references as constituting a "symbolic temple" and praised the building as a courageous architectural adventure. Whatever will be history's verdict, the Portland Building, like the AT&T tower, is an early marker of postmodernist innovation that borrowed from the lively, if more-or-less garish, language of pop culture. The night-lit dazzle of entertainment sites such as Las Vegas, and the carnival colors, costumes, and fantasy of theme park props, all lie behind the Portland Building design, which many critics regard as a vindication of architectural populism against the pretension of modernist elitism.

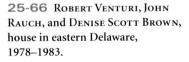

Venturi asserted that form should be separate from function and structure. This rural home has the low profile of a farmhouse, but its facade is an asymmetrical parody of a Neoclassical portico.

25-65 MICHAEL GRAVES, Portland Building, Portland, 1980.

In this early example of postmodern architecture, Graves reasserted the horizontality and solidity of the wall. He drew attention to the mural surfaces through polychromy and ornamental motifs.

ROBERT VENTURI As a coauthor of *Learning from Las Vegas* (1972), Robert Venturi (b. 1925) codified these ideas about populism and postmodernism, and in his designs for houses he adapted historical as well as contemporary styles to suit his symbolic and expressive purpose. A fundamental axiom of modernism is that a building's form must arise directly and logically from its function and structure. Against this rule, Venturi asserted that the form should be separate from function and structure and that decorative and symbolic forms of everyday life should enwrap the structural core. Thus, for a Delaware residence (FIG. **25-66**) designed in 1978 with John Rauch (b. 1930) and Denise Scott Brown (b. 1931), Venturi respected the countryside setting and its 18th-century history by recalling the stone-based barnlike, low-profile farm dwellings with their shingled roofs and double-hung multipaned windows. He fronted the house with an amusingly cut-out and asymmetrical parody of a Neoclassical portico.

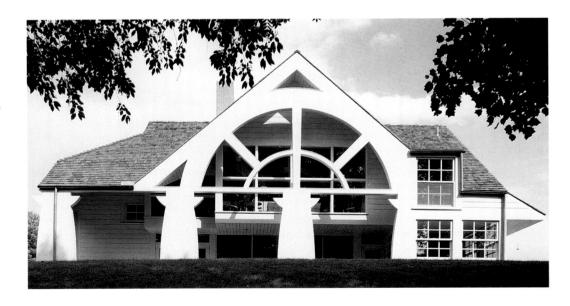

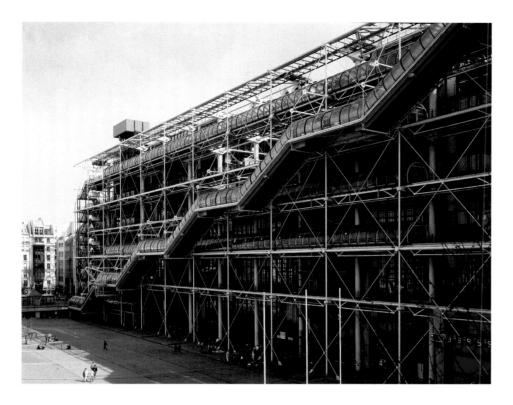

25-67 RICHARD ROGERS and RENZO PIANO, Georges Pompidou National Center of Art and Culture (the "Beaubourg"), Paris, France, 1977.

The architects fully exposed the anatomy of this six-level building, as in the century-earlier Crystal Palace (FIG. 22-48), and color-coded the internal parts according to function, as in a factory.

with visitors since it opened. The flexible interior spaces and the colorful structural body provide a festive environment for the crowds flowing through the building and enjoying its art galleries, industrial design center, library, science and music centers, conference rooms, research and archival facilities, movie theaters, rest areas, and restaurant (which looks down and through the building to the terraces outside). The sloping plaza in front of the main entrance has become part of the local scene. Peddlers, street performers, Parisians, and tourists fill this square at almost all hours of the day and night. The kind of secular

activity that once occurred in the open spaces in front of cathedral entrances now takes place next to a center for culture and popular entertainment.

Deconstructivism

In architecture, as in painting and sculpture, deconstruction as an analytical and design strategy emerged in the 1970s. Architectural Deconstructivism seeks to disorient the observer. To this end, Deconstructivist architects attempt to disrupt the conventional categories of architecture and to rupture the viewer's expectations based on them. Destabilization plays a major role in Deconstructivist architecture. Disorder, dissonance, imbalance, asymmetry, unconformity, and irregularity replace their opposites—order, consistency, balance, symmetry, regularity, and clarity, as well as harmony, continuity, and completeness. The haphazardly presented volumes, masses, planes, borders, lighting, locations, directions, spatial relations, as well as the disguised structural

> facts, challenge the viewer's assumptions about architectural form as it relates to function. According to Deconstructivist principles, the very absence of the stability of traditional categories of architecture in a structure announces a "de-

> **GÜNTER BEHNISCH** Audacious in its dissolution of form, and well along on the path of deconstruction, is the Hysolar Institute (FIG. 25-68) at the University of Stutt-

constructed" building.

gart, Germany. Günter Behnisch (b. 1922)

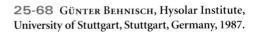

The roof, walls, and windows of this Deconstructivist structure seem to explode, avoiding any suggestion of clear, stable masses and frustrating the observer's expectations of what a building should look like.

ROGERS AND PIANO During their short-lived partnership, British architect RICHARD ROGERS (b. 1933) and Italian architect Renzo Piano (b. 1937) used motifs and techniques from ordinary industrial buildings in their design for the Georges Pompidou National Center of Art and Culture in Paris, known popularly as the "Beaubourg" (FIG. 25-67). The architects fully exposed the anatomy of this six-level building, which is a kind of updated version of the Crystal Palace (FIG. 22-48), and made its "metabolism" visible. They color-coded pipes, ducts, tubes, and corridors according to function (red for the movement of people, green for water, blue for air-conditioning, and yellow for electricity), much as in a sophisticated factory.

Critics who deplore the Beaubourg's vernacular qualities disparagingly refer to the complex as a "cultural supermarket" and point out that its exposed entrails require excessive maintenance to protect them from the elements. Nevertheless, the building has been popular

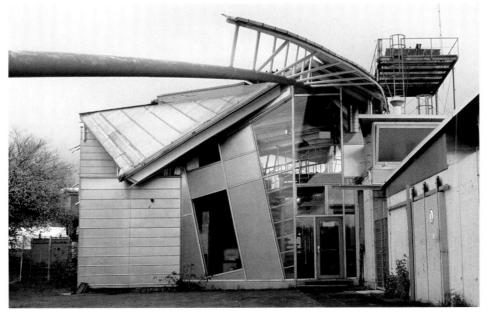

787

Frank Gehry on Architectural Design and Materials

rank Gehry has been designing buildings since the 1950s, but it was only in the 1970s that he began to break away from the rectilinearity of modernist architecture and develop the dramatic sculptural style seen in buildings like the Guggenheim Museum (FIGS. 25-69 and 25-70) in Bilbao. In 1999 the Deconstructivist architect reflected on his career and his many projects in a book titled *Gehry Talks*.

My early work was rectilinear because you take baby steps. I guess the work has become a kind of sculpture as architecture. . . . I'm a strict modernist in the sense of believing in purity, that you shouldn't decorate. And yet buildings need decoration, because they need scaling elements. They need to be human scale, in my opinion. They can't just be faceless things. That's how some modernism failed.*

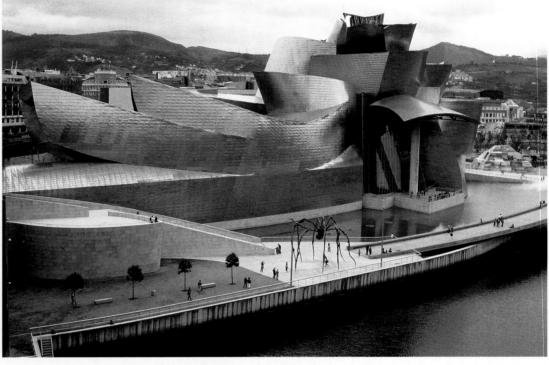

25-69 Frank Gehry, Guggenheim Bilbao Museo, Bilbao, Spain, 1997.

Gehry's limestone-and-titanium Bilbao museum is an immensely dramatic building. Its disorder and seeming randomness of design epitomize Deconstructivist architectural principles.

They teach materials and methods in architecture school, as a separate course. I'm a craftsman. . . . It seems to me that when you're doing architecture, you're building something out of something. There are social issues, there's context, and then there's how do you make the enclosure and what do you make it with? . . . I explored metal: how it dealt with the light It does beautiful things with light. . . . Flat was a fetish, and everybody was doing that. I found out that I could use metal if I didn't worry about it being flat; I could do it cheaper. It was intuitive. I just went with it. I liked it. Then when I

saw it on the building, I loved it.... Bilbao... [is] titanium.... [I] prefer titanium because it's stronger; it's an element, a pure element, and it doesn't oxidize. It stays the same forever. They give a hundred-year guarantee! †

designed it as part of a joint German–Saudi Arabian research project on the technology of solar energy. The architect intended to deny here the possibility of spatial enclosure altogether, and his apparently chaotic arrangement of the units defies easy analysis. The shapes of the Hysolar Institute's roof, walls, and windows seem to explode, avoiding any suggestion of clear, stable masses. Behnisch aggressively played with the whole concept of architecture and the viewer's relationship to it. The disordered architectural elements seem precarious and visually threaten to collapse, frustrating the observer's expectations of what a building should look like.

FRANK GEHRY The architect most closely identified with Deconstructivist architecture is the Canadian-born Frank Gehry (b. 1929). Trained in sculpture, and at different times a collaborator

with Donald Judd (Fig. 25-16) and Claes Oldenburg (Fig. 25-26), Gehry works up his designs by constructing models and then cutting them up and arranging them until he has a satisfying composition. Among Gehry's most notable projects is the Guggenheim Museum (Fig. 25-69) in Bilbao, Spain. The immensely dramatic building appears as a mass of asymmetrical and imbalanced forms, and the irregularity of the main masses—whose profiles change dramatically with every shift of a visitor's position—suggests a collapsed or collapsing aggregate of units. The scaled limestone- and titanium-clad exterior lends a space-age character to the building and highlights further the unique cluster effect of the many forms (see "Frank Gehry on Architectural Design and Materials," above). A group of organic forms that Gehry refers to as a "metallic flower" tops the museum. In the center of the museum, an enormous glass-walled

 $^{^{\}star}$ Milton Friedman, ed., Gehry Talks: Architecture + Process, rev. ed. (New York: Universe, 2002), 47–48.

[†] Ibid., 44, 47.

25-70 Frank Gehry, atrium of Guggenheim Bilbao Museo, Bilbao, Spain, 1997.

The glass-walled atrium of the Guggenheim Bilbao Museum soars to 165 feet in height. The asymmetrical and imbalanced screens and vaults flow into one another, creating a sense of disequilibrium.

atrium (FIG. **25-70**) soars to 165 feet in height, serving as the focal point for the three levels of galleries radiating from it. The seemingly weightless screens, vaults, and volumes of the interior float and flow into one another, guided only by light and dark cues. Overall, the Guggenheim in Bilbao is a profoundly compelling structure. Its disorder, its seeming randomness of design, and the disequilibrium it prompts in viewers epitomize Deconstructivist principles.

DANIEL LIBESKIND Deconstructivist architecture remains very much in vogue today. One of the leading practitioners is Polish-born Daniel Libeskind (b. 1946), whose studio is in Berlin, Germany, but who has, like other successful contemporary architects, erected buildings in several countries, including the United States. Libeskind achieved instant international fame with his design for the reconstructed World Trade Center complex in New York City. More recently, his 146,000-square-foot expansion of the Denver Art Museum (FIG. 25-71) created a sensation when it opened to the public in October 2006. Libeskind has stated that he drew his inspiration for the design from the jagged peaks of Colorado's Rocky Mountains, and the stone-and-titanium structure, despite its kinship with Gehry's Bilbao museum (FIG. 25-69), presents a striking contrast with that building's swelling curves. Tilted walls, asymmetrical shapes, and surprising sequences of spaces engender a sense of disorientation in visitors to the galleries, which, appropriately, house the museum's collection of modern and contemporary art.

25-71 Daniel Libeskind, Denver Art Museum, Denver, Colorado, 2006.

Inspired by the jagged peaks of the Rocky Mountains, Libeskind's expansion of the Denver Art Museum features tilted walls, asymmetrical shapes, and a disorienting sequence of spaces.

Environmental and Site-Specific Art

Like Maya Lin's Vietnam Veterans Memorial (FIG. 25-62), works of Environmental Art, sometimes called earthworks, exist at the intersection of architecture and sculpture. The Environmental Art movement emerged in the 1960s and included a wide range of artworks, most site-specific (created for only one location) and existing outdoors. Many artists associated with these sculptural projects also used natural or organic materials, including the land itself. It is no coincidence that this art form developed during a period of increased concern for the American environment. The ecology movement of the 1960s and 1970s aimed to publicize and combat escalating pollution, depletion of natural resources, and the dangers of toxic waste. The problems of public aesthetics (for example, litter, urban sprawl, and compromised scenic areas) were also at issue. Widespread concern about the environment led to the passage of the U.S. National Environmental Policy Act in 1969 and the creation of the federal Environmental Protection Agency. Environmental artists used their art to call attention to the landscape and, in so doing, were part of this national dialogue.

As an innovative art form that challenged traditional assumptions about art making and artistic models, Environmental Art clearly had an avant-garde, progressive dimension. But like Popartists, Environmental artists insisted on moving art out of the rar-

efied atmosphere of museums and galleries and into the public sphere. Most encouraged spectator interaction with their works. Ironically, the remote locations of many earthworks have limited public access.

ROBERT SMITHSON A leading American Environmental artist was ROBERT SMITHSON (1938-1973), who used industrial construction equipment to manipulate vast quantities of earth and rock on isolated sites. One of Smithson's best-known projects is Spiral Jetty (FIG. 25-72), a mammoth 1,500-foot-long coil of black basalt, limestone rocks, and earth that extends out into the Great Salt Lake in Utah. As he was driving by the lake one day, Smithson came across some abandoned mining equipment, left there by a company that had tried and failed to extract oil from the site. Smithson saw this as a testament to the enduring power of nature and to humankind's inability to conquer it. He decided to create an artwork in the lake that ultimately became a monumental spiral curving out from the shoreline and running 1,500 linear feet into the water. Smithson insisted on designing his work in response to the location itself. He wanted to avoid the arrogance of an artist merely imposing an unrelated concept on the site. The spiral idea grew from Smithson's first impression of the location. Then, while researching the Great Salt Lake, Smithson discovered that the molecular structure of the salt crystals coating the rocks at the water's edge was spiral in form.

25-72 ROBERT SMITHSON, Spiral Jetty, Great Salt Lake, Utah, 1970. Art © Estate of Robert Smithson/Licensed by VAGA, New York.

Smithson used industrial equipment to create Environmental artworks by manipulating earth and rock. Spiral Jetty is a mammoth coil of black basalt, limestone, and earth extending into the Great Salt Lake.

25-73 Christo and Jeanne-Claude, Surrounded Islands 1980-83, Biscayne Bay, Miami, Florida, 1980-1983.

Christo and Jeanne-Claude created this Environmental artwork by surrounding 11 small islands with 6.5 million square feet of pink fabric. Characteristically, the work existed for only two weeks.

As I looked at the site, it reverberated out to the horizons only to suggest an immobile cyclone while flickering light made the entire landscape appear to quake. A dormant earthquake spread into the fluttering stillness, into a spinning sensation without movement. The site was a rotary that enclosed itself in an immense roundness. From that gyrating space emerged the possibility of the Spiral Jetty.³⁴

Smithson not only recorded *Spiral Jetty* in photographs but also filmed its construction in a movie that describes the forms and life of the whole site. The photographs and film have become increasingly important references, because fluctuations in the Great Salt Lake's water level often place *Spiral Jetty* underwater.

CHRISTO AND JEANNE-CLAUDE Like Smithson, Christo and Jeanne-Claude (both b. 1935) seek to intensify the viewer's awareness of the space and features of rural and urban sites. However, rather than physically alter the land itself, as Smithson often did, Christo and Jeanne-Claude prompt this awareness by temporarily modifying the landscape with cloth. Christo studied art in his native Bulgaria and in Vienna. After a move to Paris, he began to encase objects in clumsy wrappings, thereby appropriating bits of the real world into the mysterious world of the unopened package whose contents can be dimly seen in silhouette under the wrap.

Starting in 1961, Christo and Jeanne-Claude, husband and wife, began to collaborate on large-scale projects that normally deal with the environment itself. For example, in 1969 the couple wrapped a million square feet of Australian coast and in 1972 hung a vast curtain across a valley at Rifle Gap, Colorado. Their works of art require years of preparation and research and scores of meetings with local authorities and interested groups of local citizens. These temporary works are usually on view for only a few weeks.

Surrounded Islands 1980-83 (FIG. 25-73), created in Biscayne Bay in Miami, Florida, for two weeks in May 1983, typifies Christo and Jeanne-Claude's work. For this project, they surrounded 11 small human-made islands in the bay (from a dredging project) with 6.5 million square feet of specially fabricated pink polypropylene floating fabric. This Environmental artwork required three years of preparation to obtain the necessary permits and to assemble the labor force and obtain the \$3.2 million needed to complete the project. The artists raised the money by selling preparatory drawings, collages, models, and works they created in the 1950s and 1960s. Huge crowds watched as crews removed accumulated trash from the 11 islands (to assure maximum contrast between their dark colors, the pink of the cloth, and the blue of the bay) and then unfurled the fabric "cocoons" to form magical floating "skirts" around each tiny bit of land. Despite the brevity of its existence, Surrounded Islands 1980-83 lives on in the host of photographs, films, and books documenting the project.

Then Richard Serra installed Tilted Arc (FIG. 25-74) in the plaza in front of the Javits Federal Building in New York City in 1981, much of the public immediately responded with hostile criticism. Prompting the chorus of complaints was the uncompromising presence of a Minimalist sculpture bisecting the plaza. Many argued that Tilted Arc was ugly, that it attracted graffiti, that it interfered with the view across the plaza, and that it prevented using the plaza for performances or concerts. Due to the sustained barrage of protests and petitions demanding the removal of Tilted Arc, the GSA held a series of public hearings. Afterward, the agency decided to remove the sculpture despite its prior approval of Serra's maquette. This, understandably, infuriated Serra, who had a legally binding contract acknowledging the site-specific nature of Tilted Arc. "To remove the work is to destroy the work," the artist stated.*

This episode raised intriguing issues about the nature of public art, including the public reception of experimental art, the

artist's responsibilities and rights when executing public commissions, censorship in the arts, and the purpose of public art. If an artwork is on display in a public space outside the relatively private confines of a museum or gallery, do different guidelines apply? As one participant in the *Tilted Arc* saga asked, "Should an artist have the right to impose his values and taste on a public that now rejects his taste and values?" One of the express functions of the historical avant-garde was to challenge convention by rejecting tradition and disrupting the complacency of the viewer. Will placing experimental art in a public place always cause controversy? From Serra's statements, it is clear he intended the sculpture to challenge the public.

Another issue *Tilted Arc* presented involved the rights of the artist, who in this case accused the GSA of censorship. Serra filed a lawsuit against the government for infringement of his First Amendment rights and insisted that "the artist's work must be uncensored, respected, and tolerated, although deemed abhorrent, or perceived as

Richard Serra's Tilted Arc

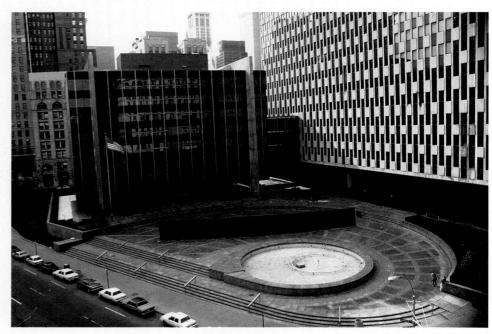

25-74 RICHARD SERRA, Tilted Arc, Jacob K. Javits Federal Plaza, New York City, 1981.

Serra intended his Minimalist *Tilted Arc* to alter the character of an existing public space. He succeeded but unleashed a storm of protest that caused the government to remove the work.

challenging, or experienced as threatening."[‡] Did removal of the work constitute censorship? A federal district court held that it did not.

Ultimately, who should decide what artworks are appropriate for the public arena? One artist argued, "we cannot have public art by plebiscite [popular vote]." But to avoid recurrences of the *Tilted Arc* controversy, the GSA changed its procedures and now solicits input from a wide range of civic and neighborhood groups before commissioning public artworks. Despite the removal of *Tilted Arc* (now languishing in storage), the sculpture maintains a powerful presence in all discussions of the aesthetics, politics, and dynamics of public art.

RICHARD SERRA Other artists have created site-specific works that are not set in nature but in the built environment. Their purpose is to focus attention on art's role in public spaces. One work that sparked national discussion about public art was *Tilted Arc* (FIG. **25-74**) by American artist RICHARD SERRA (b. 1939). The General Services Administration (GSA), the federal agency responsible for, among other tasks, overseeing the selection and installation of artworks for government buildings, commissioned *Tilted Arc*. This enormous 120-foot-long, 12-foot-high curved wall of Cor-Ten steel bisected the plaza in front of the Jacob K. Javits Federal Building in

lower Manhattan. Serra situated the sculpture in a way that significantly altered the space of the open plaza and the traffic flow across the square. He intended *Tilted Arc* to "dislocate or alter the decorative function of the plaza and actively bring people into the sculpture's context."³⁵

By creating such a monumental presence in this large public space, Serra succeeded in forcing viewers to reconsider the plaza's physical space as a sculptural form—but only temporarily, because the public forced the sculpture to be removed (see "Richard Serra's *Tilted Arc*," above).

^{*} Grace Glueck, "What Part Should the Public Play in Choosing Public Art?" New York Times, February 3, 1985, 27.

[†] Calvin Tomkins, "The Art World: Tilted Arc," New Yorker, May 20, 1985, 98.

[‡] Ibid., 98–99.

[§] Ibid., 98.

PERFORMANCE AND CONCEPTUAL ART AND NEW MEDIA

Among the most significant developments in the art world after World War II has been the expansion of the range of works considered "art." Some of the new types of artworks are the result of the invention of new media, such as computers and video cameras. But the new art forms also reflect avant-garde artists' continued questioning of the status quo. For example, in keeping with the modernist critique of artistic principles, some artists, in a spirit reminiscent of Dada and Surrealism (see Chapter 24), developed the fourth dimension—time—as an integral element of their artwork. The term that art historians use to describe these temporal works is *Performance Art*.

Performance Art

Performance artists replace traditional stationary artworks with movements, gestures, and sounds carried out before an audience, whose members may or may not participate in the performance. Generally, documentary photographs taken contemporaneously are the only evidence remaining after these performances. The informal and spontaneous events Performance artists initially staged anticipated the rebellion and youthful exuberance of the 1960s and at first pushed art outside the confines of mainstream art institutions (museums and galleries). Performance Art also served as an antidote to the affectation of most traditional art objects and challenged art's function as a commodity. In the later 1960s, however, museums commissioned performances with increasing frequency, thereby neutralizing much of the subversiveness that characterized this new art form.

JOHN CAGE Many of the artists instrumental in the development of Performance Art were students or associates of the charismatic American teacher and composer John Cage (1912-1992). Cage encouraged his students at both the New School for Social Research in New York and Black Mountain College in North Carolina to link their art directly with life. He brought to music composition some of the ideas of Duchamp and of Eastern philosophy. Cage used methods such as chance to avoid the closed structures marking traditional music and, in his view, separating it from the unpredictable and multilayered qualities of daily existence. For example, the score for one of Cage's piano compositions instructs the performer to appear, sit down at the piano, raise the keyboard cover to mark the beginning of the piece, remain motionless at the instrument for 4 minutes and 33 seconds, and then close the keyboard cover, rise, and bow to signal the end of the work. The "music" would be the unplanned sounds and noises (such as coughs and whispers) emanating from the audience during the "performance."

ALLAN KAPROW One of Cage's students in the 1950s was Allan Kaprow (b. 1927). Schooled in art history as well as music composition, Kaprow sought to explore the intersection of art and life. He believed, for example, that Jackson Pollock's actions when producing a painting (FIG. **25-6**) were more important than the finished painting. This led Kaprow to develop a type of event known as a *Happening*. He described a Happening as

an assemblage of events performed or perceived in more than one time and place. Its material environments may be constructed, taken over directly from what is available, or altered slightly: just as its activities may be invented or commonplace. A Happening, unlike a stage play, may occur at a supermarket, driving along a highway, under a pile of rags, and in a friend's kitchen, either at once or se-

quentially. If sequentially, time may extend to more than a year. The Happening is performed according to plan but without rehearsal, audience, or repetition. It is art but seems closer to life. ³⁶

Happenings were often participatory. One Happening consisted of a constructed setting with partitions on which viewers wrote phrases, while another involved spectators walking on a pile of tires. One of Kaprow's first Happenings, titled 18 Happenings in Six Parts, took place in 1959 at the Reuben Gallery in New York City. For the event, he divided the gallery space into three sections with translucent plastic sheets. Over the course of the 90-minute piece, performers, including Kaprow's artist friends, bounced balls, read from placards, extended their arms like wings, and played records as slides and lights flashed on and off in programmed sequences.

FLUXUS Other Cage students interested in the composer's search to find aesthetic potential in the nontraditional and commonplace formed the *Fluxus* group. Eventually expanding to include European and Japanese artists, this group's performances were more theatrical than Happenings. To distinguish their performances from Happenings, the artists associated with Fluxus coined the term *Events* to describe their work. Events focused on single actions, such as turning a light on and off or watching falling snow—what Fluxus artist La Monte Young (b. 1935) called "the theater of the single event." The Events usually took place on a stage separating the performers from the audience but without costumes or added decor. Events were not spontaneous. They followed a compositional "score," which, given the restricted nature of these performances, was short.

KAZUO SHIRAGA Some artists produced works that involved both painting and performance. Gutai Bijutsu Kyokai (Concrete Art Association), a group of 18 Japanese artists in Osaka, expanded the action of painting into the realm of performance—in a sense, taking Jackson Pollock's painting methods into a public arena. Led by Jiro Yoshihara (1905–1972), Gutai, founded in 1954, devoted itself to art that combined Japanese traditional practices such as Zen with a renewed appreciation for materials. In the *Gutai Art Manifesto*, Yoshihara explained: "Gutai does not alter the material. Gutai imparts life to the material. . . . [T]he human spirit and the material shake hands with each other, but keep their distance." Accordingly, Gutai works, for example, *Making a Work with His Own Body* (FIG. 25-75), by

25-75 Kazuo Shiraga, *Making a Work with His Own Body*, 1955. Mud. The Performance artists of the Japanese Gutai Bijutsu Kyokai (Concrete Art Association) expanded action painting into the realm of performance. Shiraga used his body to "paint" with mud.

Carolee Schneemann on Painting, Performance Art, and Art History

arolee Schneemann (FIG. 25-76), one of the pioneering Performance artists of the 1960s, also produced works in other media. In notes she wrote in 1962–1963, Schneemann contrasted her Performance works with more traditional art forms.

Environments, happenings—concretions—are an extension of my painting-constructions which often have moving (motorized) sections.... [But, the] steady exploration and repeated viewing which the eye is required to make with my painting-constructions is reversed in the performance situation where the spectator is overwhelmed with changing recognitions, carried emotionally by a flux of evocative actions and led or held by the specified time sequence which marks the duration of a performance. In this way the audience is actually *visually* more *passive* than when confronting a ... "still" work With paintings, constructions and sculptures the viewers are able to carry out repeated examinations of the work, to select and vary viewing positions (to walk with the eye), to touch surfaces and to freely indulge responses to areas of color and texture at their chosen speed.*

Readers of this book will also take special interest in Schneemann's 1975 essay entitled "Woman in the Year 2000," in which she envisioned what introductory art history courses would be like at the beginning of the 21st century:

By the year 2000 [every] young woman will study Art Istory [sic] courses enriched by the inclusion, discovery, and re-evaluation of works by women artists: works (and lives) until recently buried away, willfully destroyed, [or] ignored.[†]

A comparison between this 13th edition of *Art through the Ages* and editions published in the 1960s and 1970s will immediately reveal the accuracy of Schneemann's prediction.

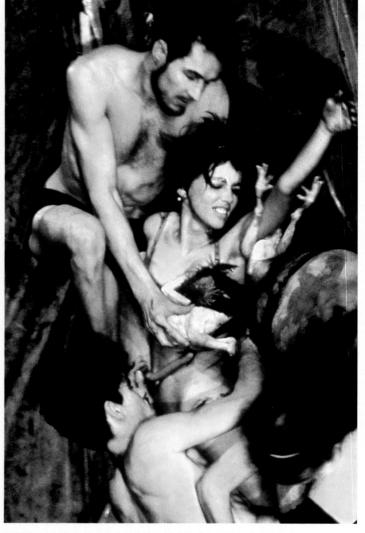

25-76 CAROLEE SCHNEEMANN, *Meat Joy*, 1964. Performance at Judson Church, New York City.

In her performances, Schneemann transformed the nature of Performance art by introducing a feminist dimension through the use of her body (often nude) to challenge traditional gender roles.

KAZUO SHIRAGA (b. 1924), involved such actions as throwing paint balls at blank canvases or wallowing in mud as a means of shaping it. In *Making a Work*, Shiraga used his body to "paint" with mud. The Gutai group dissolved upon Yoshihara's death in 1972.

CAROLEE SCHNEEMANN Like Gutai, CAROLEE SCHNEEMANN (b. 1939) integrated painting and performance in her artworks (see "Carolee Schneemann on Painting, Performance Art, and Art History," above). Her self-described "kinetic theater" radically transformed the nature of Performance Art by introducing a feminist dimension through the use of her body (often nude) to challenge "the psychic territorial power lines by which women were admitted to the Art Stud Club." In her 1964 performance *Meat Joy* (FIG. 25-76), Schneemann reveled in the taste, smell, and feel of raw sausages, chickens, and fish.

JOSEPH BEUYS The leftist politics of the Fluxus group in the early 1960s strongly influenced German artist Joseph Beuys (1921–1986). Drawing on Happenings and Fluxus, Beuys created actions aimed at illuminating the condition of modern humanity. He wanted to make a new kind of sculptural object that would include "Thinking Forms: how we mould our thoughts or Spoken Forms: how we shape our thoughts into words or Social Sculpture: how we mould and shape the world in which we live." 40

Beuys's commitment to artworks stimulating thought about art and life derived in part from his experiences as a pilot during World War II. After the enemy shot down his plane over the Crimea, no-madic Tatars nursed him back to health by swaddling his body in fat and felt to warm him. Fat and felt thus symbolized healing and regeneration to Beuys, and he incorporated these materials into many of his sculptures and actions, such as *How to Explain Pictures to a*

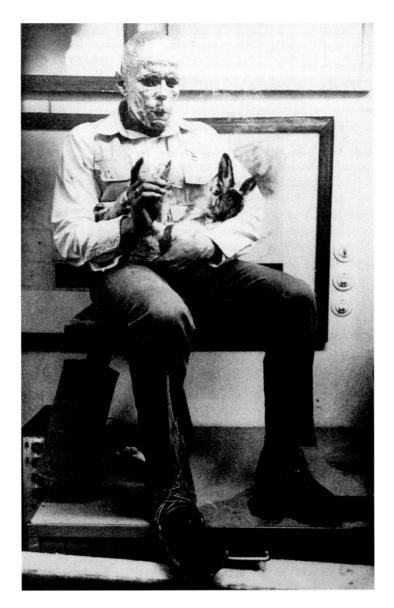

25-77 JOSEPH BEUYS, *How to Explain Pictures to a Dead Hare*, 1965. Performance at the Schmela Gallery, Düsseldorf.

In this one-person event, Beuys coated his head with honey and gold leaf. Assuming the role of a shaman, he used stylized actions to evoke a sense of mystery and sacred ritual.

Dead Hare (FIG. 25-77). This one-person event consisted of stylized actions evoking a sense of mystery and sacred ritual. Beuys appeared in a room hung with his drawings, cradling a dead hare to which he spoke softly. Beuys coated his head with honey covered with gold leaf, creating a shimmering mask. In this manner, he took on the role of the shaman, an individual with special spiritual powers. As a shaman, Beuys believed he was acting to help revolutionize human thought so that each human being could become a truly free and creative person.

JEAN TINGUELY The paradoxical notion of destruction as an act of creation surfaces in a number of kinetic artworks, most notably in the sculpture of JEAN TINGUELY (1925–1991). Trained as a painter in his native Switzerland, Tinguely gravitated to motion sculpture. In the 1950s, he made a series of *metamatics*, motor-driven devices that produced instant abstract paintings. He programmed these metamatics electronically to act with an antimechanical unpredictability when viewers inserted felt-tipped marking pens into a pincer and pressed a button to initiate the pen's motion across a small sheet of paper clipped to an "easel." Viewers could use different-colored markers in succession and could stop and start the device to achieve some degree of control over the final image. These operations created a series of small works resembling Abstract Expressionist paintings.

In 1960, Tinguely expanded the scale of his work with a kinetic piece designed to "perform" and then destroy itself in the sculpture garden of the Museum of Modern Art in New York City. He created *Homage to New York* (FIG. 25-78) with the aid of engineer Billy Klüver (1927–2004), who helped him scrounge wheels and other moving objects from a dump near Manhattan. The completed struc-

ture, painted white for visibility against the dark night sky, included a player piano modified into a metamatic painting machine, a weather balloon that inflated during the performance, vials of colored smoke, and a host of gears, pulleys, wheels, and other found machine parts.

This work premiered (and instantly self-destructed) on March 17, 1960, with New York Governor Nelson Rockefeller, an array of distinguished guests, and three television crews in attendance. Once

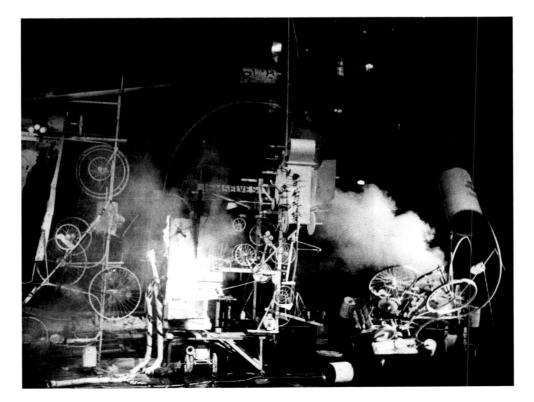

25-78 JEAN TINGUELY, Homage to New York, 1960, just prior to its self-destruction in the garden of the Museum of Modern Art, New York.

Tinguely produced motor-driven devices programmed to make instant abstract paintings. To explore the notion of destruction as an act of creation, he designed this one to perform and then destroy itself.

Tinguely turned on the machine, smoke poured from its interior and the piano caught fire. Various parts of the machine broke off and rambled away, while one of the metamatics tried but failed to produce an abstract painting. Finally, Tinguely summoned a firefighter to extinguish the blaze and ensure the demise of *Homage to New York* with his ax. Like the artist's other kinetic sculptures, *Homage to New York* recalls the satiric Dadaist spirit and the droll import of Klee's *Twittering Machine* (FIG. 24-53). But Tinguely deliberately made the wacky behavior of *Homage to New York* more playful and more endearing. Having been given a freedom of eccentric behavior unprecedented in the mechanical world, Tinguely's creations often seemed to behave with the whimsical individuality of human actors.

Conceptual Art

The relentless challenges to artistic convention fundamental to the historical avant-garde reached a logical conclusion with *Conceptual Art* in the late 1960s. Conceptual artists asserted that the "artfulness" of art lay in the artist's idea rather than in its final expression. These artists regarded the idea, or concept, as the defining component of the artwork. Indeed, some Conceptual artists eliminated the object altogether.

JOSEPH KOSUTH American artist Joseph Kosuth (b. 1945) was a major proponent of Conceptual Art.

Like everyone else I inherited the idea of art as a set of *formal* problems. So when I began to re-think my ideas of art, I had to re-think that thinking process [T]he radical shift was in changing the idea of art itself. . . . It meant you could have an art work which was that *idea* of an art work, and its formal components weren't important. I felt I had found a way to make art without formal components being confused for an expressionist composition. The expression was in the idea, not the form—the forms were only a device in the service of the idea. 41

chair (Mal), a. (DT desert DT daire). C. L. ordaring the one pressure, a mail of other are statisticity or the office man of a statistic are a statistic to the office man of a statistic are also as the order of th

25-79 Joseph Kosuth, *One and Three Chairs*, 1965. Wooden folding chair, photographic copy of a chair, and photographic enlargement of a dictionary definition of a chair; chair, $2' \ 8\frac{3}{8}'' \times 1' \ 2\frac{7}{8}'' \times 1' \ 8\frac{7}{8}''$; photopanel, $3' \times 2' \frac{1}{8}''$; text panel, $2' \times 2' \frac{1}{8}''$. Museum of Modern Art, New York (Larry Aldrich Foundation Fund).

Conceptual artists regard the concept as an artwork's defining component. To portray "chairness," Kosuth juxtaposed a chair, a photograph of the chair, and a dictionary definition of "chair."

Kosuth's work operates at the intersection of language and vision, dealing with the relationship between the abstract and the concrete. For example, in *One and Three Chairs* (FIG. **25-79**), Kosuth juxtaposed a real chair, a full-scale photograph of the chair, and an enlarged reproduction of a dictionary definition of the word "chair." By so doing, the Conceptual artist asked the viewer to ponder the notion of what constitutes "chairness."

BRUCE NAUMAN In the mid-1960s, Bruce Nauman (b. 1941) made his artistic presence known when he abandoned painting and turned to object-making. Since then, his work has been amazingly varied. In addition to sculptural pieces constructed from different materials, including rubber, fiberglass, and cardboard, he has also produced photographs, films, videos, books, and large room installations, as well as Performance Art. Nauman's work of the 1960s intersected with that of the Conceptual artists, especially in terms of the philosophical exploration that was the foundation of much of his art, and in his interest in language and wordplay. The True Artist Helps the World by Revealing Mystic Truths (FIG. 25-80) was the first of Nauman's many neon sculptures. He selected neon because he wanted to find a medium that would be identified with a nonartistic function. Determined to discover a way to connect objects with words, he used the method outlined in Philosophical Investigations, in which the Austrian philosopher Ludwig Wittgenstein (1889–1951) encouraged contradictory and nonsensical arguments. Nauman's neon sculpture spins out an emphatic assertion, but as Nauman explained, "It was kind of a test-like when you say something out loud to see if you believe it. . . . [I]t was on the one hand a totally silly idea and yet, on the other hand, I believed it."42

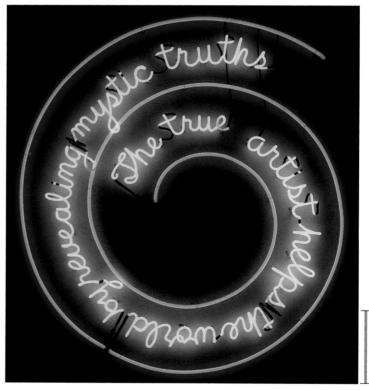

25-80 Bruce Nauman, *The True Artist Helps the World by Revealing Mystic Truths*, 1967. Neon with glass tubing suspension frame, $4'11'' \times 4'7'' \times 2''$. Private collection.

Nauman, like other Conceptual artists, explores his interest in language and wordplay in his art. He described this neon sculpture's emphatic assertion as "a totally silly idea," but one that he believed.

25-81 NAM JUNE PAIK, Video still from *Global Groove*, 1973. Color videotape, sound, 30 minutes. Collection of the artist.

Korean-born video artist Paik's best-known work is a cascade of fragmented sequences of performances and commercials intended as a sample of the rich worldwide television menu of the future.

Other Conceptual artists pursued the notion that the idea is a work of art itself by creating works involving invisible materials, such as inert gases, radioactive isotopes, or radio waves. In each case, viewers must base their understanding of the artwork on what they know about the properties of these materials, rather than on any visible empirical data, and must depend on the artist's linguistic description of the work. Ultimately, the Conceptual artists challenged the very premises of artistic production, pushing art's boundaries to a point where no concrete definition of "art" is possible.

New Media

During the past half century, many avant-garde artists have eagerly embraced new technologies in their attempt to find fresh avenues of artistic expression. Among the most popular new media are video recording and computer graphics.

VIDEO Initially, only commercial television studios possessed video equipment, but in the 1960s, with the development of relatively inexpensive portable video recorders and of electronic devices allowing manipulation of recorded video material, artists began to explore in earnest the expressive possibilities of this new technology. In its basic form, video recording involves a special motion-picture camera that captures visible images and translates them into electronic data that can be displayed on a video monitor or television screen. Video pictures resemble photographs in the amount of detail they contain, but, like computer graphics, a video image consists of a series of points of light on a grid, giving the impression of soft focus. Viewers looking at television or video art are not aware of the monitor's surface. Instead, fulfilling the Renaissance ideal, they concentrate on the image and look through the glass surface, as through a window, into the "space" beyond. Video images combine the optical realism of photography with the sense that the subjects move in real time in a deep space "inside" the monitor.

NAM JUNE PAIK When video introduced the possibility of manipulating subjects in real time, artists such as Korean-born NAM

June Paik (1932–2006) were eager to work with the medium. Inspired by the ideas of John Cage and after studying music performance, art history, and Eastern philosophy in Korea and Japan, Paik worked with electronic music in Germany in the late 1950s. In 1965, after relocating to New York City, Paik acquired the first inexpensive video recorder sold in Manhattan (the Sony Porta-Pak) and immediately recorded everything he saw out the window of his taxi on the return trip to his studio downtown. Experience acquired as artist-inresidence at television stations WGBH in Boston and WNET in New York allowed him to experiment with the most advanced broadcast video technology.

A grant permitted Paik to collaborate with the gifted Japanese engineer-inventor Shuya Abe in developing a video synthesizer. This instrument allows artists to manipulate and change the electronic video information in various ways, causing images or parts of images to stretch, shrink, change color, or break up. With the synthesizer, artists can also layer images, inset one image into another, or merge images from various cameras with those from video recorders to make a single visual kaleidoscopic "time-collage." This kind of compositional freedom permitted Paik to combine his interests in painting, music, Eastern philosophy, global politics for survival, humanized technology, and cybernetics. Paik called his video works "physical music" and said that his musical background enabled him to understand time better than could video artists trained in painting or sculpture.

Paik's best-known video work, Global Groove (FIG. 25-81), combines in quick succession fragmented sequences of female tap dancers, beat-generation poet Allen Ginsberg (1926–1997) reading his work, a performance by Fluxus artist and cellist Charlotte Moorman (1933–1991) using a man's back as her instrument, Pepsi commercials from Japanese television, Korean drummers, and a shot of the Living Theatre group performing a controversial piece called Paradise Now. Commissioned originally for broadcast over the United Nations satellite, the cascade of imagery in Global Groove gives viewers a glimpse of the rich worldwide television menu Paik predicted would be available in the future.

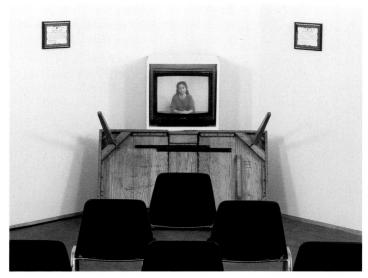

25-82 Adrian Piper, *Cornered*, 1988. Mixed-media installation of variable size; video monitor, table, and birth certificates. Museum of Contemporary Art, Chicago.

In this installation, Piper, a light-skinned African American, appeared on a video monitor, "cornered" behind an overturned table, and made provocative comments about overt racism and more subtle bigotry.

ADRIAN PIPER One video artist committed to using her art to effect social change—in particular, to combat pervasive racism—is ADRIAN PIPER (b. 1948). Appropriately, her art, such as the installation Cornered (FIG. 25-82), is provocative and confrontational. This piece included a video monitor placed behind an overturned table. Piper appeared on the video monitor, literally cornered behind the table, as she spoke to viewers. Her comments sprang from her experiences as a light-skinned African American woman and from her belief that although overt racism had diminished, subtle and equally damaging forms of bigotry were still rampant. "I'm black," she announces on the 16-minute videotape. "Now let's deal with this social fact and the fact of my stating it together. . . . If you feel that my letting people know that I'm not white is making an unnecessary fuss, you must feel that the right and proper course of action for me to take is to pass for white. Now this kind of thinking presupposes a belief that it's inherently better to be identified as white," she continues. The directness of Piper's art forces viewers to examine their own behaviors and values.

BILL VIOLA For much of his artistic career, BILL VIOLA (b. 1951) has also explored the capabilities of digitized imagery, producing many video installations and single-channel works. Often focused on sensory perception, the pieces not only heighten viewer awareness of the senses but also suggest an exploration into the spiritual realm. Viola, an American, spent years seriously studying Buddhist, Christian, Sufi, and Zen mysticism. Because he fervently believes in art's transformative power and in a spiritual view of human nature, Viola designs works encouraging spectator introspection. His recent video projects involve using techniques such as extreme slow motion, contrasts in scale, shifts in focus, mirrored reflections, staccato editing, and multiple or layered screens to achieve dramatic effects.

The power of Viola's work is evident in *The Crossing* (FIG. **25-83**), an installation piece involving two color video channels projected on 16-foot-high screens. The artist either shows the two projections on the front and back of the same screen or on two separate screens in the same installation. In these two companion videos, shown simultaneously on the two screens, a man surrounded

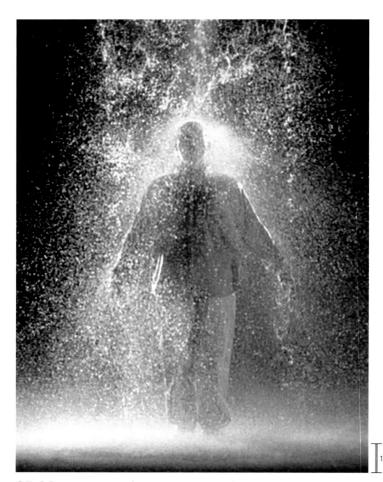

25-83 BILL VIOLA, *The Crossing*, 1996. Video/sound installation with two channels of color video projection onto screens 16' high. Private collection.

Viola's video projects use extreme slow motion, contrasts in scale, shifts in focus, mirrored reflections, and staccato editing to create dramatic sensory experiences rooted in tangible reality.

in darkness appears, moving closer until he fills the screen. On one screen, drops of water fall from above onto the man's head, while on the other screen, a small fire breaks out at the man's feet. Over the next few minutes, the water and fire increase in intensity until the man disappears in a torrent of water on one screen (FIG. 25-83) and flames consume the man on the other screen. The deafening roar of a raging fire and a torrential downpour accompany these visual images. Eventually, everything subsides and fades into darkness. This installation's elemental nature and its presentation in a dark space immerse viewers in a pure sensory experience very much rooted in tangible reality.

COMPUTER GRAPHICS Perhaps the most promising new medium for creating and manipulating illusionistic three-dimensional forms is computer graphics. This new medium uses light to make images and, like photography, can incorporate specially recorded camera images. Unlike video recording, computer graphic art allows artists to work with wholly invented forms, as painters can. Developed during the 1960s and 1970s, this technology opened up new possibilities for both abstract and figurative art. It involves electronic programs dividing the surface of the computer monitor's cathoderay tube into a grid of tiny boxes called "picture elements," or *pixels*. Artists can electronically address pixels individually to create a design, much as knitting or weaving patterns have a grid matrix as a guide for making a design in fabric. Once created, parts of a com-

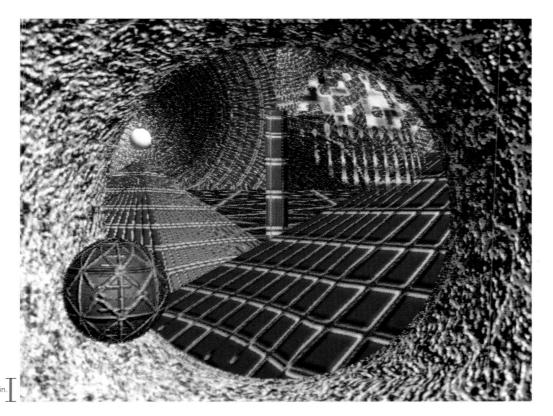

25-84 DAVID EM, *Nora*, 1979. Computer-generated color photograph, 1' 5" × 1' 11". Private collection.

Unlike video recording, computer graphic art allows the creation of wholly invented forms, as in painting. Em builds fantastic digital images of imaginary landscapes out of tiny boxes called pixels.

Institute of Technology's Jet Propulsion Laboratory, Em created brilliantly colored scenes of alien worlds using the laboratory's advanced computer graphics equipment. He also had access to software programs developed to create computer graphics simulations of NASA's missions in outer space. Creating images with the computer gave Em great flexibility in manipulating simple geometric shapes—shrinking or enlarging them, stretching or reversing them, repeating them, adding texture to their surfaces, and creating the il-

lusion of light and shadow. In images such as *Nora* (FIG. **25-84**), Em created futuristic geometric versions of Surrealistic dreamscapes whose forms seem familiar and strange at the same time. The illusion of space in these works is immensely vivid and seductive. It almost seems possible to wander through the tubelike foreground "frame" and up the inclined foreground plane or to hop aboard the hovering globe at the lower left for a journey through the strange patterns and textures of this mysterious labyrinthine setting.

JENNY HOLZER Another contemporary artist who has harnessed new technology for artistic purposes is JENNY HOLZER (b. 1950), who created several series of artworks using electronic

signs, most involving light-emitting diode (LED) technology. In 1989, Holzer did a major installation at the Guggenheim Museum in New York that included elements from her previous series and consisted of a large continuous LED display spiraling around the museum's interior ramp (FIG. **25-85**). Holzer's installation focused specifically on text, and she invented sayings with an authoritative tone for her LED displays. Statements included "Protect me from what I want," "Abuse of power comes as no

puter graphic design can be changed quickly through an electronic program, allowing artists to revise or duplicate shapes in the design and to manipulate at will the color, texture, size, number, and position of any desired detail. Computer graphics pictures appear in luminous color on the cathode-ray tube. The effect suggests a view into a vast world existing inside the tube.

DAVID EM One of the best-known artists working in this electronic painting mode, David EM (b. 1952) uses what he terms "computer imaging" to fashion fantastic imaginary landscapes. These have an eerily believable existence within the "window" of the computer monitor. When he was artist-in-residence at the California

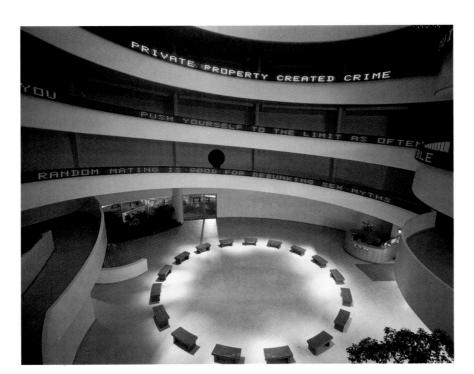

25-85 Jenny Holzer, Untitled (selections from Truisms, Inflammatory Essays, The Living Series, The Survival Series, Under a Rock, Laments, and Child Text), 1989. Extended helical tricolor LED electronic display signboard, $16' \times 162' \times 6'$. Solomon R. Guggenheim Museum, New York, December 1989–February 1990 (partial gift of the artist, 1989).

Holzer's 1989 installation consisted of electronic signs created using light-emitting diode (LED) technology. The continuous display of texts spiraled around the Guggenheim Museum's interior ramp.

25-86
TONY OURSLER,
Mansheshe, 1997.
Ceramic, glass, video
player, videocassette,
CPJ-200 video
projector, sound,
11" × 7" × 8" each.
Private collection.

Video artist Oursler projects his digital images onto sculptural objects, insinuating them into the "real" world. Here, he projected talking heads onto eggshaped forms suspended from poles.

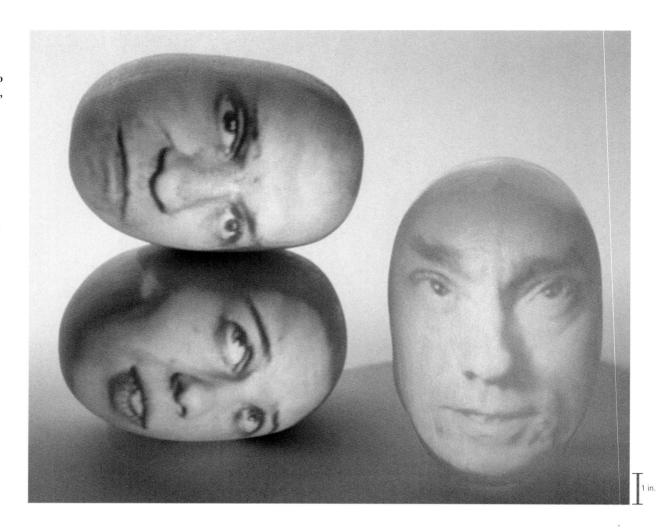

surprise," and "Romantic love was invented to manipulate women." The statements, which people could read from a distance, were intentionally vague and, in some cases, contradictory.

TONY OURSLER While many artists present video and digital imagery to the audience on familiar flat screens, thus reproducing the format in which we most often come into contact with such images, Tony Oursler (b. 1957) manipulates his images, projecting them onto sculptural objects. This has the effect of taking such images out of the digital world and insinuating them into the "real" world. Accompanied by sound tapes, Oursler's installations, such as Mansheshe (Fig. 25-86), not only engage but often challenge the viewer. In this example, Oursler projected talking heads onto eggshaped forms suspended from poles. Because the projected images of people look directly at the viewer, the statements they make about religious beliefs, sexual identity, and interpersonal relationships cannot be easily dismissed.

MATTHEW BARNEY One of the major trends in the art world of the opening decade of the 21st century is the relaxation of the traditional boundaries between and among artistic media. In fact, many artists today are creating vast and complex multimedia installations combining new and traditional media. One of these artists is MATTHEW BARNEY (b. 1967). The 2003 installation (FIG. **25-1**) of his epic *Cremaster* cycle (1994–2002) at the Solomon R. Guggenheim Museum in New York typifies the expansive scale of many contemporary works. A multimedia extravaganza involving drawings, photographs, sculptures, videos, films, and performances (presented in videos), the

Cremaster cycle is a lengthy narrative that takes place in a self-enclosed universe Barney created. The title of the work refers to the cremaster muscle, which controls testicular contractions in response to external stimuli. Barney uses the development of this muscle in the embryonic process of sexual differentiation as the conceptual springboard for the entire Cremaster project, in which he explores the notion of creation in expansive and complicated ways. The cycle's narrative, revealed in the five 35-mm feature-length films and the artworks, makes reference to, among other things, a musical revue in Boise, Idaho (Barney's hometown), the life cycle of bees, the execution of convicted murderer Gary Gilmore, the construction of the Chrysler Building (FIG. 24-76), Celtic mythology, Masonic rituals, a motorcycle race, and a lyric opera set in late-19th-century Budapest. In the installation, Barney tied the artworks together conceptually by a five-channel video piece that is projected on screens hanging in the Guggenheim's rotunda. Immersion in Barney's constructed world is disorienting and overwhelming and has a force that competes with the immense scale and often frenzied pace of contemporary life.

No one knows what the next years and decades will bring, but given the expansive scope of postmodernism, it is likely that no single approach to or style of art will dominate. But new technologies will certainly continue to redefine what constitutes a "work of art." The universally expanding presence of computers, digital technology, and the Internet may well erode what few conceptual and geographical boundaries remain and make art and information about art available to virtually everyone, thereby creating a truly global artistic community.

EUROPE AND AMERICA AFTER 1945

PAINTING AND SCULPTURE

- The art of the second half of the 20th century reflects cultural upheaval: the rejection of traditional values, the civil rights and feminist movements, and the new consumer society.
- The first major postwar avant-garde art movement was Abstract Expressionism, which championed an artwork's formal elements rather than its subject. Gestural abstractionists, such as Pollock and de Kooning, sought expressiveness through energetically applied pigment. Chromatic abstractionists, such as Rothko, struck emotional chords through large areas of pure color.
- Post-Painterly Abstraction promoted a cool rationality in contrast to Abstract Expressionism's passion. Both hard-edge painters, such as Kelly and Stella, and color-field painters, such as Frankenthaler and Louis, pursued purity in art by emphasizing the flatness of pigment on canvas.
- Pop artists, such as Johns, Lichtenstein, and Warhol, turned away from abstraction to the representation of subjects grounded in popular culture—flags, comic strips, movie stars.
- Superrealists, such as Flack, Close, and Hanson—kindred spirits to Pop artists in many ways—created paintings and sculptures featuring scrupulous fidelity to optical fact.
- The leading sculptural movement was Minimalism. Tony Smith and Judd created artworks consisting of simple unadorned geometric shapes to underscore the "objecthood" of their sculptures.
- Much of the art since 1970 addresses pressing social issues. Leading feminist artists include Chicago, whose *Dinner Party* honors important women throughout history and features crafts traditionally associated with women; Sherman and Kruger, who explored the "male gaze" in their art; and Mendieta and Wilke, whose bodies are their subjects.
- Other artists explored race, ethnicity, class, and sexual orientation. Ringgold and Simpson addressed issues important to African American women, Edwards civil rights themes, and Quick-to-See Smith Native American heritage. Wodiczko's art has documented the plight of the homeless. Wojnarowicz recorded the devastating effect of AIDS on the gay community.

ARCHITECTURE AND SITE-SPECIFIC ART

- Some of the leading early-20th-century modernist architects were also active after 1945. Wright built the snail-shell Guggenheim Museum, Le Corbusier the sculpturesque Notre-Dame-du-Haut, and Mies van der Rohe the Minimalist Seagram skyscraper. Later modernists Saarinen and Utzon designed structures having dramatic curvilinear rooflines.
- In contrast to modernist architecture, postmodernist architecture is complex and eclectic and often incorporates references to historical styles. Among the best-known postmodern projects are Moore's Piazza d'Italia and Graves's Portland Building, both of which echo classical motifs.
- Deconstructivist architects seek to disorient the viewer with asymmetrical and irregular shapes. Among the most prominent practicing today are Gehry and Libeskind.
- Site-specific art exists at the intersection of architecture and sculpture and is sometimes temporary in nature, as was Christo and Jeanne-Claude's *Surrounded Islands*.

PERFORMANCE AND CONCEPTUAL ART AND NEW MEDIA

- Among the most significant developments in the art world after World War II has been the expansion of the range of works considered "art."
- Performance artists, notably Schneemann and Beuys, replace traditional stationary artworks with movements and sounds carried out before an audience. Their Performance Art often addresses the same social and political issues that contemporary painters and sculptors explore.
- Conceptual artists, including Kosuth and Nauman, believe that the "artfulness" of art is in the artist's idea, not in the work resulting from the idea.
- Paik, Piper, Viola, and others have embraced video recording technology to produce artworks that combine images and sounds, sometimes viewed on small monitors, other times on huge screens.
- Em, Holzer, Oursler, and Barney have explored computer graphics and other new media, often in vast and complex museum installations.

Pollock, Lavender Mist, 1950

Warhol, Marilyn Diptych, 1962

Chicago, The Dinner Party, 1979

Gehry, Guggenheim Museum, Bilbao, 1997

Oursler, Mansheshe, 1997

NOTES

Introduction

- Quoted in George Heard Hamilton, Painting and Sculpture in Europe, 1880–1940, 6th ed. (New Haven, Conn.: Yale University Press, 1993), 345.
- 2. Quoted in *Josef Albers: Homage to the Square* (New York: Museum of Modern Art, 1964), n.p.

Chapter 15

 Francisco de Hollanda, *De pintura antigua* (1548). Robert Klein and Henri Zerner, *Italian Art*, 1500–1600: Sources and Documents (Englewood Cliffs, N.J.: Prentice Hall, 1966), 33.

Chapter 16

- Ghiberti, I commentarii, II. Quoted in Elizabeth Gilmore Holt, ed., A Documentary History of Art, I: The Middle Ages and the Renaissance (Princeton, N.J.: Princeton University Press, 1981), 157–158.
- 2. Giorgio Vasari, *Lives of the Painters, Sculptors, and Architects*, translated by Gaston du C. de Vere (New York: Knopf, 1996), 1: 304.
- 3. Ghiberti, I commentarii, II. Quoted in Holt, 161.
- Quoted in H. W. Janson, The Sculpture of Donatello (Princeton, N.J.: Princeton University Press, 1965), 154.
- 5. Vasari, 1: 318.

Chapter 17

- Plato, Ion, 534. Translated by Benjamin Jowett, The Dialogues of Plato, 4th ed., vol. 1 (Oxford: Clarendon, 1953), 107–108.
- Leonardo to Ludovico Sforza, ca. 1480–1481. In Elizabeth Gilmore Holt, ed., A Documentary History of Art (Princeton, N.J.: Princeton University Press, 1981), I: 274–275.
- 3. Quoted in Anthony Blunt, *Artistic Theory in Italy, 1450–1600* (London: Oxford University Press, 1964), 34.
- 4. Quoted in James M. Saslow, *The Poetry of Michelangelo: An Annotated Translation* (New Haven, Conn.: Yale University Press, 1991), 407.
- Giorgio Vasari, Lives of the Painters, Sculptors, and Architects, translated by Gaston du C. de Vere (New York: Knopf, 1996), 2: 736.
- Quoted in A. Richard Turner, Renaissance Florence: The Invention of a New Art (New York: Abrams, 1997), 163.
- 7. Quoted in Bruce Boucher, Andrea Palladio: The Architect in His Time (New York: Abbeville, 1998), 229.
- 8. Quoted in Robert J. Clements, *Michelangelo's Theory of Art* (New York: New York University Press, 1961), 320.

Chapter 18

- Translated by William Martin Conway, in Wolfgang Stechow, Northern Renaissance Art, 1400–1600: Sources and Documents (Evanston, Ill.: Northwestern University Press, 1989), 111.
- 2. Ibid., 118.
- 3. Translated by Erwin Panofsky, in Stechow, 123.
- 4. Giorgio Vasari, *Lives of the Painters, Sculptors, and Architects*, translated by Gaston du C. de Vere (New York: Knopf, 1996), 2: 863.

Chapter 19

- 1. Filippo Baldinucci, Vita del Cavaliere Giovanni Lorenzo Bernini (1681). Translated by Robert Enggass, in Robert Enggass and Jonathan Brown, Italian and Spanish Art 1600–1750: Sources and Documents (Evanston, Ill.: Northwestern University Press, 1992), 119.
- 2. Ibid., 116.
- 3. John Milton, Il Penseroso (1631, published 1645), 166.

Chapter 20

- 1. Translated by Kristin Lohse Belkin, Rubens (London: Phaidon, 1998), 47.
- Jan Harmensz Krul, Minne-beeldn (Amsterdam 1634). Translated by Bob Haak, The Golden Age: Dutch Painters of the Seventeenth Century (New York: Abrams, 1984), 75.
- 3. Albert Blankert, *Johannes Vermeer van Delft 1632–1675* (Utrecht: Spectrum, 1975), 133, no. 51. Translated by Haak, 450.

Chapter 21

- Translated by Robert Goldwater and Marco Treves, eds., Artists on Art, 3d ed. (New York: Pantheon, 1958), 157.
- Quoted in Thomas A. Bailey, The American Pageant: A History of the Republic, 2d ed. (Boston: Heath, 1961), 280.
- 3. Translated by Elfriede Heyer and Roger C. Norton, in Charles Harrison, Paul Wood, and Jason Gaiger, eds., *Art in Theory, 1648–1815: An Anthology of Changing Ideas* (Oxford: Blackwell, 2000), 451–453.

Chapter 22

- 1. Théophile Gautier, Histoire de Romantisme (Paris: Charpentier, 1874), 204.
- 2. Quoted in Helmut Borsch-Supan, Caspar David Friedrich (New York: Braziller, 1974), 7.
- Translated by Jason Gaiger, in Charles Harrison, Paul Wood, and Jason Gaiger, eds., Art in Theory, 1815–1900: An Anthology of Changing Ideas (Oxford: Blackwell, 1998), 54.
- Quoted by Brian Lukacher, in Stephen F. Eisenman, ed., Nineteenth Century Art: A Critical History, 2d ed. (New York: Thames & Hudson, 2002), 125.
- Quoted in John W. McCoubrey, American Art, 1700–1960: Sources and Documents (Upper Saddle River, N.J.: Prentice Hall, 1965), 98.
- 6. Quoted in Thomas A. Bailey, *The American Pageant: A History of the Republic*, 2d ed. (Boston: Heath, 1961), 280.
- 7. Quoted in Linda Nochlin, *Realism and Tradition in Art, 1848–1900* (Upper Saddle River, N.J.: Prentice Hall, 1966), 42.
- 8. Quoted in George Heard Hamilton, *Manet and His Critics* (New Haven, Conn.: Yale University Press, 1954), 45.
- 9. Quoted in Eisenman, 286.
- 10. New York Weekly Tribune, September 30, 1865.
- Quoted in Nikolai Cikovsky Jr. and Franklin Kelly, Winslow Homer (Washington, D.C.: National Gallery of Art, 1995), 26.
- 12. Quoted in Lloyd Goodrich, *Thomas Eakins, His Life and Work* (New York: Whitney Museum of American Art, 1933), 51–52.
- 13. Quoted in Nicholas Pevsner, An Outline of European Architecture (Baltimore: Penguin, 1960), 627.

- Letter from Delaroche to François Arao, quoted in Helmut Gernsheim, Creative Photography (New York: Bonanza, 1962), 24.
- 15. Quoted in Naomi Rosenblum, *A World History of Photography* (New York: Abbeville, 1984), 69.
- 16. Quoted in Kenneth MacGowan, Behind the Screen (New York: Delta, 1965), 49.

Chapter 23

- 1. Clement Greenberg, "Modernist Painting," *Art and Literature*, no. 4 (Spring 1965): 193–194.
- 2. Quoted in Linda Nochlin, Realism (Harmondsworth: Penguin, 1971), 28.
- Quoted in Linda Nochlin, Impressionism and Post-Impressionism 1874–1904: Sources and Documents (Englewood Cliffs, N.J.: Prentice Hall, 1966), 35.
- Translated by Carola Hicks, in Charles Harrison, Paul Wood, and Jason Gaiger, eds., Art in Theory, 1815–1900: An Anthology of Changing Ideas (Oxford: Blackwell, 1998), 595.
- Quoted in John McCoubrey, American Art, 1700–1960: Sources and Documents (Englewood Cliffs, N.J.: Prentice Hall, 1965), 184.
- 6. Quoted in Harrison et al., 835–836.
- 7. Quoted in Robert Goldwater and Marco Treves, eds., Artists on Art, from the XIV to the XX Century (New York: Pantheon, 1945), 322.
- 8. Ibid., 375.
- Vincent van Gogh to Theo van Gogh, September 1888, in J. van Gogh–Bonger and V. W. van Gogh, eds., *The Complete Letters of Vincent van Gogh* (Greenwich, Conn.: New York Graphic Society, 1979), 3: 534.
- Vincent van Gogh to Theo van Gogh, July 16, 1888, in W. H. Auden, ed., Van Gogh: A Self-Portrait: Letters Revealing His Life as a Painter (New York: Dutton, 1963), 299.
- 11. Quoted in Belinda Thompson, ed., *Gauguin by Himself* (Boston: Little, Brown, 1993), 270–271.
- Quoted in Sam Hunter, John Jacobus, and Daniel Wheeler, Modern Art, 3d ed. (Upper Saddle River, N.J.: Prentice Hall, 2004), 28.
- 13. Cézanne to Émile Bernard, March 1904. Quoted in Goldwater and Treves, 363.
- 14. Cézanne to Émile Bernard, April 15, 1904, in ibid., 363.
- 15. Translated by Akane Kawakami, in Harrison et al., 1066.
- Quoted in George Heard Hamilton, Painting and Sculpture in Europe, 1880–1940, 6th ed. (New Haven, Conn.: Yale University Press, 1993), 124.
- 17. Quoted in V. Frisch and J. T. Shipley, Auguste Rodin (New York: Stokes, 1939), 203.
- Quoted in Eileen Boris, Art and Labor: Ruskin, Morris, and the Craftsman Ideal in America (Philadelphia: Temple University Press, 1986), 7.

Chapter 24

- Quoted in John Elderfield, The "Wild Beasts": Fauvism and Its Affinities (New York: Museum of Modern Art, 1976), 29.
- Translated by Charles Harrison and Paul Wood, eds., Art in Theory, 1900–2000: An Anthology of Changing Ideas (Oxford: Blackwell, 2003), 65.
- Quoted in Frederick S. Levine, The Apocalyptic Vision: The Art of Franz Marc as German Expressionism (New York: Harper & Row, 1979), 57.
- 4. Quoted in Sam Hunter, John Jacobus, and Daniel Wheeler, *Modern Art*, rev. 3d ed. (Upper Saddle Hill, N.J.: Prentice Hall, 2004), 121.
- Quoted in George Heard Hamilton, Painting and Sculpture in Europe, 1880–1940, 6th ed. (New Haven, Conn.: Yale University Press, 1993), 246.
- 6. Ibid., 238
- 7. Quoted in Edward Fry, ed., Cubism (London: Thames & Hudson, 1966), 112-113.
- 8. Quoted in Michael Hoog, R. Delaunay (New York: Crown, 1976), 49.
- Quoted in Françoise Gilot and Carlton Lake, Life with Picasso (New York: McGraw-Hill, 1964), 77.
- Filippo Tommaso Marinetti, The Foundation and Manifesto of Futurism (Le Figaro, February 20, 1909). Translated by Joshua C. Taylor, in Herschel B. Chipp, Theories of Modern Art: A Source Book by Artists and Critics (Berkeley and Los Angeles: University of California Press, 1968), 284.
- 11. Ibid., 286.
- 12. Quoted in Robert Short, Dada and Surrealism (London: Octopus, 1980), 18.
- Quoted in Robert Motherwell, ed., The Dada Painters and Poets: An Anthology, 2d ed. (Cambridge, Mass.: Belknap Press of Harvard University, 1989).
- 14. Hans Richter, Dada: Art and Anti-Art (London: Thames & Hudson, 1961), 64–65.
- 15. Ibid., 57
- Tristan Tzara, "Chronique Zurichoise," translated by Ralph Manheim, in Motherwell, Dada Painters, 236
- Quoted in Arturo Schwarz, The Complete Works of Marcel Duchamp (London: Thames & Hudson, 1965), 466.
- 18. Quoted in Sam Hunter, American Art of the 20th Century (New York: Abrams, 1972), 30.

- 19. Ibid., 37.
- Charles C. Eldredge, "The Arrival of European Modernism," Art in America 61 (July–August 1973), 35.
- Quoted in Gail Stavitsky, "Reordering Reality: Precisionist Directions in American Art, 1915–1941," in Diana Murphy, ed., *Precisionism in America 1915–1941: Reordering Reality* (New York: Abrams, 1994), 12.
- Quoted in Karen Tsujimoto, Images of America: Precisionist Painting and Modern Photography (Seattle: University of Washington Press, 1982), 70.
- Dorothy Norman, Alfred Stieglitz: An American Seer (Millerton, N.Y.: Aperture, 1973), 9–10.
- 24. Ibid., 161.
- Pablo Picasso, "Statement to Simone Téry," in Harrison and Wood, Art in Theory, 1900–2000, 649.
- Quoted in Roland Penrose, Picasso: His Life and Work, rev. ed. (New York: Harper & Row, 1971), 311.
- Quoted in Matthias Eberle, World War I and the Weimar Artists: Dix, Grosz, Beckmann, Schlemmer (New Haven, Conn.: Yale University Press, 1985), 54.
- 28. Ibid., 22.
- 29. Ibid., 42.
- 30. Quoted in William S. Rubin, *Dada, Surrealism, and Their Heritage* (New York: Museum of Modern Art, 1968), 64.
- 31. Quoted in Hamilton, Painting and Sculpture, 392.
- 32. Quoted in Richter, Dada, 155.
- 33. Ibid., 159.
- 34. Quoted in Rubin, Dada, Surrealism, 111.
- 35. Quoted in Hunter, Jacobus, and Wheeler, Modern Art, 179.
- Quoted in William S. Rubin, Miró in the Collection of the Museum of Modern Art (New York: Museum of Modern Art, 1973), 32.
- 37. Translated by Norbert Guterman, quoted in Chipp, Theories of Modern Art, 182–186.
- Translated by Howard Dearstyne, in Robert L. Herbert, Modern Artists on Art, 2d ed. (Mineola, N.Y.: Dover, 2000), 117.
- 39. Ibid., 124.
- Translated by Herbert Read and Leslie Martin, quoted in Chipp, Theories of Modern Art. 325–330.
- 41. Translated by Nicholas Bullock, quoted in Harrison and Wood, Art in Theory, 1900–2000, 281.
- 42. Quoted in Kenneth Frampton, *Modern Architecture: A Critical History*, 3d ed. (New York: Thames & Hudson, 1992), 147.
- Quoted in Michel Seuphor, Piet Mondrian: Life and Work (New York: Abrams, 1956), 117.
- 44. Piet Mondrian, *Plastic Art and Pure Plastic Art* (1937), quoted in Hamilton, *Painting and Sculpture*, 319.
- 45. Mondrian, quoted in Chipp, Theories of Modern Art, 349.
- 46. Ibid., 350.
- 47. Quoted in H. H. Arnason and Peter Kalb, *History of Modern Art*, 5th ed. (Upper Saddle River, N.J.: Prentice Hall, 2004), 154.
- Quoted in Robert L. Herbert, Modern Artists on Art, 2d ed. (Mineola, N.Y.: Dover, 2000), 173.
- 49. Ibid., 177.
- 50. Quoted in Vivian Endicott Barnett, "Banned German Art: Reception and Institutional Support of Modern German Art in the United States, 1933–45," in Stephanie Barron, Exiles and Emigrés: The Flight of European Artists from Hitler (Los Angeles: Los Angeles County Museum of Art, 1997), 283.
- 51. Quoted in Milton Meltzer, *Dorothea Lange: A Photographer's Life* (New York: Farrar, Straus & Giroux, 1978), 133, 220.
- 52. Quoted in Frances K. Pohl, *Ben Shahn: New Deal Artist in a Cold War Climate*, 1947–1954 (Austin: University of Texas Press, 1989), 159.
- 53. Quoted in Henry Louis Gates Jr., "New Negroes, Migration, and Cultural Exchange," in Elizabeth Hutton Turner, ed., *Jacob Lawrence: The Migration Series* (Washington, D.C.: Phillips Collection, 1993), 20.
- Wanda M. Corn, Grant Wood: The Regionalist Vision (New Haven, Conn.: Yale University Press, 1983), 131.
- Quoted in Matthew Baigell, A Concise History of American Painting and Sculpture (New York: Harper & Row, 1984), 264.
- 56. Quoted in Hans L. Jaffé, De Stijl (New York: Abrams, 1971), 185-188.
- 57. Piet Mondrian, *Dialogue on the New Plastic* (1919). Translated by Harry Holzman and Martin S. James, in Harrison and Wood, *Art in Theory*, 1900–2000, 285.
- 58. Walter Gropius, from The Manifesto of the Bauhaus, April 1919.

- 59. Ibid.
- 60. Ibid.
- Quoted in John Willett, Art and Politics in the Weimar Period: The New Sobriety, 1917–1933 (New York: Da Capo, 1978), 119.
- 62. Quoted in Wayne Craven, *American Art: History and Culture* (Madison, Wis.: Brown & Benchmark, 1994), 403.
- 63. Quoted in Vincent Scully Jr., Frank Lloyd Wright (New York: Braziller, 1960), 18.
- Quoted in Edgar Kauffmann, ed., Frank Lloyd Wright: An American Architect (New York: Horizon, 1955), 205, 208.
- Quoted in Philip Johnson, Mies van der Rohe, rev. ed. (New York: Museum of Modern Art, 1954), 200–201.

Chapter 25

- Dawn Ades and Andrew Forge, Francis Bacon (London: Thames & Hudson, 1985), 8; and David Sylvester, The Brutality of Fact: Interviews with Francis Bacon, 3d ed. (London: Thames & Hudson, 1987), 182.
- Clement Greenberg, "Toward a Newer Laocoon," Partisan Review 7, no. 4 (July–August 1940): 305.
- 3. Clement Greenberg, "Sculpture in Our Time," Arts Magazine 32, no. 9 (June 1956): 22.
- Marcus Rothko and Adolph Gottlieb, quoted in Edward Alden Jewell, "The Realm of Art: A New Platform and Other Matters: 'Globalism' Pops into View," New York Times, June 13, 1943, 9.
- 5. Reprinted in Harold Rosenberg, The Tradition of the New (New York: Horizon, 1959), 25.
- 6. Quoted in Thomas Hess, Barnett Newman (New York: Walker and Company, 1969), 51.
- Quoted in John P. O'Neill, ed., Barnett Newman: Selected Writings and Interviews (New York: Knopf, 1990), 108.
- 8. Rothko and Gottlieb, 9.
- Quoted in Selden Rodman, Conversations with Artists (New York: Devin-Adair, 1957), 93–94.
- Clement Greenberg, "Recentness of Sculpture," in Gregory Battcock, ed., Minimal Art: A Critical Anthology (New York: Dutton, 1968), 183–184.
- 11. Louise Nevelson, quoted in John Gordon, Louise Nevelson (New York: Praeger, 1967), 12.
- 12. Quoted in Deborah Wye, Louise Bourgeois (New York: Museum of Modern Art, 1982), 22.
- 13. Ibid., 25.
- 14. Quoted in Lucy Lippard, Eva Hesse (New York: New York University Press, 1976), 165.
- 15. Ibid., 56.
- 16. Quoted in Richard Francis, Jasper Johns (New York: Abbeville, 1984), 21.
- 17. Andy Warhol, *The Philosophy of Andy Warhol* (New York: Harcourt Brace Jovanovich, 1975), 100.
- Quoted in Christine Lindey, Superrealist Painting and Sculpture (London: Orbis, 1980), 50.

- 19. Ibid., 130.
- Fredric Jameson, "Postmodernism and Consumer Society," in Hal Foster, ed., The Anti-Aesthetic: Essays on Postmodern Culture (Port Townsend, Wash.: Bay, 1983), 113.
- Quoted in Grace Glueck, "Susan Rothenberg: New Outlook for a Visionary Artist," New York Times Magazine, July 22, 1984, 20.
- Quoted in Walker Art Center: Painting and Sculpture from the Collection (Minneapolis: Walker Art Center, 1990), 435.
- 23. Quoted in Susanna Torruella Leval, "Recapturing History: The (Un)official Story in Contemporary Latin American Art," *Art Journal* 51, no. 4 (Winter 1992): 74.
- 24. Ibid.
- Hannah Wilke, "Visual Prejudice," in Hannah Wilke: A Retrospective (Columbia: University of Missouri Press, 1989), 141.
- Quoted in Donald Hall, Corporal Politics (Cambridge: MIT List Visual Arts Center, 1993), 46.
- Kobena Mercer, "Black Hair/Style Politics," in Russell Ferguson, Martha Gever, Trinh
 Minh-ha, and Cornel West, eds., Out There: Marginalization and Contemporary
 Culture (New York: New Museum of Contemporary Art, 1990), 248–249.
- 28. Ibid.
- 29. Jaune Quick-to-See Smith and Harmony Hammond, *Women of Sweetgrass: Cedar and Sage* (New York: American Indian Center, 1984), 97.
- Quoted in Richard Marshall and Robert Mapplethorpe, 50 New York Artists (San Francisco: Chronicle, 1986), 448–449.
- 31. Quoted in Mary Jane Jacob, Magdalena Abakanowicz (New York: Abbeville, 1982), 94.
- 32. Peter Blake, Frank Lloyd Wright (Harmondsworth: Penguin, 1960), 115.
- 33. Quoted in "Vietnam Memorial: America Remembers," *National Geographic* 167, no. 5 (May 1985): 557.
- Quoted in Nancy Holt, ed., The Writings of Robert Smithson (New York: New York University Press, 1975), 111.
- 35. Quoted in Calvin Tomkins, "The Art World: *Tilted Arc*," New Yorker, May 20, 1985, 100.
- 36. Quoted in H. H. Arnason and Peter Kalb, *History of Modern Art*, 5th ed. (Upper Saddle River, N.J.: Prentice Hall, 2004), 489.
- Quoted in Barbara Haskell, Blam! The Explosion of Pop, Minimalism, and Performance 1958–1964 (New York: Whitney Museum of American Art, 1984), 53.
- Jiro Yoshihara, "Gutai Art Manifesto" (1956), translated by Reiko Tomii, in Alexandra Munroe, Japanese Art after 1945: Scream against the Sky (New York: Abrams, 1994), 370.
- 39. Quoted in Bruce McPherson, ed., More Than Meat Joy: Complete Performance Works and Selected Writings (New Paltz, N.Y.: Documentext, 1979), 52.
- 40. Quoted in Caroline Tisdall, Joseph Beuys (New York: Thames & Hudson, 1979), 6.
- 41. Quoted in "Joseph Kosuth: Art as Idea as Idea," in Jeanne Siegel, ed., Artwords: Discourse on the 60s and 70s (Ann Arbor, Mich.: UMI Research Press, 1985), 221, 225.
- 42. Quoted in Brenda Richardson, *Bruce Nauman: Neons* (Baltimore: Baltimore Museum of Art, 1982), 20.

GLOSSARY

a secco—Italian, "dried." See fresco.

Abstract Expressionism—The first major American avant-garde movement, Abstract Expressionism emerged in New York City in the 1940s. The artists produced abstract paintings that expressed their state of mind and that they hoped would strike emotional chords in viewers. The movement developed along two lines: gestural abstraction and chromatic abstraction.

action painting—Also called gestural abstraction. The kind of Abstract Expressionism practiced by Jackson Pollock, in which the emphasis was on the creation process, the artist's gesture in making art. Pollock poured liquid paint in linear webs on his canvases, which he laid out on the floor, thereby physically surrounding himself in the painting during its creation.

additive light—Natural light, or sunlight, the sum of all the wavelengths of the visible spectrum. See also subtractive light.

additive sculpture—A kind of sculpture technique in which materials (for example, clay) are built up or "added" to create form.

aerial perspective—See perspective.

airbrush—A tool that uses compressed air to spray paint onto a surface.

aisle—The portion of a basilica flanking the nave and separated from it by a row of columns or piers.

alchemy—The medieval study of seemingly magical changes, especially chemical changes.

altarpiece—A panel, painted or sculpted, situated above and behind an altar. See also *retable*.

Analytic Cubism—The first phase of *Cubism*, developed jointly by Pablo Picasso and Georges Braque, in which the artists analyzed form from every possible vantage point to combine the various views into one pictorial whole.

anamorphic image — A distorted image that must be viewed by some special means (such as a mirror) to be recognized.

ancien régime—French, "old order." The term used to describe the political, social, and religious order in France before the Revolution at the end of the 18th century.

apse—A recess, usually semicircular, in the wall of a building, commonly found at the east end of a church.

arcade—A series of arches supported by piers or columns. Arcadian (adj.)—In Renaissance and later art, depictions of an idyllic place of rural peace and simplicity. Derived from Arcadia, an ancient district of the central Peloponnesos in southern Greece.

arch—A curved structural member that spans an opening and is generally composed of wedgeshaped blocks (voussoirs) that transmit the downward pressure laterally. See also thrust.

armature—The crossed, or diagonal, arches that form the skeletal framework of a Gothic rib vault.
In sculpture, the framework for a clay form.

arriccio—In *fresco* painting, the first layer of rough lime plaster applied to the wall.

Art Deco—Descended from Art Nouveau, this movement of the 1920s and 1930s sought to upgrade industrial design as a "fine art" and to work new materials into decorative patterns that could be either machined or handcrafted. Characterized by streamlined, elongated, and symmetrical design.

Art Nouveau—French, "new art." A late-19th- and early-20th-century art movement whose proponents tried to synthesize all the arts in an effort to create art based on natural forms that could be mass produced by technologies of the industrial age. The movement had other names in other countries: Jugendstil in Austria and Germany, Modernismo in Spain, and Floreale in Italy.

assemblage—An artwork constructed from already existing objects.

atmospheric perspective—See perspective.

atrium—The central reception room of a Roman house that is partly open to the sky. Also the open, colonnaded court in front of and attached to a Christian basilica.

attribute—(n.) The distinctive identifying aspect of a person, for example, an object held, an associated animal, or a mark on the body. (v.) To make an attribution.

attribution—Assignment of a work to a maker or makers.

automatism—In painting, the process of yielding oneself to instinctive motions of the hands after establishing a set of conditions (such as size of paper or medium) within which a work is to be created.

avant-garde—French, "advance guard" (in a platoon). Late-19th- and 20th-century artists who emphasized innovation and challenged established convention in their work. Also used as an adjective. **baldacchino**—A canopy on *columns*, frequently built over an altar. The term derives from *baldacco*.

baldacco—Italian, "silk from Baghdad." See *baldacchino*.

baldric—A sashlike belt worn over one shoulder and across the chest to support a sword.

Baroque—The traditional blanket designation for European art from 1600 to 1750. The stylistic term Baroque, which describes art that features dramatic theatricality and elaborate ornamentation in contrast to the simplicity and orderly rationality of Renaissance art, is most appropriately applied to Italian art of this period. The term derives from barroco.

barrel vault—See vault.

barroco—Portuguese, "irregularly shaped pearl." See *Baroque*.

base—In ancient Greek architecture, the molded projecting lowest part of *Ionic* and *Corinthian* columns. (Doric columns do not have bases.)

basilica—In Roman architecture, a public building for legal and other civic proceedings, rectangular in plan with an entrance usually on a long side. In Christian architecture, a church somewhat resembling the Roman basilica, usually entered from one end and with an *apse* at the other.

bas-relief—See relief.

battlement—A low parapet at the top of a circuit wall in a fortification.

Bauhaus—A school of architecture in Germany in the 1920s under the aegis of Walter Gropius, who emphasized the unity of art, architecture, and design.

bay—The space between two columns, or one unit in the *nave arcade* of a church; also, the passageway in an *arcuated* gate.

Beaux-Arts—An architectural style of the late 19th and early 20th centuries in France. Based on ideas taught at the École des Beaux-Arts in Paris, the Beaux-Arts style incorporated classical principles, such as symmetry in design, and included extensive exterior ornamentation.

belvedere—Italian, "beautiful view." A building or other structure with a view of a landscape or seascape.

benday dots—Named after the newspaper printer Benjamin Day, the benday dot system involves the modulation of colors through the placement and size of colored dots.

- **bent-axis plan**—A *plan* that incorporates two or more angular changes of direction, characteristic of Sumerian architecture.
- Biomorphic Surrealism—See Surrealism.
- **Book of Hours**—A Christian religious book for private devotion containing prayers to be read at specified times of the day.
- bottega—An artist's studio-shop.
- **breakfast piece**—A *still life* that includes bread and fruit
- **breviary**—A Christian religious book of selected daily prayers and Psalms.
- bucranium (pl. bucrania) Latin, "bovine skull." A common motif in classical architectural ornament. buon fresco—See fresco.
- burgher—A middle-class citizen.
- **burin**—A pointed tool used for *engraving* or *incising*.
- buttress—An exterior masonry structure that opposes the lateral *thrust* of an *arch* or a *vault*. A pier buttress is a solid mass of masonry. A flying buttress consists typically of an inclined member carried on an arch or a series of arches and a solid buttress to which it transmits lateral *thrust*.
- caduceus—In ancient Greek mythology, a magical rod entwined with serpents, the attribute of Hermes (Roman, Mercury), the messenger of the gods.
- calotype—From the Greek kalos, "beautiful." A photographic process in which a positive image is made by shining light through a negative image onto a sheet of sensitized paper.
- camera lucida—Latin, "lighted room." A device in which a small lens projects the image of an object downward onto a sheet of paper.
- camera obscura—Latin, "dark room." An ancestor of the modern camera in which a tiny pinhole, acting as a lens, projects an image on a screen, the wall of a room, or the ground-glass wall of a box; used by artists in the 17th, 18th, and early 19th centuries as an aid in drawing from nature.
- **campanile**—A bell tower of a church, usually, but not always, freestanding.
- **canon**—A rule, for example, of proportion. The ancient Greeks considered beauty to be a matter of "correct" proportion and sought a canon of proportion, for the human figure and for buildings. The fifth-century BCE sculptor Polykleitos wrote the *Canon*, a treatise incorporating his formula for the perfectly proportioned statue.
- capital—The uppermost member of a column, serving as a transition from the shaft to the lintel. In classical architecture, the form of the capital varies with the order.
- capriccio—Italian, "originality." One of several terms used in Italian *Renaissance* literature to praise the originality and talent of artists.
- **cartoon**—In painting, a full-size preliminary drawing from which a painting is made.
- **carving**—A *technique* of sculpture in which the artist cuts away material (for example, from a stone block) in order to create a *statue* or a *relief*.
- cassone (pl. cassoni)—A carved chest, often painted or gilded, popular in Renaissance Italy for the storing of household clothing.
- casting—A sculptural technique in which the artist pours liquid metal, plaster, clay or another material into a mold. When the material dries, the sculptor removes the cast piece from the mold.
- **cathedral**—A bishop's church. The word derives from *cathedra*, referring to the bishop's chair.
- **cella**—The chamber at the center of an ancient temple; in a classical temple, the room (Greek, *naos*) in which the *cult statue* usually stood.
- central plan—See plan.

- chancel arch—The arch separating the chancel (the apse or choir) or the transept from the nave of a basilica or church.
- **chapter house**—The meeting hall in a *monastery*. **chartreuse**—A Carthusian *monastery*.
- **chasing**—The engraving or embossing of metal.
- château (pl. châteaux)—French, "castle." A luxurious country residence for French royalty, developed from medieval castles.
- chiaroscuro—In drawing or painting, the treatment and use of light and dark, especially the gradations of light that produce the effect of modeling.
- chiaroscuro woodcut—A woodcut technique using two blocks of wood instead of one. The printmaker carves and inks one block in the usual way in order to produce a traditional black-and-white print. Then the artist cuts a second block consisting of broad highlights that can be inked in gray or color and printed over the first block's impression.
- choir—The space reserved for the clergy and singers in the church, usually east of the *transept* but, in some instances, extending into the *nave*.
- chromatic abstraction—A kind of Abstract Expressionism that focuses on the emotional resonance of color, as exemplified by the work of Barnett Newman and Mark Rothko.
- chronology—In art history, the dating of art objects and buildings.
- city-state—An independent, self-governing city.
- Classical—The art and culture of ancient Greece between 480 and 323 BCE. Lowercase *classical* refers more generally to Greco-Roman art and culture.
- clerestory—The fenestrated part of a building that rises above the roofs of the other parts. The oldest known clerestories are Egyptian. In Roman basilicas and medieval churches, clerestories are the windows that form the nave's uppermost level below the timber ceiling or the vaults.
- cloison—French, "partition." A cell made of metal wire or a narrow metal strip soldered edge-up to a metal base to hold *enamel*, semiprecious stones, pieces of colored glass, or glass paste fired to resemble sparkling jewels.
- cloisonné—A decorative metalwork technique employing *cloisons*; also, decorative brickwork in later Byzantine architecture.
- **coffer**—A sunken panel, often ornamental, in a *vault* or a ceiling.
- collage—A composition made by combining on a flat surface various materials, such as newspaper, wallpaper, printed text and illustrations, photographs, and cloth.
- **colonnade**—A series or row of *columns*, usually spanned by *lintels*.
- color—The value, or tonality, of a color is the degree of its lightness or darkness. The intensity, or saturation, of a color is its purity, its brightness or dullness. See also primary colors, secondary colors, and complementary colors.
- color-field painting—A variant of Post-Painterly Abstraction in which artists sought to reduce painting to its physical essence by pouring diluted paint onto unprimed canvas and letting these pigments soak into the fabric, as exemplified by the work of Helen Frankenthaler and Morris Louis.
- colorito—Italian, "colored" or "painted." A term used to describe the application of paint. Characteristic of the work of 16th-century Venetian artists who emphasized the application of paint as an important element of the creative process. Central Italian artists, in contrast, largely emphasized disegno the careful design preparation based on preliminary drawing.

- **colossal order**—An architectural design in which the *columns* or *pilasters* are two or more stories tall. Also called a giant order.
- **column**—A vertical, weight-carrying architectural member, circular in cross-section and consisting of a base (sometimes omitted), a shaft, and a capital.
- **combines**—The name American artist Robert Rauschenberg gave to his *assemblages* of painted passages and sculptural elements.
- **complementary colors**—Those pairs of colors, such as red and green, that together embrace the entire spectrum. The complement of one of the three *primary colors* is a mixture of the other two.
- **compline**—The last prayer of the day in a *Book of Hours*.
- **compose**—See *composition*.
- **Composite capital**—A capital combining *Ionic* volutes and *Corinthian* acanthus leaves, first used by the ancient Romans.
- **composition**—The way in which an artist organizes *forms* in an artwork, either by placing shapes on a flat surface or arranging forms in space.
- Conceptual Art—An American avant-garde art movement of the 1960s whose premise was that the "artfulness" of art lay in the artist's idea rather than its final expression.
- condottiere (pl. condottieri)—An Italian mercenary general.
- confraternity—In Late Antiquity, an association of Christian families pooling funds to purchase property for burial. In late medieval Europe, an organization founded by laypersons who dedicated themselves to strict religious observances.
- **connoisseur**—An expert in *attributing* artworks to one artist rather than another. More generally, an expert on artistic *style*.
- Constructivism—An early-20th-century Russian art movement formulated by Naum Gabo, who built up his sculptures piece by piece in space instead of carving or *modeling* them. In this way the sculptor worked with "volume of mass" and "volume of space" as different materials.
- **contour line**—In art, a continuous line defining the outer shape of an object.
- contrapposto—The disposition of the human figure in which one part is turned in opposition to another part (usually hips and legs one way, shoulders and chest another), creating a counterpositioning of the body about its central axis. Sometimes called "weight shift" because the weight of the body tends to be thrown to one foot, creating tension on one side and relaxation on the other.
- corbel A projecting wall member used as a support for some element in the superstructure. Also, courses of stone or brick in which each course projects beyond the one beneath it. Two such walls, meeting at the topmost course, create a corbeled arch or corbeled vault.
- Corinthian capital—A more ornate form than *Doric* or *Ionic;* it consists of a double row of acanthus leaves from which tendrils and flowers grow, wrapped around a bell-shaped *echinus*. Although this *capital* form is often cited as the distinguishing feature of the Corinthian *order,* no such order exists, in strict terms, but only this style of capital used in the *Ionic* order.
- **cornice**—The projecting, crowning member of the *entablature* framing the *pediment*; also, any crowning projection.
- **corona civica**—Latin, "civic crown." A Roman honorary wreath worn on the head.
- **course**—In masonry construction, a horizontal row of stone blocks.

cross-hatching—See hatching.

crossing square— The area in a church formed by the intersection (crossing) of a nave and a transept of equal width, often used as a standard module of interior proportion.

cruciform—Cross-shaped.

- **Cubism**—An early-20th-century art movement that rejected naturalistic depictions, preferring compositions of shapes and forms abstracted from the conventionally perceived world. See also *Analytic Cubism* and *Synthetic Cubism*.
- **cupola**—An exterior architectural feature composed of a *drum* with a shallow cap; a *dome*.
- cutaway—An architectural drawing that combines an exterior view with an interior view of part of a building.
- Dada—An early-20th-century art movement prompted by a revulsion against the horror of World War I. Dada embraced political anarchy, the irrational, and the intuitive. A disdain for convention, often enlivened by humor or whimsy, is characteristic of the art the Dadaists produced.
- **daguerreotype**—A photograph made by an early method on a plate of chemically treated metal; developed by Louis J. M. Daguerre.
- De Stijl—Dutch, "the style." An early-20th-century art movement (and magazine), founded by Piet Mondrian and Theo van Doesburg, whose members promoted utopian ideals and developed a simplified geometric style.
- deconstruction—An analytical strategy developed in the late 20th century according to which all cultural "constructs" (art, architecture, literature) are "texts." People can read these texts in a variety of ways, but they cannot arrive at fixed or uniform meanings. Any interpretation can be valid, and readings differ from time to time, place to place, and person to person. For those employing this approach, deconstruction means destabilizing established meanings and interpretations while encouraging subjectivity and individual differences.
- Deconstructivism—An architectural style using *deconstruction* as an analytical strategy. Deconstructivist architects attempt to disorient the observer by disrupting the conventional categories of architecture. The haphazard presentation of volumes, masses, planes, lighting, and so forth challenges the viewer's assumptions about form as it relates to function.
- **Der Blaue Reiter**—German, "the blue rider." An early-20th-century German *Expressionist* art movement founded by Vassily Kandinsky and Franz Marc. The artists selected the whimsical name because of their mutual interest in the color blue and horses.
- **Die Brücke**—German, "the bridge." An early-20thcentury German *Expressionist* art movement under the leadership of Ernst Ludwig Kirchner. The group thought of itself as the bridge between the old age and the new.
- diptych—A two-paneled painting or altarpiece; also, an ancient Roman, Early Christian, or Byzantine hinged writing tablet, often of ivory and carved on the external sides.
- **disegno**—Italian, "drawing" and "design." *Renaissance* artists considered drawing to be the external physical manifestation (*disegno esterno*) of an internal intellectual idea of design (*disegno interno*).

divisionism—See pointillism.

documentary evidence—In art history, the examination of written sources in order to determine the date of an artwork, the circumstances of its creation, or the identity of the artist(s) who made it.

- **dome**—A hemispherical *vault*; theoretically, an *arch* rotated on its vertical axis. In *Mycenaean* architecture, domes are beehive-shaped.
- **donor portrait**—A portrait of the individual(s) who commissioned (donated) a religious work, for example, an *altarpiece*, as evidence of devotion.
- Doric—One of the two systems (or *orders*) invented in ancient Greece for articulating the three units of the elevation of a *classical* building—the platform, the *colonnade*, and the superstructure (*entablature*). The Doric order is characterized by, among other features, *capitals* with funnel-shaped *echinuses*, *columns* without *bases*, and a *frieze* of *triglyphs* and *metopes*. See also *Ionic*.
- **dressed masonry**—Stone blocks shaped to the exact dimensions required, with smooth faces for a perfect fit.
- **drum**—One of the stacked cylindrical stones that form the *shaft* of a *column*. Also, the cylindrical wall that supports a *dome*.
- drypoint—An engraving in which the design, instead of being cut into the plate with a burin, is scratched into the surface with a hard steel "pencil." See also etching, intaglio.

earthworks—See Environmental Art.

- **echinus**—The convex element of a *capital* directly below the *abacus*.
- écorché—The representation of a nude body as if without skin.
- **edition**—A set of impressions taken from a single print surface.
- elevation—In architecture, a head-on view of an external or internal wall, showing its features and often other elements that would be visible beyond or before the wall.
- **empiricism**—The search for knowledge based on observation and direct experience.
- **enamel**—A decorative coating, usually colored, fused onto the surface of metal, glass, or ceramics.
- encaustic A painting technique in which pigment is mixed with melted wax and applied to the surface while the mixture is hot.
- **engaged column**—A half-round *column* attached to a wall. See also *pilaster*.
- engraving—The process of *incising* a design in hard material, often a metal plate (usually copper); also, the *print* or impression made from such a plate.
- Enlightenment—The Western philosophy based on empirical evidence that dominated the 18th century. The Enlightenment was a new way of thinking critically about the world and about humankind, independently of religion, myth, or tradition.
- **entablature**—The part of a building above the *columns* and below the roof. The entablature has three parts: *architrave*, *frieze*, and *pediment*.
- Environmental Art—An American art form that emerged in the 1960s. Often using the land itself as their material, Environmental artists construct monuments of great scale and minimal form. Permanent or impermanent, these works transform some section of the environment, calling attention both to the land itself and to the hand of the artist. Sometimes referred to as earthworks.

escutcheon—An emblem bearing a coat of arms.

- etching—A kind of *engraving* in which the design is *incised* in a layer of wax or varnish on a metal plate. The parts of the plate left exposed are then etched (slightly eaten away) by the acid in which the plate is immersed after incising. See also *drypoint*, *intaglio*.
- Eucharist—In Christianity, the partaking of the bread and wine, which believers hold to be either Christ himself or symbolic of him.

Events—See Fluxus.

- exedra—Recessed area, usually semicircular.
- **exemplum virtutis**—Latin, "example or model of virtue"
- **Expressionism** (adj. **Expressionist**)—Twentieth-century art that is the result of the artist's unique inner or personal vision and that often has an emotional dimension. Expressionism contrasts with art focused on visually describing the empirical world
- **facade**—Usually, the front of a building; also, the other sides when they are emphasized architecturally.
- fantasia—Italian, "imagination." One of several terms used in Italian *Renaissance* literature to praise the originality and talent of artists.
- **fasces**—A bundle of rods with an ax attached, representing an emblem of authority in ancient Rome.

Fauves—French, "wild beasts." See Fauvism.

- **Fauvism**—An early-20th-century art movement led by Henri Matisse. For the Fauves, color became the formal element most responsible for pictorial coherence and the primary conveyor of meaning.
- **Favrile**—A type of leaded stained glass patented by Louis Comfort Tiffany in the late 19th century.
- **femmages**—The name American artist Miriam Schapiro gave to her sewn *collages*, assembled from fabrics, quilts, buttons, sequins, lace trim, and rickrack collected at antique shows and fairs.
- **femme savante**—French, "learned woman." The term used to describe the cultured hostesses of *Rococo* salons.

fenestrated—Having windows.

- **fête galante**—French, "amorous festival." A type of *Rococo* painting depicting the outdoor amusements of French upper-class society.
- **feudalism**—The medieval political, social, and economic system held together by the relationship between landholding *liege lords* and the *vassals* who were granted tenure of a portion of their land and in turn swore allegiance to the liege lord.
- fin-de-siècle—French, "end of the century." A period in Western cultural history from the end of the 19th century until just before World War I, when decadence and indulgence masked anxiety about an uncertain future.

finial—A crowning ornament.

fleur-de-lis—A three-petaled iris flower; the royal flower of France.

Floreale—See Art Nouveau.

- **florin**—The denomination of gold coin of Renaissance Florence that became an international currency for trade.
- **Fluxus**—A group of American, European, and Japanese artists of the 1960s who created *Performance Art.* Their performances, or Events, often focused on single actions, such as turning a light on and off or watching falling snow, and were more theatrical than *Happenings*.

flying buttress—See buttress.

- **fons vitae**—Latin, "fountain of life." A symbolic fountain of everlasting life.
- **foreshortening**—The use of *perspective* to represent in art the apparent visual contraction of an object that extends back in space at an angle to the perpendicular plane of sight.
- form—In art, an object's shape and structure, either in two dimensions (for example, a figure painted on a surface) or in three dimensions (such as a statue).
- **formal analysis**—The visual analysis of artistic form.
- formalism—Strict adherence to, or dependence on, stylized shapes and methods of composition. An emphasis on an artwork's visual elements rather than its subject.

807

freestanding sculpture—See sculpture in the round.
fresco—Painting on lime plaster, either dry (dry fresco, or fresco secco) or wet (true, or buon, fresco). In the latter method, the pigments are mixed with water and become chemically bound to the freshly laid lime plaster. Also, a painting executed in either method.

fresco secco—See fresco.

frieze—The part of the *entablature* between the *ar-chitrave* and the *cornice*; also, any sculptured or painted band in a building. See *register*.

frottage—A *technique* in which the artist rubs a crayon or another medium across a sheet of paper placed over a surface having a strong textural pattern.

Futurism—An early-20th-century Italian art movement that championed war as a cleansing agent and that celebrated the speed and dynamism of modern technology.

genre—A style or category of art; also, a kind of painting that realistically depicts scenes from everyday life.

German Expressionism—An early-20th-century regional Expressionist movement.

gesso—Plaster mixed with a binding material, used as the base coat for paintings on wood panels.

gestural abstraction—Also known as *action painting*. A kind of abstract painting in which the gesture, or act of painting, is seen as the subject of art. Its most renowned proponent was Jackson Pollock. See also *Abstract Expressionism*.

giant order—See colossal order.

giornata (pl. giornate) — Italian, "day." The section of plaster that a fresco painter expects to complete in one session.

glaze—A vitreous coating applied to pottery to seal and decorate the surface; it may be colored, transparent, or opaque, and glossy or *matte*. In oil painting, a thin, transparent, or semitransparent layer applied over a color to alter it slightly.

gold leaf—Gold beaten into tissue-paper-thin sheets that then can be applied to surfaces.

Gothic—Originally a derogatory term named after the Goths, used to describe the history, culture, and art of western Europe in the 12th to 14th centuries. Typically divided into periods designated Early (1140–1194), High (1194–1300), and Late (1300–1500).

Grand Manner portraiture—A type of 18th-century portrait painting designed to communicate a person's grace and class through certain standardized conventions, such as the large scale of the figure relative to the canvas, the controlled pose, the land-scape setting, and the low horizon line.

Greek cross—A cross with four arms of equal length.
grisaille—A monochrome painting done mainly in
neutral grays to simulate sculpture.

guild—An association of merchants, craftspersons, or scholars in medieval and Renaissance Europe.

halberd—A combination spear and battle-ax.

Happenings—A term coined by American artist Allan Kaprow in the 1960s to describe loosely structured performances, whose creators were trying to suggest the aesthetic and dynamic qualities of everyday life; as actions, rather than objects, Happenings incorporate the fourth dimension (time).

hard-edge painting—A variant of Post-Painterly Abstraction that rigidly excluded all reference to gesture and incorporated smooth knife-edge geometric forms to express the notion that painting should be reduced to its visual components.

hatching—A series of closely spaced drawn or engraved parallel lines. Cross-hatching employs sets of lines placed at right angles. **hierarchy of scale**—An artistic convention in which greater size indicates greater importance.

high relief—See relief.

horizon line—See perspective.

hôtel-French, "town house."

hue—The name of a *color*. See also *primary colors*, *secondary colors*, and *complementary colors*.

humanism—In the Renaissance, an emphasis on education and on expanding knowledge (especially of classical antiquity), the exploration of individual potential and a desire to excel, and a commitment to civic responsibility and moral duty.

icon—A portrait or image; especially in Byzantine churches, a panel with a painting of sacred personages that are objects of veneration. In the visual arts, a painting, a piece of sculpture, or even a building regarded as an object of veneration.

iconoclasm—The destruction of religious or sacred images. In Byzantium, the period from 726 to 843 when there was an imperial ban on such images. The destroyers of images were known as iconoclasts. Those who opposed such a ban were known as iconophiles.

iconoclast—See iconoclasm.

iconography—Greek, the "writing of images." The term refers both to the content, or subject, of an artwork and to the study of content in art. It also includes the study of the symbolic, often religious, meaning of objects, persons, or events depicted in works of art.

illuminated manuscript—A luxurious handmade book with painted illustrations and decorations.

illusionism (adj. illusionistic)—The representation of the three-dimensional world on a two-dimensional surface in a manner that creates the illusion that the person, object, or place represented is threedimensional. See also perspective.

impasto—A layer of thickly applied pigment.

Impressionism—A late-19th-century art movement that sought to capture a fleeting moment, thereby conveying the illusiveness and impermanence of images and conditions.

incise—To cut into a surface with a sharp instrument; also, a method of decoration, especially on metal and pottery.

incubus—A demon believed in medieval times to prey, often sexually, on sleeping women.

indulgence—A religious pardon for a sin committed. ingegno—Italian, "innate talent." One of several terms used in Italian Renaissance literature to praise the originality and talent of artists.

installation—An artwork that creates an artistic environment in a room or gallery.

intaglio — A graphic technique in which the design is incised, or scratched, on a metal plate, either manually (engraving, drypoint) or chemically (etching). The incised lines of the design take the ink, making this the reverse of the woodcut technique.
intensity — See color.

internal evidence—In art history, the examination of what an artwork represents (people, clothing, hairstyles, and so on) in order to determine its date. Also, the examination of the *style* of an artwork to identify the artist who created it.

International Style—A *style* of 14th- and 15th-century painting begun by Simone Martini, who adapted the French *Gothic* manner to Sienese art fused with influences from Northern Europe. This style appealed to the aristocracy because of its brilliant color, lavish costumes, intricate ornamentation, and themes involving splendid processions of knights and ladies. Also, a style of 20th-century architecture associated with Le Corbusier, whose elegance of design came to in-

fluence the look of modern office buildings and skyscrapers.

intonaco—In fresco painting, the last layer of smooth lime plaster applied to the wall; the painting layer.

invenzione—Italian, "invention." One of several terms used in Italian *Renaissance* literature to praise the originality and talent of artists.

Ionic—One of the two systems (or orders) invented in ancient Greece for articulating the three units of the elevation of a classical building: the platform, the colonnade, and the superstructure (entablature). The Ionic order is characterized by, among other features, volutes, capitals, columns with bases, and an uninterrupted frieze.

Japonisme—The French fascination with all things Japanese. Japonisme emerged in the second half of the 19th century.

Jugendstil—See Art Nouveau.

keystone—See voussoir.

lancet—In *Gothic* architecture, a tall narrow window ending in a *pointed arch*.

landscape—A picture showing natural scenery, without narrative content.

Landschaft—German, "landscape."

lateral section—See section.

line—The extension of a point along a path, made concrete in art by drawing on or chiseling into a *plane*.

linear perspective—See perspective.

lintel—A horizontal *beam* used to span an opening. **lithograph**—See *lithography*.

lithography—A printmaking technique in which the artist uses an oil-based crayon to draw directly on a stone plate and then wipes water onto the stone. When ink is rolled onto the plate, it adheres only to the drawing. The print produced by this method is a lithograph.

local color—An object's true color in white light.

loggia—A gallery with an open *arcade* or a *colonnade* on one or both sides.

longitudinal plan—See plan.

lost-wax (cire perdue) process—A bronze-casting method in which a figure is modeled in wax and covered with clay; the whole is fired, melting away the wax (French, cire perdue) and hardening the clay, which then becomes a mold for molten metal.

low relief—See relief.

machicolated gallery—A gallery in a defensive tower with holes in the floor to allow stones or hot liquids to be dumped on enemies below.

magus (pl. magi) — One of the three wise men from the East who presented gifts to the infant Jesus.
maniera — Italian, "style" or "manner." See *Mannerism*.
maniera greca — Italian, "Greek manner." The Italo-Byzantine painting style of the 13th century.

Mannerism—A style of later *Renaissance* art that emphasized "artifice," often involving contrived imagery not derived directly from nature. Such artworks showed a self-conscious stylization involving complexity, caprice, fantasy, and polish. Mannerist architecture tended to flout the classical rules of order, stability, and symmetry, sometimes to the point of parody.

Mara—A spirit in Northern European mythology that was thought to torment and suffocate sleepers.

martyrium—A shrine to a Christian martyr *saint*. mass—The bulk, density, and weight of matter is

mass—The bulk, density, and weight of matter in *space*.

Mass—The Catholic and Orthodox ritual in which believers understand that Christ's redeeming sacrifice on the cross is repeated when the priest consecrates the bread and wine in the *Eucharist*.

matins—The dawn prayer in a Book of Hours.

matte—In painting, pottery, and photography, a dull finish.

maulstick—A stick used to steady the hand while painting.

medium (pl. **media**)—The material (for example, marble, bronze, clay, *fresco*) in which an artist works; also, in painting, the vehicle (usually liquid) that carries the pigment.

memento mori—Latin, "reminder of death." In painting, a reminder of human mortality, usually represented by a skull.

mendicants—In medieval Europe, friars belonging to the Franciscan and Dominican orders, who renounced all worldly goods, lived by contributions of laypersons (the word *mendicant* means "beggar"), and devoted themselves to preaching, teaching, and doing good works.

metamatics—The name Swiss artist Jean Tinguely gave to the motor-driven devices he constructed to produce instant abstract paintings.

miniatures—Small individual Indian paintings intended to be held in the hand and viewed by one or two individuals at one time.

Minimalism—A predominantly sculptural American trend of the 1960s characterized by works featuring a severe reduction of form, often to single, homogeneous units.

mobile—A kind of sculpture, invented by Alexander Calder, combining nonobjective organic forms and motion in balanced structures hanging from rods, wires, and colored, organically shaped plates.

modeling—The shaping or fashioning of threedimensional forms in a soft material, such as clay; also, the gradations of light and shade reflected from the surfaces of matter in space, or the illusion of such gradations produced by alterations of value in a drawing, painting, or print.

modernism—A movement in Western art that developed in the second half of the 19th century and sought to capture the images and sensibilities of the age. Modernist art goes beyond simply dealing with the present and involves the artist's critical examination of the premises of art itself.

Modernismo—See Art Nouveau.

modernist formalism—See formalism.

module (adj. modular) — A basic unit of which the dimensions of the major parts of a work are multiples. The principle is used in sculpture and other art forms, but it is most often employed in architecture, where the module may be the dimensions of an important part of a building, such as the diameter of a column.

mold—A hollow form for casting.

monastery—A group of buildings in which monks live together, set apart from the secular community of a town.

monastic order—An organization of monks living according to the same rules, for example, the Benedictine, Franciscan, and Dominican orders.

monochrome (adj. monochromatic)—One color.

mosaic — Patterns or pictures made by embedding small pieces (tesserae) of stone or glass in cement on surfaces such as walls and floors; also, the technique of making such works.

mullion—A vertical member that divides a window or that separates one window from another.

mural—A wall painting.

mystery play—A dramatic enactment of the holy mysteries of the Christian faith performed at church portals and in city squares.

mystic marriage—A spiritual marriage of a woman with Christ.

Nabis—Hebrew, "prophet." A group of *Symbolist* painters influenced by Paul Gauguin.

naturalism—The style of painted or sculptured representation based on close observation of the natural world that was at the core of the classical tradition.

Naturalistic Surrealism—See Surrealism.

nave—The central area of an ancient Roman basilica or of a church, demarcated from aisles by piers or columns.

nave arcade—In *basilica* architecture, the series of *arches* supported by *piers* or *columns* separating the *nave* from the *aisles*.

Neoclassicism—A style of art and architecture that emerged in the late 18th century as part of a general revival of interest in *classical* cultures. Neoclassical artists adopted themes and styles from ancient Greece and Rome.

Neo-Expressionism—An art movement that emerged in the 1970s and that reflects artists' interest in the expressive capability of art, seen earlier in *German Expressionism* and *Abstract Expressionism*.

Neo-Gothic—The revival of the *Gothic* style in architecture, especially in the 19th century.

Neoplasticism—The Dutch artist Piet Mondrian's theory of "pure plastic art," an ideal balance between the universal and the individual using an abstract formal vocabulary.

Neue Sachlichkeit—German, "new objectivity." An art movement that grew directly out of the World War I experiences of a group of German artists who sought to show the horrors of the war and its effects.

oculus (pl. **oculi**)—Latin, "eye." The round central opening of a *dome*. Also, a small round window in a *Gothic cathedral*.

odalisque—A woman in a Turkish harem.

ogee arch—An *arch* composed of two doublecurving lines meeting at a point.

ogive (adj. **ogival**)—The diagonal *rib* of a *Gothic vault*; a pointed, or Gothic, *arch*.

oil painting—A painting technique using oil-based pigments that rose to prominence in Northern Europe in the 15th century and is now the standard medium for painting on canvas.

optical mixture—The visual effect of juxtaposed *complementary colors.*

orbiculum—A disklike opening.

order—In classical architecture, a style represented by a characteristic design of the columns and entablature. See also superimposed orders.

Orphism—A form of *Cubism* developed by the French painter Robert Delaunay in which color plays an important role.

orrery—A mechanical model of the solar system demonstrating how the planets revolve around the sun.

orthogonal—A line imagined to be behind and perpendicular to the picture plane; the orthogonals in a painting appear to recede toward a vanishing point on the horizon.

palette knife — A flat tool used to scrape paint off the palette. Artists sometimes also use the palette knife in place of a brush to apply paint directly to the canvas.

papier collé—French, "stuck paper." See collage.

parallel hatching—See hatching.

parapet — A low, protective wall along the edge of a balcony, roof, or bastion.

parchment—Lambskin prepared as a surface for painting or writing.

pastel—A powdery paste of pigment and gum used for making crayons; also, the pastel crayons themselves. patron—The person or entity that pays an artist to produce individual artworks or employs an artist on a continuing basis.

pediment—In *classical* architecture, the triangular space (gable) at the end of a building, formed by the ends of the sloping roof above the *colonnade*; also, an ornamental feature having this shape.

pendentive—A concave, triangular section of a hemisphere, four of which provide the transition from a square area to the circular base of a covering *dome*. Although pendentives appear to be hanging (pendant) from the dome, they in fact support it.

Performance Art—An American avant-garde art trend of the 1960s that made time an integral element of art. It produced works in which movements, gestures, and sounds of persons communicating with an audience replace physical objects. Documentary photographs are generally the only evidence remaining after these events. See also *Happenings*.

period style—See style.

personal style—See style.

personification—An abstract idea represented in bodily form.

perspective (adj. perspectival)—A method of presenting an illusion of the three-dimensional world on a two-dimensional surface. In linear perspective, the most common type, all parallel lines or surface edges converge on one, two, or three vanishing points located with reference to the eye level of the viewer (the horizon line of the picture), and associated objects are rendered smaller the farther from the viewer they are intended to seem. Atmospheric, or aerial, perspective creates the illusion of distance by the greater diminution of color intensity, the shift in color toward an almost neutral blue, and the blurring of contours as the intended distance between eye and object increases.

philosophe—French, "thinker, philosopher." The term applied to French intellectuals of the Enlightenment.

photomontage—A composition made by pasting together pictures or parts of pictures, especially photographs. See also *collage*.

Photorealism—See Superrealism.

physical evidence—In art history, the examination of the materials used to produce an artwork in order to determine its date.

piazza-Italian, "plaza."

pier—A vertical, freestanding masonry support.

Pieta—A painted or sculpted representation of the Virgin Mary mourning over the body of the dead Christ.

pilaster—A flat, rectangular, vertical member projecting from a wall of which it forms a part. It usually has a base and a capital and is often fluted.

pinnacle—In Gothic churches, a sharply pointed ornament capping the piers or flying buttresses; also used on church facades.

Pittura Metafisica—Italian, "metaphysical painting." An early-20th-century Italian art movement led by Giorgio de Chirico, whose work conveys an eerie mood and visionary quality.

pixels—Shortened form of "picture elements." The tiny boxes that make up digital images displayed on a computer monitor.

plan—The horizontal arrangement of the parts of a building or of the buildings and streets of a city or town, or a drawing or diagram showing such an arrangement. In an axial plan, the parts of a building are organized longitudinally, or along a given axis; in a central plan, the parts of the structure are of equal or almost equal dimensions around the center. plane—A flat surface.

Plateresque—A style of Spanish architecture characterized by elaborate decoration based on *Gothic*, Italian *Renaissance*, and Islamic sources; derived from the Spanish word *platero*, meaning "silversmith."

platero—See Plateresque.

- plein air—An approach to painting much popular among the *Impressionists*, in which an artist sketches outdoors to achieve a quick impression of light, air, and color. The artist then takes the sketches to the studio for reworking into more finished works of art.
- poesia—A term describing "poetic" art, notably Venetian *Renaissance* painting, which emphasizes the lyrical and sensual.
- **pointed arch**—A narrow *arch* of pointed profile, in contrast to a semicircular arch.
- pointillism—A system of painting devised by the 19th-century French painter Georges Seurat. The artist separates color into its component parts and then applies the component colors to the canvas in tiny dots (points). The image becomes comprehensible only from a distance, when the viewer's eyes optically blend the pigment dots. Sometimes referred to as divisionism.
- **polyptych**—An *altarpiece* composed of more than three sections.
- Pop Art—A term coined by British art critic Lawrence Alloway to refer to art, first appearing in the 1950s, that incorporated elements from consumer culture, the mass media, and popular culture, such as images from motion pictures and advertising.
- **portico**—A roofed *colonnade*; also an entrance porch.
- **positivism**—A Western philosophical model that promoted science as the mind's highest achievement.
- Post-Impressionism—The term used to describe the stylistically heterogeneous work of the group of late-19th-century painters in France, including van Gogh, Gauguin, Seurat, and Cézanne, who more systematically examined the properties and expressive qualities of line, pattern, form, and color than the Impressionists did.
- postmodernism—A reaction against modernist formalism, seen as elitist. Far more encompassing and accepting than the more rigid confines of modernist practice, postmodernism offers something for everyone by accommodating a wide range of styles, subjects, and formats, from traditional easel painting to installation and from abstraction to illusionistic scenes. Postmodern art often includes irony or reveals a self-conscious awareness on the part of the artist of art-making processes or the workings of the art world.
- Post-Painterly Abstraction—An American art movement that emerged in the 1960s and was characterized by a cool, detached rationality emphasizing tighter pictorial control. See also color-field painting and hard-edge painting.
- Poussiniste—A member of the French Royal Academy of Painting and Sculpture during the early 18th century who followed Nicolas Poussin in insisting that *form* was the most important element of painting. See also *Rubéniste*.
- Precisionism—An American art movement of the 1920s and 1930s. The Precisionists concentrated on portraying man-made environments in a clear and concise manner to express the beauty of perfect and precise machine forms.
- **predella**—The narrow ledge on which an *altarpiece* rests on an altar.

- **primary colors**—Red, yellow, and blue—the *colors* from which all other colors may be derived.
- **primitivism**—The incorporation in early-20thcentury Western art of stylistic elements from the artifacts of Africa, Oceania, and the native peoples of the Americas.
- **print**—An artwork on paper, usually produced in multiple impressions.
- Productivism—An art movement that emerged in the Soviet Union after the Russian Revolution; its members believed that artists must direct art toward creating products for the new society.
- **proportion**—The relationship in size of the parts of persons, buildings, or objects, often based on a module.

provenance—Origin or source; findspot.

psalter—A book containing the Psalms.

pulpit—A raised platform in a church on which a priest stands while leading the religious service.

punchwork—Tooled decorative work in gold leaf.

Purism—An early-20th-century art movement that embraced the "machine aesthetic" and sought purity of *form* in the clean functional lines of industrial machinery.

putto (pl. putti)—A cherubic young boy.

- quadro riportato—A ceiling design in which painted scenes are arranged in panels that resemble framed pictures transferred to the surface of a shallow, curved vault.
- **quatrefoil**—A shape or plan in which the parts assume the form of a cloverleaf.
- quoins—The large, sometimes rusticated, usually slightly projecting stones that often form the corners of the exterior walls of masonry buildings.
- Realism—A movement that emerged in mid-19thcentury France. Realist artists represented the subject matter of everyday life (especially subjects that previously had been considered inappropriate for depiction) in a relatively naturalistic mode.
- **refectory**—The dining hall of a Christian *monastery*. **regional style**—See *style*.
- Regionalism—A 20th-century American art movement that portrayed American rural life in a clearly readable, realist style. Major Regionalists include Grant Wood and Thomas Hart Benton.
- **register**—One of a series of superimposed bands or *friezes* in a pictorial narrative, or the particular levels on which motifs are placed.
- relief—In sculpture, figures projecting from a background of which they are part. The degree of relief is designated high, low (bas), or sunken. In the last, the artist cuts the design into the surface so that the highest projecting parts of the image are no higher than the surface itself. See also repoussé.
- Renaissance—French, "rebirth." The term used to describe the history, culture, and art of 14th-through 16th-century western Europe during which artists consciously revived the *classical* style.
- **renovatio**—Latin, "renewal." During the *Carolingian* period, Charlemagne sought to revive the culture of ancient Rome (renovatio imperi Romani).
- **retable**—An architectural screen or wall above and behind an altar, usually containing painting, sculpture, carving, or other decorations. See also *altarviece*.
- revetment—In architecture, a wall covering or facing.
 rib—A relatively slender, molded masonry arch that projects from a surface. In Gothic architecture, the ribs form the framework of the vaulting. A diagonal rib is one of the ribs that form the X of a groin vault. A transverse rib crosses the nave or aisle at a 90-degree angle.

rib vault—A vault in which the diagonal and transverse ribs compose a structural skeleton that partially supports the masonry web between them.

rocaille—See Rococo.

- Rococo—A style, primarily of interior design, that appeared in France around 1700. Rococo interiors featured lavish decoration, including small sculptures, ornamental mirrors, easel paintings, tapestries, reliefs, wall paintings, and elegant furniture. The term Rococo derived from the French word rocaille ("pebble") and referred to the small stones and shells used to decorate grotto interiors.
- Romanesque—"Roman-like." A term used to describe the history, culture, and art of medieval western Europe from ca. 1050 to ca. 1200.
- Romanticism—A Western cultural phenomenon, beginning around 1750 and ending about 1850, that gave precedence to feeling and imagination over reason and thought. More narrowly, the art movement that flourished from about 1800 to 1840.

rose window.—A circular stained-glass window.

rostrum—Speaker's platform.

rotunda—The circular area under a *dome*; also a domed round building.

roundel—See tondo.

- **Rubéniste**—A member of the French Royal Academy of Painting and Sculpture during the early 18th century who followed Peter Paul Rubens in insisting that *color* was the most important element of painting. See also *Poussiniste*.
- rusticate (n. rustication)—To give a rustic appearance by roughening the surfaces and beveling the edges of stone blocks to emphasize the joints between them. Rustication is a technique employed in ancient Roman architecture, and was also popular during the *Renaissance*, especially for stone courses at the ground-floor level.
- sacra conversazione—Italian, "holy conversation." A style of altarpiece painting popular after the middle of the 15th century, in which saints from different epochs are joined in a unified space and seem to be conversing either with one another or with the audience.
- **sacra rappresentazione** (pl. **sacre rappresentazioni**)—Italian, "holy representation." A more elaborate version of a *mystery play* performed for a lay audience by a *confraternity*.
- saint—From the Latin word sanctus, meaning "made holy by God." Applied to persons who suffered and died for their Christian faith or who merited reverence for their Christian devotion while alive. In the Roman Catholic Church, a worthy deceased Catholic who is canonized by the pope.
- Saint-Simonianism—An early-19th-century utopian movement that emphasized the education and enfranchisement of women.
- sarcophagus (pl. sarcophagi)—Latin, "consumer of flesh." A coffin, usually of stone.

saturation—See color.

- satyr—A Greek mythological follower of Dionysos having a man's upper body, a goat's hindquarters and horns, and a horse's ears and tail.
- **school**—A chronological and stylistic classification of works of art with a stipulation of place.
- **scudi**—Italian, "shields." A coin denomination in 17th-century Italy.
- **sculpture in the round**—Freestanding figures, carved or modeled in three dimensions.
- **secondary colors**—Orange, green, and purple, obtained by mixing pairs of *primary colors* (red, yellow, blue).

- section—In architecture, a diagram or representation of a part of a structure or building along an imaginary plane that passes through it vertically. Drawings showing a theoretical slice across a structure's width are lateral sections. Those cutting through a building's length are longitudinal sections. See also elevation and cutaway.
- sfumato—Italian, "smoky." A smokelike haziness that subtly softens outlines in painting; particularly applied to the paintings of Leonardo da Vinci and Correggio.
- **shaft**—The tall, cylindrical part of a *column* between the *capital* and the *base*.
- **sibyl**—A Greco-Roman mythological prophetess.
- **signoria**—The governing body in the Republic of Florence.
- silk-screen printing—An industrial printing technique that creates a sharp-edged image by pressing ink through a design on silk or a similar tightly woven porous fabric stretched tight on a frame
- silverpoint—A stylus made of silver, used in drawing in the 14th and 15th centuries because of the fine line it produced and the sharp point it maintained.
- simultaneous contrasts—The phenomenon of juxtaposed colors affecting the eye's reception of each, as when a painter places dark green next to light green, making the former appear even darker and the latter even lighter. See also successive contrasts.
- sinopia—A burnt-orange pigment used in fresco painting to transfer a cartoon to the arriccio before the artist paints the plaster.
- site-specific art Art created for a specific location. See also Environmental Art.
- space—In art history, both the actual area an object occupies or a building encloses, and the *illusionistic* representation of space in painting and sculpture.
- **spectrum**—The range or band of visible colors in natural light.
- **stained glass**—In *Gothic* architecture, the colored glass used for windows.
- stanza (pl. stanze) Italian, "room."
- statue—A three-dimensional sculpture.
- stigmata—In Christian art, the wounds Christ received at his crucifixion that miraculously appear on the body of a saint.
- **still life**—A picture depicting an arrangement of inanimate objects.
- **stretcher bar**—One of a set of wooden bars used to stretch canvas to provide a taut surface for painting.
- stringcourse—A raised horizontal molding, or band, in masonry. Its principal use is ornamental but it usually reflects interior structure.
- style—A distinctive artistic manner. Period style is the characteristic style of a specific time. Regional style is the style of a particular geographical area. Personal style is an individual artist's unique manner.
- **stylistic evidence**—In art history, the examination of the *style* of an artwork in order to determine its date or the identity of the artist.
- stylobate—The uppermost course of the platform of a classical Greek temple, which supports the columns.
- stylus—A needlelike tool used in engraving and incising; also, an ancient writing instrument used to inscribe clay or wax tablets.
- **subtractive light**—The painter's light in art; the light reflected from pigments and objects. See also *additive light*.
- **subtractive sculpture**—A kind of sculpture technique in which materials are taken away from the original mass; carving.

- successive contrasts—The phenomenon of colored afterimages. When a person looks intently at a color (green, for example) and then shifts to a white area, the fatigued eye momentarily perceives the complementary color (red). See also simultaneous contrasts.
- superimposed orders—Orders of architecture that are placed one above another in an arcaded or colonnaded building, usually in the following sequence: Doric (the first story), Ionic, and Corinthian. Superimposed orders are found in later Greek architecture and were used widely by Roman and Renaissance builders.
- Superrealism—A *school* of painting and sculpture of the 1960s and 1970s that emphasized producing artworks based on scrupulous fidelity to optical fact. The Superrealist painters were also called Photorealists because many used photographs as sources for their imagery.
- Suprematism—A type of art formulated by Kazimir Malevich to convey his belief that the supreme reality in the world is pure feeling, which attaches to no object and thus calls for new, nonobjective forms in art—shapes not related to objects in the visible world.
- Surrealism—A successor to *Dada*, Surrealism incorporated the improvisational nature of its predecessor into its exploration of the ways to express in art the world of dreams and the unconscious. Biomorphic Surrealists, such as Joan Miró, produced largely abstract compositions. Naturalistic Surrealists, notably Salvador Dalí, presented recognizable scenes transformed into a dream or nightmare image.
- **symbol**—An image that stands for another image or encapsulates an idea.
- Symbolism—A late-19th-century movement based on the idea that the artist was not an imitator of nature but a creator who transformed the facts of nature into a symbol of the inner experience of that fact.
- Synthetic Cubism—A later phase of *Cubism*, in which paintings and drawings were constructed from objects and shapes cut from paper or other materials to represent parts of a subject, in order to engage the viewer with pictorial issues, such as figuration, realism, and abstraction.
- **tapestry**—A weaving technique in which the *weft* threads are packed densely over the *warp* threads so that the designs are woven directly into the fabric.
- **technique**—The processes artists employ to create *form*, as well as the distinctive, personal ways in which they handle their materials and tools.
- **tempera**—A *technique* of painting using pigment mixed with egg yolk, glue, or casein; also, the *medium* itself.
- tenebrism—Painting in the "shadowy manner," using violent contrasts of light and dark, as in the work of Caravaggio. The term derives from *tenebroso*.
- tenebroso—Italian, "shadowy." See tenebrism.
- **terracotta**—Hard-baked clay, used for sculpture and as a building material. It may be *glazed* or painted.
- **tessera** (pl. **tesserae**)—Greek, "cube." A tiny stone or piece of glass cut to the desired shape and size for use in forming a *mosaic*.
- **texture**—The quality of a surface (rough, smooth, hard, soft, shiny, dull) as revealed by light. In represented texture, a painter depicts an object as having a certain texture even though the paint is the actual texture.
- **tholos** (pl. **tholoi**)—A temple with a circular plan. Also, the burial chamber of a *tholos tomb*.

- **thrust**—The outward force exerted by an *arch* or a *vault* that must be counterbalanced by a *buttress*.
- tonality— See color.
- tondo (pl. tondi)—A circular painting or *relief* sculpture.
- tracery—Ornamental stonework for holding stained glass in place, characteristic of Gothic cathedrals. In plate tracery, the glass fills only the "punched holes" in the heavy ornamental stonework. In bar tracery, the stained-glass windows fill almost the entire opening, and the stonework is unobtrusive.
- tramezzo—A screen placed across the nave of a church to separate the clergy from the lay audience.
- **transept**—The part of a church with an axis that crosses the *nave* at a right angle.
- transubstantiation—The transformation of the Eucharistic bread and wine into the body and blood of Christ.
- **trefoil**—A cloverlike ornament or symbol with stylized leaves in groups of three.
- **triglyph**—A triple projecting, grooved member of a *Doric frieze* that alternates with *metopes*.
- **triptych**—A three-paneled painting, ivory plaque, or *altarpiece*. Also, a small, portable shrine with hinged wings used for private devotion.
- **triumphal arch**—In Roman architecture, a freestanding *arch* commemorating an important event, such as a military victory or the opening of a new road.
- **trompe Poeil**—French, "fools the eye." A form of *illusionistic* painting that aims to deceive viewers into believing they are seeing real objects rather than a representation of those objects.
- **Tuscan column**—The standard type of Etruscan *column*. It resembles ancient Greek *Doric* columns but is made of wood, is unfluted, and has a *base*. Also a popular motif in *Renaissance* and *Baroque* architecture.
- **tympanum** (pl. **tympana**)—The space enclosed by a *lintel* and an *arch* over a doorway.
- value—See color.
- vanishing point—See perspective.
- vanitas—Latin, "vanity." A term describing paintings (particularly 17th-century Dutch still lifes) that include references to death.
- vault (adj. vaulted) A masonry roof or ceiling constructed on the arch principle, or a concrete roof of the same shape. A barrel (or tunnel) vault, semicylindrical in cross-section, is in effect a deep arch or an uninterrupted series of arches, one behind the other, over an oblong space. A quadrant vault is a half-barrel vault. A groin (or cross) vault is formed at the point at which two barrel vaults intersect at right angles. In a ribbed vault, there is a framework of ribs or arches under the intersections of the vaulting sections. A sexpartite vault is one whose ribs divide the vault into six compartments. A fan vault is a vault characteristic of English Perpendicular Gothic architecture, in which radiating ribs form a fanlike pattern.
- veduta (pl. vedute)—Italian, "scenic view."
- **vellum**—Calfskin prepared as a surface for writing or painting.
- vita—Italian, "life." Also, the title of a biography.
- volume—The space that mass organizes, divides, or encloses.
- volute—A spiral, scroll-like form characteristic of the ancient Greek *Ionic* and the Roman *Composite* capital.
- voussoir—A wedge-shaped stone block used in the construction of a true arch. The central voussoir, which sets the arch, is called the keystone.

811

wainscoting—Paneling on the lower part of interior walls.

warp—The vertical threads of a loom or cloth. weft—The horizontal threads of a loom or cloth.

weld—To join metal parts by heating, as in assembling the separate parts of a *statue* made by *casting*.

wet-plate photography—An early photographic process in which the photographic plate is exposed, developed, and fixed while wet.

woodcut—A wooden block on the surface of which those parts not intended to *print* are cut away to a

slight depth, leaving the design raised; also, the printed impression made with such a block.

zoopraxiscope—A device invented by Eadweard Muybridge in the 19th century to project sequences of still photographic images; a predecessor of the modern motion-picture projector.

BIBLIOGRAPHY

This list of books is very selective but comprehensive enough to satisfy the reading interests of the beginning art history student and general reader. The resources listed range from works that are valuable primarily for their reproductions to those that are scholarly surveys of schools and periods or monographs on individual artists. The emphasis is on recent in-print books and on books likely to be found in college and municipal libraries. No entries for periodical articles appear, but the bibliography begins with a list of some of the major journals that publish art historical scholarship in English.

SELECTED PERIODICALS

African Arts American Art American Indian Art American Journal of Archaeology Antiquity Archaeology Archives of American Art Archives of Asian Art Ars Orientalis Art Bulletin Art History Art in America Art Journal Artforum International Burlington Magazine Gesta History of Photography Journal of Roman Archaeology Journal of the Society of Architectural Historians Journal of the Warburg and Courtauld Institutes Latin American Antiquity Oxford Art Journal Women's Art Journal

GENERAL STUDIES

- Baxandall, Michael. *Patterns of Intention: On the Historical Explanation of Pictures*. New Haven, Conn.: Yale University Press, 1985.
- Bindman, David, ed. *The Thames & Hudson Encyclopedia of British Art.* London: Thames & Hudson, 1988.
- Boström, Antonia. *The Encyclopedia of Sculpture*. 3 vols. London: Routledge, 2003.
- Broude, Norma, and Mary D. Garrard, eds. *The Expanding Discourse: Feminism and Art History.* New York: Harper Collins, 1992.
- Bryson, Norman. *Vision and Painting: The Logic of the Gaze.* New Haven, Conn.: Yale University Press, 1983.
- Bryson, Norman, Michael Ann Holly, and Keith Moxey. Visual Theory: Painting and Interpretation. New York: Cambridge University Press, 1991.
- Büttner, Nils. *Landscape Painting: A History*. New York: Abbeville, 2006.
- Chadwick, Whitney. *Women, Art, and Society.* 4th ed. New York: Thames & Hudson, 2007.

- Cheetham, Mark A., Michael Ann Holly, and Keith Moxey, eds. *The Subjects of Art History: Historical Objects in Contemporary Perspective*. New York: Cambridge University Press, 1998.
- Chilvers, Ian, and Harold Osborne, eds. *The Oxford Dictionary of Art.* 3d ed. New York: Oxford University Press, 2004.
- Corbin, George A. Native Arts of North America, Africa, and the South Pacific: An Introduction. New York: Harper Collins, 1988.
- Crouch, Dora P., and June G. Johnson. *Traditions in Architecture: Africa, America, Asia, and Oceania*. New York: Oxford University Press, 2000.
- Curl, James Stevens. Oxford Dictionary of Architecture and Landscape Architecture. 2d ed. New York: Oxford University Press, 2006.
- Encyclopedia of World Art. 17 vols. New York: McGraw-Hill, 1959–1987.
- Fielding, Mantle. *Dictionary of American Painters, Sculptors, and Engravers.* 2d ed. Poughkeepsie, N.Y.: Apollo, 1986.
- Fine, Sylvia Honig. Women and Art: A History of Women Painters and Sculptors from the Renaissance to the 20th Century. Rev. ed. Montclair, N.J.: Alanheld & Schram, 1978.
- Fleming, John, Hugh Honour, and Nikolaus Pevsner. The Penguin Dictionary of Architecture and Landscape Architecture. 5th ed. New York: Penguin, 2000.
- Frazier, Nancy. *The Penguin Concise Dictionary of Art History*. New York: Penguin, 2000.
- Freedberg, David. *The Power of Images: Studies in the History and Theory of Response.* Chicago: University of Chicago Press, 1989.
- Gaze, Delia., ed. *Dictionary of Women Artists.* 2 vols. London: Routledge, 1997.
- Hall, James. Illustrated Dictionary of Subjects and Symbols in Eastern and Western Art. New York: Icon Editions, 1994.
- Harris, Anne Sutherland, and Linda Nochlin. Women Artists: 1550–1950. Los Angeles: Los Angeles County Museum of Art; New York: Knopf, 1977.
- Hauser, Arnold. *The Sociology of Art.* Chicago: University of Chicago Press, 1982.
- Hults, Linda C. The Print in the Western World: An Introductory History. Madison: University of Wisconsin Press, 1996.

- Kemp, Martin. The Science of Art: Optical Themes in Western Art from Brunelleschi to Seurat. New Haven, Conn.: Yale University Press, 1990.
- Kostof, Spiro, and Gregory Castillo. A History of Architecture: Settings and Rituals. 2d ed. Oxford: Oxford University Press, 1995.
- Kultermann, Udo. *The History of Art History.* New York: Abaris, 1993.
- Lucie-Smith, Edward. *The Thames & Hudson Dictionary of Art Terms*. 2d ed. New York: Thames & Hudson, 2004.
- Moffett, Marian, Michael Fazio, and Lawrence Wadehouse. *A World History of Architecture.* Boston: McGraw-Hill, 2004.
- Murray, Peter, and Linda Murray. *A Dictionary of Art and Artists.* 7th ed. New York: Penguin, 1998.
- Nelson, Robert S., and Richard Shiff, eds. *Critical Terms* for Art History. Chicago: University of Chicago Press, 1996.
- Penny, Nicholas. *The Materials of Sculpture*. New Haven, Conn.: Yale University Press, 1993.
- Pevsner, Nikolaus. *A History of Building Types*. London: Thames & Hudson, 1987. Reprint of 1979 ed.
- ——. An Outline of European Architecture. 8th ed. Baltimore: Penguin, 1974.
- Pierce, James Smith. *From Abacus to Zeus: A Hand-book of Art History.* 7th ed. Upper Saddle River, N.J.: Pearson Prentice Hall, 1998.
- Placzek, Adolf K., ed. *Macmillan Encyclopedia of Architects.* 4 vols. New York: Macmillan, 1982.
- Podro, Michael. *The Critical Historians of Art.* New Haven, Conn.: Yale University Press, 1982.
- Pollock, Griselda. Vision and Difference: Femininity, Feminism, and Histories of Art. London: Routledge, 1988.
- Preziosi, Donald, ed. *The Art of Art History: A Critical Anthology.* New York: Oxford University Press, 1998.
- Read, Herbert. *The Thames & Hudson Dictionary of Art and Artists*. Rev. ed. New York: Thames & Hudson, 1994.
- Reid, Jane D. The Oxford Guide to Classical Mythology in the Arts 1300–1990s. 2 vols. New York: Oxford University Press, 1993.
- Roth, Leland M. *Understanding Architecture: Its Elements, History, and Meaning.* 2d ed. Boulder, Colo.: Westview, 2006.

- Schama, Simon. The Power of Art. New York: Ecco, 2006.Slatkin, Wendy. Women Artists in History: From Antiquity to the 20th Century. 4th ed. Upper Saddle River, N.J.: Prentice Hall, 2000.
- Steer, John, and Antony White. Atlas of Western Art History: Artists, Sites, and Monuments from Ancient Greece to the Modern Age. New York: Facts on File, 1994.
- Stratton, Arthur. *The Orders of Architecture: Greek, Roman, and Renaissance*. London: Studio, 1986.
- Sutton, Ian. Western Architecture: From Ancient Greece to the Present. New York: Thames & Hudson, 1999.
- Trachtenberg, Marvin, and Isabelle Hyman. *Architecture, from Prehistory to Post-Modernism.* 2d ed. Upper Saddle River, N.J.: Prentice Hall, 2003.
- Turner, Jane, ed. *The Dictionary of Art.* 34 vols. New ed. New York: Oxford University Press, 2003.
- Wittkower, Rudolf. *Sculpture Processes and Principles*. New York: Harper & Row, 1977.
- Wren, Linnea H., and Janine M. Carter, eds. Perspectives on Western Art: Source Documents and Readings from the Ancient Near East through the Middle Ages. New York: Harper & Row, 1987.

RENAISSANCE ART, GENERAL

- Adams, Laurie Schneider. *Italian Renaissance Art.* Boulder, Colo.: Westview, 2001.
- Andrés, Glenn M., John M. Hunisak, and Richard Turner. *The Art of Florence*. 2 vols. New York: Abbeville, 1988.
- Campbell, Gordon. *Renaissance Art and Architecture*. New York: Oxford University Press, 2005.
- Campbell, Lorne. Renaissance Portraits: European Portrait-Painting in the Fourteenth, Fifteenth, and Sixteenth Centuries. New Haven, Conn.: Yale University Press, 1990.
- Cole, Bruce. *Italian Art, 1250–1550: The Relation of Renaissance Art to Life and Society.* New York: Harper & Row, 1987.
- ——. The Renaissance Artist at Work: From Pisano to Titian. New York: Harper Collins, 1983.
- Frommel, Christoph Luitpold. *The Architecture of the Italian Renaissance*. London: Thames & Hudson, 2007.
- Hall, Marcia B. Color and Meaning: Practice and Theory in Renaissance Painting. Cambridge: Cambridge University Press, 1992.
- Hartt, Frederick, and David G. Wilkins. *History of Italian Renaissance Art.* 6th ed. Upper Saddle River, N.J.: Prentice Hall, 2006.
- Haskell, Francis, and Nicholas Penny. Taste and the Antique: The Lure of Classical Sculpture 1500–1900. New Haven, Conn.: Yale University Press, 1981.
- Kent, F. W., and Patricia Simons, eds. Patronage, Art, and Society in Renaissance Italy. Canberra: Humanities Research Centre and Clarendon Press, 1987
- Levey, Michael. *Florence: A Portrait.* Cambridge, Mass.: Harvard University Press, 1998.
- Lubbock, Jules. Storytelling in Christian Art from Giotto to Donatello. New Haven, Conn.: Yale University Press, 2006.
- Paoletti, John T., and Gary M. Radke. *Art, Power, and Patronage in Renaissance Italy.* Upper Saddle River, N.J.: Prentice Hall, 2005.
- Pope-Hennessy, John. *Introduction to Italian Sculpture*. 3d ed. 3 vols. New York: Phaidon, 1986.
- Richardson, Carol M., Kim W. Woods, and Michael W. Franklin. Renaissance Art Reconsidered: An Anthology of Primary Sources. Oxford: Blackwell, 2007.

- Smith, Jeffrey Chipps. *The Northern Renaissance*. New York: Phaidon, 2004.
- Snyder, James, Larry Silver, and Henry Luttikhuizen.

 Northern Renaissance Art: Painting, Sculpture, the
 Graphic Arts from 1350 to 1575. Upper Saddle
 River, N.J.: Prentice Hall, 2005.
- Thomson, David. Renaissance Architecture: Critics, Patrons, and Luxury. Manchester: Manchester University Press, 1993.
- Wittkower, Rudolf. Architectural Principles in the Age of Humanism. 4th ed. London: Academy, 1988.

Chapter 14: Italy, 1200 to 1400

- Bomford, David. Art in the Making: Italian Painting before 1400. London: National Gallery, 1989.
- Borsook, Eve, and Fiorelli Superbi Gioffredi. *Italian Altarpieces 1250–1550: Function and Design.* Oxford: Clarendon, 1994.
- Cole, Bruce. Sienese Painting: From Its Origins to the Fifteenth Century. New York: Harper Collins, 1987.
- Hills, Paul. *The Light of Early Italian Painting*. New Haven, Conn.: Yale University Press, 1987.
- Maginnis, Hayden B. J. *Painting in the Age of Giotto: A Historical Reevaluation.* University Park: Pennsylvania State University Press, 1997.
- ------. *The World of the Early Sienese Painter.* University Park: Pennsylvania State University Press, 2001.
- Meiss, Millard. Painting in Florence and Siena after the Black Death. Princeton, N.J.: Princeton University Press 1976
- Moskowitz, Anita Fiderer. *Italian Gothic Sculpture*, c. 1250–c. 1400. Cambridge: Cambridge University Press, 2001.
- Norman, Diana, ed. *Siena, Florence, and Padua: Art, Society, and Religion 1280–1400.* New Haven, Conn.: Yale University Press, 1995.
- Pope-Hennessy, John. *Italian Gothic Sculpture*. 3d ed. Oxford: Phaidon, 1986.
- Stubblebine, James H. *Duccio di Buoninsegna and His School*. Princeton, N.J.: Princeton University Press, 1979
- White, John. Art and Architecture in Italy: 1250-1400. 3d ed. New Haven, Conn.: Yale University Press,
- ——. Duccio: Tuscan Art and the Medieval Work-shop. London: Thames & Hudson, 1979.

Chapter 15: Northern Europe, 1400 to 1500

- Baxandall, Michael. The Limewood Sculptors of Renaissance Germany. New Haven, Conn.: Yale University Press, 1980.
- Campbell, Lorne. *The Fifteenth-Century Netherlandish Schools*. London: National Gallery Publications, 1998.
- Châtelet, Albert. *Early Dutch Painting*. New York: Konecky, 1988.
- Friedlander, Max J. *Early Netherlandish Painting*. 14 vols. New York: Praeger/Phaidon, 1967–1976.
- ——. From Van Eyck to Bruegel. 3d ed. Ithaca, N.Y.: Cornell University Press, 1981.
- Harbison, Craig. *The Mirror of the Artist: Northern Renaissance Art in Its Historical Context.* New York: Abrams, 1995.
- Jacobs, Lynn F. Early Netherlandish Carved Altarpieces, 1380–1550: Medieval Tastes and Mass Marketing. Cambridge: Cambridge University Press, 1998.
- Lane, Barbara G. *The Altar and the Altarpiece: Sacra*mental Themes in Early Netherlandish Painting. New York: Harper & Row, 1984.

- Meiss, Millard. French Painting in the Time of Jean de Berry: The Limbourgs and Their Contemporaries. New York: Braziller, 1974.
- Müller, Theodor. Sculpture in the Netherlands, Germany, France, and Spain: 1400–1500. New Haven, Conn.: Yale University Press, 1986.
- Pächt, Otto. Early Netherlandish Painting from Rogier van der Wayden to Gerard David. New York: Harvey Miller, 1997.
- Panofsky, Erwin. *Early Netherlandish Painting: Its Origins and Character.* 2 vols. Cambridge, Mass.: Harvard University Press, 1966.
- Parshall, Peter, and Rainer Schoch. *Origins of European Printmaking: Fifteenth-Century Woodcuts and Their Public.* New Haven, Conn.: Yale University Press, 2005.
- Prevenier, Walter, and Wim Blockmans. *The Burgundian Netherlands*. Cambridge: Cambridge University Press, 1986.
- Wolfthal, Diane. *The Beginnings of Netherlandish Can*vas Painting, 1400–1530. New York: Cambridge University Press, 1989.

Chapter 16: Italy, 1400 to 1500

- Ames-Lewis, Francis. *Drawing in Early Renaissance Italy*. New Haven, Conn.: Yale University Press, 1981.
- Baxandall, Michael. Painting and Experience in Fifteenth-Century Italy: A Primer in the Social History of Pictorial Style. 2d ed. New York: Oxford University Press, 1988.
- Bober, Phyllis Pray, and Ruth Rubinstein. *Renaissance*Artists and Antique Sculpture: A Handbook of
 Sources. Oxford: Oxford University Press, 1986.
- Borsook, Eve. *The Mural Painters of Tuscany.* New York: Oxford University Press, 1981.
- Cole, Alison. Virtue and Magnificence: Art of the Italian Renaissance Courts. New York: Abrams, 1995.
- Cole, Bruce. Masaccio and the Art of Early Renaissance Florence. Bloomington: Indiana University Press,
- Dempsey, Charles. The Portrayal of Love: Botticelli's Primavera and Humanist Culture at the Time of Lorenzo the Magnificent. Princeton, N.J.: Princeton University Press, 1992.
- Edgerton, Samuel Y., Jr. *The Heritage of Giotto's Geometry: Art and Science on the Eve of the Scientific Revolution.* Ithaca, N.Y.: Cornell University Press, 1991.
- ——. The Renaissance Rediscovery of Linear Perspective. New York: Harper & Row, 1976.
- Gilbert, Creighton, ed. *Italian Art 1400–1500: Sources and Documents*. Evanston, Ill.: Northwestern University Press, 1992.
- Goldthwaite, Richard A. *The Building of Renaissance Florence: An Economic and Social History.* Baltimore: Johns Hopkins University Press, 1980.
- Heydenreich, Ludwig H. *Architecture in Italy, 1400–1500.* 2d ed. New Haven, Conn.: Yale University Press, 1996.
- Hollingsworth, Mary. Patronage in Renaissance Italy: From 1400 to the Early Sixteenth Century. Baltimore: Johns Hopkins University Press, 1994.
- Kemp, Martin. Behind the Picture: Art and Evidence in the Italian Renaissance. New Haven, Conn.: Yale University Press, 1997.
- Kempers, Bram. Painting, Power, and Patronage: The Rise of the Professional Artist in the Italian Renaissance. London: Penguin, 1992.
- Lieberman, Ralph. *Renaissance Architecture in Venice*. New York: Abbeville, 1982.

- McAndrew, John. *Venetian Architecture of the Early Renaissance*. Cambridge, Mass.: MIT Press, 1980.
- Murray, Peter. Renaissance Architecture. New York: Electa/Rizzoli, 1985.
- Olson, Roberta J. M. *Italian Renaissance Sculpture*. London: Thames & Hudson, 1992.
- Osborne, June. *Urbino: The Story of a Renaissance City.* Chicago: University of Chicago Press, 2003.
- Seymour, Charles. *Sculpture in Italy: 1400–1500.* New Haven, Conn.: Yale University Press, 1992.
- Turner, A. Richard. Renaissance Florence: The Invention of a New Art. New York: Abrams, 1997.
- Wackernagel, Martin. The World of the Florentine Renaissance Artist: Projects and Patrons, Workshops and Art Market. Princeton, N.J.: Princeton University Press, 1981.
- Welch, Evelyn. *Art and Society in Italy 1350–1500.* Oxford: Oxford University Press, 1997.
- White, John. *The Birth and Rebirth of Pictorial Space*. 3d ed. Boston: Faber & Faber, 1987.

Chapter 17: Italy, 1500 to 1600

- Blunt, Anthony. *Artistic Theory in Italy, 1450–1600.* London: Oxford University Press, 1975.
- Brown, David Alan, and Sylvia Ferino-Pagden. *Bellini, Giorgione, Titian, and the Renaissance of Venetian Painting.* New Haven, Conn.: Yale University Press, 2006
- Brown, Patricia Fortini. *Art and Life in Renaissance Venice*. New York: Abrams, 1997.
- Franklin, David. Painting in Renaissance Florence, 1500–1550. New Haven, Conn.: Yale University Press, 2001.
- Freedberg, Sydney J. *Painting in Italy: 1500–1600.* 3d ed. New Haven, Conn.: Yale University Press, 1993.
- Goffen, Rona. Piety and Patronage in Renaissance Venice: Bellini, Titian, and the Franciscans. New Haven, Conn.: Yale University Press, 1986.
- Renaissance Rivals: Michelangelo, Leonardo, Raphael, Titian. New Haven, Conn.: Yale University Press, 2002.
- Hall, Marcia B. After Raphael: Painting in Central Italy in the Sixteenth Century. Cambridge: Cambridge University Press, 1999.
- ———, ed. *Rome*. Artistic Centers of the Italian Renaissance. New York: Cambridge University Press, 2005.
- Holt, Elizabeth Gilmore, ed. A Documentary History of Art. Vol. 2, Michelangelo and the Mannerists. Rev. ed. Princeton, N.J.: Princeton University Press, 1982.
- Humfry, Peter. *Painting in Renaissance Venice*. New Haven, Conn.: Yale University Press, 1995.
- Huse, Norbert, and Wolfgang Wolters. The Art of Renaissance Venice: Architecture, Sculpture, and Painting. Chicago: University of Chicago Press, 1990.
- Levey, Michael. *High Renaissance*. New York: Viking Penguin, 1978.
- Lotz, Wolfgang. *Architecture in Italy, 1500–1600.* 2d ed. New Haven, Conn.: Yale University Press, 1995.
- Partridge, Loren. *The Art of Renaissance Rome*. New York: Abrams, 1996.
- Pietrangeli, Carlo, André Chastel, John Shearman, John O'Malley, S.J., Pierluigi de Vecchi, Michael Hirst, Fabrizio Mancinelli, Gianluigi Colalucci, and Franco Bernbei. *The Sistine Chapel: The Art, the History,* and the Restoration. New York: Harmony, 1986.
- Pope-Hennessy, John. *Italian High Renaissance and Baroque Sculpture*. 3d ed. 3 vols. Oxford: Phaidon, 1986.

- Rosand, David. *Painting in Cinquecento Venice: Titian, Veronese, Tintoretto.* New Haven, Conn.: Yale University Press, 1982.
- Shearman, John K. G. *Mannerism*. Baltimore: Penguin, 1978
- ——. Only Connect... Art and the Spectator in the Italian Renaissance. Princeton, N.J.: Princeton University Press, 1990.
- Summers, David. *Michelangelo and the Language of Art.* Princeton, N.J.: Princeton University Press, 1981.
- Wilde, Johannes. Venetian Art from Bellini to Titian. Oxford: Clarendon, 1981.

Chapter 18: Northern Europe and Spain, 1500 to 1600

- Blunt, Anthony. *Art and Architecture in France, 1500–1700.* Rev. ed. New Haven, Conn.: Yale University Press, 1999.
- Farago, Claire, ed. Reframing the Renaissance: Visual Culture in Europe and Latin America, 1450–1650. New Haven, Conn.: Yale University Press, 1995.
- Gibson, W. S. "Mirror of the Earth": The World Landscape in Sixteenth-Century Flemish Painting. Princeton, N.J.: Princeton University Press, 1989.
- Harbison, Craig. The Mirror of the Artist: Northern Renaissance Art in Its Historical Context. New York: Abrams, 1995.
- Koerner, Joseph Leo. *The Reformation of the Image*. Chicago: University of Chicago Press, 2004.
- Landau, David, and Peter Parshall. The Renaissance Print: 1470–1550. New Haven, Conn.: Yale University Press, 1994.
- Smith, Jeffrey C. German Sculpture of the Later Renaissance, c. 1520–1580: Art in an Age of Uncertainty. Princeton, N.J.: Princeton University Press, 1993.
- Stechow, Wolfgang. Northern Renaissance Art, 1400–1600: Sources and Documents. Evanston, Ill.: Northwestern University Press, 1989.
- Zerner, Henri. Renaissance Art in France: The Invention of Classicism. Paris: Flammarion, 2003.

BAROQUE ART, GENERAL

- Blunt, Anthony, ed. *Baroque and Rococo: Architecture and Decoration*. Cambridge: Harper & Row, 1982.
- Harris, Ann Sutherland. Seventeenth-Century Art & Architecture. Upper Saddle River, N.J.: Prentice Hall, 2005.
- Harrison, Charles, Paul Wood, and Jason Gaiger, eds. Art in Theory, 1648–1815: An Anthology of Changing Ideas. Oxford: Blackwell, 2000.
- Held, Julius, and Donald Posner. 17th- and 18th-Century Art: Baroque Painting, Sculpture, Architecture. New York: Abrams, 1971.
- Minor, Vernon Hyde. *Baroque & Rococo: Art & Culture*. New York, Abrams, 1999.
- Norberg-Schulz, Christian. *Baroque Architecture*. New York: Rizzoli, 1986.
- Late Baroque and Rococo Architecture. New York: Electa/Rizzoli, 1985.
- Toman, Rolf. Baroque: Architecture, Sculpture, Painting. Cologne: Könemann, 1998.

Chapter 19: Italy and Spain, 1600 to 1700

- Brown, Jonathan. *The Golden Age of Painting in Spain.* New Haven, Conn.: Yale University Press, 1991.
- ——. *Velázquez: Painter and Courtier.* New Haven, Conn.: Yale University Press, 1988.
- Enggass, Robert, and Jonathan Brown. *Italy and Spain,* 1600–1750: Sources and Documents. Upper Saddle River, N.J.: Prentice Hall, 1970.

- Freedberg, Sydney J. Circa 1600: A Revolution of Style in Italian Painting. Cambridge, Mass.: Harvard University Press, 1983.
- Haskell, Francis. Patrons and Painters: A Study in the Relations between Italian Art and Society in the Age of the Baroque. Rev. ed. New Haven, Conn.: Yale University Press, 1980.
- Krautheimer, Richard. The Rome of Alexander VII, 1655–1677. Princeton, N.J.: Princeton University Press, 1985.
- Lagerlöf, Margaretha R. *Ideal Landscape: Annibale Carracci, Nicolas Poussin, and Claude Lorrain.* New Haven, Conn.: Yale University Press, 1990.
- Montagu, Jennifer. *Roman Baroque Sculpture: The Industry of Art.* New Haven, Conn.: Yale University Press, 1989.
- Puglisi, Catherine. Caravaggio. London: Phaidon, 2000.Varriano, John. Italian Baroque and Rococo Architecture. New York: Oxford University Press, 1986.
- Wittkower, Rudolf. *Art and Architecture in Italy* 1600–1750. 6th ed. 3 vols. Revised by Joseph Connors and Jennifer Montagu. New Haven, Conn.: Yale University Press, 1999.

Chapter 20: Northern Europe, 1600 to 1700

- Alpers, Svetlana. *The Art of Describing: Dutch Art in the Seventeenth Century.* Chicago: University of Chicago Press, 1984.
- ——. Rembrandt's Enterprise: The Studio and the Market. Chicago: University of Chicago Press, 1988.
- Belkin, Kristin Lohse. Rubens. London: Phaidon, 1998.
 Blunt, Anthony. Art and Architecture in France, 1500–1700. Rev. ed. New Haven, Conn.: Yale University Press, 1999.
- Brown, Christopher. Scenes of Everyday Life: Dutch Genre Painting of the Seventeenth Century. London: Faber & Faber, 1984.
- Bryson, Norman. Word and Image: French Painting of the Ancien Régime. Cambridge: Cambridge University Press, 1981.
- Chastel, André. French Art: The Ancien Régime, 1620–1775. New York: Flammarion, 1996.
- Franits, Wayne. *Looking at Seventeenth-Century Dutch Art: Realism Reconsidered.* Cambridge: Cambridge University Press, 1997.
- Haak, Bob. *The Golden Age: Dutch Painters of the Seventeenth Century.* New York: Abrams, 1984.
- Mérot, Alain. French Painting in the Seventeenth Century. New Haven, Conn.: Yale University Press, 1995
- Muller, Sheila D., ed. *Dutch Art: An Encyclopedia*. New York: Garland, 1997.
- North, Michael. *Art and Commerce in the Dutch Golden Age.* New Haven, Conn.: Yale University Press, 1997.
- Rosenberg, Jakob, Seymour Slive, and E. H. ter Kuile. *Dutch Art and Architecture, 1600–1800.* New Haven, Conn.: Yale University Press, 1979.
- Schama, Simon. *The Embarrassment of Riches: An Interpretation of Dutch Culture in the Golden Age.*Berkeley: University of California Press, 1988.
- Stechow, Wolfgang. *Dutch Landscape Painting of the* 17th Century. 3d ed. Oxford: Phaidon, 1981.
- Vlieghe, Hans. Flemish Art and Architecture, 1585–1700. New Haven, Conn.: Yale University Press, 1998.
- Westermann, Mariët. *Rembrandt*. London: Phaidon, 2000.
- ——. A Worldly Art: The Dutch Republic 1585–1718. New Haven, Conn.: Yale University Press, 1996.

Chapter 21: Europe and America, 1700 to 1800

- Bermingham, Ann. Landscape and Ideology: The English Rustic Tradition, 1740–1850. Berkeley: University of California Press, 1986.
- Boime, Albert. *Art in the Age of Revolution*, *1750–1800*. Chicago: University of Chicago Press, 1987.
- Braham, Allan. The Architecture of the French Enlightenment. Berkeley: University of California Press, 1980.
- Brion, Marcel. Art of the Romantic Era: Romanticism, Classicism, Realism. New York: Praeger, 1966.
- Conisbee, Philip. Painting in Eighteenth-Century France. Ithaca, N.Y.: Phaidon/Cornell University Press, 1981.
- Crow, Thomas E. *Painters and Public Life in Eighteenth-Century Paris*. New Haven, Conn.: Yale University Press, 1985.
- Gaunt, W. *The Great Century of British Painting: Hogarth to Turner.* New York: Phaidon, 1971.
- Harrison, Charles, Paul Wood, and Jason Gaiger, eds. Art in Theory, 1648–1815: An Anthology of Changing Ideas. Oxford: Blackwell, 2000.
- Herrmann, Luke. British Landscape Painting of the Eighteenth Century. New York: Oxford University Press, 1974.
- Honour, Hugh. *Neo-Classicism*. Harmondsworth: Penguin, 1968.
- Irwin, David. Neoclassicism. London: Phaidon, 1997.
- Kalnein, Wend Graf, and Michael Levey. Art and Architecture of the Eighteenth Century in France. New York: Viking/Pelican, 1973.
- Lee, Simon. David. London: Phaidon, 1999.
- Levey, Michael. *Rococo to Revolution: Major Trends in Eighteenth-Century Painting.* London: Thames & Hudson, 1966.
- Rosenblum, Robert. *Transformations in Late Eighteenth-Century Art.* Princeton, N.J.: Princeton University Press, 1970.
- Roston, Murray. Changing Perspectives in Literature and the Visual Arts, 1650–1820. Princeton, N.J.: Princeton University Press, 1990.
- Rykwert, Joseph. *The First Moderns: Architects of the Eighteenth Century.* Cambridge, Mass.: MIT Press, 1983.
- Stillman, Damie. *English Neo-Classical Architecture*. 2 vols. London: Zwemmer, 1988.
- Waterhouse, Ellis Kirkham. *Painting in Britain:* 1530–1790. 4th ed. New Haven, Conn.: Yale University Press, 1979.
- Wilton, Andrew. The Swagger Portrait: Grand Manner Portraiture in Britain from Van Dyck to Augustus John, 1630–1930. London: Tate Gallery, 1992.

19TH AND 20TH CENTURIES, GENERAL

- Arnason, H. H., and Peter Kalb. History of Modern Art: Painting, Sculpture, Architecture, Photography. 5th ed. Upper Saddle River, N.J.: Prentice Hall, 2004.
- Ashton, Dore. *Twentieth-Century Artists on Art.* New York: Pantheon Books, 1985.
- Brown, Milton, Sam Hunter, and John Jacobus. *American Art: Painting, Sculpture, Architecture, Decorative Arts, Photography.* New York: Abrams, 1979.
- Burnham, Jack. Beyond Modern Sculpture: The Effects of Science and Technology on the Sculpture of This Century. New York: Braziller, 1968.
- Chipp, Herschel B. *Theories of Modern Art.* Berkeley: University of California Press, 1968.
- Chu, Petra ten-Doesschate. *Nineteenth-Century European Art.* 2d ed. Upper Saddle River, N.J.: Prentice Hall, 2006.

- Coke, Van Deren. *The Painter and the Photograph from Delacroix to Warhol*. Rev. ed. Albuquerque: University of New Mexico Press, 1972.
- Colquhoun, Alan. *Modern Architecture*. New York: Oxford University Press, 2002.
- Craven, Wayne. *American Art: History and Culture*. Madison, Wis.: Brown & Benchmark, 1994.
- Doss, Erika. *Twentieth-Century American Art.* New York: Oxford University Press, 2002.
- Driskell, David C. Two Centuries of Black American Art. Los Angeles: Los Angeles County Museum of Art; New York: Knopf, 1976.
- Eisenman, Stephen F., ed. *Nineteenth-Century Art: A Critical History.* 3d ed. New York: Thames & Hudson, 2007.
- Elsen, Albert. *Origins of Modern Sculpture*. New York: Braziller, 1974.
- Foster, Hal, Rosalind Krauss, Yve-Alain Bois, and Benjamin H. D. Buchloh. *Art since 1900: Modernism, Antimodernism, Postmodernism.* New York: Thames & Hudson, 2004.
- Frampton, Kenneth. *Modern Architecture: A Critical History*. 3d ed. London: Thames & Hudson, 1992.
- Frascina, Francis, and Charles Harrison, eds. Modern Art and Modernism: A Critical Anthology. New York: Harper & Row, 1982.
- Giedion, Siegfried. Space, Time, and Architecture: The Growth of a New Tradition. 4th ed. Cambridge, Mass.: Harvard University Press, 1965.
- Goldwater, Robert, and Marco Treves, eds. *Artists on Art.* 3d ed. New York: Pantheon, 1958.
- Greenough, Sarah, Joel Snyder, David Travis, and Colin Westerbeck. *On the Art of Fixing a Shadow: One Hundred and Fifty Years of Photography.* Washington, D.C.: National Gallery of Art; Chicago: Art Institute of Chicago, 1989.
- Hamilton, George H. *Painting and Sculpture in Europe,* 1880–1940. 6th ed. New Haven, Conn.: Yale University Press, 1993.
- Harrison, Charles, and Paul Wood. Art in Theory, 1900–2000: An Anthology of Changing Ideas. Oxford: Blackwell, 2003.
- Herbert, Robert L., ed. *Modern Artists on Art.* Upper Saddle River, N.J.: Prentice Hall, 1971.
- Hertz, Richard, and Norman M. Klein, eds. *Twentieth-Century Art Theory: Urbanism, Politics, and Mass Culture.* Englewood Cliffs, N.J.: Prentice Hall, 1990
- Heyer, Paul. Architects on Architecture: New Directions in America. New York: Van Nostrand Reinhold, 1993.
- Hills, Patricia. Modern Art in the USA: Issues and Controversies of the 20th Century. Upper Saddle River, N.J.: Prentice Hall, 2000.
- Hitchcock, Henry-Russell. *Architecture: Nineteenth and Twentieth Centuries.* 4th ed. New Haven, Conn.: Yale University Press, 1977.
- Hunter, Sam, John Jacobus, and Daniel Wheeler. Modern Art: Painting, Sculpture, Architecture, Photography. Rev. 3d ed. Upper Saddle River, N.J.: Prentice Hall, 2004.
- Jencks, Charles. *Modern Movements in Architecture*. Garden City, N.Y.: Anchor; Doubleday, 1973.
- Kaufmann, Edgar, Jr., ed. *The Rise of an American Ar-chitecture*. New York: Metropolitan Museum of Art; Praeger, 1970.
- Krauss, Rosalind E. The Originality of the Avant-Garde and Other Modernist Myths. Cambridge, Mass.: MIT Press, 1985.
- ———. Passages in Modern Sculpture. Cambridge, Mass.: MIT Press, 1981.

- Lewis, Samella S. *African American Art and Artists*. Rev. ed. Berkeley: University of California Press, 1994.
- Licht, Fred. Sculpture, Nineteenth and Twentieth Centuries. Greenwich, Conn.: New York Graphic Society, 1967.
- Marien, Mary Warner. *Photography: A Cultural History.* 2d ed. Upper Saddle River, N.J.: Prentice Hall, 2006
- Mason, Jerry, ed. International Center of Photography
 Encyclopedia of Photography. New York: Crown,
 1984
- McCoubrey, John W. *American Art, 1700–1960: Sources and Documents.* Englewood Cliffs, N.J.: Prentice Hall, 1965.
- Newhall, Beaumont. *The History of Photography*. New York: Museum of Modern Art, 1982.
- Osborne, Harold. *The Oxford Companion to Twentieth-Century Art.* New York: Oxford University Press, 1981.
- Pohl, Francis K. Framing America: A Social History of American Art. New York: Thames & Hudson, 2002.
- Rose, Barbara. *American Art since 1900*. Rev. ed. New York: Praeger, 1975.
- Rosenblum, Naomi. *A World History of Photography.* 3d ed. New York: Abbeville, 1997.
- Rosenblum, Robert. *Modern Painting and the North*ern Romantic Tradition: Friedrich to Rothko. New York: Harper & Row, 1975.
- Rosenblum, Robert, and Horst W. Janson. *19th-Century Art.* Rev. ed. Upper Saddle River, N.J.: Prentice Hall, 2005.
- Ross, Stephen David, ed. Art and Its Significance: An Anthology of Aesthetic Theory. Albany: State University of New York Press, 1987.
- Russell, John. *The Meanings of Modern Art.* New York: Museum of Modern Art; Thames & Hudson, 1981.
- Scully, Vincent. *Modern Architecture*. Rev. ed. New York: Braziller, 1974.
- Spalding, Francis. *British Art since 1900.* London: Thames & Hudson, 1986.
- Spencer, Harold. American Art: Readings from the Colonial Era to the Present. New York: Scribner, 1980.
- Steinberg, Leo. Other Criteria: Confrontations with 20th-Century Art. New York: Oxford University Press, 1972.
- Szarkowski, John. *Photography until Now.* New York: Museum of Modern Art, 1989.
- Upton, Dell. *Architecture in the United States.* Oxford: Oxford University Press, 1998.
- Weaver, Mike. *The Art of Photography: 1839–1989.* New Haven, Conn.: Yale University Press, 1989.
- Whiffen, Marcus, and Frederick Koeper. *American Architecture*, 1607–1976. Cambridge, Mass.: MIT Press, 1983.
- Wilmerding, John. *American Art*. Harmondsworth: Penguin, 1976.
- Wilson, Simon. *Holbein to Hockney: A History of British Art.* London: Tate Gallery & Bodley Head, 1979.

Chapter 22: Europe and America, 1800 to 1870

- Bergdoll, Barry. *European Architecture 1750–1890*. New York: Oxford University Press, 2000.
- Boime, Albert. *The Academy and French Painting in the 19th Century.* London: Phaidon, 1971.
- ———. Art in the Age of Bonapartism, 1800–1815. Chicago: University of Chicago Press, 1990.
- Brown, David Blayney. *Romanticism*. London: Phaidon, 2001.

- Bryson, Norman. *Tradition and Desire: From David to Delacroix.* New York: Cambridge University Press, 1984.
- Clark, T. J. The Absolute Bourgeois: Artists and Politics in France, 1848–1851. London: Thames & Hudson, 1973.
- . Image of the People: Gustave Courbet and the 1848 Revolution. London: Thames & Hudson, 1973.
- The Painting of Modern Life: Paris in the Art of Manet and His Followers. Princeton, N.J.: Princeton University Press, 1984.
- Clay, Jean. Romanticism. New York: Phaidon, 1981.
- Eitner, Lorenz. Neoclassicism and Romanticism, 1750–1850: An Anthology of Sources and Documents. New York: Harper & Row, 1989.
- Fried, Michael. *Courbet's Realism*. Chicago: University of Chicago Press, 1982.
- Manet's Modernism, or, The Face of Painting in the 1860s. Chicago: University of Chicago Press, 1996.
- Hilton, Timothy. *The Pre-Raphaelites*. New York: Oxford University Press, 1970.
- Holt, Elizabeth Gilmore, ed. From the Classicists to the Impressionists: A Documentary History of Art and Architecture in the Nineteenth Century. Garden City, N.J.: Anchor Books; Doubleday, 1966.
- Honour, Hugh. Romanticism. New York: Harper & Row, 1979.
- Janson, Horst W. 19th-Century Sculpture. New York: Abrams, 1985.
- Krell, Alain. Manet and the Painters of Contemporary Life. London: Thames & Hudson, 1996.
- Kroeber, Karl. *British Romantic Art.* Berkeley: University of California Press, 1986.
- Mainardi, Patricia. Art and Politics of the Second Empire: The Universal Expositions of 1855 and 1867. New Haven, Conn.: Yale University Press, 1987.
- The End of the Salon: Art and the State in the Early Third Republic. Cambridge: Cambridge University Press, 1993.
- Middleton, Robin. *Architecture of the Nineteenth Century*. London: Phaidon, 2003.
- Middleton, Robin, and David Watkin. *Neoclassical and* 19th-Century Architecture. 2 vols. New York: Electa/Rizzoli, 1987.
- Needham, Gerald. 19th-Century Realist Art. New York: Harper & Row, 1988.
- Nochlin, Linda. *Realism and Tradition in Art, 1848–1900: Sources and Documents.* Upper Saddle River, N.J.: Prentice Hall, 1966.
- Novak, Barbara. American Painting of the Nineteenth Century: Realism and the American Experience. New York: Harper & Row, 1979.
- Novotny, Fritz. *Painting and Sculpture in Europe,* 1780–1880. 3d ed. New Haven, Conn.: Yale University Press, 1988.
- Porterfield, Todd. *The Allure of Empire: Art in the Service of French Imperialism 1798–1836.* Princeton, N.J.: Princeton University Press, 1998.
- Rosen, Charles, and Henri Zerner. Romanticism and Realism: The Mythology of Nineteenth-Century Art. New York: Viking, 1984.
- Rubin, James Henry. Courbet. London: Phaidon, 1997.Sloane, Joseph C. French Painting between the Past and the Present: Artists, Critics, and Traditions from 1848 to 1870. Princeton, N.J.: Princeton University Press, 1973.
- Symmons, Sarah. Goya. London: Phaidon, 1998.
- Taylor, Joshua, ed. *Nineteenth-Century Theories of Art.* Berkeley: University of California Press, 1987.

- Vaughn, William. *German Romantic Painting*. New Haven, Conn.: Yale University Press, 1980.
- Wolf, Bryan Jay. Romantic Revision: Culture and Consciousness in Nineteenth-Century American Painting and Literature. Chicago: University of Chicago Press, 1986.
- Wood, Christopher. *The Pre-Raphaelites*. New York: Viking, 1981.

Chapter 23: Europe and America, 1870 to 1900

- Adams, Steven. *The Barbizon School and the Origins of Impressionism*. London: Phaidon, 1994.
- Broude, Norma. *Impressionism: A Feminist Reading*. New York: Rizzoli, 1991.
- Duncan, Alastair. *Art Nouveau*. New York: Thames & Hudson, 1994.
- Escritt, Stephen. Art Nouveau. London: Phaidon, 2000.
- Garb, Tamar. Bodies of Modernity: Figure and Flesh in Fin-de-Siècle France. New York: Thames & Hudson, 1998.
- Gerdts, William H. *American Impressionism*. New York: Abbeville, 1984.
- Herbert, Robert L. Impressionism: Art, Leisure, and Parisian Society. New Haven, Conn.: Yale University Press, 1988.
- Jensen, Robert. Marketing Modernism in Fin-de-Siècle Europe. Princeton, N.J.: Princeton University Press, 1994.
- Lewis, Mary Tompkins. *Cézanne*. London: Phaidon, 2000
- Nochlin, Linda. *Impressionism and Post-Impressionism,* 1874–1904: Sources and Documents. Upper Saddle River, N.J.: Prentice Hall, 1966.
- Rachman, Carla. Monet. London: Phaidon, 1997.
- Rapetti, Rodolphe. *Symbolism*. Paris: Flammarion, 2006. Rubin, James H. *Impressionism*. London: Phaidon,
- Schorske, Carl E. Fin-de-Siècle Vienna: Politics and Culture. New York: Knopf, 1980.
- Shiff, Richard. Cézanne and the End of Impressionism:

 A Study of the Theory, Technique, and Critical Evaluation of Modern Art. Chicago: University of
 Chicago Press, 1984.
- Silverman, Debora L. Art Nouveau in Fin-de-Siècle France: Politics, Psychology, and Style. Berkeley: University of California Press, 1989.
- Smith, Paul. *Impressionism: Beneath the Surface*. New York: Abrams, 1995.
- Sund, Judy. Van Gogh. London: Phaidon, 2002.

Chapter 24: Europe and America, 1900 to 1945

- Antliff, Mark. Cultural Politics and the Parisian Avant-Garde. Princeton, N.J.: Princeton University Press, 1993
- Antliff, Mark, and Patricia Leighten. *Cubism and Culture*. New York: Thames & Hudson, 2001.
- Baigell, Matthew. *The American Scene: American Painting of the 1930s.* New York: Praeger, 1974.
- Barr, Alfred H., Jr. Cubism and Abstract Art: Painting, Sculpture, Constructions, Photography, Architecture, Industrial Arts, Theatre, Films, Posters, Typography. Cambridge, Mass.: Belknap, 1986.
- Barron, Stephanie. Exiles and Emigrés: The Flight of European Artists from Hitler. Los Angeles: Los Angeles County Museum of Art, 1997.
- ———, ed. *Degenerate Art: The Fate of the Avant-Garde in Nazi Germany.* Los Angeles: Los Angeles County Museum of Art, 1991.

- Bayer, Herbert, Walter Gropius, and Ise Gropius. *Bauhaus*, 1919–1928. New York: Museum of Modern Art, 1975.
- Bearden, Romare, and Harry Henderson. *A History of African-American Artists from 1792 to the Present.* New York: Pantheon, 1993.
- Breton, André. *Surrealism and Painting*. New York: Harper & Row, 1972.
- Brown, Milton. *Story of the Armory Show: The 1913 Exhibition That Changed American Art.* 2d ed. New York: Abbeville, 1988.
- Campbell, Mary Schmidt, David C. Driskell, David Lewis Levering, and Deborah Willis Ryan. *Harlem Renaissance: Art of Black America*. New York: Studio Museum in Harlem; Abrams, 1987.
- Cox, Neil. Cubism. London: Phaidon, 2000.
- Curtis, Penelope. *Sculpture 1900–1945*. New York: Oxford University Press, 1999.
- Curtis, William J. R. *Modern Architecture since 1900.* Upper Saddle River, N.J.: Prentice Hall, 1996.
- Davidson, Abraham A. Early American Modernist Painting, 1910–1935. New York: Harper & Row,
- Eberle, Matthias. *World War I and the Weimar Artists: Dix, Grosz, Beckmann, Schlemmer.* New Haven,
 Conn.: Yale University Press, 1985.
- Edwards, Steve, and Paul Wood, eds. Art of the Avant-Gardes. New Haven, Conn.: Yale University Press,
- Elderfield, John. *The "Wild Beasts": Fauvism and Its Affinities*. New York: Museum of Modern Art, 1976
- Fer, Briony, David Batchelor, and Paul Wood. *Realism, Rationalism, Surrealism: Art between the Wars.* New Haven, Conn.: Yale University Press, 1993.
- Friedman, Mildred, ed. *De Stijl, 1917–1931: Visions of Utopia.* Minneapolis: Walker Art Center; New York: Abbeville, 1982.
- Gale, Matthew. Dada and Surrealism. London: Phaidon,
- Goldberg, Rose Lee. *Performance: Live Art 1909 to the Present*. New York: Abrams, 1979.
- Golding, John. *Cubism: A History and an Analysis*, 1907–1914. Cambridge, Mass.: Belknap, 1988.
- Gordon, Donald E. *Expressionism: Art and Idea*. New Haven, Conn.: Yale University Press, 1987.
- Harrison, Charles, Francis Frascina, and Gil Perry. Primitivism, Cubism, Abstraction: The Early Twentieth Century. New Haven, Conn.: Yale University Press, 1993.
- Herbert, James D. *Fauve Painting: The Making of Cultural Politics.* New Haven, Conn.: Yale University Press, 1992.
- Hitchcock, Henry-Russell, and Philip Johnson. *The International Style*. New York: Norton, 1995.
- Hurlburt, Laurance P. The Mexican Muralists in the United States. Albuquerque: University of New Mexico Press, 1989.
- Jaffé, Hans L. C. De Stijl, 1917–1931: The Dutch Contribution to Modern Art. Cambridge, Mass.: Belknap, 1986
- Krauss, Rosalind. *The Originality of the Avant-Garde* and Other Modernist Myths. Cambridge, Mass.: MIT Press, 1986.
- Kuspit, Donald. *The Cult of the Avant-Garde Artist*. Cambridge: Cambridge University Press, 1993.
- Lloyd, Jill. *German Expressionism: Primitivism and Modernity.* New Haven, Conn.: Yale University Press, 1991.
- Lodder, Christina. *Russian Constructivism.* New Haven, Conn.: Yale University Press, 1983.

- Martin, Marianne W. Futurist Art and Theory. Oxford: Clarendon, 1968.
- Motherwell, Robert, ed. *The Dada Painters and Poets: An Anthology.* 2d ed. Boston: Hall, 1981.
- Rhodes, Colin. *Primitivism and Modern Art.* New York: Thames & Hudson, 1994.
- Richter, Hans. *Dada: Art and Anti-Art.* London: Thames & Hudson, 1961.
- Rosenblum, Robert. *Cubism and Twentieth-Century Art.* Rev. ed. New York: Abrams, 1984.
- Rubin, William S. *Dada and Surrealist Art*. New York: Abrams, 1968.
- ——, ed. Pablo Picasso: A Retrospective. New York: Museum of Modern Art; Boston: New York Graphic Society, 1980.
- ——, ed. "Primitivism" in 20th-Century Art: Affinity of the Tribal and the Modern. 2 vols. New York: Museum of Modern Art, 1984.
- Selz, Peter. German Expressionist Painting. Berkeley: University of California Press, 1974. Reprint of 1957 edition.
- Silver, Kenneth E. Esprit de Corps: The Art of the Parisian Avant-Garde and the First World War, 1914–1925. Princeton, N.J.: Princeton University Press, 1989.
- Smith, Terry. *Making the Modern: Industry, Art, and Design in America*. Chicago: University of Chicago Press, 1993.
- Stott, William. *Documentary Expression and Thirties America*. New York: Oxford University Press, 1973.
- Taylor, Joshua C. *Futurism*. New York: Museum of Modern Art, 1961.
- Tisdall, Caroline, and Angelo Bozzolla. *Futurism.* New York: Oxford University Press, 1978.
- Trachtenberg, Alan. Reading American Photographs: Images as History—Mathew Brady to Walker Evans. New York: Hill and Wang, 1989.
- Tsujimoto, Karen. *Images of America: Precisionist Painting and Modern Photography.* Seattle: University of Washington Press, 1982.
- Tucker, William. *Early Modern Sculpture*. New York: Oxford University Press, 1974.
- Vogt, Paul. *Expressionism: German Painting*, 1905–1920. New York: Abrams, 1980.
- Weiss, Jeffrey S. *The Popular Culture of Modern Art: Pi*casso, Duchamp, and Avant-Gardism. New Haven, Conn.: Yale University Press, 1994.
- Whitford, Frank. *Bauhaus*. New York: Thames & Hudson, 1984.

Chapter 25: Europe and America after 1945

- Alloway, Lawrence. *American Pop Art.* New York: Whitney Museum of American Art; Macmillan, 1974.
- Anfam, David. *Abstract Expressionism*. New York: Thames & Hudson, 1990.
- Archer, Michael. Art since 1960. New ed. New York: Thames & Hudson, 2002.
- Ashton, Dore. *American Art since 1945*. New York: Oxford University Press, 1983.
- . The New York School: A Cultural Reckoning. Harmondsworth: Penguin, 1979.
- Battcock, Gregory, ed. *Idea Art: A Critical Anthology*. New York: Dutton, 1973.
- ——. *Minimal Art: A Critical Anthology.* New York: Studio Vista, 1969.
- ——. The New Art: A Critical Anthology. New York: Dutton, 1973.

- ——. *New Artists Video: A Critical Anthology.* New York: Dutton, 1978.
- Battcock, Gregory, and Robert Nickas, eds. The Art of Performance: A Critical Anthology. New York: Dutton, 1984.
- Beardsley, John, and Jane Livingston. *Hispanic Art in the United States: Thirty Contemporary Painters and Sculptors.* Houston: Museum of Fine Arts; New York: Abbeville, 1987.
- Beardsley, Richard. *Earthworks and Beyond: Contemporary Art in the Landscape*. New York: Abbeville, 1984.
- Broude, Norma, and Mary D. Garrard. The Power of Feminist Art: The American Movement of the 1970s, History and Impact. New York: Abrams, 1994
- Bürger, Peter. *Theory of the Avant-Garde*. Minneapolis: University of Minnesota Press, 1984.
- Causey, Andrew. *Sculpture since 1945*. New York: Oxford University Press, 1998.
- Cockcroft, Eva, John Weber, and James Cockcroft. *Toward a People's Art*. New York: Dutton, 1977.
- Cook, Peter. *New Spirit in Architecture*. New York: Rizzoli, 1990.
- Crow, Thomas. *The Rise of the Sixties: American and European Art in the Era of Dissent.* New Haven, Conn.: Yale University Press, 2005.
- Cummings, P. Dictionary of Contemporary American Artists. 6th ed. New York: St. Martin's, 1994.
- Deepwell, K., ed. *New Feminist Art.* Manchester: Manchester University Press, 1994.
- Ferguson, Russell, ed. *Discourses: Conversations in Postmodern Art and Culture.* Cambridge, Mass.: MIT Press, 1990.
- Fineberg, Jonathan. *Art since 1940: Strategies of Being.* 2d ed. Upper Saddle River, N.J.: Prentice Hall, 2000.
- Frascina, Francis, ed. *Pollock and After: The Critical Debate.* New York: Harper & Row, 1985.
- Geldzahler, Henry. New York Painting and Sculpture, 1940–1970. New York: Dutton, 1969.
- Ghirardo, Diane. *Architecture after Modernism.* New York: Thames & Hudson, 1996.
- Godfrey, Tony. Conceptual Art. London: Phaidon, 1998.Goldberg, Rose Lee. Performance Art: From Futurism to the Present. Rev. ed. New York: Abrams, 1988.
- Goldhagen, Sarah Williams, and Réjean Legault. Anxious Modernisms: Experimentation in Postwar Architectural Culture. Cambridge, Mass.: MIT Press, 2002
- Goodman, Cynthia. *Digital Visions: Computers and Art.* New York: Abrams, 1987.
- Goodyear, Frank H., Jr. Contemporary American Realism since 1960. Boston: New York Graphic Society, 1981
- Green, Jonathan. American Photography: A Critical History 1945 to the Present. New York: Abrams, 1984.
- Greenberg, Clement. Clement Greenberg: The Collected Essays and Criticism. Edited by J. O'Brien. 4 vols. Chicago: University of Chicago Press, 1986–1993.
- Grundberg, Andy. *Photography and Art: Interactions since 1945*. New York: Abbeville, 1987.
- Guilbaut, Serge. *How New York Stole the Idea of Modern Art.* Chicago: University of Chicago Press, 1983.
- Hays, K. Michael, and Carol Burns, eds. Thinking the Present: Recent American Architecture. New York: Princeton Architectural, 1990.
- Henri, Adrian. Total Art: Environments, Happenings, and Performance. New York: Oxford University Press, 1974.

- Hertz, Richard, ed. *Theories of Contemporary Art.* 2d ed. Upper Saddle River, N.J.: Prentice Hall, 1993.
- Hoffman, Katherine. *Explorations: The Visual Arts* since 1945. New York: Harper Collins, 1991.
- Hopkins, David. *After Modern Art*, 1945–2000. New York: Oxford University Press, 2000.
- Hughes, Robert. *The Shock of the New.* New York: Knopf, 1981.
- Hunter, Sam. An American Renaissance: Painting and Sculpture since 1940. New York: Abbeville, 1986.
- Jacobs, Jane. *The Death and Life of Great American Cities*. New York: Random House, 1961.
- Jacobus, John. Twentieth-Century Architecture: The Middle Years, 1940–1964. New York: Praeger, 1966.
- Jencks, Charles. *The Language of Post-Modern Architecture*. 6th ed. New York: Rizzoli, 1991.
- ———. What Is Post-Modernism? 3d ed. London: Academy Editions, 1989.
- Johnson, Ellen H., ed. *American Artists on Art from* 1940 to 1980. Boulder, Colo.: Westview, 1982.
- Joselit, David. *American Art since 1945*. New York: Thames & Hudson, 2003.
- Kaprow, Allan. Assemblage, Environments, and Happenings. New York: Abrams, 1966.
- Kirby, Michael. *Happenings*. New York: Dutton, 1966.
- Kramer, Hilton. *The Age of the Avant-Garde: An Art Chronicle of 1956–1972*. New York: Farrar, Straus & Giroux, 1973.
- Leja, Michael. Reframing Abstract Expressionism: Subjectivity and Painting in the 1940s. New Haven, Conn.: Yale University Press, 1993.
- Lippard, Lucy R. Mixed Blessings: New Art in a Multicultural America. New York: Pantheon, 1990.
- ———, ed. From the Center: Feminist Essays on Women's Art. New York: Dutton, 1976.
- Six Years: The Dematerialization of the Art Object from 1966 to 1972. New York: Praeger,
- Lovejoy, Margot. Postmodern Currents: Art and Artists in the Age of the Electronic Media. Ann Arbor, Mich.: UMI Research Press, 1989.
- Lucie-Smith, Edward. *Art Now.* Edison, N.J.: Wellfleet, 1989.
- ——. *Movements in Art since 1945.* New ed. New York: Thames & Hudson, 2001.
- Mamiya, Christin J. Pop Art and Consumer Culture: American Super Market. Austin: University of Texas Press, 1992.
- Marder, Tod A. *The Critical Edge: Controversy in Recent American Architecture*. New Brunswick, N.J.: Rutgers University Press, 1980.
- ——. An International Survey of Recent Painting and Sculpture. New York: Museum of Modern Art, 1984.
- Meyer, Ursula. *Conceptual Art.* New York: Dutton, 1972. Mitchell, William J. *The Reconfigured Eye: Visual Truth in the Post-Photographic Era.* Cambridge, Mass.: MIT Press, 1992.
- Norris, Christopher, and Andrew Benjamin. What Is Deconstruction? New York: St. Martin's, 1988.
- Perry, Gill, and Paul Wood. *Themes in Contemporary Art.* New Haven, Conn.: Yale University Press, 2004.
- Polcari, Stephen. *Abstract Expressionism and the Modern Experience*. Cambridge: Cambridge University Press, 1991.
- Popper, Frank. Origins and Development of Kinetic Art. Translated by Stephen Bann. Greenwich, Conn.: New York Graphic Society, 1968.

- Price, Jonathan. *Video Visions: A Medium Discovers Itself.* New York: New American Library, 1977.
- Reichardt, Jasia, ed. *Cybernetics, Art, and Ideas.* Greenwich, Conn.: New York Graphics Society, 1971.
- Risatti, Howard, ed. *Postmodern Perspectives: Issues in Contemporary Art.* Upper Saddle River, N.J.: Prentice Hall, 1990.
- Robbins, Corinne. *The Pluralist Era: American Art*, 1968–1981. New York: Harper & Row, 1984.
- Rosen, Randy, and Catherine C. Brawer, eds. *Making Their Mark: Women Artists Move into the Mainstream*, 1970–1985. New York: Abbeville, 1989.
- Rosenberg, Harold. *The Tradition of the New.* New York: Horizon, 1959.
- Rush, Michael. *New Media in Art.* 2d ed. New York: Thames & Hudson, 2005.
- Russell, John, and Suzi Gablik. Pop Art Redefined. New York: Praeger, 1969.
- Sandford, Mariellen R., ed. *Happenings and Other Acts*. New York: Routledge, 1995.
- Sandler, Irving. *Art of the Postmodern Era*. New York: Harper Collins, 1996.

- The Triumph of American Painting: A History of Abstract Expressionism. New York: Praeger, 1970.
- Sayre, Henry M. The Object of Performance: The American Avant-Garde since 1970. Chicago: University of Chicago Press, 1989.
- Schneider, Ira, and Beryl Korot. *Video Art: An Anthology.* New York: Harcourt Brace Jovanovich, 1976.
- Shapiro, David, and Cecile Shapiro. Abstract Expressionism: A Critical Record. New York: Cambridge University Press, 1990.
- Smagula, Howard. Currents: Contemporary Directions in the Visual Arts. 2d ed. Upper Saddle River, N.J.: Prentice Hall, 1989.
- Sonfist, Alan, ed. Art in the Landscape: A Critical Anthology of Environmental Art. New York: Dutton, 1983.
- Sontag, Susan. *On Photography*. New York: Farrar, Straus & Giroux, 1973.
- Stiles, Kristine, and Peter Selz. Theories and Documents of Contemporary Art: A Sourcebook of Artists' Writings. Berkeley and Los Angeles: University of California Press, 1996.

- Taylor, Brendon. *Contemporary Art: Art since 1970.* Upper Saddle River, N.J.: Prentice Hall, 2005.
- Tuchman, Maurice. *American Sculpture of the Sixties*. Los Angeles: Los Angeles County Museum of Art, 1967
- Venturi, Robert. Complexity and Contradiction in Architecture. New York: Museum of Modern Art, 1966
- Venturi, Robert, Denise Scott-Brown, and Steven Isehour. *Learning from Las Vegas*. Cambridge, Mass.: MIT Press, 1972.
- Waldman, Diane. *Collage, Assemblage, and the Found Object.* New York: Abrams, 1992.
- Wallis, Brian, ed. Art after Modernism: Rethinking Representation. New York: New Museum of Contemporary Art in association with David R. Godine, 1984.
- Wheeler, Daniel. Art since Mid-Century: 1945 to the Present. Upper Saddle River, N.J.: Prentice Hall, 1991.
- Wood, Paul. *Modernism in Dispute: Art since the Forties*. New Haven, Conn.: Yale University Press, 1993.

CREDITS

The author and publisher are grateful to the proprietors and custodians of various works of art for photographs of these works and permission to reproduce them in this book.

Sources not included in the captions are listed here.

Introduction—I-1: Clifford Still, 1948-C, PH-15, 80-7/8 x 70-3/4 inches, Oil on canvas, © The Clyfford Still Estate. Photo: akg images; I-2: © English Heritage; I-3: akg-images/Rabatti-Domingie; I-4: National Gallery of Art, Alfred Stieglitz Collection, Bequest of Georgia O'Keeffe; 1987.58.3. © 2007 The Georgia O'Keefe Foundation/Artist's Rights Society (ARS), NY; I-5: Art © Estate of Ben Shahn/Licensed by VAGA, NY, Whitney Museum of American Art, NY. (gift of Edith and Milton Lowenthal in memory of Juliana Force); I-6: www.bednorz-photo.de; I-7: akg images; I-8: Metropolitan Museum of Art, Gift of Junius S. Morgan, 1919 (19.73.209) Image © The Metropolitan Museum of Art; I-9: Courtesy Saskia Ltd., © Dr. Ron Wiedenhoeft; I-10: Photo © Whitney Museum of American Art /© 2007 The Josef and Anni Albers Foundation/Artists Rights Society (ARS), NY; I-11: National Gallery, London. NG14. Bought, 1824; I-12: MOA Art Museum, Shizuoka-ken, Japan; I-13: Bayerische Staatsgemäldesammlungen, Alte Pinakothek, Munich and Kunstdia-Archiv ARTOTHEK, Weilheim, Germany; I-14: Jürgen Liepe, Berlin; I-15: Metropolitan Museum of Art, Michael C. Rockefeller Memorial Collection, Gift of Nelson A. Rockefeller, 1965. (1987-412.309) Photograph © 1983 The Metropolitan Museum of Art; I-16: © Nimatallah/Art Resource, NY; I-17: © Scala/Art Resource, NY; I-19: © National Library of Australia, Canberra, Australia/The Bridgeman Art Library, NY; I-19b: From The Childhood of Man by Lee Frobenius (New York; J.B. Lippincott, 1909).

Chapter 14—14-1: © Scala/Art Resource, NY; 14-2: Canali Photobank, Italy; 14-3: © Scala/Art Resource, NY; 14-4: © Scala/Art Resource, NY; 14-5: © Scala/Art Resource, NY; 14-6: Photo by Ralph Lieberman; 14-7: © Scala/Art Resource, NY; 14-8: © Summerfield Press/CORBIS; 14-9: © Scala/Art Resource, NY; 14-10: © Scala/Art Resource, NY; 14-11: © Scala/Art Resource, NY; 14-12: Canali Photobank, Italy; 14-13: Canali Photobank, Italy; 14-14: © Scala/Art Resource, NY; 14-15: © MUZZI FABIO/CORBIS SYGMA; 14-16: © Scala/Art Resource, NY; 14-17: © Scala/Art Resource, NY; 14-18: © MUZZI FABIO/CORBIS SYGMA; 14-19: Photo by Ralph Lieberman; 14-20 both: © Scala/Art Resource, NY; 14-21: www.bednorz-photo.de; 14-22: © Scala/Art Resource, NY.

Chapter 15—15-1: © Erich Lessing/Art Resource, NY; 15-2: © Erich Lessing/Art Resource, NY; 15-3: Erich Lessing/Art Resource, NY; 15-4: Image Copyright © The Metropolitan Museum of Art/Art Resource, NY; 15-5: © Scala/Art Resource, NY; 15-5: © Scala/Art Resource, NY; 15-5: © Scala/Art Resource, NY; 15-6: © Scala/Art Resource, NY; 15-7: Copyright © National Gallery, London; 15-8: © Erich Lessing/Art Resource, NY; 15-9: Photograph © 2008 Museum of Fine Arts, Boston; 15-10: Copyright © 1999 Board of Trustees, National Gallery of Art, Washington, D.C.; 15-11: Image copyright © The Metropolitan Museum of Art/Art Resource, NY; 15-12: Paul Laes; 15-13: © Scala/Art Resource, NY; 15-14: © Erich Lessing/Art Resource, NY; 15-16: © Réunion des Musées Nationaux/Art Resource, NY; 15-17a: © Bildarchiv Preussischer Kulturbesitz/Art Resource, NY; 15-17b: © Scala/Art Resource, NY; 15-18: © Erich Lessing/Art Resource, NY; 15-19: © Erich Lessing/Art Resource, NY; 15-21: Courtesy Luarine Tansey; 15-22: © Scala/Art Resource.

Chapter 16—16-1: © Scala/Art Resource, NY; 16-2: © Erich Lessing/Art Resource, NY; 16-3: © Erich Lessing/Art Resource, NY; 16-4: © Scala/Art Resource, NY; 16-5: © Scala/Art Resource, NY; 16-6: © Scala/ Art Resource, NY; 16-7: © Scala/Art Resource, NY; 16-8: © Scala/Art Resource, NY; 16-10: © Scala/Art Resource, NY; 16-11: © The Art Archive/Dagli Orti; 16-12: © Scala/Art Resource, NY; 16-13: © Scala/Art Resource, NY; 16-14: © Scala/Art Resource, NY; 16-15: © Elio Ciol/CORBIS; 16-16: © Erich Lessing/Art Resource, NY; 16-17; © Erich Lessing/Art Resource; 16-18: © Scala/Art Resource, NY; 16-19: Canali Photobank, Italy; 16-20: © Erich Lessing/Art Resource, NY; 16-21: Canali Photobank, Italy; 16-22: © Scala/Art Resource, NY; 16-23: Canali Photobank, Italy; 16-24: © Scala/Art Resource, NY; 16-25: © The Bridgeman Art Library; 16-26: © Erich Lessing/Art Resource, NY; 16-27: © Scala/Art Resource, NY; 16-28: © Summerfield Press Ltd.; 16-29: Image Copyright © The Metropolitan Museum of Art/Art Resource, NY; 16-30: From Architecture of the Italian Renaissance by P. Murray, copyright © 1963 by Peter Murray, Used by permission of Schocken books, a division of Random House, Inc.; 16-31: @ Alinari/Art Resource, NY; 16-33: © Angelo Hornak/CORBIS; 16-35: © Scala/Art Resource, NY; 16-36: © Scala/Art Resource, NY; 16-37 @ Scala/Art Resource, NY; 16-38: @ Scala/Art Resource, NY; 16-39: @ The Bridgeman Art Library; 16-40: © 1987 M. Sarri/Photo Vatican Museums; 16-41: © Scala/Art Resource, NY; 16-42: © Scala/Art Resource, NY; 16-43: @ Scala/Art Resource, NY; 16-44: @ Alinari/Art Resource, NY; 16-45: From Nikolaus Pevsner, An Outline of European Architecture, 6th ed., 1960, Penguin Books Ltd., Copyright © Nikolaus Pevsner, 1943, 1960, 1963; 16-46: Canali Photobank, Italy; 16-47: © Scala/Art Resource, NY; 16-48: © Scala/Art Resource, NY; 16-49: © Erich Lessing/Art Resource, NY.

Chapter 17—17-1: Photo Vatican Museums; 17-2: © Erich Lessing/Art Resource, NY; 17-3: © The Art Archive/National Gallery, London/Eileen Tweedy; 17-4: © Alinari/Art Resource, NY; 17-5: © Réunion des Musées Nationaux/Art Resource, NY; 17-6: The Royal Collection © 2005, Her Majesty Queen Elizabeth II; 17-7: © Erich Lessing/Art Resource, NY; 17-8: © Erich Lessing/Art Resource, NY; 17-9: © M. Sarri 1983/ Photo Vatican Museums; 17-10: © Scala/Art Resource, NY; 17-11: © Erich Lessing/Art Resource, NY; 17-12: © Araldo de Luca/CORBIS; 17-13: © Arte & Immagini/CORBIS; 17-14: © Scala/Art Resource, NY; 17-15: © Scala/Art Resource, NY; 17-16: © Réunion des Musées Nationaux/Art Resource, NY; 17-17: © Scala/Art Resource, NY; 17-18: Copyright © Nippon Television Network Corporation, Tokyo; 17-19: © Bracchietti-Zigrosi/Vatican Museums; 17-20: Copyright © Nippon Television Network Corporation,

Tokyo; 17-21: Copyright © Nippon Television Network Corporation, Tokyo; 17-22: © Scala/Art Resource, NY; 17-24: © HIP/Art Resource, NY; 17-26: © Scala/Art Resource, NY; 17-27: © Alinari/CORBIS; 17-28: © Alinari/CORBIS; 17-29: © akg-images/Schütze/Rodemann; 17-31: © Bill Ross/CORBIS; 17-32: © John Heseltine/CORBIS; 17-33: © Scala/Art Resource, NY; 17-34: © 1999 Board of Trustees, National Gallery of Art, Washington, D.C.; 17-35: © Erich Lessing/Art Resource, NY; 17-36: © Cameraphoto/Art Resource, NY; 17-37: © Scala/Art Resource, NY; 17-38: © Scala/Art Resource, NY; 17-39: © National Gallery, London; 17-40: © Scala/Art Resource, NY; 17-44: © National Gallery, London; 17-45: © Scala/Art Resource, NY; 17-44: © National Gallery, London; 17-45: Image Copyright © The Metropolitan Museum of Art/Art Resource, NY; 17-46: © The Bridgeman Art Library; 17-47: © Scala/Art Resource, NY; 17-49: Canali Photobank, Italy; 17-50: © Alinari/Art Resource, NY; 17-51: © Erich Lessing/Art Resource, NY; 17-52: © 2006 Fred S. Kleiner; 17-53: © Erich Lessing/Art Resource, NY; 17-55: © The Art Archive/Dagli Orti.

Chapter 18—18-1: Photograph © 2008 Museum of Fine Arts, Boston; 18-2 (top): © Erich Lessing/Art Resource, NY; 18-2 (bottom): © Musée d'Unterlinden Colmar, photo O. Zimmermann; 18-3: © HIP/Art Resource, NY; 18-4: © The Bridgeman Art Library; 18-5: Image Copyright © The Metropolitan Museum of Art/Art Resource, NY; 18-6: © Scala/Art Resource, NY; 18-7: © The British Museum; 18-8: © Scala/Art Resource, NY; 18-9: © National Gallery, London; 18-10: © Réunion des Musées Nationaux/Art Resource, NY; 18-11: © Charles E. Rotkin/CORBIS; 18-12: © The Art Archive/Dagli Orti; 18-13: © Institut Amatller D'art Hispànic; 18-14: © Bildarchiv Preussischer Kulturbesitz/Art Resource, NY; 18-15: © Réunion des Musées Nationaux/Art Resource, NY; 18-16: Uppsala University Art Collection; 18-17: Oeffentliche Kunstsammlung Basel, photo Martin Bühler; 18-18: The Royal Collection © 2007 Her Majesty Queen Elizabeth II; 18-19: © Erich Lessing/Art Resource, NY; 18-20: © Bildarchiv Preussischer Kulturbesitz/Art Resource, NY; 18-21: Kunsthistorisches Museum, Vienna; 18-20: © Institut Amatller D'art Hispànic; 18-25: © Scala/Art Resource, NY.

Chapter 19—19-1: @ akg-images/Pirozzi; 19-2: @ akg-images/Pirozzi; 19-3: @ Andrea Jemolo/CORBIS; 19-4: @ Alinari/CORBIS; 19-5: @ akg-images/Joseph Martin; 19-6: Canali Photobank. Italy; 19-7: @ Scala/Art Resource, NY; 19-8: @ Araldo de Luca; 19-9: www.bednorz-photo.de; 19-11: www.bednorz-photo.de; 19-12: @ 2006 Fred S. Kleiner; 19-14: @ Scala/Art Resource; 19-15: @ Alinari/Art Resource, NY; 19-16: @ Scala/Art Resource, NY; 19-17: @ Scala/Art Resource, NY; 19-18: @ Scala/Art Resource, NY; 19-19: @ Scala/Art Resource, NY; 19-20: @ Alinari/Art Resource, NY; 19-21: @ Nimatallah/Art Resource, NY; 19-22: @ The Bridgeman Art Library; 19-23: @ Scala/Art Resource, NY; 19-24: @ Summerfield Press Ltd.; 19-25: @ The Art Archive/Museo del Prado; 19-26: Photograph & Atheneum Museum of Art; 19-27: @ Victoria & Albert Museum, London/Art Resource, NY; 19-28: @ The Frick Collection, NY; 19-29: @ Scala/Art Resource, NY; 19-30: @ Erich Lessing/Art Resource, NY.

Chapter 20—20-1: © Erich Lessing/Art Resource, NY; 20-2: Copyright © IRPA-KIK, Brussels, www.kikirpa.be; 20-3: @ Erich Lessing/Art Resource, NY; 20-4: @ Scala/Art Resource, NY; 20-5: © Réunion des Musées Nationaux/Art Resource, NY; 20-6: © Scala/Art Resource, NY; 20-7: © Centraal Museum, Utrecht, photo Ernst Moritz, The Hague; 20-8: © Alinari/The Bridgeman Art Library; 20-9: © Frans Halsmuseum. Haarlem; 20-10: © Frans Halsmuseum, Haarlem; 20-11: Image © 2007 Board of Trustees, National Gallery of Art, Washington, D.C.; 20-12: @ Erich Lessing/Art Resource, NY; 20-13: @ The Bridgeman Art Library; **20-14:** © The Bridgeman Art Library; **20-15:** © English Heritage Photographic Library; 20-16: © The Pierpont Morgan Library/Art Resource, NY; 20-17: © National Gallery, London; 20-18: © Mauritshuis. The Hague; 20-19: © Rijksmuseum, Amsterdam; 20-20: © Rijksmuseum, Amsterdam; 20-21: @ Germanisches Nationalmuseum; Nuremberg: 20-22: Photo copyright @ Indianapolis Museum of Art, Indianapolis; 20-23: Photo Copyright © Toledo Museum of Art, Toledo, 1956.57; 20-24: © Erich Lessing/Art Resource, NY; 20-25: © Scala/Art Resource, NY; 20-26: Photo copyright © Philadelphia Museum of Art, Philadelphia; 20-27: © Réunion des Musées Nationaux/Art Resource, NY; 20-28: © Erich Lessing/Art Resource, NY; **20-29:** © Erich Lessing/Art Resource, NY; **20-30:** © Réunion des Musées Nationaux/Art Resource, NY; 20-31: www.bednorz-photo.de; 20-32: © Yann Arthus-Bertrand/ Altitude; 20-33: @ Massimo Listri/CORBIS; 20-34: @ Bernard Annebicque/CORBIS; 20-35: @ akgimages/Paul M. R. Maeyaert; 20-36: Saskia; 20-37: @ Angelo Hornak/CORBIS; 20-38: @ Angelo

Chapter 21—21-1: © The Bridgeman Art Library; 21-2: akg-images/Hervé Champollion; 21-3: © Erich Lessing/Art Resource, NY; 21-4: © Erich Lessing/Art Resource, NY; 21-5: © The Art Archive/Dagli Orti; 21-6: © Scala/Art Resource, NY; 21-7: © By kind permission of the Trustees of the Wallace Collection, London; 21-8: © Scala/Art Resource, NY; 21-9: © The Bridgeman Art Library; 21-10: © Giraudon/Art Resource, NY; 21-11: © The Art Archive/John Meek; 21-12: © Réunion des Musées Nationaux/Art Resource, NY; 21-3: © The Art Archive/Dagli Orti; 21-14: © The Bridgeman Art Library; 21-15: National Gallery, London; 21-16: © The Bridgeman Art Library; 21-17: © The Bridgeman Art Library; 21-18: Photo © National Gallery of Canada; 21-19: Photograph © 2008 Museum of Fine Arts, Boston, 30, 781-12: 00: © Scala/Art Resource, NY; 21-21: © Peter Aprahamian/CORBIS; 21-22: Photo: Katherine Wetzel © Virginia Museum of Fine Arts; 21-23: © Réunion des Musées Nationaux/Art Resource, NY; 21-24: © Scala/Art

Resource, NY; 21-25: © Yann Arthus-Bertrand/CORBIS; 21-26: © Eric Crichton/CORBIS; 21-27: Bildarchiv Monheim; 21-28: © Monticello/Thomas Jefferson Foundation, Inc.; 21-29: © Michael Freeman/CORBIS; 21-30: Photo © The Library of Virginia; 21-31: © Smithsonian American Art Museum, Washington, D.C./Art Resource, NY.

Chapter 22—22-1: © Bettmann/CORBIS; 22-2: Réunion des Musées Nationaux/Art Resource, NY; 22-3: © Giraudon/The Bridgeman Art Library; 22-4: © Scala/Art Resource, NY; 22-5: Réunion des Musées Nationaux/Art Resource, NY; 22-6: © Réunion des Musées Nationaux/Art Resource, NY; 22-7: © Réunion des Musées Nationaux/Art Resource, NY; 22-8: © Réunion des Musées Nationaux/Art Resource, NY; 22-9: Photograph @ 1997 The Detroit Institute of Arts, 55.5.A; 22-10: @ The Pierpont Morgan Library/Art Resource, NY; 22-11: Image copyright © The Metropolitan Museum of Art/Art Resource, NY; 22-12: © Erich Lessing/Art Resource, NY; 22-13: Institut Amatller D'Art Hispànic; 22-14: © Erich Lessing/Art Resource, NY; 22-15: © Erich Lessing/Art Resource, NY; 22-16: © Giraudon/Art Resource, NY; 22-17: © Réunion des Musées Nationaux/Art Resource, NY; 22-18: © Réunion des Musées Nationaux/Art Resource, NY; 22-19: The Art Archive/Dagli Orti; 22-20: Réunion des Musées Nationaux/Art Resource, NY; 22-21: © Bildarchiv Preussischer Kulturbesitz/Art Resource, NY; 22-22: © Art Resource, NY; 22-23: Photography © 2008 Museum of Fine Arts, Boston, 99.22; 22-24: Image copyright © The Metropolitan Museum of Art/Art Resource, NY; 22-25: © Smithsonian American Art Museum, Washington, D.C./Art Resource, NY; 22-26: Photo copyright © The Cleveland Museum of Art; 22-27: © The Bridgeman Art Library; 22-28: © Erich Lessing/Art Resource, NY; 22-29: © Réunion des Musées Nationaux/Art Resource, NY; 22-30: Photo copyright @ Philadelphia Museum of Art, 1995-86-42; 22-31: Image copyright @ The Metropolitan Museum of Art/Art Resource, NY; 22-32: Image copyright © The Metropolitan Museum of Art/Art Resource, NY; 22-33: © Erich Lessing/Art Resource, NY; 22-34: © Réunion des Musées Nationaux/Art Resource, NY; 22-35: © Sterling and Francine Clark Art Institute, Williamstown, MA; 22-36: © Bildarchiv Preussischer Kulturbesitz/Art Resource, NY; 22-37: Image copyright © The Metropolitan Museum of Art/Art Resource, NY; 22-38: Gift of the Alumni Association to Jefferson Medical College in 1878 and purchased by the Pennsylvania Academy of the Fine Arts and the Philadelphia Museum of Art in 2007 with the generous support of more than 3,400 donors, photo copyright @ Philadelphia Museum of Art; 22-39: Photograph © 2008 Museum of Fine Arts, Boston, 19.124; 22-40: © Art Resource, NY; 22-41: Photo @ Howard University Gallery of Art, Washington, D.C.; 22-42: @ Tate Gallery, London/Art Resource, NY; 22-43: © Tate Gallery, London/Art Resource, NY; 22-44: © TravelPix/Robert Harding Picture Library 22-45: © Roger Antrobus/CORBIS; 22-46: © Durand Patrick/CORBIS Sygma; 22-47: © Collection Artedia; 22-48: © The Stapleton Collection/The Bridgeman Art Library; 22-49: © The Stapleton Collection/The Bridgeman Art Library; 22-50: © Time & Life Pictures/Getty Images; 22-51: Massachusetts General Hospital Archives and Special Collections, Boston; 22-52: Courtesy George Eastman House; 22-53: © Hulton Archive/Getty Images; 22-54: Courtesy George Eastman House.

Chapter 23—23-1: @ Yann Arthus-Bertrand/CORBIS; 23-2: @ Erich Lessing/Art Resource, NY; 23-3: Image copyright © The Metropolitan Museum of Art/Art Resource, NY; 23-4: © Erich Lessing/Art Resource, NY; 23-5: Photography © The Art Institute of Chicago, 1964.336; 23-6: Photo © Los Angeles County Museum of Art; 23-7: Photo @ Norton Simon Art Foundation, Los Angeles; 23-8: @ Réunion des Musées Nationaux/Art Resource, NY; 23-9: © The Bridgeman Art Library; 23-10: © Glasgow City Counsel; 23-11 (left): © Réunion des Musées Nationaux/Art Resource; (right): © Réunion des Musées Nationaux/ Art Resource; 23-12: Photography © The Art Institute of Chicago, 1910.2; 23-13: Photograph © 1988
The Detroit Institute of Arts, 46.309; 23-14: Photography © The Art Institute of Chicago, 1928.610; 23-15: Photography © The Art Institute of Chicago, 1926.224; 23-16: © Yale University Art Gallery/Art Resource, NY; 23-17: Digital Image © The Museum of Modern Art/Licensed by Scala/Art Resource, NY; 23-18: © Art Resource, NY; 23-19: Photograph © 2008 Museum of Fine Arts, Boston, 36.270; 23-20: Photograph © Philadelphia Museum of Art, e1936-1-1; 23-21: Photography © The Art Institute of Chicago, 1926.252; 23-22: Photography © The Art Institute of Chicago, 1922.445; 23-23: © Réunion des Musées Nationaux/ $Art\ Resource, NY; \textbf{23-24:} @\ The\ Kr\"{o}ller-M\"{u}ller\ Foundation}; \textbf{23-25:}\ Digital\ Image} @\ The\ Museum\ of\ Museu$ Modern Art/Licensed by Scala/Art Resource, NY; 23-26: © Art Resource, NY; 23-27: Photo © Erich Lessing/Art Resource, NY; © 2008 Artists Rights Society (ARS), NY/The National Gallery, Oslo/ BONO, Oslo; 23-28: © Erich Lessing/Art Resource, NY; 23-29: Digital Image © The Museum of Modern Art/ Licensed by Scala/Art Resource, NY; 23-30: Smithsonian American Art Museum, Washington, D.C./Art Resource, NY; 23-31: Image copyright © The Metropolitan Museum of Art/Art Resource, NY; 23-32: Réunion des Musées Nationaux/Art Resource, NY; 23-33: © akg-images; 23-34: © Massimo Listri/CORBIS; 23-35: © Glasgow City Council; 23-36: © 2008 SOFAM/architect: V. Horta, photo Bastin & Evrard sprl; 23-37: Private collection; 23-38: © Stephanie Colasanti/CORBIS; 23-39: Chicago Architectural Photograph ing Company; 23-40: @ Thomas A. Heinz/CORBIS; 23-41: Chicago History Museum/Photo Hedrich-Blessing HB-19321-E

Chapter 24—24-1: Photo © Philadelphia Museum of Art, 1950-134-59, © 2008 Artists Rights Society (ARS), NY/ADAGP, Paris/Succession Marcel Duchamp; 24-2: Photo © San Francisco Museum of Modern Art, © 2008 Succession H. Matisse, Paris/Artists Rights Society (ARS), NY; 24-3: © 2008 Succession H. Matisse, Paris/Artists Rights Society (ARS), NY; 24-4: photo © Erich Lessing/Art Resource, NY, © 2008 Artists Rights Society (ARS), NY/ADAGP, Paris; 24-5: © by Ingeborg & Dr. Wolfgang Henze-Ketterer, Wichtrach/Bern; 24-6: @ Hamburger Kunsthalle, BPK, Berlin. Photo Elke Walford/Art Resource, NY; 24-7: Solomon R. Guggenheim Museum Founding Collection, Gift, Solomon R. Guggenheim, 37.239, © 2008 Arts Rights Society (ARS)/ADAGP, Paris; 24-8: Oeffentliche Kunstammlung, Basel, photo Martin Bühler; 24-9: Photo © Erich Lessing/Art Resource, NY, © 2008 Artists Rights Society (ARS), NY/VG Bild-Kunst, Bonn; 24-10: © Burstein Collection/CORBIS; 24-11: Image copyright © The Metropolitan Museum of Art/Art Resource, NY, 47.106, © 2008 Estate of Pablo Picasso/Artists Rights Society (ARS), NY; 24-12: Digital Image © The Museum of Modern Art/Licensed by Scala, 333.1939, © 2008 Estate of Pablo Picasso/Artists Rights Society (ARS), NY; 24-13: Photo: Coursaget, © Réunion des Musées Nationaux/Art Resource, NY, © 2008 Estate of Pablo Picasso/Artists Rights Society (ARS), NY; 24-14: Photo @ Giraudon/Art Resource, NY, © 2008 Artists Rights Society (ARS), NY/ADAGP, Paris; 24-15: Photography © The Art Institute of Chicago, Joseph Winterbotham Collection, 1959.1; 24-16: Photo: R. G. Ojeda © Réunion des Musées Nationaux/Art Resource, NY, © 2008 Estate of Pablo Picasso/Artists Rights Society (ARS), NY; 24-17: © 2008 Artists Rights Society (ARS), NY/ADAGP, Paris; 24-18: Digital Image @ The Museum of Modern Art/Licensed by Scala/Art Resource, NY, 640.1973, © 2008 Estate of Pablo Picasso/Artists Rights Society (ARS), NY; 24-19: The Nelson-Atkins Museum of Art, Kansas City, Missouri, gift of the Friends of Art, F70-12, photograph by Jamison Miller; 24-20: © Digital Image © The Museum of Modern Art/Licensed by Scala, Art Resource, NY, 581.1943, © 2008 Estate of Alexander Archipenko/Artists Rights Society (ARS), NY; 24-21: Digital Image © The Museum of Modern Art/Licensed by Scala/Art Resource, NY, 16.1953, © 2008 Artists Rights Society (ARS), NY/ADAGP, Paris; 24-22: Photo © Philadelphia Museum of Art, 1952-61-58, © 2008 Artists Rights Society (ARS), NY/ADAGP, Paris; 24-23: © Albright-Knox Art Gallery, Buffalo/The Bridgeman Art Library; 24-24: Digital Image © The Museum of Modern Art/Licensed by Scala/Art Resource, NY, 231.1948; 24-25: Photo © The Bridgeman Art Library, © 2008 Artists Rights Society (ARS), NY/ADAGP, Paris; 24-26: Digital Image © The Museum of Modern Art/Licensed by Scala/Art Resource, NY, 457.1937, © 2008 Artists Rights Society (ARS), NY/VG Bild-Kunst, Bonn; 24-27: Photo @ Philadelphia Museum of Art, 1998-74-1, @ 2008 Artists Rights Society (ARS), NY/ADAGP, Paris/Succession Marcel Duchamp; 24-28: Photo @ Philadelphia Museum of Art, 1952-98-1, © 2008 Artists Rights Society (ARS), NY/ADAGP, Paris/Succession Marcel Duchamp; 24-29: Photo © Bildarchiv Preussischer Kulturbesitz/Art Resource, NY, NG 57/61, © 2008 Artists Rights Society (ARS), NY/VG Bild-Kunst, Bonn; 24-30: Photo © Yale University Art Gallery/Art Resource, NY, © 2008 Artists Rights Society (ARS), NY/VG Bild-Kunst, Bonn; 24-31: Photo © Philadelphia Museum of Art,

1964-116-005; 24-32: Digital Image © The Museum of Modern Art/Licensed by Scala/Art Resource, NY; 24-33: Digital Image © The Museum of Modern Art/Licensed by Scala/Art Resource, NY, 249.1966, © 2008 Man Ray Trust/Artists Rights Society (ARS), NY/ADAGP, Paris; 24-34: Image copyright © The Metropolitan Museum of Art/Art Resource, NY; 49.70.42; 24-35: Digital Image © The Museum of Modern Art/Licensed by Scala/Art Resource, NY, 132.1951, Art © Estate of Stuart Davis/Licensed by VAGA, NY; 24-36: Photo © Fisk University Galleries, University of Tennessee, Nashville; 24-37: © 2003 Whitney Museum of American Art; 24-38: Photo © Sheldon Memorial Art Gallery, Lincoln, Nebraska, © 2008 Georgia O'Keeffe Museum/Artists Rights Society (ARS), NY; 24-39: Photo @ Amon Carter Museum, Fort Worth, @ 2008 Georgia O'Keeffe Museum/Artists Rights Society (ARS), NY; 24-40: @ 1981 Center for Creative Photography, Arizona Board of Regents; 24-41: Photo @ Erich Lessing/Art Resource, NY, @ 2008 Estate of Pablo Picasso/Artists Rights Society (ARS), NY; 24-42: Digital Image © The Museum of Modern Art/Licensed by Scala/Art Resource, NY, 243.1947, Art © Estate of George Grosz/Licensed by VAGA, NY; 24-43: Photo © Walter Klein, © 2008 Artists Rights Society (ARS), NY/VG Bild-Kunst, Bonn; 24-44: Photo © Erich Lessing, Art Resource, NY, © 2008 Artists Rights Society (ARS), NY/VG Bild-Kunst, Bonn; 24-45: Photo © Erich Lessing, Art Resource, NY, © Ernst Barlach Lizenzverwaltung Ratzeburg; **24-46**: Photo © The Bridgeman Art Library, © 2008 Artists Rights Society (ARS), NY/SIAE, Rome; **24-47**: Digital Image © The Museum of Modern Art/Licensed by Scala/Art Resource, NY, 00256.37, © 2008 Artists Rights Society (ARS), NY/ADAGP, Paris; 24-48: Staatliche Museen zu Berlin; 24-49: Digital Image @ The Museum of Modern Art/Licensed by Scala/Art Resource, NY, 162.1934, © 2008 Salvador Dali, Gala-Salvador Dali Foundation/Artists Rights Society (ARS), NY; 24-50: Photo © Los Angeles County Museum of Art, 78.7, © 2008 C. Herscovici, Brussels/Artists Rights Society (ARS), NY; 24-51: Digital Image @ The Museum of Modern Art/Licensed by Scala/Art Resource, NY, 130.1946a-c, © 2008 Artists Rights Society (ARS), NY/ProLitteris, Zürich; 24-52: Digital Image © The Museum of Modern Art/Licensed by Scala/Art Resource, NY, 229.1937, © 2008 Successió Miró/Artists Rights Society (ARS), NY/ADAGP, Paris; 24-53: Digital Image © The Museum of Modern Art/Licensed by Scala/Art Resource, NY, 564.1939, © 2008 Artists Rights Society (ARS), NY/VG Bild-Kunst, Bonn; 24-54: Digital Image © The Museum of Modern Art/Licensed by Scala/Art Resource, NY, 248.1935; 24-55: Photograph by David Heald @ The Solomon R. Guggenheim Foundation, NY, 55.1429; 24-56: @ 2008 Mondrian/ Holtzman Trust c/o HCR International, VA, USA; 24-57: Photo © Philadelphia Museum of Art/CORBIS 1950-134-14, 15, © 2008 Artists Rights Society (ARS), NY/ADAGP, Paris; 24-58: Photo © Tate Gallery, London/Art Resource, NY, @ Bowness, Hepworth Estate; 24-59: Photograph @ 1985 The Detroit Institute of Arts, © The Henry Moore Foundation; 24-60: Photo © Gregor M. Schmid/CORBIS, Art © Estate of Vera Mukhina/RAO, Moscow/VAGA, NY; **24-61**: Digital Image © The Museum of Modern Art/Licensed by Scala/Art Resource, NY, 590.1939.a-d, © 2008 Estate of Alexander Calder/Artists Rights Society (ARS), NY; 24-62: Courtesy The Dorothea Lange Collection, The Oakland Museum of California; 24-63: Photography © The Art Institute of Chicago, 1942.51, Estate of Edward Hopper © The Whitney Museum of American Art; 24-64: The Phillips Collection, Washington, D.C., © 2008 The Jacob and Gwendolyn Lawrence Foundation, Seattle/Artists Rights Society (ARS), NY; 24-65: Photography © The Art Institute of Chicago, 1930.934, Art © Estate of Grant Wood/Licensed by VAGA, NY; 24-66: Photo © Lloyd Grotjan/Full Spectrum Photo, Jefferson City, Art © T. H. Benton and R. P. Benton Testamentary Trusts/UMB Bank Trustee/Licensed by VAGA, NY; 24-67: Commissioned by the Trustees of Dartmouth College, Hanover, New Hampshire; 24-68: Photo © 1986 The Detroit Institute of Arts/Dirk Bakker, © 2008 Banco de México Diego Rivera & Frida Kahlo Museums Trust. Av. Cinco de Mayo No. 2, Col. Centro, Del. Cuauhtémoc 06059, México, D.F; **24-69:** Photo © Schalkwijk/Art Resource, NY; © 2008 Banco de México Trust; **24-70:** Photo © akg-images, © Estate of Vladimir Tatlin; 24-71: © 2008 Artists Rights Society (ARS), NY/Beeldrecht, Amsterdam; 24-72: Photo © Vanni/Art Resource, NY, © 2008 Artists Rights Society (ARS), NY/VG Bild-Kunst, Bonn; 24-73: Digital Image © The Museum of Modern Art/Licensed by Scala/Art Resource, NY; 24-74: Digital Image © The Museum of Modern Art/Licensed by Scala/Art Resource, NY, @ 2008 Artists Rights Society (ARS), NY/VG Bild-Kunst, Bonn; 24-75: Photo © Anthony Scibilia/Art Resource, NY, © 2008 Artists Rights Society (ARS), NY/ADAGP, Paris/FLC; 24-76: @ Michael S. Yamashita/CORBIS; 24-77: Photo @ Dennis Light/Light Photo $graphic, @\ 2008\ Frank\ Lloyd\ Wright\ Foundation, Scottsdale, AZ/Artists\ Rights\ Society\ (ARS), NY; \textbf{24-78:}$ © 2008 Frank Lloyd Wright Foundation, Scottsdale, AZ/Artists Rights Society (ARS), NY; 24-79: Photo Ezra Stoller © Esto, All rights reserved, © 2008 Frank Lloyd Wright Foundation, Scottsdale, AZ/Artists Rights Society (ARS), NY.

Chapter 25—25-1: Photograph by David Heald © The Solomon R. Guggenheim Foundation, NY; 25-2: Photo © Des Moines Art Center, © 2008 Artists Rights Society (ARS), NY/ADAGP, Paris; 25-3: Digital Image © The Museum of Modern Art/Licensed by Scala/Art Resource, NY, 229.1948, © 2008 The Estate of Francis Bacon/ARS, NY/DACS, London; 25-4: Photo © Tate Gallery, London/Art Resource, NY, © 2008 Artists Rights Society (ARS), NY/ADAGP, Paris; 25-5: Photo @ National Gallery of Art, 1976.37.1, @ 2008 The Pollock-Krasner Foundation/Artists Rights Society (ARS), NY; 25-6: Courtesy Center for Creative Photography, University of Arizona © 1991 Hans Namuth Estate; 25-7: Digital Image © The Museum of Modern Art/ Licensed by Scala/Art Resource, NY, 478.1953, © 2008 The Willem de Kooning Foundation/Artists Rights Society (ARS), NY; 25-8: Digital Image @ The Museum of Modern Art/Licensed by Scala/Art Resource, NY, 240.1969, © 2008 Barnett Newman Foundation/Artists Rights Society (ARS), NY; 25-9: Photo © San Francisco Museum of Modern Art, © 1998 Kate Rothko Prizel & Christopher Rothko/Artists Rights Society (ARS), NY; 25-10: © Ellsworth Kelly, photo by Philipp Scholz Rittermann; 25-11: Photo © CNAC/MNAM/ Dist. Réunion des Musées Nationaux/Art Resource, NY, © 2008 Frank Stella/Artists Rights Society (ARS), NY; 25-12: Photo © The Detroit Institute of Arts, Founders Society Purchase, Dr. and Mrs. Hilbert H. DeLawter Fund/The Bridgeman Art Library, Art © Helen Frankenthaler; 25-13: © Solomon R. Guggenheim, NY, 64.1685; 25-14: Photo © Tate Gallery, London/Art Resource, NY, Art © Estate of David Smith/Licensed by VAGA, NY; 25-15: Digital Image @ The Museum of Modern Art/Licensed by Scala/Art Resource, NY, 333.1998, © 2008 Estate of Tony Smith/Artists Rights Society (ARS), NY; 25-16: Hirshhorn Museum and Sculpture Garden, Smithsonian Institution, photo Lee Stalsworth, 72.154, Art © Judd Foundation/Licensed by VAGA, NY; 25-17: Photo © CNAC/MNAM/Dist. Réunion des Musées Nationaux/Art Resource, NY, © 2008 Estate of Louise Nevelson/Artists Rights Society (ARS), NY; 25-18: Photo © CNAC/MNAM/Dist. Réunion des Musées Nationaux/Art Resource, NY, Art © Louise Bourgeois/Licensed by VAGA, NY; 25-19: Photography © The Art Institute of Chicago, © 2008 The Estate of Eva Hesse/Galerie Hauser & Wirth, Zürich; 25-20: Photo © The Bridgeman Art Library, © 2008 Artists Rights Society (ARS), NY/DACS, London; **25-21:** Digital Image © The Museum of Modern Art/Licensed by Scala/Art Resource, NY, 106.1973, Art © Jasper Johns/ Licensed by VAGA, NY; 25-22: Art @ Robert Rauschenberg/Licensed by VAGA, NY; 25-23: Oeffentliche Kunstsammlung Basel, Photo Martin Bühler, © Estate of Roy Lichtenstein; 25-24: Photo © 2004 The Whitney Museum of American Art, © 2008 Andy Warhol Foundation for the Visual Arts/ARS, NY; 25-25: Photo © Tate Gallery, London/Art Resource, NY, © 2008 Andy Warhol Foundation for the Visual Arts/ARS, NY, Marilyn Monroe Estate/Curtis Management Agency; 25-26: Photo © Estate of Rudolph Burkhardt, Art © Claes Oldenburg; 25-27: Photo © University of Arizona Museum, Tucson, © Audrey Flack; 25-28: Photo © Walker Art Center, Minneapolis, © Chuck Close; 25-29: Photo by Anne Gold, Art © Estate of Duane Hanson/Licensed by VAGA, NY; 25-30: Photo @ Walker Art Center, Minneapolis, @ 2008 Susan Rothenberg/Artists Rights Society (ARS), NY; 25-31: Photo courtesy Broad Art Foundation and the Pace Gallery, NY, © Julian Schnabel; 25-32: Photo © Philadelphia Museum of Art, 1985-5-1, © Anselm Kiefer; 25-33: Photo © The Brooklyn Museum, © 2008 Judy Chicago/Artists Rights Society (ARS), NY; 25-34: © Miriam Schapiro, courtesy Flomenhaft Gallery, NY; 25-35: © Cindy Sherman, courtesy the artist and Metro Pictures; 25-36: © Barbara Kruger, courtesy Mary Boone Gallery, NY; 25-37: Courtesy of the Estate of Ana Mendieta and Galerie Lelong, NY; 25-38: Courtesy Ronald Feldman Fine Arts, NY, Art © Marsie, Emanuelle, Damon and Andrew Scharlatt/Licensed by VAGA, NY; 25-39: Copyright © 1988 Guerrilla Girls, courtesy

www.guerrillagirls.com; 25-40: Photo © Whitney Museum of American Art, © Kiki Smith, 25-41: © 1983 Faith Ringgold; 25-42: © Lorna Simpson; 25-43: Photo © Smithsonian American Art Museum, Washington, D.C./Art Resource, NY, @ Melvin Edwards; 25-44: @ Chris Ofili, courtesy Chris Ofili-Afroco and Victoria Miro Gallery, photo by Stephen White; 25-45: Photo Scott Frances © Esto, All rights reserved, © David Hammons; 25-46: Chrysler Museum of Art, Norfolk, VA, Museum Purchase, 93.2, @ Jaune Quick-to-See Smith; 25-47: Courtesy Ronald Feldman Fine Arts, Art © Estate of Leon Golub/Licensed by VAGA, NY; 25-48: Courtesy of the Estate of David Wojnarowicz and P.P.O.W. Gallery, NY; 25-49: © Krzysztof Wodiczko, courtesy Galerie Lelong, NY; 25-50: @ Magdalena Abakanowicz, courtesy Marlborough Gallery, NY; 25-51: Museum of Contemporary Art, Chicago, © Jeff Koons; 25-52: San Francisco, Museum of Modern Art, Art © Estate of Robert Arneson/Licensed by VAGA, NY; 25-53: © Mark Tansey, courtesy Gagosian Gallery, NY; 25-54: Photo Philippe Migeat © CNAC/MNAM/Dist. Réunion des Musées Nationaux/Art Resource, NY; © 2008 Hans Haacke/Artists Rights Society (ARS), NY/VG Bild-Kunst, Bonn; 25-55: Photo © Angelo $Hornak/CORBIS, © 2008 \ Frank \ Lloyd \ Wright \ Foundation, Scottsdale, AZ/Artists \ Rights \ Society \ (ARS), NY; \\$ 25-56: Photo © akg-images/L. M. Peter, © 2008 Artists Rights Society (ARS), NY/ADAGP, Paris/FLC; 25-57: Photo © Francis G. Mayer/CORBIS, © 2008 Artists Rights Society (ARS), NY/ADAGP, Paris/FLC; 25-58: Photo © Dmitri Kessel/Time & Life Pictures/Getty Images; 25-59: Photo © Michelle Chaplow/CORBIS; 25-60: Photo @ Angelo Hornak/CORBIS, @ 2008 Artists Rights Society (ARS), NY/VG Bild-Kunst, Bonn; 25-61: Photo @ Alan Schein Photography/CORBIS; 25-62: Photo @ Kokyat Choong/The Image Works;

25-63: Photo @ Robert Holmes/CORBIS; 25-64: Photo @ Ambient Images, Inc./Alamy; 25-65: Photo Peter Aaron@ Esto; 25-66: @ Robert Venturi, John Rauch, and Denise Scott Brown; 25-67: Photo @ The Art Archive/Dagli Orti; 25-68: Photo Saskia Cultural Documentation; 25-69: Photo © Rolf Haid/dpa/CORBIS; 25-70: Photo © Jacques Pavlovsky/CORBIS SYGMA; 25-71: © The Denver Art Museum; 25-72: Courtesy James Cohan Gallery, Art © Estate of Robert Smithson/Licensed by VAGA, NY, photo Gianfranco Gorgoni; 25-73: © 1983 Christo photo Wolfgang Volz. Christo and Jeanne-Claude; 25-74: Photo © Burt Roberts, courtesy of Harriet Senie, © 2008 Richard Serra/Artists Rights Society (ARS), NY; 25-75: © Kazuo Shiraga; 25-76: Photo @ Al Geise, @ 2008 Carolee Schneemann/Artists Rights Society (ARS), NY; 25-77: Photo @ Ute Klophaus, © 2008 Artists Rights Society (ARS), NY/VG Bild-Kunst, Bonn; 25-78: © 2008 Artists Rights Society (ARS), NY/ADAGP, Paris; 25-79: © Digital Image © The Museum of Modern Art/Licensed by Scala/ Art Resource, NY, 383.1970.a-c, © 2008 Joseph Kosuth/Artists Rights Society (ARS), NY; 25-80: © 2008 Bruce Nauman/Artists Rights Society (ARS), NY; 25-81: Courtesy Nam June Paik Studios, Inc.; 25-82: Adrian Piper Research Archives; 25-83: © Bill Viola, Photo: Kira Perov; 25-84: © 1979 David Em; 25-85: Solomon R. Guggenheim Museum, NY, Gift of the artist, The Jay and Donatella Chiat Collection, and purchased with funds contributed by the International Director's Council and Executive Members, 1996, 96.4499, Photograph by David Heald © The Solomon R. Guggenheim Foundation, NY; **25-86:** © Tony Oursler, courtesy of the artist and Metro Pictures, NY.

INDEX

Boldface names refer to artists. Page numbers in italics refer to illustrations.

Aachen Gospels, folio from, xxix Abakanowicz, Magdalena: work of, 776, 776 Abbey in the Oak Forest (Friedrich), 626, 626 Abduction of the Sabine Women (Giovanni da Bologna), 496-497, 497, 501 Abstract Expressionism, 748-751, 753, 754–755, 757, 758, 761, 763, 764, 765, 773, 795,801 Abstract painting, xxviii Accademia del Disegno: Gentileschi and, 540 Achilles Painter, xxix Action painting, 749, 750 Adam, Robert: work of, 598, 598, 599 Adam and Eve, 402, 407, 427; expulsion of, 433 Adams Memorial (Saint-Gaudens), 675, 675 Adoration of the Magi, xvi Adoration of the Magi (Gentile), 430-431, 430, 437 Adoration of the Shepherds, xvi Adoration of the Shepherds (de la Tour), 573, 573, 574 Adoration of the Shepherds (Giovanni Pisano), 377 Adoration of the Shepherds (Nicola Pisano), Adoration of the Shepherds (van der Goes), 408 Advantages of Being a Woman Artist, The (Guerrilla Girls), 769, 769

Aertsen, Pieter, 525; work of, 518-519, 518 Aesculapius (Asklepios), xv African Negro Art (MoMA exhibit), 730 Agnolo de Cosimo. See Bronzino Agony in the Garden, xvii Aisle, xxii

Albers, Josef: work of, xxxi, xxxi Alberti, Leon Battista, 392, 426, 427, 455, 466,

475, 477, 479, 480, 500; Brunelleschi and, 445; Piero della Francesca and, 450; work of, 444-445, 444, 445, 451, 451, 452, 452

Alexander VI, Pope, 462, 486; Signorelli and, 447-448

Alexander VII, Pope, 528, 531 Alexander the Great, 510, 511, 538 Allegory of Good Government (Lorenzetti), 390

Allegory of Law and Grace (Cranach), 509, 509, 510,525

Allegory of the Art of Painting (Vermeer), 550, 567

Allegri, Antonio. See Correggio Alloway, Lawrence, 757 Altamira (Spain), 680

Altarpiece of Saint Peter (Witz), 414, 414 Altarpiece of the Holy Sacrament (Bouts),

Altarpieces, 378, 398, 399, 400, 402, 408, 414, 417 **Altdorfer, Albrecht,** 525; work of, 510–511, 511 Amalienburg lodge (Cuvilliés), 584, 585

Ambulatory, xxii "American Action Painters, The" article, 750

American Gothic (Wood), 733, 733 American Realism, 651, 708 American Scene Painters, 733 American Sources of Modern Art (Aztec, Maya, Inca) (MoMA exhibit), 730 Amiens Cathedral (France) (Luzarches, Cormont, and Cormont), 387, 392 Among the Sierra Nevada Mountains, California (Bierstadt), 628, 629 Amor (Eros, Cupid), xv Amphitrite, 517 Amsterdam, Musketeers Hall, 562 Analytic Cubism, 697, 711 Anatomy Lesson of Dr. Tulp (Rembrandt),

561,561 Anatomy of a Kimono (Schapiro), 767, 767 Ancient Mexico (Rivera), 735-736, 735 Ancient of Days (Blake), 617, 617

Angelic Concert (Grünewald), 504 Angelico, Fra (Guido di Pietro), 376, 436; work of, 434, 434

Anguissola, Sofonisba, 489; work of, 492 493 Animal Locomotion (Muybridge), 650

Anne, Saint, 388, 436, 463 Annunciation (Angelico), 434, 434 Annunciation (Broederlam), 399-400, 399 Annunciation (Campin), 400, 401, 417 Annunciation (Giovanni Pisano), 377, 377 Annunciation (Grünewald), 504

Annunciation (Martini and Memmi), 387, 387 Annunciation (Nicola Pisano), 377

Annunciation (van Eyck), 400, 404 Annunciation group (Reims Cathedral), xvi Annunciation to Mary, xvi

Annunciation to the Shepherds, xvi Annunciation to the Shepherds, medieval lectionary, xvi

Anonymous artists, xxix Anthony, Saint, 504, 506 Anthony Abbot, Saint: statue of, 504

Anthony of Isenheim, Saint, 504 Antiquities of Athens (Stuart and Revett), 603 Aphrodite (Venus), xv; statue of, 439 Aphrodite of Knidos (Praxiteles), xv, 438

Apollinaire, Guillaume, 694, 697 Apollo, xv, 540, 541, 578; statue of, 464 Apollo Attended by the Nymphs (Girardon and Regnaudin), 577-578, 577

Apotheosis of Homer (Ingres), 614, 615 Apotheosis of the Pisani Family (Tiepolo), 588, 589

Apprentices, 388, 406 Apse, xxii

Arc de Triomphe, 625 Arcadia, 483, 570 Arcadianism, 485

Arch of Constantine, 447 Arch of Trajan, Benevento, xxi Archers of Saint Hadrian (Hals), 559-560, 559, 562

Arches, xx, xx; chancel, 387; ogee, 393; ogival, 440; pointed, xxii; triumphal, 433

Archipenko, Aleksandr, 728; work of, 700-701, 701

Architectural design/materials, Gehry on, 788 Architectural drawings, xxxv-xxxvi Architecture, xxvi Architecture of democracy, 741, 742, 743

Architrave, xviii Arena Chapel (Giotto), 374, 382-383

Ares (Mars), xv Aristotle, 419, 465, 507; statue of, 464 Armature, xxxiv

Armored Train (Severini), 704, 704 Armory Show (1913), 684, 713, 721, 729,

743; described, 710-711; installation photo of. 710

Arneson, Robert: work of, 777, 777 Arnolfini, Giovanni, 402-403, 404 Arnolfo di Cambio: work of, 391-392, 392

Arp, Jean (Hans): work of, 705, 705

Arrival of Marie de' Medici at Marseilles (Rubens), 554, 554

Art and Progress, on Armory Show, 710 Art appreciation, xxvi

Art brut, 747, 748 Art Deco, 740, 741

Art history, xxv-xxvi; in 21st century, xxvi-xxxvi; public understanding of, 778;

Schneemann on, 794 Art Institute of Chicago, Grosz and, 729

Art market, 558

Art News, Lichtenstein in, 759

Art Nouveau, 674, 678-679, 680, 683; Arts and Crafts movement and, 678; Symbolism and, 673

Arte de Calimala, 384 Arte della Lana, 384

Artemis (Diana), xv

Arts, The: Zayas in, 700

Arts and Crafts movement, 661, 674, 679, 680, 683; Art Nouveau and, 678; Morris and, 689

Ascension, xvii Ascension of Christ, Rabbula Gospels, xvii

Ash Can School, 709

Asklepios (Aesculapius), xv

Assemblages, 758

Assumption of the Virgin (Correggio), 496, 496 Assumption of the Virgin (Riemenschneider),

Assumption of the Virgin (Titian), 485, 485, 486 At the Moulin Rouge (Toulouse-Lautrec),

Athena (Minerva), xv; statue of, 464 Athena Parthenos (Phidias), xv

Athens: Parthenon, 635, 763 Atmospheric perspective, 425, 501

Simmons Architects), 785–786, 785 Attribution of authorship, xxix-xxx Augustine, Saint, 504, 524 Augustus, Emperor, xxx; portrait of, xxx, xxxvi Aurora (Reni), 540-541, 541 Automatism, 719, 723 Autun: Saint-Lazare, xxix, xxxiv, 448 Avant-garde, 687, 696, 708, 724, 743, 748, 757, 793, 801; introduction of, 684; MoMA and, 730; new media and, 797; painting, 709-714;

ATT (Sony) Building (Johnson, Burgee, with

public ridicule for, 721; rejection of, 733; sculpture, 709-714; the Steins and, 694 Aventinus, Johannes, 511 Azor-Sadoch lunette, 473

Baalbek, 602

Aztecs, 736

Bacchus (Dionysos), xv Bacon, Francis: work of, 747, 747

Bad Government and the Effects of Bad Government in the City (Lorenzetti), 390 Baerze, Jacques de, 398, 400

Baldacchino (Bernini), 530-531, 530 Baldassare Castiglione (Raphael), 465 Baldinucci, Filippo: on Bernini, 531

Baldung Grien, Hans, 507; work of, 506, 506 Ball, Hugo, 705

Balla, Giacomo: work of, 702, 703 Ballet Mécanique (Léger), 702 Ballet Rehearsal (Degas), 660, 661 Baltasar Carlos, Prince, 547 Bank of Amsterdam, 551, 557

Banqueting House, 579, 579

Baptism, xvi

Bar at the Folies-Bergère (Manet), 660, 660 Barbaro, Danielle, 480

Barberini family, 530, 542 Barbizon School, Millet and, 632

Barcelona, Casa Milá, 680, 680

Barcelona Academy of Fine Art, 694 Bardi family, 442

Barlach, Ernst, 721; work of, 719, 719 Barney, Matthew, 801; work of, 744, 800

Baroncelli family, 442 Baroque, 434, 494, 524, 587, 616, 617, 644, 785;

architecture of, 549; Italian Renaissance and, 527; origins of, 527; painting of, 535-543 Barr, Alfred H., Jr., 729, 730

Barrel vault, xx, xx

Barry, Charles: work of, 642, 643 Bartholdi, Frédéric Auguste: work of, 681

Bartholomew, Saint, 474, 475

Bartolommeo Colleoni (Verrocchio), 429-430, 429, 455, 507

Bas-relief, xxxv Base (column), xviii

Basilica Nova, 452

Basilican churches, xxii

Basket of Apples (Cézanne), 670, 670 Bath, The (Cassatt), 662, 662 Bather (Lipchitz), 700, 700 Baths of Diocletian, xxi Battle of Issus (Altdorfer), 510, 511 Battle of San Romano (Uccello), 437, 437, 455 Battle of the Ten Nudes (Pollaiuolo), 439-440, 439 Baudelaire, Charles, 641, 654 Bauhaus, 738, 739, 740, 743, 781 Bay, The (Frankenthaler), 753, 753 Bear Run, Kaufmann House, 742, 742, 743 Beardsley, Aubrey: work of, 673, 673 Beata Beatrix (Rossetti), 642, 642 Beauvais Cathedral, xxvii; choir of, xxvi; lateral section of, xxxvi; plan of, xxxvi Beaux-Arts style, 644 Beckmann, Max, 721, 729; work of, 717-718,717 Behnisch, Günter: work of, 787-788, 787 Bell, Clive, 694 Belleville Breviary (Pucelle), 410 Bellini, Giovanni, 404, 486, 506; work of, 482-483, 482, 483, 485 Bellini, Jacopo, 482 Bellori, Giovanni Pietro, 549, 599; on Caravaggio/Carracci, 536-537, 538 Benevento, Arch of Trajan, xxi Benin king, xxxiv, xxxiv, xxxv Benton, Thomas Hart: work of, 734, 734 Berlinghieri, Bonaventura, 395; work of, 378, 378 Bernini, Gianlorenzo, 537, 549, 562, 575; Saint Peter's and, 529-530; work of, 526, 529-530. 529, 530, 531-532, 531, 532 Bertoldo di Giovanni, 467 Betraval and Arrest of Jesus, xvii Betrayal of Jesus (Duccio di Buoninsegna), 386, 386 Beuys, Joseph, 801; work of, 794-795, 795 Bibliothèque Sainte-Geneviève (Labrouste), 644, 645, 651 Bierstadt, Albert, 651; work of, 628-629, 629 Big Self-Portrait (Close), 762, 762 Bilbao, Guggenheim Bilbao Museo, 788, 788 Biomorphic Surrealism, 719, 728, 743, 756 Bird in Space (Brancusi), 727, 727, 730, 743 Birth of the Virgin (Ghirlandaio), 436, 436 Birth of the Virgin (Lorenzetti), 388, 389 Birth of Venus (Botticelli), 438, 439, 455 Black Death, 380, 391, 392, 395 Black Mountain College, 793 Black Paintings (Goya), 620 Blake, Peter: on Guggenheim Museum, 779 Blake, William, 618; work of, 617, 617 Blanc, Charles, 664 Blessed Art Thou among Women (Käsebier), 674-675,675 Bliss, Lillie P., 709, 730 Blue Period (Picasso), xxviii, 694 Boccaccio, Giovanni, 380, 381, 419 Boccioni, Umberto: work of, 703-704, 703 Boffrand, Germain: work of, 584, 584 Bohr, Niels, 691 Bolognese academy, 535, 549 Bonheur, Marie-Rosalie (Rosa): work of, 634, 635 Book of Hours (Limbourg brothers), 410-411, 417 Book of the Courtier (Castiglione), 465 Books: distribution of, 419 Books of Hours, 410-411, 417, 521, 525

Borghese, Camillo, 612 Borghese, Pauline, 612, 651 Borluut, Isabel, 400 Borromini, Francesco, 549, 580; influence of, 521; work of, 532, 533, 533, 534-535, 534 Bosch, Hieronymus, 521; work of, 515-517, 515

Boucher, François, 589, 601, 607; work of, 588, 588 Bouguereau, Adolphe-William, 636-637.637 Boulogne, Jean de. See Giovanni da Bologna Bound Slave (Rebellious Captive) (Michelangelo), 469, 470, 471 Bourbon, dukes of: patronage by, 410 Bourbon dynasty, 551 Bourgeois, Louise: work of, 756, 756 Bouts, Dirk, 417; work of, 408, 408 Boyle, Richard, 607; work of, 602-603, 603 Bracciolini, Francesco, 542 Brady, Matthew B., 649 Bramante, Donato d'Angelo, 464, 479, 480, 481, 498, 499, 501, 514; Michelangelo and, 478; Saint Peter's and, 529, 530; work of, 475-478, 476, 477 Brancacci Chapel, 432-433, 435 Brancusi, Constantin, 728, 729, 730, 743; on abstract sculpture, 727; Armory Show and, 710; work of, 727, 727 Braque, Georges, 694, 700; Armory Show and, 710; Cubism and, 697, 743; work of, 697, 697, Breakfast Scene (Hogarth), 594, 594 Brera Altarpiece (Piero della Francesca), 448, 449 Breton, André, 719, 720, 723; Dada and, 704; Kahlo and, 736 Breuer, Marcel: work of, 738-739, 739 Bride Stripped Bare by Her Bachelors, Even, The (The Large Glass) (Duchamp), 706-707, 706 Brighton, Royal Pavilion, 643, 643 British Museum, 598 British Royal Academy of Arts, 595, 599, Broederlam, Melchior, 417; oil painting and, 401; work of, 398-400, 399 Bronzino (Agnolo di Cosimo): work of, 491-493, 491, 492 Brown, Denise Scott: work of, 786, 786 Bruegel, Pieter, the Elder, 525; work of, 520-521, 520, 521 Brunelleschi, Filippo, 431, 433, 434, 443, 452, 455, 475; Alberti and, 445; Florence Cathedral and, 440; linear perspective and, 425, 440; Michelozzo and, 444; work of, 421-422, 421, 441-442, 441, 442 Bruno, Saint: Carthusian order and, 398 Brussels, van Eetvelde house, 679, 679 Bubonic plague. See Black Death Buddhism, 691, 798 Buffalmacco, Buonamico: work of, 392-393, 393 Buffalo, Guaranty (Prudential) Building, 682,682 Buffon, Count de, 590 Burgee, John: work of, 785, 785

Burgess, Frank Gelett: work of, 696 Burghers of Calais (Rodin), 676-677, 677 Burgundian Netherlands, dissolution of, 503,515 Burgundy: art of, 397-410, 417; map of, 398 Burgundy, dukes of, 397, 416, 417; patronage by, 398 Burial at Ornans (Courbet), 630-632, 631, 635 Burial of Atala (Girodet-Trioson), 614, 614 Burial of Count Orgaz (El Greco), 524, 524, 525 Burial of Phocion (Poussin), 570-571, 570 Burke, Edmund, 616, 627 Butcher's Stall (Aertsen), 518, 518, 525 Byzantine architecture, xxiii Byzantine art, 382, 773; style, 524, 525 Cabaret Voltaire, 705 Cadeau (Gift) (Ray), 711, 711 Cage, John, 793, 797

474, 503; sacraments of, 525

Cenni de Pepo. See Cimabue

Cennini, Cennino, 401, 431

Central-plan churches, xxiii

work of, 668-670, 670

Chalgrin, Jean François Thérèse, 625

Chambord, Château de, 514, 514, 525

Centro de Arte Reina Sofia, 716

Cave painting, 680

481, 535, 644

Ceramics, xxvi, xxxvi

Ceres (Demeter), xv

Chacmools, 728

cella, xviii

Catholicism, 503, 579; Protestantism and, 509

Cellini, Benvenuto, 513, 589; work of, 496, 497

Central-plan buildings, 440, 441, 443, 462, 475,

Cézanne, Paul, 663, 682, 683, 694, 695, 697;

Champfleury, Jules-François-Félix Husson, 632

Caillebotte, Gustave: work of, 657-658, 657 Calais, siege of, 676, 683 Calder, Alexander, 704, 743; work of, 729-730, 730 Caliari, Paolo. See Veronese

California Artist (Arneson), 777, 777 Champs de Mars or The Red Tower (Delaunay), California Institute of Technology, Em and, 799 698, 698 California Institute of the Arts, 765 Chapel of Pietro Vittrice, 538 Chapel of Saint Ivo (Borromini), 534-535, 534; Calling of Matthew, xvi Calling of Saint Matthew (Caravaggio), 538, dome of, 534; plan of, 534 539, 549 Chardin, Jean-Baptiste-Siméon, 607; Diderot Calling of Saint Matthew (ter Brugghen), on, 592; work of, 592, 592 557,557 Charlemagne (Charles the Great): renovatio Callot, Jacques: work of, 572-573, 573 of, 375 Calvin, John, 474 Charles I, King, 552, 556, 556 Calvinists, 474, 510, 557, 559, 560, 561, 562, Charles I Dismounted (Van Dyck), 556 568,579 Charles II, King, 580 Camera degli Sposi (Mantegna), 452, 453 Charles IV, King, 618, 619 Charles V, King (France), 410, 417, 514 Camera lucida, 647 Camera obscura, 566, 567, 581, 597, 607, Charles V, King (Spain), 513, 515, 525, 552; El Escorial and, 523; Spanish Empire 646,647 Camera Picta (Mantegna), 452, 453, 453, 455, and, 521 Charles VI, King, 404 472; ceiling of, 453 Camera Work (journal), 714 Charles VII, King, 412 Cameron, Julia Margaret: work of, 649, Charles X, King, 623 649, 651 Charles the Bald, 416 Charlottesville (Va.), Rotunda and Lawn, Campbell, Colin, 602 Campin, Robert (Master of Flémalle), 401, 604, 605 405, 406, 407, 417; work of, 400, 401 Chartres Cathedral, xxii, 424 Chartreuse de Champmol, 398-400, 417 Campo, 388; aerial view of, 389 Camposanto, Pisa, 392-393 Château de Chambord, 514, 514, 525 Campus Martius, 698 Chateaubriand, François René de, 614, 642 Canaletto, Antonio, 607; work of, 597, 597 Chevalier, Étienne, 412 Canons, xxxiv Chevreul, Michel Eugène, 625, 664 Canova, Antonio, 651; work of, 612, 612 Chiaroscuro, 461, 494, 501, 506, 536, 537; Canyon (Rauschenberg), 758-759, 758 development of, 383 Capitals, xviii; Corinthian, 376, 645 Chicago: Carson, Pirie, Scott Building, 682, 682; Caprichos, Los (Gova), 618, 618, 651 Marshall Field wholesale store, 681, 681; Caradosso, Cristoforo Foppa: work of, Robie House, 741-742, 741; Sears Tower, 477, 477 782, 782 Caravaggio (Michelangelo Merisi), 535, 540, Chicago, Judy (Judy Cohen), 801; on Dinner 549, 552, 553, 557, 558, 559, 573; Bellori on, Party, 766; work of, 765-766, 766 538; influence of, 544, 545; work of, 536-539, Chigi, Agostino, 464, 465 537, 539 Chiswick House (Boyle and Kent), 602-603, Carlyle, Thomas, 649 603, 604, 605, 607 Carpeaux, Jean-Baptiste: work of, 676, 676 Choir, xxxv Carrà, Carlo, 703 Chopin, Frédéric, 622 Carracci, Annibale, 537, 540, 546, 549, 552, Christ (Jesus): crucifixion of, xxix; life of, 571; Bellori on, 538; work of, 535-536, xvi, 383 535, 536 Christ Delivering the Keys of the Kingdom to Carracci family, 535 Saint Peter (Perugino), 446, 447, 455, 473 Carrying of the Cross, xvii Christ in the House of Levi (Veronese), 494, 494 Carson, Pirie, Scott Building (Sullivan), 682, 682 Christ with the Sick around Him, Receiving the Cartoons, 382, 459 Children (Rembrandt), 564, 564 Carving, xxxiv Christian art, 470; symbols in, xxviii-xxix Casa de Montejo, 522-523, 522 Christianity, 465, 685, 798; Renaissance ideas Casa Milá (Gaudi), 680, 680 about, 472 Casino Rospigliosi, 540 Cassatt, Mary, 694, 708; Impressionists and, Jeanne-Claude 662; Japanese art and, 661; work of, 662, 662 Cast-iron construction, 644, 651 407-408, 407 Castagno, Andrea del: work of, 434, 435 Castiglione, Baldassare, 465, 465 Casting, xxxiv Chronology, xxvi Cathedra Petri, 530 Chrysler Building (van Alen), 740, 741, 800 Catherine of Alexandria, Saint, 410 Catherine the Great, 585 629-630, 629 Catholic Church: Counter-Reformation and,

Christo, 801; work of, 791, 791. See also Christus, Petrus, 417, 516; work of, Chromatic abstraction, 749, 801 Chronik der Brücke (Kirchner), 689

Church, Frederic Edwin, 651; work of,

Church of the Holy Wisdom. See Hagia Sophia Churches: medieval, design of, xxii

Cimabue (Cenni de Pepo), 376, 381, 382, 395; contract with, 384; work of, 379-380, 380 City, The (Léger), 702

City-states: Italian, 380, 381, 385, 389, 447 Civil rights movement, 746, 771, 772, 801 Civil War (U.S.), 630; photographs of, 649, 650;

Winslow Homer and, 638 Claesz, Pieter, 557, 581, 648; work of, 568, 568

Clarkson, Thomas, 627 Classical art, 459; Enlightenment and, 599; revival of, 375

Classical Greece, 426

Classical order, xviii, 395; Renaissance and, 395 Classical period: Renaissance and, 455 Classicism, 427, 515, 523, 570; influence of, 613; revival of, 597

Claude Lorrain (Claude Gellée), xxxii, 581; work of, xxxii, 571-572, 571

437-438, 438, 439

699,699

Botticelli, Sandro, 446, 455, 465; work of,

Bottle, Newspaper, Pipe, and Glass (Braque), 698,

Cleansing of the Temple, xvi Clement V, Pope, 379 Clement VII, Pope, 379, 470, 474 Clerestory, xxii Clock Tower, 643 Clodion (Claude Michel): work of, 589, 589 Close, Chuck, 801; on portrait painting/ photography, 762; work of, 762, 762 Clouet, Jean: work of, 513, 513 Coalbrookdale Bridge (Darby and Pritchard), 591, 591, 607 Coeur, Jacques, 397, 412 Cohen, Judy. See Chicago, Judy Colbert, Jean-Baptiste, 574-575 Cole, Thomas, 651; work of, 628, 628 Colegio de San Gregorio, portal of, 522, 522 Collage, xxxi, 698 Collage Arranged According to the Laws of Chance (Arp), 705, 705 College of Cardinals, Great Schism and, 379 College of the Sapienza, 534 Colleoni, Bartolommeo, 429-430 Cologne Cathedral (Gerhard of Cologne), 392 Colonial empires, map of, 686 Colonialism, 696 Colonnade, xviii Color, xxxi: complementary, xxxi, 664: local, 656; Matisse on, 688; mixing of, 656; primary, 664; primary and secondary, xxxi; psychological dimension of, 664; secondary, 656, 664: simultaneous contrasts of, 664: theory, 19th-century, 664; van Gogh on, 666 Color-field painting, 752-753 Colosseum, 445, 479 Columbus, Christopher, 521 Column (Gabo), 725, 725

Columns, xxxiv; Corinthian, 612, 644; engaged, 445 Comic books and strips, 759, 801 Commission of Fine Arts: Vietnam memorial and, 783 Communist Manifesto, The (Marx and Engels), 653 Company of Captain Frans Banning Cocq, The

Complexity and Contradictions in Architecture (Venturi), 784 Composition, xxx Composition in Red, Blue, and Yellow (Mondrian), 726, 726

(Night Watch) (Rembrandt), 562, 562

Computer art, xxxvi, 793 Computer graphics, 797, 798-799, 801 Comte, Auguste, positivism and, 630 Conceptual Art, 793, 796-797, 801 Concerning the Spiritual in Art (Kandinsky), 691

Concrete construction, xx Confraternities, 379, 384

Connoisseurship, xxix

Consequences of War (Rubens), 554, 555; Rubens on, 555

Constable, John, 627, 629, 651; work of, 626, 627

Constantine I ("the Great"), 452, 475, 528, 530; Saint Peter and, 447

Constantinople: fall of, 377, 450, 480; Hagia Sophia, xxiii, xxiii, 780

Constitution Garden, 783 Constructivism, 724-726, 737, 743

Contarelli Chapel, 538

Contour line, xxxi

Contrapposto, 423, 427 Conversion of Saint Paul (Caravaggio), 537-538,

537, 539 Copley, John Singleton: work of, 596-597, 596

Corinthian capital, xviii, xix Cornaro Chapel (Bernini), 532; interior of, 526, 532

Corneille, Pierre, 601

Cornelia Presenting Her Children as Her Treasures, or Mother of the Gracchi (Kauffmann), 599, 599 Cornered (Piper), 798, 798

Coronation of Napoleon (David), 611, 611

Correggio (Antonio Allegri): work of, 496, 496 Correspondence littéraire: Diderot in, 592, 593 Cortés, Hernán, 521

Cortese, Paolo: on Federico da Montefeltro, 448 Cosmic Cubism, 711

Council of Trent, 474, 527

Counter-Reformation, 494, 527, 528, 529, 530, 532, 533, 539, 542, 543, 545, 557, 563; art and, 549; Catholic Church and, 503; Jesuits and, 500; martyrdom scenes and, 544; religious art of, 474

Courbet, Gustave, 635, 641, 648, 651, 654, 694; photography and, 647; on Realism, 631; rejection of, 655; work of, 630-632, 630

Courier du dimanche: Courbet's letter in, 631 Coypel, Antoine: work of, 578, 578

Craft arts, xxvi

Cranach, Lucas, the Elder, 525; work of, 509, 509, 510

Creation of Adam (Michelangelo), 472-473, 472, 501, 538

Creglingen Altarpiece (Riemenschneider), 413, 413

Cremaster cycle (Barney), 744, 800 Crimean War, photographs of, 649 Cross vault, xx

Crossing, xxii Crossing, The (Viola), 798, 798

Crossing square, 440

Crucifixion, xvii; symbolism of, xxix

Crucifix(Daphni), xvii

Crucifixion scene (Grünewald), 504, 505, 506 Cruciform, 440

Crystal Palace (Paxton), 591, 644-645, 645, 651, 787

Cubi XIX (D. Smith), 754, 754

Cubism, xxviii, 684, 694-702, 710, 724, 726, 729, 743, 748, 753; Analytic, 697, 711; Cosmic, 711; Picasso on, 700; Synthetic, 698, 701-702, 711, 712, 713, 731

Cubism and Abstract Art (MoMA exhibition), 730

Cumul I (Bourgeois), 756, 756

Cupid (Eros, Amor), xv, 438, 555, 582, 588, 589; Venus and, 491

Cupid a Captive (Boucher), 588

Cut with the Kitchen Knife Dada through the Last Weimar Beer Belly Cultural Epoch of Germany (Höch), 707, 707

Cutaways, xxxvi

Cuvilliés, François de: work of, 584, 585 Cuyp, Aelbert, 581; work of, 564, 565 Cyclops, The (Redon), 672, 672

Dada, 704-708, 716, 748, 756, 759, 793; pessimism of, 704, 724; Surrealism and,

Dadaists, 707, 721, 724, 743; manifestos of, 704-705

Daguerre, Louis-Jacques-Mandé, 646, 651; work of, 647, 647

Daguerreotypes, 646, 647-648

Dalí, Salvador, 719, 729; work of, 722, 722 Damned Cast into Hell (Signorelli), 448, 448

Dance, The (Derain), 689, 689 Dante Alighieri, 380, 385, 419, 615, 623, 642, 676

Darby, Abraham, III: work of, 591, 591 Darius III, King, 510

Dark Ages, 616

Darwin, Charles, 649, 654

Darwinism, 653-654

Das Staatliche Bauhaus, 738 Daughters of Edward Darley Boit, The (Sargent),

Daumier, Honoré, 634, 635, 648, 651, 732; photography and, 647; printmaking and, 633; work of, 633-634, 633, 646

David, Jacques-Louis, 607, 618, 620, 624, 625; French Revolution and, 601; on Greek style/ public art, 600; Napoleon and, 611, 651; Neoclassicism and, 613, 651; students of,

613-615; work of, 600-601, 600, 601, 609, 611,611

David (Bernini), 531-532, 531

David (Donatello), 427, 427, 428, 455, 469, 531; transfer of, 468

David (Michelangelo), 468-469, 468, 470, 501, 531, 532, 754

David (Verrocchio), 427-428, 428, 468, 469, 531, 532

Davies, Arthur B., 694, 710

Davis, Stuart: work of, 712, 712

"De," many names with "de," "del," "di" and the like are listed under next element of name, e.g. "Chirico, Giorgio de," 999

De architectura (Vitruvius), 480

De Chirico, Giorgio: work of, 719–720, 720 De imitatione statuarum (Rubens), 553

de Kooning, Willem, 759, 765, 801; work of,

de la Tour, Georges, 572; work of, 573-574, 573 De Stijl, 724-726, 738, 740, 743; defining, 737 De Stijl (magazine), 726 de Zayas, Marius, 700

Dead Christ (Mantegna), 454

Death: personification of, xxix; symbol of, 638 Death and Assumption of the Virgin (Stoss), 412,413

Death and Life of Great American Cities, The (Jacobs), 784

Death of General Wolfe (West), 596, 596 Death of Marat (David), 601, 601

Death of Sardanapalus (Delacroix), 622, 622, 623,651

Decameron (Boccaccio), 380 Decline and Fall of the Roman Empire (Gibbon), 599

Deconstructivism, 763, 778, 787-789, 801 Decorative arts, 678-682, 683

Degas, Edgar, 650, 674; Impressionism and, 683; influence of, 663; Japanese art and, 661; photography and, 647, 648, 660; work of, 660-662, 660, 661

Degenerate art, 721, 729

Déjeuner en fourrure, Le (Oppenheim), 722, 723 Déjeuner sur l'Herbe, Le (Manet), 635-636,

Delacroix, Eugène, 608, 615, 626, 635, 648, 651, 668; in Morocco, 624; Nadar and, 649; photography and, 647; Romanticism and, 622; work of, 622-625, 622, 623, 624

Delaunay, Robert: work of, 697-698, 698 Delaware residence (Venturi, Rauch, and Brown), 786, 786

Delivery of the Keys to Peter, xvi Della Robbia, Andrea, 443 Della Robbia, Luca, 442, 443

Demeter (Ceres), xv

Demoiselles d'Avignon, Les (Picasso), 695-696, 695, 696, 697, 730

Demuth, Charles, 743; work of, 713, 713 Denver Art Museum (Libeskind), 789, 789 Departure of the Volunteers of 1792 (Rude), 625,625

Deposition, xvii

Deposition (Rogier van der Weyden), 405, 405 Depth, illusion of, xxxii

Der Blaue Reiter, 691, 692, 698, 711

Der Jugend, 678

Der Krieg (The War) (Dix), 718, 718 Der Sturm, 687

Derain, André, 710; work of, 689, 689 Derrida, Jacques, 763

Descartes, René, 578, 589

Descent from the Cross (Pontormo), 491

Descent into Limbo, xvii Dessau, Shop Block, 738, 738

Die Brücke, 689, 690, 691, 702

Diana (Artemis), xv

Diderot, Denis, 593; on Chardin/ Naturalism, 592; work of, 590 Die (Smith), 754, 755

Dijon, Chartreuse de Champmol, 398-400, 417 Dinner Party, The (Chicago), 765-766, 766, 801; Chicago on, 766

Diocletian, 423, 598

Diogenes, 464, 465

Dionysos (Bacchus), xv

Diskolobos (Discus Thrower) (Myron), 531

Dispute in the Temple, xvi

Distant View of Dordrecht, with a Milkmaid and Four Cows, and Other Figures (Cuyp), 564, 565

Divine Comedy (Dante), 380, 419

Divisionism, 664

Dix, Otto, 721; work of, 718, 718

Documentary evidence, in art history, xxvi Doge's Palace, 393-394, 393, 494, 597

Domes: concrete, xx; hemispherical, xx Dominicans, 378, 393; influence of, 379; San Marco and, 434

Donatello (Donato de Niccolo Bardi), 428, 430, 431, 432, 435, 455, 467, 468, 469, 507, 531; work of, 423-425, 423, 424, 427, 427, 429, 429

Doric order, xviii

Doric portico (Stuart), 603, 607

Doryphoros (Spear Bearer) (Polykleitos), 423 Doubting of Thomas, xvii

Douglas, Aaron, 732, 743; Cubism and, 712; work of, 712, 713

Drawings, xxvi; architectural, xxxv-xxxvi; elevation, xxxvi; pen-and-ink, 459; Renaissance, 459

Drum (of dome), xx

Drunkenness of Noah (Michelangelo), 471

Dubuffet, Jean: work of, 747-748, 747

Duccio di Buoninsegna, 387, 388, 395, 436; contract with, 384; work of, 383, 385-386,

Duchamp, Marcel, 650, 711, 729, 758, 776, 793; Armory Show and, 710; Cubism/Futurism and, 684; Dada and, 705; the Steins and, 694; work of, 684, 706-707, 706

Dürer, Albrecht, 516, 517, 520, 525, 546, 564, 633; Leonardo and, 506, 507; marketing by, 507; personification and, xxix; work of, xxix, xxxi, 502, 506-508, 507, 508

Dutch Republic, 515, 551, 552, 579; art of, 557-569, 581; art market in, 558; reclamation and, 564

Dynamism of a Dog on a Leash (Balla), 702, 703

Eadwine the Scribe: work of, 403 Eakins, Thomas, 648, 651, 676, 732; work of,

638-639, 638 Early Operation under Ether, Massachusetts General Hospital (Hawes and Southworth),

Early Renaissance, 422, 444, 455, 514, 641; architecture of, 477; sculpture of, 423

Earthworks, 790

Easel painting: Pollock on, 749

Eastern philosophy, 793, 797

Echinus, xviii

École des Beaux-Arts, 644 Ecstacy of Saint Teresa (Bernini), 532-533, 532, 537, 549

Edwards, Melvin, 774, 801; work of, 771-772,771

Effects of Good Government in the City and in the Country (Lorenzetti), 390-391; detail from, 390

Église du Dôme (Hardouin-Mansart), 578-579,

Eiffel, Alexandre-Gustave: work of, 652, 681 Eiffel Tower (Eiffel), 591, 652, 681, 683, 698, 736

Eight, The, 708, 709-710 18 Happenings in Six Parts (Kaprow), 793

80 Backs (Abakanowicz), 776, 776

Einstein, Albert, 691, 697 El Escorial (Herrera and Toledo), 523, 523, 525

El Greco (Doménikos Theotokópoulos), 525; work of, 524, 524

Index

Eldana Abbey, 626 Elevation drawings, xxxvi Elevation of the Cross (Rubens), 553, 553 Eligius, Saint, 407, 408 Elizabeth I, Queen, 519 Em, David, 799; work of, 799, 799 Emancipation Proclamation, 640, 641 Embarkation of the Queen of Sheba (Claude), xxxii, xxxii Encyclopédie, Diderot and, 590, 592 Engaged half-columns, xviii Engels, Friedrich, 632, 653 English Gothic, 642, 643 Engraving, 415, 416, 417, 439 Enlightenment, 589-597, 601, 618, 622, 691; architecture, 602-606; classical art and, 599; Greece/Rome and, 607; Neoclassicism and, 616; philosophy of, 589-591; Rationalism and, 630; rebellion against, 621; science of, 589-591; sculpture, 602-606 Entablature, xviii Entartete Kunst exhibition, 721, 721 Enthroned Madonna and Saints Adored by Federico da Montefeltro (Piero della Francesca), 448 Entombment, xvii Entombment (Caravaggio), 538-539, 539 Entombment of Christ (Pontormo), 490-491, 490 Entry into Jerusalem, xvii Environmental Art movement, 790-792 Epic of American Civilization: Hispano-America (Orozco), 734, 735 Epidauros: tholos at, xviii, xix Equitable Building, New York, 681 Erasmus, Desiderius, 503, 511; Dürer and, 506, 508 Ernst, Max, 709, 721, 729; work of, 720, 720 Eros (Amor, Cupid), xv Et in Arcadia Ego (Poussin), 569-570, 569 Étienne Chevalier and Saint Stephen (Fouquet), 412 Etruscan Room (Adam), 598, 598, 599 Etruscan tombs, 598

Eugène Delacroix (Nadar), 608, 649 Europe, map of, 504, 552, 610 Euthymides, 440 Events (as art), Fluxus and, 793

Evidence in art history, types of, xxvi-xxvii Existentialism, 746, 747 Experimentalism, 453 Exposition des Arts Décoratifs et Industriels Modernes, 740

Exposition Universelle, 631, 641, 661, 696 Expressionism, 664, 680, 687, 692, 694; postwar,

Expulsion of Adam and Eve from Eden (Masaccio), 432-433, 433

Fall of Man (Adam and Eve) (Dürer), 502, 507, 516, 517, 525

Fallingwater. See Kaufmann House Family of Charles IV (Goya), 618, 619 Family of Country People (Le Nain), 572, 572 Fantastic Art, Dada, Surrealism (MoMA exhibition), 730

Fate of the Animals (Marc), 692, 692 Fauves and Fauvism, 665, 687, 689, 690, 697, 724,743

Feast of Herod (Donatello), 424-425, 424 Feast of Saint Nicholas (Steen), 567, 567 Feast of the Gods (Bellini and Titian), 483-484, 483, 486

Federico da Montefeltro, 450, 455, 463; patronage by, 448; Piero della Francesca and, 449

Feminist art, 765-769, 772, 801 Feminist movement, 746, 770, 801 Femmages, 767 Fenton, Roger, 649 Ferdinand, King, 475, 521, 522 Ferdinand VII, King, 618, 620

Fetus and Lining of the Uterus, The (Leonardo), 461,461 Feudalism, 397 Figures, relative size of, xxxiv Fin-de-siècle, 674 Fine art, xxvi First Surrealist Manifesto, 719 Fit for Active Service (Grosz), 717 Flack, Audrey, 801; work of, 761-762, 761 Flag (Johns), 758, 758

Flagellation of Christ (Piero della Francesca), 418, 450, 450 Flemish art, 397-410, 412, 417, 552-557, 581

Florence, 380, 383, 385, 597; architecture in,

Flight into Egypt, xvi Flight into Egypt (Carracci), 535, 535

Floreale (Italian art style), 678

Flagellation, xvii

391-392, 440-446; art of, 420-446, 455; Brancacci Chapel, 432-433, 435; Florence Cathedral, 384, 391-392, 392, 420, 440, 441, 455, 468, 478; Laurentian Library, 498-499, 499; map of, 420; Medici Chapel, 442, 496; Medici family and, 427, 455; New Sacristy, 470; Old Sacristy, 442, 496; Or San Michele, 422, 423, 432, 455; painting in, 430-440; Palazzo della Signoria, 422, 427, 428, 468; Palazzo Medici, 443-444; Palazzo Medici-Riccardi, 443, 444, 444, 445, 479; Palazzo

Rucellai, 444-445, 444; Pazzi Chapel, 441-443, 441, 442, 443; Piazza della Signoria, 754; San Giovanni, 391, 392; San

Miniato al Monte, 445; Santa Croce, xxvii, xxvii, 379, 441; Santa Maria del Carmine, 432, 435, 442; Santa Maria Novella, 378-379, 379, 384, 436, 445, 445, 500; Santo Spirito, 440-441, 441, 443, 452, 455; sculpture in,

Florence Cathedral (Arnolfo di Cambio), 384, 391-392, 420, 440, 441, 455, 468, 478; baptistery at, 420, 455; interior of, 392 Flower Still Life (Ruysch), 568-569, 569 Flowers on Body (Mendieta), 768, 768

Fluxus group, 793, 794, 797 Flying buttresses, xxii, xxxv

Fontainebleau, 513, 525, 632

Fontana, Lavinia, 489

Flutes, xviii

Foreshortened Christ (Mantegna), 454, 454 Foreshortening: perspective and, xxxiii-xxxiv Forever Free (Lewis), 640-641, 640

Form, xxx Formal analysis, xxx

Formalism, 748, 755, 778 Foucault, Michel, 763

Fountain (Duchamp), 706, 706

Fouquet, Jean, 417; work of, 412, 412

Four Apostles (Dürer), 508, 508

Four Crowned Saints (Nanni di Banco), 422, 423 Four Horsemen of the Apocalypse, The (Dürer), xxix. xxix. xxxi

Fourth Style, 598

Fra Angelico. See Angelico, Fra

Fra Filippo Lippi. See Lippi, Fra Filippo

Fragonard, Jean-Honoré, 607; work of, 582, 588-589

France, map of, 398

Francis I, King, 462, 491, 496, 513, 525; châteaux and, 514

Francis I (Clouet), 513, 513

Francis of Assisi, Saint, 378, 379, 486; portrayal of. 395

Franciscans, 378, 443; influence of, 379; perspective and, 383

Franco, Francisco, 716

Frankenthaler, Helen, 801; on color-field painting, 753; Post-Painterly Abstraction and, 752; work of, 752-753, 753

Frederick II, 375, 395 French Ambassadors, The (Holbein), 512, 525 French Baroque, 576, 584, 588, 607 French Gothic, 395

French Realism, 630-637, 709 French Revolution, 590, 592, 600, 601, 609; Neoclassicism and, 598

French Rococo, 583, 584; painting, 586-589; sculpture, 586-589

French Romanticism, 618-625

French Royal Academy of Painting and Sculpture, 575, 594, 655, 671; Fauves and, 687; salon of, 592, 593; Watteau and, 587 Fresco painting, 382

Freud, Sigmund, 671, 705, 719, 722

Friedrich, Caspar David, 651; work of, 626, 626

Friend, The (Lehmbruck). See Seated Youth Frieze, xviii

Fuller, Meta Warrick, 712

Fuseli, Henry, 618; work of, 616, 617 Futurism, 684, 702-704, 724

Futurist Painting: Technical Manifesto, 703 Futurists, 698, 710, 711, 713, 743; sculpture and, 703-704, 726; World War I and, 704, 746

Gabo, Naum, 736; work of, 725, 725 Gainsborough, Thomas, 607; work of, 594-595, 595

Galatea, 672

Galatea (Raphael), 464, 465

Galerie des Glaces (Hardouin-Mansart and Le Brun), 576, 577, 584, 585

Garden of Earthly Delights (Bosch), 515-516, 515 Garden of Eden, 516

Gardner, Alexander, 649

Gardner, Isabella Stewart, 709

Garnier, Charles: work of, 644, 644 Gates of Paradise (Ghiberti), 426-427, 426, 455 Gattamelata (Donatello), 429, 429, 430, 455, 507

Gaudi, Antonio: work of, 680, 680

Gauguin, Paul, 663, 672, 673, 679, 683, 687, 689, 692, 694; Japanese art and, 661; Symbolism and, 671; work of, 667-668, 667, 668

Gaulli, Giovanni Battista: work of, 542-543, 542

Gauls, 422, 642

Gehry, Frank, 801; on architectural design/ materials, 788; work of, 788-789, 788

Gellée, Claude. See Claude Lorrain Geneva, Cathedral of Saint Peter, 414 Genghis Khan, 623

Genius of Christianity, The (Chateaubriand), 614,642

Genre painting, xxviii

Gentile da Fabriano, 437, 482; work of, 430-431, 430

Gentileschi, Artemisia: work of, 539-540, 540

George, Saint, 424, 486 George III, King, 595

George IV, King, 643

George Grosz: A Survey of His Art from 1918-1938 (exhibit), 729

George Washington (Greenough), 606, 606 George Washington (Houdon), 605, 605

Georges Pompidou National Center for Art and

Culture ("Beaubourg") (Rogers and Piano),

Géricault, Théodore, 615, 625, 626, 635; work of, 620-621, 621

German Expressionism, 665, 673, 689-693, 697, 698, 743, 763

Gérôme, Jean-Léon, 638

Gertrude Stein (Picasso), 694, 694 Gestural abstraction, 749, 750, 765, 801

Ghent, Saint Bavo Cathedral, 400, 402, 403, 564, 565

Ghent Altarpiece (van Eyck), 400, 402, 402, 403, 404, 405

Ghiberti, Lorenzo, 431, 435, 455; Florence Cathedral and, 440; work of, 421-422, 421, 426-427, 426

Ghirlandaio, Domenico, 409, 446, 455, 467; work of, 436-437, 436

Giacometti, Alberto: work of, 746, 747 Giacomo da Vignola: work of, 500, 500 Giacomo della Porta, 478, 528; work of, 500,500

Gibbon, Edward, 599

Giorgione da Castelfranco, 483, 486, 488, 501, 615; work of, 484, 485

Giotto di Bondone, 385, 392, 395, 431, 432, 436, 455, 467; work of, 374, 381-383, 381, 382

Giovanna Tornabuoni (Ghirlandaio), 436, 455 Giovanni Arnolfini and His Bride (van Eyck), 396, 402-403, 516, 548

Giovanni da Bologna (Jean de Boulogne), 501; work of, 496-497, 497

Girardon, François: work of, 577–578, 577 Girodet-Trioson, Anne-Louis, 615, 617, 651; work of, 614, 614

Gislebertus, 448; work of, xxviii Giuliano da Majano, 442 Giuliano da Sangallo, 514

Giulio Romano, 376, 501; work of, 498, 498 Gizeh: Great Pyramids, of Khafre, Khufu, and

Menkaure, xiii Glass skyscraper (Mies van der Rohe), 739

Gleaners, The (Millet), 632

Global Groove (Paik), 797, 797

Glorification of Saint Ignatius (Pozzo), 543, 543

Glykon of Athens, 538

God's Separation of Light and Darkness (Michelangelo), 471 Gods/goddesses: Greek/Roman, xv

Goethe, Johann Wolfgang von, 623, 625 Goldsmith in His Shop, A (Christus), 407-408, 407, 516

Goldsmiths, 407, 408, 422

Golub, Leon: work of, 774-775, 774

Gonzaga, Federigo, 498 Gonzaga, Francesco, 488, 489

Gonzaga, Ludovico, 450, 451, 453, 455

González, Julio: work of, 701, 701

Goodacre, Glenna, 783

Gossaert, Jan: work of, 516, 517 Gothic architecture, 642-643, 651

Gothic cathedrals, xxii, xxii, 392 Gothic style, 375, 387, 490; decline of, 394

Government Services Administration (GSA), censorship and, 792

Goya y Lucentes, Francisco José de, 633, 651, 704, 732; work of, 618, 618, 619, 620 Granada (Spain), 522

Grand Canal, 481, 597

Grand Manner portraiture, 595, 596, 605

Grand Tour, 603, 607; described, 597; Neoclassicism and, 598

Grande Odalisque (Ingres), 615, 615 Grande Revue, La: Matisse in, 688

Graves, Michael, 801; work of, 786, 786 Great Depression, 685, 686, 733, 740; art of, 730-731, 743

Great Exhibition, 645

Great Piece of Turf (Dürer), 507, 507

Great Pyramids, Gizeh, xiii Great Schism, 379, 397

Greco-Roman art, xxvi

Greco-Roman mythology, 428, 455

Greco-Roman statuary, 422, 570

Greek cross, 478, 533, 602

Greek temples, xviii

Green Coca-Cola Bottles (Warhol), 760 Green Dining Room (Morris), 678, 678

Greenberg, Clement, 752, 754, 763; influence of, 748; on minimalism, 755-756; modernism and, 654; Post-Painterly Abstraction and, 751

Greenough, Horatio: work of, 606, 606 Greuze, Jean-Baptiste, 599, 607; work of, 593, 593, 595

Groin vault, xx, xx

Gropius, Walter, 739; Bauhaus and, 738, 743; work of, 738, 738

Gros, Antoine-Jean, 615, 617, 620, 651; work of, 613, 613

Gross Clinic, The (Eakins), 638-639, 638, 648 Grosz, George, 721, 729; work of, 716-717, 717 Grotto of Thetis, 577, 577

Grünewald, Matthias (Matthias Neithardt), 718; work of, 504, 505, 506

Guaranty (Prudential) Building (Sullivan), 682, 682

Guernica (Picasso), 716, 716, 729

Guerrilla Girls: work of, 769, 769

Guggenheim Museum, Bilbao (Gehry), 788, 788; atrium of, 788

Guido di Pietro. See Angelico, Fra Guild of Saint Luke, 406

Guilds, 406, 421, 422; described, 384; training by, 388

Guitar (Picasso), 699-700, 699 Gutai Bijutsu Kvokai (Concrete Art Association), 793, 794 Gutenberg, Johannes, 414

Haacke, Hans: work of, 778, 778 Habsburg dynasties, 543, 551, 552 Habsburg Empire, 521, 543, 544, 549 Habsburg-Valois War, 513

Hades (Pluto), xv Hagar Oim, xxxviii

Hagenauer, Nikolaus, 504, 505

Hagia Sophia (Anthemius of Tralles and Isidorus of Miletus), 780 Hagia Sophia (Constantinople), xxiii, xxiii Hall of Mirrors, 576, 577, 584, 585

Hals, Frans, 557, 562, 581; work of, 558-561, 559, 560

Hamilton, Richard: work of, 757-758, 757 Hammons, David: work of, 773, 773 Hang-Up (Hesse), 757, 757 Hanging Tree (Callot), 572-573, 573

Hanson, Duane, 801; work of, 762-763, 763 Happenings, 793, 794

Hardouin-Mansart, Jules, 581, 584, 585, 602; work of, 576, 577, 578-579, 578 Harlem Renaissance, 712, 732, 743 Harper's Weekly: Winslow Homer and, 638 Hart, Frederick, 783

Hartley, Marsden, 717; work of, 711-712, 711 Harunobu, Suzuki, 660

Harvest of Death, Gettysburg, Pennsylvania, July 1863, A (O'Sullivan and Gardner), 649,649

Hatshepsut, Queen, 766

Hawes, Josiah Johnson, 651; work of, 648, 648 Haywain (Constable), 626, 627

Helena, Saint, 609

Henry II, King: Louvre and, 514

Henry III of Nassau, 516

Henry IV, King, 554

Henry VIII, King, 511, 512, 519; Thomas More and, 503-504

Hephaistos (Vulcan), xv

Hepworth, Barbara, 729, 743, 756, 765; on abstract sculpture, 727; work of, 727-728, 728

Hera (Juno), xv

Herakles (Hercules), 428, 428, 439, 455, 471 Herculaneum: excavation of, 598, 599, 607

Hercules. See Herakles

Hercules and Antaeus (Pollaiuolo), 428, 428, 439, 455

Hermes (Mercury), xv

Hermes and infant Dionysos (Praxiteles), xv Herod, King, 424, 425

Herrera, Juan de: work of, 523, 523

Hesire: portrait of, xxxv; relief of, xxxiii, yyyiii-yyyiy

Hesse, Eva: work of, 756-757, 757 Hestia (Vesta), xv

High Classical period, 445 High Gothic, 392

High Renaissance, 456, 457-489, 491, 492, 493, 498, 499, 501, 515; architecture of, 477, 494; Michelangelo and, 466; painting of, 465, 482 History of Ancient Art (Winckelmann), 599

Hitler, Adolf, 686, 721, 729, 757; Entartete Kunst exhibition and, 721

Höch, Hannah: work of, 707-708, 707 Hogarth, William, 599; work of, 594, 594 Holbein, Hans, the Younger, 519, 525, 594; work of, 511-512, 512

Holy Roman Empire, 405, 480, 510, 551; art of, 412-416, 417, 504-515, 525; Burgundian territories and, 503, 515; Counter-Reformation and, 474; graphic arts of, 414, 416; map of, 398; panel painting of, 414; sculpture of, 412-413

Holy Trinity (Masaccio), 433-434, 433, 436, 437, 455

Holy Virgin Mary, The (Ofili), 772, 772, 773

Holzer, Jenny, 801; work of, 799-800, 799 Homage to New York (Tinguely), 795, 795 Homage to the Square: "Ascending" (Albers), xxxi. xxxi

Homeless Projection, The (Wodiczko), 775, 775

Homer, Winslow, 650, 651; work of, 638, 638 Hopeless (Lichtenstein), 759, 759

Hopper, Edward, 743; work of, 731-732, 732 Horse Fair, The (Bonheur), 634, 635

Horse Galloping (Muybridge), 650, 650 Horta, Victor: work of 847, 679

Houdon, Jean-Antoine, 606, 638; work of, 605,605

Houses of Parliament (Barry and Pugin), 642, 643

How to Explain Pictures to a Dead Hare (Beuys), 794-795, 795

Hudson River School, 628, 629 Hue, in art, xxxi, 664

Hugo van der Goes. See van der Goes, Hugo Humanism, 420; classical Greek art and, 426; Italian, 375, 419, 430; Renaissance, 380-381, 395, 455; Savonarola and, 446; spread of,

Hundred-Guilder Print (Rembrandt), See Christ with the Sick around Him, Receiving the Children

Hundred Years' War, 397, 398, 410, 412, 417 Hunters in the Snow (Bruegel), 521, 521, 525 Hysolar Institute (Behnisch), 787, 787, 788

Iconoclasm, 510 Iconoclasts, 404

Iconography, xxviii-xxix, 460

Icons: Byzantine, 395

Ignatius Loyola, 500, 532, 543, 544

Iktinos, 445

Il Gesù (Giacomo della Porta and Giacomo da Vignola), 542, 543; facade of, 500, 500, 528; plan of, 500, 500

Il libro dell'arte (Cennini), 401, 431

Iliad (Homer), 615

Illumination, 378, 395, 410, 417

Illusionism, 424, 433, 434, 455, 589, 632; dimensions and, 755; expressionism and, 694, 748; moving away from, 635, 636; perspective and, 453; pictorial, 388, 389, 420, 697; rejecting, 755

Impression: Sunrise (Monet), 654, 655, 656 Impressionism, 624, 632, 635, 654-663, 664, 667, 668, 669, 670, 671, 673, 683, 687, 753; influence of, 676

Improvisation 28 (Kandinsky), 691, 691, 692 Independent Group, origins of Pop Art and, 757, 758

Industrial materials, Judd on, 755 Industrial Revolution, impact of, 583, 590, 591, 607, 609, 626, 627, 643, 653

Ingres, Jean-Auguste-Dominique, 617; Neoclassicism and, 651; photography and, 647; work of, 614-615, 614, 615 Innocent X, Pope: patronage by, 528

Insane Woman (Géricault), 621 Intensity, in art, xxxi

Interior painting, Dutch, 564, 566-567 Internal evidence, xxvi

International Style, 387, 437, 455, 482, 739; persistence of, 430

Interpretation of Dreams, The (Freud), 671, 705 Ionic order, xviii

Isaac, 422; Abraham and, 421; Esau and, 427; sacrifice of, 420-421

Isaac and His Sons (Ghiberti), 426, 426, 427

Isabella, Queen, 475, 521, 522 Isabella d'Este (Titian), 488, 489

Isenheim Altarpiece (Grünewald), 504, 505, 718 Islam, 392

Italian Baroque: architecture of, 527-535, 542, 578, 579, 586; art of, 527-543, 563, 573, 578, 581; painting of, 535; sculpture of, 527-535, 549

Italian Renaissance, 515, 538, 549, 607; art of, 420, 517; Baroque and, 527; humanism and, 380; painting of, 564

Italo-Byzantine art, 382, 383, 395 Italy, map of, 376

Jack in the Pulpit No. 4 (O'Keeffe), xxvii, xxvii, 714

Jacob K. Javits Federal Building, 792, 792

Jacobs, Jane, 784

Jambs, 398, 399

James I, King, 579

Japanese art: influence of, 661

Japanese culture, 661

Japanese prints, influence of, 662, 663, 667, 668,683

Japonisme, 661

Jean, duke of Berry, 410, 417

Jeanne-Claude, 801; work of, 791, 791. See also Christo

Jeanneret, Charles-Edouard. See Le Corbusier Jefferson, Thomas, 589, 590, 607; work of,

604, 605 Jefferson Medical College, 638–639 Jerome, Saint, 482, 520, 521; statue of, 504 Jesuits, 532, 543; Counter-Reformation and 500

Iesus. See Christ

Jewelry, xxvi, xxxvi

John, Saint, 434, 435, 459, 463, 508, 524; symbol of, xxix

John the Baptist, 400, 402, 410, 436, 448, 458 John the Evangelist, 383, 398, 400, 448, 508

Johns, Jasper, 801; work of, 758, 758 Johnson, Philip, on postmodern architecture, 785; work of, 782, 782, 785-786, 785

Jones, Inigo, 580, 581, 602; work of, 579, 579 Joseph, Saint, 462, 463, 535

Judas, 386, 435, 460

Judd, Donald, 788, 801; on sculpture/industrial materials, 755; work of, 755-756, 755

Judgment Day, 442, 509; proportion and, xxxiv; symbolism of, xxix

Judith Slaying Holofernes (Gentileschi), 540 Jugendstil, 678

Julius II, Pope, 462, 463, 464, 465, 466; League of Cambrai and, 480; New Saint Peter's and, 477; Sistine Chapel and, 471; tomb of, 469-470, 469

Julius Caesar, 462

Jung, Carl, 705, 719, 724, 749

Juno (Hera), xv

Jupiter (Zeus), xv, 453, 671, 671, 672, 759; statue of, 606

Jupiter and Semele (Moreau), 671, 671, 672 Just What Is It That Makes Today's Homes So Different, So Appealing? (Hamilton), 757, 757, 758

Kahlo, Frida, 743; work of, 736, 736 Kalf, Willem, 557, 581; work of, 568, 568 Kandinsky, Vassily, 711, 721, 726, 749, 773; chair and, 738-739; work of, 691-692, 691,710

Kaprow, Allan: work of, 793 Käsebier, Gertrude: work of, 674–675, 675 Kauffmann, Angelica, 607; work of, 599, 599 Kaufmann House (Fallingwater) (Wright), 742, 742, 743

Kelly, Ellsworth, 801; Post-Painterly Abstraction and, 752; work of, 752, 752

Kent, William: work of, 602-603, 603

Keystone, xx

Kiefer, Anselm: work of, 765, 765 Kinetic theater, 794

King on horseback with attendants, xxxiv, xxxiv King Philip IV of Spain (Velázquez), 547

Kirchner, Ernst Ludwig, 721; Armory Show and, 710; work of, 689-690, 690

Kiss, The (Klimt), 674, 674

Kiyonaga, Torii: work of, 661, 661

Klee, Paul, 721, 738, 773, 796; work of, 724, 724

Klimt, Gustav: work of, 674, 674

Klüver, Billy, 795

Knight, Death, and the Devil (Dürer), 507-508, 508

Koberger, Anton: work of, 414 Kollwitz, Käthe: work of, 692, 693

Koons, leff: work of, 776-777, 776 Korin, Ogata, xxxiii; work of, xxxii

Kosuth, Joseph, 801; work of, 796, 796

Kritios Boy, 423 Kronos, 620

Kruger, Barbara, 801; work of, 768, 768; work of, 775

Kuhn, Walt: Armory Show and, 710

La Madeleine, Paris. See Madeleine, La Labrouste, Henri, 651, 681; work of, 644, 645 Ladies Luncheon Room (Mackintosh and Mackintosh), 678, 679

Ladislaus, King, 422, 424, 427

Lamentation, xvii

Lamentation (Giotto), 382, 383

Lamentation (Grünewald), 504 Landscape painting, xxviii, 625-630; Dutch,

564, 566-567; popularity of, 630 Landscape with Cattle and Peasants

(Claude Lorrain), 571-572, 571

Landscape with Saint Jerome (Patinir), 520, 520 Lange, Dorothea, 743; work of, 731, 731

Laocoön and his sons (Athanadoros, Hagesandros, and Polydoros of Rhodes), 486, 487, 497, 676

Large Glass, The (Duchamp). See Bride Stripped Bare by Her Bachelors, Even, The (Duchamp) Last Judgment, 383, 517

Last Judgment (Gislebertus), xxviii Last Judgment (Michelangelo), 474, 475; cleaning of, 473

Last Supper, xvii, 398, 434; reinterpretation of, 766

Last Supper (Bouts), 408, 408

Last Supper (Castagno), 434, 435 Last Supper (Leonardo), 460, 465, 486, 494, 501; linear perspective and, 425; restoration

Last Supper (Tintoretto), 493-494, 493 Late Gothic, 412, 431, 455, 522; architecture of, 394, 413; Italian humanism and, 430;

popularity of, 417 Late Renaissance, 457-489, 500, 501

Lateral section, xxxv, xxxvi

Latrobe, Benjamin, 605

of 473

Laurentian Library (Michelangelo), 498-499, 499 Law (Justice), frescoes of (Raphael), 464

Lawrence, Jacob, 743; work of, 732-733, 733 Lawrence, Saint, 523

Le Brun, Charles, 581, 584, 585; work of, 575, 575, 576, 576, 577

Le Corbusier, 701, 743, 778, 801; work of,

739-740, 740, 780, 780 Le Nain, Louis: work of, 572, 572

Le Nôtre, André: work of, 576-577 Le Vau, Louis: work of, 575, 575

Learning from Las Vegas (Venturi), 786 Lectionary of Henry II, xvi

LED technology. See Light-emitting diode technology

Léger, Fernand, 729; Purism and, 701-702; work of, 701-702, 702 Lehmbruck, Wilhelm, 721; Armory Show and,

710; work of, 692-693, 693

Leibl, Wilhelm: work of, 637, 637 Lemoine, J. B.: work of, 584 Lenin, Vladimir, 686

Leo X, Pope, 465, 470

Leonardo da Vinci, 376, 401, 419, 428, 440, 463, 465, 472, 473, 475, 486, 490, 496, 501, 513, 517, 705; anatomical studies by. 461-462; atmospheric perspective and, 425; death of, 456, 462; Dürer and, 506, 507; imitation and, 431; Isabella and, 489; linear perspective and, 425; on painting/sculpture, 466; work of, 458-462, 459, 460, 461

Lescot, Pierre, 525, 575; work of, 514-515, 514 Lespinasse, Julie de: salons and, 585 Letter, The (Vermeer), 566-567, 566 Lewis, Edmonia: work of, 640-641, 640 Leyster, Judith, 557; work of, 560, 561 Liberty: personification of, 625; symbolism

of, xxix Liberty Leading the People (Delacroix), 623, 623 Libeskind, Daniel, 801; work of, 789, 789

Lichtenstein, Roy, 801; on Pop Art, 759; work of, 759, 759 Light, 562-563; additive and subtractive, xxxi;

natural, xxxi; response to, 664 Light-emitting diode (LED) technology, 799 Limbourg brothers (Herman, Jean, Pol), 417;

work of, 410-411, 411 Lin, Maya Ying, 790; work of, 782-784, 783

Lincoln, Abraham, 638, 640, 641 Lincoln Memorial, 783 L'Indifférent (Watteau), 586, 587, 589 Line, in art, xxx-xxxi Linear perspective, 417, 440; one-point, 425,

425, 426; two-point, 425, 425 Lion Hunt (Rubens), xxxiii, xxxiii, xxxiv, 553

Lipchitz, Jacques, 729; work of, 700, 700 Lippi, Fra Filippo, 437, 461; work of, 434-435, 435

Lithography, 633, 651

Lives of the Great Greeks and Romans (Plutarch), 613

Lives of the Most Eminent Painters, Sculptors, and Architects (Vasari), 381, 489, 496 Living Theatre, 797

Livy, Titus, 601

Lobster Trap and Fish Tail (Calder), 730, 730 Lombardy, 394

London: Adelphi Terrace, 598; Banqueting House, 579, 579; Chiswick House, 602-603, 603, 604, 605, 607; Crystal Palace, 591, 644-645, 645, 651, 787; Houses of Parliament, 642, 643; Saint Paul's, 580, 602; Whitehall, 579, 579

Longitudinal section, xxxv Lord Heathfield (Reynolds), 595, 595

Lorenzetti, Ambrogio, 395; work of, 390-391, 390

Lorenzetti, Pietro, 390; work of, 388, 389 Lorrain, Claude. See Claude Lorrain Lost-wax process, 530

Lotus table lamp (Tiffany), 680

Louis, Morris, 801; work of, 753, 753 Louis XIV, King, 569, 577, 578, 586; French culture and, 583, 584; Louvre and, 575-576, 581; patronage by, 574-575; portrait of, 574, 575,587

Louis XIV (Rigaud), 574, 575 Louis XV, King, 666; Rococo style and, 583, 585,592

Louvain: Bouts and, 408

Louvre, 514-515, 514, 525, 579, 580; east facade of, 575; expansion of, 581; Louis XIV and, 575-576, 581

Loves of the Gods (Carracci), 536, 536, 540 Low relief, xxxv Lucky Strike (Davis), 712, 712

Luke, Saint, 406-407, 434; symbol of, xxix

Luther, Martin, 474, 504; Dürer and, 508: Reformation and, 508-510; on religious imagery, 510; salvation and, 509; translations by, 512

Lynch Fragment series (Edwards), 771, 772

Machicolated galleries, 390

Mackintosh, Charles Rennie, 661; work of, 678, 679

Mackintosh, Margaret Macdonald: work of, 678,679

Madeleine, La, Paris, 612, 612, 651

Maderno, Carlo, 531, 533; work of, 528-529, 528

Madonna, 377, 380, 409, 435, 467, 482, 490, 491 Madonna and Child, 431

Madonna and Child with Angels (Filippo Lippi), 435, 435, 461

Madonna and Child with Saint Anne and the Infant Saint John (Leonardo), 459, 459

Madonna Enthroned (Giotto), 381-382, 381 Madonna Enthroned with Angels and Prophets (Cimabue), 380, 380, 381

Madonna in the Meadow (Raphael), 462,

Madonna of the Pesaro Family (Titian), 486, 486; linear perspective and, 425

Madonna of the Rocks (Leonardo), 458-459, 458, 461; atmospheric perspective and, 425 Madonna with the Long Neck (Parmigianino), 490, 491, 501

Madrid: El Escorial, 523, 523, 525; Palace of Buen Retiro, 546

Maestà (Duccio di Buoninsegna), 383, 384, 385-386, 385, 386, 387, 395

Magritte, René, 719; work of, 722, 722 Maison Carrée, 605, 612

Maitani, Lorenzo: work of, 386-387, 387 Making a Work with His Own Body (Shiraga), 793-794, 793

Male gaze, 767, 768, 801

Malevich, Kazimir, 736; Suprematism and, 724, 725; work of, 724-725, 725 Malouel, Jean, 398, 410

Man in a Red Turban (van Eyck), 403-404, 404.417

Man Pointing (Giacometti), 746, 747

Man Ray (Emmanuel Radnitsky), 743; work

Manet, Édouard, 637, 648, 651, 655, 658; Japanese art and, 661; work of, 635-636, 635, 636, 660, 660

Manetti, Antonio: on Brunelleschi, 440 Maniera greca, 378, 381, 395

Mannerism, 457, 490-500, 513, 524, 525, 538, 785; architecture of, 498-500, 501; Italian, 589, 615; painting of, 490-496; portraiture of, 492; sculpture of, 496-497, 501

Mansheshe (Oursler), 800, 800

Mantegna, Andrea, 388, 455, 472, 482, 494; Isabella and, 489; linear perspective and, 425; work of, 452-454, 453, 454

Mantua, 420, 552; Palazzo del Tè, 498, 498, 501; Palazzo Ducale, 452, 453, 455, 483; patronage by, 450-454, 455; press in, 419; princely court in, 446, 447; Sant'Andrea, 451, 451, 452, 452, 455, 478, 500

Manuscript painting, 410-411

Mapplethorpe, Robert, 772 Marat, John-Paul, 601

Marc, Franz, 691, 721, 763-764; work of, 692,692

Marcus Aurelius, 429 Margaret, Saint, 402

Marilyn (Flack), 761-762, 761 Marilyn Diptych (Warhol), 760, 760, 762 Marinetti, Filippo Tommaso, 702, 703

Mark, Saint, 423, 434; symbol of, xxix Marquesas Islands, 668

Marriage à la Mode (Hogarth), 594, 594 Marriage of the Virgin (Raphael), 462, 463; atmospheric perspective and, 425

Mars (Ares) xv

Marseillaise, La (Rude). See Departure of the Volunteers of 1792

Marshall Field wholesale store (Richardson), 681,681

Martin V, Pope: Great Schism and, 379

Martinet, Achille-Louis: work of, 645

Martini, Simone: work of, 387, 387

Martyrdom, 544, 545, 549, 596

Martyrdom of Saint Philip (Ribera), 544, 545 Martyrium, 477

Marxism, 653-654

Mary. See Virgin Mary

Mary Magdalene, 383, 398

Mas o Menos (Stella), 752, 752

Masaccio (Tommaso di ser Giovanni di Mone Cassai), 376, 436, 437, 449, 455, 467; linear perspective and, 425; work of,

431-434, 432, 433

Mass, xxxi-xxxii, 379, 398

Mass culture, Pop Art and, 757

Massacre of the Innocents, xvi

Massys, Quinten: work of, 517-518, 517 Master of Flémalle. See Campin, Robert

Materials, in art, xxx Matisse, Amélie, 687

Matisse, Henri, 694, 724, 743; Armory Show and, 710; on color, 688; Primitivism and, 696; work of, 687, 687, 688, 689

Matronage, 709

and, 491

Matthew, Saint, 538, 539; symbol of, xxix Maya, 522; sculpture of, 523; temples of, 523 Mazzola, Girolamo Francesco Maria.

See Parmigianino Meat Joy (Schneemann), 794, 794 Medici, Cosimo de', 420, 437, 448; Bronzino

Medici, Giovanni de', 420 Medici, Giuliano de': tomb of, 470-471, 470

Medici, Giulio de', 470

Medici, Lorenzo de' (grandson), 470, 471 Medici, Lorenzo de' (the Magnificent), 420, 437,

438, 465, 467, 470; death of, 446 Medici, Lorenzo di Pierfrancesco de': wedding of, 438

Medici, Marie de': Rubens and, 552, 554, 581 Medici, Piero di Cosimo de', 489

Medici Chapel (Old Sacristy), 442, 496 Medici family, 397, 402, 508; Donatello and, 427; fall of, 446, 467, 468; Florence and, 427, 455;

Fra Filippo Lippi and, 435; patronage by, 420, 438; Verrocchio and, 428 Meeting of Bacchus and Ariadne (Titian),

Meeting of Saints Anthony and Paul

(Grünewald), 504, 506 Melancholy and Mystery of a Street (de Chirico),

719-720, 720

Melun Diptych (Fouquet), 412, 417

Memling, Hans, 417; work of, 409-410 Memmi, Lippo: work of, 387, 387

Memoirs of Marmontel, 585 Mendicant orders, 378, 379

Mendieta, Ana, 801; work of, 768-769, 768 Meninas, Las (Velázquez), 546-548, 548, 549,

618, 619, 639 Mercenaries IV (Golub), 774-775, 774

Mercer, Kobena, 771 Mercury (Hermes), xv

Merida, Casa de Montejo, 522-523, 522 Merisi, Michelangelo. See Caravaggio

Mérode Altarpiece (Campin), 400, 401, 402, 408, 417

Merz 19 (Schwitters), 708, 708, 756

Metalwork, xxvi, 422, 668 Metaphysical painting, 719-721

Metopes, xviii

MetroMobiltan (Haacke), 778, 778 Metropolitan Museum of Art (New York), 694,778

Mexican Revolution, 734, 735 Michael, Archangel, 448

Michel Claude See Clodion

Michelangelo Buonarroti, 405, 464, 496, 500, 501, 531, 532, 536, 552, 553; Anguissola and, 493; Bramante and, 478; colossal order and, 451; on Gates of Paradise, 426; High Renaissance and, 466; imitation and, 431; on painting/sculpture, 466; Saint Peter's and, 529, 530; work of, xxxiv, xxxv, 456, 466-474, 467, 468, 469, 470, 472, 475, 477-478, 478, 479, 498-499, 499

Michelozzo di Bartolommeo, 479; work of, 443-444 443 444

Middle Ages, 616, 641; art/architecture of, 643; concept of, 380; condemnation of, 375 Middlesex, Osterley Park House, 598, 598, 599

Mies van der Rohe, Ludwig, 742, 778, 801; Johnson and, 785; work of, 739, 739,

781-782, 782 Migrant Mother, Nipomo Valley (Lange), 731, 731

Migration of the Negro, The (Lawrence), 732, 733

Milan, 380, 597; art of, 392-394; Cathedral of, 394, 394; press in, 419; princely court in, 447; Santa Maria delle Grazie, 460, 473

Millais, John Everett, 642; work of, 641, 641 Millet, Jean-François, 640; work of, 632-633.632

Minerva (Athena), xv; statue of, 464 Minimalism, 755-757, 761, 763, 781, 783, 792, 801

Minoans: painting of, 382

Miracles of Jesus, xvi Miraculous Draught of Fish (Witz), 414, 414

Miró, Joan, 719, 724, 730, 756; work of, 723, 723 Miseries of War series (Callot), 572-573

Mobiles, 729 Modernism, 654, 687, 710, 778-784, 786 Modernismo, 678

Modernist architecture, 784, 788, 801; map of. 779

Module, application in art, xxxiv Mold, xxxiv

MoMA. See Museum of Modern Art Mona Lisa (Leonardo), 461, 461, 465, 501; atmospheric perspective and, 425; Duchamp and, 705

Monasteries, 398

Monastic orders, 379; patronage by, 384 Mondrian, Piet, 729, 730, 737, 738; Cubism

and, 726; work of, 726, 726 Monet, Claude, 632, 661, 669, 682; Impressionism and, 683; work of, 654-657,

655, 656, 657 Money-Changer and His Wife (Massys), 517-518, 517

Monroe, Marilyn, 760, 762

Mont Sainte-Victoire (Cézanne), 669, 669

Montejo, Francisco de, the Younger: Plateresque-style house and, 523

Monticello, Charlottesville, Va. (Jefferson), 604, 605,607 Monument to the Third International (Tatlin),

736-737, 737 Moore, Charles, 801; work of, 784-785, 784 Moore, Henry, 729, 743; on abstract sculpture,

727; work of, 728, 728 Moorish-Spanish architecture, 680 More, Thomas, 503-504, 511

Moreau, Gustave: Symbolism and, 683; work of, 671-672, 671

Morisot, Berthe, 662; work of, 658-659, 658 Morning of Liberty, The (Lewis). See Forever Free

Morris, William, 661; Arts and Crafts movement and, 689; work of, 678, 678 Mosaics, 672 Moses (Michelangelo), 469, 470, 501

Mother of God, 674. See also Virgin Mary Moulin de la Galette, Le (Renoir), 659, 659, 664 Mount Olympus, 672

Mount Vesuvius, 598, 599

828 Index

Movable type, 414, 415, 419 Mrs. Richard Brinsley Sheridan (Gainsborough), 594-595, 595 Mukhina, Vera: work of, 729, 729 Munch, Edvard, 690, 692; work of, 673, 673 Mural painting, 382; Pollock on, 749; Roman, 598 Musée Africain (Marseilles), 696 Musée du quai Branly (Paris), 696 Musée National des Arts d'Afrique et d'Océanie (Paris), 696 Museum für Völkerkunde (Berlin), 696 Museum of Modern Art (MoMA), 709, 729; avant-garde and, 730; commission by, 730; Hammons and, 773; Johnson and, 785; Picasso and, 716; Tinguely and, 795 Museums, xxv, 709; non-Western art collections of, 696 Mussolini, Benito, 605, 686 Muybridge, Eadweard, 639, 651, 676, 677; work of, 650, 650 My Egypt (Demuth), 713, 713 Myron, 531 Mystery plays, 383, 398 Nadar (Gaspar-Félix Tournachon), 646, 651; Delacroix and, 649; work of, 608, 648-649 Nadar Raising Photography to the Height of Art (Daumier), 646 Nanni di Banco, 455; work of, 422-423, 422 Naples, 380, 597; press in, 419; princely court in, 447 Napoleon at the Pesthouse at Jaffa (Gros), 613, Napoleon Bonaparte, 618; Arc de Triomphe and, 625; art under, 609, 611-615, 651; classical tradition and, 642; David and, 611, 651; Neoclassicism and, 611, 651 Napoleon III, 655, 657 Napoleonic Empire, map of, 610 Nash, John: work of, 643, 643 National Endowment for the Arts (NEA), 772 National Socialist German Workers Party. See Nazi Party Native American art, 773, 774 Nativity, xvi Nativity (Giovanni Pisano), 377, 377 Nativity (Nicola Pisano), 376, 377, 388 Natoire, Charles-Joseph: work of, 584 "Natural" art, 592-597 Natural History (Buffon), 590 Natural Surrealism, 719, 736, 743 Naturalism, 395, 398, 408, 607; Cimabue and, 379; Diderot on, 592; Ribera and, 545 Nauman, Bruce, 801; work of, 796-797, 796 Nave, xxii Nave arcade, xxii Nazi Party, 685, 686, 716, 719, 729; Bauhaus and, 739; degenerate art and, 721 NEA. See National Endowment for the Arts NEA Four, 772 Neithardt, Matthias. See Grünewald, Matthias Neo-Expressionism, 763-765 Neo-Platonism, 457, 470 Neoclassical portico, parody of, 786, 786 Neoclassical style: architecture, 603, 604, 643; art, 597; painting, 599-601 Neoclassicism, 598-606, 607, 609, 618, 624, 651; Enlightenment and, 616; Grand Tour and, 598; popularity of, 613; Roman Empire and, 611; Romanticism and, 620; transition from, 616,618 Neoplasticism, 726 Neptune (Poseidon), xv, 496, 516, 517, 554

Neptune and Amphitrite (Gossaert), 516, 517

Netherlandish Proverbs (Bruegel), 520, 521

Neumann, Balthasar: work of, 586, 586

Nevelson, Louise, 765; work of, 756, 756

Neue Sachlichkeit, 716-719, 743

New media, 793, 797-800, 801

New Sacristy, 470

Newton, Isaac, 578, 590, 691; Enlightenment and, 589; Wren and, 580 Nicholas, Saint, 567 Nicodemus, 538 Niépce, Joseph Nicéphore, 646 Nietzsche, Friedrich, 718, 720 Night (Beckmann), 717-718, 717 Night Café (van Gogh), 665-666, 666 Night Watch (Rembrandt). See Company of Captain Frans Banning Cocq Nighthawks (Hopper), 732, 732 Nightmare, The (Fuseli), 616, 617 Nigredo (Kiefer), 765, 765 Nike, 703 Nike of Samothrace, 703 1948-C (Still), xxiv, xxv, 754 Ninety-five Theses: Martin Luther and, 504, Noah's Ark (Douglas), 712, 713 Nocturne in Black and Gold (The Falling Rocket) (Whistler), 662, 663, 678 Nolde, Emil, 721; work of, 690, 690 Noli Me Tangere, xvii Nora (Em), 799, 799 Northern Renaissance, 407, 417 Notre-Dame, Paris, 611, 643 Notre-Dame des Maccabées, 414 Notre-Dame-du-Haut (Le Corbusier), 740, 780, 780, 801; interior of, 780 Notre-Dame hors-les-murs, commission for, 405 Nude (Weston), 715, 715 Nude Descending a Staircase (Duchamp), 684, 710 Number 1, 1950 (Lavendar Mist) (Pollock), 748, 749 No. 14 (Rothko), 751, 751 No. 76 (Lawrence), 732, 733 Nuremberg Chronicle (Koberger and Wolgemut), Nymphs and a Satyr (Bouguereau), 637 Oath of the Horatii (David), 583, 600, 600, 601, 607, 611, 613, 614 Objects, relative size of, xxxiv Oceania: art of, 690 October (Limbourg brothers), 411 Oculus, xx Odyssey (Homer), 615 Ofili, Chris: work of, 772, 772, 773 Oil painting, 399, 400; described, 401; French, 583 O'Keeffe, Georgia, 743, 765, 766; style of, xxvii-xxviii, 713-714, 714; work of, xxvii Old Masters, 654, 668 Old Sacristy, 442, 496 Old Saint Peter's, 467, 469, 475, 477, 529, 530 Oldenburg, Claes, 788; work of, 761, 761 Olympia (Manet), 636, 636, 637 On Painting (Alberti), 426 On the Art of Building (Alberti), 427, 455 On the Dignity and Excellence of Man (Manetti), 445 On the Origin of the Species by Means of Natural Selection (Darwin), 654

New Saint Peter's (Bramante), 463, 464,

New School for Social Research, Cage and, 793

New York City: AT&T (Sony) Building, 785-786,

Art, 730; New York Public Library, 135th

Equitable Building, 681; Museum of Modern

Street, 732; School of Abstract Expressionism,

778-779, 779, 781, 799, 800, 801; Trans World

748, 750; Seagram Building, 781, 782, 785,

801; Solomon R. Guggenheim Museum,

785; Chrysler Building, 740, 741, 800;

477-478; plan for, 477

New Testament: authors of, xxix

Airlines terminal, 780, 781

New York World's Fair (1937), 716

New York Herald, on Armory Show, 710

New York Times, 777; on Armory Show, 710

Newman, Barnett, 753; work of, 750, 751

New York, Night (O'Keeffe), 714, 714

One and Three Chairs (Kosuth), 796, 796 Ophelia, Study no. 2 (Cameron), 649, 649 Ophelia (Millais), 641, 641, 642 Oppenheim, Meret: work of, 722–723, 723 Or San Michele, 422, 423, 432, 455 Orozco, José Clemente, 732, 733; work of, 734-735, 734 Orpheus, 697 Orphism, 697, 698 Orthogonals, 408, 425 Orvieto Cathedral (Maitani), 386-387, 386, 392, 395, 447, 448 Osterley Park House, Etruscan Room at, 598, 598, 599 O'Sullivan, Timothy, 651; work of, 649-650, 649 Ottoman Empire, 480, 551 Oursler, Tony, 801; work of, 800, 800 Oval Sculpture (No. 2) (Hepworth), 728, 728 Oxbow, The (View from Mount Holyoke, Northampton, Massachusetts, after a Thunderstorm) (Cole), 628, 628 Pablo Picasso in his studio (Burgess), 696 Padua, Arena Chapel, 374, 382-383 Paestum, 597; Temple of Hera II, xviii, xix Paganism, 465, 531 Paik, Nam June, 801; work of, 797, 797 Painting, xxvi; American, 731-736; Poussin on, 570; Schneemann on, 794; sculpture versus, 466 Painting (Bacon), 747, 747 Painting (Miró), 723, 723 Palace of Buen Retiro, 546 Palazzo Barberini, 541 Palazzo del Tè (Romano), 498, 498, 501 Palazzo della Signoria, 422, 427, 428, 468 Palazzo Ducale (Mantegna), 452, 453, 455, 483 Palazzo Farnese (Antonio da Sangallo), 479, 479; courtyard of, 479; gallery, 536, 538 Palazzo Medici (Michelozzo), 443-444 Palazzo Medici-Riccardi (Michelozzo), 444, 444, 445, 479; façade of, 443 painting for, 388-391 444-445, 444 Paleolithic art: cave painting, 680 Palladian architecture, 603 Pallas Athena, 480 Panthéon, Paris (Sainte-Geneviève) (Soufflot), 602, 602, 607

Palazzo Pubblico, 395; aerial view of, 389; Palazzo Rucellai (Alberti and Rossellino), Palladio, Andrea, 477, 493-494, 501, 579, 581, 602, 605; work of, 480-482, 480, 481

Pantheon, Rome, xxi, 441, 457, 477, 529, 531; Jefferson and, 604, 605 Papal States, 380, 422, 480; Rome and,

446-448

Paradise Now (Paik), 797

Parma Cathedral, 496

Paris: Arc de Triomphe, 625; Bibliothèque Sainte-Geneviève, 644, 645, 651; Cour Carré, 514-515, 514, 575; Église du Dôme, 578-579, 578, 602; Eiffel Tower, 591, 652, 681, 683, 698, 736; Georges Pompidou National Center for Art and Culture, 787, 787; International Exposition, 716, 729; La Madeleine, 612, 612, 651; Louvre, 514-515, 514, 525, 575-576, 575, 579, 580, 581; Notre-Dame, 611, 643; Panthéon, 602, 602, 607; Paris Opéra, 644, 644, 660; Salon de la Princesse, 584, 584; World's Fair, 655 Paris: A Rainy Day (Caillebotte), 657, 657, 658 Paris Opéra (Garnier), 644, 644, 660

Parmigianino (Girolamo Francesco Maria Mazzola), 496, 501; work of, 490, 491

Parthenon, 635, 763 Passion of Christ, xvii Passion of Sacco and Vanzetti, The (Shahn), xxviii, xxviii, 731; symbolism in, xxix Pastoral Symphony (Giorgione and/or Titian), 484, 485, 501, 635

Patinir, Joachim, 521, 525; work of, 519-520, 520 Patronage, 384, 398, 410, 438, 447, 448-454, 455, 512, 519, 528, 544, 574-575; corporate, 778; forms of, 420; mercantilist, 558; middleclass, 558; politics of, 778; portraiture and, xxx; by Renaissance women, 489; sources of, 397. See also Matronage Patrons, xxv, xxvi, 384; role of, xxx Paul, Saint, 507; conversion of, 537 Paul III, Pope, 477, 479, 536; Council of Trent and, 474; Counter-Reformation and, 474; Jesuit order and, 500 Paul V, Pope, 529; patronage by, 528 Pauline Borghese as Venus (Canova), 612 Pavilion of Realism, 631, 641, 655 Paxton, Joseph, 651, 681; work of, 644-645, 645

Pazzi family, 441 Peaceful City (Lorenzetti), 390, 391 Peaceful Country (Lorenzetti), 390, 391 Peacock Skirt (Beardsley), 673, 673 Pediment, xviii Peeters, Clara: work of, 556, 557

interior of, 442; plan of, 442

Pazzi Chapel (Brunelleschi), 441-443, 441;

Pendentives, xxiii Penitential Psalms, 411 People's Commissariat for Enlightenment, 736 Performance Art, xx, 793-796, 801; feminist, 772, 794; Schneemann on, 794 Period style, xxvii Periods, of artists, xxviii

Peripteral temple, xviii Perrault, Claude: work of, 575, 575 Perry, Cabot: on Monet, 656 Persistence of Memory, The (Dalí), 722, 722 Personal style, in art, xxvii-xxviii, xxx Personification, xxix; of Pestilence, xxix Perspective, xxxii-xxxiii, 383, 391, 408, 435, 437, 454, 458, 460, 494; atmospheric, 425, 501;

Renaissance fascination with, 425-426 Perugino (Pietro Vannucci), 455, 463, 473; work of, 446-447, 446

Peruzzi family, 442 Pesaro family, 486 Peter, Saint, 386, 432, 469, 486, 508; burial place of, 475; Constantine and, 447; crucifixion of, 475; throne of, 530

Petrarch, Francesco, 380, 381, 385, 387; humanism of, 419

Phidias, 538, 606, 615; work of, xv Philip, Saint, 544, 545 Philip II, King of Spain, 493, 515; Dutch Republic and, 525; El Escorial and, 523; Spanish Empire and, 521

Philip III, King, 544 Philip IV, King, 544; Rubens and, 552; Velázquez and, 545, 546, 547, 549 Philip the Bold, 397, 398, 400, 410, 417

Philip the Good, 400

Philosopher Giving a Lecture at the Orrery, A (Wright of Derby), 590, 591

Philosophes, 590 Philosophical Bordello (Picasso). See Demoiselles d'Avignon (Picasso)

Philosophical Enquiry into the Origins of Our Ideas of the Sublime and Beautiful, A (Burke), 616

Philosophy (School of Athens) (Raphael), 463, 464

Philoxenos of Eretria, 510

Photography, xxvi, xxxvi, 591, 608, 674, 714-715, 729-731; influence of, 663, 677, 683; invention of, 609, 647-650, 651, 743; portrait painting and, 762; wet-plate, 646 Photomontagists, 707 Photorealism, 761, 762 Physical evidence, in art history, xxvi Piano, Renzo: work of, 787, 787 Piazza della Signoria, 754

Piazza d'Italia (Moore), 784-785, 784, 801

829 Index

Piazza San Marco, 481 Picabia, Francis, 705, 713 Picasso, Pablo, 701, 722-723, 724, 729, 730, 767; Armory Show and, 710; Cubism and, 697, 700, 743; modernism and, 694; periods of, xxviii; Primitivism and, 696; work of, 694-696, 694, 695, 698, 698, 699-700, 699, 716, 716 "Picasso Speaks" (Zayas), quote from, 700 Pictorial arts, xxvi Piero della Francesca, 455, 475; Alberti and, 450; Federico da Montefeltro and, 449; perspective painting and, 417; work of, 418, 448-450, 449, 450 Pietà, 405, 467, 467, 601, 692 Pietà (Michelangelo), 467, 467, 601 Pietro da Cortona: work of, 541-542, 541 Pilgrimage to Cythera (Watteau), 583, 587-588, 587 Pilgrimages, 597 Pink Panther (Koons), 776, 776 Pioneer Days and Early Settlers (Benton), 734, 734 Piper, Adrian, 801; work of, 798, 798 Pisa, 597; art of, 392-394; Camposanto, 392-393 Pisa Cathedral, 387; baptistery of, 375, 377 Pisani family, 589 Pisano, Andrea, 421, 426; work of, 420-421 Pisano, Giovanni, 381, 394, 420, 421; work of, Pisano, Nicola (Nicola d'Apulia), 377, 388, 395, 420: work of, 375-376, 377 Piss Christ (Serrano), 772 Pissarro, Camille, 667, 668; work of, 658, 658 Pittura Metafisica (Metaphysical Painting), 719, 720 Pizarro, Francisco, 521 Place du Théâtre Français, La (Pissarro), 658,658 Plane, in art, xxxi Plans (architectural), xxxv, xxxvi, xxxvi Plateresque style, 522, 523, 525 Plato, 419, 426, 464, 465, 466, 470 Platonic Academy of Philosophy, 420 Pliny the Elder, 538 Plutarch, 570, 613 Pluto (Hades), xv Pointillism, 664, 665, 683 Poissy-sur-Seine, Villa Savoye, 740, 740, 780 Political art, 770-778 Poliziano, Angelo, 438, 439, 464, 465 Pollaiuolo, Antonio del, 447, 455, 497; work of, 428-429, 428, 439-440, 439 Pollock, Jackson, 749, 750, 756, 765, 793, 801; on easel/mural painting, 749; work of, 748, 749 Polykleitos, 423, 426, 445, 570 Polyphemos, 464, 465, 672

Pompadour, Madame de, 585, 588
Pompeii: excavation of, 598, 599, 607
Pontormo, Jacopo da: work of, 490–491, 491
Pop Art, 757–761, 763, 765, 786, 790, 801;
British, 757; Lichtenstein on, 759
Portals, 542, 542
Portinari Altarpiece (van der Goes), 408, 409
Portland Building (Graves), 786, 786, 801
Portrait of a German Officer (Hartley), 711–712, 711, 717
Portrait of a Lady (Rogier van der Weyden), 407, 407
Portrait of a Young Man (Bronzino), 492–493, 492
Portrait of Paul Revere (Copley), 596, 596

(Anguissola), 492 Portraiture: patronage and, xxx; photography and, 762; revival of, 420 Portuguese, The (Braque), 697, 697 Poseidon (Neptune), xv, 496, 516, 517, 554 Post-and-lintel architecture, xx

Portrait of Te Pehi Kupe (Sylvester), xxxvii

Portrait of the Artist's Sisters and Brother

Post-Impressionism, 654, 663–670, 673, 679, 683, 687, 724; Japanese art and, 661
Post-Painterly Abstraction, 751–754, 757, 761, 801
Postmodern architecture, 784, 801; Johnson on, 785; map of, 779
Postmodern painting, 763–778
Postmodern sculpture, 763–778
Postmodernism, 784–787, 800
Poussin, Nicolas, 578, 581, 587, 669; on painting, 570; work of, 569–571, 569, 570
Pozzo, Fra Andrea, 549, 562, 589; work of, 543, 543

Prairie house, 741, 741 **Praxiteles,** 427, 438; work of, *xv*Pre-Raphaelite Brotherhood, 641–642, 649;
Realism and, 641

Precisionism, 712–713, 714, 733, 743

Presentation in the Temple, xvi Presentation in the Temple and Flight into Egypt (Broederlam), 400 Primavera (Botticelli), 438, 438, 455

Primitivism, 694–702, 724 Princely courts, 446–454; patronage by, 447, 455 Printing press, 417 Printmaking, xxvi, 415, 419, 506, 507, 525, 564,

Primitive art, 773

Pritchard, Thomas E: work of, 591, 591
Productivism as art movement, 736
Proportion, xxxiv
Protestantism, 474, 513, 515, 579; Catholicism and, 509; establishment of, 503; iconoclasm

and, 509; establishment of, 503; iconoclasm and, 510; Reformation and, 525; visual imagery and, 510 Provenance, xxvii

Psalters, 411
Pseudoperipteral temples, xviii
Ptolemy, 464
Public art: Jacques-Louis David on, 600
Public Francy (Hammons), 773, 773

633; blossoming of, 397

Public Enemy (Hammons), 773, 773 Public funding of art, controversy over, 772

Pucelle, Jean, 410 Pugin, A.W.N.: work of, 642, 643

Pure Art, 735
Pure plastic art, 726, 743
Purising 740, South till Collins and 701

Purism, 740; Synthetic Cubism and, 701–702 **Puvis de Chavannes, Pierre:** work of, *670*, 671 Pyramids: Egyptian, *xiii*

Pythagoras, 464

Queen of Heaven, 385, 387

Quetzalcoatl, 735 Quick-to-See Smith, Jaune, 801; work of, 773–774, 773

RA. See Resettlement Administration Rabbula Gospels, xvii Radnitzky, Emmanuel. See Man Ray Raft of the Medusa (Géricault), 620, 621 Raising of the Cross, xvii

Raphael (Raffaello Santi), 470, 473, 482, 486, 490, 491, 496, 498, 501, 536, 537, 540, 549, 553, 569, 615, 672, 756; atmospheric perspective and, 425; death of, 457; linear perspective and, 425; work of, 462–465, 462, 463, 464, 465

Rationalism, Enlightenment and, 598, 630 **Rauch, John:** work of, 786, 786

Rauschenberg, Robert, 774; work of, 758–759, 758

758–759, 758 Readymades, 706 Realism, 388, 408, 417, 538, 549, 591, 616,

Realism, 388, 408, 417, 538, 549, 591, 616, 630–642, 651, 654, 667, 670, 676, 687, 694, 729, 763; American, 651, 708; Courbet on, 631; dismissal of, 671, 673, 683; French, 630–637, 709; Pre-Raphaelite Brotherhood and, 641; rise of, 609

Realistic Manifesto, The (Gabo and Pevsner), 725 Reclining Figure (Moore), 728, 728 Red Blue Green (Kelly), 752, 752 Red Room (Harmony in Red) (Matisse), 688, 689

Redon, Odilon, 683; work of, 672, 672
Reflections on the Imitation of Greek Works in Painting and Sculpture (Winckelmann), 599
Reformation, 400, 411, 503; Catholic response to, 527; launching of, 504; Luther and, 508–510; Protestants and, 525; visual imagery and, 510
Regional style, xxvii
Regionalism, 733, 734

Regnaudin, Thomas: work of, 577–578, 577 Reims Cathedral, 375, 423

Relief prints, 415, 417

Relief sculptures, xxxv

Rembrandt van Rijn, xxx, 548, 581, 633, 640, 759; light and, 562–563; self-portraits by, 563; work of, 561–564, 561, 562, 563, 564

Renaissance: classical culture and, 455; classical tradition and, 395; experimentalism of, 453; humanism and, 455; scientific spirit of, 462; style, 394, 457, 644

Renaissance architecture, 392, 394, 440, 444; Rome and, 475–479; Venice and, 480–482 Renaissance art, 418, 427, 448, 459, 473; Florence and, 501; imitation/emulation in, 431; Rome and, 501; Venice and, 501; women in, 489

Renaissance Italy: artistic training in, 388
Reni, Guido, 546; work of, 540–541, *541*Renoir, Pierre-Auguste, 632, 661, 663, 694;
Impressionism and, 683; on painting, 659;
work of, 659, 659
Resettlement Administration (RA), 731, 732
Resurrection, xvii, 383, 386, 718

Retable de Champmol (Broederlam), 399–400, 399, 417

Return of the Prodigal Son (Rembrandt), 562, 563

Revett, Nicholas: work of, 603 "Revolt against the City" essay (Wood), 733

Reynolds, Sir Joshua: work of, 595, 595 Ribera, José (Jusepe) de, 549; work of, 544–545, 544

Ribs, xxii

Richardson, Henry Hobson, 683; work of, 681, 681

Richter, Hans: on Dadaists, 705

Riemenschneider, Tilman: work of, 413, 413 Rietveld, Gerrit Thomas: work of, 737–738, 737

Rifle Gap (Colorado), curtain at, 791 **Rigaud, Hyacinthe,** 575, 587; work of, 574 **Ringgold, Faith,** 801; work of, 770–771, 770 *Riva degli Schiavoni, Venice* (Canaletto), 597, 597

Rivera, Diego, 743; work of, 735–736, 735 Robert Mapplethorpe: The Perfect Moment (exhibition), 772

Robie House (Wright), 741–742, 741; plan of, 741

Robusti, Jacopo. *See* Tintoretto Rockefeller, Abby Aldrich, 709, 730 Rockefeller, Nelson, 795

Rococo, 582, 583–589, 592, 594, 598, 602, 616; architecture, 584, 586; art, 589, 607; feminine look of, 585; painting, 595; rebellion against, 601

Rodin, Auguste, 683, 693; on movement in art/photography, 677; work of, 676–677, 677

Rogers, Richard: work of, 787, 787 Rogier van der Weyden, 400, 417, 491, 517; self-portrait of, 406; work of, 405, 405, 406-407, 406, 407

Roman architecture, xx Roman Empire, xxxvi; Neoclassicism and, 611 Roman Republic, 609 Roman temples, xviii

Romanesque period: Tuscan, 387, 392 Romantic architecture, 642–645, 651 Romanticism, 606, 615, 616–630, 632; appeal of, 622; foreshadowing, 613; Neoclassicism and, 620; rise of, 609; roots of, 616–617, 651; transition to 616, 618

Rome: Arch of Constantine, 447; architecture of, 475-479; Basilica Nova, 452; Baths of Diocletian, xxi; Casino Rospigliosi, 540; Chapel of Pietro Vittrice, 538; Chapel of Saint Ivo, 534-535, 534; Colosseum, 445, 479; Contarelli Chapel, 538; Cornaro Chapel, 526, 532, 532; New Saint Peter's, 463, 464, 477-478, 477; Old Saint Peter's, 467, 469, 475, 477, 529, 530; Palazzo Barberini, 541; Palazzo Farnese, 479, 479, 536, 538; Pantheon, xxi, 441, 457, 477, 529, 531, 604. 605; Papal States and, 446-448; patronage by, 455; princely court in, 446, 447; Renaissance/Baroque monuments of, 476 (map); Saint Peter's, 469, 478, 478, 499, 500. 523, 528-531, 528, 529, 530, 533, 580, 601, 602; Saint Peter's basilica, 447, 462; San Carlo alle Quattro Fontane, 532, 533, 533, 549; Santa Susanna, 528, 528, 533; Temple of Portunus, xviii, xix Ronchamp, Notre-Dame-du-Haut, 740, 780,

Ronchamp, Notre-Dame-du-Haut, 740, 780, *780*, 801

Rood, Ogden: on color theory, 664 Rose windows, 386 Rosenberg, Harold: on action painting, 750

Rossellino, Bernardo, 445; work of, 444 Rossetti, Dante Gabriel: work of, 641–642, 642 Rothenberg, Susan: work of, 763–764, 764 Rothko, Mark, 753, 801; on abstract

expressionism, 748; work of, 751, 751 Rotunda and Lawn, Monticello (Jefferson), 604, 605

Rouen: Cathedral of, 656, 683 Rouen Cathedral: The Portal (in Sun) (Monet), 656, 656

Rousseau, Henri, 683; work of, 672–673, 672 Rousseau, Jean-Jacques, 590, 607, 625; Enlightenment and, 592, 616 Royal Chapel, Versailles (Hardouin-Mansart), 578, 578

Royal Pavilion at Brighton resort area (Nash), 643, 643

Rubens, Peter Paul, 546, 547, 548, 556, 581, 587, 594, 624; on *Consequences of War,* 555; work of, xxxiii, xxxiii, xxxiv, 552–555, 553, 554, 555

Rude, François: work of, 625, 625 *Rue Transnonain* (Daumier), 633, 633 Ruskin, John, 641, 663, 678 Russian Revolution, 685, 686, 725, 736 **Ruysch, Rachel**, 557; work of, 568–569, 569

Saarinen, Eero, 781, 801; work of, 780, 781 Sacred Grove (Puvis de Chavannes), 670, 671 Sacrifice of Isaac (Brunelleschi), 421 Sacrifice of Isaac (Ghiberti), 421 Saint Anthony Tormented by Demons (Schongauer), 416, 416 Saint Bavo Cathedral, 400, 402, 403, 564, 565 Saint-Denis, 398 Saint Francis Altarpiece (Berlinghieri), 378, 378, 395

Saint Gata, bishop of, 540

Saint-Gaudens, Augustus: work of, 675, 675 Saint George (Donatello), 424, 424 Saint George and the Dragon (Donatello), 424, 424, 425

Saint John Altarpiece (Memling), 409 Saint-Lazare, Autun, xxix, xxxiv; tympanum at, 448

Saint-Lazare Train Station (Monet), 656–657,657

Saint Luke Drawing the Virgin (Rogier van der Weyden), 406–407, 406, 417 Saint Mark (Donatello), 423, 423, 455 Saint Mark's, Venice, xxiii, xxiii Saint Mary, Kraków: altarpiece at, 412, 413

Saint Mary of Egypt among Sinners (Nolde), 690, 690

Saint Paul's, London, 580; dome of, 602

Saint Peter, Geneva, 414 Saint Peter's, Rome, 478, 499, 523, 533, 580, 601; aerial view of, 529; baldacchino at, 530-531; Bernini and, 529-530; dome of, 478, 500. 602; facade of, 528; interior of, 530; Maderno and, 528-529; plan for, 478; rebuilding of, 469; triumph/grandeur of, 531. See also New Saint Peter's: Old Saint Peter's Saint Peter's basilica, Rome, 447, 462 Saint Savinus, altar of, 389 Saint Sebastian (Grünewald), 504 Saint Serapion (Zurbarán), 544, 545 Saint-Sernin, xxi Sala della Pace, 390 Salon d'Automne, 687 Salon de la Princesse (Boffrand), 584, 584 Salon des Indépendants, 655 Salon des Refusés, 655 Salon of 1827, 615 Salon of 1848, Bonheur and, 635 Salon of 1874, 662 Salons, 585, 592, 593, 607, 655 Saltcellar of Francis I (Cellini), 496, 497, 589 San Bernardino degli Zoccolanti, 449 San Brizio Chapel, 447 San Carlo alle Quattro Fontane (Borromini), 532, 533, 549; interior of, 533; plan of, 533 San Francesco, Città di Castello, 463 San Francesco, Pescia: altarpiece for, 378 San Giorgio Maggiore (Palladio), 481-482, 481, 494; interior of, 481 San Giovanni, baptistery of, 391, 392 San Marco, 434, 436 San Miniato al Monte, 445 San Pietro, 475 San Zaccaria Altarpiece (Bellini), 404, 482, 482 Sangallo, Antonio da, the Younger: work of, 479, 479 Santa Croce, xxvii, 379, 441; interior of, xxvii Santa Maria del Carmine, 432, 435, 442 Santa Maria del Popolo, 537 Santa Maria della Vittoria, 532 Santa Maria delle Grazie, 460, 473 Santa Maria Novella (Alberti), 384, 436, 445, 445, 500; construction of, 378-379; nave of, 379 Santa Susanna (Maderno), 533; facade of, 528, 528 Santa Trinità, 380, 431 Sant'Andrea (Alberti), 451, 451, 455, 478, 500; interior of, 452, 452; plan of, 451; pulpit at, 377 Sant'Antonio, 429 Sant'Egidio, altarpiece from, 409, 409 Santi Giovanni e Paolo, 494 Sant'Ignazio, 543; nave of, 543 Santissima Annunziata, 463 Santo Spirito (Brunelleschi), 440-441, 443, 452, 455; interior of, 440, 441; plan of, 441 Santo Tomé, 524 Saraband (Louis), 753, 753 Sarcophagi, 376, 377, 394 Sardanapalus poem (Byron), 622, 623 Sargent, John Singer, 651, 708; work of, 639,639 Sartre, Jean-Paul, 746, 747 Saturation, of color, xxxi, 664 Saturn Devouring One of His Children (Goya), Satvr Crowning a Bacchanate (Clodion), 589 Savinus, Saint: altar of, 388 Savonarola, Girolamo, 446, 516 Saying Grace (Chardin), 592, 592 Scala Regia (Bernini), 530, 531 Scale, in art, xxxiv Schapiro, Miriam, 765; work of, 766-767, 767

Schnabel, Julian: work of, 764-765, 764

Schneemann, Carolee, 801; on painting/

Schongauer, Martin, 417, 439; work of,

416, 416

performance art/art history, 794; work of,

School of Athens (Raphael), 463-465, 463, 473, 482, 486, 501, 615; linear perspective Schools, in art history, xxx Schröder House (Rietveld), 737, 737 Schwitters, Kurt, 711, 721, 756, 759; work of, 708, 708 Science: art and, 691 Scream, The (Munch), 673, 673, 690 Sculpture, xxvi; abstract, 727; Donald Judd on, 755; industrial materials and, 755; outdoor, 754; painting versus, 466; relief, xxxv; subtractive and additive, xxxiv; in the round, xxxv; types of, xxxv Seagram Building (Mies van der Rohe and Johnson), 781, 782, 785, 801 Sears Tower, 782, 782 Seated Youth (Lehmbruck), 693, 693 Sebastian, Saint, 504 Second Commandment, 510 Second Style, 452 Section, in architectural drawing, xxxv-xxxvi Seeing, different ways of, xxxvi-xxxvii Self-Portrait (Leyster), 560, 561 Self-Portrait (Rembrandt), 563 Self-Portrait (Te Pehi Kupe), xxxvii Self-Portrait (van Hemessen), 519 Self-Portrait (Vigée-Lebrun), 593-594, 593 Senefelder, Alois: lithography and, 633 Sensation: Young British Artists from the Saatchi Collection (exhibition), 772, 773 Serra, Richard, 772; work of, 792, 792 Serrano, Andres, 772 Seurat, Georges, 655, 663; pointillism and, 683; work of, 664-665, 665 Severini, Gino, 703; work of, 704, 704 Sforza family, 448, 458, 462, 489 Shahn, Ben, 743; work of, xxviii, xxviii, 731 Shchukin, Sergei, 694, 724 Sherman, Cindy, 768, 771, 801; work of, Shiraga, Kazuo: work of, 793-794, 793 Shop Block (Gropius), 738, 738 Short History of Modernist Painting, A (Tansey), Siena, 380, 597; art of, 383, 385-391; Palazzo Pubblico, 388-391, 389, 395 Siena Cathedral, 385, 386; altar for, 388; Duccio di Buoninsegna and, 384 Signorelli, Luca, 474; work of, 447-448, 448 Silk: printing on, 758 Silueta (Silhouettes) (Mendieta), 768 Silverpoint, 406, 459 Simmons Architects: work of, 785, 785 Simpson, Lorna, 801; work of, 771, 771; work of, 775 Sistine Chapel, 447, 455, 462, 475, 536, 553; ceiling of, 456, 475; cleaning, 473, 473; frescoes at, 382; interior of, 471; Michelangelo and, 471-472 Site-specific art, 778-792, 801 Sixth Avenue and Thirtieth Street, New York City (Sloan), 708, 709 Sixtus IV, Pope, 446, 447 Sixtus V, Pope, 527, 528, 529 Skidmore, Owings, and Merrill (SOM): work of, 782, 782 Skyscrapers, 681, 683, 714, 741, 782 Slave Ship, The (Slavers Throwing Overboard the Dead and Dying, Typhoon Coming On) (Turner), 627, 627, 628 Sleep of Reason Produces Monsters, The (Goya), Sleeping Gypsy (Rousseau), 672, 672, 683 Sloan, John, 709-710; work of, 708 Sluter, Claus, 417; work of, 398, 399 Smith, David: work of, 754-755, 754 Smith, Kiki: work of, 770, 770 Smith, Tony, 801; work of, 754, 755 Smithson, Robert: work of, 790–791, 790 Social Contract (Rousseau), 616

Social History of the State of Missouri, A (Benton), 734 Société des Artistes Indépendants, 655 Sociopolitical art, 770-778 Solomon R. Guggenheim Museum (Wright), 778-779, 779, 781, 801; Barney exhibit at, 800; Holzer exhibit at, 799 SOM. See Skidmore, Owings, and Merrill Sony Building. See AT&T building Sorel, Agnès, 412 S.O.S.-Starification Object Series (Wilke), 769, 769 Soufflot, Jacques-Germain: work of, 602, 602 Southworth, Albert Sands, 651; work of, Space, in art, xxxi-xxxii Spanish art styles: Baroque, 543-549; Romantic, 618-625 Spanish Habsburgs, 544, 553 "Specific Objects" art essay (Judd), 755 Spectrum, xxxi Spiral Jetty (Smithson), 790-791, 790 Stained-glass windows, xxii, xxxv; favrile, 680 Staircase (Horta), 679 Stanza d'Eliodoro, 464 Stanza della Segnatura, 464, 465, 473 Starry Night (van Gogh), 666, 667, 683, 730 Statues: freestanding, xxxv; liberating, xxxiv Steen, Jan: work of, 567, 567 Steerage, The (Stieglitz), 714, 715 Stein, Gertrude and Leo, 694, 694, 695 Stella, Frank, 801; work of, 752, 752 Stephen, Saint, 412, 524 Stereo Styles (Simpson), 771, 771 Stieglitz, Alfred, 713, 714, 743; the Steins and, 694; work of, 714-715, 715 Still, Clyfford: Post-Painterly Abstraction and, 754; work of, xxiv, xxv, 754 Still Life in Studio (Daguerre), 647, 648 Still-life painting, xxviii, 557, 592, 670, 683, 762; Dutch, 567-569 Still Life with a Late Ming Ginger Jar (Kalf), 568, 568 Still Life with Chair-Caning (Picasso), 698, 698 Still Life with Flowers, Goblet, Dried Fruit, and Pretzels (Peeters), 556, 557 Stone Breakers, The (Courbet), 630, 630 Store, The (Oldenburg), 761, 761 Stoss, Veit: work of, 412-413, 413 Street, Dresden (Kirchner), 690, 690 Stuart, James, 607; work of, 603, 603 Stuttgart, Hysolar Institute, 787, 787, 788 Style, in art history, xxxvi; questions about, xxvii-xxix Stylistic evidence, in art history, xxvii Subjects, in art history, xxviii-xxix Sullivan, Louis Henry, 683, 741, 782; work of, 681-682, 682 Sunday on La Grande Jatte, A (Seurat), 655, 664,

Tempest, The (Giorgione), 484, 485, 501 Tempietto ("Little Temple") (Bramante), 475-477, 476, 481, 501 Temple of Hera II, Paestum, xviii, xix Temple of Portunus, xviii, xix Temples: Greco-Roman design, xviii Temptation of Saint Anthony (Grünewald), 504 Ten Commandments, 510, 512 ter Brugghen, Hendrick: work of, 557, 557 Teresa of Avila, Saint, 532, 544 Textiles, xxvi, xxxvi Texture, in art, xxxi Thankful Poor, The (Tanner), 640, 640 Theodore, Saint, 424 Theology fresco (Raphael), 464 Theotokópoulos, Doménikos. See El Greco Theseus, King (Athens), 486 Third-Class Carriage (Daumier), 634 Third of May, 1808 (Goya), 618, 619, 620, 633, 704 Third Style, 598 Thirty Years' War, 544, 551, 572 This Is Tomorrow (exhibition), 758 Tholos, xviii, 476 Three Marys at the Tomb, xvii Three Women in a Village Church (Leibl), Tiepolo, Giambattista, 607; work of, 588, 589 Tiffany, Louis Comfort: work of, 680, 680 Tiffany Studios, 680 Tiger Hunt (Delacroix), 624-625, 624 Tilted Arc (Serra), 772, 792, 792 **Tinguely, Jean:** work of, 795–796, 795 Tintoretto (Jacopo Robusti), 524; work of, 493-494, 493 Titian (Tiziano Vecelli), 494, 501, 524, 536, 546, 552, 569, 615; Isabella and, 489; linear perspective and, 425; Palma il Giovane on, 487; work of, 483, 484, 485-489, 485, 486, 487, 488, 489 665, 665, 671 Toledo, Juan Bautista de: work of, 523, 523 Supermarket Shopper (Hanson), 763, 763 Superrealism, 761-763, 765, 801 Tonality, in art, xxxi Tornabuoni family, 436, 437, 446, 489 Supper at Emmaus, xvii Supper Party (van Honthorst), 558, 559 Toulouse: Saint-Sernin church, xxi Suprematism, 724-726, 737, 743 Toulouse-Lautrec, Henri de: Japanese art and, Suprematist Composition: Airplane Flying 661; work of, 663-664, 663 Tournachon, Gaspar-Félix. See Nadar (Malevich), 724, 725 Trade (Gifts for Trading Land with White People) Surrealism, 719-724, 793; Biomorphic, 719, (Quick-to-See Smith), 774, 774 728, 743, 756; Dada and, 719, 720; impact of, 721; Natural, 719, 736, 743; Pop, 786; psychic Traini, Francesco: work of, 392-393, 393 automatism of, 749 Trans World Airlines terminal (Saarinen), Surrender of Breda (Velázquez), 545-546, 780, 781 Transept, xxii 547, 557 Transfiguration of Christ, xvi Surrounded Islands 1980-83 (Christo and Jeanne-Claude), 791, 791, 801 Swing, The (Fragonard), 582, 588-589 Sydney Opera House (Utzon), 781, 781, 786 Treasures of Ancient Nigeria (exhibition), 778 Treatise on Painting (Leonardo), 466 Sylvester, John Henry: work of, xxxvii, xxxvii Treaty of Westphalia, 527, 551, 581; Europe Symbolism, 638, 654, 670-675, 679, 683, 736; after, 552 (map) Art Nouveau and, 673; religious, 400, 402, Trés Riches Heures du Duc de Berry, Les 510; subjectivism of, 671 (Limbourg brothers), 410-411, 411 Symbols, in art, xxviii Index

Synthetic Cubism, 698, 713, 731; influence of,

711, 712; Purism and, 701-702

Talbot, William Henry Fox, photographic

Tanner, Henry Ossawa, 732; work of, 640, 640

Tahiti: Gauguin and, 668

process, 646, 647, 651

Tapestries, 584

415, 416

Tambo (Edwards), 771-772, 771

Tattoo (Rothenberg), 764, 764

Technique, in art, xxx

Tempera paint, 400, 401

Tellus, 496

Tattooing, xxxvii, xxxvii, 764, 764 Te Pehi Kupe, xxxvii; work of, xxxvii, xxxvii

Teerlinc, Levina, 641, 519, 525

Tansey, Mark: work of, 777-778, 777

Tarvisium, woodcut of (Wolgemut), 414,

Tatlin, Vladimir, 725; work of, 736-737, 737

Trials of Jesus, xvii Tribute Money (Masaccio), 432, 432 Triptychs, xviii, 388, 414, 515, 517, 553 Triumph of Bacchus (Carracci), 536 Triumph of Death (Traini or Buffalmaccio), 392-393, 393 Triumph of the Barberini (Pietro da Cortona),

541, 541

Triumph of the Name of Jesus (Gaulli), 542 Triumph of Venice (Veronese), 494, 495 Tropical Garden II (Nevelson), 756, 756 True Artist Helps the World by Revealing Mystic Truths (Nauman), 796-797, 796 Tub, The (Degas), 661-662, 661 Tunnel vault, xx

Turner, Joseph Mallord William, 597, 628, 651; work of, 626-627, 627

Tuscany, Romanesque art and society in, 387, 392, 540

Twilight in the Wilderness (Church), 629-630, 629

Twittering Machine (Klee), 724, 724, 796 Two Children Are Threatened by a Nightingale (Ernst), 720, 720, 721

Two Fridas, The (Kahlo), 736, 736 Two Women at the Bath (Kiyonaga), 661

Uccello, Paolo, 455; work of, 437, 437 Ugolino and His Children (Carpeaux), 676, 676 Unfinished captive (Michelangelo), xxxv Unique Forms of Continuity in Space (Boccioni), 703 703

United Provinces of the Netherlands. See Dutch Republic United States, map of, 584 Untitled (Holzer), 799, 799 Untitled (Judd), 755, 755 Untitled (K. Smith), 770, 770 Untitled (Your Gaze Hits the Side of My Face)

(Kruger), 768, 768 Untitled Film Stills (Sherman), 767, 767 Urban VIII, Pope, 528, 530, 531, 541-542

Urbanization, 653, 657 Urbino, 420, 448-450, 455; princely court in,

Utrecht, Schröder house (Rietveld), 737, 737

Utzon, Joern, 801; work of, 781, 781

Valladolid, 523; Colegio de San Gregorio,

Value, of color, xxxi, 664 "Van," many names with "van," "von" and the like are listed under next element of name, e.g. "Goethe, J. W. von," 999

van Alen, William: work of, 740, 741 van der Goes, Hugo, 417; work of, 408-409, 409

van Doesburg, Theo, 726; on De Stijl, 737 Van Dyck, Anthony, 493, 594; work of, 556-557, 556

van Eesteren, Cor, 726

Van Eetvelde house, staircase for, 679, 679 van Evck, Jan, 401, 405, 406, 407, 507, 516, 517, 548; self-portrait of, 403, 404, 417; work of, 396, 400, 402-404, 402, 403

van Gogh, Vincent, 663, 679, 682, 683, 687, 689, 690, 730, 758; Japanese art and, 661; letters by, 665, 666; Symbolism and, 671; work of, 665-666, 666, 667

van Hemessen, Caterina, 406, 525; work of,

van Honthorst, Gerrit, 557, 573-574; work of, 558 559

van Ruisdael, Jacob, 571, 581; work of, 564, 565, 566

Vanitas paintings, 568, 648, 761 Vanitas Still Life (Claesz), 568, 568 Vannucci, Pietro. See Perugino

Vasari, Giorgio, 400, 461, 468, 517, 538, 599; on Masaccio, 432; work of, 381, 489, 496

Vatican City, 464; map of, 529; Scala Regia, 530, 531; Sistine Chapel, 382, 447, 455, 456, 462, 471-472, 471, 473, 473, 475, 475, 536, 553 Vaults, xx, xxxv; barrel (tunnel), 383, 451, 531;

Gothic, 781 Vecelli, Tiziano. See Titian

Veduta painting, 597, 607 Velázquez, Diego, 557, 563, 618, 619, 639; Philip IV and, 545, 546, 547, 549; work of, 545-548, 545, 547, 548

Venetian painting, 482-489, 535 Venice, 380; architecture of, 480-482; art of, 392-394, 485; commission from, 429; Doge's Palace, 393-394, 393, 494, 597; independence of, 480; press in, 419; Renaissance art and, 501; Saint Mark's, xxiii, xxiii; San Giorgio Maggiore, 481-482, 481,

494; Villa Rotonda, 480, 481-482, 602, 605 Venturi, Robert, 784; work of, 786, 786 Venus, 438, 488, 555, 651, 750; Cupid and, 491-492

Venus, Cupid, Folly, and Time (Bronzino), 491-492, 491

Venus (Aphrodite), xv

Venus de Milo (Alexandros of Antioch-on-the-Meander), 612

Venus of Urbino (Titian), 488, 488, 501

Vermeer, Jan, 581; work of, 550, 566-567, 566 Veronese (Paolo Caliari), 496; work of, 494,

Verrocchio, Andrea del, 455, 468, 469, 507, 531, 532; Leonardo and, 458; work of, 427-428, 428, 429-430, 429

Versailles, Palace at, 583, 584, 587, 602; aerial view of, 576; Galerie des Glaces, 576, 577, 584, 585; Grotto of Thetis, 577; Hall of Mirrors, 576, 577, 584, 585; Louis XIV and, 576, 581; park of (Le Nôtre), 576-577, 578, 578; Royal Chapel, 578, 578

Vesta (Hestia), xv

Veteran in a New Field (Winslow Homer), 638,

Victory, portrayal in art, 541, 615 Video images, 793, 797, 801 Vie Inquiète (Uneasy Life) (Dubuffet), 747, 747 Vierzehnheiligen church (Neumann): interior of, 586; plan of, 586, 586

Vietnam Veterans Memorial (Lin), 782-784, 783, 790

Vietnam Women's Memorial Project, 783 View of Haarlem from the Dunes at Overveen (van Ruisdael), 564, 565, 566, 571

Vigée-Lebrun, Élisabeth Louise: work of, 593-594, 593

Vignon, Pierre, 651; work of, 612, 612 Villa at the Seaside (Morisot), 658, 659 Villa Rotonda (Palladio), 480, 481-482, 602, 605; plan of, 480

Villa Savoye (Le Corbusier), 740, 740, 780 Village Bride (Greuze), 593, 593

Viola, Bill, 801; work of, 798, 798

Viollet-le-Duc, Eugène, 642-643

Vir Heroicus Sublimis (Newman), 750, 751 Virgin and Child, 385, 412, 412, 435, 435, 458, 458, 459, 459, 482, 482

Virgin and Child (Fouquet), 412 Virgin and Child Enthroned with the Saints (Duccio di Buoninsegna), 385

Virgin Mary: Annunciation and, 434, 674; ascension of, 413, 485; portrayal of, 773; Saint Joseph and, 462

Virgin with Saints and Angels (Memling), 409 Vision after the Sermon, or Jacob Wrestling with the Angel (Gauguin), 667-668, 667 Visitation, xvi

Visitation group (Reims Cathedral), xvi Vitruvius, 444, 445, 455, 466, 480, 602 Voltaire (François Marie Arouet), 615, 622;

Enlightenment and, 590, 592, 616 Volume, in art, xxxi-xxxii Volutes, xviii

Voussoirs, xx

Vulcan (Hephaistos), xv

Walburga, Saint, 553 Walk Home, The (Schnabel), 764, 765 Walking Man (Rodin), 676, 677, 677 War Monument (Barlach), 719, 719

Warhol, Andy, 762, 776, 801; work of, 760-761, 760

Warrior, head of, xxxv

Washington, D.C.: Vietnam Veterans Memorial, 782-784, 783, 790

Washington, George: statue of, 605, 638 "Wassily chair" (Breuer), 738-739, 739 Water Carrier of Seville (Velázquez), 545, 545

Watteau, Antoine, 589, 607; work of, 586-588, 586, 587

Welding, xxxiv

Well of Moses (Sluter), 398, 399, 417

West, Benjamin, 605, 607; work of, 595-596, 596

Weston, Edward, 743; work of, 715, 715

Wet-plate technology, 646, 649 "When I put my hands on your body" (Wojnarowicz), 775, 775

Where Do We Come From? What Are We? Where Are We Going? (Gauguin), 668, 668

Whistler, James Abbott McNeill,

678, 708; Japanese art and, 661; John Ruskin on, 663; work of, 662-663, 662 White and Red Plum Blossoms (Korin), xxxii, xxxiii

Whitney Museum of American Art, New York, 709

Who's Afraid of Aunt Jemima? (Ringgold), 770,770

Wilke, Hannah, 801; work of, 769, 769 Winckelmann, Johann Joachim: as art historian, 599

Witches' Sabbath (Baldung Green), 506, 506

Witz, Konrad: work of, 414, 414

Wodiczko, Krzysztof, 775, 801; work of, 775, 775

Wojnarowicz, David, 775, 801; work of, 775, 775

Wolgemut, Michel: work of, 414, 415, 416 Woman Combing Her Hair (Archipenko), 700,701

Woman Combing Her Hair (González), 701, 701 Woman I (de Kooning), 750, 750

"Woman in the Year 2000" essay (Schneemann), 794

Woman with Dead Child (Kollwitz), 692, 693 Woman with the Hat (Matisse), 687, 687, 694 Women Artists: 1550-1950 exhibit, 540 Women Regents of the Old Men's

Home at Haarlem, The (Hals), 560-561, 560 Wood, Grant, 743; work of, 733, 733 Woodcuts, 415, 416, 417, 506

Worker and the Collective Farmworker, The (Mukhina), 729, 729

World Trade Center: Libeskind and, 789 World War I, 644, 685, 689, 692, 693; Futurists and, 704, 746

World War II, 729, 742, 745, 747, 765; devastation of, 746, 748, 776; postwar art, 793.801

Wren, Sir Christopher: work of, 580, 581 Wright, Frank Lloyd, 737, 743, 781, 801; influence of, 742; work of, 741-742, 741, 742, 778-779, 779

Wright, Joseph (of Derby), 597; work of,

Yoshihara, Iiro, See Gutai Bijutsu Kyokai Young, La Monte: Fluxus art and, 793

Zapotec culture, 736 Zeus (Jupiter), xv, 453, 671, 672, 759; statue of, xv, 606

Zurbarán, Francisco de, 549; work of, 544, 545